The Humanities
Cultural Roots and Continuities

SIXTH EDITION

VOLUME ONE
CULTURAL ROOTS

Mary Ann Frese Witt
North Carolina State University at Raleigh

Charlotte Vestal Brown
North Carolina State University at Raleigh

Roberta Ann Dunbar
University of North Carolina at Chapel Hill

Frank Tirro
Yale University

Ronald G. Witt
Duke University

With the collaboration of

John Cell
Duke University

Herbert L. Bodman Jr.
University of North Carolina at Chapel Hill

HOUGHTON MIFFLIN COMPANY
BOSTON NEW YORK

Editor-in-Chief: Jean Woy
Sponsoring Editor: Nancy Blaine
Associate Editor: Julie Dunn
Senior Project Editor: Aileen Mason
Editorial Assistant: Rachel Levison
Production/Design Coordinator: Jodi O'Rourke
Manufacturing Manager: Florence Cadran
Senior Marketing Manager: Sandra McGuire

Drawings by Eugene Wilson Brown, A.I.A.
Cover Image: Galleria Sabauda, Turin, Italy/Scala/Art Resource, NY

For permission to use copyrighted material, grateful acknowledgment is made to the
copyright holders listed on pages 509–510, which are hereby considered an extension of
this copyright page.

Printed in the U.S.A.

Library of Congress Catalog Card Number: 00-133866
ISBN: 0-618-04537-6

1 2 3 4 5 6 7 8 9-BBS-04 03 02 01 00

Contents

Illustrations

Preface

The sixth edition of *The Humanities: Cultural Roots and Continuities* has benefited from the suggestions of readers, professors, and teachers from a wide variety of geographical locations and teaching situations, as well as from our own rethinking of the problems involved in presenting the humanities and cultural roots for the twenty-first century. However, the spirit of the book remains basically the same.

The Western Humanities in Global Perspective

The Humanities still reflects our conviction that the Greco-Roman and Judeo-Christian traditions form the basis of the Western tradition and that the study of these should be at the core of a humanities course taught in North America. From the very first (1980) edition, however, we included a section on the West African cultural root, not only because many Americans are of African descent, but also because of the influence of African culture on Western culture generally. Recognizing that the Western humanistic tradition is itself in many ways a child of more ancient cultures in Asia and Africa, we added chapters on Mesopotamia and Egypt to the fourth edition. We also added a chapter on Islamic civilization to that edition. In the fifth edition, we introduced some of the major cultural traditions of the most ancient Asian civilizations: those of India and China. In this edition, that material has been divided into two separate chapters. Not only do we emphasize the influences of non-Western cultures on the West, we also stress that comparison with other traditions helps us to understand our own. Throughout Volume Two, we discuss at some length the influences of Asian and African cultures on Western culture and the intermingling of the civilizations—from the effects of imperialism and colonialism, for example.

Asia is of course a cultural as well as an ethnic root for an increasing number of citizens of the United States and Canada. In a book of this size and nature, we cannot present in depth the cultural traditions of India and China, not to mention those of Japan and the rest of Asia. As with Africa, what we *can* do is highlight certain features that either influence or make interesting contrasts with the Western Humanities.

Changes in This Edition

The purpose of many of our changes in this edition is to make the book more accessible to students. Thus we now begin each chapter with a "bulletin" of the central issues discussed in it as well as a brief chronology of significant dates. Each chapter ends with a number of summary questions, as well as a list of the key terms presented in it. Unlike a conventional summary, the questions should help students to organize and think about the material for themselves. We have retained—and in some cases revised—our questions on the literary selections, and we have added study questions for many of the figures. Another important new feature is the "Daily Lives" boxes, which present aspects of the lives of various people in relation to the cultural period discussed in the chapter.

Some of the changes represent our continuing commitment to represent the contributions of women and ethnic minorities to the humanities. To better represent women, we have added writing by and about women to the selections from the Bible, the letters of Heloise to Abelard in the medieval section, Laura Cereta's defense of woman's education in the Renaissance section, selections from Saint Teresa of Avila and Sor Juana Inés de la Cruz and paintings by Artemisia Gentileschi in the chapter on the baroque, Marie de la Vergne de Lafayette's contribution to the birth of the modern novel in the seventeenth century, Phillis Wheatley's contributions to the beginnings of African American literature in the eighteenth century, in the nineteenth century paintings by Mary Cassat and Berthe Morisot, and in the twentieth century an example of Marita Bonner's feminist writing in the section on the Harlem Renaissance, a selection from Simone de Beauvoir's seminal feminist manifesto *The Second Sex,* and poems by Rita Dove. Additions to representation of work by people of color (in addition to those just listed) include writings by the Americans David Walker and Frederick Douglass, and the Africans Léopold Senghor, Léon Damas, and Wole Soyinka.

Other changes reflect both specific requests by readers and our own rethinking. In the Greek section, we have substituted a selection from the *Iliad* for the one from the *Odyssey,* added material on the Pre-Socratics,

and substituted Euripides's *The Women of Troy* for Aristophanes's *Lysistrata*. We have made cuts in some of the Roman reading selections and eliminated the Byzantine poetry. We have made extensive cuts in the material on Chartres cathedral. A selection from Erasmus's *The Praise of Folly* now replaces *The Shipwreck*. The chapters on modernism now group together European and American modernisms, including the Harlem Renaissance and trends in Latin America. The postmodern chapter has been extensively rewritten and includes a story by the Brazilian writer Clarice Lispector. Many new works of art and music have been added throughout the text. We continue to print short poems in their original languages as well as in English translation and have added some poems in Spanish.

Purpose of the Book

Our commitment to a truly interdisciplinary introduction to the humanities through the concept of "cultural roots" remains the same. We feel that in an introductory humanities course the student's personal growth should take place on three levels—historical, aesthetic, and philosophical. The overall purpose of the two volumes can best be described by breaking it down into these three categories.

The Historical Level

We stress the concept of "cultural roots" because one cannot understand the culture in which one lives without some notion of what went into its making. In the "Continuities" sections that conclude each major part, we not only summarize the main points made about the cultures presented, but also attempt to link the "roots" discussed to aspects of the contemporary American cultural environment. This can be a knotty problem because such links can sometimes be too facile, and we also would like students to discover that cultures remote in time or space can be worth studying simply for themselves.

In our presentation of the humanities and of cultural roots in Volume One, we have attempted to focus on certain periods and monuments rather that to survey everything. For example, the focus for the Greco-Roman root is on Athens during the fifth century B.C. This means that some significant works of classical Greek drama, sculpture, and architecture can be examined rather extensively, in relation to each other, while archaic and hellenistic Greece receive a briefer treatment. Similarly, in our treatment of West Africa, we have chosen to focus on the culture of the Yoruba people, rather than to survey all of the cultures from this part of the world. When we study the "root" of the Judeo-Christian tradition in Judaism and in the Bible, with selections from the Old and New Testaments, we focus on the re-

lations of arts and thought in the Gothic cathedral, with the specific example of Chartres during the European Middle Ages. The chapter on Byzantium and Islam helps to clarify the context of this focal culture. As previously mentioned, our brief and introductory presentation of India and China highlights their impact on the Western humanities.

In Volume Two also, we have attempted to focus rather than to survey and spread thin. In our exploration of the Renaissance and Reformation periods we emphasize the fusion of the Greco-Roman and Judeo-Christian roots and focus on the development of humanism in fifteenth-century Italy and its diffusion in the north. The court of Louis XIV in the seventeenth century, the Enlightenment in France and America, the romantic movement, the Industrial Revolution, modernist movements, and the varied aspects of postmodernism all provide centers around which the many interrelated facets of the humanities can be discussed.

The Aesthetic Level

On the whole, we follow the same "focal" principle in the aesthetic domain. In presenting music, we operate on the assumption that a student will retain more from listening to and analyzing an entire work than from reading music history and theory and hearing snippets. In the presentation of major works of literature and art in the focal periods, we assume that it is more useful for a student to look at the whole of Chartres cathedral than to skim the history of medieval art, and to read all of *Oedipus Rex* rather than bits and summaries from several Greek tragedies. With lengthy works, such as epics and novels, this is, of course, not possible. We have thus chosen portions of the *Iliad,* the *Aeneid,* and *The Divine Comedy* that are significant in themselves and representative of the whole.

Dance, an often-neglected art form, is given more extensive treatment here than in other humanities texts. Entire dance compositions can, of course, be appreciated only in live performance or film, and we suggest that instructors exploit those resources as much as possible. Although some art forms may seem unfamiliar to students at the beginning, it has been our experience that a long introductory chapter on how to look, listen, and read is largely wasted; therefore, we cover such matters in the introductions to individual works. Questions on the nature of genre are considered in the cultural context in which they originated. We place much importance on study questions that require the student to read, look, and listen carefully.

Although we try to avoid jargon, we feel that some knowledge of the technical vocabulary of criticism in the arts is essential for literate discussion. Unfamiliar terms appear in italics in the text and are defined in the Glossary.

The Philosophical Level

It may well be objected that we compromise the focal method in our presentation of philosophy, because no entire philosophical works appear in the book. This is largely due to considerations of space; but it is also true that, when dealing with a work in terms of certain fundamental ideas rather than in terms of aesthetic wholeness, the "snippet" method is not objectionable. Beginning humanities students are probably not ready to read Aristotle's *Ethics* in its entirety, but they should be able to see how Aristotle's ideas are essential to the cultural roots of the modern world.

The student's personal growth in the philosophical area means, however, something much broader than his or her contact with formal philosophy. The (ideal) student—whose historical awareness is increased by an understanding of cultural roots and whose aesthetic sensitivity is heightened by personal confrontation with a variety of works of art—should also be able to grow intellectually through contact with diverse ideas. A humanities course should enable students to refine their thinking on the basic questions that affect all human beings, to formulate more clearly their personal values, and to discuss these with intellectual rigor rather than in vaporous "bull" sessions. Instructors should welcome debates that might arise from comparing Genesis and African mythology, the issues of women's role in society as raised by authors as diverse as Sor Juana Inés de la Cruz, John Stuart Mill, and Simone de Beauvoir, or the relative merits of modernist and postmodernist art, a Bach fugue and a jazz improvisation. They and their students will find many more such issues to debate.

Individual instructors will decide which aspects of the humanities they wish to emphasize. We believe that this book offers enough flexibility to be useful for a variety of approaches.

Supplements to the Text

To facilitate teaching and study, we provide a package of supplements available to all who adopt this text. It includes

- an art web site *(Frames: Interactive Art Gallery)* that features over 50 color art images from the text. Students will be able to read detailed descriptions of the works, link to additional art resources on the web, review key artistic terminology, and test their art knowledge with online quizzes. All works of art appearing on the *Frames* site will be designated in the text with a (**W**) in the caption line.

- a set of audio compact discs containing many of the musical selections discussed in the text

- an *Instructor's Resource Manual* with advice for using the text; suggestions for approaching the interdisciplinary study of the arts, literature, philosophy, and history; and extensive bibliographic and media resource information

- *ACE* online quizzes for students to test their knowledge of the text

- a *Test Item File* for instructors to use in building their own chapter tests and examinations

Mary Ann Frese Witt
Charlotte Vestal Brown
Roberta Ann Dunbar
Frank Tirro
Ronald G. Witt

Acknowledgments

Many people have contributed time, work, ideas, and encouragement to the creation of this book. Gratitude is due, first of all, to those who provided their own research and writing: In Volume One, Professor emeritus Herbert Bodman of the University of North Carolina at Chapel Hill wrote the material on Byzantium and Islam. In Volume Two, the late Professor Ernest Mason of North Carolina Central University wrote the introduction to Freud as well as the material on African American culture, and Professor John Kelly of North Carolina State University wrote most of the sections on Latin American culture. The largest contribution comes from Professor John Cell of Duke University, who wrote most of the material on Asia in both volumes.

The plan for the first (1980) edition of *The Humanities* grew out of the four years I spent initiating and directing an interdisciplinary humanities program at North Carolina Central University in Durham. It would not have been possible without the stimulation and aid of my students and colleagues there. The late Professor Charles Ray and Dean Cecil Patterson provided me with the time, encouragement, and wherewithal to create the program. The professors who worked closely with me—Elizabeth Lee, Phyllis Lotchin, Ernest Mason, Norman Pendergraft, Earl Sanders, Winifred Stoelting, and Randolph Umberger—have all left their mark on this book. The generous support of the Kenan Foundation, which provided the humanities program with a four-year grant, enabled me to research and compile much of the material. The Kenan Foundation also gave me the opportunity to attend numerous conferences on the humanities. The workshop given at North Carolina Central University by Clifford Johnson, of the Institute for Services to Education, also provided inspiration.

The book has benefited greatly from readings and criticisms by subject-area experts. The authors particularly wish to thank Dr. John Brinkman and Dr. Emily Teeter of the Oriental Institute of the University of Chicago for their careful work with the chapters on Mesopotamia and Egypt, and Dr. John Richards and Dr. Sucheta Mazumdar of Duke University for their suggestions on and rewritings of the chapters on India and China.

We are also grateful to the instructors who reviewed all or portions of this book: Janet L. DeCosmo, Florida A&M University; Barbara Frieling, Bainbridge College; Michael E. Green, Bethune-Cookman College; Terrance Lewis, State University of New Orleans; Caroline Marshall, James Madison University; Nancy Jo Mote, DeVry University, Phoenix; Erik Peterson, University of Minnesota-Duluth; Rosemary Fox Thurston, New Jersey City University; Derek A. Williams, Florida A&M University; and Jon Young, Fayetteville State University. Thanks are also due to Janet L. DeCosmo and Derek A. Williams for their work on the test bank.

We are especially grateful to the following people at Houghton Mifflin: Nancy Blaine for overseeing all of the changes in this edition, Julie Dunn for her careful editorial work and helpful suggestions, and Aileen Mason for overseeing the production process. We are also grateful to Irmina Plaszkiewicz Pulc and Marianne L'Abbate for their scrupulous and insightful copyediting of the manuscript, Warren Freeman for his proofreading, and Sherri Dietrich for her help indexing the book. We also wish to thank Andrea Long and Deborah Carver-Thien who helped with the preparation and the mailing of the manuscripts.

Finally, my collaborating authors deserve many thanks for their fine work and their support over the years.

Mary Ann Frese Witt

Chronicle of Events

	EGYPT/KUSH	MESOPOTAMIA-SYRIA-PALESTINE	GREECE	INDIA/CHINA
3200 B.C.	Union of North and South Egypt (3100) Writing used in Egypt (3100)	First ziggurats (3500–3000) Sumerian city-states (3400–3100) Cuneiform writing begins (3200)		
3000		Successive waves of Semites occupy Palestine		Indus Valley (Harappan) civilization (3000–2400)
2800	Tomb panels of Hesira (2750)			
2600	Old Kingdom (2686–2180) Zoser pyramid (c. 2650) Pyramids of Cheops, Chephren, and Mycerinus	Gilgamesh of Uruk (2600)		
2400	Settlement of Kerma	Agade Dynasty established by Sargon (2340)		
2200	Intermediate Period (2180–2140) Middle Kingdom (2140–1786)	Agade destroyed (2150) *Epic of Gilgamesh* (first text)	Minoan Palace construction begins on Island of Crete (Knossos)	
2000		Abraham (2000) Phoenician (Canaanite) city culture	Crete dominates Mediterranean	China: Xia Dynasty (2000) India: Aryan migrations (2000–1500)
1800	Second Intermediate Period (1786–1570) (Hyksos)	Babylonian Dynasty established: Hammurabi (1792)		
1600	New Kingdom (1570–1085)	Hittites destroy Babylon	High point of Minoan civilization (1600–1400)	
1400	Queen Hatshepsut (1504–1482)	Phoenicians develop alphabet Hebrews enter Palestine Moses (1290)	Destruction of Minoan Palace (Knossos) Mycenaean expansion	China: Shang Dynasty (1500)
1200	Akhenaton (Amenhotep IV) (1379–1362)	Judges Phoenicians flourish (1200–900)	Traditional date for sack of Troy (1184) Mycenae destroyed by Dorians (1100) "Dark Ages" of Greece (1100–700)	
1000	Third Intermediate Period and the Late Period (1085–332)	Saul made King of Hebrews (1025)	Greek colonies on Aegean Coast and Greek colonies in Asia Minor established	

	AFRICA	MESOPOTAMIA-SYRIA-PALESTINE	ROME	GREEK POLITICAL & CULTURAL EVENTS		INDIA/CHINA
1000 B.C.		Biblical texts written; David King of Hebrews (1000–961); Assyrian empire begins (1000–900); Ninevah capital (1000–900); Solomon (970–922); Hebrew kingdom divides into Israel and Judah (922)				China: Zhou Dynasty (1000–700)
900	Founding of Carthage (825)	Assyria conquers Phoenicians and Israel (876–605)		Homer?		
800	Napata rules Kush (750–270)		Mythical date for founding of Rome (753)	Archaic period (700–480); Beginning of *polis*	← Archaic Age (750–480) →	Iron replaces bronze in China
700	Kushite kings of Egypt (720–656)	Torah written (600–400); Nineveh falls (612); Neo-Babylonian Empire of Nebuchadnezzar (604–562); Jews taken captive to Babylon (586); Persians take Babylon (550); Jews return home (538); Darius of Persia (521–486)		Thales (640–546?)		China: Lao-Zi (6th cent.); Lifetime of Confucius (551–479); India: Cyrus captures northwest Pakistan (530)
600			Kings expelled and Republic created (509)	Sappho (c. 610–580); Beginning of drama and Panathenian festivals; Heraclitus (late 6th century); Aeschylus (525–456)		India: Death of Gautama Buddha (486)
500	Persia conquers and rules Egypt (525–335)			Persian Wars (499–480); Pericles (490–429); Euripides (480–406); Thucydides (470–400); Socrates (470?–399); Building of Parthenon (477–438); Peloponnesian War (431–404); Plato (427?–347)	← Classical Age (480–350) →	
400			Vigorous program of Roman conquest of Italy begins (343)	Philip of Macedon (382–336); Aristotle (384–322); Hellenistic period; Alexander of Macedon (the Great) (356–323); Epicurus (342–270); Zeno (322–264) and founding of Stoic school	← Hellenistic Age (350–150)	China: Mencius (390–305); India: Alexander the Great's Invasion (327–325); India: Mauryan Dynasty (321–180)
300	Alexander conquers Egypt (332); Greek dynasty rules (331–304); Meroe rules Kush (300 B.C.–350 A.D.)		I Punic War (264–241); Sardinia and Corsica annexed (238); II Punic War (218–201)			

Timeline

		INDIA/CHINA
China: Han Dynasty (206 B.C.–221 A.D.)		
China: Emperor Wu-Di (141–87)	Rome begins conquest of Greece	

200 B.C.
- Nok civilization at its height (200 B.C.–200 A.D.)
- Terence (195–159)
- Carthage destroyed (144)
- Rome conquers North Africa
- III Punic War (149–146)
- Cicero (106–42)
- Caesar (100–44)
- Lucretius (99–55)

100 B.C.
- Cleopatra VII last Egyptian Ruler (69–30)
- Occupation of Israel by Romans (63)
- Reign of Herod the Great in Palestine (37 B.C.–4 A.D.)
- Horace's *Satires* (35–29)
- Virgil's *Aeneid* (29–19)
- Augustus begins reign (27)
- Egypt becomes Roman province (30)

AFRICA	ROMAN EMPIRE	INDIA/CHINA

A.D.
- Birth of Jesus Christ
- Death of Augustus (14)
- Conversion of Paul (35); spread of Christianity
- Conquest of Britain (43–51)
- Persecutions of Christians by Nero (64)
- Sack of Jerusalem (70)
- China: First mention of contact with Roman Empire (97)

100
- Juvenal's *Satires* (c. 100)
- Roman Pantheon built (118–125)
- China: Use of paper (c. 100–200)

200
- Composition of Mishnah (200)
- Plotinus (205–270) and Neoplatonism
- Period of disorder (235–284)
- China: Period of Decentralization (220–589)
- India: Gupta Dynasty (320–late 400s) Ramayana and Mahabharata
- China: Diffusion of Buddhism (200s–400s)

300
- Reforms of Diocletian (280–305)
- Composition of Talmud (300–600)
- Construction of Old St. Peter's (c. 333)

AFRICA	WESTERN EUROPE	EASTERN EUROPE AND MIDDLE EAST	INDIA/CHINA
		Byzantium consolidates hold on area	Kalidasa

400
- St. Augustine (354–430)
- Alaric sacks Rome (410)
- Vandals sack Rome (455)
- Traditional date for end of Western Empire (476)
- Franks invade Gaul (486)

500

xvii

Year	AFRICA	WESTERN EUROPE	EASTERN EUROPE AND MIDDLE EAST	INDIA/CHINA
500		St. Benedict (480–542) St. Apollinaire, Ravenna (533–549) Pope Gregory I (540–604) Lombards invade Italy (568)	Justinian (527–565) extends empire in East and temporarily conquers part of Italy, Africa, and Spain—codifies Roman Law Hagia Sophia completed (537)	India: *Bhagavad Gita* composed China: Sui Dynasty (581–618)
600	Muslim conquest of Egypt (632)		Muhammad begins preaching (610) The Hegira (622) Muhammad dies (632) Dome of the Rock (completed 692)	India: Ajanta cave (600) China: Tang Dynasty (618–907) Establishment of examinations for government offices
700	Empire of Ghana (700–1230)	Muslim conquest of Spain (711) Defeat of Muslims at Poitiers (732) Musical notation invented Spanish amirate establishes independence at Cordova (756) Reign of Charlemagne (768–814)	Iconoclasts begin century-long campaign against images Abbasid Caliphate established (750–1258) at Baghdad	Muslims invade India (711)
800		Second period of invasions (c. 800–950): Northmen, Hungarians, and Saracens	Final restoration of images (843)	India: First Muslim entries (9th–10th cent.) China: Song Dynasty (960–1279)
900	Beginnings of Benin	Northmen establish Normandy (911) Otto I founds German Empire (962) First systematic teaching of Aristotle's *Logic* (975) Hugh Capet King of France (987) Great mosque of Cordoba completed		Fan Kuan (active c. 990–1030)
1000		Economic and political revival begins Spanish amirate splinters (1031) into small kingdoms Building of St. Sernin—Romanesque (11th and 12th centuries) Wipo, Gregorian Chant (1017–1056)		China: Appearance of movable type (1030)
1050		Norman invasion of England (1066) St. Bernard (1090–1153) Christians retake Toledo (1085) First Crusade (1096–1097)	East-West schism (1054)	
1100		*Play of Daniel* Rebuilding of St. Denis on new lines—early Gothic Letters of Abelard and Heloise (1130s)		Sufism (1100s)
1150		Averroes (Spain) dies (1198) Bernart de Ventadorn (late 12th century) Marie de France (late 12th century) Chartres Cathedral begun (1194)	Saladin, Kurdish ruler, captures Jerusalem from Crusaders (1187)	Chinese invent gunpowder
1200	Revolt of Mande peoples against Ghana (c. 1200) and rise of Mali Empire	Mongol invasion of Russia European embassy sent to China St. Louis (1214–1270) Aquinas (1225–1274) Chartres cathedral begun (1220–1260)	Conquest of Constantinople by Fourth Crusade (1204) Fall of Latin kingdom (1261)	Mongols invade China (1215)
1250				

Romanesque Style (11th and 12th centuries)

Gothic Style (12th–15th centuries)

Date	INDIA/CHINA	EASTERN EUROPE AND MIDDLE EAST	WESTERN EUROPE	AFRICA
1250	China: Yuan (Mongol) Dynasty (1279–1368) Marco Polo's travels (1271–1295)			
1300		Expansion of Ottoman Turks in Greece and elsewhere in Balkans (1308–1337)	Giotto (1267?–1337) Dante's *Divine Comedy* (1300–1321) Petrarch (1304–1374) Boccaccio (1313–1375) Salutati (1331–1406) Hundred Years War begins (1337) First appearance of Black Death (1348–1350)	Mansa Musa pilgrimage to Mecca (1324) Exploration of Canaries (1330s and 1340s)
1350	China: Ming Dynasty (1368–1644)	Unsuccessful siege of Constantinople by Turks (1397–1402)	The Alhambra (c 1354–1391) Bruni (1370–1444) Brunelleschi (1377–1446)	
1400			Chaucer's *Canterbury Tales* (1390–1400) Masaccio (1401–1428) Henry the Navigator founds navigation school at Sagres (1419) Piero della Francesca (1420–1492) Jeanne d'Arc burned (1431) Medici dominate Florence (1434) Alberti's *On Painting* (1435) Botticelli (1444–1510) Leonardo da Vinci (1452–1519) Lorenzo il Magnifico (1469–1492)	
1450		Constantinople falls to Turks (1453)	Gutenberg invents printing (1446–1450) Angelo Poliziano (1454–1494) Pico della Mirandola (1463–1494) Isaac's *On the Death of Lorenzo dei Medici* Erasmus (1466?–1536) Copernicus (1473–1543) Spanish Inquisition established (1478) Columbus reaches America (1492) Ferdinand and Isabella finish conquest of Spanish peninsula (1492) DaGama sails for India (1497)	John Affonso d'Aveiro visits Benin (1485–1486)

Renaissance Style (15th and 16th centuries)

	AFRICA	EUROPE	EUROPEAN CULTURE	NEW WORLD	INDIA/CHINA
1500	Duarte Pacheco Pereira's *Esmeraldo de situ orbis* (1507) Benin at the height of its power (16th and 17th centuries)		Michelangelo's *David* (1504) Raphael's *School of Athens* (1510–1511) Machiavelli's *Prince* (1513–1516) First edition of Erasmus's *Colloquies* (1516) Luther publishes German *New Testament* (1521)	First black slaves in New World (1505) Magellan circumnavigates the globe (1519) Cortez in Mexico (1519–1521) Verrazano establishes French claims in North America (1524)	India: Mughal Empire (1500s–1700s)
1525		Peasants' Revolt in Germany (1525) Henry VIII declares himself head of Church of England (1534) Jesuit Order founded (1540) Council of Trent (1545–1563)	Palestrina (1525–1594) Montaigne (1533–1592) First edition of Calvin's *Institutes* (1536) Copernicus's *Revolution of Heavenly Bodies* (1543)		
1550					

← *Renaissance Style (15th and 16th centuries)* →

Introduction: Defining the Humanities and Cultural Roots for the Twenty-First Century

●●

The last decades of the twentieth century witnessed an intense debate over the role of the humanities in education. Representing various positions in what have been called the "culture wars" or the "canon wars," the books and articles as well as the televised and Internet discussions on the subject raised some fundamental questions: Is there indeed a "core" of great works and other cultural information that all educated people should be familiar with? Is it vital to understand the cultural tradition of one's own country before exploring other traditions? If it is not possible to study all the cultures of the world, which ones should be studied? Furthermore, do we experience art, in any form, primarily through its universal appeal to all human beings or its reflection of the values of a certain culture?

Controversies

Although the "wars" are no longer raging, these questions bear directly on the criteria for choosing the texts and works of art that should form the core of a high school and university education in the humanities. The questions, however, have yet to be resolved in any definitive way. On one side are those who defend the notion of a canon—that is, a core group of works deemed central to education both because they have been authoritative in the formation of our culture and because they are "great" according to universal aesthetic or philosophical standards. On the other side are the cultural relativists, who take issue with the very notion of universal value. Arguing that the canon has tended to be white, male, European, and elitist, they prefer to choose works according to the author's gender, race, class, or culture. Faced with the pragmatic choice of what to read and study in a semester or a year, most teachers and students of the humanities fall somewhere in between these positions, trying to reconcile the universal, the canonical, and the multicultural.

This book attempts its own form of reconciliation. We [that is, the authors] believe that we cannot know where one is going unless we know where one has come from, and that an understanding of the Western humanistic tradition is crucial to an education in the humanities. At the same time, we emphatically agree about the importance of listening to the voices of women, ethnic minorities, and others who have been unjustly marginalized. We are well aware, too,

that the notion of cultural roots is becoming ever more global. We will return to that notion in the final section of this introduction. For now, let us attempt a definition of "the humanities" by first looking at the original formulation of the concept.

Development of the Western Humanities

Although every culture has its canon, or body of works deemed authoritative and of aesthetic or spiritual value, the notion of the humanities as an educational discipline is a Western one. It arose in Italy some six hundred years ago. The Renaissance humanists, reacting against a curriculum dominated by theology in the Middle Ages, passionately devoted themselves to reading Latin and Greek secular texts because they believed that human-centered inquiry should be revived. The studies that they called the humanities—in Latin, *studia humanitatis*—centered on the literature of antiquity.

The humanists considered the human individual the finest creature in God's creation and, like God, a maker, a doer, a creative force. Nonetheless, humans remained creatures, mortal and imperfect. The humanists' criticism of much medieval education was that it had concentrated on "man" as intellect outside a time frame. The human being was a product of history. A close study of the past, especially of the ancient Greek and Roman world, in which human achievement seemed to have been maximized, could guide people in the present and toward the future. Nor did the lessons of history contradict the truths found in the humanists' ultimate source of truth, the Holy Scriptures. For the humanists, moreover, the emotional component of human nature had to be recognized as a reality, and this recognition was the foundation for ethical development through the use of eloquence. Studying the writings of the ancients, models of eloquence, not only stimulated the mind but also aroused the passions to pursue the good. Having learned the lessons of effective presentation from the ancients, the humanists themselves not only helped others to lead a higher moral life but also, by conveying the message of Scripture, made their audience better Christians.

In spite of their affirmation of the basic dignity of all human beings, the Renaissance humanists believed that some were more "human" than others. According to them, those who studied the humanities acquired more "humanity," not only because they were able to think for themselves more creatively and to express themselves more fully but also because they gained a deeper understanding of people. Ideally, this kind of humanistic growth should be available to all. In practice, however, it was available only to those with enough wealth, family support, or patronage to have a certain amount of leisure. Moreover, the program of humanistic studies was, with a few notable exceptions, a male monopoly.

It is only fair to point out that people who called themselves humanists, in both Europe and America, have at times associated themselves with cultural elitism, blind worship of tradition, class oppression, and racism. Yet the study of the humanities has also served to stimulate creative men and women to redefine the humanist spirit for their own time. Seventeenth-century humanists in Europe allied themselves with scientists to fight for the liberty of the questioning human mind against the dictates of established authority. Eighteenth-century humanists, speaking out for religious tolerance and for liberty, equality, and fraternity, helped to create revolutions. Nineteenth-century humanists struggled to save the human spirit from threatening industrial growth and technological progress. They also considerably broadened the areas encompassed by humanistic study through the creation of new fields such as folklore, comparative religion, art history, and music history. Late-nineteenth- and early-twentieth-century pioneers in "Oriental" and African studies began the process of making us aware that the study of the humanities can include artistic and philosophical creations from traditions other than the Western one. Humanists such as the many intellectuals who fled Nazi Germany in the 1930s reaffirmed the humanistic demand for freedom of intellectual inquiry and artistic expression, as well as the opposition to oppression, intolerance, and fanaticism in all its forms. Humanists continue to struggle against dogmatism and narrow definitions of truth. One humanistic value seems to be a commitment to the fullest possible development of the intellectual, moral, and aesthetic faculties of individual human beings, along with a belief that the study of the humanities may at least contribute to that endeavor.

The Humanities Today

Although we have come a long way from a study confined to Greek and Roman literature, it is still relevant to our present concerns. A line from the Roman poet Terence, a slave of African origin, might in fact define an ideal modern humanist:

> *Homo sum; humani nihil a me alienum puto.*
> (I am a man; I hold nothing human foreign to me.)

The interest in everything human covers a very broad range indeed. It means inquiry into the world's cultures and into the wide range of disciplines and creations focused on human beings. The National Endowment for the Humanities has formulated a partial list of areas in the humanities:

> The humanities include, but are not limited to: history, philosophy, languages, linguistics, literature, archaeology, jurisprudence, history and criticism of the arts, ethics, comparative religion, and those aspects of the social sciences employing historical or

philosophical approaches. This last category includes political theory, international relations, and other subjects primarily concerned with questions of quality and value rather than methodologies.

Contemporary technology continues to expand the scope of the humanities to include productions for film, television, disk, and the Internet. The question of whether the book and the printed word as we know it will become obsolete is a very real one. At present, however, the study of books is still vital to our understanding of both past and present.

What, it may well be asked, can the study of the humanities do for a student at the beginning of the twenty-first century? We are no longer certain, as the Renaissance humanists were, that the study of the humanities will make one a better or "more human" person. Yet the study of the humanities should involve a process of individual growth and self-knowledge just as valid today as it was hundreds of years ago. Involvement in the humanities means stretching and expanding one's capacity for thought, sensitivity, and creativity. It means searching for the answers to fundamental questions, such as What are good and evil? What is the nature of God? What constitutes the good life and the just society? What is beauty? What is love?

The study of the humanities will not supply readymade answers to these or other questions, but it will provide contact with minds and imaginations that have pondered them, and it should help students to think more sharply and more critically. Understanding developed through work in the humanities may, it is hoped, change lives as well as ideas.

The Interdisciplinary Humanities

In this introductory text, we cannot pretend to deal with all of the fields mentioned above. Our focus is on literature, art history, cultural history, philosophy, and music, with some attention to dance, theater arts, and film. The interdisciplinary method of approaching the humanities stresses their relationships but at the same time makes clear the limits and boundaries of each discipline.

What justifies studying a poem or story, a building, a statue, a dance, a musical composition, and a work of philosophy together? One reason often given is enriched understanding of a particular human culture: for example, the study of the masks, dances, poetry, music, and religion of the Yoruba people will give more insight into their culture than will the study of their poetry alone. Another reason is that the comparative method enables one art form to shed light on another. A third, more general, reason is that all of these enable us to understand more about the human spirit and its creative capacity.

The various disciplines in the humanities are all concerned with human values, beliefs, and emotions and with the way in which these are expressed through human creations. Philosophy and religion embody more or less systematically organized values and beliefs, whereas works of art embody the creative expression of these values and beliefs. But these distinctions are not hard and fast. A philosophical tract may also be artistic, and a play or a painting may open up new dimensions in philosophy. The study of cultural history—of values and beliefs prevalent at certain times and places—helps to bind the humanities together, even if a given artist may oppose prevailing values and systems.

What do the arts have in common? Let us suppose that for the creation of a work of art basically two elements are needed: some kind of raw material and a creative spirit. Examples from the Western tradition include Michelangelo and a block of marble, Shakespeare and the English language, Beethoven and the tones of the scale and instruments of the orchestra. The artist works on the raw material, giving it shape and form. The finished product then bears the imprint of the artist's individual genius, but it also shows the influence of the cultural tradition and the era from which it comes. The combination of these constitutes its style. The work of art also has a certain subject matter, structure, and theme that are composed of the "fundamentals" of the art form used. All of these can be analyzed, step by step. A technical analysis of a work of art, though a necessary and useful step in the process of understanding, is still only a means to an end. The end can be called "aesthetic awareness"—the expansion of one's capacity to perceive meaning in art and react to it.

A humanistic education presupposes a willingness to open the mind and senses to the unfamiliar and to judge only after attempting to understand. And the interdisciplinary method invites speculation and comparisons that transcend traditional boundaries.

Culture and Cultural Roots

Culture, a word that has acquired many meanings in recent years, is in need of some definition. We all feel that we belong to a group culture, whose values we may either defend or reject; and in the educational process (broadly speaking, not limited to schooling) we also acquire an individual culture. In addition, we may classify certain works as belonging to "popular" or to "high" culture.

It may be useful to look at the root meaning of the word. In Latin, the verb *colere* means "to cultivate or till," and the noun *cultura,* "soil cultivation." Our word *agriculture* comes from this root and from the Latin word for *field.* Language often grows by metaphors, and the word *culture,* applied to human beings, suggests that the human mind, especially the mind of a child, is like a field that must be tilled, fertilized, planted, and *cultivated* by parents, teachers, and other

influential members of the society in which the child lives. Applied to an adult, it implies the acquisition of learning and knowledge not merely for their practical value but also for the growth of the mind in its intellectual, moral, and aesthetic capacities. It is in this sense that the African American poet Dudley Randall, describing the beliefs of the humanist W. E. B. DuBois, speaks of "the right to cultivate the brain."[1] We are, of course, vitally concerned with culture in this sense of individual development in the humanities. The Renaissance humanists believed, as we have seen, that this sort of culture was best acquired through the study of Greek and Latin literature. For most humanists today, the study of any and all of the fields considered to be humanistic may further this goal.

If the humanities are concerned with culture in an individual sense, they are also concerned with it in an anthropological sense. Let us return for a moment to the comparison between the child's mind and the farmer's field. As it is cultivated, that mind not only develops as an individual but also acquires certain habits, values, beliefs, and ways of thinking, seeing, feeling, and expressing that attach the child to a certain culture. When we use the word in this sense, it might help to think of its meaning in the biological sciences. Certain types of bacteria growing in certain types of environments are called "cultures." When we extend this notion to human beings, we are aware of what it means to speak of European culture, Asian culture, or African culture. More specifically, we may speak of Slavic or Latin culture, of Ibo or Bantu culture, or of Japanese culture. We may speak of American culture, or we may break it down into African American culture, Italian American culture, Midwestern culture, urban culture, rural culture, and so on. We may make other categories such as youth culture, female culture, male culture, or

Baptist culture. In other words, there are a variety of ways to slice the cultural pie.

Anthropologists looking at a culture are interested in its language, religion, social customs, food, and clothing; its moral and philosophical beliefs; its political, economic, and familial systems; and its plastic arts, poetry, tales, music, and dance. Humanists are interested in all of these as well, but primarily in a given culture's intellectual and artistic achievements. Ideally, in the study of the humanities, we should combine the two meanings of the word culture discussed here: we should both acquire individual culture and learn about a social culture. In reading a Greek tragedy or examining a piece of African sculpture, we learn something about the values, beliefs, and sense of beauty of a culture remote from us in time or space; but we also cultivate our own minds in the present through new aesthetic experiences and contact with unfamiliar ideas. Human beings differ from bacteria in that they can flourish and develop through exposure to cultures different from their own.

The matter of tracing our own cultural roots can be extremely complex. On the American continent, particularly, where so many of us have several different ethnic origins, we have all been influenced by a number of cultures. Although most would agree that the Greco-Roman and Judeo-Christian traditions still form the basis of American culture, particularly in the humanities, we are beginning to understand more fully the impact of other, diverse cultural traditions, such as the African and Asian ones represented here. We cannot, of course, study all possible cultural roots in an introductory course in the humanities. We hope that you will begin to explore your own cultural roots more fully by asking questions such as "what lies at the root of the ways in which I think, perceive, and express myself?" or "what are the origins of the books, films, TV programs, web sites, buildings, and music of my culture?"

Not everyone of you who reads this book will agree that all the works presented here form part of your "cultural roots." Nevertheless, if you are willing to experience them openly and creatively, they will become part of your personal culture.

[1] In "Booker T. and W.E.B." The relevant lines are: "Some men rejoice in skill of hand, / And some in cultivating land, / But there are others who maintain / The right to cultivate the brain."

Part I

• Earliest Civilizations

1 Mesopotamia

CENTRAL ISSUES

- The importance of the shift from a pastoral to an agricultural economy
- The role of the Tigris and Euphrates rivers in shaping Mesopotamian civilization
- The development of the first cities and their significance
- Sumerian architecture and music and their relationship to religious beliefs and rituals
- The concept of myth
- *Gilgamesh* as an epic poem and as a reflection of Mesopotamian values
- The Code of Hammurabi and its conception of justice

Since the beginning of human existence on this planet it has been generally agreed that three enormous revolutions have transformed the nature of our lives: the shift from hunting and gathering to food production, the birth of the city, and industrialization. The last revolution occurred relatively recently in the late eighteenth and early nineteenth centuries of our era in western Europe. The other two began in the Near East on the banks of the Tigris and Euphrates rivers between 9000 and 3000 B.C.

Revolutions in the Land Between Two Rivers

We can think of ancient Mesopotamia (the name means "between rivers"), the area now roughly equivalent to modern Iraq, as being divided into two zones. In the north were the foothills shut in to the north and east by the Taurus and Zagros mountains; below them to the south was the low and level plain. The plain was crossed by the Tigris and the Euphrates rivers, which came out of the

mountains, sloped southward for five hundred miles, and poured into the Persian Gulf. Whereas the northern third of the plain had substantial rainfall, the southern two-thirds consisted largely of barren desert except along the banks of the life-giving waters of the two rivers. Here, by contrast with the wastelands stretching beyond, the land, built up by deposits of topsoil carried along by the Tigris and Euphrates, was one of the most fertile areas in the world. (See map.)

Agriculture

The earliest societies of human beings lived by hunting and by gathering fruits, nuts, and wild plants. They lived in extended families composed of all their relatives. While the men hunted, the women cared for the children and did the gathering. Families were forced to move frequently in search of new game and other food supplies. The domestication of animals—first dogs, and then sheep, cows, and goats—appears to have begun in the foothills of Mesopotamia about 9000 B.C. It was followed by the cultivation of wheat and barley shortly before 9000 B.C. No longer compelled to keep constantly moving in search of food, families and groups of families could now build permanent shelters against the weather and fortifications against hostile people and animals. Because of more favorable living conditions, population increased, and by 6000 B.C., settlers were moving out of the foothills down into the two river valleys, where the rich land promised more abundant harvests.

To exploit the possibilities of the land, however, pioneers had to work and contrive. Of the two rivers, the Tigris was the more difficult to navigate. Both, however, overflowed their banks in March and April, just during harvesting season, occasionally carrying away fields and whole settlements. In the intense heat of the plain, moreover, the fields, which had been flooded in spring, were often parched for moisture by summer. Thus, settlers had to learn to harness the rivers by using canals and dikes so as to maintain a steady flow of water to the fields even when nature gave too much or too little. Archaeological evidence suggests that the beginnings of artificial irrigation came around 3400 B.C., coincident with the appearance of the first cities on the southern banks of the Euphrates. Among the first was Uruk (called Erech in the biblical Old Testament), controlled by the Sumerians, a people whose origins remain unknown.

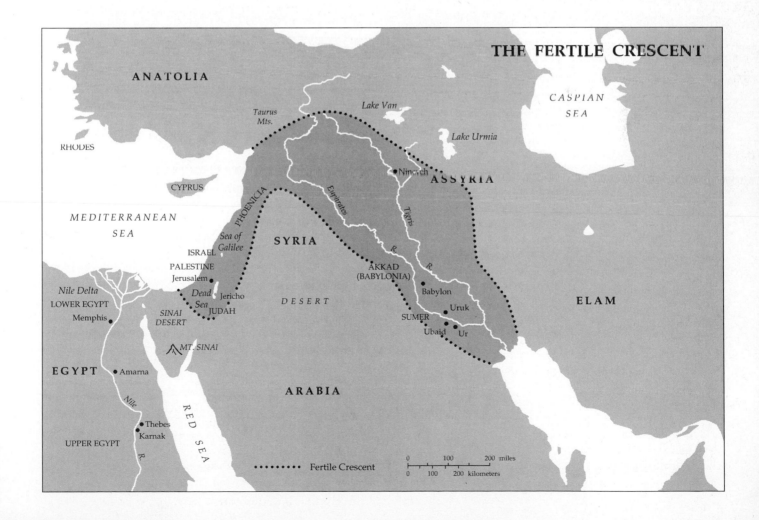

THE FERTILE CRESCENT

ANATOLIA · Taurus Mts. · Lake Van · CASPIAN SEA · RHODES · Nineveh · ASSYRIA · Lake Urmia · CYPRUS · MEDITERRANEAN SEA · PHOENICIA · Euphrates · Tigris · SYRIA · Sea of Galilee · ISRAEL · PALESTINE · Jerusalem · Dead Sea · Jericho · DESERT · AKKAD (BABYLONIA) · Babylon · Uruk · ELAM · SUMER · Ubaid · Ur · Nile Delta · LOWER EGYPT · Memphis · SINAI DESERT · JUDAH · MT. SINAI · EGYPT · Amarna · ARABIA · Nile · RED SEA · Thebes · Karnak · UPPER EGYPT

······· Fertile Crescent

0 100 200 miles
0 100 200 kilometers

Urbanization

With the founding of cities came an acceleration of cultural and technological developments, bringing into being the first urban and literate civilization. Urbanization, the second great revolution in human existence, with its specialization of arts and professions and its trade with distant regions, vastly enriched life. A large grouping of people, moreover, had a greater chance of permanence than a village vulnerable to the first attackers.

The three centuries from 3400 to 3100 B.C. mark the appearance of several of the arts of civilization: a calendar based on observation of the movements of celestial bodies, the first writing, and monumental architecture. Preoccupation with laying out canals and irrigation ditches encouraged the creation of arithmetic, geometry, and the art of surveying. Increased urbanization also led to important developments in architecture. The art of building could move from the construction of simple shelters and monuments for sacred places to specific types of houses and elaborate temples.

By 2900 B.C. the banks of the Euphrates River were occupied by at least twelve fiercely independent city-states. The pattern of the river delayed the creation of central government for centuries, however. The Euphrates broke up midway in its course into six channels and then recombined lower down. As it neared the Persian Gulf, moreover, it created a great area of marshland. This kind of landscape furnished natural defenses for cities and towns against an ambitious conqueror and nourished local independence.

By the beginning of the third millennium (3000 B.C.) the area was inhabited by a variety of different ethnic groups. However, the Sumerians appear to have dominated in the cities and they gave their name to the area. Their language had already taken written form at Uruk, and it became the written language of the whole area. Independent of one another, these Sumerian cities frequently warred among themselves over land and especially over water rights. The rise of Sargon, who established a dynasty at Agade about 2340 B.C., temporarily brought to an end this period of political independence by establishing a central government in Mesopotamia lasting about a century.

The Sumerian City In Sumer the city constituted the principal unit of organization. In the first centuries of city life political control appears to have rested in the hands of an assembly as it had previously in the village communities. There also seems to have been a council of elders, which gave direction to the business of the assembly and executed its commands. In times of trouble a leader was elected for the duration of the emergency, usually caused by the outbreak of war, and at the end of the trouble he was expected to resign. But when emer-gencies persisted or war followed war it proved easy for the leader to retain control so that by the last centuries of the Sumerian period these cities were ruled by kings from hereditary dynasties. Since they were originally elected, Sumerian kings, unlike the Egyptian pharaohs, were not regarded as living gods. The most celebrated of these early kings, Gilgamesh, king of Uruk about 2600 B.C., was said to have had a partially divine origin, yet the texts written about him, as we will see, recount that he suffered and died.

Sumerian Architecture and Art

A Sumerian myth about the moon god Nanna begins as follows:

> Behold the bond of Heaven and Earth, the city . . .
> Behold the kindly wall, the city . . .
> . . . its pure river . . .
> its quay where the boats stand
> Behold the Pulal, its well of good water
> Behold the Idnunbirdu, its pure canal . . . [1]

This fragment indicates something of the pride that the Sumerians took in their cities and also the importance of boundaries in architecture for the definition of living space. The high city walls of hard clay bricks enclosed individual private houses, shops, streets, shrines, temples, and the royal palace. Houses had only doors and tiny windows on the street. The life of the family was lived around an inner courtyard during the day, and at night, during the hot months, the family slept on the flat roof of the house. Houses of the prosperous were usually two floors high with a balcony around the courtyard. Pottery pipes buried deep in the ground carried away sewage and oil lamps were used for light.

The Temple

Early temples were freestanding shrines with a table for offerings and a niche for the statue of the god or goddess to be worshiped there. As urban centers developed, however, each adopted its own particular deity. The city then belonged to the patron god or goddess whom the inhabitants served as he or she provided for the city. This idea affected the architecture of the temple. Each temple was the household of a god or goddess who had a hierarchy of people and subordinate deities to serve him or her, from the high priest down to the diviners, exorcists, and musicians to the slaves who swept the courtyard. Associated with the temple building were granaries and workshops where artisans

[1] The Oriental Institute, the University of Chicago.

produced goods for consumption in the temple and for sale in the city and abroad. Outside the city walls lay large estates that grew crops and raised animals for the same purposes. Finally, the king and individuals made offerings from their private estates that supplemented the temple's own resources. Throughout the city there were also smaller temples for lesser deities.

To create a space set apart from the dense urban fabric, the temple complex within the walled city was itself walled. Eventually, this complex gave rise to a distinctive form, the *ziggurat* or temple-tower (Fig. 1-1). A ziggurat was created by stacking as many as seven layers of earth, with each succeeding layer becoming smaller and connected to the layer beneath it by ramps and stairs. As they grew, the ziggurats incorporated previously built smaller temples. At the top of this symbolic mountain—an intermediate territory between the earth and the sky—lay the temple, the place of the god's *epiphany* or appearance. Earth gods could dwell within such a temple, sky gods could stop off for a ritual meal, and the god or goddess of the city could reside there. One ziggurat was named the House of the Mountain, Mountain of the Storm, Bond between Heaven and Earth.

The idea that the ziggurat represents a sacred mountain that raises the temple on high and makes it visible from afar can be seen in the great ziggurat of Ur-Nammu at Ur (c. 2100 B.C.), a stepped pyramid in a number of levels, three of which survive (Fig. 1-2). The core was mudbrick, with the exterior faces made of baked brick set in bitumen mortar. Three stairways formed an approach on the northeast side, one set at right angles to the building, the other two leaning against the wall. They met at the foot of a gateway to a great stairway, which ran straight up to the front of the temple door. Planted trees graced the upper terraces, colored tiles supplied further decoration, and *weep holes* cut into the fabric allowed interior moisture to seep out. At some sites exterior walls were curved slightly and battered inward; at others the walls were whitewashed. In later periods glazed bricks would create distinctive, bright-colored surfaces that sparkled in the sun.

The distinctive structure of a sacred mountain—the ziggurat—in the flat, low-lying plains of Mesopotamia necessitated a winding journey along the processional way to the altar of the god. One writer has called it "reverential climbing"; another the bent-axis approach in which the object of the pilgrimage not only is hidden from view but also demands many steps and turns before the approach to the god can be made. It will be interesting to compare this processional way with that of the Egyptians, who lined up different architectural spaces on a long axis to create a processional way with a variety of architectural experiences. "Reverential climbing" also forms an important aspect of many Greek temple complexes, discussed in Chapter 4. The

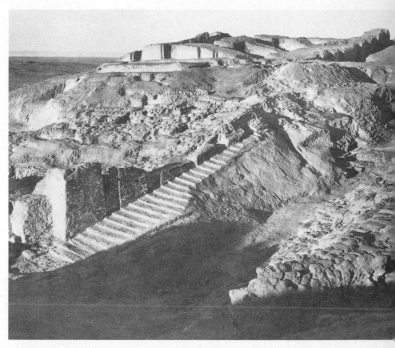

1-1 *The White Temple on its ziggurat, Uruk (present-day Warka, Iraq), c. 3500–3000 B.C. (Courtesy, German Archaeological Institute, Berlin)*

winding approach has some parallels with the Minoan Labyrinth or maze of Bronze Age Crete (3000–1100 B.C.), which has been interpreted as an ascending way made flat.

Sumerian Art

The city, the temple, and the palace complexes were all means for rulers, religious or secular, to give physical, objective expression to power, just as the individual's dwelling describes something about his or her place in society. The forms of the Sumerian city and its buildings provide us with our first encounter with a fairly complete building language. The wonderful artifacts from Sumer introduce us to an artistic language. Objects made by Sumerian artists derive from a cluster of shared ideas or traditions about the way to depict the human figure, the landscape, and events. To be sure, the objects were never thought of as "art objects" in our sense of the term. Rather, they were highly functional, while still aesthetically pleasing, like the cave paintings or carvings of prehistoric people. The objects that have been preserved help us understand the powers that shaped life in the land between the rivers.

The art objects can be roughly divided into three major categories: ritual objects, objects of state, and personal objects. Among the earliest three-dimensional survivals are a stunning collection of marble statuettes from the Abu Temple at Tell Asmar, c. 2700–2500 B.C.

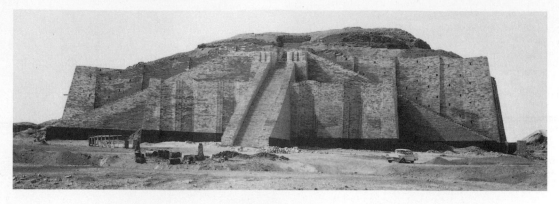

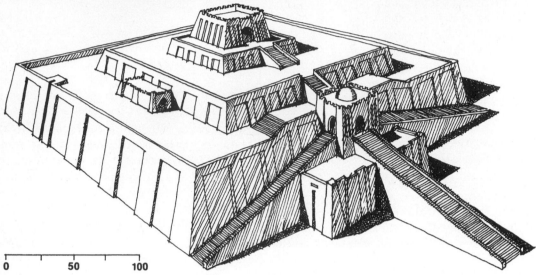

1-2 *Ziggurat of King Ur-Nammu, Ur, c. 2100* B.C. *(Hirmer Fotoarchiv, Munich) with reconstructed view below.* (**W**)

▲
- How does the form remind you of a mountain?
- Could every worshipper climb directly to the top?
- Why do the walls lean inward?
- What parts of the temple would have been brick and what parts fill dirt?

(Fig. 1-3). The tallest figure (about thirty inches) represents Abu, god of vegetation; the next tallest, a mother goddess. The next largest figures are priests and the smallest are worshipers. The cylindrical bodies, scarcely differentiated by gender, with their uplifted heads and their hands clasped on the breast, create powerful images and feelings. The symmetry and abstraction of the human form, concealed within the long skirt, and the reduction and stylization of textures to represent cloth and hair reinforce the riveting aspect of the faces dominated by the vast eyes, whose cavities would once have been inlaid with colored stone or enamel. These are not silent figures; they seem to speak, if in unfamiliar sounds, as they stare open-eyed, offering constant supplication to their god on behalf of their donors.

A panel from the Standard of Ur, c. 2600 B.C., shows Scenes from War (Fig. 1-4), a seemingly full-time business in this period. The people depicted here bear a strong resemblance to those from Tell Asmar, and many of the same artistic ideas are used: repetition, simplification, and abstraction. The standard depicts an image of war that is both organized and brutal.

The experience engendered by these artifacts is quite different from that created by an offering stand from Ur, c. 2600 B.C. (Color Plate I). Here a wooden, gold-fleeced ram made of a wood core overlaid with metal stands upright before a golden, flowering tree. The bearded face, bright eyes, curling horns, and springing flowers are filled with energy and power, perhaps the power of the god Tammuz, the male principle in nature. The maker of this stand has used artistic principles similar to those of the Tell Asmar statuettes. The figure is abstracted, the fleece reduced to repeated curling patterns. However, the more pliant materials, carved wood overlaid with thin sheets of gold, create a lively creature that glitters with life and energy.

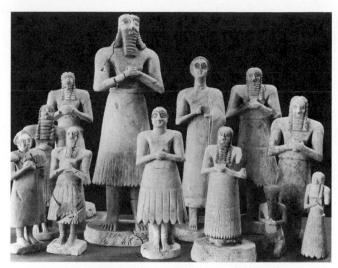

1-3 *Statuettes from the Abu Temple, Tell Asmar, c. 2700–2500 B.C., marble. (The Iraq Museum, Baghdad, and the Oriental Institute, University of Chicago)* (**W**)

Sumerian Mythology, Religion, and Worship

Concepts of Myth and Mythology

The terms *myth* and *mythology*, used in a variety of ways, need some clarification. In popular usage, a myth designates something that the person using the word believes to be untrue even though many people may accept it as true. Thus we speak of myths created by advertising or the myth of pure and honest government. Used by psychologists, anthropologists, or literary critics, however, the word has a much broader meaning, one that is nearly the opposite of its popular one. It comes from the

◀

- What is meant by symmetry and abstraction in relation to the human form presented here? How do these terms apply to the *Ram in the Thicket* from Ur (Color Plate I)? Do you think the statuettes look like specific Sumerians who have been chosen to represent deities? Why or why not?
- How are the figures on the panel from the Royal Standard of Ur, in Figure 1-4, like the Tell Asmar statuettes?
- Find images on the panel that support the statement that war was both organized and brutal.
- Find figures on this panel that are like figures on the Stela of King Naram-Sin (Fig. 1-10).

Greek word *mythos*, which can mean "a word" or "a story." Every culture in the world has or has had a set of stories passed down orally from one generation to the next that are called its myths; the body of a culture's myths is its mythology. Myths differ from legends in that they are not usually based on historical events situated in time. Myths take place outside of historical time, in what students of mythology call "sacred time" and the Australian aborigines call "dream time." They often attempt to explain the origins of some phenomenon of nature such as the creation of humankind or why the sun rises and sets. Their characters are gods, sacred beings, or semidivine heroes and heroines. Studies in comparative mythology show that many figures such as the sky god, the earth goddess, the vegetation god, the divine child, and the virgin mother are, with different names and in various forms, found in widely divergent cultures, which apparently had no influence on each other. Calling such figures *archetypes*, the Swiss psychoanalyst Carl Gustav Jung (1875–1961) postulated a "collective unconscious" from which human beings draw their vital myths.

1-4 *A panel from the Royal Standard of Ur, sounding box of a musical instrument, decorated with mosaic in shell, lapis lazuli, and set in bitumen, showing Scenes from War, c. 2600 B.C., 18½″ × 8″. (Reproduced by Courtesy of the Trustees of the British Museum)*

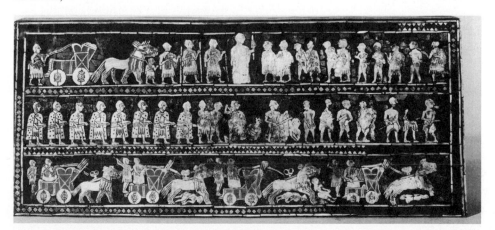

Far from being a pack of lies, as popular usage would have it, the myths of a particular culture represent for that culture the deepest form of truth—a reality that is lived and practiced through ritual. For those outside of the culture they may also portray profound human truths, whether in a psychological, sociological, or spiritual sense. Thus we may distinguish between mythological truth and factual truth.

The notion of "mythological truth" also informs the way in which Western culture views its own religions. After the work of Charles Darwin and of biblical criticism in the nineteenth century, many believing Jews and Christians found that they could no longer accept the account of the origin of the world and of humanity given in Genesis to be true in a literal sense; and yet most believers today accept it as true in a symbolic, religious, or mythological sense. Religion, of course, is much more than a particular set of myths, although these are part of it. The word means a "binding together" and implies a system of beliefs, rituals, and standards of conduct. Great world religions such as Judaism, Christianity, Islam, Hinduism, and Buddhism have given human beings a core of meaning to their lives outlasting political change, scientific discoveries, and other cultural developments. The religion of ancient Mesopotamia, despite its fascinating mythology, was not one of these.

Mesopotamian Religion

It is somewhat difficult to generalize about the religion of the Mesopotamians since they had numerous gods and goddesses whose names and attributes shifted according to city and era. However, the Sumerian concept of creation seems to have been as follows. The primeval sea, which may have existed eternally, begat the cosmic mountain consisting of heaven and earth united. The Sumerian word for universe, *an-ki*, literally means "heaven-earth," and denotes the god An and the goddess Ki. From their union was born Enlil, the air god, who is usually depicted as the most powerful god of the pantheon. From An and Ki also sprang Ninhursag, or Aruru, the Great Mother or goddess of procreation, and Enki, or Ea, the god of flowing water. Many other gods and goddesses were born of these, but the most important for our purposes are Shamash the sun god and Inanna (Sumerian) or Ishtar (Semitic), the goddess of love and war. Human beings were created so that the gods would have servants, or as the Babylonian creation epic puts it, "Man shall be charged with the service of the gods, that they might be at ease." There was no one creator god, but the Great Mother goddess, perhaps like a potter, is usually depicted as creating human beings out of clay. In addition to the patron deity of the city, each person had his or her own personal deity.

The Mesopotamians' idea of an afterlife was quite different from that of other religious traditions. Although they believed in an underworld where something of the person survived after death, this was a place neither of punishment nor of reward, but (so it seems in the *Epic of Gilgamesh*) a dark, dusty cave where the crowded shades of the dead bumped into each other like bats. Those dead remembered and cared for by loved ones still on earth fared better than those who were forgotten, but death brought with it no promise of a better life. Only one man, Utanapishtim, and one woman, his wife, were given immortality by the gods. Utanapishtim is in many ways the equivalent of the biblical Noah: as in the Bible when the great flood destroyed humanity, Utanapishtim built an ark with a pair of each species so that the world would be peopled again after its destruction. He and his wife were said to reside in the mountain of the gods. This story figures importantly in the *Epic of Gilgamesh*.

Since the Sumerians believed that the gods had created humans to serve them, one of the duties of the temple staff was to make sure that the statues of the gods were fed regularly. If properly cared for, the gods would bring wealth and power to the city that worshiped them. Writing in about 2250 B.C., a poet praising the generosity of Inanna, goddess of love and patron of his city Agade, captures the belief in these lines:

> Inanna filled Agade, her home, with gold.
> She filled the radiant house, her home, with silver.
> She filled the storerooms with barley, bronze, and
> lumps of lapis lazuli . . .
> She gave its elderly women the gift of good counsel.
> She gave its elderly men the gift of wise counsel.
> She gave its young girls the joy of dancing.
> She gave its young men the strength of weapons.
> She gave its little ones a joyful heart . . .
> The ships at the wharves were an awesome sight.
> All the lands around rested in security.
> The people saw beautiful things.
> The king, Naram-Sin, shone forth like the sun on the
> holy throne of Agade.[2]

Several times a day in an elaborate ritual the god was served an abundant meal. Course after course was set before the statue to the accompaniment of music and the sprinkling of incense. The hands of the god were washed both before and after meals. Here is the daily menu of the god Anu at Uruk:

12	vessels of wine	2	bulls	4	wild boars
2	vessels of milk	1	bullock	3	ostrich eggs
108	vessels of beer	8	lambs	3	duck eggs[3]
243	loaves of bread	60	birds		
29	bushels of dates	3	cranes		
21	rams	7	ducks		

At special festivals unusual cakes were also offered. Except for leaving offerings with the priests for the divine

[2] The Oriental Institute, the University of Chicago.

[3] Ibid.

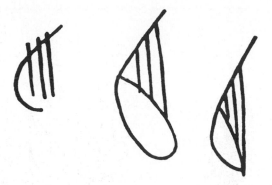

1-5 *Sumerian characters, representing boat-shaped harps, copied from stone tablets, c. 2800 B.C. (From Wilhelm Stauder,* Die Harfen und Leiern der Sumerer, *Frankfurt, 1957)*

meal, however, private individuals had nothing to do with this cult. The only time they came into contact with the public gods was when the deities' statues were brought out of the temple and were carried through the streets in procession.

Sumerian Music

Dancing, as the poem above indicates, was considered one of the joys of city life. Pictorial evidence, as well as fragments of instruments excavated from the royal cemetery at Ur, suggests that music was also an important part of religious and civic life in Sumer. We can no longer hear the sounds as they were performed thousands of years ago, but we can reconstruct the instruments, imagine the sounds and rhythms, and visualize the rituals of court and temple. From approximately 2800 B.C., harps were made in the form of a boat with a keel-shaped soundbox and eleven to fifteen strings that slanted up to the neck, which ran up like a mast from the prow (Figs. 1-5, 1-6). A decorative cap of silver or gold at the end of the neck gives some indication of the value placed on the instrument. Although we know that copper and gold pegs were used to secure and tighten the strings, we will never be able to discover the exact tunings this instrument enjoyed.

In Sumer the bull was a symbol of fertility and divine power, and another musical instrument, the lyre, was fashioned on its figure. The bull's body could act as the resonant soundbox with two necks and a cross brace rising to stretch the strings, but instruments in the shape of a bull's head alone, with two large horns rising symmetrically on each side to stretch the strings, were also used in performance during the Sumerian period (Fig. 1-7).

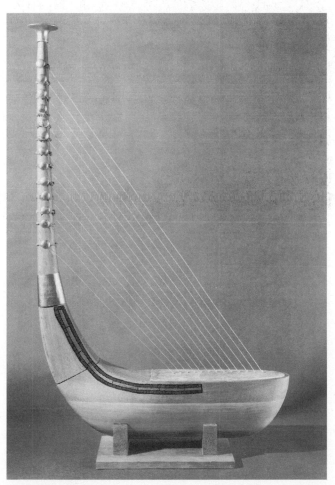

1-6 *Reconstruction of a boat-shaped harp from the Royal Cemetery at Ur, c. 2600–2350 B.C. (Reproduced by Courtesy of the Trustees of the British Museum)*

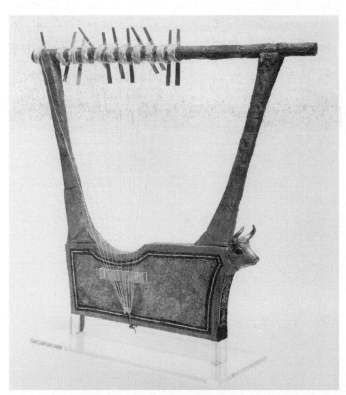

1-7 *Reconstruction of a silver Sumerian lyre from the Royal Cemetery at Ur, c. 2600–2350 B.C. (Reproduced by Courtesy of the Trustees of the British Museum)*

● D A I L Y L I V E S ●

•••• A Day in School

From the beginning of their training, students specialized in writing for one of the various fields where documents were needed: the temple, business, the army, and medicine. Most schools were located in buildings adjoining temples. The schoolroom was of moderate size, with clay benches fixed to the floor and a number of large earthenware receptacles around the room. These receptacles contained wet clay, which could be taken out and kneaded into tablets when the students used up the ones they had. Learning was by rote: the students repeated aloud phrases spoken by the teacher and made a copy of the phrases on their clay tablets below the same phrases already written on the tablets by the teacher. Gradually the students built up a treasury of expressions connected with the branch of affairs in which they intended to specialize. An educated scribe was expected to know which ones should be put together in order to compose a document appropriate to a particular situation.

Mastering the art of cuneiform writing was not an easy task, and the majority of the population, including royalty, was illiterate. Reading and writing were the tasks of specialized scribes, who included both men and women. To become a scribe, one had to begin to attend school as a child.

In one surviving clay tablet called "School Days," from the eighteenth or seventeenth century B.C., a pupil describes life at school. Here are two excerpts:

> The days I spend in school are as follows:
> My vacation days are three days a month,
> Various festivals are three days a month,
> That leaves twenty-four days a month in which I sit
> in school.
>
> My mother gave me two pieces of bread and I went
> to school.
> In school the supervisor asked me, why are you
> late?
> I was afraid. My heart was pounding.
> I entered into the presence of the masters.
> I bowed down, and I recited my tablet to the Master
> of the school.
> He said, "You are going to be beaten because you
> left out some lines."[a]

a. The Oriental Institute, the University of Chicago.

Dancing girls used clappers to provide rhythmic accompaniment for their dance, and eventually drums and wind instruments made their appearance as well.

It is unlikely that concerts of music, as we know them today—public concerts by professional musicians in spaces designated for music—took place in antiquity, for such events are neither described nor pictured. We also know nothing about independent instrumental music in Sumer. We believe music was inseparably linked to the recitation or intonation of poetry used for ritual occasions. Music was used in the daily celebration of temple rites, during the annual holy festivals, and on special occasions such as a birth in the royal family, a marriage of rulers or gods, the construction of a palace or temple, or the burial of a head of state. The words of hymns and laments are preserved in cuneiform texts, but no melodies were recorded in writing, for not only was there no developed system of notation (a means to indicate pitch and duration), but the melodies were considered priestly secrets to be transmitted orally from elder to neophyte.

Literacy and Literature in Mesopotamia

One of the great inventions of Mesopotamian civilization was the art of writing. The very earliest writing system (using clay tokens) dates back before 7000 B.C., but the invention of writing, with the first setting of words on tablets, is generally dated 3200 B.C. The Sumerians developed a system of signs in which each sign seems to have represented a single word. Dominated by wedge shapes, their writing system is called cuneiform, from the Latin word *cuneus*, "wedge" (see Fig. 1-8, a tablet of *Gilgamesh*). The writing was done on soft clay tablets with a reed stylus. The earliest tablets that we possess are economic records and vocabulary lists for training scribes. Later, writing was used for legal transactions, receipts, historical records such as lists of kings, sacred texts, and works of literature. Letters were sent by wrapping a tablet in a clay envelope, sealing it with a cylinder seal, and having a messenger deliver it. The earliest writings were in Sumerian; after the conquest of Sargon about 2340 B.C. (see page 16), Akkadian be-

1-8 *A fragment of the eleventh tablet of the* Epic of Gilgamesh, *Nineveh, showing cuneiform writing, c. 800–600* B.C., *clay, 5¼″ × 5¾″ × 1¼″. (Reproduced by Courtesy of the Trustees of the British Museum)*

came the dominant language. Not until the 1850s did scholars decipher the complex cuneiform script.

In the course of their training, scribes copied texts from the traditional writings of Mesopotamia. Roughly two hundred thousand lines of these writings were preserved in the library of Ashurbanipal, an Assyrian king of the seventh century B.C. They include myths, laments, songs, and proverbs. For the modern reader, the most interesting are the tablets that form the *Epic of Gilgamesh*, discussed below. Other surviving examples include "The Instructions of Shuruppak"—some 280 proverbs consisting of the king's advice to his son—the earliest copies of which date from 2500 B.C. Among the proverbs are these: "Heaven is far away, but earth is precious" (you will notice how this might be applied to *Gilgamesh*); "Love maintains a family"; and "Do not speak arrogantly to your mother; you will be hated." Songs praising kings were frequent, as were praise songs or prayers to the gods.

The Epic of Gilgamesh

The most important literary work from Mesopotamia that has come down to us concerns a historical and legendary figure who was probably king of the city of Uruk around 2600 B.C. Gilgamesh was revered as a great

hero, and the various legends that grew up about him were written in both the Sumerian and Akkadian languages. Although the first clay tablets about Gilgamesh may have been written not long after his actual rule, we have no existing texts written before 2100 B.C. What has come to be known as the "standard version" of the Gilgamesh story consists of eleven cuneiform tablets in Akkadian, written in the first millennium B.C. (see Fig. 1-8). Some scholars believe that they were originally written by a single author, Sinlequeunninni, a priest at Uruk in the fourteenth century B.C. Unfortunately, we do not have any complete version of the story of Gilgamesh; many of the clay tablets are broken, so that several parts are missing, but it is hoped that these may eventually still be discovered. Yet the basic story line is clear. Gilgamesh, who established Uruk as the supreme city in Mesopotamia, was thought to be two-thirds divine and one-third human. Renowned for both his strength and his beauty, he nonetheless overstepped the boundaries of his duties as king by oppressing the young men and women of the city. The gods decide to create a counterpart to Gilgamesh with Enkidu, the "wild man," who lives with animals. A trapper, who finds that Enkidu is disturbing his hunting, devises a plan to strip him of his animal powers. He goes to Gilgamesh and asks for a love-priestess or temple prostitute. The woman, who stays with Enkidu for "six days and seven nights," begins to "civilize" him. She also leads him to Gilgamesh, and after a wrestling match that Gilgamesh wins, the two become close friends, indeed brothers, since Gilgamesh's mother adopts Enkidu. They decide to go off on an expedition to kill the monster Humbaba, the guardian of the Cedar Forest. Despite Gilgamesh's terrifying dreams and Enkidu's fear, they continue their journey, urged on by the sun god Shamash, and Gilgamesh finally kills the monster (Fig. 1-9).

1-9 The Slaying of Humbaba. *An impression of a Neo-Assyrian period cylinder seal, c. ninth–eighth century* B.C. *(Reproduced with the permission of Dr. Leonard Gorelick)*

Once they are back in Uruk, the goddess of love and patron of the city, Ishtar, smitten with Gilgamesh's strength and beauty, asks him to become her husband. Gilgamesh, however, refuses, citing the terrible fate that has befallen all of Ishtar's many lovers. Insulted, the goddess convinces her father, Anu, to send the Bull of Heaven to punish Gilgamesh, but Enkidu and Gilgamesh succeed in slaying the bull. The gods decide to kill Enkidu in revenge. After a long illness, watched over by his devoted friend, Enkidu succumbs to death and Gilgamesh to a profound grief. Fearing his own death as well as mourning his friend, Gilgamesh decides to undertake a journey to meet Utanapishtim, the only man to have been granted immortal life, in order to learn from him his secret. He reaches the mountain of the gods but is warned of the impossibility of his quest by all the creatures he meets. He nevertheless succeeds in reaching Utanapishtim, who tells him a "secret of the gods," the story of the Flood resembling the account in Genesis. Utanapishtim's wife persuades her husband to give Gilgamesh a plant that will make him young again, but on the way home he loses it to a snake. At the end, Gilgamesh returns to Uruk to continue his reign. Although he has learned that there is no immortality, he has also learned to value the accomplishments of earthly life such as the construction and ruling of a great city.

What kind of a poem is *Gilgamesh*? The word *epic*, although invented by the Greeks considerably later to characterize the *Iliad* and the *Odyssey* of Homer, may be used to classify this first story of a cultural hero, as well as many other such stories from around the world. The epic is centered on a human rather than a divine figure, and recounts the famous deeds of a hero important to the audience. Yet the hero may also undertake a quest and in so doing face anguish and loneliness resembling a kind of symbolic death and rebirth. Often this journey involves a visit to the underworld or to the realm of the gods. The *Epic of Gilgamesh* may be divided into two parts, the first celebrating the hero's strength and exploits and the second recounting his "dark night of the soul" and his quest. Although remote and strange to us in many ways, *Gilgamesh* nevertheless speaks vividly to the modern reader.

1-10 *Stela of King Naram-Sin, from Susa, Iran, c. 2300–2200 B.C., sandstone, height 78", Louvre, Paris. (Copyright PHOTO Réunion des Musées Nationaux)*

▲

- Explain why some figures are larger than others.
- How do you know that a holy mountain is depicted here?
- Compare the organization of figures here with that on the Royal Standard of Ur (Fig. 1-4).

Mesopotamian Empire: The Akkadians at Agade (2340–2150 B.C.)

None of the many cities of Mesopotamia dominated the whole region until 2375 B.C., when the king of Sumer united the country. But only thirty-five years later, in 2340 B.C., Sumerian power was overthrown by Sargon, who was from Akkadia, located north of the main concentration of Sumerian cities. During his long reign (he is reported to have ruled for fifty-six years), Akkadian, also written in cuneiform, became the official language of the area, although scribes still learned Sumerian as a "classical" language. Soon after assuming power, Sargon created a new capital city, Agade, which was to become the center of an enormous empire.

Indeed, before his death, Sargon conquered all of southern and northern Mesopotamia and moved with his armies into Syria and Anatolia, which is now part of modern Turkey. His grandson, Naram-Sin (praised in the poem on page 12), is reported to have pushed these conquests into the eastern Mediterranean. The victory stela of Naram-Sin (Fig. 1-10) shows the king above the ranks

of his soldiers as well as the defeated, who plead for mercy. Larger than all the other figures, Naram-Sin wears the horned crown usually reserved for the gods. Only the top of the mountain and the celestial bodies, his "good stars," appear above him. The carving shows that the Akkadians absorbed the artistic language of the Sumerians just as they appropriated their writing, and they turned that language to the glorification of the king.

Domination of such an enormous territory, however, required genius, and under Naram-Sin's less fortunate successors, the kingdom of Akkad decayed. Ferocious tribes from the mountains burned Agade itself about 2150 B.C., and a three-hundred-year period of confusion followed. By 1800 B.C., Mesopotamia was again a united country, with Babylon as its capital.

Babylon, 1800–1600 B.C.

Hammurabi, crowned king in 1792 B.C., became the first ruler of the Babylonian empire. The literally thousands of written records surviving from his reign reveal the city of Babylon on the southern Euphrates as a great center for international trade. Precious stones from the Persian Gulf, cotton cloth from India, and exotic spices from Egypt competed for purchasers in the city's bazaars. Of all the written documents of the period, perhaps the most important is the Code of Hammurabi, recorded on an eight-foot-high block of basalt stone covered with writing in horizontal columns. At the top of the block Hammurabi is depicted in the act of receiving the symbols of kingship from Shamash, the sun god and lawgiver (Fig. 1-11). Stylistically, the Babylonians did little to change the artistic language of their predecessors. The figure of Hammurabi has the intense gaze that recalls the oversized eyes of the Sumerians from Tell Asmar (Fig. 1-3). But the gift that Hammurabi receives is nothing less than a code of the 282 laws written on the block.

Assyria, 1000–600 B.C.

The kingdom of Babylon lasted until about 1600 B.C., when it fell to the Hittites, invading from Syria. Recognized by its invaders as superior, the Mesopotamian culture remained strong throughout the following five-hundred-year period because it was embraced by its conquerors. The rise of Assyria between 1000 and 900 B.C. brought an end to Hittite domination over the region.

By contrast with the Babylonian kingdom in southern Mesopotamia, Assyria was located in the northern third of the plain, where sufficient rainfall obviated the need for irrigation. A land naturally hospitable to human life, Assyria still suffered from its proximity to the mountains. Perpetually open to attack from mountain tribes eager to seize booty, the Assyrian peasants had become as adroit at using the sword and bow as they were at the hoe and plow.

The new Assyrian kingdom, centered on Nineveh, used these peasant warriors to build one of the greatest empires of the ancient world. Within the previous thousand years, warfare in these regions had undergone several changes. The use of iron weapons, much stronger than bronze, became common. The horse appeared in Mesopotamia sometime shortly after 2000 B.C., making possible the creation of cavalry. The Hyksos (see Chapter 2, on Egypt) had, within a few centuries, tied the horse to a light cart to create the battle chariot.

Integrating these new inventions into a military force composed of hardy peasant warriors, Assyria set out to rule the world. Absolutely ruthless against their enemies, the Assyrians became the terror of the Middle East. When King Ashurnasirpal (883–859 B.C.) overcame a conspiracy of princes in Syria, for example, he made their punishment a public spectacle and boasted of its brutality:

> I built a pillar over against his city gate and I flayed all the chiefs who had revolted, and I covered the pillar with their skin. Some I walled up within the pillar, some I impaled upon the pillar on stakes, and others I bound to stakes round about the pillar. . . . And I cut the limbs of the officers, of the royal officers who had rebelled. . . .
>
> Many captives from among them I burned with fire, and many I took as living captives. From some I cut off their noses, their fingers, of many I put out the

1-11 *Stela of the Law Code of Hammurabi (detail), c. 1792–1750 B.C., 7" × 9". (Copyright PHOTO Réunion des Musées Nationaux)*

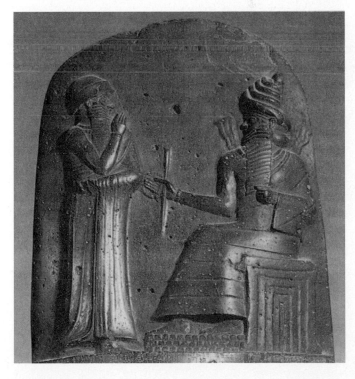

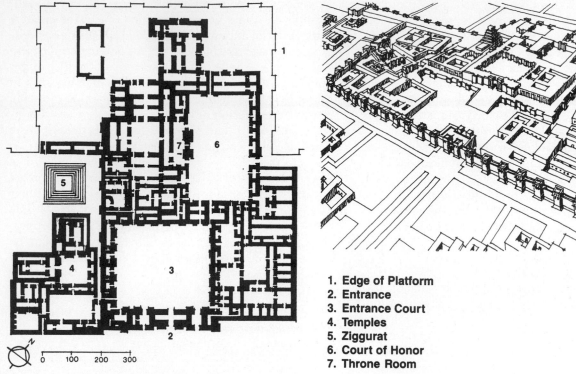

1. Edge of Platform
2. Entrance
3. Entrance Court
4. Temples
5. Ziggurat
6. Court of Honor
7. Throne Room

1-12 *Reconstructed view of the palace of Sargon II at Khorsabad, and plan of the inner palace precincts, c. 742–706* B.C.

eyes. I made one pillar of the living and another of the dead, and I bound their heads to tree trunks round about the city. Their young men and maidens I burned in the fire.[4]

The Assyrians also conducted a policy of massive deportations, transferring Hittite mountain people to the southern desert regions of Syria and placing Syrians in the mountains. At its height, this terrifying power controlled an empire reaching from the Arabian Peninsula across Mesopotamia and including parts of Anatolia, all of Syria and Palestine, and a great part of Egypt.

Development of the Assyrian Palace The Mesopotamians never believed, as did the Egyptians, that the king was actually divine, but they did come to believe that the institution of kingship was sent from the gods to humanity. In Sumerian times, the royal palace with its many courtyards was a more elaborate form of the private house. Although the king had the power to tax his people, in normal times he, like the gods, maintained himself and his court from the goods produced in royal workshops around the palace and from his estates lying outside the wall. Because the territories governed by the individual Sumerian kings were diminutive and their tax

base small, they did not have the resources to build great palaces, and the temple or ziggurat was the most important architectural feature of the city. By the time of the Babylonians, the increased powers of kingship were expressed in a palace architecture that rivaled the temple complex in its glorification of the sovereign.

The palace of Sargon II at Khorsabad, built in the eighth century B.C., reveals the extent to which the palace building had become a passion with Mesopotamian rulers. The Assyrian palace was no longer a part of the city but was set adjacent to the city walls within its own walls, and the ziggurat was reduced to an ornament within the complex (Fig. 1-12). In the long, narrow throne room, the king's throne sat on a base decorated with *relief sculptures* of the bodies of the victims of Sargon II. *Bas-reliefs* decorated the walls of all Assyrian palaces. Some of the best examples of this art form depict royal lion hunts.

Ashurnasirpal II Killing Lions, from Nimrud (Calah), about 883–859 B.C., shows a lion as heroic as the king (Fig. 1-13). Knowing that the lions were captured and let loose for this event does not tarnish the power with which the sculptor presents the scene. The energetic pose of the king with drawn bow that contrasts with the more regular upright warriors who advance in step behind the lion. The horses pull away, each nose just beyond the other, to leap over the recumbent wounded lion while another lion rears to attack.

[4] In Georges Roux, *Ancient Iraq* (New York: Allen & Unwin, 1964), p. 2.

1-13 Ashurnasirpal II Killing Lions, *from the Palace of King Ashurnasirpal II, Nimrud, c. 883–859 B.C., alabaster relief, 39″ × 100″. (Reproduced by Courtesy of the Trustees of the British Museum)*

The power and energy of the event are further enhanced by the stylized, abstracted depiction of sinew and muscle in both man and beast.

Two hundred years later another court artist would create another lion hunt, this time at Nineveh. *Dying Lioness* (c. 668–627 B.C., Fig. 1-14) is an incredibly powerful image that arouses strong feelings of pathos. The artist has observed and recorded the lion's dead hindquarters and the head lifted in pain, but the presentation seems to represent all such noble animals. Other reliefs, like that of a *Herd of Fleeing Gazelles* (Fig. 1-15), produce a similar feeling, as if the artist empathizes with the animals as they flee from hunters.

1-14 Dying Lioness *(detail of* The Great Lion Hunt*), from the Palace of King Ashurbanipal, Nineveh, c. 668–627 B.C., alabaster relief, height 13¾″. (Reproduced by Courtesy of the Trustees of the British Museum)*

Decline of Assyria The power, the terror, and the armed might of the Assyrian Empire did not prevent the recurrence of rebellions, and every Assyrian king spent most of his life waging either external or civil wars. Gradually, in the seventh century B.C., the rebels, aided by outside forces, were able successfully to detach pieces of the empire. The most effective group of allies were the Babylonians, whose homeland was in the southern part of Mesopotamia, and the Medes, a nomadic horse-riding people living on the high Persian plateau. Finally, in 612 B.C., the coalition successfully conquered and leveled Nineveh itself. The biblical prophet Ezekiel celebrated the destruction of Israel's oppressors, the Assyrians, by declaring "all of them slain, fallen by the sword which caused terror in the land of the living."

The Second Babylonia, 612–550 B.C.

The allies divided the lands of Assyria between them: the Medes took all the territories east and north of the Tigris, and the Babylonians took the rest. With their capital located at a restored Babylon, it appeared that the Babylonians would be able to regain the ancient cultural domination exercised by previous Mesopotamian societies over much of the world. Babylonia's greatest king, Nebuchadnezzar II (604–562 B.C.), embellished the old city with impressive monuments, the most magnificent of which was a new palace for his Median wife. Rising to a height of about 350 feet, the building consisted of a series of vaulted terraces, each one of which, watered by a system of hydraulic pumps, supported trees and gardens. The city during these years numbered about one hundred thousand people and occupied an area of twenty-five hundred acres, about five times the size of ancient Athens at the height of its development in the fifth century B.C.

This was a history-conscious society, one that endeavored to restore the culture of the Sumerian, Akkadian, and Old Babylonian periods. It was also a progressive society that made marked advances in astronomy. In fact, the Babylonians' interest in creating a more accurate calendar and improving navigation by astronomical research laid the basis for the modern science of astronomy. Their use of some of the information for prophecy, however, was to connect the name "Chaldean" with astrology for the next two thousand years.

Babylonian Music

Cosmology was also important in Babylonian musical theory, for the association of gods and stars, the connection between astronomy and mathematics, and the significance of number and proportion in music gave rise to a music theory relating these elements. The holy instruments of the temple, especially the long-necked lute, had strings whose lengths were determined by mathematical calculations. The scales and intervals demonstrated mathematical precision, for fingers were placed on the strings at points determined by numerical ratios in order to play this instrument. In Babylonia, temple schools for music developed alongside schools for other academic disciplines, and temple musicians were admitted to the profession only after about three years of instruction and rigorous examination. The musician was required to perform on a number of instruments, memorize sacred texts and melodies, and demonstrate a proficiency in Sumerian even after this language had become obsolete for everyday use.

1-15 Herd of Fleeing Gazelles *(detail of a relief) from the Palace of King Ashurbanipal, Nineveh, c. 668–627 B.C., alabaster, height 20⅞". (Reproduced by Courtesy of the Trustees of the British Museum)*

The End of Mesopotamian Civilization

For all its glory, the new Babylonian kingdom was conquered by Cyrus of Persia in 550 B.C. The conquest of Babylon and the subjection of Mesopotamia to a new Persian power farther to the east marked the beginning of a new era. The river valleys of the Tigris and Euphrates, with their great mixture of different peoples, had for almost three thousand years been the generators of civilization for a large part of the world. Now having lost its political integrity, Mesopotamia ceased to be a creative force. Yet its cultural heritage had become an endowment for a vastly larger territory than that enclosed within the boundaries of its successive kingdoms. Mesopotamian building traditions, artistic conventions, legal, religious, and scientific ideas, and the art of writing became part of the resources of the other peoples dwelling near the Mediterranean Sea. Along with the civilization of Egypt, to which we will turn in Chapter 2, that of Mesopotamia brought nourishment to the developing cultures of Crete, Greece, and their successors in the West.

from the *Epic of Gilgamesh*

Translation by Maureen Gallery Kovacs

Because we will see similar journeys in the *Odyssey*, the *Aeneid*, and the *Divine Comedy*, we have chosen to focus on Gilgamesh's visit to the dwelling of the gods in the excerpts below. Refer to the introduction to and summary of *Gilgamesh* on pages 15–16.

Tablet I

The Legacy

He who has seen everything, I will make known to
 the lands.
I will teach about him who experienced all things . . .
Anu granted him the totality of knowledge of all.
He saw the Secret, discovered the Hidden,
he brought information of the time before the
 Flood. 5
He went on a distant journey, pushing himself to
 exhaustion,
but then was brought to peace.
He carved on a stone stela all of his toils,
and built the wall of Uruk-Haven,
the wall of the sacred Eanna Temple, the holy
 sanctuary. 10
Look at its wall which gleams like copper,
inspect its inner wall, the likes of which no one can
 equal!
Take hold of the threshold stone—it dates from
 ancient times!
Go close to the Eanna Temple, the residence of
 Ishtar,
such as no later king or man ever equaled! 15
Go up on the wall of Uruk and walk around,
examine its foundation, inspect its brickwork
 thoroughly.
Is not even the core of the brick structure made of
 kiln-fired brick,
and did not the Seven Sages themselves lay out its
 plans?
One league city, one league palm gardens, one league
 lowlands, the open area of the Ishtar Temple, 20
three leagues and the open area of Uruk the wall
 encloses.
Find the copper tablet box,
open . . . its lock of bronze,
undo the fastening of its secret opening.
Take and read out from the lapis lazuli tablet 25
how Gilgamesh went through every hardship.

Gilgamesh

Supreme over other kings, lordly in appearance,
he is the hero, born of Uruk, the goring wild bull.
He walks out in front, the leader,
and walks at the rear, trusted by his companions. 30
Mighty net, protector of his people,
raging flood-wave who destroys even walls of stone!
Offspring of Lugalbanda, Gilgamesh is strong to
 perfection,
son of the august cow, Rimat-Ninsun, . . . Gilgamesh
 is awesome to perfection.
It was he who opened the mountain passes, 35
who dug wells on the flank of the mountain.
It was he who crossed the ocean, the vast seas, to the
 rising sun,
who explored the world regions, seeking life.
It was he who reached by his own sheer strength
 Utanapishtim, the Faraway,
who restored the sanctuaries (or: cities) that the
 Flood had destroyed! 40
. . . for teeming mankind.
Who can compare with him in kingliness?
Who can say like Gilgamesh: "I am King!"?
Whose name, from the day of his birth, was called
 "Gilgamesh"?
Two-thirds of him is god, one-third of him is
 human. 45
The Great Goddess [Aruru] designed the model for
 his body,
she prepared his form . . .
. . . beautiful, handsomest of men,
. . . perfect

Tablet IX

[After the death of Enkidu]

The Quest

Over his friend, Enkidu, Gilgamesh cried bitterly,
 roaming the wilderness.
 "I am going to die!—am I not like Enkidu?!
 Deep sadness penetrates my core,

I fear death, and now roam the wilderness—
I will set out to the region of Utanapishtim, son
 of Ubartutu, and will go with utmost
 dispatch! 5
When I arrived at mountain passes at nightfall,
I saw lions, and I was terrified!
I raised my head in prayer to Sin,
to . . . the Great Lady of the gods my
 supplications poured forth, 'Save me . . . !'"

The Scorpion-Beings

The mountain is called Mashu. 10
When he reached Mount Mashu,
which daily guards the rising and setting of the Sun,
above which only the dome of the heavens reaches,
and whose flank reaches as far as the Netherworld
 below,
there were scorpion-beings watching over its gate.
Trembling terror they inspire, the sight of them is
 death, 15
their frightening aura sweeps over the mountains.
At the rising and setting they watch over the Sun.
When Gilgamesh saw them, trembling terror
 blanketed his face,
but he pulled himself together and drew near to
 them.
The scorpion-being called out to his female: 20
 "He who comes to us, his body is the flesh of
 gods!"
The scorpion-being, his female, answered him:
 "(Only) two-thirds of him is a god, one-third is
 human."
The male scorpion-being called out,
saying to the offspring of the gods: 25
 "Why have you traveled so distant a journey?
 Why have you come here to me,
 over rivers whose crossing is treacherous?
 I want to learn your . . . "
 . . .

[Twenty-six lines are missing here. When the text resumes
Gilgamesh is speaking.]

 "I have come on account of my ancestor
 Utanapishtim, 30
 who joined the Assembly of the Gods, and was
 given eternal life.
 About Death and Life I must ask him!"
The scorpion-being spoke to Gilgamesh . . . , saying:
 "Never has there been, Gilgamesh, a mortal
 man who could do that.
 No one has crossed through the mountains, 35
 for twelve leagues it is darkness throughout—
 dense is the darkness, and light there is none. . . ."

[Sixty-seven lines are missing, in which Gilgamesh convinces
the scorpion-being to allow him passage.]

 "Though it be in deep sadness and pain,
 in cold or heat . . .
 gasping after breath . . . I will go on! 40
 Now! Open the Gate!"
The scorpion-being spoke to Gilgamesh, saying:
 "Go on, Gilgamesh, fear not!
 The Mashu mountains I give to you freely,
 the mountains, the ranges, you may
 traverse . . . 45
 In safety may your feet carry you"

The Journey Through the Night

. . . As soon as Gilgamesh heard this
he heeded the utterances of the scorpion-being.
Along the Road of the Sun° he journeyed—
one league he traveled . . . , 50
dense was the darkness, light there was none.
Neither what lies ahead nor behind does it allow
 him to see. . . .

 [Gilgamesh travels for ten leagues in darkness.]

Eleven leagues he traveled and came out before the
 sun(rise).
Twelve leagues he traveled and it grew brilliant.

The Jeweled Garden

Before him there were trees of precious stones, 55
and he went straight to look at them.
The tree bears carnelian° as its fruit,
laden with clusters (of jewels), dazzling to behold,
—it bears lapis lazuli as foliage,
bearing fruit, a delight to look upon. 60

Tablet X

The Tavern-Keeper by the Sea

The tavern-keeper Siduri who lives by the
 seashore, . . .
She is covered with a veil . . .
Gilgamesh was roving about . . .
wearing a skin, . . .
having the flesh of the gods in his body, 5
but sadness deep within him,
looking like one who has been traveling a long
 distance.
The tavern-keeper was gazing off into the distance,
puzzling to herself, she said,
wondering to herself: 10
 "That fellow is surely a murderer!
 Where is he heading? . . ."

49. The Road of the Sun refers to the course of the sun through the
Netherworld at night. [Translator's notes, unless otherwise indicated.]
57. A pale to deep red or reddish-brown precious stone. [Au.]

As soon as the tavern-keeper saw him, she bolted her
 door,
bolted her gate, bolted the lock.
But at her noise Gilgamesh pricked up his ears, 15
lifted his chin (to look about) and then laid his eyes
 on her.
Gilgamesh spoke to the tavern-keeper, saying:
 "Tavern-keeper, what have you seen that made
 you bolt your door,
 bolt your gate, bolt the lock?
 If you do not let me in I will break your door,
 and smash the lock! . . ." 20
Gilgamesh said to the tavern-keeper:
 "I am Gilgamesh, I killed the Guardian!
 I destroyed Humbaba who lived in the Cedar
 Forest,
 I slew lions in the mountain passes!
 I grappled with the Bull that came down from
 heaven, and killed him." 25
The tavern-keeper spoke to Gilgamesh, saying:
 "If you are Gilgamesh, who killed the Guardian,
 who destroyed Humbaba who lived in the
 Cedar Forest,
 who slew lions in the mountain passes,
 who grappled with the Bull that came down
 from heaven, and killed him, 30
 why are your cheeks emaciated, your expression
 desolate?
 Why is your heart so wretched, your features so
 haggard?
 Why is there such sadness deep within you?
 Why do you look like one who has been
 traveling a long distance
 so that ice and heat have seared your face? 35
 . . . you roam the wilderness?"°

36. In the Old Babylonian version, the tavern-keeper offers her in-
sights on the true goal of life, which is not to escape death, but to en-
joy the normal, if transitory, pleasures of life.
 "Gilgamesh, where are you wandering?
 The life that you are seeking all around you will not find.
 When the gods created mankind
 they fixed Death for mankind,
 and held back Life in their own hands.
 Now you, Gilgamesh, let your belly be full!
 Be happy day and night,
 of each day make a party,
 dance in circles day and night!
 Let your clothes be sparkling clean,
 let your head be clean, wash yourself with water!
 Attend to the little one who holds onto your hand,
 let a wife delight in your embrace.
 This is the (true) task of *mankind*."
(Some restore the last words differently, as "this is the task of *wom-
ankind*," and take it to refer to intercourse as the natural duty of
women, as it was for the harlot in Tablet I.)

Gilgamesh spoke to her, to the tavern-keeper he
 said:
 "Tavern-keeper, should not my cheeks be
 emaciated?
 Should my heart not be wretched, my features
 not haggard?
 Should there not be sadness deep within me? 40
 Should I not look like one who has been
 traveling a long distance,
 and should ice and heat not have seared my
 face?
 . . . , should I not roam the wilderness?
 My friend, the wild ass who chased the wild
 donkey, panther of the wilderness, 45
 Enkidu, the wild ass who chased the wild
 donkey, panther of the wilderness,
 we joined together, and went up into the
 mountain.
 We grappled with and killed the Bull of Heaven,
 we destroyed Humbaba who lived in the Cedar
 Forest,
 we slew lions in the mountain passes!
 My friend, whom I love deeply, who went
 through every hardship with me, 50
 Enkidu, whom I love deeply, who went through
 every hardship with me,
 the fate of mankind has overtaken him.
 Six days and seven nights I mourned over him
 and would not allow him to be buried
 until a maggot fell out of his nose. 55
 I was terrified by his appearance,
 I began to fear death, and so roam the
 wilderness.
 The issue of my friend oppresses me,
 so I have been roaming long trails through the
 wilderness.
 The issue of Enkidu, my friend, oppresses me, 60
 so I have been roaming long roads through the
 wilderness.
 How can I stay silent, how can I be still?
 My friend whom I love has turned to clay.
 Am I not like him? Will I lie down, never to get
 up again?"
Gilgamesh spoke to the tavern-keeper, saying: 65
 "So now, tavern-keeper, what is the way to
 Utanapishtim?
 What are its markers? Give them to me! Give
 me the markers!
 If possible, I will cross the sea;
 if not, I will roam through the wilderness."
The tavern-keeper spoke to Gilgamesh, saying: 70
 "There has never been, Gilgamesh, any passage
 whatever,
 there has never been anyone since days of yore
 who crossed the sea.
 The (only) one who crosses the sea is valiant

Shamash, except for him who can cross?
The crossing is difficult, its ways are
 treacherous—
and in between are the Waters of Death that bar
 its approaches! 75
And even if, Gilgamesh, you should cross the
 sea,
when you reach the Waters of Death what
 would you do?
Gilgamesh, over there is Urshanabi, the
 ferryman of Utanapishtim.
. . .
Go on, let him see your face.
If possible, cross with him; 80
if not, you should turn back."

[Gilgamesh convinces the ferryman to take him.]

The Waters of Death

. . .
Gilgamesh and Urshanabi boarded the boat,
Gilgamesh launched the *magillu*-boat° and they
 sailed away.
By the third day they had traveled a stretch of a
 month and a half, and
Urshanabi arrived at the Waters of Death. 85
Urshanabi said to Gilgamesh:
 "Hold back, Gilgamesh, take a punting pole,
 but your hand must not pass over the Waters of
 Death . . . !
 Take a second, Gilgamesh, a third, and a fourth
 pole,
 take a fifth, Gilgamesh, a sixth, and a seventh
 pole, 90
 take an eighth, Gilgamesh, a ninth, and a tenth
 pole,
 take an eleventh, Gilgamesh, and a twelfth
 pole!"
In twice 60 rods Gilgamesh had used up the punting
 poles.
Then he loosened his waist-cloth . . .
Gilgamesh stripped off his garment 95
and held it up on the mast with his arms.

[Gilgamesh comes to Utanapishtim, who asks him the
 same questions as the tavern keeper; Gilgamesh gives
 the same answers. See Tablet X, lines 25–36.]

. . .
"Enkidu, my friend whom I love, has turned to
 clay!
Am I not like him? Will I lie down never to get
 up again?"
Gilgamesh spoke to Utanapishtim, saying:

"That is why I must go on, to see Utanapishtim
 whom they call 'The Faraway.'° 100
I went circling through all the mountains,
I traversed treacherous mountains, and crossed
 all the seas—
that is why sweet sleep has not mellowed my
 face,
through sleepless striving I am strained,
my muscles are filled with pain. 105
I had not yet reached the tavern-keeper's area
 before my clothing gave out.
I killed bear, hyena, lion, panther, tiger, stag,
 red-stag, and beasts of the wilderness;
I ate their meat and wrapped their skins around
 me. . . ."
Utanapishtim spoke to Gilgamesh, saying:
 . . .
 You have toiled without cease, and what have
 you got? . . . 110
 Through toil you wear yourself out,
 you fill your body with grief,
 your long lifetime you are bringing near (to a
 premature end)
 No one can see death,
 no one can see the face of death, 115
 no one can hear the voice of death,
 yet there is savage death that snaps off
 mankind.
 For how long do we build a household?
 For how long do we seal a document?
 For how long do brothers share the
 inheritance? 120
 For how long is there to be jealousy in the land?
 For how long has the river risen and brought
 the overflowing waters,
 so that dragonflies drift down the river?
 The face that could gaze upon the face of the
 Sun
 has never existed ever. 125
 How alike are the sleeping and the dead.
 The image of Death cannot be depicted.
 Yes, you are a human being, a man!
 After Enlil had pronounced the blessing,°

83. *Magillu* is the name of a boat taken from mythology.

100. Apparently Gilgamesh has not yet realized that he is already talking with Utanapishtim, whom he expected to look very different from an ordinary human being. It is only after Utanapishtim's soliloquy on death that Gilgamesh realizes to whom he is speaking.
129. Finishing his soliloquy on life and death, Utanapishtim here reveals how death came to be the fate of mankind, and implicitly how Utanapishtim himself was spared. This is apparently the "secret of the gods" that Gilgamesh has been seeking. These last five lines refer to the "Myth of Atrahasis" (Atrahasis = Uta-napishtim), in which Enlil grudgingly allows the pious Atrahasis, who escaped the Flood, to live for eternity, but Enlil and the other gods then establish death for all other human beings as a necessary means of population control.

the Anunnaki, the Great Gods, assembled. 130
Mammetum, she who fashions destiny,
 determined destiny with them.
They established Death and Life,
but they did not make known 'the days of
 death.'"°

Tablet XI

The Story of the Flood

Gilgamesh spoke to Utanapishtim, the Faraway:
 "I have been looking at you,
 but your appearance is not strange—you are like me!
 You yourself are not different—you are like me!
 My mind was resolved to fight with you, 5
 (but instead?) my arm lies useless over you.
 Tell me, how is it that you stand in the Assembly
 of the Gods, and have found life?"
Utanapishtim spoke to Gilgamesh, saying:
 "I will reveal to you, Gilgamesh, a thing that
 is hidden,
 a secret of the gods I will tell you! 10
 Shuruppak, a city that you surely know,
 situated on the banks of the Euphrates,
 that city was very old, and there were gods inside it.
 The hearts of the Great Gods moved them to
 inflict the Flood.
 Their Father Anu uttered the oath (of secrecy), 15
 Valiant Enlil was their Adviser,
 Ninurta was their Chamberlain,
 Ennugi was their Minister of Canals.
 Ea, the Clever Prince(?), was under oath with them
 so he repeated their talk to the reed house: 20
 'Reed house, reed house! Wall, wall!
 Hear, O reed house! Understand, O wall!
 O man of Shuruppak, son of Ubartutu:
 Tear down the house and build a boat!
 Abandon wealth and seek living beings! 25
 Spurn possessions and keep alive living beings!
 Make all living beings go up into the boat.
 The boat which you are to build,
 its dimensions must measure equal to each other:
 its length must correspond to its width. 30
 Roof it over like the Apsu.'
I understood and spoke to my lord, Ea:
 'My lord, thus is the command which you have
 uttered
 I will heed and will do it.
 But what shall I answer the city, the populace, and
 the Elders?' 35
Ea° spoke, commanding me, his servant:

'You, well then, this is what you must say to them:
 "It appears that Enlil is rejecting me
 so I cannot reside in your *city* (?),
 nor set foot on Enlil's earth. 40
 I will go down to the Apsu to live with my lord, Ea,
 and upon you he will rain down abundance,
 a profusion of fowl, myriad(?) fishes.
 He will bring to you a harvest of wealth,
 in the morning he will let loaves of bread shower
 down, 45
 and in the evening a rain of wheat!"'
Just as dawn began to glow
 the land assembled *around me*—
 the carpenter carried his hatchet,
 the reed worker carried his (flattening) stone, 50
. . . the men . . .

. . .

The child carried the pitch,
 the weak brought whatever else was needed.
On the fifth day I laid out her exterior.
It was a field in area,° 55
 its walls were each 10 times 12 cubits in height,
 the sides of its top were of equal length, 10 times 12
 cubits each.
I laid out its (interior) structure and drew a picture
 of it (?).
I provided it with six decks,
 thus dividing it into seven (levels). 60
The inside of it I divided into nine (compartments).
I drove plugs (to keep out) water in its middle part.
I saw to the punting poles and laid in what was
 necessary.
Three times 3,600 (units) of raw bitumen I poured into
 the bitumen kiln,
 three times 3,600 (units of) pitch . . . into it, 65
there were three times 3,600 porters of casks who
 carried (vegetable) oil,
apart from the 3,600 (units of) oil which they con-
 sumed (?)
and two times 3,600 (units of) oil which the boatman
 stored away.
I butchered oxen for *the meat*(?),
 and day upon day I slaughtered sheep. 70
I gave the workmen(?) ale, beer, oil, and wine, as if it
 were river water,
so they could make a party like the New Year's Festival.
. . . and I set my hand to the oiling(?).
The boat was finished by sunset.
The launching was very difficult. 75
They had to keep carrying a runway of poles front to
 back,
until two-thirds of it had gone into the water(?).

133. The "days of death" probably means the day on which an indi-
vidual's death will occur, although some interpret the line to mean
"they did not fix a limit to death."

36. Utanapishtim appears to have a special relationship with the god Ea.

55. The boat as described is clearly a cube, not at all like ordinary
Mesopotamian boats, and is probably a theological allusion to the
dimensions of a ziggurat. (translator's note)

Whatever I had I loaded on it:
whatever silver I had I loaded on it,
whatever gold I had I loaded on it. 80
All the living beings that I had I loaded on it,
I had all my kith and kin go up into the boat,
all the beasts and animals of the field and the
 craftsmen I had go up.
Shamash had set a stated time:°
 'In the morning I will let loaves of bread shower
 down, 85
 and in the evening a rain of wheat!
 Go inside the boat, seal the entry!'
That stated time had arrived.
In the morning he let loaves of bread shower down,
and in the evening a rain of wheat. 90
I watched the appearance of the weather—
the weather was frightful to behold!
I went into the boat and sealed the entry.
For the caulking of the boat, to Puzuramurri, the
 boatman,
I gave the palace together with its contents. 95
Just as dawn began to glow
there arose from the horizon a black cloud.
Adad rumbled inside of it,
before him went Shullat and Hanish,
heralds going over mountain and land. 100
Erragal pulled out the mooring poles,
forth went Ninurta and made the dikes overflow.
The Anunnaki lifted up the torches,
setting the land ablaze with their flare.
Stunned shock over Adad's deeds overtook the
 heavens, 105
and turned to blackness all that had been light.
The . . . land shattered like a . . . pot.
All day long the South Wind blew . . . ,
blowing fast, *submerging the* mountain *in water,*
overwhelming *the people* like an attack. 110
No one could see his fellow,
they could not recognize each other in the torrent.
The gods were frightened by the Flood,
and retreated, ascending to the heaven of Anu.
The gods were cowering like dogs, crouching by the
 outer wall. 115
Ishtar shrieked like a woman in childbirth,
the sweet-voiced Mistress of the Gods wailed:
 'The olden days have alas turned to clay,
 because I said evil things in the Assembly of the
 Gods!
 How could I say evil things in the Assembly of the
 Gods, 120
 ordering a catastrophe to destroy my people?!
 No sooner have I given birth to my dear people
 than they fill the sea like so many fish!'

The gods—those of the Anunnaki—were weeping with
 her,
the gods humbly sat weeping, sobbing with
 grief(?), 125
their lips burning, parched with thirst.
Six days and seven nights
came the wind and flood, the storm flattening the land.
When the seventh day arrived, the storm was
 pounding,
the flood was a war—struggling with itself like a
 woman writhing (in labor). 130
The sea calmed, fell still, the whirlwind (and) flood
 stopped up.
I looked around all day long—quiet had set in
and all the human beings had turned to clay!
The terrain was as flat as a roof.
I opened a vent and fresh air (daylight?) fell upon the
 side of my nose. 135
I fell to my knees and sat weeping,
tears streaming down the side of my nose.
I looked around for coastlines in the expanse of the sea,
and at twelve leagues there emerged a region (of land).
On Mt. Nimush the boat lodged firm, 140
Mt. Nimush held the boat, allowing no sway.
One day and a second Mt. Nimush held the boat,
 allowing no sway.
A third day, a fourth, Mt. Nimush held the boat,
 allowing no sway.
A fifth day, a sixth, Mt. Nimush held the boat,
 allowing no sway.
When a seventh day arrived 145
I sent forth a dove and released it.
The dove went off, but came back to me;
no perch was visible so it circled back to me.
I sent forth a swallow and released it.
The swallow went off, but came back to me; 150
no perch was visible so it circled back to me.
I sent forth a raven and released it.
The raven went off, and saw the waters slither back.
It eats, it scratches, it bobs, but does not circle back
 to me.
Then I sent out everything in all directions and sacri-
 ficed (a sheep). 155
I offered incense in front of the mountain-ziggurat.
Seven and seven cult vessels I put in place,
and (into the fire) underneath (or: into their bowls) I
 poured reeds, cedar, and myrtle.
The gods smelled the savor,
the gods smelled the sweet savor, 160
and collected like flies over a (sheep) sacrifice.
Just then Beletili arrived.
She lifted up the large flies (beads)° which Anu had
 made for his enjoyment(?):

84. Earlier, in lines 36–47, Ea, not Shamash, had given the stated
time.

163. A necklace with carved lapis lazuli fly beads, representing the
dead offspring of the mother goddess Beletili/Aruru.

'You gods, as surely as I shall not forget this lapis
 lazuli around my neck,
 may I be mindful of these days, and never forget
 them! 165
 The gods may come to the incense offering,
 but Enlil may not come to the incense offering,
 because without considering he brought about the
 Flood
 and consigned my people to annihilation.'
Just then Enlil arrived. 170
He saw the boat and became furious,
he was filled with rage at the Igigi gods:
 'Where did a living being escape?
 No man was to survive the annihilation!'
Ninurta spoke to Valiant Enlil, saying: 175
 'Who else but Ea could devise such a thing?
 It is Ea who knows every machination!'
Ea spoke to Valiant Enlil, saying:
 'It is *you*, O Valiant One, who is the Sage of the
 Gods.
 How, how could *you* bring about a Flood without
 consideration? 180
 Charge the violation to the violator,
 charge the offense to the offender,
 but be compassionate lest (mankind) be cut off,
 be patient lest *they be killed*.
 Instead of your bringing on the Flood, 185
 would that a lion had appeared to diminish the
 people!
 Instead of your bringing on the Flood,
 would that a wolf had appeared to diminish the
 people!
 Instead of your bringing on the Flood,
 would that famine had occurred to slay the
 land! 190
 Instead of your bringing on the Flood,
 would that (Pestilent) Erra had appeared to ravage
 the land!
 It was not I who revealed the secret of the Great
 Gods,
 I (only) made a dream appear to Atrahasis, and
 (thus) he heard the secret of the gods.
 Now then! The deliberation should be about
 him!' 195
Enlil went up inside the boat
and, grasping my hand, made me go up.
He had my wife go up and kneel by my side.
He touched our forehead and, standing between us, he
blessed us: 200
 'Previously Utanapishtim was a human
 being.
 But now let Utanapishtim and his wife become like
 us, the gods!
 Let Utanapishtim reside far away, at the Mouth of
 the Rivers.'
They took us far away and settled us at the Mouth of
 the Rivers."

A Second Chance at Life

The wife of Utanapishtim the Faraway said to him:
 "Gilgamesh came here exhausted and worn out.
 What can you give him so that he can return to his
 land (with honor)?"
Then Gilgamesh raised a punting pole
and drew the boat to shore. 5
Utanapishtim spoke to Gilgamesh, saying:
 "Gilgamesh, you came here exhausted and worn
 out.
 What can I give you so you can return to your
 land?
 I will disclose to you a thing that is hidden,
 Gilgamesh,
 . . .
 There is a plant . . . like a boxthorn, 10
 whose thorns will prick your hand like a rose.
 If your hands reach that plant you will become
 a young man again."
Hearing this, Gilgamesh opened a conduit . . .
and attached heavy stones to his feet.
They dragged him down, to the Apsu° they pulled
 him. 15
He took the plant, though it pricked his hand,
and cut the heavy stones from his feet,
letting the waves throw him onto its shores.
Gilgamesh spoke to Urshanabi, the ferryman, saying:
 "Urshanabi, this plant is a plant against
 decay 20
 by which a man can attain his survival
 I will bring it to Uruk-Haven,
 and have an old man eat the plant to test it.
 The plant's name is 'The Old Man Becomes a
 Young Man.'°
 Then I will eat it and return to the condition of my
 youth." 25
At twenty leagues they broke for some food,
at thirty leagues they stopped for the night.
Seeing a spring and how cool its waters were,
Gilgamesh went down and was bathing in the water.
A snake smelled the fragrance of the plant, 30
silently came up and carried off the plant.
While going back it sloughed off its casing.
At that point Gilgamesh sat down, weeping,
his tears streaming over the side of his nose.
 "Counsel me, O ferryman Urshanabi! 35
 For whom have my arms labored, Urshanabi?
 For whom has my heart's blood roiled?
 I have not secured any good deed for myself,
 but done a good deed for the 'lion of the
 ground'!"°

15. Abyss(?). 24. The same as the apparent meaning of the
name "Gilgamesh." 39. This scene is an etiological story of
how the snake came to shed its old skin—after eating a "plant of
rejuvenation."

Deeds over Death

. . .

At twenty leagues they broke for some food, 40
at thirty leagues they stopped for the night.
They arrived in Uruk-Haven.
Gilgamesh said to Urshanabi, the ferryman:
> "Go up, Urshanabi, onto the wall of Uruk and
> walk around.
> Examine its foundation, inspect its brickwork
> thoroughly— 45
> is not (even the core of) the brick structure of
> kiln-fired brick,
> and did not the Seven Sages themselves lay out
> its plan?
> One league city, one league palm gardens, one
> league lowlands, the open area of the Ishtar
> Temple,
> three leagues and the open area of Uruk the
> wall encloses."

. .

COMMENTS AND QUESTIONS

1. The Western *epic* traditionally begins by describing the theme and stating the story the poet intends to tell. Does this apply to *Gilgamesh*?

2. Another characteristic of the epic is that it begins *in medias res*, in the "middle of things," rather than, like the folk tale or myth, at the beginning, or "once upon a time." Is this true of *Gilgamesh*?

3. What does the description of Uruk indicate about the Mesopotamian attitude toward cities?

4. We cannot know if Gilgamesh stories were told orally before they were written down, but it seems probable. We are fairly certain that this was the case with the Homeric epics. Repetitions of key words and phrases and the use of *epithets*, or adjectival phrases defining a character, may indicate orality. What effect does the repeated description of Gilgamesh's condition during his grief produce in the written text?

5. Describe the world of the gods that Gilgamesh enters. Can you attribute any symbolic value to the creatures that he encounters?

6. What is the role of women as goddesses and priestesses here? Note that, contrary to the Adam and Eve story, it is the male who makes the mistake that loses eternal life. (Gilgamesh loses the plant.) What accounts for this?

7. What is the "lesson" that Gilgamesh learns from Utanapishtim?

8. What seems to be the role of the gods in "The Story of the Flood"? Compare it with the story of the Flood in Genesis.

9. What is the effect of repeating the description of the city in the first and last tablets?

10. Some readers, comparing *Gilgamesh* with other epics, consider it pessimistic or depressing because Gilgamesh's grief is not consoled by a faith in life after death. Others consider it life-affirming and close to modern concerns because Gilgamesh after his painful quest learns the value of life on earth. What is your opinion?

. .

. .

from *The Hammurabi Code*
Translation by C. Edwards

The Code of Hammurabi is not, as was once believed, the oldest law code known to humanity, for earlier ones have been discovered in Mesopotamia. It is still, however, the most complete set of laws surviving from these centuries. It relies on two sorts of punishment, a monetary penalty paid by the offender to the victim and retribution in kind. The laws reveal three social classes: (1) free men and women; (2) commoners,[1] partially free but dependent in various ways on landlords or the government; and (3) slaves. Observe how in some of the following laws the penalties varied according to the social classes. Note as well that in some cases the decision on the guilt or innocence of the accused is left to the gods to determine.

53. If a man has been too lazy to strengthen his dyke, and has not strengthened the dyke, and a breach has opened in the dyke, and the ground has been flooded with water; the man in whose dyke the breach has opened shall reimburse the corn he has destroyed.

54. If he has not corn to reimburse, he and his goods shall be sold for silver, and it shall be divided among those whose corn has been destroyed.

55. If a man has opened his irrigation ditch, and, through negligence, his neighbour's field is flooded with water, he shall measure back corn according to the yield of the district.

130. If a man has forced the wife of another man, who has not known the male, and who still resides in the house of her father, and has lain within her breasts, and he is found, that man shall be slain; that woman is guiltless.

131. If a man's wife has slandered her husband, but has not been found lying with another male, she shall swear by the name of God and return into her house.

[1] In the selection, we have substituted *commoner* for *plebeian,* used in Edwards' translation. The full title of Edwards' work from which the excerpts are taken is *The Hammurabi Code, and the Sinaitic Legislation; with a Complete Translation of the Great Babylonian Inscription Discovered at Susa.*

132. If the finger is pointed against a man's wife because of another male, and she has not been found lying with another male; then she shall plunge for her husband into the holy river.

134. If a man has been taken prisoner, and there is no food in his house, and his wife enters the house of another; then that woman bears no blame.

135. If a man has been taken prisoner, and there is no food before her, and his wife has entered the house of another, and bears children, and afterwards her husband returns and regains his city; then that woman shall return to her spouse. The children shall follow their father.

136. If a man has abandoned his city, and absconded, and after that his wife has entered the house of another; if that man comes back and claims his wife; because he had fled and deserted his city, the wife of the deserter shall not return to her husband.

151. If a woman who dwells in a man's house has bound her husband not to assign her to a creditor, and has received a tablet; then if that man had a debt upon him before he married that woman, his creditor may not seize his wife. And if that woman had incurred debt before she entered the man's house, her creditor may not seize her husband.

152. If, after that woman has entered the man's house, they incur debt, both of them must satisfy the trader.

196. If a man has destroyed the eye of a free man, his own eye shall be destroyed.

197. If he has broken the bone of a free man, his bone shall be broken.

198. If he has destroyed the eye of a commoner, or broken a bone of a commoner, he shall pay one mina of silver.

199. If he has destroyed the eye of a man's slave, or broken a bone of a man's slave, he shall pay half his value.

200. If a man has knocked out the teeth of a man of the same rank, his own teeth shall be knocked out.

201. If he has knocked out the teeth of a commoner, he shall pay one-third of a mina[2] of silver.

209. If a man strike the daughter of a free man, and causes her foetus to fall; he shall pay ten shekels of silver for her foetus.

210. If that woman die, his daughter shall be slain.

211. If he has caused the daughter of a commoner to let her foetus fall through blows, he shall pay five shekels of silver.

212. If that woman die, he shall pay half a mina of silver.

213. If he has struck the slave of a man, and made her foetus fall; he shall pay two shekels of silver.

214. If that slave die, he shall pay a third of a mina of silver.

215. If a doctor has treated a man with a metal knife for a severe wound, and has cured the man, or has opened a man's tumour with a metal knife, and cured a man's eye; then he shall receive ten shekels of silver.

216. If the son of a commoner, he shall receive five shekels of silver.

217. If a man's slave, the owner of the slave shall give two shekels of silver to the doctor.

218. If a doctor has treated a man with a metal knife for a severe wound, and has caused the man to die, or has opened a man's tumour with a metal knife, and destroyed the man's eye; his hands shall be cut off.

219. If a doctor has treated the slave of a commoner with a metal knife for a severe wound, and caused him to die; he shall render slave for slave.

229. If a builder has built a house for a man, and his work is not strong, and if the house he has built falls in and kills the householder, that builder shall be slain.

230. If the child of the householder be killed, the child of that builder shall be slain.

231. If the slave of the householder be killed, he shall give slave for slave to the householder.

··

QUESTIONS

1. What do paragraphs 53–55 tell us about the relationship of the river to agriculture?
2. To what extent is there equality before the law for men and women?
3. What do these laws tell us about the value of human life in Mesopotamian society?
4. Compare these laws with similar ones in the Bible, such as those in Deuteronomy, and with those of our own legal system.
5. How does the concept of guilt in Mesopotamian law differ from our modern concept?

··

[2] A mina was a unit of coinage; a shekel was a division of a mina.

Summary Questions

1. What significance is there in the shift of focus in architecture from the temple to the palace between 3000 and 1000 B.C.?

2. What is the importance of pride in a city? Do you think the Sumerians and the Assyrians took pride in their cities and why do you think so? What role do walls play in the city, in urbanization?

3. What part did processions and a flat landscape play in the design of Mesopotamian architecture?

4. How did geography affect Mesopotamian urbanization?

5. Discuss the views of this society on the value of human life. How are they depicted in art?

6. Describe the roles of the principal gods and goddesses in Mesopotamian religion.

7. Dividing objects into ritual objects, objects of state, and personal objects represents concepts that will be used throughout this text. Name some objects from each category that you have seen or know about.

8. What kind of a hero is Gilgamesh? How does the poem about him qualify as an epic?

9. What is the fundamental principle of Hammurabi's code?

10. What importance does writing have for a civilization?

Key Terms

pastoral and agricultural economies

urbanization

ziggurat

myth

epic

abstraction in art

cuneiform writing

palace

relief sculpture (bas relief)

2

Egypt and the Kingdom of Kush

CENTRAL ISSUES

- The formative effects of geography on the development of Egyptian civilization
- The concept of the pharaoh as ruler
- The characteristics of Egyptian religion and their effect on art and architecture
- The nature and development of the pyramid
- The significance of Akhenaton's religious reform
- The role of music in Egyptian religion and culture
- The distinctive charactersitics of religion, politics, and art in the kingdoms of Kush, Napata, and Meroe

While Mesopotamia was the product of two rivers, the Tigris and Euphrates, Egypt, in the words of the fifth-century B.C. Greek historian Herodotus, was "the gift of the Nile." Although settlement along the Nile developed fairly early, population on its banks began to rise significantly only in the sixth millennium as the Sahara region, hitherto a land of lakes and forests, became increasingly dry. Over the next two thousand years, during which the desiccation of the Sahara steadily increased, most of its former inhabitants scattered in different directions. Some groups moved into moister areas toward the south. Others moved east as far as the Nile valley. Still others pushed north into Syria and Palestine and further east into Mesopotamia. In this last region late in the fourth millennium it was these people who joined with the Sumerians coming from the east to build the first cities.

The Nile

The Nile proved even more favorable for human habitation than the Euphrates and the Tigris. Rising deep in the African highlands in Uganda and Ethiopia, the river travels 4,000 miles north to the Mediterranean Sea. In its last 675 miles it creates the land of Egypt. Beginning at the first cataract at Aswan, the river descends slowly for 500 miles to Memphis (near modern Cairo), where it divides into many shallow branches, growing ever wider and shallower through a 60-mile-wide marsh until its many mouths empty into the Mediterranean (see map). Unlike its Mesopotamian counterparts, the Nile moves calmly, making navigation easy. Boats going north toward the Mediterranean are carried along by the current, and those going south use the wind to face the water's flow. Also, whereas the Mesopotamian rivers often crest when the planting season has passed, destroying crops in the fields, the annual flooding of the Nile begins at about the same time each summer and, unlike the rise of the Tigris and Euphrates rivers, is generally not destructive.

The predictability of the inundation was crucial to the rise of Egyptian civilization. It made agriculture nearly effortless, for each year, as the flood receded at planting time, a fresh layer of rich silt was left on the fields. Seeds were scattered on the nutrient-rich banks, and very little effort was required to produce several crops each year. In contrast to Mesopotamia, the Nile valley did not experience problems with sanitization or nutrient depletion of the agricultural lands.

However, the annual inundation of the Nile may actually have delayed the development of agriculture there by comparison with Mesopotamia. The natural supply of fish, wild animals, and wild grains was so rich that people did not need to work hard to feed themselves. Only as population became more dense along the river, with the increasing immigration from the Sahara after 5000 B.C., were collective efforts undertaken, as in Mesopotamia a few centuries earlier, to construct dikes and canals both to direct water to the fields and to preserve it as long as possible.

The First and Second Dynasties (3100–2686 B.C.)

Protected from hostile intrusions by deserts stretching off to the east and west, by the Mediterranean to the north and the river cataracts to the south, Egypt enjoyed long periods of tranquillity denied the Sumerian states, periods that allowed it to work out its own destiny. Because easy navigation of the river gave access to the whole country bordering the Nile, central government rose there early. Several centuries before 3000 B.C. the settlements along the river became divided into two countries ruled by separate kings: Upper Egypt, which began at the first cataract and ran north as far as Memphis, and Lower Egypt, taking in the area from Memphis to the sea. By about 3100 B.C. the whole length of the river lay under the control of a certain Menes, the founder of the First Dynasty of Egyptian pharaohs, who, uniting the country, established his government at Memphis near the border between Upper and Lower Egypt. Thus, five hundred years before Sargon (2371–2316 B.C.) unified Mesopotamia, Egypt had a central government with a single capital for the whole country.

From the earliest period, the pharaoh, as ruler of Egypt, was considered to be the protector of natural forces such as the Nile inundation, rain, fertility, and other aspects of life. His personal welfare was so intimately tied to the welfare of the whole society that his will deserved unquestioned obedience. Although the identification of his divine parentage changed over time, in the early period no one disputed that he was himself a god. Early Mesopotamian rulers, whose original powers arose out of a popular assembly, could well envy the Egyptian pharaohs; even later, when royal absolutism became accepted in Mesopotamia, a tradition of the divinity of the ruler never took deep root.

The Old Kingdom (2686–2180 B.C.)

Few specific historical events are known about the history of Egypt before the Third Dynasty, but from this time records become numerous. Egyptian society was closely governed by the pharaoh's officials who were charged with justice, management of water and food resources, collecting taxes, and keeping royal records.

Egyptian Writing

Hieroglyphics An administrative organization as complex as that of ancient Egypt would have been impossible to maintain had it not been for the existence of writing and teams of scribes to staff the various departments. Like the Mesopotamians, the Egyptians seem to have first used writing (about 3100) as a practical means of recording historical events and government and business transactions and, later, for scientific and literary purposes. Egyptian hieroglyphics (Fig. 2-1) began as a form of picture writing, but eventually a

2-1 Maxims of Ani, *from E. Wallis Budge,* The Gods of the Egyptians: Study in Egyptian Mythology, *2 vols. [London, 1904] 1:128.*

7. *uṭennu* *neter-ku* *sau-tu* • *er*
"In making offerings to thy God guard thou thyself against

na *betau-tuf*
"the things which he abominateth.

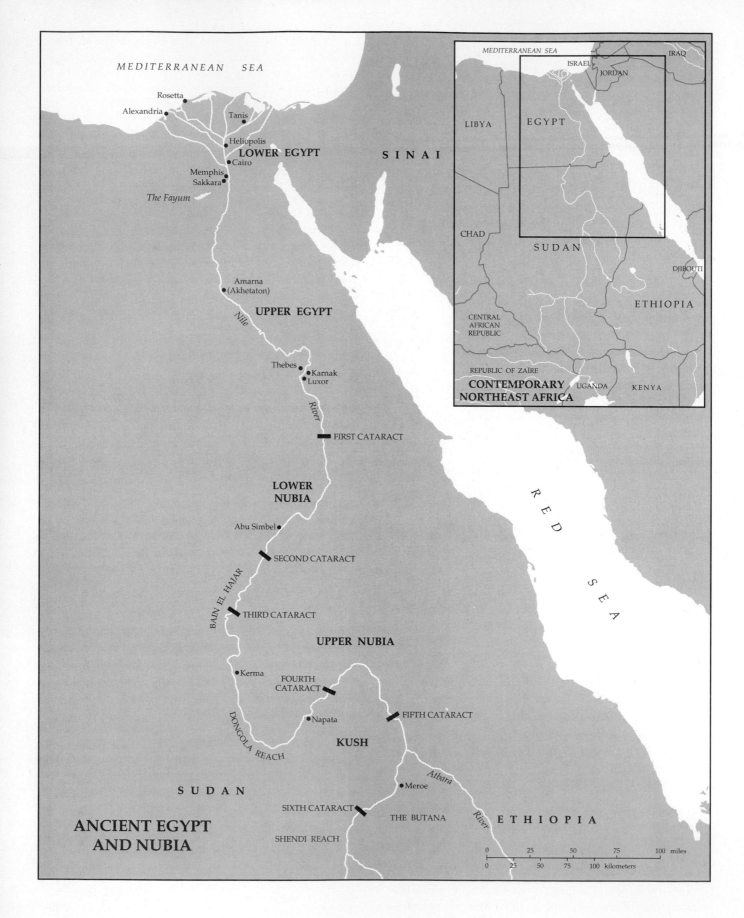

2-2 *The Rosetta Stone, Egyptian, 196* B.C., *British Museum, London. (Bildarchiv Preussischer Kulturbesitz, Berlin)*

hieroglyphic symbol could represent a word, a sound, a whole idea, or all three.

It was not until 1822 that moderns were able to translate the ancient Egyptian language. In that year a young French scholar, Jean-François Champollion, published his research on the inscriptions that are engraved on the Rosetta Stone (Fig. 2-2). This slab of basalt is incised with a temple decree written in Greek and two Egyptian scripts. Champollion was the first to recognize that the three scripts contained the same message. By matching up often-repeating words, he was able to determine the phonetic value of the hieroglyphic signs. From that time, the study of Egyptology flourished as the words of the ancient Egyptians came to life.

As in Mesopotamia, most Egyptian writing was done by scribes who attended special schools. Although most of the student scribes were from wealthy families and most were boys, there were exceptions, and being literate was the key to social advancement.

The strictness of the schools is evident from this piece of advice given to a student: "O scribe, don't be idle, or you will be punished straightaway. Don't give your heart to pleasures, or you will fail. Write with your hand, recite with your mouth, and speak with those more knowledgeable than you. Don't be idle or you will be beaten. The youth has ears on his back and he hears when he is beaten. Pay attention!" Another papyrus advises the student on the advantages of being a scribe. "Your body will be sleek; your hand will be soft. . . . You call for one; a thousand answer you. You stride freely on the road. You will not be like a hired ox. You are in front of others."[1]

Scribes learned to write with reed pens dipped in colored pigment or in an ink made of soot. *Papyrus,* a

[1] Miriam Lichtheim, ed., *Ancient Egyptian Literature: A Book of Readings,* vol. 2: *The New Kingdom* (Berkeley: University of California Press, 1976), p. 171.

paperlike substance made of overlapped fibers from a plant that grows along the Nile, was used, but since it was expensive its use was reserved for purposes such as official documents and funerary texts. More frequently, scribes wrote on flat flakes of limestone or broken bits of pottery. Scribes were a very important element in society, for literacy was highly valued in ancient Egypt. Scribes were employed by the local and central governments, and they would hire themselves out to write personal letters and to compose lengthy biographies and prayers that might be carved in stone tombs or on statues.

The Invention of the Alphabet Both Mesopotamian cuneiform and Egyptian hieroglyphics were cumbersome systems of writing and could be practiced only by those who could devote many years to training as scribes. A form of writing corresponding to what we call the alphabet (from *alpha* and *beta*, the first letters of the Greek alphabet) seems to have developed in response to the need of soldiers, traders, and merchants for a writing system that was both more efficient and easier to learn. Findings by Egyptologists in 1999 indicate that the alphabet was developed by people from the region of Syria or Palestine living in Egypt between 1900 and 1800 B.C. The alphabetic system of writing was further developed by the Phoenicians and probably passed on to the Greeks as early as the twelfth century B.C.

Egyptian Religion

Egyptian religious beliefs are very complex and difficult to understand because there were hundreds of gods, and these gods combined temporarily to form other deities. So, too, the real "power" or association of some of the important gods is unclear. Specific gods rose in importance in certain times and then retreated into relative obscurity in other years.

Another difficulty is that the Egyptian religious beliefs grew through accretion rather than through evolution. In other words, no beliefs were discarded, but they were added to or kept alongside other seemingly contradictory beliefs. For example, there are several myths about the creation of the gods and people because the Egyptians' fluid religious beliefs admitted each equally, rather than replacing one with another.

A further feature of the Egyptian pantheon is that although gods were created by combining one god with another, such as the fusion of Amon (also spelled Amen or Amun) and Ra (Re) to become Amon-Ra, the same general cast of gods was revered for the three thousand years of Egyptian history. When the Greeks conquered Egypt, in 332 B.C. with Alexander the Great, many Egyptian gods were adopted by the Greeks. For example, the Greek god Hermes was associated with the ancient Egyptian god Thoth, a god of writing and wisdom.

A major characteristic of Egyptian gods is their generally benevolent nature. In general, the ancient Egyptians did not fear their gods, as was often the case in Mesopotamia. We have many letters and hymns that express the comfort that the gods gave to worshipers. The oldest Egyptian gods were protectors of particular cities or provinces and continued to be worshiped throughout Egyptian history. Among these early gods was the sun god Ra (Color Plate II), whose earliest cult center was at Heliopolis, near modern Cairo. In the Heliopolitan myth of creation it is recorded that Ra created himself out of his mother, Nun, the primordial waters. He then created the air god Shu, the moisture goddess Tefnut, the earth god Geb, and the sky goddess Nut. From Geb and Nut were born gods and goddesses in human form: Set, Nephthys, Osiris, and Isis.

Ra was among the most important gods in the Old Kingdom, and the religious beliefs surrounding the king were based on the solar theology of that god. By the middle of the Old Kingdom (Fourth Dynasty), the belief that the pharaoh was semidivine was firmly established, and a primary title of the king from that time onward was the "son of Ra."

However, this was only one aspect of the divine associations of the king. From the very earliest time, the living king was associated with the falcon god Horus. On his death he was equated with the god Osiris, the father of Horus. In this way, the royal succession was enforced by myth, for each new king, whether or not he was actually related to his predecessor by birth, succeeded his father as the new Osiris. In that fashion the ancient Egyptians created a myth that there had been a single line of kings in orderly succession for most of Egypt's history.

The myths surrounding Horus and Osiris entered into other aspects of religion and morality as well. The legend recounts that Osiris was the first king of Egypt. According to the legend, Set, the brother of Osiris, killed the king, dismembered his body, and cast the pieces into the Nile. Osiris's faithful wife, Isis, collected the pieces, wrapped them as a mummy, and later conceived their son, Horus. This story became the basis not only for the family relationship of Horus and Osiris, which was associated with the king, but also for a model for the Egyptian family and role models of the dutiful wife and son. The characteristic fertility of Osiris, who was able to engender a son even after his death, gave rise to the idea of Osiris as the god of fertility and rebirth.

In contrast with Osiris and Horus, who as gods were men written large, the goddess Maat was an abstract deity. A personification of the concept of truth, she was depicted as a woman with a feather on her head or with spreading wings. Goddess of truth, moral

and physical order, and also of justice, Maat had no temples and no official cult. She represented the balance of forces within the universe, and violations of her order would inevitably be punished. The Egyptians considered the earthly ruler to be Maat's surrogate because his duty was to uphold the forces of order in the world against those who worked for disorder, represented by Maat's divine opposite, Izfet.

The Afterlife One of the most important religious implications of the Osirian myth was the promise of personal immortality. From the Old Kingdom onward through Egyptian history, it was thought that on death, one became equated with the god Osiris, and like that god, the individual was reborn again in the afterlife. Several requirements, however, had to be met for this rebirth. The spirit of the deceased had to pass a judgment before the tribunal of the gods to prove that the soul (envisioned as the human heart) was free from sin. He or she had to recite a long "negative confession" containing statements such as "I did not harm anyone" and "I did not defy any god." The next procedure was for the person's heart to be weighed against the feather of Maat, goddess of truth. If the scale did not balance, the person would be devoured by the monster Ammit and die a permanent death, but if it did balance, he or she would be admitted to the presence of Isis and Osiris and live forever.

Egyptian faith in the afterlife contrasts sharply with that of the Mesopotamians for whom even Gilgamesh, partly divine, faced extinction with the death of his body. No other aspect of the Egyptian mentality is more important to understanding the culture of this civilization of the Nile than its confidence that the spirit survived death. The Egyptian Book of the Dead contains a wealth of rituals and secret magic formulas to help individuals pass into the afterlife.

Pyramids: The Zoser Pyramid Complex

When compared with the closely grouped cities of contemporary Mesopotamia, the cities of Egypt lay widely separated from one another along the Nile. Although tremendous resources were lavished on the palaces of the Old Kingdom, these structures, built of mudbrick, have not survived. On the other hand, the pyramids, built of stone, continue to testify to the appropriateness of the title given them in antiquity as "first great wonder of the world."

Whereas the ziggurat at Ur was a temple that replicated a mountain for access to the gods (Chapter 1, Fig. 1-2), the stepped pyramid at Saqqara (Fig. 2-3) was a tomb for the Old Kingdom pharaoh Zoser (2686–2613 B.C.). It stood at the heart of a vast necropolis site surrounded by many nonroyal tombs. Like the ziggurat, the pyramid had its origins in a tra-

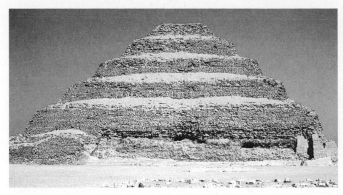

2-3 *Imhotep, Funerary complex of King Zoser with step pyramid, Saqqara, c. 2650 B.C., limestone. (Vanni/Art Resource, NY)*

ditional building vocabulary of mudbrick, reeds, and timber. Zoser's complex, however, was built of limestone, and the architect's name, Imhotep, was chiseled on a statue base.

King Zoser's tomb is composed of the pyramid resting on a terrace surrounded by buildings and enclosed within a stone wall, originally thirty-three feet high and nearly a third of a mile around (Fig. 2-4). The complex resembles a huge movie set, for although there are many buildings within its walls, they are all false fronts, with only representations of doors. It is thought that all these buildings were to serve the spirit of the king in the afterlife. The complex was built to commemorate the king after his death and to make it possible for him to enact rituals of renewal in the afterlife.

The true pyramid evolved from the design of Zoser's stepped pyramid tomb. The best-known true pyramids are the tombs of Cheops, Chephren, and Mycerinus (c. 2600–2500 B.C.). These tombs, a few miles north of Saqqara, were not isolated, for they stood in the middle of a vast cemetery built for the royal family and administrators. The royal pyramid was only one part of the royal tomb complex, which was composed of a mortuary temple on the east side and a long, covered causeway leading to a valley temple. Processions of priests would have come on the river to the valley temple and, from there, up through the causeway to the pyramid itself. The elements of the royal funerary complex can still be seen in the Chephren complex, which is also marked by the famous Sphinx, a portrait of the king shown with the body of a lion. This general style of pyramid complex was retained for the burials of the kings of the Old and Middle kingdoms (Fig. 2-5).

Sculpture

The architecture of the Zoser complex both builds on an old tradition and creates a new one. The sculptural

1. **Enclosing Wall**
2. **Entrance**
3. **Entry Hall with Columns**
4. **Grand Court**
5. **Heb-Seb Court**
6. **House of the South**
7. **House of the North**
8. **Court of the Serdab**
9. **Serdab**
10. **Mortuary Temple**
11. **Step Pyramid**
12. **Sarcophagus Chamber**
13. **Original Mastaba**

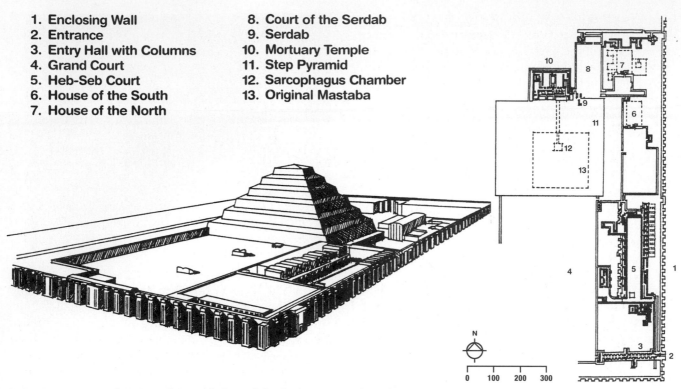

2-4 *Reconstructed view and partial plan of the funerary complex of King Zoser at Saqqara.*

▲

- How does the ziggurat differ from the pyramid? Materials, layout, purpose?
- What role does the pharoah play in the Zoser complex? Compare that role with the role of the king in Mesopotamia.
- What is the dominant value represented by the Zoser complex? How does that compare with the Mesopotamian view of life after death?

decoration at the tomb, too, has artifacts whose forms show artistic conventions that would endure until the end of the Old Kingdom.

The wood tomb panels of Hesira (c. 2750 B.C.) (Fig. 2-6), a scribe and a physician, show him with other attributes of his authority. He is rendered with head, legs, and hips in profile, whereas the eyes and shoulders are presented as if seen *frontally*. This artistic principle of frontality is expressed in the head of the re-

2-5 *Pyramids of Mycerinus, Chephren, and Cheops, Giza, Egypt. Limestone, height of Cheops pyramid c. 480'. (Hirmer Fotoarchiv, Munich)*

2-6 *Portrait Panel of Hesira, from Saqqara, c. 2750* B.C. *Wood, height 45", Egyptian Museum, Cairo. (Hirmer Fotoarchiv, Munich)*

▲

- Compare this relief with the Royal Standard of Ur (Fig. 1-4) and with the stela of King Naram-Sin (Fig. 1-10). What are some differences in the way the figures are represented and placed on the panel?
- Does the material of the panels make a difference in how you respond?

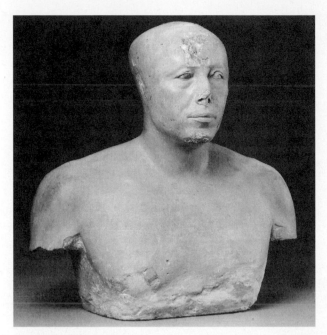

2-7 *Bust of Ankhhaf, Egyptian, Fourth Dynasty, from Giza chapel. Sculpture, limestone; partially molded in plaster. Height 21". (Harvard University–MFA Expedition. Courtesy, Museum of Fine Arts, Boston)*

2-8 *Seated Scribe, from Saqqara, c. 2400* B.C. *Painted limestone, height 21". (The Louvre, Paris; copyright* PHOTO *Réunion des Musées Nationaux)* (**W**)

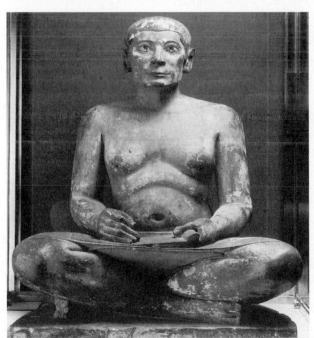

▲

- Compare this figure (its eyes, cheeks, mouth, hair, head, face, and body) with one of the Tell Asmar statuettes (Fig. 1-3), and then compare the two with the statue of King Akhenaton (Fig. 2-13).
- Describe how the different ways the artist has rendered the figures affect your perception of each figure.

lief and in the convention that shows the body's weight evenly distributed on both legs, the left leg advanced. Presentation of the human figure in this way may have been created to ensure that all the necessary parts could be seen and would therefore be present in the afterlife. The wood would have been brightly painted, but the paint would not alter the carved surfaces, which render the figure noble and dignified.

Other examples of sculpture from the Old Kingdom, such as the bust of Prince Ankhhaf (c. 2550 B.C.) (Fig. 2-7) or the *Seated Scribe* (c. 2400 B.C.) (Fig. 2-8), illustrate the range possible within these conventions. Both figures are somewhat idealized—that is, they are presented without obvious blemishes, wrinkles, or

DAILY LIVES

•••• *The Settlement of the Tomb Builders of Thebes*

On the west bank of the Nile directly opposite Thebes, beyond the fields made green by irrigation canals leading inland from the river, lay the desert valleys used by the people of the New Kingdom as the site for the tomb temples of their kings (see illustration of Hapshepsut's temple tomb, Fig. 2-12) and the burial chambers of lesser folk. In the midst of that desert was the village of the tombmakers, now known as Deir el Medina. The story of the lives of these workers and their families over more than three centuries has been reconstructed on the basis of writing found there on literally thousands of pieces of stone used by scribes to keep records.

"Lacking both soil and water, the village's needs were entirely supplied from outside: they were either sent from the warehouses of the royal temples or by the retainers working directly for the tombmakers and their families. Labourers tended a continuous line of donkeys that carried earthenware jars filled with water out across the desert to the bone-dry village and all the village's grains, vegetables, meats and fish arrived by the same route. Everything indeed, except the honey that the villagers collected from their own desert hives, was sent up to them from the fertile valley."

Public feasts are described as follows: "a male harper sang at these feasts to encourage the revellers to enjoy themselves. . . . So the villagers sat and swayed with the music and ate and talked. . . . All the guests wore rich brown wigs and white gossamer linens, bright, loose and elaborately pleated. The women's wigs were especially massive, as wide as their shoulders, and, emphasized in this dark thick frame, their faces were exquisitely made-up: eyebrows shaped to narrow arcs, eyelids carefully painted and colored. Both men and women wore jewelry: fragile faience bracelets and rings which could shatter almost at a touch, ear-rings and necklaces, and for special feasts large collars made of fresh flowers and aromatic plants strung together with beads and fine linen tassels. Perfumes too, were a major part of this elaborate display. They were a special attribute of the gods and, along with seeding lettuce plants, held to be aphrodisiac.

"[Apart from the public festivals, there were feasts] observed only by individuals or single families: the attendance registers of the village scribes often note a man's absence from the work in the Great Place (The Valley of the Kings) when he was either celebrating 'his festival' or brewing beer for the accompanying feast. . . . Other village festivals connected the living with the dead. All the families would go to their tomb chapels, light lamps, tend the small gardens that were sometimes kept in the cemetery, and feast in the chapels above the burial vaults filled with their ancestors."

Excerpts from John Romer, *Ancient Lives: Daily Life in Egypt of the Pharaohs* (New York: Holt, Rinehart and Winston, 1984), pp. 50, 53–54.

other distracting individualized characteristics; yet both sculptures also clearly capture the personality and presence of the figure. The prince's skin, and the skin folds under his eyes and around his mouth, convey maturity and a thoughtful, almost melancholy mood. The scribe is bright, alert, and intense. Egyptian representations of human beings like this contrast sharply with the sculpture of Greece, which hardly knows individuals, and seem more like the sculptures of the Romans, whose public figures have public, familiar faces.

The Middle Kingdom (2140–1786 B.C.)

The causes behind the breakup of the Old Kingdom and the period of confusion that followed are difficult to ascertain. Order was finally restored by the Eleventh Dynasty rulers Mentuhetep II (2065–2060 B.C.) and his son Mentuhetep III (2060–2010 B.C.), under whom Egypt returned to its former position as the dominant power of the region.

Associated closely with Thebes, both these monarchs encouraged the worship of Amon-Ra, the sun

god of Thebes. These pharaohs and their successors showered Amon-Ra with treasures and properties in thanks for the prosperity and conquests abroad that marked the first centuries of the Middle Kingdom.

The pharaohs of the Middle Kingdom showed themselves much more expansionist than those of the Old. During the centuries of the Middle Kingdom, Egypt not only subjugated Nubia and the Sudan but also advanced its own boundaries into Palestine. One of these pharaohs, Amenemhat III (1850–1800 B.C.), also built the largest habitable structure ever constructed in ancient Egypt, his palace of Hawara.

The decay of the Middle Kingdom has so far eluded explanation by scholars. It is clear that the Middle Kingdom traditions were disrupted by the infiltration of the Hyksos, people from Palestine, who established their capital at Avaris in the eastern Delta. The Hyksos, whose name is a corruption of the title "foreign kings," had a lasting impact on Egypt. The psychological effect of proud Egypt being dominated by foreigners was never forgotten, and this disgrace became a theme in pessimistic literature of the time. The Hyksos also forever changed Egypt by the introduction of new technology: the compound bow, the chariot, a style of bronze dagger, and new agricultural techniques. Ironically, the military innovations allowed the Egyptians of the New Kingdom to dominate the homelands of the Hyksos.

The Hyksos were expelled by a line of rulers at the end of the Seventeenth Dynasty in Thebes in Upper Egypt. Their expulsion marked the beginning of the glorious period called the New Kingdom.

The New Kingdom (1570–1085 B.C.)

In the New Kingdom, Egypt was the dominant power in the entire Near East. It was a time of cultural achievement as well. From the onset of the Eighteenth Dynasty, the pharaohs dedicated their energies to the conquest of Nubia to the south and the entire eastern Mediterranean area. By the middle of the dynasty, Egypt maintained garrisons throughout these regions, and under Thutmose III (c. 1504–1450 B.C.), called the "Napoleon of Egypt," Egyptian armies campaigned across the Euphrates River in Mesopotamia. The end of the dynasty was devoted to consolidating the political gains, and also to incredible accomplishments in architecture, sculpture, and painting.

Queen Hatshepsut (c. 1504–1482 B.C.)

Hatshepsut was the daughter, sister, and wife of pharaohs (see Figs. 2-9, 2-10). As the widow and half sister of Thutmose II, she ruled as regent for her nephew, Thutmose III, when he was a young boy. After four years, she adopted the full title of king rather

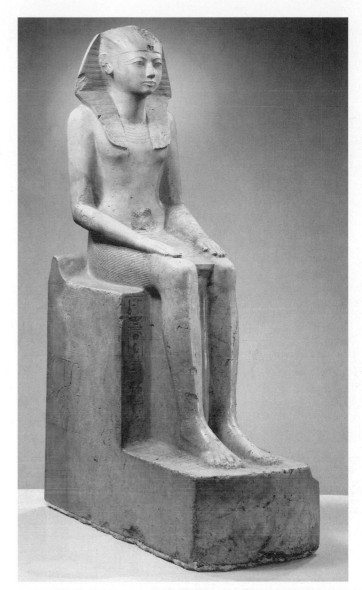

2-9 *Statue of Queen Hatshepsut. Indurated limestone from Thebes: Deir el Bahri: Temple of Hatshepsut ca. 1485 B.C. (The Metropolitan Museum of Art, Rogers Fund and Contributions from Edward S. Harkness, 1929)*

than of queen and ruled in her own right. Although many aspects of her reign suggest that her nephew was co-regent with her, her usurpation of royal rituals was unprecedented. She executed the duties of any male king, sending military campaigns to Nubia and Palestine and acting as a patron of extravagant arts and architecture. After her death, Thutmose III, perhaps out of frustration at being denied the sole rule, attempted to destroy many of Hatshepsut's monuments.

The Temple of Hatshepsut at Deir el Bahari In the time of Hatshepsut, the rulers of Egypt no longer were buried in pyramids. Their tombs were in chambers cut

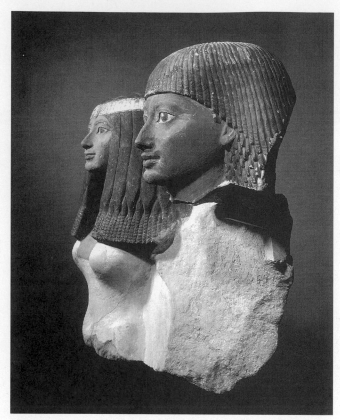

2-10 *Statue of Hatshepsut and Senynefer. New Kingdom. Paint on sandstone—height 68 cm. Musee du Louvre © Photo RMN-Chuzeville.*

deep into the rock faces of the Valley of the Kings in Thebes. A mortuary temple that was built during their lifetime to serve as a monument to their memory and a religious center was separated from the tomb and was located on the valley floor over the hills from the Valley of the Kings (Fig. 2-11).

The mortuary temple of Hatshepsut at Deir el Bahari in Thebes is in stark contrast to the Old and Middle Kingdom pyramid complexes. The structure is linear with strong, heavy columns (round posts) and *piers* (square posts) that were used, along with walls, to define and divide spaces and to carry the great *lintels* and *slabs* that provided for the roofs. Columns might be fluted and painted or carved. Walls were carved, painted, and decorated with elaborate reliefs. The physical energy and engineering skill required to erect these buildings are still impressive (Fig. 2-12). The processional way—up ramps and through courts—recalls the processional way from the river to the pyramids at Giza. Here, however, space is shared among the divine ruler and the divinities themselves.

Monumental Writing The walls of the tomb are decorated with hieroglyphic inscriptions that praise the queen and the god Amon. Partially destroyed by her

nephew, the series recounts Hatshepsut's divine paternity and the legitimacy of her claim to the throne. The union of the god Amon with Queen Ahmose, Hatshepsut's mother, is described as follows: "When he came before her, she rejoiced at the sight of his beauty, his love passed into her limbs, which the fragrance of the god flooded." Amon then declares, "Khnemet-Amon-Hatshepsut shall be the name of this my daughter, whom I have placed in thy body. . . . She shall exercise the excellent kingship in this whole land. My soul is hers . . . , my crown is hers, that she may rule the Two Lands, that she may lead all the living."[2]

The Amarna Period

This period includes the reigns of Amenophis III and IV as well as Tutankhamen. In the reign of Amenophis III (c. 1417–1379 B.C.), the Egyptian court came in closer and more consistent contact with Mesopotamia. This contact is best recorded by a group of documents called the "Amarna letters," correspondence written to the king of Egypt from the kings of Assyria, Babylonia, and the Hittites. The letters, named for the city where they were written, indicate that these lands maintained diplomatic relations with each other. This was a period of great cultural achievement and prosperity in Egypt, brought about primarily by a century of military campaigns by the pharaohs of the Eighteenth Dynasty. During the second half of the reign of Amenophis III, the kingdom was at peace and the state resources were directed toward massive temple and palace building projects. Because of the increased contact with the southern and eastern areas, Egypt had become a multicultural and multiracial society. Inhabitants from Nubia in particular were assimilated into Egyptian culture and had equal standing with native Egyptians in the bureaucracy and society. This period also saw the rise of the sun god Aten (also spelled Aton). Unlike other Egyptian gods, Aten was not represented as a man or an animal, but only as the round disk of the sun.

Under Amenophis IV (c. 1379–1362 B.C.) the god Aten was elevated to a new prominence. In the early years of the king's reign, he built temples to the god in the precinct of the god Amon-Ra at Karnak. Although the motivation of Amenophis IV is not clear, by year five of his reign he professed his special allegiance to Aten by changing his throne name from Amenophis (the Greek form for "the one who satisfies Amon") to Akhenaton ("the one who is beneficial to Aten"). Shortly afterward, Akhenaton and his wife, Nefertiti, moved the administrative center of Egypt from Thebes

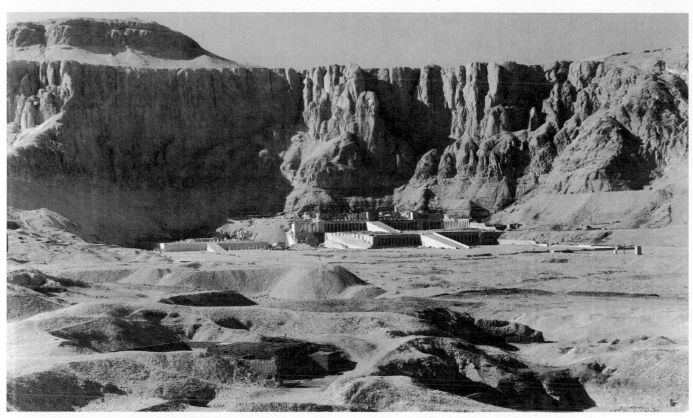

2-11 *Funerary temple of Queen Hatshepsut, Deir el Bahari, c. 1480 B.C. (Hirmer Fotoarchiv, Munich)* (**W**)

- Referring also to Figure 2-12, compare this temple complex with Zoser's complex (Figs. 2-3, 2-4). What are the major differences in the sites and how do these differences relate to the role of the pharaoh?
- Figure 2-12 is an architect's drawing of the complex. Do you find that figure or this one easier to understand and why? Does the drawing make the temple seem larger or smaller?

2-12 *Perspective view and plan of the funerary complex of Queen Hatshepsut.*

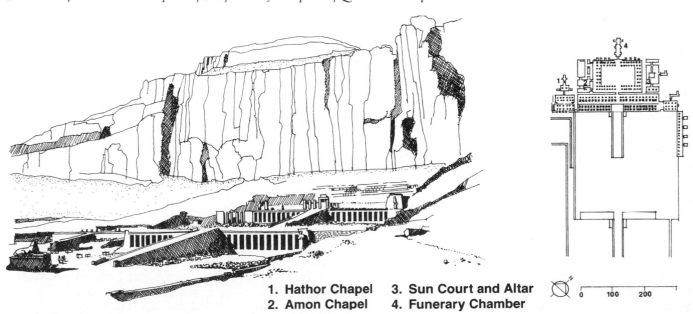

1. **Hathor Chapel** 3. **Sun Court and Altar**
2. **Amon Chapel** 4. **Funerary Chamber**

0 100 200

to a new site, called Tel el Amarna, in the middle of Egypt. The dedication decrees of the city indicate that the king wished to establish a city that was associated with no other god. From this time through the end of his reign, there was a deliberate attempt to erase the mention of other gods in the pantheon. Crews of workers were dispatched to temples to hack away the stone hieroglyphs that invoked the names of other gods. Although this appears to be an early form of *monotheism,* there are many indications that Akhenaton himself was considered to be divine and of a status nearly equal to Aten. His praise for his sole god, Aten, is best summed up in the "Hymn to the Aten."

Akhenaton's refusal to accept the worship of other deities not only did honor to Aten but also provided the pharaoh with the wealth to continue his ambitious building projects for the new worship. With Amon-Ra suppressed, the rich revenues from the lands held by his priesthood were now diverted into the royal treasury. On the other hand, Akhenaton's policies made him hated by the religious establishment of the country, which the populace, deprived of the reassuring contact with their gods through rites and processions, probably supported wholeheartedly. The priests could accept Aten as another god but not that he alone was divine.

Akhenaton reigned for seventeen years. During the last of those years, there was political unrest in Mesopotamia and Palestine, and the Egyptian armies were less effective in maintaining Egypt's hold on its colonies. Its foreign domains were diminished and were not revived for a century.

Shortly after the death of Akhenaton, a young boy named Tutankhaton, perhaps the son of Akhenaton and a secondary queen, came to the throne. By the third year of his reign he modified his name to replace the Aten element with that of the old god Amon and adopted the name Tutankhamen (c. 1361–1352 B.C.). Under his rule the city of Amarna was abandoned and *polytheistic* beliefs were again adopted throughout the society.

Art Under Akhenaton The radical changes in theology and society during Akhenaton's reign are paralleled by equally radical changes in art. Sculptures of the pharaoh from the Aten temple at Karnak show not the heroic, athletic, idealized figure, but a dreamy-eyed, heavy-lipped face and almost feminine body (Fig. 2-13). In an incised relief (Fig. 2-14) from Tel el Amarna, Akhenaton, Queen Nefertiti, and a daughter sacrifice to Aten, and we see the same kind of style applied to all three actors in this scene. The bust of Nefertiti, a model found in a sculptor's studio in Amarna, presents us with a queen beautiful, regal, and self-composed (Color Plate III).

Decay of the New Kingdom

Under Tutankhamen's successors Egypt returned to its warlike stance, aggressively defending its expanded bor-

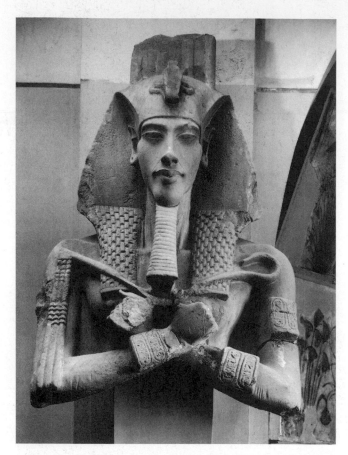

2-13 *King Akhenaton, from the Temple of Aten, Karnak (fragment), c. 1360 B.C. Sandstone, height 60¼". Egyptian Museum, Cairo. (Hirmer Fotoarchiv, Munich)*

ders, which ran from the south deep within Nubia, east across the Arabian Desert to the Euphrates, and then west again, including Syria and Palestine. After 1150 B.C., renewed invasions from the west and from the Mediterranean islands placed Egypt in a defensive position, causing it to withdraw most of the troops that had formerly maintained its colonies and garrisons in Palestine and Syria.

The Third Intermediate Period and the Late Period (1085–332 B.C.)

For much of the seven hundred years between 1085 B.C. and the end of the fourth century B.C., Egypt survived as a divided country. The pharaoh in the north, at the new administrative center named Tanis, was challenged by princes and military leaders in the south and in Middle Egypt; a pharaoh in the south was at Thebes. This lack of central authority weakened Egypt's ability to protect its interests along the Mediterranean coast.

Unity was restored to Egypt by the kings of Kush from Nubia (see page 47), who, at the request of beleaguered rulers in Thebes, invaded Egypt. These Kushite kings of the Twenty-fifth Dynasty (c. 720–656 B.C.)

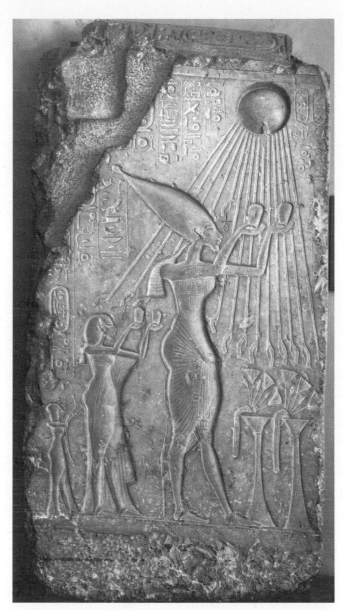

2-14 *King Akhenaton and His Family Sacrificing to Aten, from Tel el Amarna, Egypt, c. 1360 B.C. Limestone relief. Egyptian Museum, Cairo. (Hirmer Fotoarchiv, Munich)*

2-15 *Alabaster statue of the Divine Consort Amenirdis I, sister of King Shabaka, from the Chapel of Osiris Nebankh at north Karnak, c. 710 B.C. (Egyptian Museum, Cairo)*

dressed in imitation of the Egyptian pharaohs and worshiped Amon, to whom they built great temples in their homeland. Although many of the Nubian kings did not reside in Egypt, they ruled the land by means of their daughters, whom they installed as "God's Wives of Amon" in Thebes (Fig. 2-15). These women, who ruled as virtual kings, were forbidden to marry, for their children would be potential rivals to the Egyptian throne.

The Kushite dynasty was overthrown by the Assyrian army of Ashurbanipal, who entered Egypt and sacked Thebes in 667 B.C. When the Assyrians withdrew to their homeland to attend to threats from the Persians, they installed a family of administrators, who later overthrew their Assyrian masters to establish the Twenty-sixth Dynasty, also called the Saite period.

The Saite period (664–525 B.C.), the last independent Egyptian dynasty, was a time of relative peace, prosperity, and considerable achievement in building. Under the Saite kings, Egypt was further drawn into the greater sphere of the Near East. Foreign soldiers from Greece and Phoenicia were drafted into the Egyptian army, and trading colonies expressly for Greeks and other nationalities were established in the Delta area. However, there seems to have been some resistance among the native population to the Hellenizing tendencies of the Saite rulers.

After conquering most of the Middle East, including Mesopotamia, the Persians took Egypt in 525 B.C. Although the Persians were expelled in 405 B.C., the brief and troubled reigns of a series of Egyptian rulers could not give peace to the country, and between 341 and 332 B.C., Alexander the Great invaded Egypt.

The Ptolemaic Period (332–30 B.C.)

Alexander was viewed as a savior for Egypt. He adopted Egyptian royal titles and allowed the temples and administration to function as they had before the Persian conquest. With the death of Alexander in 323 B.C., his vast empire was divided among his generals. Egypt fell

2-16 *Coin with head of Cleopatra. Graeco-Roman period c. 51–30 B.C. British Museum, London (Werner Forman Archive/Art Resource, NY)*

2-17 *Musician animals with double-reed pipes, lute, lyre, and harp; reconstruction of a detail from a painting on a wooden box containing "ushabti," c. 1320–1200 B.C. (Cat. 2031, CGT 55001, Collezione Drovetti, Museo Egizio, Torino)*

to Ptolemy I, a Macedonian, for whom the Ptolemaic period is named. During the next centuries of Greek rule at least the upper classes of the Nile valley became culturally a part of the Hellenistic society, which dominated the Mediterranean from Syria to Spain.

Cleopatra (69–30 B.C.), the last of the Ptolemaic dynasty, was considered one of the great beauties of the ancient world (see Fig. 2-16). For centuries a book of beauty secrets circulated under the title *Cosmetics of Cleopatra*. But contemporary biographers also praised her intelligence and gift for politics. Married at thirteen to her brother, she ruled over Egypt at the time when Rome threatened to absorb her country, the richest in the Western world, into its empire. Her affairs with Julius Caesar and with Mark Antony, with each of whom she had children, have been interpreted as largely efforts to preserve the freedom of Egypt. In league with Mark Antony after 37 B.C., she expanded the power of Egypt to include islands in the Mediterranean and parts of the Arabian Peninsula and Syria. Captured in 31 B.C. by Octavian after the civil war and unable to seduce him by her charms, she took her life either by snakebite or by an injection of poison kept in a clasp she wore in her hair.

Egyptian Music

The abundance and variety of music making in ancient Egypt is recorded in the wall paintings and artifacts of Egyptian tombs, as well as in the literature about its kings and gods. Also, the classical authors Plutarch, Strabo, and Plato inform us at a later date, during and after the decline of the Egyptian empire, about the excellence of Egyptian musical standards, the nature of some instruments, performance practices, and the richness and importance of Egyptian musical life. However, although we have the poetry of some ancient Egyptian song texts and specific references to instruments that accompanied the singing, we have not the least trace of musical notation to reveal or suggest what the music actually sounded like. We can play the reconstructions of some ancient Egyptian instruments, but we cannot know the

beat, the melody, the tempo, or the tuning. At best, we can imagine elaborate temple ceremonies, ritual song and dance, and musical entertainment in the palaces.

Some instruments are described or depicted as early as the Old Kingdom (c. 2686–2180 B.C.), and these seem to have a continuous history of use: the end-blown flute (much like a recorder), a single-reed pipe (roughly similar in principle to a clarinet), the harp, and the sistrum, an Egyptian rattle of great significance in mythology, ritual, and everyday practice. (See Fig. 2-17.) Osiris, god of the lower world and judge of the dead, is known as the sistrum player, and he apparently carried this instrument with him as he civilized the world. (See Fig. 2-18.) Plutarch, writing that the inhabitants of Busiris and Lycopolis did not use the trumpet because its performance resembled the braying of an ass, also implies that such an instrument was present and probably in use somewhere else. During the Ptolemaic period, Strabo informs us, the aulos, an oboelike instrument with a double reed, performed licentious music. We see a similarity in practice to the music of classical Greece, for the aulos was an instrument associated with the orgies of the Dionysian festivals. Even before the Old Kingdom, we infer some musical practice suggested by the record of prehistoric dancing in rock drawings and on pottery figures. Then the record of the tomb illustrations from the Old and Middle kingdoms shows us singers, dancers, and players of string, wind, and percussion instruments, principally the harp, flute, and sistrum. A variety of new instruments appear during the New Kingdom, including the lute, lyre, drums, tambourine, and trumpet. Because music was clearly so important in the religious and cultural life of Egypt, and also because the Egyptian kingdoms were so powerful and influential over a vast time period,

2-18 *Scene on papyrus showing sistrum. Museo Egizio, Torino. (Alinari/Art Resource, NY)*

we must assume that Egyptian music played a significant role in the development of music in the classical world of Greece and Rome, even though we do not yet know much about those specific relationships.

Nubia and the Kingdom of Kush

Ancient Egypt's continuing wealth and power depended on its relations with the rest of Africa, as well as with Asia. Fragmentary and uneven as our evidence is concerning Egypt's ties to the Saharan and Libyan peoples in the west, to the Nubians in the south, and to Punt in the east, attempting to understand them will improve our knowledge of the influence that other African cultures and Egypt had on each other. Perhaps the most important contacts were to the south, with Nubia, an area within the modern African country of Sudan. Nubia is a region whose history is distinct, but at times so intertwined with that of Egypt as to be one.

Historical Background

Nubia is a geographical term referring to the part of the Nile valley in Egypt and Sudan that extends between the first and sixth cataracts. From the time of the late Old Kingdom on through the Middle Kingdom, Egyptians referred to the area above the first cataract as Kush. Settlements in this region appeared as early as 2300 B.C. at a site called Kerma. Modern scholarship uses the name Kush to refer to the kingdom that entered history under King Kashta around 800 B.C. and that dominated the middle reaches of the Nile for over

a thousand years from its two centers, Napata and Meroe.

Nubia's wealth in cattle, precious metals, copper, iron, and jewels led to lively trade with Egypt and brought about a fusion of their cultural features. We will deal briefly here with the two cultural centers at Napata and Meroe.

The Napatan Period (750–270 B.C.) Napata owed its origin to its location at the head of a major track, the Bayuda road, which ran overland to avoid a particularly difficult stretch of the Nile between the fifth and the fourth cataracts. Under the New Kingdom, Napata became a religious and bureaucratic center about the year 1400 B.C. The location of the town is uncertain, but the complex of burial grounds, pyramids, and temples at El Kurru and Nuri near Jebal Barkal are identified with Napata.

In the eighth century B.C., a succession of kings invaded Egypt from Napata. In 750 B.C., one of these, Piye (also called Piankhi) led his armies north of the first cataract and finally captured the city of Memphis. Thirty-six years later, in 714, the conquest and unification were completed.

For the next fifty years, until the capture and sack of Thebes by the Assyrian king Ashurbanipal in 663 B.C., this Kushite dynasty—as Egypt's Twenty-fifth Dynasty—provided a brilliant flash of energy amid the declining years of pharaonic Egypt. It restored pride in Egypt's glorious past by a refurbishing and building program in both Egypt and Nubia. After the Assyrian invasion, the Kushite kings withdrew to Napata, where the kingdom flourished until the city was sacked in 591 B.C. by Egyptian armies. For the next three hundred years, Kush's kings were troubled by challenges to their authority from Lower and Upper Nubia and the eastern desert. They gradually shifted their political center southward to Meroe, diminishing Napata's role to that of a religious center and burial ground for the kings and queens until the third century B.C.

The Meroitic Period (270 B.C.–A.D. 350) Meroe provides greater evidence of state development and urbanization. The large city harbored a palace precinct that contained numerous stores, baths, domestic quarters, and reception rooms. Among the many temples, major ones for Amon, Isis, and Apedemek the lion god are prominent sources of our knowledge of Kush's history during the Meroitic period. Far from Egypt, Meroe's culture moved further away from the Egyptian models so prominent in Napata. But the kings were in frequent contact with Ptolemaic and Roman Egypt: a major agricultural, manufacturing, and trade center for the Meroitic period developed far to the north of the capital city, near the third cataract—in easy reach of Egyptian sites downstream. Indeed, this was the region that

preserved remnants of Kush's culture after the fall of Meroe in the fourth century A.D. It was also the first Nubian region to convert to Christianity (in A.D. 543). As we examine other features of Kushite culture, notice that some are more characteristic of Napata, others of Meroe. Given the great extent of the kingdom in both time and space, the resilience of a conservative core of values and institutions is remarkable.

Population and Social Structure

The entire population of the Nile valley was distinct from other areas by the time of early dynastic Egypt. The skin color of people in the middle reaches of the Nile valley was dark: the peoples of the region were probably ancestors to those called Nubian today. The social structure of Kushite society seems to have been strictly stratified on the basis of wealth. At the top was the ruling class, composed of the king, members of the royal family, palace officials, the priests and priestesses of the temples, and perhaps the provincial bureaucrats. Elaborate residences and associated buildings dominated the urban landscape; fine pottery, tools, clothing, leather goods, shell, bone, and ivory jewelry, and other objects were early indications of these differences in wealth.

At the bottom of the social hierarchy were slaves, captured through warfare and raids on the surrounding desert peoples. Donated in very large numbers to the temples, they were also settled as colonists to occupy newly conquered territory. Their work as gardeners, builders, and preparers of irrigation canals and beds was probably the greatest source of their value. Inscriptions relating to slavery feature women more than men, suggesting that domestic service must have been an important activity as well. Slaves were exported from Nubia to Egypt and the Mediterranean in large numbers during Roman times. How far back in time the systematic trading of slaves goes, however, is unknown.

The majority of the population in between these two social poles probably consisted of free cultivators and herders. The visual prominence of the latter, and the symbolic importance of cattle and other animals in graves and on temple reliefs, are mute testimony to the nomadic origins of the civilization of the middle Nile. Artisans were imported from Egypt from time to time and clearly left their mark on material culture—they introduced the pottery wheel, which remained a preserve of men, distinct from the indigenous pottery made by women. The production of the elaborate silver and gold jewelry, ivory carvings of animal motifs, weaving, leather working, basketry, decorated pottery, and furniture making, all requiring the skill of specialists, reflects a blend of the alien and indigenous in their design and manufacture.

Politics and Religion

In Kush, as in Egypt, politics and religion inspired the artistic works that provide us with the evidence of Kush's past. During the Napatan period, the legacy of Egyptian values and religion, imported during the New Kingdom, is obvious. Moreover, when the kings from Kush ruled Egypt during the Twenty-fifth Dynasty, their commitment to Egyptian institutions, especially their veneration of the Egyptian "state god" Amon-Ra, was an important strategy to establish their legitimacy. Despite these indications of Egyptian cultural power, the picture of the Kushite monarchy that emerges from inscriptions, reliefs, tombs, and other archaeological remains distinguishes it from Egyptian forms in a number of ways. Succession to the kingship passed through the maternal line, with the succession often going to a younger brother of the preceding monarch rather than his son, as was the case in Egypt. The ruler was chosen from among the appropriate candidates for his personal qualities—his wealth, power, and success in animal husbandry being important—by designated figures of the realm. The queen mother and military officials appear to have been the most important electors.

Importance of Women

One of the unique features of the monarchy that contrasts with Egypt was the singular role played by royal women. The queen mothers played important roles both in the selection of the king and in the coronation rituals, which created a bond between the king and the gods. During the Twenty-fifth Dynasty, the kings' daughters or sisters held the title of *Dewat Neter,* chief priestess to the god Amon at Thebes. This bestowed on them great economic wealth and authority: they received numerous allotments of revenues and tribute in kind, and during the ruler's absence the chief priestess acted as ruler of the country.

The importance of queen mothers seems to have increased during the Meroitic period. Known as *Candaces* (the term comes from transcriptions of Meroitic *KDKE* by classical authors), they hold a prominence in the scenes on temple walls that places them second only to the king. For a period of time beginning in the second century B.C. in Meroe, there was a series of reigning queens, the first of whom was Shanakdakhete (c. 170–160 B.C.). The Candaces were evidently well-known figures in the ancient world, as may be seen from the biblical reference to them in Acts 8:26–28. The apostle Philip encountered "an Ethiopian [Ethiopian in Greek means black], a eunuch, a minister of Candace the queen of the Ethiopians, in charge of all her treasure, [who] had come to Jerusalem to worship and was returning; seated in his chariot, he was reading the prophet Isaiah."

Although the monarchy was buttressed by an ideology that during the early period drew heavily on Egyptian principles, the flow of religious ideas between Kush and Egypt may have been in two directions: by the end of the Old Kingdom, at least one deity from Africa beyond the Nile, Dedun, provider of incense, had been added to the Egyptian pantheon. In Napata, the numerous prayers and praises of Amon, the ram god, on stelae and temple walls testify to the importance of that Egyptian god in Kush. Amon's historic association with Kush survived the shift of the capital to Meroe, although a temple in Amon's honor was built there only during the first century B.C. But the dominant figure in the religious thought of the Meroitic period was the lion god, Apedemek. A warrior deity, Apedemek originated in the southern part of Kush and rose to prominence in Meroe. Representations of lions and lion heads are found in temples all over the region. Another Meroitic god that had no counterpart in Egypt was Sebiumeker, a creator god. His colossal image is paired with that of Arensnuphis as protective figures on the façade of Temple 300 in the Great Enclosure at Musawwarat es-Sufra, a major temple complex of the Meroitic period. One could conclude that Kushite religion was eclectic and open; this fact enabled the religious system to absorb new peoples and local deities without calling into question the legitimacy of the entire framework.

Language and Writing in Napata and Meroe

Egyptian was the diplomatic language of Kush during the hegemony of Napata, and it is through the inscriptions on temples and stelae that some record of Kushite thought and modes of expression is preserved. Among these are the inscriptions of two rulers, Piye and Taharqa.

Piye came to the throne in Napata in 751 B.C. and ruled until 716 B.C. During his long reign, he led successful military campaigns as far north as the Delta, which enabled his successors to eventually unite Egypt and Nubia under the Kushite or Twenty-fifth Dynasty. The Victory Stela of Piye, fashioned in magnificent gray granite with a rounded top, contains a remarkable and lengthy historical account of Piye's campaign of conquest, rich with details of military and diplomatic conventions.

The following excerpt comes near the end of the narrative of the campaign, when the last of Piye's enemies were surrendering and he headed for home. It illustrates the manner in which Kushite kings were eulogized. The use of praise names and the characterization of rulers in terms of both beauty and fierceness are features typical of praise poetry throughout Africa (see Chapter 13). The frequent use of cattle metaphors reflects the importance of pastoralism in the life (or certainly in the history) of Kush. Notice also how food taboos and circumcision are used to distinguish royalty and those with access to the king.

Final Surrenders, Piye Returns to Nubia

One came to say to his majesty: "Hut-Sobk has opened its gate; Meten has thrown itself on its belly. No nome is shut against his majesty, of the nomes of the south and the north. The west, the east, and the islands in the midst are on their bellies in fear of him, and are sending their goods to where his majesty is, like the subjects of the palace."

At dawn of the next day there came the two rulers of Upper Egypt and the two rulers of Lower Egypt, the uraeus wearers, to kiss the ground to the might of his majesty. Now the kings and counts of Lower Egypt who came to see his majesty's beauty, their legs were the legs of women.[3] They could not enter the palace because they were uncircumcised and were eaters of fish, which is an abomination to the palace. But the King *Namart* entered the palace because he was clean and did not eat fish. The three stood there while the one entered the palace.

Then the ships were loaded with silver, gold, copper, and clothing; everything of Lower Egypt, every product of Syria, and all plants of god's land. His majesty sailed south, his heart joyful, and all those near him shouting. West and East took up the announcement, shouting around his majesty. This was their song of jubilation:

"O mighty ruler, O mighty ruler,
Piye, mighty ruler!
Your return having taken Lower Egypt,
You made bulls into women!
Joyful is the mother who bore you,
The man who begot you!
The valley dwellers worship her,
The cow that bore the bull!
You are eternal,
Your might abides,
O ruler loved of Thebes!"[4]

The Stela of Tanis

King Taharqa (701–667 B.C.) erected a stela in Tanis, in the northeastern Delta, to commemorate the arrival of his mother from the south at the time of Taharqa's coronation in Lower Egypt. It is interesting because it reflects both the affection of a son for his mother, from whom he had long been separated, and the honor conventionally bestowed on the queen mother.

The queen-mother was in Napata. . . . Now I had been separated from her as a youth of twenty years, accompanying his majesty when he came to the Northland (Delta). Then she went north to the Northland where I was after a long period of years,

[3] That is, they were weak, unmanly.

[4] Miriam Lichtheim, ed., *Ancient Egyptian Literature: A Book of Readings,* vol. 3: *The Late Period* (Berkeley: University of California Press, 1980), p. 80.

and she found me crowned as king upon the throne of Horus. I had taken the diadems of Re, and I had assumed the double serpent-crest, as . . . the protection of my limbs. She rejoiced greatly when she saw the beauty of his majesty, as Isis saw her son, Horus, crowned upon the throne . . . while he was a youth in the marsh. . . . They bowed to the ground to this King's-Mother. . . . Their old as well as their young ones gave praise to this King's-Mother, saying: Isis hath . . . [seen] her son, King of Upper and Lower Egypt, Taharka, living forever. . . .[5]

When the capital of Kush shifted south to Meroe after the sixth century B.C., Egyptian inscriptions declined and by the third century B.C. were replaced by Meroitic ones, written first in hieroglyphics, then in cursive (see Fig. 2-19). There is much debate about the origin of Meroitic: some scholars believe it is a member of the Afro-Asiatic family of languages, others that it belongs to the great family of Sudanic (or Nilo-Saharan) languages.

The barriers that remain to our understanding of the Meroitic language leave us with few indications of the nature of Meroitic literature. However, on the walls of the lion temple at Musawwarat es-Sufra there are two inscriptions that, although written in Egyptian, are about the two gods that were Meroitic in origin. The first, a prayer to Apedemek, reflects an awareness of formal features of Egyptian religious texts, with the addition of praising, typical of African oral literature. It is to be hoped that future discoveries of texts will enable us to unravel the puzzle of Meroitic and enhance our understanding of this ancient civilization.

The Art of Napata and Meroe

The arts of the kingdom of Kush achieved distinction in many areas: human and figurative sculpture; architecture, particularly the construction of tombs, temples, and palaces; engraved friezes on the walls of tombs and temples; and a fine array of metal, glass, decorated pottery, and inlaid crafted objects used as burial goods. All of these give us telling glimpses into ritual and utilitarian features of life. By now it will not be surprising to read that Egyptian influence is more clearly seen in the art of the Napatan period, whereas Meroitic forms owe much less to the artists of Egypt. The examples selected for study here have been chosen for their fine quality, with an eye to showing differences between Napatan and Meroitic art, and to illustrate changes in style and content over Nubia's history.

[5] Breasted, *Ancient Records of Egypt,* vol. 4, pp. 456–457.

2-19 *Names of King Netekamani and Queen Amanitare in Egyptian and Meroitic. (From P. L. Shinnie,* Meroe: A Civilization of the Sudan, © *Thames and Hudson, Ltd.)*

Bronze of Shabaqo (716–701 B.C.) The fine, solid cast bronze figure of King Shabaqo (Fig. 2-20) is one of the earliest sculpted images we have of Kushite kings that reflect their distinctive regalia and sculptural style of the period. The kneeling figure poses in a balanced, *frontal* posture, the arms in a gesture of offering with palms vertical. The features typical of regal attire include the close-fitting cap with the double uraei (serpent crests symbolizing the union of Kush and Egypt); the necklace with three ram's-head pendants (symbol of the god Amon), surmounted by a serpent crest and sun disk; wide bracelets and armbands; and the short kilt. The king's name is inscribed on the buckle of the waistband. Typical of Kushite figure modeling are the muscular torso and smooth round face, distinguished by the "Kushite fold" extending horizontally out from the nose and accentuating the high cheekbones.

Granite Statue of King Aspelta (600–580 B.C.) In the early seventh century B.C. King Taharqa commissioned a massive granite statue (4.18 meters high) for the great temple of Amon at Jebel Barkal. The statue of King Aspelta (Fig. 2-21), also from Jebel Barkal, is comparable to it. Although reminiscent of Egyptian figures in stance, this statue is typically Kushite in the rounded face and muscular torso and the distinctive regalia. In addition, the crown is surmounted by the double towering feathers characteristic of the headdress of Amon, god of Thebes, who, as we have seen, was at the center of Napatan religion.

Plan of the Temple at Kawa King Taharqa was the great builder of the Twenty-fifth Dynasty. In Egypt he constructed the colossal columns at all four of the cardinal points of the great temple of Amon at Karnak. But

2-20 King Shabaqo Offering. *Twenty-fifth Dynasty, late eighth century* B.C. *Bronze, solid cast, height 15.6 cm, width 3.4 cm. (National Archaeological Museum, Athens)*

▲

• Compare this figure with one of the Tell Amarna statuettes. What difference does the material make? Which figure seems larger?
• Compare this sculpture's head with that of Ankhhaf in Figure 2-7. What do they have in common, and what is different? What difference does the material make?

his main accomplishments were in Nubia, where he refurbished the great temple at Jebel Barkal, and constructed nearly identical temples for Amon at Sanam, Tebo, and Kawa. Although these temples were designed following Egyptian prototypes and constructed by builders imported from Memphis, their construction of

2-21 *King Aspelta, kingdom of Kush, c. 600–580* B.C. *Nubian, Jebel Barkal, Sudan. Granite. Height: c. 12'. (Museum expedition. Courtesy, Museum of Fine Arts, Boston.)*

▲

• Compare this figure with that of King Shabaqo (Fig. 2-20) and also with that of King Akhenaton (Fig. 2-13). What elements do these three figures have in common?
• Do these figures have elements in common with other images of rulers? Hammurabi or King Naram-Sin, for example?

2-22 *Plan of the Amon Temple at Kawa, built by King Taharqa, Napatan period, 690–664* B.C.

stone faced with mudbrick was original. The processional way at Kawa was bordered by stone rams representing the sacred animal of Amon, each of which protected a statuette of Taharqa. Within the temple (see Fig. 2-22), mudbrick walls linking some of the columns with each other or with the inside walls were constructed as worksites for the manufacture of *ushabti* figures (votive figures used in burials) and other commercial activities. The *pronaos* contained an offering table for the god, while the *sanctuary* housed the sacred bark on its pedestal. Both the temple and the adjacent town were enclosed by a wall, also probably constructed at Taharqa's bidding.

The Swimming Girl The exceptional skill of artisans' work with metals and ceramics during the Napatan period is revealed in a small but stunningly beautiful object found among the tomb goods at Sanam: a swimming girl, prone and holding a small basin in her outstretched arms (Fig. 2-23). The figure was probably used for dispensing myrrh or wine in cult or burial ceremonies. The fashioning of the girl's head and face

2-23 Swimming Girl with Basin, *faience, length 10.8 cm, height 2.8 cm, width 2.3 cm, eighth to seventh century* B.C. *(Collection Ashmolean Museum)* **(W)**

reflects the distinctive Kushite fold, full mouth, and relatively large ears typical of Napatan figures from the eighth to the seventh century B.C.

Friezes from Meroe Although the art of the Meroitic period was as diverse in type as that of Napata, the reliefs on temples and chapels are the primary focus of study here. Ranging over a six-hundred-year period from roughly the late fourth century B.C. to the third century A.D., they provide ample evidence of changes in Meroitic styles over time. A frequent theme throughout the period was a scene like that in the pyramid chapel of Queen Nahirqa (186–177 B.C.) (Fig. 2-24). It consists of a king seated on a throne with lion-shaped armrests. Standing protectively behind the ruler is the goddess Isis and sometimes, as in this example, other members of the royal family. Nahirqa, the queen, is seated behind the unnamed king and in front of Isis, whose outstretched wings shelter them both. The king wears the distinctive banded cap highlighted by the uraeus in front and flowing streamers down the back, the transverse fringed tunic with a wide collar, and armbands. Notice the queen's beaded collar and pendant, and her finely modeled coiffure. This version is particularly interesting because of its graceful line, the detail, and the earliest use of small figures bearing palm branches, a feature that became ubiquitous thereafter. The stylistic use of contrasts in size to denote marked differences in status is a trait that will also be seen later in the plaques of the Benin kingdom in West Africa. An-

other characteristic is the repetition of a symbol to underline its importance, seen here in the repetition of the uraeus in the crown of Isis and the dominant upper border as well as in the king's crown to convey an aura of great power.

A common scene in lion temples, and borne out in the two most important examples at Musawwarat es-Sufra and at Naqa, is a profile of the king standing with arms bent at the elbow, palms forward in a gesture of worship before the lion god Apedemek. In the relief at Naqa of King Natakamani (12 B.C.–A.D. 12) (Fig. 2-25), we can identify a number of features common to Meroitic *iconography* and style as well as contrasts with

2-25 *Engraving from Richard Lepsius,* Denkmaeler aus Aegypten und Nubien, *1848, depicting Natakamani, king of Meroe, early first century A.D., from the west wall of the Lion Temple at Naqa, Sudan. (Photo courtesy of Timothy Kendall)*

2-24 *Relief from the pyramid chapel of Nahirqa. (Drawing by Lucinda Rodd. From P. L. Shinnie,* Meroe: A Civilization of the Sudan, © *Thames and Hudson, Ltd.)*

earlier forms (Fig. 2-24). The king's costume bears some similarity to the one in the relief of Nahirqa, but is more elaborate and fussy: instead of one necklace, he appears to wear three, one of which has a lion-god pendant. Elaborately carved armbands cover the forearm from above the wrist to the elbow, in addition to the armbands worn just below the shoulder. Neck rings, a sometime feature of Meroitic figurative sculpture that is also seen in West Africa, are just visible. The *hemhem*-crown—consisting of various numbers of highly stylized serpents—was widely used in reliefs, sculpture, and jewelry throughout the Meroitic period. A gradual simplification of forms together with emphasis on some aspects over others developed over time in Meroitic art—such as greater stress on eyes and the shift from naturalism toward abstraction, as exemplified in Figures 2-24 and 2-25. Queens are portrayed with ample proportions, whereas goddesses are slender (look again at the figure of the goddess Isis in comparison to that of the queen in Fig. 2-24). Other iconographic changes included a shift from unnaturally slender human forms to short, stocky ones. Clothing, which was a cardinal indicator of social status, also changed: the royal sash, originally quite narrow, grew wider in the first century B.C. and continued to expand for another one hundred years.

Kush and the Rest of Africa

The precise ways in which Kush (and Egypt, for that matter) influenced the rest of ancient Africa may never be known. We have stressed the importance of trade to Kush's economy; Kush was one of the corridors through which goods from the heart of Africa reached the outside world. The view once popular among historians that Kush was the filter through which the rest of Africa acquired ironworking technology and political and religious ideas has been modified somewhat. Research suggests that Kush's rule may have been more important for some areas than for others, and that independent innovation, as well as alternative sources for borrowing, has played a significant role in the evolution of material culture elsewhere on the continent.

Scholars such as the late Cheikh Anta Diop have also pointed to important similarities between Egyptian and Kushite ideas and institutions associated with kingship and those of certain West African peoples. Moreover, the Yoruba and Ashanti, to name only two, include in their traditions stories of eastern origins. Archaeological excavations along the east-west trade routes may one day provide tangible evidence of the nature of past contacts between Kush and West Africa. On the other hand, the long history of north-south trade is better documented, and suggests that cultural features might well have traveled to the Great Lakes region of the continent. On balance, it seems more appropriate to acknowledge the incomparable value of the Nile valley civilizations for what they were: testimony to the ingenuity of the human community in ancient times in being able not only to survive profound environmental change but also to succeed in becoming the progenitors of culture.

The Disappearance of Kush as a State

By the time the first Christian missionaries arrived in lower Nubia around A.D. 543, some two hundred and fifty years had elapsed since the last known king ruled in Meroe. What happened to this state? Why did it disappear? Did Axum, a rising kingdom in the Ethiopian Highlands, inflict (as its historic inscriptions suggest) a major defeat on Kush, which dispersed the population? We may never know. However, recent archaeological and historical evidence suggests that the remnants of the old state served as the basis for three independent kingdoms, Nobatia, Makouria, and Alwa, which dominated lower, upper, and southern Nubia until they were finally defeated in the fourteenth century by Muslim forces from the north. Although Christianity thrived in these kingdoms from the sixth to the fourteenth century, it did so in part by borrowing heavily from pre-Christian symbolism and ritual. As scholars learn more about this intermediary period, we may hope to obtain a clearer picture of the links between ancient and modern Africa.

Egyptian literature includes royal monumental inscriptions, some of which are hymns of victory, hymns to the gods, and poems in praise of the pharaoh. Poetic narrations of battles may be compared with the epic, although there is nothing extant from Egypt of the size of the *Epic of Gilgamesh*. There is a substantial body of "wisdom literature," containing words of advice, which probably influenced the books of Proverbs and Deuteronomy in the Bible. Tales, both mythical and realistic, were well developed, as was lyric poetry, although love poetry does not appear until the period of the New Kingdom.

The Book of the Dead, with its spells of protection and transformation, shows a characteristic mixing of morality with magic. The Negative Confession reprinted here, forty-two statements to forty-two different gods on commandments *not* broken, made by souls in their passage to the afterlife, is reminiscent of the Ten Commandments in the Old Testament book of Exodus.

The Instruction of Ptah-hotep
Translation by F. L. Griffith

The author of these maxims, who lived during the Old Kingdom, around 2450 B.C., was the vizier of a pharaoh. The author is instructing his son in the rules of behavior and morality. Whereas in later Egyptian literature religion and morality are always intertwined, here the emphasis seems to be more on the social and practical aspects of morality.

Title and Aim

Beginning of the maxims of good words spoken by the . . . mayor and vizier, Ptah-hotep, teaching the ignorant to know according to the standard of good words, expounding the profit to him who shall listen to it, and the injury to him who shall transgress it. He said to his son:

Intellectual Snobbery

Be not arrogant because of your knowledge, and be not puffed up because you are a learned man. Take counsel with the ignorant as with the learned, for the limits of art cannot be reached, and no artist is perfect in his

skills. Good speech is more hidden than the precious greenstone, and yet it is found among slave girls at the millstones. . . .

Leadership and "Maat"

If you are a leader, commanding the conduct of many, seek out every good aim, so that your policy may be without error. A great thing is truth [*Maat*], enduring and surviving; it has not been upset since the time of Osiris. He who departs from its laws is punished. It is the right path for him who knows nothing. Wrongdoing has never brought its venture safe to port. Evil may win riches, but it is the strength of truth that it endures long, and a man can say, "I learned it from my father.". . .

Relations with Women

If you wish to prolong friendship in a house into which you enter as master, brother or friend, or any place that you enter, beware of approaching the women. No place in which that is done prospers. There is no wisdom in it. A thousand men are turned aside from their own good because of a little moment, like a dream, by tasting which death is reached. . . . He who fails because of lusting after women, no plan of his will succeed.

Greed

If you want your conduct to be good, free from every evil, then beware of greed. It is an evil and incurable sickness. No man can live with it; it causes divisions between fathers and mothers, and between brothers of the same mother; it parts wife and husband; it is a gathering of every evil, a bag of everything hateful. A man thrives if his conduct is right. He who follows the right course wins wealth thereby. But the greedy man has no tomb. . . .

Marriage

If you are prosperous you should establish a household and love your wife as is fitting. Fill her belly and clothe her back. Oil is the tonic for her body. Make her heart glad as long as you live. She is a profitable field for her lord. . . .

Conduct in Council

If you are a worthy man sitting in the council of his lord, confine your attention to excellence. Silence is more valuable than chatter. Speak only when you know you can resolve difficulties. He who gives good counsel is an artist, for speech is more difficult than any craft. . . .

Behavior in Changed Circumstances

If you are now great after being humble and rich after being poor in the city that you know, do not boast because of what happened to you in the past. Be not miserly with your wealth, which has come to you by the god's gift. You are no different from another to whom the same has happened.

Obedience to a Superior

Bend your back to him who is over you, your superior in the administration; then your house will endure by reason of its property, and your reward will come in due season. Wretched is he who opposes his superior, for one lives only so long as he is gracious. . . .

Conclusion

May you succeed me, may your body be sound, may the king be well pleased with all that is done, and may you spend many years of life! It is no small thing that I have done on earth; I have spent one hundred and ten years of life, which the king gave me, and with rewards greater than those of the ancestors, by doing right for the king until death.

COMMENTS AND QUESTIONS

1. The concept of Maat is primarily a religious one. How is it applied here in terms of morality?
2. What seems to be Ptah-hotep's view of women?
3. What aspects of this advice would you consider to be still applicable today?

from the *Book of the Dead*
Translation by E. Wallis Budge

The Negative Confession

The confession takes place in the hall of double Maat, or the hall of the goddesses Isis and Nephthys, who stand for right and truth. In the hall are forty-two other gods. The soul to be judged addresses a negative statement to each one of them.

Some of the stages in the judgment of the soul can be seen in the illustration on the papyrus of the Negative Confession (Fig. 2-26). In the top band the Maat goddesses are seated on thrones, holding scepters. In the second band a deceased person stands before the god Osiris with both hands raised in adoration. The third represents a scale with a heart (the conscience of the dead person) on one end and a feather (representing Maat, right and truth) on the other. The god Anubis is testing the balance, and the monster Am-met stands close by. In the fourth band the god Thoth, with the head of an ibis, is seated on a pedestal, painting a large Maat feather.

1. "Hail, thou whose strides are long, who comest forth from Ȧnnu [Heliopolis], I have not done iniquity.

2. "Hail, thou who art embraced by flame, who comest forth from Kher-āḥa, I have not robbed with violence.

3. "Hail, thou divine Nose [Fenti], who comest forth from Khemennu [Hermopolis], I have not done violence [to any man].

4. "Hail, thou who eatest shades, who comest forth from the place where the Nile riseth,[1] I have not committed theft.

5. "Hail, Neḥa-ḥāu, who comest forth from Restau, I have not slain man or woman.

6. "Hail, thou double Lion-god, who comest forth from heaven, I have not made light the bushel.

7. "Hail, thou whose two eyes are like flint, who comest forth from Sekhem [Letopolis], I have not acted deceitfully.

8. "Hail, thou Flame, who comest forth as [thou] goest back, I have not purloined the things which belong unto God.

9. "Hail, thou Crusher of bones, who comest forth from Suten-ḥenen [Heracleopolis], I have not uttered falsehood.

10. "Hail, thou who makest the flame to wax strong, who comest forth from Ḥet-ka-Ptaḥ [Memphis], I have not carried away food.

11. "Hail, Qerti [i.e., the two sources of the Nile], who come forth from Ȧmentct, I have not uttered evil words.

12. "Hail, thou whose teeth shine, who comest forth from Ta-she [i.e., the Fayyûm], I have attacked no man.

13. "Hail, thou who dost consume blood, who comest forth from the house of slaughter, I have not killed the beasts [which are the property of God].

14. "Hail, thou who dost consume the entrails, who comest forth from the *mābet* chamber, I have not acted deceitfully.

[1] The *qerti* or caverns out of which flowed the Nile were thought to be situated between Aswân and Philae. [Translator's notes, unless otherwise indicated.]

2-26 *Papyrus of Any. Nineteenth Dynasty, c. 1250 B.C.*
Painted papyrus. Height 38 cm. (Courtesy of the Trustees
of the British Museum. EA 10470, sheet 32)

15. "Hail, thou god of Right and Truth, who comest forth from the city of double Maāti, I have not laid waste the lands which have been ploughed[?].[2]

16. "Hail, thou who goest backwards, who comest forth from the city of Bast [Bubastis], I have never pried into matters [to make mischief].

17. "Hail, Āti, who comest forth from Ȧnnu [Heliopolis], I have not set my mouth in motion [against any man].

18. "Hail, thou who art doubly evil, who comest forth from the nome of Āti,[3] I have not given way to wrath concerning myself without a cause.

19. "Hail, thou serpent Uamenti, who comest forth from the house of slaughter, I have not defiled the wife of a man.

20. "Hail, thou who lookest upon what is brought to him, who comest forth from the Temple of Ȧmsu, I have not committed any sin against purity.

21. "Hail, Chief of the divine Princes, who comest forth from the city of Nehatu,[4] I have not struck fear [into any man].

22. "Hail, Khemi [i.e., Destroyer], who comest forth from the Lake of Ḳaui [Khas?], I have not encroached upon [sacred times and seasons].

23. "Hail, thou who orderest speech, who comest forth from Urit, I have not been a man of anger.

24. "Hail, thou Child, who comest forth from the Lake of Ḥeq-āṭ,[5] I have not made myself deaf to the words of right and truth.

25. "Hail, thou disposer of speech, who comest forth from the city of Unes,[6] I have not stirred up strife.

26. "Hail, Basti, who comest forth from the Secret city, I have made no [man] to weep.

27. "Hail, thou whose face is [turned] backwards, who comest forth from the Dwelling, I have not committed acts of impurity, neither have I lain with men.

28. "Hail, Leg of fire, who comest forth from Ākhekhu, I have not eaten my heart.[7]

29. "Hail, Kenemti, who comest forth from [the city of] Kenemet, I have abused [no man].

30. "Hail, thou who bringest thine offering, who comest forth from the city of Sau [Saïs], I have not acted with violence.

31. "Hail, thou lord of faces, who comest forth from the city of Tchefet, I have not judged hastily.

32. "Hail, thou who givest knowledge, who comest forth from Unth, I have not. . . , and I have not taken vengeance upon the god.

33. "Hail, thou lord of two horns, who comest forth from Satiu, I have not multiplied [my] speech overmuch.

34. "Hail, Nefer-Tem, who comest forth from Ḥetka-Ptaḥ [Memphis], I have not acted with deceit, and I have not worked wickedness.

[2] (?): Indicates translator is unsure of meaning of word in the original text. [Au.]

[3] The ninth nome of Lower Egypt, the capital of which was Per Ausar or Busiris.

[4] The "city of the sycamore"; a name of a city of Upper Egypt.

[5] The thirteenth nome of Lower Egypt.

[6] The metropolis of the nineteenth nome of Upper Egypt.

[7] That is, "lost my temper and become angry."

35. "Hail, Tem-Sep, who comest forth from Ṭaṭṭu, I have not uttered curses [on the king].

36. "Hail, thou whose heart doth labour, who comest forth from the city of Ṭebti, I have not fouled (?) water.

37. "Hail, Ahi of the water, who comest forth from Nu, I have not made haughty my voice.

38. "Hail, thou who givest commands to mankind, who comest forth from [Sau (?)], I have not cursed the god.

39. "Hail, Neheb-nefert, who comest forth from the Lake of Nefer (?), I have not behaved with insolence.

40. "Hail, Neheb-kau, who comest forth from [thy] city, I have not sought for distinctions.

41. "Hail, thou whose head is holy, who comest forth from [thy] habitation, I have not increased my wealth, except with such things as are [justly] mine own possessions.

42. "Hail, thou who bringest thine own arm, who comest forth from Åukert [underworld], I have not thought scorn of the god who is in my city."

··

QUESTIONS

1. Enumerate the actions that are prohibited under Egyptian religious codes. Under what general categories do they fall?
2. Compare these categories of prohibition with the "thou shalt not" prohibitions in the biblical Ten Commandments (see Chapter 8).
3. Why are forty-two gods necessary here in addition to the two goddesses of Maat?
4. Can you define more precisely the concept of Maat after reading this confession?

··

Amenhotep IV (Akhenaton)
··
The Great Hymn to the Aten
Translation by Miriam Lichtheim

The long text columns begin at the top of the wall. Below the text are the kneeling relief figures of Ay and his wife.

Splendid you rise in heaven's lightland,
O living Aten, creator of life!
When you have dawned in eastern lightland,
You fill every land with your beauty.
You are beauteous, great, radiant,
High over every land;
Your rays embrace the lands,
To the limit of all that you made.
Being Re, you reach their limits,
You bend them [for] the son whom you love;

Though you are far, your rays are on earth,
Though one sees you, your strides are unseen.

When you set in western lightland,
Earth is in darkness, as if in death;
One sleeps in chambers, heads covered,
One eye does not see another.
Were they robbed of their goods,
That are under their heads,
People would not remark it.
Every lion comes from its den,
All the serpents bite;
Darkness hovers, earth is silent,
As their maker rests in lightland.

Earth brightens when you dawn in lightland,
When you shine as Aten of daytime;
As you dispel the dark,
As you cast your rays,
The Two Lands are in festivity.
Awake they stand on their feet,
You have roused them;
Bodies cleansed, clothed,
Their arms adore your appearance.
The entire land sets out to work,
All beasts browse on their herbs;
Trees, herbs are sprouting,
Birds fly from their nests,
Their wings greeting your ka.[1]
All flocks frisk on their feet,
All that fly up and alight,
They live when you dawn for them.
Ships fare north, fare south as well,
Roads lie open when you rise;
The fish in the river dart before you,
Your rays are in the midst of the sea.

Who makes seed grow in women,
Who creates people from sperm;
Who feeds the son in his mother's womb,
Who soothes him to still his tears.
Nurse in the womb,
Giver of breath,
To nourish all that he made.
When he comes from the womb to breathe,
On the day of his birth,
You open wide his mouth,
You supply his needs.
When the chick in the egg speaks in the shell,
You give him breath within to sustain him;
When you have made him complete,
To break out from the egg,
He comes out from the egg,

[1] Living spirit or soul. [Translator's notes.]

To announce his completion,
Walking on his legs he comes from it.

How many are your deeds,
Though hidden from sight,
O Sole God beside whom there is none!
You made the earth as you wished, you alone,
All peoples, herds, and flocks;
All upon earth that walk on legs,
All on high that fly on wings,
The lands of Khor and Kush,
The land of Egypt.
You set every man in his place,
You supply their needs;
Everyone has his food,
His lifetime is counted.
Their tongues differ in speech,
Their characters likewise;
Their skins are distinct,
For you distinguished the peoples.

You made Hapy in *dat*,[2]
You bring him when you will,
To nourish the people,
For you made them for yourself.
Lord of all who toils for them,
Lord of all lands who shines for them,
Aten of daytime, great in glory!
All distant lands, you make them live,
You made a heavenly Hapy descend for them;
He makes waves on the mountains like the sea,
To drench their fields and their towns.
How excellent are your ways, O Lord of eternity!
A Hapy from heaven for foreign peoples,
And all lands' creatures that walk on legs,
For Egypt the Hapy who comes from *dat*.

Your rays nurse all fields,
When you shine they live, they grow for you;
You made the seasons to foster all that you made,
Winter to cool them, heat that they taste you.
You made the far sky to shine therein,
To behold all that you made;
You alone, shining in your form of living Aten,
Risen, radiant, distant, near.
You made millions of forms from yourself alone,
Towns, villages, fields, the river's course;
All eyes observe you upon them,
For you are the Aten of daytime on high.
. . .
You are in my heart,
There is no other who knows you,

Only your son, *Neferkheprure, Sole-one-of-Re,*
Whom you have taught your ways, and your might.
(Those on) earth come from your hand as you made
 them,
When you have dawned they live,
When you set they die;
You yourself are lifetime, one lives by you.
All eyes are on (your) beauty until you set,
All labor ceases when you rest in the west;
When you rise you stir [everyone] for the King,
Every leg is on the move since you founded the earth.
You rouse them for your son who came from your body,
The King who lives by Maat, the Lord of the Two Lands,
Neferkheprure, Sole-one-of-Re,
The Son of Re who lives by Maat, the Lord of crowns,
Akhenaten, great in his lifetime;
(And) the great Queen whom he loves, the Lady of the
 Two Lands,
Nefer-nefru-Aten Nefertiti, living forever.

· ·

COMMENTS AND QUESTIONS

1. What indications are there in the poem that Akhen-
 aton believed in one universal god?
2. What are the attributes of this god?
3. What is the *tone* of this poem?
4. What imagery does the poet use to convey his ado-
 ration of Aten?
5. This poem has been compared with the biblical
 Psalms (see Chapter 8). Do you see any similarities?
6. What indications do you see of the cosmopoli-
 tanism, or multicultural and multiracial society, that
 characterized Akhenaton's reign?
7. Look at the sculpture of the king and his family
 making an offering to Aten (Fig. 2-14). In what
 sense do they illustrate or correspond to the poem?

· ·

● EGYPTIAN LOVE POETRY ●

The *lyric* as a style of writing may have been first
defined in Greece (see Chapter 3), but it was prac-
ticed earlier by the Egyptians and by the Hebrews
(see The Song of Songs, Chapter 8). Poems, almost
certainly words meant to be accompanied by music,
emphasizing personal feeling and in particular ro-
mantic love, flourished in the New Kingdom. We
do not know who the authors were, but they seem
to have been both men and women and were per-
haps scribes. Since we are still ignorant of Egyptian
prosody, poetic rendering of these often fragmen-
tary verses into a modern language—always a diffi-
cult task—is based somewhat on guesswork. As op-
posed to a literal translation, we prefer the work
of a modern American poet, Noel Stock. In these

[2] Hapy, the inundating Nile, emerges from the netherworld (*dat*) to
 nourish Egypt, while foreign peoples are sustained by a "Nile from
 heaven" that descends as rain.

poetic adaptations, Stock continues the work of Ezra Pound, who died before he was able to complete them. Pound, who was interested in poetic traditions from all over the world, did not read ancient Egyptian but worked closely with an Italian Egyptologist. The adaptations seem to capture the intensity and directness of these highly emotional but not sentimental poems.

I

Diving and swimming with you here
Gives me the chance I've been waiting for:
To show my looks
Before an appreciative eye.

My bathing suit of the best material,
The finest sheer,
Now that it's wet
Notice the transparency,
How it clings.

Let us admit, I find you attractive.
I swim away, but soon I'm back,
Splashing, chattering,
Any excuse at all to join your party.

Look! A redfish flashed through my fingers!
You'll see it better
If you come over here,
Near me.

II

Nothing, nothing can keep me from my love
Standing on the other shore.

Not even old crocodile
There on the sandbank between us
Can keep us apart.

I go in spite of him,
I walk upon the waves,
Her love flows back across the water,
Turning waves to solid earth
For me to walk on.

The river is our Enchanted Sea.

III

To have seen her
To have seen her approaching
Such beauty is
Joy in my heart forever.
Nor time eternal take back
What she has brought to me.

IV

When she welcomes me
Arms open wide
I feel as some traveller returning
From the far land of Punt.

All things change; the mind, the senses,
Into perfume rich and strange.
And when she parts her lips to kiss
My head is light, I am drunk without beer.[1]

V

If I were one of her females
Always in attendance
(Never a step away)
I would be able to admire
The resplendence
Of her body
Entire.

If I were her laundryman, for a month,
I would be able to wash from her veils
The perfumes that linger.

I would be willing to settle for less
And be her ring, the seal on her finger.

Pleasant Songs of the Sweetheart Who Meets You in the Fields

I

You, mine, my love,
My heart strives to reach the heights of your love.

See, sweet, the bird-trap set with my own hand.

See the birds of Punt,
Perfume a-wing
Like a shower of myrrh
Descending on Egypt.

Let us watch my handiwork,
The two of us, together in the fields.

II

The shrill of the wild goose
Unable to resist
The temptation of my bait.

[1] The most common drink in ancient Egypt.

While I, in a tangle of love,
Unable to break free,
Must watch the bird carry away my nets.

And when my mother returns, loaded with birds,
And finds me empty-handed,
What shall I say?
That I caught no birds?
That I myself was caught in your net?

III

Even when the birds rise
Wave mass on wave mass in great flight
I see nothing, I am blind
Caught up as I am and carried away
Two hearts obedient in their beating
My life caught up with yours
Your beauty the binding.

IV

Without your love, my heart would beat no more;
Without your love, sweet cake seems only salt;
Without your love, sweet "shedeh" turns to bile.
O listen, darling, my heart's life needs your love;
For when you breathe, mine is the heart that beats.

V

With candour I confess my love;
I love you, yes, and wish to love you closer;
As mistress of your house,
Your arm placed over mine.

Alas your eyes are loose.
I tell my heart: "My lord
Has moved away. During
The night moved away
And left me. I am like a tomb."

And I wonder: Is there no sensation
Left, when you come to me?
Nothing at all?

Alas those eyes which lead you astray,
Forever on the loose.
And yet I confess with candour
That no matter where else they roam
If they roam towards me
I enter into life.

VI

The swallow sings "Dawn,
 Whither fadeth the dawn?"

So fades my happy night
My love in bed beside me.
Imagine my joy at his whisper:
"I'll never leave you," he said.
"Your hand in mine we'll stroll
In every beautiful path."

Moreover he lets the world know
That I am first among his women
And my heart grieves no longer.

VII

Head out the door—
Is he coming?

Ears alert for his step,
And a heart that never stops talking about him.

A messenger:
"I'm not well ..."
Why doesn't he come straight out
And tell me
He's found another girl.

One more heart to suffer.

VIII

I writhe so for lost love
Half my hair has fallen in grief.
I am having my hair recurled and set,
Ready, just in case . . .

..

COMMENTS AND QUESTIONS

1. One of these lyric cycles (groups of poems) may have been written by a man and the other by a woman (although stylistically both are the work of the translator). What similarities and differences in the expression and the nature of love do you find between the two?
2. What images specific to Egypt and what depictions of Egyptian life do you find in these poems?
3. How does the narrator in the first cycle use the image of water? How does he portray himself?
4. How does the narrator in the second cycle use the image of birds? What is her attitude toward her rivals?
5. Do you notice a musical quality in these poems? Can you be specific? To what kind of music would you set them? Refer to the section on Egyptian music.
6. Compare these love lyrics with modern songs or poems that are especially meaningful to you.

..

Summary Questions

1. How did the Egyptians' concept of life after death shape their temple and tomb architecture?
2. What were the principal materials of Egyptian architecture?
3. Compare and contrast the contribution of the Nile and the Tigris and Euphrates rivers to Mesopotamian and Egyptian civilizations.

4. Describe how the representation of the human figure evolved in Egypt.
5. Why was the power of the pharaohs in Egypt more stable than that of the kings in Mesopotamia?
6. What do *The Instruction of Ptah-hotep* and *The Book of the Dead* tell us about Egyptian mortality?
7. What are the distinctive features of art and culture in the civilizations of Kush, Napata, and Meroe?

Key Terms

temple and tomb complex

pyramid

hieroglyphics

Maat

Amon-Ra

the Aten

monotheism

the pharaoh

Nubia

Kush

Napata

Meroe

Earliest Civilizations

The development of agriculture, one of the most important revolutions in human existence, was the foundation of the great civilizations of the Tigris-Euphrates and the Nile. Beginning about 3400 B.C., after six thousand years of agricultural development, the Mesopotamians, followed closely by the Egyptians, formed the increasing population generated by this new mode of food production into societies organized around cities. From that point on, although later peoples introduced many changes in urban and rural modes of life, their accomplishments were essentially exploitations of the original revolutionary combination of agriculture and urbanization.

The City

The creation of the city between 3200 and 3000 B.C. presupposed a degree of efficiency in food production that permitted some members of society to be exempted from cultivation of the fields to perform other tasks. Within the city wall were centered the religious and governmental agencies of the people as well as the major stores of food. Whereas commerce tended to play a minor role in Egyptian cities, Mesopotamian cities developed very early a sophisticated trade network initially between themselves and later with foreign areas. The work of many urban dwellers was devoted to commercial life.

Political Life

Initially governed by an assembly of male city dwellers, Sumerian cities developed a monarchy about 3000 B.C. Nonetheless, until the conquests of Sargon in 2340 B.C., cities remained largely independent from one another. Although the rulers of Mesopotamia endeavored to establish their own divinity, they were largely unsuccessful. On the other hand, from the beginning of the political organization of Egypt the country was ruled by monarchs who, after unification of the country,

adopted the title pharaoh. These rulers rested their authority to govern on their claimed divine origin, and throughout a three-thousand-year period this claim remained largely uncontested. Nubians from the kingdom of Kush ruled Egypt during the Twenty-fifth Dynasty, bringing with them a slightly different concept of the monarchy. Although the Egyptian queen Hatshepsut ruled as sole monarch, Kush, given the importance of the Candaces and the daughters of the king, seemed in general to accord more power to women.

Religion

In both Mesopotamia and Egypt, religious concerns were intertwined with political ones from the beginning. Both societies had a complicated variety of gods, but in Egypt the sun god, Amon-Ra, emerged as the official chief god and ancestor of the pharaohs. The first great constructions within the Sumerian cities along the Euphrates were the ziggurat temples designed as residences of the patron gods of the city. At the same time in Egypt, the main common goal of the society was to provide a proper burial monument for the pharaoh, who on his death would return to his divine family. As the belief in the immortality of the soul spread throughout Egyptian society along with the worship of Osiris, the interest in a proper burial became a preoccupying personal concern for all. By contrast the Mesopotamian deemphasis of the afterlife encouraged the population to focus attention on the here-and-now. A type of monotheism emerged in Egypt in the reign of Akhenaton, but thereafter the Egyptians returned to the worship of many gods.

Art and Music

As in most traditional societies, art in these ancient civilizations was not an independent activity but was intimately connected to its religious or social function. The ziggurat expressed devotion to the patron god, the

power of the ruler, and the pride in the city characteristic of Mesopotamia. Assyrian art tended to emphasize political and military power over religious devotion. Egyptian pyramids, with their elaborate systems of preparation for the afterlife, show striking and significant developments in architecture. In sculpture, the Mesopotamian style tended to be more fluid and lifelike than the monumental, *frontal* Egyptian one. Although Egyptian sculpture and painting underwent a significant transformation under Akhenaton, on the whole they changed very little, reflecting a conservative and stable society. The kingdom of Kush, adapting Egyptian artistic forms to its own needs and evolving others independently, also created a less rigid style in sculpture. We know much less about ancient music than about ancient art, but we do have evidence that string and wind instruments were developed in Mesopotamia and in Egypt. Music was probably an important part of religious ceremonies and civic festivals. It was also used to accompany poetry.

Writing and Literature

The art of writing is surely one of this period's great contributions to civilization. Although the first written tablets that have been discovered are from Sumer, writing seems to have developed independently in both Mesopotamia and Egypt. Both societies instituted schools to train scribes, but literacy was perhaps more widespread among the upper classes in Egypt. Writing was first used as a record of economic transactions, then for other documents, letters, and sacred and literary texts. Letters were exchanged between Mesopotamia and Egypt under the New Kingdom. For us, the two most important written works from Mesopotamian culture are the *Epic of Gilgamesh* and the legal code of Hammurabi. Gilgamesh may be called the first epic hero of Western civilization, and his journey to the realm of the gods in quest of immortal life is, as we shall see, a

theme that will be repeated and varied in the epics of Greece, Rome, and Europe. Egyptian literature, in addition to tales, historical writings, and proverbs, has given us a variety of poetry. Hymns such as the "Hymn to the Aten" and the love lyrics anticipate some of the devotional and lyric poetry of Greece and Rome. Because Meroitic has not yet been deciphered, we know much less about literature from Kush, but those texts that we do have (written in Egyptian hieroglyphics) demonstrate features perhaps linking them to the typically African praise poem, a form that will be studied in the unit on western Africa. The reciprocal influences between Egypt and the rest of Africa are still a matter of scholarly discussion and debate.

Decline of the Riverine Civilizations

For most of three thousand years, these great riverine societies acted as sources of cultural innovation for peoples in Europe, other parts of Africa, and the Middle East. However, in the last centuries of their existence the kingdoms of the Nile and the Tigris-Euphrates valleys, fixed on rehearsing their past achievements and copying earlier forms, were superseded by a series of new powers that had learned the lessons they were taught only too well.

We will explore the influence of ancient Egypt on African culture when we study western Africa as a cultural root. Then, for comparative purposes, we will briefly examine the development of the two other great riverine cultures of the world, India and China: the first generated largely by the rich mix of the native culture of the Indus valley with those of Egypt and Mesopotamia; and the second developing in isolation from the other three. But our present goal is to examine the two primary cultural roots of Western civilization: the Greco-Roman and the Judeo-Christian. After the societies of river valleys, we now turn to those of the great inland sea.

Part II

- The Greco-Roman
 and Judeo-Christian
 Roots

3

Early Greece

CENTRAL ISSUES

- The meaning of "classical" as applied to Greek and Roman culture
- The "archaic" period of Greek history and its achievements
- Contrasts between the matriarchal culture of Crete and the patriarchal culture of Mycenae
- Characteristics of Greek religion and mythology
- The development and the nature of the epic and the lyric as literary forms in Greece

The civilization of ancient Greece, which we can date roughly from about the eighth century to the first century B.C., and the civilization of ancient Rome, lasting from about the first century B.C. to the fifth century A.D., are often referred to collectively as *Greco-Roman* or as *classical*. This should not be interpreted to mean that their cultures were identical. There are many points of contrast, and, although the Romans assimilated a good deal of Greek culture, they added many unique features of their own. Still, the two cultures do share a common cluster of ways of thinking and creating that differ from those of other ancient cultures and that have clearly influenced the development of the Western humanistic tradition. Both Greeks and Romans gave human reason, in forms like rule by law and philosophical discussion, more importance than

mystical experience or reliance on tradition. In literature, art, and architecture, both cultures stressed balance, proportion, simplicity, and nobility as their criteria for beauty. Yet their view of human beings was not cold or merely rationalistic. The whole person was very much in focus; and, if reason was to dominate the passions, the emotional, ecstatic side of human nature was also recognized as essential.

It is quite possible to argue that Western culture, particularly North American culture, has been more influenced by the Romans than by the Greeks. Yet Greek cultural monuments, especially the tragedies, are more alive and significant for us today than are their Roman counterparts. We will devote most attention to the "classical" phase of Greek culture, that is, Athens in the fifth century B.C.; but, to avoid confusion, it is necessary to remember that *all* of Greco-Roman culture is sometimes called classical, as when we speak of classical languages (Greek and Latin) or classical literature. The word was first adopted by the Renaissance humanists, who used it in the sense of "first class" or "best" because they considered the artistic and literary style of the ancient Greeks and Romans as the model for all good art. That ideal model was generally accepted until the nineteenth century in the West. We will define the classical *canons* more specifically when examining the creations from the fifth century B.C. First, however, it will be necessary to examine briefly the rise of Greek civilization and some important prior cultural developments.

Hellenism: The Rise of Greek Culture

What was so important about a small Mediterranean civilization that flourished over two thousand years ago in a country we now call Greece?

In the context of world history, Greek civilization is a relative latecomer. Not only did the civilizations of Mesopotamia and Egypt precede it in the Mediterranean by thousands of years, but, as we will see in Chapter 16, highly developed civilizations in the Indus valley and in China flourished while the peoples of Greece still lived in primitive conditions. In their written literature, painting, sculpture, music, and science, the Greeks were often indebted to Mesopotamia and, especially, to Egypt. Yet the ways in which they developed the humanities and sciences were unique. Those developments are significant for our search for cultural roots because the Greeks were the first to express themselves in ways that can be designated as characteristically Western.

There is a more specific reason that the culture of the ancient Greeks is especially important to the study of the humanities. Theirs was the first culture that we can truly call humanistic. The Greeks were the first to

be interested in, and indeed to glorify, human beings simply as human beings—for themselves and their own unique qualities rather than because of their place in a religious, familial, or social order. This stress on the value of the individual made Greek culture less conservative than its predecessors. In contrast with the stable, slowly changing, and long-lasting Egyptian culture, Greek culture changed rapidly and was short-lived.

It used to be fairly commonplace for Western historians to assume that because Greek culture changed more rapidly than did its predecessors in Africa and Asia, the Greeks contributed more to the development of the human spirit. We are now perhaps better able to see that the restless, dynamic character of the West has created its own problems and also that we have much to learn from the older cultures of the rest of the world. Nevertheless, the Greeks' emphasis on the uniqueness of the individual has been particularly significant for the development of the Western humanities.

Crete

How did the Hellenes (the Greeks) develop their particular form of culture? The first civilization to exist in the country now called Greece developed on the island of Crete in the Mediterranean Sea around 2000 B.C. (See map.) The island's location between Egypt and mainland Greece was crucial to its role in helping to transmit one culture to the other. The Minoans, as they were called, after their legendary king, Minos, apparently developed trade with Egypt and led peaceful and creative lives. The form of government in Crete seems to have been matriarchal; the island was ruled by a queen whose husband, the king, was ritually sacrificed each year. A mother-earth goddess was the principal deity in Minoan religion. A modern African scholar has interpreted the importance given to the female principle in Crete as evidence that Minoan civilization is basically African in its origins. Whether or not this theory is true, the matriarchal emphasis in Minoan culture recalls that in Kush (see Chapter 2) and contrasts with the later, male-dominated, Greek culture.

Minoan artists used natural forms—plants, animals, fish, and fowl—to decorate walls, pottery, and gems. Their loosely structured, vividly colorful designs suggest a deep love for, and profound observation of, nature. The unfortified, elaborate, and labyrinthine palaces at Knossos (Fig. 3-1), Phaistos, and Mallia contrast sharply with the hierarchical, ceremonial, ritualistic tomb and temple complexes of Egypt and with the Mesopotamian ziggurat. Built of wood, mudbrick, and stone, the multileveled palaces had light walls, folding doors, and winding stairs that connected

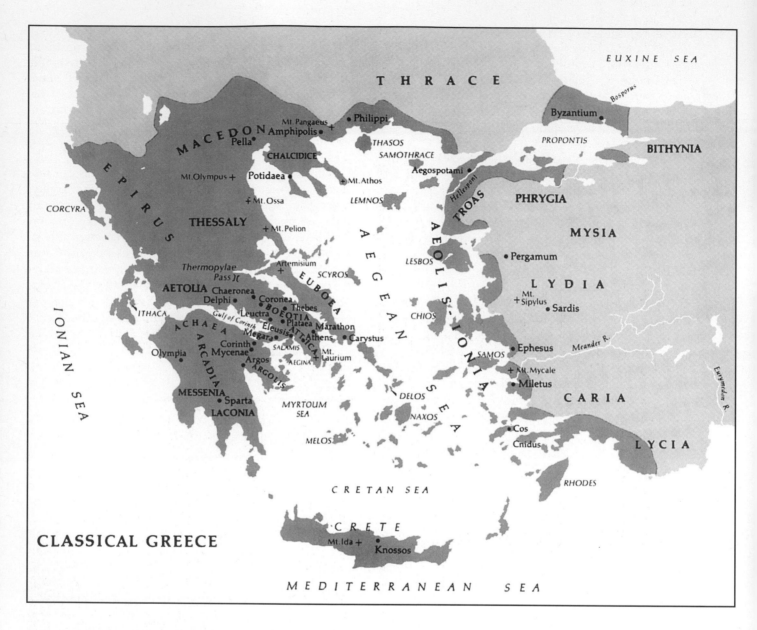

CLASSICAL GREECE

Mycenae and the Trojan War

In 1400 B.C. Crete was conquered by a more war-like people, the first we can truly call Greek. Wandering tribes from Europe, settling in mainland Greece, eventually developed a rich civilization centered in the city of Mycenae, which flourished between 1600 and 1200 B.C. This civilization is referred to as either Achaean, from the name of its principal tribe, or Mycenaean, from the name of the city. Within it a number of kings ruled over small, independent states. The most famous

apartments, ceremonial rooms, workshops, and storage areas. The beautiful *frescoes,* seal stones, jewelry, and other artifacts suggest a lifestyle in which satisfaction and pleasure were more important than ceremonial or military discipline.

of these kings were Agamemnon, who ruled in Mycenae with Queen Clytemnestra, and his brother Menelaus, who ruled in Sparta with his wife, Helen. The names of these kings and queens became familiar because of the legend of the Trojan War. The legend begins with the story of the golden apple as a prize for a beauty contest. Eris (goddess of strife) was angry because she had not been invited to the wedding of Peleus and Thetis, and thus decided to get revenge. Knowing how vain goddesses could be, she staged a contest among Hera, Aphrodite, and Athena, offering a golden apple as the prize for the most beautiful. Zeus chose the judge: Paris, the son of the Trojan king Priam. Each of the three goddesses proposed a bribe to him. Hera offered political dominion and power, Athena offered victory in war, and Aphrodite offered possession of the most beautiful woman alive. Paris chose the last. Since the

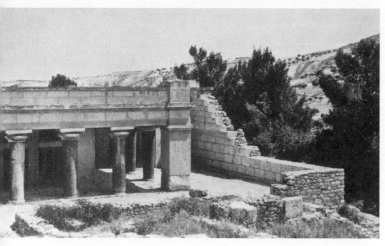

3-1 *Knossos, Crete, palace, east wing. (Eugene Brown)*
(W)

most beautiful woman was Helen, the wife of Menelaus, Paris went to Sparta to get her, and she followed him willingly to Troy.

The kings of Greece saw the seduction of the wife of the king of Sparta as a major affront to Greece by the Trojans. Determined to recapture Helen, they raised a huge fleet. Commanded by Agamemnon, it sailed for Troy, where the Greeks remained for nine years, fighting and plundering but unable to take the city. In the tenth year Agamemnon quarreled with his most powerful fighter, Achilles. As Achilles and his followers withdrew from the fighting, the brother of Paris, Hektor, began to lead the Trojans toward victory. Achilles then returned to battle and succeeded in entering Troy; he killed Hektor but was soon killed himself. Although the Greeks were aided by powerful new allies such as Memnon, the black prince from Ethiopia, and Penthisilea, queen of the Amazons, with her female warriors, Troy still continued to hold out. It was finally overcome by a ruse devised by the "wily" Greek, Odysseus. The Greeks, pretending to acknowledge defeat, actually boarded their ships to prepare for departure, leaving behind them a huge wooden horse as an offering to the gods. The horse was, in fact, full of armed Greek soldiers. When the Trojans, overcome with curiosity, took it into their city, the Greeks came out and set fire to Troy. Thus the will of the gods was accomplished: Troy was subdued by the Achaeans, and Helen returned to Menelaus. Historians today believe that the Trojan War (c. 1200 B.C.) was actually fought, but probably for economic reasons. The ruins of Troy, which was located in Asia Minor, have been excavated in what is now Turkey. The legendary material, however, is more important for our cultural roots: it has spawned a wealth of Western literature, beginning with the *Iliad* and the *Odyssey*.

Mycenaean Art

The Mycenaean age of Greek culture, about which we have little factual information, is often called the heroic age because most of the heroic deeds such as the Trojan War that were later written and sung about took place then. In contrast to matriarchal Crete, it was a masculine-oriented and male-ruled society. The painting, sculpture, and architecture of Mycenae affirm this orientation. The citadel (Fig. 3-2) at Mycenae, overlooking the plain and visible from the sea, was heavily fortified. One entered it through the Lion Gate, so called for its monumental *relief sculpture* of two lions. The king's palace dominated the entire complex. A rectangular building with a deep porch on its narrow end, it contained a main room where the king received dignitaries, held court, and entertained. Frescoes of shields and warriors decorated the walls. The heraldic lions at the gate and the massive scale of the masonry create an image of power controlled by will, solemnity, and ritual.

Mycenae, "rich in gold," was eventually destroyed by uncivilized invaders from the north, the Dorians. The next four hundred years are often called the "dark ages" of Greece. We know little about this period except that what would later become the classical city-states—Athens, Corinth, Argos, and finally Sparta—were beginning to emerge as centers of power.

3-2 *Mycenae, Lion Gate, c. 1250* B.C. *(Eugene Brown)*

The Archaic Period

The next epoch of Greek culture is sometimes referred to as the Archaic period. *Archaic* refers to something in its initial stages. This period, which we can date from approximately 700 to 480 B.C., indeed saw the beginnings of several forms of Greek culture. In politics the unit of the city-state, or *polis*, was formed; and the type of government known as *democracy*, which means in Greek "rule by the people," evolved. In architecture the Doric temple was created, and in sculpture the first free-standing human figures appeared. Greek vase painting was also developed during this time, and the first people who can properly be called philosophers began to speculate and reason about the nature of the universe. Early forms of drama evolved throughout this period; and Thespis, the founder of Greek drama as we know it, won the first dramatic contest in Athens in the sixth century B.C. We will discuss all of these forms in connection with their classical stages in the next chapter. Here we look at two elements of Greek culture that reached a kind of culmination in the Archaic period: religion and poetry—specifically the forms of the *epic* and the *lyric*.

Greek Religion and Mythology

The Greeks, in contrast with the ancient peoples of India and the ancient Hebrews, did not have what we might call a religious genius. They seem to have been too much oriented toward this world to have devised either a great theology or a literature of mystical experience. Unlike the early Hindu scriptures or the Bible, the stories of the gods on Mount Olympus have given rise to no enduring religion. Why, then, have these stories been so appealing to people for so many generations, and why are names of gods and goddesses like Zeus, Apollo, and Aphrodite still familiar to us? Unlike the Hebrew, Muslim, and Christian God, who belongs to a realm inaccessible to human beings except through faith, the Greek gods are comprehensible. They may be seen as a kind of wish fulfillment—they are like us but powerful, beautiful, and immortal; they live "at ease." Created through prescientific attempts to explain the universe, they embody deep, intuitive understandings of human psychology.

Like those of the Mesopotamians and the Egyptians, the Greek *pantheon* ("all the gods") is considerable, and it is not possible to mention the names of all the gods and goddesses here. Instead, we will look briefly at the Greek myth of the origin of the world and at some of the major deities. The Greeks probably adopted some Egyptian deities and practices in the development of their religion.

The Greeks believed that the universe was created from Chaos, a great mass in which everything now existing was jumbled. The first beings to spring forth were a female divinity, earth (Gaea), and a male divinity, heaven (Uranus). It is worth noting here that nearly all myths of creation and religious systems except Judaism and Christianity have seen the need for a divine female role in creation. The children of Gaea and Uranus were the Titans, the first gods, whose leader was Cronos (Saturn, in Latin). (The Romans largely assimilated Greek religion, and all of the Greek gods and goddesses are probably more familiar under their Latin names, which appear here in parentheses.) Cronos was deposed by his son Zeus (Jupiter). Zeus became lord of the heavens, his brother Poseidon (Neptune) lord of the sea, and their brother Dis (Pluto) lord of the underworld, or the realm of the dead. Hera (Juno), the wife of Zeus, was goddess of childbirth and protector of married women. Because the family of Zeus was said to live on Mount Olympus, its members were called the Olympian gods and goddesses. Some of the others are these:

> Athena (Minerva), patron of the city of Athens and goddess of wisdom. She sprang full-grown from the head of Zeus.
>
> Phoebus Apollo, god of the sun, reason, music, and medicine. He established the oracle at Delphi, where the Greeks went to receive enigmatic prophecies about their future. He is associated with two Greek sayings: "Know thyself" and "Nothing in excess."
>
> Dionysus (Bacchus), god of wine, ecstasy, fertility, and the theater.
>
> Aphrodite (Venus), goddess of love and beauty. She caused amorous complications among gods and mortals as well as great happiness. Her son Eros (Cupid) was well known for shooting his arrows in the wrong place at the wrong time.

Above the gods was a concept of fate, or destiny. It was believed that every individual on earth had a *moira*, or pattern of life, to fulfill. Although the gods could predict what it would be, they could not alter fate. Just how an individual destiny would be fulfilled depended on the individual's character and the choices that he or she made during life. We will see how this problem of the relations between human beings, gods, and fate is examined in the tragedy *Oedipus Rex*.

Greek religion was practiced throughout the "heroic" or Mycenaean age but was not systematically written down and explained until the Archaic period. Religious practices consisted of the sacrifice of animals and the pouring of libations (usually wine or oil) to the gods. Each god or goddess had a temple where his or her sacred image was kept and the gifts of the worshipers were stored. The rites usually took place before, not within, the temple. Thus the building and the area around it became a sanctuary. Here statues and

stelae (standing slabs of stone, painted or carved) were placed as offerings and commemoratives of events such as victories. Some of the important sanctuaries, like Delphi, belonged to all Greeks and had statues, stelae, and small treasuries to hold offerings from each of the great city-states. Others, like the Athenian Acropolis, were the manifestation of the power and glory of a particular city.

The gods, for the Greeks, could take part in human affairs. This divine intervention is also reflected in the close association of a particular divinity with a city. Athens and Athena are the most famous example: Athena was said to be directly involved in the evolution of Athenian law and justice. Thus religious observances became intermingled with political life in a complex way that enhanced the city's vitality and cohesiveness.

The epic poems of Homer show to what extent the Greek gods were seen as involved in human activities long before Athens became the principal Greek city.

Homer and the Epic

The poet Homer, who probably lived around 800 B.C., has been traditionally revered as the first writer of Western literature. Yet he was not a writer at all in the sense that we use the word today, and it is possible that he did not even know how to read and write. Homer belonged to an oral tradition, the nature of which we will study more fully in the chapter on African literature, and he was "a singer of tales." He composed, rather than wrote, his poems, probably basing them on a long tradition of singers who recited stories about the Trojan War, accompanied by the music of a stringed instrument, the lyre. The original purpose of this *epic* poetry was to "sing the famous deeds of men": to teach people in a pleasurable way about the great heroes of their culture. It should be stressed that Homer's poetry is not folk poetry—it is highly polished poetry, composed according to strict rules, but it was composed orally. It is probable that the Mesopotamian *Epic of Gilgamesh* was also originally composed orally; this is also true of other early epics. Oral epics are still being transmitted in the Balkan countries of Europe and in Africa. The *Epic of Sundiata* (Chapter 13) is an example of an epic from a living oral tradition. When we read Homer, we are reading an English text translated from an ancient Greek text that is a written version of the chanted oral epic. We do not know who decided to write down the Homeric poems or why and when this was done, but that act was in itself a momentous event for our cultural history. Homer's two great epics, the *Iliad* and the *Odyssey,* have been translated by generations of poets and scholars and are still widely read. They have also been instrumental in the creation of a long tradition of written epics.

The epic as a literary type was first defined by the first critic of Western literature, Aristotle (384–322 B.C.), in the *Poetics.* Using Aristotle's definition, Thrall, Hibbard, and Holman in their *Handbook to Literature* define the epic for the modern reader thus: "A long narrative poem in elevated style presenting characters of high position in a series of adventures which form an organic whole through their relation to a central figure of heroic proportions and through their development of episodes important to the history of a nation or race."[1] There are four important elements to retain from this definition: style, hero, action, and culture. In spite of its folk origins, the Western epic uses a noble rhythmic pattern or *meter* (in Greek the six-foot line, dactylic hexameter) and intricate figures of speech. The epic hero, although he may have human faults, must be almost superhuman in courage, strength, and greatness of character. Epic actions often include great wars and range over an entire country or continent. Supernatural beings, in Homer's case the gods, are usually involved in these actions. The actions must be important ones in the history of a nation or race and the hero must be in some sense a savior of that nation or race. Thus the hero is not only a great individual but also a culture-hero. Achilles, the hero of the *Iliad,* exemplifies what Homer perceived to be the greatness of the Greeks, and he is instrumental in an event highly significant for their culture: the downfall of Troy.

The Homeric poems were written down and read years after they were composed. The epic became a written form in Western literature with the Latin poet Virgil's *Aeneid* (Chapter 7). Important examples of the epic in English literature are *Beowulf* and Milton's *Paradise Lost.* The epic as a literary form began to die out in the nineteenth century when it was replaced by the novel. In American culture the film industry attempted to take over the form—think how many movies have been advertised as "epic." In recent years, "epic" films, such as *Star Wars,* have become more and more dependent on special effects.

Both of Homer's epics are concerned with the Trojan War. The *Iliad* (Greek for "Song of Troy") depicts the war itself, and the *Odyssey* depicts the long and adventurous return home of the hero of the Trojan horse episode, Odysseus. The *Iliad* has thus been called the epic of war and the *Odyssey* the epic of peace; yet both investigate the nature of these two fundamental states of human society. The *Iliad* presents war in both its terror and its glory. Through our own experience of these matters we can, as modern readers, relate to Homer's

[1] William Flint Thrall, Addison Hibbard, and C. Hugh Holman, *A Handbook to Literature* (New York: The Odyssey Press, 1960), pp. 174–175.

vivid portrayal of the human urge for violence and the human yearning for peace.

The *Iliad*

The opening lines of Homer's first epic tell the reader (or listener) exactly what the poet intends to do, and set the tone for the rest.

> Sing, goddess, the anger of Peleus' son Achilleus and
> its devastation, which put pains thousandfold
> upon the Achaians,
> hurled in their multitudes to the house of Hades
> strong souls
> of heroes, but gave their bodies to be the delicate
> feasting
> of dogs, of all birds, and the will of Zeus was
> accomplished
> since that time when first there stood in division of
> conflict
> Atreus' son the lord of men and brilliant Achilleus.

The translator of this passage, Richmond Lattimore, has attempted to render in English the stately rhythm of the Greek hexameter. You should be able to count six beats in each line. Even this short passage reveals Homer's attention to realistic detail—the line about the dead bodies—and his use of *epithets* or repeated modifiers that succinctly characterize a person or thing, such as "lord of men" for Atreus' son, Agamemnon, and "brilliant" for Achilles (Achilleus). One of the most famous of these (not in this passage) is "the rosy-fingered dawn."

The goddess invoked by Homer is the muse, who was supposed to inspire the poet to sing. The poem's subject as stated is not the general one of the war but the immediate one of the anger of Achilles. Yet the poet branches out from this internal theme of the individual character of his hero to the external one of the war and its destruction. He then extends his point of view to an even more universal one—this war and its outcome were the will of the supreme god, Zeus. The introduction is rounded out by a return to the original subject. We now learn that Achilles was angry because of a conflict with Agamemnon, and the poet is ready to begin his tale.

These three levels—which we might call the internal, the external, and the universal—remain in interplay throughout the *Iliad*. The story begins with an explanation of how Achilles came to be angry with Agamemnon. Briefly, Achilles feels that he has been dishonored because Agamemnon took from him his war prize and concubine, a girl named Briseis. We are in the tenth year of the Trojan War, and Achilles withdraws himself from the fighting to prove to the Greeks how necessary he is to them. The gods become involved in this personal quarrel when Achilles prays to his mother, Thetis, a sea divinity, to let the Greeks be defeated in his absence; she carries his prayer to Zeus. This is the situation at the end of the first book of the *Iliad*. Books 2–7 describe the fighting between the Greeks and Trojans and develop individual characters, human and divine. By the end of Book 8 the Greek leaders are discouraged, and Agamemnon offers to give Briseis back to Achilles, along with many other gifts, if he will rejoin the fighting. Achilles is too angry to accept. It is only when his best friend, Patroklos, has been killed by Hektor, son of King Priam of Troy, that he is moved to return to battle. He succeeds in driving the Trojans back, slays Hektor, and drags his body behind his chariot. The Greeks hold an elaborate funeral for Patroklos. The body of Hektor remains unburied, a sign of dishonor; but, when King Priam comes to Achilles to ask for his son's body, Achilles takes pity on the old man and the *Iliad* ends with the Trojans' funeral for Hektor.

This brief outline cannot give any sense of the power of the *Iliad*, but it may serve as a guideline to the nature of the Homeric epic. The *Iliad* is not the story of the Trojan War; it is the story of an event in the life of Achilles. And yet the destiny of the hero is intertwined with the destiny of his people, and that in turn with the designs of the gods. An individual personality is at its core, but the great world of war and peace is the domain of this epic.

The *Odyssey*

Like the opening lines of the *Iliad,* those of the second Homeric epic also state the subject and introduce the hero. The translator here is Robert Fitzgerald.

> Sing in me, Muse, and through me tell the story
> of that man skilled in all ways of contending,
> the wanderer, harried for years on end,
> after he plundered the stronghold
> on the proud height of Troy.
>
> He saw the townlands
> and learned the minds of many distant men,
> and weathered many bitter nights and days
> in his deep heart at sea, while he fought only
> to save his life, to bring his shipmates home.
> But not by will nor valor could he save them,
> for their own recklessness destroyed them all—
> children and fools, they killed and feasted on
> the cattle of Lord Hêlios, the Sun,
> and he who moves all day through heaven
> took from their eyes the dawn of their return.
> Of these adventures, Muse, daughter of Zeus,
> tell us in our time, lift the great song again.
> Begin when all the rest who left behind them
> headlong death in battle or at sea
> had long ago returned, while he alone still hungered
> for home and wife. Her ladyship Kalypso

clung to him in her sea-hollowed caves—
a nymph, immortal and most beautiful,
who craved him for her own.
 And when long years and seasons
wheeling brought around that point of time
ordained for him to make his passage homeward,
trials and dangers, even so, attended him
even in Ithaka, near those he loved.
Yet all the gods had pitied Lord Odysseus,
all but Poseidon, raging cold and rough
against the brave king till he came ashore
at last on his own land.

Here we learn that the *Odyssey* takes place after the Trojan War and that it tells the story of the wanderings (by sea) and adventures of Odysseus, a man skilled in argumentation and verbal art. Because of his cleverness, Odysseus survived, whereas his shipmates, because of their foolishness, were destroyed. Although goddesses and exotic and beautiful women love Odysseus and try to retain him, his guiding passion continues to be to return home to his wife, Penelope, and his son, Telemakos, in Ithaka. The *Odyssey* tells of his adventures during his return journey, which takes ten years.

The poem begins with the goddess Athena's plea to her father, Zeus, to save Odysseus. The first four books tell of the adventures of Telemakos as he searches for his father, whom he has never known, since he was a baby when Odysseus left for the Trojan War. In Book 5 we find Odysseus living with the beautiful nymph Kalypso, yet yearning to leave to find his home and his wife. Odysseus sets out to sea and comes to the land of the Phaiákians, where he is welcomed in the royal household. There he narrates the tale of his and his companions' many adventures, which include combat with one-eyed giants (Odysseus, characteristically, tricks them), overcoming the powers of magic charms and enchanting witches, and a visit to the realm of the dead. At the end, Odysseus returns at last to Ithaka, slays the suitors who are attempting to usurp his kingdom and his wife, and is reunited with his household and the ever-faithful Penelope. Thus the tale ends happily.

Because of the fairy-tale, romantic quality of several of its episodes, some scholars believe that ancient Asiatic and African legends may be embedded in the *Odyssey*. It seems almost certain that there is some such influence and also quite probable that the author of the poem was acquainted with the *Epic of Gilgamesh*. The atmosphere of the *Odyssey* is indeed quite different from that of the *Iliad*—for one thing its protagonist is a wise and seasoned middle-aged man instead of an exuberant and "wrathful" young man. Critics have called it a "romance" or "the first novel" rather than an epic; the poet Robert Graves believed that its author was a woman. There is, or course, no

conclusive evidence that "Homer" composed both poems, yet this was the tradition followed by the Greeks. In fact, reading the two Homeric epics formed the core of classical Greek education. In spite of the differences in tone and content, there is no compelling reason to conclude that the two great epics of the Trojan War, although their oral sources may have been different, were not the work of an accomplished poet named Homer.

The Lyric

With Homer, the individual poet begins to make his personal voice heard, even in the context of singing the deeds of heroes and great social events. But the trend toward individual expression of personal sentiment so characteristic of modern poetry came to perfection with the development of the *lyric* about two centuries after Homer. We use the word today for words set to music (song lyrics) or to describe a particular kind of poetry, characterized by a subjective presentation of an intense emotion, often (but not necessarily) love. Even if not set to music, lyric poetry usually has a musical effect on the listener or reader.

The love lyric, as we have seen, was already developed in Egypt. But we know much more about Greek lyric poetry. The lyric in Greece was inseparable from music; melody and rhythm were tied intimately to the words of the poem. The word meant simply "accompanied by the lyre," a stringed musical instrument (see Fig. 3-3) used in the cult of Apollo. The earliest lyric poets were primarily musicians who simultaneously composed both words and music. Their musical pieces (all of which have been lost) were probably simple tunes; at least, they lacked any harmony in the modern sense. Lyric poetry developed along two lines: choric and monodic. The choral songs, sung by groups and usually performed at religious or festive occasions, were accompanied by dancing. The combined arts of the choral spoken word, music, and dance would develop into the choruses of classical Greek drama. The monodic (one voice, solo) lyric was performed at less formal occasions, sometimes at weddings, and used more personal and colloquial language.

The lyric spirit seems to have developed almost in opposition to the heroic, warlike ethos of earlier times. A fragment from the man who is generally considered the first lyric poet, Archilochos, makes this clear. Archilochos, who probably lived during the late eighth century B.C., fought as a mercenary soldier in the colonization of the Aegean island of Thasos. The Greek warrior was typically told to come home carrying his shield or *being* carried *on* it; loss of the shield meant loss of manly honor. But Archilochos presents a different view:

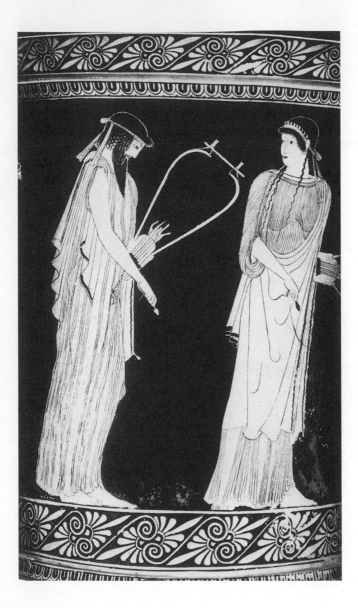

Well, what if some barbaric Thracian glories in the
 perfect shield I left under a bush?
I was sorry to leave it—but I saved my skin. Does it
 matter? O hell, I'll get a better one.

The lyric was to develop primarily in the islands of the
Aegean sea and on the coast of Asia Minor, where a
peaceful, refined, graceful, and aristocratic life flour-
ished. Most renowned for its lyric poetry was the island
of Lesbos, where the greatest poet of this period, Sap-
pho, and her friend and fellow poet Alcaeus, flourished.

3-3 *Vase representing imaginary portraits of Alcaeus and
Sappho holding lyres, c. 470* B.C. *(Courtesy, Staatliche
Antikensammlungen und Glyptothek, Munich)*

HOMER

·······································

from the *Iliad*

Translation by Richmond Lattimore

Although no one selection can adequately represent the scope and power of the *Iliad*, Book Six shows the contrast between its glorification of war and its portrayal of human tenderness and opposition to war. Although this book does not mention the principal hero, Achilles, it does develop the character of his opponent, the more mature and, to the modern reader, probably more sympathetic Hektor, the leader of the Trojans. The accounts of battle and of the various slayings of Greeks and Trojans, although an important aspect of the epic style, may not have much fascination for us. However, the drama of Hektor's encounter with Paris and Helen, the cause of the war that brought about so much suffering, and Hektor's subsequent farewell to his beloved wife Andromache and his small son have an undeniable and universal emotional impact.

Book Six

So the grim encounter of Achaians° and Trojans was left
to itself, and the battle veered greatly now one way,
 now in another,
over the plain as they guided their bronze spears at
 each other
in the space between the waters of Xanthos and
 Simoeis.
First Telamonian Aias, that bastion of the Achaians, 5
broke the Trojan battalions and brought light to his
 own company,
striking down the man who was far the best of the
 Thracians,
Akamas, the huge and mighty, the son of Eussoros.
Throwing first, he struck the horn of the horse-haired
 helmet
and the bronze spear-point fixed in his forehead and
 drove inward 10
through the bone; and a mist of darkness clouded
 both eyes.

───────

1. Achaians: Greeks.

Diomedes° of the great war cry cut down Axylos,
Teuthras' son, who had been a dweller in strong-
 founded Arisbe,
a man rich in substance and a friend to all humanity
since in his house by the wayside he entertained all
 comers 15
Yet there was none of these now to stand before him
 and keep off
the sad destruction, and Diomedes stripped life from
 both of them,
Axylos and his henchman Kalesios, who was the
 driver
guiding his horses; so down to the underworld went
 both men.

Now Euryalos° slaughtered Opheltios and Dresos, 20
and went in pursuit of Aisepos and Pedasos, those
 whom the naiad
nymph Abarbare had born to blameless Boukolion.
Boukolion himself was the son of haughty Laomedon,°
eldest born, but his mother conceived him in darkness
 and secrecy.
While shepherding his flocks he lay with the nymph
 and loved her, 25
and she conceiving bore him twin boys. But now
 Mekisteos'
son° unstrung the strength of these and the limbs in
 their glory,
Euryalos, and stripped the armour away from their
 shoulders.

Polypoites the stubborn in battle cut down Astyalos,
while Odysseus° slaughtered one from Perkote,
 Pidytes, 30
with the bronze spear, and great Aretaon was killed by
 Teukros.

───────

12. Diomedes: Son of Tydeus, lord of Argos, one of the greatest of the Achaian fighters, prominent in battle until wounded by Paris. 20. Euryalos: Leader, with Diomedes and Sthenelos, of the men of Argos. 23. Laomedon: King of Troy, son of Ilos, and father of Priam. 26–27. Mekisteos' son: Euryalos. 30. Odysseus: Son of Laertes, lord of Ithaka and the neighbouring islands, great fighter and counselor, close friend of Agamemnon.

Nestor's° son Antilochos with the shining shaft killed
Ableros; the lord of men, Agamemnon,° brought death
 to Elatos,
whose home had been on the shores of Satnioeis' lovely
 waters,
sheer Pedasos. And Leitos the fighter caught Phylakos 35
as he ran away; and Eurypylos made an end of
 Melanthios.

Now Menelaos° of the great war cry captured Adrestos
alive; for his two horses bolting over the level land
got entangled in a tamarisk growth, and shattered the
 curving
chariot at the tip of the pole; so they broken free
 went 40
on toward the city, where many beside stampeded in
 terror.
So Adrestos was whirled beside the wheel from the
 chariot
headlong into the dust on his face; and the son of
 Atreus,
Menelaos, with the far-shadowed spear in his hand,
 stood over him.
But Adrestos, catching him by the knees,
 supplicated: 45
"Take me alive, son of Atreus, and take appropriate
 ransom.
In my rich father's house the treasures lie piled in
 abundance;
bronze is there, and gold, and difficultly wrought iron,
and my father would make you glad with abundant
 repayment
were he to hear that I am alive by the ships of the
 Achaians." 50

So he spoke, and moved the spirit inside Menelaos.
And now he was on the point of handing him to a
 henchman
to lead back to the fast Achaian ships; but Agamemnon
came on the run to join him and spoke his word of
 argument:
"Dear brother, o Menelaos, are you concerned so
 tenderly 55
with these people? Did you in your house get the best
 of treatment
from the Trojans? No, let not one of them go free of
 sudden
death and our hands; not the young man child that the
 mother carries
still in her body, not even he, but let all of Ilion's°

people perish, utterly blotted out and unmourned
 for." 60

The hero spoke like this, and bent the heart of his
 brother
since he urged justice. Menelaos shoved with his hand
 Adrestos
the warrior back from him, and powerful Agamemnon
stabbed him in the side and, as he writhed over,
 Atreides,
setting his heel upon the midriff, wrenched out the ash
 spear. 65

Nestor in a great voice cried out to the men of Argos:
"O beloved Danaan fighters, henchmen of Ares,
let no man any more hand back with his eye on the
 plunder
designing to take all the spoil he can gather back to the
 vessels;
let us kill the men now, and afterwards at your leisure 70
all along the plain you can plunder the perished corpses."

So he spoke, and stirred the spirit and strength in each
 man.
Then once more would the Trojans have climbed back
 into Ilion's
wall, subdued by terror before the warlike Achaians,
had not Priam's° son, Helenos, best by far of the
 augurs, 75
stood beside Aineias and Hektor° and spoken a word
 to them:
"Hektor and Aineias, on you beyond others is leaning
the battle-work of Trojans and Lykians, since you are
 our greatest
in every course we take, whether it be in thought or
 in fighting:
stand your ground here; visit your people everywhere;
 hold them 80
fast by the gates, before they tumble into their
 women's arms, and become to our enemies a thing
 to take joy in.
Afterwards, when you have set all the battalions in
 motion,
the rest of us will stand fast here and fight with the
 Danaans
though we are very hard hit indeed; necessity forces
 us; 85
but you, Hektor, go back again to the city, and there tell
your mother and mine to assemble all the ladies of
 honour
at the temple of gray-eyed Athene high on the citadel;
there opening with a key the door to the sacred
 chamber

32. Nestor: Leader of the Pylians, once a great warrior and still active
as a commander and counselor. 33. Agamemnon: Son of Atreus
(therefore sometimes called Atreides), brother of Menelaos, king of
Mykenai, and chief leader of the Achaians. 37. Menelaos: Son of
Atreus, brother of Agamemnon, first husband of Helen, lord of
Lakedaimon. 59. Ilion: Troy, the city of Ilos.

75. Priam: Son of Laomedon, king of Troy, father of Hektor, Paris,
and many other children. 76. Hektor: Son of Priam, field com-
mander of the Trojans and their greatest fighter.

let her take a robe, which seems to her the largest and
 loveliest 90
in the great house, and that which is far her dearest
 possession,
and lay it along the knees of Athene the lovely haired.
 Let her
promise to dedicate within the shrine twelve heifers,
yearlings, never broken, if only she will have pity
on the town of Troy, and the Trojan wives, and their
 innocent children. 95
So she might hold back from sacred Ilion the son of
 Tydeus,°
that wild spear-fighter, the strong one who drives men
 to thoughts of terror,
who I say now is become the strongest of all the
 Achaians.
For never did we so fear Achilleus even, that leader
of men, who they say was born of a goddess. This man
 has gone clean 100
berserk, so that no one can match his warcraft against
 him.”

So he spoke, and Hektor did not disobey his brother,
but at once in all his armour leapt to the ground from
 his chariot
and shaking two sharp spears in his hands ranged over
 the whole host
stirring them up to fight and waking the ghastly
 warfare. 105
So they whirled about and stood their ground against
 the Achaians,
And the Argives° gave way backward and stopped
 their slaughtering,
and thought some one of the immortals must have
 descended
from the starry sky to stand by the Trojans, the way
 they rallied.
But Hektor lifted his voice and cried aloud to the
 Trojans. 110
“You high-hearted Trojans and far-renowned
 companions,
be men now, dear friends, and remember your furious
 valour
until I can go back again to Ilion, and there tell
the elder men who sit as counsellors, and our own
 wives,
to make their prayer to the immortals and promise
 them hecatombs.” 115

So spoke Hektor of the shining helm, and departed;
and against his ankles as against his neck clashed the
 dark ox-hide,

the rim running round the edge of the great shield
 massive in the middle.
Now Glaukos, sprung of Hippolochos, and the son of
 Tydeus
came together in the space between the two armies,
 battle-bent. 120
Now as these advancing came to one place and
 encountered,
first to speak was Diomedes of the great war cry:
“Who among mortal men are you, good friend? Since
 never
before have I seen you in the fighting where men win
 glory,
yet now you have come striding far out in front of all
 others 125
in your great heart, who have dared stand up to my
 spear far-shadowing.
Yet unhappy are those whose sons match warcraft
 against me.
But if you are some one of the immortals come down
 from the bright sky,
know that I will not fight against any god of the heaven,
since even the son of Dryas, Lykourgos the powerful,
 did not 130
live long; he who tried to fight with the gods of the
 bright sky,
who once drove the fosterers of rapturous Dionysos
headlong down the sacred Nyseian hill, and all of them
shed and scattered their wands on the ground, stricken
 with an ox-goad
by murderous Lykourgos, while Dionysos in terror 135
dived into the salt surf, and Thetis took him to her
 bosom,
frightened, with the strong shivers upon him at the
 man’s blustering.
But the gods who live at their ease were angered with
 Lykourgos,
and the son of Kronos° struck him to blindness, nor
 did he live long
afterwards, since he was hated by all the immortals. 140
Therefore neither would I be willing to fight with
 the blessed
gods; but if you are one of those mortals who eat what
 the soil yields,
come nearer, so that sooner you may reach your
 appointed destruction.”

Then in turn the shining son of Hippolochos answered:
“High-hearted son of Tydeus, why ask of my
 generation? 145
As is the generation of leaves, so is that of humanity.
The wind scatters the leaves on the ground, but the live
 timber

96. Tydeus: Father of Diomedes. 107. Argives: The same as
Achaians.

139. Son of Kronos: Zeus.

burgeons with leaves again in the season of spring
 returning.
So one generation of men will grow while another dies.
 Yet if you wish to learn all this and be certain 150
of my genealogy: there are plenty of men who know it.
There is a city, Ephyre, in the corner of horse-pasturing
Argos; there lived Sisyphos, that sharpest of all men,
Sisyphos, Aiolos' son, and he had a son named
 Glaukos,
and Glaukos in turn sired Bellerophontes the
 blameless. 155
To Bellerophontes the gods granted beauty and
 desirable
manhood; but Proitos in anger devised evil things
 against him,
and drove him out of his own domain, since he was far
 greater,
from the Argive country Zeus had broken to the sway
 of his sceptre.
Beautiful Anteia the wife of Proitos was stricken 160
with passion to lie in love with him, and yet she could
 not
beguile valiant Bellerophontes, whose will was
 virtuous.
So she went to Proitos the king and uttered her
 falsehood:
'Would you be killed, o Proitos? Then murder
 Bellerophontes
who tried to lie with me in love, though I was
 unwilling.' 165
So she spoke, and anger took hold of the king at her
 story.
He shrank from killing him, since his heart was awed
 by such action,
but sent him away to Lykia, and handed him
 murderous symbols,
which he inscribed in a folding tablet, enough to
 destroy life,
and told him to show it to his wife's father, that he
 might perish. 170
Bellerophontes went to Lykia in the blameless convoy
of the gods; when he came to the running stream of
 Xanthos, and Lykia,
the lord of wide Lykia tendered him full-hearted
 honour.
Nine days he entertained him with sacrifice of nine
 oxen,
but afterwards when the rose fingers of the tenth dawn
 shown, then 175
he began to question him, and asked to be shown the
 symbols,
whatever he might be carrying from his son-in-law,
 Proitos.
Then after he had been given his son-in-law's wicked
 symbols
first he sent him away with orders to kill the Chimaira

none might approach; a thing of immortal make, not
 human, 180
lion-fronted and snake behind, a goat in the middle,
and snorting out the breath of the terrible flame of
 bright fire.
He killed the Chimaira, obeying the portents of the
 immortals.
Next after this he fought against the glorious Solymoi,°
and this he thought was the strongest battle with men
 that he entered; 185
but third he slaughtered the Amazons,° who fight men
 in battle.
Now as he came back the king spun another entangling
treachery; for choosing the bravest men in wide Lykia
he laid a trap, but these men never came home
 thereafter
since all of them were killed by blameless
 Bellerophontes. 190
Then when the king knew him for the powerful stock
 of the god,
he detained him there, and offered him the hand of his
 daughter,
and gave him half of all the kingly privilege. Thereto
the men of Lykia cut out a piece of land, surpassing
all others, fine ploughland and orchard for him to
 administer. 195
His bride bore three children to valiant
 Bellerophontes,
Isandros and Hippolochos and Laodameia.
Laodameia lay in love beside Zeus of the counsels
and bore him godlike Sarpedon of the brazen helmet.
But after Bellerophontes was hated by all the
 immortals, 200
he wandered alone about the plain of Aleios, eating
his heart out, skulking aside from the trodden track of
 humanity.
As for Isandros his son, Ares the insatiate of fighting
killed him in close battle against the glorious Solymoi,
while Artemis° of the golden reins killed the daughter
 in anger. 205
But Hippolochos begot me, and I claim that he is my
 father,
he sent me to Troy, and urged upon me repeated
 injunctions,
to be always among the bravest, and hold my head
 above others,
not shaming the generation of my fathers, who were
the greatest men in Ephyre and again in wide Lykia. 210
Such is my generation and the blood I claim to be born
 from.'

184. Solymoi: Tribe in Asia Minor. 186. Amazons: A race of
warrior women who invaded Asia Minor. 205. Artemis: Sister of
Apollo.

He spoke, and Diomedes of the great war cry was
 gladdened.
He drove his spear deep into the prospering earth, and
 in winning
words of friendliness he spoke to the shepherd of the
 people:
"See now, you are my guest friend from far in the time
 of our fathers. 215
Brilliant Oineus once was host to Bellerophontes
the blameless, in his halls, and twenty days he detained
 him,
and these two gave to each other fine gifts in token of
 friendship.
Oineus gave his guest a war belt bright with the red dye,
Bellerophontes a golden and double-handled
 drinking-cup, 220
a thing I left behind in my house when I came on my
 journey.
Tydeus, though, I cannot remember, since I was little
when he left me, that time the people of the Achaians
 perished
in Thebe. Therefore I am your friend and host in the
 heart of Argos;
you are mine in Lykia, when I come to your country. 225
Let us avoid each other's spears, even in the close
 fighting.
There are plenty of Trojans and famed companions in
 battle for me
to kill, whom the god sends me, or those I run down
 with my swift feet,
many Achaians for you to slaughter, if you can do it.
But let us exchange our armour, so that these others
 may know 230
how we claim to be guests and friends from the days of
 our fathers."

So they spoke, and both springing down from behind
 their horses
gripped each other's hands and exchanged the promise
 of friendship;
but Zeus the son of Kronos stole away the wits of
 Glaukos
who exchanged with Diomedes the son of Tydeus
 armour 235
of gold for bronze, for nine oxens' worth the worth of
 a hundred.

Now as Hektor had come to the Skaian gates and the
 oak tree,
all the wives of the Trojans and their daughters came
 running about him
to ask after their sons, after their brothers and
 neighbours,
their husbands; and he told them to pray to the
 immortals, 240
all, in turn; but there were sorrows in store for many.

Now he entered the wonderfully built palace of Priam.
This was fashioned with smooth-stone cloister walks,
 and within it
were embodied fifty sleeping chambers of smoothed
 stone
built so as to connect with each other; and within these
 slept 245
each beside his own wedded wife, the sons of Priam.
In the same inner court on the opposite side, to face
 these,
lay the twelve close smooth-stone sleeping chambers of
 his daughters
built so as to connect with each other; and within these
 slept,
each beside his own wedded wife, the sons of Priam. 250
There there came to meet Hektor his bountiful mother
with Laodike, the loveliest looking of all her daughters.
She clung to his hand and called him by name and
 spoke to him: "Why then,
child, have you come here and left behind the bold
 battle?
Surely it is these accursed sons of the Achaians who
 wear you 255
out, as they fight close to the city, and the spirit stirred
 you
to return, and from the peak of the citadel lift your
 hands, praying
to Zeus. But stay while I bring you honey-sweet wine,
 to pour out
a libation to father Zeus and the other immortals,
first, and afterwards if you will drink yourself, be
 strengthened. 260
In a tired man, wine will bring back his strength to its
 bigness,
in a man tired as you are tired, defending your
 neighbours."

Tall Hektor of the shining helm spoke to her
 answering:
"My honoured mother, lift not to me the kindly sweet
 wine,
for fear you stagger my strength and make me forget
 my courage; 265
and with hands unwashed I would take shame to pour
 the glittering
wine to Zeus; there is no means for a man to pray to
 the dark-misted
son of Kronos, with blood and muck all spattered
 upon him.
But go yourself to the temple of the spoiler Athene,
assembling the ladies of honour, and with things to be
 sacrificed, 270
and take a robe, which seems to you the largest and
 loveliest
in the great house, and that which is far your dearest
 possession.

Lay this along the knees of Athene the lovely haired.
 Also
promise to dedicate within the shrine twelve heifers,
yearlings, never broken, if only she will have pity 275
on the town of Troy, and the Trojan wives, and their
 innocent children,
if she will hold back from sacred Ilion the son of
 Tydeus,
that wild spear-fighter, the strong one who drives men
 to thoughts of terror.
So go yourself to the temple of the spoiler Athene,
while I go in search of Paris,° to call him, if he will
 listen 280
to anything I tell him. How I wish at this moment the
 earth might
open beneath him. The Olympian let him live, a great
 sorrow
to the Trojans, and high-hearted Priam and all of his
 children.
If only I could see him gone down to the house of the
 death god,
then I could say my heart had forgotten its joyless
 affliction." 285

So he spoke, and she going into the great house called
 out
to her handmaidens, who assembled throughout the
 city of the highborn
women; while she descended into the fragrant store-
 chamber.
There lay the elaborately wrought robes, the work of
 Sidonian
women, whom Alexandros° himself, the godlike, had
 brought home 290
from the land of Sidon, crossing the wide sea, on that
 journey
when he brought back also gloriously descended Helen.°
Hekabe° lifted out one and took it as gift to Athene,
that which was the loveliest in design and the largest,
and shone like a star. It lay beneath the others. She
 went on 295
her way, and a throng of noble women hastened about
 her.

When these had come to Athene's temple on the peak
 of the citadel,
Theano° of the fair cheeks opened the door for them,
 daughter
of Kisseus, and wife of Antenor, breaker of horses,
she whom the Trojans had established to be Athene's
 priestess. 300

With a wailing cry all lifted up their hands to Athene,
and Theano of the fair cheeks taking up the robe laid it
along the knees of Athene the lovely haired, and praying
she supplicated the daughter of powerful Zeus: "O lady,
Athene, our city's defender, shining among
 goddesses: 305
break the spear of Diomedes, and grant that the man
 be
hurled on his face in front of the Skaian gates; so may we
instantly dedicate within your shrine twelve heifers,
yearlings, never broken, if only you will have pity
on the town of Troy, and the Trojan wives, and their
 innocent children." 310

She spoke in prayer, but Pallas Athene turned her head
 from her.

So they made their prayer to the daughter of Zeus the
 powerful.
But Hektor went away to the house of Alexandros,
a splendid place he had built himself, with the men
 who at that time
were the best men for craftsmanship in the generous
 Troad, 315
who had made him a sleeping room and a hall and a
 courtyard
near the houses of Hektor and Priam, on the peak of
 the citadel.
There entered Hektor beloved of Zeus, in his hand
 holding
the eleven-cubit-long spear, whose shaft was tipped
 with a shining
bronze spearhead, and a ring of gold was hooped to
 hold it. 320
He found the man in his chamber busy with his splendid
 armour,
the corselet and the shield, and turning in his hands the
 curved bow,
while Helen of Argos was sitting among her attendant
 women
directing the magnificent work done by her
 handmaidens.

But Hektor saw him, and in words of shame he
 rebuked him: 325
"Strange man! It is not fair to keep in your heart this
 coldness.
The people are dying around the city and around the
 steep wall
as they fight hard; and it is for you that this war with
 its clamour
has flared up about our city. You yourself would fight
 with another
whom you saw anywhere hanging back from the
 hateful encounter. 330
Up then, to keep our town from burning at once in the
 hot fire."

280. Paris: Son of Priam and Hekabe, who carried Helen from
Lakedaimon. 290. Alexandros: Another, and in the *Iliad* more
usual, name for Paris 292. Helen: Wife of Menelaos who ran
away with Paris, the cause of the war. 293. Hekabe: Daughter of
Dymas, Priam's queen. 298. Theano: Priestess of Athene.

Then in answer the godlike Alexandros spoke to him:
"Hektor, seeing you have scolded me rightly, not
 beyond measure,
therefore I will tell, and you in turn understand and
 listen.
It was not so much in coldness and bitter will toward
 the Trojans 335
that I sat in my room, but I wished to give myself over
 to sorrow.
But just now with soft words my wife was winning me
 over
and urging me into the fight, and that way seems to me
 also
the better one. Victory passes back and forth between
 men.
Come then, wait for me now while I put on my armour
 of battle, 340
or go, and I will follow, and I think I can overtake you."

He spoke, but Hektor of the shining helm gave him no
 answer,
but Helen spoke to him in words of endearment:
 "Brother
by marriage to me, who am a nasty bitch evil-intriguing,
how I wish that on that day when my mother first bore
 me 345
the foul whirlwind of the storm had caught me away
 and swept me
to the mountain, or into the wash of the sea deep-
 thundering
where the waves would have swept me away before all
 these things happened.
Yet since the gods had brought it about that these vile
 things must be,
I wish I had been the wife of a better man than this
 is, 350
one who knew modesty and all things of shame that
 men say.
But this man's heart is no steadfast thing, nor yet will it
 be so
ever hereafter; for that I think he shall take the
 consequence.
But come now, come in and rest on this chair, my
 brother,
since it is on your heart beyond all that the hard work
 has fallen 355
for the sake of dishonoured me and the blind act of
 Alexandros,
us two, on whom Zeus set a vile destiny, so that
 hereafter
we shall be made into things of song for the men of the
 future."

Then tall Hektor of the shining helm answered her:
 "Do not, Helen,
make me sit with you, though you love me. You will
 not persuade me. 360

Already my heart within is hastening me to defend the
 Trojans, who when I am away long greatly to have
 me.
Rather rouse this man, and let himself also be swift to
 action
so he may overtake me while I am still in the city.
For I am going first to my own house, so I can visit 365
my own people, my beloved wife and my son, who is
 little,
since I do not know if ever again I shall come back this
 way,
or whether the gods will strike me down at the hands
 of the Achaians."

So speaking Hektor of the shining helm departed
and in speed made his way to his own well-established
 dwelling, 370
but failed to find in the house Andromache of the
 white arms;
for she, with the child, and followed by one fair-robed
 attendant,
had taken her place on the tower of lamentation, and
 tearful.
When he saw no sign of his perfect wife within the
 house, Hektor
stopped in his way on the threshold and spoke among
 the handmaidens: 375
"Come then, tell me truthfully as you may,
 handmaidens:
where has Andromache of the white arms gone? Is she
with any of the sisters of her lord or the wives of his
 brothers?
Or has she gone to the house of Athene, where all the
 other
lovely-haired women of Troy propitiate the grim
 goddess?" 380

Then in turn the hard-working housekeeper gave him
 an answer:
"Hektor, since you have urged me to tell you the truth,
 she is not
with any of the sisters of her lord or the wives of his
 brothers,
nor has she gone to the house of Athene, where all the
 other
lovely-haired women of Troy propitiate the grim
 goddess, 385
but she has gone to the great bastion of Ilion, because
 she heard that
the Trojans were losing, and great grew the strength of
 the Achaians.
Therefore she has gone in speed to the wall, like a
 woman
gone mad, and a nurse attending her carries the baby."

So the housekeeper spoke, and Hektor hastened from
 his home 390

backward by the way he had come through the well-
laid streets. So
as he had come to the gates on his way through the
great city,
the Skaian gates, whereby he would issue into the
plain, there
at last his own generous wife came running to meet
him,
Andromache, the daughter of high-hearted Eëtion; 395
Eëtion, who had dwelt underneath wooded Plakos,
in Thebe below Plakos, lord over the Kilikian people.
It was his daughter who was given to Hektor of the
bronze helm.
She came to him there, and beside her went an atten-
dant carrying
the boy in the fold of her bosom, a little child, only a
baby, 400
Hektor's son, the admired, beautiful as a star shining,
whom Hektor called Skamandrios, but all of the others
Astyanax—lord of the city; since Hektor alone saved
Ilion.
Hektor smiled in silence as he looked on his son, but
she,
Andromache stood close beside him, letting her tears
fall, 405
and clung to his hand and called him by name and
spoke to him: "Dearest,
your own great strength will be your death, and you
have no pity
on your little son, nor on me, ill-starred, who soon
must be your widow;
for presently the Achaians, gathering together,
will set upon you and kill you; and for me it would be
far better 410
to sink into the earth when I have lost you, for there is
no other
consolation for me after you have gone to your
destiny—
only grief; since I have no father, no honoured mother.
It was brilliant Achilleus who slew my father, Eëtion,
when he stormed the strong-founded citadel of the
Kilikians, 415
Thebe of the towering gates. He killed Eëtion
but did not strip his armour, for his heart respected the
dead man,
but burned the body in all its elaborate war-gear
and piled a grave mound over it, and the nymphs of the
mountains,
daughters of Zeus of the aegis, planted elm trees about
it. 420
And they who were my seven brothers in the great
house all went
upon a single day down into the house of the death god,
for swift-footed brilliant Achilleus slaughtered all of
them
as they were tending their white sheep and their
lumbering oxen;

and when he had led my mother, who was queen under
wooded Plakos, 425
here, along with all his other possessions, Achilleus
released her again, accepting ransom beyond count, but
Artemis
of the showering arrows struck her down in the halls
of her father.
Hektor, thus you are father to me, and my honoured
mother,
you are my brother, and you it is who are my young
husband. 430
Please take pity upon me then, stay here on the rampart,
that you may not leave your child an orphan, your wife
a widow,
but draw your people up by the fig tree, there where
the city
is openest to attack, and where the wall may be
mounted.
Three times their bravest came that way, and fought
there to storm it 435
about the two Aiantes and renowned Idomeneus,
about the two Atreidai and the fighting son of Tydeus.
Either some man well skilled in prophetic arts had
spoken,
or the very spirit within themselves had stirred them to
the onslaught."

Then tall Hektor of the shining helm answered her:
"All these 440
things are in my mind also, lady; yet I would feel deep
shame
before the Trojans, and the Trojan women with trailing
garments,
if like a coward I were to shrink aside from the fighting;
and the spirit will not let me, since I have learned to be
valiant
and to fight always among the foremost ranks of the
Trojans, 445
winning for my own self great glory, and for my father.
For I know this thing well in my heart, and my mind
knows it:
there will come a day when sacred Ilion shall perish,
and Priam, and the people of Priam of the strong ash
spear.
But it is not so much the pain to come of the Trojans
that troubles me, not even Priam the king nor 451
Hekabe,
not the thought of my brothers who in their numbers
and valour
shall drop in the dust under the hands of men who hate
them,
as troubles me the thought of you, when some
bronze-armoured
Achaian leads you off, taking away your day of
liberty, 455
in tears; and in Argos you must work at the loom of
another,

and carry water from the spring Messeis or Hypereia,
all unwilling, but strong will be the necessity upon you;
and some day seeing you shedding tears a man will say
 of you:
'This is the wife of Hektor, who was ever the bravest
 fighter 460
of the Trojans, breakers of horses, in the days when
 they fought about Ilion.'
So will one speak of you; and for you it will be yet a
 fresh grief,
to be widowed of such a man who could fight off the
 day of your slavery.
But may I be dead and the piled earth hide me under
 before I
hear you crying and know by this that they drag you
 captive." 465

So speaking glorious Hektor held out his arms to his
 baby,
who shrank back to his fair-girdled nurse's bosom
screaming, and frightened at the aspect of his own
 father,
terrified as he saw the bronze and the crest with its
 horse-hair,
nodding dreadfully, as he thought, from the peak of the
 helmet. 470
Then his beloved father laughed out, and his honoured
 mother,
and at once glorious Hektor lifted from his head the
 helmet
and laid it in all its shining upon the ground. Then
 taking
up his dear son he tossed him about in his arms, and
 kissed him,
and lifted his voice in prayer to Zeus and the other
 immortals: 475
"Zeus, and you other immortals, grant that this boy,
 who is my son,
may be as I am, pre-eminent among the Trojans,
great in strength, as am I, and rule strongly over Ilion;
and some day let them say of him: 'He is better by far
 than his father,'
as he comes in from the fighting; and let him kill his
 enemy 480
and bring home the blooded spoils, and delight the
 heart of his mother."

So speaking he set his child again in the arms of his
 beloved
wife, who took him back again to her fragrant bosom
smiling in her tears; and her husband saw, and took
 pity upon her,
and stroked her with his hand, and called her by name and
 spoke to her: 485
"Poor Andromache! Why does your heart sorrow so
 much for me?
No man is going to hurl me to Hades, unless it is fated,

but as for fate, I think that no man yet has escaped it
once it has taken its first form, neither brave man nor
 coward.
Go therefore back to our house, and take up your own
 work, 490
the loom and the distaff, and see to it that your
 handmaidens
ply their work also; but the men must see to the
 fighting,
all men who are the people of Ilion, but I beyond
 others."

So glorious Hektor spoke and again took up the helmet
with its crest of horse-hair, while his beloved wife went
 homeward, 495
turning to look back on the way, letting the live tears
 fall.
And as she came in speed into the well-settled
 household
of Hektor the slayer of men, she found numbers of
 handmaidens
within, and her coming stirred all of them into
 lamentation.
So they mourned in his house over Hektor while he
 was living 500
still, for they thought he would never again come back
 from the fighting
alive, escaping the Achaian hands and their violence.

But Paris in turn did not linger long in his high house,
but when he had put on his glorious armour with
 bronze elaborate
he ran in the confidence of his quick feet through the
 city. 505
As when some stalled horse who has been corn-fed at
 the manger
breaking free of his rope gallops over the plain in
 thunder
to his accustomed bathing place in a sweet-running
 river
and in the pride of his strength holds high his head,
 and the mane floats
over his shoulders; sure of his glorious strength, the
 quick knees 510
carry him to the loved places and the pasture of horses;
so from uttermost Pergamos° came Paris, the son of
Priam, shining in all his armour of war as the sun
 shines,
laughing aloud, and his quick feet carried him;
 suddenly thereafter
he came on brilliant Hektor, his brother, where he yet
 lingered 515
before turning away from the place where he had
 talked with his lady.

512. Pergamos: The citadel of Troy (also Pergamon).

It was Alexandros the godlike who first spoke to him:
"Brother, I fear that I have held back your haste, by being
slow on the way, not coming in time, as you commanded me."

Then tall Hektor of the shining helm spoke to him in
 answer: 520
"Strange man! There is no way that one, giving
 judgment in fairness,
could dishonour your work in battle, since you are a
 strong man.
But of your own accord you hang back, unwilling. And
 my heart
is grieved in its thought, when I hear shameful things
 spoken about you
by the Trojans, who undergo hard fighting for your
 sake. 525
Let us go now; some day hereafter we will make all
 right
with the immortal gods in the sky, if Zeus ever grant it,
setting up to them in our houses the wine-bowl of liberty
after we have driven out of Troy the strong-greaved
 Achaians."

COMMENTS AND QUESTIONS

1. Point out the *epithets* used in this book. What is
 their effect?
2. What stories are told within the main story? What
 purpose do they serve?
3. How does the couple Paris and Helen contrast with
 the couple Hektor and Andromache?
4. The concept of fate will be an important one in our
 study of Greek tragedy. What notion of fate is elaborated here?
5. What role do the gods play in this book?

from the *Odyssey*
Translation by Robert Fitzgerald

This selection, from Book Eleven of *The Odyssey*, is
part of Odysseus's narration of his visit to the realm
of the dead. After hearing a prophecy from Tiresias,
and encountering the shade of his mother, he speaks
with the shade of Achilles and then witnesses various
punishments.
 You may wish to reread the selection from the
Epic of Gilgamesh to compare the two versions of
the epic hero's voyage to the underworld. It is possible that Homer may have directly or indirectly

known of that part of *Gilgamesh*. The selections
from the *Aeneid* (Chapter 7) and the *Divine Comedy*
(Chapter 11) will give us two other points of comparison for this important theme.

(The shade of Achilles recognizes Odysseus and calls to
 him.)
"'Son of Laërtês and the gods of old,
Odysseus, master mariner and soldier,
old knife, what next? What greater feat remains
for you to put your mind on, after this?
How did you find your way down to the dark 470
where these dimwitted dead are camped forever,
the after images of used-up men?'

 I answered:

'Akhilleus, Peleus' son, strongest of all
among the Akhaians, I had need of foresight
such as Teirêsias alone could give 475
to help me, homeward bound for the crags of Ithaka.
I have not yet coasted Akhaia, not yet
touched my land; my life is all adversity.
But was there ever a man more blest by fortune
than you, Akhilleus? Can there ever be? 480
We ranked you with immortals in your lifetime,
we Argives did, and here your power is royal
among the dead men's shades. Think, then, Akhilleus:
you need not be so pained by death.'

 To this
he answered swiftly:

 'Let me hear no smooth talk
of death from you, Odysseus, light of councils. 486
Better, I say, to break sod as a farm hand
for some poor country man, on iron rations,
than lord it over all the exhausted dead.
Tell me, what news of the prince my son: did he 490
come after me to make a name in battle
or could it be he did not? Do you know
if rank and honor still belong to Peleus
in the towns of the Myrmidons? Or now, may be,
Hellas and Phthia° spurn him, seeing old age 495
fetters him, hand and foot. I cannot help him
under the sun's rays, cannot be that man
I was on Troy's wide seaboard, in those days
when I made bastion for the Argives
and put an army's best men in the dust. 500
Were I but whole again, could I go now
to my father's house, one hour would do to make
my passion and my hands no man could hold
hateful to any who shoulder him aside.'

―――――
495. *Phthia:* the kingdom of Peleus, Achilles' father.

Now when he paused I answered:

 'Of all that—
of Peleus' life, that is—I know nothing; 506
but happily I can tell you the whole story
of Neoptólemos, as you require.
In my own ship I brought him out from Skyros
to join the Akhaians under arms.

 And I can tell
in every council before Troy thereafter 511
your son spoke first and always to the point;
no one but Nestor and I could out-debate him.
And when we formed against the Trojan line
he never hung back in the mass, but ranged 515
far forward of his troops—no man could touch him
for gallantry. Aye, scores went down before him
in hard fights man to man. I shall not tell
all about each, or name them all—the long
roster of enemies he put out of action, 520
taking the shock of charges on the Argives.
But what a champion his lance ran through
in Eurýpulos° the son of Télephos! Keteians
in throngs around that captain also died—
all because Priam's gifts had won his mother 525
to send the lad to battle; and I thought
Memnon° alone in splendor ever outshone him.

But one fact more: while our picked Argive crew
still rode that hollow horse Epeios built,
and when the whole thing lay with me, to open 530
the trapdoor of the ambuscade or not,
at that point our Danaan lords and soldiers
wiped their eyes, and their knees began to quake,
all but Neoptólemos. I never saw
his tanned cheek change color or his hand 535
brush one tear away. Rather he prayed me,
hand on hilt, to sortie, and he gripped
his tough spear, bent on havoc for the Trojans.
And when we had pierced and sacked Priam's tall city
he loaded his choice plunder and embarked 540
with no scar on him; not a spear had grazed him
nor the sword's edge in close work—common wounds
one gets in war. Arês° in his mad fits
knows no favorites.'

 But I said no more,
for he had gone off striding the field of asphodel, 545
the ghost of our great runner, Akhilleus Aiákidês,
glorying in what I told him of his son.

523. *Eurýpulos*: a chief of warriors fighting for the Trojans.
527. *Memnon*: "Black Memnon,": king of Ethiopia who led a battalion of his countrymen on the side of the Trojans. He was said to be the most handsome of all warriors. He was killed by Achilles. Memnon was venerated as a god in Egypt. 543. *Arês*: the Greek god of war (equivalent to the Roman Mars).

Now other souls of mournful dead stood by,
each with his troubled questioning, but one
remained alone, apart: the son of Télamon, 550
Aîas, it was—the great shade burning still
because I had won favor on the beachhead
in rivalry over Akhilleus' arms.
The Lady Thetis, mother of Akhilleus,
laid out for us the dead man's battle gear, 555
and Trojan children, with Athena,
named the Danaan fittest to own them. Would
god I had not borne the palm that day!
For earth took Aîas then to hold forever,
the handsomest and, in all feats of war, 560
noblest of the Danaans after Akhilleus.
Gently therefore I called across to him:

'Aîas, dear son of royal Télamon,
you would not then forget, even in death,
your fury with me over those accurst 565
calamitous arms?—and so they were, a bane
sent by the gods upon the Argive host.
For when you died by your own hand we lost
a tower, formidable in war. All we Akhaians
mourn you forever, as we do Akhilleus; 570
and no one bears the blame but Zeus.
He fixed that doom for you because he frowned
on the whole expedition of our spearmen.
My lord, come nearer, listen to our story!
Conquer your indignation and your pride.' 575

But he gave no reply, and turned away,
following other ghosts toward Erebos.
Who knows if in that darkness he might still
have spoken, and I answered?

 But my heart
longed, after this, to see the dead elsewhere. 580
And now there came before my eyes Minos,°
the son of Zeus, enthroned, holding a golden staff,
dealing out justice among ghostly pleaders
arrayed about the broad doorways of Death.

And then I glimpsed Orion, the huge hunter, 585
gripping his club, studded with bronze, unbreakable,
with wild beasts he had overpowered in life
on lonely mountainsides, now brought to bay
on fields of asphodel.

 And I saw Tityos,
the son of Gaia, lying 590
abandoned over nine square rods of plain.
Vultures, hunched above him, left and right,
rifling his belly, stabbed into the liver,
and he could never push them off.

581. *Minos*: king of Crete who after his death was made judge in the realm of the dead. [Trans.]

had once committed rape of Zeus's mistress, 595
Lêto, in her glory, when she crossed
the open grass of Panopeus toward Pytho.

Then I saw Tántalos° put to the torture:
in a cool pond he stood, lapped round by water
clear to the chin, and being athirst he burned 600
to slake his dry weasand° with drink, though drink
he would not ever again. For when the old man
put his lips down to the sheet of water
it vanished round his feet, gulped underground,
and black mud baked there in a wind from hell. 605
Boughs, too, drooped low above him, big with fruit,
pear trees, pomegranates, brilliant apples,
luscious figs, and olives ripe and dark;
but if he stretched his hand for one, the wind
under the dark sky tossed the bough beyond him. 610

Then Sísyphos° in torment I beheld
being roustabout to a tremendous boulder.
Leaning with both arms braced and legs driving,
he heaved it toward a height, and almost over,
but then a Power spun him round and sent 615
the cruel boulder bounding again to the plain.
Whereon the man bent down again to toil,
dripping sweat, and the dust rose overhead.
Next I saw manifest the power of Heraklês°—
a phantom, this, for he himself has gone 620
feasting amid the gods, reclining soft
with Hêbê of the ravishing pale ankles,
daughter of Zeus and Hêra, shod in gold.
But, in my vision, all the dead around him
cried like affrighted birds; like Night itself 625
he loomed with naked bow and nocked arrow
and glances terrible as continual archery.
My hackles rose at the gold swordbelt he wore
sweeping across him: gorgeous intaglio
of savage bears, boars, lions with wildfire eyes, 630
swordfights, battle, slaughter, and sudden death—
the smith who had that belt in him, I hope
he never made, and never will make, another.
The eyes of the vast figure rested on me,
and of a sudden he said in kindly tones: 635

 This hulk

'Son of Laërtês and the gods of old,
Odysseus, master mariner and soldier,
under a cloud, you too? Destined to grinding
labors like my own in the sunny world?
Son of Kroníon Zeus or not, how many 640
days I sweated out, being bound in servitude
to a man far worse than I, a rough master!
He made me hunt this place one time
to get the watchdog of the dead: no more
perilous task, he thought, could be; but I 645
brought back that beast, up from the underworld;
Hermês and grey-eyed Athena showed the way.'

And Heraklês, down the vistas of the dead,
faded from sight; but I stood fast, awaiting
other great souls who perished in times past. 650
I should have met, then, god-begotten Theseus
and Peirithoös, whom both I longed to see,
but first came shades in thousands, rustling
in a pandemonium of whispers, blown together,
and the horror took me that Perséphonê 655
had brought from darker hell some saurian death's
 head.
I whirled then, made for the ship, shouted to crewmen
to get aboard and cast off the stern hawsers,
an order soon obeyed. They took their thwarts,
and the ship went leaping toward the stream of
 Ocean 660
first under oars, then with a following wind."

. .

COMMENTS AND QUESTIONS

1. How would you characterize Homer's vision of the afterlife here? Compare it with that in the *Epic of Gilgamesh* and with that in other myths and religions with which you are familiar.
2. What is Achilles' attitude toward death? How might this typify a Greek point of view?
3. What kinds of punishment are recounted here and how do they fit the sins? We will return to this question when reading Virgil and Dante.

. .

SAPPHO

● SELECTED LYRIC POEMS ●
AND FRAGMENTS
Translation by Willis Barnstone

Sappho, who was born around 610 B.C. and died around 580 B.C., was something like the headmistress of a school for girls that was devoted to poetry and to the service of the goddess of love and beauty, Aphrodite. The term *lesbian* comes from the

598. *Tántalos:* king of Lydia, who was invited to dine with the gods on Mount Olympus but stole their nectar and ambrosia. When he returned the invitation, he served them the body of his son Pelops, whom the gods later restored to life. One of Pelops' sons was Agamémnon. 601. *weasand:* an archaic, Anglo-Saxon word meaning "throat." 611. *Sísyphos:* a king of Corinth, known for treachery. 619. *Heraklês:* Hercules, who had to perform twelve extremely difficult labors under an exacting master. One of these was to retrieve the watchdog Cerberus from Hades.

island Lesbos, Sappho's home, and its customs, and it is true that Sappho formed passionate attachments to her pupils. A wife and mother, Sappho also wrote poems about love between men and women. Unfortunately, most of Sappho's poetry has come down to us only in fragments; in fact, only two poems, "Seizure" and "A Prayer to Aphrodite," both printed below, have remained intact. Sappho developed a metric stanza that became known as the "Sapphic" and was adopted by later lyric poets. Here is a rendering of a Sapphic stanza in English. The symbol (ˉ) stands for a long beat and (˘) for a short one.

> Fādĕd ĕvĕry vĭŏlĕt, āll thĕ rōsĕs
> Gōne thĕ prŏmĭse glōrĭŏus, ănd thĕ vīctĭm,
> Brōkĕn īn thĭs āngĕr ŏf Āphrŏdītĕ,
> Yĭēlds tŏ thĕ vīctŏr.

Even with this fixed meter, the poetry of Sappho seems straightforward, spontaneous, almost simple. She wrote without reservation about her personal world of emotions, and her apparently plain images have great evocative power. Perhaps most important for us is that in a world dominated by men she was an independent woman and sang proudly about the woman's sphere in which she lived. In keeping with the new lyric spirit, she glorified her world of intimate emotions and friendships and her cult of Aphrodite as superior to politics or warfare.

A Prayer to Aphrodite

On your dappled throne, Aphrodite,
sly eternal daughter of Zeus,
I beg you: do not crush me with grief,

but come to me now—as once
you heard my far cry, and yielded,
slipping from your father's house

to yoke the birds to your gold
chariot, and came. Handsome swallows
brought you swiftly to the dark earth,

their wings whipping the middle sky.
Happy, with deathless lips, you smiled:
"What is wrong, why have you called me?

What does your mad heart desire?
Whom shall I make love you, Sappho,
who is turning her back on you?

Let her run away, soon she'll chase you;
refuse your gifts, soon she'll give them.
She will love you, though unwillingly."

Then come to me now and free me
from fearful agony. Labor
for my mad heart, and be my ally.

Seizure

To me that man equals a god
as he sits before you and listens
closely to your sweet voice

and lovely laughter—which troubles
the heart in my ribs. For Brocheo,
when I look at you my voice fails,

my tongue is broken and thin fire
runs like a thief through my body.
My eyes are dead to light, my ears

pound, and sweat pours down over me.
I shudder, I am paler than grass,
and am intimate with dying—but

I must suffer everything, being poor.

To Aphrodite of the Flowers, at Knossos

Come to the holy temple of the virgins
where the pleasant grove of apple trees
circles an altar smoking with frankincense.

The roses leave shadows on the ground
and cool springs murmur through apple branches
where shuddering leaves pour down profound sleep.

In that meadow where horses have grown
glossy, and all spring flowers grow wild,
the anise shoots fill the air with aroma.

And there our queen Aphrodite pours
celestial nectar in the gold cups,
which she fills gracefully with sudden joy.

A Letter to Atthis (I)

My Atthis, although our dear Anaktoria
lives in distant Sardis,
she thinks of us constantly, and

of the life we shared in days when for her
you were a splendid goddess,
and your singing gave her deep joy.

Now she shines among Lydian women as
when the red-fingered moon
rises after sunset, erasing

stars around her, and pouring light equally
across the salt sea
and over densely flowered fields;

and lucent dew spreads on the earth to quicken
roses and fragile thyme
and the sweet-blooming honey-lotus.

Now while our darling wanders she remembers
lovely Atthis' love,
and longing sinks deep in her breast.

She cries loudly for us to come! We hear,
for the night's many tongues
carry her cry across the sea.

To Anaktoria, Now a Soldier's Wife in Lydia

Some say cavalry and some would claim
infantry or a fleet of long oars
is the supreme sight on the black earth.
 I say it is

the girl you love. And easily proved.
Did not Helen, who was queen of mortal
beauty choose as first among mankind the very
 scourge

of Trojan honor? Haunted by Love
she forgot kinsmen, her own dear child,
and wandered off to a remote country.
 O weak and fitful

Woman bending before any man:
So Anaktoria, although you are
Far, do not forget your loving friends.
 And I for one

Would rather listen to your soft step
and see your radiant face—than watch
all the dazzling horsemen and armored
 Hoplites of Lydia.

Full Moon

The glow and beauty of the stars
are nothing near the splendid moon
when in her roundness she burns silver
about the world.

Then

In gold sandals
dawn like a thief
fell upon me.

Shrill Song

When sun sprays the earth
with straight-falling flames,
a cricket rubs his wings,
scraping up thin sweet song.

..

QUESTIONS

1. Contrast Sappho's view of the story of the origins of
 the Trojan War in "To Anaktoria" with Homer's.
2. What is the nature of love expressed in "Seizure"
 and "A Prayer to Aphrodite"?
3. What other emotions associated with love can you
 find in these poems?
4. What *images* does Sappho use? What effects do they
 have?
5. What themes besides love do you find in these poems?

..

Summary Questions

1. Why do we apply the term *classical* to the ancient Greek and Roman civilizations?
2. What major similarities and differences can be distinguished between early Greek civilization and its predecessors in Mesopotamia and Egypt?
3. Compare and contrast government and art in Crete and Mycenae.
4. What is meant by *archaic* Greece?
5. Who are the major gods and goddesses in the Greek pantheon and what are their functions?
6. Compare and contrast the nature of the epic in *Gilgamesh* and the *Iliad*.
7. Define the lyric and apply the definition to Sappho's poetry.

Key Terms

classical

archaic

Crete

Minos

Minoan

Mycenae

Mycenaean

the Trojan War

Mount Olympus

The Greek pantheon

epic

lyric

Homer

Sappho

4 Classical Greece: Life and Art

CENTRAL ISSUES

- The polis and Greek democracy according to Pericles
- The role of women in ancient Greece
- The Parthenon and the classical Greek temple
- The Doric, Ionic, and Corinthian orders
- Characteristics of classical Greek sculpture
- The links and differences between Hellenistic and classical sculpture

The time between the world of Homer and Sappho and the world of "classical" Athens saw a growth in the population of Greece, greater material prosperity, and shifts in political power. The city-states in Mycenaean times had been governed by kings, but control had then passed to the nobles; now, in the seventh century B.C., a rising merchant class began to make its power felt. Through revolutions against the nobles, this class assumed control in several of the city-states through a strongman or *tyrant*. This word originally had no bad connotations; but, as these men began to depend more and more on force to impose their wills, the word took on its modern significance. Other governments soon replaced the tyrannies. The form of government that arose in the city-state of Athens was called *democracy,* which means in Greek "rule

by the people." Athens' rival city-state, Sparta, did not go through the tyrant stage but retained an aristocratic government or *oligarchy,* which means in Greek "rule by the few." The relative advantages and disadvantages of these two opposing forms of government became an important theme in Greek thought during the period with which we are concerned here.

Athens and Sparta began as allies in a series of wars that were decisive for the political, economic, and cultural importance that Greece was to assume. Persia, the last great power of the Middle East, controlled an empire stretching from India and the Asiatic steppes to the Aegean and the Nile. Naturally, the Persians attempted to annex the tiny land of Greece to their empire. The surprise on all sides was great when the Greek allies, led by the Athenians, defeated the mighty Persian army, led by King Xerxes, at the naval battle of Salamis in 480 B.C. Prior to the battle, however, the Athenians themselves had had to evacuate their city before the advancing Persians. Xerxes took the city and burned the Acropolis but, defeated at Salamis, was forced to abandon Athens and return to Persia.

The Greeks saw this battle not only as a great military victory but, perhaps more important, as a cultural one. Persia represented to the Athenians in particular all the values that were anti-Greek. The Persian empire, with its political hierarchy and remote, powerful king at the top, was a far cry from the small state with its "rule by the people." Another negative value that the Persians represented is summed up by the Greek word *hubris.* This is best translated as arrogance, unbridled ambition, or stepping out of the boundaries that the gods have set for people. Xerxes' ambition to conquer the world and his manner of acting and treating himself more like a god than a man were seen to be examples of hubris. In the example of Xerxes' defeat, the Greeks could see a rhythm of tragedy: hubris leads people into folly, or actions that are contrary to reason; such acts bring on *nemesis.* Nemesis was the name of a Greek goddess, but the word is translated as retribution, punishment, or disaster. A tragedy written by Aeschylus in 472 B.C. entitled *The Persians* showed just this cycle. In opposition, the Greeks upheld an ideal they called *sophrosyne,* which means wisdom and moderation. It is perhaps best expressed by the famous motto of the oracle at Delphi: "Nothing in excess." We will see the importance of this concept to the art and thought that we call classical.

Politics and Life in Ancient Athens

Greek culture was concentrated in the *polis* (from which comes the word *politics*), a city-state. Territorially, the polis included the city and the surrounding countryside; but, as it was customarily observed, no citizen should live more than a day's walk from the center. The contrast between the care lavished on public buildings and the humble construction of private houses demonstrates the important role of the polis in the lives of its citizens. The market, the courts, and the temples were the focuses of activity, not private gardens and domiciles. It was generally believed that people could realize their humanity only through participation in political processes. The polis provided the religious forms and the moral and cultural values that gave meaning and fullness to a citizen's existence. Citizenship was a privilege acquired by males through birth; normally both one's father and mother had to be natives of the state. Citizenship guaranteed membership in a political community and at least some share in the government of the polis. Whereas in more aristocratic city-states participation was often limited to membership in an assembly with minimal powers, in fifth-century Athens every citizen over twenty-five was eligible for the whole range of state offices, which were filled for short terms either by election or by drawing lots.

All policy decisions and laws were made by the Assembly of the People, composed of the whole body of male citizens. Day-to-day matters and the responsibility of preparing an agenda for the frequent meetings of the Assembly were in the hands of a Council of Five Hundred. Chosen annually by lot, this council functioned by means of a rotating committee meeting daily. A variety of magistrates performed specialized tasks relating to finance and military matters, but the closely defined powers delegated them allowed almost no room for personal initiative. Ultimately, all public officials were responsible to the Assembly, and anyone wishing to exert political authority in the state had to do so through leadership within that body.

Despite its democratic constitution, Athens, like all Greek city-states (and all ancient societies), endorsed slaveholding. Slaves numbered about 90,000, while citizens and their families made up about 150,000 and foreigners about 35,000. A majority of the slaves were employed in domestic service, but about 50,000 worked in industry and another 10,000 (surely the most unfortunate) toiled in the silver mines of Laurion. Apart from the mines, Athenian slavery was not oppressive. Citizens worked alongside slaves in industrial production, and it was usually difficult to distinguish slaves from free people by their dress. In a society where the productive capacity was low and consumption needs relatively simple, the use of slaves was motivated by a desire not for the luxurious life but rather for the creation of an amount of leisure so that citizens could carry out their duties as members of the polis.

The status of women in this society is a matter of debate. They were not citizens, nor did they have rights in law. Marriage seems to have meant the passing from the protection of the father to that of the husband. Wives were expected to remain at home to supervise their households and children. The women free to

● D A I L Y L I V E S ●

● ● ● ● The Ideal Wife

Xenophon, the author of the following excerpt, was born in Athens in 431 B.C. and died there about 352 B.C. In his younger days a professional soldier, serving successively in the armies of the kings of Persia and of Sparta, he later became a prolific writer on contemporary history. The *Oeconomicus,* however, was devoted to instructing readers on estate management, a very different but popular genre of writing at the time. The work is written as a dialogue in which Socrates asks the questions and a successful estate owner, Ischomachus, gives the answers. Taken together, the latter's responses constitute Xenophon's advice for the proper running of a farm. Xenophon felt very strongly that the success of an estate owner depended on having the right kind of wife and, through the owner's portrayal of his own wife, the author sets forth his idea of the perfect spouse. In this selection, Ischomachus is speaking to his new fifteen-year-old bride, giving her instructions on her duties.

"Thus, to the woman it is more honourable to stay indoors than to abide in the fields, but to the man it is unseemly rather to stay indoors than to attend to the work outside. If a man acts contrary to the nature God has given him, possibly his defiance is de-

tected by the gods and he is punished for neglecting his own work, or meddling with his wife's. I think that the queen bee is busy about just such other tasks appointed by God."

"And pray," said she, "how do the queen bee's tasks resemble those that I have to do?"

"How? she stays in the hive," I answered, "and does not suffer the bees to be idle; but those whose duty it is to work outside she sends forth to their work; and whatever each of them brings in, she knows and receives it, and keeps it till it is wanted. And when the time is come to use it, she portions out the just share to each. She likewise presides over the weaving of the combs in the hive, that they may be well and quickly woven, and cares for the brood of little ones, that it be duly reared up. And when the young bees have been duly reared and are fit for work, she sends them forth to found a colony, with a leader to guide the young adventurers."

"Then shall I too have to do these things?" said my wife.

"Indeed you will," said I; "your duty will be to remain indoors and send out those servants whose work is outside, and superintend those who are to work indoors, and to receive the incomings, and distribute so much of them as must be spent, and watch over so much as is to be kept in store, and take care

attend gatherings of men outside the home were either prostitutes or high-class courtesans—foreign women called *hetaerae.* On the other hand, tender scenes between husband and wife depicted on funeral vases suggest the existence of deep ties of affection between some married couples. Representations of strong, intelligent women in Greek tragedy and comedy indicate that such women, at least in the upper class, did exist; but, on the whole, we must think of Greek women as excluded from active roles in the community. A female political leader such as Queen Hatshepsut or, even more, the Candaces of Kush would have been unthinkable in fifth-century Greek society.

The great age of Athens fell between the end of the Persian War in 480 B.C. and the end of the Peloponnesian War in 404 B.C., when Athens was defeated by Sparta. The Peloponnesian War is so called because Sparta is located in that section of Greece called the Peloponnesus (see map, Chapter 3). As rivals for commercial power and representatives of conflicting politi-

cal ideologies, the two cities of Athens and Sparta came to an inevitable clash. The Athenian Thucydides, one of the first historians of Western culture, has given us both a chronicle of the war between the two city-states and a vision of the workings of history in his *History of the Peloponnesian War,* probably completed about 400 B.C. His history is conceived in terms related to classical tragedy. In particular, he sees the reckless Athenian attack on the city of Syracuse in Sicily as a manifestation of hubris, which led to the downfall of the Athenians.

Thucydides' view of human history, like that of other Greek historians of his generation, was modeled on nature, which for them was a spectacle of incessant change. Indeed, human history changed more violently than anything else in their experience. Although not deriving a historical law, they believed that in the general scheme of change certain causes normally produced specific effects. Particularly, excessive action in one direction produced a violent reaction in the other. Thus examples of history could be used to teach individuals

that the sum laid by for a year be not spent in a month. And when wool is brought to you, you must see that cloaks are made for those that want them. You must see too that the dry corn is in good condition for making food. One of the duties that fall to you, however, will perhaps seem rather thankless: you will have to see that any servant who is ill cared for."

"Oh no," cried my wife, "it will be delightful, assuming that those who are well cared for are going to feel grateful and be more loyal than before."

"Why, my dear," cried I, delighted with her answer, "what makes the bees so devoted to their leader in the hive, that when she forsakes it, they all follow her, and not one thinks of staying behind? Is it not the result of some such thoughtful acts on her part?"

"It would surprise me," answered my wife, "if the leader's activities did not concern you more than me. For my care of the goods indoors and my management would look rather ridiculous, I fancy, if you did not see that something is gathered in from outside."

"And my ingathering would look ridiculous," I countered, "if there were not someone to keep what is gathered in. Don't you see how they who 'draw water in a leaky jar,' as the saying goes, are pitied, because they seem to labour in vain?"

"Of course," she said, "for they are indeed in a miserable plight if they do that."

"But I assure you, dear, there are other duties peculiar to you that are pleasant to perform. It is delightful to teach spinning to a maid who had no knowledge of it when you received her, and to double her worth to you: to take in hand a girl who is ignorant of housekeeping and service, and after teaching her and making her trustworthy and serviceable to find her worth any amount: to have the power of rewarding the discreet and useful members of your household, and of punishing anyone who turns out to be a rogue. But the pleasantest experience of all is to prove yourself better than I am, to make me your servant; and, so far from having cause to fear that as you grow older you may be less honoured in the household, to feel confident that with advancing years, the better partner you prove to me and the better housewife to our children, the greater will be the honour paid to you in our home. For it is not through outward comeliness that the sum of things good and beautiful is increased in the world, but by the daily practice of the virtues."

Excerpts from Xenophon's *Oeconomicus*, translated by E. C. Marchant.

to control their emotional life so that they would resist excess and avoid disaster. In the case of political leaders, the consequences of lack of self-control could ruin not only themselves but their people. While stressing the use of reason to control human destiny, the Hellenic historians, however, saw in human history no general pattern, no direction, only ceaseless change.

Classical Greek Architecture

When the Athenians returned to Athens after their triumph over Xerxes at Salamis, they found a ravaged city. On the Acropolis, temples had been burned, statues toppled, and inscriptions destroyed or defaced. After the city rebuilt its fortifications, its leaders began the great rebuilding project on the Acropolis. This activity not only built morale but also provided jobs. The majestic buildings on the Acropolis, now ruined by time and subsequent wars, are the results of a building program supervised by Pericles, Athens's leading statesman. They

and the sculpture adorning them constitute the best models for the ideals of the classical style (Fig. 4-1).

Like all cultural monuments, the buildings on the Acropolis have a history. To understand the accomplishments of the expert builders and artisans who created the buildings, it is necessary to know something of the origins of Greek architecture.

Origins of Greek Architecture

The beginnings of architecture in Greece were humble, as they had been in Mesopotamia and Egypt. The first temples built by the Greeks were simple rectangular boxes, sometimes curved at one end. The ground plan would show a room whose walls extend to flank the doorway. This room, called a *naos*, was for the cult statue, and the extended walls made an entrance porch, the *pronaos*; together they formed the *cella*. Beams for the roof rested on the top edge of the cella walls and, when crossed to form a triangular shape, could carry a

4-1 *Athens, Acropolis, general view. (Courtesy, TWA)*

▲

- Using the ground plan (Fig. 4-5), compare this site with the temple at Deir el Bahari (Figs. 2-11, 2-12).
- Describe the role that mountains play in the design of Mesopotamian, Egyptian, and Greek temples.

wooden gable or ridge pole that followed the long axis of the cella, leaving an open triangular space at each end, the *pediment*. The roof would slope down from the center to the sides, creating a deep overhang. Any openings, such as doors or windows, would be made by using posts and lintels. The combinations of posts and lintels would also carry the weight of the roof (Fig. 4-2).

A comparison of this form with Mesopotamian or Egyptian temples shows a basic similarity—a room for the statue separated from the public. The Greeks enclosed the cult statue in the cella and soon surrounded it with rows of columns or posts on all four sides to create a *colonnade*. Ceremonies took place outside at an altar placed on the long axis of the building that faced east.

The experience of this form diverges radically from that of the sacred mountain, the ziggurat, which rises as a great mass, and is also unlike the long processional entries to the Egyptian temple complex. Our bodies respond differently to the columns and roof of the Greek form because they are physically lighter, more elastic, and therefore more active in feeling than the heavy monoliths of Egypt. The Greeks used the smooth mass of the exterior wall and the great downward pressing weight of the roof with its overhang to contrast with the dynamic power of the upward-thrusting posts or columns. Similarly, the rhythm of light and dark created by the columns against the smooth cella walls also plays a part in our perception of the temple.

The Greek Temple

The architectural factor that became the most significant formal element of the Greek temple was the shape and scale of the column and its combination with other specific features—its *capital* (the cushion and flat block under the lintel) and the lintel, or *entablature,* above. The two most important combinations or *orders* are the *Doric* and the *Ionic*. Documents tell us that the Doric order evolved in the Dorian Peloponnesus. The Ionic order was first found in Asia Minor. Both were used by the Greeks of the fifth century (Fig. 4-3).

Observing the orders side by side, you can see that there is a difference in the height and thickness of the column, the presence or absence of a base for the column, the forms of the capital, and the lintel and *frieze* above the column. Vitruvius, a first-century B.C. Roman who

4-2 *Basic post-and-lintel construction.*

RIDGE BEAM

PRINCIPAL RAFTER

TIE BEAM

KINGPOST

WALLPLATE

LINTEL

POST

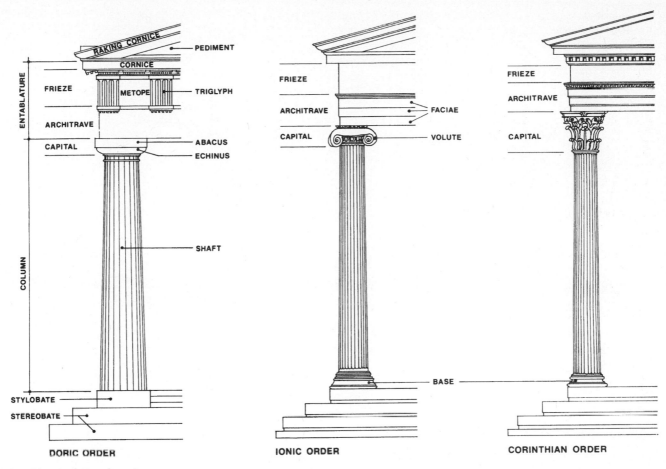

4-3 *Classical Greek orders.*

wrote a treatise on architecture, tells us that the Doric was the more ancient order and was serious, grave, dignified, and masculine. The slender, lighter, more elegant Ionic was considered feminine. Femininity, in this case, was not associated with the gender of the gods but with the universal aspects of the female principle.

The Parthenon The temple form, a cella with a colonnade on all four sides, became the rule for major temples; but its builders enriched and elaborated it, as we will see in the Parthenon. The Parthenon, built between 477 and 438 B.C., was designed and executed under the direction of Ictinus and Kallicrates, expert builders (Figs. 4-4, 4-5). The sculptural program was directed by the sculptor Phideas, who did some images himself and was solely responsible for the cult statue of Athena, placed in the cella. Tradition dictated that the temple be Doric; this one has six columns on its ends and seventeen down each flank. Located on the highest point of the Acropolis, the third temple to Athena Parthenos on that site, it was the crown of the complex. Forms originally built in mudbrick and wood, then in local stone, were now interpreted in gleaming white marble. The

4-4 *Athens, Acropolis, the Parthenon. (Greek National Tourist Organization)* (**W**)

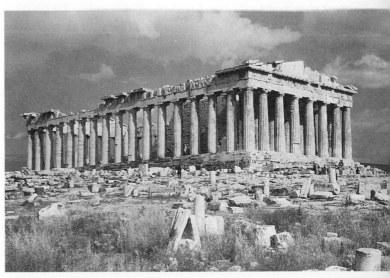

• Compare the use of columns on the Parthenon with those of Deir el Bahari and the Propylaea (Figs. 2-11, 4-13).

A Propylaea
B Statue of Athena
C Parthenon
D Erectheum
E Site of Older Parthenon
F Temple of Athena Nike

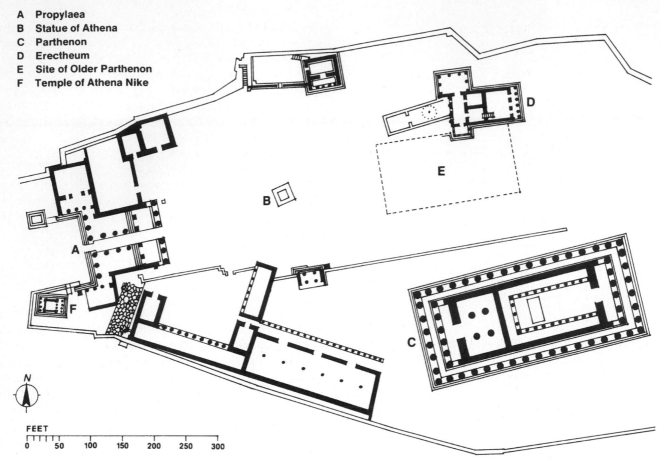

FEET
0 50 100 150 200 250 300

4-5 *Athens, Acropolis, ground plan.*

pediment on the west end, facing the sea, had its triangular space filled with sculptures depicting the story of Athena's rivalry with Poseidon for the homage of the city. The sculpture of the east pediment showed Athena's birth. The *metopes,* the spaces between the ends of the lateral beams of the roof, above the lintel, were sculpted in *low relief* with scenes from the Trojan War, the Battle of Gods and Giants, Lapiths and Centaurs, Greeks and Amazons, all historical allusions to the Greeks' struggle with the Persians—allegories for the struggle between light and darkness, civilization and barbarism. At the top of the cella walls was a sculpted frieze, showing the procession of the Panathenaea, the festival held every four years to honor Athena. Finally, the whole building was painted and polished. Capitals and moldings received color: blue, red, and gilding. Sculpture was given natural coloring; weapons, horse tack, shields, and other objects were bronze, brass, or gold. Within the cella, the gold and ivory cult statue was placed at the far end from the door.

Surrounded by terraces, trees, statues, and stelae, as well as the other buildings that soon rose around it, the Parthenon dominated the Acropolis. The entire com-

plex was so moving that even the embittered Spartans did not destroy it when they finally defeated the Athenians in 404 B.C. Time and wars following the fall of the Roman Empire ravaged the site, the worst destruction being the Venetian bombardment of 1678.

Even in the ruined state in which the Parthenon stands today, one senses an order of intractable stone formed into an ideal relationship between weight and support, repose and response, symmetry and rhythm. These characteristics recall the system of balances in Pericles' *Funeral Oration* or the search for a mean between passion and will, intuition and reason, that we will observe in Greek philosophy. Perhaps we can better understand the Parthenon by looking now at Greek sculpture, whose origins lie in the same past and whose possibilities, like the temple form, seem completely realized by the late fifth century.

Greek Sculpture

The sculpture of Egypt provides numerous points of comparison with that of Greece. The Egyptians produced three-dimensional sculpture carved from solid blocks of

4-6 Kouros *of Sounion, c. 600* B.C. *(National Archaeo-logical Museum, Athens)*

Beginning with the head, the face, jawline, ears, and back of the head are seen as almost separate flat sections. The forehead, eyebrow ridge, and nose form one smooth plane, and the eyes are simplified into a wide open stare, the eyelids marked only by a groove. Similarly, the shoulders and chest flow into another smooth plane, where slight ridges, grooves, and swellings incorrectly delineate the body but are formally pleasing and symmetrical. The hip joint and the hips are reduced to one generalized swell into the thighs. Kneecaps are rigid designs, and the calves have some incised ridges for musculature. The spinal column is almost perfectly straight, and shoulder blades are incised grooves. The arms mask the sides of the body, and the clenched fists make the arms seem to press in toward the body.

The total impression is one of a compact, sculptural solid. It is a memorable and commanding form that deserves our attention because it is a familiar form—a human body—transformed into something timeless. The *Kouros* can be walked around and studied, touched and compared mentally with the surface, texture, articulation, and movement of our own bodies. When we compare the flexible elbow, the soft flesh behind the knee, the loose, floating oval kneecap, and the soft ridges behind the neck and ears with those of this figure, we begin to realize that although the statue is *not* lifelike, its own symmetry, the incised ridges, and the contrast between the way it is and what it seems to be—a human body—create a pleasing and enlightening experience. The *Kouros,* made to commemorate an event, inhabits a space different from our own, and we, like it, are confined to a different place and space. The columnar *Kore,* a female, is equally rigid and posed, yet the symmetry, balance, and harmony of the drapery of the figure, the hair, and the very stylized face are pleasing (Fig. 4-7).

Early Classical Sculpture

The *Kritios Boy* found on the Acropolis was made about 480 B.C. (Fig. 4-8). How different he seems from the previous figures! The body now moves and turns—weight flows into one leg as the figure poses and balances. The body has become a flexible, smooth-muscled, and tactile form. One feels that a touch would reveal a yielding surface of skin and flesh. The body is perceived in the round; it reaches outside the imaginary lines of the block from which it was carved. Yet, because of its perfection, the sculpture remains separate from us. Not a blemish or scar, an undeveloped muscle or unhappy emotion breaks the graceful forms of the body and face. Our own form would rarely compare favorably with this athletic perfection that seems to speak of self-restraint and control, perpetual youth and self-awareness. This is humanity idealized into what one *might* become.

stone. The Greeks learned from those techniques just as they learned from the formal, frontal, and almost ideal nature of Egyptian sculpture. In the developing culture of Greece its sculpture seems born of two almost contradictory desires: the desire to attain complete naturalism and the desire to make the figures ideal types. The gods and goddesses, votive figures, and even the more personalized portraits seem both human and divine.

Archaic Sculpture

The *Kouros* of Sounion (*kouros* is Greek for "youth," a standing male nude) was made in the Archaic period about 600 B.C. (Fig. 4-6). Over life size (ten feet), this freestanding male nude is characteristic of many such figures that exhibit some attempt to have them appear natural but are still confined to the stone block from which they were carved. One foot steps forward, but the body weight does not shift. The body itself is really perceived as a columnar shape in which anatomical details are arranged in a symmetrical, stylized way.

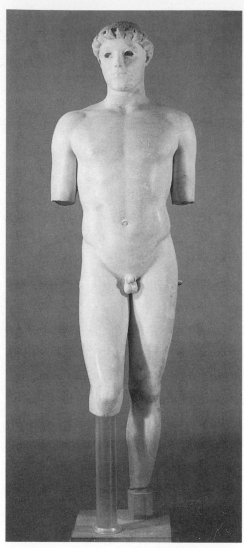

4-7 Kore. *Louvre, Paris. (Copyright PHOTO Réunion des Musées Nationaux)*

4-8 Kritios Boy, *c. 480* B.C. *(Acropolis Museum, Athens)*

• Compare the *Kore* with one of the female figures from Tel el Amarna (Fig. 2-14). What physical characteristics are most different, most alike? Which figure seems more sacred, or holy?

• Compare the *Kritios Boy* with the *Kouros* (Fig. 4-6), considering differences in pose and material. Then compare it with Egyptian standing figures. What difference does the nude body make?

Classical Sculpture

The development of freestanding figures toward this expressive perfection is paralleled in other kinds of sculpture. The frieze of the Panathenaic procession gives us more insight into the qualities of the ideal and the real that combine to make the expressive and dramatic scenes of classical art. The frieze has a rhythm that quickens and slows like that of an anthem.

On the southeast side, where the procession begins, figures stand or begin to walk slowly. Riders hold their horses, and the sacrificial beasts are readied. As the procession moves along the south flank and turns the western corner, the participants move more rapidly, cluster-

ing together. In the section illustrated here (Fig. 4-9), horses and riders, bodies mingling in the low sculpted relief, seem to push eagerly forward. Cloaks blow in the wind; manes and hair are breeze-tossed. As the procession reaches the east end, movement becomes quiet and figures halt in the presence of the gods and goddesses on Mount Olympus. The participants are almost anonymous, the ideally beautiful youths and maids of a procession still going on. The older priest-celebrants will always remain so, as will for all time the gods watching the ceremony.

In the blasted, broken fragments that remain from the Parthenon's pedimental sculptures, scholars and stu-

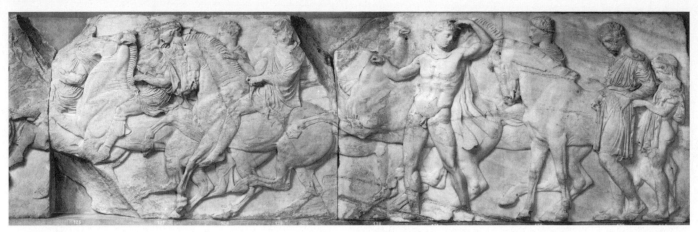

4-9 *Mounted horses, followed by men on foot, detail of Panathenaic procession from Parthenon frieze, 432* B.C. *(Reproduced by Courtesy of the Trustees of the British Museum)*

▲
• Compare this relief with that of *King Ashurnasirpal II Killing Lions* (Fig. 1-13). Consider focus, distance from the figure, and representation of emotion on the faces of the figures.

dents of Greek sculpture see some of the most beautiful forms of the fifth century. Yet it is difficult for us, as novices, to penetrate the veil of destruction and time that lies over these forms. Only in the *Dionysus* (Fig. 4-10) or the now headless figures of the goddesses from the pediment can we begin to perceive the magnificent beauty of the body, perfectly harmonized with an expressive ideal (Fig. 4-11). The three women sit, lean, and recline to fit the space of the triangular pediment. Their bodies are substantial, weighty volumes. Their clothes do not con-

4-10 Dionysus *from the east pediment of the Parthenon, c. 438–432* B.C. *(Reproduced by Courtesy of the Trustees of the British Museum)*

ceal, but cling, turn, reveal, and emphasize the physical presence of these figures.

Classical Architecture and Sculpture Compared

The Spearbearer, by Polykleitos (Fig. 4-12), is a bronze sculpture that in many ways incorporates the classical ideal. Just as it harmonizes nature—the real with the ideal, of what one might be—the Parthenon harmonizes the forces of gravity and weight and the characteristics of the building system itself into a perfect balance of vertical and horizontal, compression and support (Fig. 4-4). The Parthenon's colonnade is not too tall or it would seem spindly; the columns are not too thick or they would be stumpy; the spaces between the columns are not too great or the rhythm they create would be broken; the lintels are not too long; neither are the capitals too large or small. The floor rises slightly to the center on both the long and short axis; the columns lean inward ever so slightly to counter visually the outward, downward pressure of the roof. The columns at the corner are slightly larger since they, as Vitruvius says, would seem too slender because they must be seen against light from both sides. The columns themselves swell slightly as though in vigorous, elastic response to the downward pressure of the roof. Greek architects grasped these fine points in the way that sculptors came to know the body. As head, neck, and chest become understood, as surface dissolves so that muscles swell and move rather than appear as ridges and grooves, as the body turns in space and becomes free of the solid compact mass of stone, so the Parthenon is lifted from the intractable marble to sit lightly in its landscape, its mass balanced between the reality of gravity and a thrust into bright light. To be seen from all sides, experienced during ceremonies, the building is like an ideal body, completely harmonious, self-aware and whole, mysterious and moving.

4-11 Three Goddesses *from the east pediment of the Parthenon, c. 438–432* B.C. *(Reproduced by Courtesy of the Trustees of the British Museum)*

Other Classical Greek Buildings

The temple form is a complete entity with its traditional, ritual, and formal demands; nevertheless, we should remember that it was not the only type of Greek building. There were theaters, meeting houses, and the colonnaded porticoes of the marketplace. Moreover, the basic temple form itself was capable of elaborate variation, and it is in this context that we should see the Parthenon. Two buildings on the Acropolis help us to do so.

Built after the Parthenon, the Propylaea is a monumental gateway providing a secondary focus for processions, bridging the physical changes in the levels of entry and creating a place of passage from which one can focus on the sanctuary (Fig. 4-13). The expert builders employed the Doric and Ionic orders; on the porticoes and exterior passages the Doric order gives substance to the idea of gateway and entrance. As the levels change, the interior Ionic columns stretch upward easily to carry the roof and visually lighten its weight. The complete gateway once acted also as entrance to the two wings, which were picture galleries containing scenes of Athenian victories.

The Erechtheum, on the north side of the Parthenon, is a very irregular but equally harmonious adjustment of building to its site and to the variety of functions it had to serve (Fig. 4-14). A number of shrines and ancient artifacts of the city had to be accommodated. To

▶

• Comparing this sculpture with the *Kritios Boy* (Fig. 4-8), which seems more confined in an imaginary blocklike space? How is movement suggested? Of the two bodies, which is more convincingly lifelike, which is more nearly perfect? Compare both works with a present-day athlete of the same general build. What does this tell you about the classical ideal?

4-12 *Polykleitos,* The Spearbearer, *bronze, c. 450–430* B.C. *(Ludwig-Maximilians-Universitat, Munich)*

4-13 *Acropolis, view of the Propylaea from the west. (Alinari/Art Resource, NY)*

the east was a shallow Ionic portico; on the north side was a deeper, richer Ionic porch for entry to the rooms that contained ancient relics; on the south side was the Porch of the Maidens, its flat roof supported by columns transformed into maidens, the *caryatid* order. Instead of a uniform building with a single *gable*, there are intersecting gables and two stories united with one. The Ionic order not only stretches but, along the west side, is also flattened into half-columns that unite the north and south porches, minimizing the change in location and in scale. Each porch has its own symmetry; but, in the balance of each against each, harmony is attained by the

4-14 *Athens, Acropolis, Erechtheum, the Porch of the Maidens, Caryatides, from the west side. (Greek National Tourist Organization)*

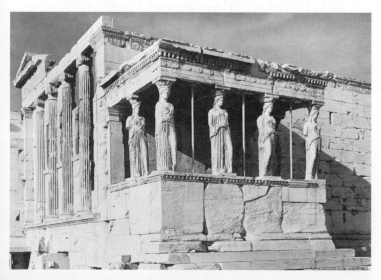

contrast of height and weight, openness and enclosure, shallowness and depth.

Greek architecture and sculpture were accompanied and enhanced by all the other arts: painting, music, dance, and drama. We know about painting only through written accounts, surviving vase painting, and later Roman copies of Greek work. But we do know that other arts shared in the conquest of space and movement and that, after the Parthenon, the builder's art continued to grow, flourish, and change. New needs inspired new ideas that provided a growing and changing art. After the Peloponnesian War new states acquired power and wealth; their ideals and beliefs were manifested in sculpture, painting, and building.

From Classical to Hellenistic Sculpture

The rich and complex art and architecture of the third and second centuries B.C. are called Hellenistic because of their roots in Hellas, or Greece. Hellenistic art and architecture use the language of the classical period coupled with ideas, energy, and inspiration drawn from the local traditions, settings, and practices of a wide range of metropolitan centers around the Mediterranean. The examples discussed below illustrate the vitality of the art of the Hellenistic period and its differences from that of classical Greece.

The Cnidian *Aphrodite,* made in the fourth century B.C., was among the first nude female sculptures. The original statue was carved by the Greek Praxiteles for Aphrodite's important shrine on the island of Cnidos. The ideal female form had evolved at the same time as the ideal male form, and portraying the goddess nude had become widely accepted. The *Aphrodite* illustrated here (Fig. 4-15) is a Roman copy of the Greek original and lacks the sensual liveliness that writers ascribed to the original. But the artist's realization of the ideal female as a relaxed, elegant figure, unabashed by her nudity, which is so wonderfully revealed as she steps from the bath, fueled the imagination of artists for many centuries. This ideal was revived again by the Italian artists of the fifteenth century in their search for the classical female prototype. The later Roman *Aphrodite* from Cyrene, in North Africa (Fig. 4-16), relies on the same hipshot pose, general proportions, and support of the water jar and drapery as does the *Aphrodite* from Cnidos.

Another example of later Greek art is the great Altar of Zeus at Pergamon in Asia Minor (Fig. 4-17). It was part of an architectural complex radically different from that of the Athenian Acropolis, and the form of the altar itself gives an idea of the many ways in which the Greek columnar orders and architectural details could be used to create new buildings and public spaces. The actual space of the altar is raised above the frieze, which has come down off the walls of the temple and out to the steps where the figures could be more

4-15 Praxiteles, Cnidian Aphrodite, c. 350 B.C., Vatican Museums, Vatican State. (Alinari/Art Resource, NY)

4-16 Aphrodite of Cyrene, from North Africa, early first century B.C., marble. (Hirmer Fotoarchiv, Munich)

- Compare this figure with the Cnidian Aphrodite (Fig. 4-15) and with The Spearbearer (Fig. 4-12). How has the Greek ideal been extended to women? Is there any change from the previous centuries?

easily seen and understood. The figures themselves are much more dramatic and graphically expressive than those of the Panathenae. Consider the striking differences of scale, depth of relief, and movement of figures (Fig. 4-18). In this detail of Zeus fighting three giants, the forms themselves seem almost trapped by the architectural framework, and as they struggle with each other they also seem to struggle to be free of the stones

from which they are carved. The swirling drapery and heavy muscular bodies of these figures have an emotional power quite different from the calm mien imparted by sculptors of earlier generations.

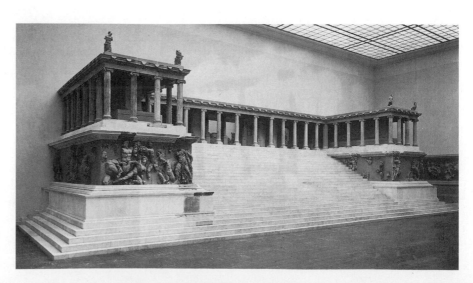

4-17 Altar of Zeus, Pergamon, c. 181–159 B.C. Staatliche Museen zu Berlin. (Bildarchiv Preussischer Kulturbesitz, Berlin)

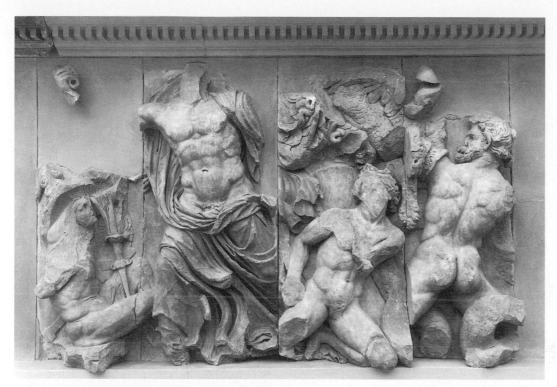

4-18 *Detail from Altar of Zeus, Zeus Fighting Three Giants, Staatliche Museen zu Berlin. (Bildarchiv Preussischer Kulturbesitz, Berlin)*

The stylistic innovations, and the presentation of intense emotions in the art of the Hellenistic period reflect the expansion of Greek culture beyond the confines of the Greek city-states. Once thought to represent a decline, or a decadent period, of Greek art, Hellenistic art is now appreciated for its own sake. Like the art of Egypt in the third millennium B.C. or that of classical Greece, it is part of a constantly changing language adapted to suit the needs and purposes of the maker and the user.

THUCYDIES

Pericles' Funeral Oration

Translation by Benjamin Jowett

The most famous passage of Thucydides' *History of the Peloponnesian War* is a funeral oration for some young Athenian soldiers by the Athenian statesman Pericles. Pericles, who headed the Athenian democracy during its greatest (classical) period, speaks for the young men who died. He does so by praising the way of life for which they gave their own lives.

I will speak first of our ancestors, for it is right and becoming that now, when we are lamenting the dead, a tribute should be paid to their memory. There has never been a time when they did not inhabit this land, which by their valor they have handed down from generation to generation, and we have received from them a free state. But if they were worthy of praise, still more were our fathers, who added to their inheritance, and after many a struggle transmitted to us their sons this great empire. And we ourselves assembled here today, who are still most of us in the vigor of life, have chiefly done the work of improvement, and have richly endowed our city with all things, so that she is sufficient for herself both in peace and war. Of the military exploits by which our various possessions were acquired, or of the energy with which we or our fathers drove back the tide of war, Hellenic or Barbarian, I will not speak; for the tale would be long and is familiar to you. But before I praise the dead, I should like to point out by what principles of action we rose to power, and under what institutions and through what manner of life our empire became great. For I conceive that such thoughts are not unsuited to the occasion, and that this numerous assembly of citizens and strangers may profitably listen to them.

Our form of government does not enter into rivalry with the institutions of others. We do not copy our neighbors, but are an example to them. It is true that we are called a democracy, for the administration is in the hands of the many and not of the few. But while the law secures equal justice to all alike in their private disputes, the claim of excellence is also recognized; and when a citizen is in any way distinguished, he is preferred to the public service, not as a matter of privilege, but as the reward of merit. Neither is poverty a bar, but a man may benefit his country whatever be the obscurity of his condition. There is no exclusiveness in our public life, and in our private intercourse we are not suspicious of one another, nor angry with our neighbor if he does what he likes; we do not put on sour looks at him which, though harmless, are not pleasant. While we are thus unconstrained in our private intercourse, a spirit of reverence pervades our public acts; we are prevented from doing wrong by respect for authority and for the laws, having an especial regard to those which are ordained for the protection of the injured as well as to those unwritten laws which bring upon the transgressor of them the reprobation of the general sentiment.

And we have not forgotten to provide for our weary spirits many relaxations from toil; we have regular games and sacrifices throughout the year; at home the style of our life is refined; and the delight which we daily feel in all these things helps to banish melancholy. Because of the greatness of our city the fruits of the whole earth flow in upon us; so that we enjoy the goods of other countries as freely as of our own.

Then, again, our military training is in many respects superior to that of our adversaries. Our city is thrown open to the world, and we never expel a foreigner or prevent him from seeing or learning anything of which the secret if revealed to an enemy might profit him. We rely not upon management or trickery, but upon our own hearts and hands. And in the matter of education, whereas they from early youth are always undergoing laborious exercises which are to make them brave, we live at ease, and yet are equally ready to face the perils which they face. And here is the proof. The Lacedaemonians come into Attica not by themselves, but with their whole confederacy following; we go alone into a neighbor's country; and although our opponents are fighting for their homes and we on a foreign soil, we have seldom any difficulty in overcoming them. Our enemies have never yet felt our united strength; the care of a navy divides our attention, and on land we are obliged to send our own citizens everywhere. But they, if they meet and defeat a part of our army, are as proud as if they had routed us all, and when defeated they pretend to have been vanquished by us all.

If then we prefer to meet danger with a light heart but without laborious training, and with a courage which is gained by habit and not enforced by law, are we not greatly the gainers? Since we do not anticipate the pain, although, when the hour comes, we can be as brave as those who never allow themselves to rest; and thus too our city is equally admirable in peace and in war. For we are lovers of the beautiful, yet simple in our tastes, and we cultivate the mind without loss of manliness. Wealth we employ, not for talk and ostentation, but when there is a real use for it. To avow poverty with us is no disgrace: the true disgrace is in doing nothing to avoid it. An Athenian citizen does not neglect the state because he takes care of his own household; and even those of us who are engaged in business have a very fair idea of politics. We alone regard a man who takes no interest in public affairs, not as a harmless, but as a useless character; and if few of us are originators, we are all sound judges of a policy. The great impediment to action is, in our opinion, not discussion, but the want of that knowledge which is gained by discussion preparatory to action. For we have a peculiar power of thinking before we act and of acting too, whereas other men are courageous from ignorance but hesitate upon reflection. And they are surely to be esteemed the bravest spirits who, having the clearest sense both of the pains and pleasures of life, do not on that account shrink from danger. In doing good, again, we are unlike others; we make our friends by conferring, not by receiving favors. Now he who confers a favor is the firmer friend, because he would fain by kindness keep alive the memory of an obligation; but the recipient is colder in his feelings, because he knows that in requiting another's generosity he will not be winning gratitude, but only paying a debt. We alone do good to our neighbors not upon a calculation of interest, but in the confidence of freedom and in a frank and fearless spirit. To sum up: I say that Athens is the school of Hellas, and that the individual Athenian in his own person seems to have the power of adapting himself to the most varied forms of action with the utmost versatility and grace. This is no passing and idle word, but truth and fact; and the assertion is verified by the position to which these qualities have raised the state. For in the hour of trial Athens alone among her contemporaries is superior to the report of her. No enemy who comes against her is indignant at the reverses which he sustains at the hands of such a city; no subject complains that his masters are unworthy of him. And we shall assuredly not be without witnesses; there are mighty monuments of our power which will make us the wonder of this and of succeeding ages; we shall not need the praises of Homer or of any other panegyrist whose poetry may please for the moment, although his representation of the facts will not bear the light of day. For we have compelled every land and every sea to open a path for our valor, and have everywhere planted eternal memorials of our friendship and of our enmity. Such is the city for whose sake these men nobly fought and died; they could not bear the thought that she might be taken from them; and every one of us who survive should gladly toil on her behalf.

COMMENTS AND QUESTIONS

1. Thucydides, through his spokesman Pericles, is defining a balanced system of government in a style that is also balanced. Define and point out the balances in style and content.
2. Where does Pericles describe the Athenian taste in art, and what is it?
3. What are the potential disadvantages of a democracy, and how does Athenian democracy avoid these disadvantages, according to Pericles?
4. How does Athenian democracy compare with modern democracies?

Summary Questions

1. What was the significance of the Persian War to the Greeks' definition of their political ideals?
2. What are the major reasons for Pericles' pride in the city of Athens?
3. What roles did women have in ancient Greek society?
4. Contrast the sacred architecture of Greece with that of Mesopotamia and Egypt, pointing out the main differences.
5. Why is the nude human form so important in Greek art?
6. What major contributions did Greek architects and builders make to the language of architecture?

Key Terms

democracy

tyranny

oligarchy

hubris

nemesis

sophrosyne

the Persian War

the Peloponnesian War

archaic

classical

Hellenistic

low relief

classical Greek orders (Doric, Ionic, Corinthian)

the Parthenon

5

Classical Greece: Drama

A long with its creativity in the visual arts, the age of Pericles saw a flourishing of drama. Drama, as we know it in the West, is in fact a creation of the Greeks. Theatergoing was more than a festive activity for Athenians; it was regarded as an important part of a citizen's education and was supported by the state. *Tragedies* and *comedies*, as well as other theatrical events, were performed annually at the festival of Dionysus. The ruins of the theater of Dionysus on the Acropolis and the better-preserved theater at Epidaurus (Figs. 5-1 and 5-2) give us a clear idea of the circular orchestra, where the chorus sang and danced, and the *theatron*, the horseshoe-shaped area for the audience. A *skene*, or backdrop against which the actors performed, would have been set up in the back of the orchestra, facing the audience. Acoustics in this theater are still remarkable. A clear voice from the orchestra is deflected by the stone sides and can be heard without any form of artificial amplification.

Even though the Athenian theatergoer's experience was different from ours, it is recognizable to us because it is at the base of our own experience with the theater. We are all familiar with actors who act out a story and come into conflict with each other, but fifth-century B.C. Athens was, as far as we know, the first place in the world where this type of performance had been or was being staged. How did it come about? Was the drama someone's invention or a long-standing development? It should be stated immediately that no one knows the definitive answer to this question. We can best examine it in relation to the two principal forms themselves, tragedy and comedy.

The Development of Tragedy

Tragedy developed into a full-fledged dramatic form sometime before the classical age and earlier than comedy. Τραγωιδια (*tragoidia*) in Greek comes from words meaning "goat" and "song." For this reason it has been assumed that tragedy developed from "goat songs," or choric performances similar to, or identical with, the grotesque satyr plays mentioned in Daily Lives. According to this theory, the serious play that we now know as tragedy would have begun

5-1 *Epidaurus, theater from above. Polykleitos the Younger, c. 350* B.C. *(Eugene Brown)*

as a kind of ecstatic comedy, perhaps far from Athens, in the Peloponnesus. Since tragedy was performed at the festival of Dionysus, many have also assumed that it grew out of some sort of religious ritual. According to one of these theories, the chants of the priest and the response of the worshipers gave rise to the actors and chorus, respectively. Another theory holds that Greek tragedy had nothing to do with religious rituals but was essentially the creation of the first man of the theater, Thespis, who created drama out of poetic recitations of stories from Homer.

The tragedies written by Thespis probably featured only one actor, along with a chorus. The actor, who probably represented an epic hero from Homer, would have to present his own story, which would be concentrated on his *pathos*, or suffering. The chorus would begin the play with a hymn to the gods and end with a lamentation over the hero. The *aulos*, a type of oboe and the characteristic instrument of the Dionysian cult, was employed in the performance of elegies, or songs of mourning; and it is likely that it was also used for instrumental preludes and interludes in the drama. In between the short scenes or *episodes* during which the hero spoke, the chorus would sing lyrics as a comment on his sufferings.

The Role of Music and Dance in the Performance of Tragedy

From the beginning, tragedy was intimately associated with the arts of music and dance. The Greek word for *chorus*, which comes from the verb "to dance," indicates that the choruses were originally groups of dancers as well as singers (all men, as were the actors). It is probable that individual actors danced, too. Although there is little evidence on what the dances were like, we do know that they were mimetic; that is, they mimed or imitated the action of the play. The use of the hands was very important in expressing emotion, just as it is in the traditional dancing of India.

Music, instrumental as well as choral, also played an important role in creating emotional effects in tragedy. Just as the lyre was the instrument of lyric poetry, the aulos, a double-reeded wind instrument, was seen as most appropriate for tragedy. It had a shrill, piercing tone, perhaps associated with the ecstatic worship of Dionysus. The Greeks composed music in several *modes*, scales whose organization of notes differs from our modern major and minor system. Each mode was said to produce a special kind of feeling. In modern

● DAILY LIVES ●

●●●● *Going to the Theater*
in Ancient Athens

Theatergoing in fifth century B.C. Athens might be compared with attending a rock concert, a football game, a patriotic rally, a religious service, a play, and a movie today—all combined. Rather than going out for an evening's entertainment, however, the Athenian theatergoer would devote several days to this activity. The performance of drama was originally part of various religious ceremonies honoring Dionysus, the god of wine, fertility, and ecstasy. The most important of these ceremonies, the City Dionysia, spanned several days in March and April. This festival included contests among playwrights, who were financed by wealthy citizens of Athens. The playwright directed his plays, sometimes acted in them, and, if he won the contest, shared his prize with his sponsor. As these dramatic contests gained prominence, the Athenians built their first theater, the theater of Dionysus at the foot of the Acropolis. It was an enormous space, in proportion to the population, estimated to have held as many as seventeen thousand spectators (Fig. 5-2).

The City Dionysia began with a citywide parade in which religious figures, city officials, and actors took part. This was followed by tributes and sacrifices to the gods, as well as by patriotic manifestations, held in the theater. All citizens were expected to attend this event, which was supported by the state. It is believed that women, slaves, and prisoners were sometimes allowed to attend the performances, although evidence for this is less certain. No women participated in the performances, however; all female roles were played by male actors. Business activity in the city ceased completely for the duration of the festival. Every day—all day long—the audience sat on the stone benches.

Each playwright in the competition staged a trilogy: three tragedies, usually centered on a common mythological subject, over three days. At the end of each trilogy, the playwright offered relief from tragic intensity by presenting a *satyr play*—a grotesque skit in

5-2 *This ground plan is of the sacred precinct of Dionysus in Athens, fourth century* B.C. *Notice that the theater is much larger than the earlier theater at provincial Eretria. The large and permanent* skene *was constructed after the fifth century* B.C.

which actors mimicked the gods, wearing costumes to make them look like the half-man–half-goat satyrs. Comedies were added to the repertoire later. Although theatergoing declined in Athens after the Spartan victory in the Peloponnesian War, its legacy to the concept of drama, spectacle, and performance in the Western world has been immeasurable.

music, we distinguish between the forceful major mode and the wistful or melancholy minor mode. The Greek theory of modes was more complicated. The Dorian mode was considered manly and strong, appropriate for the training of young men, whereas the emotional Mixolydian mode was considered piercing and suitable for lamentations. Both, however, were appropriate for tragedy. The Greeks, as we will see in the section on philosophy, had great faith in the ability of music to influence and mold the characters of human beings. Unfortunately, very little Greek music remains—none from the classical period—so we can only conjecture what the total spectacle of an Athenian drama would have been like.

The Form of Tragedy and the Principal Greek Tragedians

In its most developed state, during the classical period, Greek tragedy had a consistent form, comparable to the structure of a temple. First of all, it was always in verse, never in prose. The *prologue* usually consisted of a dialogue that informed the audience of the situation or background to the play. The entrance of the chorus on stage was called the *parodos*. The *episodes*, equivalent to modern acts, were performed by actors, never more than three in number, who wore masks and costumes to represent the characters they played. In between the episodes, the chorus would sing an ode, called a *stasimon*, consisting of three parts: *strophe*, *antistrophe*, and *epode*. At the end of the play, the actors and the chorus left the stage in the *exodus*. The principal aim of tragedy remained the portrayal of the sufferings of the hero, along with his or her greatness in facing those sufferings.

Aeschylus (525–456 B.C.) The first tragedian whose plays are known to us is Aeschylus, who participated in the growth and the glory of Athens. He was proud of having fought at the battle of Marathon. Aeschylus had the genius to add a second actor to the tragic form; thus, in his plays two actors appear at once on the stage. There is still a principal hero, whose sufferings are the main subject of the tragedy, but now he can be seen interacting with other human beings. The chorus, though, is still of major importance in the dramas of Aeschylus, who was himself a musician and was said to have been most attentive in fitting his choral songs to music. Aeschylus' most famous work is the trilogy, or series of three tragedies, entitled the *Oresteia* (Orestes plays). The first play in the trilogy is *Agamemnon*, the name of the king of Mycenae and leader of the Greeks in the Trojan War. In the play Agamemnon returns from the war, a glorious hero, only to be murdered by his wife, Clytemnestra. In the second tragedy, *The Libation Bearers*, Agamemnon's

son, Orestes, avenges his father's death by killing his mother and her lover. In the final part of the trilogy Orestes is pursued by the Eumenides, horrible furies who torment him because of the slaying of his mother; but he is finally put on trial, judged, and acquitted by Athena, the patron goddess of Athens. The outcome of the trilogy shows the belief in law and the new system of justice developing in Athens.

Aeschylus wrote some ninety tragedies altogether. Besides the Oresteia those that survive are *The Persians, Seven Against Thebes, Prometheus Bound,* and *The Suppliants.* The plots of all of Aeschylus' tragedies are extremely simple, and the characters are not what we would call well rounded, but rather embodiments of a single passion. Everything is concentrated on the tragic event and the emotional and spiritual meaning of that event. This simplicity and concentration are, as we have seen in other art forms, part of what we mean by classical. Aeschylus' plays, in their spareness and grandeur, have been compared with early classical sculpture such as the *Kritios Boy* (Fig. 4-8).

Sophocles (496–406 B.C.) Sophocles, a younger contemporary of Aeschylus, further developed the tragic form by adding a third actor. During his long life he wrote some 125 plays, of which only eight have come down to us. Of these, the best known are the plays of the Oedipus cycle: *Antigone, Oedipus Rex,* and *Oedipus at Colonus.* Unlike the *Oresteia,* these plays were not written as a trilogy but at different points of Sophocles' career. It is *Oedipus Rex,* the most renowned of all Greek tragedies, that we will study in detail here. Sophocles' characters, while maintaining a sense of classical balance and restraint, seem more human and alive than those of Aeschylus. They may be compared with "high" classical sculpture. The chorus has less importance relative to the actors than in Aeschylus' drama, but we should bear in mind that music and dance still played a vital role. Sophocles was himself a dancer.

Euripides (480–406 B.C.) The next great tragedian, Euripides, began to break out of the limits of classicism by creating more realistic characters and more complex plots. The traditional critical judgment on Euripides and his older contemporary holds that "Sophocles shows man as he ought to be and Euripides shows man as he is." Euripides wrote about ninety plays, of which eighteen have survived. His plays were enormously popular and performed often during his lifetime, but the critics judged them less favorably. Some deemed Euripides too hard on his contemporaries, and others saw his attitude toward religion as subversive. His portrayal of characters is more realistic and less idealized than that of the other dramatists, and his dialogue is sometimes more colloquial or prosaic that poetic. His plots,

not as neatly worked out as those of Sophocles, may appear to be confusing, and he sometimes resolves dilemmas by means of a *deus ex machina*, or a god who appears to come from nowhere.

Euripides' interest in individual psychology and in extreme real-life situations makes him in many ways closer to modern sensibilities. Although, like all ancient Greek playwrights, he uses old myths as the basis for his plots, Euripides appears to many readers as a religious skeptic or even an atheist. Euripides also wrote an *Orestes*, which differs considerably from the trilogy by Aeschylus. Like all great psychological writers, he had a considerable interest in women, as shown in plays such as *Hippolytus*, which treats the myth of Phaedra driven mad by love, and *Medea*, in which the title character kills her own children to punish her husband, Jason, who has deserted her for another woman. The Reading Selections for this chapter include the tragedy that portrays the sorrow of the women who remain in Troy after the fall of their city. Sometimes translated as *The Trojan Women*, it is, in Philip Vellacott's translation, *The Women of Troy*. The realism, emotionalism, and individuality of Euripides' characters make them comparable to postclassical or Hellenistic sculptures.

Oedipus: Legend and Tragedy

It is Sophocles, among these three tragedians, who now seems most representative of the cultural spirit of Athens in its classical, Periclean age. His *Oedipus Tyrannus*, or, using the Latin word for king, *Oedipus Rex*, was probably first performed soon after a plague that swept over Athens in 429 B.C. Although the action is set in Greece's remote, legendary past in the city of Thebes, the Athenian audience would have identified immediately with the plague that has fallen like a curse on that city as the play opens. Through the writings of Aristotle, *Oedipus Rex* has come to stand for the most nearly perfect example of classical tragedy in the Western humanistic tradition.

One important notion to bear in mind while reading a Greek tragedy is that, unlike modern audiences, the Greeks who attended the festival of Dionysus did not attend a play for its plot suspense or to find out "what happens next." Today, when recommending a movie to friends, we do not tell the plot for fear of spoiling it for them. Greek tragedies were all based on myths or legends that the theatergoers already knew. Thus, when they went to see *Oedipus*, they did not wonder what the play would be about but rather what Sophocles had done with an old, familiar story. Since the tragedies at the festival of Dionysus were presented as a contest, the judges would also choose the best three tragedies on the basis of how well the already given material had been worked into dramatic form. It will therefore be useful to know something about the myth of Oedipus before approaching the tragedy.

The story takes place in a much earlier period of Greek history, when the city-states had been ruled by kings. The city of Thebes, it was told, was ruled by King Laius (Laïos) and his queen, Jocasta (Iokastê). Thebes was founded by Laius' ancestor Cadmus, who was cursed by the gods and told that all of his descendants would receive some form of this curse. Thus Laius was told by a prophet of the god Apollo that he and Jocasta would bear a son who would kill his father and marry his mother. Hoping to avert this fate, the king and queen asked one of their shepherds to take their firstborn son to Mount Cithaeron (Kithairon) near Thebes, to leave the baby to be exposed to die. The shepherd, out of pity for the child, gave him to a slave from the Greek city of Corinth, on the other side of the mountain, hoping that he would remain in that city and thus have no chance to fulfill the dreadful prophecy. The child is, of course, Oedipus, whose name means "swollen foot," a deformity he acquired from the pins put in his feet when he was left to die. He grows up believing that he is the natural son of King Polybus (Polybos) and Queen Meropê of Corinth, but one day he, too, receives a prophecy declaring that he will kill his father and marry his mother. He then flees Corinth and vows never to see his parents again.

During his travels Oedipus arrives at the outskirts of Thebes. There he gets into a quarrel with an old man whom he kills in a fit of anger—the man is Laius. He then finds that Thebes is under the control of a monster called the Sphinx, who has stationed herself outside the city and demands a yearly tribute from its citizens. Her power over Thebes can be overcome only if someone answers her riddle: "What walks on four legs in the morning, on two in the afternoon, and on three in the evening, and is strongest when it uses the fewest number of legs?" Oedipus solves the riddle: the answer is *man*, who crawls on all fours as a baby, walks on two legs as an adult, and with a stick as an old man. Oedipus is hailed in Thebes as the savior of the city and given the hand of Laius' widow, Queen Jocasta, in marriage. Sophocles' play opens several years after this event, at a time when the city is again in peril and the people again look to Oedipus to help them. This time the trouble is a plague, a disease that is spreading among the people of Thebes, killing many of them.

The legend of Oedipus, no doubt originally an oral tale, contains many of the elements found in familiar folk or fairy tales—the curse, the prophecies, the riddle, and the hero-savior. There are numerous imaginable ways of treating this material. Sophocles' task was to mold it into the form of tragedy.

Unlike the oral folk tale that opens with "once upon a time," Sophocles does not begin the story at the beginning. Since Homer, it has been the rule in Western drama and fiction to begin "in the middle of things." *Oedipus* begins in the midst of a tense situation that demands a solution: a plague is raging; what will the king do? In fact, Sophocles begins his story after the important events have already occurred. The action of the play takes place in less than a day; yet the entire life of Oedipus, from his birth to his preparation for death, is brought into the development. Also, although we hear about Corinth and other parts of Thebes, the stage setting is in only one place—just outside the palace of the king and queen. There is only one plot or action in the play—no subplots or other distractions. There is certainly no comic relief, as found in Shakespeare. This simplicity of structure and unity of tone contribute to the play's classical quality. Just as in the Parthenon or the statue of *The Spearbearer*, everything nonessential is stripped away. What is left is a clear and balanced presentation of the essence of an aspect of life, rather than a realistic "slice of life." Part of the force and the impact of Greek tragedy lies in this classical simplicity.

Humanism and Sophoclean Tragedy

During the great classical age of Athens, intellectuals, intrigued with new developments in science and philosophy, began to challenge the old, accepted religious beliefs. In art, in politics, as in thought, human beings were upstaging the gods. The philosopher Protagoras summed up the new attitude with the phrase "man is the measure of all things." Confidence in human abilities and powers has perhaps never been greater than at this time. We see this in *Oedipus* in the hero's self-confidence at the beginning of the play. The people of Thebes who look to him as their savior treat him almost like a god. We see an extreme confidence in human reason and a denial of the power of the gods over people in Iokastê's scoffing at prophecies. But here, as in other aspects, Sophocles portrays a balance between extremes. The outcome of the tragedy shows that the gods, or fate, have the last word, but it certainly does not show people to be little puppets whose destiny is simply to obey the divine will. Oedipus is "blind" in that he does not recognize the limits set by divine power, but great in that he struggles to find the truth through his own individual human reason. Sophocles wanted to warn his fellow Athenians not to neglect religion, but he also wanted to demonstrate to them the greatness of human character and intelligence. Sophocles' faith in humanity, or his "humanism," is perhaps best exemplified in the famous choral ode in another of his tragedies, *Antigone* (translated by Elizabeth Wyckoff):

Many the wonders but nothing walks stranger than
 man.
This thing crosses the sea in the winter's storm,
 making his path through the roaring waves.
And she, the greatest of gods, the earth—
ageless she is, and unwearied—he wears her away
as the ploughs go up and down from year to year
and his mules turn up the soil.

Gay nations of birds he snares and leads,
wild beast tribes and the salty brood of the sea,
with the twisted mesh of his nets, this clever man.
He controls with craft the beasts of the open air,
walkers on hills. The horse with his shaggy mane
he holds and harnesses, yoked about the neck,
and the strong bull of the mountain.

Language, and thought like the wind
and the feelings that make the town;
he has taught himself, and shelter against the cold,
refuge from rain. He can always help himself.
He faces no future helpless. There's only death
that he cannot find an escape from. He has contrived
refuge from illnesses once beyond all cure.

Clever beyond all dreams
the inventive craft that he has
which may drive him one time or another to well or
 ill.

Classical Greek tragedy shows that a belief in the dignity and greatness of human beings is not incompatible with a full awareness of their limitations.

The Women of Troy

Written in 415 B.C., Euripides' tragedy in many ways stands in stark contrast to Sophocles' *Oedipus Rex*, demonstrating that Greek tragedies do not all follow a single formula. Until recently, it was often criticized as a play in which "nothing happens," plotless and static. Although Euripides, like all Greek tragedians, uses ancient myth—in this case the Trojan War—as his subject, he was probably inspired by contemporary events. A year before the play was written, the Athenians had committed an uncustomary atrocity against the Greek island of Melos. When the Melians refused to join them in their war against Sparta, the Athenians slaughtered the men and enslaved the women and children. Athens then began to plan an attack against Syracuse, on the island of Sicily. Euripides clearly had antiwar sentiments, and the play reflects his view that cruelty in war dehumanizes not only the victims, but also the victors. Adaptations of *The Women of Troy* by European, American, and Japanese writers over the last forty years, as well as more frequent performances of Euripides' play, testify to the fact that this tragedy has also spoken to the twentieth century's experience of the horrors and devastations of war.

Although it is true that it lacks the suspense and the reversals of fortune found in Sophocles' plays, *The Women of Troy* is not simply a long lament, but a different type of drama. The characters come from the *Iliad* (see Chapter 3), with Hecuba, widow of King Priam and mother of the slain hero Hector, as the protagonist. Her wretched, grief-stricken figure is pointed out by the god Poseidon in the prologue, in which he and the goddess Athena speak of the destruction that has occurred and that will come. The major action of the tragedy consists of the revelations of the ills that befall Hecuba, her reaction to them, and the lyrical grieving and consolations of the chorus. Euripides thus views the legendary-historical events not through the "famous deeds of men" and heroic battle scenes of the epic, but through their emotional effect on the women who remain after the destruction is complete. Music, gesture, and movement, as well as lyrical language, are all important to the performance of this drama.

Greek Comedy

Tragedy, according to the philosopher Aristotle, provides a release for the emotions of pity and terror. Spectators pity the unfortunate protagonist and fear that they themselves might undergo a disaster, thus purging themselves of those emotions. Whatever else went on at the festival of Dionysus, it must have offered an opportunity for the release of pent-up feelings. The people who attended it let off steam in all sorts of ways—first of all by feeling liberated from the everyday world of work and duty. There was drinking, feasting, carousing. At the plays themselves the idea was to participate emotionally as a spectator rather than merely to view passively. The Greeks, like most peoples of the world, recognized society's need for a true holiday, or festival—a time of collective celebration and liberation. The way that a culture celebrates, or organizes its festivals, says a great deal about its values. One might well ask if our contemporary society recognizes this need adequately. Do people who spend their days off at home watching television experience a release and liberation from the everyday world? Is there a basic difference between the theatrical and the media experience? Or do we provide other, communal ceremonies of celebration?

Comedy is one response to the human need to "let go" or to transcend the everyday world. Human beings, if they remain truly human, never lose the childlike need to play, and they certainly need to be able to laugh at their own and at others' shortcomings and to remember that life is not all earnestness and work. If we transcend the everyday world with tragedy through an almost religious sense of awe, we transcend it with comedy through our laughter. We laugh at comic characters either because they are quick, witty, and always able to outsmart the "bad guys" or, on the contrary, because they are always getting into trouble. Comedy is often worked out on the level of *action*, whereas tragedy is often worked out on the level of *thought*. Whereas tragic writers tend to view people in the context of a universal human condition, comic writers often take a hard look at their immediate society, satirizing its customs and institutions. For this reason, it will be useful to look at the development of comedy in Greece and at the society in which the comic playwright Aristophanes (c. 445–385 B.C.) lived.

The word *comedy* comes from *komos*, which means "revel." It seems probable that fertility rituals and celebrations are at the origins of comedy. From the earliest days of Greece, groups of men, revelers, would go around from village to village, wearing huge artificial phalluses, telling jokes (often obscene ones), singing, and dancing. The community would participate in the revels. These were not only for fun but also intended to increase fertility—in the land, in people, in animals. Worship of the phallus as a symbol of fertility is common among all "primitive" peoples, and Freud and Jung have shown that phallic symbols appear in the dreams of "civilized" people as well. Often the *komos* would end with some sort of sexual union—a ritual orgy, a pairing off with mates, or a marriage. This was meant not to encourage free sex on all occasions but to ensure fertility.

We do not know exactly how comedy as an art form grew from these revels, but it was recognized as such at the festival of Dionysus in Athens around 486 B.C., thus later than tragedy. Aristophanes, the only Greek classical comic author whose works survive, composed "old comedies." In his comedies, many of the old ritual features of the *komos*—the big phalluses, padding, animal costumes, grotesque masks, colloquial speech, and obscene jokes—are retained. There are often two choruses in opposition to each other. Certainly, music and dance were of great importance. Of course, the purpose was no longer to promote fertility but to entertain people.

The situations in old comedy are often fantastic ones (in some, such as *The Birds* and *The Frogs*, the characters are dressed like animals), but the people or the institutions made fun of were real enough. In *Lysistrata*, Aristophanes attacks a real problem with a comical situation. The women of Sparta and Athens organize something like a sex strike, refusing to go to bed with their husbands until the men stop the war between the two cities—and the plan works. Old Greek comedy, however, seems in many ways remote from the modern reader or spectator and is very rarely staged today. A closer forerunner of modern comedy is

Greek "new comedy" and its descendants in Rome in early modern Europe. About a hundred years after Aristophanes we find new comedy, in the hands of its most famous practitioner, Menander, without phalluses, grotesque costumes, or indecent jokes. This comedy was realistic rather than fantastic—it reflected everyday life and created stock, yet individualized, characters. Roman comedy, as practiced by Plautus and Terence, is more similar to the comedies of manners with which we are familiar in modern theater, films, and television. The situations in new comedy often arise from misunderstandings, there is often a great deal of verbal play and wit, and the endings are happy. New comedy has lost touch with its origins in ritual fertility except that—even today—it often ends with a marriage or a happy love.

SOPHOCLES

Oedipus Rex

Translation by Dudley Fitts and Robert Fitzgerald

As noted on page 112, most of the story of Oedipus has taken place before the play begins. What, then, *is* the plot or action of this tragedy? Most of it lies in the discovery of previous events. In this sense it resembles a detective story that opens after the crime has been committed. Oedipus begins by trying to find the answer to the question, "Who killed King Laius?" He ends by asking, and then answering, a much more profound question, "Who am I?" His tragedy, or his downfall, occurs when he finds the answer to his questions. As you read the play, notice how Sophocles builds up to the climactic point step by step. Try to determine, too, what emotional effect the tragic discovery of Oedipus has on you, the reader or spectator, and whether or not this changes by the end of the play. Notice how Sophocles has interpreted and portrayed the character of Oedipus. Finally, try to define for yourself what constitutes the personal tragedy of Oedipus and what makes the play a tragedy.

CHARACTERS

OEDIPUS, *King of Thebes, supposed son of Polybos and Meropê, King and Queen of Corinth*

IOKASTÊ, *wife of Oedipus and widow of the late King Laïos*

KREON, *brother of Iokastê, a prince of Thebes*

TEIRESIAS, *a blind seer who serves Apollo*

PRIEST

MESSENGER, *from Corinth*

SHEPHERD, *former servant of Laïos*

SECOND MESSENGER, *from the palace*

CHORUS OF THEBAN ELDERS

CHORAGOS, *leader of the Chorus*

ANTIGONE *and* ISMENE, *young daughters of Oedipus and Iokastê. They appear in the Éxodos but do not speak.*

SUPPLIANTS, GUARDS, SERVANTS

THE SCENE. *Before the palace of* OEDIPUS, *King of Thebes. A central door and two lateral doors open onto a platform which runs the length of the façade. On the platform, right and left, are altars; and three steps lead down into the orchês-tra or chorus-ground. At the beginning of the action these steps are crowded by suppliants who have brought branches and chaplets of olive leaves and who sit in various attitudes of despair.* OEDIPUS *enters.*

PROLOGUE

OEDIPUS My children, generations of the living
In the line of Kadmos,[1] nursed at his ancient hearth:
Why have you strewn yourselves before these altars
In supplication, with your boughs and garlands?
The breath of incense rises from the city
With a sound of prayer and lamentation.

 Children,
I would not have you speak through messengers,
And therefore I have come myself to hear you—
I, Oedipus, who bear the famous name.
(*To a* PRIEST) You, there, since you are eldest in the
 company,
Speak for them all, tell me what preys upon you,
Whether you come in dread, or crave some blessing:
Tell me, and never doubt that I will help you
In every way I can; I should be heartless
Were I not moved to find you suppliant here.

PRIEST Great Oedipus, O powerful king of Thebes!
You see how all the ages of our people
Cling to your altar steps: here are boys
Who can barely stand alone, and here are priests
By weight of age, as I am a priest of God,
And young men chosen from those yet unmarried;
As for the others, all that multitude,
They wait with olive chaplets in the squares,
At the two shrines of Pallas, and where Apollo
Speaks in the glowing embers.

 Your own eyes
Must tell you: Thebes is tossed on a murdering sea
And can not lift her head from the death surge.
A rust consumes the buds and fruits of the earth;
The herds are sick; children die unborn,
And labor is vain. The god of plague and pyre
Raids like detestable lightning through the city,

[1] Founder of Thebes. [Translators' notes.]

And all the house of Kadmos is laid waste,
All emptied, and all darkened: Death alone
Battens upon the misery of Thebes.
You are not one of the immortal gods, we know;
Yet we have come to you to make our prayer
As to the man surest in mortal ways
And wisest in the ways of God. You saved us
From the Sphinx, that flinty singer, and the tribute
We paid to her so long; yet you were never
Better informed than we, nor could we teach you:
A god's touch, it seems, enabled you to help us.

Therefore, O mighty power, we turn to you:
Find us our safety, find us a remedy,
Whether by counsel of the gods or of men.
A king of wisdom tested in the past
Can act in a time of troubles, and act well.
Noblest of men, restore
Life to your city! Think how all men call you
Liberator for your boldness long ago;
Ah, when your years of kingship are remembered,
Let them not say *We rose, but later fell*—
Keep the State from going down in the storm!
Once, years ago, with happy augury,
You brought us fortune; be the same again!
No man questions your power to rule the land:
But rule over men, not over a dead city!
Ships are only hulls, high walls are nothing,
When no life moves in the empty passageways.

OEDIPUS Poor children! You may be sure I know
All that you longed for in your coming here.
I know that you are deathly sick; and yet,
Sick as you are, not one is as sick as I.
Each of you suffers in himself alone
His anguish, not another's; but my spirit
Groans for the city, for myself, for you.

I was not sleeping, you are not waking me.
No, I have been in tears for a long while
And in my restless thought walked many ways.
In all my search I found one remedy,
And I have adopted it: I have sent Kreon,
Son of Menoikeus, brother of the queen,
To Delphi, Apollo's place of revelation,
To learn there, if he can,
What act or pledge of mine may save the city.
I have counted the days, and now, this very day,
I am troubled, for he has overstayed his time.
What is he doing? He has been gone too long.
Yet whenever he comes back, I should do ill
Not to take any action the god orders.

PRIEST It is a timely promise. At this instant
They tell me Kreon is here.

OEDIPUS O Lord Apollo!
May his news be fair as his face is radiant!

PRIEST Good news, I gather! he is crowned with bay,
The chaplet is thick with berries.

OEDIPUS We shall soon know;
He is near enough to hear us now.

(*Enter* KREON)

 O prince:
Brother: son of Menoikeus:
What answer do you bring us from the god?

KREON A strong one. I can tell you, great afflictions
Will turn out well, if they are taken well.

OEDIPUS What was the oracle? These vague words
Leave me still hanging between hope and fear.

KREON Is it your pleasure to hear me with all these
Gathered around us? I am prepared to speak,
But should we not go in?

OEDIPUS Speak to them all,
It is for them I suffer, more than for myself.

KREON Then I will tell you what I heard at Delphi.
In plain words
The god commands us to expel from the land of
Thebes
An old defilement we are sheltering:
It is a deathly thing, beyond cure;
We must not let it feed upon us longer.

OEDIPUS What defilement? How shall we rid
ourselves of it?

KREON By exile or death, blood for blood. It was
Murder that brought the plague-wind on the city.

OEDIPUS Murder of whom? Surely the god has
named him?

KREON My lord: Laïos once ruled this land,
Before you came to govern us.

OEDIPUS I know;
I learned of him from others; I never saw him.

KREON He was murdered; and Apollo commands us
now
To take revenge upon whoever killed him.

OEDIPUS Upon whom? Where are they? Where shall
we find a clue
To solve that crime, after so many years?

KREON Here in this land, he said. Search reveals
Things that escape an inattentive man.

OEDIPUS Tell me: Was Laïos murdered in his house,
Or in the fields, or in some foreign country?

KREON He said he planned to make a pilgrimage.
He did not come home again.

OEDIPUS And was there no one,
No witness, no companion, to tell what happened?

KREON They were all killed but one, and he got away
So frightened that he could remember one thing only.

OEDIPUS What was the one thing? One may be the key
To everything, if we resolve to use it.

KREON He said that a band of highwaymen attacked
them,
Outnumbered them, and overwhelmed the king.

OEDIPUS Strange, that a highwayman should be so
daring—
Unless some faction here bribed him to do it.

KREON We thought of that. But after Laïos' death
 New troubles arose and we had no avenger.
OEDIPUS What troubles could prevent your hunting
 down the killers?
KREON The riddling Sphinx's song
 Made us deaf to all mysteries but her own.
OEDIPUS Then once more I must bring what is dark to
 light.
 It is most fitting that Apollo shows,
 As you do, this compunction for the dead.
 You shall see how I stand by you, as I should,
 Avenging this country and the god as well,
 And not as though it were for some distant friend,
 But for my own sake, to be rid of evil.
 Whoever killed King Laïos might—who knows?—
 Lay violent hands even on me—and soon.
 I act for the murdered king in my own interest.

 Come, then, my children: leave the altar steps,
 Lift up your olive boughs!
 One of you go
 And summon the people of Kadmos to gather here.
 I will do all that I can; you may tell them that.

(*Exit a* PAGE)

 So, with the help of God,
 We shall be saved—or else indeed we are lost.
PRIEST Let us rise, children. It was for this we came,
 And now the king has promised it.
 Phoibos[2] has sent us an oracle; may he descend
 Himself to save us and drive out the plague.

(*Exeunt* OEDIPUS *and* KREON *into the palace by the central door. The* PRIEST *and the* SUPPLIANTS *disperse R and L. After a short pause the* CHORUS *enters the orchestra*)

PARODOS[3]

Strophe 1

CHORUS What is God singing in his profound
 Delphi of gold and shadow?

[2] Apollo.

[3] The *parodos* is the song or ode chanted by the chorus on its entry. It is accompanied by dancing and music played on an oboe. The chorus, in this play, represents elders of the city of Thebes. They remain on stage (on a level lower than the principal actors) for the remainder of the play. The choral odes and dances serve to separate one scene from another (there was no curtain in Greek theater) as well as to comment on the action, reinforce the emotion, and interpret the situation. The chorus also performs dance movements during certain portions of the scenes themselves. *Strophe* and *antistrophe* are terms denoting the movement and countermovement of the chorus from one side of its playing area to the other. When the chorus participates in dialogue with the other characters, the lines are spoken by the Choragos, its leader.

What oracle for Thebes, the sunwhipped city?
Fear unjoints me, the roots of my heart tremble.
Now I remember, O Healer, your power, and
 wonder:
Will you send doom like a sudden cloud, or weave it
Like nightfall of the past?
Speak to me, tell me, O
Child of golden Hope, immortal Voice.

Antistrophe 1

Let me pray to Athenê, the immortal daughter of
 Zeus,
And to Artemis her sister
Who keeps her famous throne in the market ring,
And to Apollo, archer from distant heaven—
O gods, descend! Like three streams leap against
The fires of our grief, the fires of darkness;
Be swift to bring us rest!
As in the old time from the brilliant house
Of air you stepped to save us, come again!

Strophe 2

Now our afflictions have no end,
Now all our stricken host lies down
And no man fights off death with his mind;
The noble plowland bears no grain,
And groaning mothers can not bear—
See, how our lives like birds take wing,
Like sparks that fly when a fire soars,
To the shore of the god of evening.

Antistrophe 2

The plague burns on, it is pitiless,
Though pallid children laden with death
Lie unwept in the stony ways,
And old gray women by every path
Flock to the strand about the altars
There to strike their breasts and cry
Worship of Phoibos in wailing prayers:
Be kind, God's golden child!

Strophe 3

There are no swords in this attack by fire,
No shields, but we are ringed with cries.
Send the besieger plunging from our homes
Into the vast sea-room of the Atlantic
Or into the waves that foam eastward of Thrace—
For the day ravages what the night spares—
Destroy our enemy, lord of the thunder!
Let him be riven by lightning from heaven!

Antistrophe 3

Phoibos Apollo, stretch the sun's bowstring,
That golden cord, until it sing for us,

Flashing arrows in heaven!
 Artemis, Huntress,
Race with flaring lights upon our mountains!
O scarlet god, O golden-banded brow,
O Theban Bacchos in a storm of Maenads,

(*Enter* OEDIPUS, C)

Whirl upon Death, that all the Undying hate!
Come with blinding torches, come in joy!

SCENE 1

OEDIPUS Is this your prayer? It may be answered.
 Come,
Listen to me, act as the crisis demands,
And you shall have relief from all these evils.

Until now I was a stranger to this tale,
As I had been a stranger to the crime.
Could I track down the murderer without a clue?
But now, friends,
As one who became a citizen after the murder,
I make this proclamation to all Thebans:
If any man knows by whose hand Laïos, son of
 Labdakos,
Met his death, I direct that man to tell me
 everything.
No matter what he fears for having so long
 withheld it.
Let it stand as promised that no further trouble
Will come to him, but he may leave the land in
 safety.
Moreover: If anyone knows the murderer to be
 foreign,
Let him not keep silent: he shall have his reward
 from me.
However, if he does conceal it; if any man
Fearing for his friend or for himself disobeys this
 edict,
Hear what I propose to do:

I solemnly forbid the people of this country,
Where power and throne are mine, ever to receive
 that man
Or speak to him, no matter who he is, or let him
Join in sacrifice, lustration, or in prayer.
I decree that he be driven from every house,
Being, as he is, corruption itself to us: the Delphic
Voice of Apollo has pronounced this revelation.
Thus I associate myself with the oracle
And take the side of the murdered king.

As for the criminal, I pray to God—
Whether it be a lurking thief, or one of a number—
I pray that that man's life be consumed in evil and
 wretchedness.

And as for me, this curse applies no less
If it should turn out that the culprit is my guest here,
Sharing my hearth.
 You have heard the penalty.
I lay it on you now to attend to this
For my sake, for Apollo's, for the sick
Sterile city that heaven has abandoned.
Suppose the oracle had given you no command:
Should this defilement go uncleansed for ever?
You should have found the murderer: your king,
A noble king, had been destroyed!
 Now I,
Having the power that he held before me,
Having his bed, begetting children there
Upon his wife, as he would have, had he lived—
Their son would have been my children's brother,
If Laïos had had luck in fatherhood!
(And now his bad fortune has struck him down)—
I say I take the son's part, just as though
I were his son, to press the fight for him
And see it won! I'll find the hand that brought
Death to Labdakos' and Polydoros' child,
Heir of Kadmos' and Agenor's line.[4]
And as for those who fail me,
May the gods deny them the fruit of the earth,
Fruit of the womb, and may they rot utterly!
Let them be wretched as we are wretched, and worse!

For you, for loyal Thebans, and for all
Who find my actions right, I pray the favor
Of justice, and of all the immortal gods.
CHORAGOS Since I am under oath, my lord, I swear
 I did not do the murder, I can not name
 The murderer. Phoibos ordained the search;
 Why did he not say who the culprit was?
OEDIPUS An honest question. But no man in the
 world
 Can make the gods do more than the gods will.
CHORAGOS There is an alternative, I think—
OEDIPUS Tell me.
 Any or all, you must not fail to tell me.
CHORAGOS A lord clairvoyant to the lord Apollo,
 As we all know, is the skilled Teiresias.
 One might learn much about this from him,
 Oedipus.
OEDIPUS I am not wasting time:
 Kreon spoke of this, and I have sent for him—
 Twice, in fact; it is strange that he is not here.
CHORAGOS The other matter—that old report—
 seems useless.
OEDIPUS What was that? I am interested in all reports.

[4] Father, grandfather, great-grandfather, and great-great-grandfather
of Laïos.

CHORAGOS The king was said to have been killed
 by highwaymen.
OEDIPUS I know. But we have no witnesses to that.
CHORAGOS If the killer can feel a particle of dread,
 Your curse will bring him out of hiding!
OEDIPUS No.
 The man who dared that act will fear no curse.

(*Enter the blind seer* TEIRESIAS, *led by a* PAGE)

CHORAGOS But there is one man who may detect
 the criminal.
 This is Teiresias, this is the holy prophet
 In whom, alone of all men, truth was born.
OEDIPUS Teiresias: seer: student of mysteries,
 Of all that's taught and all that no man tells,
 Secrets of Heaven and secrets of the earth:
 Blind though you are, you know the city lies
 Sick with plague; and from this plague, my lord,
 We find that you alone can guard or save us.
 Possibly you did not hear the messengers?
 Apollo, when we sent to him,
 Sent us back word that this great pestilence
 Would lift, but only if we established clearly
 The identity of those who murdered Laïos.
 They must be killed or exiled.
 Can you use
 Birdflight[5] or any art of divination
 To purify yourself, and Thebes, and me
 From this contagion? We are in your hands.
 There is no fairer duty
 Than that of helping others in distress.
TEIRESIAS How dreadful knowledge of the truth
 can be
 When there's no help in truth! I knew this well,
 But did not act on it: else I should not have come.
OEDIPUS What is troubling you? Why are your eyes
 so cold?
TEIRESIAS Let me go home. Bear your own fate,
 and I'll
 Bear mine. It is better so: trust what I say.
OEDIPUS What you say is ungracious and unhelpful
 To your native country. Do not refuse to speak.
TEIRESIAS When it comes to speech, your own is
 neither temperate
 Nor opportune. I wish to be more prudent.
OEDIPUS In God's name, we all beg you—
TEIRESIAS You are all ignorant.
 No; I will never tell you what I know.
 Now it is my misery; then, it would be yours.
OEDIPUS What! You do know something, and will
 not tell us?
 You would betray us all and wreck the State?

TEIRESIAS I do not intend to torture myself, or you.
 Why persist in asking? You will not persuade me.
OEDIPUS What a wicked old man you are! You'd
 try a stone's
 Patience! Out with it! Have you no feeling at all?
TEIRESIAS You call me unfeeling. If you could only
 see
 The nature of your own feelings . . .
OEDIPUS Why,
 Who would not feel as I do? Who could endure
 Your arrogance toward the city?
TEIRESIAS What does it matter?
 Whether I speak or not, it is bound to come.
OEDIPUS Then, if "it" is bound to come, you are
 bound to tell me.
TEIRESIAS No, I will not go on. Rage as you please.
OEDIPUS Rage? Why not!
 And I'll tell you what I think:
 You planned it, you had it done, you all but
 Killed him with your own hands: if you had eyes,
 I'd say the crime was yours, and yours alone.
TEIRESIAS So? I charge you, then,
 Abide by the proclamation you have made:
 From this day forth
 Never speak again to these men or to me;
 You yourself are the pollution of this country.
OEDIPUS You dare say that! Can you possibly think
 you have
 Some way of going free, after such insolence?
TEIRESIAS I have gone free. It is the truth sustains me.
OEDIPUS Who taught you shamelessness? It was not
 your craft.
TEIRESIAS You did. You made me speak. I did not
 want to.
OEDIPUS Speak what? Let me hear it again more
 clearly.
TEIRESIAS Was it not clear before? Are you
 tempting me?
OEDIPUS I did not understand it. Say it again.
TEIRESIAS I say that you are the murderer whom
 you seek.
OEDIPUS Now twice you have spat out infamy.
 You'll pay for it!
TEIRESIAS Would you care for more? Do you wish
 to be really angry?
OEDIPUS Say what you will. Whatever you say is
 worthless.
TEIRESIAS I say you live in hideous shame with those
 Most dear to you. You can not see the evil.
OEDIPUS Can you go on babbling like this for ever?
TEIRESIAS I can, if there is power in truth.
OEDIPUS There is:
 But not for you, not for you,
 You sightless, witless, senseless, mad old man!
TEIRESIAS You are the madman. There is no one here
 Who will not curse you soon, as you curse me.

[5] Prophets predicted the future or divined the unknown by observing
the flight of birds.

OEDIPUS You child of total night! I would not
 touch you;
 Neither would any man who sees the sun.
TEIRESIAS True: it is not from you my fate will come.
 That lies within Apollo's competence,
 As it is his concern.
OEDIPUS Tell me, who made
 These fine discoveries? Kreon? or someone else?
TEIRESIAS Kreon is no threat. You weave your own
 doom.
OEDIPUS Wealth, power, craft of statesmanship!
 Kingly position, everywhere admired!
 What savage envy is stored up against these,
 If Kreon, whom I trusted, Kreon my friend,
 For this great office which the city once
 Put in my hands unsought—if for this power
 Kreon desires in secret to destroy me!
 He has bought this decrepit fortune-teller, this
 Collector of dirty pennies, this prophet fraud—
 Why, he is no more clairvoyant than I am!
 Tell us:
 Has your mystic mummery ever approached the
 truth?
 When that hellcat the Sphinx was performing here,
 What help were you to these people?
 Her magic was not for the first man who came
 along:
 It demanded a real exorcist. Your birds—
 What good were they? or the gods, for the matter
 of that?
 But I came by,
 Oedipus, the simple man, who knows nothing—
 I thought it out for myself, no birds helped me!
 And this is the man you think you can destroy,
 That you may be close to Kreon when he's king!
 Well, you and your friend Kreon, it seems to me,
 Will suffer most. If you were not an old man,
 You would have paid already for your plot.
CHORAGOS We can not see that his words or yours
 Have been spoken except in anger, Oedipus,
 And of anger we have no need. How to accomplish
 The god's will best: that is what most concerns us.
TEIRESIAS You are a king. But where argument's
 concerned
 I am your man, as much a king as you.
 I am not your servant, but Apollo's.
 I have no need of Kreon or Kreon's name.

 Listen to me. You mock my blindness, do you?
 But I say that you, with both your eyes, are blind:
 You can not see the wretchedness of your life,
 Nor in whose house you live, no, nor with whom.
 Who are your father and mother? Can you tell me?
 You do not even know the blind wrongs
 That you have done them, on earth and in the
 world below.

But the double lash of your parents' curse will
 whip you
Out of this land some day, with only night
Upon your precious eyes.
Your cries then—where will they not be heard?
What fastness of Kithairon[6] will not echo them?
And that bridal-descant of yours—you'll know it
 then,
The song they sang when you came here to Thebes
And found your misguided berthing.
All this, and more, that you can not guess at now,
Will bring you to yourself among your children.

Be angry, then. Curse Kreon. Curse my words.
I tell you, no man that walks upon the earth
Shall be rooted out more horribly than you.
OEDIPUS Am I to bear this from him?—Damnation
 Take you! Out of this place! Out of my sight!
TEIRESIAS I would not have come at all if you had
 not asked me.
OEDIPUS Could I have told that you'd talk
 nonsense, that
 You'd come here to make a fool of yourself, and of
 me?
TEIRESIAS A fool? Your parents thought me
 sane enough.
OEDIPUS My parents again!—Wait: who were
 my parents?
TEIRESIAS This day will give you a father, and
 break your heart.
OEDIPUS Your infantile riddles! Your damned
 abracadabra!
TEIRESIAS You were a great man once at solving
 riddles.
OEDIPUS Mock me with that if you like; you will
 find it true.
TEIRESIAS It was true enough. It brought about
 your ruin.
OEDIPUS But if it saved this town?
TEIRESIAS (*to the* PAGE) Boy, give me your hand.
OEDIPUS Yes, boy; lead him away.
 —While you are here
 We can do nothing. Go; leave us in peace.
TEIRESIAS I will go when I have said what I have to
 say.
 How can you hurt me? And I tell you again:
 The man you have been looking for all this time,
 The damned man, the murderer of Laïos,
 That man is in Thebes. To your mind he is foreign-
 born,
 But it will soon be shown that he is a Theban,

[6] The mountain where Oedipus was taken to be exposed as an infant.

A revelation that will fail to please.
 A blind man,
Who has his eyes now; a penniless man, who is
 rich now;
And he will go tapping the strange earth with his
 staff.
To the children with whom he lives now he will be
Brother and father—the very same; to her
Who bore him, son and husband—the very same
Who came to his father's bed, wet with his father's
 blood.
Enough. Go think that over.
If later you find error in what I have said,
You may say that I have no skill in prophecy.

(*Exit* TEIRESIAS, *led by his* PAGE. OEDIPUS *goes into
the palace*)

ODE 1

Strophe 1

CHORUS The Delphic stone of prophecies
 Remembers ancient regicide
 And a still bloody hand.
 That killer's hour of flight has come.
 He must be stronger than riderless
 Coursers of untiring wind,
 For the son[7] of Zeus armed with his father's thunder
 Leaps in lightning after him;
 And the Furies hold his track, the sad Furies.

Antistrophe 1

 Holy Parnassos'[8] peak of snow
 Flashes and blinds that secret man,
 That all shall hunt him down:
 Though he may roam the forest shade
 Like a bull gone wild from pasture
 To rage through glooms of stone.
 Doom comes down on him; flight will not avail him;
 For the world's heart calls him desolate,
 And the immortal voices follow, for ever follow.

Strophe 2

 But now a wilder thing is heard
 From the old man skilled at hearing Fate in the
 wing-beat of a bird.
 Bewildered as a blown bird, my soul hovers and
 can not find

Foothold in this debate, or any reason or rest of
 mind.
But no man ever brought—none can bring
Proof of strife between Thebes' royal house,
Labdakos' line, and the son of Polybos;
And never until now has any man brought word
Of Laïos' dark death staining Oedipus the King.

Antistrophe 2

 Divine Zeus and Apollo hold
 Perfect intelligence alone of all tales ever told;
 And well though this diviner works, he works in
 his own night;
 No man can judge that rough unknown or trust in
 second sight,
 For wisdom changes hands among the wise.
 Shall I believe my great lord criminal
 At a raging word that a blind old man let fall?
 I saw him, when the carrion woman[9] faced him of
 old,
 Prove his heroic mind. These evil words are lies.

SCENE II

KREON Men of Thebes:
 I am told that heavy accusations
 Have been brought against me by King Oedipus.

 I am not the kind of man to bear this tamely.

 If in these present difficulties
 He holds me accountable for any harm to him
 Through anything I have said or done—why, then,
 I do not value life in this dishonor.
 It is not as though this rumor touched upon
 Some private indiscretion. The matter is grave.
 The fact is that I am being called disloyal
 To the State, to my fellow citizens, to my friends.
CHORAGOS He may have spoken in anger, not from
 his mind.
KREON But did you not hear him say I was the one
 Who seduced the old prophet into lying?
CHORAGOS The thing was said: I do not know how
 seriously.
KREON But you were watching him! Were his eyes
 steady?
 Did he look like a man in his right mind?
CHORAGOS I do not know.
 I can not judge the behavior of great men.
 But here is the king himself.

[7] Apollo.
[8] Mountain sacred to Apollo.

[9] The Sphinx.

(*Enter* OEDIPUS)

OEDIPUS So you dared come back.
Why? How brazen of you to come to my house,
You murderer!
 Do you think I do not know
That you plotted to kill me, plotted to steal my
 throne?
Tell me, in God's name: am I coward, a fool,
That you should dream you could accomplish this?
A fool who could not see your slippery game?
A coward, not to fight back when I saw it?
You are the fool, Kreon, are you not? hoping
Without support or friends to get a throne?
Thrones may be won or bought: you could do
 neither.

KREON Now listen to me. You have talked; let me
 talk, too.
You can not judge unless you know the facts.

OEDIPUS You speak well: there is one fact; but I find
 it hard
To learn from the deadliest enemy I have.

KREON That above all I must dispute with you.

OEDIPUS That above all I will not hear you deny.

KREON If you think there is anything good in being
 stubborn
Against all reason, then I say you are wrong.

OEDIPUS If you think a man can sin against his own
 kind
And not be punished for it, I say you are mad.

KREON I agree. But tell me: What have I done to you?

OEDIPUS You advised me to send for that wizard, did
 you not?

KREON I did. I should do it again.

OEDIPUS Very well. Now tell me:
How long has it been since Laïos—

KREON What of Laïos?

OEDIPUS Since he vanished in that onset by the road?

KREON It was long ago, a long time.

OEDIPUS And this prophet,
Was he practicing here then?

KREON He was; and with honor, as now.

OEDIPUS Did he speak of me at that time?

KREON He never did,
At least, not when I was present.

OEDIPUS But . . . the enquiry?
I suppose you held one?

KREON We did, but we learned nothing.

OEDIPUS Why did the prophet not speak against me
 then?

KREON I do not know; and I am the kind of man
Who holds his tongue when he has no facts to go on.

OEDIPUS There's one fact that you know, and you
 could tell it.

KREON What fact is that? If I know it, you shall have
 it.

OEDIPUS If he were not involved with you, he could
 not say
That it was I who murdered Laïos.

KREON If he says that, you are the one that knows
 it!—
But now it is my turn to question you.

OEDIPUS Put your questions. I am no murderer.

KREON First, then: You married my sister?

OEDIPUS I married your sister.

KREON And you rule the kingdom equally with her?

OEDIPUS Everything that she wants she has from me.

KREON And I am the third, equal to both of you?

OEDIPUS That is why I call you a bad friend.

KREON No. Reason it out, as I have done.
Think of this first: Would any sane man prefer
Power, with all a king's anxieties,
To that same power and the grace of sleep?
Certainly not I.
I have never longed for the king's power—only his
 rights.
Would any wise man differ from me in this?
As matters stand, I have my way in everything
With your consent, and no responsibilities.
If I were king, I should be a slave to policy.

How could I desire a scepter more
Than what is now mine—untroubled influence?
No, I have not gone mad; I need no honors,
Except those with the perquisites I have now.
I am welcome everywhere; every man salutes me,
And those who want your favor seek my ear,
Since I know how to manage what they ask.
Should I exchange this ease for that anxiety?
Besides, no sober mind is treasonable.
I hate anarchy
And never would deal with any man who likes it.
Test what I have said. Go to the priestess
At Delphi, ask if I quoted her correctly.
And as for this other thing: if I am found
Guilty of treason with Teiresias,
Then sentence me to death. You have my word
It is a sentence I should cast my vote for—
But not without evidence!
 You do wrong
When you take good men for bad, bad men for
 good.
A true friend thrown aside—why, life itself
Is not more precious!
 In time you will know this well:
For time, and time alone, will show the just man,
Though scoundrels are discovered in a day.

CHORAGOS This is well said, and a prudent man
 would ponder it.
Judgments too quickly formed are dangerous.

OEDIPUS But is he not quick in his duplicity?
And shall I not be quick to parry him?

Would you have me stand still, hold my peace, and
 let
This man win everything, through my inaction?

KREON And you want—what is it, then? To banish
 me?

OEDIPUS No, not exile. It is your death I want,
 So that all the world may see what treason means.

KREON You will persist, then? You will not
 believe me?

OEDIPUS How can I believe you?

KREON Then you are a fool.

OEDIPUS To save myself?

KREON In justice, think of me.

OEDIPUS You are evil incarnate.

KREON But suppose that you are wrong?

OEDIPUS Still I must rule.

KREON But not if you rule badly.

OEDIPUS O city, city!

KREON It is my city, too!

CHORAGOS Now, my lords, be still. I see the queen,
 Iokastê, coming from her palace chambers;
 And it is time she came, for the sake of you both.
 This dreadful quarrel can be resolved through her.

(*Enter* IOKASTÊ)

IOKASTÊ Poor foolish men, what wicked din is this?
 With Thebes sick to death, is it not shameful
 That you should rake some private quarrel up?
 (*To* OEDIPUS) Come into the house.
 —And you, Kreon, go now:
 Let us have no more of this tumult over nothing.

KREON Nothing? No, sister: what your husband
 plans for me
 Is one of two great evils: exile or death.

OEDIPUS He is right.
 Why, woman I have caught him squarely
 Plotting against my life.

KREON No! Let me die
 Accurst if ever I have wished you harm!

IOKASTÊ Ah, believe it, Oedipus!
 In the name of the gods, respect this oath of his
 For my sake, for the sake of these people here!

Strophe 1

CHORAGOS Open your mind to her, my lord. Be
 ruled by her, I beg you!

OEDIPUS What would you have me do?

CHORAGOS Respect Kreon's word. He has never
 spoken like a fool,
 And now he has sworn an oath.

OEDIPUS You know what you ask?

CHORAGOS I do.

OEDIPUS Speak on, then.

CHORAGOS A friend so sworn should not be baited so,
 In blind malice, and without final proof.

OEDIPUS You are aware, I hope, that what you say
 Means death for me, or exile at the least.

Strophe 2

CHORAGOS No, I swear by Helios, first in Heaven!
 May I die friendless and accurst,
 The worst of deaths, if ever I meant that!
 It is the withering fields
 That hurt my sick heart:
 Must we bear all these ills,
 And now your bad blood as well?

OEDIPUS Then let him go. And let me die, if I must,
 Or be driven by him in shame from the land of
 Thebes.
 It is your unhappiness, and not his talk,
 That touches me.
 As for him—
 Wherever he goes, hatred will follow him.

KREON Ugly in yielding, as you were ugly in rage!
 Natures like yours chiefly torment themselves.

OEDIPUS Can you not go? Can you not leave me?

KREON I can.
 You do not know me; but the city knows me,
 And in its eyes I am just, if not in yours.

(*Exit* KREON)

Antistrophe 1

CHORAGOS Lady Iokastê, did you not ask the King
 to go to his chambers?

IOKASTÊ First tell me what has happened.

CHORAGOS There was suspicion without evidence;
 yet it rankled
 As even false charges will.

IOKASTÊ On both sides?

CHORAGOS On both.

IOKASTÊ But what was said?

CHORAGOS Oh let it rest, let it be done with!
 Have we not suffered enough?

OEDIPUS You see to what your decency has brought
 you:
 You have made difficulties where my heart saw
 none.

Antistrophe 2

CHORAGOS Oedipus, it is not once only I have told
 you—
 You must know I should count myself unwise
 To the point of madness, should I now forsake you—
 You, under whose hand,
 In the storm of another time,
 Our dear land sailed out free.
 But now stand fast at the helm!

IOKASTÊ In God's name, Oedipus, inform your wife
 as well:

Why are you so set in this hard anger?

OEDIPUS I will tell you, for none of these men deserves

My confidence as you do. It is Kreon's work,
His treachery, his plotting against me.

IOKASTÊ Go on, if you can make this clear to me.

OEDIPUS He charges me with the murder of Laïos.

IOKASTÊ Has he some knowledge? Or does he speak from hearsay?

OEDIPUS He would not commit himself to such a charge,

But he has brought in that damnable soothsayer
To tell his story.

IOKASTÊ Set your mind at rest.

If it is a question of soothsayers, I tell you
That you will find no man whose craft gives knowledge
Of the unknowable.

 Here is my proof:

An oracle was reported to Laïos once
(I will not say from Phoibos himself, but from
His appointed ministers, at any rate)
That his doom would be death at the hands of his own son—
His son, born of his flesh and of mine!

Now, you remember the story: Laïos was killed
By marauding strangers where three highways meet;
But his child had not been three days in this world
Before the king had pierced the baby's ankles
And left him to die on a lonely mountainside.

Thus, Apollo never caused that child
To kill his father, and it was not Laïos' fate
To die at the hands of his son, as he had feared.
This is what prophets and prophecies are worth!
Have no dread of them.

 It is God himself

Who can show us what he wills, in his own way.

OEDIPUS How strange a shadowy memory crossed my mind,

Just now while you were speaking; it chilled my heart.

IOKASTÊ What do you mean? What memory do you speak of?

OEDIPUS If I understand you, Laïos was killed

At a place where three roads meet.

IOKASTÊ So it was said;

We have no later story.

OEDIPUS Where did it happen?

IOKASTÊ Phokis, it is called; at a place where the Theban Way

Divides into the roads toward Delphi and Daulia.

OEDIPUS When?

IOKASTÊ We had the news not long before you came

And proved the right to your succession here.

OEDIPUS Ah, what net has God been weaving for me?

IOKASTÊ Oedipus! Why does this trouble you?

OEDIPUS Do not ask me yet.

First, tell me how Laïos looked, and tell me
How old he was.

IOKASTÊ He was tall, his hair just touched

With white; his form was not unlike your own.

OEDIPUS I think that I myself may be accurst

By my own ignorant edict.

IOKASTÊ You speak strangely.

It makes me tremble to look at you, my king.

OEDIPUS I am not sure that the blind man can not see.

But I should know better if you were to tell me—

IOKASTÊ Anything—though I dread to hear you ask it.

OEDIPUS Was the king lightly escorted, or did he ride

With a large company, as a ruler should?

IOKASTÊ There were five men with him in all: one was a herald.

And a single chariot, which he was driving.

OEDIPUS Alas, that makes it plain enough!

 But who—

Who told you how it happened?

IOKASTÊ A household servant,

The only one to escape.

OEDIPUS And is he still

A servant of ours?

IOKASTÊ No; for when he came back at last

And found you enthroned in the place of the dead king,

He came to me, touched my hand with his, and begged

That I would send him away to the frontier district
Where only the shepherds go—
As far away from the city as I could send him.
I granted his prayer; for although the man was a slave,

He had earned more than this favor at my hands.

OEDIPUS Can he be called back quickly?

IOKASTÊ Easily.

But why?

OEDIPUS I have taken too much upon myself

Without enquiry; therefore I wish to consult him.

IOKASTÊ Then he shall come.

 But am I not one also

To whom you might confide these fears of yours?

OEDIPUS That is your right; it will not be denied you,

Now least of all; for I have reached a pitch
Of wild foreboding. Is there anyone
To whom I should sooner speak?
Polybos of Corinth is my father.
My mother is a Dorian: Meropê.
I grew up chief among the men of Corinth
Until a strange thing happened—
Not worth my passion, it may be, but strange.

At a feast, a drunken man maundering in his cups
Cried out that I am not my father's son![10]

I contained myself that night, though I felt anger
And a sinking heart. The next day I visited
My father and mother, and questioned them. They
 stormed,
Calling it all the slanderous rant of a fool;
And this relieved me. Yet the suspicion
Remained always aching in my mind;
I knew there was talk; I could not rest;
And finally, saying nothing to my parents,
I went to the shrine at Delphi.
The god dismissed my question without reply;
He spoke of other things.
 Some were clear,
Full of wretchedness, dreadful, unbearable:
As, that I should lie with my own mother, breed
Children from whom all men would turn their eyes;
And that I should be my father's murderer.

I heard all this, and fled. And from that day
Corinth to me was only in the stars
Descending in that quarter of the sky,
As I wandered farther and farther on my way
To a land where I should never see the evil
Sung by the oracle. And I came to this country
Where, so you say, King Laïos was killed.

I will tell you all that happened there, my lady.
There were three highways
Coming together at a place I passed;
And there a herald came towards me, and a chariot
Drawn by horses, with a man such as you describe
Seated in it. The groom leading the horses
Forced me off the road at his lord's command;
But as this charioteer lurched over towards me
I struck him in my rage. The old man saw me
And brought his double goad down upon my head
As I came abreast.
 He was paid back, and more!
Swinging my club in this right hand I knocked him
Out of his car, and he rolled on the ground.
 I killed him.
I killed them all.
Now if that stranger and Laïos were—kin,
Where is a man more miserable than I?
More hated by the gods? Citizen and alien alike
Must never shelter me or speak to me—

I must be shunned by all.
 And I myself
Pronounced this malediction upon myself!

Think of it: I have touched you with these hands,
These hands that killed your husband. What
 defilement!

Am I all evil, then? It must be so,
Since I must flee from Thebes, yet never again
See my own countrymen, my own country,
For fear of joining my mother in marriage
And killing Polybos, my father.
 Ah,
If I was created so, born to this fate,
Who could deny the savagery of God?

O holy majesty of heavenly powers!
May I never see that day! Never!
Rather let me vanish from the race of men
Than know the abomination destined me!
CHORAGOS We too, my lord, have felt dismay at this.
 But there is hope: you have yet to hear the shepherd.
OEDIPUS Indeed, I fear no other hope is left me.
IOKASTÊ What do you hope from him when he
 comes?
OEDIPUS This much:
 If his account of the murder tallies with yours,
 Then I am cleared.
IOKASTÊ What was it that I said
 Of such importance?
OEDIPUS Why, "marauders," you said,
 Killed the king, according to this man's story.
 If he maintains that still, if there were several,
 Clearly the guilt is not mine: I was alone.
 But if he says one man, singlehanded, did it,
 Then the evidence all points to me.
IOKASTÊ You may be sure that he said there were
 several;
 And can he call back that story now? He can not.
 The whole city heard it as plainly as I.
 But suppose he alters some detail of it:
 He can not ever show that Laïos' death
 Fulfilled the oracle: for Apollo said
 My child was doomed to kill him; and my child—
 Poor baby!—it was my child that died first.
 No. From now on, where oracles are concerned,
 I would not waste a second thought on any.
OEDIPUS You may be right.
 But come: let someone go
 For the shepherd at once. This matter must be
 settled.
IOKASTÊ I will send for him.
 I would not wish to cross you in anything,
 And surely not in this.—Let us go in.

[10] Oedipus perhaps interprets this as an allegation that he is a bastard, the son of Meropê but not of Polybos. The implication, at any rate, is that he is not of royal birth, not the legitimate heir to the throne of Corinth.

(Exeunt into the palace)

ODE II

Strophe 1

CHORUS Let me be reverent in the ways of right,
Lowly the paths I journey on;
Let all my words and actions keep
The laws of the pure universe
From highest Heaven handed down.
For Heaven is their bright nurse,
Those generations of the realms of light;
Ah, never of mortal kind were they begot,
Nor are they slaves of memory, lost in sleep:
Their Father is greater than Time, and ages not.

Antistrophe 1

The tyrant is a child of Pride
Who drinks from his great sickening cup
Recklessness and vanity,
Until from his high crest headlong
He plummets to the dust of hope.
That strong man is not strong.
But let no fair ambition be denied;
May God protect the wrestler for the State
In government, in comely policy,
Who will fear God, and on His ordinance wait.

Strophe 2

Haughtiness and the high hand of disdain
Tempt and outrage God's holy law;
And any mortal who dares hold
No immortal Power in awe
Will be caught up in a net of pain:
The price for which his levity is sold.
Let each man take due earnings, then,
And keep his hands from holy things,
And from blasphemy stand apart—
Else the crackling blast of heaven
Blows on his head, and on his desperate heart.
Though fools will honor impious men,
In their cities no tragic poet sings.

Antistrophe 2

Shall we lose faith in Delphi's obscurities,
We who have heard the world's core
Discredited, and the sacred wood
Of Zeus at Elis praised no more?
The deeds and the strange prophecies
Must make a pattern yet to be understood.
Zeus, if indeed you are lord of all,
Throned in light over night and day,
Mirror this in your endless mind:
Our masters call the oracle
Words on the wind, and the Delphic vision blind!
Their hearts no longer know Apollo,
And reverence for the gods has died away.

SCENE III

(Enter IOKASTÊ*)*

IOKASTÊ Princes of Thebes, it has occurred to me
To visit the altars of the gods, bearing
These branches as a suppliant, and this incense.
Our king is not himself: his noble soul
Is overwrought with fantasies of dread,
Else he would consider
The new prophecies in the light of the old.
He will listen to any voice that speaks disaster,
And my advice goes for nothing.

(She approaches the altar, R)

To you, then, Apollo,
Lycéan lord, since you are nearest, I turn in prayer.
Receive these offerings, and grant us deliverance
From defilement. Our hearts are heavy with fear
When we see our leader distracted, as helpless sailors
Are terrified by the confusion of their helmsman.

(Enter MESSENGER*)*

MESSENGER Friends, no doubt you can direct me:
Where shall I find the house of Oedipus,
Or, better still, where is the king himself?
CHORAGOS It is this very place, stranger; he is inside.
This is his wife and mother of his children.
MESSENGER I wish her happiness in a happy house,
Blest in all the fulfillment of her marriage.
IOKASTÊ I wish as much for you: your courtesy
Deserves a like good fortune. But now, tell me:
Why have you come? What have you to say to us?
MESSENGER Good news, my lady, for your house
and your husband.
IOKASTÊ What news? Who sent you here?
MESSENGER I am from Corinth.
The news I bring ought to mean joy for you,
Though it may be you will find some grief in it.
IOKASTÊ What is it? How can it touch us in both
ways?
MESSENGER The word is that the people of the
Isthmus
Intend to call Oedipus to be their king.
IOKASTÊ But old King Polybos—is he not reigning
still?
MESSENGER No. Death holds him in his sepulchre.
IOKASTÊ What are you saying? Polybos is dead?
MESSENGER If I am not telling the truth, may I die
myself.
IOKASTÊ *(to a* MAIDSERVANT*)* Go in, go quickly;
tell this to your master.

O riddlers of God's will, where are you now!
This was the man whom Oedipus, long ago,
Feared so, fled so, in dread of destroying him—
But it was another fate by which he died.

(*Enter* OEDIPUS, C)

OEDIPUS Dearest Iokastê, why have you sent for me?
IOKASTÊ Listen to what this man says, and then tell me
What has become of the solemn prophecies.
OEDIPUS Who is this man? What is his news for me?
IOKASTÊ He has come from Corinth to announce your father's death!
OEDIPUS Is it true, stranger? Tell me in your own words.
MESSENGER I can not say it more clearly: the king is dead.
OEDIPUS Was it by treason? Or by an attack of illness?
MESSENGER A little thing brings old men to their rest.
OEDIPUS It was sickness, then?
MESSENGER Yes, and his many years.
OEDIPUS Ah!
Why should a man respect the Pythian hearth,[11] or
Give heed to the birds that jangle above his head?
They prophesied that I should kill Polybos,
Kill my own father; but he is dead and buried,
And I am here—I never touched him, never,
Unless he died of grief for my departure,
And thus, in a sense, through me. No. Polybos
Has packed the oracles off with him underground.
They are empty words.
IOKASTÊ Had I not told you so?
OEDIPUS You had; it was my faint heart that betrayed me.
IOKASTÊ From now on never think of those things again.
OEDIPUS And yet—must I not fear my mother's bed?
IOKASTÊ Why should anyone in this world be afraid,
Since Fate rules us and nothing can be foreseen?
A man should live only for the present day.

Have no more fear of sleeping with your mother:
How many men, in dreams, have lain with their mothers!
No reasonable man is troubled by such things.
OEDIPUS That is true; only—
If only my mother were not still alive!
But she is alive. I can not help my dread.
IOKASTÊ Yet this news of your father's death is wonderful.
OEDIPUS Wonderful. But I fear the living woman.

MESSENGER Tell me, who is this woman that you fear?
OEDIPUS It is Meropê, man; the wife of King Polybos.
MESSENGER Meropê? Why should you be afraid of her?
OEDIPUS An oracle of the gods, a dreadful saying.
MESSENGER Can you tell me about it or are you sworn to silence?
OEDIPUS I can tell you, and I will.
Apollo said through his prophet that I was the man
Who should marry his own mother, shed his father's blood
With his own hands. And so, for all these years
I have kept clear of Corinth, and no harm has come—
Though it would have been sweet to see my parents again.
MESSENGER And is this the fear that drove you out of Corinth?
OEDIPUS Would you have me kill my father?
MESSENGER As for that
You must be reassured by the news I gave you.
OEDIPUS If you could reassure me, I would reward you.
MESSENGER I had that in mind, I will confess: I thought
I could count on you when you returned to Corinth.
OEDIPUS No: I will never go near my parents again.
MESSENGER Ah, son, you still do not know what you are doing—
OEDIPUS What do you mean? In the name of God tell me!
MESSENGER —if these are your reasons for not going home.
OEDIPUS I tell you, I fear the oracle may come true.
MESSENGER And guilt may come upon you through your parents?
OEDIPUS That is the dread that is always in my heart.
MESSENGER Can you not see that all your fears are groundless?
OEDIPUS Groundless? Am I not my parents' son?
MESSENGER Polybos was not your father.
OEDIPUS Not my father?
MESSENGER No more your father than the man speaking to you.
OEDIPUS But you are nothing to me!
MESSENGER Neither was he.
OEDIPUS Then why did he call me son?
MESSENGER I will tell you:
Long ago he had you from my hands, as a gift.
OEDIPUS Then how could he love me so, if I was not his?
MESSENGER He had no children, and his heart turned to you.
OEDIPUS What of you? Did you buy me? Did you find me by chance?

[11] Delphi.

MESSENGER I came upon you in the woody vales of
 Kithairon.
OEDIPUS And what were you doing there?
MESSENGER Tending my flocks.
OEDIPUS A wandering shepherd?
MESSENGER But your savior, son, that day.
OEDIPUS From what did you save me?
MESSENGER Your ankles should tell you that.
OEDIPUS Ah, stranger, why do you speak of that
 childhood pain?
MESSENGER I pulled the skewer that pinned your
 feet together.
OEDIPUS I have had the mark as long as I can
 remember.
MESSENGER That was why you were given the
 name you bear.
OEDIPUS God! Was it my father or my mother who
 did it?
 Tell me!
MESSENGER I do not know. The man who gave you
 to me
 Can tell you better than I.
OEDIPUS It was not you that found me, but another?
MESSENGER It was another shepherd gave you to me.
OEDIPUS Who was he? Can you tell me who he was?
MESSENGER I think he was said to be one of Laïos'
 people.
OEDIPUS You mean the Laïos who was king here
 years ago?
MESSENGER Yes; King Laïos; and the man was one
 of his herdsmen.
OEDIPUS Is he still alive? Can I see him?
MESSENGER These men here
 Know best about such things.
OEDIPUS Does anyone here
 Know this shepherd that he is talking about?
 Have you seen him in the fields, or in the town?
 If you have, tell me. It is time things were made plain.
CHORAGOS I think the man he means is that same
 shepherd
 You have already asked to see. Iokastê perhaps
 Could tell you something.
OEDIPUS Do you know anything
 About him, Lady? Is he the man we have summoned?
 Is that the man this shepherd means?
IOKASTÊ Why think of him?
 Forget this herdsman. Forget it all.
 This talk is a waste of time.
OEDIPUS How can you say that,
 When the clues to my true birth are in my hands?
IOKASTÊ For God's love, let us have no more
 questioning!
 Is your life nothing to you?
 My own is pain enough for me to bear.
OEDIPUS You need not worry. Suppose my mother
 a slave,
 And born of slaves: no baseness can touch you.

IOKASTÊ Listen to me, I beg you: do not do this thing!
OEDIPUS I will not listen; the truth must be made
 known.
IOKASTÊ Everything that I say is for your own good!
OEDIPUS My own good
 Snaps my patience, then! I want none of it.
IOKASTÊ You are fatally wrong! May you never
 learn who you are!
OEDIPUS Go, one of you, and bring the shepherd here.
 Let us leave this woman to brag of her royal name.
IOKASTÊ Ah, miserable!
 That is the only word I have for you now.
 That is the only word I can ever have.

(*Exit into the palace*)

CHORAGOS Why has she left us, Oedipus? Why has
 she gone
 In such a passion of sorrow? I fear this silence:
 Something dreadful may come of it.
OEDIPUS Let it come!
 However base my birth, I must know about it.
 The Queen, like a woman, is perhaps ashamed
 To think of my low origin. But I
 Am a child of Luck; I can not be dishonored.
 Luck is my mother; the passing months, my
 brothers,
 Have seen me rich and poor.
 If this is so,
 How could I wish that I were someone else?
 How could I not be glad to know my birth?

ODE III

Strophe

CHORUS If ever the coming time were known
 To my heart's pondering,
 Kithairon, now by Heaven I see the torches
 At the festival of the next full moon,
 And see the dance, and hear the choir sing
 A grace to your gentle shade:
 Mountain where Oedipus was found,
 O mountain guard of a noble race!
 May the god[12] who heals us lend his aid,
 And let that glory come to pass
 For our king's cradling-ground.

Antistrophe

Of the nymphs that flower beyond the years,
Who bore you,[13] royal child,

[12] Apollo.

[13] The chorus is suggesting that perhaps Oedipus is the son of one of
 the immortal nymphs and of a god—Pan, Apollo, Hermes, or Diony-
 sus. The "sweet god-ravisher" (below) is the presumed mother.

To Pan of the hills or the timberline Apollo,
Cold in delight where the upland clears,
Or Hermês for whom Kyllenê's heights are piled?
Or flushed as evening cloud,
Great Dionysos, roamer of mountains,
He—was it he who found you there,
And caught you up in his own proud
Arms from the sweet god-ravisher
Who laughed by the Muses' fountains?

SCENE IV

OEDIPUS Sirs: though I do not know the man,
 I think I see him coming, this shepherd we want:
 He is old, like our friend here, and the men
 Bringing him seem to be servants of my house.
 But you can tell, if you have ever seen him.

(*Enter* SHEPHERD *escorted by* SERVANTS)

CHORAGOS I know him, he was Laïos' man. You
 can trust him.
OEDIPUS Tell me first, you from Corinth: is this the
 shepherd
 We were discussing?
MESSENGER This is the very man.
OEDIPUS (*to* SHEPHERD) Come here. No, look at me.
 You must answer
 Everything I ask.—You belonged to Laïos?
SHEPHERD Yes: born his slave, brought us in his
 house.
OEDIPUS Tell me: what kind of work did you do for
 him?
SHEPHERD I was a shepherd of his, most of my life.
OEDIPUS Where mainly did you go for pasturage?
SHEPHERD Sometimes Kithairon, sometimes the
 hills near-by.
OEDIPUS Do you remember ever seeing this man
 out there?
SHEPHERD What would he be doing there? This man?
OEDIPUS This man standing here. Have you ever
 seen him before?
SHEPHERD No. At least, not to my recollection.
MESSENGER And that is not strange, my lord. But
 I'll refresh
 His memory: he must remember when we two
 Spend three whole seasons together. March to
 September,
 On Kithairon or thereabouts. He had two flocks;
 I had one. Each autumn I'd drive mine home
 And he would go back with his to Laïos'
 sheepfold.—
 Is this not true, just as I have described it?
SHEPHERD True, yes; but it was all so long ago.
MESSENGER Well, then: do you remember, back in
 those days,
 That you gave me a baby boy to bring up as my own?
SHEPHERD What if I did? What are you trying to say?

MESSENGER King Oedipus was once that little child.
SHEPHERD Damn you, hold your tongue!
OEDIPUS No more of that!
 It is your tongue needs watching, not this man's.
SHEPHERD My king, my master, what is it I have
 done wrong?
OEDIPUS You have not answered his question about
 the boy.
SHEPHERD He does not know . . . He is only making
 trouble . . .
OEDIPUS Come, speak plainly, or it will go hard
 with you.
SHEPHERD In God's name, do not torture an old man!
OEDIPUS Come here, one of you; bind his arms
 behind him.
SHEPHERD Unhappy king! What more do you wish
 to learn?
OEDIPUS Did you give this man the child he speaks of?
SHEPHERD I did.
 And I would to God I had died that very day.
OEDIPUS You will die now unless you speak the truth.
SHEPHERD Yet if I speak the truth, I am worse than
 dead.
OEDIPUS (*to* ATTENDANT) He intends to draw it
 out, apparently—
SHEPHERD No! I have told you already that I gave
 him the boy.
OEDIPUS Where did you get him? From your house?
 From somewhere else?
SHEPHERD Not from mine, no. A man gave him to me.
OEDIPUS Is that man here? Whose house did he
 belong to?
SHEPHERD For God's love, my king, do not ask me
 any more!
OEDIPUS You are a dead man if I have to ask you again.
SHEPHERD Then . . . Then the child was from the
 palace of Laïos.
OEDIPUS A slave child? or a child of his own line?
SHEPHERD Ah, I am on the brink of a dreadful speech!
OEDIPUS And I of dreadful hearing. Yet I must hear.
SHEPHERD If you must be told, then . . .
 They said it was Laïos' child;
 But it is your wife who can tell you about that.
OEDIPUS My wife!—Did she give it to you?
SHEPHERD My lord, she did.
OEDIPUS Do you know why?
SHEPHERD I was told to get rid of it.
OEDIPUS Oh heartless mother!
SHEPHERD But in dread of prophecies . . .
OEDIPUS Tell me.
SHEPHERD It was said that the boy would kill
 his own father.
OEDIPUS Then why did you give him over to this
 old man?
SHEPHERD I pitied the baby, my king,
 And I thought that this man would take him far
 away

To his own country.
 He saved him—but for what a fate!
For if you are what this man says you are,
No man living is more wretched than Oedipus.

OEDIPUS Ah God!
 It was true!
 All the prophecies!
 —Now,
O Light, may I look on you for the last time!
I, Oedipus,
Oedipus, damned in his birth, in his marriage
 damned,
Damned in the blood he shed with his own hand!

(*He rushes into the palace*)

ODE IV

Strophe 1

CHORUS Alas for the seed of men.
 What measure shall I give these generations
 That breathe on the void and are void
 And exist and do not exist?
 Who bears more weight of joy
 Than mass of sunlight shifting in images,
 Or who shall make his thought stay on
 That down time drifts away?
 Your splendor is all fallen.
 O naked brow of wrath and tears,
 O change of Oedipus!
 I who saw your days call no man blest—
 Your great days like ghosts gone.

Antistrophe 1

That mind was a strong bow.
Deep, how deep you drew it then, hard archer,
At a dim fearful range,
And brought dear glory down!
You overcame the stranger[14]—
The virgin with her hooking lion claws—
And though death sang, stood like a tower
To make pale Thebes take heart.
Fortress against our sorrow!
True king, giver of laws,
Majestic Oedipus!
No prince in Thebes had ever such renown,
No prince won such grace of power.

Strophe 2

And now of all men ever known
Most pitiful is this man's story:

His fortunes are most changed, his state
Fallen to a low slave's
Ground under bitter fate.
O Oedipus, most royal one!
The great door[15] that expelled you to the light
Gave at night—ah, gave night to your glory:
As to the father, to the fathering son.
All understood too late.
How could that queen whom Laïos won,
The garden that he harrowed at his height,
Be silent when that act was done?

Antistrophe 2

But all eyes fail before time's eye,
All actions come to justice there.
Though never willed, though far down the deep past,
Your bed, your dread sirings,
Are brought to book at last.
Child by Laïos doomed to die,
Then doomed to lose that fortunate little death,
Would God you never took breath in this air
That with my wailing lips I take to cry:
For I weep the world's outcast.
I was blind, and now I can tell why:
Asleep, for you had given ease of breath
To Thebes, while the false years went by.

EXODOS[16]

(*Enter, from the palace,* SECOND MESSENGER)

SECOND MESSENGER Elders of Thebes, most
 honored in this land,
 What horrors are yours to see and hear, what weight
 Of sorrow to be endured, if, true to your birth,
 You venerate the line of Labdakos!
 I think neither Istros nor Phasis, those great rivers,
 Could purify this place of all the evil
 It shelters now, or soon must bring to light—
 Evil not done unconsciously, but willed.

 The greatest griefs are those we cause ourselves.

CHORAGOS Surely, friend, we have grief enough
 already;
 What new sorrow do you mean?

SECOND MESSENGER The queen is dead.

CHORAGOS O miserable queen! But at whose hand?

SECOND MESSENGER Her own.
 The full horror of what happened you can not know,
 For you did not see it; but I, who did, will tell you
 As clearly as I can how she met her death.

[14] The Sphinx.

[15] Iokastê's womb.

[16] Final scene.

When she had left us,
In passionate silence, passing through the court,
She ran to her apartment in the house,
Her hair clutched by the fingers of both hands.
She closed the doors behind her; then, by that bed
Where long ago the fatal son was conceived—
That son who should bring about his father's
 death—
We heard her call upon Laïos, dead so many years,
And heard her wail for the double fruit of her
 marriage,
A husband by her husband, children by her child.
Exactly how she died I do not know:
For Oedipus burst in moaning and would not let us
Keep vigil to the end: it was by him
As he stormed about the room that our eyes were
 caught.
From one to another of us he went, begging a sword,
Hunting the wife who was not his wife, the mother
Whose womb had carried his own children and
 himself.
I do not know: it was none of us aided him,
But surely one of the gods was in control!
For with a dreadful cry
He hurled his weight, as though wrenched out of
 himself,
At the twin doors: the bolts gave, and he rushed in.
And there we saw her hanging, her body swaying
From the cruel cord she had noosed about her neck.
A great sob broke from him, heartbreaking to hear,
As he loosed the rope and lowered her to the ground.

I would blot out from my mind what happened
 next!
For the king ripped from her gown the golden
 brooches
That were her ornament, and raised them, and
 plunged them down
Straight into his own eyeballs, crying, "No more,
No more shall you look on the misery about me,
The horrors of my own doing! Too long you have
 known
The faces of those whom I should never have seen,
Too long been blind to those for whom I was
 searching!
From this hour, go in darkness!" And as he spoke,
He struck at his eyes—not once, but many times;
And the blood spattered his beard,
Bursting from his ruined sockets like red hail.

So from the unhappiness of two this evil has sprung,
A curse on the man and woman alike. The old
Happiness of the house of Labdakos
Was happiness enough: where is it today?
It is all wailing and ruin, disgrace, death—all
The misery of mankind that has a name—
And it is wholly and for ever theirs.

CHORAGOS Is he in agony still? Is there no rest for
 him?
SECOND MESSENGER He is calling for someone to
 open the doors wide
 So that all the children of Kadmos may look upon
 His father's murderer, his mother's—no,
 I can not say it!
 And then he will leave Thebes,
 Self-exiled, in order that the curse
 Which he himself pronounced may depart from the
 house.
 He is weak, and there is none to lead him,
 So terrible is his suffering.
 But you will see:
 Look, the doors are opening; in a moment
 You will see a thing that would crush a heart of
 stone.

(*The central door is opened*; OEDIPUS, *blinded, is led in*)

CHORAGOS Dreadful indeed for men to see.
 Never have my own eyes
 Looked on a sight so full of fear.

 Oedipus!
 What madness came upon you, what daemon
 Leaped on your life with heavier
 Punishment than a mortal man can bear?
 No: I can not even
 Look at you, poor ruined one.
 And I would speak, question, ponder,
 If I were able. No.
 You make me shudder.
OEDIPUS God. God.
 Is there a sorrow greater?
 Where shall I find harbor in this world?
 My voice is hurled far on a dark wind.
 What has God done to me?
CHORAGOS Too terrible to think of, or to see.

Strophe 1

OEDIPUS O cloud of night,
 Never to be turned away: night coming on,
 I can not tell how: night like a shroud!
 My fair winds brought me here.
 O God. Again
 The pain of the spikes where I had sight,
 The flooding pain
 Of memory, never to be gouged out.
CHORAGOS This is not strange.
 You suffer it all twice over, remorse in pain,
 Pain in remorse.

Antistrophe 1

OEDIPUS Ah dear friend
 Are you faithful even yet, you alone?

Are you still standing near me, will you stay here,
Patient, to care for the blind?
 The blind man!
Yet even blind I know who it is attends me,
By the voice's tone—
Though my new darkness hide the comforter.

CHORAGOS Oh fearful act!
What god was it drove you to rake black
Night across your eyes?

Strophe 2

OEDIPUS Apollo. Apollo. Dear
Children, the god was Apollo.
He brought my sick, sick fate upon me.
But the blinding hand was my own!
How could I bear to see
When all my sight was horror everywhere?

CHORAGOS Everywhere; that is true.

OEDIPUS And now what is left?
Images? Love? A greeting even,
Sweet to the senses? Is there anything?
Ah, no, friends: lead me away.
Lead me away from Thebes.
 Lead the great wreck
And hell of Oedipus, whom the gods hate.

CHORAGOS Your misery, you are not blind to that.
Would God you had never found it out!

Antistrophe 2

OEDIPUS Death take the man who unbound
My feet on that hillside
And delivered me from death to life! What life?
If only I had died,
This weight of monstrous doom
Could not have dragged me and my darlings down.

CHORAGOS I would have wished the same.

OEDIPUS Oh never to have come here
With my father's blood upon me! Never
To have been the man they call his mother's
husband!
Oh accurst! Oh child of evil,
To have entered that wretched bed—
 the selfsame one!
More primal than sin itself, this fell to me.

CHORAGOS I do not know what words to offer you.
You were better dead than alive and blind.

OEDIPUS Do not counsel me any more. This
punishment
That I have laid upon myself is just.
If I had eyes,
I do not know how I could bear the sight
Of my father, when I came to the house of Death,
Or my mother: for I have sinned against them both
So vilely that I could not make my peace
By strangling my own life.

 Or do you think my children,
Born as they were born, would be sweet to my eyes?
Ah never, never! Nor this town with its high walls,
Nor the holy images of the gods.
 For I,
Thrice miserable!—Oedipus, noblest of all the line
Of Kadmos, have condemned myself to enjoy
These things no more, by my own malediction
Expelling that man whom the gods declared
To be a defilement in the house of Laïos.
After exposing the rankness of my own guilt,
How could I look men frankly in the eyes?
No, I swear it,
If I could have stifled my hearing at its source,
I would have done it and made all this body
A tight cell of misery, blank to light and sound:
So I should have been safe in my dark mind
Beyond external evil.
 Ah Kithairon!
Why did you shelter me? When I was cast upon you,
Why did I not die? Then I should never
Have shown the world my execrable birth.

Ah Polybos! Corinth, city that I believed
The ancient seat of my ancestors: how fair
I seemed, your child! And all the while this evil
Was cancerous within me!
 For I am sick
In my own being, sick in my origin.

O three roads, dark ravine, woodland and way
Where three roads met: you, drinking my father's
blood,
My own blood, spilled by my own hand: can you
remember
The unspeakable things I did there, and the things
I went on from there to do?
 O marriage, marriage!
That act that engendered me, and again the act
Performed by the son in the same bed—
 Ah, the net
Of incest, mingling fathers, brothers, sons,
With brides, wives, mothers: the last evil
That can be known by men: no tongue can say
How evil!
 No. For the love of God, conceal me
Somewhere far from Thebes; or kill me; or hurl me
Into the sea, away from men's eyes for ever.

Come, lead me. You need not fear to touch me.
Of all men, I alone can bear this guilt.

(*Enter* KREON)

CHORAGOS Kreon is here now. As to what you ask,
He may decide the course to take. He only
Is left to protect the city in your place.

OEDIPUS Alas, how can I speak to him? What right have I
To beg his courtesy whom I have deeply wronged?
KREON I have not come to mock you, Oedipus,
Or to reproach you, either. (*To* ATTENDANTS)
 —You, standing there:
If you have lost all respect for man's dignity,
At least respect the flame of Lord Helios:
Do not allow this pollution to show itself
Openly here, an affront to the earth
And Heaven's rain and the light of day. No, take him
Into the house as quickly as you can.
For it is proper
That only the close kindred see his grief.
OEDIPUS I pray you in God's name, since your courtesy
Ignores my dark expectation, visiting
With mercy this man of all men most execrable:
Give me what I ask—for your good, not for mine.
KREON And what is it that you turn to me begging for?
OEDIPUS Drive me out of this country as quickly as may be
To a place where no human voice can ever greet me.
KREON I should have done that before now—only,
God's will had not been wholly revealed to me.
OEDIPUS But his command is plain: the parricide
Must be destroyed. I am that evil man.
KREON That is the sense of it, yes; but as things are,
We had best discover clearly what is to be done.
OEDIPUS You would learn more about a man like me?
KREON You are ready now to listen to the god.
OEDIPUS I will listen. But it is to you
That I must turn for help. I beg you, hear me.

The woman in there—
Give her whatever funeral you think proper:
She is your sister.
 —But let me go, Kreon!
Let me purge my father's Thebes of the pollution
Of my living here, and go out to the wild hills,
To Kithairon, that has won such fame with me,
The tomb my mother and father appointed for me,
And let me die there, as they willed I should.

And yet I know
Death will not ever come to me through sickness
Or in any natural way: I have been preserved
For some unthinkable fate. But let that be.

As for my sons, you need not care for them.
They are men, they will find some way to live.
But my poor daughters, who have shared my table,
Who never before have been parted from their father—
Take care of them, Kreon; do this for me.

And will you let me touch them with my hands
A last time, and let us weep together?
Be kind, my lord,
Great prince, be kind!
 Could I but touch them,
They would be mine again, as when I had my eyes.

(*Enter* ANTIGONE *and* ISMENE, *attended*)

Ah God!
Is it my dearest children I hear weeping?
Has Kreon pitied me and sent my daughters?
KREON Yes, Oedipus: I knew that they were dear to you
In the old days, and know you must love them still.
OEDIPUS May God bless you for this—and be a friendlier
Guardian to you than he has been to me!
Children, where are you?
Come quickly to my hands: they are your brother's—
Hands that have brought your father's once clear eyes
To this way of seeing—
 Ah dearest ones,
I had neither sight nor knowledge then, your father
By the woman who was the source of his own life!
And I weep for you—having no strength to see you—,
I weep for you when I think of the bitterness
That men will visit upon you all your lives.
What homes, what festivals can you attend
Without being forced to depart again in tears?
And when you come to marriageable age,
Where is the man, my daughters, who would dare
Risk the bane that lies on all my children?
Is there any evil wanting? Your father killed
His father; sowed the womb of her who bore him;
Engendered you at the fount of his own existence!
That is what they will say of you.
 Then, whom
Can you ever marry? There are no bridegrooms for you,
And your lives must wither away in sterile dreaming.

O Kreon, son of Menoikeus!
You are the only father my daughters have,
Since we, their parents, are both of us gone for ever.
They are your own blood: you will not let them
Fall into beggary and loneliness;
You will keep them from the miseries that are mine!
Take pity on them; see, they are only children,
Friendless except for you. Promise me this,
Great prince, and give me your hand in token of it.

(KREON *clasps his right hand*)

Children:
I could say much, if you could understand me,

But as it is, I have only this prayer for you:
Live where you can, be as happy as you can—
Happier, please God, than God has made your
 father.

KREON Enough. You have wept enough. Now go
 within.

OEDIPUS I must; but it is hard.

KREON Time eases all things.

OEDIPUS You know my mind, then?

KREON Say what you desire.

OEDIPUS Send me from Thebes!

KREON God grant that I may!

OEDIPUS But since God hates me . . .

KREON No, he will grant your wish.

OEDIPUS You promise?

KREON I can not speak beyond my knowledge.

OEDIPUS Then lead me in.

KREON Come now, and leave your children.

OEDIPUS No! Do not take them from me!

KREON Think no longer
 That you are in command here, but rather think
 How, when you were, you served your own
 destruction.

(*Exeunt into the house all but the* CHROUS; *the*
CHORAGOS *chants directly to the audience*)

CHORAGOS Men of Thebes: look upon Oedipus.

This is the king who solved the famous riddle
And towered up, most powerful of men.
No mortal eyes but looked on him with envy,
Yet in the end ruin swept over him.
Let every man in mankind's frailty
Consider his last day; and let none
Presume on his good fortune until he find
Life, at his death, a memory without pain.

COMMENTS AND QUESTIONS

1. Describe Oedipus' character as fully as you can. To
 what extent is he a realistic human being and to
 what extent an ideal type?
2. What are Iokastê's religious beliefs? How does she
 serve as a foil to Oedipus?
3. What kinds of "blindness" are there in this play?
 Explain their significance.
4. Sophocles uses much tragic *irony* in this tragedy
 and in others. Irony, in this sense, means that the
 tragic figure says something "all too true," related
 to his fate, that the audience understands but that
 he does not. Find examples of tragic irony. What
 is their effect?
5. To what extent is Oedipus a puppet of the gods and
 to what extent is he a free man?
6. *Oedipus Rex* has been interpreted both as a glorifi-
 cation of humanity and as a defense of religion that
 points out human limitations. Which view seems
 truer in your opinion?
7. What is Oedipus' attitude at the end of the play?
 What has he learned about himself and life? What is
 the difference between a tragic view of life and a
 merely pessimistic one?
8. Look up Freud's notion of the "Oedipus complex"
 if you are not familiar with it. To what extent is
 this useful for a modern interpretation of the
 tragedy?
9. If you were to take the legend of Oedipus and
 rewrite it for the modern stage, film, or television,
 what would you do with it? Is a modern tragedy
 possible?

EURIPIDES

The Women of Troy
Translation by Philip Vellacott

CHARACTERS

POSEIDON, *God of the Sea*
ATHENE, *a goddess*
HECABE, *widow of Priam King of Troy*
CHORUS *of captive Trojan women*
TALTHYBIUS, *a Greek herald*
CASSANDRA, *daughter of Hecabe*
ANDROMACHE, *daughter-in-law of Hecabe*
MENELAUS, *a general of the Greek army*
HELEN, *his wife*

THE SCENE. *The ruins of Troy, two days after the city's
capture, before dawn. First are seen only silhouettes of shat-
tered buildings against a red glow and rising smoke; then light
falls on the god* POSEIDON.

POSEIDON I come from the salt depths of the Aegean
 Sea,
 Where the white feet of Nereids tread their circling
 dance:
 I am Poseidon. Troy and its people were my city.
 That ring of walls and towers I and Apollo built—
 Squared every stone in it; and my affection has not
 faded.
 Now Troy lies dead under the conquering Argive
 spear,
 Stripped, sacked and smouldering.

 Epeius, a Phocian from Parnassus, made
 To Athene's plan that horse pregnant with armed men,
 Called by all future ages the Wooden Horse, and
 sent it
 To glide, weighty with hidden death, through the
 Trojan walls.

The sacred groves are deserted; the temples run with blood;
On Zeus the Protector's altar-steps Priam lies dead.
Measureless gold and all the loot of Troy goes down
To the Greek ships; and now they wait for a following wind
To make glad, after ten long years, with the sight of their wives and children
The men who sailed from Greece to attack and destroy his town.

Athene, and Hera of Argos, the gods who joined in league
To achieve this end, have worsted me: now I must leave
Ilion the famous, leave my altars. When desolation
Falls like a blight, the day for the worship of gods is past.

Scamandros echoes with endless cries of captured women
Assigned by lottery as slaves to various Greeks—Arcadians,
Thessalians, or Athenians. Those not yet allotted
Are in this house, reserved for the chiefs of the Greek army;
With them, justly held as a prisoner, is Tyndareus' daughter,
Spartan Helen. Here by the door, you may contemplate,
If you wish, this pitiable, prostrate figure, drowned in tears
For a world of sorrows. It is Hecabe. She does not know
That her daughter Polyxena died just now most pitiably,
An offering slaughtered at Achilles' grave. Her husband, Priam,
Is dead, so are her sons. Her daughter the prophetess,
Cassandra, whom Apollo himself left virgin—she
Will be taken by force, in contempt of the god and all pious feeling
By King Agamemnon as his concubine.
 Farewell, then, city!
Superb masonry, farewell! You had your day of glory.
You would stand firm yet, were it not for Athene, daughter of Zeus.

(*Enter* ATHENE)

ATHENE You are a great god honoured by gods—and my father's brother:
May our old feud be buried? I have something to say to you.
POSEIDON Welcome, Athene. Family love has a magic power.

ATHENE You are generous, and I thank you. The matter I wish to discuss
Equally concerns us both.
POSEIDON I suppose you bring some word
From Zeus, or from some other god, greater or less.
ATHENE No. I come to entreat your powerful aid and alliance
On behalf of Troy—yes, of this place!
POSEIDON Have you renounced
Your hatred? Now she is blackened with fire, do you pity Troy?
ATHENE First answer: will you support me, and join your will with mine?
POSEIDON Of course. Tell me your mind: is it Greece or Troy you are helping?
ATHENE I am disposed to favour the Trojans, whom I hated;
And to make this homeward voyage disastrous for the Greeks.
POSEIDON But why? Surely your change of affection is somewhat casual?
Why this leaping at random between hate and love?
ATHENE You know of the insult offered my temple—offered to me?
POSEIDON When Aias dragged Cassandra from sanctuary? I know.
ATHENE No punishment from the Greeks, not even a reprimand.
POSEIDON After the decisive help you gave them in winning the war!
ATHENE Therefore I look to you to help me make them suffer.
POSEIDON My powers await your wished, Athene. What is your plan?
ATHENE I mean to make their homeward journey—unfortunate.
POSEIDON Before they embark, or on the open sea?
ATHENE At sea!
When they are under sail from Troy, nearing their homes!
Zeus will himself send rain in floods with incessant hail
And black tornadoes—give me his lightning-fire to blast
And burn the Achaean ships. Then do your part: infuriate
The Aegean with waves and whirlpools; let floating corpses jostle
Thick down the Euboean Gulf; so that Greeks may learn in future
To respect my altars and show humility before the gods.
POSEIDON Athene, the help you need shall be given without more words.
I will uproar the whole Aegean; the shores of Myconos,

The Delian reefs, Scyros, Lemnos, the Capherian
 capes,
Shall gather the drowned by thousands. Now go
 back to Olympus;
Receive the lightning-shafts from your father's hand;
 and watch
For the Argive ships of was to spread their sails for
 home.
 When a man who takes a city includes in the
 general destruction
Temples of the high gods and tombs that honour the
 dead,
He is a fool: his own destruction follows him close.

(ATHENE *and* POSEIDON *depart in different directions.
The recumbent figure of* HECABE *stirs: she rises on one
arm*)

Strophe 1

HECABE Lift your neck from the dust;
 Up with your head!
 This is not Troy; the kings of Troy are dead:
 Bear what you must.
 The tide has turned at length:
 Ebb with the tide, drift helpless down.
 Useless to struggle on,
 Breasting the storm when Fate prevails.
 I mourn for my dead world, my burning town,
 My sons, my husband, gone, all gone!
 What pride of race, what strength
 Once swelled our royal sails!
 Now shrunk to nothing, sunk in mean oblivion!

Antistrophe 1

 How must I deal with grief?
 Hold, or give rein?
 See where my outcast limbs have lain!
 Stones for a bed bring sorrow small relief.
 My heart would burst,
 My sick head beats and burns,
 Till passion pleads to ease its pain
 In restless rocking, like a boat
 That sways and turns,
 Keeping sad time to my funereal song.
 For those whom Fate has cursed
 Music itself sings but one note—
 Unending miseries, torment and wrong!

Strophe 2

 When the swift-winged Hellene ships
 Sailing from their land-locked ports
 Through the salt sea's purple glow
 Swooped on sacred Ilion,
 Shrill, triumphant from a thousand flutes and pipes
 Rose their martial music.
 In the gulf of Troas

 (Ah, poor Troas!)
 They made fast their hawsers of Egyptian twine,
 Sworn to bring back hated Helen,
 The cursed wife of Menelaus,
 Sparta's shame and Castor's ruin, her whose sin
 Struck down Priam, patriarch of fifty sons,
 Wrecked my life, and left me
 Stranded and despairing.

Antistrophe 2

 Here near Agamemnon's tent,
 Prisoner and slave, I sit,
 An unpitied exile,
 Old, my grey hair ravaged
 With the knife of mourning.
 Come, you widowed brides of Trojan fighting-men,
 Weeping mothers, trembling daughters,
 Come, weep with me while the smoke goes up from
 Troy!
 Once with cheerful Phrygian music,
 Solemn hymns and sacred dances,
 I, Queen Hecabe, Priam's sceptre in my hand,
 Led your steps and voices:
 Now the song is saddened
 To the seagull's crying round her helpless young.

(*The first half of the* CHORUS *has begun to enter: they
group themselves round* HECABE)

Strophe 3

CHORUS 1 We heard your voice, Hecabe; why did
 you call?
 What did you say? As we sat there indoors
 Thinking of slavery with bitter tears,
 Your cry of agony came to us, and we all
 Shuddered with nameless fears.
HECABE The Argive crews muster and grip their oars.
CHORUS Will they take us now? What have you heard?
 Is this our last breath of our native air?
HECABE Who knows? I guess the worst.
CHORUS Soon we shall hear the final, dreaded word:
 'Out of the house, you Trojan slaves! On board!
 The Argive fleet sets sail for home!'
HECABE Cassandra—no! That must not be!
 Keep my frenzied child Cassandra there!
 Hold her—she must not come!
 It would crown my grief to see
 Her go dishonoured to her captor's bed.
 Troy, Troy! This is your ultimate agony—
 Robbed of your living remnant, deserted by your dead!

 (*The second half of the* CHORUS *now enters*)

Antistrophe 3

CHORUS 2 I came to ask for news;
 Speak to me, Hecabe! Terrors come
 crowding thick—

HECABE (continued column left, first speaker rows)

	Have they resolved to kill us? Are the crews
	Taking their places at the oars?
	Is there no word yet of our fate?
HECABE	My child, I do not know.
	I came out here because, maddened and sick
	With horror, I could not sleep.
CHORUS	Oh! To what pitiless master shall I go?
HECABE	You have not long to wait.
CHORUS	But long to weep.
	A slave? Where will my new home be?
	Some island? Famous Argos, or Thessaly?
	Far, far form Troy!
HECABE	A queen—to fall so low!
	On what strange, distant shore
	Shall I, to whom my country gave
	Honour, authority, imperial sway,
	Be set by some Greek lord
	To tend his children, or to keep
	Watch at his door—
	An aged, useless ghost, unknown, ignored,
	A shadow of death—a slave!

Strophe 4

CHORUS What words of yours can release
Pity to match your pain?
And I—never again
Shall I sway to the shuttle's song,
Weaving wool spun from a home-bred fleece!
Instead, one last, last look at the faces of my dead
 sons,
Then go to meet yet worse—
Forced, maybe, to the bed of some lustful
 Greek—
Listen, gods, to my curse
On the night that hides such wrong!
By day, servile and meek,
Carrying water from the well—
Perhaps, holy Peirene!—This is my first prayer,
To go to famous Athens, where
The streets are golden, so they tell;
But not to Sparta, where the wild Eurotas runs,
Not to hated Helen's cruel employ—
Menial to Menelaus, murderer of Troy!

Antistrophe 4

I have heard it told
That, above broad Peneius, enchanting fields,
The green plinth of Olympus, hold
Rich fruits and heavy harvest; there,
After King Theseus' sacred earth,
My second choice would lie.
They say, the land of Aetna, where
Hephaestus' forge clangs underground,
And eastward, fronting the Phoenician Sound,
The Mother of Sicily's mountains towers high—
Far-reaching fame has crowned

This land for people of heroic worth.
There is a valley, yet again,
Lying nearest to the Ionian Sea,
Where the most lovely of all rivers runs,
Crathis, whose waters, fed by fertile dews,
The gift of Heaven, supply
Wealth and good living to its hardy sons:
There is a home that I would choose!

Look! The herald from the Achaean camp,
Hurrying here with urgent orders!
What has been decided? What will be his message?
Now our slavery begins:
We are chattles of the Dorian State!

(*Enter* TALTHYBIUS. HECABE, *who did not turn when the* CHORUS *announced his approach, still stands without looking at him*)

TALTHYBIUS Hecabe, my frequent journeys here to
 Troy as herald
Of the Achaean army have made me known to you.
I am Talthybius, lady; and I come with news.

HECABE Dear friends, it has come. Women of Troy,
 The moment we have dreaded is now here.

TALTHYBIUS You have all now been allotted—if this
 was what you feared.

HECABE What is our fate? Are we for Thessaly?
 Or Phthia? Or for the land of Cadmus?

TALTHYBIUS Each is assigned to a different man, not
 all to one.

HECABE Tell each of us her fortune.
 Which of Troy's women has a golden future?

TALTHYBIUS I know; but you must ask one question at
 a time.

HECABE Then tell me about my daughter, poor
 Cassandra.
 Whose share is she?

TALTHYBIUS King Agamemnon chose her as his special
 prize.

HECABE A slave for his Spartan wife?
 O miserable fate!

TALTHYBIUS No, for his own bed. She is to be his
 concubine.

HECABE But she belongs to the bright-haired Apollo—
 A consecrated virgin, set aside
 By him to live in single purity!

TALTHYBIUS She is god-possessed; but she has
 captured the king's heart.

HECABE Cassandra, fling your temple-keys away,
 Strip off your vestments, tear your holy
 wreath!

TALTHYBIUS Is it not good fortune that she is chosen
 for the king's bed?

HECABE What of my other daughter, whom you
 took
 From me last night?

TALTHYBIUS Is it Polyxena you are speaking of?

HECABE It is.
 Has she been drawn for? Whose yoke does she
 bear?
TALTHYBIUS She has been made attendant at Achilles'
 tomb.
HECABE Attendant at the tomb! My child! Talthybius,
 Is this some Greek tradition?
TALTHYBIUS Be happy for your daughter; all is well
 with her.
HECABE What do you mean? At least she is alive?
TALTHYBIUS Her fate is settled. She is free from
 suffering.
HECABE What is decided for my daughter-in-law,
 Iron-hearted Hector's wife, Andromache?
TALTHYBIUS She too was specially chosen, by Achilles'
 son.
HECABE And I, whose shaking hand leans on a stick,
 Whose slave am I, grey-headed Hecabe?
TALTHYBIUS You were assigned to Odysseus, king of
 Ithaca.
HECABE Odysseus? Oh! Odysseus! Now
 Shear the head, tear the cheek,
 Beat the brow!
 Cruellest fate of all! Now I belong
 To a perjured impious outcast, who defies
 Man's law and God's; monster of wickedness
 Whose tongue twists straight to crooked, truth to
 lies,
 Friendship to hate, mocks right and honours wrong!
 Now my fated life, dear friends,
 Sinks and ends.
 Weep for me, and veil my head;
 Hope is dead; today I know
 The last throe of misery!
CHORUS Mistress, you know your own fate now; but
 what of us?
 What Greek lord holds our helpless future in his
 hands?
TALTHYBIUS Men, go inside and bring Cassandra out
 at once.
 First I must hand *her* over to the general; next,
 Distribute the other women according to the draw.
 —Why, look there! Flames, pine-torches burning!
 Those women—
 Are they now trying to set the place on fire, or what?
 Have they resolved to burn themselves to death,
 rather
 Than be brought back to Argos? Strange how
 intolerable
 The indignity of slavery is to those born free.
 Open the door, there! This may suit the prisoners;
 But our generals will be annoyed, and they'll blame
 me.
HECABE No, no: there is no fire. It is my poor
 daughter
 Cassandra—here she comes, possessed with
 prophecy.

(CASSANDRA *comes in with a flaming torch in each
hand. One she places in a sconce on the pediment of a
broken statue, and to this she turns when she addresses
Hymen; the other she holds in one hand as she moves
about the stage*)

CASSANDRA Raise the torch and fling the flame!
 Flood the walls with holy light!
 Worship the Almighty
 Hymen, God of Marriage!
 Agamemnon, master of my maiden flesh,
 King of Argos, take me!
 Heaven's blessing falls on me and falls on you.
 Hear our cry of worship,
 Hymen, God of Marriage!

 Mother, since *you* crouch and cry
 Weak with tears and loud with grief
 For my dear dead city
 And my murdered father,
 I have brought them—torches for my wedding-night,
 Leaping light and dancing flame,
 In your honour, Hymen, God of hot desire!
 Queen of Darkness, send the gleam you love to lend
 To the ritual blessing
 Of the wedded virgin!

 Dancers, come!
 Loose your leaping feet,
 Wild with wine of ecstasy!
 Glorify my father's happy fate!
 God Apollo, lead this holy ritual dance!
 In your temple-court,
 Under your immortal laurel-tree,
 I your priestess call on you!
 Hymen, mighty god,
 Hymen, hear!

 Come and dance,
 Mother, dance with me;
 Charm the Powers with lucky words,
 Loudly chant your daughter's wedding-song!
 Wildly whirl and turn in purest ecstasy!
 Maids of Troy,
 Wear your brightest gowns:
 Come, and sing my wedding-song,
 Hail the lover Love and Fate appoint for me!
CHORUS Queen Hecabe, she is out of her mind. Oh,
 can you not
 Control her?—or she'll go dancing down to the
 Greek camp!
HECABE Hephaestus! In our weddings you are
 torch-bearer;
 But this torch-bearing is a hideous mockery
 Of all that I once hoped for. O my child, my child!
 I little thought your marriage would be thus—a slave
 Taken in war, the plunder of a conquering Greek!—

Give me that torch; to carry it is sacrilege,
When you are raving. You are unchanged; all that we
Have suffered brings no healing to your distracted
 mind.
Women of Troy, take in these torches. Let your tears
Offer the only answer to her wedding-songs.
CASSANDRA Mother, wreathe a triumphal garland
 round my head;
I'm to be married to a king; rejoice at it!
If you find me unwilling, take me, make me go.
As sure as Apollo is a prophet, Agamemnon,
This famous king, shall find me a more fatal bride
Than Helen. I shall kill him and destroy his house
In vengeance for my brothers' and my father's death.
But let that go; my song shall not tell of the axe
Which is to fall on my neck—and not only mine;
Nor of the agonies my marriage will beget
When son shall murder mother; nor of the overthrow
Of the whole house of Atreus. Yes, there is a god
Possesses me; but this at least is truth untouched
With madness: I will show you that this Troy of ours
Was more to be envied that those Greeks. They, for
 the sake
Of one woman and her unlawful love, unleashed
The hunt for Helen and sent ten thousand men to
 death.
Their sage leader, to win what he most loathed,
 destroyed
What most he cherished; sacrificed the joys of home,
And his own child's life, to his brother—for a woman
Who was not plundered from him, but went willingly.
 And when they reached the shore where the
 Scamander flows,
What did they die for? To thrust invasion from their
 borders
Or siege from their town walls? No! When a man was
 killed,
He was not wrapped and laid to rest by his wife's
 hands,
He had forgotten his children's faces; now he lies
In alien earth. At home, things were as bad; women
Died in widowhood; fathers sank to childless age,
Missing the sons they brought up—who will not be
 there
To pour loving libation on their graves. Hellas
Has much, in truth, to thank this expedition for!
And there were worse things still, horrors too
 shameful for
A tongue turned to the holy muse of prophecy.
 How different for the men of Troy, whose glory it
 was
To die defending their own country! Those who fell
Were carried back by comrades to their homes,
 prepared
For burial by the hands they loved, and laid to rest
In the land that bore them; those who survived the
 field returned

Each evening to their wives and children—joys denied
To the invaders. Even in Hector's death, mother,
I can see more than sorrow; for he did not die
Till he had made himself a hero's name; and this
Came through the Greek invasion—had they stayed
 at home
Where would be Hector's glory? Paris too received
For his bride no nameless stranger, but the daughter
 of Zeus.
 Indeed to avoid war is a wise man's duty; yet
If war comes, then a hero's death confers as much
Fame on his city as a coward's brings infamy.
Therefore, dear Mother, you must not bewail our land,
Nor weep for my lost maidenhood. My bridal-bed
Promises death to my worst enemy and to yours.
CHORUS You speak of the extinction of your family
With a bland smile! And as for your prophetic muse,
You've little truth to show for all this eloquence.
TALTHYBIUS Were it not that Apollo has unhinged
 your mind,
Your ill-conceived words, aimed at our commander
 just
As he sets sail, would meet their proper punishment.
 And yet—how strange that reputation and high
 place
Can prove itself no wiser than a common clown!
Here's Agamemnon, son of Atreus, supreme head
Of a great Hellenic army, picks out this mad girl
To fall in love with! Well, I'm a poor man, but I
Would not accept her as a wife on any terms.
So (*to Cassandra*) your insults to Argos, and your
 praise of Troy,
May go to the winds, seeing you're not in your right
 mind.
Follow me to the ship—our general's lovely bride!
—You too, Hecabe, when Odysseus sends for you,
Go at once. You will be servant to Penelope,
Whom all the Greeks here speak of as a virtuous
 woman.
CASSANDRA 'Servant'! You hear this servant? He's a
 herald. What
Are heralds, then, but creatures universally loathed—
Lackeys and menials to governments and kings?
You say my mother is destined for Odysseus' home:
What then of Apollo's oracles, spelt out to me,
That she shall die here? There are other things, and
 worse,
Which I will not tell. Poor Odysseus! If he knew
What miseries are in store for him, my fate and Troy's
Would seem the bliss of paradise! When he as added
To these ten years at Troy another ten, at last
He shall reach home alone. (In his long wandering
He shall pass the rocky gorge where dread Charybdis
 lives;
The mountains haunted by the cannibal Cyclopes;
Meet with Ligurian Circe, who turns men to swine;
Be shipwrecked; tested by the lotus-food; appalled

By the sacred oxen of the Sun, whose flesh shall speak
In human tones; he shall go down alive to hell;
Escape the dark mere, and win home to Ithaca
To find his palace plagued with ills innumerable.)
 Why lament Odysseus' troubles with these flights of
 prophecy?
Lead on quickly! At the porch of death my
 bridegroom waits for me.
Great chief of the Hellenes, fleeting shadow of
 magnificence,
Your accursed life shall sink in darkness to an
 accursed grave;
Me too they'll fling out beside you naked, where the
 wild ravine
Roars in flood—Apollo's priestess; and the beasts
 will pick my bones.
Garlands of a god belov'd, dear ritual vestments,
 now farewell!
Go, his gifts, with the lost joys of holy feasts, my
 glory once;
From my still untainted body I tear you, thus!—for
 the swift winds
To receive and carry back to Apollo, lord of prophecy.
Where's the commander's ship? Which way? Come,
 lose no time, take me on board;
Watch for a wind to stir the sails. The prisoner you
 will bring to Greece
Comes as one of three Avengers.—Mother, no more
 tears; farewell!
O my brothers, deep in this dear earth of Troy; my
 father too,
Priam, you whose blood we all inherit! You will not
 be long
Waiting for me. I will come triumphant to the house
 of Death,
When I have brought to ruin the sons of Atreus, who
 destroyed us all.

(CASSANDRA *goes out with* TALTHYBIUS. HECABE *collapses to the ground*)

CHORUS Look, friends! Our mistress has collapsed
 without a word.
We should look after her, not leave her lying there
Stretched out. She is old and weak; come, help her,
 lift her up.
HECABE Let me lie. There's no comfort in your
 comforting.
Here in the dust pain such as mine belongs—today's,
yesterday's, and tomorrow's pain. O gods!—The gods,
I know, are treacherous allies; yet, when misery
Drives to despair, it seems in some way suitable
To call on gods. First, then, I'll sing past happiness;
This tale will edge the piteousness of present grief.
 I was a princess born; my husband was a king.
The sons I bore were heros to a man, not cast
In the common mould, but manliest of the Phrygian
 race;

No mother in Troy, in Hellas, or in all Asia,
Could ever boast such sons. I saw them one by one
Fall to Greek spears. I cut locks of my hair to lay
On their still graves. The father of them all, Priam,
Is gone. No message taught me to weep seemly tears;
Myself, with these same eyes, I saw him hacked to
 death
At his own altar, and his city laid in dust.
My virgin daughters, whom I cherished as choice gifts
For husbands worthy of them, were torn from my
 arms,
Given to our enemies. There is no hope that they
Ever again will see their mother, nor I them.
Now comes the last, the crowning agony; that I
In my old age shall go to Hellas as a slave.
They will lay on me tasks to humble my grey head—
Answering the door, or keeping keys, or cooking
 food—
I, who bore Hector! I shall lay my shrivelled sides
To rest, not in a royal bed, but on the floor;
And wear thin, faded rags to match my skin and mock
My royalty. O misery! Through one woman's love,
What pains have racked me, what despair still waits
 for me!
 Dear child, Cassandra, you who shared the
 mysteries
Of gods, what outrage cancels your virginity!
And you, Polyxena, child of sorrow, where are you?
Of all my children, not one daughter, not one son
Is left to help me. Then why lift me up? What hope
Is there? The soft proud days of Troy are past; lead
 me
To find my hard slave's pallet and my pillow of
 stones,
And die under the lash of tears. Good fortune means
Nothing; call no man happy till the day he dies.
CHORUS Come, Muse, in tears begin,
 And sing strange dirges over Ilion's grave.
 Now loud and clear the story shall be told
 Of that wheeled horse that brought the Argives in,
 Made Troy a ruin, me a slave.

 On towering legs, bridled with gold,
 Stuffed with swords that rang to the sky,
 They left it near our city's gate.
 Up to the Trojan Rock we rushed, and stood
 Shouting, 'The war is over! Come,
 Bring in the wooden horse for an offering
 To the Daughter of Zeus, Pallas, Lady of Troy!'
 Then what girl would stay behind?
 When even the old men left their chairs,
 And with laughing and singing all laid hold
 Of that hidden death that had marked them
 down.

 The nation of Troy streamed from the town,
 And Priam himself went with them,

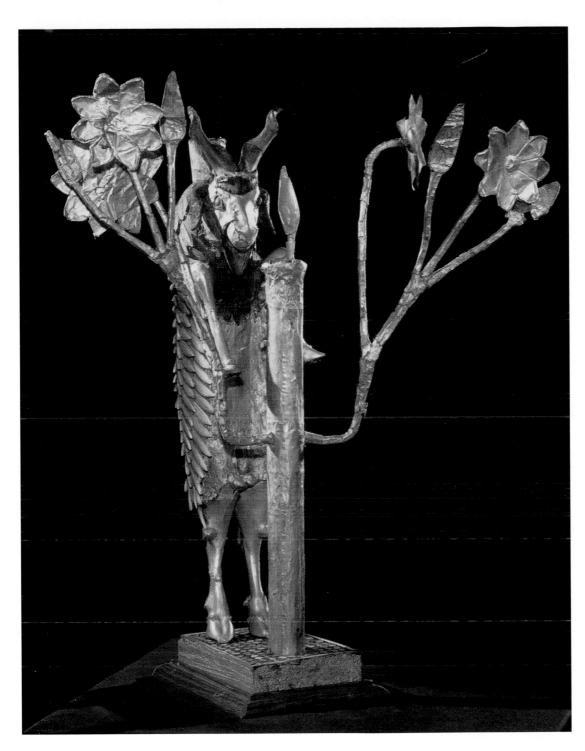

Plate I
Ram in the Thicket,
offering stand from
Ur, about 2600 B.C.
Gold, silver, lapis
lazuli, shell, and red
sandstone on wood.
Height 20″.

Plate II
Sun God on a Lotus,
Tutankhamen, c. 1342
B.C. 18th Dynasty.
(Egyptian National Museum,
Cairo Museum/Superstock)

Plate III
Queen Nefertiti,
c. 1365 B.C. Painted
limestone. Height 19⅝″.
(Agyptisches Museum SMPK,
Berlin. Photograph: Bildarchiv
Preussischer Kulturbesitz,
Berlin)

Plate IV
The Court of Emperor Justinian, mosaic, from apse of San Vitale, Ravenna, c. A.D. 547.
(Scala/Art Resource, NY)

Plate V
Interior, Great Mosque
of Cordoba, Spain,
A.D. 786.
(Scala/Art Resource, NY)

To honour the Virgin Pallas,
Driver of Heaven's immortal horses, and offer to her
This gleaming monster of mountain pine
That hid the waiting swords of Greece.
Hauling on cables of flaxen twine
Like a ship's dark hulk they drew it along
And up the hill to the Temple rising white;
And placed their gift on the holy floor of Pallas,
Where the slaughter of Troy began.

Over their happy weariness fell the shadow of night.
Then Libyan flutes rang out,
And the old tunes were played,
And our hearts were joined in singing
And in music of dancing feet;
Until through the darkened palace
One flare still left alight
Flickered on sleeping faces its dim gleam of fire.
I was at home that night,
Joining in songs and dances
To honour the Maiden Goddess,
Artemis of the Mountains;
When—over the streets of the central city
A shriek of death rose like a grip at the throat;
And trembling children clutched at their mothers'
 skirts;
And War went forth from his secret lair;
And the work of the virgin Pallas was accomplished.

Men sank in blood while their dead hands clasped
 the altar;
The head half-raised from the pillow
Defenceless rolled from the severed neck;
And beside the dead the victor's lust
Planted the seed of a son for Hellas,
Watered with tears of Troy's despair.

(ANDROMACHE *approaches, drawn in a chariot by
Greek soldiers. She holds* ASTYANAX *on her lap*)

CHORUS Hecabe, see! Andromache is coming,
 Drawn in a Greek chariot, beating her breast;
 And Hector's son Astyanax is with her.
 Where are they taking you, sad Andromache,
 And beside you Hector's sword and armour of bronze,
 And other spoils of Troy, which Achilles' son
 Shall dedicate in distant temples of Thessaly?
ANDROMACHE The Achaeans are carrying home their
 property.
HECABE O Zeus, have pity!
ANDROMACHE That prayer is mine by right—
HECABE O Zeus!
ANDROMACHE —bought with my husband's blood,
 my tears.
HECABE Children!—
ANDROMACHE No more your children: all that is ended.
HECABE Once we were happy, and Troy—all that is
 ended.

ANDROMACHE Ended.
HECABE My noble children!
ANDROMACHE They are gone.
HECABE Gone; and my home, my lovely city—
ANDROMACHE Gone!
HECABE Now smoke and ashes!
ANDROMACHE Hector, my own husband—
HECABE Hector is with the dead. Hector, my son!
 My daughter!
ANDROMACHE Hector, when will you come to help
 me?
HECABE Priam, aged king of my princely sons,
 Priam, fallen a sport for your enemies,
 Soothe my head on the pillow of death!
ANDROMACHE All the love we have lost!
HECABE The grief we have gained!
ANDROMACHE All that we knew, destroyed!
HECABE All anguish doubled!
ANDROMACHE The gods have hated us, since the day
 when Paris
 Was spared at his birth, to live and destroy his country
 For the sake of the accursed Helen. Now vultures
 wheel,
 Waiting to tear the dead stretched at the feet
 Of Pallas, while we—are slaves and must look on.
HECABE O city, dead, deserted, I weep for you.
 Home where my babes were born, this is your end:
 Who would not weep? City lost, children lost,
 All lost! Was there ever heard such chorus of pain?
 When were such tears shed for a murdered house?
 Can even the dead see this, and forget to weep?
CHORUS In times of sorrow it is a comfort to lament,
 To shed tears, and find music that will voice our grief.
ANDROMACHE Do you see this armour? It is your son
 Hector's. He
 With this spear killed more Greeks than any other
 man.
HECABE I see how the high gods dispose this world;
 I see
 The mean exalted to the sky, the great brought low.
ANDROMACHE I and my son are carried off as spoils
 of war;
 Royalty is enslaved, the world turned upside down.
HECABE It's a strange thing to meet the irresistible.
 Just now I saw Cassandra dragged away by force.
ANDROMACHE Poor child, poor girl!—to meet a
 second Aias like
 The first. But listen: there's more bitterness for you.
HECABE There is always more; my suffering has no
 limit, none;
 And each new misery outdoes what went before.
ANDROMACHE Polyxena is dead. They sacrificed
 her at
 Achilles' tomb—an offering to a lifeless corpse.
HECABE Oh, no! Oh, horror! That was what
 Talthybius meant
 By his evasive answers. It was plain enough.

ANDROMACHE I saw her there myself. I left the chariot,
 Wrapped a robe round her body, and paid my due of tears.
HECABE What sacrilegious murder! Oh, my child, my child
 Polyxena! How terrible to die like this!
ANDROMACHE It is over now. Yes, it was terrible; and yet,
 Being dead, she is more fortunate than I who live.
HECABE Not so, my daughter; death and life are not the same.
 Death is extinction; but in life there is still hope.
ANDROMACHE Hecabe!—you are my mother, as you are hers—let me
 Comfort your heart with welcome truth. I believe this:
 To be dead is the same as never to have been born,
 And better far than living on in wretchedness.
 The dead feel nothing; evil then can cause no pain.
 But one who falls from happiness to unhappiness
 Wanders bewildered in a strange and hostile world.
 For Polyxena it is as though she had not been born;
 In death she recalls none of her past sufferings.
 For me it is different. I made high repute my aim,
 Achieved it, and now forfeit all that I achieved.
 As Hector's wife I strictly set myself to attain
 All womanly perfections, every sober grace.
 First, since a woman, however high her reputation,
 Draws slander on herself by being seen abroad,
 I renounced restlessness and stayed in my own house;
 Refused to open my door to the fashionable chat
 Of other wives. Having by nature a sound mind
 To school me, I was sufficient to myself. I kept
 Before my husband a quiet tongue, a modest eye.
 I knew in what matters it was for me to rule,
 And where in turn I should yield him authority.
 It seems report of me reached the Greek camp; and this
 Was my undoing. When I was taken, Achilles' son
 Asked for me as his wife. So I shall live a slave
 In the house of the very man who struck my husband dead.
 If I put from me my dear Hector's memory,
 And accept my new husband with an open heart,
 I prove a traitor to the dead; but if I hate
 This man, I shall be hateful to my own master.
 And yet they say one night dispels antipathy
 To any man's embrace! How I despise the woman
 Who in a strange bed turns against the man she knew
 And loves another! Even a horse, when separated
 From its stable-companion, will not pull its weight;
 And beasts are in their nature far inferior
 To man, wanting both voice and rational discourse.
 Dear Hector, you had all I looked for in a man,
 All in abundance—wisdom, birth, wealth, manliness!
 You took me untouched from my father's house to be

Your wife; my maiden flesh was first and only yours.
 Now you are dead; and I, a prize of war, must sail
 To slavery in Hellas. Hecabe, you weep
 For dead Polyxena: is not her fate less hard
 That what I have to bear? For me there is not even
 The common refuge, hope. I cannot cheat myself
 With sweet delusions of some future happiness.
CHORUS Your suffering is the same as ours; your bitter words
 Teach us to sound the depths of our own misery.
HECABE At sea, when sailors meet rough weather, the whole crew
 Works with good heart to outlive danger. One man stands
 By the helm, another trims the sail, while a third keeps
 The hull from filling; though I was never in a ship,
 I have seen pictures and heard many talk of it.
 But when the sea boils with an overwhelming surge,
 Then they give in to Fate, and let the racing waves
 Hurl them along at will. So I am vanquished by
 This storm the gods have sent; my troubles multiply
 And leave me speechless with despair. But, O my dear
 Daughter, cease mourning now for Hector; all your tears
 Cannot help him. And honour your new master; win
 His love as a husband by your own sweetness and worth.
 The favour so gained will bring joy to all your friends,
 And—who knows?—you may yet bring up our Hector's son
 To light new hope for Troy; your sons, one day, may yet
 Found a new Ilion, and our city live again.
 But look—I see the Achaean herald coming back.
 Word grows from word; why is he here? He has instructions
 To tell us something new that they've decided on.

(*Enter* TALTHYBIUS)

TALTHYBIUS Andromache, now widow of Troy's once greatest man,
 Do not hate me. I speak these words reluctantly.
 The Greeks and their two generals sent me to convey—
ANDROMACHE Your words sound heavy with foreboding.
 What is it?
TALTHYBIUS Their joint decision, that your son—how can I say it?
ANDROMACHE We are assigned to different masters— is it this?
TALTHYBIUS No; no Achaean will ever be your son's master.
ANDROMACHE What? Must he stay here, the sole remnant of our city?

TALTHYBIUS My news is bad. I don't know how to find the words.

ANDROMACHE At least you show some scruple, if you bring no joy.

TALTHYBIUS Then know the worst: the Greeks are going to kill your son.

ANDROMACHE Oh, no, no! This is worse than what they do to me.

TALTHYBIUS Odysseus in a full assembly made his point—

ANDROMACHE But this is horrible beyond all measure! Oh!

TALTHYBIUS That such a great man's son must not be allowed to live—

ANDROMACHE By such a sentence may his own son be condemned!

TALTHYBIUS But should be thrown down from the battlements of Troy.
Now accept this decision, and be sensible.
Don't cling to him, or tell yourself you have some strength,
When you have none; but bear what must be like a queen.
You have no possible source of help. See for yourself:
Your city is destroyed, your husband dead; you are
A prisoner. Shall we match our strength against one woman?
We can. I hope, therefore, you will not feel inclined
To struggle, or attempt anything unseemly, or
Likely to cause resentment. This too: don't call down
Curses upon the Greeks. If you say anything
To make the army angry, this child will receive
No mourning rites, no burial. If you are quiet,
And in a proper spirit accept what comes to you,
You will not have to leave his body unburied, and
You'll find the Achaeans more considerate to yourself.

ANDROMACHE O darling child, prized at too great a worth to live!
You die, at enemy hands, and leave me desolate.
Your noble father's greatness, which to other men
Brought hope and life and victory, will cost you your death.
For you his courage proved a fatal heritage.
O marriage-bed, which welcomed me as Hector's bride—
Ill-fated happiness! I thought then my son would be
King over Asia's teeming multitudes; not die
By a Greek ritual of murder.—Little one,
You are crying. Do you understand? You tug my dress,
Cling to my fingers, nestling like a bird under
It's mother's wing. No Hector will come now to save
Your life, rise from the grave gripping his famous spear;
No army of your father's family, no charge

Of Phrygian fighters. You must leap from that sickening
Height, and fall, and break your neck, and yield your breath,
With none to pity you. Dear child, so young in my arms,
So precious! O the sweet smell of your skin! When you
Were newly born I wrapped you up, gave you my breast,
Tended you day and night, worn out with weariness—
For nothing, all for nothing! Say good-bye to me
Once more, for the last time of all. Come close to me,
Wind your arms round my neck, and put your lips to mine.
 Hellenes! Inventors of barbaric cruelties!
What has he done? Why will you kill this child?—
 Helen,
Tyndareos' daughter! You were never daughter of Zeus!
You had many fathers; the Avenging Curse was one,
Hate was the next, then Murder, Death, and every plague
That this earth breeds. I'll swear Zeus never fathered you
To fasten death on tens of thousands east and west!
My curse on you! The beauty of your glance has brought
This rich and noble country to a shameful end.
Take him, you robbers, throw him, carry out your decree!
Feast on his flesh! The great gods are destroying us;
I am powerless to save my son from death. Hide me,
Fling my miserable body into your ship! I go
To my princely marriage, and leave behind me my dead child.

CHORUS O miserable Troy, you have lost ten thousand dead
All for one woman's sake and her accursed love!

TALTHYBIUS Come, child; I pity your mother, but time is up.
 No more embracing now.
You must climb to the topmost fringe of your father's towers,
Where the sentence says you must leave your life behind.
 Take him.—A job like this
Is fit for a man without feeling or decency;
 I'm not half brutal enough.

(TALTHYBIUS *and his men go out with* ASTYANAX, *followed by* ANDROMACHE)

HECABE O little child, son of my dear lost son,
 Your life is ravished from us by murderers.
 What will become of us? What can I do for you?

Only to beat the head and bruise the breast—
 This we can give; no more.
Lost city, lost child; what climax of suffering
 Lacks now? Have we now reached
 In a headlong plunge the abyss of pain?

Strophe 1

CHORUS:
Far off in the island of Salamis, whose
 bee-haunted slopes
Look out over the circling surf to that holy rock
Where Athene first displayed the dark-green shoot of
 an olive.
To anoint and bless with a heavenly crown the city of
 Athens,—
 In Salamis lived King Telamon,
Who once, as ally and friend of the mighty archer
 Heracles,
 Came with an army to Ilion,
Came long ago to plunder and burn our city of Ilion.

Antistrophe 1

That was the former time, when Heracles, enraged
For loss of the just reward our king refused him,
 landed
The flower of Grecian youth on the lovely banks of
 Simois,
Eased his oars from the sea, and fastened his
 stern-cables.
 Then from the ship he brought his bow,
Shaped for the skill of his hand, bent for Laomedon's
 blood;
And he split with fire's red blast the stones that
 Apollo squared,
 And laid in the dust our city's life.
So twice the reeking sword has pierced the heart of
 Troy,
 Twice her towers have crashed in thunder.

Strophe 2

Why, then, Ganymede, son of Laomedon,
You who walk delicately among golden wine-cups
Pouring out wine for Zeus, your exalted office
Brought little help to your boyhood's home!
Look! The land of your birth is a blazing heap!
Listen! What cry comes from the shore?
Seagulls robbed of their young?
No! Wives for their husbands, mothers for sons,
Daughters for aged mothers weep and howl!

 The sandy course you ran and wrestled on,
 The dewy fountains where you bathed, are gone.
 Still near the heavenly throne the same fresh grace
 Lights the untroubled beauty of your face;
 But Troy, where you began,
 Greeks have stamped out the last man.

Antistrophe 2

Love once came to the house of Laomedon,
Beguiling gods to favour the royal family,
Linking Troy with Olympus in marriage-bonds,
Exalting Troy to the height of Heaven.
Had Zeus, for Ganymede's sake—No! no reproach!
But how could Dawn, of the gleaming wing,
Dawn, that the whole world loves,
How could *she* smile down on us dying, dying,
Rise on our devastated streets, and smile?

 For this land gave her what she held most dear,
 Our royal prince, Tithonus, who begot
 Her sons, whom in hcr goldcn chariot
 She bore off heavenward through the starry
 sphere.
 He was Troy's hope; but he
 And all Troy's hopes from Heaven were vanity.

(*Enter* MENELAUS, *with soldiers*)

MENELAUS How gloriously the sun shines on this
 happy day!
 Today I shall lay hands on Helen my wife. I am
 Menelaus, the man who has endured this ten years'
 toil—
 With the help of the Greek army. Yes, I came to Troy
 Not so much for her sake as people think; but rather
 To find the man who entered my house as a guest,
 Deceived me, and stole my wife. That man—the gods
 be praised—
 Has paid for it; so has his country, laid in ruin
 By the Greek army. And I am here now to fetch home
 The Spartan woman, once my wife—even to speak
 Her name I find distasteful. She is in this building,
 Held prisoner with all the women taken in Troy.
 The men whose years of fighting captured her at last
 Gave her to me to kill, or not kill, if I chose
 Instead to take her back to Argive territory.
 And I've decided not to carry out sentence here
 But take her back to Hellas, and there see that she
 Pays with her blood for all my friends who died at
 Troy.
 (*To the soldiers*) What are you waiting for? Get in
 and fetch her here,
 Drag her out by the hair—bloodthirsty murderess!
 Then all we need is a fair wind, and we'll have her
 home.
HECABE O thou, this earth's upholder, throned above
 the earth,
 Great Zeus, whoever thou art, mysterious and
 unknown,
 Be thou human intelligence, or natural law,
 I praise thee! For thou movest on a noiseless path
 And guidest all the affairs of men to their just end.
MENELAUS That's a new kind of prayer to heaven.
 What does it mean?

HECABE I applaud you, Menelaus, if you will kill your
 wife;
 But avoid seeing her, or she will take prisoner
 Your tender heart. She captures men's eyes, destroys
 cities,
 Burns houses to the ground, so potent are her spells.
 I know her, so do you, and all who have suffered
 know.

(HELEN *enters, the soldiers following her*)

HELEN Menelaus, is this beginning meant to frighten
 me?
 Your men seized me and hurried me out here by force.
 I think I know you hate me; but I wish to ask,
 What sentence have the Greeks, and you, passed on
 my life?
MENELAUS There was no question in your case. The
 whole army
 Of Greece gave you to me, whom you have wronged,
 to kill.
HELEN Have I permission to reply to that sentence
 And plead that it would be unjust to take my life?
MENELAUS I've come to kill you, not to bandy
 arguments.
HECABE Let her speak, Menelaus; she must not die
 without
 A hearing. And let *me* undertake in turn to speak
 Against her. Of the mischief that she made in Troy
 You know nothing. The whole indictment, once
 complete,
 Will ensure her death; there can be no chance of
 escape.
MENELAUS It is a favour, and will take time; but if she
 wants
 To defend herself, she may. I grant this, let her note,
 For your sake, not from any indulgence towards her.
HELEN Perhaps, since you regard me as your enemy,
 You will not answer, whether I speak well or ill.
 But I will guess what charges you would level at me,
 And, since I too have things I would accuse you of,
 I will reply by weighing the one against the other.
 Hecabe here produced the first cause of our troubles
 When she bore Paris. Secondly, this city, and I,
 Were doomed by Priam, when he ignored the warning
 given
 By a dream of firebrands, and refused to kill his child.
 What followed then? Listen, I'll tell you. Paris was
 Made judge between three goddesses. Athene's bribe
 Was this: that he should lead the Phrygians to war
 And destroy Hellas. Hera promised him a throne
 Bestriding Asia and Europe, if he placed her first.
 Aphrodite, with extravagant praise of my beauty,
 Promised him that, if he judged her the loveliest,
 I should be his. What next? See how the story goes.
 Aphrodite won; and from my marriage Hellas gained
 This benefit: you today are neither overwhelmed
 By Asian armies, nor ruled by an Asian king.

The gain for Hellas was for me disastrous loss;
Sold for my beauty, I endure vile calumny
From those who should have placed a crown upon
 my head.
 You will say that I have not yet answered the main
 point—
How I came to set forth in secret from your house.
It was a goddess of invincible power who came
With Hecabe's evil genius, Paris (call him by
That name, or Alexander, as you please); and you,
To your shame, sailed off to Crete and left him in
 your house.
 My next question I ask myself rather than you.
What happened in my heart, to make me leave my
 home
And my own land, to follow where a stranger led?
Rail at the goddess; be more resolute than Zeus,
Who holds power over all other divinities
But is himself the slave of love. Show Aphrodite
Your indignation; me, pardon and sympathy.
 There is a further charge you may feel justified
In urging against me. When Paris was in his grave,
And no god was concerned to find me a husband—
 then,
You will say, I ought to have left Troy and made my
 way
To the Argive ships. I tried to do this. The gate-
 warders,
The sentries on the city walls, could testify
That more than once they found me slipping secretly
Down from the battlements by a rope. Then
 Deiphobus,
Defying the whole city's wish, took me by force
And kept me as his wife. Can you still think it just
To kill me? Would it not be more just to comfort
 me?
Not only was this marriage forced upon me, but
What ought to have been my crown of glory, my
 own person,
Condemned my life to this harsh bondage. Do you
 aspire
To govern gods? To wish this is mere foolishness.
CHORUS Now, Queen, speak for your children and
 your fatherland.
 Demolish this persuasiveness. Plausible speech
 Combined with such immorality is sinister.
HECABE To begin, then, I will vindicate the goddesses,
 And show how she has slandered them. I don't believe
 Gods to be capable of such folly, as that Hera
 Should bargain away Argos to barbarians,
 Or virgin Pallas see her Athens subjected
 To Troy. Why should they indulge in such frivolity
 As travelling to Mount Ida for a beauty-match?
 What reason could the goddess Hera have for being
 So anxious about beauty? Did she want to get
 A husband of higher rank than Zeus? Or was Athene,
 Who begged her father for perpetual maidenhood,

Disdaining love—now husband-hunting among the
 gods?
To cloak your own guilt, you dress up the gods as
 fools;
But only fools would listen to you. And Aphrodite,
You say—what could be more absurd?—went with
 my son
To Menelaus' palace! Could she not have brought
You, and your town of Amyclae, from Peloponnese
To Ilion, without stirring from her seat in heaven?
 No; Paris was an extremely handsome man—one
 look,
And your appetite became your Aphrodite. Why,
Men's lawless lusts are all called love—it's a confusion
Easily made. You saw him in his gorgeous robes
Glittering with oriental gold; and you went mad.
At home your style was cramped by insufficient
 means;
Once clear of Sparta—Troy would be a perpetual
Fountain flowing with gold, you hoped, for you to
 spend.
The palace of Menelaus was too confined a sphere
To give full scope to your luxurious insolence.
 Well now, you say my son abducted you by force.
What Spartan noble heard you call for help? What
 sort
Of outcry did you raise? Both Castor and his twin
Were there—they had not yet been placed among the
 stars.
Then, when you came to Troy, the Argives on your
 track,
And spears and shields were locked in battle, when
 you heard
Of a Greek victory, at once you praised Menelaus,
To remind my son of his great rival and gall his heart;
When Troy gained ground, you had no use for
 Menelaus.
You watched events; became a practised follower
Of fortune; duty and loyalty were not your concern.
 And then—this tale of slipping away by ropes let
 down
From the battlements, of being kept here against your
 will!
I'd like to ask, when were you found fitting a noose
To your neck, or sharpening a dagger? That was the
 obvious course
For a woman of breeding, if she pined for her first
 husband.
In fact I urged you constantly to get out of Troy;
My sons, I told you, could find other women to love.
'Go on,' I said, 'I'll help you escape to the Greek
 ships,
And end the war for them as well as for us.' But no;
The proposal did not please you; for in Paris's
 house
You could queen it haughtily; you liked to see
 Phrygians

Kneeling before you; this flattered your pride. And
 now,
To crown all, you have come out here beautifully
 dressed,
You have the loathsome impudence to lift your eyes
To the same sky as your husband! If you felt some
 sense
Of what you have been guilty of in the past, you
 would
Have come crawling and shivering, your dress in rags,
Your hair clipped to the scalp, to show some
 penitence.
 Menelaus, this is my last word: be worthy of
Yourself, and set the crown on Hellas' victory.
Kill Helen, and establish in all lands this law,
That every wife unfaithful to her husband dies.
CHORUS Punish your wife, Menelaus, in a manner
 worthy
Both of the house of Atreus, and of your ancestors;
Make Greece, which calls you womanish, keep
 silence; be
A pattern of noble vengeance on your enemies.
MENELAUS Your verdict tallies with my own exactly:
 she
Left my house willingly for a lover's bed. Her talk
Of Aphrodite is mere invention and pretence.—
Get out of my sight! Death by stoning is too short
A penance for the long-drawn sufferings of the
 Greeks;
But it will teach you not to bring disgrace on me.
HELEN (*kneeling*) No, no, I beg of you! The gods sent
 this on me;
Don't take my life for their misdoing, but forgive!
HECABE (*also kneeling*) Think of your fellow-soldiers
 whom this woman killed.
I beg you not to fail them, and their children,
 now.
MENELAUS Say no more, Hecabe; I pay no heed to
 her.
She shall sail back to Sparta. Men, put her on board.
HECABE Menelaus, let her not sail on the same ship
 with you!
MENELAUS And why not? Is she heavier than she used
 to be?
HECABE A lover once, a lover always!
MENELAUS That depends
On the ensuing attitude of the person loved.
However, since you wish it, she shall not set foot
On my own ship; there may be truth in what you say.
Once back in Sparta, shameful death will fittingly
Reward her shameful life, and thus commend all
 women
To chastity—no easy matter; but at least
Her end will inspire terror in their lecherous hearts,
Even if their hatred burns more deadly than before.

(MENELAUS *goes, the soldiers leading* HELEN *before him*)

Strophe 1

CHORUS So, Zeus, our God, you have forsaken us;
Given to Troy's enemies temple and ritual,
Smoke of rich spices, altar and incense-flame,
The holy Rock of Pergamus,
And Ida—dear remembered name—
Where steep snow-swollen rivers foam and fall
Through ivied forest-glades, past that bare height,
Earth's frontier, hushed with breath of gods, that
 glows
With dawn's first shaft of light.

Antistrophe 1

Zeus, God, farewell! Now with your going goes
Music of prayer, sweet singing, mystic nights
Of darkness and of vision, the dear forms
Of golden gods we knew,
The Trojan Twelve, the full-moon festal rites.
Therefore we ask, Monarch of all that lives,
Firm in your heavenly throne,
While the destroying Fury gives
Our homes to ashes and our flesh to worms—
We ask, and ask: What does this mean to You?

Strophe 2

Dearest husband, dear lost ghost,
Seas and worlds divide our ways:
 You, unwashed, unburied,
 Roam the shadowy spaces,
I to Argos wing the sea with restless oars,
 To the Cyclops' walls of stone
Rising heaven-high from green turf where horses graze.
 At Troy's gates our children
 Cling and cry by hundreds,
Calling, wailing, 'Mother, they are taking me
 From you! See their dark ships,
 Oars and rowers ready!
Will our home be holy Salamis,
Or the peak between two seas
 Where the gate of Isthmus
 Guards the Spartan stronghold?'

Antistrophe 2

And when Menelaus' ship
In mid-ocean rides and runs
 May there fall a furious
 Thunderbolt from heaven,
Blaze amidships, burn his oars and break his keel!
 Fall while I, poor prisoner, sail,
Lost in weeping, farther every hour from home;
 Fall while Helen gazes
 In her golden mirror
Aping girlhood! May she never come safe home
 To the streets of Sparta
 And the Brazen Temple!

She whose lightness shamed the pride of Greece,
Fouled with blood and tears of Troy
 The once pure and lovely
 Waters of Simois!

Look, oh, look, you weeping wives of Troy!
Stroke on stroke
Scars our bleeding land!
See, the dead Astyanax,
Whom the Greeks
Murdered without mercy,
Flung from Troy's high towers!

(*Enter* TALTHYBIUS *with the body of* ASTYANAX *carried on* HECTOR'S *shield*)

TALTHYBIUS Hecabe, one ship of Neoptolemus still rides
At anchor, ready to set sail for Thessaly
With the remainder of the spoils assigned to him.
Neoptolemus himself has gone; disturbing news
Reached him that Peleus, his grandfather, had been
 driven
Out of the country by Acastus, Peleas' son.
He had no wish to linger; and on hearing this
He at once set sail, and took with him Andromache.
She, as the ship left harbour, wailed aloud for Troy
And called on Hector's grave. She brought tears to
 my eyes.
She implored Neoptolemus that this child, your
 grandson,
Who was flung from the city walls and gave up his life,
Might receive burial; asking that this bronze-ribbed
 shield,
The terror of the Achaeans, which his father carried
To fence his body in battle, be not sent away
To Peleus' palace, to hang in that same chamber where
Andromache his mother, now her captor's bride,
Would see it to her sorrow; but that it should serve
This child in place of a coffin of cedar-wood or stone.
She wished him to be given into your care, to dress
And adorn his body, as time and your constraint
 allows;
Since she herself is far away, and her master's haste
Prevented her from staying to give him burial.
 So now, as soon as you have made him ready, we
Will wrap him in a mound of earth, and then hoist
 sail;
But do what you have been asked as quickly as
 possible.
One sad task I have saved you: as we came along
By the Scamander, I bathed him in the running stream
And cleaned his wounds. I am going now to break the
 ground
For a grave. If only you and I both do our best
To waste no time, we'll soon be under way for home.

(TALTHYBIUS *goes. The soldiers bearing* ASTYANAX *obey* HECABE'S *direction to lay the shield on the ground; then follow him out*)

HECABE Bring the great rounded shield of Hector; lay
 it here—
 A sight which should be welcome, but now stabs my
 eyes.
 You Achaeans are fine fighters; but where is your
 pride?
 Did you so dread this young boy that you must invent
 A new death for him? Were you afraid that he one day
 Would raise Troy from the dust? When Hector held
 the field,
 With thousands fighting at his side, even then we fell
 Before your swords; today, with Troy a ruined heap,
 And every Trojan dead, did you so shake with fear
 Before this babe? Are you not cowards? Fear is bad;
 But fear lacking all ground or reason is far worse.
 O dearest child, there is deep bitterness in your
 death.
 If you had fallen in battle for your city, knowing
 Your manhood's strength, love's sweetness, and the
 godlike pride
 Of royalty, then—if blessing can be in this world—
 You would be blessed. But, though you saw and
 recognized
 This wealth of life which was your heritage, my son,
 You had no use of it; and now you know it not.
 Poor little head, your soft curls were a garden where
 Your mother planted kisses; oh, how cruelly they
 Were shorn by your own city's god-built bastions!
 Now through the shattered skull the blood smiles,
 tempting me
 To unseemly words. Your little hands—how like your
 father's!
 But when I lift them they hang limp. Dear, lifeless lips,
 You made me a promise once, nestled against my
 dress:
 'Grandmother, when you die,' you said, 'I will cut off
 A long curl of my hair for you, and bring my friends
 With me to grace your tomb with gifts and holy
 words.'
 You broke your promise, son; instead, I bury you;
 I, an old, homeless, childless woman, bury you.
 All my fond kisses, anxious care, and wakeful
 nights—
 All end in this. What would a poet write for you
 As epitaph? 'This child the Argives killed because
 They feared him.' An inscription to make Hellas blush.
 Now, though you lose your father's heritage, you
 shall have
 His broad, bronze-fronted shield to make your earthy
 bed.
 Dear shield! You guarded Hector's splendid arm, as he
 Courageously kept you; but you have lost him now.
 Here on your handgrip is the dear print of his palm;
 Here, where his beard pressed on your round rim, ran
 the sweat
 Which in the heat of battle flowed from Hector's brow.

(To the CHORUS) Come, bring whatever robes our
 poverty can find
 To drape his body. Rigorous Fate does not allow
 The handsome gift; from what I have, these shall be
 yours.
 The man who finds his own wealth and security
 A cause for pleasure, is a fool. Those forces which
 Control our fortunes are as unpredictable
 As capering idiots. Happiness does not exist.
CHORUS See, we have brought robes taken from our
 Trojan dead;
 Wrap him in these, to dignify his burial.
HECABE Dear child, your father's mother lays on you
 these gifts;
 Not as a prize for chariot-race or archery—
 In honouring such things Phrygians use due restraint;
 But these gifts are the remnant of what once was
 yours,
 Now robbed from you by Helen, whom the gods
 abhor,
 Who took your life, and laid your father's house in
 dust.
CHORUS Yesterday so great a prince;
 Now a sight to break my heart!
HECABE I fasten on you the Phrygian splendour of
 this robe
 You should have put on for your wedding, to lead
 home
 The royalest bride in Asia. And you, Hector's shield,
 Triumphant once, mother of many victories,
 Receive your crown—an honour far more richly
 earned
 Than any the cunning coward Odysseus' arms could
 win.
 Earth shall receive you, the undying, with the dead.
CHORUS Earth shall receive you, child, with anguish
 and tears.
 Mother, intone the dirge for the dead.
HECABE Farewell!
CHORUS Farewell, dead by the curse of heaven!
HECABE Farewell!
 Here's linen to close up your wounds. This wound
 I'll heal,
 And this, and this. Pitiful healer, having skill,
 But not the effect of healing! All your other hurts
 Your father's hands shall care for in the home of
 death.
CHORUS Beat the breast and bruise the head,
 Let the hand be merciless!
HECABE O dearest friends, I see the cold abyss of truth.
CHORUS Take courage, Hecabe, speak;
 What will you say to us?
HECABE All through these years the gods had but one
 end in mind,
 No other destiny than this for me, and Troy—
 The one city they chose for their especial hate.

Our sacrifices and our prayers have all been vain.
Yet, had not heaven cast down our greatness and
 engulfed
All in the earth's depth, Troy would be a name
 unknown,
Our agony unrecorded, and those songs unsung
Which we shall give to poets of a future age.

(*Two* SOLDIERS *of* TALTHYBIUS *appear;* HECABE *turns to
them*)

Go now and lay him in his pitiful grave. He has
His burial robe and garland; they are all he needs.
A costly funeral proclaims the self-conceit
Of the living; I think the dead care little for such
 things.

(*The* SOLDIERS *carry* ASTYANAX *away*)

CHORUS Weep for Andromache—all her strong hopes
 broken
With this broken body! And weep for him
Whose royal birth the world envied and honoured,
Whose death will be told with terror.—
 Look! Who are they,
There on the city heights, waving their arms
With torches ablaze? What is to happen now?

(*Enter* TALTHYBIUS, *attended*)

TALTHYBIUS (*shouting*) You officers appointed to burn
 Priam's town,
Why are those torches idle in your hands? Use them!
Let flame swallow this rubble that was Ilion;
Our work's over; so good-bye Troy, and hoist for
 home!
(*To the* CHORUS) The same order concerns you too;
 as soon as you hear
A fanfare on the trumpets from the generals' tents,
Get straight down to the ships, ready to sail.—Hecabe,
I am sorry for you; but you must go with these men.
They've come for you from Odysseus, who is your
 master now.
HECABE My hour has come. The gods have pity on
 me! This is
My last ordeal, to sail away and see Troy fall
In flames. Up, aged feet; if you can climb so far,
I will stand here and bid farewell to my poor city.

(*She climbs on to a step*)

Troy! You who once among the Asian cities drew
The breath of pride, your glorious name shall vanish
 now.
They are burning you. They are carrying me away, a
 slave.
Gods! Gods! Where are you?—Why should I clamour
 to the gods?
We called on them before, and not one heard us call.
 Now! Into the fire! There is a royal way to die—

Wrapped in the flame that swallows my beloved
 city!

(*She makes towards the flames, but is seized by the
soldiers*)

TALTHYBIUS Poor creature! You are out of your mind
 with suffering.
—You men, take her to the ships; be watchful. She
 belongs
To Odysseus; she's his prize, and he must have her
 safe.
HECABE (*sobbing violently*) Zeus, our maker, begetter,
 Lord of our land!
We are Dardanus' children! See: is our torment just?
CHORUS He sees, and the flames burn on. The Mother
 of Cities
Is now no city; Troy is no longer Troy.
Hecabe Troy is a beacon—look! On the hill every
 house is blazing;
Along the crest of the ramparts, over the roofs,
The fire rushes and roars in the wake of the spear!
CHORUS Troy in her fearful fall has faded, vanished
At the breath of War, as smoke at the beating of wings!

Strophe

HECABE (*kneeling and gazing at the ground*) Listen,
 Phrygian earth that nursed my children!
Listen, my sons! You know your mother's voice.
CHORUS No more prayers to the gods:
Call the dead in a ghostly chant!
HECABE I call the dead, I who am near to death,
Stretched on the soil, my hands beating the ground.
CHORUS (*kneeling with her*)
 We will kneel at your side,
 Call on our dear lost dead below.
HECABE Listen, souls of the dead!
CHORUS Tell them our torment!
HECABE We are driven like cattle far from home,
 Away to a house of slavery!
 Dead Priam, do you hear,
 Unburied and unwept?
 No, your ghost knows nothing of my agony.
CHORUS Though he died
 By unholy murder,
 Holy Death
 Darkly closed his eyes.

Antistrophe

HECABE Listen, temples of gods, beloved city,
 Ravaged with flame, flowing with guiltless blood!
CHORUS Soon you will fall, and lie
 With the earth you loved, and none shall name you!
HECABE Dust mingled with smoke spreads wings to
 the sky,
I can see nothing, the world is blotted out!

CHORUS Earth and her name are nothing;
 All has vanished, and Troy is nothing!

(*A distant crash is heard*)

HECABE Listen, friends—did you hear?
CHORUS Pergamus fell!
HECABE Reverberations rock the walls,
 Each ruin reels and sinks engulfed!

(*A fanfare of trumpets*)

 Come, trembling aged feet,
 You must not fail me now.
 There your way lies: forward into slavery!
CHORUS Farewell, Troy!
 Now the lifted oar
 Waits for us:
 Ships of Greece, we come!

(*Exeunt*)

QUESTIONS

1. What goes on in the prologue? How does the pro-
 logue affect our understanding of the play?
2. What indications are there that the chrous consists
 only of women? Why is this important?
3. How do you envisage the use of gesture, dance, and
 music in the tragedy?
4. Describe the roles and characters of Cassandra,
 Andromache, and Helen.
5. What exactly happens in this tragedy? Do you
 agree with the judgment that *The Women of Troy*
 is "plotless"?
6. Is Hecabe heroic or merely pitiable? Support your
 answer with examples.
7. Compare the sense of tragedy in *The Women of
 Troy* with that in *Oedipus Rex*.

Summary Questions

1. What theories are used to explain the origins of
 tragedy?
2. What function did theatergoing have in Greek society?
3. Describe the Greek theater and the nature of a per-
 formance in ancient Greece.
4. How did Greek comedy originate?
5. What are the differences between "old" and "new"
 comedy?
6. Describe the subjects and plots of *Oedipus Rex* and
 The Women of Troy. In what sense are both tragic?

Key Terms

the City Dionysia

tragedy

comedy

satyr play

theatron

skene

parodos

episode

stasimon

exodus

Aeschylus

Sophocles

Euripides

Aristophanes

legend of Oedipus

the Trojan War

6

Classical Greece: Philosophy and Ethical Thought

Although thinkers and artists in the ancient civilizations of Africa and the Middle East had asked questions about human destiny and the universe that may be called "philosophical," the ancient Greeks were, as far as we know, the first to attempt to understand their universe as an order governed by a rational principle. The word *philosophy*, from the words *philo* and *sophia*, is in fact a Greek term that literally means "love of wisdom." From the late sixth century B.C., a group of philosophers, usually called the Pre-Socratics because they flourished before Socrates, looked beyond the arbitrary, willful gods worshiped by the masses to define a universal principle of rationality. Whereas the popular gods were like human beings, only more powerful, the philosophers were in search of a unitary principle giving order and intelligibility to the world. The most ancient of these Pre-Socratic thinkers can be considered physicists, in that they tried to locate the unitary principle in a material element.

The Pre-Socratics

Thales (640–546? B.C.), the earliest of the group, was the first in a line of philosophers from Miletus, located on the western shores of Anatolia, now in Turkey. Tradition has it that he brought back knowledge of arithmetic and geometry from Egypt to Greece. He may have gone to Egypt as a merchant because he is also reported to have cornered the grain market while there and become very rich. Thales believed that the underlying element of all existence was water and that the various objects of the universe were made up of water in various stages of transformation. A younger Milesian, Anaximander, agreed that all things were composed of the same substance; only he called it "the boundless." In the next generation, Anaximenes, also of Miletus, believed that the substance of all life was air.

These thinkers, defined as monists—that is, those who believe that all being is one substance—were faced with explaining how it was that the world appeared to be composed of individual objects. Thales maintained that division in the basic stuff of existence occurred through evaporation, rainfall, silting of rivers, and the like. For Anaximander, the cause lay in the constant circular motion of the

limitless stuff, while for Anaximenes individual objects were produced by the condensation and rarefaction of air. Significantly, in each of these three theories, changes were internal to the substance and no god or external force was needed to explain the process.

Heraclitus (late 6th century), a citizen of Ephesus, also now in Turkey, took a different approach to the nature of being. For him the basic stuff of the universe was fire, whose shape was constantly changing, but which always remained the same. Just as fire was created by rubbing two sticks together in opposition, so universal change was a product of the harmonizing of opposing forces. Fire as the stuff of the universe operated in regular, ordered ways, and while all things were in a state of flux, they changed according to "measures," or in an orderly way.

Heraclitus' description of the cosmos clashed directly with common sense. What appeared as the same object over time was never the same object for Heraclitus because it was in a constant state of alteration. His most noted statement described it well: "One cannot step into the same river twice." Whereas the Milesians created the problem of how the many could come from the one, Heraclitus introduced the distinction between the appearance of things and their reality.

The late sixth century and the early fifth century B.C. were particularly fertile in philosophical thinking, and the theories of the Milesians and Heraclitus had to compete for acceptance with a wide range of other philosophies. In southern Italy, Pythagoras (late sixth century B.C.) propounded a theory that all objects in the universe and the relationships between them were reducible to numbers and that the universe constituted a single intelligible order accessible to the mathematician. Further south, in Sicily, Empedocles (first half of the fifth century B.C.) identified all being as composed of different mixtures of four indestructible, eternal, and unchanging elements: earth, air, fire, and water. His contemporary Leucippus developed an atomic theory of being, which served as an antecedent of Epicureanism—a philosophy we discuss in Chapter 7.

But already in Empedocles and Leucippus' generation concern with explaining the nature of the universe was taking second place to ethical issues focusing on the human being. The first half of the fifth century B.C. in Greece saw the rapid breakdown of the social order and government, which raised pressing questions about the individual's place in society.

The major intellectuals dominating Greece by this time were the Sophists. The Sophists promised to teach wisdom for a price. In actual fact, their lessons were aimed at teaching students the art of eloquence to enable them to win influence in the new popular governments emerging all over the peninsula. They attacked the ideal of absolute right and wrong and taught that all things were relative. In the words of the fifth-century Sophist Protagoras: "Man is the measure of all things."

Socrates (470?–399 B.C.)

Socrates set himself to oppose the skepticism and self-interested orientation of the Sophists. He was convinced that there was an absolute set of moral laws and that most people in a confused way assumed this to be true. His general goal was to make people aware of their assumptions about what they thought they knew—not to make them skeptics but so that they might begin the pursuit of knowledge in the proper way. He believed that knowledge begins with knowing what we do *not* know. So it was that the short, powerfully built, snub-nosed man, looking very much like a wrestler, spent most of his days in the streets of Athens, his native city, asking questions of his fellow citizens. Seemingly never satisfied with the first answer, he pushed his questions to the point where his companions in the dialogues had finally to admit that they did not know what they believed they knew at the outset. He became known as the gadfly of Athens—after the little gnat that pesters its object to desperation. Finally, he appeared so threatening to the traditions of his city that he was arrested and condemned to death for his detrimental influence on the youth of Athens.

Plato (427?–347 B.C.)

Socrates never wrote a word, but his greatest disciple, Plato, wrote volumes; in many of his writings, called *Dialogues*, he immortalized Socrates by making him the voice of the philosopher in the discussion. It is impossible to be certain how much of Plato's thought was borrowed from his master. It was said in antiquity that Plato had studied in Egypt. At least the technique of seeking an immutable, eternal basis for our knowledge by interrogation certainly derived from Socrates, but it was probably Plato who formulated the technique into a method. The typical dialogue begins with Socrates asking for the definition of justice, or of courage, or of virtue itself. The person questioned responds usually with confidence, giving a traditional commonsense definition. Further questioning shows the answer to be inadequate, and a second definition is proposed—only to be rejected in turn—then a third and even a fourth without any results. At length the discussant admits reluctantly to being ignorant of what he believed himself to know. Perhaps the dialogue ends there, but frequently the interrogation continues until some positive conclusions are achieved.

It would appear that Socrates' main concern was ethical, but Plato extended Socrates' method to embrace

a much wider variety of philosophical problems. Through the method of interrogation, or *dialectic*, Plato eventually established the existence of two levels of reality. From eternity there were three elements in the universe: a Demiurge, or creator God; a world of eternal unchanging Ideas, or patterns, perfect exemplars of truth, beauty, and justice, and of all numbers, geometrical shapes, and natural things; and the receptacle, equivalent to pure space or matter. The work of the Demiurge was to model the receptacle into shapes resembling the eternal patterns of the Ideas, or forms. Because the matter he worked with was mobile, his creations could never remain fixed for long; but at least the world he fashioned represented or imitated imperfectly the immutable exemplars of the transcendent world. Before this life people had lived as souls in the world of the Ideas and had beheld them in their splendor. Only like can know like: human beings could know the Ideas in this other world because they, like the Ideas, were divine.

Imprisoned at birth in a body, subject to the sensations of matter, the individual has forgotten that earlier life; nevertheless, enough remains to serve as the basis for judging experience. When we say that that thing is more beautiful than this thing, we are comparing both objects with a standard of beauty not found in our earthly experience but rather brought with us into this life from our contact in the upper world with the Idea of pure beauty. The same is true with our judgment about other objects in our experience.

For Plato the soul is a divine entity, buried in a body from which at death it will escape. Because of our contact with the absolute beauty and good in a preexistence, we continue in this life to seek the experience we once had. Motivated by love of beauty and good, we strive to satisfy our needs through possession of material objects and other human beings. Only education can teach us the true end of our longing, directing our gaze away from the imperfect, transitory objects of this world to contemplation of the Ideas themselves of which these objects are but a dim reflection. Once in possession of the knowledge of mathematics, geometry, and other truths, we will come to look on our bodies and this world as a prison from which death will free us.

The psychology of the philosopher constituted the first attempt to define various aspects of the human personality. Plato believed that the human soul consists of three fundamental parts: reason, which governs; moral courage, which pursues the honorable even against great obstacles; and the appetite. The third part of the soul must be kept in close confinement; otherwise it would topple reason from its seat and create chaos in the life of the soul. Moral courage, on the other hand, is the ally of reason. A loyal member of a Greek city-state, Plato was convinced that the individual could not attain moral perfection or reach the stage where reason contemplated

the eternal realities while living in a corrupt community. Plato's ideal state reflects in its organization the three divisions of the soul. Like the soul it has its rational principle in the Guardians, those who govern the whole. The auxiliaries, the soldiers, correspond to moral courage; and the artisans, who do most of the hard work in the society, reflect the appetitive principle. Just as in the individual soul, the whole is in harmony when reason rules, so in the state ruled by philosophers everyone keeps his or her place, performs his or her function, and is content. In striking contrast to Athenian society's tendency to absolute male dominance, Plato specifies that males and females in his ideal republic receive the same education from childhood and, depending on their individual abilities to learn, are ultimately assigned to one of the three classes in the state.

Aristotle (384–322 B.C.)

For Plato knowledge was essentially *deductive*, that is, it came from within the human mind and was applicable to the world. Human beings brought categories of organization to experience. In his later years Plato came increasingly to conceive of the world of the Ideas in terms of mathematical relationships. From Plato derives, therefore, the conception that mathematics is the key to understanding nature. By contrast, his student Aristotle approached the universe not as a mathematician but as a biologist. Knowledge of humanity and nature in Aristotle's judgment was *inductive*. It was derived by the human intellect from nature itself.

Like Plato, Aristotle requires that knowledge, to be knowledge, must be eternally and immutably true. Accordingly, there can be knowledge only of that which is eternal and unchanging. At the same time, however, Aristotle in his mature work considered Plato's belief in a world of the Ideas to be nonsense. There are not two levels of reality—the world we know and a world of perfect forms, or Ideas; there is only one reality. But how is knowledge possible in such a world where all seems in a state of constant change? What in our experience is immutable and eternal when all about us is moving from place to place, being born, dying, becoming bigger or lesser, changing colors and the like? Aristotle's reply is that there is no need to postulate a world of ideal forms because this needlessly duplicates the forms already in nature. There are in the universe of Aristotle a finite if immense number of different kinds of things, which he calls forms or species. The species are eternal and never change, but they never exist apart from individual members of that species. Each individual member of the species, say of human beings, carries within him- or herself the form of humanness that makes the individual "be" what he or she is. Individuals of a species differ one from the

other (that is, they are individuals) because they differ in their matter. Each is composed of a different mass of bone and flesh. Individuals are born, grow old, and die, but the form or species lives on, passing from generation to generation to all eternity. Thus Aristotle has found the eternal forms in the things of this world themselves. We experience them in our encounter with each of the individual representatives of the species. In sense experience my intellect has the power to grasp the eternal form in the individual. When, for example, I see a tree, I know it is a tree because my mind perceives the form of "treeness" in it. Gradually, through experience with different trees, I can develop a knowledge of the various operations of the species; this knowledge will be immutable and eternal because the species in itself never changes. What I learn generally about these trees will be true for all trees.

How does Aristotle explain the cause of change in the universe? Why do streams flow, flowers grow, and the heavenly spheres circle? Each individual thing in the universe for Aristotle moves and changes because it is attempting in this way to realize perfection in its form. Indirectly, however, God is the ultimate cause of all movement. Aristotle sets the earth at the center of the universe, ringing it round with ten revolving spheres. The innermost sphere takes the moon around the earth, the next the sun, and so on, moving outward for each of the planets until we reach the tenth sphere, which holds the fixed stars. Beyond that sphere lies God. Aristotle's God is perfect mind who exists eternally, thinking only of himself and absolutely motionless. He knows nothing of the universe below him. Like him, the universe with its species is eternal. He did not create them. His only relationship to the universe is that all objects on earth and in heaven are attracted to him and attempt to imitate his perfection by being themselves perfect. To do so, they must undergo change. He is perfect and therefore unmoving. The individual members of the countless species of things must constantly strive to perfect their particular species in themselves; thus they move. Aristotle's God, consequently, is not a creator God but the underlying cause of all universal motion through the force of attraction he exerts on them.

What is the nature of humanity and human destiny in such a universe? Whereas everything in the universe consists of matter and form, in living things the form is called a soul. Plants and animals have souls, but not as complex as those of human beings. People, as opposed to all other living things, have the power to know truth. They are endowed with minds that can grasp the forms of things and can develop a body of knowledge about nature through reasoning and observation. On the basis of the axiom "like alone can know like," does the fact that the human mind can know the eternal form found in individual members of a species mean that a person's soul as opposed to other living souls is immortal? Although we cannot be certain, Aristotle seems to reject personal immortality. The part of the human mind that grasps the forms of things is specifically designated as immortal, but Aristotle describes it in such a way that it does not really belong to us individually: it leaves us at death, whereas the personal elements of our souls perish. Thus people—like every other thing on earth—bear the species for their time; and, as this generation passes away, another rises to replace it.

If there is no afterlife for the human being, what is the nature of happiness? Aristotle replies: humanity's happiness lies in the perfection of its form as humanity. A human being is distinctive in being a rational animal; therefore, an individual's highest good lies in perfecting reason. Such perfection occurs in two areas. First of all, individuals must control their lives through reason. Such a life is a virtuous life. Honesty, courage, temperance, and the like are virtues; they are different aspects of the behavior of a rational person. The second area in which reason must be perfected to obtain happiness is in the intellectual sphere. Since human reason has the capacity to learn the truth, the rational person must study the sciences, mathematics, and divine matters to fulfill human nature. Aristotle himself, following his inductive method of investigation, produced an immense number of works devoted to the widest range of subjects, including botany, zoology, astronomy, physics, rhetoric, psychology, physiology, and political science.

But the attainment of moral and intellectual virtue is not sufficient to create happiness. Aristotle willingly acknowledged that even the virtuous person could not be happy if poor or sick. Accordingly, Aristotle maintained that although virtue was the highest good for happiness, people needed both health and a degree of wealth to reach their end. The demands placed on the individual by this kind of ethic were obviously not excessively rigorous and could easily be met by the upper class of the Greek polis.

Although differing from Plato on the place of the forms and on the immortality of the human soul among other things, Aristotle was in complete agreement with the older man who had once been his teacher on the close relationship between ethics and politics. For Aristotle, as for Plato, the state was humankind writ large. People were only animals outside the state; only through the state could they obtain moral and intellectual perfection. But whereas for Plato the best form of government was a monarchy ruled by a philosopher king, Aristotle, rejecting what he considered Plato's purely theoretical approach, opted for republican government as the best form of government in the world as it was. Through participation in the political life of his

state, the citizen could maximize his power and talents, thereby finding happiness.

The Politics

While Aristotle wrote extensively concerning the ideal man, he ignored the matter of the ideal woman. The selection from the *Politics* indicates that Aristotle shared the common prejudice of his society that woman was naturally inferior to man and not worthy of special analysis. In a treatise entitled "On the Generation of Animals," Aristotle writes that a female was simply a failed male. Nature in producing human beings aims at making a male offspring, but when the process is defective, a female is the result. Because the woman by nature is colder than the man, girls are usually born when the father is either young or old, that is, when he has not yet reached the heat of maturity or when he is past that point. This view of man as the most perfect creature in nature and of woman as a defective or second-rate man was to have long-range repercussions in Western culture. Yet one should not conclude that the ancient Greeks consistently viewed the female as inferior. The goddesses in Greek mythology, the ideal female form in sculpture, the admiration shown for Sappho, and characters such as Lysistrata in comedy and Antigone in tragedy attest to the contrary. Plato, as mentioned earlier, envisaged equality between superior men and women in *The Republic.*

The Poetics

In addition to having made enormous contributions to the fields of metaphysics, politics, and ethics, Aristotle was also the Western world's first literary critic, and his views on poetic and dramatic form continue to be influential to this day. Having before him the major works of classical Greek literature, Aristotle in the *Poetics* sought not only to define the nature of the forms of the epic, tragedy, comedy, and the dithyramb (a wild, emotional hymn), but also to produce a kind of manual for writers who wished to write in these forms. He was also, in a sense, answering his former master Plato, who thought that poetry, with its dangerous effects on emotions, ought to be banished from the ideal republic. For Aristotle, poetry was actually superior to history, because poetry deals with the general and the philosophical, whereas history treats the particular. All poetry, for Aristotle, is an imitation (*mimesis*) of life, but this imitation involves not merely the realistic copying of a "slice of life" but rather the condensation of life into a form, with a beginning, a middle, and an end, resulting in both pleasure and self-knowledge for the audience. For Aristotle, tragedy, because it portrays people as better than they actually are, and because its form is the most cohesive, is superior to both comedy and epic. Indeed, most of the *Poetics* concerns tragedy, and because Aristotle apparently never finished the section on comedy, we can only speculate as to what his views on that form might have been.

HERACLITUS OF EPHESUS

Fragments

Translation by Ingram Bywater

Our knowledge of Heraclitus' thought derives from 129 fragments culled from citations in the works of later philosophers who still had access to his writings. All the fragments are short and their often enigmatic character continues to stimulate debate about their meaning. For instance, scholars disagree as to whether certain statements are to be taken literally. When Heraclitus wrote "The sun's breadth is that of a human foot" (Frag. 3), did he believe that that was literally true or was he pointing out the difference between reality and appearance? Central to Heraclitean thought is the concept of *Logos*. It is (1) the substance of fire, composing all objects in the cosmos; (2) the logically ordered process of change inherent in fire; (3) the intelligence of human beings, which allows them to understand the logical process of universal change; and (4) the property of language allowing this process to be explained.

Here are other examples of Heralitus' writing. Interpretations of terms are in brackets.

1. Of this eternally existing *logos* people lack understanding, both before and after they hear the primary thing [the truth about this principle]. For since everything comes to be according to this *logos*, they are like ignorant people when experiencing such words and actions as I expound—when I describe each [object] according to its nature, indicating how it is. But what other people do when awake is unnoticed by them just as they forget what they do when sleeping.

2. Thus it is necessary to follow the common (that is, the universal: for 'common' is 'universal'). But although the *logos* is common, most people live as though they possess a private purpose [that is, they do not see that they are part of the whole].

3. The order, the same for all, was made neither by gods nor by humans, but it was always and is and will be fire ever-living—being lighted in measures and going out in measures.

6. The sun is not only new each day but continually new.

49. In the same streams we both step and do not step; we both are and are not.

54. The hidden harmony is superior to the visible.

73. We should not act or speak like sleeping people.

91. One cannot step twice into the same river . . . nor can one twice take hold of mortal substance in a stable condition; for by the quickness and swiftness of its alteration it scatters and gathers—at the same time it endures and dissolves, approaches and departs.

102. For God all things are beautiful and good and just, but humans have supposed some things to be unjust, other things to be just.

QUESTIONS

1. Why are all things "beautiful and good and just"?
2. In Heraclitus' world, where everything happens as part of an orderly process without external intervention, what is justice? God?
3. What is the philosopher's opinion of common folk?
4. What does he mean by "hidden harmony" and "the *logos* is common"?
5. Why can't we step into the same river twice?

PLATO

The Allegory of the Cave

Translation by Benjamin Jowett

An important characteristic of Plato's method was to illustrate profound philosophical ideas through use of stories, in the manner of myths. The selection below is taken from *The Republic*, Plato's great dialogue on justice, illustrated by the perfect state. Commonly known as "The Allegory of the Cave," this passage endeavors to dramatize the predicament of humankind, which takes the shifting, temporary things of this world for ultimate reality. It also describes the problem of the philosopher, who has looked on the realm of the Ideas through contemplation and who yet has to return to live in this world among the shadows with which other people are content. The dialogue is between Socrates and Glaucon. Socrates speaks first.

"And now," I said, "let me show in a figure how far our nature is enlightened or unenlightened. Behold! Human beings living in an underground den, which has a mouth open towards the light and reaching all along the den; here they have been from their childhood, and have their legs and necks chained so that they cannot move, and can only see before them, being prevented by the chains from turning round their heads. Above and behind them a fire is blazing at a distance, and between the fire and the prisoners there is a raised way; and you will see, if you look, a low wall built along the way, like the screen which marionette players have in front of them, over which they show the puppets."

"I see."

"And do you see," I said, "men passing along the wall carrying all sorts of vessels, and statues and figures of animals made of wood and stone and various materials, which appear over the wall? Some of them are talking, others silent."

"You have shown me a strange image, and they are strange prisoners."

"Like ourselves," I replied; "and they see only their own shadows, or the shadows of one another, which the fire throws on the opposite wall of the cave?"

"True," he said; "how could they see anything but the shadows if they were never allowed to move their heads?"

"And of the objects which are being carried in like manner they would only see the shadows?"

"Yes," he said.

"And if they were able to converse with one another, would they not suppose that they were naming what was actually before them?"

"Very true."

"And suppose further that the prison had an echo which came from the other side, would they not be sure to fancy when one of the passers-by spoke that the voice which they heard came from the passing shadow?"

"No question," he replied.

"To them," I said, "the truth would be literally nothing but the shadows of the images."

"That is certain."

"And now look again, and see what will naturally follow if the prisoners are released and disabused of their error. At first, when any of them is liberated and compelled suddenly to stand up and turn his neck round and walk and look towards the light, he will suffer sharp pains; the glare will distress him, and he will be unable to see the realities of which in his former state he had seen the shadows; and then conceive someone saying to him that what he saw before was an illusion, but that now, when he is approaching nearer to being and his eye is turned towards more real existence, he has a clearer vision-what will be his reply? And you may further imagine that his instructor is pointing to the objects as they pass and requiring him to name them-will he not be perplexed? Will he not fancy that the shadows which he formerly saw are truer than the objects which are now shown to him?"

"Far truer."

"And if he is compelled to look straight at the light, will he not have a pain in his eyes which will make him turn away to take refuge in the objects of vision which he can see, and which he will conceive to be in reality clearer than the things which are now being shown to him?"[1]

"True," he said.

"And suppose once more, that he is reluctantly dragged up a steep and rugged ascent, and held fast until he is forced into the presence of the sun himself, is he not likely to be pained and irritated? When he approaches the light his eyes will be dazzled, and he will not be able to see anything at all of what are now called realities."

"Not all in a moment," he said.

"He will require to grow accustomed to the sight of the upper world. And first he will see the shadows best, next the reflections of men and other objects in the water, and then the objects themselves; then he will gaze upon the light of the moon and the stars and the spangled heaven; and he will see the sky and the stars by night better than the sun or the light of the sun by day?"

"Certainly."

"Last of all he will be able to see the sun, and not mere reflections of him in the water, but he will see him in his own proper place, and not in another; and he will contemplate him as he is."

"Certainly."

"He will then proceed to argue that this is he who gives the season and the years, and is the guardian of all that is in the visible world, and in a certain way the cause of all things which he and his fellows have been accustomed to behold?"

"Clearly," he said, "he would first see the sun and then reason about him."

"And when he remembered his old habitation, and the wisdom of the den and his fellow prisoners, do you not suppose that he would felicitate himself on the change, and pity them?"

"Certainly, he would."

"And if they were in the habit of conferring honors among themselves on those who were quickest to observe the passing shadows and to remark which of them went before, and which followed after, and which were together; and who were therefore best able to draw conclusions as to the future, do you think that he would

[1] He will think the shadows to which he is accustomed more real than the puppets behind him that caused them. The puppets in turn he will find easier to look at than the living creatures in the world of sunlight outside, of which the puppets were but copies.

care for such honors and glories, or envy the possessors of them? Would he not say with Homer, 'Better to be the poor servant of a poor master,' and to endure anything, rather than think as they do and live after their manner?"

"Yes," he said, "I think that he would rather suffer anything than entertain these false notions and live in this miserable manner."

"Imagine once more," I said, "such a one coming suddenly out of the sun to be replaced in his old situation;[2] would he not be certain to have his eyes full of darkness?"

"To be sure," he said.

"And if there were a contest, and he had to compete in measuring the shadows with the prisoners who had never moved out of the den, while his sight was still weak, and before his eyes had become steady (and the time which would be needed to acquire this new habit of sight might be very considerable), would he not be ridiculous? Men would say of him that up he went and down he came without his eyes; and that it was better not even to think of ascending; and if any one tried to loose another and lead him up to the light, let them only catch the offender, and they would put him to death."

"No question," he said.

"This entire allegory," I said, "you may now append, dear Glaucon, to the previous argument; the prison house is the world of sight, the light of the fire is the sun, and you will not misapprehend me if you interpret the journey upwards to be the ascent of the soul into the intellectual world according to my poor belief, which, at your desire, I have expressed—whether rightly or wrongly, God knows. But, whether true or false, my opinion is that in the world of knowledge the idea of good appears last of all, and is seen only with an effort; and, when seen, is also inferred to be the universal author of all things beautiful and right, parent of light and of the lord of light in this visible world, and the immediate source of reason and truth in the intellectual; and that this is the power upon which he who would act rationally either in public or private life must have his eye fixed."

"I agree," he said, "as far as I am able to understand you."

"Moreover," I said, "you must not wonder that those who attain to this beatific vision are unwilling to descend to human affairs; for their souls are ever hastening into the upper world where they desire to dwell; which desire of theirs is very natural, if our allegory may be trusted."

"Yes, very natural."

"And is there anything surprising in one who passes from divine contemplations to the evil state of man, misbehaving himself in a ridiculous manner; if, while his eyes are blinking and before he has become accustomed to the surrounding darkness, he is compelled to fight in courts of law, or in other places, about the images or the shadows of images of justice, and is endeavoring to meet the conceptions of those who have never yet seen absolute justice?"

"Anything but surprising," he replied.

"Anyone who has common sense will remember that the bewilderments of the eyes are of two kinds, and arise from two causes, either from coming out of the light or from going into the light, which is true of the mind's eye, quite as much as of the bodily eye; and he who remembers this when he sees anyone whose vision is perplexed and weak, will not be too ready to laugh; he will first ask whether that soul of man has come out of the brighter life, and is unable to see because unaccustomed to the dark, or having turned from darkness to the day is dazzled by excess of light. And he will count the one happy in his condition and state of being, and he will pity the other; or, if he have a mind to laugh at the soul which comes from below into the light, there will be more reason in this than in the laugh which greets him who returns from above out of the light into the den."

"That," he said, "is a very just distinction."

"But then, if I am right, certain professors of education must be wrong when they say that they can put a knowledge into the soul which was not there before, like sight into blind eyes."

"They undoubtedly say this," he replied.

"Whereas our argument shows that the power and capacity of learning exists in the soul already; and that just as the eye was unable to turn from darkness to light without the whole body, so too the instrument of knowledge can only by the movement of the whole soul be turned from the world of becoming into that of being, and learn by degrees to endure the sight of being, and of the brightest and best of being, or in other words, of the good."

..

QUESTIONS

1. If the artificial objects carried along the wall designate objects that we perceive in our experience with the world, what, then, do the shadows signify?
2. Why does Plato stress the difficulty that the prisoners have in looking at the light of the sun?
3. Why do prisoners receive their returning colleague as they do? What does this tell us about the position of the philosopher in society?
4. In what ways does this allegory attack contemporary Greek education?

..

[2] Or "such a one going down again and taking his old position."

The Death of Socrates

Translation by Benjamin Jowett

Plato's dialogue *Phaedo* depicts Socrates' last hours. Having been tried and found guilty of corrupting the youth of Athens, he has been sentenced to die by drinking a cup of poison. As the appointed time for the execution approaches, he spends his last hours in prison philosophizing with his friends Cebes, Simmias, and Crito, proving to the satisfaction of all that the soul is immortal.

"Tell me, then, what is that of which the inherence will render the body alive?"[1]

"The soul," he replied.

"And is this always the case?"

"Yes," he said, "of course."

"Then whatever the soul possesses, to that she comes bearing life?"

"Yes, certainly."

"And is there any opposite to life?"

"There is," he said.

"And what is that?"

"Death."

"Then the soul, as has been acknowledged, will never receive the opposite of what she brings."

"Impossible," replied Cebes.

"And now," he said, "what did we just now call that principle which repels the even?"

"The odd."

"And that principle which repels the musical or the just?"

"The unmusical," he said, "and the unjust."

"And what do we call that principle which does not admit of death?"

"The immortal," he said.

"And does the soul admit of death?"

"No."

"Then the soul is immortal?"

"Yes," he said.

"And may we say that this has been proven?"

"Yes, abundantly proven, Socrates," he replied.

"Supposing that the odd were imperishable, must not three be imperishable?"

"Of course."

"And if that which is cold were imperishable, when the warm principle came attacking the snow, must not the snow have retired whole and unmelted—for it could never have perished, nor could it have remained and admitted the heat?"

"True," he said.

"Again, if the uncooling or warm principle were imperishable, the fire when assailed by cold would not have perished or have been extinguished, but would have gone away unaffected?"

"Certainly," he said.

"And the same may be said of the immortal: if the immortal is also imperishable, then the soul will be imperishable as well as immortal; but if not, some other proof of her imperishableness will have to be given."

"No other proof is needed," he said; "for if the immortal, being eternal, is liable to perish, then nothing is imperishable."

"Yes," replied Socrates, "and yet all men will agree that God, and the essential form of life, and the immortal in general, will never perish."

"Yes, all men," he said; "that is true; and what is more, gods, if I am not mistaken, as well as men."

"Seeing then that the immortal is indestructible, must not the soul, if she is immortal, be also imperishable?"

"Most certainly."

"Then when death attacks a man, the mortal portion of him may be supposed to die, but the immortal retires at the approach of death and is preserved safe and sound?"

"True."

"Then, Cebes, beyond question, the soul is immortal and imperishable, and our souls will truly exist in another world!"

"I am convinced, Socrates," said Cebes, "and have nothing more to object; but if my friend Simmias, or anyone else, has any further objection to make, he had better speak out, and not keep silence, since I do not know to what other season he can defer the discussion, if there is anything which he wants to say or to have said."

"But I have nothing more to say," replied Simmias; "nor can I see any reason for doubt after what has been said. But I still feel and cannot help feeling uncertain in my own mind, when I think of the greatness of the subject and the feebleness of man."

"Yes, Simmias," replied Socrates, "that is well said: and I may add that first principles, even if they appear certain, should be carefully considered; and when they are satisfactorily ascertained, then, with a sort of hesitating confidence in human reason, you may, I think, follow the course of the argument; and if that be plain and clear, there will be no need for any further inquiry."

"Very true."

"But then, O my friends," he said, "if the soul is really immortal, what care should be taken of her, not only in respect of the portion of time which is called life, but of eternity! And the danger of neglecting her from this point of view does indeed appear to be awful. If death had only been the end of all, the wicked would have had a good bargain in dying, for they would have

[1] Or "what is that which by its presence in the body makes it alive?"

been happily quit not only of their body, but of their own evil together with their souls. But now, inasmuch as the soul is manifestly immortal, there is no release or salvation from evil except the attainment of the highest virtue and wisdom. For the soul, when on her progress to the world below, takes nothing with her but nurture and education; and these are said greatly to benefit or greatly to injure the departed, at the very beginning of his journey thither. . . .

"Wherefore, Simmias, seeing all these things, what ought not we to do that we may obtain virtue and wisdom in this life? Fair is the prize, and the hope great!

"A man of sense ought not to say, nor will I be very confident, that the description which I have given of the soul and her mansions is exactly true. But I do say that, inasmuch as the soul is shown to be immortal, he may venture to think, not improperly or unworthily, that something of the kind is true. The venture is a glorious one, and he ought to comfort himself with words like these, which is the reason why I lengthen out the tale. Wherefore, I say, let a man be of good cheer about his soul, who having cast away the pleasures and ornaments of the body as alien to him and working harm rather than good, has sought after the pleasures of knowledge; and has arrayed the soul, not in some foreign attire, but in her own proper jewels, temperance, and justice, and courage, and nobility, and truth—in these adorned she is ready to go on her journey to the world below, when her hour comes. You, Simmias and Cebes, and all other men will depart at some time or other. Me already, as a tragic poet would say, the voice of fate calls. Soon I must drink the poison; and I think that I had better repair to the bath first, in order that the women may not have the trouble of washing my body after I am dead."

When he had done speaking, Crito said: "And have you any commands for us, Socrates—anything to say about your children, or any other matter in which we can serve you?"

"Nothing particular, Crito," he replied; "only, as I have always told you, take care of yourselves; that is a service which you may be ever rendering to me and mine and to all of us, whether you promise to do so or not. But if you have no thought for yourselves, and care not to walk according to the rule which I have prescribed for you, not now for the first time, however much you may profess or promise at the moment, it will be of no avail."

"We will do our best," said Crito: "And in what way shall we bury you?"

"In any way that you like; but you must get hold of me, and take care that I do not run away from you."

Then he turned to us, and added with a smile: "I cannot make Crito believe that I am the same Socrates who has been talking and conducting the argument; he fancies that I am the other Socrates whom he will soon see, a dead body—and he asks, How shall he bury me? And though I have spoken many words in the endeavor to show that when I have drunk the poison I shall leave you and go to the joys of the blessed—these words of mine, with which I was comforting you and myself, have had, as I perceive, no effect upon Crito. And therefore I want you to be surety for me to him now, as at the trial he was surety to the judges for me: but let the promise be of another sort; for he was surety for me to the judges that I would remain, and you must be my surety to him that I shall not remain, but go away and depart; and then he will suffer less at my death, and not be grieved when he sees my body being burned or buried. I would not have him sorrow at my hard lot, or say at the burial, Thus we lay out Socrates, or, Thus we follow him to the grave or bury him; for false words are not only evil in themselves, but they infect the soul with evil. Be of good cheer then, my dear Crito, and say that you are burying my body only, and do with that whatever is usual, and what you think best."

When he had spoken these words, he arose and went into a chamber to bathe; Crito followed him and told us to wait. So we remained behind, talking and thinking of the subject of discourse, and also of the greatness of our sorrow; he was like a father of whom we were being bereaved, and we were about to pass the rest of our lives as orphans. When he had taken the bath his children were brought to him (he had two young sons and an elder one); and the women of his family also came, and he talked to them and gave them a few directions in the presence of Crito; then he dismissed them and returned to us.

Now the hour of sunset was near, for a good deal of time had passed while he was within. When he came out, he sat down with us again after his bath, but not much was said. Soon the jailer, who was the servant of the Eleven, entered and stood by him, saying: "To you, Socrates, whom I know to be the noblest and gentlest and best of all who ever came to this place, I will not impute the angry feelings of other men, who rage and swear at me, when, in obedience to the authorities, I bid them drink the poison—indeed, I am sure that you will not be angry with me; for others, as you are aware, and not I, are to blame. And so fare you well, and try to bear lightly what must needs be—you know my errand." Then bursting into tears he turned away and went out.

Socrates looked at him and said: "I return your good wishes, and will do as you bid." Then turning to us, he said, "How charming the man is: since I have been in prison he has always been coming to see me, and at times he would talk to me, and was as good to me as could be, and now see how generously he sorrows on my account. We must do as he says, Crito; and therefore let the cup be brought, if the poison is prepared: if not, let the attendant prepare some."

"Yet," said Crito, "the sun is still upon the hilltops, and I know that many a one has taken the draught late, and after the announcement has been made to him, he has eaten and drunk, and enjoyed the society of his beloved; do not hurry—there is time enough."

Socrates said: "Yes, Crito, and they of whom you speak are right in so acting, for they think that they will be gainers by the delay; but I am right in not following their example, for I do not think that I should gain anything by drinking the poison a little later; I should only be ridiculous in my own eyes for sparing and saving a life which is already forfeit. Please then to do as I say, and not to refuse me."

Crito made a sign to the servant, who was standing by; and he went out, and having been absent for some time, returned with the jailer carrying the cup of poison. Socrates said: "You, my good friend, who are experienced in these matters, shall give me directions how I am to proceed."

The man answered: "You have only to walk about until your legs are heavy, and then to lie down, and the poison will act."

At the same time he handed the cup to Socrates, who in the easiest and gentlest manner, without the least fear or change of colour or feature, looking at the man with all his eyes, Echecrates, as his manner was, took the cup and said: "What do you say about making a libation out of this cup to any god? May I, or not?"

The man answered: "We only prepare, Socrates, just so much as we deem enough."

"I understand," he said, "but I may and must ask the gods to prosper my journey from this to the other world—even so—and so be it according to my prayer." Then raising the cup to his lips, quite readily and cheerfully he drank off the poison. And hitherto most of us had been able to control our sorrow; but now when we saw him drinking, and saw too that he had finished the draught, we could no longer forbear, and in spite of myself my own tears were flowing fast; so that I covered my face and wept, not for him, but at the thought of my own calamity in having to part from such a friend. Nor was I the first; for Crito, when he found himself unable to restrain his tears, had got up, and I followed; and at that moment, Apollodorus, who had been weeping all the time, broke out in a loud and passionate cry which made cowards of us all.

Socrates alone retained his calmness: "What is this strange outcry?" he said. "I sent away the women mainly in order that they might not misbehave in this way, for I have been told that a man should die in peace. Be quiet then, and have patience." When we heard his words we were ashamed, and refrained our tears; and he walked about until, as he said, his legs began to fail, and then he lay on his back, according to the directions, and the man who gave him the poison now and then looked at his feet and legs; and after a while he pressed his foot hard, and asked him if he could feel; and he said, "No"; and then his leg, and so upwards and upwards, and showed us that he was cold and stiff. And he felt them himself, and said: "When the poison reaches the heart, that will be the end." He was beginning to grow cold about the groin, when he uncovered his face, for he had covered himself up, and said—they were his last words—he said: "Crito, I owe a cock to Asclepius;[2] will you remember to pay the debt?"

"The debt shall be paid," said Crito; "is there anything else?" There was no answer to this question; but in a minute or two a movement was heard, and the attendants uncovered him; his eyes were set, and Crito closed his eyes and mouth.

Such was the end, Echecrates, of our friend; concerning whom I may truly say, that of all the men of his time whom I have known, he was the wisest and justest and best.

..

COMMENTS AND QUESTIONS

1. What is Socrates' proof for the immortality of the soul? On what premises is it based?
2. The death of Socrates has served for twenty-five hundred years as the humanistic example of how a person should face death. Is it a relevant example for our age?
3. What moral values does Socrates uphold?

..

ARISTOTLE

..

from the *Politics*
Translation by Benjamin Jowett

In the *Politics*, Aristotle describes the state as a self-sufficient community based on a union of villages, each one more or less composed of a large family. If the family is a natural institution, so, for Aristotle, is the state, because it is the culminating organization toward which political life tends. Only at the state level can the human community be self-sufficient and individuals live a truly virtuous life. Put another way, the state is prior to the family, not because it actually existed before the family, but because the desire to form a state is innate in human beings and constitutes the driving force in political organization. Fathers rule over their families as

[2] The god of medicine and healing. Sick people sacrificed roosters to him to be cured. Socrates apparently means that death cures the sickness of life.

kings rule over their subjects. Women and slaves are subordinate. Moreover, the passage reflects the low opinion the Hellenic Greeks had of the "barbarians"—that is, male and female non-Greeks—whom they considered to be slaves by nature and unworthy of freedom. Although the passage does not say so explicitly, it prepares the way for Aristotle's assertion that, while the government of the family or village is royal, that of the state ought to be republican. Ideally, male family heads participate in a constitutional government whose leadership is elected and where citizens alternate between ruling and obeying.

He who thus considers things in their first growth and origin, whether a state or anything else, will obtain the clearest view of them. In the first place there must be a union of those who cannot exist without each other; namely, of male and female, that the race may continue (and this is a union which is formed, not of deliberate purpose, but because, in common with other animals and with plants, mankind have a natural desire to leave behind them an image of themselves), and of natural ruler and subject, that both may be preserved. For that which can foresee by the exercise of mind is by nature intended to be lord and master, and that which can with its body give effect to such foresight is a subject, and by nature a slave; hence master and slave have the same interest. Now nature has distinguished between the female and the slave. For she is not niggardly, like the smith who fashions the Delphian knife for many uses; she makes each thing for a single use, and every instrument is best made when intended for one and not for many uses. But among barbarians no distinction is made between women and slaves, because there is no natural ruler among them: they are a community of slaves, male and female. Wherefore the poets say—

It is meet that Hellenes should rule over barbarians;

as if they thought that the barbarian and the slave were by nature one.

Out of these two relationships between man and woman, master and slave, the first thing to arise is the family, and Hesiod is right when he says—

First house and wife and an ox for the plough,

for the ox is the poor man's slave. The family is the association established by nature for the supply of men's everyday wants, and the members of it are called by Charondas "companions of the cupboard," and by Epimenides the Cretan, "companions of the manger." But when several families are united, and the association aims at something more than the supply of daily needs, the first society to be formed is the village. And the most natural form of the village appears to be that of a colony from the family, composed of the children and grandchildren, who are said to be "suckled with the same milk." And this is the reason why Hellenic states were originally governed by kings; because the Hellenes were under royal rule before they came together, as the barbarians still are. Every family is ruled by the eldest, and therefore in the colonies of the family the kingly form of government prevailed because they were of the same blood. As Homer says:

Each one gives law to his children and to his wives.

For they lived dispersedly, as was the manner in ancient times. Wherefore men say that the Gods have a king, because they themselves either are or were in ancient times under the rule of a king. For they imagine, not only the forms of the Gods, but their ways of life to be like their own. . . .

Now, that man is more of a political animal than bees or any other gregarious animals is evident. Nature, as we often say, makes nothing in vain, and man is the only animal whom she has endowed with the gift of speech. And whereas mere voice is but an indication of pleasure or pain, and is therefore found in other animals (for their nature attains to the perception of pleasure and pain and the intimation of them to one another, and no further), the power of speech is intended to set forth the expedient and inexpedient, and therefore likewise the just and the unjust. And it is a characteristic of man that he alone has any sense of good and evil, of just and unjust, and the like, and the association of living beings who have this sense makes a family and a state.

Further, the state is by nature clearly prior to the family and to the individual, since the whole is of necessity prior to the part; for example, if the whole body be destroyed, there will be no foot or hand, except in an equivocal sense, as we might speak of a stone hand; for when destroyed the hand will be no better than that. But things are defined by their working and power; and we ought not to say that they are the same when they no longer have their proper quality, but only that they have the same name. The proof that the state is a creation of nature and prior to the individual is that the individual, when isolated, is not self-sufficing; and therefore he is like a part in relation to the whole. But he who is unable to live in society, or who has no need because he is sufficient for himself, must be either a beast or a god: he is no part of a state. A social instinct is implanted in all men by nature, and yet he who first founded the state was the greatest of benefactors. For man, when perfected, is the best of animals, but, when separated from law and justice, he is the worst of all; since armed injustice is the more dangerous, and he is equipped at birth with arms, meant to be used by intelligence and virtue, which he may use for the worst ends. Wherefore, if he have not virtue, he is the most unholy and the most savage of animals, and the most

full of lust and gluttony. But justice is the bond of men in states for the administration of justice, which is the determination of what is just, is the principle of order in political society.

. .

QUESTIONS

1. What, for Aristotle, makes certain men the masters of women and other men?
2. According to Aristotle, for what purpose did nature create woman?
3. Why does Aristotle think that man within the state is the best of all animals and outside the state the worst?

. .

. .

The High-Minded Man
Translation by F. H. Peters

Aristotle's discussion of high-mindedness presents the philosopher's ideal of the happy man in some detail. Virtue for Aristotle was fundamentally a mean between two extremes. Self-esteem was a mean between arrogance and humility. Generosity held the middle place between spendthriftiness and stinginess. The other virtues are similarly defined. Obviously again the classical ideal of balance, "nothing too much," is at work in Aristotle's ethics. The high-minded person must most of all cultivate the virtue of prudence: the ability to measure each situation and to determine the correct course of action. He must be able to establish the correct middle course for appropriate action. The resultant picture of the gentleman is very different from that of the later Christian ideal. We are clearly dealing with a male member of the upper classes, affluent, confident, calculating, and disdainful of members of the lower classes, who have no hope of matching his standards of conduct. This selection is from the *Nicomachean Ethics*.

High-mindedness would seem from its very name to have to do with great things; let us first ascertain what these are.

It will make no difference whether we consider the quality itself, or the man who exhibits the quality.

By a high-minded man we seem to mean one who claims much and deserves much: for he who claims much without deserving it is a fool; but the possessor of a virtue is never foolish or silly. The man we have described, then, is high-minded.

He who deserves little and claims little is temperate [or modest], but not high-minded: for high-mindedness [or greatness of soul] implies greatness, just as beauty implies stature; small men may be neat and well proportioned, but cannot be called beautiful.

He who claims much without deserving it is vain (though not every one who claims more than he deserves is vain).

He who claims less than he deserves is little-minded, whether his deserts be great or moderate, or whether they be small and he claims still less: but this little-mindedness is most conspicuous in him whose deserts are great; for what would he do if his deserts were less than they are?

The high-minded man, then, in respect of the greatness of his deserts occupies an extreme position, but in that he behaves as he ought, observes the mean; for he claims that which he deserves, while all the others claim too much or too little.

But now if he deserves much and claims much, and most of all deserves and claims the greatest things, there will be one thing with which he will be especially concerned. For desert has reference to external good things. Now, the greatest of external good things we may assume to be that which we render to the Gods as their due, and that which people in high stations most desire, and which is the prize appointed for the noblest deeds. But the thing that answers to this description is honour, which, we may safely say, is the greatest of all external goods. Honours and dishonours, therefore, are the field in which the high-minded man behaves as he ought.

And indeed we may see, without going about to prove it, that honour is what high-minded men are concerned with; for it is honour that great men claim and deserve.

The little-minded man falls short, whether we compare his claims with his own deserts or with what the high-minded man claims for himself.

The vain or conceited man exceeds what is due to himself, though he does not exceed the high-minded man in his claims.

But the high-minded man, as he deserves the greatest things, must be a perfectly good or excellent man; for the better man always deserves the greater things, and the best possible man the greatest possible things. The really high-minded man, therefore, must be a good or excellent man. And indeed greatness in every virtue or excellence would seem to be necessarily implied in being a high-minded or great-souled man.

It would be equally inconsistent with the high-minded man's character to run along swinging his arms, and to commit an act of injustice; for what thing is there for love of which he would do anything unseemly, seeing that all things are of little account to him? . . .

. . . The gifts of fortune also are commonly thought to contribute to high-mindedness. For those who are well born are thought worthy of honour, and those who are powerful or wealthy; for they are in a position of superiority, and that which is superior in any good thing is always held in greater honour. And so these things do make people more high-minded in a sense; for

such people find honour from some. But in strictness it is only the good man that is worthy of honour, though he that has both goodness and good fortune is commonly thought to be more worthy of honour. Those, however, who have these good things without virtue, neither have any just claim to great things, nor are properly to be called high-minded, for neither is possible without complete virtue. . . .

The high-minded man is not quick to run into petty dangers, and indeed does not love danger, since there are few things that he much values; but he is ready to incur a great danger, and whenever he does so is unsparing of his life, as a thing that is not worth keeping at all costs.

It is his nature to confer benefits, but he is ashamed to receive them; for the former is the part of a superior, the latter of an inferior. And when he has received a benefit, he is apt to confer a greater in return; for thus his creditor will become his debtor and be in the position of a recipient of his favour.

It is thought, moreover, that such men remember those on whom they have conferred favours better than those from whom they have received them; for the recipient of a benefit is inferior to the benefactor, but such a man wishes to be in the position of a superior. So he likes to be reminded of the one, but dislikes to be reminded of the other. . . .

It is characteristic of the high-minded man, again, never or reluctantly to ask favours, but to be ready to confer them, and to be lofty in his behaviour to those who are high in station and favoured by fortune, but affable to those of the middle ranks; for it is a difficult thing and a dignified thing to assert superiority over the former, but easy to assert it over the latter. A haughty demeanor in dealing with the great is quite consistent with good breeding, but in dealing with those of low estate is brutal, like showing off one's strength upon a cripple.

Another of his characteristics is not to rush in wherever honour is to be won, nor to go where others take the lead, but to hold aloof and to shun an enterprise, except when great honour is to be gained, or a great work to be done—not to do many things, but great things and notable.

Again, he must be open in his hate and in his love; for concealment shows fear.

He must care for truth more than for what men will think of him, and speak and act openly; he will not hesitate to say all that he thinks, as he looks down upon mankind. So he will speak the truth, except when he speaks ironically; and irony he will employ in speaking to the generality of men.

Another of his characteristics is that he cannot fashion his life to suit another, except he be a friend, for that is servile: and so all flatterers or hangers on of

great men are of a slavish nature, and men of low natures become flatterers.

Nor is he easily moved to admiration; for nothing is great to him.

He readily forgets injuries; for it is not consistent with his character to brood on the past, especially on past injuries, but rather to overlook them.

He is no gossip; he will neither talk about himself nor about others; for he cares not that men should praise him, nor that others should be blamed (though, on the other hand, he is not very ready to bestow praise); and so he is not apt to speak evil of others, not even of his enemies, except with the express purpose of giving offence.

When an event happens that cannot be helped or is of slight importance, he is the last man in the world to cry out or to beg for help; for that is the conduct of a man who thinks these events very important.

He loves to possess beautiful things that bring no profit, rather than useful things that pay; for this is characteristic of the man whose resources are in himself.

Further, the character of the high-minded man seems to require that his gait should be slow, his voice deep, his speech measured; for a man is not likely to be in a hurry when there are few things in which he is deeply interested, nor excited when he holds nothing to be of very great importance: and these are the causes of a high voice and rapid movements.

This, then, is the character of the high-minded man.

But he that is deficient in this quality is called little-minded; he that exceeds, vain or conceited.

..

QUESTIONS

1. Would you like to have this man for a friend?
2. From a modern point of view, how would you criticize this ideal?
3. What information about Greek social structure does this passage give us?

..

..

from the *Poetics*

Translation by Leon Golden

IV

Speaking generally, the origin of the art of poetry is to be found in two natural causes. For the process of imitation is natural to mankind from childhood on: Man is differentiated from other animals because he is the most imitative of them, and he learns his first lessons through imitation, and we observe that all men

find pleasure in imitations. The proof of this point is what actually happens in life. For there are some things that distress us when we see them in reality, but the most accurate representations of these same things we view with pleasure—as, for example, the forms of the most despised animals and of corpses. The cause of this is that the act of learning is not only most pleasant to philosophers but, in a similar way, to other men as well, only they have an abbreviated share in this pleasure. Thus men find pleasure in viewing representations because it turns out that they learn and infer what each thing is—for example, that this particular object is that kind of object; since if one has not happened to see the object previously, he will not find any pleasure in the imitation *qua* imitation but rather in the workmanship or coloring or something similar.

V

As we have said, comedy is an imitation of baser men. These are characterized not by every kind of vice but specifically by "the ridiculous," which is a subdivision of the category of "deformity." What we mean by "the ridiculous" is some error or ugliness that is painless and has no harmful effects. The example that comes immediately to mind is the comic mask, which is ugly and distorted but causes no pain.

VI

Let us now discuss tragedy, bringing together the definition of its essence that has emerged from what we have already said. Tragedy is, then, an imitation of a noble and complete action, having the proper magnitude; it employs language that has been artistically enhanced by each of the kinds of linguistic adornment, applied separately in the various parts of the play; it is presented in dramatic, not narrative form, and achieves, through the representation of pitiable and fearful incidents, the catharsis of such pitiable and fearful incidents. I mean by "language that has been artistically enhanced," that which is accompanied by rhythm and harmony and song; and by the phrase "each of the kinds of linguistic adornment applied separately in the various parts of the play," I mean that some parts are accomplished by meter alone and others, in turn, through song.

Now I mean by the plot the arrangement of the incidents, and by character that element in accordance with which we say that agents are of a certain type; and by thought I mean that which is found in whatever things men say when they prove a point or, it may be, express a general truth. It is necessary, therefore, that tragedy as a whole have six parts in accordance with which, as a genre, it achieves its particular quality. These parts are plot, character, diction, thought, spectacle, and melody. Two of these parts come from the means by which the imitation is carried out; one from the manner of its presentation, and three from the objects of the imitation. Beyond these parts there is nothing left to mention. Not a few poets, so to speak, employ these parts; for indeed, every drama [theoretically] has spectacle, character, plot, diction, song, and thought.

The most important of these parts is the arrangement of the incidents; for tragedy is not an imitation of men, *per se*, but of human action and life and happiness and misery. Both happiness and misery consist in a kind of action; and the end of life is some action, not some quality. Now according to their characters men have certain qualities; but according to their actions they are happy or the opposite. Poets do not, therefore, create action in order to imitate character; but character is included on account of the action. Thus the end of tragedy is the presentation of the individual incidents and of the plot; and the end is, of course, the most significant thing of all. Furthermore, without action tragedy would by impossible, but without character it would still be possible.

. . .

In addition to the arguments already given, the most important factors by means of which tragedy exerts an influence on the soul are parts of the plot, the reversal, and the recognition. We have further proof of our view of the importance of plot in the fact that those who attempt to write tragedies are able to perfect diction and character before the construction of the incidents, as we see, for example, in nearly all of our early poets. . . .

Tragedy, then, is an imitation of an action; and it is, on account of this, an imitation of men acting.

XI

Reversal is the change of fortune in the action of the play to the opposite state of affairs, just as has been said; and this change, we argue, should be in accordance with probability and necessity. Thus, in the *Oedipus* the messenger comes to cheer Oedipus and to remove his fears in regard to his mother; but by showing him who he actually is he accomplishes the very opposite effect. And in *Lynceus*, Lynceus is being led away to die and Danaus is following to kill him; but it turns out, because of the action that has taken place, that Danaus dies and Lynceus is saved. Recognition, as the name indicates, is a change from ignorance to knowledge, bringing about either a state of friendship or one of hostility on the part of those who have been marked out for good fortune or bad.

XIV

Pity and fear can arise from the spectacle and also the very structure of the plot, which is the superior way

and shows the better poet. The poet should construct the plot so that even if the action is not performed before spectators, one who merely hears the incidents that have occurred both shudders and feels pity from the way they turn out. That is what anyone who hears the plot of the *Oedipus* would experience. The achievement of this effect through the spectacle does not have much to do with poetic art and really belongs to the business of producing the play. Those who use the spectacle to create not the fearful but only the monstrous have no share in the creation of tragedy; for we should not seek every pleasure from tragedy but only the one proper to it.

QUESTIONS

1. Why does Aristotle think that we enjoy the imitation ("mimesis") of certain events more than the events themselves? Do you agree that the human need for imitation constitutes the basis of art and literature?
2. Why does Aristotle consider plot to be the most important part of tragedy?
3. How should the poet arouse pity and fear?
4. What, do you think, is meant by *catharsis*?
5. To what extent do these remarks apply to *Oedipus Rex* and *The Women of Troy*? Can you apply them to any modern plays or films?

Summary Questions

1. What kind of role does God or do gods play in the philosophies of the Pre-Socratics? What kind of a god is Plato's Demiurge or Aristotle's Unmoved Mover?
2. In the light of what you have read about the Pre-Socratics, what would their position be on the immortality of the human being?
3. How do Plato and Aristotle differ on the immortality of the human soul?
4. Compare Plato's philosophical proofs for the immortality of the soul with beliefs of various religions (Mesopotamian and Egyptian religions, as well as Christianity, Judaism, Islam, Hinduism, and Buddhism).
5. Plato calls the eternal, immutable exemplars Ideas, or forms. What is the difference between these forms and the forms of Aristotle? How does Aristotle's conception of the form make it possible to have knowledge of the world without having to resort to memories of the world of the Ideas that we brought with us into our earthly existence?

Key Terms

philosophy

ethics

Platonic dialectic

Ideas, or forms

deductive versus inductive knowledge

virtue

soul

mimesis (imitation)

7

The Culture of Rome

CENTRAL ISSUES

- The effect of the breakup of the Greek polis on culture and society
- Two philosophies of the cosmopolitan Hellenic culture, Stoicism and Epicureanism
- Cicero as a moral philosopher
- The status of slaves and women
- Distinctive contributions of the Romans to art and architecture
- The growth of the Roman Republic, its decline, and the establishment of the emperors
- The comparison between Roman and Greek epic poetry
- Satire as the uniquely Roman literary genre

Already before the deaths of Plato and Aristotle, their political philosophies, assuming as they did the existence of the independent city-state, were becoming out of date. Athens was conquered by Sparta in 404 B.C., and for about thirty years Sparta controlled the leadership of the Greek city-state system. Sparta, however, was neither intellectually suited nor powerful enough to carry such a burden, and in 371 B.C. the Spartans were defeated by the Thebans, who in turn became the leading military force in Greece. But the Greek city-states were so isolated and divided by rivalries that they fell easy prey to the armies of Philip II of Macedon, a kingdom in the northern part of the Aegean peninsula. By 338 B.C. almost all Greece was under Philip's control.

Hellenistic and Roman History and Thought

Hellenistic Empires

When Philip died in 336 B.C., his place was taken by his son Alexander (356–323 B.C.). With Alexander, the West took the offensive against the East. The armies of Macedon and Greece invaded and conquered the Persian empire, and Greek rule was established in the Near East, including all of Mesopotamia, and in Egypt. Alexander even made a brief incursion into India. Educated in the ideas of Greek culture partially instilled in him by Aristotle, who acted as his tutor for a time, Alexander spread the civilization and language of Greece wherever his armies went (see map).

In the process, Greek culture became more cosmopolitan and sophisticated while remaining essentially Greek. Because of this modification in the character of Greek life, the age beginning with Alexander is referred to as Greeklike, or Hellenistic. The graceful nudity of the Cnidian *Aphrodite* and the dramatic power of the frieze for the Pergamon altar (Figs. 4-15 and 4-18) are examples of the expansion and transformation of Greek art. In learning, in contrast to the wide-ranging interest of earlier thinkers, there was a tendency toward specialization. Euclid produced his masterful geometrical treatise, *The Elements*; Archimedes did basic work in statistics and hydrostatics; great advances were also made in biology, astronomy, geography, and city planning.

The expansion of the frontiers of Greek culture, moreover, had a dissolving effect on the political and cultural shell around the individual created by the polis. Individuals came increasingly to live on their own. They found themselves in a larger, more international community than the one they had known. The sharp distinction drawn by Hellenic culture between the Greek, free by nature, and the barbarian, by nature a slave, broke down. However, freedom from the encompassing pressures of the integrated life of the polis made people uneasy. Eastern religions extending hope of personal immortality became popular. These beliefs often centered on a suffering god, who through his earthly death extended to his worshipers the hope of everlasting life. People in the Hellenistic empire also turned to philosophies focusing on the ethical conduct of the individual and providing a vision of political association more adapted to a period of world empire.

Stoicism

Among the variety of new philosophical movements rising at the end of the fourth century, the one with the greatest future was Stoicism. First taught by Zeno (322–264 B.C.) at Athens, the Stoic doctrine maintained that the principle of the world was reason. Reason was a divine essence that lay behind everything occurring in the universe and was the ultimate cause of all that happened. This rational principle was the Stoic God. The human being was a rational creature whose soul, moreover, was a particle of that divine reason. Thus all peo-

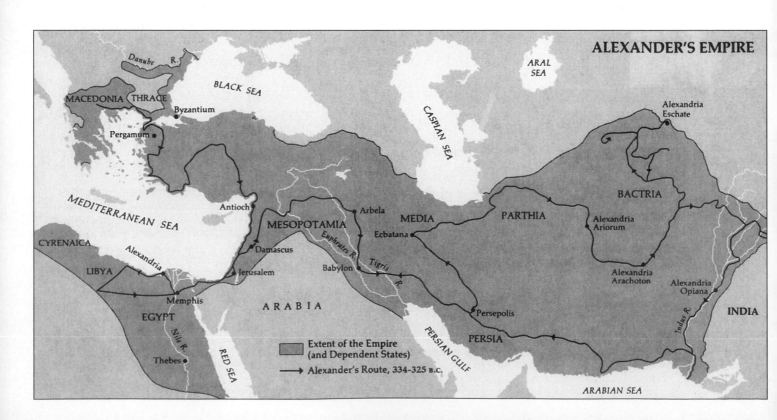

ple were equal, one to the other, because each, whether slave or free, man or woman, was a particle of the same divine substance. Divine reason operated according to certain laws. If individuals carefully examined their consciences, they would see in themselves, as particles of divine reason, the same laws. Every individual, moreover, if he or she submitted himself or herself to an honest examination, would produce the same conclusions: that it was wrong to kill, to steal, to hurt another human being. Thus for the Stoic, at the basis of every human mind lay the same principle of ethical action, a natural law, which was common to world reason and the individual reason of human beings. What better kind of philosophy was there for a world state?

What of human happiness? Since the cause of the world was pure reason, everything had to happen for the best. Divine reason was not a cold indifferent force but rather a providential goodness that aimed for the good of the whole. Human beings must learn to accept this external world as it is. The individual should not regret failures and lose control in times of success. Rather, the individual must welcome everything calmly. To do so was to put oneself in accord with world reason and to follow one's own nature, which was essentially reason. Furthermore, because the principle of divine reason was beneficent, so the individual, truly following his or her own nature, would also be a force for good in the world and especially for other human beings. This doctrine gave a strong social direction to followers of the school and defined a new conception of the relationship of the individual to the state.

For Plato and Aristotle, human beings derived their identity from the state, which bestowed on individuals its values and cultural and political ideals—all those attributes that make them human beings. In a word, their state was totalitarian. Only animals and gods lived outside the state. By contrast, the Stoics, living in a period when the parochial city-states had given way to large cosmopolitan empires, composed of different peoples, believed that before the existence of the state human beings had led rational lives and did so within communities seeking the common good. Indeed, rational human beings created the state so that they might obtain through it greater protection and benefits. Consequently, rather than being natural as Plato and Aristotle believed, the state was an artificial creation, a product of human reason.

The doctrine of the early Stoics pictured the ethical ideal as apathy—indifference to all that was not concerned with virtue. The wise man was to do his duty regardless of the personal costs. Other "goods" of the soul, health and wealth (which for Aristotle were necessary for happiness), were irrelevant for the Stoic. Nor did the Stoic expect eternal reward. At death the individual human soul of good and evil people alike would fall back into the reservoir of divine reason whence it came. With the centuries, however, Stoicism became less harsh, more reconciled to human weaknesses. By the first century B.C., adherents of the school rejected the ideal of apathy as inhuman and admitted that, if not "goods," health and wealth were nonetheless useful for happiness. Increasingly, Stoics also came to believe in some kind of personal immortality of the human soul even though it was difficult to reconcile that belief with the general structure of their thought.

Epicureanism

A second Hellenistic philosophy, which vied with Stoicism for the loyalty of intellectuals in this period of world empire, was Epicureanism. Founded by Epicurus (b. 342), a contemporary of Zeno, Epicureanism taught that fear of the gods and anxiety about life after death were the underlying causes of wars and human misery. As they understood the nature of the universe, the Epicureans believed that such fear was groundless because the individual died with the body. They conceived of the universe as composed of an infinite number of worlds made up of two elements, atoms of different shapes and sizes and the void, that is, matter and space. Product of chance, the universe was originally created as we know it by atoms falling through the void and, because they did not necessarily fall in a straight line, they became entangled with one another and formed material objects. All such objects, even the gods, were composed of atoms, but because the gods resided in spaces between the worlds where collisions did not occur, they were indestructible. According to the Epicureans, people, like other beings, were composed of different kinds of atoms temporarily linked together. Human souls were deemed material even if composed of very fine atoms. At death these atoms would separate to form other objects and a person would cease to exist as an individual. Consequently, there was nothing to fear after death. Furthermore, even in this world people did not need to fear the displeasure of the gods, for the gods lived in their own region far from humankind and cared nothing for what people did or left undone.

Having thus dispelled the fear of death that plagued human existence, the Epicureans urged their followers to seek happiness by maximizing pleasure and minimizing pain. In their view, there was no absolute standard of good and evil independent of one's feelings. The only unconditional good was pleasure, and the only evil, pain. A person's duty was to maximize his or her pleasures over a lifetime. Consequently, pleasures such as heavy drinking and gambling had to be avoided, for in the long run they brought more pain than pleasure. Specifically, the Epicureans defined pleasure as the product of fulfilling a need, such as eating when hungry or finding heat when cold. Thus they tended to define pleasure in a relatively negative way as freedom from

pain. They strove not for crass pleasure but rather for contentment.

Consequently, in Epicurean terms, the wise man was a disciplined calculator, who judged his actions by the amount of pleasure these actions would produce in the long run of life. At bottom, then, the Epicurean was a self-regarding individual. Friendship, for example, could be a source of pleasure but essentially one acquired friends in order to keep them from doing one harm. Epicurean political thought bore out this conception of human beings as selfish. Like the Stoics, the Epicureans believed that individuals existed before the state. In the Epicurean primitive state, however, human beings waged all-out war against one other. Ultimately they realized that their own interests lay in creating a state to establish order. But the state was merely an expediency, and one obeyed the law only so long as the pain one suffered was less than it would have been in the original condition of freedom.

Whereas for the Stoic a human community existed before the state, for the Epicurean there had been only individuals. To the Stoic belief in absolute moral standards based on innate reason, the Epicurean opposed a subjective morality based on pleasure. While both saw the state as necessary to maintain order, the Stoic felt a moral responsibility to other people, whereas the Epicurean sought only personal satisfaction.

By the second century B.C. the writings of the Greek thinkers Plato, Aristotle, Zeno, and Epicurus and their followers were circulating widely in Roman Italy. In the course of the next century the Romans themselves were debating and writing about the merits of the various philosophies of life. Of all these philosophies, however, Stoicism, with its stern insistence on duty and its view of human beings as particles of divine reason possessing the same consciousness of right and wrong, exercised the strongest appeal. By this time the Romans were moving into position to rule a large portion of the known Western world. They needed a philosophy that stressed service to the state and provided a theoretical background for a legal system designed to integrate the disparate territories into a world state, governed by an overarching system of laws. Stoicism met these needs.

The Rise of Rome

The great Macedonian empire of Alexander was unstable. When, after his death in 323 B.C., it was divided among his generals, disintegration set in. Throughout most of the third century B.C. a power vacuum existed in the Mediterranean area; in the second century B.C. Rome would fill that vacuum. Founded sometime in the eighth century B.C. (the mythical date is 753), Rome was initially ruled by a series of kings. The last of them, Tarquin the Proud, was driven out around 509 B.C., and a republic replaced the monarchy. As merely one in a series of small city-states dotting the Italian peninsula, Rome, under its kings and in the early republic, came close to extinction several times at the hands of its enemies.

After Tarquin's expulsion, the royal powers were divided among two consuls, who governed by the principle of collegiality: both had to agree on a policy or nothing could be done. On the battlefield they usually alternated the command daily; in cases of a major war, however, a *dictator* was appointed and given absolute power over the army for a period of six months. Both the consuls and the occasional *dictator*[1] were patricians, or *optimates*; that is, they came from the large landholding families, which consisted of about 10 percent of the population. The plebeian class, or *populares*, comprising artisans, merchants, and small farmers, constituted the other 90 percent. Of the two assemblies of the government, the Senate was entirely patrician. Although plebeians could participate in the second—called the Centuriate Assembly because it represented the *centuriae*, or army units of one hundred men—the patrician class dominated it as well. Moreover, like the consuls and the *dictator*, all the magistrates of the government had to be patrician.

Deeply resenting their lack of power, the plebeians in 495 B.C. threatened to march out of Rome to found a new city unless they were granted a measure of protection against patrician oppression. Unable to survive without the plebeians, the patricians compromised, and over the next fifty years the people were given four officials, called tribunes, who were charged with protecting plebeian interests. These officials were elected annually by a new plebeian assembly, the Tribal Assembly; its decisions, however, had to be approved by the Senate in order to become law. Nonetheless, in time the Tribal Assembly replaced the Centuriate Assembly. Furthermore, in 449 B.C. the plebeians forced the patricians to publish the laws so that everyone might know and use them. At the same time the tribunes gained the right to veto Senate proposals that contravened plebeian liberties. The balance of power then clearly shifted toward the plebeians. By 264 B.C. one of the consuls had to be a plebeian; plebeians could be magistrates; and the Tribal Assembly had become the chief lawmaking power in the city-state. The Senate remained the patricians' citadel, but it exercised its influence primarily in informal ways. As the Roman example suggests, a republic is not necessarily a democracy. The ancient Greek cities were democratic republics because a large body of the male population participated actively in government. By contrast, the early Roman government was an aristocratic republic, with a limited

[1] Although derived from Latin, the English word *dictator* usually means a ruler with unlimited power, whereas the Roman *dictator* enjoyed absolute power only for a limited period of time.

number of active citizens. The United States, to give a third example, began as a republic with limited suffrage and by the late nineteenth century became a democratic republic.

While these political arrangements were being worked out in Rome itself, the city-state underwent enormous expansion beyond its original borders. The Romans created federations of city-states, eventually subordinating them to Rome's authority. Since the Romans were exceptionally sensitive to local customs and institutions, they were often called in to establish peace between warring factions. They worked well with the local leadership in these city-states, guaranteeing them control under Rome's aegis. By creating degrees of linkage to Rome, with full Roman citizenship as the final status, the Romans were able to generate something like a national feeling on the Italian peninsula. Expanding in this way, Rome became the dominant force in most of the peninsula by the middle decades of the third century B.C.

The Wars with Carthage This expansion brought Rome into a conflict of interest with the great African commercial power, Carthage, a republican city-state founded by the Phoenicians on the northern coast of Africa about 825 B.C. (see map). Well situated to control east-west Mediterranean trade, Carthage dominated most of the northern coast of Africa, numerous Mediterranean islands including Sardinia, most of Sicily, and parts of Spain. Beginning in 264 B.C., the Carthaginian wars taxed both powers—Carthage and Rome—as well as their allies, to the utmost. The struggle ended in 144 B.C. with the destruction of Carthage, the selling of its remaining inhabitants into slavery, and the sowing of the city's soil with salt. Victorious Rome was now the major imperial power in the Western world. By 144 B.C., too, Rome had already become the arbitrator of Greek politics, although it would not annex Greece until the next century.

The decades of war with Carthage and Rome's eastward expansion had tremendous repercussions on political institutions at home. When pressures of war demanded quick decisions, the smaller Senate was a much more effective arena for decision making than the larger popular assembly. Furthermore, the nature of the Senate had changed by 144 B.C. Through a policy of advancing to the Senate those who had served as consuls or magistrates, the leading men among the plebeians—those elected to public offices—became senators at the expiration of their terms. This reinvigoration of the Senate's membership, along with the increase in power occasioned by war, enhanced the Senate's political position. It also brought about its revival as the leading authority in the Roman state.

The senators' political position was reinforced by a long-term trend toward large-scale farming using cheap slave labor. Small farmers could not compete, and in time a significant number sold what land they had and joined the urban poor, primarily at Rome. A series of reform efforts in the 130s and 120s B.C. by Tribunes of the People Tiberius Gracchus and Gaius Gracchus ended in the murder of both. They had tried to settle landless peasant families on state land but met resistance from large landowners, who were leasing much of it. The gap between rich and poor kept widening.

The Breakdown of the Republic In the first century B.C. power passed from the Senate to individual generals, who at the head of their victorious armies could govern the area of the Roman state under their control pretty much as they willed. By the start of the century Rome was for all practical purposes mistress of the Mediterranean. From this point on its major interest was to push back the frontiers from the coasts of the inland sea. On the east Rome expanded into Arabia, the Levant, and Persian territory; on the south, into the deserts of North Africa and Egypt; and on the north, into southern Germany and southern Russia. Meanwhile Roman legions from Gaul invaded and conquered England. By A.D. 1 Rome controlled most of western Europe, the Middle East, and North Africa. To the north stretched the German forests, to the east the decaying Persian empire, to the south the deserts of Africa, and to the west Ireland and the ocean (see map).

The struggle of the various generals for political control of the empire during the first half of the first century B.C. threatened Rome's republican institutions. A devoted republican, Cicero was aware of the growing threat and strove to reconcile the different factions dividing the state. But political reality overwhelmed him. When the bitter civil war between two of these generals, Pompey and Julius Caesar, ended in the death of Pompey and Caesar's complete victory in 45 B.C., the end of the Republic was imminent. Upon Caesar's triumphal return to Rome, he was named dictator for life. He then set about establishing control of the state by assuming many of the powers traditionally divided among a number of offices and by putting his trusted followers in key posts. In 44 B.C., however, Caesar was assassinated in the Senate by conspirators, whose leaders were the senators Brutus and Cassius.

The assassination caused the outbreak of yet another civil war: between Caesar's murderers and a new triumvirate, consisting of his nephew and adopted son, Octavian; a consul, Mark Antony; and a former general, Lepidus, who soon lost importance. After defeating the armies of Caesar's assassins in 42 B.C., Octavian and Antony divided the Roman world between them. Octavian took the West, and Mark Antony the East. Inevitably, war broke out between them for mastery, and

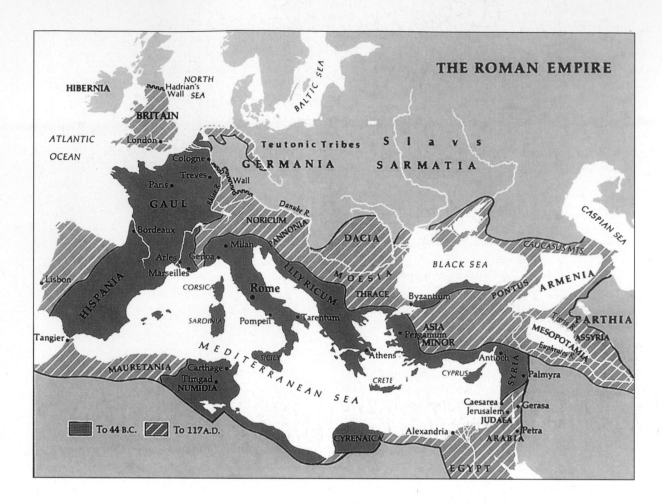

at the sea battle of Actium in 31 B.C. Octavian triumphed and Antony committed suicide. For all practical purposes the Roman Republic had ended.

Augustus Caesar (63 B.C.–A.D. 14)

The Roman government changed significantly after 31 B.C. Although Octavian gained the designation *imperator* among other titles, it merely meant that he was leader of the army. He is known in history as *Augustus* ("revered"), a title bestowed on him in 27 B.C. by the Senate. However, the title *princeps* ("foremost"), which he assumed as early as 32 B.C., perhaps best describes his place in the Roman state. He was the first citizen of Rome. He had no wish to become a despot and honestly endeavored to restore the old republican institutions, especially the Senate, to a position of power and honor. In his own hands were concentrated the direction of the army and control over most of the state's finances. He also directly appointed governors to a number of provinces. On the other hand, all public business was debated by the Senate, the *princeps* frequently consulted the Senate on policy, and the senators ruled over a number of provinces and held high positions in both the army and imperial civil service. Although gradually

over the next two hundred years the *princeps* assumed more power at the expense of the Senate, he usually tried to maintain at least the trappings of the republican institutions.

With the establishment of the principate, the empire remained, as before, organized around hundreds of cities, with the territory attached to them; it stayed so to the end of the imperial period, but now for the first time there was a truly unified authority at the center. In the last century of the Republic, the Roman senators sent out as governors of the provinces had often treated their charges as a means for self-enrichment. With Augustus and his successors the provincials felt that there was an overseer in the capital to whom they could appeal for justice. Although a number of the emperors, such as Caligula and Nero, were probably madmen, on the whole the provinces saw their general condition improve with the principate. The Roman world, moreover, was tired of years of civil war and longed for peace. With Augustus' assumption of power as *princeps* began a two-hundred-year period of peace, the *Pax Romana,* which Edward Gibbon, the eighteenth-century author of *The History of the Decline and Fall of the Roman Empire,* characterized as "perhaps the happiest period in the history of the human race."

Roman Law

The Roman Empire, with its myriad of city-states and big and little kingdoms subject to Rome, was a legal nightmare. Each of these areas had its own law code, and the task of the conqueror was to develop some kind of legal system that would provide justice for the whole. From at least the first century B.C. on, Roman jurists began transforming the Stoic conception of a natural law present in the consciousness of all into practical forms. This task took centuries, and the final codification of Roman law was not finished until long after the Roman Empire in the West had fallen to the barbarians. While allowing each of the city-states to keep its own peculiar set of laws, the Roman state in matters of basic law and procedure forced all parts of its territory—from England to Asia—to follow the principles of the law of nations, the *jus gentium*. Those principles of justice had been derived by Roman jurists and statesmen from the abstract natural law found in human consciousness. With time the individual city-states came to follow the law of Rome in other aspects of law than just its basic principles.

Cicero (106–43 B.C.)

Perhaps the most eloquent testimony to the faith in the essential equality of all human beings is found in the writings of Marcus Tullius Cicero, the most gifted orator of his day, who used his talent to defend the republican institutions from the twin threats of dictatorship and anarchy. He lived to realize that his political work was a failure and, dying, could only hope that the coming monarchy would be benevolent. Despite a busy political career, Cicero found time to translate the terminology and ideas of Greek philosophers into Latin and composed numerous philosophical works of his own. Although skeptical of the validity of vast systems of thought found in many philosophers such as Plato and Aristotle, Cicero was vitally concerned with moral or ethical philosophy. He fervently believed that the eloquence of the orator, joined with moral philosophy, could have a tremendously positive effect on people's hearts and minds. In a series of books primarily devoted to ethics and politics—*On Duties, On the Republic,* and *On the Laws*—he captured the Stoics' cosmopolitan vision of humanity, using their conception of natural law as the background against which to judge the legal institutions and customs of his world. His God was the Stoic divine reason, and humanity, being essentially rational, was a particle of God. God's reason is right reason and right reason applied to the world is God's law. Sharing reason with God, all human beings can know this law and thus distinguish the just from the unjust.

Intimately connected with the ideal of justice is that of the dignity of human beings, who, in possession of

consciousness of the law, are akin to divine reason. Cicero, like the ancient philosophers before him, looked on the human predicament as essentially one of ignorance. In Cicero's view, humanity was divine but had lowered itself by commitment to the passions. The salvation of the individual lay in becoming aware of one's true nature and of training oneself to conform with the commandments of reason. Thus, as for Plato, Aristotle, and the Stoics, human happiness was within a person's grasp. The task of the philosopher was to educate individuals in the truth; the rest was up to them.

The Questions of Slavery and Women

Despite what might appear as the revolutionary tendencies of these doctrines of the basic equality of people and their common human dignity, neither Cicero nor his Stoic predecessors intended them to be attacks on the institution of slavery in their society. The Stoic conception that humanity had originally existed in a state of nature without formal government received wide acceptance. Without property and forced subjection, it was believed, people had led lives of peace and harmony. At some point when this tranquillity was disrupted by passion, the state was instituted as a means for restoring peace. Both slavery and property were essential ingredients of the new order. Thus, although slavery was not natural, it was a necessary institution designed to fit a corrupted human nature and was consequently legitimate. The only practical corollary of the doctrines of equality and human dignity in regard to the institution of slavery itself was the admonition to slaveholders to be humane with their chattels and to treat them more as hired workers than as possessions.

As for the condition of women, until the late republican period it differed very little from that of their Greek counterparts. Under the control of her father or a male relative until marriage, the woman was subject to her husband thereafter. If her husband died or divorced her, she passed back under the authority of her own family. Not only did her family choose her husband but, although he had the right to divorce her, she had no such option.

By the time of Cicero the status of women had improved considerably. It then became common for women to choose their own husbands, and women as well as men could obtain divorces. In the first century of the Empire women were also granted extensive control over the management of their own property. Women's freedom often sparked criticism among conservatives loyal to the "old republican values," who blamed it for the high divorce rate—at least among members of the upper classes. Yet the imperial society of the first and second centuries A.D. furnishes many historical examples of deep attachment between husband and wife, unmatched by anything comparable in ancient Greece.

DAILY LIVES

On the Construction of a Villa and the Treatment of Slaves

Written more than four hundred years after Xenophon's *Oeconomicus*, Columella's *On Agriculture* covers the same subject: estate management. Born in Cadiz, Spain, Columella had extensive experience in farming and his *On Agriculture* was a masterpiece of the genre. Composed in twelve books, the work deals with farming and country life in general. The first nine books are concerned with estate buildings, cultivation of the fields, and the treatment of livestock and slaves. Book 10 focuses on gardening, while Books 11 and 12 discuss the ideal estate foreman and his wife. The selections given here pertain to the construction of the villa and the control of field slaves.

> The size of the villa and the number of its parts should be proportioned to the whole inclosure, and it should be divided into three groups: the *villa urbana* or manor house, the *villa rustica*[a] or farmhouse, and the *villa fructuaria* or storehouse. The manor house should be divided in turn into winter apartments and summer apartments, in such a way
>
> that the winter bedrooms may face the sunrise at the winter solstice,[b] and the winter dining room face the sunset at the equinox.[c] The summer bedrooms, on the other hand, should look toward the midday sun at the time of the equinox,[d] but the dining-rooms of that season should look toward the rising sun of winter.[e] The baths should face the setting sun of summer,[f] that they may be lighted from midday up to evening. The promenades should be exposed to the midday sun at the equinox, so as to receive both the maximum of sun in winter and the minimum in summer. But in the part devoted to farm uses there will be placed a spacious and high kitchen, that the rafters may be free from the danger of fire, and that it may offer a convenient stopping-place for the slave household at every season of the year. It will be best that cubicles for unfettered slaves be built to admit the midday sun at the equinox; for those who are in chains there should be an underground prison, as wholesome as possible, receiving light through a number of narrow windows built so high from the ground that they cannot be reached with the hand. . . . (VI. 1–3)
>
> In the case of the . . . slaves, the following are, in general, the precepts to be observed, and I do not regret having held to them myself: to talk rather familiarly with the country slaves, provided only that they have not conducted themselves unbecomingly, more frequently than I would with the town

a. Properly including quarters for the overseer, slaves, and livestock.
b. South-east.

c. Due west. d. Due south. e. South-east. f. North-west.

Roman Art and Architecture

The practical, orderly aspects of Roman life are reflected in Roman art and architecture. Although they adopted Greek forms and techniques, the Romans used their statues and buildings not primarily in pursuit of ideal beauty but to proclaim the Roman system to the world.

Roman Sculpture

A bronze from the first century B.C., called the *Arringatore (The Orator)* presents a man who may have been a Roman official (Fig. 7-1). He stands before us as he might have stood in the forum any day of the week. His stance is simple and straightforward, as is the rendering of his features; here is a particular person, a physiognomy that could belong to no one but himself. He is not an ideal politician of any sort.

The realism that we see in *The Orator* is also evident in the many surviving portrait busts and heads. The Egyptians created many wonderful portraits as a means to portray the person for his or her afterlife. The Greeks did not accept the idea of portrait busts or heads, feeling that these detached objects were too reminiscent of a decapitated body. The Romans, like the Egyptians, took portrait masks of the deceased; but unlike the Egyptians, who made these visages part of the ritual of the tomb, the Romans preserved the masks at home and brought them out for ceremonies. The patrician families sought to preserve their identity from generation to generation in this way.

slaves; and when I perceive that their unending toil was lightened by such friendliness on the part of the master, I would even jest with them at times and allow them also to jest more freely. Nowadays I make it a practice to call them into consultation on any new work, as if they were more experienced, and to discover by this means what sort of ability is possessed by each of them and how intelligent he is. Furthermore, I observe that they are more willing to set about a piece of work on which they think that their opinions have been asked and their advice followed. Again, it is the established custom of all men of caution to inspect the inmates of the workhouse, to find out whether they are carefully chained, whether the places of confinement are quite safe and properly guarded, whether the overseer has put anyone in fetters or removed his shackles without the master's knowledge. For the overseer should be most observant of both points—not to release from shackles anyone whom the head of the house has subjected to that kind of punishment, except by his leave, and not to free one whom he himself has chained on his own initiative until the master knows the circumstances; and the investigation of the householder should be the more painstaking in the interest of slaves of this sort, that they may not be treated unjustly in the matter of clothing or other allowances, inasmuch as, being liable to a greater number of

people, such as overseers, taskmasters, and jailers, they are the more liable to unjust punishment, and again, when smarting under cruelty and greed, they are more to be feared. Accordingly, a careful master inquires not only of them, but also of those who are not in bonds, as being more worthy of belief, whether they are receiving what is due to them under his instructions; he also tests the quality of their food and drink by tasting it himself, and examines their clothing, their mittens, and their foot-covering. In addition he should give them frequent opportunities for making complaint against those persons who treat them cruelly or dishonestly. In fact, I now and then avenge those who have just cause for grievance, as well as punish those who incite the slaves to revolt, or who slander their taskmasters; and, on the other hand, I reward those who conduct themselves with energy and diligence. To women, too, who are unusually prolific, and who ought to be rewarded for the bearing of a certain number of offspring, I have granted exemption from work and sometimes even freedom after they had reared many children. For to a mother of three sons exemption from work was granted; to a mother of more her freedom as well. (VIII. 15–19)

Excerpts from Lucius Columella's *On Agriculture*. The roman numerals refer to sections of Book 1. Translator: Harrison Boyd Ash.

By the time of Augustus the Romans had absorbed much from the Greek artists and Roman realism became modified by the effort to embody the imperial ideal in art.

We know Augustus Caesar from statues, coins, and gems. As emperor he was priest-king, military leader, and ruler. It was important that he be represented in all the facets of his power not only to secure it for himself but also to make it legitimate. The statue of Augustus found at the imperial villa of Prima Porta is an excellent example of the military type of portrait (Fig. 7-2). Dressed in very decorative armor but without boots (therefore probably made after his death when he had been made a god and did not need boots), he stands alert but at ease, addressing his troops. The features are distinctively those of the emperor, virile and youthful.

He has been ennobled and idealized by the absence of age, flaws, or any of the other markings of a fallible human being. The small figure on the left may be one of his grandsons. Compare the statue with *The Spearbearer* and *The Orator*. What has been taken from each, and what has been left behind in this effort to present Augustus Imperator?

The *Ara Pacis Augustae* (The Altar of the Peace of Augustus), probably begun in 13 B.C., was made to commemorate the peace brought about by the imperial might of Rome (Fig. 7-3). It is useful to compare it with the frieze of the Panathenaic festival (Fig. 4-9). At first sight it recalls the frieze, but there are subtle differences. First, the Greek procession is presented as an institutionalized event without regard to the particular individuals who participate. The *Ara Pacis* commemorates

7-1 Arringatore, *or* The Orator, *from Sanguineto, first century* B.C. *Archaeological Museum, Florence. (Alinari/ Art Resource, NY)*

7-2 Augustus of Prima Porta, *c. 20* B.C. *Vatican Museum, Vatican State. (Alinari/Art Resource, NY)*

one specific historical moment—the moment when the altar was begun. Second, the figures of the *Ara Pacis* are more closely crowded together, as if they had indeed just gathered, giving them an air of immediacy and realism absent in the formal rhythms of the Parthenon frieze. Concentration is not directed toward the focal event but on the interaction between those who make up the event. This frieze has a false calm that seems comparable to the nobility and wisdom that overlay the ruthless Augustus. It was power and decisiveness that made the Empire.

In the reliefs of *The Spoils from the Temple at Jerusalem* (Fig. 7-4) on the Arch of Titus, we confront an almost reportorial scene of victory. The conquering Romans return to the city with captives and treasure, including the great sacred menorah (seven-branched candelabra) from the temple. The sculpture is carved in low relief, and the space is filled with people and objects. This somewhat crowded quality gives the relief an air of urgency and energy that seems to symbolize the power of Rome. This is not myth or allegory but the direct reality of success. To the Roman mind this record of victory would ensure an immortality of which no divinity was capable. No Athenian of the fifth century B.C. would have dared to so memorialize himself.

• Compare *The Spearbearer* (Fig. 4-12) with *The Orator* (Fig. 7-1). Contrast the facial expressions and the effect of nudity versus clothes. Compare both statues with this one of Augustus. Which aspects of each are ideal and which represent a naturalistic interpretation of the person? Which of the three sculptures is the most realistic?

Roman Architecture

As the Romans learned from the Greeks, so they also learned from other tribes and nations. The Roman system of building probably came from the Etruscans, a powerful tribe that lived in the peninsula until they were conquered by the Romans. It is not clear whether the Etruscans learned arcuated construction from the Mesopotamians or whether they discovered the advantages of building with arches for themselves. Employed by the Romans, the wall, post, lintel, and arch produced a major building system that would be carried across Europe.

As a building system the true arch is a combination of *pier* (post) and a semicircle of material that replaces the *lintel* (Fig. 7-5). The arch itself is made of stones or bricks cut to fit so that they help hold each other in place. Erecting an arch requires a wooden scaffold with an arch-shaped top called a *centering*. This will support the arch while all the sections are being put into place.

7-3 *Imperial procession from the* Ara Pacis *frieze, Rome. (Alinari/Art Resource, NY)*

When the last top, center stone, the *keystone,* is inserted, the centering can be moved to the next arch. The diagram shows how an arch exerts pressure outward and downward, necessitating pressure at those points to keep it from falling apart.

A series of arches produces a *barrel vault.* The weight of the vault rests equally along the wall. When two barrel vaults intersect at right angles, a *groin vault* results (Fig. 7 5d); the weight of the vault then rests on the corner piers instead of along the wall, which can then be opened up for doors and windows. An arch rotated in space 360 degrees produces a *dome.* Like a barrel vault, a dome's weight rests equally on the wall, which is its circumference.

To this potentially very rich collection of forms the Romans added a much cheaper, faster means of building—brick and rubble masonry fill. To make this, a sticky liquid mass is poured into a form in which small rocks, gravel, and stones are introduced to give greater density and strength. When dried, the surface is covered with plaster or a thin layer of marble or granite called a *veneer.*

The types of building that assumed great importance in Rome are not the same as those that were important for fifth-century Athens. When we think of Athens, we see the great Acropolis complex of sacred buildings towering over the city. The Roman city seems more of a piece, less divided between sacred and secular. The Romans were among the first to develop city planning on an extensive basis, and their methods of planning are in themselves a significant guide to their values.

If we had a Roman town or city perfectly planned and preserved, we would see first that the city itself was

7-4 The Spoils from the Temple at Jerusalem, *Arch of Titus, Rome. (Alinari/Art Resource, NY)*

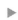

• What bas-reliefs do you know comparable to this scene of war? Is the Pergamon Altar of Zeus (Fig. 4-17) a good comparison or do reliefs of the Sumerian kings make a better one? Compare *The Spoils* with the relief of the Panathenaic procession (Fig. 4-9). Consider the differences in body type, composition, and subject. What aspects of the sculpture most affect your response to the work?

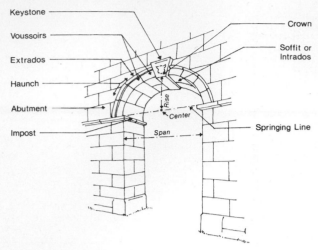

7-5a *Roman arch*

7-5c *Barrel vault*

7-5b *Action of forces in arch*

7-5d *Groin vault*

a rectangle, bounded by walls and traversed by major streets at right angles to each other (Fig. 7-6). These major streets were oriented to the cardinal points of the compass and traversed by other streets, also at exact right angles: this formed a grid pattern of city blocks, which were assigned different functions—for living, markets, and areas of entertainment. The town would be reached by well-laid Roman roads and, if need be, fed water by aqueducts, like the Pont du Gard, still standing outside Nîmes in southern France (Fig. 7-7). At the center would be a *forum.*

The forum began as an open space with a rostrum for public speeches; but under Julius and then Augustus Caesar it became a place for a temple with surrounding walkways. In time it included a law court (*basilica*). The forum was for the reading of proclamations, the promulgation of laws, and the celebration of triumphs and religious rites. It was a visible sign of Roman conquest, law, and administration.

The temple in the forum might have been dedicated to Jupiter or to the emperor. One of the best preserved Roman temples is the late republican Maison Carrée in southern France (Fig. 7-8). It is interesting to compare it with the Parthenon. By studying both the temples and their locations in the city plan, we can conclude that the temple was not the focus of the complex, but one of its

parts—an important building among several important buildings in a system.

In a different section of the perfectly planned imaginary Roman city, we would find the buildings for entertainment—baths, theaters, and an arena. Although not the most perfect surviving example, the Colosseum in Rome is certainly the most famous of the great amphitheaters (Fig. 7-9). Here spectacles and gladiatorial combat took place. A view of the interior of the building shows that the Colosseum is essentially made up of a series of groin vaults and barrel vaults on massive walls that support tiers of seats and provide passageways (Fig. 7-10). But the arches that open to the outside are framed with half-round columns of Greek orders—the Doric, the Ionic, and another, the Corinthian (Fig. 7-11). These have been applied to the piers between the arches for articulation and decoration. No longer supporting a lintel, the columns are used to emphasize the scale and height of the exterior. It is appropriate that the most massive, the Doric, is on the bottom, while at the topmost tier we find a thin, flattened column, a *pilaster,* with a rich flat capital. This use of the column is radically different from that employed by the Greeks. The Colosseum is not sacred at all, but a setting for human sports.

The Romans, in short, transformed whatever they inherited from Greek architecture to fulfill their needs.

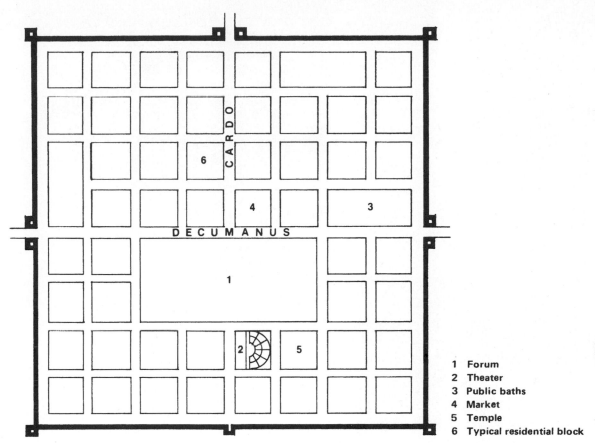

1 Forum
2 Theater
3 Public baths
4 Market
5 Temple
6 Typical residential block

7-6 *Ideal Roman city, ground plan*

▲

• Compare the plan of the Acropolis (Fig. 4-5) with the Roman city plan. Where is the temple? What role does it play in the space? What can you conclude about the role of the religious building in the two city plans?

Another example is the Pantheon, a temple to all the planetary deities, dedicated in Rome about A.D. 118–125 (Fig. 7-12). The plan (Fig. 7-13, p. 184) shows us a great round, domed space contained within massive walls. Attached to the front is a deep portico that looks like one end of a Greek temple. The combination of circular and rectangular forms is among the first such combinations—a solution to give a sense of direction and ennobled entry to a round and therefore nondirectional space.

The Pantheon also presents us with the first important interior architectural space (Fig. 7-14, p. 184). The dome rises above the floor, and the only light spills in through the oculus, a round eye in the ceiling. This great hollow space creates a very different experience from the outdoor sanctuary of the Greeks or the Roman forum. It recalls the dome of heaven, the overarching sky; it seems to float or be suspended rather than to depend on the usual weight and support of the post and lintel system of building. The vital soaring quality of this majestic space and its accompanying technology would be influential for many centuries.

The creation of great interiors joins with the Greek forms to make a rich supply of ideas. The basilica, another element of the forum, was also a majestic interior space, with long interior colonnades. Half-domes rose above the curved ends where judges sat to dispense the law (Fig. 7-15, p. 185). This vision of earthly power and administration of justice could be allied with the sacred architecture of Greece to form a complex series of symbols and ideas.

Roman Literature

As in other aspects of their culture, the Romans looked to Greek models for their literature. Greek literature began before the Greeks as a people had any political importance; with Rome it was the opposite. The Romans had been too busy organizing, building, and conquering to write; they began to do so only when, in the third century B.C., they dominated Greece and discovered Greek literature. The first real example of a literary work in Latin is a translation of Homer's *Odyssey*. Toward the end of the third century Plautus put some Greek "new comedies" into Latin, but his bawdy plays, such as *The Braggart Soldier,* have something distinctively Roman about them. The plays of Terence (195–159 B.C.), who was a slave of African origins, are

7-7 *Roman aqueduct, Pont du Gard at Nîmes, France, first century* A.D. *(Art Resource, NY)*

7-8 *Maison Carrée, Nîmes, France, c. 19* B.C. *(Giraudon/ Art Resource, NY)* **(W)**

▲

• Compare this temple with the Parthenon (Fig. 4-4). What elements do the two buildings have in common? What order is used? How are the columns used? Is this an important difference? Why or why not? Which building is one-directional? Both buildings are placed on a podium but the former is very different from the latter. What difference does that make?

more subdued and more subtle in their humor, closer to the Greek ideal of new comedy. At the time of Terence, more and more Roman men of letters were seriously studying Greek literature.

Roman oratory and rhetoric, of which Cicero's work is an example, arose during the first century B.C.

This was also the time of the great philosophical poet Lucretius, who explained the philosophy of Epicureanism (a philosophy opposed to Stoicism) in a long poem entitled *De rerum natura* (*On the Nature of Things*). Catullus, a poet who admired and imitated Sappho, gave the Latin language a new lyric power.

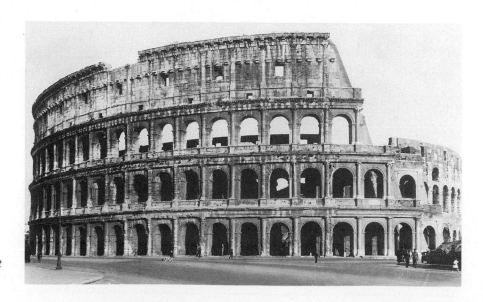

7-9 *Colosseum, Rome. (Alinari/Art Resource, NY)*

Roman Literature 181

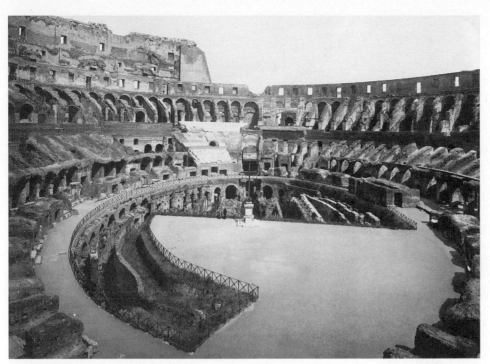

7-10 *Colosseum interior. (Alinari/Art Resource, NY)*

7-11 *Exterior arches, Colosseum, Rome. (Alinari/ Art Resource, NY)*

Virgil (70–19 B.C.) and the Aeneid

Rome's greatest poet was undoubtedly Virgil, whose Latin name is Publius Vergilius Maro. During Virgil's lifetime Julius Caesar was murdered and Augustus Caesar became the first of Rome's emperors. The years of Augustus' reign (27 B.C.–A.D. 14), known as the Augustan Age, were viewed both by contemporaries and by later generations as Rome's golden years, comparable to Periclean Athens. These years indeed saw not only

7-12 *Front view of Pantheon, Rome.*

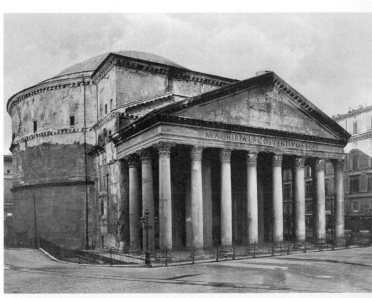

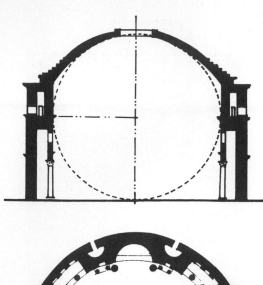

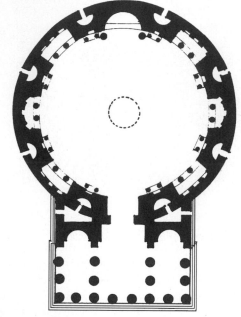

7-13 *Pantheon, Rome, ground plan and section.*

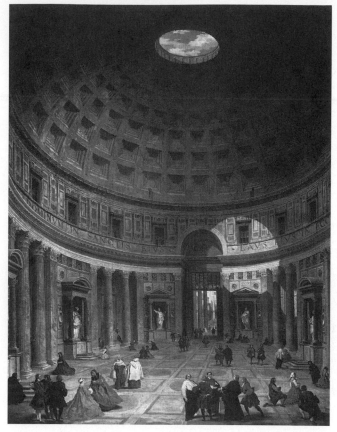

7-14 *Giovanni Paolo Panini,* The Interior of the Pantheon, *c. 1740, oil on canvas, 50½" × 39". (Samuel H. Kress Collection, Copyright 1992. National Gallery of Art, Washington, D.C.)* **(W)**

tremendous political and administrative achievements but also the finest Roman accomplishments in literature, as in other aspects of art and life. In the early years of this new era, Virgil wrote the great epic of Rome, the *Aeneid,* named for its hero, Aeneas.

Highly conscious of living in a period when Rome ruled most of the known world and was at the height of its glory, Virgil set out to write an epic poem in praise of Rome. Some even believe that Augustus might have commissioned him to write it. For an epic, there was only one model to which he could turn—Homer. Although Virgil's poem resembles both the *Iliad* and the *Odyssey* in its subject—it is about a hero in battle and the wanderings of a hero—and in its literary devices, it differs in two basic ways. First, it is a literary, *written* work instead of an oral, *composed* one. Meant to be read instead of heard, it inaugurates the tradition of the written epic in Western literature.

Second, Virgil's hero, Aeneas, is much less of an individual than Achilles or Odysseus. Homer's heroes represented the values of their culture in their own particular manner, but Virgil's hero seems to embody the values of his culture. Unlike Achilles or Odysseus, Aeneas is always sacrificing personal honor, glory, and happiness to something greater—and the "something greater" that seems to rule over the entire epic is the destiny of Rome.

As in the case of the *Iliad,* the first lines of the *Aeneid* tell us a great deal about the poem as a whole. Here is the opening sentence in the original Latin:

> Arma, virumque cano, Troiae qui primus ab oris
> Italiam, fato profugus, Lavinaque venit
> litora—

Here are the first seven lines put into twelve lines of English (Latin is a more concise language) by a modern translator, Allen Mandelbaum:

> I sing of arms and of a man: his fate
> had made him fugitive; he was the first
> to journey from the coasts of Troy as far
> as Italy and the Lavinian shores.

7-15 *Basilica of Maxentius, Rome, with ground plan.*
(Photo: Alinari/Art Resource, NY)

> Across the lands and waters he was battered
> beneath the violence of High Ones, for
> the savage Juno's unforgetting anger;
> and many sufferings were his in war—
> until he brought a city into being
> and carried in his gods to Latium;
> from this have come the Latin race, the lords
> of Alba, and the ramparts of high Rome.

The outline of the story of Aeneas and Aeneas' place as an instrument of Roman destiny is presented in these opening lines. First Virgil states his subject, "*arms*" and "*a man*," as Homer's subject was "the anger of Achilles." The *Aeneid* is about both war and the struggles of Aeneas. Aeneas was predestined by Fate, a concept that looms larger than the gods, to come from Troy to Italy. According to legend he was a Trojan who, after the Trojan War, escaped from his defeated city, piously carrying his old father on his shoulders. After long years of various hardships and delays, he at last arrived in Italy. There he married Lavinia, the daughter of King Latinus, thus uniting the Trojan people with the native Latin people to found the Roman race. Aeneas' enemy in his wanderings and struggles is Juno, queen of the gods and rival of Aeneas' mother, Venus. His protector is the king of the gods, Jupiter, who, allied with Fate, is assured victory in the end. Every act of Aeneas will be determined by the destiny marked out for him. He is not a mere puppet of Jupiter; but, since he is conscious that he has a greater will to accomplish, he struggles against the traps laid for him by Juno and sacrifices personal happiness and comfort to the greater good. Virgil's prologue goes beyond the scope of the *Aeneid* itself, which ends with a duel between Aeneas and one of his Italian opponents. Aeneas founds the city of Lavinium with his bride *after* the close of the epic.

Thirty years later his son establishes a new city, Alba Longa. Some three hundred years after that, Romulus and Remus, princes of Alba, found Rome, which will ultimately rule over not only all of Italy but most of the known world. This perspective puts Aeneas in his proper place. He is not a mere individual; he is an instrument of the great destiny of Rome.

Like Odysseus and Gilgamesh, Aeneas travels to the underworld to learn of his destiny. He returns from there inspired with love for the future greatness of his people. He is now more Roman than Trojan, and the rest of the epic is devoted to his feats in arms necessary to the founding of Rome.

The cultural values asserted in this epic are clearly Roman. The Romans were, as we have seen, a practical people, conscious that their real genius was not in the cult of individualism or in art for its own sake, but in the art of administrating and ruling. They did not see their imperialism in moralistic terms, as did European imperialists in Africa and Asia in the nineteenth century, who believed that destiny had sent them to "civilize" heathens. The Romans knew that the cultures they ruled in Greece, the Near East, and North Africa were in most

cases more highly developed than their own. But they knew, too, that they gave the world an unparalleled peace and a system of law that could not have been obtained without their particular kind of imperialism.

Ovid (43 B.C.–A.D. 17/18)

Although he highly esteemed Virgil, Virgil's younger contemporary Ovid (Publius Ovidius Naso) realized that his own poetic talents were not fitted for the stately epic but rather for the celebration of amorous fantasy and sensual pleasure. His youthful *Art of Love,* a cynical poetic treatise on seduction, immediately established him as one of the leading poets of Augustan Rome. His association with this immoral poem together with a rumor of his involvement in the lascivious behavior of Augustus' granddaughter, Julia, helps to explain his banishment from Rome in A.D. 8. Ovid's exile by the emperor to the distant shores of the Black Sea was a living death for the pleasure-loving poet of the capital. Despite his dispatch home of an unending flood of poetry lamenting his wretchedness, he remained under banishment until his death.

Finished in rough draft before his departure from Rome, Ovid's great poem the *Metamorphoses* was completed in the first years of his exile. Essentially a narrative of twelve thousand lines in Latin hexameter divided into fifteen books, the poem recounts two hundred legends and myths arranged chronologically. Although some of these stories were well known at the time, Ovid saved for future generations dozens of others almost forgotten in his own generation. Indeed, the *Metamorphoses* constitutes our major single source for such material.

As the title suggests, Ovid chose for his organizational theme the changes of state commonly experienced by divine and human actors in these ancient stories. Two examples are the transformation of Zeus into the bull that carried off the maiden Europa and of Daphne, who became a tree to ward off the lusty embrace of Apollo. Ovid's keen eye for natural beauty and his power to bring to life the fantastic world of gods, demigods, and heroes has made the *Metamorphoses* one of the most delightful writings produced by the ancient world.

Horace (65–8 B.C.)

Another great poet of the Augustan Age was Horace (Quintus Horatius Flaccus). Horace was the son of an uneducated freedman (a former slave), who saw to it that his son received the best schooling that Rome could provide. Horace was in his early years an ardent republican but became just as ardent a supporter of the emperor. He is, in fact, often called Augustus' "poet laureate" because his later poems celebrate the emperor's policies and ideals. Interested in literary criticism and theory, among other things, Horace formulated the basic tenet for Roman poets: poetry must be both *dulce* (pleasing) and *utile* (useful). The poem should combine patriotic, moral, or philosophical messages with sensuous beauty of rhythm and language. This idea that poetry should be useful is certainly more Roman than Greek.

Satire

Horace wrote lyrics (the *Epodes* and *Odes*) as well as the *Epistles,* including *The Art of Poetry.* He also excelled in the uniquely Roman genre of *satire.* Although satire as a mode of human expression had been in existence long before the Romans, the Romans developed it into a literary form, just as the Greeks had done with comedy. The nonliterary origins of the mode are related to those of the *komos.* The desire to ridicule, or to expose human vices and follies, seems universal. In certain cultures, the process of ridiculing one's enemy with particularly vicious words was believed to have magical effects. It could actually injure enemies or even cause them to kill themselves and thus be used as a weapon of war. Pre-Islamic Arabs, especially women, used invectives hurled against their enemies as magical, deadly curses. We still use words like *caustic, biting,* and *venomous* to describe words used in satire and ridicule. The magical and ritual origins of satire are evident if we bear in mind that such descriptions were for many peoples not merely *metaphorical.*

The ancient Greeks also seem to have used satire for magical purposes. At the phallic ceremonies, which we mentioned in connection with old comedy, two ritual purposes were involved. One ceremony was intended to ensure fertility of land and people through the power of the phallus; the other was to expel evil spirits and influence through abuse. Out of the latter practice grew a tradition of composing *iambs,* short invective verses directed against a particular person. The practice of this kind of satire certainly influenced old comedy. Aristophanes held many important public figures, including Socrates and Euripides, up to devastating ridicule. In *Lysistrata* the invectives that the choruses of old men and old women hurl against each other are in the same satirical tradition.

No word for satire as such existed until the Romans gave it one: *satura,* which means both "full" and "a mixture of different things." Compared with more refined and subtle forms of literature, satire is down-to-earth, hearty, and full of all kinds of things, like a good stew. For example, the satires of Horace contain lyrical poetry, philosophical arguments, folk tales, descriptions of everyday life, slapstick comedy, and obscene jokes. It is not surprising that this literary type should have developed among a people whose tastes were more practical and realistic than contemplative and abstract. Although the Roman writers of satire no longer believed

in its magical effects, they believed that the function of satire to expose the vices and follies of individuals and society could be greatly therapeutic.

Roman verse satire is, then, a particular literary form. Satires were written in hexameters, the six-foot Latin line, and are of two types. One, represented by Horace, is mild, humorous, and fundamentally optimistic. Horace claimed that the actions of some of his contemporaries impelled him to satirize—"fools rush into my head, and so I write"—but that his purpose was to enable the "fools" to reform by exposing their foolishness rather than to punish them. The second type is best represented by the later Roman writer Juvenal (died c. A.D. 130), who lived in a period when Roman society was more corrupt. Juvenal's satire is truly biting: it exposes and castigates. Satirists like Juvenal seem to believe that evil is inherent in human nature and in the structure of society. It can be identified but not easily cured. These two types of satire—we might call them simply optimistic and pessimistic—can be found throughout the history of literature, in stage and media entertainment, and in ordinary conversation.

CICERO

...

from *On the Laws*

Translation by Clinton Walker Keyes

The selection from *On the Laws* concerns the nature of justice. Cicero (*M,* for Marcus) is the major speaker of the dialogue. His friend Atticus (*A*) is the other. Against the argument that the law is a matter of convenience and custom, Cicero maintains that it is rooted in the consciences of all peoples.

M. . . . That animal which we call man, endowed with foresight and quick intelligence, complex, keen, possessing memory, full of reason and prudence, has been given a certain distinguished status by the supreme God who created him; for he is the only one among so many different kinds and varieties of living beings who has a share in reason and thought, while all the rest are deprived of it. But what is more divine, I will not say in man only, but in all heaven and earth, than reason? And reason, when it is full grown and perfected, is rightly called wisdom. Therefore, since there is nothing better than reason, and since it exists both in man and God, the first common possession of man and God is reason. But those who have reason in common must also have right reason in common. And since right reason is Law, we must believe that men have Law also in common with the gods. Further, those who share Law must also share Justice; and those who share these are to be regarded as members of the same commonwealth. If indeed they obey the same authorities and powers, this is true in a far greater degree; but as a matter of fact they do obey this celestial system, the divine mind, and the God of transcendent power. Hence we must now conceive of this whole universe as one commonwealth of which both gods and men are members.

And just as in States distinctions in legal status are made on account of the blood relationships of families, according to a system which I shall take up in its proper place, so in the universe the same thing holds true, but on a scale much vaster and more splendid, so that men are grouped with Gods on the basis of blood relationship and descent. For when the nature of man is examined, the theory is usually advanced (and in all probability it is correct) that through constant changes and revolutions in the heavens, a time came which was suitable for sowing the seed of the human race. And when this seed was scattered and sown over the earth, it was granted the divine gift of the soul. For while the other elements of which man consists were derived from what is mortal, and are therefore fragile and perishable, the soul was generated in us by God. Hence we are justified in saying that there is a blood relationship between ourselves and the celestial beings; or we may call it a common ancestry or origin. Therefore among all the varieties of living beings, there is no creature except man which has any knowledge of God, and among men themselves there is no race either so highly civilized or so savage as not to know that it must believe in a god, even if it does not know in what sort of god it ought to believe. Thus it is clear that man recognizes God because, in a way, he remembers and recognizes the source from which he sprang.

Moreover, virtue exists in man and God alike, but in no other creature besides; virtue, however, is nothing else than Nature perfected and developed to its highest point; therefore there is a likeness between man and God. As this is true, what relationship could be closer or clearer than this one? For this reason, Nature has lavishly yielded such a wealth of things adapted to man's convenience and use that what she produces seems intended as a gift to us, and not brought forth by chance; and this is true, not only of what the fertile earth bountifully bestows in the form of grain and fruit, but also of the animals; for it is clear that some of them have been created to be man's slaves, some to supply him with their products, and others to serve as his food. Moreover innumerable arts have been discovered through the teachings of Nature; for it is by a skillful imitation of her that reason has acquired the necessities of life. Nature has likewise not only equipped man himself with nimbleness of thought, but has also given him the senses, to be, as it were, his attendants and messengers; she has laid bare the obscure and none too [obvious] meanings of a great many things, to serve as the foundations of knowledge, as we may call them; and she has granted us a bodily form which is convenient and well suited to the human mind. For while she has bent the other creatures down toward their food, she has made man

alone erect, and has challenged him to look up toward heaven, as being, so to speak, akin to him, and his first home. In addition, she has so formed his features as to portray therein the character that lies hidden deep within him; for not only do the eyes declare with exceeding clearness the innermost feelings of our hearts, but also the countenance, as we Romans call it, which can be found in no living thing save man, reveals the character. (The Greeks are familiar with the meaning which this word "countenance" conveys, though they have no name for it.) I will pass over the special faculties and aptitudes of the other parts of the body, such as the varying tones of the voice and the power of speech, which is the most effective promoter of human intercourse; for all these things are not in keeping with our present discussion or the time at our disposal; and besides, this topic has been adequately treated, as it seems to me, by Scipio in the books which you have read. But, whereas God has begotten and equipped man, desiring him to be the chief of all created things, it should now be evident, without going into all the details, that Nature, alone and unaided, goes a step farther; for, with no guide to point the way, she starts with those things whose character she has learned through the rudimentary beginnings of intelligence, and, alone and unaided, strengthens and perfects the faculty of reason.

A. Ye immortal gods, how far back you go to find the origins of Justice! And you discourse so eloquently that I not only have no desire to hasten on to the consideration of the civil law, concerning which I was expecting you to speak, but I should have no objection to your spending even the entire day on your present topic; for the matters which you have taken up, no doubt, merely as preparatory to another subject, are of greater import than the subject itself to which they form an introduction.

M. The points which are now being briefly touched upon are certainly important; but out of all the material of the philosophers' discussions, surely there comes nothing more valuable than the full realization that we are born for Justice, and that right is based, not upon men's opinions, but upon Nature. This fact will immediately be plain if you once get a clear conception of man's fellowship and union with his fellow-men. For no single thing is so like another, so exactly its counterpart, as all of us are to one another. Nay, if bad habits and false beliefs did not twist the weaker minds and turn them in whatever direction they are inclined, no one would be so like his own self as all men would be like all others. And so, however we may define man, a single definition will apply to all. This is a sufficient proof that there is no difference in kind between man and man; for if there were, one definition could not be applicable to all men; and indeed reason, which alone raises us above the level of the beasts and enables us to draw inferences, to prove and disprove, to discuss and solve problems, and to come to conclusions, is certainly common to us all, and, though varying in what it learns, at least in the capacity to learn it is invariable. For the same things are invariably perceived by the senses, and those things which stimulate the senses, stimulate them in the same way in all men; and those rudimentary beginnings of intelligence to which I have referred, which are imprinted on our minds, are imprinted on all minds alike; and speech, the mind's interpreter, though differing in the choice of words, agrees in the sentiments expressed. In fact, there is no human being of any race who, if he finds a guide, cannot attain to virtue.

The similarity of the human race is clearly marked in its evil tendencies as well as in its goodness. For pleasure also attracts all men; and even though it is an enticement to vice, yet it has some likeness to what is naturally good. For it delights us by its lightness and agreeableness; and for this reason, by an error of thought, it is embraced as something wholesome. It is through a similar misconception that we shun death as though it were a dissolution of nature, and cling to life because it keeps us in the sphere in which we were born; and that we look upon pain as one of the greatest of evils, not only because of its cruelty, but also because it seems to lead to the destruction of nature. In the same way, on account of the similarity between moral worth and renown, those who are publicly honoured are considered happy, while those who do not attain fame are thought miserable. Troubles, joys, desires, and fears haunt the minds of all men without distinction, and even if different men have different beliefs, that does not prove, for example, that it is not the same quality of superstition that besets those races which worship dogs and cats as gods, as that which torments other races. But what nation does not love courtesy, kindliness, gratitude, and remembrance of favours bestowed? What people does not hate and despise the haughty, the wicked, the cruel, and the ungrateful? Inasmuch as these considerations prove to us that the whole human race is bound together in unity, it follows, finally, that knowledge of the principles of right living is what makes men better.

QUESTIONS

1. What does Cicero mean by Law?
2. What effect would this belief have on one's approach to law and custom?
3. What is the basis of the natural equality of man? Do you think that we hold this belief now?

Ovid

..

from the *Metamorphoses*
Translated by Gilbert Highet

The following story of Pygmalion from Book 10 of the *Metamorphoses* served as the plot of George Bernard Shaw's play *Pygmalion*, written early in the twentieth century. The play in turn served as the plot for *My Fair Lady*, a famous musical comedy of the 1950s.

Pygmalion and Galatea

Pygmalion loathed the vices given by nature
To women's hearts: he lived a lonely life,
Shunning the thought of marriage and a wife.
Meanwhile he carved the snow-white ivory
With happy skill: he gave it beauty greater
Than any woman's: then grew amorous of it.
It was a maiden's figure—and it lived
(You thought) but dared not move for modesty.
So much did art conceal itself. The sculptor
Marvelled, and loved his beautiful pretence.
Often he touched the body, wondering
If it were ivory or flesh—he would not
Affirm it ivory. He gave it kisses,
Thinking they were returned; and he embraced it,
Feeling its body yield beneath his fingers,
Fearing the limbs he pressed would show a bruise.
Sometimes he courted it with flatteries
And charming gifts: shells and rounded stones,
And little birds, and many-colored flowers,
Lilies, and painted balls, and amber tears
Dropped from the trees: he dressed it with fine clothes,
Rings on its fingers, chains about its neck,
Light pearls for earrings, pendants on its bosom.
All made it lovely: it was lovely naked.
He laid the statue on a purple couch,
Calling it partner of his bed, laying its neck
On feather pillows, just as though it felt.
The festival of Venus crowded Cyprus;
And with broad horns gilded to do her honor,
The snowy heifers fell for sacrifice,
And incense fumed her altars. Then Pygmalion
Made sacrifice and prayed, "If the gods can give
Whatever they may wish, grant me a wife"
(not venturing "my ivory girl") "like her."
The golden goddess in her seat of power
Knew what the prayer meant and showed her favor:
Her altar blazed three times, shooting aloft.

When he returned, he went to his ivory image,
Lay on its couch and kissed it. It grew warm.
He kissed again and touched the ivory breast.
The ivory softened, and its carven firmness

Sank where he pressed it, yielded like the wax
Which in the sunlight takes a thousand shapes
From moulding fingers, while use makes it useful.
Pygmalion was aghast and feared his joy,
But like a lover touched his love again.
It was a body, beating pulse and heart.
Now he believed and in an ardent prayer
Gave thanks to Venus: pressed his mouth at last
To a living mouth. The maiden felt his kiss—
She blushed and trembled: when she raised her eyes
She saw her lover and heaven's light together.

..

COMMENTS AND QUESTIONS

1. Ovid stops his poem at the point where the statue of the maiden becomes alive. What do you imagine the relationship of the sculptor and his model would have been like thereafter?
2. Why is the story set in Cyprus?

..

Virgil
..

from the *Aeneid*
Translation by Allen Mandelbaum

For many readers the most interesting part of the *Aeneid* is Book 4, in which Aeneas falls in love with Dido, the queen of Carthage (Rome's great rival city in North Africa). Aeneas' decision to leave Dido after he has been with her for some time and her consequent suicide make him a heartless character for some readers; but Virgil intended to show in this episode the great personal tragedies that a public destiny like Aeneas' entails.

Book 4

Too late. The queen is caught between love's pain
and press. She feeds the wound within her veins;
she is eaten by a secret flame. Aeneas'
high name, all he has done, again, again
come like a flood. His face, his words hold fast 5
her breast. Care strips her limbs of calm and rest.

A new dawn lights the earth with Phoebus'° lamp
and banishes damp shadows from the sky
when restless Dido turns to her heart's sharer:
"Anna, my sister, what dreams make me shudder? 10
Who is this stranger guest come to our house?
How confident he looks, how strong his chest
and arms! I think—and I have cause—that he

7. Phoebus: Apollo, god of the sun.

is born of gods. For in the face of fear
the mean must fall. What fates have driven him! 15
What trying wars he lived to tell! Were it not
my sure, immovable decision not
to marry anyone since my first love
turned traitor, when he cheated me by death,
were I not weary of the couch and torch, 20
I might perhaps give way to this one fault.
For I must tell you, Anna, since the time
Sychaeus, my poor husband, died and my
own brother° splashed our household gods with blood,
Aeneas is the only man to move 25
my feelings, to overturn my shifting heart.
I know too well the signs of the old flame.
But I should call upon the earth to gape
and close above me, or on the almighty
Father to take his thunderbolt, to hurl 30
me down into the shades, the pallid shadows
and deepest night of Erebus,° before
I'd violate you, Shame, or break your laws!
For he who first had joined me to himself
has carried off my love, and may he keep it 35
and be its guardian within the grave."
She spoke. Her breast became a well of tears.

And Anna answers: "Sister, you more dear
to me than light itself, are you to lose
all of your youth in dreary loneliness, 40
and never know sweet children or the soft
rewards of Venus? Do you think that ashes
or buried Shades will care about such matters?
Until Aeneas came, there was no suitor
who moved your sad heart—not in Libya nor, 45
before, in Tyre: you always scorned Iarbas
and all the other chiefs that Africa,
a region rich in triumphs, had to offer.
How can you struggle now against a love
that is so acceptable? Have you forgotten 50
the land you settled, those who hem you in?
On one side lie the towns of the Gaetulians,
a race invincible, and the unbridled
Numidians and then the barbarous Syrtis.°
And on the other lies a barren country, 55
stripped by the drought and by Barcaean raiders,
raging both far and near. And I need not
remind you of the wars that boil in Tyre°
and of your brother's menaces and plots.
For I am sure it was the work of gods 60
and Juno that has held the Trojan galleys
fast to their course and brought them here to Carthage.

If you marry Aeneas, what a city
and what a kingdom, sister, you will see! 65
With Trojan arms beside us, so much greatness
must lie in wait for Punic° glory! Only
pray to the gods for their good will, and having
presented them with proper sacrifices,
be lavish with your Trojan guests and weave
excuses for delay while frenzied winter 70
storms out across the sea and shatters ships,
while wet Orion° blows his tempest squalls
beneath a sky that is intractable."

These words of Anna fed the fire in Dido.
Hope burned away her doubt, destroyed her
 shame. 75
First they move on from shrine to shrine,
 imploring
the favor of the gods at every altar.
They slaughter chosen sheep, as is the custom,
and offer them to Ceres° the lawgiver,
to Phoebus, Father Bacchus,° and—above all— 80
to Juno,° guardian of marriage. Lovely
Dido holds the cup in her right hand;
she pours the offering herself, midway
between a milk-white heifer's horns. She studies
slit breasts of beasts and reads their throbbing
 guts. 85
But oh the ignorance of augurs! How
can vows and altars help one wild with love?

Meanwhile the supple flame devours her marrow;
within her breast the silent wound lives on.
Unhappy Dido burns. Across the city 90
she wanders in her frenzy—even as
a heedless hind hit by an arrow when
a shepherd drives for game with darts among
the Cretan woods and, unawares, from far
leaves winging steel inside her flesh; she roams 95
the forests and the wooded slopes of Dicte,°
the shaft of death still clinging to her side.
So Dido leads Aeneas around the ramparts,
displays the wealth of Sidon° and the city
ready to hand; she starts to speak, then falters 100
and stops in midspeech. Now day glides away.
Again, insane, she seeks out that same banquet,
again she prays to hear the trials of Troy,
again she hangs upon the teller's lips. . . .

But now the guests are gone. The darkened moon, 105
in turn, conceals its light, the setting stars

24. Pygmalion. 32. Erebus: The god of darkness and the realm of
the underworld. 54. The Gaetulians, Numidians, and Syrtians
were neighboring African peoples. Iarbas was king of the Gaetylians.
58. Tyre: A famous seaport of the Phoenicians, from which Dido fled
with her supporters to found Carthage, a new city in Africa.

67. Punic: An equivalent of Phoenician. 72. Orion: A constella-
tion of stars related to storms. 79. Ceres: Goddess of agriculture.
80. Bacchus: God of wine. 81. Juno: Queen of the gods and wife
of Jupiter. 96. Dicte: A mountain in the eastern part of Crete.
99. Sidon: Ancient city of Phoenicians and mother-city of Tyre.

invite to sleep; inside the vacant hall
she grieves alone and falls upon the couch
that he has left. Absent, she sees, she hears
the absent one or draws Ascanius,° 110
his son and counterfeit, into her arms,
as if his shape might cheat her untellable love.

Her towers rise no more; the young of Carthage
no longer exercise at arms or build
their harbors or sure battlements for war; 115
the works are idle, broken off; the massive,
menacing rampart walls, even the crane,
defier of the sky, now lie neglected.

As soon as Jove's° dear wife sees that her Dido
is in the grip of such a scourge and that 120
no honor can withstand this madness, then
the daughter of Saturn° faces Venus°: "How
remarkable indeed: what splendid spoils
you carry off, you and your boy; how grand
and memorable is the glory if 125
one woman is beaten by the guile of two
gods. I have not been blind. I know you fear
our fortresses, you have been suspicious of
the houses of high Carthage. But what end
will come of all this hate? Let us be done 130
with wrangling. Let us make, instead of war,
an everlasting peace and plighted wedding.
You have what you were bent upon: she burns
with love; the frenzy now is in her bones.
Then let us rule this people—you and I— 135
with equal auspices; let Dido serve
a Phrygian° husband, let her give her Tyrians
and her pledged dowry into your right hand."

But Venus read behind the words of Juno
the motive she had hid: to shunt the kingdom 140
of Italy to Libyan° shores. And so
she answered Juno: "Who is mad enough
to shun the terms you offer? Who would prefer
to strive with you in war? If only fortune
favor the course you urge. For I am ruled 145
by fates and am unsure if Jupiter
would have the Trojans and the men of Tyre
become one city, if he like the mingling
of peoples and the writing of such treaties.
But you are his wife and it is right for you 150
to try his mind, to entreat him. Go. I'll follow."

Queen Juno answered her: "That task is mine.
But listen now while in few words I try
to tell you how I mean to bring about
this urgent matter. When tomorrow's Titan° 155
first shows his rays of light, reveals the world,
Aeneas and unhappy Dido plan
to hunt together in the forest. Then
while horsemen hurry to surround the glades
with nets, I shall pour down a black raincloud, 160
in which I have mixed hail, to awaken all
the heavens with my thundering. Their comrades
will scatter under cover of thick night.
Both Dido and the Trojan chief will reach
their shelter in the same cave. I shall be there. 165
And if I can rely on your goodwill,
I shall unite the two in certain marriage
and seal her as Aeneas' very own;
and this shall be their wedding." Cytherea°
said nothing to oppose the plan; she granted 170
what Juno wanted, smiling at its cunning.
Meanwhile Aurora rose; she left the Ocean.
And when her brightness fills the air, select
young men move from the gates with wide-meshed nets
and narrow snares and broad-blade hunting
 spears, 175
and then Massylian° horsemen hurry out
with strong, keen-scented hounds. But while the
 chieftains
of Carthage wait at Dido's threshold, she
still lingers in her room. Her splendid stallion,
in gold and purple, prances, proudly champing 180
his foaming bit. At last the queen appears
among the mighty crowd; upon her shoulders
she wears a robe of Sidon with embroidered
borders. Her quiver is of gold, her hair
has knots and ties of gold, a golden clasp 185
holds fast her purple cloak. Her Trojan comrades
and glad Ascanius advance behind her.
Aeneas, who is handsome past all others,
himself approaches now to join her, linking
his hunting band to hers. Just as Apollo, 190
when in the winter he abandons Lycia°
and Xanthus° streams to visit his maternal
Delos,° where he renews the dances—Cretans,
Dryopians, and painted Agathyrsi,°
mingling around the altars, shout—advances 195
upon the mountain ridges of high Cynthus°
and binds his flowing hair with gentle leaves
and braids its strands with intertwining gold;

110. Ascanius: Young son of Aeneas and his dead Trojan wife
Creusa. 119. Jove: Jupiter. 122. Daughter of Saturn: Juno, an
enemy of the Trojans. 122. Venus: Goddess of love, true mother
of Aeneas, and protector of the Trojans. 137. Troy had been
located on the coast of Phrygia. 141. Libyan: North African.

155. Tomorrow's Titan: The sun. 169. Cytherea: Another name
for Venus. 176. Massylian: Refers to a people of Africa. 191.
Lycia: An area of Asia Minor where Apollo had an oracle. 192.
Xanthus: A river of Lycia. 193. Delos: The island where Apollo
was born. 194. Cretans, Dryopians, and Agathyrsi are peoples of
the Mediterranean basin. 196. Cynthus: A mountain on Delos.

his arrows clatter on his shoulder: no
less graceful is Aeneas as he goes;　200
an equal beauty fills his splendid face.
And when they reach the hills and pathless thickets,
the wild she-goats, dislodged from stony summits,
run down the ridges; from another slope
stags fling themselves across the open fields;　205
they mass their dusty bands in flight, forsaking
the hillsides. But the boy Ascanius
rides happy in the valleys on his fiery
stallion as he passes on his course
now stags, now goats; among the lazy herds　210
his prayer is for a foaming boar or that
a golden lion come down from the mountain.

Meanwhile confusion takes the sky, tremendous
turmoil, and on its heels, rain mixed with hail.
The scattered train of Tyre, the youth of Troy,　215
and Venus' Dardan° grandson in alarm
seek different shelters through the fields; the torrents
roar down the mountains. Dido and the Trojan
chieftain have reached the same cave. Primal Earth
and Juno, queen of marriages, together　220
now give the signal: lightning fires flash,
the upper air is witness to their mating,
and from the highest hilltops shout the nymphs.
That day was her first day of death and ruin.
For neither how things seem nor how they are
　　deemed　225
moves Dido now, and she no longer thinks
of furtive love. For Dido calls it marriage,
and with this name she covers up her fault.
Then, swiftest of all evils, Rumor runs
straightway through Libya's mighty cities—
　　Rumor,　230
whose life is speed, whose going gives her force.
Timid and small at first, she soon lifts up
her body in the air. She stalks the ground;
her head is hidden in the clouds. Provoked
to anger at the gods, her mother Earth　235
gave birth to her, last come—they say—as sister
to Coeus and Enceladus;° fast-footed
and lithe of wing, she is a terrifying
enormous monster with as many feathers
as she has sleepless eyes beneath each feather　240
(amazingly), as many sounding tongues
and mouths, and raises up as many ears.
Between the earth and skies she flies by night,
screeching across the darkness, and she never
closes her eyes in gentle sleep. By day　245
she sits as sentinel on some steep roof

or on high towers, frightening vast cities;
for she holds fast to falsehood and distortion
as often as to messages of truth.
Now she was glad. She filled the ears of all　250
with many tales. She sang of what was done
and what was fiction, chanting that Aeneas
one born of Trojan blood, had come, that lovely
Dido has deigned to join herself to him,
that now, in lust, forgetful of their kingdom,　255
they take long pleasure, fondling through the
　　winter,
the slaves of squalid craving. Such reports
the filthy goddess scatters everywhere
upon the lips of men. At once she turns
her course to King Iarbas; and his spirit　260
is hot, his anger rages at her words.

Iarbas was the son of Hammon by
a ravished nymph of Garamantia.°
In his broad realm he had built a hundred temples,
a hundred handsome shrines for Jupiter.　265
There he had consecrated sleepless fire,
the everlasting watchman of the gods;
the soil was rich with blood of slaughtered herds,
and varied garlands flowered on the thresholds.
Insane, incited by that bitter rumor,　270
he prayed long—so they say—to Jupiter;
he stood before the altars in the presence
of gods, a suppliant with upraised hands:
"All-able Jove, to whom the Moorish nation,
feasting upon their figured couches, pour　275
Lenaean° sacrifices, do you see
these things? Or, Father, are we only trembling
for nothing when you cast your twisting thunder?
Those fires in the clouds that terrify
our souls—are they but blind and aimless
　　lightning　280
that only stirs our empty mutterings?
A woman, wandering within our borders,
paid for the right to build a tiny city.
We gave her shore to till and terms of tenure.
She has refused to marry me, she has taken　285
Aeneas as a lord into her lands.
And now this second Paris, with his crew
of half-men, with his chin and greasy hair
bound up beneath a bonnet of Maeonia,°
enjoys his prey; while we bring offerings　290
to what we have believed to be your temples,
still cherishing your empty reputation."

216. Dardan: Dardanus was founder of the Trojan race.
237. Angered at the gods for killing her children, the Titans,
Earth bore the Giants, one of whom was Rumor.

263. King Iarbas had the Egyptian god Hammon for a father and a
nymph from the interior of Africa for a mother.　276. Lenaean:
Pertaining to Bacchus, god of wine.　289. Maeonia: An area of
Asia Minor.

And as he prayed and clutched the altar stone,
all-able Jupiter heard him and turned
his eyes upon the royal walls, upon 295
the lovers who had forgotten their good name.
He speaks to Mercury, commanding him:
"Be on your way, my son, call up the Zephyrs,
glide on your wings, speak to the Dardan chieftain
who lingers now at Tyrian Carthage, paying 300
not one jot of attention to the cities
the Fates have given him. Mercury, carry
across the speeding winds the words I urge:
his lovely mother did not promise such
a son to us; she did not save him twice 305
from Grecian arms for this—but to be master
of Italy, a land that teems with empire
and seethes with war; to father a race from Teucer's°
high blood, to place all earth beneath his laws.
But if the brightness of such deeds is not 310
enough to kindle him, if he cannot
attempt the task for his own fame, does he—
a father—grudge Ascanius the walls
of Rome? What is he pondering, what hope
can hold him here among his enemies, 315
not caring for his own Ausonian° sons
or for Lavinian° fields. He must set sail.
And this is all; my message lies in this."

His words were ended. Mercury made ready
to follow his great father's orders. First 320
he laces on his golden sandals: winged
to bear him, swift as whirlwinds, high across
the land and water. Then he takes his wand;
with this he calls pale spirits up from Orcus°
and down to dreary Tartarus° sends others; 325
he uses this to give sleep and recall it,
and to unseal the eyes of those who have died.
His trust in this, he spurs the winds and skims
the troubled clouds. And now in flight, he sights
the summit and high sides of hardy Atlas° 330
who props up heaven with his crest—Atlas,
whose head is crowned with pines and battered by
the wind and rain and always girdled by
black clouds; his shoulders' cloak is falling snow;
above the old man's chin the rivers rush; 335
his bristling beard is stiff with ice. Here first
Cyllene's° god poised on his even wings
and halted; then he hurled himself headlong
and seaward with his body, like a bird
that, over shores and reefs where fishes throng, 340

swoops low along the surface of the waters.
Not unlike this, Cyllene's god between
the earth and heaven as he flies, cleaving
the sandy shore of Libya from the winds
that sweep from Atlas, father of his mother. 345

As soon as his winged feet have touched the outskirts,
he sees Aeneas founding fortresses
and fashioning new houses. And his sword
was starred with tawny jasper, and the cloak
that draped his shoulders blazed with Tyrian
 purple— 350
a gift that wealthy Dido wove for him;
she had run golden thread along the web.
And Mercury attacks at once. "Are you
now laying the foundation of high Carthage,
as servant to a woman, building her 355
a splendid city here? Are you forgetful
of what is your own kingdom, your own fate?
The very god of gods, whose power sways
both earth and heaven, sends me down to you
from bright Olympus. He himself has asked me 360
to carry these commands through the swift air:
what are you pondering or hoping for
while squandering your ease in Libyan lands?
For if the brightness of such deeds is not
enough to kindle you—if you cannot 365
attempt the task for your own fame—remember
Ascanius growing up, the hopes you hold
for Iülus,° your own heir, to whom are owed
the realm of Italy and land of Rome."
So did Cyllene's god speak out. He left 370
the sight of mortals even as he spoke
and vanished into the transparent air.

This vision stunned Aeneas, struck him dumb;
his terror held his hair erect; his voice
held fast within his jaws. He burns to flee 375
from Carthage; he would quit these pleasant lands,
astonished by such warnings, the command
of gods. What can he do? With what words dare
he face the frenzied queen? What openings
can he employ? His wits are split, they shift 380
here, there; they race to different places, turning
to everything. But as he hesitated,
this seemed the better plan: he calls Sergestus
and Mnestheus and the strong Serestus,° and
he asks them to equip the fleet in silence, 385
to muster their companions on the shore,
to ready all their arms, but to conceal
the reasons for this change; while he himself—
with gracious Dido still aware of nothing
and never dreaming such a love could ever 390

308. Teucer: An early king of Troy. 316. Ausonian: Pertaining to
middle or lower Italy. 317. Lavinia: A city in Latium in Middle
Italy near the seacoast. 324. Orcus: God of the underworld and
brother of Jupiter. The underworld itself is sometimes called Orcus.
325. Tartarus: The infernal regions. 330. Atlas: A god who
supports heaven on his shoulders. 337. Cyllene: A mountain in
Greece, birthplace of the winged god Mercury.

368. Iülus: Another name for Ascanius. 384. Sergestus,
Mnestheus, and Serestus are Trojans.

be broken—would try out approaches, seek
the tenderest, most tactful time for speech,
whatever dexterous way might suit his case.
And all are glad. They race to carry out
the orders of Aeneas, his commands. 395

But Dido—for who can deceive a lover?—
had caught his craftiness; she quickly sensed
what was to come; however safe they seemed,
she feared all things. That same unholy Rumor
brought her these hectic tidings: that the boats 400
were being armed, made fit for voyaging.
Her mind is helpless; raging frantically,
inflamed, she raves throughout the city—just
as a Bacchante when, each second year,
she is startled by the shaking of the sacred 405
emblems, the orgies urge her on, the cry
"o Bacchus" calls to her by night; Cithaeron°
incites her with its clamor. And at last
Dido attacks Aeneas with these words:

"Deceiver, did you even hope to hide 410
so harsh a crime, to leave this land of mine
without a word? Can nothing hold you back—
neither your love, the hand you pledged, nor even
the cruel death that lies in wait for Dido?
Beneath the winter sky are you preparing 415
a fleet to rush away across the deep
among the north winds, you who have no feeling?
What! Even if you were not seeking out
strange fields and unknown dwellings, even if
your ancient Troy were still erect, would you 420
return to Troy across such stormy seas?
Do you flee me? By tears, by your right hand—
this sorry self is left with nothing else
by wedding, by the marriage we began,
if I did anything deserving of you 425
or anything of mine was sweet to you,
take pity on a fallen house, put off
your plan, I pray—if there is still place for prayers.
Because of you the tribes of Libya, all
the Nomad princes hate me, even my 430
own Tyrians are hostile; and for you
my honor is gone and that good name that once
was mine, my only claim to reach the stars.
My guest, to whom do you consign this dying
woman? I must say 'guest': this name is all 435
I have of one whom once I called my husband.
Then why do I live on? Until Pygmalion,
my brother, batters down my walls, until
Iarbas the Gaetulian takes me prisoner?
Had I at least before you left conceived 440
a son in me; if there were but a tiny

Aeneas playing by me in the hall,
whose face, in spite of everything, might yet
remind me of you, then indeed I should
not seem so totally abandoned, beaten." 445

Her words were ended. But Aeneas, warned
by Jove, held still his eyes; he struggled, pressed
care back within his breast. With halting words
he answers her at last: "I never shall
deny what you deserve, the kindnesses 450
that you could tell; I never shall regret
remembering Elissa° for as long
as I remember my own self, as long
as breath is king over these limbs. I'll speak
brief words that fit the case. I never hoped 455
to hide—do not imagine that—my flight;
I am not furtive. I have never held
the wedding torches as a husband; I
have never entered into such agreements.
If fate had granted me to guide my life 460
by my own auspices and to unravel
my troubles with unhampered will, then I
should cherish first the town of Troy, the sweet
remains of my own people and the tall
rooftops of Priam° would remain, my hand 465
would plant again a second Pergamus°
for my defeated men. But now Grynean°
Apollo's oracles would have me seize
great Italy, the Lycian prophecies
tell me of Italy: there is my love, 470
there is my homeland. If the fortresses
of Carthage and the vision of a city
in Libya can hold you, who are Phoenician,
why, then, begrudge the Trojans' settling on
Ausonian soil? There is no harm; it is 475
right that we, too, seek out a foreign kingdom.
For often as the night conceals the earth
with dew and shadows, often as the stars
ascend, afire, my father's anxious image
approaches me in dreams. Anchises° warns 480
and terrifies; I see the wrong I have done
to one so dear, my boy Ascanius,
whom I am cheating of Hesperia,°
the fields assigned by fate. And now the gods'
own messenger, sent down by Jove himself— 485
I call as witness both our lives—has brought
his orders through the swift air. My own eyes
have seen the god as he was entering
our walls—in broad daylight. My ears have drunk
his words. No longer set yourself and me 490

407. Cithaeron: A mountain in Greece where the rites of Bacchus are celebrated.

452. Elissa: Another name for Dido. 465. Priam: Late king of Troy. 466. Pergamus: Troy. 467. Grynean: Pertaining to an oracle of Apollo in Asia Minor. 480. Anchises: Aeneas' dead father. 483. Hesperia: A place of fabled orchards in the west; here it means Italy.

afire. Stop your quarrel. It is not
my own free will that leads to Italy."

But all the while Aeneas spoke, she stared
askance at him, her glance ran this way, that.
She scans his body with her silent eyes. 495
Then Dido thus, inflamed, denounces him:

"No goddess was your mother, false Aeneas,
And Dardanus no author of your race;
the bristling Caucasus was father to you
on his harsh crags; Hyrcanian tigresses 500
gave you their teats. And why must I dissemble?
Why hold myself in check? For greater wrongs?
For did Aeneas groan when I was weeping?
Did he once turn his eyes or, overcome,
shed tears or pity me, who was his loved one? 505
What shall I cry out first? And what shall follow?
No longer now does mighty Juno or
our Father, son of Saturn,° watch this earth
with righteous eyes. Nowhere is certain trust.
He was an outcast on the shore, in want. 510
I took him in and madly let him share
my kingdom; his lost fleet and his companions
I saved from death. Oh I am whirled along
in fire by the Furies! First the augur
Apollo, then the Lycian oracles, 515
and now, sent down by Jove himself, the gods'
own herald, carrying his horrid orders.
This seems indeed to be a work for High Ones,
a care that can disturb their calm. I do not
refute your words. I do not keep you back. 520
Go then, before the winds, to Italy.
Seek out your kingdom overseas; indeed,
if there by pious powers still, I hope
that you will drink your torments to the lees
among sea rocks and, drowning, often cry 525
the name of Dido. Then, though absent, I
shall hunt you down with blackened firebrands;
and when chill death divides my soul and body,
a Shade, I shall be present everywhere.
Depraved, you then will pay your penalties. 530
And I shall hear of it, and that report
will come to me below, among the Shadows."
Her speech is broken off; heartsick, she shuns
the light of day, deserts his eyes; she turns
away, leaves him in fear and hesitation, 535
Aeneas longing still to say so much.
As Dido faints, her servants lift her up;
they carry her into her marble chamber;
they lay her body down upon the couch.

But though he longs to soften, soothe her sorrow 540
and turn aside her troubles with sweet words,

though groaning long and shaken in his mind
because of his great love, nevertheless
pious Aeneas carries out the gods'
instructions. Now he turns back to his fleet. 545

At this the Teucrians indeed fall to.
They launch their tall ships all along the beach;
they set their keels, well-smeared with pitch, afloat.
The crewmen, keen for flight, haul from the forest
boughs not yet stripped of leaves to serve as oars 550
and timbers still untrimmed. And one could see them
as, streaming, they rushed down from all the city:
even as ants, remembering the winter,
when they attack a giant stack of spelt
to store it in their homes; the black file swarms 555
across the fields; they haul their plunder through
the grass on narrow tracks; some strain against
the great grains with their shoulders, heaving hard;
some keep the columns orderly and chide
the loiterers; the whole trail boils with work. 560

What were your feelings, Dido, then? What were
the sighs you uttered at that sight, when far
and wide, from your high citadel, you saw
the beaches boil and turmoil take the waters,
with such a vast uproar before your eyes? 565
Voracious Love, to what do you not drive
the hearts of men? Again, she must outcry,
again, a suppliant, must plead with him,
must bend her pride to love—and so not die
in vain, and with some way still left untried. 570

"Anna, you see them swarm across the beaches;
from every reach around they rush to sea:
the canvas calls the breezes, and already
the boisterous crewmen crown the sterns with
 garlands.
But I was able to foresee this sorrow; 575
therefore I can endure it, sister; yet
in wretchedness I must ask you for this
one service, Anna. Treacherous Aeneas
has honored you alone, confiding even
his secret feelings unto you; and you 580
alone know all his soft approaches, moods.
My sister, go—to plead with him, to carry
this message to my arrogant enemy.
I never trafficked with the Greeks at Aulis°
to root the Trojans out, I never sent 585
a fleet to Pergamus, never disturbed
his father's ashes or Anchises' Shade,
that now Aeneas should ward off my words
from his hard ears. Where is he hurrying?
If he would only grant his wretched lover 590

508. Saturn was father of both Jupiter and his wife Juno.

584. Aulis: The town in Greece where the Greek fleet set sail to attack Troy.

this final gift; to wait for easy sailing
and favoring winds. I now no longer ask
for those old ties of marriage he betrayed,
nor that he lose his kingdom, be deprived
of lovely Latium;° I only ask 595
for empty time, a rest and truce for all
this frenzy, until fortune teaches me,
defeated, how to sorrow. I ask this—
pity your sister—as a final kindness.
When he has granted it, I shall repay 600
my debt, and with full interest, by my death."

So Dido pleads, and her poor sister carries
these lamentations, and she brings them back.
For lamentation cannot move Aeneas;
his graciousness toward any plea is gone. 605
Fate is opposed, the god makes deaf the hero's
kind ears. As when, among the Alps, north winds
will strain against each other to root out
with blasts—now on this side, now that—a stout
oak tree whose wood is full of years; the roar 610
is shattering, the trunk is shaken, and
high branches scatter on the ground; but it
still grips the rocks; as steeply as it thrusts
its crown into the upper air, so deep
the roots it reaches down to Tartarus: 615
no less than this, the hero; he is battered
on this side and on that by assiduous words;
he feels care in his mighty chest, and yet
his mind cannot be moved; the tears fall, useless.
Then maddened by the fates, unhappy Dido 620
calls out at last for death; it tires her
to see the curve of heaven. That she may
not weaken in her plan to leave the light,
she sees, while placing offerings on the altars
with burning incense—terrible to tell— 625
the consecrated liquid turning black,
the outpoured wine becoming obscene blood.
But no one learns of this, not even Anna.
And more: inside her palace she had built
a marble temple to her former husband 630
that she held dear and honored wonderfully.
She wreathed that shrine with snow-white fleeces and
holy-day leaves. And when the world was seized
by night, she seemed to hear the voice and words
of her dead husband, calling out to Dido. 635
Alone above the housetops, death its song,
an owl often complains and draws its long
slow call into a wailing lamentation.
More, many prophecies of ancient seers
now terrify her with their awful warnings. 640
And in her dreams it is the fierce Aeneas
himself who drives her to insanity;
she always finds herself alone, abandoned,

and wandering without companions on
an endless journey, seeking out her people, 645
her Tyrians in a deserted land:
even as Pentheus,° when he is seized by frenzy,
sees files of Furies, and a double sun
and double Thebes appear to him; or when
Orestes, son of Agamemnon, driven 650
across the stage, flees from his mother armed
with torches and black serpents; on the threshold
the awful goddesses of vengeance squat.

When she had gripped this madness in her mind
and, beaten by her grief, resolved to die, 655
she plotted with herself the means, the moment.
Her face conceals her meaning; on her brow
she sets serenity, then speaks to Anna:
"My sister, wish me well, for I have found
a way that will restore Aeneas to me 660
or free me of my love for him. Near by
the bounds of Ocean and the setting sun
lies Ethiopia, the farthest land;
there Atlas, the incomparable, turns
the heavens, studded with their glowing stars, 665
upon his shoulders. And I have been shown
a priestess from that land—one of the tribe
of the Massylians°—who guards the shrine
of the Hesperides; for it was she
who fed the dragon and preserved the holy 670
branches upon the tree, sprinkling moist honey
and poppy, bringing sleep. She promises
to free, with chant and spell, the minds of those
she favors but sends anguish into others.
And she can stay the waters in the rivers 675
and turn the stars upon their ways; she moves
the nightly Shades; makes earth quake underfoot
and—you will see—sends ash trees down the
 mountains.
Dear sister, I can call the gods to witness,
and you and your dear life, that I resort 680
to magic arts against my will. In secret
build up a pyre within the inner courtyard
beneath the open air, and lay upon it
the weapons of the hero. He, the traitor,
has left them hanging in my wedding chamber. 685
Take all of his apparel and the bridal
bed where I was undone. You must destroy
all relics of the cursed man, for so
would I, and so the priestess has commanded."
This said, she is silent and her face is pale. 690
But Anna cannot dream her sister hides
a funeral behind these novel rites;
her mind is far from thinking of such frenzy;

595. Latium: A town of central Italy noted above.

647. Pentheus: A king of the Greek city of Thebes who was driven mad, seeing all things double. 668. Massylians: African people who guard the sacred western orchards, here placed in North Africa.

and she fears nothing worse than happened when
Sychaeus died. And so, she does as told. 695

But when beneath the open sky, inside
the central court, the pyre rises high
and huge, with logs of pine and planks of ilex,
the queen, not ignorant of what is coming,
then wreathes the place with garlands, crowning
 it 700
with greenery of death; and on the couch
above she sets the clothes Aeneas wore,
the sword he left, and then his effigy.
Before the circling altars the enchantress,
her hair disheveled, stands as she invokes 705
aloud three hundred gods, especially
Chaos and Erebus and Hecate,°
the triple-shaped Diana,° three-faced virgin.
And she had also sprinkled waters that
would counterfeit the fountain of Avernus;° 710
she gathered herbs cut down by brazen sickles
beneath the moonlight, juicy with the venom
of black milk; she had also found a love charm
torn from the forehead of a newborn foal
before his mother snatched it. Dido herself— 715
with salt cake in her holy hands, her girdle
unfastened, and one foot free of its sandal,
close by the altars and about to die—
now calls upon the gods and stars, who know
the fates, as witness; then she prays to any 720
power there may be, who is both just and watchful,
who cares for those who love without requital.

Night. And across the earth the tired bodies
were tasting tranquil sleep; the woods and savage
waters were resting and the stars had reached 725
the midpoint of their gliding fall—when all
the fields are still, and animals and colored
birds, near and far, that find their home beside
the limpid lakes or haunt the countryside
in bristling thickets, sleep in silent night. 730
But not the sorrowing Phoenician; she
can not submit to sleep, can not admit
dark night into her eyes or breast; her cares
increase; again love rises, surges in her;
she wavers on the giant tide of anger. 735
She will not let things rest but carries on;
she still revolves these thoughts within her heart:
"What can I do? Shall I, whom he has mocked,
go back again to my old suitors, begging,
seeking a wedding with Numidians whom 740

I have already often scorned as bridegrooms?
Or should I sail away on Trojan ships,
to suffer there even their harshest orders?
Shall I do so because the Trojans once
received my help, and the gratefulness for such 745
old service is remembered by the mindful?
But even if I wish it, would they welcome
someone so hated to their haughty ships?
For, lost one, do you not yet know, not feel
the treason of the breed of Laomedon?° 750
What then? Shall I accompany, alone,
the exultant sailors in their flight? Or call
on all my Tyrians, on all my troops
to rush upon them? How can I urge on
those I once dragged from Sidon, how can I 755
now force them back again upon the sea
and have them spread their canvas to the winds?
No; die as you deserve, and set aside
your sorrow by the sword. My sister, you,
won over by my tears—you were the first 760
to weigh me down with evils in my frenzy,
to drive me toward my enemy. And why
was it not given me to lead a guiltless
life, never knowing marriage, like a wild
beast, never to have touched such toils? I have
 not 765
held fast the faith I swore before the ashes
of my Sychaeus." This was her lament.

Aeneas on the high stern now was set
to leave; he tasted sleep; all things were ready.
And in his sleep a vision of the god 770
returned to him with that same countenance—
resembling Mercury in everything:
his voice and coloring and yellow hair
and all his handsome body, a young man's—
and seemed to bring a warning once again: 775
"You, goddess-born, how can you lie asleep
at such a crisis? Madman, can't you see
the threats around you, can't you hear the breath
of kind west winds? She conjures injuries
and awful crimes, she means to die, she stirs 780
the shifting surge of restless anger. Why
not flee this land headlong, while there is time?
You soon will see the waters churned by
 wreckage,
ferocious torches blaze, and beaches flame,
if morning finds you lingering on this coast. 785
Be on your way. Enough delays. An ever
uncertain and inconstant thing is woman."
This said, he was at one with the black night.

707. Hecate: A goddess of witchcraft and the underworld.
708. Diana: Goddess of the chase and the moon, identified with
Hecate. 710. Avernus: A lake and woods near Cumae, close to
which there allegedly was an entrance to the underworld.

750. Laomedon: Legendary ancestor of the Trojans and a notorious
perjurer.

The sudden apparition terrifies
Aeneas. And he tears his body free 790
from sleep. He stirs his crewmen: "Quick! Awake!
Now man the benches, comrades, now unfurl
our sails with speed! Down from the upper air
a god was sent to urge us on again,
to rush our flight, to slice our twisted cables. 795
O holy one among the gods, we follow
your way, whoever you may be; again
rejoicing, we shall do as you command.
Be present, help us with your kindness, bring
your gracious constellations to the heavens." 800
He spoke; and from his scabbard snatches up
his glowing sword; with drawn blade, strikes the
 hawsers.
And all are just as eager, hurrying
to leave the shore; the ships conceal the sea.
They strain to churn the foam and sweep blue
 waters. 805
Now early Dawn had left Tithonus'° saffron
bed, scattering new light upon the earth.
As soon as from her lookout on the tower
the queen could see the morning whitening,
the fleet move on with level sails, the shores 810
and harbors now abandoned, without oarsmen,
she beat against her lovely breast three times,
then four, and tore her golden hair, and cried:
"O Jupiter, you let him go, a stranger
who mocked our kingdom! Will my men not
 ready 815
their weapons, hunt him down, pour from my city
and rip the galleys from their moorings? Quick!
Bring torches, spread your sails, and ply your oars!
What am I saying? Where am I? What madness
has turned awry what I had meant to do? 820
Poor Dido, does his foulness touch you now?
It should have then, when you gave him your scepter.
This is the right hand, this the pledge of one
who carries with him, so they say, the household
gods of his land, who bore upon his shoulders 825
his father weak with years. And could I not
have dragged his body off, and scattered him
piecemeal upon the waters, limb by limb?
Or butchered all his comrades, even served
Ascanius himself as banquet dish 830
upon his father's table? True enough—
the battle might have ended differently.
That does not matter. For, about to die,
need I fear anyone? I should have carried
my torches to his camp and filled his decks 835
with fire, destroyed the son, the father, that
whole race, and then have thrown myself upon them.
You, Sun, who with your flames see all that is done

on earth; and Juno, you, interpreter
and witness of my sorrows; Hecate, 840
invoked with shrieks, by night, at every city's
crossways; and you, the Furies; and the gods
that guard dying Elissa—hear these words
and turn your power toward my pain; as I
deserve, take up my prayers. If it must be 845
that he, a traitor, is to touch his harbor,
float to his coasts, and so the fates of Jove
demand and if this end is fixed; yet let
him suffer war and struggles with audacious
nations, and then—when banished from his
 borders 850
and torn from the embrace of Iülus—let him
beg aid and watch his people's shameful slaughter.
Not even when he has bent low before
an unjust peace may he enjoy his kingdom,
the light that he has wished for. Let him fall 855
before his time, unburied in the sand.
These things I plead; these final words I pour
out of my blood. Then, Tyrians, hunt down
with hatred all his sons and race to come;
send this as offering unto my ashes. 860
Do not let love or treaty tie our peoples.
May an avenger rise up from my bones,
one who will track with firebrand and sword
the Dardan settlers, now and in the future,
at any time that ways present themselves. 865
I call your shores to war against their shores,
your waves against their waves, arms with their arms.
Let them and their sons' sons learn what is war."

This said, she ran her mind to every side,
for she was seeking ways with which to slice— 870
as quickly as she can—the hated light;
and then, with these brief words, she turned to Barce,
Sychaeus' nurse—for Dido's own was now
black ashes in Phoenicia, her old homeland:
"Dear nurse, call here to me my sister Anna; 875
and tell her to be quick to bathe her body
with river water; see that she brings cattle
and all that is appointed for atonement.
So must my sister come; while you yourself
bind up your temples with a pious fillet. 880
I mean to offer unto Stygian Jove
the sacrifices that, as is ordained,
I have made ready and begun, to put
an end to my disquiet and commit
to flames the pyre of the Trojan chieftain." 885
So Dido spoke. And Barce hurried off;
she moved with an old woman's eagerness.

But Dido, desperate, beside herself
with awful undertakings, eyes bloodshot
and rolling, and her quivering cheeks flecked 890
with stains and pale with coming death, now bursts

806. Tithonus: Husband of Aurora, the dawn.

across the inner courtyards of her palace.
She mounts in madness that high pyre, unsheathes
the Dardan sword, a gift not sought for such
an end. And when she saw the Trojan's clothes 895
and her familiar bed, she checked her thought
and tears a little, lay upon the couch
and spoke her final words: "O relics, dear
while fate and god allowed, receive my spirit
and free me from these cares; for I have lived 900
and journeyed through the course assigned by fortune.
And now my Shade will pass, illustrious,
beneath the earth; I have built a handsome city,
have seen my walls rise up, avenged a husband,
won satisfaction from a hostile brother: 905
o fortunate, too fortunate—if only
the ships of Troy had never touched our coasts."
She spoke and pressed her face into the couch.
"I shall die unavenged, but I shall die,"
she says. "Thus, thus, I gladly go below 910
to shadows. May the savage Dardan drink
with his own eyes this fire from the deep
and take with him the omen of my death."

Then Dido's words were done, and her companions
can see her fallen on the sword; the blade 915
is foaming with her blood, her hands are bloodstained.
Now clamor rises to the high rooftop.
Now rumor riots through the startled city.
The lamentations, keening, shrieks of women
sound through the houses; heavens echo mighty 920
wailings, even as if an enemy
were entering the gates, with all of Carthage
or ancient Tyre in ruins, and angry fires
rolling across the homes of men and gods.

And Anna heard. Appalled and breathless, she 925
runs, anxious, through the crowd, her nails wounding
her face; her fists, her breasts; she calls the dying
Dido by name: "And was it, then, for this,
my sister? Did you plan this fraud for me?
Was this the meaning waiting for me when 930
the pyre, the flames, the altar were prepared?
What shall I now, deserted, first lament?
You scorned your sister's company in death;
you should have called me to the fate you met;
the same sword pain, the same hour should have
 taken 935
the two of us away. Did my own hands
help build the pyre, and did my own voice call
upon our fathers' gods, only to find
me, heartless, far away when you lay dying?
You have destroyed yourself and me, my sister, 940
the people and the elders of your Sidon,
and all your city. Let me bathe your wounds
in water, and if any final breath

still lingers here, may my lips catch it up."
This said, she climbed the high steps, then she
 clasped 945
her half-dead sister to her breast, and moaning,
embraced her, dried the black blood with her dress.
Trying to lift her heavy eyes, the queen
falls back again. She breathes; the deep wound in
her chest is loud and hoarse. Three times she
 tried 950
to raise herself and strained, propped on her elbow;
and three times she fell back upon the couch.
Three times with wandering eyes she tried to find
high heaven's light and, when she found it, sighed.

But then all-able Juno pitied her 955
long sorrow and hard death and from Olympus°
sent Iris° down to free the struggling spirit
from her entwining limbs. For as she died
a death that was not merited or fated,
but miserable and before her time 960
and spurred by sudden frenzy, Proserpina°
had not yet cut a gold lock from her crown,
not yet assigned her life to Stygian° Orcus.
On saffron wings dew-glittering Iris glides
along the sky, drawing a thousand shifting 965
colors across the facing sun. She halted
above the head of Dido: "So commanded,
I take this lock as offering to Dis;°
I free you from your body." So she speaks
and cuts the lock with her right hand; at once 970
the warmth was gone, the life passed to the
 winds.

· ·

COMMENTS AND QUESTIONS

1. How does Juno, an enemy of the Trojans, attempt to frustrate their mission to settle in Italy? Why does Venus, protectress of the Trojans, concede so easily to Juno? How are her plans foiled?
2. Is Dido's anger against Aeneas justified?
3. What tricks does Dido use in order to have her funeral pyre prepared?
4. Throughout the Middle Ages, Dido was used as a cautionary example for Christians. Why?
5. What purposes does Virgil's extensive use of *similes* throughout the work serve?

· ·

956. Olympus: Mountain home of the gods. 957. Iris: Goddess of the rainbow and Juno's messenger. 961. Proserpina: Goddess of the underworld and wife of Pluto. She was supposed to cut a lock of hair from the head of the dying as an offering to the gods of the underworld. 963. Stygian: Pertaining to one of the rivers of Orcus, the underworld. 968. Dis: Pluto, god of the underworld.

Book 5 of the *Aeneid* recounts the journey of Aeneas from Carthage to Italy and contains an elaborate description of the funeral games for his father, Anchises. At the beginning of Book 6, Aeneas lands at Cumae and visits the Grotto of the Sibyl near the temple of Apollo. He asks the Sibyl to prophesy to him, not scattering her prophecies on leaves, as is her custom, but speaking to him directly. After her prophecy, she commands Aeneas to sacrifice and pray to the gods. She then accompanies him on a trip to the underworld, where he sees many shades (including that of Dido) and witnesses both the punishments and the rewards of the afterlife. At last he reaches his father, Anchises, who reveals to him the future glory of Rome, stressing the continuity between past and future, of which Aeneas is a pivotal part.

The selection offered here describes the journey to the underworld.

Book 6

. . . There was a wide-mouthed cavern, deep and vast
and rugged, sheltered by a shadowed lake
and darkened groves; such vapor poured from
 those 320
black jaws to heaven's vault, no bird could fly
above unharmed (for which the Greeks have called
the place "Aornos," or "The Birdless"). Here
the priestess places, first, four black-backed steers;
and she pours wine upon their brows and plucks 325
the topmost hairs between their horns and these
casts on the sacred fires as offering,
calling aloud on Hecate, the queen
of heaven and of hell. Then others slit
the victims' throats and catch warm blood in
 bowls. 330
Aeneas sacrifices with his sword
a black-fleeced lamb for Night, the Furies' mother,
and Terra, her great sister; and for you,
Proserpina, he kills a barren heifer.
And then for Pluto, king of Styx, he raises 335
nocturnal altars, laying on their fires
whole carcasses of bulls; he pours fat oil
across the burning entrails. But no sooner
are dawn and brightness of the early sun
upon them than the ground roars underfoot, 340
the wooded ridges shudder, through the shadows
dogs seem to howl as Hecate draws near.
"Away, away, you uninitiated,"
the priestess shrieks, "now leave the grove; only
Aeneas move ahead, unsheathe your sword; 345
you need your courage now; you need your
 heart."
This said, she plunges, wild, into the open
cavern; but with unfaltering steps Aeneas
keeps pace beside his guide as she advances.

You gods who hold dominion over spirits; 350
you voiceless Shades; you, Phlegethon and Chaos,
immense and soundless regions of the night:
allow me to retell what I was told;
allow me by your power to disclose
things buried in the dark and deep of earth! 355

They moved along in darkness, through the
 shadows,
beneath the lonely night, and through the hollow
dwelling place of Dis, his phantom kingdom:
even as those who journey in a forest
beneath the scanty light of a changing moon, 360
when Jupiter has wrapped the sky in shadows
and black night steals the color from all things.
Before the entrance, at the jaws of Orcus,°
both Grief and goading Cares have set their couches;
their pale Diseases dwell, and sad Old Age, 365
and Fear and Hunger, that worst counsellor,
and ugly Poverty—shapes terrible
to see—and Death and Trials; Death's brother, Sleep,
and all the evil Pleasures of the mind;
and War, whose fruits are death; and facing
 these, 370
the Furies' iron chambers; and mad Strife,
her serpent hair bound up with bloody garlands.

Among them stands a giant shaded elm,
a tree with spreading boughs and aged arms;
they say that is the home of empty Dreams 375
that cling, below, to every leaf. And more,
so many monstrous shapes of savage beasts
are stabled there: Centaurs and double-bodied
Scyllas;° the hundred-handed Briareus;°
the brute of Lerna, hissing horribly; 380
Chimaera armed with flames; Gorgons and Harpies;
and Geryon, the shade that wears three bodies.°
And here Aeneas, shaken suddenly
by terror, grips his sword; he offers naked
steel and opposes those who come. Had not 385
his wise companion warned him they were only
thin lives that glide without a body in
the hollow semblance of a form, he would
in vain have torn the shadows with his blade.

Here starts the pathway to the waters of 390
Tartarean° Acheron. A whirlpool thick
with sludge, its giant eddy seething, vomits

363. Orcus: God of death who carried souls to the underworld.
379. Scylla: A sea monster.　379. Briareus: A giant with a hundred hands who engaged in battle against the gods.　381–82. Chimaera, Gorgons, Harpies, Geryon: All monsters.　391. Tartarean: Of the region of the underworld (Tartarus) in which the shades of the evil are punished.

all of its swirling sand into Cocytus.°
Grim Charon is the squalid ferryman,
is guardian of these streams, these rivers; his 395
white hairs lie thick, disheveled on his chin;
his eyes are fires that stare, a filthy mantle
hangs down his shoulder by a knot. Alone,
he poles the boat and tends the sails and carries
the dead in his dark ship, old as he is; 400
but old age in a god is tough and green.

And here a multitude was rushing, swarming
shoreward, with men and mothers, bodies of
high-hearted heroes stripped of life, and boys
and unwed girls, and young men set upon 405
the pyre of death before their fathers' eyes:
thick as the leaves that with the early frost
of autumn drop and fall within the forest,
or as the birds that flock along the beaches,
in flight from frenzied seas when the chill season 410
drives them across the waves to lands of sun.
They stand; each pleads to be the first to cross
the stream; their hands reach out in longing for
the farther shore. But Charon, sullen boatman,
now takes these souls, now those; the rest he
 leaves; 415
thrusting them back, he keeps them from the beach.

That disarray dismays and moves Aeneas:
"O virgin, what does all this swarming mean?
What do these spirits plead? And by what rule
must some keep off the bank while others sweep 420
the blue-black waters with their oars?" The words
the aged priestess speaks are brief: "Anchises'
son, certain offspring of the gods, you see
the deep pools of Cocytus and the marsh
of Styx,° by whose divinity even 425
the High Ones are afraid to swear falsely.
All these you see are helpless and unburied.
That ferryman is Charon. And the waves
will only carry souls that have a tomb.
Before his bones have found their rest, no one 430
may cross the horrid shores and the hoarse waters.
They wander for a hundred years and hover
about these banks until they gain their entry,
to visit once again the pools they long for."

Anchises' son has stopped; he stays his steps 435
and ponders, pitying these unkind fates.
There he can see the sorrowing Leucaspis,
Orontes, captain of the Lycian fleet:
both dead without death's honors, for the south
 wind

had overwhelmed them, sinking ships and sailors, 440
when they were crossing stormy seas from Troy.

And there the pilot, Palinurus, passed:
lately, upon the Libyan voyage, as
he scanned the stars, he had fallen from the stern,
cast down into the center of the sea. 445
And when at last in that deep shade Aeneas
had recognized his grieving form, he was
the first to speak: "O Palinurus, what
god tore you from us, plunged you in midsea?
O tell me. For Apollo, who had never 450
been false before, in this one oracle
deceived me; he had surely prophesied
that you would be unharmed upon the waters
and reach the coastline of Ausonia.
Is this the way he keeps his word?" He answered: 455
"Anchises' son, my captain, you must know:
Apollo's tripod did not cheat, no god
hurled me into the waves. For as it happened,
the rudder that, as my appointed charge,
I clutched, to steer our course, was twisted off 460
by force; I dragged it down headlong with me.
I swear by those harsh seas that I was taken
by no fear for myself; I was afraid
your ship, without its gear, without a helmsman,
might swamp in such a surge. Three nights of
 winter, 465
along vast fields of sea, across the waters,
the south wind lashed me violently; only
on my fourth dawn, high on a wave crest, I
saw Italy, dimly. I swam toward land
slowly and was just at the point of safety— 470
my sea-drenched clothing heavy, my hooked hands
were clinging to a jagged cliffside—when
barbarians attacked me with the sword,
ignorantly thinking me a prize.
And now I am the breakers', beach winds toss
 me. . . . 475
I beg you, therefore, by the gentle light
and winds of heaven, undefeated one,
and by your father, by your growing son,
Iülus, save me from these evils: either
cast earth upon my body—for you can— 480
and seek again the port of Velia; or
if there be any way, if you are given
such power by your goddess mother (for
I cannot think that you are now prepared
to cross such mighty rivers and the marsh 485
of Styx without the gods' protection), give
your own right hand to wretched Palinurus
and take me with you past the waters, that
at least in death I find a place of rest."

But then the priestess turned on the dead pilot. 490
"Where was it, Palinurus, that you learned

393. Cocytus: One of the rivers of Tartarus (the river of lamentation). 425. Styx: Another river of Tartarus.

such dread desire? For how can you, unburied,
look at the waves of Styx, upon the Furies'
stern river, and approach its shore, unasked?
Leave any hope that prayer can turn aside 495
the gods' decrees. But keep in memory
these words as comfort in your cruel trial:
for all around, the neighboring cities will
be goaded by the plague, a sign from heaven
to make peace with your bones; and they will
 build 500
a tomb and send their solemn sacrifices;
the place will always be named Palinurus."
These words have set his cares to rest, his sorrow
is exiled for a while from his sad heart.
The land that bears his name has made him glad. 505

The journey they began can now continue.
They near the riverbank. Even the boatman,
while floating on the Styx, had seen them coming
across the silent grove and toward the shore.
He does not wait for greeting but attacks, 510
insulting with these words: "Enough! Stop there!
Whoever you may be who make your way,
so armed, down to our waters, tell me now
why you have come. This is the land of shadows,
of Sleep and drowsy Night; no living bodies 515
can take their passage in the ship of Styx.
Indeed, I was not glad to have Alcides°
or Theseus or Pirithoüs° cross the lake,
although the three of them were sons of gods
and undefeated in their wars. Alcides 520
tried to drag off in chains the guardian
of Tartarus; he tore him, trembling, from
the king's own throne. The others tried to carry
the queen away from Pluto's wedding chamber."
Apollo's priestess answered briefly. "We 525
bring no such trickery; no need to be
disturbed; our weapons bear no violence;
for us, the mighty watchman can bark on
forever in his cavern, frightening
the bloodless shades; Proserpina can keep 530
the threshold of her uncle faithfully.
Trojan Aeneas, famed for piety
and arms, descends to meet his father, down
into the deepest shades of Erebus.
And if the image of such piety 535
is not enough to move you, then"—and here
she shows the branch concealed beneath her robe—
"you may yet recognize this bough." At this
the swollen heart of Charon stills its anger.
He says no more. He wonders at the sacred 540
gifts of the destined wand, so long unseen,

and turns his blue-black keel toward shore. He clears
the other spirits from the gangways and
long benches and, meanwhile, admits the massive
Aeneas to the boat, the vessel's seams 545
groaning beneath the weight as they let in
marsh water through the chinks. At last he sets
the priestess and the soldier safe across
the stream in ugly slime and blue-gray sedge.
These regions echo with the triple-throated 550
bark of the giant Cerberus,° who crouches,
enormous, in a cavern facing them.
The Sibyl, seeing that his neck is bristling
with snakes, throws him a honeyed cake of wheat
with drugs that bring on sleep. His triple mouths 555
yawn wide with rapid hunger as he clutches
the cake she cast. His giant back falls slack
along the ground; his bulk takes all the cave.
And when the beast is buried under sleep,
Aeneas gains the entrance swiftly, leaves 560
the riverbank from which no one returns.

Here voices and loud lamentations echo:
the souls of infants weeping at the very
first threshold—torn away by the black day,
deprived of their sweet life, ripped from the
 breast, 565
plunged into bitter death. And next to them
are those condemned to die upon false charges.
These places have not been assigned, indeed,
without a lot, without a judge; for here
Minos° is magistrate. He shakes the urn 570
and calls on the assembly of the silent,
to learn the lives of men and their misdeeds.
The land that lies beyond belongs to those
who, although innocent, took death by their
own hands; hating the light, they threw away 575
their lives. But now they long for the upper air,
and even to bear want and trials there.
But fate refuses them: the melancholy
marshland, its ugly waters, hem them in,
the prisoners of Styx and its nine circles. 580

Nearby, spread out on every side, there lie
the Fields of Mourning: this, their given name.
And here, concealed by secret paths, are those
whom bitter love consumed with brutal waste;
a myrtle grove encloses them; their pains 585
remain with them in death. Aeneas sees
Phaedra and Procris and sad Eriphyle,
who pointed to the wounds inflicted by
her savage son; he sees Pasiphaë
and then Evadne; and Laodamia 590

517. Alcides: Hercules. 518. Theseus and his friend Pirithoüs
attempted to steal Proserpina from the underworld.

551. Cerberus: Three-headed guard dog of the gates of Hades.
570. Minos: Formerly king of Crete, judge of the dead in the
underworld.

and Caeneus, once a youth and now a woman,
changed back again by fate to her first shape.

Among them, wandering in that great forest,
and with her wound still fresh: Phoenician Dido.
And when the Trojan hero recognized her 595
dim shape among the shadows (just as one
who either sees or thinks he sees among
the cloud banks, when the month is young, the moon
rising), he wept and said with tender love:
"Unhappy Dido, then the word I had 600
was true? That you were dead? That you pursued
your final moment with the sword? Did I
bring only death to you? Queen, I swear by
the stars, the gods above, and any trust
that may be in this underearth, I was 605
unwilling when I had to leave your shores.
But those same orders of the gods that now
urge on my journey through the shadows, through
abandoned, thorny lands and deepest night,
drove me by their decrees. And I could not 610
believe that with my going I should bring
so great a grief as this. But stay your steps.
Do not retreat from me. Whom do you flee?
This is the last time fate will let us speak."

These were the words Aeneas, weeping, used, 615
trying to soothe the burning, fierce-eyed Shade.
She turned away, eyes to the ground, her face
no more moved by his speech than if she stood
as stubborn flint or some Marpessan crag.
At last she tore herself away; she fled— 620
and still his enemy—into the forest
of shadows, where Sychaeus, once her husband,
answers her sorrows, gives her love for love.
Nevertheless, Aeneas, stunned by her
unkindly fate, still follows at a distance 625
with tears and pity for her as she goes.

He struggles on his given way again.
Now they have reached the borderlands of this
first region, the secluded home of those
renowned in war. Here he encounters Tydeus, 630
Parthenopaeus, famous soldier, and
the pale shade of Adrastus; here are men
mourned in the upper world, the Dardan captains
fallen in battle. And for all of these,
on seeing them in long array, he grieves: 635
for Glaucus, Medon, and Thersilochus,
the three sons of Antenor; Polyboetes,
who was a priest of Ceres; and Idaeus,
still clinging to his chariot, his weapons.
The spirits crowd Aeneas right and left, 640
and it is not enough to see him once;
they want to linger, to keep step with him,
to learn the reasons for his visit there.
But when the Grecian chieftains and the hosts

of Agamemnon see the hero and 645
his weapons glittering across the shadows,
they tremble with an overwhelming terror;
some turn their backs in flight, as when they once
sought out their ships; some raise a thin war cry;
the voice they now have mocks their straining
 throats. 650

And here Aeneas saw the son of Priam,
Deiphobus, all of his body mangled,
his face torn savagely, his face and both
his hands, his ears lopped off his ravaged temples,
his nostrils slashed by a disgraceful wound. 655
How hard it was to recognize the trembling
Shade as he tried to hide his horrid torments.
Aeneas does not wait to hear his greeting
but with familiar accents speaks to him:
"Deiphobus, great warrior, and born 660
of Teucer's brilliant blood, who made you pay
such brutal penalties? Who was allowed
to do such violence to you? For Rumor
had told me that on that last night, worn out
by your vast slaughter of the Greeks, you sank 665
upon a heap of tangled butchery.
Then I myself raised up an empty tomb
along Rhoeteum's° shore; three times I called
loudly upon your Shade. Your name and weapons
now mark the place. I could not find you, friend, 670
or bury you, before I left, within
your native land." The son of Priam answered:

"My friend, you left no thing undone; you paid
Deiphobus and his dead Shade their due.
But I was cast into these evils by 675
my own fate and the deadly treachery
of the Laconian woman; it was she
who left me these memorials. You know
and must remember all too well how we
spent that last night among deceiving pleasures. 680
For when across high Pergamus the fatal
horse leaped and, in its pregnant belly, carried
armed infantry, she mimed a choral dance
and, shrieking in a Bacchic orgy, paced
the Phrygian women; it was she herself 685
who held a giant firebrand and, from
the citadel, called in the Danaans.
I lay, sleep-heavy, worn with cares, within
our luckless bridal chamber, taken by
a sweet, deep rest much like the peace of death. 690
And meanwhile my incomparable wife
has stripped the house of every weapon, even
removing from beneath my head my trusted
sword; and she throws the doorway open, calls
her Menelaeus to my palace, hoping 695

668. Rhoeteum: Another name for Troy.

her lover surely will be grateful for
this mighty favor, and her infamy
for old misdeeds will be forgotten. Why
delay? They burst into my room. The son
of Aeolus joins them as a companion, 700
encourager of outrage. Gods, requite
the Greeks for this if with my pious lips
I ask for satisfaction. But, in turn,
come tell me what misfortunes bring you here
alive? Have you been driven here by sea 705
wanderings or by warnings of the gods?
What fate so wearies you that you would visit
these sad and sunless dwellings, restless lands?"

But as they talked together, through the sky
Aurora with her chariot of rose 710
has passed her midpoint; and they might have spent
all this allotted time with words had not
the Sibyl, his companion, warned him thus:
"The night is near, Aeneas, and we waste
our time with tears. For here the road divides 715
in two directions: on the right it runs
beneath the ramparts of great Dis,° this is
our highway to Elysium;° the wicked
are punished on the left—that path leads down
to godless Tartarus." Deiphobus: 720
"Do not be angry, mighty priestess, I
now leave to fill the count, return to darkness.
Go on, our glory, go; know better fates."
He said no more; his steps turned at these words.

Aeneas suddenly looks back; beneath 725
a rock upon his left he sees a broad
fortress encircled by a triple wall
and girdled by a rapid flood of flames
that rage: Tartarean Phlegethon whirling
resounding rocks. A giant gateway stands 730
in front, with solid adamantine pillars—
no force of man, not even heaven's sons,
enough to level these in war; a tower
of iron rises in the air; there sits
Tisiphone, who wears a bloody mantle. 735
She guards the entrance, sleepless night and day.
Both groans and savage scourgings echo there,
and then the clang of iron and dragging chains.
Aeneas stopped in terror, and the din
held him. "What kind of crimes are these? Virgin, 740
o speak! What penalties are paid here? What
loud lamentations fill the air?" The priestess
began: "Great captain of the Teucrians,
no innocent can cross these cursed thresholds;
but when the goddess Hecate made me 745
the guardian of Avernus' groves, then she

revealed the penalties the gods decreed
and guided me through all the halls of hell.
The king of these harsh realms is Rhadamanthus
the Gnosian: he hears men's crimes and then 750
chastises and compels confession for
those guilts that anyone, rejoicing, hid—
but uselessly—within the world above,
delaying his atonement till too late,
beyond the time of death. Tisiphone 755
at once is the avenger, armed with whips;
she leaps upon the guilty, lashing them;
in her left hand she grips her gruesome vipers
and calls her savage company of sisters.
And now at last the sacred doors are opened, 760
their hinges grating horribly. You see
what kind of sentry stands before the entrance,
what shape is at the threshold? Fiercer still,
the monstrous Hydra° lives inside; her fifty
black mouths are gaping. Tartarus itself 765
then plunges downward, stretching twice as far
as is the view to heaven, high Olympus.
And here the ancient family of Earth,
the sons of Titan who had been cast down
by thunderbolts, writhe in the deepest gulf. 770
Here, too, I saw the giant bodies of
the twin sons of Aloeus, those who tried
to rip high heaven with their hands, to harry
Jove from his realms above. I saw Salmoneus:
how brutal were the penalties he paid 775
for counterfeiting Jove's own fires and
the thunders of Olympus. For he drove
four horses, brandishing a torch; he rode
triumphant through the tribes of Greece and through
the city in the heart of Elis, asking 780
for his own self the honor due to gods:
a madman who would mime the tempests and
inimitable thunder with the clang
of bronze and with the tramp of horn-foot horses.
But through the thick cloud banks all-able Jove 785
let fly his shaft—it was no firebrand
or smoky glare of torches: an enormous
blast of the whirlwind drove Salmoneus headlong.
And I saw Tityos,° the foster child
of Earth, mother of all, his body stretched 790
on nine whole acres; and a crooked-beaked
huge vulture feeds upon his deathless liver
and guts that only grow the fruits of grief.
The vulture has his home deep in the breast
of Tityos, and there he tears his banquets 795
and gives no rest even to new-grown flesh.
And must I tell you of Ixion and
Pirithoüs, the Lapithae? Of those
who always stand beneath a hanging black

717. Dis: Another name for Pluto, god of the underworld.
718. Elysium: The region of the underworld in which those who
led righteous lives reside.

764. Hydra: Fifty-headed water monster of Tartarus.
789. Tityos: A giant who tried to rape Apollo's mother.

flint rock that is about to slip, to fall, 800
forever threatening? And there are those
who sit before high banquet couches, gleaming
upon supports of gold; before their eyes
a feast is spread in royal luxury,
but near at hand reclines the fiercest Fury: 805
they cannot touch the tables lest she leap
with lifted torch and thundering outcries.
And here are those who in their lives had hated
their brothers or had struck their father or
deceived a client or (the thickest swarm) 810
had brooded all alone on new-won treasure
and set no share apart for kin and friends;
those slain for their adultery; those who followed
rebellious arms or broke their pledge to masters—
imprisoned, all await their punishment. 815
And do not ask of me what penalty,
what shape or fate has overwhelmed their souls.
For some are made to roll a giant boulder,
and some are stretched along the spokes of wheels.
Sad Theseus has to sit and sit forever; 820
and miserable Phlegyas° warns them all—
his roaring voice bears witness through the darkness:
'Be warned, learn justice, do not scorn the gods!'
Here is one who sold his fatherland for gold
and set a tyrant over it; he made 825
and unmade laws for gain. This one assailed
the chamber of his daughter and compelled
forbidden mating. All dared horrid evil
and reached what they had dared. A hundred tongues,
a hundred mouths, an iron voice were not 830
enough for me to gather all the forms
of crime or tell the names of all the torments."
So did the aged priestess of Apollo
speak, and she adds, "But come now, on your way,
complete the task you chose. Let us be quick. 835
I see the walls the Cyclops° forged, the gates
with arching fronts, where we were told to place
our gifts." She has spoken. Side by side they move
along the shaded path; and hurrying
across the space between, they near the doors. 840
Aeneas gains the entrance, and he sprinkles
his body with fresh water, then he sets
the bough across the threshold facing them.

Their tasks were now completed; they had done
all that the goddess had required of them. 845
They came upon the lands of gladness, glades
of gentleness, the Groves of Blessedness—
a gracious place. The air is generous;
the plains wear dazzling light; they have their very
own sun and their own stars. Some exercise 850

their limbs along the green gymnasiums
or grapple on the golden sand, compete
in sport, and some keep time with moving feet
to dance and chant. There, too, the Thracian priest,
the long-robed Orpheus, plays, accompanying 855
with seven tones; and now his fingers strike
the strings, and now his quill of ivory.

The ancient race of Teucer, too, is here,
most handsome sons, great-hearted heroes born
in better years: Assaracus and Ilus 860
and Dardanus, who founded Pergamus.
From far Aeneas wonders at their phantom
armor and chariots; their spears are planted,
fixed in the ground; their horses graze and range
freely across the plain. The very same 865
delight that once was theirs in life—in arms
and chariots and care to pasture their
sleek steeds—has followed to this underearth.

And here to right and left he can see others:
some feasting on the lawns; and some chanting 870
glad choral paeans in a fragrant laurel
grove. Starting here, Eridanus in flood
flows through a forest to the world above.
Here was the company of those who suffered
wounds, fighting for their homeland; and of those 875
who, while they lived their lives, served as pure
 priests:
and then the pious poets, those whose songs
were worthy of Apollo; those who had
made life more civilized with newfound arts;
and those whose merits won the memory 880
of men: all these were crowned with snow-white
 garlands.
And as they streamed around her there, the Sibyl
addressed them, and Musaeus° before all—
he stood, his shoulders towering above
a thronging crowd whose eyes looked up to him: 885
"O happy souls and you the best of poets,
tell us what land, what place it is that holds
Anchises. It is for his sake we have come
across the mighty streams of Erebus."
The hero answered briefly: "None of us 890
has one fixed home: we live in shady groves
and settle on soft riverbanks and meadows
where fresh streams flow. But if the will within
your heart is bent on this, then climb the hill
and I shall show to you an easy path." 895
He spoke, and led the way, and from the ridge
he pointed out bright fields. Then they descend.

But in the deep of a green valley, father
Anchises, lost in thought, was studying

821. Phlegyas: Ruler of the Lapithae (a people from Thessaly) who
was punished in Tartarus for having set fire to Apollo's temple at
Delphi. The others mentioned all attempted some crime against the
gods. 836. Cyclops: The one-eyed giants in the *Odyssey*.

883. Musaeus: Disciple of Orpheus, poet of Thrace.

the souls of all his sons to come—though now 900
imprisoned, destined for the upper light.
And as it happened, he was telling over
the multitude of all his dear descendants,
his heroes' fates and fortunes, works and ways.
And when he saw Aeneas cross the meadow, 905
he stretched out both hands eagerly, the tears
ran down his cheeks, these words fell from his lips:

"And have you come at last, and has the pious
love that your father waited for defeated
the difficulty of the journey? Son, 910
can I look at your face, hear and return
familiar accents? So indeed I thought,
imagining this time to come, counting
the moments, and my longing did not cheat me.
What lands and what wide waters have you
 journeyed 915
to make this meeting possible? My son,
what dangers battered you? I feared the kingdom
of Libya might do so much harm to you."

Then he: "My father, it was your sad image,
so often come, that urged me to these thresholds. 920
My ships are moored on the Tyrrhenian.
O father, let me hold your right hand fast,
do not withdraw from my embrace." His face
was wet with weeping as he spoke. Three times
he tried to throw his arms around Anchises' 925
neck; and three times the Shade escaped from that
vain clasp—like light winds, or most like swift
 dreams.

Meanwhile, Aeneas in a secret valley
can see a sheltered grove and sounding forests
and thickets and the stream of Lethe° flowing 930
past tranquil dwellings. Countless tribes and peoples
were hovering there: as in the meadows, when
the summer is serene, the bees will settle
upon the many-colored flowers and crowd
the dazzling lilies—all the plain is murmuring. 935
The sudden sight has startled him. Aeneas,
not knowing, asks for reasons, wondering
about the rivers flowing in the distance,
the heroes swarming toward the riverbanks.
Anchises answers him: "These are the spirits 940
to whom fate owes a second body, and
they drink the waters of the river Lethe,
the care-less drafts of long forgetfulness.
How much, indeed, I longed to tell you of them,
to show them to you face to face, to number 945
all of my seed and race, that you rejoice
the more with me at finding Italy."

930. Lethe: The river of forgetfulness in the underworld.

"But, Father, can it be that any souls
would ever leave their dwelling here to go
beneath the sky of earth, and once again 950
take on their sluggish bodies? Are they madmen?
Why this wild longing for the light of earth?"
"Son, you will have the answer; I shall not
keep you in doubt," Anchises starts and then
reveals to him each single thing in order. 955

"First, know, a soul within sustains the heaven
and earth, the plains of water, and the gleaming
globe of the moon, the Titan sun, the stars;
and mind, that pours through every member, mingles
with that great body. Born of these: the race 960
of men and cattle, flying things, and all
the monsters that the sea has bred beneath
its glassy surface. Fiery energy
is in these seeds, their source is heavenly;
but they are dulled by harmful bodies, blunted 965
by their own earthly limbs, their mortal members.
Because of these, they fear and long, and sorrow
and joy, they do not see the light of heaven;
they are dungeoned in their darkness and blind prison.
And when the final day of life deserts them, 970
then, even then, not every ill, not all
the plagues of body quit them utterly;
and this must be, for taints so long congealed
cling fast and deep in extraordinary
ways. Therefore they are schooled by punishment 975
and pay with torments for their old misdeeds:
some there are purified by air, suspended
and stretched before the empty winds; for some
the stain of guilt is washed away beneath
a mighty whirlpool or consumed by fire. 980
First each of us must suffer his own Shade;
then we are sent through wide Elysium—
a few of us will gain the Fields of Gladness—
until the finished cycle of the ages,
with lapse of days, annuls the ancient stain 985
and leaves the power of ether pure in us,
the fire of spirit simple and unsoiled.
But all the rest, when they have passed time's circle
for a millennium, are summoned by
the god to Lethe in a great assembly 990
that, free of memory, they may return
beneath the curve of the upper world, that they
may once again begin to wish for bodies."

Anchises ended, drew the Sibyl and
his son into the crowd, the murmuring throng, 995
then gained a vantage from which he could scan
all of the long array that moved toward them,
to learn their faces as they came along:

"Listen to me: my tongue will now reveal
the fame that is to come from Dardan sons 1000
and what Italian children wait for you—

bright souls that are about to take your name;
in them I shall unfold your fates. The youth
you see there, leaning on his headless spear,
by lot is nearest to the light; and he 1005
will be the first to reach the upper air
and mingle with Italian blood; an Alban,
his name is Silvius, your last-born son.
For late in your old age Lavinia,
your wife, will bear him for you in the forest; 1010
and he will be a king and father kings;
through him our race will rule in Alba Longa.°
Next Procas stands, pride of the Trojan race;
then Capys, Numitor,° and he who will
restore your name as Silvius Aeneas, 1015
remarkable for piety and arms
if he can ever gain his Alban kingdom.
What young men you see here, what powers they
display, and how they bear the civic oak
that shades their brows! For you they will
 construct 1020
Nomentum, Gabii, Fidena's city,
and with the ramparts of Collatia,
Pometia and Castrum Inui,
and Bola, Cora, they will crown the hills.
These will be names that now are nameless
 lands.° 1025

"More: Romulus,° a son of Mars. He will
join Numitor, his grandfather, on earth
when Ilia, his mother, gives him birth
out of the bloodline of Assaracus.°
You see the double plumes upon his crest: 1030
his parent Mars already marks him out
with his own emblem for the upper world.
My son, it is beneath his auspices
that famous Rome will make her boundaries
as broad as earth itself, will make her spirit 1035
the equal of Olympus, and enclose
her seven hills within a single wall,
rejoicing in her race of men: just as
the Berecynthian mother,° tower-crowned,
when, through the Phrygian cities, she rides on 1040
her chariot, glad her sons are gods, embraces
a hundred sons of sons, and every one
a heaven-dweller with his home on high.

"Now turn your two eyes here, to look upon
your Romans, your own people. Here is Caesar 1045
and all the line of Iülus that will come
beneath the mighty curve of heaven. This,
this is the man you heard so often promised—

Augustus Caesar, son of a god, who will
renew a golden age in Latium, 1050
in fields where Saturn once was king, and stretch
his rule beyond the Garamantes° and
the Indians—a land beyond the paths
of year and sun, beyond the constellations,
where on his shoulders heaven-holding Atlas 1055
revolves the axis set with blazing stars.
And even now, at his approach, the kingdom
of Caspia and land of Lake Maeotis
shudder before the oracles of gods;
the seven mouths of Nile, in terror, tremble. 1060
For even Hercules himself had never
crossed so much of the earth, not even when
he shot the brazen-footed stag and brought
peace to the groves of Erymanthus° and
made Lerna's monster quake before his arrows; 1065
nor he who guides his chariot with reins
of vine leaves, victor Bacchus, as he drives
his tigers down from Nysa's° steepest summits.
And do we, then, still hesitate to extend
our force in acts of courage? Can it be 1070
that fear forbids our settling in Ausonia?

"But who is he who stands apart, one crowned
with olive boughs and bearing offerings?
I recognize his hair and his white beard:
when called from humble Cures, a poor land, 1075
to mighty rulership, he will become
first king of Rome to found the city's laws.
And after Numa: Tullus, who will shatter
his country's idleness and wake to arms
the indolent and ranks unused to triumph. 1080
Beside him is the ever-boastful Ancus,
one even now too glad when people hail him.
And would you see the Tarquin kings?° And, too,
the haughty spirit of avenging Brutus,
the fasces° he regained? He will be first 1085
to win the power of a consul, to use
the cruel axes; though a father, for
the sake of splendid freedom he will yet
condemn his very sons who stirred new wars.
Unhappy man! However later ages 1090
may tell his acts, his love of country will
prevail, as will his passion for renown.

"Then see, far off, the Decii and Drusi;
Torquatus° of the ruthless ax; Camillus°

1012. Alba Longa: Mother city of Rome. 1014. Procas, Capys,
and Numitor are kings of Alba Longa. 1025. The aforemen-
tioned are names of Italian cities. 1026. Romulus: Legendary
founder of Rome. 1029. Assaracus: Anchises' grandfather.
1039. The Berecynthian mother: Cybele, the mother-goddess.

1052. Garamantes: A people in Africa. 1064. Erymanthus:
Mountain range in Arcadia where Hercules killed a legendary wild
boar. 1068. Nysa: Mountain in India said to be the birthplace
of Bacchus. 1083. Anchises lists the earliest kings of Rome.
1085. Fasces: Bundle of rods with ax used as Roman symbol of
authority (root of the word *fascism*). 1094. Decii, Drusi, and
Torquatus are heroic consuls. 1094. Camillus: Conqueror of
the Gauls.

as he brings back the standards. But those spirits 1095
you see there—gleaming in their equal armor
and now, while night restrains them, still at peace—
if they but reach the light of life, how great
a war they will incite against each other,
what armies and what slaughter! There is
 Caesar, 1100
descending from the summits of the Alps,
the fortress of Monoecus, and Pompey,
his son-in-law, arrayed against him with
the legions of the East. My sons, do not
let such great wars be native to your minds, 1105
or turn your force against your homeland's vitals:
and Caesar, be the first to show forbearance;
may you, who come from heaven's seed, born of
my blood, cast down the weapon from your hand!

"And there is Mummius, who—famous for 1110
his slaying of Achaeans, conqueror
of Corinth—will yet drive his chariot
triumphantly to the high Capitol.
There stands Aemilius Paulus, the destroyer
of Agamemnon's own Mycenae and 1115
of Argos and the sons of Aeacus,
the seed of powerful-in-arms Achilles:
he will yet avenge the Trojan elders and
Minerva's outraged altars. Who could leave
to silence you, great Cato,° or you, Cossus?° 1120
Who can ignore the Gracchi or the Scipios,°
twin thunderbolts of war, the lash of Libya;
Fabricius, so strong and with so little;
or you, Serranus, as you sow your furrow?
And Fabii, where does your prodding lead me— 1125
now weary—with your many deeds and numbers!
You are that Maximus, the only man
who, by delaying, gave us back our fortunes.
For other peoples will, I do not doubt,
still cast their bronze to breathe with softer
 features, 1130
or draw out of the marble living lines,
plead causes better, trace the ways of heaven
with wands and tell the rising constellations;
but yours will be the rulership of nations,
remember, Roman, these will be your arts: 1135
to teach the ways of peace to those you conquer,
to spare defeated peoples, tame the proud."

So, while Aeneas and the Sibyl marveled,
father Anchises spoke to them, then added:
"And see Marcellus° there, as he advances 1140
in glory, with his splendid spoils, a victor

who towers over all! A horseman, he
will set the house of Rome in order when
it is confounded by great mutiny;
he will lay low the Carthaginians 1145
and rebel Gaul; then for a third time father
Quirinus° will receive his captured arms."

At this, Aeneas had to speak; he saw
beside that Shade another—one still young,
of handsome form and gleaming arms, and yet 1150
his face had no gladness, his eyes looked down:
"Who, Father, moves beside this man? A son
or one of the great race of his sons' sons?
For how his comrades clamor as they crowd!
What presence—his! And yet, around his head 1155
black night is hovering with its sad shade!"

With rising tears Anchises answered him:
"My son, do not search out the giant sorrow
your people are to know. The Fates will only
show him to earth; but they will not allow 1160
a longer stay for him. The line of Rome,
o High Ones, would have seemed too powerful
for you, if his gifts, too, had been its own.
What cries of mourning will the Field of Mars
send out across that overwhelming city, 1165
what funerals, o Tiber, will you see
when you glide past the new-made tomb! No youth
born of the seed of Ilium will so
excite his Latin ancestors to hope;
the land of Romulus will never boast 1170
with so much pride of any of its sons.
I weep for righteousness, for ancient trust,
for his unconquerable hand: no one
could hope to war with him and go untouched,
whether he faced the enemy on foot 1175
or dug his foaming horse's flank with spurs.
O boy whom we lament, if only you
could break the bonds of fate and be Marcellus.°
With full hands, give me lilies; let me scatter
these purple flowers, with these gifts, at least, 1180
be generous to my descendant's spirit,
complete this service, although it be useless."

And so they wander over all that region,
across the wide and misted plains, surveying
everything. And when father Anchises 1185
has shown his son each scene and fired his soul
with love of coming glory, then he tells
Aeneas of the wars he must still wage,
of the Laurentians,° of Latinus'° city,
and how he is to flee or face each trial. 1190

1120. Cato: Famous Roman statesman. 1120. Cossus: Roman general. 1121. Gracchi and Scipios are families of Roman statesmen and generals. 1140. Marcellus: Roman consul who killed the king of the Gauls in battle.

1147. Quirinus: The deified Romulus as god of war. 1178. Marcellus: Nephew of Augustus who died young. 1189. Laurentians: From Laurentum, a city near Rome. 1189. Latinus: King of Latium and father of Aeneas' wife-to-be, Lavinia.

There are two gates of Sleep: the one is said
to be of horn, through it an easy exit
is given to true Shades; the other is made
of polished ivory, perfect, glittering,
but through that way the Spirits send false
 dreams 1195
into the world above. And here Anchises,
when he is done with words, accompanies
the Sibyl and his son together; and
he sends them through the gate of ivory.
Aeneas hurries to his ships, rejoins 1200
his comrades, then he coasts along the shore
straight to Caieta's° harbor. From the prow
the anchor is cast. The sterns stand on the beach.

..

COMMENTS AND QUESTIONS

1. For what reason does Aeneas want to visit the un-
 derworld? Compare his quest to those of Gilgamesh
 and Odysseus.
2. What is the significance of the golden bough?
3. Note that the categories of shades are much more
 developed here than they are in either the *Epic of
 Gilgamesh* or the *Odyssey*. Does there seem to be a
 system or a plan at work here? Can you describe it?
4. What seems to be the relationship between crime
 and punishment here? (We will return to this ques-
 tion, with far more complexity, in our study of
 Dante.)
5. What vision of Rome does Anchises wish to impress
 on Aeneas? What is, according to him, the particular
 genius of the Roman people?

..

HORACE

..

My Slave Is Free to Speak Up for Himself

Translation by Smith Palmer Bowie

The scene of the following satire is the Roman holi-
day at the end of December, the *Saturnalia,* which
was characterized by a general freedom from work,
normal duties, and normal social restraints. Slaves,
during the Saturnalia, were supposed to be treated
with great indulgence. Horace uses this setting to
treat a theme prevalent in Stoicism: the true nature
of freedom. Is the man of material wealth, appar-
ently free, but enslaved to his greed and his passions,
any freer than a slave? For the Stoics, only the
philosopher, or the man whose mind was unencum-

bered by material wants, was truly free. A slave, in
this sense, could be freer than his master. The Stoics
were particularly fond of such paradoxes or appar-
ent contradictions. As the slave lectures the master
on freedom, the philosophical paradox becomes
good material for satire. Here, the object of the
satire is the writer himself. During the course of the
satire, Horace's portrayal of himself changes from
that of a liberal to that of a tyrant. Like everyone
else, he finds that the blows of satire, especially
when they contain truth, can be wounding.

DAVUS I've been listening for quite some time now,
 wanting to have
 A word with you. Being a slave, though, I haven't
 the nerve.
HORACE That you, Davus?
DAVUS Yes, it's Davus, slave as I am.
 Loyal to my man, a pretty good fellow: *pretty* good,
 I say. I don't want you thinking I'm too good to live.
HORACE Well, come on, then. Make use of the
 freedom traditionally yours
 At the December holiday season. Speak up, sound off!
DAVUS Some people *like* misbehaving: they're
 persistent and consistent.
 But the majority waver, trying at times to be good,
 At other times yielding to evil. The notorious Priscus
 Used to wear three rings at a time, and then again,
 none.
 He lived unevenly, changing his robes every hour.
 He issued forth from a mansion, only to dive
 Into the sort of low joint your better-class freedman
 Wouldn't want to be caught dead in. A libertine at
 Rome,
 At Athens a sage, he was born, and he lived, out of
 season.
 When Volanerius, the playboy, was racked by the gout
 In the joints of his peccant fingers (so richly deserved),
 He hired a man, by the day, to pick up the dice
 For him and put them in the box. By being consistent
 In his gambling vice, he lived a happier life
 Than the chap who tightens the reins and then lets
 them flap.
HORACE Will it take you all day to get to the bottom
 of this junk,
 You skunk?
DAVUS But I'm saying, *you're* at the bottom.
HORACE How so, you stinker?
DAVUS You praise the good old days, ancient fortunes,
 and manners,
 And yet, if some god were all for taking you back,
 You'd hang back, either because you don't really think
 That what you are praising to the skies is all that
 superior
 Or because you defend what is right with weak
 defenses
 And, vainly wanting to pull your foot from the mud,

..

Stick in it all the same. At Rome, you yearn
For the country, but, once in the sticks, you praise to
 high heaven
The far-off city, you nitwit. If it happens that no one
Asks you to dinner, you eulogize your comfortable
 meal
Of vegetables, acting as if you'd only go out
If you were dragged out in chains. You hug yourself,
Saying how glad you are not to be forced to go out
On a spree. But Maecenas *suggests*, at the very last
 minute,
That you be his guest: "Bring some oil for my lamp,
 somebody!
Get a move on! Is everyone deaf around here?" In a
 dither
And a lather, you charge out. Meanwhile, your
 scrounging guests,
Mulvius & Co., make their departure from your
 place
With a few descriptive remarks that won't bear
 repeating—
For example, Mulvius admits, "Of course, I'm fickle,
Led around by my stomach, and prone to follow my
 nose
To the source of a juicy aroma, weak-minded, lazy,
And, you may want to add, a gluttonous souse.
But you, every bit as bad and perhaps a bit worse,
Have the gall to wade into me, as if you were better,
And cloak your infamy in euphemism?"
 What if you're found out
To be a bigger fool than me, the hundred-dollar slave?
Stop trying to browbeat me! Hold back your hand,
And your temper, while I tell you what Crispinus'
 porter
Taught me.
 Another man's wife makes you her slave.
A loose woman makes Davus hers. Of us two sinners,
Who deserves the cross more? When my passionate
 nature
Drives me straight into her arms, she's lovely by
 lamplight,
Beautifully bare, all mine to plunge into at will,
Or, turning about, she mounts and drives me to death.
And after it's over, she sends me away neither
 shamefaced
Nor worried that someone richer or better to look at
Will water the very same plant. But when you go out
 for it,
You really come in for it, don't you? Turning your-
 self into
The same dirty Dama you pretend to be when you
 take off
Your equestrian ring and your Roman robes, and
 change
Your respectable self, hiding your perfumed head
Under your cape?
 Scared to death, you're let in the house,

And your fear takes turns with your hope in rattling
 your bones.
What's the difference between being carted off to be
 scourged
And slain, in the toils of the law (as a gladiator is),
And being locked up in a miserable trunk, where the
 maid,
Well aware of her mistress' misconduct, has stored
 you away,
With your knees scrunched up against your head?
 Hasn't the husband
Full power over them both, and even more over the
 seducer?
For the wife hasn't changed her attire or her location,
And is not the uppermost sinner. You walk open-eyed
Right under the fork, handing over to a furious master
Your money, your life, your person, your good
 reputation.
Let's assume that you got away: you learned your
 lesson,
I trust, and will be afraid from now on, and be
 careful?
Oh, no! You start planning how to get in trouble
 again,
To perish again, enslave yourself over and over.
But what wild beast is so dumb as to come back again
To the chains he has once broken loose from?
 "But I'm no adulterer,"
You say. And I'm not a thief when I wisely pass up
Your good silver plate. But our wandering nature
 will leap
When the reins are removed, when the danger is
 taken away.
Are you my master, you, slave to so many
Other people, so powerful a host of other things,
 whom no
Manumission could ever set free from craven anxiety,
Though the ritual were conducted again and again?
 And besides,
Here's something to think about: whether a slave
 who's the slave
Of a slave is a plain fellow slave or a "subslave," as
 you masters
Call him, what am I your?[1] You, who command me,
Cravenly serve someone else and are led here and there
Like a puppet, the strings held by others.
 Who, then, is free?
The wise man alone, who has full command of
 himself,
Whom poverty, death, or chains cannot terrify,
Who is strong enough to defy his passions and scorn
Prestige, who is wholly contained in himself, well
 rounded,

[1] If Horace is himself a slave, Davus wonders what status he, as a slave of a slave, has. [Trans.]

Smooth as a sphere on which nothing external can
 fasten,
On which fortune can do no harm except to herself.
Now which of those traits can you recognize as one
 of yours?
Your woman asks you for five thousand dollars,
 needles you,
Shuts the door in your face and pours out cold water,
Then calls you back. Pull your neck from that yoke!
Say, "I'm free, I'm free!" Come on, say it. You can't!
 A master
Dominates your mind, and it's no mild master who
 lashes
You on in spite of yourself, who goads you and
 guides you.
Or when you stand popeyed in front of a painting by
 Pausias,
You madman, are you less at fault than I am who
 marvel
At the posters of athletes straining their muscles in
 combat,
Striking out, thrusting, and parrying, in red chalk
 and charcoal,
As if they were really alive and handling these
 weapons?
But Davus is a no-good, a dawdler, and you? Oh,
 MONSIEUR
Is an EXPERT, a fine CONNOISSEUR of antiques, I
 ASSURE you.
I'm just a fool to be tempted by piping-hot pancakes.
Does your strength of character and mind make
 much resistance
To sumptuous meals? Why is it worse for me
To supply the demands of my stomach? My back
 will pay for it,
To be sure. But do you get off any lighter, hankering
After delicate, costly food? Your endless indulgence
Turns sour in your stomach, your baffled feet won't
 support
Your pampered body. Is the slave at fault, who
 exchanges
A stolen scraper for a bunch of grapes, in the dark?
Is there nothing slavish in a man who sells his estate
To satisfy his need for rich food?
 Now, add on these items:
(1) You can't stand your own company as long as
 an hour;
(2) You can't dispose of your leisure in a decent
 fashion;
(3) You're a fugitive from your own ego, a vagabond
 soul,
Trying to outflank your cares by attacking the bottle
Or making sorties into sleep. And none of it works:
The Dark Companion rides close along by your side,
Keeps up with and keeps on pursuing the runaway
 slave.

HORACE Where's a stone?

DAVUS What use do you have for it?
HORACE Hand me my arrows!
DAVUS The man is either raving or satisfying his
 craving
For creative writing.
HORACE If you don't clear out, instanter,
 I'll pack you off to the farm to be my ninth planter.

..

COMMENTS AND QUESTIONS

1. What proofs does Davus use to show that Horace is
 more enslaved than he?
2. How is the nature of "true freedom" defined, and in
 what context? Relate this to what you know of
 Stoicism.
3. What aspects of Horace's self-satire do you find
 particularly comic? Why?
4. What are the difficulties involved in writing a self-
 satire? The best way to appreciate these would be to
 try your hand at it.
5. Collect examples of satire from the media as well as
 from modern literature, and compare the techniques
 used with those of Horace.

..

JUVENAL
..

The Roman Matron
Translation by Peter Green

This selection on the life of a rich Roman matron
typifies Juvenal's ruthless social criticism, which
aims at teaching by example.

Worse still is the well-read menace, who's hardly
 settled for dinner 1
Before she starts praising Virgil, making a moral case
For Dido (death justifies all), comparing, evaluating
Rival poets, Virgil and Homer suspended
In opposite scales, weighed up one against the other. 5
Critics surrender, academics are routed, all
Fall silent, not a word from lawyer or auctioneer—
Or even another woman. Such a rattle of talk,
You'd think all the pots and bells were being clashed
 together
When the moon's in eclipse. No need now for trumpets
 or brass: 10
One woman can act, single-handed, as lunar midwife.°

11. Eclipses were supposedly caused by witchcraft. By spells the witch
would torture and reduce the moon. If enough noise was made, how-
ever, the spells could not be heard. The waxing of the moon was asso-
ciated with pregnancy. This woman is so noisy that in time of eclipse
no other noise is needed to bring the moon back to its full size.

But wisdom imposes limits, even on virtue, and if
She's so determined to prove herself eloquent, learned,
She should hoist up her skirts and gird them above the
knee,
Offer a pig to Silvanus (female worshippers banned)
and 15
Scrub off in the penny baths.° So avoid a dinner-
partner
With an argumentative style, who hurls well-rounded
Syllogisms like slingshots, who has all history pat:
Choose someone rather who doesn't understand *all* she
reads.
I hate these authority-citers, the sort who are always
thumbing 20
Some standard grammatical treatise, whose every
utterance
Observes all the laws of syntax, who with antiquarian
zeal
Quote poets I've ever heard of. Such matters are men's
concern.
If she wants to correct someone's language, she can
always
Start with her unlettered girl-friends. A husband should
be allowed 25
His solecisms in peace.
 There's nothing a woman
Baulks at, no action that gives her a twinge of
conscience
Once she's put on her emerald choker, weighted down
her ear-lobes
With vast pearl pendants. What's more insufferable
Than your well-heeled female? But earlier in the
process 30
She presents a sight as funny as it's appalling,
Her features lost under a damp bread face-pack,
Or greasy with vanishing-cream that clings to her
husband's
Lips when the poor man kisses her—though it's all
Wiped off for her lover. She takes no trouble
about 35
The way she looks at home: those imported Indian
Scents and lotions she buys with a lover in mind.
First one layer, then the next: at last the contours
emerge
Till she's almost recognizable. Now she freshens
Her complexion with asses' milk. (If her husband's
posted 40
To the godforsaken North, a herd of she-asses
Will travel with them.) But all these medicaments
And various treatments—not least the damp bread-
poultice—
Make you wonder what's underneath, a face or a boil.

It's revealing to study the details of such a
woman's 45
Daily routine, to see how she occupies her time.
If her husband, the night before, has slept with his back
to her, then
The wool-maid's had it, the dressers are stripped and
flogged,
The litter-bearer's accused of coming late. One victim
His rods broken over his back, another bears
bloody stripes 50
From the whip, a third is lashed with a cat-o'-
nine-tails:
Some women pay their floggers an annual salary.
While the punishment's carried out she'll be fixing her
face,
Gossiping with her friends, giving expert consideration
To the width of the hem on some gold-
embroidered robe— 55
Crack! Crack!—or skimming through the daily gazette;
Till at last, when the flogger's exhausted, she snaps
'Get out!'
And for one day at least the judicial hearing is over.
Her household's governed with all the savagery
Of a Sicilian court.° If she's made some assignation 60
That she wants to look her best for, and is in a
tearing hurry
Because she's late, and her lover's waiting for her
In the public gardens, or by the shrine (bordello
Might be a more accurate term) of Isis°—why then, the
slave girl
Arranging her coiffure will have her own hair torn
out, 65
Poor creature, and the tunic ripped from her shoulders
and breasts.
'Why isn't this curl in place?' the lady screams, and her
rawhide
Lash inflicts chastisement for the offending ringlet.
But what was poor Psecas's° crime? How could you
blame an attendant
For the shape of your own nose? Another maid 70
Combs out the hair on her left side, twists it round the
curlers;
The consultative committee is reinforced by
An elderly lady's-maid inherited from Mama,
And now promoted from hairpins to the wool
department. She
Takes the floor first, to be followed by her
inferiors 75
In age and skill, as though some issue of reputation
Or life itself were at stake, so obsessionally they strive
In beauty's service. See the tall edifice

16. Wearing skirts above the knees, worshiping Silvanus, and going
to the public baths were attributes of males.

60. The ancient tyrants of Sicilian city-states were notorious for their
cruelty. 64. One aspect of the worship of the Eastern goddess
Isis was ritualistic prostitution connected with a fertility cult.
69. Psecas: A slave girl's name.

Rise up on her head in serried tiers and storeys!
See her heroic stature—at least, that is, from in
 front: 80
Her back view's less impressive, you'd think it belonged
To a different person. The effect is ultra-absurd
If she's lacking in inches, the sort who without stilettos
Resembles some sawn-off pygmy, who's forced to stand
On tiptoe for a kiss. 85
 Meantime she completely
Ignores her husband, gives not a moment's thought
To all she costs him. She's less a wife than a neighbor—
Except when it comes to loathing his friends and
 slaves,
Or running up bills. . . .

QUESTIONS

1. What is Juvenal's position on female learning?
2. What suggests that the poet might have personal motives for his criticism?
3. Why does the lady's dressing-up affect her conscience?
4. How does the lady conduct herself differently with husband and lover?
5. Juvenal's satires generally reveal the arbitrary cruelty of Rome's slave economy. What motivates the lady's cruelty here?

LUCRETIUS

from the *Triumph Song of Death*

Translation by W. H. D. Rouse

The two final texts represent Epicurean and Stoic philosophy respectively. In his long Latin poem *On the Nature of Things,* Titus Lucretius Carus (c. 99–55 B.C.) gives a systematic presentation of Epicurean philosophy for the Roman reading public. Having argued that everything in the universe, including the human being, is composed of atoms, which will eventually come apart to form new combinations and therefore new objects, Lucretius in this part of the poem contends that death is not to be feared.

. . . Therefore death is nothing to us, it matters not one jot, since the nature of the mind is understood to be mortal: and as in time past we felt no distress, while from all quarters the Carthaginians were coming to the conflict, when the whole world shaken by the terrifying tumult of war shivered and quaked under the high heaven, and men were in doubt under which domination all men were destined to fall by land and sea;[1] so when we shall no longer be, when the parting shall have come about between body and spirit from which we are compacted into one whole, then sure enough nothing at all will be able to happen to us who will then no longer be, or to make us feel, not if earth be commingled with sea and sea with sky.[2] And grant for the moment that the nature of mind and power of spirit does feel after it has been torn away from our body, yet that is nothing to us, who by the welding and wedding together of body and spirit exist compacted into one whole. Even if time shall gather together our matter after death and bring it back again as it is now placed, and if once more the light of life shall be given to us, yet it would not matter one bit to us that even this had been done, when the recollection of ourselves has once been broken asunder; and now to us from the we who were before there appertains nothing, nor from those does any anguish now touch us. For when you look back upon all the past expanse of measureless time, and think how various are the motions of matter, you may easily come to believe that these same seeds of which now we consist have been often before placed in the same arrangement they now are in. And yet we cannot call that back by memory: for in between has been cast a stoppage of life, and all the motions have wandered and scattered afar from those sensations. For if by chance anyone is to have misery and pain in the future, he must needs himself also exist then in that time to be miserable. Since death takes away this possibility, and forbids him to exist for whom these inconveniences may be gathered together, we may be sure that there is nothing to be feared after death, that he who is not cannot be miserable, that it makes not one jot of difference whether he has ever been born at any time before, when death the immortal has taken away his mortal life. . . .

This also is the way among men, when they have laid themselves down at table and hold goblets in their hands and shade their brows with garlands, that they often say from their hearts "Short enjoyment is given to poor mankind; soon it will be gone, and none will ever be able to recall it." As if after death their chief trouble will be to be miserably parched with thirst and burning drought, or a craving possess them for some other thing! "No longer now will your happy home give you welcome, no longer will your best of wives and sweet children race to win the first kisses, and thrill your heart to its depths with sweetness. You will no longer be able

[1] Although people at the time of the Carthaginian wars were deeply affected by uncertainty as to who would be the victor, the wars have no emotional effect on us because they were long ago.

[2] Even if the universe will one day be in chaos, we the dead will feel nothing.

to live in prosperity, and to protect your own. Poor man, poor man!" they say, "one fatal day has robbed you of all these prizes of life." But they do not go on to add "No longer withal does any craving possess you for these things." If they could see this clearly in mind and so conform their speech, they would free themselves from great fear and anguish of mind. "Yes, as you now lie in death's quiet sleep, so you will be for all time that is to come removed from all distressing pains; but we beside you, as you lay burnt to ashes on the horrible pyre, have bewailed you inconsolably, and that everlasting grief no time shall take from our hearts." Of such an one then we may well ask, if all ends in sleep and quiet rest, what bitterness there is in it, so great that one could pine with everlasting sorrow. Why, no one feels the want of himself and his life when both mind and body alike are quiet in sleep; for all we care that sleep might be everlasting, and no craving for ourselves touches us at all; and yet those first-beginnings dispersed through the body are not straying far from sense-giving motions at the time when a man startled from sleep gathers himself together. Death therefore must be thought of much less moment to us, if there can be anything less than what we see to be nothing: for a greater dispersion of the disturbed matter takes place at death, and no one awakens and rises whom the cold stoppage of life has once overtaken.

Besides, if nature should suddenly utter a voice, and thus take her turn to upbraid one of us: "What ails you so, O mortal, to indulge overmuch in sickly lamentations? Why do you groan aloud and weep at death? For if your former life now past has been to your liking, if it is not true that all your blessings have been gathered as it were into a riddled jar, and have run through and been lost without gratification: why not like a banqueter fed full of life, withdraw with contentment and rest in peace, you fool? But if all that you have enjoyed has been spilt out and lost, and if you have a grudge at life, why seek to add more, only to be miserably lost again and to perish wholly without gratification? Why not rather make an end of life and trouble? For there is nothing else I can devise and invent to please you; everything is always the same. If your body is not already withering with years and your limbs worn out and languid, yet everything remains the same, if you should go on to outlive all generations, and even more if you should be destined never to die": what have we to answer, but that nature urges against us a just charge and in her plea sets forth a true case? But if in this regard some older man well stricken in years should make complaint, wretchedly bewailing his death more than he ought, would she not have reason to cry more loudly still and to upbraid in bitter words? "Away, away with your tears, ruffian, check your lamentations. All life's prizes you have enjoyed and now you wither. But because you always crave what you have not, and con-

demn what you have, life has slipped by for you incomplete and ungratifying, and death stands by your head unexpected, before you can retire glutted and full of the feast. But now in any case dismiss all that befits not your years, and be content; come, depart with dignity: thus it needs must be." She would be right, I think, to do so, right to upbraid and reproach. For the old order always passes thrust out by the new, and one thing has to be made afresh from others; but no one is delivered into the pit or black Tartarus:[3] matter is wanted, that coming generations may grow; and yet they all when their life is done will follow you, and before you, no less than you, these generations have fallen and shall fall. So one thing will never cease to arise from another, and no man possesses life in freehold—all as tenants.[4] Look back also and see how the ages of everlasting time past before we were born have been to us nothing. This therefore is a mirror which nature holds up to us, showing the time to come after we at length shall die. Is there anything horrible in that? Is there anything gloomy? Is it not more peaceful than any sleep?

QUESTIONS

1. Even if some feeling remains in the mind and/or the body after death, why should this bother us?
2. If, as Lucretius believes, in the course of the ages the same combination of atoms of which we are composed has recurred many times and will recur again, should this concern us?
3. How does nature console the dying man whose life has been happy? The man whose life has been a failure?
4. What conclusions does Lucretius draw from his denial of life after death about the way we ought to lead our lives?

MARCUS AURELIUS

from the *Meditations*
Translation by George Long

Marcus Aurelius (A.D. 121–180) was Plato's realization of the philosopher-king. He would have preferred a scholar's life, but when he was chosen emperor to succeed his father in 161, Marcus Aurelius, as a good Stoic, loyally served the Empire until his death. As he was engaged almost constantly in warfare on the frontiers during his two decades of rule, it was mostly during these military campaigns that the

[3] Tartarus: Hades.

[4] We do not own life as a possession; we hold it only for a time.

emperor composed, in Greek, his *Meditations*: a collection of his thoughts on the best way to live. In this particular selection from Book II, he urges himself to follow the "third part" of him—that is, reason. To do so is to see that all that happens, whether by fortune, nature, or Providence, is for the best because all three are manifestations of God or Divine Reason. Following reason will enable him to "live a life which flows in quiet, and is like the existence of the gods."

. . . Begin the morning by saying to thyself, I shall meet with the busybody, the ungrateful, arrogant, deceitful, envious, unsocial. All these things happen to them by reason of their ignorance of what is good and evil. But I who have seen the nature of the good that it is beautiful, and of the bad that it is ugly, and the nature of him who does wrong, that it is akin to me, not [only] of the same blood or seed, but that it participates in [the same] intelligence and [the same] portion of the divinity, I can neither be injured by any of them, for no one can fix on me what is ugly, nor can I be angry with my kinsman, nor hate him. For we are made for co-operation, like feet, like hands, like eyelids, like the rows of the upper and lower teeth. To act against one another then is contrary to nature; and it is acting against one another to be vexed and to turn away.

2.　Whatever this is that I am, it is a little flesh and breath, and the ruling part. Throw away thy books; no longer distract thyself: it is not allowed; but as if thou wast now dying, despise the flesh; it is blood and bones and a network, a contexture of nerves, veins and arteries. See the breath also, what kind of a thing it is; air, and not always the same, but every moment sent out and again sucked in. The third then is the ruling part: consider thus: Thou art an old man; no longer let this be a slave, no longer be pulled by the strings like a puppet to unsocial movements, no longer be either dissatisfied with thy present lot, or shrink from the future.

3.　All that is from the gods is full of providence. That which is from fortune is not separated from nature or without an interweaving and involution with the things which are ordered by Providence. From thence all things flow; and there is besides necessity, and that which is for the advantage of the whole universe, of which thou art a part. But that is good for every part of nature which the nature of the whole brings, and what serves to maintain this nature. Now the universe is preserved, as by the changes of the elements so by the changes of things compounded of the elements. Let these principles be enough for thee; let them always be fixed opinions. But cast away the thirst after books, that thou mayest not die murmuring, but cheerfully, truly, and from thy heart thankful to the gods.

4.　Remember how long thou hast been putting off these things, and how often thou hast received an opportunity from the gods, and yet dost not use it. Thou must now at last perceive of what universe thou art a part, and of what administrator of the universe thy existence is an efflux, and that a limit of time is fixed for thee, which if thou dost not use for clearing away the clouds from thy mind, it will go and thou wilt go, and it will never return.

5.　Every moment think steadily as a Roman and a man to do what thou hast in hand with perfect and simple dignity, and feeling of affection, and freedom, and justice; and to give thyself relief from all other thoughts. And thou wilt give thyself relief, if thou doest every act of thy life as if it were the last, laying aside all carelessness and passionate aversion from the commands of reason, and all hypocrisy, and self-love, and discontent with the portion which has been given to thee. Thou seest how few the things are, the which if a man lays hold of, he is able to live a life which flows in quiet, and is like the existence of the gods; for the gods on their part will require nothing more from him who observes these things.

QUESTIONS

1. What is the cause of ugliness and evil in the world?
2. How is it that good and evil human beings participate in the same intelligence and the same portion of divinity?
3. Why can the good not abandon the evil?
4. Why does the individual human being benefit when nature benefits?
5. What must Marcus Aurelius do to achieve happiness on this earth?

Summary Questions

1. To what extent do Stoicism and Epicureanism represent the end of city-state culture? What solution do they offer?
2. Why and how did Rome's aggressive policy of expansion favor the concentration of power, leading in the second century B.C. to domination by the Senate and in the first century B.C. to domination by individual leaders?
3. To what extent did Roman law reflect Stoicism?
4. The Roman use of portraiture differs greatly from that of the Greeks. Using the words *idealism* and *naturalism* describe the differences.
5. The major structural elements of the arch and the dome, like the Greek orders, combine to make a much richer architectural language. What are the essential elements of a dome and how is it erected? What are the essential elements of a basilica and what are its origins?
6. The Romans made major contributions to city planning. Describe at least two major concepts employed by the Romans in an ideal city plan.
7. Compare and contrast the relations between men and women in Homer's *Iliad* and Virgil's *Aeneid*.
8. Compare and contrast the depiction of the afterlife in the underworld in the *Odyssey* and the *Aeneid*.
9. Why is satire a truly Roman form of literature?

Key Terms

Stoicism

divine reason

ius gentium

princeps

apathy

satire

arch

dome

basilica

barrel vault

groin vault

senate

tribunes

forum

dictator

8 Judaism and Early Christianity

CHRONOLOGY	CULTURAL	HISTORICAL
2000 B.C.		Abraham (2000)
		Moses (ca. 1290)
		Judges (1300–1100)
1000 B.C.	The *Bible* begins to be written (1000–961)	Reign of King David (1000–961)
		Death of King Solomon; division of kingdom into Israel and Judah (922)
	The *Torah* is written (600–400)	Babylonian Captivity of Israel (586)
500 B.C.		Reign of Emperor Augustus; life of Jesus (27 B.C.–A.D. 14)
A.D. 1	Composition of *Mishnah* (ca. 200)	Conversion of Paul; spread of Christianity throughout Roman Empire (35)
	Completion of *Talmud* (300–600)	
	Old Saint Peter's built (c. 333)	
	Augustine's *Confessions* (397)	
	Life of St. Benedict (480–542)	
A.D. 500	Gregorian chant codified (540–604)	Pope Gregory I (540–604)
	Invention of musical notation (768–814)	Reign of Charlemagne (768–814)
	Wipo composes Gregorian chant (1017–1056)	Emperor Henry III of Germany (1017–1056)

CENTRAL ISSUES

- The history of the Jews and Jewish sacred literature
- The essential beliefs of Judaism and Christianity
- Eastern mystery religions and Christianity
- The diffusion of Christianity
- The shift of imperial power to Constantinople
- Saint Augustine and the increasing tendency toward introspection
- The development of early Christian art and architecture
- The institution of monasticism
- Early Christian music and Gregorian chant

In moving to another major root of the Western humanities, we shift from a culture centered on human beings to a culture centered on an all-powerful God. The first major religious manifestation of this belief was Judaism, the religion of the ancient Hebrews in Israel. Two other religions adopted the God of the Hebrews: Christianity and Islam. As Christianity developed from Judaism, it brought elements of Greco-Roman culture to bear on the Hebraic core. We will examine a few important monuments of the culture of Christianity in our focal point for Part Three, the European High Middle Ages. Before that, however, we will look briefly at the seminal Hebraic culture and at early Christianity, and then at two influential cultures in the East: the empires of Christian Byzantium and of Islam.

The Ancient Hebrews and the Bible

Modern Christian versions of the Bible include the scriptures of Judaism, called the Old Testament, and the scriptures of Christianity, called the New Testament. Originally, however, the Bible referred only to the Old Testament. It can be defined as a collection of religious literature written in Hebrew (with some parts in other Middle Eastern languages) from about 1000 to 165 B.C. Like the Homeric epics, biblical literature had existed previously as *oral* narratives and poetry. The written Bible contains a variety of literary genres: history, short stories, drama, lyric poetry, and philosophical meditation.

What of the people who composed these greatly influential works? The Hebrews were originally a Middle Eastern tribe belonging to the racial group known as Semites, a group that includes the Arabs. Their early history can be divided into three parts: (1) the period of the patriarchs or founding fathers, that is, Abraham, his son Isaac, and Isaac's son Jacob; (2) the captivity of the Hebrews (now called Israelites) in Egypt; and (3) the Exodus, or deliverance from Egypt to the promised land of Canaan. The extent to which biblical tradition reflects actual historical people and events is a matter of debate.

The Patriarchs

Abraham According to Hebrew tradition, Abraham, who probably lived about four thousand years ago, was the original founder of the Jewish people. His most important contribution was to establish the worship of one God—Adonai—not god as an aspect of nature or as a sun god as in Mesopotamia, Egypt, and other Middle Eastern religions, but a truly personal God who took a direct interest in his chosen people, the Israelites. God himself initiates a contractual relationship with Abraham. The relationship between Abraham and his God came to be known as the covenant.

In this agreement, God promised that Abraham's clan would be led to a new land and would become a great nation. In return, the Israelites were to place their trust and faith in God. Abraham's grandson Jacob, driven by famine out of the Israelites' land of Canaan, settled with his clan in Egypt. Although the Egyptians were originally tolerant of them, the Israelites eventually became slaves until they were delivered by Moses, around 1200 B.C.

Miriam and Moses The Book of Exodus (Chapters 14–15) recounts the story of Moses leading the Israelites to freedom across the Red Sea while the pharaoh's troops pursuing them were swallowed up by the waters. It also tells of the important role of Miriam, a prophetess, and her woman followers in uniting the people. What is believed to be one of the oldest surviving fragments of biblical literature, the Song of Miriam, appears in Exodus: "Then Miriam, the prophetess, the sister of Aaron, took a timbrel in her hand; and all the women went out after her with timbrels and dancing. And Miriam sang to them: 'Sing to the Lord, for he has triumphed gloriously; the horse and his rider he has thrown into the sea'" (15:20–21).

Once the Israelites had safely crossed the sea, Moses led them to Mount Sinai, where a new covenant between the God of Israel and his people was made. God revealed himself to Moses under the name of "Jahweh," which means in Hebrew "he brings into existence." Jahweh was not only the creator of everything but could also enter into history to influence the course of human events. Israel itself was a creation of divine action in time. It was felt that God not only cared for his people but ordered events for their good. History was not, as the pagans conceived of it, meaningless change or a series of endlessly repeating cycles of events. Rather, it was the means through which God revealed his will. This conception of God gave the Israelites their strong sense of destiny. They were the chosen people—God would take care of them. In the covenant at Mount Sinai, Jahweh promised his protection and gave the Israelites the Ten Commandments to follow. The first of these is, of course, "Thou shalt have no other gods before me." The principle of one supreme personal God was firmly established, as it has been in Judaism ever since.

Moses' successor, Joshua, brought his people to the promised land of Canaan, and at that point the Israelites became a settled, rather than a nomadic, people.

Judges The next period of Hebrew history was marked by a series of battles in the attempt to bring the "promised land" of Canaan under the control of the Israelites. The tribes of Israel were not yet united under one ruler but were led by "judges," heroes and heroines who took them into battle or demonstrated their leadership by other legendary actions. One of the earliest of these was the prophetess Deborah, who with Barak led the Israelites in victorious battles over the Canaanites of the north. The Song of Deborah (Judg. 5:1–31), in which she proclaims her victory, is considered, along with the Song of Miriam, to be one of the earliest surviving examples of Hebrew literature. Other judges include Gideon, Jephthah, and Samson.

Kings

The tribes of Israel at last become united as one people under their first king, Saul. David, the second and most famous king, founded the capital at Jerusalem, establishing a splendid court there with a luxury never known to the Israelites previously. It is during the reign of David (1000–961 B.C.) that the Hebrew literature we know as the Bible was first written down. Until then the legends of the patriarchs, the account of the

Creation, and other biblical narratives had been passed along orally.

Solomon The writing of biblical literature continued under the reign of the next king, Solomon. Solomon's court and kingdom were the most lavish and splendid that Israel ever knew. The king's great achievement was to construct the magnificent temple at Jerusalem of which his father, David, had dreamed. This and other building projects, together with his lavish expenditure on a harem—although the three hundred wives and seven hundred concubines attributed to him are probably an exaggeration—forced him to impose heavy taxes on his people and provoked much criticism. Reputed to be the wisest man in the world, he was also considered a poet. Most scholars now, however, cast doubt on his authorship of the Song of Songs and think that this great Hebrew poem, also called the Song of Solomon, was the work of a later writer. Still, it seems to fit the splendor of Solomon's court.

The Prophets and the Fall of Israel

Solomon's power and magnificence did not outlast him for long. Soon after his death in 922 B.C., the kingdom was divided into two parts: Israel and Judah. Then in 721 B.C. Israel was conquered by Assyria and its people dispersed. In the two centuries before this conquest, however, a more sophisticated conception of Jahweh developed. Through the teachings of a remarkable series of great prophets—Isaiah, Jeremiah, Amos, and others—Jahweh evolved from a parochial God of a single people to the universal God of all human beings.

From the mid-eighth to the sixth century B.C., the spiritual life of Jews was dominated by a succession of prophets. Men who considered themselves inspired by God, the prophets took it as their mission to warn kings and their people of the divine punishment to be inflicted on those who failed to fulfill the duties and moral standards imposed on the chosen people of God. Generally speaking, these were centuries of great difficulty for the Jews. They saw their kingdom—divided in two since the death of Solomon in 922 B.C.—pressured first by the Assyrians and then by the Babylonians. The northern kingdom, Israel, with its capital at Samaria, finally fell to the Assyrians in 722 B.C., while the southern kingdom, Judah, centered at Jerusalem, held out until conquered by the Babylonians in 587 B.C.

Biblical Literature

The revolt against Syria that lasted from 167 to 141 B.C. ushered in a century of Jewish independence. By the time of the revolt, the two rival religious groups that were to control Jewish society for the next centuries had already been formed. Both groups, or sects, the

Pharisees and the Sadducees, accepted the same biblical texts divided into three series. The first of these, the Torah, or Pentateuch, contains the first five books of the Bible. Judaism's central document, the Torah relates the history of the Jews from the Creation to the death of Moses and serves as the cornerstone of later Jewish law. The second, the Nevi'im, consists of twenty-one books, which narrate the history of the Jews from Moses' death down to the Babylonian captivity in 586 B.C. The final series of books, poetic in form, comprises proverbs, psalms, and historical chronicles, often critical of the Israelites' failure to keep faith with Jahweh.

The Sadducees accepted as authoritative only the biblical law. By contrast, the Pharisees believed that the Bible needed interpretation and that it had to be adapted to the conditions of daily life. Accordingly, on the basis of biblical injunctions, they created new rules and obligations, which came to form part of the Oral Law. They regarded this Oral Law as binding on Jews as the biblical texts themselves. The Oral Law was finally united into one volume, called the Mishnah, about A.D. 200. This work, together with the Gemara, a compilation of discussions and interpretations of the Mishnah by Jewish scholars completed between A.D. 300 and 600, forms the Talmud, the basic guide to the teachings and the religious and civil laws of the Jewish faith. All modern Jews derive from the sect of the Pharisees, whereas the Sadducees, who apparently had an intimate link to service in the Temple, seem to have disappeared as a force after the destruction of that building by the Roman army in A.D. 70.

The destruction of the Temple by the Roman army is usually taken as the event that marked the beginning of the *diaspora,* or exile of the Jews. Although Jews were already widely spread throughout the Roman Empire, the loss of whatever political and religious independence remained encouraged a far-reaching dispersal. But even without a homeland, Jews remained largely loyal to their religion, maintaining it through fidelity to its rituals and laws, through the education of their children, and through intensive study of the sacred texts.

Judaism never developed a central authority. Every congregation chooses its own rabbi, the spiritual leader who teaches the congregation and interprets the law for it. The cornerstone of Judaic theology is belief in one God, lord of creation and omnipresent in the world; its essential corollaries are that God created human beings in his image and consequently all people have dignity and deserve respect. The sacred texts described earlier provide guidance for life in this world. Although Jews are divided on the issue of an individual afterlife, they believe in the future coming of a Messiah, sent by God to redeem the human race. However, they disagree on how effectual human effort can be in bringing about his advent. Finally, ritual, such as observance of holidays, plays a vital role in Jewish life generally, although there

are wide differences in some matters, such as dietary restrictions and the role of women.

For Christianity, offspring of Judaism, the most important books of the Old Testament are those of the prophets (see, for example, Isaiah 11), who predicted that from the house of David would come the Messiah, or Savior, who would redeem Israel and bring about an era of peace and justice on earth. It is this promise that the followers of Jesus of Nazareth believed he fulfilled. The hope of a Messiah yet to come, however, still remains at the core of Judaism.

Early Christianity

Jesus of Nazareth was born during the reign of the emperor Augustus (27 B.C.–A.D. 14). Nazareth was a part of Judea, a Roman province ruled by a Roman governor; but Judea was also the kingdom of the Jews and had a Jewish king, Herod. The original followers of Jesus were all Jews and did not intend to establish a separate religion but to carry out a radical reform of Judaism. A powerful group centered at Jerusalem fervently believed that proselytizing should be limited only to Jews or to those who were willing to convert to Judaism, accepting circumcision along with the other rules of the faith. Opposed to this position was Saul of Tarsus, whose Roman name was Paul.

Paul of Tarsus and the Spread of Christianity

Raised in a strict orthodox Jewish family in apparently comfortable circumstances—his father was a Roman citizen—Paul initially viewed the Christians as dangerous fanatics bent on destroying Judaism, and he joined in their persecution. Then, about A.D. 35, during a journey to Jerusalem on an errand of persecution, he had a vision in which Jesus called him to his service. Transformed by the experience, Paul became an ardent Christian and for the rest of his life devoted himself to missionary work, founding churches all over the eastern half of the Roman Empire. Paul's letters to these early churches are included among the Epistles in the New Testament.

To the converted Paul, Jesus had died for everyone and Christians enjoyed a freedom from all laws, including those of Judaism. "All things," he wrote to the church at Corinth (1 Cor. 6:12), "are lawful for me," and, in 1 Cor. 2:15, "But he that is spiritual judgeth all things, and he himself is judged of no man." Paul was in no way proclaiming absolute license. Rather, he believed that one who had accepted Christ (a Greek word meaning "anointed") would of his or her own accord do what was right, and that adherence to elaborate dietary practices and other rituals had no spiritual value for the believer.

Despite a number of efforts by Paul and the Jerusalem Jews to reach a reconciliation that would allow Paul to continue his missionary work among the Gentiles and also allow the Jerusalem congregation to proselytize Jews exclusively, the issue was not settled in Paul's lifetime. Nevertheless, Paul's universalistic interpretation quickly triumphed throughout the empire, and Christianity emerged as a religion in its own right rather than as a sect of Judaism.

Persecution of Christians Under the Roman Empire

However, because of its broad appeal, Christianity appeared to menace Roman authority. Perhaps the Romans' apprehension stemmed partly from the fact that Rome was a society founded on the institution of slavery; its upper classes could never forget the horrors of the great slave revolt of Spartacus, in the last century of the Republic, which had threatened to incite slaves throughout Italy to murder their masters. If mere workers and slaves became preoccupied with the personal salvation of their souls and believed that they possessed truth through their religion, would this not endanger their obedience to their masters and thus the whole structure of Roman society? The new religion must be destroyed. But the more the state persecuted, the more the faith grew.

In A.D. 64 much of Rome was destroyed by fire. The emperor, Nero, may have set it himself (to clear large areas in the center city, where he intended to build a new palace complex); but he blamed the destruction on the Christians, whom he accused of "hatred of the human race." Christianity then became illegal and went underground. The Christians were accused of disloyalty to the emperor; of refusing to worship the state gods; and of practicing incest, black magic, and cannibalism ("eating" their god in the communion rite). The Roman persecution of Christians, especially the suffering of Christian martyrs, is well known, notably in its popular film versions. To be Christian in Rome was to risk imprisonment or death. Why then did Christianity appeal to so many people and spread so rapidly? To answer this question is also to determine why the Christians were so easily marked out for harassment by the Roman authorities, who were usually tolerant of religious differences.

Religions in the Roman Empire

Official Roman religion at the time that the Christian message was being spread had adopted the Greek pantheon and encouraged loyalty to the state. To have a happy love affair, an easy childbirth, a safe trip, or a good business deal, one might pray for help to one god or another but would not expect much more of them. The average lower-class person, for example, would not get any help from the gods at the hour of death. The

slave or former slave (freedman) could only hope to cross a dark river and then, as a shade, to wander eternally in the kingdom of the dead. The Elysian Fields—the realm of happiness after death—were reserved for the upper classes. This kind of religion had obviously satisfied the Romans for hundreds of years, but already in the last century of the Roman Republic, before the advent of Caesar Augustus, a change in religious interests was beginning to take place.

From the third century B.C. on, the spread of Greek culture to the East was balanced by a gradual penetration of Eastern mystery religions into Europe—for instance, the Egyptian cult of Isis and Osiris or the Persian worship of Mithra, both of which emphasized resurrection. These religions offered their adherents hope for a personal immortality beyond the grave and tended to deemphasize the importance of success in this earthly life. Philosophies too, like Stoicism, increasingly came to look on God not merely as some kind of a rational principle needed to explain the nature of the world as it was but also as a personality who exercised a providential power over human destiny.

By the reign of Augustus, while the official religion remained centered on the pagan gods, this same movement was well under way in the western half of the Roman Empire as well. It affected men and women at all levels of society. Large numbers of Romans were rejecting the classical ethos that death in the service of the motherland was the highest moral end of the citizen. Even members of the upper class began to regard the state as a primarily negative force designed to keep order so that people could go about their central task of finding spiritual fulfillment in religious worship or philosophical contemplation of a divine being who promised individual salvation.

With so many mystery religions to choose from, why did Christianity attract such great numbers of people and ultimately triumph over its competitors? The Christians saw in their victory the vindication of their claims that the Christian faith was the true religion, but there are obvious historical explanations for the rapid growth of the sect and the intensive persecution of its members.

Of the Eastern mystery religions only Christianity was exclusive. Worshipers of Isis, Mithras, or the Asiatic "Great Mother" Cybele could belong to cults worshiping these deities and at the same time sacrifice to the gods of Rome. Christians forbade any worship of other gods. More than this, they condemned all other religions as sinful and inferior. Thus, while they offered their membership eternal life, Christians also claimed that theirs was the only way to heaven. This exclusiveness must have attracted many, but it made enemies of others who could not understand Christian intolerance.

In a sense the Christians were like the Jews in their unwillingness to participate in public religious ceremonies and to take an oath of loyalty to the emperor. But Judaism was an established religion with a limited potential for membership. Christians by contrast were bursting with missionary zeal. They claimed that the souls of all, whether slave or free, Jew or Gentile, man or woman, were equal in God's sight. This message of equality, love, and charity had a tremendous appeal, especially among the poor and enslaved.

By the second century A.D., as Christian thinking about the faith gained in sophistication, it began to attract the well educated. The gods of Greek and Roman antiquity, as we have seen in the *Iliad* and the *Aeneid,* were often characterized by an arbitrary conduct. They were essentially willful, superior beings who protected those who worshiped them but who changed their minds so often that it was difficult to know what was expected of the believer. On the other hand, the works of ancient philosophers such as Plato, Aristotle, and Cicero show that they believed in a God of reason, a first principle of the universe who gave order in one way or another to all things. Believers, however, could not have a personal relationship with such a God as they could with the popular pagan gods. One could not pray to Plato's Idea of the Good or Aristotle's First Mover. By the second century, with large borrowings from Jewish theologians, who had done much the same thing for Jahweh, thinkers began to develop the concept of the Christian God not only as having a will, which allowed him to love and hate, but also as the ultimate principle of reason. Thus Christians could love and fear this God as the ancient pagans did their gods while at the same time knowing that belief in this God made sense of the world. Philosophers would not have to forget all they had learned about the workings of reason when they entered a church.

Early Christian Art

With the growth of the Christian faith, we find the first stirrings of an art that gives expression to the central ideas of the movement. Unlike the Greeks and Romans, or the Jews with their synagogues, the early Christians had no specific building or architectural setting for their celebrations. Without money or power, all they had was their sense of separateness and community within the great world. They met in homes or rented rooms; but, as persecution grew, they had to seek a safer place for the celebration of the Eucharist (Holy Communion)—the central rite that affirmed fellowship and God's presence among people.

Outside Rome were underground chambers for burial; in these catacombs the Christians met in secret. The walls were decorated with paintings that tell stories from the Old and New Testaments, especially about miracles, persecutions, and Christ's saving grace. The painting reproduced here (Fig. 8-1) shows

Christ as the Good Shepherd. This person, the Good Shepherd who "lays down" his life for his sheep, is the same Christ who speaks in the Sermon on the Mount, the New Testament text that best introduces the Christian message.

The End of Antiquity

While Christianity grew ever stronger in the first three centuries after the death of its founder, the Roman Empire itself in the third century began a rapid decline. The middle half of the century saw almost continuous civil war among at least fifty claimants to the imperial throne.

The decline of Rome was temporarily halted in the last quarter of the century by Diocletian (A.D. 280–305), who, through a series of reforms and careful management of resources, laid the groundwork of an imperial organization that kept the empire together

8-1 The Good Shepherd, *Catacomb of Saint Callixtus, Rome. (Hirmer Fotoarchiv Munich)* (**W**)

▲
• What is the motive behind this representation? Compare the figure with other male figures that we have seen. Is he like an emperor or more like a young athlete?

for more than another hundred years. On his death the arrangement for succession broke down and rivals for the throne began a civil war. One of these was Constantine, who claimed to have had a vision in a battle in A.D. 312 with his opponent that converted him to Christianity.

A New Era of Christianity

With the conversion of Constantine, who won the battle and became emperor, a new era in the history of Christianity opened. Given the divisive tendencies at work in the Empire in the third century, the conversion of Constantine strikes the observer as politically opportune. In the three hundred years of its growth the Christian Church under the pressure of persecution had created a kind of state within a state. Christians settled disputes among themselves within the Christian community; treasuries were created for the purposes of providing for the poor, orphans, and widows. By A.D. 200 almost every major city in the Empire had its bishop and its body of priests, chosen by the community. From this time as well, the bishop of Rome, the Roman pope, asserted his claim to be the spiritual leader of the whole Church. His claim rested on the scriptural passage in which Christ tells Peter, his disciple:

> Thou art Peter, and upon this rock I will build my church; and the gates of hell shall not prevail against it. And I will give unto thee the keys of the kingdom of heaven; and whatsoever thou shalt bind on earth shall be bound in heaven; and whatsoever thou shalt loose on earth shall be loosed in heaven. (Matthew 16:18–19)

Saint Peter was believed to have been the first bishop of Rome; as a result, his successors in that office were thought to have inherited this power of binding and loosing human souls on earth and in heaven. Although these claims were hotly disputed, especially by bishops in the eastern half of the Empire, by the fourth century the leadership of Rome was generally recognized in the western portion.

At the time of Constantine's conversion, only about 10 percent of the population in the Roman Empire, most of them city dwellers, were Christian. Constantine and his successors were able to support the failing imperial machine with the vital, dynamic organization of the Christian Church. From the beginning the emperors looked on the Church as another branch of the imperial government. They influenced the election of bishops and even that of the pope himself. Clerics were treated as public officials, and the emperors drew on the various Church treasures when the need arose. Thus Christianity developed into something totally different from its beginnings: from an underground sect, it became a state religion.

The First Church Buildings

The alliance of Christianity with the state is immediately evident in the appearance of churches—specific complexes for the preaching, teaching, and propagation of the faith. Old Saint Peter's in Rome (Figs. 8-2 and 8-3) was built in the early fourth century (333). Archaeological reconstructions show us a complex of buildings—a great gate, an open courtyard, a roofed porch (*narthex*), and then the church itself—a large simple building with a central space, the *nave*, for the congregation. Parallel to the nave on each side are two passageways, *aisles*. These reinforce the directional quality of the nave that focuses on the altar at the east end, supposedly placed above the bones of Saint Peter. Columns separating the nave and aisles support the roof and walls rising above. The roofs of the aisles do not rise the full height of the nave so that there is a story left free for windows before we reach the combinations of beams—called *trusses*—of the roof. These windows in the *clerestory* provided light. Candles and lamps were used for night services.

Before the east end is reached, another space crosses the nave at right angles. The *transept* was for the pulpit and separated the nave from the altar. The semicircular east end, called the *apse,* had a half-dome above it. The clerics and the bishop would sit here during services.

In addition to the church and courtyard there was a round building called a *baptistery.* Walls were probably painted with stories like those of the catacombs. The exterior would have been fairly plain since the significant events took place in the interior space.

Early Christian Sculpture

Other important monuments that document the spread and power of Christianity are the numerous *sarcophagi* (caskets) that were found in Rome and at other Christian sites. Decorated with scenes from the Christian story, they emphasize the importance of its association with life, death, and afterlife. An excellent example is the sarcophagus of Junius Bassus, a Roman noble (Fig. 8-4). Along the side represented here we see scenes that will appear again and again in Christian art.

The sarcophagus is divided into two registers or rows with five scenes each; each scene is separated by a column giving each a strong architectural framework. In the top register from left to right are the sacrifice of Isaac; Saint Peter taken prisoner; Christ enthroned between Saint Peter and Saint Paul; and Christ before Pontius Pilate (the last two scenes). In the bottom register we see Job and his comforters; Adam, Eve, and the serpent (the Fall of Man); Christ's entry into Jerusalem; Daniel in the lions' den; and Saint Paul led to his martyrdom. The artist has combined Old and New Testament scenes emphasizing sin, martyrdom, and death.

8-3 *Old Saint Peter's, Rome, ground plan.*

A **Nave**
B **Transept**
C **Apse**
D **Aisle**
E **Atrium**

8-2 *Reconstruction of Old Saint Peter's, Rome.*

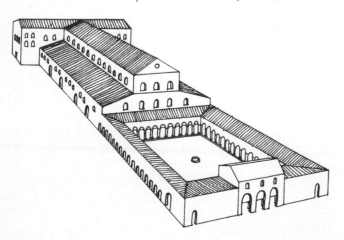

• Compare this building (Fig. 8-2) and plan (Fig. 8-3) with that of a Roman basilica (Fig. 7-15). What are the major differences? Why would a law court be a good source for designing a church? Compare this building with the Parthenon (Fig. 4-4), the Maison Carrée (Fig. 7-8), and the Pantheon (Fig. 7-12). What elements of the early Christian church are particularly Greek or Roman? Where did the atrium come from? How would this church arrangement fit into a Roman city plan?

8-4 *Sarcophagus of Junius Bassus, c.* A.D. *359. Saint Peter's Basilica, Vatican State. (Alinari/Art Resource, NY)*

▲

• How does this sculpture differ from those we have considered such as the *Ara Pacis* (Fig. 7-3) and *The Spoils from the Temple* (Fig. 7-4)? Is it "classical?" What do you think the artist is trying to convey? Why? How is Christ presented? Youthful or dignified, imperial or divine? How do the nude bodies of Adam and Eve compare with *The Spearbearer* (Fig. 4-12) or the Cnidian *Aphrodite* (Fig. 4-16)? What accounts for the differences?

These are mitigated by the two central scenes—Christ the heavenly king (he sits on a personification of the firmament) and Christ the earthly king, cheered as he enters Jerusalem.

These sculptures demonstrate the fact that art and architecture were at this point in a state of transition. Artists and thinkers were searching for the best means to convey new and important ideas at a time when there were no clear patterns for the presentation of these ideas. Greek and Roman art served as sources and acted as strong influences but did not provide the perfect match for making images of Christianity's beliefs. Moreover, what does faith, Christianity's basic tenet, look like? Visual art could only give examples of the acts of people who had taken the path of faith.

The Founding of Constantinople

Constantine's conversion was not the only break to be made with the Roman past. He also definitively moved the capital of the Empire to the east, selecting the town of Byzantium on the Bosporus as the site. Rome had in fact already been abandoned (for Milan) as capital. Constantine's choice reflects his awareness of the displacement of political and economic power from the western to the eastern half of the Empire by the fourth century.

The eastern provinces of Asia Minor, Egypt, and Syria were the wealthy regions of the Empire, those with prosperous cities, a dynamic cultural elite, productive agriculture, and critical pools of workers. The western provinces stood in sharp contrast. Only the North African regions were vital, and their importance was essentially as a grain supplier for Rome. At the same time the nostalgia of Rome's elite for ancient republican ideas, totally impractical in these centuries, had already caused the emperors whose power had become absolute to feel more comfortable living outside the city.

Byzantium, Constantine's choice for the new capital, was an ancient but unremarkable town situated on a promontory overlooking both the Sea of Marmara and the Bosporus. On its third side was the Golden Horn, an estuary forming a magnificent harbor. Strategically, the location, almost equidistant from the Danubian and Persian frontiers, was unsurpassed. Constantine consciously created a permanent capital city, designated "New Rome," although "Constantinople" became its popular name. The popular language of the city was from the outset Greek; however, Latin remained the official language of the imperial bureaucracy until after the reign of Justinian (A.D. 527–565). Whether Greek or Latin speakers, the emperor's eastern subjects continued to regard themselves as "Romans," their empire as "Roman," and the languages they spoke

as "Romanic." As we shall see in the next chapter, only centuries later, after a major shift toward Greek culture, did the old adjective "Byzantine" reemerge to designate both the empire and its people.

Saint Augustine (A.D. 354–430)

Perhaps the greatest theologian of the Christian Church, Aurelius Augustinus belonged to the generation that witnessed the most massive barbarian invasions of the western half of the Roman Empire. He came from a family living in modest circumstances in a small town on the North African coast near Carthage. His mother, Monica, was a devout Christian, but his father converted only late in life. A brilliant speaker and writer, Augustine himself found it difficult to accept a faith whose basic text, the Bible, was so simply written and dealt with such humble people. His *Confessions,* written about A.D. 397, recounts how after a youth given to pleasure and to acquiring fame as a teacher of eloquence, he began to question his life after reading a now-lost work of Cicero. From this point on, moving from one philosophy to another, he eagerly sought the true nature of God and the soul. In none did he find the answer he sought except that Platonism introduced him to the existence of a spiritual realm of which he had been unaware. At the same time this pursuit of knowledge had had little effect on the quality of his moral life. Finally, in Milan, he tells us, he could no longer resist the call to turn to Christ, a call that he had heard since his childhood but to which, proud of his intellect and talents, he would not surrender. He then decided to abandon his profession of teaching rhetoric and devote his life to God. He recounts his conversation with his mother on his faith as they embark to return to Africa together and the death of his mother during the voyage. The rest of the book is composed primarily of meditations on Scripture and on the doctrines of Christianity.

The *Confessions* is a highly significant book in the Western tradition in that it is, as far as we know, the first autobiography. The project of writing about the self, the soul and its relation to God, and the centrality of conversion in life experience is itself indicative of a change in outlook brought about by Christianity. It did not seem to have occurred to the ancients that an intimate account of individual experience could be a worthy subject for literature. The autobiographical genre would be taken up by Petrarch in his *Secret,* Montaigne in his *Essays,* Rousseau in his *Confessions,* and in countless modern narratives. A work by a man steeped in the ancient humanities but convinced of the superior truth of the Christian faith, Saint Augustine's *Confessions* marks the transition between the end of antiquity and the era intellectually dominated by Christianity.

The Barbarian Influence in the Western Roman Empire

On the death of Emperor Theodosius (A.D. 378–395) the Empire was divided between his two sons. Honorius was given the western half and Arcadius the eastern. Because Germanic tribes were threatening to invade Italy, Honorius moved the capital of his half of the Empire into the marshes on the eastern coast of Italy at Ravenna, where he would be insulated from attack. But during the fifth century, as wave upon wave of German tribes passed across the northern and northeastern frontiers of the Western Empire, resistance gave way and Romans at the local level tried to make an accommodation with their German occupiers (see map).

These Germanic tribes, despite the name "barbarians" given them by the Romans, left many of the art objects and buildings they found intact. They had in fact been in contact with Roman civilization for centuries. Their intention was not to destroy a civilization but to garner its fruits for themselves.

Most of the barbarians were already Christian or were converted to Christianity soon after settling on Roman soil. Those who had converted in the homeland, however, had done so largely under the influence of heretical preachers and, once in the Empire, had to be converted to the Catholic faith. Although the central role of the tribal king was a religious one and war chiefs supervised military expeditions, the pressures of invading the Empire created a need for more central direction and led to a significant increase in the king's military powers. To an extent, the conversion of the various tribes to Christianity reduced the significance of the religious character of the king, but throughout most of the Middle Ages the office retained something of its sacred, priestly qualities. German kings in these newly conquered lands fully expected to control not only the churches but also another important religious institution, the monastery.

Western Monasticism

From the third century, beginning in the eastern portion of the Empire, men and women who rejected life in the world moved out into the wilderness individually to worship God in isolation. They were called hermits. The term *monasticism* derives from the individualistic nature of this practice; it comes from *monos,* the Greek word for "single" or "separate." Others, however, who would have liked to withdraw from the world, felt unable to endure the loneliness of such a retreat or believed that isolation contradicted the Christian's duty to love one's neighbor. To such Christians, communal retreat seemed preferable. Thus, by the fourth century, communities of like-minded men and women came into existence, normally founded in remote places, and emphasizing common worship and mutual service.

THE BARBARIAN SUCCESSION STATES
About 500 A.D.

Saint Jerome (A.D. 340–420), also known by his Greek name, Eusebius Hieronymus, was one of the greatest proponents of monasticism in the West. Born into a moderately wealthy Christian family in Dalmatia and educated in Rome, he was attracted to the ascetic life, but soon found the company of others a hindrance to his devotions. He retired to the Syrian desert to live as a hermit for five years. He returned to Rome, however, and had a major role in establishing the connection between the ascetic Christian life of withdrawal and Christian scholarship, a link that was to characterize Western monasticism. Among his many works, surely the most important was his retranslation of older Latin versions of the New Testament, completed about A.D. 388. With the help of Jewish scholars he then translated the Old Testament from Hebrew into Latin. The result of Jerome's labor was the *Vulgate,* used in the Roman Church down to the sixteenth century, when humanists undertook revisions. Yet the death of his papal patron unleashed opponents who resented his ascetic influence. Threatened with death, he left Rome for Palestine, where he built a monastery and a hospice to minister to the pilgrims of the Holy Land.

By the fifth century, monasticism was flourishing in the disintegrating western half of the Roman Empire, but its development was chaotic. Many were joining monasteries for other than religious reasons and legions of monks went from one monastery to another in search of a style of life that suited them. Individual monasteries had separate rules, and the rules ranged from those that inflicted harsh, sometimes barbaric, discipline on their inhabitants, even involving castration, to those that allowed riotous living. Benedict of Nursia (480–542) provided a rule for Western monasticism, which required anyone joining the monastery to establish permanent residence. It also made demands that, while severe, did not go beyond the power and ability of the average devout Christian to fulfill. By the ninth century, the Rule of Saint Benedict had become almost universal in European monasteries.

Often the object of rich donations in land and money, monasteries grew to be powerful economic and political forces in society. An ideal plan for a monastery, drawn up about A.D. 800, the Saint Gall plan (Fig. 8-5) shows a basilica, dormitories, dining room, library, hospital, hostel, cemetery, and gardens. It resembles a small, self-contained city. Given the wealth and importance of the great monasteries, it is easy to understand why the kings in the centuries after

A	Church Nave	E	Public Entrance	J	Refectory
B	Choirs	F	Guest House	K	Cloister
C	Main Altar	G	School	L	Cemetery
D	Towers	H	Abbot's House	M	Gardens, Barns

8-5 *Schematic plan for an ideal monastery at Saint Gall, Switzerland, c. A.D. 819. (Drawing after a ninth-century manuscript, Chapter Library, Saint Gall, Switzerland)*

▲
• Does the Saint Gall plan have any features in common with the Roman town plan (Fig. 7-6)? What is the main focus of the Saint Gall plan?

the invasions were concerned with asserting some control over the resources of these foundations and regulating the election of abbots.

Decline of Roman Centralization

Yet, even with the support of the local churches and monasteries, the barbarian rulers after A.D. 500 proved unable to keep the old Roman institutions running. The Roman conception of political power enshrined in the imperial institutions of government was a public one; that is, the Romans considered political authority to be a series of magistracies. Obedience was owed to a magistrate not as a person but as an official representing the majesty of the Roman people. The most effective political bonds in Germanic society were, on the other hand, the personal ones between a war chief and

his followers, established by an oath. The warrior obeyed the chief not because the latter represented the tribe but because the warrior had sworn to follow this particular man. As noted earlier, the tendency to local autonomy had already set in under the late emperors; the coming of the barbarians only accentuated the development. In a period of insecurity, when people must seek protection wherever they can, the private conception of political power almost inevitably comes to dominate governmental relationships. By the seventh and eighth centuries a large portion of Europe's population found itself involved in a welter of political and economic relationships founded on oaths involving promises to obey or to protect.

The Germanic and surviving Roman aristocracies were the chief beneficiaries of this proliferation of power because they alone had the military might to maintain order at the local level. This group also seized control of churches and monasteries in their various regions, using them to advance their families. Whereas under the late Empire and the early barbarian kings, the Church had been a tool in the hands of the central

governments, now it had ten thousand masters. The papacy at Rome also fell under the control of the Roman nobility. The effort of the Carolingian rulers of France in the eighth and early ninth centuries to reunite authority over a large expanse of territory had only a temporary effect on the process of political disintegration in most areas. Central government required a vigorous economic basis, but until the eleventh century western Europe had, generally speaking, a localized subsistence economy.

Early Christian Music: Gregorian Chant

The early music of the Christian Church certainly began in the upper room where it is recorded that Jesus, in the Jewish tradition, sang psalms, hymns, and spiritual songs with his disciples. But the informal nature of religious meetings in homes of the early Christian Church gradually evolved over the centuries into formal, elaborate, and beautiful liturgies and rituals. They were celebrated in magnificent houses of worship and the services required equally beautiful and elaborate music to support them. By the fourth century A.D., known hymn writers, such as Saint Ambrose and Saint Augustine contributed words and music to a church that would become the dominant force, both spiritual and political, in Europe throughout the Middle Ages. In the sixth century, Pope Gregory I took measures to codify the numerous and varied elements of Christian worship, including music, and the music of the Church that multiplied and evolved over the next several centuries took his name, Gregorian chant.

Gregorian chant is the unaccompanied vocal music of the Christian Church of the Middle Ages and Gothic era, and it served to embellish the words of Christian worship. Always meant to be a vehicle for the words and not a musical end in itself, chants were composed by the thousands. They were the work of hundreds of mostly anonymous servants of the Church over many centuries who sought by this means to praise God, to ask favor of the deity, to enhance the celebration of holy rites, and to help fulfill the many spiritual needs of European Christians. Music was composed for the observance of mass and the other services of the Church, such as vespers and complin, and those compositions that pleased the singers were reused and remembered; those that did not were discarded and forgotten.

At first, none of this music was written down, for an adequate musical notation was not invented until the ninth century, eight hundred years after Christ and nearly five hundred years after the contributions of the earliest known hymn writers. The entire corpus of song was stored in the minds of musicians and passed on from generation to generation as a sacred trust. But by the time of Charlemagne in the ninth century, too many variants in both the services and the music had developed in different corners of Europe to please this Christian ruler, and he ordered that the approved words and music be written down, preserved, and disseminated to the various corners of his empire. It is from these manuscripts and those created later that we are able to sing the music our forebears sang a thousand years ago. Our knowledge about this music and its performance derives from these manuscripts and related documents, as well as from a musical tradition that has continued uninterrupted within the Catholic Church to the present day.

By and large, Gregorian chant was sung by men young and old, the monks, priests, clerics, and novices of the Catholic Church, but chant was also sung and composed by women. For example, a famous abbess of the twelfth century, Hildegard of Bingen, was a remarkable composer in addition to her many other outstanding accomplishments. The chants were composed for all the feasts and festivals of the Christian year, as well as for the services that recurred weekly or daily in the monasteries. All Gregorian chant uses melodies that avoid wide leaps and contrasts, and these readily singable and thoroughly graceful musical lines move gently in a smooth rising and falling motion that listeners often identify as prayers in song. The number of melodies in the repertory soon began to run into many thousands, and memory became a constant problem, even for skilled musicians.

Even after the invention of musical notation, when chant was written down and thus recorded, manuscripts were few and precious. Memory was still an important element in preserving and performing this music. Because he had a problem in this regard, a ninth-century monk, Notker Balbulus, claimed to have invented a new kind of chant as an aid to memory, one that set new words to the music of earlier chants, which he found difficult to remember. These new compositions became so popular that they started a new chant genre of their own, which Balbulus called "sequence." He and many others composed Latin religious poems for old and new melodies alike in the ninth and subsequent centuries.

These sequences found their place in the Gregorian repertory and the regular observances of the Christian religious services. Today, at funerals, we might hear the sequence "Dies irae, dies illa" ("Day of wrath, day of mourning"). And at the celebration of Easter mass throughout the world, right after the *Alleluia* chant is sung, we can still hear the sequence "Victimae paschali laudes" ("Praise to the Paschal Victim") intoned by priests and choirs. The beauty and poetic simplicity of this Gregorian chant commends it to our attention. Composed by Wipo, the eleventh-century chaplain to the Emperor Henry III of Germany, it bears the classical sequence form of paired strophes—A BB CC DD—in both the words and the

• D A I L Y L I V E S •

• • • • Life in an Early Medieval Monastery

Because pride, the desire to be like God by eating of the tree of knowledge, was the original sin, Benedictine monasticism focused on eradicating pride. To this end, candidates for entry had to take a threefold vow of chastity, poverty, and obedience. The oath of chastity was to diminish pride in the body, and that of poverty, to remove pride in possession of external things. The oath of strict obedience to the will of the abbot, the head of the monastery, was designed to humble the will. The main task of the monks, referred to as the "work of God," was prayer, both for themselves and others.

The following excerpts are taken from the rule composed by St. Benedict himself to govern monasteries. The three dates associated with each passage are the dates when that passage of the rule would have been read aloud in the monastery dining hall. In this way, three times a year, the monks would absorb the whole rule along with their food and drink. The translation is by Leonard J. Boyle, *St. Benedict's Rule for Monasteries* (Collegeville, MN: The Liturgical Press, 1948).

Jan. 22—May 23—Sept. 22
The first degree of humility is obedience without delay. This is the virtue of those who hold nothing dearer to them than Christ; who, because of the

holy service they have professed, and the fear of hell, and the glory of life everlasting, as soon as anything has been ordered by the Superior, receive it as a divine command and cannot suffer any delay in executing it. Of these the Lord says, "As soon as he heard, he obeyed Me." And again to teachers He says, "He who hears you, hears Me."

Feb. 19—June 20—Oct. 20
"Seven times in the day," says the Prophet, "I have rendered praise to You." . . .

Let us therefore bring our tribute of praise to our Creator "for the judgments of His justice" at these times: the Morning Office, Prime, Terce, Sext, None, Vespers, and Compline; and in the night let us arise to glorify Him.

Feb. 27 (28)—June 29—Oct. 29
Let each one sleep in a separate bed. Let them receive bedding suitable to their manner of life, according to the Abbot's directions. If possible let all sleep in one place; but if the number does not allow this, let them take their rest by tens and twenties with the seniors who have charge of them.

A candle shall be kept burning in the room until morning.

Let the monks sleep clothed and girded with belts and cords—but not with their knives at their sides, lest they cut themselves in their sleep—and thus be always ready to rise without delay when the signal

music. Notice that the entire work has a planned, or composed, shape. The A phrase is sung midrange, C is lower and both B and D are higher. The A and C portions are performed solo while both B and D are for men's choir. Notice that the melody for the second B section repeats that of the first, the second C section repeats its first C, and the second D repeats the first D as well. Listen carefully, and you will hear that the music for B and D is almost the same, giving a sense of unity and finality to the piece. It is considerations like these that influenced musicians of later centuries to compose well-structured large works organized on purely musical and artistic principles. This sequence is not just an endless stream of notes. It is a carefully wrought chant by Wipo, a sacred song from the Gregorian repertory that has lasted, because of its beauty and reverence, for almost a thousand years of continuous and continuing performances.

A Victimae paschali laudes immolent Christiani.	A Let Christians offer songs of praise to the Paschal Victim.
B Agnus redemit oves: Christus innocens Patri reconciliavit peccatores.	B The Paschal Lamb has redeemed the sheep: Christ, the innocent, has reconciled us sinners to the Father.
B Mors et vita duello conflixere mirando: dux vitae mortuus, regnat vivus.	B Life and death have fought a miraculous combat: the leader of life has lost his life, and yet he reigns alive.
C Dic nobis Maria, quid vidisti in via? Sepulcrum Christi viventis, et gloriam vidi resurgentis:	C Tell us, Mary, what did you see along the way? I saw the tomb of the living Christ, and I saw the glory of the risen Christ.

CD-1, 1

is given and hasten to be before one another at the Work of God, yet with all gravity and decorum.

The younger brethren shall not have beds next to one another, but among those of the older ones.

When they rise for the Work of God let them gently encourage one another, that the drowsy may have no excuse.

Mar. 6—July 6—Nov. 5

If a brother who through his own fault leaves the monastery should wish to return, let him first promise full reparation for his having gone away; and then let him be received in the lowest place, as a test of his humility. And if he should leave again, let him be taken back again, and so a third time; but he should understand that after this all way of return is denied him.

Mar. 28—July 28—Nov. 27

Idleness is the enemy of the soul. Therefore the brethren should be occupied at certain times in manual labour, and again at fixed hours in sacred reading. To that end we think that the times for each may be prescribed as follows.

From Easter until the Calends of October, when they come out from Prime in the morning let them labour at whatever is necessary until about the fourth hour, and from the fourth hour until about the sixth let them apply themselves to reading. After the sixth hour, having left the table, let them rest on their beds in perfect silence; or if anyone may perhaps want to read, let him read to himself in such a way as not to disturb anyone else. Let None be said rather early, at the middle of the eighth hour, and let them again do what work has to be done until Vespers.

And if the circumstances of the place or their poverty should require that they themselves do the work of gathering the harvest, let them not be discontented; for then are they truly monks when they live by the labour of their hands, as did our Fathers and the Apostles. Let all things be done with moderation, however, for the sake of the fainthearted.

Mar. 11—July 11—Nov. 10

This vice especially is to be cut out of the monastery by the roots. Let no one presume to give or receive anything without the Abbot's leave, or to have anything as his own—anything whatever, whether book or tablets or pen or whatever it may be—since they are not permitted to have even their bodies or wills at their own disposal; but for all their necessities let them look to the Father of the monastery. And let it be unlawful to have anything which the Abbot has not given or allowed. Let all things be common to all, as it is written, and let no one say or assume that anything is his own. But if anyone is caught indulging in this most wicked vice, let him be admonished once and a second time. If he fails to amend, let him undergo punishment.

C Angelicos testes, sudarium, et vestes. Surrexit Christus spes mea: praecedet suos in Galilaeam.

C I saw the angelic witnesses, and the shroud, and his garments. Christ, my hope, is risen. He will lead his own to Galilee.

D Credendum est magis soli Mariae veraci quam Judaeorum turbae fallaci.

D Only the honest Mary is to be believed and not the fallible multitudes of Judaea.

D Scimus Christum surrexisse a mortuis vere: tu nobis, victor Rex, miserere.

D We truly believe that Christ has risen from the dead. You conquerer and king, have mercy upon us.

Amen. Alleluia.

Amen. Alleluia.

Polyphonic music is music sung or played in more than one part, that is, music with two or more different melodic lines performed at the same time, like bass and soprano, or tenor, alto, and soprano. From this early arrangement of part music, harmony eventually developed, but harmony, for its own sake, was not a concern of medieval composers. The musicians of this period focused most of their attention on the individual melodic lines and how they came together or stood apart rather than on the smooth congruence of sounds into harmonies with which we are familiar today. Outside the church, polyphonic music accompanied dance and provided intellectual recreation.

Poetry was set to music, just as it had been in the past, but now a new possibility came into being, and some composers of the fourteenth century exploited this new dimension: the possibility of singing more than one poem at the same time. These polyphonic motets, part songs with words (*motet* derives from the French word *mot,* meaning "word"), were sometimes used to set satirical French poetry to music. Often the

texts made fun of both the Church and the political powers of the day.

Philippe de Vitry—a mathematician, astronomer, and an accomplished poet and musician—was a learned man who was clearly offended by some of the abuses he observed in the Church. He saw priests and bishops growing rich and fat at the expense of their parishioners. On the secular side, he saw counselors giving self-serving advice to their kings and princes. In fourteenth-century France, death or excommunication were the possible penalties for openly opposing a prince or bishop, and these were risks not many were willing to take. In Philippe de Vitry's case, he encoded his message in satirical poems and set these to music in a manuscript entitled the *Roman de Fauvel,* or the "Story of Fauvel." The poems described the adventures of an ass, a long-eared quadruped whose name, Fauvel, derived from the first letters of six cardinal sins: *Flattery, Avarice, Villainy* ("U" = "V" in the fourteenth century), *Variety* (inconstancy), *Envy,* and cowardice (*Lâcheté* in French). Perhaps for added protection, and partly because it was the new style of the day, Vitry also capitalizes on the incomprehensibility of the words during performance, for his musicians sing two different lines of text at the same time.

SINGER 1 (Triplum):[1]
Garrit Gallus flendo dolorose
Luget quippe Gallorum concio.
Que satrape traditur dolose,
Ex cubino sedens officio.
etc.

> The cock[2] crows sorrowfully
> for the whole assembly of cocks.
> He mourns because while he does
> his faithful duty he is betrayed by
> his master's advisors.

> And the fox,[3] like a grave robber,
> sly as the wicked evil angel, Belial,
> thrives and rules like a monarch.
> etc.

SINGER 2 (Duplum):[4]
In nova fert animus mutatas
Dicere formas.
Draco nequam quam olim penitus
Mirabilis crucis potencia
etc.

> My soul will speak of things newly changing from one form to another. The evil dragon that St. Michael once killed with the miraculous power of the Cross is alive once more, this time handsome, and eloquent, and armed with wolfish teeth. etc.

MUSICIAN 3 (Tenor, performed on viol)

In another, similar motet, Vitry requires his musicians to sing three different texts at the same time. The Latin poems *Gratissima virginis/Vos qui admiramini/Gaude gloriosa* at first glance appear to be sacred lyrics in praise of the Virgin Mary, the mother of Christ. The composition was likely sung in church. However, closer scrutiny of the text reveals the work to be a statement of lustful desire for beautiful virgins. The music effectively conceals this from the reverent listener through the simultaneous singing of different words and melodic interruptions that skip from one voice to another.

CD-1, 2

Another fourteenth-century work, the "Mass of Our Lady" (*Messe de Notre Dame*) is the most famous work of the century by the most famous composer of his day, Guillaume de Machaut. For the first time, a single composer signs his name to a large work in five movements (Kyrie, Gloria, Credo, Sanctus, and Agnus—the five sections of the ordinary of the mass) and organizes sounds in such a way that all five parts sound as though they belong to the same work. The Gloria begins with a line of Gregorian chant sung by the cantor, and then the choir of men responds in four parts. Machaut's mass is more chordal than the music of Philippe de Vitry's motet, but there is no mistaking the similarity of sound. These medieval chords are far different from those we hear in today's modern music.

Gloria in excelsis Deo

CD-1, 3

Glory to God in the highest and on earth
 peace to all men of good will.
We praise Thee, we worship Thee, we
 glorify Thee,
We bless Thee, we give thanks to Thee for
 thy great glory.
O Lord God, heavenly King, God the Father almighty.
O Lord, the only begotten Son, Jesus Christ,
O Lord God, Lamb of God, Son of the Father,
Who takes away the sins of the world,
Have mercy upon us, receive our prayer.
You, who sit at the right hand of God the Father,
Have mercy upon us.
For Thou only are Holy; Thou only are the Lord;
Thou only are most high.
Jesus Christ, with the Holy Ghost, and
In the glory of God the Father. Amen.

[1] Third part, third singer, third line of music.

[2] "Gallus" is a pun. The word means "cock" or "rooster," but the French are Gauls, and the "Gallus" also equals "Gauls."

[3] The "fox" was Enguerran de Marigny, chief counselor of the French king, Philip the Fair.

[4] Second part, second singer, second line of music.

Every age has its avant-garde musicians even though we tend to think the term is reserved for radical thinkers of the twentieth and twenty-first centuries. The fourteenth century was an exciting and fearsome age of traditionalists struggling with modernists in the boiling cauldron of intellectual ferment. Vitry made fun of princes of the Church and state, and the Church itself struggled, with more than one pope claiming authority over the Western Christian, or Catholic, Church. In music, the sacrosanct nature of the Trinity and its application to music, dividing lengths of time into three and its multiples, was challenged by theorists and composers who said, "Why not use two and four?" Composers began to experiment with different meters, new varieties of notation, melodies not in one of the church modes, pieces too high or low, and the liberal addition of sharps and flats to give an unexpected turn of phrase.

One of the strangest pieces of the century, and in some ways one of the strangest pieces of all time, was composed in the late 1300s by a Frenchman named Solage. Associated with the court of Gaston Febus, the count of Foix and Béarn, Solage was one of a group of philosophers and rhetoricians who called themselves *fumeurs,* or smokers. After listening to this music one might find it easy to imagine this composer fully at home in one of the cloudy cellar bookstores of the 1960s, when beat generation poets and jazz musicians gathered late at night to read poetry with jazz, play chess, and smoke. His composition, *Fumeux fume,* is a bizarre conglomeration of bass voices, alliterative text, hidden meaning, and surprisingly chromatic harmonies and melodies. Much of the preserved French music of the late fourteenth century is mannered—that is, it uses an excess of fine detail to complicate or ornament the basic structure (in other words, it has mannerisms or affectations)—and this work is a prime example. It is almost a secret music for a secret society, the *fumeurs.*

SOLAGE

···

Fumeux Fume

Fumeux fume par fumee,	Smokey, scented smoke.	
Fumeuse speculacion.	Smokey speculation.	**CD-1, 4**
Qu'autre fummer sa pensee	Let another send his thought up in smoke.	
Fumeux fume par fumee.	Smokey, scented smoke.	
Quar fumer molt li agree	For smoking pleases one greatly	
Tant qu'il ait son entencion.	So long as it holds one's attention.	
Fumeux fume par fumee	Smokey, scented smoke.	
Fumeuse speculacion.	Smokey speculation.	

● TEXTS FROM THE OLD ● TESTAMENT

GENESIS

..

The Creation

The first biblical text included here is one that may appear all too familiar, but a student of the humanities should approach it with new questions. All cultures of the world have myths of creation. Compare this Hebrew account of the beginnings of things (the meaning of the Latin word *genesis*) with the Mesopotamian, Egyptian, and Greek ones summarized in earlier chapters and with the West African accounts in Chapter 13. The following biblical passage and others are from the King James translation of 1611, itself a cultural monument of great importance to the formation of the English language. However, for contrast, there are also some from the Revised Standard Version of 1952.

Chapter 1

1 In the beginning God created the heaven and the earth.

2 And the earth was without form, and void; and darkness was upon the face of the deep. And the Spirit of God moved upon the face of the waters.

3 And God said, Let there be light: and there was light.

4 And God saw the light, that it was good: and God divided the light from the darkness.

5 And God called the light Day, and the darkness he called Night. And the evening and the morning were the first day.

6 And God said, Let there be a firmament in the midst of the waters, and let it divide the waters from the waters.

7 And God made the firmament, and divided the waters which were under the firmament from the waters which were above the firmament: and it was so.

8 And God called the firmament Heaven. And the evening and the morning were the second day.

9 And God said, Let the waters under the heaven be gathered together unto one place, and let the dry land appear: and it was so.

10 And God called the dry land Earth; and the gathering together of the waters called he Seas: and God saw that it was good.

11 And God said, Let the earth bring forth grass, the herb yielding seed, and the fruit tree yielding fruit after his kind, whose seed is in itself, upon the earth: and it was so.

12 And the earth brought forth grass, and herb yielding seed after his kind, and the tree yielding fruit, whose seed was in itself, after his kind: and God saw that it was good.

13 And the evening and the morning were the third day.

14 And God said, Let there be lights in the firmament of the heaven to divide the day from the night; and let them be for signs, and for seasons, and for days, and years:

15 And let them be for lights in the firmament of the heaven to give light upon the earth: and it was so.

16 And God made two great lights; the greater light to rule the day, and the lesser light to rule the night: he made the stars also.

17 And God set them in the firmament of the heaven to give light upon the earth,

18 And to rule over the day and over the night, and to divide the light from the darkness: and God saw that it was good.

19 And the evening and the morning were the fourth day.

20 And God said, Let the waters bring forth abundantly the moving creature that hath life, and fowl that may fly above the earth in the open firmament of heaven.

21 And God created great whales, and every living creature that moveth, which the waters brought forth abundantly, after their kind, and every winged fowl after his kind: and God saw that it was good.

22 And God blessed them, saying, Be fruitful, and multiply, and fill the waters in the seas, and let fowl multiply in the earth.

23 And the evening and the morning were the fifth day.

24 And God said, Let the earth bring forth the living creature after his kind, cattle, and creeping thing, and beast of the earth after his kind: and it was so.

25 And God made the beast of the earth after his kind, and cattle after their kind, and every thing that creepeth upon the earth after his kind: and God saw that it was good.

26 And God said, Let us make man in our image, after our likeness: and let them have dominion over the fish of the sea, and over the fowl of the air, and over the cattle, and over all the earth, and over every creeping thing that creepeth upon the earth.

27 So God created man in his own image, in the image of God created he him; male and female created he them.

28 And God blessed them, and God said unto them, Be fruitful, and multiply, and replenish the earth, and subdue it: and have dominion over the fish of the sea, and over the fowl of the air, and over every living thing that moveth upon the earth.

29 And God said, Behold, I have given you every herb bearing seed, which is upon the face of all the earth, and every tree, in the which is the fruit of a tree yielding seed; to you it shall be for meat.

30 And to every beast of the earth, and to every fowl of the air, and to every thing that creepeth upon the earth, wherein there is life, I have given every green herb for meat: and it was so.

31 And God saw every thing that he had made, and, behold, it was very good. And the evening and the morning were the sixth day.

Chapter 2

1 Thus the heavens and the earth were finished, and all the host of them.

2 And on the seventh day God ended his work which he had made; and he rested on the seventh day from all his work which he had made.

3 And God blessed the seventh day, and sanctified it: because that in it he had rested from all his work which God created and made.

4 These are the generations of the heavens and of the earth when they were created, in the day that the Lord God made the earth and the heavens,

5 And every plant of the field before it was in the earth, and every herb of the field before it grew: for the Lord God had not caused it to rain upon the earth, and there was not a man to till the ground.

6 But there went up a mist from the earth, and watered the whole face of the ground.

7 And the Lord God formed man of the dust of the ground, and breathed into his nostrils the breath of life; and man became a living soul.

8 And the Lord God planted a garden eastward in Eden; and there he put the man whom he had formed.

9 And out of the ground made the Lord God to grow every tree that is pleasant to the sight, and good for food; the tree of life also in the midst of the garden, and the tree of knowledge of good and evil.

10 And a river went out of Eden to water the garden; and from thence it was parted, and became into four heads.

11 The name of the first is Pison: that is it which compasseth the whole land of Havilah, where there is gold;

12 And the gold of that land is good: there is bdellium and the onyx stone.

13 And the name of the second river is Gihon: the same is it that compasseth the whole land of Ethiopia.

14 And the name of the third river is Hiddekel: that is it which goeth toward the east of Assyria. And the fourth river is Euphrates.

15 And the Lord God took the man, and put him into the garden of Eden to dress it and to keep it.

16 And the Lord God commanded the man, saying, Of every tree of the garden thou mayest freely eat:

17 But of the tree of the knowledge of good and evil, thou shalt not eat of it: for in the day that thou eatest thereof thou shalt surely die.

18 And the Lord God said, It is not good that the man should be alone; I will make him an help meet for him.

19 And out of the ground the Lord God formed every beast of the field, and every fowl of the air; and brought them unto Adam to see what he would call them: and whatsoever Adam called every living creature, that was the name thereof.

20 And Adam gave names to all cattle, and to the fowl of the air, and to every beast of the field; but for Adam there was not found an help meet for him.

21 And the Lord God caused a deep sleep to fall upon Adam, and he slept; and he took one of his ribs, and closed up the flesh instead thereof;

22 And the rib, which the Lord God had taken from man, made he a woman, and brought her unto the man.

23 And Adam said, This is now bone of my bones, and flesh of my flesh: she shall be called Woman, because she was taken out of man.

24 Therefore shall a man leave his father and his mother, and shall cleave unto his wife: and they shall be one flesh.

25 And they were both naked, the man and his wife, and were not ashamed.

. .

COMMENTS AND QUESTIONS

1. The two different accounts of creation in Genesis have caused biblical scholars to believe that each was written at a different time and by a different

author. What are the two accounts? Where does one end and the other begin?

2. Does God create from nothing? Does it seem that anything was there before God?

3. How does the role of the Hebrew God of creation differ from that of divinities in Mesopotamian, Egyptian, Greek, and (see Part Four) West African myths?

4. How do the two accounts of the creation of woman differ? How might these accounts have influenced ways in which we think about the nature of woman?

The Fall

The following text is central to the Judaic and Christian concepts of humanity's relationship to God and to the problem of evil. Whereas the first two chapters of Genesis show human beings as a part of the totality of creation and in harmony with it, in this chapter human beings, quite unlike the other living things in the created world, begin to act on their own: to make their own decisions apart from God. They have *free will*: they are given an orderly and harmonious world but are capable of creating disorder in it.

Chapter 3

1 Now the serpent was more subtil than any beast of the field which the Lord God had made. And he said unto the woman, Yea, hath God said, Ye shall not eat of every tree of the garden?

2 And the woman said unto the serpent, We may eat of the fruit of the trees of the garden:

3 But of the fruit of the tree which is in the midst of the garden, God hath said, Ye shall not eat of it, neither shall ye touch it, lest ye die.

4 And the serpent said unto the woman, Ye shall not surely die:

5 For God doth know that in the day ye eat thereof, then your eyes shall be opened, and ye shall be as gods, knowing good and evil.

6 And when the woman saw that the tree was good for food, and that it was pleasant to the eyes, and a tree to be desired to make one wise, she took of the fruit thereof, and did eat, and gave also unto her husband with her; and he did eat.

7 And the eyes of them both were opened, and they knew that they were naked; and they sewed fig leaves together, and made themselves aprons.

8 And they heard the voice of the Lord God walking in the garden in the cool of the day: and Adam and his wife hid themselves from the presence of the Lord God amongst the trees of the garden.

9 And the Lord God called unto Adam, and said unto him, Where art thou?

10 And he said, I heard thy voice in the garden, and I was afraid, because I was naked; and I hid myself.

11 And he said, Who told thee that thou wast naked? Hast thou eaten of the tree, whereof I commanded thee that thou shouldest not eat?

12 And the man said, The woman whom thou gavest to be with me, she gave me of the tree, and I did eat.

13 And the Lord God said unto the woman, What is this that thou hast done? And the woman said, The serpent beguiled me, and I did eat.

14 And the Lord God said unto the serpent, Because thou hast done this, thou art cursed above all cattle, and above every beast of the field; upon thy belly shalt thou go, and dust shalt thou eat all the days of thy life:

15 And I will put enmity between thee and the woman, and between thy seed and her seed; it shall bruise thy head, and thou shalt bruise his heel.

16 Unto the woman he said, I will greatly multiply thy sorrow and thy conception; in sorrow thou shalt bring forth children; and thy desire shall be to thy husband, and he shall rule over thee.

17 And unto Adam he said, Because thou hast hearkened unto the voice of thy wife, and hast eaten of the tree, of which I commanded thee, saying, Thou shalt not eat of it: cursed is the ground for thy sake; in sorrow shalt thou eat of it all the days of thy life;

18 Thorns also and thistles shall it bring forth to thee; and thou shalt eat the herb of the field;

19 In the sweat of thy face shalt thou eat bread, till thou return unto the ground; for out of it wast thou taken: for dust thou art, and unto dust shalt thou return.

20 And Adam called his wife's name Eve; because she was the mother of all living.

21 Unto Adam also and to his wife did the Lord God make coats of skins, and clothed them.

22 And the Lord God said, Behold, the man is become as one of us, to know good and evil: and now, lest he put forth his hand, and take also of the tree of life, and eat, and live for ever:

23 Therefore the Lord God sent him forth from the garden of Eden, to till the ground from whence he was taken.

24 So he drove out the man; and he placed at the east of the garden of Eden Cherubims, and a flaming sword which turned every way, to keep the way of the tree of life.

QUESTIONS

1. How does this story reconcile the idea of God's infinite justice with the presence of evil in the world?

2. How does God appear in this story in relation to human beings?

3. What, specifically, tempts Eve and then Adam to eat the forbidden fruit? What does this tell you about the Hebrews' concept of the nature of human beings?

4. Compare the relationship between human curiosity and divine power here with the treatment of the same theme in *Oedipus Rex*.

5. Do you as a reader feel admiration or scorn for the human desire to eat the fruit?

Noah and the Flood

This selection, from Genesis 6–9, recounts the story of the Flood, by which God destroyed humanity because of its wickedness. God restored the human race through the patriarch Noah and his wife. This story should be compared with the tale of the flood in *Gilgamesh*. The translation comes from the Revised Standard Version of the Bible.

5 The LORD saw that the wickedness of man was great in the earth, and that every imagination of the thoughts of his heart was only evil continually. 6 And the LORD was sorry that he had made man on the earth, and it grieved him to his heart. 7 So the LORD said, "I will blot out man whom I have created from the face of the ground, man and beast and creeping things and birds of the air, for I am sorry that I have made them." 8 But Noah found favor in the eyes of the LORD.

9 These are the generations of Noah. Noah was a righteous man, blameless in his generation; Noah walked with God. 10 And Noah had three sons, Shem, Ham, and Japheth.

11 Now the earth was corrupt in God's sight, and the earth was filled with violence. 12 And God saw the earth, and behold, it was corrupt; for all flesh had corrupted their way upon the earth. 13 And God said to Noah, "I have determined to make an end of all flesh; for the earth is filled with violence through them; behold, I will destroy them with the earth. 14 Make yourself an ark of gopher wood; make rooms in the ark, and cover it inside and out with pitch. 15 This is how you are to make it: the length of the ark three hundred cubits, its breadth fifty cubits, and its height thirty cubits. 16 Make a roof for the ark, and finish it to a cubit above; and set the door of the ark in its side; make it with lower, second, and third decks. 17 For behold, I will bring a flood of waters upon the earth, to destroy all flesh in which is the breath of life from under heaven; everything that is on the earth shall die. 18 But I will establish my covenant with you; and you shall come into the ark, you, your sons, your wife, and your sons' wives with you. 19 And of every living thing of all flesh, you shall bring two of every sort into the ark, to keep them alive with you; they shall be male and female. 20 Of the birds according to their kinds, and of the animals according to their kinds, of every creeping thing of the ground according to its kind, two of every sort shall come in to you, to keep them alive. 21 Also take with you every sort of food that is eaten, and store it up; and it shall serve as food for you and for them." 22 Noah did this; he did all that God commanded him.

Chapter 7

Then the LORD said to Noah, "Go into the ark, you and all your household, for I have seen that you are righteous before me in this generation. 2 Take with you seven pairs of all clean animals, the male and his mate; and a pair of the animals that are not clean, the male and his mate; 3 and seven pairs of the birds of the air also, male and female, to keep their kind alive upon the face of all the earth. 4 For in seven days I will send rain upon the earth forty days and forty nights; and every living thing that I have made I will blot out from the face of the ground." 5 And Noah did all that the LORD had commanded him.

6 Noah was six hundred years old when the flood of waters came upon the earth. 7 And Noah and his sons and his wife and his sons' wives with him went into the ark, to escape the waters of the flood. 8 Of clean animals, and of animals that are not clean, and of birds, and of everything that creeps on the ground, 9 two and two, male and female, went into the ark with Noah, as God had commanded Noah. 10 And after seven days the waters of the flood came upon the earth.

11 In the six hundredth year of Noah's life, in the second month, on the seventeenth day of the month, on that day all the fountains of the great deep burst forth, and the windows of the heavens were opened. 12 And rain fell upon the earth forty days and forty nights. 13 On the very same day Noah and his sons, Shem and Ham and Japheth, and Noah's wife and the three wives of his sons with them entered the ark, 14 they and every beast according to its kind, and all the cattle according to their kinds, and every creeping thing that creeps on the earth according to its kind, and every bird according to its kind, every bird of every sort. 15 They went into the ark with Noah, two and two of all flesh in which there was the breath of life. 16 And they that entered, male and female of all flesh, went in as God had commanded him; and the LORD shut him in.

17 The flood continued forty days upon the earth; and the waters increased, and bore up the ark, and it rose high above the earth. 18 The waters prevailed and increased greatly upon the earth; and the ark floated on the face of the waters. 19 And the waters prevailed so mightily upon the earth that all the high mountains under the whole heaven were covered; 20 the waters

prevailed above the mountains, covering them fifteen cubits deep. 21 And all flesh died that moved upon the earth, birds, cattle, beasts, all swarming creatures that swarm upon the earth, and every man; 22 everything on the dry land in whose nostrils was the breath of life died. 23 He blotted out every living thing that was upon the face of the ground, man and animals and creeping things and birds of the air; they were blotted out from the earth. Only Noah was left, and those that were with him in the ark. 24 And the waters prevailed upon the earth a hundred and fifty days.

Chapter 8

But God remembered Noah and all the beasts and all the cattle that were with him in the ark. And God made a wind blow over the earth, and the waters subsided; 2 the fountains of the deep and the windows of the heavens were closed, the rain from the heavens was restrained, 3 and the waters receded from the earth continually. At the end of a hundred and fifty days the waters had abated; 4 and in the seventh month, on the seventeenth day of the month, the ark came to rest upon the mountains of Ar'arat. 5 And the waters continued to abate until the tenth month; in the tenth month, on the first day of the month, the tops of the mountains were seen.

6 At the end of forty days Noah opened the window of the ark which he had made, 7 and sent forth a raven; and it went to and fro until the waters were dried up from the earth. 8 Then he sent forth a dove from him, to see if the waters had subsided from the face of the ground; 9 but the dove found no place to set her foot, and she returned to him to the ark, for the waters were still on the face of the whole earth. So he put forth his hand and took her and brought her into the ark with him. 10 He waited another seven days, and again he sent forth the dove out of the ark; 11 and the dove came back to him in the evening, and lo, in her mouth a freshly plucked olive leaf; so Noah knew that the waters had subsided from the earth. 12 Then he waited another seven days, and sent forth the dove; and she did not return to him any more.

13 In the six hundred and first year, in the first month, the first day of the month, the waters were dried from off the earth; and Noah removed the covering of the ark, and looked, and behold, the face of the ground was dry. 14 In the second month, on the twenty-seventh day of the month, the earth was dry. 15 Then God said to Noah, 16 "Go forth from the ark, you and your wife, and your sons and your sons' wives with you. 17 Bring forth with you every living thing that is with you of all flesh—birds and animals and every creeping thing that creeps on the earth—that they may breed abundantly on the earth, and be fruitful and multiply upon the earth." 18 So Noah went forth, and his sons and his wife and his sons' wives with him. 19 And every beast, every creeping thing, and every bird, everything that moves upon the earth, went forth by families out of the ark.

20 Then Noah built an altar to the LORD, and took of every clean animal and of every clean bird, and offered burnt offerings on the altar. 21 And when the LORD smelled the pleasing odor, the LORD said in his heart, "I will never again curse the ground because of man, for the imagination of man's heart is evil from his youth; neither will I ever again destroy every living creature as I have done. 22 While the earth remains, seedtime and harvest, cold and heat, summer and winter, day and night, shall not cease."

Chapter 9

And God blessed Noah and his sons, and said to them, "Be fruitful and multiply, and fill the earth. 2 The fear of you and the dread of you shall be upon every beast of the earth, and upon every bird of the air, upon everything that creeps on the ground and all the fish of the sea; into your hand they are delivered. 3 Every moving thing that lives shall be food for you; and as I gave you the green plants, I give you everything. 4 Only you shall not eat flesh with its life, that is, its blood. 5 For your lifeblood I will surely require a reckoning; of every beast I will require it and of man; of every man's brother I will require the life of man. 6 Whoever sheds the blood of man, by man shall his blood be shed; for God made man in his own image. 7 And you, be fruitful and multiply, bring forth abundantly on the earth and multiply in it."

8 Then God said to Noah and to his sons with him, 9 "Behold, I establish my covenant with you and your descendants after you, 10 and with every living creature that is with you, the birds, the cattle, and every beast of the earth with you, as many as came out of the ark. 11 I establish my covenant with you, that never again shall all flesh be cut off by the waters of a flood, and never again shall there be a flood to destroy the earth." 12 And God said, "This is the sign of the covenant which I make between me and you and every living creature that is with you, for all future generations: 13 I set my bow in the cloud, and it shall be a sign of the covenant between me and the earth. 14 When I bring clouds over the earth and the bow is seen in the clouds, 15 I will remember my covenant which is between me and you and every living creature of all flesh; and the waters shall never again become a flood to destroy all flesh. 16 When the bow is in the clouds, I will look upon it and remember the everlasting covenant between God and every living creature of all flesh that is upon the earth." 17 God said to Noah, " This is the sign of the covenant which I have established between me and all flesh that is upon the earth."

18 The sons of Noah who went forth from the ark were Shem, Ham, and Japheth. Ham was the father of Canaan. ¹⁹ These three were the sons of Noah; and from these the whole earth was peopled.

20 Noah was the first tiller of the soil. He planted a vineyard; ²¹ and he drank of the wine, and became drunk, and lay uncovered in his tent. ²² And Ham, the father of Canaan, saw the nakedness of his father, and told his two brothers outside. ²³ Then Shem and Japheth took a garment, laid it upon both their shoulders, and walked backward and covered the nakedness of their father; their faces were turned away, and they did not see their father's nakedness. ²⁴ When Noah awoke from his wine and knew what his youngest son had done to him, ²⁵ he said,

"Cursed be Canaan;
 a slave of slaves shall he be to
 his brothers."
²⁶ He also said,
"Blessed by the LORD my God
 be Shem;
 and let Canaan be his slave.
²⁷ God enlarge Japheth,
 and let him dwell in the tents
 of Shem;
 and let Canaan be his slave."

28 After the flood Noah lived three hundred and fifty years. ²⁹ All the days of Noah were nine hundred and fifty years; and he died.

••

QUESTIONS

1. What similarities do you recognize between the Biblical story of the Flood and that in *Gilgamesh*? What common meaning, if any, can be found in the two ancient Middle Eastern tales?
2. What differences do you see between this account of the Flood and the one in *Gilgamesh*? What differences in particular can be attributed to a monotheistic versus a polytheistic theology?
3. What is the nature of God's covenant with Noah?
4. What symbolic meaning can be attributed to the flood?

••

EXODUS

••

The Ten Commandments

As liberator and savior of Israel, God brought his people out of bondage in Egypt and into the wilderness, where he forged them into a community under the leadership of Moses. In the very first days of their desert sojourn he led them to Mount Sinai where, through Moses, he declared his offer of a covenant with them and sealed the agreement with the revelation of his laws. The translation here is from the King James Version.

Chapter 19

1 In the third month, when the children of Israel were gone forth out of the land of Egypt, the same day came they into the wilderness of Sinai.

2 For they were departed from Rephidim, and were come to the desert of Sinai, and had pitched in the wilderness; and there Israel camped before the mount.

3 And Moses went up unto God, and the Lord called unto him out of the mountain, saying, Thus shalt thou say to the house of Jacob, and tell the children of Israel;

4 Ye have seen what I did unto the Egyptians, and how I bear you on eagles' wings, and brought you unto myself.

5 Now therefore, if ye will obey my voice indeed, and keep my covenant, then ye shall be a peculiar treasure unto me above all people: for all the earth is mine:

6 And ye shall be unto me a kingdom of priests, and an holy nation. These are the words which thou shalt speak unto the children of Israel.

7 And Moses came and called for the elders of the people, and laid before their faces all these words which the Lord commanded him.

8 And all the people answered together, and said, All that the Lord hath spoken we will do. And Moses returned the words of the people unto the Lord.

9 And the Lord said unto Moses, Lo, I come unto thee in a thick cloud, that the people may hear when I speak with thee, and believe thee for ever. And Moses told the words of the people unto the Lord.

10 And the Lord said unto Moses, Go unto the people, and sanctify them to day and to morrow, and let them wash their clothes. . . .

14 And Moses went down from the mount unto the people, and sanctified the people; and they washed their clothes.

15 And he said unto the people, Be ready against the third day: come not at your wives.

16 And it came to pass on the third day in the morning, that there were thunders and lightnings, and a thick cloud upon the mount, and the voice of the trumpet exceeding loud; so that all the people that was in the camp trembled.

17 And Moses brought forth the people out of the camp to meet with God; and they stood at the nether part of the mount.

18 And mount Sinai was altogether on a smoke, because the Lord descended upon it in fire: and the smoke thereof ascended as the smoke of a furnace, and the whole mount quaked greatly.

19 And when the voice of the trumpet sounded long, and waxed louder and louder, Moses spake, and God answered him by a voice.

20 And the Lord came down upon mount Sinai, on the top of the mount; and the Lord called Moses up to the top of the mount; and Moses went up.

21 And the Lord said unto Moses, Go down, charge the people, lest they break through unto the Lord to gaze, and many of them perish.

22 And let the priests also, which come near to the Lord, sanctify themselves, lest the Lord break forth upon them.

23 And Moses said unto the Lord, The people cannot come up to mount Sinai: for thou chargedst us, saying, Set bounds about the mount, and sanctify it.

24 And the Lord said unto him, Away, get thee down, and thou shalt come up, thou, and Aaron with thee: but let not the priests and the people break through to come up unto the Lord, lest he break forth upon them.

25 So Moses went down unto the people, and spake unto them.

Chapter 20

1 And God spake all these words, saying,

2 I am the Lord thy God, which have brought thee out of the land of Egypt, out of the house of bondage.

3 Thou shalt have no other gods before me.

4 Thou shalt not make unto thee any graven image, or any likeness of any thing that is in heaven above, or that is in the earth beneath, or that is in the water under the earth:

5 Thou shalt not bow down thyself to them, nor serve them: for I the Lord thy God am a jealous God, visiting the iniquity of the fathers upon the children unto the third and fourth generation of them that hate me;

6 And shewing mercy unto thousands of them that love me, and keep my commandments.

7 Thou shalt not take the name of the Lord thy God in vain; for the Lord will not hold him guiltless that taketh his name in vain.

8 Remember the sabbath day, to keep it holy.

9 Six days shalt thou labour, and do all thy work:

10 But the seventh day is the sabbath of the Lord thy God: in it thou shalt not do any work, thou, nor thy son, nor thy daughter, thy manservant, nor thy maidservant, nor thy cattle, nor thy stranger that is within thy gates:

11 For in six days the Lord made heaven and earth, the sea, and all that in them is, and rested the seventh day: wherefore the Lord blessed the sabbath day, and hallowed it.

12 Honour thy father and thy mother: that thy days may be long upon the land which the Lord thy God giveth thee.

13 Thou shalt not kill.

14 Thou shalt not commit adultery.

15 Thou shalt not steal.

16 Thou shalt not bear false witness against thy neighbour.

17 Thou shalt not covet thy neighbour's house, thou shalt not covet thy neighbour's wife, nor his manservant, nor his maidservant, nor his ox, nor his ass, nor any thing that is thy neighbour's.

18 And all the people saw the thunderings, and the lightnings, and the noise of the trumpet, and the mountain smoking: and when the people saw it, they removed, and stood afar off.

19 And they said unto Moses, Speak thou with us, and we will hear: but let not God speak with us, lest we die.

20 And Moses said unto the people, Fear not: for God is come to prove you, and that his fear may be before your faces, that ye sin not.

21 And the people stood afar off, and Moses drew near unto the thick darkness where God was.

22 And the Lord said unto Moses, Thus thou shalt say unto the children of Israel, Ye have seen that I have talked with you from heaven. . . .

COMMENTS AND QUESTIONS

1. What previous event does God use to gain credibility for his promise?
2. What is God's promise to the Israelites?
3. In what sense is a covenant established between them and God?
4. The Ten Commandments, or Decalogue, are divided into two parts. The first four relate to the individual's relationship with God, while the last six deal with the sphere of human relationships. Why is the command to honor parents often described as the "bridge" commandment between the two parts?
5. Why, according to Moses, did God reveal himself in a cloud?

JUDGES

The Song of Deborah

This passage recounts and praises in both prose and poetry not only Deborah's victory and her moral leadership, but also the heroic (and bloody) deeds of another heroine, Jael. The translation comes from the Revised Standard Version.

4 Now Deb'orah, a prophetess, the wife of Lapp'-idoth, was judging Israel at that time. [5] She used to sit under the palm of Deb'orah between Ramah and Bethel

in the hill country of E'phraim; and the people of Israel came up to her for judgment. ⁶ She sent and summoned Barak the son of Abin'o-am from Kedesh in Naph'tali, and said to him, "The LORD, the God of Israel, commands you, 'Go, gather your men at Mount Tabor, taking ten thousand from the tribe of Naph'tali and the tribe of Zeb'ulun. ⁷ And I will draw out Sis'era, the general of Jabin's army, to meet you by the river Kishon with his chariots and his troops; and I will give him into your hand.'" ⁸ Barak said to her, "If you will go with me, I will go; but if you will not go with me, I will not go." ⁹ And she said, "I will surely go with you; nevertheless, the road on which you are going will not lead to your glory, for the LORD will sell Sis'era into the hand of a woman." Then Deb'orah arose, and went with Barak to Kedesh. ¹⁰ And Barak summoned Zeb'ulun and Naph'tali to Kedesh; and ten thousand men went up at his heels; and Deb'orah went up with him.

11 Now Heber the Ken'ite had separated from the Ken'ites, the descendants of Hobab the father-in-law of Moses, and had pitched his tent as far away as the oak in Za-anan'nim, which is near Kedesh.

12 When Sis'era was told that Barak the son of Abin'o-am had gone up to Mount Tabor, ¹³ Sis'era called out all his chariots, nine hundred chariots of iron, and all the men who were with him, from Haro'sheth-ha-goiim to the river Kishon. ¹⁴ And Deb'orah said to Barak, "Up! For this is the day in which the LORD has given Sis'era into your hand. Does not the LORD go out before you?" So Barak went down from Mount Tabor with ten thousand men following him. ¹⁵ And the LORD routed Sis'era and all his chariots and all his army before Barak at the edge of the sword; and Sis'era alighted from his chariot and fled away on foot. ¹⁶ And Barak pursued the chariots and the army to Haro'sheth-ha-goiim, and all the army of Sis'era fell by the edge of the sword; not a man was left.

17 But Sis'era fled away on foot to the tent of Ja'el, the wife of Heber the Ken'ite; for there was peace between Jabin the king of Hazor and the house of Heber the Ken'ite. ¹⁸ And Ja'el came out to meet Sis'era, and said to him, "Turn aside, my lord, turn aside to me; have no fear." So he turned aside to her into the tent, and she covered him with a rug. ¹⁹ And he said to her, "Pray, give me a little water to drink, for I am thirsty." So she opened a skin of milk and gave him a drink and covered him. ²⁰ And he said to her, "Stand at the door of the tent, and if any man comes and asks you, 'Is any one here?' say, No." ²¹ But Ja'el the wife of Heber took a tent peg, and took a hammer in her hand, and went softly to him and drove the peg into his temple, till it went down into the ground, as he was lying fast asleep from weariness. So he died. ²² And behold, as Barak pursued Sis'era, Ja'el went out to meet him, and said to him, "Come, and I will show you the man whom you are seeking." So he went in to

her tent; and there lay Sis'era dead, with the tent peg in his temple.

23 So on that day God subdued Jabin the king of Canaan before the people of Israel. ²⁴ And the hand of the people of Israel bore harder and harder on Jabin the king of Canaan, until they destroyed Jabin king of Canaan.

Chapter 5

Then sang Deb'orah and Barak the son of Abin'o-am on that day:

²"That the leaders took the lead in Israel,
 that the people offered themselves
 willingly,
 bless the LORD!
³"Hear, O kings; give ear, O princes;
 to the LORD I will sing,
 I will make melody to the
 LORD, the God of Israel.

⁴ "LORD, when thou didst go forth
 from Se'ir,
 when thou didst march from the
 region of Edom,
 the earth trembled,
 and the heavens dropped,
 yea, the clouds dropped water.
⁵ The mountains quaked before the
 LORD,
 yon Sinai before the LORD, the
 God of Israel.

⁶ "In the days of Shamgar, son of
 Anath,
 in the days of Ja'el, caravans
 ceased
 and travelers kept to the byways.
⁷ The peasantry ceased in Israel, they
 ceased
 until you arose, Deb'orah,
 arose as a mother in Israel.
⁸ When new gods were chosen,
 then war was in the gates.
 Was shield or spear to be seen
 among forty thousand in Israel?
⁹ My heart goes out to the
 commanders of Israel
 who offered themselves willingly
 among the people.
 Bless the LORD.

¹⁰ "Tell of it, you who ride on tawny
 asses,
 you who sit on rich carpets
 and you who walk by the way.

11 To the sound of musicians at the
 watering places,
 there they repeat the triumphs of
 the LORD,
 the triumphs of his peasantry in
 Israel.

 "Then down to the gates marched
 the people of the LORD.

12 "Awake, awake, Deb'orah!
 Awake, awake, utter a song!
 Arise, Barak, lead away your
 captives,
 O son of Abin'o-am.
13 Then down marched the remnant
 of the noble;
 the people of the LORD marched
 down for him against the
 mighty.
14 From E'phraim they set out thither
 into the valley,
 following you, Benjamin, with
 your kinsmen;
 from Machir marched down the
 commanders,
 and from Zeb'ulun those who
 bear the marshal's staff;
15 the princes of Is'sachar came with
 Deb'orah,
 and Is'sachar faithful to Barak;
 into the valley they rushed forth
 at his heels.
 Among the clans of Reuben
 there were great searchings of
 heart.
16 Why did you tarry among the
 sheepfolds,
 to hear the piping for the flocks?
 Among the clans of Reuben
 there were great searchings of
 heart.
17 Gilead stayed beyond the Jordan;
 and Dan, and why did he abide with
 the ships?
 Asher sat still at the coast of the sea,
 settling down by his landings.
18 Zeb'ulun is a people that jeoparded
 their lives to the death;
 Naph'tali too, on the heights of
 the field.

19 "The kings came, they fought;
 then fought the kings of Canaan,
 at Ta'anach, by the waters of
 Megid'do;
 they got no spoils of silver.

20 From heaven fought the stars,
 from their courses they fought
 against Sis'era.
21 The torrent Kishon swept them
 away,
 the onrushing torrent, the
 torrent Kishon.
 March on, my soul, with might!

22 "Then loud beat the horses' hoofs
 with the galloping, galloping of
 his steeds.

23 "Curse Meroz, says the angel of the
 LORD,
 curse bitterly its inhabitants,
 because they came not to the help
 of the LORD,
 to the help of the LORD against the
 mighty.

24 "Most blessed of women be Ja'el,
 the wife of Heber the Ken'ite,
 of tent-dwelling women most
 blessed.
25 He asked water and she gave him
 milk,
 she brought him curds in a lordly
 bowl.
26 She put her hand to the tent peg
 and her right hand to the
 workmen's mallet;
 she struck Sis'era a blow,
 she crushed his head,
 she shattered and pierced his
 temple.
27 He sank, he fell,
 he lay still at her feet;
 at her feet he sank, he fell;
 where he sank, there he fell
 dead.
28 "Out of the window she peered,
 the mother of Sis'era gazed
 through the lattice:
 'Why is his chariot so long in
 coming?
 Why tarry the hoofbeats of his
 chariots?'
29 Her wisest ladies make answer,
 nay, she gives answer to herself,
30 'Are they not finding and dividing
 the spoil?—
 A maiden or two for every man;
 spoil of dyed stuffs for Sis'era,
 spoil of dyed stuffs embroidered,
 two pieces of dyed work

embroidered for my neck
as spoil?'

[31] "So perish all thine enemies,
O LORD!
But thy friends be like the sun as
he rises in his might."

······································

QUESTIONS

1. Summarize the stories that are recounted here. Do you see any differences in the prosaic and poetic versions? Why do you think that both were included in the Scripture?
2. What do we learn of the character and the leadership of Deborah in this passage?
3. In what sense is Jael a heroine? How would we judge her act today?

······································

PSALMS
······································

Psalm 8

No other Old Testament book has enjoyed the perennial success of the Psalms in appealing to readers. A few of the one hundred fifty poems composing the book may go back in some form to the period of King David in the tenth century B.C., but others were doubtless composed centuries later. These poetic works were designed to fulfill specific purposes in temple ritual. More than fifty years ago the German biblical scholar Hermann Gunkel[1] distinguished five major categories of psalms according to functions: (1) hymns of praise, (2) communal laments, (3) royal psalms, (4) individual laments, and (5) individual thanksgiving psalms.

The following hymn of praise (from the King James Version) has as its object the praise of God, but closely associated with the idea of divine greatness here is that of the dignity of the human being. People have a unique relationship with the Creator, and to them he has committed the government of the earth. Consequently, in the biblical tradition, the worth of the individual is grounded directly in God's personal love and in the responsibilities created by that love.

1 O Lord our Lord, how excellent is thy name in all the earth! who hast set thy glory above the heavens.

2 Out of the mouth of babes and sucklings hast thou ordained strength because of thine enemies, that thou mightest still the enemy and the avenger.

3 When I consider thy heavens, the work of thy fingers, the moon and the stars, which thou hast ordained;

4 What is man, that thou art mindful of him? and the son of man, that thou visitest him?

5 For thou hast made him a little lower than the angels, and hast crowned him with glory and honour.

6 Thou madest him to have dominion over the works of thy hands: thou hast put all things under his feet:

7 All sheep and oxen, yea, and the beasts of the field;

8 The fowl of the air, and the fish of the sea, and whatsoever passeth through the paths of the seas.

9 O Lord our Lord, how excellent is thy name in all the earth!

······································

COMMENTS AND QUESTIONS

1. What is meant by the mouths of babes and infants chanting God's glory?
2. A famous saying praising human dignity is attributed to the fifth-century B.C. Greek philosopher Protagoras: "Man is the measure of all things." Compare the basis for human dignity suggested by this statement with that in verse 4 of this psalm.

······································

AMOS
······································

The Prophets

The first in the line of prophets, Amos, lived in the mid-eighth century. During his lifetime, the northern kingdom, to which he primarily directed his words, still enjoyed peace and prosperity. Landed estates expanded; costly homes were built; religious shrines were richly endowed; and the arts flourished. To Amos, however, the scrupulous insistence on religious rites, which was characteristic of the period, masked wholesale immorality: sexual liberty, oppression of the poor, bribery of judges, and corruption in government and business. Amos' emphasis on the spirit rather than the letter of religion and his burning sense of social justice also characterized the prophets who followed him.

This translation is from the King James Version.

Chapter 5

10 They hate him that rebuketh in the gate, and they abhor him that speaketh uprightly.

11 Forasmuch therefore as your treading is upon the poor, and ye take from him burdens of wheat: ye have built houses of hewn stone, but ye shall not dwell in them; ye have planted pleasant vineyards, but ye shall not drink wine of them.

[1] Hermann Gunkel, *The Psalms,* trans. Thomas M. Horner (Philadelphia: Fortress Press, 1967).

12 For I know your manifold transgressions and your mighty sins: they afflict the just, they take a bribe, and they turn aside the poor in the gate from their right.

13 Therefore the prudent shall keep silence in that time: for it *is* an evil time.

14 Seek good, and not evil, that ye may live: and so the Lord, the God of hosts, shall be with you, as ye have spoken.

15 Hate the evil, and love the good, and establish judgment in the gate: it may be that the Lord God of hosts will be gracious unto the remnant of Joseph.

16 Therefore the Lord, the God of hosts, the Lord, saith thus; Wailing shall be in all streets; and they shall say in all the highways, Alas! alas! and they shall call the husbandman to mourning, and such as are skilful of lamentation to wailing.

17 And in all vineyards shall be wailing: for I will pass through thee, saith the Lord.

18 Woe unto you that desire the day of the Lord! to what end is it for you? the day of the Lord is darkness, and not light.

19 As if a man did flee from a lion, and a bear met him; or went into the house, and leaned his hand on the wall, and a serpent bit him.

20 Shall not the day of the Lord be darkness, and not light? even very dark, and no brightness in it?

21 I hate, I despise your feast days, and I will not smell in your solemn assemblies.

22 Though ye offer me burnt offerings and your meat offerings, I will not accept them: neither will I regard the peace offerings of your fat beasts.

23 Take thou away from me the noise of thy songs; for I will not hear the melody of thy viols.

24 But let judgment run down as waters, and righteousness as a mighty stream.

QUESTIONS

1. How does Amos expect his prophesy to be received? What does the prudent man say in such dangerous times?
2. What is meant in verse 12 when the poor in the gate are said to be turned aside "from their right"? What does "the gate" refer to here and elsewhere in this selection?
3. Why will the Lord not accept the sacrifices and prayers of his people?
4. What threats does Amos make?

from the *Song of Solomon*

Hebraic literature has greatly influenced our culture, primarily through the religious views that are devel-

oped in it and, along with them, a concept of morality. One book of the Bible, however, has been influential in quite different ways and represents a unique form of biblical literature. This is the Song of Songs, called in the King James Version the Song of Solomon. Its authorship is unknown, but because of King Solomon's reputation for wisdom and poetic gifts, it was attributed to him. It is unique in the Bible in that God is never mentioned in it. What it appears to be is a passionate love poem, or more likely several love lyrics that were at some point (scholars speculate by the fifth century B.C.) collected together. Sometimes the speaker is the lover, or bridegroom, sometimes the beloved, or bride. In the course of the poems they are united, separated, sought by each other, found. The awakening of love is closely allied with the awakening of nature in springtime. The lovers celebrate each other's physical beauty and the marvel of being in love, all with a direct and sensuous imagery.

One may well ask how such a poem found its way into a collection of sacred Scripture. No one has the definitive answer to this question, but it has puzzled scholars for centuries. Both Jewish and Christian commentators have attempted to explain away its sensuous, physical aspects by *allegorical* interpretations. In the Jewish tradition, the lover was said to represent Jahweh and the beloved his people, Israel. In the Christian version of the *allegory,* the lover becomes Christ, the beloved his Church. This allegorical way of thinking came to be of great importance to the medieval Christian mentality, as we shall discover in later chapters.

More recent scholars believe that the poems in the Song of Songs are what they appear to be—celebrations of human love. They were probably originally folk poems, and they may have been sung at weddings. In any case, they have become a part of our lyric tradition and have influenced the ways in which we express love between man and woman.

Chapter 1

1 The song of songs, which is Solomon's.

2 Let him kiss me with the kisses of his mouth: for thy love is better than wine.

3 Because of the savour of thy good ointments thy name is as ointment poured forth, therefore do the virgins love thee.

4 Draw me, we will run after thee: the king hath brought me into his chambers: we will be glad and rejoice in thee, we will remember thy love more than wine: the upright love thee.

5 I am black, but comely, O ye daughters of Jerusalem, as the tents of Kedar, as the curtains of Solomon.

6 Look not upon me, because I am black, because the sun hath looked upon me: my mother's children were angry with me; they made me the keeper of the vineyards; but mine own vineyard have I not kept.

7 Tell me, O thou whom my soul loveth, where thou feedest, where thou makest thy flock to rest at noon: for why should I be as one that turneth aside by the flocks of thy companions?

8 If thou know not, O thou fairest among women, go thy way forth by the footsteps of the flock, and feed thy kids beside the shepherds' tents.

9 I have compared thee, O my love, to a company of horses in Pharaoh's chariots.

10 Thy cheeks are comely with rows of jewels, thy neck with chains of gold.

11 We will make thee borders of gold with studs of silver.

12 While the king sitteth at his table, my spikenard sendeth forth the smell thereof.

13 A bundle of myrrh is my wellbeloved unto me; he shall lie all night betwixt my breasts.

14 My beloved is unto me as a cluster of camphire in the vineyards of Engedi.

15 Behold, thou art fair, my love; behold, thou art fair; thou hast doves' eyes.

16 Behold, thou art fair, my beloved, yea, pleasant: also our bed is green.

17 The beams of our house are cedar, and our rafters of fir.

Chapter 2

1 I am the rose of Sharon, and the lily of the valleys.

2 As the lily among thorns, so is my love among the daughters.

3 As the apple tree among the trees of the wood, so is my beloved among the sons. I sat down under his shadow with great delight, and his fruit was sweet to my taste.

4 He brought me to the banqueting house, and his banner over me was love.

5 Stay me with flagons, comfort me with apples: for I am sick of love.

6 His left hand is under my head, and his right hand doth embrace me.

7 I charge you, O ye daughters of Jerusalem, by the roes, and by the hinds of the field, that ye stir not up, nor awake my love, till he please.

8 The voice of my beloved! behold, he cometh leaping upon the mountains, skipping upon the hills.

9 My beloved is like a roe or a young hart: behold, he standeth behind our wall, he looketh forth at the windows, shewing himself through the lattice.

10 My beloved spake, and said unto me, Rise up, my love, my fair one, and come away.

11 For, lo, the winter is past, the rain is over and gone;

12 The flowers appear on the earth; the time of the singing of birds is come, and the voice of the turtle is heard in our land;

13 The fig tree putteth forth her green figs, and the vines with the tender grape give a good smell. Arise, my love, my fair one, and come away.

14 O my dove, that art in the clefts of the rock, in the secret places of the stairs, let me see thy countenance, let me hear thy voice; for sweet is thy voice, and thy countenance is comely.

15 Take us the foxes, the little foxes, that spoil the vines: for our vines have tender grapes.

16 My beloved is mine, and I am his: he feedeth among the lilies.

17 Until the day break, and the shadows flee away, turn, my beloved, and be thou like a roe or a young hart upon the mountains of Bether.

COMMENTS AND QUESTIONS

1. The best-known, most often quoted part of the Song of Solomon is in its Chapter 2, verses 10–17. How would you explain its appeal?

2. The association between love and spring is, of course, by now an overworked cliché. Is the statement made here nevertheless still fresh and powerful?

3. Compare these love lyrics with the Egyptian ones in Chapter 2 of this textbook and with those of Sappho in Chapter 3. Which is the richest in imagery? If you were to paint your impressions of them, which would have more color and more varied *textures*?

4. How would you describe the relationship between man and woman as it appears in these two chapters of the Song of Solomon?

5. Do you see any justification for the Jewish or the Christian allegorical interpretations?

● TEXTS FROM THE NEW ● TESTAMENT

THE GOSPEL ACCORDING TO LUKE

The Magnificat

Stories about the birth of Jesus vary in the accounts of the four Gospels (Matthew, Mark, Luke, and John), with Luke giving the most complete account (in Chapter 1 of his Gospel) and John none at all. One of the important events in this narrative is the visitation of the angel Gabriel to Mary, to announce to her that God has chosen her to be the mother of the Messiah. The song that Mary sings in response to this announcement, called The Magnificat because it begins with the phrase "My soul magnifies the

Lord," has been set to music by numerous composers. The visit of the angel—or the Annunciation—became a frequent subject of painting in the Middle Ages and the Renaissance (see Color Plate VII). At the same time, the angel announces that Mary's cousin Elizabeth is pregnant with the prophet John the Baptist.

For purposes of comparison, we have printed this passage in four different English translations from the original Greek.

King James Version

26 And in the sixth month the angel Gabriel was sent from God into a city of Galilee, named Nazareth, 27 To a virgin espoused to a man whose name was Joseph, of the house of David; and the virgin's name *was* Mary. 28 And the angel came in unto her, and said, Hail, *thou that art* highly favoured, the Lord *is* with thee: blessed *art* thou among women. 29 And when she saw *him*, she was troubled at his saying, and cast in her mind what manner of salutation this should be. 30 And the angel said unto her, Fear not, Mary: for thou hast found favour with God. 31 And, behold, thou shalt conceive in thy womb, and bring forth a son, and shalt call his name JESUS. 32 He shall be great, and shall be called the Son of the Highest; and the Lord God shall give unto him the throne of his father David: 33 And he shall reign over the house of Jacob for ever; and of his kingdom there shall be no end. 34 Then said Mary unto the angel, How shall this be, seeing I know not a man? 35 And the angel answered and said unto her, The Holy Ghost shall come upon thee, and the power of the Highest shall overshadow thee: therefore also that holy thing which shall be born of thee shall be called the Son of God. 36 And, behold, thy cousin Elisabeth, she hath also conceived a son in her old age; and this is the sixth month with her, who was called barren. 37 For with God nothing shall be impossible. 38 And Mary said, Behold the handmaid of the Lord; be it unto me according to thy word. And the angel departed from her. 39 And Mary arose in those days, and went into the hill country with haste, into a city of Juda; 40 And entered into the house of Zacharias, and saluted Elisabeth. 41 And it came to pass, that, when Elisabeth heard the salutation of Mary, the babe leaped in her womb; and Elisabeth was filled with the Holy Ghost: 42 And she spake out with a loud voice, and said, Blessed *art* thou among women, and blessed *is* the fruit of thy womb. 43 And whence *is* this to me, that the mother of my Lord should come to me? 44 For, lo, as soon as the voice of thy salutation sounded in mine ears, the babe leaped in my womb for joy. 45 And blessed *is* she that believed: for there shall be a performance of those things which were told her from the Lord. 46 And Mary said,

My soul doth magnify the Lord, 47 And my spirit hath rejoiced in God my Saviour. 48 For he hath regarded the low estate of his handmaiden: for, behold, from henceforth all generations shall call me blessed. 49 For he that is mighty hath done to me great things; and holy *is* his name. 50 And his mercy *is* on them that fear him from generation to generation. 51 He hath shewed strength with his arm; He hath scattered the proud in the imagination of their hearts. 52 He hath put down the mighty from *their* seats, and exalted them of low degree. 53 He hath filled the hungry with good things; and the rich he hath sent empty away. 54 He hath holpen his servant Israel, in remembrance of *his* mercy; 55 As he spake to our fathers, to Abraham, and to his seed for ever.

Revised Standard Version

26 In the sixth month the angel Gabriel was sent from God to a city of Galilee named Nazareth, 27 to a virgin betrothed to a man whose name was Joseph, of the house of David; and the virgin's name was Mary. 28 And he came to her and said. "Hail, O favored one, the Lord is with you." 29 But she was greatly troubled at the saying, and considered in her mind what sort of greeting this might be. 30 And the angel said to her, "Do not be afraid, Mary, for you have found favor with God. 31 And behold, you will conceive in your womb and bear a son, and you shall call his name Jesus.

> 32 He will be great, and will be called the Son
> of the Most High;
> and the Lord God will give to him the
> throne of his father David,
> 33 and he will reign over the house of Jacob
> for ever;
> and of his kingdom there will be no end."

34 And Mary said to the angel, "How can this be, since I have no husband?" 35 And the angel said to her,

> "The Holy Spirit will come upon you,
> and the power of the Most High will over-
> shadow you;
> therefore the child to be born will be called
> holy,
> the Son of God.

36 And behold, your kinswoman Elizabeth in her old age has also conceived a son; and this is the sixth month with her who was called barren. 37 For with God nothing will be impossible." 38 And Mary said, "Behold, I am the handmaid of the Lord; let it be to me according to your word." And the angel departed from her.

39 In those days Mary arose and went with haste into the hill country, to a city of Judah, 40 and she en-

tered the house of Zechariah and greeted Elizabeth. [41] And when Elizabeth heard the greeting of Mary, the babe leaped in her womb; and Elizabeth was filled with the Holy Spirit [42] and she exclaimed with a loud cry, "Blessed are you among women, and blessed is the fruit of your womb! [43] And why is this granted me, that the mother of my Lord should come to me? [44] For behold, when the voice of your greeting came to my ears, the babe in my womb leaped for joy. [45] And blessed is she who believed that there would be a fulfilment of what was spoken to her from the Lord." [46] And Mary said,

> "My soul magnifies the Lord,
> [47] and my spirit rejoices in God my Savior,
> [48] for he has regarded the low estate of his
> handmaiden.
> For behold, henceforth all generations will
> call me blessed;
> [49] for he who is mighty has done great things
> for me,
> and holy is his name.
> [50] And his mercy is on those who fear him
> from generation to generation.
> [51] He has shown strength with his arm,
> he has scattered the proud in the imagina
> tion of their hearts,
> [52] he has put down the mighty from their
> thrones,
> and exalted those of low degree;
> [53] he has filled the hungry with good things,
> and the rich he has sent empty away.
> [54] He has helped his servant Israel,
> in remembrance of his mercy,
> [55] as he spoke to our fathers,
> to Abraham and to his posterity for ever."

Phillips

A vision comes to a young woman in Nazareth 1.26

Then, six months after Zacharias' vision, the angel Gabriel was sent from God to a Galilean town, Nazareth by name, to a young woman who was engaged to a man called Joseph (a descendant of David). The girl's name was Mary. The angel entered her room and said,

"Greetings to you, Mary. O favored one!—the Lord be with you!"

Mary was deeply perturbed at these words and wondered what such a greeting could possibly mean. But the angel said to her:

"Do not be afraid, Mary; God loves you dearly. You are going to be the mother of a son, and you will call him Jesus. He will be great and will be known as the Son of the most high. The Lord God will give him the throne of his forefather, David, and he will be king over the people of Jacob for ever. His reign shall never end."

Then Mary spoke to the angel,

"How can this be?" she said, "I am not married!" But the angel made this reply to her:

"The Holy Spirit will come upon you, the power of the most high will overshadow you. Your child will therefore be called holy—the Son of God. Your cousin Elisabeth has also conceived a son, old as she is. Indeed, this is the sixth month for her, a woman who was called barren. For no promise of God can fail to be fulfilled."

"I belong to the Lord, body and soul," replied Mary, "let it happen as you say." And at this the angel left her.

With little delay Mary got ready and hurried off to the hillside town in Judaea where Zacharias and Elisabeth lived. She went into their house and greeted her cousin. When Elisabeth heard her greeting, the unborn child stirred inside her and she herself was filled with the Holy Spirit, and cried out:

"Blessed are you among women, and blessed is your child! What an honor it is to have the mother of my Lord come to see me! Why, as soon as your greeting reached my ears, the child within me jumped for joy! Oh, how happy is the woman who believes in God, for he does make his promises to her come true!"

Then Mary said: "My heart is overflowing with praise of my Lord; my soul is full of joy in God my Savior. For he has deigned to notice me, his humble servant and, after this, all the people who ever shall be will call me the happiest of women! The one who can do all things has done great things for me—oh, holy is his Name! Truly, his mercy rests on those who fear him in every generation. He has shown the strength of his arm, he has swept away the high and mighty. He has set kings down from their thrones and lifted up the humble. He has satisfied the hungry with goods things and sent the rich away with empty hands. Yes, he has helped Israel, his child: he has remembered the mercy that he promised to our forefathers, to Abraham and his sons for evermore!"

New English Bible

In the sixth month the angel Gabriel was sent from God to a town in Galilee called Nazareth, with a message for a girl betrothed to a man named Joseph, a descendant of David; the girl's name was Mary. The angel went in and said to her, 'Greetings, most favoured one! The Lord is with you.' But she was deeply troubled by what he said and wondered what this greeting might mean. Then the angel said to her, 'Do not be afraid, Mary, for God has been gracious to you; you shall conceive and bear a son, and you shall give him the name Jesus. He will be great; he will bear the title "Son of the Most High"; the Lord God will give him the throne of his ancestor David, and he will be king over Israel for ever; his reign shall never end.' 'How can this be,' said Mary 'when I have no husband?'

The angel answered, 'The Holy Spirit will come upon you, and the power of the Most High will overshadow you; and for that reason the holy child to be born will be called "Son of God". Moreover your kinswoman Elizabeth has herself conceived a son in her old age; and she who is reputed barren is now in her sixth month, for God's promises can never fail.' 'Here am I,' said Mary; 'I am the Lord's servant; as you have spoken, so be it.' Then the angel left her.

About this time Mary set out and went straight to a town in the uplands of Judah. She went into Zechariah's house and greeted Elizabeth. And when Elizabeth heard Mary's greeting, the baby stirred in her womb. Then Elizabeth was filled with the Holy Spirit and cried aloud, 'God's blessing is on you above all women, and his blessing is on the fruit of your womb. Who am I, that the mother of my Lord should visit me? I tell you, when your greeting sounded in my ears, the baby in my womb leapt for joy. How happy is she who has had faith that the Lord's promise would be fulfilled!'

And Mary said:

'Tell out, my soul, the greatness of the Lord,
rejoice, rejoice, my spirit, in God my saviour;
so tenderly has he looked upon his servant,
 humble as she is.
For, from this day forth,
all generations will count me blessed,
so wonderfully has he dealt with me,
 the Lord, the Mighty One.

 His name is Holy;
his mercy sure from generation to generation
 toward those who fear him;
the deeds his own right arm has done
 disclose his might:
the arrogant of heart and mind he has put to
 rout,
he has torn imperial powers from their thrones,
 but the humble have been lifted high.
The hungry he has satisfied with good things,
 the rich sent empty away.
He has ranged himself at the side of Israel his
 servant;
 firm in his promise to our forefathers,
he has not forgotten to show mercy to Abraham
 and his children's children, for ever.'

QUESTIONS

1. What significant differences can you find in the four translations? How do they differ in style?
2. In your view, which translation renders best the beauty of the Magnificat? What is the primary emotion expressed in this song?
3. How and why does Mary's attitude change in the course of the story?
4. What do we learn of the characters of Mary and Elizabeth in this passage?

THE GOSPEL ACCORDING TO MATTHEW

The Sermon on the Mount

In the following text (King James Version), Jesus tells his followers the essentials of Christian doctrine.

Chapter 5

1 And seeing the multitudes, he went up into a mountain: and when he was set, his disciples came unto him:

2 And he opened his mouth, and taught them, saying,

3 Blessed are the poor in spirit: for theirs is the kingdom of heaven.

4 Blessed are they that mourn: for they shall be comforted.

5 Blessed are the meek: for they shall inherit the earth.

6 Blessed are they which do hunger and thirst after righteousness: for they shall be filled.

7 Blessed are the merciful: for they shall obtain mercy.

8 Blessed are the pure in heart: for they shall see God.

9 Blessed are the peacemakers: for they shall be called the children of God.

10 Blessed are they which are persecuted for righteousness' sake: for theirs is the kingdom of heaven.

11 Blessed are ye, when men shall revile you, and persecute you, and shall say all manner of evil against you falsely, for my sake.

12 Rejoice, and be exceeding glad: for great is your reward in heaven: for so persecuted they the prophets which were before you.

13 Ye are the salt of the earth: but if the salt have lost his savour, wherewith shall it be salted? it is thenceforth good for nothing, but to be cast out, and to be trodden under foot of men.

14 Ye are the light of the world. A city that is set on an hill cannot be hid.

15 Neither do men light a candle, and put it under a bushel, but on a candlestick; and it giveth light unto all that are in the house.

16 Let your light so shine before men, that they may see your good works, and glorify your Father which is in heaven.

17 Think not that I am come to destroy the law, or the prophets: I am not come to destroy, but to fulfil.

18 For verily I say unto you, Till heaven and earth pass, one jot or one tittle shall in no wise pass from the law, till all be fulfilled.

19 Whosoever therefore shall break one of these least commandments, and shall teach men so, he shall be called the least in the kingdom of heaven: but whosoever shall do and teach them, the same shall be called great in the kingdom of heaven.

20 For I say unto you, That except your righteousness shall exceed the righteousness of the scribes and Pharisees, ye shall in no case enter into the kingdom of heaven.

21 Ye have heard that it was said by them of old time, Thou shalt not kill; and whosoever shall kill shall be in danger of the judgment:

22 But I say unto you, That whosoever is angry with his brother without a cause shall be in danger of the judgment: and whosoever shall say to his brother, Raca, shall be in danger of the council: but whosoever shall say, Thou fool, shall be in danger of hell fire.

23 Therefore if thou bring thy gift to the altar, and there rememberest that thy brother hath ought against thee;

24 Leave there thy gift before the altar, and go thy way; first be reconciled to thy brother, and then come and offer thy gift.

25 Agree with thine adversary quickly, whiles thou art in the way with him; lest at any time the adversary deliver thee to the judge, and the judge deliver thee to the officer, and thou be cast into prison.

26 Verily I say unto thee, Thou shalt by no means come out thence, till thou has paid the uttermost farthing.

27 Ye have heard that it was said by them of old time, Thou shalt not commit adultery:

28 But I say unto you, That whosoever looketh on a woman to lust after her hath committed adultery with her already in his heart.

29 And if thy right eye offend thee, pluck it out, and cast it from thee: for it is profitable for thee that one of thy members should perish, and not that thy whole body should be cast into hell.

30 And if thy right hand offend thee, cut it off, and cast it from thee: for it is profitable for thee that one of thy members should perish, and not that thy whole body should be cast into hell.

31 It hath been said, Whosoever shall put away his wife, let him give her a writing of divorcement:

32 But I say unto you, That whosoever shall put away his wife, saving for the cause of fornication, causeth her to commit adultery: and whosoever shall marry her that is divorced committeth adultery.

33 Again, ye have heard that it hath been said by them of old time, Thou shalt not forswear thyself, but shalt perform unto the Lord thine oaths:

34 But I say unto you, Swear not at all; neither by heaven; for it is God's throne:

35 Nor by the earth; for it is his footstool: neither by Jerusalem; for it is the city of the great King.

36 Neither shalt thou swear by thy head, because thou canst not make one hair white or black.

37 But let your communication be, Yea, yea; Nay, nay: for whatsoever is more than these cometh of evil.

38 Ye have heard that it hath been said, An eye for an eye, and a tooth for a tooth:

39 But I say unto you, That ye resist not evil: but whosoever shall smite thee on thy right cheek, turn to him the other also.

40 And if any man will sue thee at the law, and take away thy coat, let him have thy cloke also.

41 And whosoever shall compel thee to go a mile, go with him twain.

42 Give to him that asketh thee, and from him that would borrow of thee turn not thou away.

43 Ye have heard that it hath been said, Thou shalt love thy neighbour, and hate thine enemy.

44 But I say unto you, Love your enemies, bless them that curse you, do good to them that hate you, and pray for them which despitefully use you, and persecute you;

45 That ye may be the children of your Father which is in heaven: for he maketh his sun to rise on the evil and on the good, and sendeth rain on the just and on the unjust.

46 For if ye love them which love you, what reward have ye? do not even the publicans the same?

47 And if ye salute your brethren only, what do ye more than others? do not even the publicans so?

48 Be ye therefore perfect, even as your Father which is in heaven is perfect.

Chapter 6

1 Take heed that ye do not your alms before men, to be seen of them: otherwise ye have no reward of your Father which is in heaven.

2 Therefore when thou doest thine alms, do not sound a trumpet before thee, as the hypocrites do in the synagogues and in the streets, that they may have glory of men. Verily I say unto you, They have their reward.

3 But when thou doest alms, let not thy left hand know what thy right hand doeth:

4 That thine alms may be in secret: and thy Father which seeth in secret himself shall reward thee openly.

5 And when thou prayest, thou shalt not be as the hypocrites are: for they love to pray standing in the synagogues and in the corners of the streets, that they may be seen of men. Verily I say unto you, They have their reward.

6 But thou, when thou prayest, enter into thy closet, and when thou hast shut thy door, pray to thy Father which is in secret; and thy Father which seeth in secret shall reward thee openly.

7 But when ye pray, use not vain repetitions, as the heathen do: for they think that they shall be heard for their much speaking.

8 Be not ye therefore like unto them: for your Father knoweth what things ye have need of, before ye ask him.

9 After this manner therefore pray ye: Our Father which art in heaven, Hallowed be thy name.

10 Thy kingdom come. Thy will be done in earth, as it is in heaven.

11 Give us this day our daily bread.

12 And forgive us our debts, as we forgive our debtors.

13 And lead us not into temptation, but deliver us from evil: For thine is the kingdom, and the power, and the glory, for ever. Amen.

14 For if ye forgive men their trespasses, your heavenly Father will also forgive you:

15 But if ye forgive not men their trespasses, neither will your Father forgive your trespasses.

16 Moreover when ye fast, be not, as the hypocrites, of a sad countenance: for they disfigure their faces, that they may appear unto men to fast. Verily I say unto you, They have their reward.

17 But thou, when thou fastest, anoint thine head, and wash thy face;

18 That thou appear not unto men to fast, but unto thy Father which is in secret: and thy Father, which seeth in secret, shall reward thee openly.

19 Lay not up for yourselves treasures upon earth, where moth and rust doth corrupt, and where thieves break through and steal:

20 But lay up for yourselves treasures in heaven, where neither moth nor rust doth corrupt, and where thieves do not break through nor steal:

21 For where your treasure is, there will your heart be also.

22 The light of the body is the eye: if therefore thine eye be single, thy whole body shall be full of light.

23 But if thine eye be evil, thy whole body shall be full of darkness. If therefore the light that is in thee be darkness, how great is that darkness!

24 No man can serve two masters: for either he will hate the one, and love the other; or else he will hold to the one, and despise the other. Ye cannot serve God and mammon.

25 Therefore I say unto you, Take no thought for your life, what ye shall eat, or what ye shall drink; nor yet for your body, what ye shall put on. Is not the life more than meat, and the body than raiment?

26 Behold the fowls of the air: for they sow not, neither do they reap, nor gather into barns; yet your heavenly Father feedeth them. Are ye not much better than they?

27 Which of you by taking thought can add one cubit unto his stature?

28 And why take ye thought for raiment? Consider the lilies of the field, how they grow; they toil not, neither do they spin:

29 And yet I say unto you, That even Solomon in all his glory was not arrayed like one of these.

30 Wherefore, if God so clothe the grass of the field, which to day is, and to morrow is cast into the oven, shall he not much more clothe you, O ye of little faith?

31 Therefore take no thought, saying, What shall we eat? or, What shall we drink? or, Wherewithal shall we be clothed?

32 For after all these things do the Gentiles seek: for your heavenly Father knoweth that ye have need of all these things.

33 But seek ye first the kingdom of God, and his righteousness; and all these things shall be added unto you.

34 Take therefore no thought for the morrow: for the morrow shall take thought for the things of itself. Sufficient unto the day is the evil thereof.

Chapter 7

1 Judge not, that ye be not judged.

2 For with what judgment ye judge, ye shall be judged: and with what measure ye mete, it shall be measured to you again.

3 And why beholdest thou the mote that is in thy brother's eye, but considerest not the beam that is in thine own eye?

4 Or how wilt thou say to thy brother, Let me pull out the mote out of thine eye; and, behold, a beam is in thine own eye?

5 Thou hypocrite, first cast out the beam out of thine own eye; and then shalt thou see clearly to cast out the mote out of thy brother's eye.

6 Give not that which is holy unto the dogs, neither cast ye your pearls before swine, lest they trample them under their feet, and turn again and rend you.

7 Ask, and it shall be given you; seek, and ye shall find; knock, and it shall be opened unto you:

8 For every one that asketh receiveth; and he that seeketh findeth; and to him that knocketh it shall be opened.

9 Or what man is there of you, whom if his son ask bread, will he give him a stone?

10 Or if he ask a fish, will he give him a serpent?

11 If ye then, being evil, know how to give good gifts unto your children, how much more shall your Father which is in heaven give good things to them that ask him?

12 Therefore all things whatsoever ye would that men should do to you, do ye even so to them: for this is the law and the prophets.

13 Enter ye in at the strait gate: for wide is the gate, and broad is the way, that leadeth to destruction, and many there be which go in thereat:

14 Because strait is the gate, and narrow is the way, which leadeth unto life, and few there be that find it.

15 Beware of false prophets, which come to you in sheep's clothing, but inwardly they are ravening wolves.

16 Ye shall know them by their fruits. Do men gather grapes of thorns, or figs of thistles?

17 Even so every good tree bringeth forth good fruit; but a corrupt tree bringeth forth evil fruit.

18 A good tree cannot bring forth evil fruit, neither can a corrupt tree bring forth good fruit.

19 Every tree that bringeth not forth good fruit is hewn down, and cast into the fire.

20 Wherefore by their fruits ye shall know them.

21 Not every one that saith unto me, Lord, Lord, shall enter into the kingdom of heaven; but he that doeth the will of my Father which is in heaven.

22 Many will say to me in that day, Lord, Lord, have we not prophesied in thy name? and in thy name have cast out devils? and in thy name done many wonderful works?

23 And then will I profess unto them, I never knew you: depart from me, ye that work iniquity.

24 Therefore whosoever heareth these sayings of mine, and doeth them, I will liken him unto a wise man, which built his house upon a rock:

25 And the rain descended, and the floods came, and the winds blew, and beat upon that house; and it fell not: for it was founded upon a rock.

26 And every one that heareth these sayings of mine, and doeth them not, shall be likened unto a foolish man, which built his house upon the sand:

27 And the rain descended, and the floods came, and the winds blew, and beat upon that house; and it fell: and great was the fall of it.

28 And it came to pass, when Jesus had ended these sayings, the people were astonished at his doctrine:

29 For he taught them as one having authority, and not as the scribes.

QUESTIONS

1. What does Jesus demand of his followers, and what does he promise?
2. What kind of a leader, what kind of personality, is Jesus?
3. Why do you think he speaks in parables and "similitudes"? What is the effect of the comparisons made?
4. To what extent does Jesus, in his views, reject the Jewish heritage?

THE APOSTLE PAUL

from the *Letter to the Ephesians*
King James Version

Paul has frequently been referred to as the founder of Christian theology. His mind well trained in Jewish law and clearly influenced by late Hellenistic culture, Paul was sure to offer a highly developed interpretation of what came to him as the simple faith of primitive Christianity. His emphasis on the central significance of Christ's death and resurrection for human salvation was doubtless original. By nature children of Adam, we share in the heritage of sin. We are Christ's, on the other hand, by adoption—a concept of Roman law—and thereby share in God's kingdom. Through the suffering and death of Christ, human sins are forgiven, and the belief in that redemptive act becomes the source for a new life of love: "Far be it from me to glory save in the cross of our Lord Jesus Christ" (Gal. 6:14). Christ's resurrection, moreover, is proof that Jesus was God's own son and that we, as believers, after leading a rich spiritual life, will also live eternally in paradise. Thus Paul proclaims (1 Cor. 2:2): "For I decided to know nothing . . . except Jesus Christ and him crucified."

Paul declares emphatically that no one has a *right* to become a child of Christ. Adoption is a gift of God, that is, an act of divine grace. God decides on whom he will bestow the privilege. The condition for the reception of grace is faith. As Paul writes (Rom. 10:9): "If thou shalt confess with thy mouth Jesus as Lord, and shalt believe in thy heart that God raised Him from the dead, thou shalt be saved." The essence of Christian life, therefore, lies in a vital, personal relationship between the individual and Christ. For Paul, Christ, the Son of God, is his Lord and Redeemer.

Chapter 2

1 And you hath he quickened, who were dead in trespasses and sins;

2 Wherein in time past ye walked according to the course of this world, according to the prince of the power of the air, the spirit that now worketh in the children of disobedience:

3 Among whom also we all had our conversation in times past in the lusts of our flesh, fulfilling the desires of the flesh and of the mind; and were by nature the children of wrath, even as others.

4 But God, who is rich in mercy, for his great love wherewith he loved us,

5 Even when we were dead in sins, hath quickened us together with Christ, (by grace ye are saved;)

6 And hath raised us up together, and made us sit together in heavenly places in Christ Jesus:

7 That in the ages to come he might shew the exceeding riches of his grace in his kindness toward us through Christ Jesus.

8 For by grace are ye saved through faith; and that not of yourselves: it is the gift of God:

9 Not of works, lest any man should boast.

10 For we are his workmanship, created in Christ Jesus unto good works, which God hath before ordained that we should walk in them.

11 Wherefore remember, that ye being in time past Gentiles in the flesh, who are called Uncircumcision by that which is called the Circumcision in the flesh made by hands;

12 That at that time ye were without Christ, being aliens from the commonwealth of Israel, and strangers from the covenants of promise, having no hope, and without God in the world:

13 But now in Christ Jesus ye who sometimes were far off are made nigh by the blood of Christ.

14 For he is our peace, who hath made both one, and hath broken down the middle wall of partition between us;

15 Having abolished in his flesh the enmity, even the law of commandments contained in ordinances; for to make in himself of twain one new man, so making peace;

16 And that he might reconcile both unto God in one body by the cross, having slain the enmity thereby:

17 And came and preached peace to you which were afar off, and to them that were nigh.

18 For through him we both have access by one Spirit unto the Father.

19 Now therefore ye are no more strangers and foreigners, but fellowcitizens with the saints, and of the household of God;

20 And are built upon the foundation of the apostles and prophets, Jesus Christ himself being the chief corner stone;

21 In whom all the building fitly framed together groweth unto an holy temple in the Lord:

22 In whom ye also are builded together for an habitation of God through the Spirit.

Chapter 3

1 For this cause I Paul, the prisoner of Jesus Christ for you Gentiles,

2 If ye have heard of the dispensation of the grace of God which is given me to you-ward:

3 How that by revelation he made known unto me the mystery; (as I wrote afore in few words,

4 Whereby, when ye read ye may understand my knowledge in the mystery of Christ)

5 Which in other ages was not made known unto the sons of men, as it is now revealed unto his holy apostles and prophets by the Spirit;

6 That the Gentiles should be fellowheirs, and of the same body, and partakers of his promise in Christ by the gospel:

7 Whereof I was made a minister, according to the gift of the grace of God given unto me by the effectual working of his power.

8 Unto me, who am less than the least of all saints is this grace given, that I should preach among the Gentiles the unsearchable riches of Christ;

9 And to make all men see what is the fellowship of the mystery, which from the beginning of the world hath been hid in God, who created all things by Jesus Christ:

10 To the intent that now unto the principalities and powers in heavenly places might be known by the church the manifold wisdom of God,

11 According to the eternal purpose which he purposed in Christ Jesus our Lord:

12 In whom we have boldness and access with confidence by the faith of him.

COMMENTS AND QUESTIONS

1. How does Paul characterize the life of the individual before coming to Christ?
2. Why did God give us eternal life?
3. The Church of Ephesus in Asia Minor was composed primarily of Gentiles. How did they become, according to Paul, one with the commonwealth of Israel? That is, how was peace established between Jew and Gentile?
4. How did Christ abolish the "law of commandments and ordinances"?

from the *First Letter to the Corinthians*

At the center of the new spiritual life of the Christian is love. In the following passage from 1 Cor. 13, Paul strikingly dramatizes the emphasis Christ placed on the love toward God and one's neighbor (translated as "charity" in the King James Version below) that he expected from his followers.

Chapter 13

1 Though I speak with the tongues of men and of angels, and have not charity, I am become as sounding brass, or a tinkling cymbal.

2 And though I have the gift of prophecy, and understand all mysteries, and all knowledge; and though I have all faith, so that I could remove mountains, and have not charity, I am nothing.

3 And though I bestow all my goods to feed the poor, and though I give my body to be burned, and have not charity, it profiteth me nothing.

4 Charity suffereth long, and is kind; charity envieth not; charity vaunteth not itself, is not puffed up,

5 Doth not behave itself unseemly, seeketh not her own, is not easily provoked, thinketh no evil;

6 Rejoiceth not in iniquity, but rejoiceth in the truth;

7 Beareth all things, believeth all things, hopeth all things, endureth all things.

8 Charity never faileth: but whether there be prophecies, they shall fail; whether there be tongues, they shall cease; whether there be knowledge, it shall vanish away.

9 For we know in part, and we prophesy in part.

10 But when that which is perfect is come, then that which is in part shall be done away.

11 When I was a child, I spake as a child, I understood as a child, I thought as a child: but when I became a man, I put away childish things.

12 For now we see through a glass, darkly; but then face to face: now I know in part; but then shall I know even as also I am known.

13 And now abideth faith, hope, charity, these three; but the greatest of these is charity.

· ·

QUESTIONS

1. Why are the power of tongues, prophetic powers, faith, and self-denial nothing without charity?
2. What does Paul mean when he writes: "When I was a child, I spake as a child?"

· ·

SAINT AUGUSTINE
· ·

from the *Confessions*
Translation by E. M. Blaiklock

In the first passage of the *Confessions,* Augustine looks back on his sensuous youth when he came to Carthage to study rhetoric; in the second he chastises himself for his former love of theater. The next passage recounts the experience of conversion in the garden of his house in Milan, and the final one his last conversation with his mother, Monica.

I
Way of Restlessness

I came to Carthage where a whole frying-pan of wicked loves sputtered all around me. I was not yet in love, but I was in love with love, and with a deep-seated want I hated myself for wanting too little. I was looking for something to love, still in love with love. I hated safety and a path without snares, because I had a hunger within—for that food of the inner man, yourself, my God. Yet that hunger did not make me feel hungry. I was without appetite for incorruptible food, not because I was sated with it, but with less hunger in proportion to my emptiness. And so my soul was sick. Its ulcers showed, wretchedly eager to be scratched by the touch of material things which yet, if they had no life, would not be loved at all. To love and to be loved was sweet to me, the more so if I could enjoy the person of the one I loved.

I polluted, therefore, the stream of friendship with the foulness of lust, and clouded its purity with the dark hell of illicit desire. Though sordid and without honour, in my overweening pride, I longed to be a polished man about town. I plunged, too, into the love with which I sought ensnarement, my merciful God. With what gall did you in your goodness sprinkle that sweetness! I was loved. I went as far as the bondage of enjoyment. Because I so desired I was being tied in the entanglements of sorrow, just to be scourged with redhot iron rods of jealousy, suspicions, fears, bouts of rage and quarrelling.

II
The Lure of Drama

The drama enthralled me, full of representations of my own miseries and fuel for my own fire. Why does a man make himself deliberately sad over grievous and tragic events which he would not wish to suffer himself? Yet he is willing as an onlooker to suffer grief from them, and the grief itself is what he enjoys. What is that but wretched lunacy? He is the more stirred by them in proportion to his sanity. When he suffers personally it is commonly called misery. When he feels for others it is called mercy. But what source of mercy is it in imaginary situations on the stage? The hearer is not stirred to help but invited only to grieve, and he compliments the author of such fictions in proportion to his grief. And if those human catastrophes, out of ancient history or simply made up, are so presented that the spectator does not grieve, he goes off disgusted or critical. If he is moved to grief, he stays on, attentive and enjoying it. Tears and sorrows are therefore loved. To be sure we all like joyfulness. No one wants to be miserable though he likes to be sympathetic, and it is only in such case that grief is loved, because it is really without grief. This is a rill from that stream of friendship.

What is its course and flow? Why does it flow down into that torrent of boiling pitch, with its vast tides of foul lusts, into which of its own nature it is transmuted, of its own will twisted and precipitated from its heavenly clearness? Is compassion therefore to be cast aside? By no means. Let there be times when sorrows are welcomed. Beware of uncleanness, my soul, under my protecting God, the God of our fathers,

to be praised and exalted for ever, beware of uncleanness. I am not now past compassion, but in those days, in the theatre, I rejoiced with lovers wickedly enjoying one another, imaginary though the situation was upon the stage. And when they lost one another, I shared their sadness with pity—in both ways enjoying it all.

VIII
Strife in the Garden

Then in that mighty conflict of my inner dwelling place, which I had strongly stirred up in the chamber of my heart, troubled in both face and mind, I assailed Alypius.[1] I cried: "What is wrong with us? What is this you have heard? The unlearned rise and take heaven by storm, and we, with our learning, see where we wallow in flesh and blood. Are we ashamed to follow because others have gone ahead, and not ashamed not to follow at all?" Some such words I said, and my fever tore me away from him while he, looking at me with astonishment, said nothing. I did not sound like myself. Forehead, cheeks, eyes, colour, the level of my voice gave expression to my mind more than the words I uttered. A small garden was attached to our dwelling, and we have freedom to use it, as indeed, the whole house, for the master of the house, our host, did not live on the premises. To the garden, the tempest in my breast snatched me. There no one would hinder the fiery disputation I had begun against myself until its consummation, known already to you, but not to me. I was only healthily mad, dying in order to live, knowing what an evil thing I was, but not knowing what good thing I was about to be. So I went off into the garden with Alypius following close behind. His presence did not make my privacy the less, and how could he desert me in so disturbed a state? We sat as far away from the house as we could. I groaned in spirit, tempestuously indignant that I was not surrendering to your will and covenant, my God, and which all my bones, praising it to high heaven, called out to me to do. Not only to go there, but also to arrive, asked for no more than the will to go. The way was not by ships, carriages or feet. It was not so far from the house as the place to which we had gone where we were sitting. It required no more than the will to go there, a resolute and thorough act of will, not to toss and turn this way and that, a half-maimed will, struggling, one half rising, one half sinking.

In the wild passions of my irresolution, I did with my body what people sometimes want to do but cannot, either lacking the limbs, their limbs in chains, weakened by weariness, or otherwise impeded. If I tore my hair, beat my brow, clasped my knee with knitted fingers, it was because I wanted to do so. Yet I could

have wanted to, and not done so, if my limbs had not been pliable enough to do my will. So much then I did when to will was not in itself to be able. And I did not what I both longed immeasurably more to do, and which soon, when I should will, I should be able to do, because soon, when I should will, I should will thoroughly. In such case power and will coincide, and willing is forthwith doing. And yet it was not done, and my body obeyed more easily the weakest willing of my mind, moving limbs as it directed, than my soul obeyed itself to carry out in the will alone, this great will which should be done.

X
Conversation with Monica

When the day was near for her departure from this life (you knew it though we did not) it happened, I think by your secret guidance, that we two should be standing alone leaning on a window. It was at Ostia-on-Tiber, and the window looked on to a courtyard garden in the house we had. Removed from the bustling crowds after the fatigue of a long journey, we were building up strength for the sea voyage. So we were conversing most pleasantly, "forgetting the things behind and reaching for those before," and speculating together in the light of present truth (which you are) about what the eternal life of the saints will be, which "eye has not seen, ear heard, nor has it come into the heart of anyone." Yet we panted, as though our hearts had lips, for those upper streams of your fountain, the fountain of life which is in your presence, so that sprinkled from it, as we are able to receive, we might set our thoughts on so vast a theme.

We agreed that the greatest imaginable delight of the senses, in the brightest conceivable bodily context, set beside the sweetness of that life, seemed not only unworthy of comparison, but not even of mention. With deeper emotion we tried to lift our thoughts to that Reality itself, covering step by step all things bodily, and heaven itself whence sun, moon and stars shine above the earth. We soared higher, and by the heart's meditation, by speech, by wonder at your work, penetrated to our naked minds and past them to reach the place where plenty never fails, from which store you feed Israel for ever with truth for food, where life is the wisdom with which all this universe is made in the past and in time yet to be. This wisdom is not created but is as it was and forever will be. Indeed, to have been and to be about to be are irrelevant terms in this wisdom, only eternal being. While we talked and panted after it, with all our heart's outreaching we seemed just to touch it. We sighed and left captured there the firstfruits of our spirits and made our way back to the sound of our voices, where a word has both beginning and end—unlike your Word, our Lord, which endures in itself without ageing yet renewing all.

[1] Alypius: Augustine's good friend and companion.

So we were saying: If for anyone the tempest of the flesh should grow still, the phantasies of the earth, the waters and the air be quietened, along with the axis of the skies, if the very soul should fall silent and transcend itself by forgetting itself with its dreams, imaginary insights, and speech, and all else taking form from the transient (for they all say to him who has ears: We made not ourselves but he who abides eternally made us), if all these, at such words, could fall silent, because they are straining their ear to their creator, and if he should speak alone, not through them, but by himself and audibly, not by human speech nor voice of angels, the sound of thunder nor obscure similitude, so that we should hear only him whom in such matters we love (in such fashion as we were straining and in swift thought touching the eternal wisdom in all things immanent) if this state could go on, leached utterly of all alien conceptions, and if this one rapture could seize, absorb, and so envelop its beholder in more inward joys, so that eternal life should be quite like that moment of understanding to which we aspired, would not this be: "Enter into the joy of your Lord"? When? When we shall rise again, though "we shall not all be changed"?

Such was our conversation though not precisely in this sequence and these words. Yet you know, Lord, that on that day, when we were speaking thus and the world grew base to us amid such conversation with its delights, she said: "Son, as for me, I find nothing in this life which delights me. I do not know what I have left to do here or why I am here, not that my hopes in this world are gone. There was one thing for which I used to desire to stay on a little in this life, to see you a Catholic Christian before I died. God has granted me this more abundantly, in that I see you his servant, all earthly happiness cast aside. What am I doing here?"

QUESTIONS

1. What are the various meanings of "love" and "friendship" in these texts?
2. What paradox does Augustine find inherent in our enjoyment of tragedy? Why does drama seem to him opposed to Christian faith?
3. What relations between mind and body appear in Augustine's account of his conversion?
4. What influences of Platonism can you find in these passages?
5. What use of rhythm and images does Augustine make and what is their effect on the reader?

Summary Questions

1. What are the major parts of the Hebrew Bible (the Old Testament) and what is the function of each?
2. Compare the code of morality in the Ten Commandments with the Sermon on the Mount.
3. Why was Christianity persecuted by the ancient Romans during the first centuries of its existence?
4. What does early Christian art tell us about early Christian beliefs?
5. What was the significance of Constantine's conversion to Christianity?
6. What new dimensions did Augustine bring to Christian thought?
7. What were the ideas behind monasticism?
8. What characterizes Gregorian chant and what was its function?

Key Terms

patriarchs, judges, kings, and prophets

the Torah, the Nevi'im, and the Mishnah

the diaspora

Jahweh

the Annunciation

the Magnificat

the Good Shepherd

basilica

parts of church (narthex, nave, aisles, transept, apse, clerestory)

baptistery

Byzantium

barbarians

martyrs

monasticism

Gregorian chant

The Greco-Roman and Judeo-Christian Roots

The Classical Ideal

The classical cultures, Greece and Rome, in spite of many differences, form together a unified system of cultural values and creations that has profoundly influenced the course of Western culture and is still with us today. In our focus on the "classical" phase of "classical" culture—Athens in the fifth century B.C.—we witnessed the aesthetic and moral values associated with the term. The Greek mentality of that century looks to human reason as the force giving order to the world. It is humanistic in that it stresses the dignity and worth of human individuals as such more than as part of a social or divine order. Yet it cautions against the dangers of human pride, *hubris.* "Nothing in excess" were the words of the oracle at Delphi, and we see this applied to Oedipus when he tries to outwit fate; in Pericles' description of the equilibrium between private and public good in Athens; in Euripides' and the historians' demonstrations of the evils entailed by extreme action; in the sculptural and architectural monuments that strive to balance or harmonize the real and the ideal; and in Aristotle's golden mean. Classical art is dynamic and pleasing because its proportions and symmetry represent an attempt to harmonize forces such as body and soul, humanity and the gods, reason and emotion. The Greeks admired the power of reason very much, but they were deeply interested in the *whole* human being.

Greek Philosophy and Mathematics

The debt of the Greeks to Mesopotamian and Egyptian culture is still a question for scholars. Stories that Plato visited Egypt as a young man and brought back with him much of its learning commonly circulated in the ancient world. Some of the Babylonian achievements in mathematics and astronomy were probably transmitted to the West through the Greeks of Asia Minor. That the earliest of the Pre-Socratic philosophers were all from this area lends strong support for such transmission.

Nonetheless, the Greeks seem to have been the first to elaborate the logical structures of our thought, structures that have become so natural to the modern mind that we take them for granted. Greek logicians laid down the basic rules for determining when arguments are valid or invalid; that is, when conclusions follow from a given set of premises and when they do not. Greek terminology still predominates in textbooks of logic. Perhaps more significantly, the Greeks were almost certainly the first to use logic and its companion mathematics for the systematic understanding of nature. These instruments of human reason were believed to work because the world was viewed as by nature intelligible and its functioning capable of being reduced to laws. Something of this same trust in the capability of human intellect to solve the mysteries of nature motivates numbers of scientists and their supporters today.

Finally, Greek philosophers endeavored to see human life within the context of a world system integrating all the elements of the universe into a consistent whole. Plato, Aristotle, Zeno, and others, confident in the powers of human reason, constructed vast synthetic structures of thought that promised to answer the basic questions surrounding human existence. Even though today we recognize the ability of the intellect to organize large segments of human experience through the use of rational powers, few would grant it such scope.

Greek Science and Politics

Modern culture owes to the ancient Greeks most of the basic categories for ordering knowledge into disciplines, such as physics, ethics, politics, and poetics (all Greek words). The Greeks also defined and distinguished the methodologies or ways of investigating truth appropriate to various disciplines. Using these methodologies, the Greeks made such advances that, in the sciences at least, western Europe was not to surpass them until after 1600. The myriad ancient Greek city-states experimented with every conceivable form of government over

the centuries. Aristotle in fact wrote a now lost work on 126 different Greek constitutions. He along with other Greek political theorists provided an analysis of the basic constitutional forms of monarchy, tyranny, aristocracy, oligarchy, republican government, and democracy that still informs modern political science.

Greek and Roman Literature, Architecture, and Sculpture

Greek writers, building on previous achievements in Mesopotamia and Egypt, codified basic literary forms that influenced not only the course of Western literature but also the ways in which we think about life. The English language acknowledges its debt to Greek concepts with terms such as *epic, lyric, tragedy,* and *comedy.* The Romans adapted and modified these forms, adding an influential one of their own, *satire.*

In much the same way, Greek architectural orders and the temple form and Roman arch and dome construction are the basic elements of a major architectural language that has persisted to the present. The Romans adapted Greek sculptural and artistic forms to more practical uses: the portrait, the forum, the triumphal arch, the coliseum. Our engineering and city planning derive from Roman innovation.

Similarly, the accomplishments of the Greeks and Romans in sculpture and painting provided the archetypes for early Christian art. Later the remembered greatness of Rome was a major impetus for the artists of Renaissance Italy, who sought to equal the ancients. Through the Renaissance, ideas on Greek and Roman art and architecture were to be a goad and support for artistic development in the West.

Roman Expansion of Greek Culture

Although the Greeks were undoubtedly the originators of most of the cultural forms we have been studying here, the term *Greco-Roman* makes sense because of what the Romans did with Greek culture. The parochialism of Hellenic Greece had already been broken down by the empire of Alexander in the late fourth century B.C., but the long-enduring conquests of the Romans institutionalized Greek culture among the ruling classes of a vast area from Persia to England and from the Sahara to northern Germany and the steppes of Russia.

Furthermore, the Romans added their own cultural forms to the Greek ones. The Greeks philosophized about the laws of nature, but the Romans realized them in the form of actual codes of law. Although Aristotle first defined the characteristics of republican government, the founders of the United States looked back more to Rome than to Greece for a model, because in the Roman Republic they saw a practical embodiment of the government for which the Greeks could offer only theories. Committed as they were to limited male suffrage based on property qualifications, the makers of the U.S. Constitution considered the kind of democracy found in fourth-century B.C. Athens as little short of anarchy.

Hellenic and Hebraic Ways of Thinking

Over the course of Western civilization, thinkers have attempted to compare and contrast the mentalities of the two cultures considered as its primary "roots," the Greek and Jewish, or Hellenic and Hebraic. In an essay entitled "Culture and Anarchy," the English poet and critic Matthew Arnold defined the differences by stating that Hellenism, or the Greek mentality, aims to "see things as they really are," whereas the aim of Hebraism is "conduct and obedience." The former stresses "right thinking," individual reasoning, and logic; the latter stresses "right acting," ethical understanding, and obeying God's commandments. "Man is the measure of all things," the dictum of the Greek philosopher Protagoras, would have been inconceivable in African, Asiatic, and Near Eastern cultures such as Egypt and Mesopotamia, as well as in Israel. Although the Greeks were also aware of human frailty, the question of the Psalmist, "What is man, that thou art mindful of him?" would not have occurred to them. The Greeks assumed that human beings were the primary interest of the gods, just as the gods themselves were glorified human beings.

A more recent writer, the Scandinavian theologian Thorleif Boman, has developed further the comparisons and contrasts between Hebrew and Greek thought.[1] His major thesis is that whereas the Greek is a culture of space, the Hebrew is a culture of time. For the Hebrews, all sources of being are in God, who alone is, and who manifests his being by his words and guidance of his people in history. For the Greeks, on the other hand, truth is to be discovered by the tools of logic and geometry. Whereas the Greeks were a primarily visual people and used their art to make representations of their gods as well as of themselves, the ancient Hebrews forbade visual representation of God and human beings. Boman notes the rhythmic and dynamic properties of biblical poetry as opposed to the more visual images of Greek poetry. A literary critic, Erich Auerbach, has called biblical literature "fraught with

[1] Thorleif Boman, *Hebrew Thought Compared with Greek,* trans. Jules Moreau (New York: Norton Library, 1960).

background," or with the sense of God's presence, as opposed to the clarity and the present quality of Greek literature. All such vast syntheses, although useful, are of course open to exceptions.

Greco-Roman and Judeo-Christian Parallels

If it is possible to make a distinction between the Hellenic and Hebraic mentalities, one must remember that Christianity (and, for that matter, Judaism from the second century B.C.) was strongly influenced by Greek ways of thinking. The New Testament is itself a document of Greek literature, containing Greek philosophical terms; and the influence of Plato and Aristotle on the development of Catholic theology was enormous. Nor can one neglect the Roman contribution to Christian culture. The economic, political, and legal structures provided by the Roman Empire facilitated communication and helped make Christianity the dominant cultural influence in Europe. We have seen how the Christian church, God's house on earth, grew out of the Roman basilica.

Once this is said, however, it is nonetheless evident that certain aspects of Christianity deriving from Judaism differentiate it profoundly from the classical values of Greece and Rome. Foremost of these is the Hebraic concept of one supreme God. The God of both Jews and Christians (and of Muslims, as we will see) is a creator who made the world as we know it from nothing and a lawgiver who dictates to human beings, his creatures, fundamental principles of morality. Socrates determined what was right and good according to the dictates of reason; the Jew or Christian accepts the Ten Commandments or the Sermon on the Mount as moral law because it is the word of God.

Opposing itself to the values of the Greco-Roman world as a small, radical group, Christianity demanded allegiance to Christ before allegiance to the Roman emperor and the gods of the state. Yet Paul molded it into a potentially universalist faith. Once Emperor Constantine converted, Christianity was able to use the Empire to its advantage, not, of course, without making bargains with the secular world in the process.

Just as Rome had diffused the Greco-Roman culture as a part of its imperial mission in previous centuries, so in the fourth and fifth centuries the Christian Roman emperors endeavored to impose on their subjects a uniform belief in the Christian message. Although the Empire collapsed in the West by the end of this period, within the barbarian kingdoms Christianity survived its demise. In the East, where the Empire continued, the emperors fought a losing battle to keep the faithful uncontaminated by a rash of heresies that threatened both religious and civil unity. They rightly perceived these heresies as a menace to the Empire, but they were defeated in their efforts to contain them. By the seventh century a new Semitic religion, Islam, profited from this religious discontent by capturing a significant portion of what remained of the Roman Empire.

Part III

• Medieval Cultures

9

The Byzantine and the Islamic Empires

CENTRAL ISSUES

- The major goals of Justinian
- Hagia Sophia as a new form of church architecture
- Byzantium as a transmitter of ancient Greek culture
- The division between the Greek Orthodox and Roman Catholic Churches
- The origins and core beliefs of the Muslim religion
- The expansion of Islam from the Arabian Peninsula
- The contact between Arabic and Christian cultures in Spain and Sicily
- Divisions within the Muslim faith: Shi'ites, Sunnis, and Sufis

Out of the breakup of the Roman Empire in the fifth century rose three new political formations: the Eastern Roman Empire, which over time became known as the Byzantine Empire; the empire created by Islam; and the various states constituting western Europe. None of the three political and cultural areas developed in isolation or in a vacuum. In many ways less sophisticated than their neighbors, the Byzantines and Muslims, Europeans for centuries remained on the defensive, especially against Islam. At the same time they had frequent intellectual and economic contact with both empires. Although the Crusades beginning in 1095 marked the initial stages of a vigorous European assault on the East, into the thirteenth century the West remained largely a borrower of ideas and technology from these areas. Before tracing the rise of

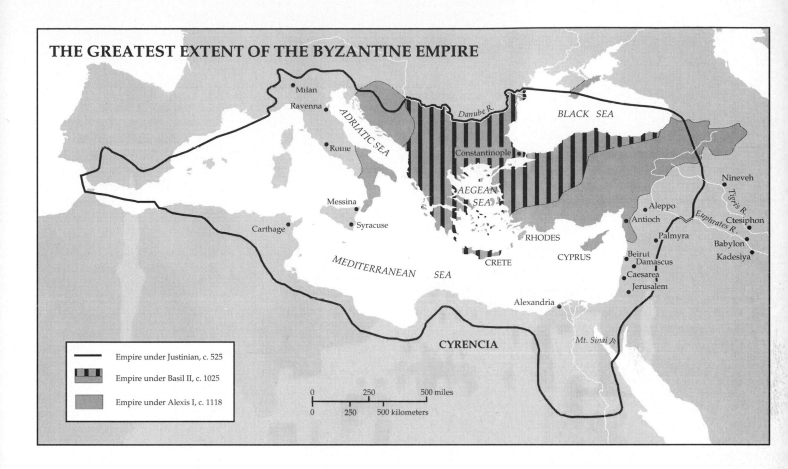

THE GREATEST EXTENT OF THE BYZANTINE EMPIRE

Empire under Justinian, c. 525

Empire under Basil II, c. 1025

Empire under Alexis I, c. 1118

western European culture we will present a brief characterization of the cultures of Byzantium and Islam. This will provide a better context in which to trace the development of European culture, acknowledging its debt to these two contemporary cultures as well as to ancient Greece, Rome, and the Christian and Renaissance past.

The Eastern Roman Empire, or Byzantium

The Byzantine, or Eastern, Empire was the surviving half of the ancient Roman Empire, now centered not on Rome but on the "New Rome," the official name for Constantinople throughout the Middle Ages. Its civilization constituted a synthesis of all the intellectual, political, and religious aspects of the ancient world in its declining centuries, that is, the Latin, Hellenistic, and Christian traditions, together with the oriental culture of the revitalized Persian empire. The greatness of Byzantium lay in its preservation of the sources of ancient civilization in the period when the West experienced political, social, artistic, and intellectual decline. Of particular importance was its role as the guardian of Greek literature and Roman law for the use of distant posterity. At the same time it acted as a barricade for the West in holding off new invasions from the East and as the vital

force in Christianizing the Slavic peoples on the great northern plains of eastern Europe and western Asia.

Justinian (527–565)

Byzantine history began with the reign of Justinian. The greatest of the Byzantine emperors, he was born a humble, Latin-speaking peasant in what is now a part of modern Turkey. He became emperor after the death of an uncle, an illiterate but gifted soldier, who seized the throne in Constantinople in 518. Justinian's wife, Theodora, a former prostitute of remarkable intelligence and courage, played an active role in government.

The major goals of Justinian's reign were to reassert Roman power in the West against the barbarian invaders and at the same time to expand universal Christianity into pagan lands and defend the faith against those he considered heretics. Beginning in 533, Justinian, served by two brilliant generals, undertook a military campaign that ultimately seized control from the barbarian invaders of the North African coastline, eastern Spain, and most of Italy. The recapture of these territories by fire and sword probably inflicted more destruction on the land than had more than a century of barbarian invasions (see map).

The expansion of Rome's new religion and its protection from heresy constituted Justinian's second goal.

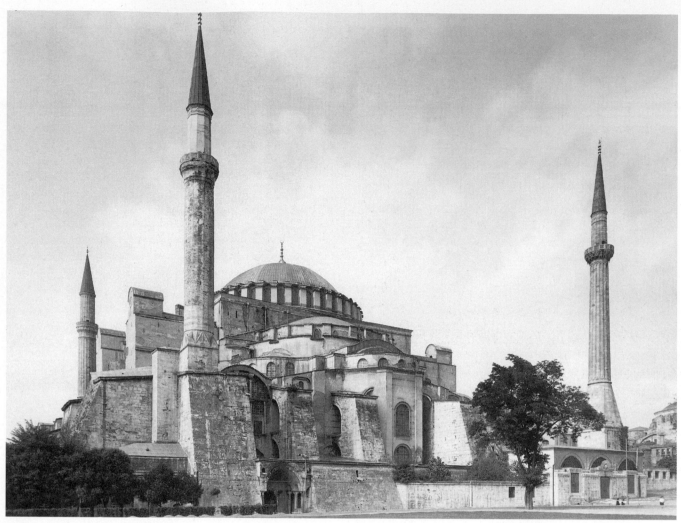

9-1 *Anthemius of Tralles and Isidorus of Miletus, Hagia Sophia, Istanbul,* A.D. *532–537. (Bildarchiv Foto Marburg/Art Resource, NY)*

He supported missionary efforts to Christianize barbarians to the north in Russia and peoples as far away as China to the east. Within his kingdom religious deviation was ruthlessly suppressed. Partly a product of his strong religious beliefs, Justinian's strict religious policy toward his subjects had political overtones as well. He believed that religious conformity would augment his central control. For this reason he subordinated the patriarch of Constantinople, in theory the second most powerful cleric after the pope in Rome, to his control, while his governor at Ravenna, the Byzantine capital of Italy, closely monitored the actions of the pope himself.

This was to be the last serious effort to hold the two parts of the Roman Empire together, and it did not endure long. Within a few years of Justinian's death in 565, western European kingdoms began to develop without fear of interference from the Empire. Spain and northern and central Italy fell back into barbarian hands and the North African coast was lost to the Muslims in the seventh century. However, in one area, southern Italy, Byzantine power lasted into the eleventh

century and left an indelible mark on the culture and arts of the region. The failure of the reconquest had immense significance for the papacy. Had it succeeded, the Roman pope and the Church he led would have remained captive to imperial policy, as did the patriarch of Constantinople. As it was, the pope remained relatively free without a powerful monarch in the vicinity, and from that position he ultimately was able to uphold the independence of the spiritual power, a distinctive characteristic of Christianity in western Europe.

Roman Law Codes A more positive contribution of Justinian to western European culture related to his belief that a united Empire and Church should be accompanied by a common law. Particularly disturbing to him was the confusion in the legal system created by the lack of an integrated code of Roman law. Ancient Roman law consisted of (1) the statutes and edicts made by Roman legal agencies, including the emperor, and (2) the decisions handed down in cases by Roman judges. Over the centuries this material had come to fill many volumes,

and the mass was filled with many contradictions. At the beginning of his reign Justinian resolved to integrate into one book, called the *Code*, all the Roman laws having validity in his kingdom. To this would be added two other books: the *Digest* or *Pandects*, a collection of the opinions of ancient legal scholars regarding the laws, and the *Institutes*, a textbook to train lawyers. Given the enormity of the enterprise, Justinian's commission of legal scholars worked with surprising rapidity and between 528 and 535 accomplished its task. The three books together with a fourth—called the *New Constitutions*, containing laws enacted after the completion of the other three—became known as the *Corpus of Civil Law*. Justinian's preface to the *Digest* explains in detail his motivation for ordering a revision of the legal books.

Subsequently, this law code circulated in western Europe as a regional code until the eleventh century, when Western scholars revived the conception of Roman law as the basic law of all peoples. Within a few centuries it came to be accepted throughout continental Europe as the law against which all local law must be tested for validity. It still underlies the legal system of most countries in modern western Europe.

Hagia Sophia A great builder, Justinian endowed the cities of the Empire with new monuments, the most splendid of which, the church of Hagia Sophia (Holy Wisdom), was located in Constantinople. Its architects, Anthemius of Tralles and Isidorus of Miletus, combined the languages and skills of their artistic resources to create a fresh, new form (Fig. 9-1).

The rectangular basilican churches of Rome focused attention on the *apse* end, where the altar stood. Hagia Sophia has the form of a square, topped with a great central dome, supported by two half-domes (Fig. 9-2). Four great *piers*, seventy feet high, rise from the square corners. These piers carry four great semicircular arches connected by curved, triangular-shaped membranes called *pendentives*. The pendentives join their upper edges to form the base of the central dome. The weight of the arches and dome is supported by four great *buttresses*, and the two half-domes, like the central dome, are made using traditional Roman techniques of bricks and masonry (see Chapter 7 and Fig. 9-3). The entire structure beneath the dome is enclosed in massive walls pierced with many windows. Procopius, Justinian's court historian, wrote that the church seemed to soar to heaven and rise above the city "like a huge ship anchored among them."

Procopius also tells us that artisans and precious materials came from all over the Empire. Eight porphyry columns came from Rome and eight green marble ones from Ephesus. Marble in varied colors, alabaster, and onyx were cut, fitted, carved, pierced, and veneered to cover walls and pavements in geometric patterns. No contemporary tells us whether there was any figurative, narrative mosaic decoration, but one writes: "The vaulting is formed of countless little squares of gold cemented

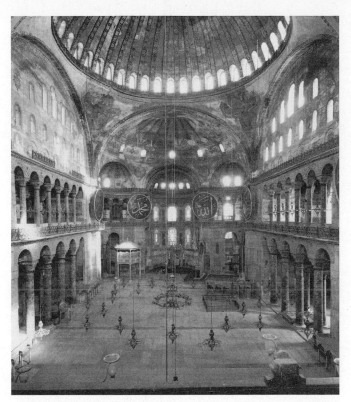

9-2 *Anthemius of Tralles and Isidorus of Miletus, interior of Hagia Sophia, Istanbul,* A.D. *532–537. (Hirmer Fotoarchiv, Munich)* (**W**)

* Compare Hagia Sophia's interior to that of the Pantheon (Fig. 7-14). What is the most immediate difference, and what is its effect?

together. And the golden stream of glittering rays pours down and strikes the eyes of men so that they can scarcely bear to look. It is as if one were to gaze upon the mid-day sun in spring, when it gilds every mountain height." The effect of light—whether from the sun or from hundreds of lamps suspended in the building—must have been otherworldly. There was a huge silver iconostasis—a screen with doors to which were attached many icons and images—that separated the sanctuary/altar from the congregation; an immense circular *ambo* (platform raised on columns) that stood near the center, for preaching; and a silver *ciborium* (canopy) that stood over the altar. With all its gold and silver and its many holy relics, the church contained an immense treasure of worldly and spiritual riches. When it was completed in 537, Justinian was heard to say: "Solomon, I have surpassed thee."

Ravenna Ravenna, once the capital of Honorius, the Western Roman emperor, and now the capital of newly conquered Italy, provided Justinian's architects and artists with models for imitation for his building at Constantinople, which became the focus of the emperor's passion for monumental architecture.

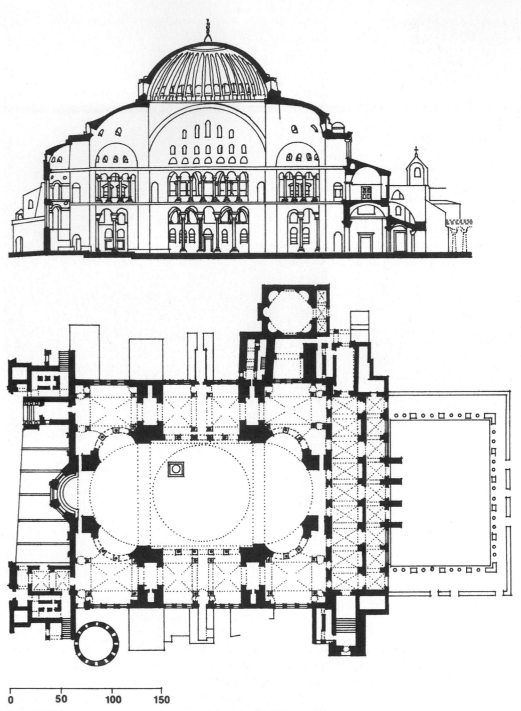

0 50 100 150

9-3 *Plan and section of Hagia Sophia, Istanbul.*

In Ravenna, Christians had adopted the basilican plan for many of their churches. A church like Sant' Apollinare in Classe, founded around 504 (Fig. 9-4), could easily be compared with old Saint Peter's. They also erected domed buildings for baptismal rites like the Baptistery of the Orthodox (Fig. 9-5). These domed structures focused attention on the single act that occurred there and seemed ill suited to the congregations of Christians who gathered for preaching. The church of San Vitale, however, built under the patronage of

Justinian and Theodora, shows how a centrally planned church like Hagia Sophia could be adapted.

The Church of San Vitale San Vitale is an octagonal domed church (see plan and section, Fig. 9-6). The very plain redbrick exterior with deeply shaded windows and tile roofs hardly prepares one to experience the inside (Fig. 9-7). Entry is through a hall-like *narthex* placed on one side of the octagon. One moves from the narthex into a two-story, vaulted *ambulatory* that is

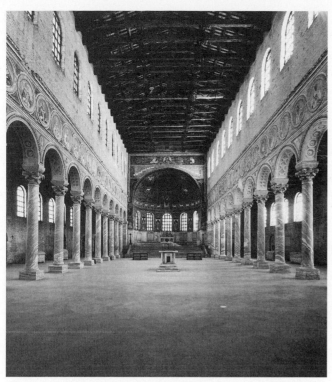

9-4 *Sant' Apollinare in Classe, Ravenna. Interior, nave looking toward apse, built* A.D. *533–549. (Hirmer Fotoarchiv, Munich)*

* Which elements in this church are specifically Roman and which are Greek? Which are new?

9-5 *Baptistery of the Orthodox, Ravenna. (Hirmer Fotoarchiv, Munich)*

separated from the central space by seven niches formed from piers and columns. The eighth niche ends in a half-dome that contains the apse, separated from the ambulatory by screens of columns. A third story rises above the central space, topped by a dome set on the *clerestory* beneath (Fig. 9-8).

The space is flooded with light, but light transformed by the intersecting spaces formed by columns and niches, gallery and dome, which are covered entirely in gold and vividly colored mosaics. Stories from the Old Testament that prefigure Christ fill the walls, and a youthful, idealized, imperial Christ seated on the orb of heaven appears in the half-dome above the apse. To the left and right of the chancel are Justinian and Theodora, who also stand in this immaterial space—the gold ground of the mosaic (Color Plate IV). Each faces frontally, centered among prelates and attendants. Justinian holds the bread, the body of Christ, and Theodora, in a gold cup encrusted with emeralds, the wine, his blood—the elements of the Eucharist that will be celebrated in this place. Both wear their imperial crowns, each head haloed, like the saints. The frontal poses, the glorious robes, and the trappings of state do not diminish the individuality of the faces of Justinian, Theodora, and their attendants. Although the faces and forms are

rendered abstractly, the artist shows each person clearly as they both watch and participate in this ritual.

This art form—the mosaic—involves a new visual dimension and thus new conventions that allow the artist to move from depicting a naturalistic world, as in Roman painting, to a symbolic world in which saints and emperors, dead and living, share a holy space. Perhaps more than any other art that we have seen, these mosaics are filled with that quiet splendor and timelessness that recall Egyptian sculpture.

Justinian's buildings at Ravenna, however, had little immediate effect on western European architecture. The poor economy permitted few large churches and Western artists lacked the talent for imitating such elaborate constructions. Nevertheless, when Charlemagne built himself a new capital city at Aachen, around 800, he looked to San Vitale in Ravenna as a model for his own chapel.

Venice The influence of Byzantine art on Venice came not from Ravenna but directly from Constantinople, to which Venice was closely linked by trade. Saint Mark's Cathedral in Venice, begun in 1063, is Byzantine in plan and decoration (see Fig. 9-9). The church is designed as a Greek cross—a cross with equal arms. A great dome rises above the crossing, and slightly lower

9-6 *Plan and section of San Vitale, Ravenna.*

9-7 *Basilica of San Vitale, Ravenna,* A.D. *c. 525–547.* *(Alinari/Art Resource, NY)*

9-8 *San Vitale, Ravenna, interior view from the galleries.* *(Alinari/Art Resource, NY)*

▲

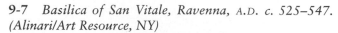

* Compare this domed space with Hagia Sophia (Fig. 9-2) and compare both with the Pantheon (Fig. 7-14). What elements might have come from a church like old Saint Peter's?

domes, sheathed in wooden helmets covered by gilt copper sheeting, cap the four arms. The interior is covered with mosaics, figures on a gold ground that float above the viewer and suggest another world.

The Threat of Islam and Separation from the West

Within a hundred years of Justinian's death the forces of Islam, inflamed by a new form of monotheism, began advancing beyond their native Arabian Peninsula both toward the kingdom of Persia on the east and Byzantium on the west. By the late seventh century, the forces of Islam had occupied much of the Persian empire; had seized Syria, Palestine, and Egypt; and were working their way along the shore of North Africa toward Spain. Faced at the same time with new barbarian tribes invading the Balkans, Byzantium simply had to recognize the Muslim conquests.

9-9 *Saint Mark's, Venice. Begun* A.D. *1063. (Alinari/Art Resource, NY)*

Although the Empire's historians tenaciously held to the fiction of eternal Rome, all that remained by 750 were the Greek-speaking provinces of Asia Minor, the Balkans, and parts of the Italian south. In such circumstances the Greek heritage of the Byzantine Empire came to the fore. By this time the emperor himself was officially designated as *basileus*, the Greek word for "king," and the official language of the state had become Greek. By the ninth century this reorientation of culture resulted in a renaissance of art and letters inspired by ancient Greek classical influences.

Eastern Monasticism

Not only did Byzantium increasingly distinguish itself from the West by its use of Greek, but its dominant religious tendencies also encouraged a separation from Western Catholicism. Monasticism in the Eastern Roman Empire had a different flavor from that in the West. The roots of the movement in both East and West emerged from Egypt and Syria in the third century among those who desired a completely spiritual life. In those arid provinces withdrawal into the desert, first in solitude and later in communities, satisfied this need. Transplanted to the West, monasticism assumed regu-

larized forms, devoted to worship, public service, and religious scholarship. Indeed, monasteries were in large part responsible from the fifth to the ninth centuries for the preservation of much of the Greco-Roman tradition. On the other hand, in Byzantium monks tended to be more rigorously ascetic and given to mysticism than their Western counterparts. Although they copied manuscripts and provided some education, they tended to be highly pietistic and uninterested in scholarly and intellectual concerns.

Iconoclasm

The issue of iconoclasm in the early eighth century marked a major crisis in East-West relations. The use of images of Christ and the saints had been a common feature of religious worship throughout Christendom from the early centuries. A peculiar feature of Byzantine worship was the reverence shown to icons, or images of Christ and the saints. In a Byzantine church the icons, frescoes, and lustrous mosaics were ranged in a saintly hierarchy on the walls, culminating at the highest vault in the image of Christ Pantokrater, the All-Ruling Christ, often in the pose of judge over all humankind (Fig. 9-10). The church altar was screened from the

9-10 *Christ Pantokrater, Hosios Loukas, Phocis, Greece, ninth century. (Michos Tzovaras/Art Resource, NY)* (**W**)

9-11 Madonna and Child, *twelfth-century Russian icon.* (*Superstock*)

congregation by a row of icons, each holy figure in frontal pose, luminous eyes focused on the believers. So placed, these icons were considered by the common people to be inherently rather than just symbolically holy. The twelfth-century icon of the Madonna and Child in Figure 9-11, with its stylized, linear figure of Mary and its Christ child resembling a little man, is a good example of the Byzantine style in painting. As we shall see in Chapter 18, resurgence of European interest in Byzantine painting in the late thirteenth century forms a prelude to the Renaissance.

Beginning in 717 the emperor Leo III led an attack on the veneration of icons, arguing that they were associated with paganism and also contravened the prohibition against the graven image found in Old Testament law. His command to strip the icons from the churches led to open warfare between, on one side, the emperor, most of the clergy, and the army, and on the other the monasteries and the common people, backed by the pope and the whole Western Church. Iconoclastic puritanism rocked the Empire for more than a century and almost led to a division of Christianity before dying out in futility in the late ninth century.

The defeat of the iconoclasts ensured the continuity of Byzantine art with the Greco-Roman artistic tradition, which had encouraged depiction of human beings and natural objects. Had the iconoclasts won, all forms of representation in religious art in the Eastern Empire would have been forbidden and Eastern Christian art would have moved away from its Western counterpart in a direction similar to that taken by Islam (see page 275).

The Schism of 1054: Division between the Greek Orthodox and Roman Catholic Churches

The century-long struggle over iconoclasm, even if resisted by many in Byzantium itself, had almost produced a rupture in the Christian Church. This did not happen, but other sources of conflict were pushing the two areas apart. West and East had traditionally been disposed to approach the Christian faith from different viewpoints. Westerners were more legalistic, whereas Easterners were more philosophical and mystical. Westerners believed in an inherited deformity in human nature that encourages sin. On the other hand, while believing that human beings committed sin, Christians in the East did not hold to a notion of an original sin inherited from Adam and Eve. This meant that the sense of sin was deeper and the need for divine grace correspondingly greater in the West. Whereas Easterners believed religion's goal was to transform human nature and rescue it from earthliness and death, Westerners were less abstract. For them the Gospel was primarily a new law against which the believer could reckon his or her sins. Religion's aim was to help the believer establish the right relationship with God by the performance of specific acts of good.

Eastern and Western Christianity also differed in some of their rites, tradition, and theology—for example, clerics in the Eastern Church could marry—but the primary conflicts arose over differing claims for jurisdiction. For centuries the patriarch of Constantinople had been quarreling off and on with the Roman pope over the papal claim to supremacy in the Church. Constantinople, since at least the ninth century, demanded to be regarded as equal in stature to Rome. The conversion of the prince of Kiev in Russia by Byzantine missionaries during the reign of Basil II (976–1025) had substantially reinforced this claim. The eventual Christianization of all of Russia constituted the greatest religious conquest of Constantinople. Thus the patriarch of Constantinople now laid claim to the spiritual leadership of Christians in all the lands from southern Italy and the southern Balkans to the eastern borders of Asia Minor, and from the steppes of Russia south to the Christian communities living in Muslim lands in Syria, Egypt, and North Africa.

Matters came to a head in 1054, largely because of the expanding influence of the Roman papacy over the Christian churches in southern Italy. Attempts to establish peace ended in failure and Christianity divided into two churches, the Eastern or Greek Orthodox Church and Western or Roman Catholic Church. Through later centuries the Greek Orthodox Church retained the loyalties of the vast majority of Christians in eastern Europe and it followed the expansion of Russia to the Pacific in the seventeenth and eighteenth centuries. Late-eighteenth-century Russian colonists would carry their faith to Alaska and California.

The Crusades

This split made alliance between the two halves of Christianity against the new common enemy, the Turks, almost impossible. Converting to Islam in the tenth century, the Turks, a people of central Asia, conquered Persia early in the eleventh century and by the end of that century held Palestine, Syria, and much of Asia Minor almost up to Constantinople itself. In 1095 the Byzantine emperor called on the West for aid. He had no idea that the West would respond with such enthusiasm. The First Crusade (1096–1097) marked only the beginning of a wave of military expeditions from Western countries to Palestine and Syria over the next two hundred years—expeditions designed to free the Holy Places from Muslim rule. The First Crusade was largely an idealistic enterprise, but very quickly Crusaders became aware of the rich opportunities for political and economic gains in these eastern lands.

After the initial expedition, in which Westerners established a kingdom in Syria and Palestine, lands claimed by the Byzantine Empire, relations between Constantinople and the Western intruders deteriorated. Finally in 1204, the Venetians, expecting great economic advantages for themselves, were able to convince the leadership of the Fourth Crusade that the only way to stabilize Western control of Palestine was to capture Constantinople. The city fell after a short siege and the Crusaders thereupon created a Latin kingdom, with Constantinople as capital, that was composed of western Anatolia and parts of the Balkans. A Roman Catholic patriarch replaced the Orthodox one, who had taken flight.

The prolonged occupation of Constantinople by the Roman Catholics and their conduct in the city did little to enhance mutual understanding between the two peoples. Much of the city's gold and silver and many of its art treasures were simply seized and transported to western Europe. The four great bronze horses astride Saint Mark's Cathedral in Venice are conspicuous items of this stolen treasure. Occupying Western nobles came to appreciate the high degree of comfort enjoyed by the Byzantine upper class and to imitate them in wearing silks instead of wool and covering their stone floors with rugs, but intellectually and religiously there was almost no interchange.

Collapse of the Empire (1261–1453)

The attack on Constantinople caused a dispersion of bureaucrats, intellectuals, and artists to outlying parts of the kingdom left untouched by the Crusaders. Small independent Byzantine states formed in parts of Greece and along the Black Sea coast out of the remnants. By 1261 Michael Palaeologus, ruler of one of these little dominions, succeeded in conquering Constantinople and expelling the Westerners.

The newly established dynasty held the throne for the next 192 years but remained on the defensive throughout the whole period, its territory often extending only a few miles beyond the city walls. The most fierce among the enemies who threatened the city were the Janissaries. Originally Christian male children born in Turkish-occupied lands, they were taken from their parents at an early age, converted to Islam, and then trained to be soldiers.

Byzantium as a Transmitter of Ancient Greek Culture to the West

Despite the Empire's gradual strangulation at the hands of the Turks, literature and art in the tiny Byzantine kingdom flourished. The University of Constantinople continued to function almost down to 1453, remodeled, however, by the emperor on lines resembling those of the University of Paris. The commitment of scholars to ancient Greek literature and Greek culture in general intensified in this time of trouble. The high quality of art in these centuries is brilliantly manifested by the early-fourteenth-century church of the Chora, with its rich mosaics and frescoes.

Within the last century of Byzantium, moreover, western European scholars, primarily the Italians, awoke to the importance of ancient Greek literature and of Plato's philosophy, only fragments of which existed in Latin. From the late fourteenth century a number of young men went to Constantinople to study the language and to bring back manuscripts of Greek classics. Consequently, in the very last decades of the life of Byzantium, Italy welcomed Byzantine scholars and the books they brought with them. By 1500 the study of Greek, almost extinct in the West for a thousand years, became a part of the regular school curriculum.

With the entry of the Turks into Constantinople on May 29, 1453, the last citadel of what had been a major civilization became Muslim. We shall now turn to follow the development of the Muslim faith from its birth in the Arabian desert in the seventh century to its impact on the West.

The Islamic Empire

The Early History of the Arabs

No one, least of all the Byzantine and Persian governments, anticipated the extraordinary expansion of the Arabs, an ancient Semitic people, under the banner of Islam in the seventh century of our era. The Arabian Peninsula was a backwater of the ancient world. Periodically, large caravans of heavily laden camels would appear in Damascus or other cities fronting on the desert to offer for sale exotic goods such as spices, gums, perfumes, and aromatic woods. Occasionally, the desert frontiers of both the Byzantine and Persian empires were threatened by raids from the Bedouin, Arab nomadic pastoralists. Both governments therefore made a practice of hiring friendly Arabs to keep the Bedouin, to whom raiding was often a matter of existence, from plundering agricultural lands and villages on the desert fringes.

In the sixth and early seventh centuries, it is true, the cataclysmic wars between the Byzantines and Persians had led to both empires' weakening their desert frontiers. Still, who would have expected that by 732, Arab tribes would be ruling from southern France to central Asia, having eradicated the Persian empire and thrust the Byzantines back to a new frontier in Asia Minor? The course and pace of Arab expansion were nothing short of phenomenal (see map).

Islam, a New Monotheism

About the year 610, a middle-aged Arab, Muhammad, began to preach in the commercial and religious center of Mecca. When he delivered his revelations, he spoke in an Arabic rhythmic prose different from his ordinary speech. It was the God of the Jews and Christians speaking to him, he said. They, however, had distorted the message, so here it was again, for the last time, in its original, clear Arabic.

The message was straightforward: Be grateful to the sole God, Allah, who created you. God is all-powerful but merciful, compassionate toward weak and forgetful human beings. Worship and obey him, not those idols in the Meccan temple, the Ka'ba, which will be cleansed of paganism. There is only one God and I, Muhammad, am his Messenger. The greedy and the disobedient who fail to observe this warning will feel the wrath of God at the approaching Day of Judgment. Heed the prophets who came before me, he said, heed Abraham, Moses, Jesus, and all the others. My message only confirms what God was saying to them before their followers strayed from the truth.

Most Meccans, however, disbelieved Muhammad. He was forced eventually to leave the city in 622 and take his message to Medina, some 250 miles to the north. There an oasis racked by civil strife welcomed him, and a new community of Muslims formed—those who lived according to God's commandments, as progressively made known to the Messenger in periodic revelations. Muhammad's passage from Mecca to Medina, where his preaching first enjoyed success, is known as the Hegira, and the year 622 marks the beginning of the Muslim calendar. The name of the Muslims' religion, Islam, means submission to the will of God. Years after Muhammad's death these messages from God to his Prophet were assembled in the Islamic holy book, the Quran we have today.

Apparently, the more sophisticated Arabs of the peninsula were ready for a religion more encompassing than the worship of tribal spirits residing in idols or nature. There already were Jewish and Christian Arabs. The Quran is familiar with both predecessor religions. In the eyes of Muslims, Islam is a reform of Christianity, just as the latter is a reform of Judaism in the opinion of the Christian faithful. Much of the Quran's content resembles that of the Bible. Although the Quran is addressed specifically to Arabs in their tongue, its message is cast in a universal context. The Arabs formed the core of the Muslim community.

Islamic Culture and the Five Pillars

Above all, the core of this community is religious. The Word of God is everywhere, prefacing every writing, embellishing speech, adorning textiles and the walls of mosques, the places of congregational prayer. At birth the first words heard by a Muslim infant testify to the faith: "There is no god but God, Muhammad is his Messenger." They are the last words at death. Ritual prayer five times a day brings the remembrance of God persistently to the forgetful. The annual pilgrimage to Mecca, to be accomplished at least once in a lifetime, if possible, spiritually and corporally unites the Muslim world; a

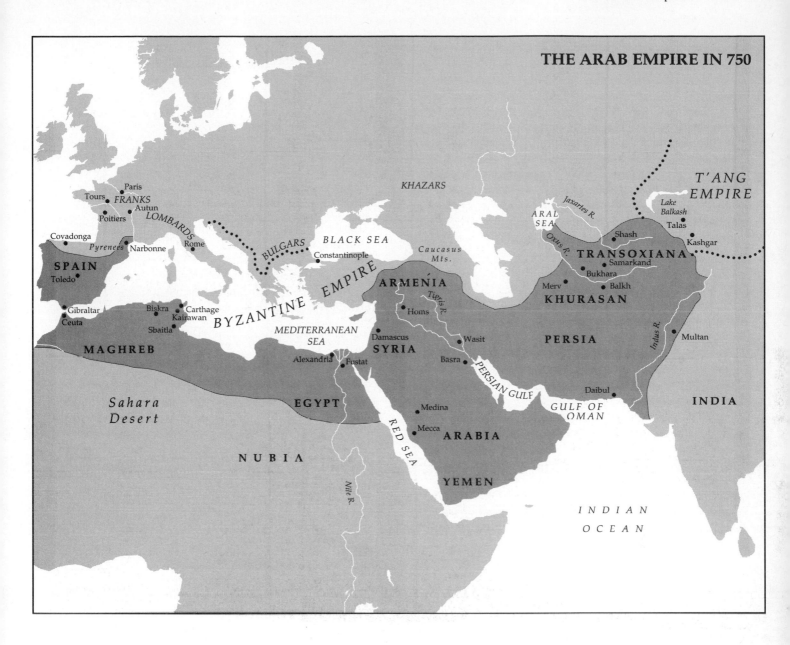

month of fasting from dawn to sunset disciplines the heart and mind. The giving of alms for the benefit of the community's less fortunate purifies the earnings of the donor. The affirmation of faith, the frequent prayers, the pilgrimage to Mecca, the month of fasting, and the giving of alms constitute the Five Pillars of Islam.

The entire scale of ethical values developed from the teachings of the Prophet. For example, male support of the family, including aged parents, is required as is participation in warfare in defense of Islam. Setting slaves free, providing a dower to a bride, and marriage itself are recommended for all Muslims, whereas acts such as gambling and usury are frowned on. Totally forbidden are any sort of idolatry and the eating of certain foods, such as pork. These ethics extend throughout the Muslim world and mold a distinct way of life, to which local custom often adapts.

Expansion of Islam and Conversion to the Faith

Muhammad brought Mecca into the Muslim community through an astute combination of warfare and diplomacy. In doing so, he acquired not only the religious center of western Arabia but the important talents of its merchant community as well. The Meccans provided the early leadership of Islam. The Muslims of Medina, on the other hand, found their role more in the meticulous preservation of the holy revelations.

Muhammad died in 632, throwing the Muslims into a crisis. There would be no more revelations, but new leadership in the form of a caliph, or deputy of the Messenger, continued his temporal mission. The caliph, as civil, religious, and military head of Islam, fulfilled all the duties performed by Muhammad, but unlike him

● D A I L Y L I V E S ●

···· *The Quran on Women*

This selection[a] from the *Quran* shows that the Muslim scriptures contain not only spiritual writings, but also practical guides to daily life. The passage contains the basis for Muslim law that a man may marry up to four wives and for Muslim emphasis on female modesty.

In the Name of Allah, the Compassionate, the Merciful

Men, have fear of your Lord, who created you from a single soul. From that soul He created its mate, and through them He bestrewed the earth with countless men and women.

Fear God, in whose name you plead with one another, and honor the mothers who bore you. God is ever watching you.

Give orphans the property which belongs to them. Do not exchange their valuables for worthless things or cheat them of their possessions; for this would surely be a great sin. If you fear that you cannot treat orphan [girls] with fairness, then you may marry other women who seem good to you: two, three, or four of them. But if you fear that you cannot maintain equality among them, marry one only or any slave-girls you may own. This will make it easier for you to avoid injustice.

a. It is taken from *The Koran*, trans. N.J. Dawood (New York and Harmondsworth, Middlesex: Penguin Books, 1990), pp. 60–62, 64, 74. Copyright © N.J. Dawood, 1993. Reprinted by permission.

Give women their dowry as a free gift; but if they choose to make over to you a part of it, you may regard it as lawfully yours. . . .

God has thus enjoined you concerning your children: A male shall inherit twice as much as a female. If there be more than two girls, they shall have two-thirds of the inheritance; but if there be one only, she shall inherit the half. . . .

If any of your women commit fornication, call in four witnesses from among yourselves against them; if they testify to their guilt confine them to their houses till death overtakes them or till God finds another way for them. . . .

Men have authority over women because God has made the one superior to the other, and because they spend their wealth to maintain them. Good women are obedient. They guard their unseen parts because God has guarded them. As for those from whom you fear disobedience, admonish them and send them to beds apart and beat them. Then if they obey you, take no further action against them. God is high, supreme. . . .

If a woman fears ill-treatment or desertion on the part of her husband, it shall be no offence for them to seek a mutual agreement, for agreement is best. . . . Try as you may, you cannot treat all your wives impartially. Do not set yourself altogether against any of them, leaving her, as it were in suspense. If you do what is right and guard yourselves against evil, you will find God forgiving and merciful. If they separate, God will compensate both out of His own abundance: God is munificent and wise.

the caliph was not a prophet. Until the fourteenth century, the caliph also belonged to the Quraysh tribe, the tribe of Muhammad.

Knowing that the feuding Arab tribes would tear themselves apart, the caliph directed them outward from Arabia with results startling to the seventh-century world. Within a century Arab tribes under the leadership of the Meccan aristocracy had penetrated into Syria and Mesopotamia, which they knew through trade. In 713 an Arab force had landed in the delta of the Indus River in what is now Pakistan and gradually established a Muslim colony there. Deep in central Asia, Arab forces defeated a Chinese army in 751 to halt for good the westward expansion of the Chinese

empire. In these same years the Muslims moved their capital to Baghdad in the agriculturally rich Mesopotamian basin. Here the trade routes linking the Indian Ocean and the Mediterranean Sea converged. This city, growing to become one of the great cities of the world, was to enjoy three centuries of unparalleled prosperity.

In the north a frontier zone with Byzantium came into being along the Taurus mountain range. Summer raids into Asia Minor became customary, while Constantinople came under siege from Muslim seaborne expeditionary forces several times in the seventh and eighth centuries. Failing to take the Byzantine capital, Muslim rulers lost interest in the endeavor until the

Turks successfully revived the challenge in the fifteenth century. Thus Byzantium served as a shield for Europe against Muslim expansion until the Fourth Crusade shortsightedly destroyed that shield.

To the west small Arab contingents took Egypt in 639 after having defeated Byzantine soldiers in Syria. They then dashed across North Africa, accepted Berber tribes as enthusiastic converts to Islam, and with them invaded the Iberian Peninsula in 711. The weak barbarian kingdom of Spain fell quickly, and Muslim armies soon found themselves in southern France, raiding out from their base at Narbonne, just across the Pyrenees.

The encounter between the Muslims and the French at the battle of Poitiers/Tours in central France in 732 marked the deepest penetration the invaders were to make in northern Europe. The defeat of the Muslim "infidels" by the French was a decisive victory. According to Muslim sources, however, the French defeated no more than a raiding party. In the Arabic texts the defeat is noted only as the "martyrdom" of those killed. In fact, France was beyond the limit of the Muslims' concern. Their overriding interest lay in the fertile valleys of the Iberian Peninsula, so much so that they never tried to conquer the northern mountainous parts.

From bases in North Africa the Muslims slowly crossed the Sahara to establish footholds in the western Sudan. They accomplished this primarily by trade, not by force of arms. The east coast of Africa, moreover, had long been a commercial partner of southern Arabia. The conversion of the Arabian Peninsula to Islam merely added a new cultural dimension to an already ongoing relationship with East Africa.

The Muslim world became a vast common market extending from sub-Saharan Africa to central Asia. The elements of a common culture imbued with Islamic values spread throughout that region and constituted the civilization that underlies the culture of many of these same regions today.

By the same means, peaceful trade over centuries, the Muslim world expanded to include much of the Southeast Asian archipelago and colonies on the south China coast. There was, for example, a vigorous Muslim trading community in Canton, China, as early as the latter half of the seventh century.

Quite understandably conversions came rapidly among Arabs, but more slowly among other peoples since they were not encouraged to convert. In the early years of Islam non-Arabs had to be adopted into Arab tribes, the only social structure the Arabs knew. Didn't the spectacular conquests confirm that this was an Arab religion? Non-Arab Muslims were long considered outsiders. Christians, Jews, and other monotheists were granted religious toleration and considerable autonomy provided they submitted to rule by Muslims and paid a discriminatory tax.

Art and Architecture The art and architecture of Islam demonstrate the power with which religion can invest all things. Under the Muslim rulers, whether in Persia, North Africa, Spain, or Turkey, the prohibition against images in a religious context rendered sculpture of little importance and reduced painting to exquisite manuscript illustration and decoration for the private enjoyment of the elite. The written word—calligraphy—also achieved new heights of importance as an expressive art form found not only in manuscripts of the Quran but also in the words of the Prophet, which were inscribed on walls and carved in stone. A page from a ninth-century Quran written in either Syria or Iraq demonstrates the potent energy of a beautiful hand. The letters in Kufic script achieve a life of their own, becoming very like human forms, at prayer, with arms upraised or bodies prostrate (Fig. 9-12).

A medical textbook (1224) shows script combined with the illustration of two physicians preparing a poultice to draw out snake venom (Fig. 9-13). The figures are flattened and their forms enriched and enlivened with patterns. Nudes appear rarely and then only in a context of primeval innocence or error. For example, a fourteenth-century *Chronology of Ancient Peoples*, painted at Tabriz in Iran, and depicting the temptation of Adam and Eve, is filled with lively decoration as well as presenting, in a very powerful but chaste way, the dilemma of these forebears (Fig. 9-14).

Manuscript illustrations were usually a secular private art form with circulation limited to the court and wealthy merchants. The Muslims created other art forms—such as ceramics, textiles, and metalwork—that had wide circulation and influence.

The Mosque As it developed, Islamic civilization found special expression in architecture. At first Muslims converted churches into their own places of prayer

9-12 *Page written in Kufic script from a Quran. Syria or Iraq, c. ninth century. Illumination. (The Metropolitan Museum of Art, New York. Rogers Fund, 1937)*

9-13 Two Physicians Preparing Medicine, *Iraqi painting from an Arabic translation of the* Materia Medica of Dioscorides. *Baghdad school, 1224. Opaque color and gold: paper—33.1 × 24.6 cm; painting—8.8 × 17.5 cm. (Courtesy, Freer Gallery of Art, Smithsonian Institution, Washington, D.C.)*

• With what paintings can you compare these two figures? Justinian and his court? Egyptian painting?

but soon developed their own mosque designs. They abandoned the axial orientation of the church, which focused attention on the altar, for an architectural style that encouraged equality in the presence of God.

The Prophet commanded that the faithful pray five times daily, at first facing toward Jerusalem, later toward Mecca. This admonition, combined with the principle of equality in the presence of God, produced the need for a large, undifferentiated enclosure in which the praying faithful could prostrate themselves in rows. The mosque was oriented toward Mecca, the "navel of the earth." That direction, the *qibla,* came to have a niche, the *mihrab,* to identify it for the worshipers. To the right of that niche was the *minbar,* a pulpit for the Friday sermon. Two other major architectural features are the *sahn,* a courtyard to accommodate an overflow of worshipers, and a fountain for the required ritual ablutions before prayer. Minarets, used for the muezzin's call to prayer, came into use in the eighth century but are not as essential as the other features.

Muslims also rejected any representation of animate forms in a religious setting, so the interiors of their

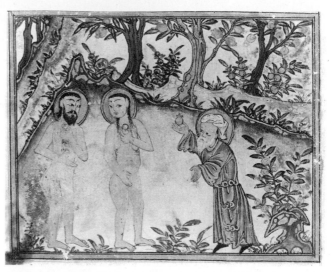

9-14 Temptation of Adam and Eve, *from the* Chronology of Ancient Peoples *manuscript of al-Biruni, painted in Tabriz, Iran, 1307. Illumination, 7½" × 12½". (Edinburgh University Library)*

mosques contrasted sharply with those of Byzantine churches. Instead of saintly images, any Muslim religious context was rigorously aniconic, that is, devoid of animate images. Mosques were adorned instead with intricate calligraphic bands of verses from the Quran. To write the word of God in a beautiful hand according to a variety of styles became one of the highest art forms of Islamic civilization.

None of the first mosques has survived, although Muslims realized very early that their buildings might compete with those of Christians. For example, it is said that the seventh-century Dome of the Rock (Fig. 9-15) was built in Jerusalem by the caliph 'Abd al-Malik, who, "noting the greatness of the Church of the Holy Sepulcher and its magnificence, was moved lest it should dazzle the minds of the Muslims, and hence erected above

9-15 *Dome of the Rock, Jerusalem, late seventh century. (Art Resource, NY)* (**W**)

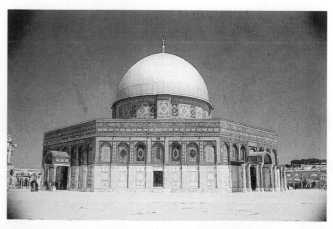

the Rock the dome which is now to be seen there," according to one scholar.

The Dome of the Rock is unique symbolically and architecturally. Completed in 692 at a time when the city's Christians still doubted the permanence of Islam, the octagonal structure is in essence a victory monument, located on a site hallowed by three faiths. Its quranic inscriptions emphasize the superiority of Islam and its interpretation of Jesus as a prophet and the son of Mary. With the passage of time, however, the original significance of the Dome of the Rock has been replaced by an association with the Prophet's alleged ascent to heaven from the rock that the sanctuary encloses.

Although it is unique, some of the forms in the Dome of the Rock can be seen in subsequent mosque architecture. Above all is the emphasis on surface decoration. The graceful, slightly pointed dome, which may have been inspired by other pointed arches found throughout the building, may be derived from Byzantine forms. The exterior, clad in veined marble set in simple patterns, recurs in many mosques; the vivid white, blue, yellow, and green tiles above the marble are sixteenth-century replacements for the original mosaics executed by the Byzantine artisans hired to build the monument.

The pointed dome and the pointed arches of the interior arcades are two features readily associated with the architecture of Islam. The pointed arch was not an unknown structural form, but the Muslims used it in ways that gave rise to new kinds of architectural articulation. The Roman semicircular or round arch required substantial support at its springing (see Fig. 7-5) because the thrust of both sides of the arch was outward and down. The two sides of the pointed arch, in contrast, lean against each other and require less pressure at the springing, which means that it does not have to be embedded in a heavy wall or roof (Fig. 9-16). The arch, in this form, began to appear where the Muslims built.

In the eighth century, gigantic mosques were erected in Cairo, Damascus, Baghdad, and Samarra. The exterior walls of the Great Mosque of al-Mutawakkil, c. 848–852, in Samarra still stand. The enclosure provided for prayer was 784 × 512 feet, a size considerably greater than that of any Christian church. The mosque's 176-foot minaret, built as a spiral of fired brick, looks very like a Mesopotamian ziggurat and may well have been inspired by one (Fig. 9-17).

The Great Mosque of Cordoba, Spain (now the cathedral), gives us some idea of the experience of the interior of these structures. Begun in the eighth century

9-16 Comparison drawing: The Muslim system of building, using pointed arches (right) was highly flexible and capable of expression quite different from that of the Roman system (left).

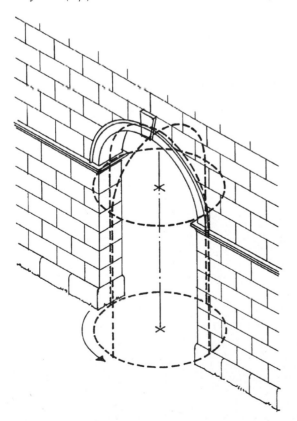
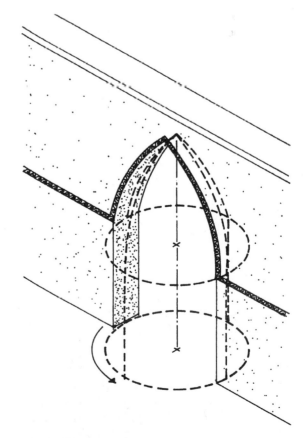

9-17 *Spiral minaret, Great Mosque of al-Mutawakkil, Samarra, Iraq. Fired brick, height 176'. (Bildarchiv Preussischer Kulturbesitz, Berlin)*

9-18 *Plan of the Great Mosque of Cordoba, c.* A.D. *786–987, showing successive enlargements.*

▲

• Compare this plan with the plan of Hagia Sophia (Fig. 9-3). What is the most significant difference and why?

by 'Abd ar-Rahman I, it was enlarged repeatedly until the tenth century. In plan it is a huge rectangle filled with aisles, all of which are located on the qibla side of the sahn (Color Plate V). The interior with its striped arches within arches seems an infinite range of spaces of equal value with a ceiling of continuous expanse. The vaults of the vestibule of the mihrab introduce another level of complexity, where the arches are interlaced and scalloped and their interior faces carved with intricate patterns (Figs. 9-18 and 9-19).

The Great Mosque of Cordoba with its rows of columns and arcades also illustrates the decoration not only found in mosques but also characteristic of palaces, one of the other major building types of Islamic civilization. The façade of the palace at Mshatta, Jordan, c. 743, is an early surviving example of the rich patterns derived by combining floral, animal, and geometric forms in fantastic repeating and symmetrical patterns that came to be known as *arabesque* (Fig. 9-20). These complex patterns, with forms abstracted from nature, look like the fabulous woven textiles still produced by Muslim artists today.

The Alhambra Palace The palaces of the Muslim rulers are epitomized and unsurpassed in the Alhambra, built in Granada in the fourteenth century by the Nasrids of southern Spain, who were defeated by Ferdinand and Isabella in 1492. The palace consists of two major units: the Court of Myrtles with its reflecting pool and surrounding apartments, and on axis and almost perpendicular to it the Court of the Lions, which is centered with a fountain supported on the backs of lions. It is believed that the former court and rooms were for

more public use and the latter for private use, but the divisions are not absolute.

As it is described in literature and music, the Alhambra is an unearthly place, apparently designed to resemble paradise. The building focuses inward and its courts, column-filled halls, and carved, gilded, painted, and vaulted spaces induce a feeling of placidity and contemplation. The Court of the Lions is seen in Figure 9-21 through a screen of columns and scalloped arches of the Hall of Justice (1394) with its three bays of equal size, each carrying a dome with a lantern. This space produces feelings similar to those of the infinite space suggested by the Great Mosque of Cordoba. The walls of the Hall of Justice (Fig. 9-22), carved and cut away, create lacy shadows while eliminating any feeling for the structure of the building.

The influence of the Muslims on the art and architecture of Europe can be found not only in architectural forms and techniques but also in the names of things. From Damascus came damask, a finely woven monochromatic patterned fabric combining linen and silk; from Mosul in Iraq came muslin. Muslim art also influenced metalwork, ceramics, and glassware because most Europeans imported, collected, and copied from the work that traveled east and west from Persia to Spain where the Prophet's power was felt.

9-19 *Vestibule of the mihrab, Great Mosque of Cordoba, c. tenth century. (Alinari/Art Resource, NY)*

• Compare this interior with that of the Church of the Chora (Color Plate XIV).

9-21 *Court of the Lions, the Alhambra, Granada, Spain, c. A.D. 1354–91. (Alinari/Art Resource, NY)* (**W**)

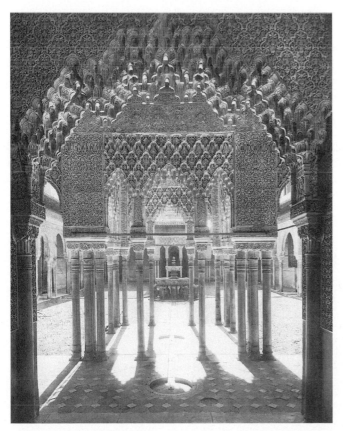

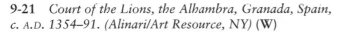

• Compare this "earthly paradise" with sacred spaces in Egyptian tombs, the Parthenon, and Hagia Sophia.

9-20 *South façade of the palace at Mshatta in Jordan, c. A.D. 743. Height: 5.54 m. Staatliche Museen zu Berlin. (Bildarchiv Preussischer Kulturbesitz, Berlin)*

Law and Doctrine

The evolution of Islamic doctrine contrasts with that of Christianity. Under persecution underground, Christians had early honed the rough edges of their religion. Muslims in the seventh century, on the other hand, were too involved with expansion and territorial consolidation to devote full attention to the development of Islam as a religion. It was not until the eighth century that a corpus of specifically Islamic law began to be distinguished from traditional Arab custom. In this process the practice and words of Muhammad came to complement the modest legal content of the Quran itself. With obedience to God's will the primary commitment of the Muslim, the discovery of that will was a crucial prerequisite. Hence the evolution of the law was the earliest development of the religion. In this respect Islam appeared closer in spirit to Judaism than to Christianity.

9-22 *Hall of Justice, the Alhambra, Granada, Spain, c. A.D. 1354–91. (Bildarchiv Preussischer Kulturbesitz, Berlin)*

As this evolution occurred during the second Islamic century, non-Arabs began to play a significant role in Muslim society, even while Arabic remained the dominant language. New converts to Islam asked the sorts of questions familiar to them in their former faiths: Does the human being have free will or are we predestined? How can a just God permit evil in this world? Do quranic expressions such as "God's speech," "the hand of God," "in the sight of God," and so forth imply divine likeness to the human being?

In the emerging Islamic civilization the relationship between philosophy and religion produced nearly as much tension as it did in western Europe but with a different result. Greek philosophical texts were translated into Arabic and became influential, but the central position of the Quran as God's exact Word relegated human reason to the periphery. All Muslims, even the illiterate, recited the revelation as the core of their faith. No effort to rationalize it in a manner that modified revelation was generally acceptable.

Shi'ism, a Branch of Islam One exception may be noted. Within the first generation of Islamic history a schism took root in the community over the question of leadership. A minority felt that the caliph should be a descendant of the prophet Muhammad, and they proved willing to fight for that concept. Their struggle, however, generally ended in defeat. This revolutionary faction became known as the Shi'ites, whereas the mainstream assumed the name of Sunnis. Among the small but important Shi'ite minority, philosophy retained an honored position throughout history, since it was often used to buttress their arguments for the legitimacy of the Prophet's heirs.

Sufism, or Islamic Mysticism As the ideal of an Islamic society diverged with time from the reality of political power, and as Islamic law stressed the immense gulf between a transcendent God and forgetful humankind, some Muslims turned to an inner search for truth. The Sufis, as the Muslim mystics are called, seek to know God by devoting their whole being to the search for the divine essence within themselves. Grounded in Islam, Sufism nevertheless created a tension within it, for the mystics felt little need for the ritual and the law. Some even ostentatiously rejected the formalities of Islam and paid for their boldness with martyrdom. This dimension of Islam, this yearning of the mystic's soul for reunion with the divine, sought expression in deeply emotional poetry. The masterpieces of that Sufi poetry have long appealed to the devout of other faiths as well as to Islam's own. In recent years, Sufi poetry has enjoyed a marked popularity among segments of American youth who seek spiritual experiences they seem unable to find through more mainstream religious traditions.

Political Decentralization

The vast extent of the Muslim world doomed any prospect of the centralized control that the caliphs of Baghdad initially desired. Even the caliph himself became a tool in the hands of his Turkish bodyguard and was soon to be relegated to a mere cipher under Turkish sultans, in essence military dictators. Elsewhere, governors asserted their independence, and in Spain even a rival caliph emerged. Yet the cultural and spiritual unity of the Muslim world remained vigorous despite political decentralization and internecine warfare among Muslim principalities.

The Impact of Islamic Civilization on Europe

From the early eighth century of the Christian era to the fifteenth century, Europe shared the Mediterranean Sea with Muslims in North Africa, the Iberian Peninsula, and Sicily. At first the contacts were sporadic and hostile, with Arab and Berber raiding parties seeking what booty they could find on the coasts of the barbarian kingdoms.

As Islamic governments consolidated their holds on the southern and western shores of the Mediterranean, however, raiding receded in favor of trade, most of it east-west commerce within the Muslim world. But an increasing portion of the trade became north-south as Europe slowly regained a level of prosperity sufficient to attract Muslim commerce.

It was not long before the dynamic cultural synthesis emerging in the central Islamic lands reached their Muslim coreligionists in the West. Cultural elements as diverse as Asian spices, fruits and grains, Chinese paper, Indian numerals, and Greek thought were carried along trade routes to the Muslim courts of the West.

Congenial conditions for the cultivation of foods new to the West such as rice, sugar cane, watermelon, oranges, and lemons were found in the Mediterranean basin. The Arabic words for these foods soon found their way into local and then European languages. Cotton, too, was introduced as an industrial crop, ultimately affecting the clothing styles of Europeans. For several of these crops the development of irrigation works was necessary. Since the Arab conquerors of the Iberian Peninsula were originally from Syria, the extant waterwheels of Seville, for example, duplicate those today in Hama, Syria.

Mediterranean Islam society sought to emulate Baghdad, the caliphal seat of Islam, and thus the cultural attainments of the central Islamic lands came within the reach of a Europe soon able to appreciate them. For instance, Ziryab, a musician and singer, fell out of the caliph's favor in early-ninth-century Baghdad and made his way to the rival Muslim caliphate in al-Andalus, as Muslim Spain is generally known. Until his death in 857, Ziryab was the arbiter of taste in the Islamic West not only in his profession as a musician but

in fashion and the culinary arts as well. Quite as nine-teenth-century Bostonians modeled their society on London fashion and culture, so the courts of al-Andalus recognized and sought the refined taste, standards of luxury, and intellectual attainments that emanated from the central Islamic lands.

Intellectual Life in the Iberian Peninsula Andalusian society was a very mixed one in which cross-cultural diffusion was accentuated. It was made up of frequent Spanish converts to Islam as well as many Arabic-speaking Christians and prominent tricultural Jews fluent in Hebrew, Arabic, and a romance language. All were soon immersed in a milieu, known today as Hispano-Arabic culture, that by the tenth and eleventh centuries had become the intellectual, artistic, and literary peer of Baghdad's. Before it was extinguished by Christian reconquest, Hispano-Arabic culture had produced luminaries such as Ibn Rushd (died 1198), the philosopher known in the West as Averroes, whose commentaries on Aristotle heavily influenced the preeminent Roman Catholic philosopher Thomas Aquinas (died 1274; see Chapter 10) and Maimonides (died 1204), a Jewish philosopher and physician writing in Arabic whose *Guide for the Perplexed* likewise drew on the thought of Aristotle. In literature, Hispano-Arab poets applied local strophic forms to the Arabic ode to create a unique genre, the *zajal*, that was in turn carried back to the central Islamic lands. This Hispano-Arabic culture was largely tolerant, and virtually all Arabic-speaking Andalusians—Muslim, Jew, and Christian—could identify with it.

Christian Spain, on the other hand, was culturally impoverished. Hostile to but economically dependent on al-Andalus, it was a relatively isolated backwater until French influence began to penetrate the northern kingdoms in the tenth century. Then, from the eleventh to the fifteenth century, during the recovery of the Iberian Peninsula for Christendom—known as the Reconquista—there was a second cross-cultural diffusion, even while warfare continued between Catholic and Muslim rulers. Mediated by Andalusian scholars of various backgrounds, the European acquisition of Hispano-Arabic culture was initiated by church leaders from north of the Pyrenees who appreciated the high civilization of al-Andalus although they disparaged its Islamic context.

Cultural Transmission in Spain After it passed into Christian hands in 1085, the city of Toledo in the center of Spain became the most renowned of the hubs of cultural transmission. Arabs and Jews worked with European patrons to translate and edit Arabic texts, some of which were translations of Greek originals, while others were unique contributions. Although the names of certain translators, such as Herman of Dalmatia, Robert of Ketton, and Michael Scot, are well known, the attribution of specific works to them is debatable. More certain is the patronage of, for example, the ab-bot Peter the Venerable (died 1156) and the Castilian king Alfonso the Wise (reigned 1252–1284).

The Sicilian Milieu Not all intellectual transmission was through Hispano-Arabic culture, however. Another route was through Sicily, conquered by North African Muslims in the ninth century. Although this Mediterranean island was retaken by the Christian Normans in the eleventh century, several of these kings admired the culture they found in Sicily and patronized Arabic scholars. The *Book of Roger*, commissioned by Roger II (1127–1154) and composed by al-Idrisi (died 1166), is a complete description of the world as known to Muslims; it laid the basis for European knowledge of India, China, and the northern part of Africa. At Salerno in southern Italy, the medical lore of Islamic civilization was both taught and applied in its famous school. Both Salerno and a later medical school at Montpellier in southern France were the principal sites for European acquisition of Islamic medicine.

The Role of the Crusades in Cultural Transmission The Levantine Crusades provided less opportunity for cross-cultural diffusion than might have been expected. Granted, the Europeans gained some knowledge of military architecture and technology from their two centuries' experience on the eastern shores of the Mediterranean Sea. From there as well as through Sicily and Spain they learned of new foods, clothing materials, and ways of caring for the sick and wounded. As opposed to mutual exchanges between the two cultures in Spain and Sicily, the religious passions of the Crusaders inhibited an extensive appreciation of Islamic civilization.

If the Crusades made only minor positive contributions to Western life, they generated a negative impression of Islam that has continued to deeply mark the western European mentality. Although initially conceived in religious terms, the Crusades were the product of new energies generated by a rapidly changing society, and Islam easily became identified as the enemy blocking the expansionist tendencies of this society and of its religion.

Indeed, it seemed that the Muslim world, covering more than half the known earth, was steadily pressing in on the Christian West. Tales of pilgrims to the Holy Land suffering from Bedouin raids had been magnified, and the Byzantine emperor had appealed for aid against the Muslims. The initiative of the papacy for the crusading movement was soon expanded by church leaders writing enthusiastic tracts. These introduced or repeated crude errors about Islam, declaring it to be a deliberate perversion of the Christian truth, and Muhammad to be an impostor or an Antichrist. Dante, in his *Divine Comedy* (see Chapter 11), put Muhammad in the depths of hell. Muslims were also portrayed as violent people spreading their faith by the sword. Such tracts excused the Europeans' own resorting to the sword as no more than a defense of their religion.

For a considerable period the Crusades hardly caused a ripple in the Muslim world. Muslim writers saw them initially as an extension of the Byzantine efforts to regain lost territory. But gradually, aided by the rebukes of the religious scholars, the Muslim attitude approached the diatribes of the Crusader propagandists. Muslim embitterment manifested in the East came to be matched in the West as the victorious forces of Spain and Portugal moved down to the tip of the Iberian Peninsula, forcing conversions of their Muslim subjects and, when the conquest was completed, compelling those who clung to their faith to leave the land. The era of Hispano-Arabic florescence was buried deep under the burnings and expulsions of the Inquisition.

In the long term it was the existence of this feared yet denigrated Islam, positioned to the south and east of Europe, that propelled the Portuguese in the fifteenth century to attempt the circumnavigation of the Muslim world. They hoped to reach by sea the spices the Europeans sought. Wedding crusade and commerce, however, proved in the end to be unprofitable for such a small kingdom. The task of exploring and exploiting the world fell to others such as Spain, France, and eventually England. Nonetheless, the Portuguese expedition was for Muslims the first instance of European colonialism that would so often join military occupation with efforts to undermine the social fabric of Muslim society and religion.

In summary, the impact of Islamic civilization on Europe has had three facets: first, the often unconscious adoption of foods, vocabulary, technology, and architecture through the Hispano-Arabic synthesis; second, the deliberate acquisition of the Islamic intellectual tradition through the translation into European languages of major scientific and philosophical works; and third, the negative interpretation of the religious tradition of the Muslim world, Islam. This interpretation, which resulted from the Crusader mentality, has had consequences that are still with us today.

JUSTINIAN

from *The Digest* or *Pandects*

Translation by S. P. Scott

The Emperor Caesar, Flavius, Justinianus, Pious,
Fortunate, Renowned, Conquerer and Triumpher,
Ever Augustus, to Tribonianus His Quæstor:
Greeting.

With the aid of God governing Our Empire which
was delivered to Us by His Celestial Majesty, We carry
on war successfully, We adorn peace and maintain the
Constitution of the State, and have such confidence in
the protection of Almighty God that We do not depend
upon Our arms, or upon Our soldiers, or upon those
who conduct Our Wars, or upon Our own genius, but
We solely place Our reliance upon the providence of
the Holy Trinity, from which are derived the elements
of the entire world and their disposition throughout
the globe.

(1) Therefore, since there is nothing to be found in
all things so worthy of attention as the authority of the
law, which properly regulates all affairs both divine and
human, and expels all injustice; We have found the en-
tire arrangement of the law which has come down to us
from the foundation of the City of Rome and the times
of Romulus, to be so confused that it is extended to an
infinite length and is not within the grasp of human ca-
pacity; and hence We were first induced to begin by ex-
amining what had been enacted by former most vener-
ated princes, to correct their constitutions, and make
them more easily understood; to the end that being in-
cluded in a single Code, and having had removed all
that is superfluous in resemblance and all iniquitous
discord, they may afford to all men the ready assistance
of their true meaning.

(2) After having concluded this work and collected
it all in a single volume under Our illustrious name,
raising Ourself above small and comparatively in-
significant matters, We have hastened to attempt the
most complete and thorough amendment of the entire
law, to collect and revise the whole body of Roman ju-
risprudence, and to assemble in one book the scattered
treatises of so many authors; which no one else has

herebefore ventured to hope for or to expect, and it
has indeed been considered by Ourselves a most diffi-
cult undertaking, nay, one that was almost impossible;
but with Our hands raised to heaven, and having in-
voked the Divine aid, We have kept this object in Our
mind, confiding in God who can grant the accomplish-
ment of things which are almost desparate, and can
Himself carry them into effect by virtue of the great-
ness of His power.

(3) We have also taken into consideration your
marked integrity as disclosed by your labors, and have
committed this work to you, after having already re-
ceived the evidence of your talents in the preparation of
Our Code; and We have ordered you in the prosecution
of your task, to select as your assistants whomever you
might approve of from among the most eloquent pro-
fessors of law, as well as from the most learned men be-
longing to the bar of this great city. These, therefore,
having been collected and introduced into Our palace,
and accepted by Us upon your statements, We have per-
mitted the entire work to be accomplished; it being pro-
vided, however, that it should be conducted under the
supervision of your most vigilant mind.

(4) Therefore We order you to read and revise the
books relating to the Roman law drawn up by the ju-
rists of antiquity, upon whom the most venerated
princes conferred authority to write and interpret the
same; so that from these all the substance may be col-
lected, and, as far as may be possible, there shall remain
no laws either similar to or inconsistent with one an-
other, but that there may be compiled from them a sum-
mary which will take the place of all. And while others
have written books relating to the law, for the reason
that their writings have not been adopted by any au-
thorities, or made use of in practice, We do not deem
their treatises worthy of Our consideration. . . .

(12) We desire Our compilation which, God will-
ing, is to be drawn up by you, to bear the name of the
Digest or Pandects, and no person learned in the law
shall dare hereafter to add any commentaries thereto,
and to confuse by his own prolixity the abridgement
of the aforesaid work, as was done in former times,
for almost all law was thrown into confusion by the
opposite opinions of those interpreting it; but it is suf-
ficient merely by indexes, and a skilful use of titles

(which are called παράτιτλα), to give such warning that no change may take place in the interpretation of the same.

..

QUESTIONS

1. According to Justinian, what purpose does the law serve? To what extent would Cicero agree with the emperor's conception of law?
2. Why does Justinian highly prize the interpretations of the law found in ancient jurists but forbid modern jurists to make additions or commentaries on the text as he has had it codified?
3. How do you reconcile Justinian's reluctance to permit changes or commentaries on the three books making up the *Corpus* and his willingness to add a fourth book of new laws, *The New Constitutions*, which would expand over time?

..

..

from the Quran
Translation by A. J. Arberry

The Quran, the holy scripture of Islam, is not meant to be translated. Muslims say, quite correctly, that in any language other than Arabic the revelations are not the Quran. They do indeed lose much of their force in English, since the rhythmic prose is lacking. These selections have been chosen to show the very different sorts of material to be found in the Quran: hortative, didactic, worshipful.

The first selection is also the first *sura*, or chapter, one that is repeated by the devout Muslim at least fifteen times a day, since it forms an integral part of the five daily ritual prayers.

The second selection is a verse from the longest sura in the Quran, the second. It is known as the "Throne Verse" and is often reproduced alone on placards to be hung in the home.

In the third selection Mary, the mother of Jesus, appears.

I
The Opening

In the Name of God, the Merciful, the
Compassionate

Praise belongs to God, the Lord of all Being,
the All-merciful, the All-compassionate,
 the Master of the Day of Doom.

Thee only we serve; to Thee alone we pray for
 succour.
 Guide us in the straight path,
the path of those whom Thou hast blessed,

not of those against whom Thou art wrathful,
 nor of those who are astray.

II
The Throne Verse

God
 there is no god but He, the
 Living, the Everlasting.
Slumber seizes Him not, neither sleep;
 to Him belongs
all that is in the heavens and the earth.
Who is there that shall intercede with Him
 save by His leave?
 He knows what lies before them
 and what is after them,
and they comprehend not anything of His knowledge
 save such as He wills.
His Throne comprises the heavens and earth;
 the preserving of them oppresses Him not;
He is the All-high, the All-glorious.

XIX
Mary

. . . And mention in the Book Mary
when she withdrew from her people
 to an eastern place,
and she took a veil apart from them;
then We sent unto her Our Spirit
that presented himself to her
 a man without fault.
She said, "I take refuge in
the All-merciful from thee!
 If thou fearest God"
He said, "I am but a messenger
come from thy Lord, to give thee
 a boy most pure."
She said, "How shall I have a son
whom no mortal has touched, neither
 have I been unchaste?"
He said, "Even so thy Lord has said:
'Easy is that for Me; and that We
may appoint him a sign unto men
and a mercy from Us; it is
 a thing decreed.'"
So she conceived him, and withdrew with him
 to a distant place.
And the birthpangs surprised her by
the trunk of the palm-tree. She said,
"Would I had died ere this, and become
 a thing forgotten!"
But the one that was below her
called to her, "Nay, do not sorrow;
see, thy Lord has set below thee
 a rivulet.

Shake also to thee the palm-trunk,
and there shall come tumbling upon thee
 dates fresh and ripe.
Eat therefore, and drink, and be
comforted; and if thou shouldst see
 any mortal,
say, 'I have vowed to the All-merciful
a fast, and today I will not speak
 to any man.'"
Then she brought the child to her folk
carrying him; and they said,
"Mary, thou hast surely committed
 a monstrous thing!
Sister of Aaron, thy father was not
a wicked man, nor was thy mother
 a woman unchaste."
Mary pointed to the child then;
but they said, "How shall we speak
to one who is still in the cradle,
 a little child?"
He said, "Lo, I am God's servant;
God has given me the Book, and
 made me a Prophet.
Blessed He has made me, wherever
I may be; and He has enjoined me
to pray, and to give the alms, so
 long as I live,
and likewise to cherish my mother;
He has not made me arrogant,
 unprosperous.
Peace be upon me, the day I was born,
and the day I die, and the day I am
 raised up alive!"
That is Jesus, son of Mary,
in word of truth, concerning which
 they are doubting.
It is not for God to take a son
unto Him. Glory be to Him! When He
decrees a thing, He but says to it
 "Be," and it is.
Surely God is my Lord, and your
Lord; so serve you Him. This is
 a straight path.

COMMENTS AND QUESTIONS

1. Is there anything in the first sura to which a monotheist other than a Muslim would take exception? Note that it does not even mention either Islam or Muhammad.
2. How would you characterize Allah in the second sura? What differences do you find between Allah and Yahweh, the God of the Jews (see Chapter 8)?
3. Do portions of the "Throne Verse" remind you of one of the biblical Psalms? If so, which one? Why do you suppose this verse is such a favorite with Muslims?
4. How does the third selection's account of Mary differ from that in the Gospel according to Saint Luke (see Chapter 8)? In what respects is it similar? From this account, what is the role of Jesus in Islam?

● SUFI LITERATURE ●

Sufism brought to Islam a religious dimension especially appealing to the individual, who could convey a deep love of God in his or her own language. The Sufis were thus important agents in the diffusion of Islam far beyond its homeland.

Here, for example, are the ecstatic utterances of the Persian eleventh-century mystic known as Baba Kuhi of Shiraz and a poem expressing the experience of the divine by al-Junayd of Baghdad, the greatest teacher of Sufism of the late ninth century.

BABA KUHI OF SHIRAZ
Translation by Reynold A. Nicholson

In the market, in the cloister—only God I saw.
In the valley and on the mountain—only God I saw.
Him I have seen beside me oft in tribulation;
In favour and in fortune—only God I saw.
In prayer and fasting, in praise and contemplation,
In the religion of the Prophet—only God I saw.
Neither soul nor body, accident nor substance,
Qualities nor causes—only God I saw.
I opened mine eyes and by the light of His face
 around me
In all the eye discovered—only God I saw.
Myself with mine own eyes I saw most clearly,
But when I looked with God's eyes—only God I saw.
I passed away into nothingness, I vanished,
And lo, I was the All-living—only God I saw.

AL-JUNAYD OF BAGHDAD
Translation by A. J. Arberry

Now I have known, O Lord,
What lies within my heart;
In secret, from the world apart,
My tongue hath talked with my Adored.

So in a manner we
United are, and One;
Yet otherwise disunion
Is our state eternally.

Though from my gaze profound
Deep awe hath hid Thy face,
In wondrous and ecstatic grace
I feel Thee touch my inmost ground.

1. Why is poetry the usual genre of Sufi literature?
2. Do either of these selections contradict what you know of the Quran? What are their main themes?

from the *Epic of 'Antar*

This enormous epic tale about pre-Islamic Arabia stands in the Arab world at least on a par with the *Thousand Nights and a Night*, although it is less well known in the West. It is the tale of a black knight, originally a slave, who gains his freedom by his exploits and his chivalry. It tells of his loves and his achievements as a leader of men. Thus it reflects the values of that society, filtered, however, through those of medieval Egypt.

As we have it today, its style is of tenth- to fourteenth-century Egypt, and occasionally an Islamic anachronism creeps into the narrative. The selection is rewritten for an English-speaking audience by Diana Richmond from nineteenth-century translations.

The Fourth Story

'Abla

It was the custom in those far-off days that the Arab women should drink sheep's milk as they arose in the early morning, and this milk would be brought to the tents of the leaders of the tribe by a servant who had seen to it that the warm milk had been cooled in the dawn breeze. 'Antar performed this service for Samiya, wife of his father Sheddad, and for Sheriya, the wife of Malec, son of Karad, uncle of 'Antar. Malec was a man of suspicious nature, and one in whom envy and jealousy strove with arrogance for mastery of his soul. He lacked the graces of magnanimity so precious to the Arab people. His son, Amr, inherited his father's meanness, but his daughter, 'Abla, displayed in her person and in her personality all the gifts most admired in a daughter of the desert. Her merry humour, her kindness to the unfortunate and her respect for her elders rendered her a byword in the tribe; and as she emerged from childhood to womanhood her beauty was fast becoming legendary.

Yet, for all her good humour, there was little love between sister and brother, 'Abla and Amr. Indeed, he disliked what he considered to be her lack of dignity. For Amr was proud of the nobility of his family which he shared by birth, and he had not realized, as had his sister, that noble behaviour should accompany a high position. Moreover, as children, 'Abla had far excelled him as a rider of horses, for in those days she had sought to emulate Robab, and the Princess Zenobia, who led her father's men into battle in the days when Palmyra was still a fair city at the height of its beauty; and 'Abla would still recount the story of the conception of the mare, Dahis, the Thruster, and of the Great Race, but Amr did not like these stories.

And it happened at this time—and it was springtime—that when 'Antar entered the women's tent to serve the cool milk, he surprised his cousin 'Abla at her toilet, for she sat unveiled and only half-dressed while her mother combed and plaited her long black hair. 'Abla cried out in her embarrassment and fled across the tent, her hair flowing behind her as a silken pennant floats in the wind; and 'Antar, though almost bereft of his senses by her beauty, yet retained enough of them to observe the loveliness of her form—her ivory skin, and her firm breasts rising cleanly as do the desert dunes in the moonlight; and the rustle of her dress was soft as the wings of starlings flocking to the wadi [a dry stream bed] in the evening hours. So 'Antar lost his heart to his cousin 'Abla, who was yet so far above him in rank that never could he aspire to marriage with her, being but a slave although of noble blood.

On the following morning, as he entered the tent again, he was overcome with embarrassment, for 'Abla cried in her merry way, "It seems, friend, that I must rise earlier than you to preserve my modesty! See how well I have done today, almost beating the dawn itself!" And she laughed, and her aunt and her mother laughed too; but as for poor 'Antar, his love and his confusion were so great that he offered the sheep's milk to his fair cousin before he had served it to the elder women. Then Samiya, wife of Sheddad, was furious, and drove him from the tent. But 'Abla smiled to herself and was not unaware of 'Antar's strength and comeliness for all that his colour was black as the pitch which oozes over the sand at the foot of the Persian mountains in the far desert.

In those days, as in our own, there were plots and intrigues among the slaves and servants, and among their masters too. Samiya's anger with 'Antar was exploited now by Zajir, slave of Rabia, who bore a grudge against 'Antar. Zajir told Samiya how 'Antar had learned his camel-riding and his horse-riding at the expense of the herds, and how he had injured the few and precious trees of the desert fringes by aiming at them his javelins and spears. And Samiya sought her husband and complained to him of the black slave who could not care for the animals in his charge nor appreciate the true position of an elder woman's rank compared to that of young 'Abla.

And Sheddad was angry, and seizing his son he beat him cruelly. But 'Antar, although he was already as strong as his father, suffered the beating in all humility because he respected his father and his father's position in the tribe. Zebeeba came also to her son and warned him to remember his lowly position. But 'Antar, who lay bound after the beating, burst his bonds simply by flexing his muscles, and seizing a horse he followed the

slave Zajir into the desert, and there killed him for his treachery. "For," he said to himself, "a man should, if he have a grievance, speak openly to his opponent of the quarrel, nor should he secretly persuade a woman to speak for him."

Among the leaders of the tribe, too, there were feuds and dissension, for Rabia, clever and ambitious as he was, disliked the Prince and his brothers, and Sheddad and Malec swayed to one side or the other side, but all respected and feared, or loved, lord Zuhair.

Now when 'Antar had killed the second slave he sought protection from the Prince against Rabia's wrath, and the Prince made up his mind to settle the affair with no further bloodshed, for the Prince was a kindly man. He sought the elders in their assembly, and all rose as he entered, giving and receiving the greetings. And the Prince, still standing, turned to Rabia and said, "Cousin, I greet you, and if you love me I would ask a favour of you." "Indeed I love you," growled Rabia, who did no such thing, but to whom the courtesies were important as they are to all true Arabs. "Give me then, I pray, your slave Zajir," continued the Prince. Now Rabia valued Zajir, and thought he was still alive, and to give himself time to think he reproached the Prince, saying, "Sit down in your place, I beg of you, my cousin, for are we not all standing because you continue so?" "Do you wish I should sit down, and do you love me?" queried the Prince. "Then favour me with your slave, else I remain standing and may disbelieve your love." Rabia had no choice but to agree, and the company was seated, and when Zuhair joined them, then did the Prince reveal Zajir's death, and he explained to Rabia that this unfortunate fact was now of little consequence to the dishonest slave's former master. And Zuhair and his elders smiled at the Prince's trick, and Rabia appeared pacified by the gift of two new slaves.

But afterwards, Rabia sought out his brother, Amara the Coxcomb, who hated the Prince, and together they approached Sheddad, and they persuaded Sheddad that his Negro son was becoming a menace to the unity of the tribe, and Sheddad agreed, and a plot was laid to kill 'Antar when he was alone and unprotected in the desert. "For," said these uncles of his, and his father, "Lord Zuhair and the Prince think well of 'Antar, but may we not be overwhelmed by a veritable ocean of calamities and misfortunes if he continues to live among us? He must die."

Now 'Antar's flocks were grazing in a secluded valley far from the camp, and 'Antar was composing to himself a poem in praise of his beautiful cousin 'Abla, when an enormous lion burst through the bushes and confronted him. And behind the rocks, on the other side of the valley, 'Antar's father and his two uncles crept up in hiding, planning to murder him. But 'Antar thrust the crook he carried between the lion's teeth and, advancing, seized the animal's upper jaw in one hand

and its lower jaw in the other hand, and tore the lion in two. Then he skinned the lion and burned its flesh, and started scraping its pelt for his own use; and as he scraped he sang:

> "O lion, father of lion cubs and king of the sandy
> wastes and of the animals which dwell there,
> How strong thou art, how proud of thy strength.
>
> But thou art brought low.
>
> And I—I did not use my sword or my lance,
> With my bare hands I brought about thy downfall.
> Of the two of us, is it not I that am the lion?"

And the men hidden behind the rocks shuddered and said, "Which of us would dare to attack this youth? Prudence demands we abandon our plan and return whence we came." And this they did, and when 'Antar returned with his flocks and his lion's skin, they joined in the rejoicing at his exploit and appeared as friendly and as deeply impressed as Zuhair himself.

So when, in a few days, the elders of the tribe and the fighting men went off upon a desert raid, Sheddad repented his harshness and left 'Antar, of whom he was secretly proud, in charge of his tents and of the flocks and of the women, and he warned 'Antar not to let any of them wander far, and 'Antar answered proudly, "O my master, should the smallest object be missing on your return, let me, for the remainder of my life, be kept in chains and bondage."

But when the warriors had departed, and after a few days constrained within the camp the women became bored, and Samiya, wife of Sheddad, proposed that a feast should be held on the shores of Dhat al Arsad's pools, not far from the camp, and 'Antar dared not hinder her, and indeed rejoiced with the women, for he would be for a whole day in 'Abla's company.

When the pleasure-seekers reached the lakeside on the following day, the sun sparkled upon the waters and was not too hot to hinder their preparations. The servants fanned the charcoal to a steady glow, and lambs were put to roast over it; and the two kids, which had been baking overnight buried in clay pots beneath the soil, were uncovered and distributed with rice and leben[1] among the hungry children. Birds sang among the reeds, and the broad beaches of the lake were bright with flowers. Flushed with wine, some among the girls danced for their elders' delight, discarding their veils; and, among them all, 'Abla was the most beautiful.

Then suddenly a cry rang down the valley, "The Qahtan, the Qahtan!" And seventy horsemen armed to the teeth seemed to pour like a torrent from the crest of the eastern hill down to the waterside. Each horseman seized one of the girls or the women, and the children

[1] Artificially soured milk.

scattered, and the servants fled. And 'Antar? As he saw his beloved seized by one of the armed men and dragged to the saddle, 'Antar sprang like a panther and threw the marauder to the dust where death welcomed him as her own. 'Antar seized the warrior's arms and his horse, and pausing only to shelter 'Abla behind some rocks, out-stripped the raiders and faced them, crying: "A curse upon you, evil ones, who dare only to attack women, the daughters and the wives of noble men. Now must you reckon with 'Antar!" Twenty men fell to his lance and sword, and the remainder fled, calling to each other, "If the slaves of this tribe display such strength and courage, what can the warriors be like!" So the women were saved and returned to camp, praising 'Antar with smiles and tears of gratitude, and 'Antar himself drove before him the arms and the horses of the twenty-one raiders he had slain, and he was elated, remembering 'Abla's heart-felt thanks at her rescue. Only Samiya feared the wrath of Sheddad, her husband, at having so wantonly exposed the tribeswomen to danger, so she swore all to secrecy; and only 'Abla and 'Antar remembered what looks had passed between them after the encounter.

But after a few days, when the warriors also had re-turned to the camp, Sheddad noticed the twenty-one new horses among his own horses, and he reproached 'Antar unjustly with having organized some raiding party of his own instead of minding the womenfolk—so winning for his tribe the slur of troublemaking. And 'Antar, bound by his promise, gritted his teeth and bore upon his body the whipping his father inflicted, and in his mind the humiliation he so little deserved. But

Samiya's heart melted towards him, and in confessing all she saved him further punishment and, indeed, won for him Sheddad's good opinion, for he thought, In truth I have a noble son who has saved all the women of the tribe from rapine and who has allowed himself to suffer unjustly rather than betray a promise. Sheddad rewarded 'Antar with presents, as did the lord Zuhair. And Samiya praised 'Antar in poetry, saying:

> "It is right that I respect him, that I protect him,
> For did not his strength and valour preserve my
> honour,
> His courage preserve honour among us all?"

'Antar replied with a poem of gratitude, describing also his own steadfastness, for, he said:

> "Men are of two kinds—those whose hearts
> Crack with fear as a glass goblet crazes in the heat,
> And those whose hearts are of rock."

So was Sheddad charmed, as 'Abla had been charmed by a poem on her gaiety and beauty on the day of the picnic by the lake.

· ·

QUESTIONS

1. What qualifies 'Antar as an epic hero?
2. What positive and negative social values do you find in this story?
3. What is the function of the poetry in the narrative?
4. What concepts of love are at work here?

· ·

Summary Questions

1. What were the significant events of Justinian's reign?
2. What new dimensions does Hagia Sophia bring to church architecture? To what extent are precedents found in Ravenna?
3. Compare and contrast Western and Eastern monasticism.
4. What are the five pillars of Islam?
5. Compare the Judaic, Christian, and Islamic concepts of God.
6. To what extent did the Islamic religion affect art and architecture?
7. How can we explain the rapid diffusion of Islam?
8. Why was law so important to early Muslim thinkers?
9. What was the effect of the Crusades on Islam and Byzantium?
10. What roles did Islam and Byzantium play in the development of Western culture?

Key Terms

Byzantium, Byzantine

Hagia Sophia

architectural terms: pier, pendentive, buttress, dome

mosaic

iconoclasm

Orthodox Christianity

patriarch

the Crusades

Islam

Muslim

Allah

the Quran

mosque

minaret

pointed dome and pointed arch

Shi'ism

Sufism

10 Medieval Europe: Culture and the Cathedral

The continuity of political authority in Byzantium ensured the preservation of a high degree of antique culture in the areas under its control. Similarly, when Islam conquered a significant portion of the Eastern Empire's lands in the seventh century, the victors quickly incorporated the Greco-Roman culture into a high-level amalgam with their own religion and elements of advanced Persian culture. By comparison, in the western half of the Empire occupied by barbarian tribes, the heritage of antiquity survived largely in elementary forms. Only after the year 1000 did western Europe begin to make serious, permanent efforts to catch up with Byzantium and Islam, but by 1350 the gap had been closed.

The years between 1000 and 1350 are generally known in European history as the High Middle Ages. Within these centuries we can speak with some assurance of a civilization of the Middle Ages. Before 1000 medieval culture was still in formation; after 1350 new currents (which historians generally label

as characteristic of the Renaissance) were becoming dominant. Medieval society was doubtless affected by survivals of primitive Germanic, Italic, and Celtic folk culture, together with admixtures of sophisticated pagan philosophy and literature, but the informing ideas centered on belief in a transcendent, all-powerful God who, through the God-man Christ, offered redemption to the sinful human race. Most cultural forms tended to be manifestations and expressions of this Christian conception of God and the human predicament.

Having characterized briefly the two other medieval cultures arising out of the wreckage of the Roman Empire, we are now in a position to focus on high medieval Europe, the medieval culture and society most directly the antecedent of our own. Prior to examining productions in the art and literature of this society, we will take up medieval developments in economics, in the Church, in political history, and in intellectual history generally. The early eleventh century in all these four areas initiated revivals that were interrelated. After five hundred years of progressive decline and relative stabilization at a low plateau, western Europe by 1000 began to stir with new life.

Medieval Revivals

Economic Revival

Already by the end of the tenth century the tempo of economic life was changing. The development of the castle had finally provided the population with a source of security. Agricultural techniques and inventions such as the horse collar gradually came into widespread use, leading to an increase in agricultural productivity and ultimately to an enormous population rise between 1000 and 1250. The distribution of the population was also altered; because food was easier to produce, a portion of the population could be spared from direct employment in agriculture for other work. Established towns grew in size, and new ones were founded. By 1300 only about 10 percent of Europe's population lived in towns of more than 2,000; nonetheless, the towns, serving as they did as focuses of economic and cultural life, played a role in medieval society much greater than this percentage would suggest. Silver deposits were exploited by mining; and when the bullion produced poured into the economy as currency, there was further expansion. International markets developed again, and large-scale production was encouraged.

Religious Revival

This renewed vitality in the economy was paralleled by a revival of religious interests. In the decades after 1050 the popes at Rome initiated a program to dislodge the churches and monasteries from the hands of secular powers and to make them independent. The whole present relationship of the Church to the secular power, they argued, was sinful. Men of the world dominated the men of God. The soul is superior to the body, yet those who by divine command are to control bodily things now dominate heavenly ones. The priest is in fact superior to the king because his realm is higher. The priest controls the sacraments, that is, rites such as baptism and communion, which are the channels through which divine, life-giving grace pours. The pope, at the very pinnacle of the channels of grace, can let it flow or cut it off from whom he deems unworthy. The other priests act by his authority. For all his earthly power, the greatest monarch of Christendom will perish eternally if separated from the divine source; it depends on the priest and, first of all, the pope to decide whether the monarch is worthy to receive the sacraments.

On the basis of this theory the papacy from the mid-eleventh century embarked on a policy of removing secular rulers—kings and princes included—from power over the churches in their areas. Bishops, priests, abbots, and monks were to give ultimate obedience to the pope, the Vicar of Christ in Rome. Every Christian was commanded to follow divine law as it was interpreted by the papacy, and monarchs who disobeyed God's rule were to cease being monarchs. The result of the development was that by the early thirteenth century the Roman pope was the most powerful figure in Christendom. Not only did he effectively supervise all the churches and monasteries, but he also acted as the conscience of the secular rulers and their governments.

Yet as we have seen in discussing Byzantium (Chapter 9), it was in the eleventh century that the papacy lost whatever authority it had enjoyed over the eastern half of the Christian Church. The extension of the new reform movement south of Rome into Greek Italy so threatened the claim of the patriarch of Constantinople to control that area that it led to a break between East and West and the creation of two separate Christian churches.

Political Revival

This same century also witnessed a political revival. The economic revival intensified contact between the different regions of a realm and created a tendency for political integration. In the long run this served the cause of the secular rulers. Princes came increasingly to stress the public nature of political power and the obligations of subjects to obey them not on the basis of a personal oath but because the ruler was the prince in a given territory. In the course of the twelfth and thirteenth centuries the monarchies gradually asserted their authority at the local level and subordinated that of the nobility.

Increased central government, however, required money to pay for an army, a bureaucracy, and a royal court. This meant taxes. The king could not seize the money of his subjects. The Germanic conception of

private political power founded on an oath was coupled with an implicit understanding that the leader would protect his follower's person and property. By the eleventh century there was a general recognition of the lord's right to demand aid from his followers in certain cases, but both the lord and his men had to agree in council when such circumstances existed and to work out the obligations of each man to his lord. Roman law, studied in Europe again from the eleventh century, also stipulated that "what touches all must be approved of by all." This was interpreted to mean that when levying a tax for the good of the country, the king had to consult with important individuals and with representatives of various segments of the population. Thus the desire of the monarchs to increase their power over the country led to the need for taxation, and this called into being consultative assemblies. Almost everywhere in Europe a tradition of consent of the people to taxation was developing.

By the fourteenth century the political revival would significantly hinder the effectiveness of papal intervention in international politics. Already in the twelfth, monarchies were diverting loyalties of their peoples to themselves not only away from local nobility but also away from the Christian republic led by the pope. But even by the first half of the thirteenth century this process was still only under way: though its glory was fragile, the papacy remained the most important political force in Europe.

Intellectual Revival

Along with the political, economic, and religious revivals beginning in the eleventh century came an intellectual revival. In its early stages in the eleventh and twelfth centuries, this revival can generally be described as a process of ordering knowledge in an effort to control experience. The initial step in this development around the year 1000 was the introduction of elementary texts of Aristotle's logic. Although these texts had been circulating separately for centuries, the study of them as a group was novel in the West and may have been introduced from Muslim Spain. Certainly the advanced texts of Aristotle's logic and his other works came to the west largely via Muslim Spain (see Chapter 9).

From the ancient Greek system of logic, Europeans learned to subordinate one idea to another, the part to the whole. Logic instructed them in the process of arriving at new truth and of organizing their knowledge into categories. Trained in logic, Europeans were able to present systematically pieces of knowledge that before were a confused jumble. A great European logician, Peter Abelard, wrote a book in the first half of the twelfth century called *Sic et Non* (Yes and No) in which he asked hundreds of central questions regarding human life and theology, such as "Is it right to murder another?" and "Does God exist?" After each question he

placed the answers given by ancient great authorities, both pagan and Christian writers. Logic was also an aid in the reorganization of the highly confused laws of the Church. The scholars of the twelfth century gave an ordered form to Church or canon law, besides systematically presenting in concise fashion the fruits of numerous commentaries on the Holy Bible. All these endeavors gave people a confidence in the power of reason to understand the universe and offered them a possibility of eventually controlling it.

In the centuries between the fall of Rome and the eleventh century, learning was centered in cathedrals, monasteries, and a few princely courts of Europe. With the revival of the towns, however, the cathedral came to dominate intellectual life. Christianity was divided into hundreds of administrative units called dioceses. The major church of the diocese—and the residence of the bishop—was the cathedral. Almost without exception located in an urban center, the cathedral contained a school in which the young clergy of the diocese could learn Latin and the proper way of performing their future religious functions. The reinvigoration of town life was accompanied by a new concern for learning in these cathedral schools. The first organized teaching of Aristotle's basic logical works occurred around the year 975 in a cathedral school, that of Rheims. From this point until the twelfth century the initiative in education belonged to these schools. By the twelfth century the number of students had increased to such a degree that in places such as Paris and Cologne the cathedral was no longer able to contain the classes; then private teachers opened up their own schools in the vicinity. In the next century, as organization was given to this diversified instruction, the university was born.

The term *scholasticism* is usually applied to the scientific, theological, and philosophical learning taught in these schools and universities. First of all, this kind of learning was a monopoly of the schools, rather than of private scholars or secluded groups. The method, moreover, of presenting the thought in question-and-answer form was that followed in actual schoolroom teaching. But the term also applied to a common assumption of the thinkers of this three-hundred-year period. There was among them an implicit confidence that there was no conflict between the conclusions produced by reason and those accepted on faith, that the two sets of truth were compatible.

Initially, with the introduction of Aristotelian logic, the primary question became: to what extent could reason be employed to understand faith? As Christians, Europeans were committed to belief in the need of divine revelation to know certain truths. By the fifth century A.D. the basic doctrines of the Christian Church had been worked out on the basis of God's revealed word in the Bible, as follows: (1) The belief in a Trinity composed of Father, Son, and Holy Ghost, three persons in one divine substance. How this could be with-

out making them three separate gods was acknowledged as divine mystery. (2) The belief in the creation of the universe out of nothing by an all-powerful God. (3) The doctrine of the fall of human beings into evil through their own free will. (4) The belief in heaven as a final resting place for the good and in a hell as the place for punishment of the evil. (5) The belief in Christ, human and divine, as the redeemer of humanity. Because he was God, he could live on earth without sin, and by virtue of his humanity he could redeem sinful, fallen humankind. (6) The doctrine of eternal life for the soul in paradise and the resurrection of the body through redemption. (7) The promise of redemption to those who believed in Christ as lord and who did good works on earth. (8) The necessity of God's grace for salvation. Whether some people are predestined by God to believe in Christ and do good works with God's grace doing everything, or whether grace is offered to all and people must cooperate with it in the process of salvation, was a debated point. The overwhelming tendency in the Church, however, was to stress the power and responsibility of people to cooperate.

The most congenial philosophic school of antiquity for early Christian thinkers had been that of Plato and his followers. Christians were attracted by the Platonic doctrine of two levels of reality, the world of the Ideas and that of the senses. Plato embraced the idea of the immortality of the soul; and the negative attitude of Platonists to the body, which they considered a prison, also proved attractive to Christians eager to dominate bodily lusts. The Christians were so influenced by these ascetic impulses that they often overlooked their own doctrine that the body, too, would be raised to heaven with the soul. Plato seemed so close to Christianity in some things he wrote that many Christian scholars believed that he had written either under the influence of the Holy Ghost or with knowledge of the works of the Hebrew prophets.

Stoicism also proved attractive to Christians, at least in its moral doctrines. Stoic stress on indifference to worldly success or failure seemed to be helpful to believers in their efforts to turn to God from the false joys of the world. The late Stoic view of government as having largely negative functions of keeping order reappeared in the works of the Church Fathers. As reformulated by the latter, the duty of the state was to prevent sinners from killing one another while the Church went about saving human souls. The sword of kings was to be at the service of the Church: monarch and bishop were to work in harmony to bring people to seek righteousness.

The Church Fathers of the second to the fifth centuries, therefore, used the writings of Platonists and Stoics both as aids in elaborating Christian theological, philosophical, and moral ideas and as witnesses to the truth of Christian doctrine. Whereas the writings of ancient Latin Stoics such as Seneca survived in numbers between the fifth and the eleventh centuries, almost all of Plato was lost, and European knowledge of his thought came mainly from what the Church Fathers had written about him. Aristotle's thought had not been popular in late antiquity and had had little effect on Christian doctrine in its formative stages. However, the craze for Aristotelian logic beginning in the eleventh century added a third ancient Greek influence on Christian thought. Working with Latin translations of Aristotle's elementary logic texts and ancient commentaries on these, European scholars were eager to sharpen their newfound intellectual instruments on the Christian faith. The danger to divine mystery was clearly perceived by critics of such efforts. Pious Christians in the twelfth century were especially alarmed at what appeared to be the assumption of some theologians that God's mind, working by the same processes, was subject to the same rules and conditions in its operations as was the human mind and that it was thus possible for the human mind to understand why God had operated as he did. Did this not detract from God's all-powerful nature and will? But what, then, were the limits of reason?

In the course of the twelfth century Latin translations first of Aristotle's advanced logical writings and then of his philosophical, moral, and scientific works began to circulate in western Europe. Along with the Aristotelian texts came Latin translations of Arabic and Hebrew commentaries interpreting the philosopher's meaning.

The recovery of the whole Aristotelian corpus only further aggravated the problem of faith and reason. Aristotle's logical works had been simply an introduction to this masterpiece of thought. Medieval Europe had been particularly weak in scientific knowledge, and, with the introduction of Aristotle's entire body of writings, Europeans became aware of a system of thinking, ultimately reducible to a few basic principles, that had something to say about almost everything in the universe. Aristotle answered questions that they had not even learned to ask.

During the thirteenth century, however, as they came with the help of the Arabic and Jewish commentators to understand what Aristotle had written—his work was and is very difficult to read—Christian thinkers began to see that Aristotle believed in an eternal world and in a God who did not create the universe but who served only to explain why things in it moved. Moreover, he also seemed to believe that the human soul died with the human body. Aristotle appeared to be the culmination of the power of human reason; yet the results of his investigation, conducted according to the procedures of his logic (on which they too relied), seemed to point to some conclusions that contradicted the faith. Was the Christian faith therefore irrational? God was supposed to be truth, yet reason's conclusions apparently were not those of revelation.

Saint Thomas Aquinas (1225–1274) The most influential attempt to reconcile reason and revelation in the thirteenth century was that of Thomas Aquinas, who showed, first of all, that Aristotle's proof for the eternity of the world was not a conclusive one. In fact, he maintained that there is no way by reason to prove either the eternity or the creation of the universe. We know that it was created, but that knowledge comes from faith. In the matter of Aristotle's position on the immortality of the human soul, Aquinas argued that Aristotle himself is ambiguous. Thus, he concluded, there is no proof that reason contradicts faith. Quite the contrary.

There are, according to Thomas Aquinas, many truths about the world that reason can discover: the causes of the rainbow, the source of locomotion in animals, and the like. More than this, there are certain truths revealed to us by God that could also be known by reason; for instance, that God exists and that he is one God. After all, some ancient pagans knew this through the use of their reason. Then there are truths about God that no pagan could have known, such as the existence of the Trinity. Thus for Aquinas the two spheres of truth, that established by reason and that by revelation, overlap.

If we follow reason according to the rules of logic, we can know many things about God and heaven; and, at the very pinnacle of this kind of truth, reason duplicates the lowest truths of revelation. Moreover, even the truths of revelation not open to human reason are not in themselves illogical, irrational. When reason examines them, in fact, they are quite reasonable. If people use reason according to the proper procedures of logic, they will gradually define a body of truth that at its greatest heights demands to be completed by the truths of faith.

Accordingly, Aquinas and thinkers like him were able to construct enormous systems of thought beginning with our awareness of ourselves and the world and integrating all aspects of our internal and external experience. Every natural phenomenon from the falling of the raindrops to the movement of the stars could be set within a framework of explanation that literally required the truths of revelation to cap it with ultimate meaning. Just as these edifices of human thought presented a world where all truth pointed heavenward, so did the great stone cathedrals that dotted the landscape of western Europe in the thirteenth century.

Crusades

Beginning in 1095, Christian Crusades aimed at recovering the Holy Land continued sporadically into the sixteenth century, but the last serious enterprise was that of Saint Louis in 1248–1250 (see map). These Crusaders looked to Saint Maurice as their patron saint (Fig. 10-1). Maurice was a soldier in the Egyptian army who had refused to fight against the Christians in the Gaul battles of 286. The Crusaders initially were sparked to battle by the religious zeal following the great reform movement of the eleventh century, but soon were influenced by economic and political factors as well (for example, the capture of Constantinople in 1204, Chapter 9). Although deeply prejudiced against the foreign cultures they encountered, the Crusaders, and eventually western Europeans as a whole, were nonetheless much affected by the contact. To a significant degree the new pursuit of the upper classes for greater elegance in dress—silks and perfumes were introduced—and more refined forms of conduct stemmed from Eastern influences. Among technological innovations of Eastern origin were gunpowder ("Greek fire") for warfare and the astrolabe for sailing. Furthermore, the intellectual revival already under way at the time of the First Crusade was unquestionably invigorated by direct—even if often hostile—contact with intellectually superior cultures. If in the long run the repeated efforts of western Europe to establish a Catholic Christian base on the eastern Mediterranean coast proved a colossal failure, European society had been helped to greater maturity by the experience.

Contact with Asia

The Mongol conquest of most of China and much of the land to the west as far as Syria, Palestine, Austria, and Poland by 1250 inspired a grand design in the courts of Europe. It was hoped that, were westerners able to convert the Great Khan of the Mongols to Christianity, it would be possible to crush Islam with the coming together of Christian forces from both sides. With this purpose in mind in 1253 Louis IX, king of France, sent several missionaries, led by the Franciscan friar William of Rubruck, to the great tent city of Karakoram in Mongolia, where the Great Khan had his capital. Although the expedition failed to convert the prince from his devotion to animism—the belief in the presence of spirit in all objects—this first contact was followed by others, many of which were for commercial purposes. Although the phrase "Mongol hordes" became legendary, in fact the sophisticated Mongolian empire succeeded in imposing peace and stability over more of the Eurasian landmass than any power had ever done before. Indeed, the Mongol Khans could guarantee the security of overland caravan trade in silk and other commodities, which increased markedly. European merchants could now ignore the Arab intermediaries on whom they had depended for Eastern goods up to this time and go directly to the sources.

By 1300 a regular trade between Europe and China, primarily through Venice, brought Asian luxury wares and some foods, possibly pasta, to the West. It was in the context of this international trade that the Venetian merchant Marco Polo made his famous visit to China in the last third of the thirteenth century. He went with his father and uncle, both of whom were making their second trip. Marco, who remained in

● D A I L Y L I V E S ●

•••• *Hildegard of Bingen: An Exceptional Medieval Woman[a]*

Most women in the Middle Ages lived under the domination of their husbands, brothers, or fathers. By the accident of birth and death, a noble woman, the sole surviving child of a noble family, might exercise extensive power, but this was exceptional. Once she married, she lost control to her husband. The most common space for female freedom was the convent. Although under the overall supervision of the local bishop, the nunnery was run on a daily basis by the abbess/prioress and the various other officers, all female. The life of Hildegard of Bingen illustrates opportunities afforded by the monastic life to an exceptional woman—opportunities denied to women leading lives within a normal family.

Hildegard of Bingen's life extends through nearly the whole of the twelfth century, for she was born in 1099 and died in 1179. Her parents were of the lesser nobility, holding lands in the area of Mainz. A certain holy woman, one Jutta, had secluded herself in a solitary cell at Disenberg, near a Benedictine monastery. Drawn by her reputation, Hildegard's parents brought their daughter to Jutta, who received her so that she could live a life like her own. The ceremony, which took place in the presence of a number of people, was that of the last rites of the dead, performed with funeral torches. Hildegard was buried to the world. She was eight years old. At the same time a niece of Jutta's also became a recluse, and afterward others joined them.

When Jutta died in 1136, Hildegard was compelled to take the office of prioress. But when the fame of the dead Jutta began to draw numerous pilgrims to her shrine, Hildegard decided to seek greater quiet, and possibly more complete independence (the abbot of the neighboring monastery may have been trying to meddle in the nunnery's affairs). In 1147, she moved the nuns to Bingen and established their new home near the tomb of a local saint, Rupert. From this center, the energies and influence of Hildegard, and rumors of her visions, soon began to radiate. She was highly intelligent, learned in

theology, and versed in medicine and the limited amount of science available in the days before the rediscovery of Aristotle's works. She wrote voluminously on all these subjects. She was also a composer, writing many hymns sung by the nuns. Her learning, believed to have been inspired by divine grace, led both men and women to write to her for enlightenment on points of doctrine and biblical interpretation. They would wait patiently for her answers because the answers were assumed to be not the product of her own mind, but inspired by her visions. As she wrote late in her long life,

> From infancy, even to the present time when I am more than seventy years old, my soul has always held this power of sight, and in it my soul, as God may will, soars to the summit of the firmament and into a different air, and diffuses itself among diverse peoples, however remote they may be. Therefore, I perceive these matters in my soul, as if I saw them through dissolving views of clouds and other objects. I do not hear them with my outer ears, nor do I perceive them by the meditations of my heart, or by any collaboration of my five senses; but only in my soul, my eyes open, and not sightless as in a trance; wide awake, whether by day or night, I see these things. And I am perpetually bound by my infirmies and with pains so severe as to threaten death, but hitherto God has raised me up.

She corresponded with the great and influential, admonishing dukes and kings and emperors, monks, abbots, and popes. She was fearless in her criticism of evil conduct, even that of the greatest princes of the age. Here is a letter she sent to Frederick I, Emperor of Germany, threatening him with divine wrath if he did not reform his life:

> O King, it is very necessary for you to be watchful in your affairs. For, in mystic vision, I see you living, small and ignorantly, beneath the Living Eyes of God. You have still some time to reign over earthly matters. Therefore, beware lest the Supreme King cast you down for the blindness of your eyes, which do not rightly see how you hold the rod of right government in your hand. See also to it that you are such that the grace of God may not be lacking in you.

Protected by the aura of sanctity that surrounded her, Hildegard had nothing to fear.

a. This account is based on Henry Osborn Taylor, *The Medieval Mind. A History of the Development of Thought and Emotion in the Middle Ages*, 4th ed., 2 vols. (Cambridge, Mass., 1951) I: 462–464.

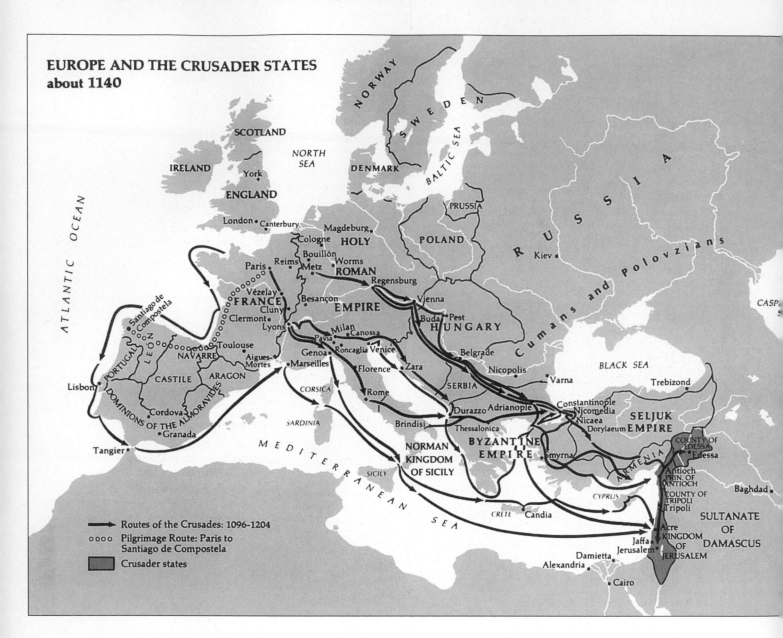

China from 1271 to 1295, was unusual not in making the trip but in writing about it. He dictated his account, entitled *The Book of Marvels,* in French to his cellmate in a Genoese prison after being captured in a battle. By 1300, too, there was a Christian archbishop in the new Mongol capital of Beijing and six bishops with about thirty thousand Catholic converts throughout the empire.

Medieval Art and the Church: The Gothic Cathedral

Art in the ninth, tenth, and eleventh centuries, like learning, was centered in the court, the monastery, and the cathedral. These three institutions had the means, personnel, and time to produce creative work. Painting, sculpture, and architecture were viewed as ways to enhance and explain Christian doctrine. It is

also true that both monarchs and clergy realized the power of beauty and wealth to enhance their respective positions.

Along with the economic, religious, political, and intellectual revivals of Europe in the twelfth and thirteenth centuries, an artistic growth flourished. This gave rise to the Gothic style in art and architecture, a style whose forms and conventions would be practiced all over northern Europe and in the British Isles. Two particular occurrences were of great significance for this development: the pilgrimage and the Crusades. Both activities united people and provided them with profound new experiences.

Pilgrimages

Since every Christian could not be a monk, nun, priest, or have some other direct affiliation with the Church,

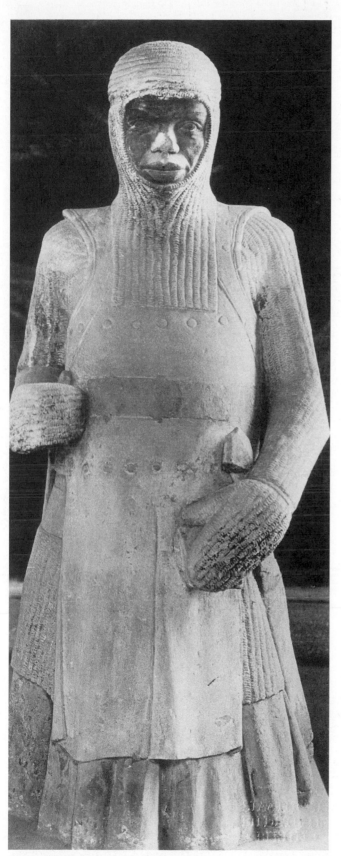

10-1 *Sculpture of Saint Maurice in Magdeburg Cathedral, Germany (c. 1240–1250).*

it fell to the great numbers of lay Catholics to seek alternative ways to ensure their salvation. One of these was the path of penance—the undertaking of a pilgrimage to Rome, the Holy Land, or another shrine to seek the aid of a saint or saints. Along the route, the pilgrim could visit the relics and shrines of important local saints, who would then act on behalf of the sinner.

For the French and Germans one of the most favored pilgrimages was to Santiago de Compostela in northern Spain. This was the site of the tomb of Saint James, the son of Zebedee, one of Christ's chosen disciples. We know of it as a pilgrimage site as early as the mid-ninth century. By the mid-tenth century, clerics and laity were making the journey in increasing numbers. The map shows the route followed. Chaucer's *Canterbury Tales*—a set of stories told by a group of English pilgrims on their way to Thomas à Becket's shrine—reflects the spirit of comradeship that pilgrimages instilled (see Chapter 11).

Movement in a pilgrimage was slow, fifteen or twenty miles a day, mostly on foot. Monasteries and churches provided accommodations along the road and broke the monotony of the trip by their beauty. As pilgrims came from many directions to Santiago, churches and cathedrals began to develop specific regional types. In the great burst of building activity many architectural ideas were tried, discarded, and elaborated.

A brief look at one of the great pilgrimage churches in France will be of help in understanding the Gothic tradition that developed after the eleventh and twelfth centuries. Saint Sernin, located at Toulouse, in southern France, was one of many great churches built in the eleventh and twelfth centuries in response to the pilgrimages and to growing wealth, mobility, and ambition. All over France and Germany and in England, many builders employed the means of Roman architecture to create new feelings and form. We generally call this art *Romanesque* because of its relation to Roman architecture (Fig. 10-2).

The plan of Saint Sernin at Toulouse (Fig. 10-3) represents a shape called a Latin cross. There is an entrance porch that opens into a nave with double aisles on each side. The transept and apse are sharply defined. On the east side of the transept and around the apse are separate small apses, which are called chapels. These are all related to each other by an *ambulatory*, an aisle that goes all the way around the transept arms and around the apse itself. It is comparable in some ways to the passage around the base of a dome.

From the outside we see that Saint Sernin is a brick and stone building with clearly defined roof forms. The nave roof is the highest, then lower down are the roofs over the aisles and the distinctly roofed apse and chapels. On entering we see a church meant to accommodate not only the monastery but also crowds of pilgrims. (See Fig. 10-3.) These pilgrims came not only for salvation, but also as a result of the Crusades.

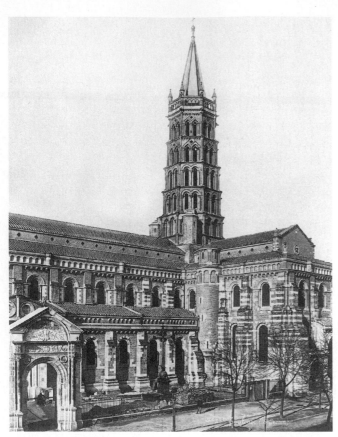

10-2 *Saint Sernin, Toulouse, east end. (Copyright 1996 ARS, NY/SPADEM, Paris)*

10-3 *Ground plan of Saint Sernin, Toulouse, c. 1100.*

▲

• Compare this ground plan with the passageway around the center of San Vitale in Ravenna (Fig. 9-6). Which spaces are more clearly defined? Compare it with the arrangement of old Saint Peter's (Fig. 8-3) and with the Colosseum (Fig. 7-10). Where did the barrel and groin vaults come from? Compare this plan with the Great Mosque of Cordoba (Color Plate V). What major differences do you observe? What accounts for these differences?

Effect of the Crusades

The Crusades afforded another opportunity for clergy and laity to gain wider knowledge of art, buildings, and building techniques. The pilgrimages took people to Spain with its important Islamic monuments. The Crusaders visited Jerusalem, Constantinople, northern Africa, and other Eastern sites (see map). The building forms and methods observed there contributed to the rise of the Gothic style.

The Rise of Gothic Architecture

Many villages in France today still give the impression that an enormous church dominates the small houses, shops, and other buildings around it. Fantastic energy was put into the construction of these great stone works. Usually everyone in the village, from the lords and ladies down to the peasants, joined the professional stonemasons in doing their part to construct an edifice to the glory of God and to the representation of the Church on earth (Figs. 10-4, 10-5, and 10-6).

Why did medieval people devote so much time, energy, and money to the construction of these huge and complex buildings? The answer is that churches were not merely places to go on Sunday or decorations for a town; they represented a vital aspect of the town's or city's spiritual life. Churches were dwellings for God on earth and a bridge between the physical and spiritual realms. They began as heavy stone set on the ground, but they soared upward toward heaven. They contained something for everyone. For the common people, many of whom could neither read nor write, they offered a kind of visual religious education.

The stained-glass windows, the sculptures, and the architectural design of the churches built in the twelfth and thirteenth centuries tell us a great deal about the values and beliefs of the people who built them and worshiped in them. The term *Gothic*, used to describe their style, was coined in the Renaissance and was, until the late eighteenth century, a derogatory term, implying an uncivilized style, greatly inferior to the classical. (In a similar way, westerners once considered African art barbaric until European artists in the early part of the twentieth century began to

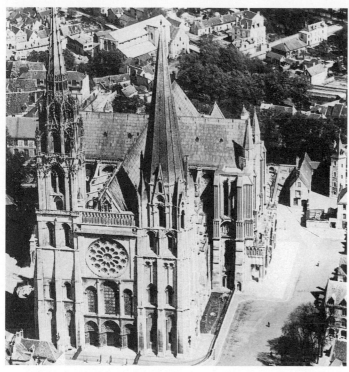

10-4 *Cathedral of Chartres, aerial view. (Foto Marburg/ Art Resource, NY)*

▲

• Compare Notre Dame (Our Lady) of Chartres with the Pantheon, Hagia Sophia, and the Great Mosque of Cordoba. Consider actual size, the importance of the interior versus the exterior for the user and the arrangement of interior spaces. For example, is it clear where to enter and where to exit each of these buildings? What is the difference in materials and do they affect how you experience the building? Which building(s) make the most use of natural light?

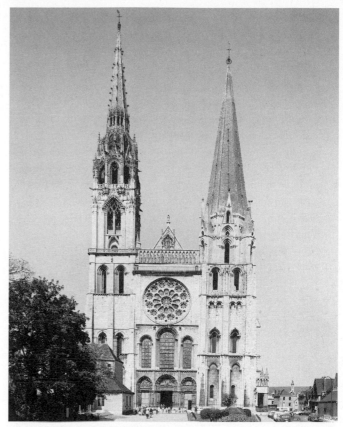

10-5 *Cathedral of Chartres, west front, exterior. (Giraudon/ Art Resource, NY)*

10-6 *Cathedral of Chartres, nave. (Giraudon/Art Resource, NY)*

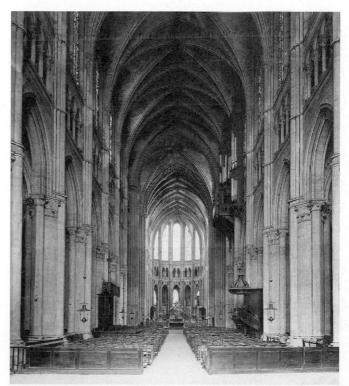

appreciate its originality.) Certainly, one can say that the aesthetic impression felt inside a Gothic cathedral is different from the impression one has inside a Roman building like the Pantheon, but most modern viewers would agree that the difference is based on taste and world view, not inferiority.

Now we will analyze some of the technical and artistic features of the Gothic cathedral. Gothic buildings, like all other architecture, evolved from the technology, needs, and ideals of a particular time and place. The patrons and artisans who created these great churches drew on the current architectural solutions and skills while experimenting with and expanding both structural and formal capabilities. Masons, carpenters, and other artisans followed the routes of the Crusades and pilgrimages, learning from the great accomplishments of Muslim and Christian alike.

The monastery church of Saint Denis (Fig. 10-7), in the Île-de-France, near Paris, and the cathedral of Notre Dame of Chartres, which we will consider in this chapter, document the origin and extraordinary capacities of

10-7 *Saint Denis, west front. (Giraudon/Art Resource, NY)*

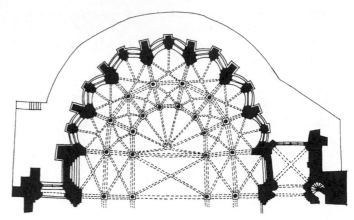

10-8 *Ground plan of the choir, Saint Denis, near Paris, c. 1140.*

the period for visual expression of metaphysical and deeply religious ideas.

Suger and Saint Denis

In 1120 the monk Suger became abbot of Saint Denis, one of the oldest and most venerable monastic foundations in France. Named for the founding saint of French Catholicism, it was also associated with the Capets, successors to Charlemagne, many of whom were buried there. Suger had been at Saint Denis since childhood and had grown up with Louis VI, the Capetian king. A dynamic, ambitious, and highly intelligent individual, he had already distinguished himself as a diplomat for the papacy before becoming abbot. In 1147, when Louis VII left for the Second Crusade, Suger was made regent of the kingdom. But Suger did not seek power for its own sake. His association of the abbey with secular power came from his Christian desire to bring order and spiritual enlightenment to the poor and to the powerful. These beliefs, in combination with other factors (the church was in disrepair and crowded on feast days), caused Suger to begin to work on rebuilding the church at Saint Denis.

Descriptions of churches seen by Crusaders provided Suger with some ideas; but he derived many from his theology, which was primarily Neoplatonic and Aristotelian. The two central themes were harmony and

light. Suger believed that all matter in some degree partakes of God and in some way reflects ultimate reality. Visible light, for example, was analagous to the light of God, and thus symbolic of the unity of all creation. As natural light infuses and transforms, so are we transformed by knowledge of God, the heavenly light. Suger also believed that the contemplation of the truly beautiful "worthy materials" of gold, gemstones, chalices, and altars could transport one from the world here below to the heavenly one. In 1144 he wrote:

> Thus, when out of my delight in the beauty of the house of God—the loveliness of the many-colored gems has called me away from external cares, and worthy meditation has induced me to reflect, transferring that which is material to that which is immaterial, on the diversity of the sacred virtues—then it seems to me that I see myself dwelling, as it were, in some strange region of the universe which neither exists entirely in the slime of the earth nor entirely in the purity of Heaven; and that, by the grace of God, I can be transported from this inferior to that higher world.

It became his ambition to make his church such a means of transcendence, to fill it with light and to give it a spiritual significance as great as that of its saint and the French kingdom.

We do not know how Suger conveyed his ideas to the expert builders who undertook the work at Saint Denis. The combination of his visions and the technical skill and imagination of the builders produced a number of important changes in church design and construction that were absorbed at once by builders in the area around Saint Denis.

Perhaps the most significant innovation was a new system of *piers* and *vaults,* employing pointed arches that allowed the enlargement of the east end, creating a large *choir* (a rectangular space for the clergy between the transept and apse) surrounded by an aisle (ambulatory) with seven chapels spaced equidistantly on its outer

edge (Fig. 10-8). These were roofed with vaults. Most important of all, however, the outside walls of the chapel and the *clerestory* above were now largely glass. This glass was richly colored—reds, blues, yellows, and some white. The small pieces of glass were arranged in patterns, figures, and stories. Joined together by lead strips, the panels were then set within a framework of stone. The east end of the church became a vessel for the transmission of divine, transforming light. Suger continued:

> Once the new rear part [east end] is joined to the part in front, the church shines with its middle part brightened. For bright is that which is brightly coupled with the bright. And bright is the noble edifice that is pervaded by the new light.

The church, filled with light, was a bridge to the ultimate reality of divine revelation, the harmonious and orderly world. The windows transformed light, as God's light transformed the dull heaviness of matter. Uplifted by this created light within the church, the worshipers' souls would rise to seek God, its uncreated source.

This new way of building will be explored further in the next section, about the rebuilding of the Cathedral of Notre Dame of Chartres (Fig. 10-5), which is among the finest examples of Gothic design and construction.

The Cathedral at Chartres

The village of Chartres is dominated by the cathedral. The church, dedicated to the Virgin, was founded before 743 (the first sure date associated with it). Its chief relic, the tunic of the Virgin, had been given by King Charles the Bald. This gift made Chartres the center of the veneration of the Virgin in western Europe, and successive buildings on the site, including the new basilica erected in the eleventh century, confirm this. Then in June 1194 a fire devastated the basilica and town, leaving only the west front standing. From this anonymous account, written early in the thirteenth century, we can get a good idea of the role of this church in the life of the people.

> Therefore, in the year 1194 after the Incarnation of the Lord, since the church at Chartres had been devastated on the third of the Ides of June [June 10] by an extraordinary and lamentable fire making it necessary later, after the walls had been broken up and demolished and leveled to the ground, to repair the foundations and then erect a new church. . . . The inhabitants of Chartres, clerics as well as laymen, . . . considered as their chief misfortune, the fact that they, unhappy wretches, in justice for their own sins, had lost the palace of the Blessed Virgin, the special glory of the city, the showpiece of the entire region, the incomparable house of prayer. . . .
>
> Indeed, when for several days they had not seen the most sacred reliquary of the Blessed Mary, the population of Chartres was seized with incredible anguish and grief, concluding that it was unworthy to restore the structures of the city or the church, if it

had lost such a precious treasure, [which was] indeed the glory of the whole city. At last, on a particular holy day, when the entire populace had assembled by order of the clergy at the spot where the church had stood, the above mentioned reliquary was brought forth from the crypt. . . . The fact must not be passed over that when, at the time of the fire, the reliquary frequently referred to had been moved by certain persons into the lower crypt (whose entrance the laudable foresight of the ancients had cut near the altar of the Blessed Mary), and they had been shut up there, not daring to go back out because of the fire now raging, they were so preserved from mortal danger under the protection of the Blessed Mary that neither did the rain of burning timbers falling from above shatter the iron door covering the face of the crypt, nor did the drops of melted lead penetrate it, nor the heap of burning coals overhead injure it. . . . And after such a fierce conflagration, when men who were considered already dead from smoke or excessive heat had come back unharmed, all present were filled with such gladness that they rejoiced together, weeping affectionately with them.

> . . . When, following the ruin of the walls mentioned above, necessity demanded that a new church be built and the wagons were at last ready to fetch the stone, all beckoned as well as exhorted each other to obey instantly and do without delay whatever they thought necessary for this construction or [whatever] the master workers prescribed. But the gifts or assistance of the laymen would never have been adequate to raise such a structure had not the bishop and the canons contributed so much money, as stated above, for three years from their own revenues. For this became evident to everyone at the end of the three-year period when all finances suddenly gave out, so that the supervisors had no wages for the workmen, nor did they have in view anything that could be given otherwise. But I recall that at that moment someone said—I know not by what spirit of prophecy—that the purses would fail before the coins needed for the work on the church of Chartres [were obtained]. What is there to add? Since, in view of the utter failure of human resources, it was necessary for the divine to appear, the blessed Mother of God, desiring that a new and incomparable church be erected in which she could perform her miracles, stirred up the power of this Son of hers by her merits and prayers. When there was a large gathering of people there, she openly and clearly exhibited a certain new miracle, one unheard of for a long time past, seen by all for the first time. As a result, news of the miracle spread far and wide through the whole of Gaul and made it easier to give credence to succeeding miracles.

Out of despair the people, clerics, and nobility of Chartres created an enduring act of devotion when they built a new palace for the Queen of Heaven. The new church was occupied by 1220 and dedicated in 1260—an astonishingly short time given the technology of the age. The changes that Suger had made at Saint Denis were adopted for this church.

10-9 *Cathedral of Chartres, Royal Portal, exterior, west front. Left tympanum:
Ascension of Christ; central tympanum: Second Coming of Christ; right tympanum:
Incarnation of Christ. (Giraudon/Art Resource, NY)* (**W**)

The west front (Fig. 10-9) of the building looks familiar. The three central doors suggest that the nave and aisles lie behind, as well as the apse at the east end. A transept crosses the nave at right angles, and the aisle walls rise to meet the nave and the clerestory above (Figs. 10-10 and 10-11). It looks familiar, but it is radically different.

Extension of the Building What is so radically different? Compare the exterior walls of Chartres with those of Saint Sernin. The aisle wall has six large, single pointed windows, and the wall of the nave rising above the aisle repeats the window, which is now a pair of windows supporting a round window between their arches, and they rise to meet the sharply pointed lead-covered roof. The exterior walls, however, seem less like walls than elaborate piers, called *buttresses* (Figs. 10-12 and 10-13). Each buttress continues to rise vertically but becomes thinner and lighter as it is stepped in toward the clerestory wall. Beginning at the gabled opening with its sculpted figure, a section of stone arch reaches out to join the stone pier between the clerestory windows. Finally, as each buttress towers almost to the parapet of the nave roof, another arch reaches out to join the stone pier between the clerestory windows. These are the *flying buttresses,* arches of stone that transfer the weight of

the wall and roof to the foundation. This is the building framework; a great skeleton of stone. Walls and windows move in and out, responding to the location of the chapels around the apse. Flying buttresses surround the apse, supporting its great windows that rise above the ambulatory. Saint Denis may have looked like this; Chartres resembles it in plan. The transept entrances like the west front (built in 1194) are towered and columned but they look quite different, just like the plan itself, which is basilican but with an interior filled with magical, multicolored light.

The physical achievement that made Chartres possible is based on Roman vaulting and the pointed arches of Muslim architecture (see page 275). But why are the vaults and bays of Chartres so different from those of Saint Sernin or the Colosseum? Study Figures 10-14a and 10-14b. What permitted this new configuration of vaulting and therefore the plan was the pointed arch, whose ribs allowed greater flexibility and acted as a kind of permanent support, or *centering,* for the vault. The new combination of pointed arch and rib made a lighter, more flexible vaulting system, which allowed more wall to be opened for glass. The new system also created spaces with no sharp delineations between ambulatory and chapel or apse and aisle. The separate cells of space made by the chapels at Saint

10-10 *Cathedral of Chartres, south aisle, exterior. Windows of aisle are separated by wall buttresses that rise to the parapet. (Foto Marburg/Art Resource, NY)*

10-11 *Ground plan, Chartres.*

10-12 *Cathedral of Chartres, detail of nave, exterior, showing wall buttresses between aisle windows. These rise above aisle parapet as detached and flying buttresses of clerestory arcade. (Giraudon/Art Resource, NY)*

10-13 *Cathedral of Chartres, choir, exterior, west end. Aisle, clerestory and flying buttresses between windows. (Copyright 1996 ARS, NY/SPADEM, Paris)*

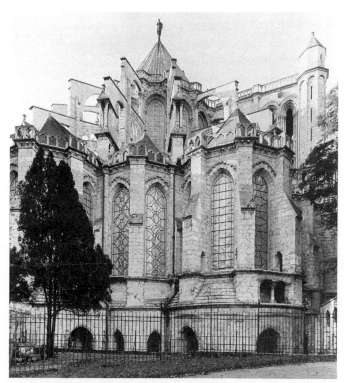

10-14a *Groin vaults normally require square bays. When a rectangular bay is needed, the arches on the shorter sides (1) must be raised to keep the four sides of the vault equal in height. This is not a very satisfactory solution.*

10-14b *The pointed arch permits the arches of the short (1), long (2), and diagonal (3) spans to accommodate a rectangular bay with greater efficiency.*

▲

• Compare the ground plan of a groin vault with that of the arch constructed using a pointed arch. Look at Figure 10-11 and consider the difference the new vault with its pointed arch makes in the arrangement of spaces. What permits the pointed arch to behave so differently? Where is the weight placed—on the wall or on the pier? Which kind of vault needs the larger pier? Why?

Sernin (Fig. 10-3) have been replaced with a greater unity—a whole greater than the sum of its parts.

For the modern mind, it is difficult to think of art as a teaching tool; but for medieval people, art, like everything else, had a purpose in the divine scheme of things. The cathedral, like the philosophical system of Thomas Aquinas, was concerned with God, the world, and humankind—with the accumulation of human knowledge and speculation and their relation to divine knowledge and revelation.

The Sculptural Program at Chartres

There are three entrances to the great building and each reflects the period in which it was made from the older, weighty form of the earliest, west front (1194) to the north tower, which was added only in the early sixteenth century.

Exterior Sculptures The three doors of the west front, called the Royal Portal (Fig. 10-9), sit in round arches deep in the thick wall. The wall, the door *jamb*, is slanted outward; these jambs carry richly decorated columns with carved bases and elaborate capitals, which provide a horizontal contrast to the tall, elegant jamb figures. The door lintels are also sculpted, as is the *tympana* (the panels above the doors) and the *archivolts* (the stones that support the arch). All these sculptures, like Greek or Egyptian ones, would have been painted, gilded, and decorated.

The sculptures of the west front present the fundamentals of the Christian dogma with directness and clarity. The tympanum of the right door is sculpted with a crowned, haloed Virgin seated on a throne with the Christ child in her lap (Figure 10-15). On either side of the central figures is an angel swinging a censer, an incense burner. The Virgin and child face the viewer directly; the folds of their garments fall symmetrically and

emphasize this frontality. The poses and attendants tell us that we are before the Virgin as the Queen of Heaven.

The lintel below is divided into two tiers or registers. The lower register (left to right) tells the story of Christ's birth: the Annunciation (Gabriel visits Mary and tells her she will conceive and bear a son, Jesus); the Visitation (Mary visits Elizabeth, John the Baptist's mother); the birth of Jesus; and the angels announcing the birth to the shepherds. The upper register shows the presentation of Jesus in the Temple.

These representations were filled with much deeper meaning for medieval people—meanings that have been discovered from medieval treatises and sermons. For example, seeing Christ as a child and in young manhood reminds us that he was human as well as being God. Mary, his mother, is also human, divine, Queen of Heaven and an intercessor. In the nativity scene, Mary rests on a bed, but a medieval person would have recognized it as an altar, and placing the child in the manger on the bed/altar alludes to Christ as the sacrifice. The presentation in the Temple scene repeats the same idea, only Christ stands on the altarlike form.

In the archivolts around the tympanum are personifications of the seven liberal arts: grammar, dialectic, rhetoric, arithmetic, music, geometry, and astronomy. The cathedral at Chartres was a seat of great learning. The major concern of the school was to forge the links in knowledge from the human to the divine. These sculptures also remind the viewer that Christ is wisdom incarnate, the Logos, the word of God made human.

Plate VI
Chartres Cathedral,
13th century. Madonna
and Child ("Our Lady
of the Beautiful Glass").
Stained glass window
from south ambulatory,
upper part.
(Giraudon/Art Resource, NY)

Plate VII
Simone Martini,
Annunciation,
1333, Galleria degli
Uffizi, Florence.
(Scala/Art Resource, NY)

Plate VIII
Kente cloth: Ghana,
Ashanti. Strip weave.
Length 92½″, width
59¹/₁₆″.
(Seattle Art Museum. Gift of
Katherine White and the Boeing
Company)

Plate IX
Nigeria. *Ogunic Exploits*, 1992 by Moyo Okediji, Ph.D. Pigment and glue binder on linen, 69 × 100″.
(Courtesy of the artist.)

Plate X
Wall painting of Lovers. Cave no. 17, Gupta dynasty, 475–510. Ajanta Caves, Maharashtra, India.
(Scala/Art Resource, NY)

Plate XI
Horse. China, Tang dynasty, 618–907 A.D. Glazed pottery, H. 76.8 cm.
(© The Cleveland Museum of Art, 2000, Anonymous gift.)

Plate XII
The Five-Colored Parakeet, China, datable to the 1110s; Emperor Huizong, Chinese (1082–1135). Handscroll; ink and color on silk; H × W: 21 × 49⁵⁄₁₆ in. (53.3 × 125.1 cm).

(Maria Antoinette Evans Fund. Courtesy, Museum of Fine Arts, Boston.)

Plate XIII
Twelve Views of Landscape (Shan-shui shih-erh-ching) by Hsai Kuei, Southern Song dynasty (1127–1279). Handscroll, ink on silk; 11 × 90¾ inches total (27.9 × 230.5 cm).

(The Nelson Atkins Museum of Art, Kansas City, Missouri)

Plate XIV
Parecclesian Apse Vault, Church of the Chora, Anastasis, Constantinople (1310–20) Fresco.

(The Bridgeman Art Library)

10-16 *Cathedral of Chartres, west front, left tympanum,* Ascension of Christ. *(Giraudon/Art Resource, NY)*

10-17 *Cathedral of Chartres, west front, central tympanum,* Second Coming of Christ. *(Giraudon/Art Resource, NY)*

10-15 *Cathedral of Chartres, west front, right tympanum,* Incarnation of Christ. *(Giraudon/Art Resource, NY)*

- Describe the figures in the lintel scenes. Are they comparable to the *Ara Pacis* figures? Explain. What is the value of spacing the figures equidistantly apart? Was naturalism the artist's goal? What was the goal?

The other two tympana expand the story begun in the right portal. In the left is the Ascension: Christ being carried up to heaven seated on a cloud and supported by angels (Fig. 10-16). In the center tympanum, Christ is shown in majesty, one hand raised in blessing, surrounded by the four symbols of the Evangelists: Mark's lion, John's eagle, Matthew's man (or angel), and Luke's bull (Fig. 10-17). The two angels who hold the crown at the top of the archivolts emphasize Christ's ultimate kingship.

Knowledge of the subject matter of the sculpture, stained glass windows and the architecture at Chartres is possible because the work there was not an isolated event. Similar programs exist at numerous other churches, such as the cathedrals in Rheims, Amiens, Paris, and Strasbourg, to name a few. The entire exterior was planned as the entry to the Court of Heaven, of Mary and her Son, Jesus.

The Interior Passing from the exterior into the nave at Chartres is like leaving the real world. The nave arcade

- Compare the figures in this scene with those in Figure 10-15. Use words like simplicity, order, clarity, idealization, and symmetry. Look at the clouds and the angel's drapery in Figure 10-16. How do these figures compare with the *Ara Pacis* figures and with the Parthenon frieze? Which scenes or figures seem most naturalistic?

(walls) rises to vaults 118 feet above the floor (Fig. 10-16. The piers that make up the nave arcade are not single columns but are like bunches of many small columns. The nave is seven bays long; the transept spreads left and right; the choir, apse and ambulatory are distant but light filled. The nave is filled with radiant colored light

from the clerestory windows. The interior expresses the diversity and unity of a system of building with arches, ribs, piers, and columns.

The architectural framework of the interior of Chartres reads as a united whole—not as separate blocks of space as at Saint Sernin. The bays of the aisles, like those of the nave, move you smoothly forward down the nave to the light-filled apse. The building is experienced as a unique whole and not as a sum of parts.

The structural knowledge and expertise that produced the cathedral are not a matter of speculation. Guilds and lodges of masons and other craftsmen worked from experience and knowledge firmly grounded in mathematics. The mason, like the philosopher and theologian, believed that numbers, and therefore harmony, were reflections of the divine order of the world. Thus the Gothic cathedral is a concrete example of the use of reason in the service of faith, comparable to the philosophies of Abelard and Aquinas mentioned earlier in this chapter. The culture of the High Middle Ages was both practical and intellectual, but these two aspects were subordinated to humanity's primary purpose in life: the aspiration of the soul toward salvation by God, to be accomplished through the Church.

Stained-Glass Windows Harmony and light are the two binding physical motifs at Chartres: the harmony of its spaces and forms, and light, the luminescence of the translucent window wall stretching between the stones. These two values, harmony and light, are presented perhaps most completely in the stained glass of Chartres. Unlike a painting, which reflects light, the windows transmit and transform light. The jewel-like windows adorn the building as gold and gems adorn the cross of the altar. The Madonna herself is enthroned in the central window of the west front and in windows in the north transept, but it is in *Notre Dame de la Belle Verrière* (Color Plate VI) that she seems to reach out to her people with compassion. This window was probably saved from the debris of the fire. Our Lady of the Beautiful Glass sits enthroned holding her child on her knees like the Virgin on the west front. Angels with censers and candles fill the panels on either side. The deep ruby glass seems to fall behind the Virgin's blue robe and warms the air around her. The deep, intense-blue side panels have ruby niches for the angels, whose animated poses contrast with the stability of the Mother and child.

The other windows in the basilica organize and present all facts of medieval knowledge—Old and New Testament, lives of the saints, fundamentals of Christian doctrine, labors of the months, signs of the zodiac, vices and virtues, and the activities of the guilds. The subjects of the windows are high up and not easy to read, but the quality of the light, which changes from early morning through high noon to dusk, is supremely

important as it falls into the church. The light transforms the spaces just as the people did who constantly came within its great walls.

At Chartres, the deep relationship between the cleric and the layperson is evident. The townspeople depended on the cathedral for economic life through fairs and pilgrims. They met on the church's steps, sold wine from the crypt, gathered to seek jobs in the nave, attended plays, socialized, and were baptized and buried from Our Lady's chapels. To these people we owe many of the windows. The five great windows of the apse honoring the Virgin were paid for largely by the butchers and bakers. In another window a banner with a red stocking tells us that the hosiers gave it. No matter what their earthly calling, medieval people saw their church as an intrinsic part of their world.

Music and Drama in the Cathedral

The combined visual arts of the great Gothic cathedrals—architecture, painting, sculpture, and stained glass—exemplify the medieval Catholic belief (quite opposed to later, puritanical ones) that spiritual truths could be apprehended through physical, sensuous beauty. This same belief seems to underlie the service of the mass and the music developed for it. Earlier, in the monasteries, one-voiced (*monophonic*) chants called Gregorian chants (after Pope Gregory the Great) were sung at masses and at the monks' spiritual exercises during the day. In the Gothic period, individual singers were used along with a choir, and a many-voiced (*polyphonic*) type of music for the mass developed. The resonance provided by the soaring vaults of the cathedral gave this music a special richness that it would not have had in another setting. The performance of the mass, with its procession of priests and choirs, the play of light through the stained glass, the burning of incense, and the reverberations of music and oratory from the stones must have been an experience to delight both senses and spirit.

Each cathedral, as mentioned earlier, had a school for instructing the young clerics who sang in the choir and performed other services in the church. The school and the rest of the cathedral were administered and cared for by the chapter, a group of clergy associated with the cathedral and subject to a rule, or canon, that ordered their way of life. One of the duties of the chapter, and the boys in its school, was to provide music for the services of the church. Except for the *jongleurs*, or wandering minstrels, medieval musicians were part of a community, either religious or secular. Their aim in composing and performing was never purely musical, just as the motivation of medieval sculptors, painters, and architects was never purely artistic. In this regard they were unlike modern composers and performers

who sell their wares as individuals to the public on an open market, for it was the community that imposed rules and requirements both on their daily lives and on their musical activities.

The demands of the community did not seem to restrict the musicians' creativity—on the contrary, medieval people seemed to be eager for more and more elaborate forms. It is perhaps because of this kind of demand that a type of drama developed out of the mass. This form, called *liturgical drama* because it was probably a part of the worship service, represented the same religious stories from the Old and New Testaments as were represented on the windows and walls and in the niches of the cathedral; it acted on the imaginations of the faithful in much the same way. *The Play of Daniel,* which we will study here, is an example of liturgical drama; it must be understood both as music and as drama. This would, of course, ideally be true of Greek drama too, but we are fortunate enough to have manuscripts of medieval music (preserved in monasteries and cathedral schools) that give us some idea, if not a totally accurate one, of how it was performed. Medieval liturgical drama, in some ways stranger to the modern mind than Greek tragedy, is an important phenomenon in our cultural history because it developed at a time when the theater was all but dead in the Western world. Liturgical drama thus made possible the growth of modern drama.

The theater, as it was known in the classical world, was in effect killed by the combined influence of barbarians and Christianity. The invaders of the Roman Empire had no idea what a theater was, and by the time of the fall of Rome, drama survived only in the form of bloody spectacles or rituals associated with pagan feasts. Seeing these survivals as corruptions of the body and spirit, Christians attempted to wipe them out; actors were, in fact, excommunicated from the Church. Nevertheless, it is a tribute to the human desire to participate in or to observe shows—to mime the outside world—that some form of dramatic activity continued throughout the early Middle Ages. Wandering minstrels, jugglers, tumblers, and other performers continued to entertain willing audiences in village squares and other public places.

Ironically, after centuries of hostility, it was within the Church itself that drama was reborn as an art form. It was as if the Church at last recognized the human need for imitation and spectacle and thus incorporated it for spiritual purposes. The mass itself is dramatic in character: it is a reenactment of the sacrifice of Christ. Processions, such as those held on Palm Sunday and Easter, added to its spectacular qualities. In line with the Gothic tendency to elaborate and enrich, evident in the art of the cathedral, the mass itself became more complex and decorative. Choirs began to sing in alternation with one another, an arrangement called *antiphony,* which is already somewhat dramatic. Then, in the early tenth century, lengthened musical passages and elaborations on the text of the mass were added. These *tropes,* as they were called, led to the rebirth of drama. A trope used in the Easter mass, referred to as "Quem Quaeritis?" (Whom do you seek?), is, as far as we know, the first "drama" ever to be performed within a church. Here (translated from Latin) is the text:

ANGEL: Whom do you seek in the tomb, O Christians?

THE THREE MARYS: Jesus of Nazareth, the crucified, O celestial ones.

ANGEL: He is not here, he is risen as he predicted. Go and tell that he is risen from the tomb.

Probably this text was sung by antiphonal choirs and did not involve actors. It is admittedly not much of a drama, but from it an entire new tradition was born. By the twelfth century, musical drama as part of the mass involved characters, choruses, and real dramatic action.

The Play of Daniel

A good surviving example of medieval liturgical drama is *The Play of Daniel,* created in the twelfth century for the cathedral of Beauvais, a flourishing city of medieval France just northwest of Paris.

According to the prologue of *The Play of Daniel,* this music was written by the young scholars of Beauvais.

Ad honorem tui, Christe,	In your honor, Christ,
Danielis ludus iste,	This play of Daniel
In Belvaco est inventus,	Was created in Beauvais;
Et invenit hunc juventus.	The youth created it.

CD-1, 5

The language is Latin (with some phrases in Old French), and this is not surprising, for the affairs of the Church were conducted in Latin as, most likely, were the classes that these young men attended. At the end of the play appears the rubric, or performance instruction:

Hic auditis, cantores	After hearing this, the singers
incipient Te Deum	intone the "O God,
Laudamus.	We praise Thee."

CD-1, 8

This is the clue informing us that this play was probably performed at matins, a religious service celebrated daily by the chapter in the early hours of the morning before dawn. Matins is normally a long service, for it contains the chanting of nine complete Psalms and their antiphons as well as the reading of nine scriptural lessons and the singing of nine Responses and the Te Deum. Obviously, the addition of a complete drama would occur only for a special holiday; and, from references in the text, including the final prophecy of Daniel (which Christians interpret as foretelling the birth of Christ), we conclude that it was

written for the Christmas season, probably performed at the end of matins on Christmas morning.

The Play of Daniel has many features that made it particularly attractive to twelfth-century Christians. Coming at the time of the first Crusades, the story includes the great historical personages of the Persian empire, King Belshazzar and King Darius, subjects most in keeping with current political interest. Then the story of the miracle of Daniel's salvation from the terror of the lions' den provides an opportunity for the dramatization of a spectacular event for people who fervently believed in the miraculous. The pageantry of the processions and the rituals of the Persian court were also affairs that could be related to the regular activities of the chapter but that were elevated to a higher level by being unusual or extraordinary. Lastly, the music itself had its own fascination. Each of these elements, when understood within the context of the whole, can speak to us directly when we listen to, and witness a performance of, *The Play of Daniel*.[1]

The music of the play is divided into nine sections, and it is possible that it substituted for, or replaced parts of, the nine sections of matins. The following divisions outline the Daniel story:

1. Prologue. Introduction of characters and synopsis of the story.

2. Belshazzar commands a feast and orders his wise men to interpret the riddle "Mene, Tekel, Peres," which a mysterious hand has written on the wall.

3. The queen arrives, suggests asking Daniel, and he is called before the king.

4. Daniel prophesies doom for Belshazzar but is rewarded for having spoken the truth.

5. The procession of Darius the Great arrives, Belshazzar is slain, and the musicians celebrate the ascendancy of the new ruler.

6. Darius calls for Daniel, raises him to high office, and Daniel pledges allegiance.

7. The jealous counselors find a way to force the king to condemn Daniel.

8. Daniel is saved from the lions by an angel, and he delivers his prophecy of the coming of the Son of Man.

9. Epilogue. An angel announces the birth of Christ, and the Te Deum is sung.

What about the music of the play? After all, it is radically different from current musical sounds. If we take the version recorded by the New York Pro Musica as a fair representation of the way it might have been performed during the twelfth century,[2] we are immediately struck by the presence of instruments no longer used in modern orchestras, a singing style that is certainly not common now, music that does not use *harmony,* and a language that is no longer spoken. Where does one begin in order to understand and enjoy? Perhaps first with the *dynamics,* the volume level of the performance.

Nothing in *The Play of Daniel* is loud. Europeans of the twelfth century were accustomed to a quiet unknown to us, and their hearing was sensitive to minute aural detail. The words of a solo voice at speaking level are much easier to understand and carry the excitement of the story line more effectively and intimately than an amplified voice artificially enhanced with electronic reverberation. Besides, the cathedral walls were reverberant enough. The listeners had no noise pollution from overamplified music, jet landings and freeway traffic, or background sounds of radio and television, vacuum cleaners, or dishwashers. Awareness of subtle variations in melody, in the *timbre* (or tonal color) of instruments, and in performer *inflection* is reflected in this music composed to glorify God and the world. Medieval people did not need volume to hear; they were more interested in finesse and detail.

Even the instruments play softly. The straight trumpet (fifteenth century!) used for this performance could in no way match the gross dynamics of a twentieth-century orchestral trumpet. What does play a significant role in medieval orchestration and replaces volume as an important factor of instrumental sonority is timbre, or tone color. Medieval musicians delighted in the variety, rather than the unity, of the instrumental sounds. The rebec is a little bowed fiddle with a thin nasal sound; the vielle a larger bowed string instrument with a more open tone; the minstrel's harp a stringed instrument that is plucked rather than bowed; and the psaltery another type of plucked string instrument. There were many different sounds from the percussion: jingles, triangles, finger cymbals, cymbals, tambourine, bells, and drums of varying size and pitch; likewise with the wind instruments: portative organ, recorders, and bagpipes. These instruments were designed not to blend but to stand apart and remain distinct. Medieval people heard and enjoyed the differences, and we can, too. Perhaps nineteenth-century America was striving for musical sameness, but early-twenty-first-century America seems interested in cultivating, preserving, and appreciating individuality in a way

[1] The reader is advised to listen to *A Twelfth-Century Music Drama: The Play of Daniel,* recorded by the New York Pro Musica directed by Noah Greenberg (Decca DL 9402). Specific listening assignments refer to this album. The text of the play (in Latin and in English) is included in the album.

[2] The scoring and editing are modern reconstructions, for the original source does not indicate instruments, dynamics, voices, and so on.

much in keeping with that of medieval musicians and their audience.

In the same way that twelfth-century listeners would distinguish individual voices and separate timbres, they could also isolate different song types. Some kinds of music were appropriate for one action or emotion; other kinds were suitable for different situations. In *The Play of Daniel* two distinct musical types are easily discerned: songs and processionals. There are others, but let us study those two as the most important in this work. Daniel's lament, on being condemned to the lions, reads:

CD-1, 7

Heu, heu, heu!	Woe, woe, woe!
Quo casu sortis venit haec damnatio mortis?	By what chance of fate do I receive this condemnation to death?
Heu, heu, heu!	Woe, woe, woe!
Scelus infandum!	Unspeakable calamity!
Cur me dabit ad lacerandum	Why will this savage multitude
Haec fera turba feris?	Give me to be torn by wild beasts?
Sic me, Rex, perdere quaeris?	Thus, O King, do you seek to kill me?
Heu!	Woe!
Qua morte mori me cogis?	To what death do you compel me?
Parce furori.	Spare your fury.

The music is *through-composed* to emphasize the emotional intensity of each portion of the text. No repeated passages appear that would use the same music for different words, and, in this case, the beginning is non-melodic (that is, it opens on a monotone) to underline the cry of despair, *"Heu, heu, heu!"*

As you listen to the recording, note that the composer further clarifies the text of this lament by basically setting the text one syllable to one pitch. In ecstatic passages of celebration and jubilation, it was customary to sing florid groups of notes, thus giving the music a sense of freedom and release. Here the opposite is true, for the sense of fear, uncertainty, and self-doubt calls for restraint and reflection.

CD-1, 6

A contrasting type of composition is a *conductus* or processional, and an excellent example is the procession of the queen coming to King Belshazzar: *"Cum doctorum."*

Cum doctorum et magorum omnis adsit contio	All the throng of learned and wise men is present.
Secum volvit, neque solvit, quae sit manus visio.	They ponder, but cannot explain, the appearance of the hand.
Ecce prudens, styrpe cluens, dives cum potentia;	Behold the prudent, well-born, rich in power,
In vestitu deaurato coniunx adest regia.	Gold-clad spouse of the King is here.
Haec latentem promet vatem per cujus inditium	She will reveal the unknown prophet by whose information
Rex describi suum ibi noverit exitium.	The King will learn and know of his destruction.
Laetis ergo haec virago comitetur plausibus;	Let this heroine be accompanied with joyful applause;
Cordis, orisque sonoris personetur vocibus.	With strings and voices, let loud songs resound.

First notice that the Latin text is strophic; that is, it is written in verse form. The words are both metrical and rhymed, and so is the music. The meter for the first verse is

♩♩♩♩	(strong, weak, strong, weak . . .)
♩♩♩♩	(strong, weak . . . strong)
♩♩♩♩	(. . .)
♩♩♩♩	

This is the basic meter of all the verses, but a few poetic changes in verses 3 and 4 are regularized by the music, which was probably composed with verse 1 in mind.

In listening, notice that the melody for *"Cum doctorum"* (the first stanza) is the same as that for the following three stanzas. In other words, the form is similar to some folk songs, modern hymns, a few pop songs, and many country and western tunes in which several verses are sung to the same melody. Music written this way is easily remembered; and, if it has a good beat (as this does), it carries the listener along in a forward movement of insistent rhythm. It cannot express the precise meaning of the text as well as a through-composed piece, but that is not important in this case, for this *conductus* was written not to express deep feelings and heighten a monologue but to accompany a parade. In other words, the medieval composer used different compositional means to accomplish quite different artistic ends.

It should be apparent by now that the music of this play is not just one long, continuous, undifferentiated monophonic song but a logical series of discrete artistic songs, balanced and blended into a recipe that produces effective music drama. The wedding of drama with music was certainly not new—we saw it with the Greeks, although their music is lost to us. (It is, rather, drama without music that is a recent form.) Both medieval liturgical drama and Greek drama have influenced modern drama, musical theater, and opera. Medieval music may, of course, still be found within the mass. But the music of the cathedral was only one side of the medieval contribution; the court would produce its own music.

WILLIAM OF RUBRUCK

Letter from Mongolia[1]

In 1253 Friar William of Rubruck traveled to the tent city of Karakoram in Mongolia, hoping to convert the Great Khan, Mangu.

The following day the Khan sent his secretaries to me, and they said: "Our lord sent us to you to let you know that you here are Christians, Saracens [Muslims], and Tuins [idol-worshipers]. Each of you says that his law is the best and that his Scriptures, that is, his books, are the truest. That is why he wishes that you all assemble in the same place, and that each write down his laws, so that the truth may be known." So I said: "Blessed be God who has inspired the Khan with such a thought. But our Scriptures teach that the servant of God must not dispute, only be kind to all. I am thus ready to explain, without hatred, the faith and hope of the Christians to whoever wishes to question me."

They wrote down my response and took it to the Khan. The Nestorians [heretics who denied the divinity of Christ] were also ordered to write down all they wished to say, and the same was told to the Saracens and the Tuins. . . . [The debate was held, the disputants agreeing to disagree. Afterward the Khan sent for Friar William.]

On Pentecost day [31 May], Mangu Khan called me and the Tuin with whom I had discussed, and before entering, my interpreter . . . told me that we must return to our country and that I must make no objection, for it was a thing decided. . . . And he [the Khan] held out toward me the stick on which he was leaning, and said, "Have no fear." And I, smiling, said in a low tone: "If I had fear, I would not be here." And he asked the interpreter what I had said, and he repeated it to him.

Then he [the Khan] professed his faith to me. ". . . We believe there is but one God, by whom we live and by whom we die, and we have for him an upright heart." Then I said to him: "May God grant you grace, for without it you can do nothing.". . .

While I was waiting for him to confess still another phase of his faith, he began to talk of my return, saying: "You have been here a long while; I wish that you leave. . . ." And from then on, I no longer had the occasion or the time to explain to him the Catholic faith. For no one can speak before him longer than he wishes to. . . . Then he asked me: "How far do you wish to be conducted?" I replied: "To the kingdom of Armenia your power extends; if I could be conducted as far as there, it would suffice me." And he said: "I will have you conducted as far as that place; after that, take care of yourself.". . .

[Friar William said he would like to return someday.] Then he remained silent for a long while as though absorbed in his thoughts, and the interpreter told me to say no more. But I, anxious, was awaiting a reply. At last he said to me: "You have far to go, strengthen yourself with food, so you may arrive in your country in good health." And he had drink given me. Then he left and I did not see him again. Had I the power to perform miracles like Moses, he would perhaps have humbled himself.

QUESTIONS

1. What is Friar William's attitude toward the Great Khan? The Great Khan's attitude toward the religious representatives who appear before him?
2. Why did Friar William want to convert the Great Khan?
3. Where is Armenia?

MARCO POLO

from the *Travels of Marco Polo*

Marco Polo was in the East between 1271 and 1295.

[The Tartars] dwelt in the northern countries. . . , but without fixed habitations, that is, without towns or fortified places; where there were extensive plains, good pasture, large rivers, and plenty of water. They had no sovereign of their own, and were tributary to a powerful prince, who (as I have been informed) was named in

[1] From Manuel Komroff (ed.), *Contemporaries of Marco Polo* (New York: Boni & Liveright, 1928).

their language, Un-khan, by some thought to have the same significance as Prester John in ours.[1] . . . At length the Tartars, becoming sensible of the slavery to which he attempted to reduce them, resolved to maintain a strict union among themselves [and moved] from the places which they then inhabited. . . .

Chingis Khan

About the year of our Lord 1162, they proceeded to elect for their king a man who was named Chingis-khan [or Ghengis Khan], one of approved integrity, great wisdom, commanding eminence, and eminent for his valor. He began his reign with so much justice and moderation, that he was beloved and revered as their deity rather than their sovereign. . . . Finding himself at the head of so many brave men, he became ambitious of emerging from the deserts and wildernesses by which he was surrounded, and gave them orders to equip themselves with bows and such other weapons as they were expert at using, from the habits of their pastoral life. He then proceeded to render himself master of cities and provinces [in China]; and such was the effect produced by his character for justice and other virtues, that wherever he went, he found the people disposed to submit to him, and to esteem themselves happy when admitted to his protection and favor. . . .

Tartar Warfare

When one of the great Tartar chiefs proceeds on an expedition, he puts himself at the head of an army of an hundred thousand horses. . . . They subsist for the most part upon milk. . . . Each man has, on an average, eighteen horses and mares, and when that which they ride is fatigued, they change it for another. . . . When these Tartars come to engage in battle, they never mix with the enemy, but keep hovering about him, discharging their arrows first from one side and then from the other, occasionally pretending to fly. . . . In this sort of warfare the adversary imagines he has gained a victory, when in fact he has lost the battle; for the Tartars . . . wheel about and, renewing the fight, overpower his remaining troops and make them prisoners. . . .

The Port of Shanghai

. . . Although not large, [it] is a place of great commerce. The number of vessels that belong to it is prodigious, in consequence of its being situated near the Kiang [Yellow], which is the largest river in the world, its width being in some places ten, in others eight, and in others six miles. Its length, to the place where it discharges itself into the sea, is upwards of one hundred days' journey. It is indebted for its great size to the vast number of other navigable rivers that empty their waters into it, which have their sources in distant countries. A great number of cities and large towns are situated upon its banks, and more than two hundred, with sixteen provinces, partake of the advantages of its navigation, by which the transport of merchandise is to an extent that might appear incredible to those who have not had an opportunity of witnessing it. . . . On one occasion . . . [Marco] saw there not fewer than fifteen thousand vessels; and yet there are other towns along the river where the number is still more considerable. . . .

• •

QUESTIONS

1. What is Marco's perception of the Mongols [Tartars]? Chingis Khan? How do you account for his attitudes?
2. Is Marco a reliable witness? Does he have any interest? Any reason to exaggerate the volume of Chinese commerce and shipping?

• •

• •

The Play of Daniel
Translation by George G. Yehling III

(*Trumpet*)

(*Instruments in procession*)

(*Prologue*)

BELSHAZZAR'S PRINCE:　　　　　　　(*Solo tenor*)
In your honor, Christ,
This Play of Daniel
Was created in Beauvais;
The youth created it.

CD-1, 5

THE COURT:　　　　　　　　　　　(*Solo tenor*)
To the Almighty One who holds the stars,
The crowd of men and mob of boys
Gives praise.

For they hear how faithful Daniel　　　　(*Boys*)
Undergoes and bears many things
With constancy.

[1] Prester John was a legendary Christian prince who was supposed to have control of immense forces somewhere to the east of the Muslims. Europeans of the late Middle Ages hoped to join forces with him and catch the Muslims in a vise. Although he turned out to be fictitious, the legend was an important influence on the European expansion eastward.

The King calls the wise men to him (*Men*)
That they may explain
The handwriting.

But they could not solve it, (*Solo tenor*)
And they fell silent, on the spot,
Before the King.

But to Daniel, upon reading the writing, (*Boys*)
The words, which had been a mystery to them,
Soon became clear.

Because Belshazzar saw him surpass them, (*Men*)
He was exalted in the assembly,
It is told.

An insufficient case, brought to trial, (*Boys*)
Delivered him to the lions' mouths
To be torn apart.

But you, O God, (*All*)
Wanted Daniel's enemies
To be good to him.

Also, that he might not hunger,
You sent a prophet on wings
To give him food.

(*The play proper begins*) (*Trumpet*)

THE COURT:
O King, live forever! (*All*)

BELSHAZZAR: (*Bass*)
You who obey my voice,
Bring, for my use, the vessels
Which my father carried off from the temple
When he smote Judaea mightily.

THE COURT: (*Men and all*)
Let us rejoice in our King, great and powerful!
Let us sing his worthy praise in a suitable voice!
Let the joyous crowd resound with solemn odes!
Let them play harps, clap hands, make a thousand
 noises.

His father, who destroyed the temple of the
 Jews, (*Solo*)
Did great things, and this one rules by his
 example.
His father despoiled the kingdom of the
 Jews; (*Men*)
This one celebrates, appropriately, with their
 vessels. (*All*)

These are royal vessels, which were
 plundered (*Solo*)
From Jerusalem to enrich royal Babylon. (*Men*)

Let us present them to Belshazzar our King, (*Solo*)
Who has adorned his servants with purple. (*Boys*)

He is mighty, he is strong, he is glorious, (*Solo*)
Virtuous, courtly, handsome, and fair. (*Men*)
Let us rejoice in such a King with melodious
 voice; (*Solo*)
Let all resound his loud praises in unison; (*All*)
Babylon applauds, laughing, Jerusalem
 weeps. (*Solo*)
The latter is despoiled; the former, triumphant,
 worships Belshazzar. (*Boys*)
Let us all, therefore, exult in such a mighty
 one, (*Men*)
Offering the King's vessels to His Majesty. (*All*)
Behold, here they are before you. (*Solo*)

(*A hand writes* "MENE, TEKEL, PERES" *on the
 wall*) (*Bells*)

BELSHAZZAR:
Call the Chaldean mathematicians and
 astrologers. (*Bass*)
Find the soothsayers,
And bring the wise men in! (*Trumpet*)

TWO WISE MEN: (*Two men*)
O King, live forever!
Here we are.

BELSHAZZAR:
Whoever shall read this writing (*Bass*)
And disclose its meaning,
Under his power
Babylonia shall be placed,
And he shall wear purple
And a golden necklace.

THE TWO WISE MEN:
We do not know, nor can we explain, (*Solo*)
What the writing is, nor what the hand
 means. (*Solo*)
 (*Finger cymbals*)

THE QUEEN AND HER ATTENDANTS:
All the throng of learned
 and wise men is present. (*Sung by boys*)
They ponder, but cannot explain,
 the appearance of the hand.

CD-1, 6

Behold the prudent, well-born,
 rich in power,
Gold-clad spouse
 of the King is here.

She will reveal the unknown prophet
 by whose information
The King will learn and know
 of his destruction.

Let this heroine be accompanied
 with joyful applause;
With strings and voices,
 let loud songs resound.

 (*Trumpet*)

THE QUEEN:
 O King, live forever! (*Soprano*)

That you may know the writer's meaning,
King Belshazzar, hear my advice.
With the captive people of Judaea; (*fade*)
Daniel, learned in prophetic oracles,
Was brought from his country,
A prisoner of your father's victory.
He lives here under your rule,
And reason demands that he be called.
Therefore send for him without delay,
For he will show you what the vision conceals.

BELSHAZZAR:
 Seek Daniel and bring him here
 When he has been found.

THE COURTIERS:
 O Daniel, man and prophet of God
 Come to the King.
 Come, he wishes
 To speak to you.
 He is fearful and disturbed, Daniel,
 Come to the King.
 He wants to learn from you what is a secret to us,
 He will make you rich with gifts, Daniel,
 Come to the King.
 If he can learn from you the meaning of the writing.

DANIEL:
 I wonder greatly by whose advice
 The King's command seeks me out.
 I will go, however, and he shall know from me,
 At no cost, what is hidden.

THE COURTIERS:
 This is God's true servant,
 Whom all people praise,
 The fame of whose prudence
 Is known in the King's court.
 The King sends for him by us.

DANIEL:
 Poor, and an exile, I go to the King by your request.

THE COURTIERS:
 In the glory of youth,
 Full of heavenly grace,
 He greatly excels all men
 In virtue, in living, in his habits.
 The King sends for him by us.

DANIEL:
 Poor, and an exile, I go to the King by your
 request.

THE COURTIERS:
 This is he whose help
 Will explain that vision,
 In which the writing of a hand
 Disturbed the King deeply.
 The King sends for him by us.

DANIEL:
 Poor, and an exile, I go to the King by your
 request.

(DANIEL *appears before the* KING)

 O King, live forever!

BELSHAZZAR:
 Are you he who is called Daniel,
 Brought here with the wretched of Judaea?
 They say that you have the spirit of God,
 And that you know whatever is hidden.
 If, therefore, you can explain the writing,
 Huge rewards will be given to you.

DANIEL:
 King, I do not want your rewards.
 The writings will be explained for no fee.
 Now this is the solution:
 Your destruction is at hand.
 Your father was once mighty
 Above all others.
 Greatly puffed up with pride,
 He was cast down from his glory.
 For not walking with God,
 But making himself like God,
 He snatched the vessels from the temple
 For his own use.
 But after many excesses,
 He finally lost his riches,
 And divested of human form,
 He ate grass for fodder.
 You too, his son,
 Are no less impious,
 For you follow after his deeds
 And use his vessels.
 But whatever displeases God
 Has a time for retribution,
 And now the handwriting
 Threatens a punishment.
 And God says, MENE,
 Your reign is at an end.
 TEKEL means scales,
 Which show you to be lacking.
 PERES is distribution,
 Your rule is given to another.

BELSHAZZAR:
Let him who thus has solved the
 mystery
Be clothed in a royal garment.
Take away the vessels, prince of the army,
Lest they be a source of misery to me.

THE QUEEN AND HER ATTENDANTS:
There is recorded,
 in the book of Solomon,
Fitting and proper praise of woman.
Her value is that of a strong man
From far and distant lands.
Her husband's heart trusts in her;
He possesses abundant riches.
Let this woman be compared
To one whose king is worthy of support.
For the eloquence of her words
Overcomes the wisdom of the learned.
Let us who are performing this play
On this solemn day
Give to her devout praise;
Let the ends of the earth come and sing.

THE MEN OF THE COURT:
Carrying the vessels of the King
Before whom the peoples of Judaea tremble,
And giving praise to Daniel,
Let us rejoice! Fitting praises
Let us bear him!
He foretold the King's downfall
When he explained the writing;
He proved the witnesses guilty
And freed Susannah.
Let us rejoice!
Fitting praises
Let us bear him!
Babylon exiled him,
When the Jews were taken captive
Whom Belshazzar honors.
Let us rejoice!
Fitting praises
Let us bear him!
He is a holy prophet of God.
Honored by Chaldeans
And Gentiles and Jews.
Therefore, making merry before him,
Let us rejoice!
Fitting praises
Let us bear him!

(KING DARIUS *and his soldiers and courtiers now enter,
having overthrown* BELSHAZZAR)

DARIUS'S SOLDIERS AND COURT:
Behold! King Darius
Comes with his princes,
The noble one with his nobles.

And his court
Resounds with joy,
And there is dancing.
He is awesome,
Venerated by all.
Empires are
His tributaries.
All honor him as King
And worship him.
The land of Babylonia
Fears him, also.
With his armed troops,
Descending like a whirlwind,
He crushes armies
And destroys the strong.
Honesty and nobility
Are his endowments.
He is the noble King,
Darius of Babylonia.
Let this throng
Rejoice in him with dancing
And praise with joy
His mighty deeds,
So wondrous.
Let us all be glad together;
Let the drums sound,
Let harpists pluck their strings;
Let the musicians' instruments
Resound his praises.

(DARIUS *is seated on the throne. All acclaim him, saying*)

O King, live forever!

TWO COUNSELORS:
Hear us, you princes of the King's court,
Who administer the laws throughout the land.
There is a certain wise man in Babylonia,
Who by the gods' grace reveals secret things.
His advice pleased the King,
For he explained the writing to Belshazzar.
So quickly, let there be no delay—
We want to make use of his counsel.
If he will come, let him be made counselor
To the King, and he shall rank third in the
kingdom.

(*Three* MESSENGERS *are sent to* DANIEL)

MESSENGERS:
Our embassy comes by command of the King,
O servant of God.
Your uprightness is praised to the King;
Your amazing skill commends you.
Through you alone was explained
The apparition of a hand which was a mystery to
 everyone.
The King calls you to his court,
That he may acknowledge your discretion.

You shall be, according to what Darius says,
His principal adviser.
Therefore come, for the whole court
Is being readied for your pleasure.

DANIEL:
 I will go to the King.

(DANIEL *is led before* DARIUS)

COUNSELORS, MESSENGERS, COURTIERS:
 With great rejoicing let us celebrate the Christmas
 solemnities;
 God's Wisdom has now redeemed us from death.
 He who created all things is born man, in the flesh;
 His birth was foretold by the words of the prophet.
 The old anointing of Daniel's time had ended;
 The dispensation of the Jews is over.
 On this Christmas,
 With joy, O Daniel,
 This crowd praises you.
 You freed Susannah from a capital charge;
 God inspired you by his holy spirit.
 You proved the witnesses guilty by their own
 accusations;
 You destroyed the dragon Bel in the sight of the
 people.
 And God guarded you from the lions' pit.
 Therefore, praised be the Word of God, born of a
 Virgin.

DANIEL:
 O King, live forever!

DARIUS:
 Because I know your prudence,
 Daniel, I give you responsibility
 Over the entire kingdom
 And award you the highest place.

DANIEL:
 King, if you trust in me,
 You will do no evil by following my advice.

TWO ENVIOUS ADVISERS:
 O King, live forever!
 It was decreed in your court
 By the rulers who are glorious
 That, by the power of your name,
 Every god should be rejected
 For the space of thirty days,
 And that you should be adored as God by all,
 O King!
 If anyone should be so rash
 As to disregard your command
 And to prefer another god above you,
 The punishment should be
 That he be delivered to the lions' pit;
 Let this be proclaimed throughout your realm, O King!

DARIUS:
 I command and ordain
 That this decree be obeyed. Hear it!

(DANIEL *worships his own God in spite of the
decree*)

TWO ENVIOUS ADVISERS:
 Do you remember, Darius, the observance you
 commanded,
 That whoever is guilty of praying to any god
 but you
 For anything will be given to the lions?
 This law was proclaimed by your princes.

DARIUS:
 It is true that I commanded
 All people to worship me.

TWO ENVIOUS ADVISERS:
 We saw this Jew, Daniel, worshiping
 And praying to his God in defiance of your laws.

DARIUS:
 May it never be granted you
 That that holy man should be so destroyed.

TWO ENVIOUS ADVISERS:
 The law of the Medes and the Persians in the annals
 commands
 That whoever scorns the King's decree be given to
 the lions.

DARIUS:

 If he has disobeyed the law that I made,
 Let him receive the punishment that I
 decreed.

CD-1, 7
 (DANIEL *is seized and brought to the lions'
 den*)

DANIEL:
 Woe, woe, woe!
 By what chance of fate do I receive this
 condemnation to death?
 Woe, woe, woe!
 Unspeakable calamity!
 Why will this savage multitude
 Give me to be torn by wild beasts?
 Thus, O King, do you seek to kill me?
 Woe!
 To what death do you compel me?
 Spare your fury.

DARIUS:
 The God whom you worship so faithfully
 Will deliver you miraculously.

(DANIEL *is thrown into the lions' den*)

DANIEL:
I am not guilty of this crime;
God have mercy on me, eleyson.
To this place, O God, send a defender
Who will restrain the power of the lions, eleyson.

(*An* ANGEL *is sent to protect* DANIEL *from the lions.*
Another ANGEL *comes to* HABAKKUK, *far away*)

ANGEL:
Habakkuk, pious old man,
Bring food to Daniel,
To the pit in Babylonia;
The King of all commands it of you.

HABAKKUK:
God in his wisdom knows
That I know nothing of Babylon,
Nor of the pit
Into which Daniel has been put.

(*The angel leads him there*)

HABAKKUK:
Arise, brother, and take food;
God has seen your sufferings;
God has sent me, give thanks to him
Who made you.

DANIEL:
You have remembered me, Lord;
I accept this in your name, Alleluiah!

(DARIUS *approaches the pit*)

DARIUS:
Do you think, Daniel,
That he whom you revere and worship
Will save you and rescue you
From the death to which you are sent?

DANIEL:
O King, live forever!
With his accustomed pity, God sent an angelic
 protection
To close the lions' mouths for the time being.

DARIUS:
Bring Daniel out,
And throw the envious ones in.

(*His* PRINCES *proclaim the command*)

Bring Daniel out,
And throw the envious ones in.

TWO ENVIOUS ADVISERS:
We suffer this deservedly, for we have
Sinned against a holy man of God;
We have acted unjustly
And have done evil.

DARIUS:
I command all people to worship
Daniel's God, who rules the world.

DANIEL:
Behold, the holy one shall come,
The holiest of the holy,
Whom this king, powerful and mighty,
Commands us to worship.

Temples, anointings,
This kingdom shall cease;
The end of the Kingdom of Judaea,
And of its oppression, is at hand.

(*An* ANGEL *appears to announce the fulfillment of*
DANIEL'S *prophecy*)

ANGEL:

CD-1, 8

I bring you a message from on high:
Christ, the ruler of the world, is born
In Bethlehem in Judah,
As the Prophet foretold.

(*The entire company sings the "Te Deum*
laudamus")

We praise thee, O God;

(*Cantor, men, and boys, antiphonally*)

We acknowledge thee to be the Lord.
All the earth doth worship thee,
The Father everlasting.
To thee all Angels cry aloud;
The Heavens and all the Powers therein;
To thee Cherubim and Seraphim continually do cry:

Holy, holy, holy,
Lord God of Sabaoth;
Heaven and earth are full of the Majesty of thy glory.
The glorious company of the Apostles praise thee.
The goodly fellowship of the Prophets praise thee.
The noble army of Martyrs praise thee.
The holy Church throughout all the world doth
 acknowledge thee;
The Father of an infinite Majesty;
Thine adorable true and only Son;
Also the Holy Ghost the Comforter.
Thou are the King of Glory, O Christ.
Thou art the everlasting Son of the Father.
When thou tookest upon thee to deliver man,
Thou didst humble thyself to be born of a Virgin.
When thou hadst overcome the sharpness of death,
Thou didst open the Kingdom of Heaven to all
 believers.
Thou sittest at the right hand of God, in the glory of
 the Father.
We believe that thou shalt come to be our Judge.
We therefore pray thee help thy servants,

Whom thou hast redeemed with thy precious blood.
Make them to be numbered with thy Saints in glory
 everlasting.
O Lord, save thy people
And bless thine heritage.
Govern them, and lift them up for ever.
Day by day we magnify thee;
And we worship thy Name ever world without end.
Vouchsafe, O Lord, to keep us this day without sin.
Have mercy upon us, O Lord, have mercy upon us.
O Lord, let thy mercy be upon us,
As our trust is in thee.
O Lord, in thee have I trusted;
Let me never be confounded.

COMMENTS AND QUESTIONS

1. Read the book of Daniel in the Bible, asking yourself what the author has done with the biblical story. Has he Christianized any of its specifically Jewish aspects? Has he added anything to the various characters or depicted them more clearly than they are in the story?

2. In noting the differences between the story of Daniel in the Bible and the way that it is handled in the play, you may be able to see something of the same process of transformation of myth into drama that was at work in Sophocles' creation of *Oedipus Rex*. Does the hero of *The Play of Daniel* show the same internal development or character transformations that Oedipus does? Are the other characters as well defined? Why or why not?

3. From a comparison of these two plays, what inferences can you make about the differences between the classical and the medieval aesthetic, particularly concerning the view of the place of human beings held by each culture?

4. Could *The Play of Daniel* have been written as a tragedy? What keeps it from being a tragedy?

5. In what ways does the lack of harmony and orchestration affect the function of the melody in *The Play of Daniel*?

6. Even though you might not recognize distinctive melodies as such in *The Play of Daniel*, do you hear sounds that are more appropriate for one kind of action or emotion than for another?

Summary Questions

1. What were the centuries of the High Middles Ages and what characterized them?
2. What were the four "revivals" of the High Middle Ages and how can you define them?
3. What were the effects of the Crusades?
4. What contacts did Europe have with Asia in this period?
5. When and where did Gothic architecture begin and why is it called *Gothic*?
6. Which ideas of the Abbot Suger influenced the creation of Gothic architecture?
7. Describe the most important innovations in the cathedral at Chartres.
8. How did drama develop within the church?
9. What are the main characteristics of the music for *The Play of Daniel*?

Key Terms

cathedral

cathedral school

scholasticism

reason and revelation

Romanesque

Gothic

Latin cross

pointed arch

choir

stained glass

liturgical drama

monophonic

polyphonic

through-composed

11 Divine and Human Love

The cathedral of Notre Dame de Chartres, built as a palace for the Queen of Heaven, containing a relic of her tunic, full of images of her in stone and stained glass, is, among other things, a testament to the enormous importance that the mother of Jesus had in the spiritual and daily lives of medieval men and women. And Chartres was not the only such palace. Romanesque churches were dedicated to a variety of saints, but in the Gothic period the greatest cathedrals of France—Amiens, Reims, Laon, Rouen, and Paris—were named for the Virgin *Notre Dame* (Our Lady). Why did Mary play such an important part in medieval lives, and what were the effects of this worship of her?

The Adoration of the Virgin Mary

The devotion to Mary was part of a general humanizing trend in religion that began in the eleventh and twelfth centuries. Monastic literature of this time began to emphasize the theme of tenderness and compassion for Jesus' sufferings. In art, Jesus was portrayed as more human. Whereas Byzantine portrayals of the Christ child had tended to be allegorical, making the baby look already like the king of the world, twelfth-century artists began to portray a more childlike child and with him a mother who could express the tenderness of human, as well as divine, love. The artists who represented this divine mother took care to represent her as a lady of great beauty, combining physical attractiveness with a more ethereal quality. In the language of Mary's devotees, the praise of spiritual and physical beauty was often intermingled. Mary was seen as a queen but also as a mother— a kind and warm woman full of compassion for human sufferings and shortcomings, able and willing to intercede between individuals and God and thereby to save souls. A great many stories about miracles done by the Virgin circulated orally in the twelfth century; some were written down. The following examples illustrate the common person's view of the Virgin's compassion and power.

> A clerk at Chartres led an unchaste life, but often prayed to the Virgin. When he died, he was buried outside the churchyard because of his bad reputation. The Virgin appeared to one of his colleagues, asked him why her "chancellor" had been so badly treated, and ordered that he be reburied in the churchyard.

> A certain thief named Ebbo was devoted to the Virgin, and even hailed her when he went out to steal. He was finally arrested and hanged [a common punishment for thieves] but the Virgin supported him for two days and when the hangmen

tried to tighten the rope, she put her hands around his throat and prevented them. Finally he was let go.

One of the spiritual leaders most responsible for promoting the adoration of the Virgin in theology, as well as in popular devotion, was Saint Bernard (1090–1153). Bernard, abbot of Clairvaux and a close associate of the abbot Suger, was a Cistercian monk who emphasized in his teachings the value of the inner life and self-knowledge as part of a mystical ascension to God. Divine love, the essential attribute of the Virgin, could aid the soul in its progressive ascent from the love of bodily things to the love of spiritual things to the selfless love of God. The Virgin, human and yet the mother of God, could aid human beings in their progress from carnal to spiritual love. Saint Bernard's spiritual devotion to Mary would be immortalized by Dante Alighieri's presentation of his hymn to the Virgin near the end of the *Divine Comedy*.

Representations of the Virgin Mary

The Virgin Mary was naturally a great subject for artists of all kinds. In the sculpture and glass at Chartres she is majestic and beautiful, portrayed as the mother of Christ and, therefore, the queen of heaven. Somewhat later, in the jamb sculptures on the west portal of Notre Dame de Reims (Fig. 11-1) she is depicted as a young, shy, innocent girl when visited by the archangel Gabriel. On the adjacent jamb she is the pregnant matron who greets her cousin Elizabeth, pregnant with the child who will be John the Baptist. Both women have a weight and gravity in their bearing, conveyed by pose and drapery,

that is almost classical in feeling, and highly appropriate to the roles that God has assigned them.

The association of Mary with Christian and courtly love, and thus with majesty and divinity, provided the inspiration for Simone Martini's late-Gothic *Annunciation*, painted in 1333 (Color Plate VII). Martini (1283–1344) was born in Siena, but one of his chief patrons was Robert of Anjou, king of Naples (1278–1343). Through the Neapolitan court Martini was exposed to French art. The consequences of this contact are to be found in his stunning, glittering altarpieces executed in these years. The *Annunciation* is divided into panels that seem to echo the elaborate designs and proportions of the east portals of a French Gothic cathedral with its finials and carved, embossed, and double-curved arches. In this frame Martini has placed a most retiring, but nevertheless sinuous, sensuous Mary shrinking from the splendid beauty of the archangel Gabriel who has just alighted, his drapery still fluttering in the air.

This Mary annunciate is not a simple woman like the one depicted at Reims (Fig. 11-1), but rather a demure, decorous young princess with slender hands and delicate features. This is the Mary of the Court of Heaven, where she is seated on a marble throne, reads from a beautiful book, and is separated from her visitor by a gilded vase with unfading lilies, symbolic of her virtue and purity. Martini's careful attention to the things of the experienced world—the gold embroidered border of Mary's gown, the plaid pattern of Gabriel's drapery, the minute varicolored feathers of his wings—links us to the temporal world, which courtly love is to enlighten and inform with virtue like that of Mary's.

The Literature and Music of Courtly Love

The graceful reverence for Mary apparent in both painting and music is representative of the tradition that has come to be known as courtly love. Although it reflected a literary vision of love rather than contemporary reality, this style was associated with the new princely courts that first appeared in southern France in the early twelfth century and subsequently in northern France, England, and southern Germany. By this period, the economic revival had enriched rulers enough that they were able to maintain a modest group of friends and retainers around them. Like courts everywhere and at all times, these courts were marked by the effort to make an art of leisure and by the prominence of women in this attempt. The strong desire for entertainment and novelty was fulfilled either through the nobles' creativity and ingenuity or through attracting to the court someone endowed with these gifts.

One of the chief means of entertainment and artistic expression was literature, particularly songs and stories of love. Although the medieval nobles usually knew no Latin, both men and women were literate in the

11-1 Annunciation *and* Visitation, *jamb statues, west portal, cathedral of Reims, c. 1225–45. (Giraudon/Art Resource, NY)*

vernacular—that is, the modern European languages. Although stories about heroes, or epics, had been composed from as early as the seventh century in Anglo-Saxon and then in the other European tongues, the main literary language of the early Middle Ages was still Latin. By the twelfth century, however, the vernacular was increasingly the vehicle for literature, and love became the main theme.

Courtly literature was formed primarily from classical expressions of ideal friendship (Cicero's *On Friendship*), destructive passions (Ovid's *Heroides* and *Metamorphoses*), and sexual love (Ovid's *Art of Love* and *Remedies of Love*). These were combined with biblical expressions of mystical love (Song of Solomon) and of charity (1 Corinthians), as well as with themes taken from the love poetry of Muslim Spain. The late-twelfth-century writer Andreas Capellanus, in his *Art of Courtly Love,* attempted to codify the nature of love and the rules of loving for an era obsessed with these questions.

The court of William of Aquitaine (1071–1137) was probably the first center for the new literature of love. Himself a poet, this prince of the southern French principality of Aquitaine encouraged the writing of vernacular poetry by his entourage, as did his more famous daughter, Eleanor of Aquitaine (1122–1205). Surely one of the greatest women of the Middle Ages, Eleanor—beautiful, passionate, and willful—became first the wife of Louis VII, king of France, and then of Henry II, king of England. Patron of a number of poets, including Bernart de Ventadorn, son of a mercenary soldier and a serving lady, she proved a significant influence in spreading love poetry to northern France and to England. Like the poets of ancient Greece and modern folksingers, the poets entertained their (usually aristocratic) audiences with solo voice, accompanied by a stringed instrument, the lute.

Troubadour Poetry

Evolving as it did in the courts of southern France, this poetry celebrating love reflected to an extent the circumstances of its origin. While some of the poets, or *troubadours,* were great lords, like William of Aquitaine, most were poor knights or minstrels who depended on the lord of the castle for their livelihood. Within this milieu the lady of the castle exercised a powerful attraction both as an object of love and as a source of patronage. Married, separated from the poet by class and wealth, the noblewoman became the inspiration for the beloved in troubadour poetry. Its themes were almost always the same: they concerned a beautiful, idealized lady for whom the poet languished with love but who did not return his affection. Because of the woman's married status the love had to be kept a secret, sometimes even from the lady herself: consequently, the poet, never giv-

ing her name, addressed her as "my lady" and he presented himself as her servant. The love he felt for her, however, ennobled him, and it inspired him to seek moral and spiritual improvement so that he might be worthy of his beloved. At the same time the poet's very capacity to feel such love was represented as denoting a natural nobility in the lover—a nobility of character having nothing to do with noble status in the world.

The *trobairitz* were female counterparts of the troubadours. Women of the aristocracy, they were less likely than the male poets to formulate their relationship to the beloved as that of servant to master. Their poetry generally was less controlled by poetic devices and allowed the personal voice of the writer to become more audible.

Despite the extensive physical and sensual imagery of the poems, the love they expressed, *fin'amor* or courtly love—what we now call romantic love—was generally presented as a spiritual emotion. Although it sprang from the physical beauty of the beloved, by remaining unconsummated it directed the lover to higher goals of conduct in the world and to spiritual enrichment.

Possible Muslim Influences

Most scholars agree that the devotion to the Virgin Mary so predominant in the twelfth century had an impact on expressions of courtly love. Others identify the origins of troubadour poetry in the love poetry of Muslim Spain in the eleventh century. An Arab tradition of innocent and pure love expressed in poetical form reached its fullest development there, perhaps because the mixed society of Muslims, Christians, and Jews offered relatively freer social relations than the more conservative Muslim East. The eleventh-century handbook on love, *Ring of the Dove* by Ibn Hazm of Cordoba (in prose interspersed with poetry), dwells on the spiritual aspects of love while censuring sexual excesses and counseling continence. The themes of the poetry written in the princely Spanish courts from this period are indeed similar to those of later troubadour songs. Normally an idealized, beautiful, and innocent lady is loved passionately but chastely and submissively by the poet. He expresses his willingness to endure endless anguish in vain hope of her favorable response to his plea. For example, in the following verses, the poet Ibn Zaydun lyrically proclaims his unreturned love for the princess Walladah:

> When shall I unfold what I feel for you
> O my delight and suffering?
> When shall my tongue take the place
> Of a letter to explain my love?
> God knows what
> Has become of me because of you:
> My bedroom has become a void
> And my drink tasteless. . . .

> Know that if you imposed on my heart what those
> Of other people could not bear, mine can
> withstand:
> Disdain me, I'll bear it; postpone, I'll be patient;
> Be haughty, I'll be humble;
> Turn back, I shall follow; speak, I shall listen;
> Order, I shall obey![1]

Such love poems were meant to be sung, although the music is unknown because there was no tradition of notation.

The Romance

By the second half of the twelfth century the *fin'amor* of the troubadours appears in northern France embodied in narrative compositions in both prose and poetry. Quickly to become the dominant narrative form in France, this new literary genre was called the *romance,* a term originally signifying a composition in a Romance (from Roman) language—French, Italian, or Spanish. However, by the late twelfth century romances were already being composed in Germany in local vernaculars.

In romances the main characters were knights and ladies, and the concerns were chivalry and love rather than heroic combat (as in the epic). But although the characters may have suggested ideals of courtesy and nobility, neither they nor their actions should be thought of as reflecting daily life at the time. As with the lyric poetry of the troubadours, however, the social ideals embodied in the romances over time played a civilizing role on their listeners and gave shape to the rituals of court life.

Story material for the written romances frequently came from oral legends, such as those about King Arthur and the knights of the Round Table. These legends were often Celtic in origin. One of the most popular among them, as well as one of the most influential on later notions of romantic love, was the story of Tristan and Iseult. Although many written variations of this legend exist, Béroul's *Roman de Tristan,* written in French, was the most widely circulated. The story involves Mark, the king of Cornwall, his nephew Tristan (meaning the sad one), and Iseult the Fair from Ireland, whom Tristan, through knightly exploits, wins as a bride for King Mark. On the boat headed to Cornwall, Tristan and Iseult accidentally drink a "philtre," or magic potion, that Iseult's mother had prepared for her daughter and her husband. The effects of the potion are such that whoever drinks it will fall unremittingly in love with the next person he or she sees. Iseult does become the bride of King Mark, but the two lovers

devote the rest of their lives to plotting secret trysts and deceptions. They wander together in the forest for two years when they are banished from court. Goaded by Tristan's enemies, Mark is alternately suspicious and trusting. God often seems to be on the lovers' side, even in their deceptions. Finally, Mark takes Iseult back as his queen and sends Tristan away, but the lovers can never forget each other. Tristan even marries another Iseult—"Iseult of the White Hands"—but when he is ill and near death, he sends for his true love Iseult to come to heal him. Jealous, the wife Iseult makes Tristan think that the lover Iseult is not coming, and so he dies. When Iseult does arrive, she lies beside her lover's body and dies of grief. As in *Romeo and Juliet,* the final union of the ill-starred lovers can take place only in death.

Celtic legends, particularly those from Brittany in northwestern France, also inspired another writer of romances, known as Marie de France. We know nothing about Marie except that she wrote in French at the Norman court in England during the late twelfth century. Her primary work was to put into written, literary form the long narrative songs known as *lais* from Brittany. Like other literature of courtly love, these songs are mainly concerned with adulterous passion. Marie explores not only the ennobling and beautiful aspects of all-consuming sexual love but also its destructive and egotistical side.

The romances draw heavily on the emotional and sensual aspects of the southern lyric. The lovers in both genres engage in intense analysis of their feelings and are assailed by doubts as to the loyalty of their beloved. In both genres, too, either marriage or some other obstacle impedes free contact between the lovers. Because narratives demand a social dimension, the chivalric element plays a major role in the romance. The lover is always a knight whose love of the lady must be proved by arms. Often the plot hinges on the knight's conflict of loyalties to his lord and to his lady.

The men and women of the Middle Ages, however, were not completely at ease with this literature of love and adventure. They were well aware that the freedom of love and the preoccupation with mortal attachments were contrary to the teachings of the Church. Still, this literature quite likely both entertained the aristocratic audiences of twelfth- and thirteenth-century Europe and appealed to their imaginations. What is more, it helped to civilize a warlike nobility by making courtesy and decorum essential ingredients of courtly life. In contrast to the antifeminism of classical antiquity and Judeo-Christian tradition, it endowed women with moral and spiritual value, gave them a leading role in the social and cultural life of the court, and challenged traditional conceptions of male dominance. Troubadour poetry invested sensual love between men and women, toward which the Church manifested great ambivalence,

[1] Anwar G. Chejne, *Muslim Spain: Its History and Culture* (Minneapolis: University of Minnesota Press, 1974), p. 260.

with positive spiritual attributes and envisaged it as a moralizing force in society. Finally, contrary to the medieval view of the woman as an item of trade between two families, the literature of courtly love presented marriage as an agreement between two consenting individuals who cared for one another. Nonetheless, in the twelfth century we are merely at the start of a long process in the civilizing of western Europe and the articulation of the self in both men and women.

Dante Alighieri (1265–1321)

The courtly lyrics and romances of France had an influence on what is undoubtedly the greatest love poem ever written, Dante Alighieri's *Divina Commedia (Divine Comedy)*. Although human and divine love act as the impetus and the goal of this poem, the poem also encompasses a great deal more, especially politics and theology, and it is necessary to know something of Dante's life and times in order to approach it.

Thirteenth-Century Florence and Dante's Early Life

Dante was the product of a society in transition from rural and courtly to urban and mercantile, from medieval to Renaissance. Although he was to know the bitterness of exile from his native city, Dante was thoroughly urban and Florentine. The Florence of his youth was just entering into its period of greatness. In the course of his lifetime, the city on the Arno River established its international reputation as the producer of the finest woolen fabrics made. The soundness of its gold coin, the florin, made it the standard of the Western world. By 1300, Florence's population of about one hundred thousand people equaled that of Venice, making them the two largest cities in Europe.

Legally, Florence, together with much of the upper half of Italy, formed the Kingdom of Italy, which in turn was part of the Holy Roman Empire. This empire, consisting of the kingdoms of Germany, Italy, and Arles (principally what is now eastern France), had, since the tenth century, been ruled by a German prince. The German emperor's capability to exert power over Italy had always been sporadic, so that Italian cities had, for long periods of time, found themselves, for all practical purposes, independent. Naturally, the stronger cities tended to expand and to create around themselves a ring of dependent little towns and cities over which they ruled, just as Athens and Sparta had done in ancient Greece. Although the governments of these city-states were not democratic, as those in Greece had been, by the thirteenth century most could be classified as republican— that is, they were ruled by a large body of citizens, although with the lower social elements excluded. In the

Florence of Dante's time, the basis for citizenship and political participation in government was membership in one of the numerous guilds in the city.

The German emperors rarely exerted much real power over their Italian kingdom, but when they took their authority seriously and came into Italy with an army, the result was usually political chaos. At those times, the bulwark of Italian independence became the Roman papacy. A secular prince over a band of territories that straddled the central portion of the peninsula, the pope had good reason to fear the emperor's presence. Both pope and emperor had rival claims to certain areas, and friction between the two was almost inevitable. From the late twelfth century, when the German emperor Frederick Barbarossa had been exceptionally active in Italy, this struggle became institutionalized in Italian politics through the development of two political parties, the Guelf party, loyal to the pope, and the Ghibellines, loyal to the emperor. Within decades, the political life of every major Italian city-state was disrupted by a struggle between the two parties. Clearly, although the papal-imperial rivalry provided a kind of ideological umbrella for the parties throughout Italy, in each city-state local issues counted more in determining party loyalty.

The party struggle dividing Florence in the thirteenth century was particularly bitter. In 1267, the leaders of the Guelf party, who had been exiled by the Ghibellines, returned triumphantly to the city, drove out their enemies, and established an enduring Guelf domination in Florence. But the Guelf victory did not bring peace, because within decades the Guelfs themselves divided into two parties called the White and Black Guelfs, and the struggle of parties resumed. Dante's involvement in this factional struggle was to change the course of his life, and his involvement in the political struggles of his time would also have a profound impact on his great work, the *Divina Commedia*.

Relatively little is known of Dante's life. Born in 1265, he was the son of a family that, on his father's side, claimed descent from the Romans. Although the family was at the time in modest circumstances, Dante (Fig. 11-2) never had to seek gainful employment, and in early manhood managed to devote his time to study. In an early work, the *Vita Nuova* (the New Life), Dante recounts the great influence on his life and on the *Commedia* of his love for a girl named Beatrice.

Dante tells us that he first met Beatrice when he was nine and she eight, and from that moment his heart was possessed by a passionate and enduring love. Nine years later he saw her again, dressed all in white, walking in the street between two older ladies. On this occasion she turned and greeted him. Overjoyed, Dante promptly retired to the solitude of his bedroom where, thinking of Beatrice, he fell asleep and had a marvelous vision. When he woke, he composed the poem "To every captive soul, and gentle heart," his earliest known

11-2 *Giotto's portrait of Dante as a young man, included in the crowd in one of Giotto's frescoes. Museo Nazionale, Florence. (Alinari/Art Resource, NY)*

composition. To conceal his love for Beatrice, he paid attention to another lady, but this caused Beatrice to deny him her glance and plunged Dante into the deepest grief. When he saw her next at a wedding feast, perhaps her own in 1288, he could not keep from looking at her, whereupon Beatrice and the ladies about her began to whisper and make fun of him. Dante had to be led from the house by a friend.

Dante by this time was already married to a rich banking heiress to whom he had been betrothed since he was twelve. His wife, who ultimately bore him three or four children, could not have failed to notice her husband's utter desolation when in 1290 his beloved Beatrice died. Dante tells us that for a time he could do nothing, but finally, through the study of philosophy, he regained enough control to set down, in a mixture of prose and verse, the story of his love. Composed between 1292 and 1293, the *Vita Nuova* recounts Dante's moral regeneration through his pure love for Beatrice. At the end of this work, the author vows that he will write of her what has never yet been written of any woman, a resolve he was to carry out in the *Divina Commedia*.

The Sonnet and a New Vision of Love

From very early in his life, Dante had been one of a group of Florentine writers of poetry who wrote love poetry in the "vulgar" language—that is, in Tuscan Italian, Latin being still the official literary language of Italy. Influenced by the French and Provençal poets of courtly love, this *dolce stil nuovo* (sweet new style) celebrated the lofty, idealized figure of the beloved woman. Its poetry differed from the French, however, in placing heavier emphasis on the woman's redemptive role. Whereas the troubadours emphasized their ladies' social position and refinements, the Italian poets, in their less hierarchical urban society, tended to interpret "nobility" in terms of moral qualities and beauty. Perhaps the greatest contrast with the older courtly love tradition lay in the psychological sophistication of the Florentine poets—their concentration on the details of the effect of love on inner life.

The form most often used and indeed perfected by this group of poets, the *sonnet*, probably originated in Sicily, at the court of Frederick II, although some claim that its origins are Provençal. The sonnet, which we will study more extensively in Volume 2, Chapter 20, is practically the only fixed form of medieval poetry to continue to be used by modern poets. The many sonnets in the *Vita Nuova*, interspersed with the prose narrative of Dante's relationship with Beatrice, express a vision of love that seems to originate in the courtly praise of the beloved, and to extend beyond this to an almost religious awe, which prefigures the religious role that Beatrice will play in the *Divine Comedy*. The following two sonnets, in the famous translation by the English poet Dante Gabriel Rossetti, illustrate this new vision of love. Rossetti has kept both the original rhyme scheme and the traditional division of the Italian sonnet—two quatrains, or the octave (eight lines), and two tercets, or the sestet (six lines).

DANTE ALIGHIERI

Two Sonnets from the *Vita Nuova*

Love and the gentle heart are one same thing,
 Even as the wise man[2] in his ditty saith:
 Each, of itself, would be such life in death
As rational soul bereft of reasoning.
'Tis Nature makes them when she loves: a king
 Love is, whose palace where he sojourneth
 Is called the Heart; there draws he quiet breath
At first, with brief or longer slumbering.
Then beauty seen in virtuous womankind
 Will make the eyes desire, and through the heart
 Send the desiring of the eyes again;
Where often it abides so long enshrin'd
 That Love at length out of his sleep will start.
 And women feel the same for worthy men.

[2] Guido Guinicelli, in the canzone that begins "Within the gentle heart Love shelters him."

My lady carries love within her eyes;
　All that she looks on is made pleasanter;
　Upon her path men turn to gaze at her;
He whom she greeteth feels his heart to rise,
And droops his troubled visage, full of sighs,
　And of his evil heart is then aware:
Hate loves, and pride becomes a worshipper.
O women; help to praise her in somewise.
Humbleness, and the hope that hopeth well,
　By speech of hers into the mind are brought,
　　And who beholds is blessèd oftenwhiles.
　　The look she hath when she a little smiles
Cannot be said, nor holden in the thought;
'Tis such a new and gracious miracle.

Dante's Later Life

Because Dante, during the years immediately following his composition of the *Vita Nuova,* spent his time writing and studying, he played only a minor role in Florentine political life. Then in 1300 he was chosen to serve on the Signoria, the highest executive body of the Florentine Republic. Hardly a political partisan, Dante nevertheless felt that, in the tense situation created by rivalry between the Black and White Guelfs, the latter had the interests of the city more at heart. Dante's identification with the Whites led to his exile when in 1302 the Blacks, supported by a French prince and Pope Boniface VIII, took over the city by force. Moving periodically from city to city in northern and central Italy, leading a life of poverty, he produced a remarkable series of works in prose and poetry.

Dante's one formal contribution to political theory, *On Monarchy,* was written between 1310 and 1313 in the period when Henry VII, the German emperor, was attempting to reassert control over the Italian kingdom in the name of peace. Dante's work reflects his thoughts on Italian politics after years of exile. Over the centuries the papacy had developed the doctrine that because the king ruled over the body and the Church over the soul, the ecclesiastical authority not only was morally superior but also had the prerogative to command the royal power. This position was closely linked to the view that the earth was a vale of tears and that the king's main task was to keep sinners from interrupting the Church as it went about the really important task of showing souls the way to the transcendent world. Essentially, royal power was negative, aimed at punishing evildoing. Given the central religious goal of the society, the Church expected Christian kings to look for guidance to the pope, who headed the great salvific enterprise.

Dante became convinced that the only way to stop factional divisions rending the fabric of Italian political and social life was to have a strong emperor, who would establish order. The arrival in Italy, in 1310, of Emperor Henry VII, who refused to recognize either the Guelf or the Ghibelline party, raised his hopes. Everywhere, however, the papacy was trying to thwart Henry's policies, justifying itself on the grounds that the emperor was disobedient to the pope. Consequently, Dante felt it necessary to attack directly the claim of the papacy for a supervisory role over the emperor. The two powers, the emperor and the pope, he declared, have authority in two separate realms, the worldly and the religious. The role of the emperor is to use his authority to help his subjects attain "terrestrial beatitude," whereas the pope seeks their "celestial beatitude." Thus there is no justification for one power to interfere with the other's work.

Clearly, what Dante has done is to reject the almost-unquestioned medieval assumption that the Church has a monopoly on moral and spiritual values. In contrast, Dante argues that life in this world, although of short duration, has its own integrity, significance, and rewards. Over this realm the secular power reigns supreme. The pope, on the other hand, rules the other sphere, that concerned with religious values, in which the goal can be reached only beyond the grave. This view of the separation of church and state was to have an impact on modern political ideas. The significance of the Roman Empire in God's design for humanity, and the importance of life on earth, are crucial to an understanding of the *Divine Comedy.*

The Divine Comedy

Shortly before his death, Dante finished the work he called his "comedy" (the adjective "divine" was added by later admirers). This is certainly no comedy in the ordinary sense, but Dante so named it because it was written in the "vulgar" (Italian, rather than Latin) tongue and because, in contrast to tragedy, it begins in despair and ends in bliss. The work is also akin to comedy in its realistic view of human nature and in its inclusiveness of a wide variety of human types. It might best be described as a spiritual epic, for it is essentially the story of the poet's quest for salvation. In his "comedy," Dante developed in an entirely new way a motif that he knew from the sixth book of the *Aeneid* and from earlier medieval literature—a journey by a living man through the realm of the dead. As we saw in the *Epic of Gilgamesh* and in the *Odyssey,* the quest of the hero in the "other world" is central to the epic from its beginnings.

The *Divine Comedy* is composed of three books, or canticles, each divided into thirty-three cantos, with one introductory canto. In addition, the entire poem is composed in a verse scheme called *terza rima*—stanzas of three lines with interlocking rhymes. Multiples of three appear throughout the poem. The emphasis on the number three, symbol of the Holy Trinity, is quite intentional. Part of Dante's genius was to combine abstract

forms of medieval symbolism with a new realism. In its overall design, the work is often compared with the philosophical system of Thomas Aquinas and with the great cathedrals, such as Chartres. Like them, it is an edifice that embraces and builds on almost every conceivable aspect of life, in this world and the next, with the whole pointing toward God. And yet Dante's graphic interest in individual human dilemmas and in the intricacies of Florentine politics reveals an artistic sensibility that goes beyond the medieval view.

Dante intended his readers to read his poetic journey on both a literal and an allegorical level. It is at the same time the story of Dante himself and of the people he meets during the course of his journey and the representation of Everyman's quest for salvation. The introductory canto begins with the poet's description of himself at age thirty-five on Good Friday in the year 1300, "midway in our life's journey" and "alone in a dark wood." The dark wood may symbolize the corruption in Florence that had so dismayed Dante, or his turning away from the pure love of Beatrice to baser loves, or a spiritual confusion resulting from neglect of religion. On a universal level, for the modern reader, the dark wood may signify something like a "midlife crisis" or any form of mental and spiritual confusion. In the depths of despair, Dante meets the shade of Virgil, who tells him that in order to find his way out of the dark wood he must first journey through the three parts of the Catholic afterlife—hell, purgatory, and paradise. Virgil will serve as his guide through the first two. Allegorically, Virgil represents human reason. Reason can understand the nature of sin, punishment, and purgation, but not the divine mysteries of faith. In paradise, therefore, Virgil will be replaced by the shade of Beatrice, at once Dante's long-lost love and a symbol of divine revelation.

In the first canticle, the *Inferno* (hell), Dante, guided by Virgil, witnesses the gamut of human sins and their punishments, suffering intensely himself. Dante's order of sins comes partly from classical sources, partly from other medieval texts, and is partly his own invention. Hell is shaped like a cone, with the lesser sins at the wide top and the gravest sins in the narrow bottom, where Satan resides (Fig. 11-3). The sins of passion are lighter than the sins of the intellect, and the worst sins of all are treachery to the two important powers in God's plan for earth, the Church and the Roman Empire. Thus the three heads of Satan, in the icy depths of hell, chew on the shades of Brutus and Cassius, traitors to the Roman Republic, and Judas, traitor to Christ. The law of punishment for sins in hell, as in purgatory, is defined by what Dante calls *contrapasso,* or retribution: sinners pay for their sins with a punishment of the same nature. Thus the lustful, who let themselves be carried away by stormy passions, are blown about by a violent wind; gluttons

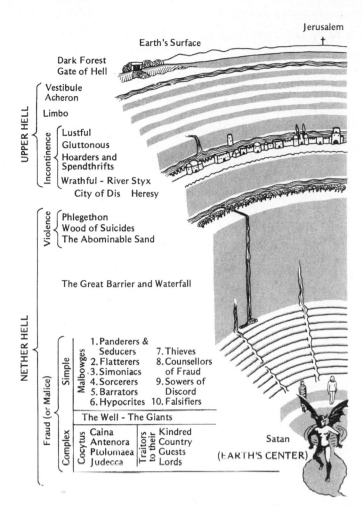

11-3 *Cross-Section of Dante's Circular Hell. (Reprinted with permission of David Higham Associates Limited, London, from Dante Alighieri,* The Divine Comedy, *trans. Dorothy L. Sayers, © 1949 by Dorothy L. Sayers.)*

who "made pigs" of themselves wallow in mud; murderers are steeped in rivers of boiling blood, and so forth.

Once Dante has passed through the depths of hell, he must climb the mountain of purgatory (Fig. 11-4). Here, in the second book, *Purgatorio,* the sinners are not merely being punished; they are also purging themselves of sin for eventual entrance into paradise. On top of the mountain, in the earthly paradise, Beatrice comes to take Dante into heaven. The third book, *Paradiso,* recounts this final journey and assures Dante of his salvation (Fig. 11-5).

In the medieval worldview that Dante held, earth was believed to be at the center of the universe and the heavens were a series of spheres around it from the closest sphere of the moon to the farthest empyrean sphere, the dwelling place of God. When Dante and Beatrice reach the empyrean, she prepares to leave the pilgrim to

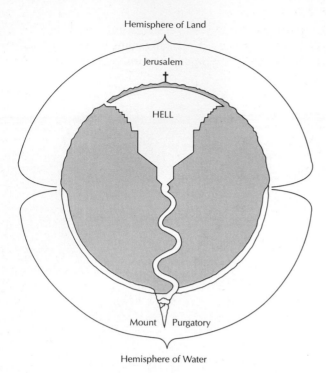

11-4 *Dante's Earth, showing Hell and Purgatory. (Reprinted with permission of David Higham Associates Limited, London, from Dante Alighieri,* The Divine Comedy, *trans. Dorothy L. Sayers, © 1949 by Dorothy L. Sayers.)*

11-5 *Dante's Circular Heaven.*

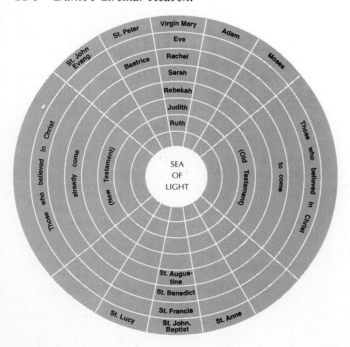

return to her place in heaven, entrusting him to Saint Bernard (Bernard of Clairvaux, devotee of Mary). Dante sings his final song of praise for Beatrice, conceding (although he praises his own poetic powers in the *Inferno*) that her heavenly beauty utterly undoes his art. Bernard promises Dante a vision of God, to be attained through the intercession of the Virgin Mary. Dante raises his eyes to the center of the mystic rose (a symbol of Mary, like the rose windows in the cathedrals) and, while experiencing unearthly bliss, sees the queen of heaven herself enthroned. Saint Bernard then offers a prayer to the Virgin, asking her to intercede for Dante, and Dante experiences a final rapture as he gazes directly on God. God is the source of all love—"the Love that moves the Sun and the other stars" are the final words of the poem—and the Eternal Light. Light, bearing much the same significance as it did for Suger when he created his cathedral, is the dominant image in paradise. It is a tribute to Dante's genius that he was able to render the ineffable in human language.

Chaucer (c. 1342–1400) and the Comedy of Love

The love of noble knights for noble ladies was not the only aspect of passion that interested medieval people. They were also well aware of the comic aspects of romantic entanglements. Sex seems to have universal potential for comedy. Geoffrey Chaucer, writing in England at the end of the Middle Ages, was interested in a wide range of people and topics, among them the comic aspects of love and sex.

It has been said that if we possessed nothing of medieval literature other than Chaucer's narrative poem *The Canterbury Tales* (1390–1400), we would still have all the major types of medieval narrative represented. Covering three days of tale-telling by pilgrims on their way to Canterbury Cathedral, *The Canterbury Tales* develops by presenting apparent truths that are then undercut to seem not entirely valid. Chaucer's method enables him both to give *mirthe* and to provide *doctryne* or instruction. By insisting that his audience be aware of the complexities and ramifications of actions, especially those having moral significance, he forces them to participate in the creation of meaning and to look beyond the surface appearance of things.

Each of the tales is told by a different pilgrim, reflecting its narrator's personality in its tone and content. For instance, in "The Miller's Tale," on the surface a bawdy comedy, Chaucer uses an unlikely vehicle to undercut the noble appearance of courtly love, as brought out in "The Knight's Tale," which immediately precedes it. The situation of the piece is one typically ripe for sexual hanky-panky, with the old husband,

John, married to a young woman, Alison. But even though John is jealous and worried about being cuckolded, he is apparently oblivious of their lodger, the young cleric Nicholas. In a sense John's unconcern is understandable, for clerics were supposed to be contemplatives, loving God and the Virgin, and being beyond the concerns of the flesh. But when Nicholas casts his eyes heavenward, it is only to deceive. Instead of using the things of this world as means of getting to eternal verities, Nicholas ironically reverses the process, using the other world as a means of obtaining his love in this world. The incongruous blend of contemplative and worldly may be seen when Nicholas embraces Alison and at the same time speaks to her as a subservient courtly lover and also when he uses a fictitious vision of the Second Deluge to effect his deception of the old husband. Although Noah's Flood was a traditional symbol of cleansing and purification, it is here ironically used as a vehicle for lechery. But John, the old husband, is so foolish that he cannot be pitied, for he does not even know God's covenant with humanity after the original Deluge that God would never again flood the earth.

The illicit love of Nicholas and Alison not only is contrasted with the inadequate but licit marriage but is also the basis for the love expressed by Absalon, another cleric. When Absalon sings outside the bedroom window urging Alison to love, he employs language clearly recognizable from the Song of Solomon. Chaucer's point is far from burlesquing this mystical love; rather, by including it in an obviously inappropriate situation, he evokes the ideal love lacking in the bawdy sexuality at hand and makes the amorous passion of Absalon seem as inadequate as Absalon himself is ridiculous. It is at least as inappropriate for him to refer to Alison in terms of the imagery of mystical love as it is for Nicholas at the beginning of the tale to ask her for the "mercy" traditionally associated with prayers to the Virgin.

from *The Letters of Abelard and Heloise*

Translation by Betty Radice

The love affair of Heloise and Abelard was one of the most famous of the Middle Ages. Peter Abelard (1079–1142) was the greatest theologian and philosopher of his generation (see Chapter 10). His lectures in Paris were thronged by students, his name was widely known among the people because of his love songs, and his provocative writings led to two trials for heresies. About 1114 he was given lodging in the house of a rich cleric of Paris in exchange for private lessons for the young Heloise, the cleric's niece. Within a short time Heloise became pregnant, gave birth to a child, and, when the furious uncle demanded that they marry, Albelard did so but insisted that it be kept a secret. Subsequently learning that Abelard had put his new wife in a convent outside the city and believing that Abelard meant to abandon her, the uncle had Abelard castrated.

In shame Abelard became a monk, but before he did so, he made sure that Heloise became a nun. Heloise went on to become the abbess of a new foundation of nuns called the Paraclete, which Abelard undertook to guide through his letters. In the early 1130s, however, fifteen years after their separation, Heloise wrote him begging for some personal message after so many years. Her letter, the one excerpted below, initiated the correspondence between them. Throughout their interchange, whereas the letters of Heloise vented a flood of varying emotions, those of Abelard remained reserved and pastoral. We cannot know what he really felt for her; of her feelings there is no doubt. On his death his body was carried to the Paraclete and both bodies now lie side by side in the cemetery of Père-la-Chaise in Paris.

Letter I. Heloise to Abelard

To her master, or rather her father, husband, or rather brother; his handmaid, or rather his daughter, wife, or rather sister; to Abelard, Heloise.

You know, beloved, as the whole world knows, how much I have lost in you, how at one wretched stroke of fortune that supreme act of flagrant treachery robbed me of my very self in robbing me of you; and how my sorrow for my loss is nothing compared with what I feel for the manner in which I lost you. Surely the greater the cause for grief the greater the need for the help of consolation, and this no one can bring but you; you are the sole cause of my sorrow, and you alone can grant me the grace of consolation. . . .

God is my witness that if Augustus, Emperor of the whole world, thought fit to honour me with marriage and conferred all the earth on me to possess for ever, it would be dearer and more honourable to me to be called not his Empress but your whore.

For a man's worth does not rest on his wealth or power; these depend on fortune, but worth on his merits. And a woman should realize that if she marries a rich man more readily than a poor one, and desires her husband more for his possessions than for himself, she is offering herself for sale. Certainly any woman who comes to marry through desires of this kind deserves wages, not gratitude, for clearly her mind is on the man's property, not himself, and she would be ready to prostitute herself to a richer man, if she could. . . .

What king or philosopher could match your fame? What district, town or village did not long to see you? When you appeared in public, who did not hurry to catch a glimpse of you, or crane his neck and strain his eyes to follow your departure? Every wife, every young girl desired you in absence and was on fire in your presence; queens and great ladies envied me my joys and my bed.

You had besides, I admit, two special gifts whereby to win at once the heart of any women—your gifts for composing verse and song, in which we know other philosophers have rarely been successful. This was for you no more than a diversion, a recreation from the labours of your philosophic work, but you left many love-songs and verses which won wide popularity for the charm of their words and tunes and kept your name continually on everyone's lips. The beauty of the airs ensured that even the unlettered did not forget you; more than anything this made women sigh for love of you. And as most of these songs told of our love, they soon made me widely known and roused the envy of many women against me. For your manhood was adorned by every grace of mind and body, and among the women who envied me then, could there be one

now who does not feel compelled by my misfortune to sympathize with my loss of such joys? Who is there who was once my enemy, whether man or woman, who is not moved now by the compassion which is my due? Wholly guilty though I am, I am also, as you know, wholly innocent. It is not the deed but the intention of the doer which makes the crime, and justice should weigh not what was done but the spirit in which it is done. What my intention towards you has always been, you alone who have known it can judge. I submit all to your scrutiny, yield to your testimony in all things.

Tell me one thing, if you can. Why, after our entry into religion, which was your decision alone, have I been so neglected and forgotten by you that I have neither a word from you when you are here to give me strength nor the consolation of a letter in absence? Tell me, I say, if you can—or I will tell you what I think and indeed the world suspects. It was desire, not affection which bound you to me, the flame of lust rather than love. So when the end came to what you desired, any show of feeling you used to make went with it. This is not merely my own opinion, beloved, it is everyone's. There is nothing personal or private about it; it is the general view which is widely held. I only wish that it *were* mine alone, and that the love you professed could find someone to defend it and so comfort me in my grief for a while. I wish I could think of some explanation which would excuse you and somehow cover up the way you hold me cheap.

I beg you then to listen to what I ask—you will see that it is a small favour which you can easily grant. While I am denied your presence, give me at least through your words—of which you have enough and to spare—some sweet semblance of yourself. It is no use my hoping for generosity in deeds if you are grudging in words. Up to now I had thought I deserved much of you, seeing that I carried out everything for your sake and continue up to the present moment in complete obedience to you. It was not any sense of vocation which brought me as a young girl to accept the austerities of the cloister, but your bidding alone, and if I deserve no gratitude from you, you may judge for yourself how my labours are in vain. I can expect no reward for this from God, for it is certain that I have done nothing as yet for love of him.

QUESTIONS

1. What attitude toward marriage does Heloise express? How would this differ from conventional notions of marriage at the time?
2. What traits of Abelard does Heloise especially admire?
3. What does she mean by her statement: "It is not the deed but the intention of the doer which makes the crime, and justice should weigh not what was done but the spirit in which it was done"?
4. What ideas of Heloise might be considered heretical?
5. How does Heloise distinguish between love and lust?
6. How would you describe Heloise's character from reading this letter?

GUIRAUT RIQUIER (FL. 1252–1294)

Song to the Virgin
Translation by William R. Trask

Representations of the Virgin Mary in medieval art and literature had many facets. Queen of heaven, loving mother, sister of the humble, she also appeared as a beautiful lady. The expression of mystical love for the Virgin began, in the twelfth century, to influence secular love poetry, so that poets began to write of their ladyloves in terms more religious than amorous, as if they were worshiping them. In turn, love poetry had its influence on devotional poetry, so that the modern reader senses a confusion between the two realms. The following poem by the Provençal troubadour Guiraut Riquier may serve as a transition between the art of the cathedral and the art of the court.

Often in times past I thought that I was singing of love; yet I knew it not, for what I called love was my folly. But now love brings me to love such a lady that I can neither honor her nor fear her nor cherish her to the measure of her worth. But I hope that her love will hold me until the hope that I have in her is fulfilled.

For by her love I hope to increase in worth and honor and riches and joy. To nothing else, then, should I turn my thought or my desire. For, since all that I want I can have through her, I must do all that I can to serve her. For I have her love, if only I behave toward her as true love teaches me to do.

And so I must try my best: since she loves me, let me, too, love, for I could not love her if she did not give me the power. Hence it is only right that, for her love, I should give mine. For without her I am good for nothing. I can do nothing for her except to honor her. God, who has the power, grant that I may hold before my lady the banner of true lovers among whom love reigns.

I have neither wit nor knowledge to praise her; such is her honor that there is room for no more, such her virtue that nothing can increase it. How, then, can my praise honor her? The honor is mine, for I can only speak what is true. Hence I must do my best to tell the truth of her from morning to evening; for I can never fail in anything that I should do, if only I remember my lady.

So great is her beauty that it can never lessen, there is no imperfection in it, it shines night and day. So great is her power that it cannot fail. Such are her kindness and charity and wisdom and knowledge and pity and mercy that I hope her love—since she deigns to love me—will keep me joyful, if only I truly come to her.

QUESTIONS

1. Describe the relationship between the speaker and the Virgin Mary in the poem above.
2. What relationship do you see between the attitude to the Virgin here and the portrayal of her in sculpture and painting?

BERNART DE VENTADORN (FL. 1145–1180)

Be m'an perdut

Translation by Carl Parrish

Bernart's chanson *Be m'an perdut* has only three musical *phrases*—that is, only three very short melodic ideas—and the first two are identical. This construction results in an *AAB* musical form, a common secular music pattern known in the Middle Ages as *barform*. Notice in the music that the end of the third phrase is repeated and that these are the same notes as the endings of the first two phrases. All this repetition creates easily remembered tunes, and, after all, we are dealing with song that is somewhat analogous to today's popular music. If the tune is not catchy, it will fail in its function of light and pleasant entertainment music.

The poet uses the same approach and care with the poetic devices of rhyme and *meter* in his composition. These qualities disappear in the translation, but their presence in the original allows an easy match of words and music as well as creating an ingenious and clever "way with words."

Be m'an perdut lai enves Ventadorn
 Tuih mei amic, pois ma domna no m'ama;
Et es be dreihz que jamais lai no torn,
 C'ades estai vas me salvatj' e grama.

CD-1, 9

᷃℩℩℩/ (weak, strong, weak, strong, . . .)
᷃℩℩℩℩
᷃℩℩℩/
᷃℩℩℩℩

The syllables in each line are grouped by units of length (short-long, short-long . . .), and this is matched to the metrical style of the day, the *modal* rhythm of long-short groupings.

Like many popular songs and folk songs of today that tell a story, this piece has several verses sung to the same melody. Notice in the translation that

the male singer, the troubadour, sings about a rather unapproachable lady and refers to familiar images (the regions of Ventadorn and Provence as well as the lord of Beaucaire) in addition to fanciful creations of his imagination.

I am indeed lost from the region of Ventadorn
To all my friends, for my lady loves me not;
With reason I turn not back again,
For she is bitter and ill-disposed toward me.
See why she turns a dark and angry countenance
 to me:
Because I take joy and pleasure in loving her!
Nor has she aught else with which to charge me.

So, like the fish who rushes to the lure
And suspects nothing until caught upon the hook,
Once I rushed to the overpowering love
And was not aware until I was in the flame
That burns hotter than ever furnace did.
And yet I cannot free my hands from it,
So greatly does my love hold and chain me.

I marvel not that love holds me fast,
For a more entrancing form, I believe, was never
 seen;
Beautiful and white she is, and fresh and smooth,
And wholly as I wish and desire her.
I can say no ill of her, for there is none in her;
Yet gladly would I say it if I knew any,
But I know none, and so forbear to speak it.

Ever shall I wish her honor and good,
And shall be her aid, her friend and servant,
And shall love her whether it please her or not,
For one cannot gainsay one's heart without
 destroying it.
I know no lady, whether she will or not,
Whom I could not love if I wished.
They all can bring one to grief, though.

To others, then, I am in forfeit;
Whichever will can draw me to her
On condition that what honor and benefit
She thinks to do me will not be sold too dearly,
For the seeking is grievous if sought in vain.
From experience I speak, for I have suffered,
And beauty has betrayed me badly.

To Provence I send joy and greeting
And more of good than I could speak.
And it is a wonder that I do this;
For I send that which I have not;
I have no joy save what is brought me
By my beauteous vision, and Sire Enchantment, my
 confidant,
And Sire Pleasure, the Lord of Beaucaire.

Tornada[1]

My beauteous vision, God works such wonder
 through you
That no one seeing you would not be enraptured
Who knew what to tell you and what to do.

..

QUESTIONS

1. How would you describe the poet's relationship
 with his beloved?
2. What images are used here and what is their effect?

..

Quis Dabit Capiti

Toward the end of the twelfth century, a Cistercian convent was founded in Spain, the Royal Monastery of Las Huelgas. Built by King Alfonso VIII of Castile as a Pantheon for the royal house, it served as a fitting location for coronations, royal burials, and affairs of state, as well as a religious retreat for members of the order. The sisters of the abbey community were girls and women of noble birth who, among their many other accomplishments, produced one of the most famous music manuscripts of the thirteenth century: the Las Huelgas Codex, a vitally important source of music from the *Ars antiqua*. (Ars antiqua refers to the "old art" of the thirteenth century and earlier, as labeled by the "modern" composers of the fourteenth century, who saw their own music as new and different—a music they called the "ars nova.") During this same period, the convent developed into a cultural center of great renown under the sponsorship of King Alfonso the Wise. Here Jewish scholars and Moslems under Christian authority lived and worked side by side with the Catholic population of the abbey. In the music preserved in the Las Huelgas manuscript, many forms and styles are present, and it is interesting to remember that this music would most likely have been performed, and perhaps written, by women, sisters of the Cistercian order. Because the works had been collected anonymously, we cannot be certain of their authorship. However, because this manuscript has remained in the place of its origin until the present day, we can make some assumptions about this music with a greater sense of certainty than we can about any other musical source of this period.

Quis dabit capiti is a lament—a *planctus,* or funeral song—probably sung at a memorial service or graveside ceremony for a male member of the royal house of Spain. Perhaps, too, it might have been used in the procession from the church to the grave. We

do not know. Composed in the Lydian church mode (one of the medieval scales used for church melodies, and a scale considered harsh because of a grating interval between the notes F and B), this Lydian song symbolizes in music the bitterness and sense of loss associated with death. The text was taken up again three hundred years later, when Renaissance composer Heinrich Isaac wrote a funeral motet for his beloved Florentine patron, Lorenzo the Magnificent (see Volume 2, Chapter 18). In this recording, it is sung by a woman, as a sister of the abbey at Las Huelgas might have sung it seven hundred years ago. A bowed string instrument—a fiddle, or *viella*—accompanies the singer.

CD-1, 10

Quis dabit capiti meo aquam	Who will give water for my head
Et oculis meis fontem lacrimarum	And a fountain of tears for my eyes,
Ut plorem die ac nocte	That I might weep day and night
Interfectos filios populi mei?	The fallen sons of my people?

THE COUNTESS OF DIE (FL. C. 1160)
..

Selected Lyrics

Nothing is known about the life of this countess, although she was the most important of the *trobairitz.* The following lyrics exemplify the "female troubadour's" poetry.

It will be mine to sing of that which I would not desire,
I am so aggrieved by the one to whom I am the friend,
for I love him more than anything than can be.
Pity does not help me toward him, nor courtliness,
nor my beauty, nor my good name, nor my wit;
and so I am cheated and betrayed as much
as I'd deserve to be if I were ugly.

I draw strength from one thing, I never did wrong,
my friend, toward you, by any act,
no, I love you more than Seguin loved Valensa,[1]
and I am most pleased that I could conquer you in
 love,
my friend, for you are worth more than everyone.
You display such arrogance to me in your words and
 your bearing,
and yet you are open with everyone else.

It makes me wonder how you are cold with pride,
my friend, to me, I have reason to lament;

[1] The provençal equivalent of *envoi,* which refers to the short concluding stanza of a poem, sending or dedicating it to someone.

[1] Refers to a romance, now lost.

it is not right that another love take you away from me,
no matter what things she says to you, or how she
 makes you welcome.
And remember what was the beginning
of our love. May the Lord God never want
that in my fault lies the parting.

The great manliness at home in you
and your ringing merit, they disquiet me,
for I do not know one woman, far or near,
who, desiring to love, does not lean toward you.
But, friend, you have judgment,
you can tell who is more true:
remember our sharing.

My name and high descent should help me,
and my beauty, and the purity of my heart most of all;
therefore I send this song to you down there,
to your dwelling, let it be my messenger,
and I wish to know, my fair gentle friend,
why are you so barbarous and cruel to me,
is it pride, or wishing ill?

And also I want you to tell him, messenger,
many people suffer for having too much pride.

BÉROUL

from *The Romance of Tristan and Iseult*
Retold by Joseph Bédier

This selection is the last chapter of the romance, entitled "Death." Tristan is in Brittany with his wife, Iseult of the White Hands.

Death[1]

When he was come back to Brittany, to Carhaix, it happened that Tristan, riding to the aid of Kaherdin his brother in arms, made war on a baron named Bedalis. He fell into an ambush laid by Bedalis and his brothers. Tristan slew the seven brothers. But he himself was wounded by a blow from a spear, and this spear was poisoned.

Painfully he returned to the castle of Carhaix and had his wounds dressed. Many doctors came but none could cure him of the poison, for they did not even find it. They fixed no plaster to draw the poison forth, and vainly pounded and ground their roots, culled their herbs, boiled their potions. And Tristan weakened, the poison spread throughout his body, he paled and his bones showed.

Then he knew that his life was going, and that he must die, and he had a desire to see once more Iseult the Fair, but he could not seek her, for the sea would have killed him in his weakness, and how could Iseult come to him? And sad, and suffering the poison, he awaited death.

He called Kaherdin secretly to tell him his pain, for they loved each other with a loyal love; and as he would have no one in the room save Kaherdin, nor even in the neighbouring rooms, Iseult of the White Hands began to wonder. She was afraid and wished to hear, and she came back and listened at the wall by Tristan's bed; and as she listened one of her maids kept watch for her.

Now, within, Tristan had gathered up his strength, and had half risen, leaning against the wall, and Kaherdin wept beside him. They wept their good comradeship, broken so soon, and their friendship.

"Fair friend and gentle," said Tristan, "I am in a foreign land where I have neither friend nor cousin, save you; and you alone in this place have given me comfort. My life is going, and I wish to see once more Iseult the Fair. Ah, did I but know of a messenger who would go to her! For now I know that she will come to me—Kaherdin, my brother in arms, by our friendship, by the nobility of your heart, by our comradeship, I entreat you: undertake this errand for me, and if you carry my word, I will become your liege, and I will cherish you beyond all other men."

And as Kaherdin saw Tristan broken down, his heart reproached him and he said:

"Fair comrade, do not weep; I will do what you desire, even if it were risk of death I would do it for you. Nor no distress nor anguish will let me from doing it according to my power. Give me the word you send, and I will make ready."

And Tristan answered:

"Thank you, friend; this is my prayer: take this ring, it is a sign between her and me; and when you come to her land pass yourself at court for a merchant, and show her silk and stuffs, but make so that she sees the ring, for then she will find some ruse by which to speak to you in secret. Then tell her that my heart salutes her; tell her that she alone can bring me comfort; tell her that if she does not come I shall die. Tell her to remember our past time, and our great sorrows, and all the joy there was in our loyal and tender love. And tell her to remember that draught we drank together on the high seas. For we drank our death together.[2] Tell her to remember the oath I swore to serve a single love, for I have kept that oath."

But behind the wall, Iseult of the White Hands heard all these things; and she almost swooned. Tristan continued:

[1] From *The Romance of Tristan and Iseult,* retold by Joseph Bédier from versions by Béroul and others, translated by Hilaire Belloc, completed by Paul Rosenfeld (New York: Pantheon Books, 1945).

[2] Tristan here refers to the potion that made them fall in love forever.

"Hasten, my friend, and come back quickly, or you will not see me again. Take forty days for your term, but come back with Iseult the Fair. And tell your sister nothing, or tell her that you seek some doctor. Take my fine ship, and two sails with you, one white, one black. And as you return, if you bring Iseult, hoist the white sail; but if you bring her not, the black. Now I have nothing more to say, but God guide you and bring you back safe."

He sighed, wept and bewailed his fate, and Kaherdin also wept, embraced Tristan and took leave.

With the first fair wind Kaherdin took the open, weighed anchor and hoisted sail, and ran with a light air and broke the seas. They bore rich merchandise with them, dyed silks of rare colours, enamel of Touraine, wines of Poitou, and gerfalcons from Spain, for by this ruse Kaherdin thought to reach Iseult. Eight days and nights they ran full sail to Cornwall.

Now a woman's wrath is a fearful thing, and all men fear it, for according to her love, so will her vengeance be; and their love and their hate come quickly, but their hate lives longer than their love; and they will make play with love, but not with hate. Standing by the wall, Iseult of the White Hands had overheard everything. How much she had loved Tristan! . . . At last she learned of his love for another. She kept every word in mind: if only some day she could, how she would avenge herself on her whom he loved most in the world. But she hid it all; and when the doors were open again she came to Tristan's bed and served him with food as a lover should, and spoke him gently and kissed him on the lips, and asked him if Kaherdin would soon return with one to cure him . . . but all day long she thought upon her vengeance.

And Kaherdin sailed and sailed till he dropped anchor in the haven of Tintagel.[3] He landed, placed a great gerfalcon on his wrist, took with him a cloth of rare dye and a cup well chiselled and worked, and made a present of them to King Mark, and courteously begged of him his peace and safeguard that he might traffick in his land; and the King gave him his peace before all the men of his palace.

Then Kaherdin offered the Queen a buckle of fine gold; and "Queen," said he, "the gold is good."

Then taking from his finger Tristan's ring, he put it side by side with the jewel and said:

"See, O Queen, the gold of the buckle is the finer gold; yet that ring also has its worth."

When Iseult saw what ring that was, her heart trembled and her colour changed, and fearing what might next be said she drew Kaherdin apart near a window, as if to see and bargain the better; and Kaherdin said to her, low down:

"Lady, Tristan is wounded of a poisoned spear and is about to die. He sends you word that you alone can bring him comfort, and recalls to you the sorrows that you bore together. Keep you the ring—it is yours."

But Iseult answered, nearly swooning:

"Friend, I will follow you; get ready your ship tomorrow at dawn."

And on the morrow at dawn the Queen announced that she wished to hunt with falcons and had her dogs and birds made ready. But Duke Andret,[4] ever on the watch, accompanied her. When they reached the fields not far from the shore of the sea, a pheasant whirred up. Andret unleashed a falcon to seize it; but the day was clear and fine: the falcon soared aloft and disappeared.

"See, Sir Andret," said the Queen, "the falcon has perched itself on the mast of a ship which I do not know. Whose is it?"

"Mistress," said Andret, "it is the ship of that Breton merchant who yesterday made you a present of a gold clasp. Let us go there to recapture our falcon."

Kaherdin had stretched a plank as a gangway from his ship to the shore. He came to meet the Queen:

"Lady, if it please you, enter my ship and I will show you my rich wares."

"Willingly, Sir," said the Queen.

She dismounted, stepped to the plank, crossed it, and stepped into the ship. Andret sought to follow her and was on the plank when Kaherdin from the deck struck him with his oar: Andret staggered and fell into the sea. He tried to swim; Kaherdin struck him blow after blow and held him under the waves and cried:

"Die, traitor! These are your wages for the evil you have done to Tristan and to the Queen Iseult."

Thus God avenged the lovers on the felons who had so hated them. All four were dead: Guenelon, Gondoïne, Denoalen, Andret.

They raised anchor, stepped mast and hoisted sail. The fresh wind of morning whistled in the rigging and swelled the sails. Out of the harbour, towards the high seas, white and flashing under the rays of the sun, sailed the ship.

But at Carhaix Tristan lay and longed for Iseult's coming. Nothing now filled him any more, and if he lived it was only as awaiting her; and day by day he sent watchers to the shore to see if some ship came, and to learn the colour of her sail. There was no other thing left in his heart.

He had himself carried to the cliff of the Penmarks, where it overlooks the sea, and all the daylight long he gazed far off over the water.

Hear now a tale most sad and pitiful to all who love. Already was Iseult near; already the cliff of the

[3] Town in Cornwall where King Mark and Queen Iseult reside.

[4] One of Tristan's enemies at court.

Penmarks showed far away, and the ship ran heartily, when a storm wind rose on a sudden and grew, and struck the sail, and turned the ship all round about, and the sailors bore away and sore against their will they ran before the wind. The wind raged and big seas ran, and the air grew thick with darkness, and the ocean itself turned dark, and the rain drove in gusts. The yard snapped, and the sheet; they struck their sail, and ran with wind and water. In an evil hour they had forgotten to haul their pinnace aboard; it leapt in their wake, and a great sea broke it away.

Then Iseult cried out: "God does not will that I should live to see him, my love, once—even one time more. God wills my drowning in this sea. O, Tristan, had I spoken to you but once again, it is little I should have cared for a death come afterwards. But now, my love, if I do not come to you, it is because God does not will it, and this is my deepest grief. My death is as nothing to me: since God wishes it, I accept it; but, friend, when you learn of it, you will die, well I know. Our love is such that you cannot die without me nor I without you. I see your death before me at the same time as my own. Alas, friend, I have failed of my wish: it was to die in your arms, to be buried in your tomb; but we both have failed. I shall die alone, and without you, disappear in the sea. Perhaps you will not hear of my death, you will live, ever hoping that I come. If God wishes, you may even grow well again Ah, maybe afterwards you will love another woman, you will love Iseult of the White Hands. I do not know how it will be with you: for my part, if I knew you dead, I would not live on. May God bring us together, friend, or may I heal you, or may we both die of the same wound."

And thus the Queen complained so long as the storm endured; but after five days it died down. Kaherdin hoisted the sail, the white sail, right up to the very masthead with great joy; the white sail, that Tristan might know its colour from afar; and already Kaherdin saw Brittany far off like a cloud. Hardly were these things seen and done when a calm came, and the sea lay even and untroubled. The sail bellied no longer, and the sailors held the ship now up, now down the tide, beating backwards and forwards in vain. They saw the shore afar off, but the storm had carried their boat away and they could not land. On the third night Iseult dreamt this dream: that she held in her lap a boar's head which befouled her skirts with blood; then she knew that she would never see her lover again alive.

Tristan was now too weak to keep his watch from the cliff of the Penmarks, and for many long days, within walls, far from the shore, he had mourned for Iseult because she did not come. Dolorous and alone, he mourned and sighed in restlessness: he was near death from desire.

At last the wind freshened and the white sail showed. Then it was that Iseult of the White Hands took her vengeance.

She came to where Tristan lay, and she said: "Friend, Kaherdin is here. I have seen his ship upon the sea. She comes up hardly—yet I know her; may he bring that which shall heal thee, friend."

And Tristan trembled and said: "Beautiful friend, you are sure that the ship is his indeed? Then tell me what is the manner of the sail?"

"I saw it plain and well. They have shaken it out and hoisted it very high, for they have little wind. For its colour, why, it is black."

And Tristan turned him to the wall, and said: "I cannot keep this life of mine any longer." He said three times: "Iseult, my friend." And in saying it the fourth time, he died.

Then throughout the house, the knights and the comrades of Tristan wept out loud, and they took him from his bed and laid him on a rich cloth, and they covered his body with a shroud. But at sea the wind had risen; it struck the sail fair and full and drove the ship to shore, and Iseult the Fair set foot upon the land. She heard loud mourning in the streets, and the tolling of bells in the minsters and the chapel towers; she asked the people the meaning of the knell and of their tears. An old man said to her:

"Lady, we suffer a great grief. Tristan that was so loyal and so right, is dead. He was open to the poor; he ministered to the suffering. It is the chief evil that has ever fallen on this land."

But Iseult, hearing them, could not answer them a word. She went up to the palace, following the way, and her cloak was random and wild. The Bretons marvelled as she went; nor had they ever seen woman of such a beauty, and they said:

"Who is she, or whence does she come?"

Near Tristan, Iseult of the White Hands crouched, maddened at the evil she had done, and calling and lamenting over the dead man. The other Iseult came in and said to her:

"Lady, rise and let me come by him; I have more right to mourn him than have you—believe me. I loved him more."

And when she had turned to the east and prayed God, she moved the body a little and lay down by the dead man, beside her friend. She kissed his mouth and his face, and clasped him closely; and so gave up her soul, and died beside him of grief for her lover.

When King Mark heard of the death of these lovers, he crossed the sea and came into Brittany; and he had two coffins hewn, for Tristan and Iseult, one of chalcedony for Iseult, and one of beryl for Tristan. And he took their beloved bodies away with him upon his ship to Tintagel, and by a chantry to the left and right of the apse he had their tombs built round. But in one night there sprang from the tomb of Tristan a green and leafy briar, strong in its branches and in the scent of its flowers. It climbed the chantry and fell to root again by Iseult's tomb. Thrice did the peasants cut it down, but

thrice it grew again as flowered and as strong. They told the marvel to King Mark, and he forbade them to cut the briar any more.

QUESTIONS

1. What devices does the storyteller use to generate suspense and sympathy for the lovers?
2. What does this selection indicate about the characters of the two Iseults, Tristan, and Mark?
3. How do you interpret symbols in the story such as the potion, the love-death, and the briar?

MARIE DE FRANCE

Equitan

Translation by Edmund Reiss

All of Marie de France's *lais* were written in verse, and they represent different explorations of love and its effects on men and women. "Equitan," which appears here in a modern prose translation, demonstrates especially vividly the destructiveness of illicit passion that was, as mentioned earlier, a prime concern in this period. By being so concerned with pleasure, the king in this story is unable to rule justly. Not only does he seek to murder his loyal seneschal, or field marshal; he also ultimately brings about his own death as well as that of his lady.

The tale also shows a blend of the courtly and the ludicrous, especially at the end with the action centering on the bath. Here what had seemed noble and even beautiful is undercut so successfully that the deaths of the lovers do not result in our feeling any sense of tragedy. In fact, the fate of the two lovers may be seen as a *parody* of the tragic ending of lovers such as Tristan and Iseult, who are ultimately ennobled by being joined together in death.

Many noble lords have lived in Brittany. In times past, through their prowess, courtesy, and nobility they would compose lays of various adventures that they had heard so that these could be held in mind and not forgotten. They made one, which I have heard told and which should not be neglected, about Equitan, lord of Nantes, who was very courteous, just, and royal.

Equitan was held in great esteem and loved much in his country. He delighted in pleasure and lovemaking, which to him constituted chivalry. Those who love without sense or measure place their lives at nought; such is the rule of love that no one who feels passion can maintain his reason.

Equitan had a seneschal, a good knight, worthy and loyal, who administered all his land and ruled it justly, for the king was concerned only with hunting, hawking, and love-making, and would not leave these pursuits except to wage war.

The seneschal had married a woman from whom great evil came to the country. The lady was exceptionally beautiful and of very good breeding. She had a fine body and a lovely figure which Nature had taken pains to fashion. Her eyes were clear and her face beautiful, her mouth lovely, and her nose well shaped. There was none her equal in the entire kingdom. The king often heard her praised, and frequently he sent her his greetings as well as gifts. Even though he had never seen her, he desired her and wished that he could speak with her.

One day, to amuse himself, he secretly went hunting in the country where the seneschal lived. At night, when the king returned from his sport, he took his lodging at the castle where the lady was. There he could talk with her as much as he wished and reveal to her his heart and his desire. He found her to be very courteous and wise, beautiful of body and of face, well-mannered and cheerful. Love had taken him into His household. Love had shot an arrow at him, which made a great wound where it lodged in his heart. Love had no need for craft or subtlety. The king was so overcome by the lady that he became mournful and pensive. Now when he needed most to understand, he could not help himself. That night he neither slept nor rested, but blamed and accused himself.

"Alas!" he said. "What destiny has brought me into this country? Because of this lady whom I have seen I have an ache in my heart and all my body is trembling. I thought I would never fall in love, and if I love now I shall do evil. This is the wife of my seneschal. I should love and keep faith with him just as I wish him to do with me. If through some mishap he should learn of my passion, I know well that it would disturb him greatly. Nevertheless, it would be worse for me if I should go mad because of him. And it would be a shame if such a beautiful lady was without a lover. What would happen to her courtesy if she did not have a lover? There is no man on earth who would not benefit greatly from her love. Even if the seneschal should hear about it, he should not be too heavy-hearted. He should not have all of that treasure for himself alone; indeed, I wish to share it with him."

When he had said these things, the king sighed, then tossed and turned, and thought more. Finally he said, "Why am I so upset and so afraid? I still do not know, and have not tried to learn, whether she will have me for her lover. I will soon find out, and if she feels what I feel, I will be rid of this sorrow. God, it is so long until daylight! I still cannot sleep, and it has been so long since I went to bed last night."

The king stayed awake until dawn, which he awaited with great discomfort. He went out as though he planned to hunt, but soon he returned, saying that he felt ill. He went to his room and went to bed. The seneschal was concerned about him; he did not know what the sickness was that was causing the king to

tremble so. But his wife was the real cause of it. The seneschal had her go talk with the king in order to amuse and comfort him. The king opened his heart to her and let her know that he was dying because of her. She could either bring him comfort or give him death.

"Sir," the lady replied, "I must have some time to think. This is the first time I have been in this position. You are a king of great nobility. I am not so rich that you should approach me with love. If you do take your desire, I know truly that it will lead to nothing. You will soon leave me, and I will be ruined. If it should be that I love you and grant your request, love would not be equally divided between the two of us, for you are a powerful king, and my husband is one of your vassals. You would think to have mastery in this love, and love is not worthy if it is not among equals. A poor man who is honest, if he has sense and worth, is better than a prince or king who is not honest; the poor man will also have greater joy in love. She who loves above her station will be insecure in every way. The rich man believes that nothing can take away from him the love that he has acquired through his position."

Equitan replied, "Lady, please! Say no more to me! These words are not refined or courteous but are rather the business dealings of a merchant, who for gain or property devotes his efforts to an unworthy cause. There is no lady on earth, if she is wise, courteous, and generous of heart, provided she set a high value on her love and not be fickle, who, if she had nothing more than a rich prince of a castle under her mantle, would not suffer for him and love him loyally and well. Those who are fickle in love and who turn to deceit are in turn scorned and deceived. We have seen several of these false lovers; it is no wonder that they lose what they have earned through their efforts. My dear lady, I surrender myself to you. Do not take me as your king, but as your servant and your friend. I swear to you that I will do your pleasure. Do not cause me to die for you. You will be the lady and I the servant, you the proud lord and I the suppliant."

The king spoke to her so long and begged mercy so much that she finally assured him of her love and gave up her body to him. With their rings they pledged themselves to each other and swore their loyalty to each other. They desired each other greatly and loved each other fervently. Through their passion they died and came to their end.

For a long time their love affair lasted, for it was not known by anyone. At the time of their meetings— when they would speak together—the king told his people that he was to be bled privately. The doors of his chamber were closed, and you could not have found a man so daring as to enter unless summoned by the king. The seneschal held the court to hear the various pleas and petitions.

The king loved the lady for a long time and desired no other woman. He did not wish to marry anyone; indeed he did not wish to hear the subject spoken of. The people disliked this greatly, so much so that the wife of the seneschal often heard about it. It weighed on her heavily, and she feared losing the king. When she was able to speak with him—at a time when she should have been happy kissing, hugging, embracing, and playing with him—she wept sorely and expressed great sadness. The king asked what was wrong.

The lady answered, "Sir, I weep for our love which for me has turned to great sorrow. You will take a wife, the daughter of a king, and so you will leave me. I have heard it said often, and I know it well. And alas, what will become of me? Because of you I will die, for I know no other comfort."

The king said to her with great love, "Fair friend, do not be afraid. Indeed, I will not take a wife or leave you for another. Know this truly and believe it. If your husband were dead, I would make you my wife and queen. I swear, for no other will I leave you."

The lady thanked him and said he had made her very happy. And since he had assured her that he would not leave her for another, she would bring about the death of her husband right away. It would be easy to accomplish if the king would help her. He answered that he would do so. In fact there was nothing he would not do for her if it lay in his power, no matter whether it were wise or foolish.

"Sir," she said, "if it please you, come to hunt in the forest in the country where I live. Stay at the castle of my lord; there you will be bled and, three days later, bathed. My husband will be bled and also bathed along with you. Be sure to command him, without fail, to accompany you. And I will have the baths heated and the two tubs brought. His bath will be so boiling hot that no man on earth could sit in it without being scalded and killed. As soon as he is dead, call your men and his, and show them how he died suddenly in his bath."

The king agreed that he would do her will in everything.

Not three months passed before the king went hunting in the country. He had himself bled, on account of his illness. Along with him went his seneschal. On the third day the king said that he wished to bathe; the seneschal wished likewise.

"Bathe with me," said the king.

The seneschal said, "Gladly."

The lady had the baths heated and the two tubs brought and placed by each bed as planned. She had the boiling water poured in the seneschal's tub. That gentleman had arisen and gone out for his ease. The lady came to speak to the king who sat her down beside him. They lay on the bed of the seneschal and amused themselves playing with each other. They played together by the tub of scalding water which was in front of them.

They had posted a servant girl to guard the door. The seneschal returned shortly and found his way blocked. He became so angry that he flung it open and discovered the king and his wife lying on the bed embracing each other. The king saw the seneschal as soon as he came in, and to cover up his villainy, he jumped into the tub with his feet together. There he was scalded and died. All his evil came back on them, and the seneschal remained safe and well. He had seen what happened to the king and immediately seized his wife and pushed her head first into the same bath. There both died, the king first and the lady after him.

Whoever wishes to understand the meaning of this can discover a lesson here. Those who pursue evil toward another will find all this evil returned on them. This happened as I have told you. The Bretons made a lay of it, about Equitan, how he and the lady whom he loved so much came to their end.

QUESTIONS

1. What feelings, as a reader, do you have toward the two lovers? Is the author's portrayal of them ambivalent in any way?
2. Do you find any contradiction between the story and the moral?
3. What elements of comedy or parody do you see in this story, and what do you think medieval people would have seen?
4. Could you write a modern version of this tale? How do you think the portrayal of love here might have influenced our ideas of love?
5. How did our term *romance* derive from stories such as *Tristan and Iseult* and "Equitan"?
6. What meanings are attached to terms such as *refined* and *courteous*, and what have these values to do with the idea of courtly love?

DANTE ALIGHIERI

from the *Divine Comedy*
Translation by John Ciardi

Because the *Inferno* is the book most accessible to modern readers, we have chosen most of our selections from it. From the *Purgatorio* we have chosen Canto XXX, in which Dante is at last reunited with the long-lost Beatrice. The *Paradiso* is represented by the last canto, XXXIII, in which Saint Bernard leads Dante to a vision of the Virgin Mary, and at last to a vision of God. In addition to the translation, the introductions and notes are by the American poet John Ciardi. The note references are to line numbers.

from the *Inferno*

Canto I
The Dark Wood of Error

Midway in his allotted threescore years and ten, DANTE *comes to himself with a start and realizes that he has strayed from the True Way into the Dark Wood of Error (Worldliness). As soon as he has realized his loss, Dante lifts his eyes and sees the first light of the sunrise (the Sun is the Symbol of Divine Illumination) lighting the shoulders of a little hill (The Mount of Joy). It is the Easter Season, the time of resurrection, and the sun is in its equinoctial rebirth. This juxtaposition of joyous symbols fills Dante with hope and he sets out at once to climb directly up the Mount of Joy, but almost immediately his way is blocked by the Three Beasts of Worldliness: the* LEOPARD OF MALICE AND FRAUD, *the* LION OF VIOLENCE AND AMBITION, *and the* SHE-WOLF OF INCONTINENCE. *These beasts, and especially the She-Wolf, drive him back despairing into the darkness of error. But just as all seems lost, a figure appears to him. It is the shade of* VIRGIL, *Dante's symbol of* Human Reason.

*Virgil explains that he has been sent to lead Dante from error. There can, however, be no direct ascent past the beasts: the man who would escape them must go a longer and harder way. First he must descend through Hell (The Recognition of Sin), then he must ascend through Purgatory (The Renunciation of Sin), and only then may he reach the pinnacle of joy and come to the Light of God. Virgil offers to guide Dante, but only as far as Human Reason can go. Another guide (*BEATRICE, *symbol of Divine Love) must take over for the final ascent, for Human Reason is self-limited. Dante submits himself joyously to Virgil's guidance and they move off.*

Midway in our life's journey, I went astray
 from the straight road and woke to find myself
 alone in a dark wood. How shall I say 3

what wood that was! I never saw so drear,
 so rank, so arduous a wilderness!
 Its very memory gives a shape to fear. 6

Death could scarce be more bitter than that place!
 But since it came to good, I will recount
 all that I found revealed there by God's grace. 9

1. *Midway in our life's journey:* The Biblical life span is three-score years and ten. The action opens in Dante's thirty-fifth year, i.e., A.D. 1300. [Translator's notes.]

How I came to it I cannot rightly say,
 so drugged and loose with sleep had I become
 when I first wandered there from the True Way. 12

But at the far end of that valley of evil
 whose maze had sapped my very heart with fear
 I found myself before a little hill 15

and lifted up my eyes. Its shoulders glowed
 already with the sweet rays of that planet
 whose virtue leads men straight on every road, 18

and the shining strengthened me against the fright
 whose agony had wracked the lake of my heart
 through all the terrors of that piteous night. 21

Just as a swimmer, who with his last breath
 flounders ashore from perilous seas, might turn
 to memorize the wide water of his death— 24

so did I turn, my soul still fugitive
 from death's surviving image, to stare down
 that pass that none had ever left alive. 27

And there I lay to rest from my heart's race
 till calm and breath returned to me. Then rose
 and pushed up that dead slope at such a pace 30

each footfall rose above the last. And lo!
 almost at the beginning of the rise
 I faced a spotted Leopard, all tremor and flow 33

and gaudy pelt. And it would not pass, but stood
 so blocking my every turn that time and again
 I was on the verge of turning back to the wood. 36

17. *that planet:* The sun. Ptolemaic astronomers considered it a planet. It is also symbolic of God as He who lights man's way.
31. *each footfall rose above the last:* The literal rendering would be: "So that the fixed foot was ever the lower." "Fixed" has often been translated "right" and an ingenious reasoning can support that reading, but a simpler explanation offers itself and seems more competent: Dante is saying that he climbed with such zeal and haste that every footfall carried him above the last despite the steepness of the climb. At a slow pace, on the other hand, the rear foot might be brought up only as far as the forward foot. This device of selecting a minute but exactly-centered detail to convey the whole of a larger action is one of the central characteristics of Dante's style.
33–48. THE THREE BEASTS: These three beasts undoubtedly are taken from *Jeremiah* v, 6. Many additional and incidental interpretations have been advanced for them, but the central interpretation must remain as noted. They foreshadow the three divisions of Hell (incontinence, violence, and fraud) which Virgil explains at great length in Canto XI, 16–111. I am not at all sure but what the She-Wolf is better interpreted as Fraud and the Leopard as Incontinence. Good arguments can be offered either way.

This fell at the first widening of the dawn
 as the sun was climbing Aries with those stars
 that rode with him to light the new creation. 39

Thus the holy hour and the sweet season
 of commemoration did much to arm my fear
 of that bright murderous beast with their good
 omen. 42

Yet not so much but what I shook with dread
 at sight of a great Lion that broke upon me
 raging with hunger, its enormous head 45

held high as if to strike a mortal terror
 into the very air. And down his track,
 a She-Wolf drove upon me, a starved horror 48

ravening and wasted beyond all belief.
 She seemed a rack for avarice, gaunt and craving.
 Oh many the souls she has brought to endless
 grief! 51

She brought such heaviness upon my spirit
 at sight of her savagery and desperation,
 I died from every hope of that high summit. 54

And like a miser—eager in acquisition
 but desperate in self-reproach when Fortune's
 wheel
 turns to the hour of his loss—all tears and
 attrition 57

I wavered back; and still the beast pursued,
 forcing herself against me bit by bit
 till I slid back into the sunless wood. 60

And as I fell to my soul's ruin, a presence
 gathered before me on the discolored air,
 the figure of one who seemed hoarse from long
 silence. 63

At sight of him in that friendless waste I cried:
 "Have pity on me, whatever thing you are,
 whether shade or living man." And it replied: 66

38–39. *Aries . . . that rode with him to light the new creation:* The medieval tradition had it that the sun was in Aries at the time of the Creation. The significance of the astronomical and religious conjunction is an important part of Dante's intended allegory. It is just before dawn of Good Friday 1300 A.D. when he awakens in the Dark Wood. Thus his new life begins under Aries, the sign of creation, at dawn (rebirth) and in the Easter season (resurrection). Moreover the moon is full and the sun is in the equinox, conditions that did not fall together on any Friday of 1300. Dante is obviously constructing poetically the perfect Easter as a symbol of his new awakening.

"Not man, though man I once was, and my blood
was Lombard, both my parents Mantuan.
I was born, though late, *sub Julio,* and bred 69

in Rome under Augustus in the noon
of the false and lying gods. I was a poet
and sang of old Anchises' noble son 72

who came to Rome after the burning of Troy.
But you—why do *you* return to these distresses
instead of climbing that shining Mount of Joy 75

which is the seat and first cause of man's bliss?"
"And are you then that Virgil and that fountain
of purest speech?" My voice grew tremulous: 78

"Glory and light of poets! now may that zeal
and love's apprenticeship that I poured out
on your heroic verses serve me well! 81

For you are my true master and first author,
the sole maker from whom I drew the breath
of that sweet style whose measures have brought
me honor. 84

See there, immortal sage, the beast I flee.
For my soul's salvation, I beg you, guard me from
her,
for she has struck a mortal tremor through
me." 87

And he replied, seeing my soul in tears:
"He must go by another way who would escape
this wilderness, for that mad beast that flees 90

before you there, suffers no man to pass.
She tracks down all, kills all, and knows no glut,
but, feeding, she grows hungrier than she was. 93

She mates with any beast, and will mate with more
before the Greyhound comes to hunt her down.
He will not feed on lands nor loot, but honor 96

and love and wisdom will make straight his way.
He will rise between Feltro and Feltro, and in him
shall be the resurrection and new day 99

of that sad Italy for which Nisus died,
and Turnus, and Euryalus, and the maid Camilla.
He shall hunt her through every nation of sick
pride 102

till she is driven back forever to Hell
whence Envy first released her on the world.
Therefore, for your own good, I think it well 105

you follow me and I will be your guide
and lead you forth through an eternal place.
There you shall see the ancient spirits tried 108

in endless pain, and hear their lamentation
as each bemoans the second death of souls.
Next you shall see upon a burning mountain 111

souls in fire and yet content in fire,
knowing that whensoever it may be
they yet will mount into the blessed choir. 114

To which, if it is still your wish to climb,
a worthier spirit shall be sent to guide you.
With her shall I leave you, for the King of
Time, 117

who reigns on high, forbids me to come there
since, living, I rebelled against his law.
He rules the waters and the land and air 120

and there holds court, his city and his throne.
Oh blessed are they he chooses!" And I to him:
"Poet, by that God to you unknown, 123

lead me this way. Beyond this present ill
and worse to dread, lead me to Peter's gate
and be my guide through the sad halls of
Hell." 126

And he then: "Follow." And he moved ahead
in silence, and I followed where he led. 128

and the Latians when, according to legend, Aeneas led the survivors of Troy into Italy. Nisus and Euryalus (*Aeneid* IX) were Trojan comrades-in-arms who died together. Camilla (*Aeneid* XI) was the daughter of the Latian king and one of the warrior women. She was killed in a horse charge against the Trojans after displaying great gallantry. Turnus (*Aeneid* XII) was killed by Aeneas in a duel. 110. *the second death:* Damnation. "This is the second death, even the lake of fire." (*Revelation* xx, 14) 118. *forbids me to come there since, living, etc.:* Salvation is only through Christ in Dante's theology. Virgil lived and died before the establishment of Christ's teachings in Rome, and cannot therefore enter Heaven. 125. *Peter's gate:* The gate of Purgatory. (See *Purgatorio* IX, 76 ff.) The gate is guarded by an angel with a gleaming sword. The angel is Peter's vicar (Peter, the first Pope, symbolized all Popes; i.e., Christ's vicar on earth) and is entrusted with the two great keys.

Some commentators argue that this is the gate of Paradise, but Dante mentions no gate beyond this one in his ascent to Heaven. It should be remembered, too, that those who pass the gate of Purgatory have effectively entered Heaven.

The three great gates that figure in the entire journey are: the gate of Hell (Canto III, 1–11), the gate of Dis (Canto VIII, 79–113, and Canto IX, 86–87), and the gate of Purgatory, as above.

69. *sub Julio:* In the reign of Julius Caesar. 95. *the Greyhound . . . Feltro and Feltro:* Almost certainly refers to Can Grande della Scala (1290–1329), great Italian leader born in Verona, which lies between the towns of Feltre and Montefeltro. 100–101. *Nisus, Turnus, Euryalus, Camilla:* All were killed in the war between the Trojans

Canto III

The Vestibule of Hell: The Opportunists

The Poets pass the Gate of Hell and are immediately assailed by cries of anguish. Dante sees the first of the souls in torment. They are the OPPORTUNISTS, *those souls who in life were neither for good nor evil but only for themselves. Mixed with them are those outcasts who took no sides in the Rebellion of the Angels. They are neither in Hell nor out of it. Eternally unclassified, they race round and round pursuing a wavering banner that runs forever before them through the dirty air; and as they run they are pursued by swarms of wasps and hornets, who sting them and produce a constant flow of blood and putrid matter which trickles down the bodies of the sinners and is feasted upon by loathsome worms and maggots who coat the ground.*

The law of Dante's Hell is the law of symbolic retribution. As they sinned so are they punished. They took no sides, therefore they are given no place. As they pursued the ever-shifting illusion of their own advantage, changing their courses with every changing wind, so they pursue eternally an elusive, ever-shifting banner. As their sin was a darkness, so they move in darkness. As their own guilty conscience pursued them, so they are pursued by swarms of wasps and hornets. And as their actions were a moral filth, so they run eternally through the filth of worms and maggots which they themselves feed.

Dante recognizes several, among them POPE CELESTINE V, *but without delaying to speak to any of these souls, the Poets move on to Acheron, the first of the rivers of Hell. Here the newly-arrived souls of the damned gather and wait for monstrous* CHARON *to ferry them over to punishment. Charon recognizes Dante as a living man and angrily refuses him passage. Virgil forces Charon to serve them, but Dante swoons with terror, and does not reawaken until he is on the other side.*

I AM THE WAY INTO THE CITY OF WOE.
I AM THE WAY TO A FORSAKEN PEOPLE.
I AM THE WAY INTO ETERNAL SORROW. 3

SACRED JUSTICE MOVED MY ARCHITECT.
I WAS RAISED HERE BY DIVINE OMNIPOTENCE,
PRIMORDIAL LOVE AND ULTIMATE INTELLECT. 6

ONLY THOSE ELEMENTS TIME CANNOT WEAR
WERE MADE BEFORE ME, AND BEYOND TIME I STAND.
ABANDON ALL HOPE YE WHO ENTER HERE. 9

7–8. *Only those elements time cannot wear:* The Angels, the Empyrean, and the First Matter are the elements time cannot wear, for they will last to all time. Man, however, in his mortal state, is not

These mysteries I read cut into stone
 above a gate. And turning I said: "Master,
 what is the meaning of this harsh inscription?" 12

And he then as initiate to novice:
 "Here must you put by all division of spirit
 and gather your soul against all cowardice. 15

This is the place I told you to expect.
 Here you shall pass among the fallen people,
 souls who have lost the good of intellect." 18

So saying, he put forth his hand to me,
 and with a gentle and encouraging smile
 he led me through the gate of mystery. 21

Here sighs and cries and wails coiled and recoiled
 on the starless air, spilling my soul to tears.
 A confusion of tongues and monstrous accents toiled 24

in pain and anger. Voices hoarse and shrill
 and sounds of blows, all intermingled, raised
 tumult and pandemonium that still 27

whirls on the air forever dirty with it
 as if a whirlwind sucked at sand. And I,
 holding my head in horror, cried: "Sweet Spirit, 30

what souls are these who run through this black haze?"
 And he to me: "These are the nearly soulless
 whose lives concluded neither blame nor praise. 33

They are mixed here with that despicable corps
 of angels who were neither for God nor Satan,
 but only for themselves. The High Creator 36

eternal. The Gate of Hell, therefore, was created before man. The theological point is worth attention. The doctrine of Original Sin is, of course, one familiar to many creeds. Here, however, it would seem that the preparation for damnation predates Original Sin. True, in one interpretation, Hell was created for the punishment of the Rebellious Angels and not for man. Had man not sinned, he would never have known Hell. But on the other hand, Dante's God was one who knew all, and knew therefore that man would indeed sin. The theological problem is an extremely delicate one.

It is significant, however, that having sinned, man lived out his days on the rind of Hell, and that damnation is forever below his feet. This central concept of man's sinfulness, and, opposed to it, the doctrine of Christ's ever-abounding mercy, are central to all of Dante's theology. Only as man surrenders himself to Divine Love may he hope for salvation, and salvation is open to all who will surrender themselves.

8. *and beyond time I stand:* So odious is sin to God that there can be no end to its just punishment. 9. *Abandon all hope ye who enter here:* The admonition, of course, is to the damned and not to those who come on Heaven-sent errands. The Harrowing of Hell (Canto IV) provided the only exemption from this decree, and that only through the direct intercession of Christ.

scourged them from Heaven for its perfect beauty,
and Hell will not receive them since the wicked
might feel some glory over them." And I: 39

"Master, what gnaws at them so hideously
their lamentation stuns the very air?"
"They have no hope of death," he answered me, 42

"and in their blind and unattaining state
their miserable lives have sunk so low
that they must envy every other fate. 45

No word of them survives their living season.
Mercy and Justice deny them even a name.
Let us not speak of them: look, and pass on." 48

I saw a banner there upon the mist.
Circling and circling, it seemed to scorn all pause.
So it ran on, and still behind it pressed 51

a never-ending rout of souls in pain.
I had not thought death had undone so many
as passed before me in that mournful train. 54

And some I knew among them; last of all
I recognized the shadow of that soul
who, in his cowardice, made the Great Denial. 57

At once I understood for certain: these
were of that retrograde and faithless crew
hateful to God and to His enemies. 60

These wretches never born and never dead
ran naked in a swarm of wasps and hornets
that goaded them the more the more they fled, 63

and made their faces stream with bloody gouts
of pus and tears that dribbled to their feet
to be swallowed there by loathsome worms and
maggots. 66

Then looking onward I made out a throng
assembled on the beach of a wide river,
whereupon I turned to him: "Master, I long 69

to know what souls these are, and what strange usage
makes them as eager to cross as they seem to be
in this infected light." At which the Sage: 72

"All this shall be made known to you when we stand
on the joyless beach of Acheron." And I
cast down my eyes, sensing a reprimand 75

in what he said, and so walked at his side
in silence and ashamed until we came
through the dead cavern to that sunless tide. 78

There, steering toward us in an ancient ferry
came an old man with a white bush of hair,
bellowing: "Woe to you depraved souls! Bury 81

here and forever all hope of Paradise:
I come to lead you to the other shore,
into eternal dark, into fire and ice. 84

And you who are living yet, I say begone
from these who are dead." But when he saw me stand
against his violence he began again: 87

"By other windings and by other steerage
shall you cross to that other shore. Not here! Not here!
A lighter craft than mine must give you passage." 90

And my Guide to him: "Charon, bite back your spleen:
this has been willed where what is willed must be,
and is not yours to ask what it may mean." 93

The steersman of that marsh of ruined souls,
who wore a wheel of flame around each eye,
stifled the rage that shook his woolly jowls. 96

But those unmanned and naked spirits there
turned pale with fear and their teeth began to chatter
at sound of his crude bellow. In despair 99

they blasphemed God, their parents, their time on earth,
the race of Adam, and the day and the hour
and the place and the seed and the womb that
gave them birth. 102

But all together they drew to that grim shore
where all must come who lose the fear of God.
Weeping and cursing they come for evermore, 105

57. *who, in his cowardice, made the Great Denial:* This is almost certainly intended to be Celestine V, who became Pope in 1294. He was a man of saintly life, but allowed himself to be convinced by a priest named Benedetto that his soul was in danger since no man could live in the world without being damned. In fear for his soul he withdrew from all worldly affairs and renounced the papacy. Benedetto promptly assumed the mantle himself and became Boniface VIII, a Pope who became for Dante a symbol of all the worst corruptions of the church. Dante also blamed Boniface and his intrigues for many of the evils that befell Florence. . . . In Canto XIX . . . the fires of Hell are waiting for Boniface in the pit of the Simoniacs, and [there is] further evidence of his corruption in Canto XXVII. Celestine's great guilt is that his cowardice (in selfish terror for his own welfare) served as the door through which so much evil entered the church.

80. *an old man:* Charon. He is the ferryman of dead souls across the Acheron in all classical mythology. 88–90. *By other windings:* Charon recognizes Dante not only as a living man but as a soul in grace, and knows, therefore, that the Infernal Ferry was not intended for him. He is probably referring to the fact that souls destined for Purgatory and Heaven assemble not at his ferry point, but on the banks of the Tiber, from which they are transported by an Angel. 100. *they blasphemed God:* The souls of the damned are not permitted to repent, for repentance is a divine grace.

and demon Charon with eyes like burning coals
 herds them in, and with a whistling oar
 flails on the stragglers to his wake of souls. 108

As leaves in autumn loosen and stream down
 until the branch stands bare above its tatters
 spread on the rustling ground, so one by one 111

the evil seed of Adam in its Fall
 cast themselves, at his signal, from the shore
 and streamed away like birds who hear their
 call. 114

So they are gone over that shadowy water,
 and always before they reach the other shore
 a new noise stirs on this, and new throngs gather. 117

"My son," the courteous Master said to me,
 "all who die in the shadow of God's wrath
 converge to this from every clime and country. 120

And all pass over eagerly, for here
 Divine Justice transforms and spurs them so
 their dread turns wish: they yearn for what they
 fear. 123

No soul in Grace comes ever to this crossing;
 therefore if Charon rages at your presence
 you will understand the reason for his cursing." 126

When he had spoken, all the twilight country
 shook so violently, the terror of it
 bathes me with sweat even in memory: 129

the tear-soaked ground gave out a sigh of wind
 that spewed itself in flame on a red sky,
 and all my shattered senses left me. Blind, 132

like one whom sleep comes over in a swoon,
I stumbled into darkness and went down. 134

123. *they yearn for what they fear:* Hell (allegorically Sin) is what the souls of the damned really wish for. Hell is their actual and deliberate choice, for divine grace is denied to none who wish for it in their hearts. The damned must, in fact, deliberately harden their hearts to God in order to become damned. Christ's grace is sufficient to save all who wish for it. 133–134. DANTE'S SWOON: This device (repeated at the end of Canto V) serves a double purpose. The first is technical: Dante uses it to cover a transition. We are never told how he crossed Acheron, for that would involve certain narrative matters he can better deal with when he crosses Styx in Canto VII. The second is to provide a point of departure for a theme that is carried through the entire descent: the theme of Dante's emotional reaction to Hell. These two swoons early in the descent show him most susceptible to the grief about him. As he descends, pity leaves him, and he even goes so far as to add to the torments of one sinner. The allegory is clear: we must harden ourselves against every sympathy for sin.

Canto V

Circle Two: The Carnal

The Poets leave Limbo and enter the Second Circle. *Here begin the torments of Hell proper, and here, blocking the way, sits* MINOS, *the dread and semi-bestial judge of the damned who assigns to each soul its eternal torment. He orders the Poets back; but Virgil silences him as he earlier silenced Charon, and the Poets move on.*

They find themselves on a dark ledge swept by a great whirlwind, which spins within it the souls of the CARNAL, *those who betrayed reason to their appetites. Their sin was to abandon themselves to the tempest of their passions: so they are swept forever in the tempest of Hell, forever denied the light of reason and of God. Virgil identifies many among them.* SEMIRAMIS *is there, and* DIDO, CLEOPATRA, HELEN, ACHILLES, PARIS, *and* TRISTAN. *Dante sees* PAOLO *and* FRANCESCA *swept together, and in the name of love he calls to them to tell their sad story. They pause from their eternal flight to come to him, and Francesca tells their history while Paolo weeps at her side. Dante is so stricken by compassion at their tragic tale that he swoons once again.*

So we went down to the second ledge alone;
 a smaller circle of so much greater pain
 the voice of the damned rose in a bestial moan. 3

There Minos sits, grinning, grotesque, and hale.
 He examines each lost soul as it arrives
 and delivers his verdict with his coiling tail. 6

That is to say, when the ill-fated soul
 appears before him it confesses all,
 and that grim sorter of the dark and foul 9

decides which place in Hell shall be its end,
 then wraps his twitching tail about himself
 one coil for each degree it must descend. 12

2. *a smaller circle:* The pit of Hell tapers like a funnel. The circles of ledges accordingly grow smaller as they descend. 4. *Minos:* Like all the monsters Dante assigns to the various offices of Hell, Minos is drawn from classical mythology. He was the son of Europa and of Zeus, who descended to her in the form of a bull. Minos became a mythological king of Crete, so famous for his wisdom and justice that after death his soul was made judge of the dead. Virgil presents him fulfilling the same office at Aeneas' descent to the underworld. Dante, however, transforms him into an irate and hideous monster with a tail. The transformation may have been suggested by the form Zeus assumed for the rape of Europa—the monster is certainly bullish enough here—but the obvious purpose of the brutalization is to present a figure symbolic of the guilty conscience of the wretches who come before it to make their confessions. Dante freely reshapes his materials to his own purposes. 8. *it confesses all:* Just as the souls appeared eager to cross Acheron, so they are eager to confess even while they dread. Dante is once again making the point that sinners elect their Hell by an act of their own will.

The soul descends and others take its place:
 each crowds in its turn to judgment, each confesses,
 each hears its doom and falls away through
 space. 15

"O you who come into this camp of woe,"
 cried Minos when he saw me turn away
 without awaiting his judgment, "watch where
 you go 18

once you have entered here, and to whom you turn!
 Do not be misled by that wide and easy passage!"
 And my Guide to him: "That is not your
 concern; 21

it is his fate to enter every door.
 This has been willed where what is willed must be,
 and is not yours to question. Say no more." 24

Now the choir of anguish, like a wound,
 strikes through the tortured air. Now I have come
 to Hell's full lamentation, sound beyond sound. 27

I came to a place stripped bare of every light
 and roaring on the naked dark like seas
 wracked by a war of winds. Their hellish flight 30

of storm and counterstorm through time foregone,
 sweeps the souls of the damned before its charge.
 Whirling and battering it drives them on, 33

and when they pass the ruined gap of Hell
 through which we had come, their shrieks begin anew.
 There they blaspheme the power of God eternal. 36

And this, I learned, was the never ending flight
 of those who sinned in the flesh, the carnal and
 lusty
 who betrayed reason to their appetite. 39

As the wings of wintering starlings bear them on
 in their great wheeling flights, just so the blast
 wherries these evil souls through time foregone. 42

Here, there, up, down, they whirl and, whirling, strain
 with never a hope of hope to comfort them,
 not of release, but even of less pain. 45

As cranes go over sounding their harsh cry,
 leaving the long streak of their flight in air,
 so come these spirits, wailing as they fly. 48

And watching their shadows lashed by wind, I cried:
 "Master, what souls are these the very air
 lashes with its black whips from side to side?" 51

"The first of these whose history you would know,"
 he answered me, "was Empress of many tongues.
 Mad sensuality corrupted her so 54

that to hide the guilt of her debauchery
 she licensed all depravity alike,
 and lust and law were one in her decree. 57

She is Semiramis of whom the tale is told
 how she married Ninus and succeeded him
 to the throne of that wide land the Sultans hold. 60

The other is Dido; faithless to the ashes
 of Sichaeus, she killed herself for love.
 The next whom the eternal tempest lashes 63

is sense-drugged Cleopatra. See Helen there,
 from whom such ill arose. And great Achilles,
 who fought at last with love in the house of
 prayer. 66

And Paris. And Tristan." As they whirled above
 he pointed out more than a thousand shades
 of those torn from the mortal life by love. 69

I stood there while my Teacher one by one
 named the great knights and ladies of dim time;
 and I was swept by pity and confusion. 72

27. *Hell's full lamentation:* It is with the second circle that the real tortures of Hell begin. 34. *the ruined gap of Hell:* At the time of the Harrowing of Hell a great earthquake shook the underworld shattering rocks and cliffs. Ruins resulting from the same shock are noted in Canto XII, 34, and Canto XXI, 112 ff. At the beginning of Canto XXIV, the Poets leave the *bolgia* of the Hypocrites by climbing the ruined slabs of a bridge that was shattered by this earthquake.
39. THE SINNERS OF THE SECOND CIRCLE (THE CARNAL): Here begin the punishments for the various sins of Incontinence (The sins of the She-Wolf). In the second circle are punished those who sinned by excess of sexual passion. Since this is the most natural sin and the sin most nearly associated with love, its punishment is the lightest of all to be found in Hell proper. The Carnal are whirled and buffeted endlessly through the murky air (symbolic of the beclouding of their reason by passion) by a great gale (symbolic of their lust).

53. *Empress of many tongues:* Semiramis, a legendary queen of Assyria who assumed full power at the death of her husband, Ninus.
61. *Dido:* Queen and founder of Carthage. She had vowed to remain faithful to her husband, Sichaeus, but she fell in love with Aeneas. When Aeneas abandoned her she stabbed herself on a funeral pyre she had had prepared.

 According to Dante's own system of punishments, she should be in the Seventh Circle (Canto XIII) with the suicides. The only clue Dante gives to the tempering of her punishment is his statement that "she killed herself for love." Dante always seems readiest to forgive in that name.

65. *Achilles:* He is placed among this company because of his passion for Polyxena, the daughter of Priam. For love of her, he agreed to desert the Greeks and to join the Trojans, but when he went to the temple for the wedding (according to the legend Dante has followed) he was killed by Paris.

At last I spoke: "Poet, I should be glad
 to speak a word with those two swept together
 so lightly on the wind and still so sad." 75

And he to me: "Watch them. When next they pass,
 call to them in the name of love that drives
 and damns them here. In that name they will
 pause." 78

Thus, as soon as the wind in its wild course
 brought them around, I called: "O wearied souls!
 if none forbid it, pause and speak to us." 81

As mating doves that love calls to their nest
 glide through the air with motionless raised wings,
 borne by the sweet desire that fills each breast— 84

Just so those spirits turned on the torn sky
 from the band where Dido whirls across the air;
 such was the power of pity in my cry. 87

"O living creature, gracious, kind, and good,
 going this pilgrimage through the sick night,
 visiting us who stained the earth with blood, 90

were the King of Time our friend, we would pray
 His peace
 on you who have pitied us. As long as the wind
 will let us pause, ask of us what you please. 93

The town where I was born lies by the shore
 where the Po descends into its ocean rest
 with its attendant streams in one long murmur. 96

Love, which in gentlest hearts will soonest bloom
 seized my lover with passion for that sweet body
 from which I was torn unshriven to my doom. 99

Love, which permits no loved one not to love,
 took me so strongly with delight in him
 that we are one in Hell, as we were above. 102

Love led us to one death. In the depths of Hell
 Caïna waits for him who took our lives."
 This was the piteous tale they stopped to tell. 105

And when I had heard those world-offended lovers
 I bowed my head. At last the Poet spoke:
 "What painful thoughts are these your lowered
 brow covers?" 108

When at length I answered, I began: "Alas!
 What sweetest thoughts, what green and young desire
 led these two lovers to this sorry pass." 111

Then turning to those spirits once again,
 I said: "Francesca, what you suffer here
 melts me to tears of pity and of pain. 114

But tell me: in the time of your sweet sighs
 by what appearances found love the way
 to lure you to his perilous paradise?" 117

And she: "The double grief of a lost bliss
 is to recall its happy hour in pain.
 Your Guide and Teacher knows the truth of this. 120

But if there is indeed a soul in Hell
 to ask of the beginning of our love
 out of his pity, I will weep and tell: 123

On a day for dalliance we read the rhyme
 of Lancelot, how love had mastered him.
 We were alone with innocence and dim time. 126

74. *those two swept together*: Paolo and Francesca (PAH-oe-loe: Frahn-CHAY-ska).

 Dante's treatment of these two lovers is certainly the tenderest and most sympathetic accorded any of the sinners in Hell, and legends immediately began to grow about this pair.

 The facts are these. In 1275 Giovanni Malatesta (Djoe-VAH-nee Mahl-ah-TEH-stah) of Rimini, called Giovanni the Lame, a somewhat deformed but brave and powerful warrior, made a political marriage with Francesca, daughter of Guida da Polenta of Ravenna. Francesca came to Rimini and there an amour grew between her and Giovanni's younger brother Paolo. Despite the fact that Paolo had married in 1269 and had become the father of two daughters by 1275, his affair with Francesca continued for many years. It was sometime between 1283 and 1286 that Giovanni surprised them in Francesca's bedroom and killed both of them.

 Around these facts the legend has grown that Paolo was sent by Giovanni as his proxy to the marriage, that Francesca thought he was her real bridegroom and accordingly gave him her heart irrevocably at first sight. The legend obviously increases the pathos, but nothing in Dante gives it support.

102. *that we are one in Hell, as we were above*: At many points of the *Inferno* Dante makes clear the principle that the souls of the damned are locked so blindly into their own guilt that none can feel sympathy for another, or find any pleasure in the presence of another. The temptation of many readers is to interpret this line romantically: i.e., that the love of Paolo and Francesca survives Hell itself. The more Dantean interpretation, however, is that they add to one another's anguish (a) as mutual reminders of their sin, and (b) as insubstantial shades of the bodies for which they once felt such great passion. 104. *Caïna waits for him*: Giovanni Malatesta was still alive at the writing. His fate is already decided, however, and upon his death, his soul will fall to Caïna, the first ring of the last circle (Canto XXXII), where lie those who performed acts of treachery against their kin. 124–125. *the rhyme of Lancelot*: The story exists in many forms. The details Dante makes use of are from an Old French version. 126. *dim time*: The original simply reads "We were alone, suspecting nothing." "Dim time" is rhyme-forced, but not wholly outside the legitimate implications of the original, I hope. The old courtly romance may well be thought of as happening in the dim ancient days. The apology, of course, comes after the fact: one does the possible, then argues for justification, and there probably is none.

Pause after pause that high old story drew
 our eyes together while we blushed and paled;
 but it was one soft passage overthrew 129

our caution and our hearts. For when we read
 how her fond smile was kissed by such a lover,
 he who is one with me alive and dead 132

breathed on my lips the tremor of his kiss.
 That book, and he who wrote it, was a pander.
 That day we read no further." As she said this, 135

the other spirit, who stood by her, wept
 so piteously, I felt my senses reel
 and faint away with anguish. I was swept 138

by such a swoon as death is, and I fell,
as a corpse might fall, to the dead floor of Hell. 140

LOWER HELL: The structure of Dante's Hell is based on Aristotle (as Virgil makes clear in his exposition), but with certain Christian symbolisms, exceptions, and misconstructions of Aristotle's text. The major symbolisms are the three beasts met in Canto I. The exceptions are the two peculiarly Christian categories of sin: Paganism and Heresy. The misconstructions of Aristotle's text involve the classification of "bestiality." Aristotle classified it as a different thing from vice or malice, but medieval commentators construed the passage to mean "another sort of malice." Dante's intent is clear, however; he understood Aristotle to make three categories of sin: Incontinence, Violence and Bestiality, and Fraud and Malice. Incontinence is punished in the Upper Hell. The following chart sets forth the categories of the Lower Hell.

THE CLASSIFICATIONS OF SIN IN LOWER HELL

HERESY CIRCLE VI

THE VIOLENT AND BESTIAL (CIRCLE VII) (SINS OF THE LION)
- ROUND 1. AGAINST NEIGHBORS. (MURDERERS AND WAR-MAKERS)
- ROUND 2. AGAINST SELF. (SUICIDES AND DESTROYERS OF THEIR OWN SUBSTANCE)
- ROUND 3. AGAINST GOD, ART, AND NATURE. (BLASPHEMERS, PERVERTS, AND USURERS)

THE FRAUDULENT AND MALICIOUS (SINS OF THE LEOPARD)

(CIRCLE VIII) (SIMPLE FRAUD)
- BOLGIA 1. SEDUCERS AND PANDERERS.
- BOLGIA 2. FLATTERERS.
- BOLGIA 3. SIMONIACS.
- BOLGIA 4. FORTUNE TELLERS AND DIVINERS.
- BOLGIA 5. GRAFTERS.
- BOLGIA 6. HYPOCRITES.
- BOLGIA 7. THIEVES.
- BOLGIA 8. EVIL COUNSELORS.
- BOLGIA 9. SOWERS OF DISCORD.
- BOLGIA 10. COUNTERFEITERS AND ALCHEMISTS.

(CIRCLE IX) (COMPOUND FRAUD)
- CAÏNA. TREACHERY AGAINST KIN.
- ANTENORA. TREACHERY AGAINST COUNTRY.
- PTOLEMEA. TREACHERY AGAINST GUESTS AND HOSTS.
- JUDECCA. TREACHERY AGAINST LORDS AND BENEFACTORS.

134. *That book, and he who wrote it, was a pander:* "Galeotto," the Italian word for "pander," is also the Italian rendering of the name of Gallehault, who in the French Romance Dante refers to here, urged Lancelot and Guinevere on to love.

Canto XXVI

Circle Eight

Bolgia Eight: The Evil Counselors

Dante turns from the Thieves toward the Evil Counselors of the next Bolgia (ditch), and between the two he addresses a passionate lament to Florence prophesying the griefs that will befall her from these two sins. At the purported time of the Vision, it will be recalled, Dante was a Chief Magistrate of Florence and was forced into exile by men he had reason to consider both thieves and evil counselors. He seems prompted, in fact, to say much more on this score, but he restrains himself when he comes in sight of the sinners of the next Bolgia, for they are a moral symbolism, all men of gift who abused their genius, perverting it to wiles and stratagems. Seeing them in Hell he knows his must be another road: his way shall not be by deception.

So the Poets move on and Dante observes the Eighth Bolgia in detail. Here the EVIL COUNSELORS *move about endlessly, hidden from view inside great flames. Their sin was to abuse the gifts of the Almighty, to steal his virtues for low purposes. And as they stole from God in their lives and worked by hidden ways, so are they stolen from sight and hidden in the great flames which are their own guilty consciences. And as, in most instances at least, they sinned by glibness of tongue, so are the flames made into a fiery travesty of tongues.*

Among the others, the Poets see a great double-headed flame, and discover that ULYSSES *and* DIOMEDE *are punished together within it. Virgil addresses the flame, and through its wavering tongue Ulysses narrates an unforgettable tale of his last voyage and death.*

Joy to you, Florence, that your banners swell,
 beating their proud wings over land and sea,
 and that your name expands through all of Hell! 3

Among the thieves I found five who had been
 your citizens, to my shame; nor yet shall you
 mount to great honor peopling such a den! 6

But if the truth is dreamed of toward the morning,
 you soon shall feel what Prato and the others
 wish for you. And were that day of mourning 9

already come it would not be too soon.
 So may it come, since it must! for it will weigh
 more heavily on me as I pass my noon. 12

We left that place. My Guide climbed stone by stone
 the natural stair by which we had descended
 and drew me after him. So we passed on, 15

and going our lonely way through that dead land
 among the crags and crevices of the cliff,
 the foot could make no way without the hand. 18

I mourned among those rocks, and I mourn again
 when memory returns to what I saw:
 and more than usually I curb the strain 21

of my genius, lest it stray from Virtue's course;
 so if some star, or a better thing, grant me merit,
 may I not find the gift cause for remorse. 24

As many fireflies as the peasant sees
 when he rests on a hill and looks into the valley
 (where he tills or gathers grapes or prunes his
 trees) 27

in that sweet season when the face of him
 who lights the world rides north, and at the hour
 when the fly yields to the gnat and the air grows
 dim— 30

such myriads of flames I saw shine through
 the gloom of the eighth abyss when I arrived
 at the rim from which its bed comes into view. 33

As he the bears avenged so fearfully
 beheld Elijah's chariot depart—
 the horses rise toward heaven—but could not
 see 36

more than the flame, a cloudlet in the sky,
 once it had risen—so within the fosse
 only those flames, forever passing by 39

were visible, ahead, to right, to left;
 for though each steals a sinner's soul from view
 not one among them leaves a trace of the theft. 42

I stood on the bridge, and leaned out from the edge;
 so far, that but for a jut of rock I held to
 I should have been sent hurtling from the ledge 45

without being pushed. And seeing me so intent,
 my Guide said: "There are souls within those flames;
 each sinner swathes himself in his own torment." 48

7. *if the truth is dreamed of toward the morning:* A semi-proverbial expression. It was a common belief that those dreams that occur just before waking foretell the future. "Morning" here would equal both "the rude awakening" and the potential "dawn of a new day."

34. *he the bears avenged:* Elisha saw Elijah translated to Heaven in a fiery chariot. Later he was mocked by some children, who called out tauntingly that he should "Go up" as Elijah had. Elisha cursed the children in the name of the Lord, and bears came suddenly upon the children and devoured them. (2 *Kings* ii, 11–24.)

"Master," I said, "your words make me more sure,
 but I had seen already that it was so
 and meant to ask what spirit must endure 51

the pains of that great flame which splits away
 in two great horns, as if it rose from the pyre
 where Eteocles and Polynices lay?" 54

He answered me: "Forever round this path
 Ulysses and Diomede move in such dress,
 united in pain as once they were in wrath; 57

there they lament the ambush of the Horse
 which was the door through which the noble seed
 of the Romans issued from its holy source; 60

there they mourn that for Achilles slain
 sweet Deidamia weeps even in death;
 there they recall the Palladium in their pain." 63

"Master," I cried, "I pray you and repray
 till my prayer becomes a thousand—if these souls
 can still speak from the fire, oh let me stay 66

until the flame draws near! Do not deny me:
 You see how fervently I long for it!"
 And he to me: "Since what you ask is worthy, 69

it shall be. But be still and let me speak;
 for I know your mind already, and they perhaps

might scorn your manner of speaking, since they
 were Greek." 72

And when the flame had come where time and place
 seemed fitting to my Guide, I heard him say
 these words to it: "O you two souls who pace 75

together in one flame!—if my days above
 won favor in your eyes, if I have earned
 however much or little of your love 78

in writing my High Verses, do not pass by,
 but let one of you be pleased to tell where he,
 having disappeared from the known world, went
 to die." 81

As if it fought the wind, the greater prong
 of the ancient flame began to quiver and hum;
 then moving its tip as if it were the tongue 84

that spoke, gave out a voice above the roar.
 "When I left Circe," it said, "who more than a
 year
 detained me near Gaëta long before 87

Aeneas came and gave the place that name,
 not fondness for my son, nor reverence
 for my aged father, nor Penelope's claim 90

to the joys of love, could drive out of my mind
 the lust to experience the far-flung world
 and the failings and felicities of mankind. 93

I put out on the high and open sea
 with a single ship and only those few souls
 who stayed true when the rest deserted me. 96

53–54. *the pyre where Eteocles and Polynices lay:* Eteocles and Poly-
nices, sons of Oedipus, succeeded jointly to the throne of Thebes,
and came to an agreement whereby each one would rule separately
for a year at a time. Eteocles ruled the first year and when he refused
to surrender the throne at the appointed time, Polynices led the Seven
against Thebes in a bloody war. In single combat the two brothers
killed one another. Statius (*Thebaid* XII, 429 ff.) wrote that their
mutual hatred was so great that when they were placed on the same
funeral pyre the very flame of their burning drew apart in two great
raging horns. 56–63. *Ulysses and Diomede, etc.:* They suffer
here for their joint guilt in counseling and carrying out many
stratagems which Dante considered evil, though a narrator who was
less passionately a partisan of the Trojans might have thought their
actions justifiable methods of warfare. They are in one flame for
their joint guilt, but the flame is divided, perhaps to symbolize the
moral that men of evil must sooner or later come to a falling out, for
there can be no lasting union except by virtue.

 Their first sin was the stratagem of the Wooden Horse, as a re-
sult of which Troy fell and Aeneas went forth to found the Roman
line. The second evil occurred at Scyros. There Ulysses discovered
Achilles in female disguise, hidden by his mother, Thetis, so that he
would not be taken off to the war. Deidamia was in love with Achilles
and had borne him a son. When Ulysses persuaded her lover to sail
for Troy, she died of grief. The third count is Ulysses' theft of the
sacred statue of Pallas from the Palladium. Upon the statue, it was
believed, depended the fate of Troy. Its theft, therefore, would result
in Troy's downfall.

72. *since they were Greek:* Dante knew no Greek, and these sinners
might scorn him, first, because he spoke what to them would seem a
barbarous tongue, and second, because as an Italian he would seem
a descendant of Aeneas and the defeated Trojans. Virgil, on the other
hand, appeals to them as a man of virtuous life (who therefore has
a power over sin) and as a poet who celebrated their earthly fame.
(Prof. MacAllister suggests another meaning as well: that Dante [and
his world] had no direct knowledge of the Greeks, knowing their
works through Latin intermediaries. Thus Virgil stood between
Homer and Dante.) 80–81. *one of you:* Ulysses. He is the figure
in the larger horn of the flame (which symbolizes that his guilt, as
leader, is greater than that of Diomede). His memorable account of
his last voyage and death is purely Dante's invention. 86. *Circe:*
Changed Ulysses' men to swine and kept him a prisoner, though with
rather exceptional accommodations. 87. *Gaëta:* Southeastern
Italian coastal town. According to Virgil (*Aeneid,* VII, 1 ff.) it was
earlier named Caieta by Aeneas in honor of his aged nurse.
90. *Penelope:* Ulysses' wife.

As far as Morocco and as far as Spain
 I saw both shores; and I saw Sardinia
 and the other islands of the open main. 99

I and my men were stiff and slow with age
 when we sailed at last into the narrow pass
 where, warning all men back from further
 voyage, 102

Hercules' Pillars rose upon our sight.
 Already I had left Ceuta on the left;
 Seville now sank behind me on the right. 105

'Shipmates,' I said, 'who through a hundred thousand
 perils have reached the West, do not deny
 to the brief remaining watch our senses stand 108

experience of the world beyond the sun.
 Greeks! You were not born to live like brutes,
 but to press on toward manhood and
 recognition! 111

With this brief exhortation I made my crew
 so eager for the voyage I could hardly
 have held them back from it when I was
 through; 114

and turning our stern toward morning, our bow
 toward night,
 we bore southwest out of the world of man;
 we made wings of our oars for our fool's flight. 117

That night we raised the other pole ahead
 with all its stars, and ours had so declined
 it did not rise out of its ocean bed. 120

Five times since we had dipped our bending oars
 beyond the world, the light beneath the moon
 had waxed and waned, when dead upon our
 course 123

we sighted, dark in space, a peak so tall
 I doubted any man had seen the like.
 Our cheers were hardly sounded, when a squall 126

broke hard upon our bow from the new land:
 three times it sucked the ship and the sea about
 as it pleased Another to order and command. 129

At the fourth, the poop rose and the bow went
 down
 till the sea closed over us and the light was
 gone." 131

Canto XXXIII

Circle Nine
Cocytus: Compound Fraud
Round Two
Antenora: The Treacherous to Country
Round Three
Ptolomea: The Treacherous
to Guests and Hosts

*In reply to Dante's exhortation, the sinner who is
gnawing his companion's head looks up, wipes his
bloody mouth on his victim's hair, and tells his harrow-
ing story. He is* COUNT UGOLINO *and the wretch he
gnaws is* ARCHBISHOP RUGGIERI. *Both are in Antenora
for treason. In life they had once plotted together. Then
Ruggieri betrayed his fellow-plotter and caused his
death, by starvation, along with his four "sons." In the
most pathetic and dramatic passage of the Inferno,*
UGOLINO *details how their prison was sealed and how
his "sons" dropped dead before him one by one, weep-
ing for food. His terrible tale serves only to renew his
grief and hatred, and he has hardly finished it before he
begins to gnaw Ruggieri again with renewed fury. In
the immutable Law of Hell, the killer-by-starvation be-
comes the food of his victim.*

 The Poets leave Ugolino and enter Ptolomea, *so
named for the Ptolomaeus of* MACCABEES, *who mur-
dered his father-in-law at a banquet. Here are pun-
ished those who were* TREACHEROUS AGAINST THE TIES
OF HOSPITALITY. *They lie with only half their faces
above the ice and their tears freeze in their eye sock-
ets, sealing them with little crystal visors. Thus even
the comfort of tears is denied them. Here Dante finds*
FRIAR ALBERIGO *and* BRANCA D'ORIA, *and discovers
the terrible power of Ptolomea: so great is its sin that*

98. *both shores:* Of the Mediterranean. 101. *narrow pass:* The
Straits of Gibraltar, formerly called the Pillars of Hercules. They were
presumed to be the Western limit beyond which no man could navi-
gate. 104. *Ceuta:* In Africa, opposite Gibraltar.
105. *Seville:* In Dante's time this was the name given to the general
region of Spain. Having passed through the Straits, the men are now
in the Atlantic. 115. *morning . . . night:* East and West.
118. *we raised the other pole ahead:* i.e., They drove south across the
equator, observed the southern stars, and found that the North Star
had sunk below the horizon. The altitude of the North Star is the
easiest approximation of latitude. Except for a small correction, it is
directly overhead at the North Pole, shows an altitude of 45° at
North latitude 45, and is on the horizon at the equator.

124. *a peak:* Purgatory. They sight it after five months of passage.
According to Dante's geography, the Northern hemisphere is land
and the Southern is all water except for the Mountain of Purgatory
which rises above the surface at a point directly opposite Jerusalem.

*the souls of the guilty fall to its torments even before
they die, leaving their bodies still on earth, inhabited
by Demons.*

The sinner raised his mouth from his grim repast
 and wiped it on the hair of the bloody head
 whose nape he had all but eaten away. At last 3

he began to speak: "You ask me to renew
 a grief so desperate that the very thought
 of speaking of it tears my heart in two. 6

But if my words may be a seed that bears
 the fruit of infamy for him I gnaw,
 I shall weep, but tell my story through my tears. 9

Who you may be, and by what powers you reach
 into this underworld, I cannot guess,
 but you seem to me a Florentine by your
 speech. 12

I was Count Ugolino, I must explain;
 this reverend grace is the Archbishop Ruggieri:
 now I will tell you why I gnaw his brain. 15

That I, who trusted him, had to undergo
 imprisonment and death through his treachery,
 you will know already. What you cannot
 know— 18

that is, the lingering inhumanity
 of the death I suffered—you shall hear in full:
 then judge for yourself if he has injured me. 21

A narrow window in that coop of stone
 now called the Tower of Hunger for my sake
 (within which others yet must pace alone) 24

had shown me several waning moons already
 between its bars, when I slept the evil sleep
 in which the veil of the future parted for me. 27

This beast appeared as master of a hunt
 chasing the wolf and his whelps across the mountain
 that hides Lucca from Pisa. Out in front 30

of the starved and shrewd and avid pack he had placed
 Gualandi and Sismondi and Lanfranchi
 to point his prey. The father and sons had raced 33

a brief course only when they failed of breath
 and seemed to weaken; then I thought I saw
 their flanks ripped open by the hounds' fierce
 teeth. 36

Before the dawn, the dream still in my head,
 I woke and heard my sons, who were there with me,
 cry from their troubled sleep, asking for bread. 39

You are cruelty itself if you can keep
 your tears back at the thought of what foreboding
 stirred in my heart; and if you do not weep, 42

at what are you used to weeping?—The hour when
 food
 used to be brought, drew near. They were now
 awake,
 and each was anxious from his dream's dark
 mood. 45

And from the base of that horrible tower I heard
 the sound of hammers nailing up the gates:
 I stared at my sons' faces without a word. 48

I did not weep: I had turned stone inside.
 They wept. 'What ails you, Father, you look so
 strange,'
 my little Anselm, youngest of them, cried. 51

But I did not speak a word nor shed a tear:
 not all that day nor all that endless night,
 until I saw another sun appear. 54

13–14. *Ugolino . . . Ruggieri:* (Oog-oh-LEE-noe: Roo-DJAIR-ee) Ugolino, Count of Donoratico and a member of the Guelph [Guelf] family della Gherardesca. He and his nephew, Nino de' Visconti, led the two Guelph factions of Pisa. In 1288 Ugolino intrigued with Archbishop Ruggieri degli Ubaldini, leader of the Ghibellines, to get rid of Visconti and to take over the command of all the Pisan Guelphs. The plan worked, but in the consequent weakening of the Guelphs, Ruggieri saw his chance and betrayed Ugolino, throwing him into prison with his sons and his grandsons. In the following year the prison was sealed up and they were left to starve to death. The law of retribution is clearly evident: in life Ruggieri sinned against Ugolino by denying him food; in Hell he himself becomes food for his victim. 18. *you will know already:* News of Ugolino's imprisonment and death would certainly have reached Florence. *What you cannot know:* No living man could know what happened after Ugolino and his sons were sealed in the prison and abandoned. 22. *coop:* Dante uses the word *muda,* in Italian signifying a stone tower in which falcons were kept in the dark to moult. From the time of Ugolino's death it became known as the Tower of Hunger.

25. *several waning moons:* Ugolino was jailed late in 1288. He was sealed in to starve early in 1289. 28. *This beast:* Ruggieri. 29–30. *the mountain that hides Lucca from Pisa:* These two cities would be in view of one another were it not for Monte San Giuliano. 32. *Gualandi and Sismondi and Lanfranchi:* (Gwah-LAHN-dee . . . Lahn-FRAHN-kee) Three Pisan nobles, Ghibellines and friends of the Archbishop. 38. *my sons:* Actually two of the boys were grandsons and all were considerably older than one would gather from Dante's account. Anselm, the younger grandson, was fifteen. The others were really young men and were certainly old enough for guilt despite Dante's charge in line 90.

When a tiny ray leaked into that dark prison
 and I saw staring back from their four faces
 the terror and the wasting of my own, 57

I bit my hands in helpless grief. And they,
 thinking I chewed myself for hunger, rose
 suddenly together. I heard them say: 60

'Father, it would give us much less pain
 if you ate us: it was you who put upon us
 this sorry flesh; now strip it off again.' 63

I calmed myself to spare them. Ah! hard earth,
 why did you not yawn open? All that day
 and the next we sat in silence. On the fourth, 66

Gaddo, the eldest, fell before me and cried,
 stretched at my feet upon that prison floor:
 'Father, why don't you help me?' There he died. 69

And just as you see me, I saw them fall
 one by one on the fifth day and the sixth.
 Then, already blind, I began to crawl 72

from body to body shaking them frantically.
 Two days I called their names, and they were
 dead.
 Then fasting overcame my grief and me." 75

His eyes narrowed to slits when he was done,
 and he seized the skull again between his teeth
 grinding it as a mastiff grinds a bone. 78

Ah, Pisa! foulest blemish on the land
 where "si" sounds sweet and clear, since those
 nearby you
 are slow to blast the ground on which you
 stand, 81

may Caprara and Gorgona drift from place
 and dam the flooding Arno at its mouth
 until it drowns the last of your foul race! 84

For if to Ugolino falls the censure
 for having betrayed your castles, you for your part
 should not have put his sons to such a torture: 87

you modern Thebes! those tender lives you spilt—
 Brigata, Uguccione, and the others
 I mentioned earlier—were too young for guilt! 90

We passed on further, where the frozen mine
 entombs another crew in greater pain;
 these wraiths are not bent over, but lie supine. 93

Their very weeping closes up their eyes;
 and the grief that finds no outlet for its tears
 turns inward to increase their agonies: 96

for the first tears that they shed knot instantly
 in their eye-sockets, and as they freeze they form
 a crystal visor above the cavity. 99

And despite the fact that standing in that place
 I had become as numb as any callus,
 and all sensation had faded from my face, 102

somehow I felt a wind begin to blow,
 whereat I said: "Master, what stirs this wind?
 Is not all heat extinguished here below?" 105

And the Master said to me: "Soon you will be
 where your own eyes will see the source and
 cause
 and give you their own answer to the mystery." 108

And one of those locked in that icy mall
 cried out to us as we passed: "O souls so cruel
 that you are sent to the last post of all, 111

relieve me for a little from the pain
 of this hard veil; let my heart weep a while
 before the weeping freeze my eyes again." 114

75. *Then fasting overcame my grief and me:* i.e., He died. Some interpret the line to mean that Ugolino's hunger drove him to cannibalism. Ugolino's present occupation in Hell would certainly support that interpretation but the fact is that cannibalism is the one major sin Dante does not assign a place to in Hell. So monstrous would it have seemed to him that he must certainly have established a special punishment for it. Certainly he could hardly have relegated it to an ambiguity. Moreover, it would be a sin of bestiality rather than of fraud, and as such it would be punished in the Seventh Circle. 79–80. *the land where "si" sounds sweet and clear:* Italy. 82. *Caprara and Gorgona:* These two islands near the mouth of the Arno were Pisan possessions in 1300.

86. *betrayed your castles:* In 1284, Ugolino gave up certain castles to Lucca and Florence. He was at war with Genoa at the time and it is quite likely that he ceded the castles to buy the neutrality of these two cities, for they were technically allied with Genoa. Dante, however, must certainly consider the action as treasonable, for otherwise Ugolino would be in Caïna for his treachery to Visconti. 88. *you modern Thebes:* Thebes, as a number of the foregoing notes will already have made clear, was the site of some of the most hideous crimes of antiquity. 91. *we passed on further:* Marks the passage into Ptolomea. 105. *Is not all heat extinguished:* Dante believed (rather accurately, by chance) that all winds resulted from "exhalations of heat." Cocytus, however, is conceived as wholly devoid of heat, a metaphysical absolute zero. The source of the wind, as we discover in the next Canto, is Satan himself.

And I to him: "If you would have my service,
 tell me your name; then if I do not help you
 may I descend to the last rim of the ice." 117

"I am Friar Alberigo," he answered therefore,
 "the same who called for the fruits from the bad
 garden.
 Here I am given dates for figs full store." 120

"What! Are you dead already?" I said to him.
 And he then: "How my body stands in the world
 I do not know. So privileged is this rim 123

of Ptolomea, that often souls fall to it
 before dark Atropos has cut their thread.
 And that you may more willingly free my spirit 126

of this glaze of frozen tears that shrouds my face,
 I will tell you this: when a soul betrays as I did,
 it falls from flesh, and a demon takes its place, 129

ruling the body till its time is spent.
 The ruined soul rains down into this cistern.
 So, I believe, there is still evident 132

in the world above, all that is fair and mortal
 of this black shade who winters here behind me.
 If you have only recently crossed the portal 135

from that sweet world, you surely must have known
 his body: Branca D'Oria is its name,
 and many years have passed since he rained
 down." 138

"I think you are trying to take me in," I said,
 "Ser Branca D'Oria is a living man;
 he eats, he drinks, he fills his clothes and his
 bed." 141

"Michel Zanche had not yet reached the ditch
 of the Black Talons," the frozen wraith replied,
 "there where the sinners thicken in hot pitch, 144

when this one left his body to a devil,
 as did his nephew and second in treachery,
 and plumbed like lead through space to this dead
 level. 147

But now reach out your hand, and let me cry."
 And I did not keep the promise I had made,
 for to be rude to him was courtesy. 150

Ah, men of Genoa! souls of little worth,
 corrupted from all custom of righteousness,
 why have you not been driven from the earth? 153

For there beside the blackest soul of all
 Romagna's evil plain, lies one of yours
 bathing his filthy soul in the eternal 156

glacier of Cocytus for his foul crime,
 while he seems yet alive in world and time! 158

Canto XXXIV

Circle Nine
Cocytus: Compound Fraud
Round Four
Judecca: The Treacherous to Their Masters
The Center
Satan

*"On march the banners of the King," Virgil begins as
the Poets face the last depth. He is quoting a medieval
hymn, and to it he adds the distortion and perversion
of all that lies about him. "On march the banners of
the King—of Hell." And there before them, in an infer-
nal parody of Godhead, they see Satan in the distance,
his great wings beating like a windmill. It is their beat-
ing that is the source of the icy wind of Cocytus, the
exhalation of all evil.*

*All about him in the ice are strewn the sinners of
the last round, Judecca, named for Judas Iscariot.
These are the* TREACHEROUS TO THEIR MASTERS. *They
lie completely sealed in the ice, twisted and distorted
into every conceivable posture. It is impossible to speak
to them, and the Poets move on to observe Satan.*

*He is fixed into the ice at the center to which flow
all the rivers of guilt; and as he beats his great wings as
if to escape, their icy wind only freezes him more surely
into the polluted ice. In a grotesque parody of the Trin-
ity, he has three faces, each a different color, and in
each mouth he clamps a sinner whom he rips eternally
with his teeth.* JUDAS ISCARIOT *is in the central mouth:*
BRUTUS *and* CASSIUS *in the mouths on either side.*

117. *may I descend to the last rim of the ice*: Dante is not taking any
chances; he has to go on to the last rim in any case. The sinner, how-
ever, believes him to be another damned soul and would interpret
the oath quite otherwise than as Dante meant it. 118. *Friar Al-
berigo*: (Ahl-beh-REE-ghoe) Of the Manfredi of Faenza. He was an-
other Jovial Friar. In 1284 his brother Manfred struck him in the
course of an argument. Alberigo pretended to let it pass, but in 1285
he invited Manfred and his son to a banquet and had them mur-
dered. The signal of the assassins was the words: "Bring in the
fruit." "Friar Alberigo's bad fruit" became a proverbial saying.
125. *Atropos*: The Fate who cuts the thread of life. 137. *Branca
D'Oria*: (DAW-ree-yah) A Genoese Ghibelline. His sin is identical in
kind to that of Friar Alberigo. In 1275 he invited his father-in-law,
Michel Zanche (see Canto XXII), to a banquet and had him and his
companions cut to pieces. He was assisted in the butchery by
his nephew.

*Having seen all, the Poets now climb through the
center, grappling hand over hand down the hairy flank
of Satan himself—a last supremely symbolic action—
and at last, when they have passed the center of all grav-
ity, they emerge from Hell. A long climb from the earth's
center to the Mount of Purgatory awaits them, and they
push on without rest, ascending along the sides of the
river Lethe, till they emerge once more to see the stars of
Heaven, just before dawn on Easter Sunday.*

"On march the banners of the King of Hell,"
 my Master said. "Toward us. Look straight ahead:
 can you make him out at the core of the frozen
 shell?" 3

Like a whirling windmill seen afar at twilight,
 or when a mist has risen from the ground—
 just such an engine rose upon my sight 6

stirring up such a wild and bitter wind
 I cowered for shelter at my Master's back,
 there being no other windbreak I could find. 9

I stood now where the souls of the last class
 (with fear my verses tell it) were covered wholly;
 they shone below the ice like straws in glass. 12

Some lie stretched out; others are fixed in place
 upright, some on their heads, some on their soles;
 another, like a bow, bends foot to face. 15

When we had gone so far across the ice
 that it pleased my Guide to show me the foul creature
 which once had worn the grace of Paradise, 18

he made me stop, and, stepping aside, he said:
 "Now see the face of Dis! This is the place
 where you must arm your soul against all dread." 21

Do not ask, Reader, how my blood ran cold
 and my voice choked up with fear. I cannot write it:
 this is a terror that cannot be told. 24

I did not die, and yet I lost life's breath:
 imagine for yourself what I became,
 deprived at once of both my life and death. 27

The Emperor of the Universe of Pain
 jutted his upper chest above the ice;
 and I am closer in size to the great mountain 30

the Titans make around the central pit,
 than they to his arms. Now, starting from this part,
 imagine the whole that corresponds to it! 33

If he was once as beautiful as now
 he is hideous, and still turned on his Maker,
 well may he be the source of every woe! 36

With what a sense of awe I saw his head
 towering above me! for it had three faces:
 one was in front, and it was fiery red; 39

the other two, as weirdly wonderful,
 merged with it from the middle of each shoulder
 to the point where all converged at the top of
 the skull; 42

the right was something between white and bile;
 the left was about the color that one finds
 on those who live along the banks of the Nile. 45

Under each head two wings rose terribly,
 their span proportioned to so gross a bird:
 I never saw such sails upon the sea. 48

They were not feathers—their texture and their form
 were like a bat's wings—and he beat them so
 that three winds blew from him in one great
 storm: 51

it is these winds that freeze all Cocytus.
 He wept from his six eyes, and down three chins
 the tears ran mixed with bloody froth and pus. 54

In every mouth he worked a broken sinner
 between his rake-like teeth. Thus he kept three
 in eternal pain at his eternal dinner. 57

For the one in front the biting seemed to play
 no part at all compared to the ripping: at times
 the whole skin of his back was flayed away. 60

"That soul that suffers most," explained my Guide,
 "is Judas Iscariot, he who kicks his legs
 on the fiery chin and has his head inside. 63

Of the other two, who have their heads thrust
 forward,

1. *On march the banners of the King:* The hymn (*Vexilla regis prod-
eunt*) was written in the sixth century by Venantius Fortunatus,
Bishop of Poitiers. The original celebrates the Holy Cross, and is part
of the service for Good Friday to be sung at the moment of uncover-
ing the cross. 17. *the foul creature:* Satan.

38. *three faces:* Numerous interpretations of these three faces exist.
What is essential to all explanation is that they be seen as perversions
of the qualities of the Trinity. 54. *bloody froth and pus:* The gore
of the sinners he chews which is mixed with his slaver. 62. *Judas
Iscariot:* Note how closely his punishment is patterned on that of the
Simoniacs (Canto XIX).

the one who dangles down from the black face
 is Brutus: note how he writhes without a word. 66

And there, with the huge and sinewy arms, is the
 soul
 of Cassius.—But the night is coming on
 and we must go, for we have seen the whole." 69

Then, as he bade, I clasped his neck, and he,
 watching for a moment when the wings
 were opened wide, reached over dexterously 72

and seized the shaggy coat of the king demon;
 then grappling matted hair and frozen crusts
 from one tuft to another, clambered down. 75

When we had reached the joint where the great
 thigh
 merges into the swelling of the haunch,
 my Guide and Master, straining terribly, 78

turned his head to where his feet had been
 and began to grip the hair as if he were climbing;
 so that I thought we moved toward Hell again. 81

"Hold fast!" my Guide said, and his breath came
 shrill
 with labor and exhaustion. "There is no way
 but by such stairs to rise above such evil." 84

At last he climbed out through an opening
 in the central rock, and he seated me on the rim;
 then joined me with a nimble backward spring. 87

I looked up, thinking to see Lucifer
 as I had left him, and I saw instead
 his legs projecting high into the air. 90

Now let all those whose dull minds are still vexed
 by failure to understand what point it was
 I had passed through, judge if I was perplexed. 93

"Get up. Up on your feet," my Master said.
 "The sun already mounts to middle tierce,
 and a long road and hard climbing lie ahead." 96

It was no hall of state we had found there,
 but a natural animal pit hollowed from rock
 with a broken floor and a close and sunless air. 99

"Before I tear myself from the Abyss,"
 I said when I had risen, "O my Master,
 explain to me my error in all this: 102

where is the ice? and Lucifer—how has he
 been turned from top to bottom: and how can the
 sun
 have gone from night to day so suddenly?" 105

And he to me: "You imagine you are still
 on the other side of the center where I grasped
 the shaggy flank of the Great Worm of Evil 108

which bores through the world—you *were* while I
 climbed down,
 but when I turned myself about, you passed
 the point to which all gravities are drawn. 111

You are under the other hemisphere where you
 stand;
 the sky above us is the half opposed
 to that which canopies the great dry land. 114

Under the midpoint of that other sky
 the Man who was born sinless and who lived
 beyond all blemish, came to suffer and die. 117

You have your feet upon a little sphere
 which forms the other face of the Judecca.
 There it is evening when it is morning here. 120

And this gross Fiend and Image of all Evil
 who made a stairway for us with his hide
 is pinched and prisoned in the ice-pack still. 123

On this side he plunged down from heaven's height,
 and the land that spread here once hid in the sea
 and fled North to our hemisphere for fright; 126

and it may be that moved by that same fear,
 the one peak that still rises on this side
 fled upward leaving this great cavern here. 129

Down there, beginning at the further bound
 of Beelzebub's dim tomb, there is a space
 not known by sight, but only by the sound 132

67. *huge and sinewy arms:* The Cassius who betrayed Caesar was
more generally described in terms of Shakespeare's "lean and hungry
look." Another Cassius is described by Cicero (*Catiline* III) as huge
and sinewy. Dante probably confused the two. 68. *the night is
coming on:* It is now Saturday evening. 82. *his breath came
shrill:* Cf. Canto XXIII, 85, where the fact that Dante breathes
indicates to the Hypocrites that he is alive. Virgil's breathing is
certainly a contradiction. 95. *middle tierce:* In the canonical
day tierce is the period from about six to nine A.M. Middle tierce,
therefore, is seven-thirty. In going through the center point, they
have gone from night to day. They have moved ahead twelve hours.

128. *the one peak:* The Mount of Purgatory. 129. *this great
cavern:* The natural animal pit of line 98. It is also "Beelzebub's dim
tomb," line 131.

of a little stream descending through the hollow
 it has eroded from the massive stone
 in its endlessly entwining lazy flow." 135

My Guide and I crossed over and began
 to mount that little known and lightless road
 to ascend into the shining world again. 138

He first, I second, without thought of rest
 we climbed the dark until we reached the point
 where a round opening brought in sight the
 blest 141

and beauteous shining of the Heavenly cars.
And we walked out once more beneath the
 Stars. 143

··

from the *Purgatorio*

(Dante and Virgil have climbed the mountain.)

Canto XXX

The Earthly Paradise: Beatrice
Virgil Vanishes

*The procession halts and the Prophets turn to the
chariot and sing "Come, my bride, from Lebanon."
They are summoning* BEATRICE, *who appears on the
left side of the chariot, half-hidden from view by show-
ers of blossoms poured from above by a* HUNDRED
ANGELS. *Dante, stirred by the sight, turns to Virgil to
express his overflowing emotions, and discovers that
Virgil has vanished.*

*Because he bursts into tears at losing Virgil Dante
is reprimanded by Beatrice. The Angel Choir overhead
immediately breaks into a Psalm of Compassion, but
Beatrice, still severe, answers by detailing Dante's of-
fenses in not making proper use of his great gifts. It
would violate the ordering of the Divine Decree, she
argues, to let Dante drink the waters of Lethe, thereby
washing all memory of sin from his soul, before he had
shed the tears of a real repentance.*

133. *a little stream:* Lethe. In classical mythology, the river of forget-
fulness, from which souls drank before being born. In Dante's sym-
bolism it flows down from Purgatory, where it washes away the
memory of sin from the souls that are undergoing purification. That
memory it delivers to Hell, which draws all sin to itself.
143. *Stars:* As part of his total symbolism Dante ends each of the
three divisions of the *Commedia* with this word. Every conclusion of
the upward soul is toward the stars, God's shining symbols of hope
and virtue. It is just before dawn of Easter Sunday that the Poets
emerge—a further symbolism.

When the Septentrion of the First Heaven,
 which does not rise nor set, and which has never
 been veiled from sight by any mist but sin, 3

and which made every soul in that high court
 know its true course (just as the lower Seven
 direct the helmsman to his earthly port), 6

had stopped; the holy prophets, who till then
 had walked between the Griffon and those lights,
 turned to the car like souls who cry "Amen." 9

And one among them who seemed sent from Heaven
 clarioned: "*Veni, sponsa, de Libano,*"
 three times, with all the others joining in. 12

As, at the last trump every saint shall rise
 out of the grave, ready with voice new-fleshed
 to carol *Alleluiah* to the skies; 15

just so, above the chariot, at the voice
 of such an elder, rose a hundred Powers
 and Principals of the Eternal Joys, 18

all saying together: "*Benedictus qui venis*";
 then, scattering flowers about on every side:
 "*Manibus o date lilia plenis.*" 21

Time and again at daybreak I have seen
 the eastern sky glow with a wash of rose
 while all the rest hung limpid and serene, 24

1. *the Septentrion of the First Heaven:* The Septentrion is the seven
stars of the Big Dipper. Here Dante means the seven candelabra.
They are the Septentrion of the First Heaven (the Empyrean) as dis-
tinct from the seven stars of the dipper which occur lower down in
the Sphere of the Fixed Stars. 2. *which does not rise nor set:* The
North Star does not rise or set north of the equator, but the Septen-
trion, revolving around the North Star, does go below the horizon in
the lower latitudes. This Septentrion of the First Heaven, however,
partaking of the perfection and constancy of Heaven, neither rises
nor sets but is a constant light to mankind. So these unchanging
lights guide the souls of man on high, as the "lower Seven" (line 5),
in their less perfect way, guide the earthly helmsmen to their earthly
ports. 7. *the holy prophets:* The twenty-four elders who represent
the books of the Old Testament. 10. *one among them:* The Song
of Solomon. 11. *Veni, sponsa, de Libano:* "Come [with me] from
Lebanon, my spouse." (*Song of Solomon,* iv, 8.) This cry, re-echoed
by choirs of angels, summons Beatrice, who may be taken here as
revelation, faith, divine love, hence as the bride of the spirit, to Dante
(man's redeemed soul). 17–18. *a hundred Powers and Principals:*
Angels. 19. *Benedictus qui venis:* "Blessed is he who cometh."
(*Matthew,* xxi, 9.) 21. *Manibus o date lilia plenis:* "Oh, give lilies
with full hands." These are the words of Anchises in honor of Mar-
cellus. (*Aeneid,* VI, 883.) Thus they are not only apt to the occasion
but their choice is a sweetly conceived last literary compliment to
Virgil before he vanishes.

and the Sun's face rise tempered from its rest
 so veiled by vapors that the naked eye
 could look at it for minutes undistressed. 27

Exactly so, within a cloud of flowers
 that rose like fountains from the angels' hands
 and fell about the chariot in showers, 30

a lady came in view: an olive crown
 wreathed her immaculate veil, her cloak was green,
 the colors of live flame played on her gown. 33

My soul—such years had passed since last it saw
 that lady and stood trembling in her presence,
 stupefied by the power of holy awe— 36

now, by some power that shone from her above
 the reach and witness of my mortal eyes,
 felt the full mastery of enduring love. 39

The instant I was smitten by the force,
 which had already once transfixed my soul
 before my boyhood years had run their course, 42

I turned left with the same assured belief
 that makes a child run to its mother's arms
 when it is frightened or has come to grief, 45

to say to Virgil: "There is not within me
 one drop of blood unstirred. I recognize
 the tokens of the ancient flame." But he, 48

he had taken his light from us. He had gone.
 Virgil had gone. Virgil, the gentle Father
 to whom I gave my soul for its salvation! 51

Not all that sight of Eden lost to view
 by our First Mother could hold back the tears
 that stained my cheeks so lately washed with
 dew. 54

"Dante, do not weep yet, though Virgil goes.
 Do not weep yet, for soon another wound
 shall make you weep far hotter tears than those!" 57

As an admiral takes his place at stern or bow
 to observe the handling of his other ships
 and spur all hands to do their best—so now, 60

on the chariot's left side, I saw appear
 when I turned at the sound of my own name
 (which, necessarily, is recorded here), 63

that lady who had been half-veiled from view
 by the flowers of the angel-revels. Now her eyes
 fixed me across the stream, piercing me
 through. 66

And though the veil she still wore, held in place
 by the wreathed flowers of wise Minerva's
 leaves,
 let me see only glimpses of her face, 69

her stern and regal bearing made me dread
 her next words, for she spoke as one who saves
 the heaviest charge till all the rest are read. 72

"Look at me well. I am she. I am Beatrice.
 How dared you make your way to this high
 mountain?
 Did you not know that here man lives in bliss?" 75

I lowered my head and looked down at the stream.
 But when I saw myself reflected there,
 I fixed my eyes upon the grass for shame. 78

I shrank as a wayward child in his distress
 shrinks from his mother's sternness, for the taste
 of love grown wrathful is a bitterness. 81

She paused. At once the angel chorus sang
 the blessed psalm: "*In te, Domine, speravi.*"
 As far as "*pedes meos*" their voices rang. 84

31. *a lady:* Beatrice. She is dressed in the colors of Faith (white), Hope (green), and Charity (red). 34. *since last it saw:* Beatrice died in 1290. Thus Dante has passed ten years without sight of her. 36. *stupefied:* Dante describes the stupor of his soul at the sight of the living Beatrice in *La Vita Nuova,* XIV and XXIV. Then, however, it was mortal love; here it is eternal, and the effect accordingly greater. 54. *washed with dew:* By Virgil. I, 124. 55. *Dante:* This is the only point in the *Commedia* at which Dante mentions his own name. Its usage here suggests many allegorical possibilities. Central to all of them, however, must be the fact that Dante, in ending one life (of the mind) and beginning a new one (of faith), hears his name. The suggestion of a second baptism is inevitable. And just as a child being baptized is struck by the priest, so Beatrice is about to strike him with her tongue before he may proceed to the holy water.

64. *that lady:* There are thirty-four Cantos in the *Inferno* and this is the thirtieth of the *Purgatorio,* hence the sixty-fourth Canto of the *Commedia.* This is the sixty-fourth line of the sixty-fourth Canto. In Dante's numerology such correspondences are always meaningful. Six plus four equals ten and ten equals the sum of the square of trinity and unity. Obviously there can be no conclusive way of establishing intent in such a structure of mystic numbering, but it certainly is worth noting that the line begins with "that lady." The Italian text, in fact, begins with *vidi la donna,* i.e., I saw the lady (who represents the sum of the square of trinity plus unity?). The lady, of course, is Beatrice. 68. *wise Minerva's leaves:* The olive crown. 80. *his mother's sternness:* Beatrice appears in the pageant as the figure of the Church Triumphant. The Church is the mother of the devout and though she is stern, as law decrees, her sternness is that of a loving mother. 83–84. *In te, Domine, speravi . . . pedes meos:* In mercy the angel chorus sings Psalm XXXI, 1–8, beginning "In thee, O Lord, do I put my trust" and continuing as far as "thou hast set my feet in a large room."

As on the spine of Italy the snow
 lies frozen hard among the living rafters
 in winter when the northeast tempests blow; 87

then, melting if so much as a breath stir
 from the land of shadowless noon, flows through
 itself
 like hot wax trickling down a lighted taper— 90

just so I froze, too cold for sighs or tears
 until I heard that choir whose notes are tuned
 to the eternal music of the spheres. 93

But when I heard the voice of their compassion
 plead for me more than if they had cried out:
 "Lady, why do you treat him in this fashion?" 96

the ice, which hard about my heart had pressed,
 turned into breath and water, and flowed out
 through eyes and throat in anguish from my
 breast. 99

Still standing at the chariot's left side,
 she turned to those compassionate essences
 whose song had sought to move her, and
 replied: 102

"You keep your vigil in the Eternal Day
 where neither night nor sleep obscures from you
 a single step the world takes on its way; 105

but I must speak with greater care that he
 who weeps on that far bank may understand
 and feel a grief to match his guilt. Not only 108

by the workings of the spheres that bring each seed
 to its fit end according to the stars
 that ride above it, but by gifts decreed 111

in the largesse of overflowing Grace,
 whose rain has such high vapors for its source
 our eyes cannot mount to their dwelling place; 114

this man, potentially, was so endowed
 from eazly youth that marvelous increase
 should have come forth from every good he
 sowed. 117

But richest soil the soonest will grow wild
 with bad seed and neglect. For a while I stayed
 him
 with glimpses of my face. Turning my mild 120

and youthful eyes into his very soul,
 I let him see their shining, and I led him
 by the straight way, his face to the right goal. 123

The instant I had come upon the sill
 of my second age, and crossed and changed my
 life,
 he left me and let others shape his will. 126

When I rose from the flesh into the spirit,
 to greater beauty and to greater virtue,
 he found less pleasure in me and less merit. 129

He turned his steps aside from the True Way,
 pursuing the false images of good
 that promise what they never wholly pay. 132

Not all the inspiration I won by prayer
 and brought to him in dreams and
 meditations
 could call him back, so little did he care. 135

He fell so far from every hope of bliss
 that every means of saving him had failed
 except to let him see the damned. For this 138

I visited the portals of the dead
 and poured my tears and prayers before that
 spirit
 by whom his steps have, up to now, been led. 141

The seal Almighty God's decree has placed
 on the rounds of His creation would be
 broken
 were he to come past Lethe and to taste 144

the water that wipes out the guilty years
without some scot of penitential tears!" 146

85–90. *the spine of Italy:* The Apennines. *the living rafters:* The trees. *the land of shadowless noon:* Africa. In equatorial regions the noonday sun is at the zenith over each point twice a year. Its rays then fall straight down and objects cast no shadows. 101. *compassionate essences:* The Angel chorus. 106. *greater care:* For his understanding than for your intercession. 109–111. *the workings of the spheres:* The influence of the stars in their courses which incline men at birth to good or evil ends according to the astrological virtue of their conjunctions. 114. *our eyes:* Beatrice is still replying to the plea of the Angel choir. Hence "our eyes" must refer not to mortal eyes, but to the eyes of the blessed. Not even such more-than-human eyes may mount to the high place of those vapors, for that place is nothing less than the Supreme Height, since Grace flows from God Himself.

125–126. *my second age . . . will:* When Beatrice had reached the full bloom of young womanhood Dante turned from her and wrote to his *donna gentile.* Allegorically, he turned from divine "sciences" to an overreliance upon philosophy (the human "sciences"). For this sin he must suffer. 144. *were he to come past Lethe:* In passing Lethe and drinking its waters, the soul loses all memory of guilt. This, therefore, is Dante's last opportunity to do penance.

from the *Paradiso*

Canto XXXIII

The Empyrean
St. Bernard
Prayer to the Virgin
The Vision of God

ST. BERNARD *offers a lofty* Prayer to the Virgin, *asking her to intercede in Dante's behalf, and in answer Dante feels his soul swell with new power and grow calm in rapture as his eyes are permitted the* Direct Vision of God.

There can be no measure of how long the vision endures. It passes, and Dante is once more mortal and fallible. Raised by God's presence, he had looked into the Mystery and had begun to understand its power and majesty. Returned to himself, there is no power in him capable of speaking the truth of what he saw. Yet the impress of the truth is stamped upon his soul, which he now knows will return to be one with God's Love.

"Virgin Mother, daughter of thy son;
 humble beyond all creatures and more exalted;
 predestined turning point of God's intention; 3

thy merit so ennobled human nature
 that its divine Creator did not scorn
 to make Himself the creature of His creature. 6

The Love that was rekindled in Thy womb
 sends forth the warmth of the eternal peace
 within whose ray this flower has come to bloom. 9

Here, to us, thou art the noon and scope
 of Love revealed; and among mortal men,
 the living fountain of eternal hope. 12

Lady, thou art so near God's reckonings
 that who seeks grace and does not first seek thee
 would have his wish fly upward without wings. 15

Not only does thy sweet benignity
 flow out to all who beg, but oftentimes
 thy charity arrives before the plea. 18

In thee is pity, in thee munificence,
 in thee the tenderest heart, in thee unites
 all that creation knows of excellence! 21

Now comes this man who from the final pit
 of the universe up to this height has seen,
 one by one, the three lives of the spirit. 24

He prays to thee in fervent supplication
 for grace and strength, that he may raise his eyes
 to the all-healing final revelation. 27

And I, who never more desired to see
 the vision myself than I do that he may see It,
 add my own prayer, and pray that it may be 30

enough to move you to dispel the trace
 of every mortal shadow by thy prayers
 and let him see revealed the Sum of Grace. 33

I pray thee further, all-persuading Queen,
 keep whole the natural bent of his affections
 and of his powers after his eyes have seen. 36

Protect him from the stirrings of man's clay;
 see how Beatrice and the blessed host
 clasp reverent hands to join me as I pray." 39

The eyes that God reveres and loves the best
 glowed on the speaker, making clear the joy
 with which true prayer is heard by the most
 blest. 42

Those eyes turned then to the Eternal Ray,
 through which, we must indeed believe, the eyes
 of others do not find such ready way. 45

And I, who neared the goal of all my nature,
 felt my soul, at the climax of its yearning,
 suddenly, as it ought, grow calm with rapture. 48

Bernard then, smiling sweetly, gestured to me
 to look up, but I had already become
 within myself all he would have me be. 51

1–39. ST. BERNARD'S PRAYER TO THE VIRGIN MARY. No reader who has come this far will need a lengthy gloss of Bernard's prayer. It can certainly be taken as a summarizing statement of the special place of Mary in Catholic faith. For the rest only a few turns of phrase need underlining. 3. *predestined turning point of God's intention:* All-foreseeing God built his whole scheme for mankind with Mary as its pivot, for through her He would become man. 7. *The Love that was rekindled in thy womb:* God. In a sense He withdrew from man when Adam and Eve sinned. In Mary He returned and Himself became man. 35. *keep whole the natural bent of his affections:* Bernard is asking Mary to protect Dante lest the intensity of the vision overpower his faculties. 37. *Protect him from the stirrings of man's clay:* Protect him from the stirrings of base human impulse, especially from pride, for Dante is about to receive a grace never before granted to any man and the thought of such glory might well move a mere mortal to an hybris that would turn glory to sinfullness.

40. *The eyes:* Of Mary. 50. *but I had already become:* i.e., "But I had already fixed my entire attention upon the vision of God." But if so, how could Dante have seen Bernard's smile and gesture? Eager students like to believe they catch Dante in a contradiction here. Let them bear in mind that Dante is looking directly at God, as do the souls of Heaven, who thereby acquire—insofar as they are able to contain it—God's own knowledge. As a first stirring of that heavenly power, therefore, Dante is sharing God's knowledge of St. Bernard.

Little by little as my vision grew
 it penetrated further through the aura
 of the high lamp which in Itself is true. 54

What then I saw is more than tongue can say.
 Our human speech is dark before the vision.
 The ravished memory swoons and falls away. 57

As one who sees in dreams and wakes to find
 the emotional impression of his vision
 still powerful while its parts fade from his
 mind— 60

just such am I, having lost nearly all
 the vision itself, while in my heart I feel
 the sweetness of it yet distill and fall. 63

So, in the sun, the footprints fade from snow.
 On the wild wind that bore the tumbling leaves
 the Sybil's oracles were scattered so. 66

O Light Supreme who doth Thyself withdraw
 so far above man's mortal understanding,
 lend me again some glimpse of what I saw; 69

make Thou my tongue so eloquent it may
 of all Thy glory speak a single clue
 to those who follow me in the world's day; 72

for by returning to my memory
 somewhat, and somewhat sounding in these verses,
 Thou shalt show man more of Thy victory. 75

So dazzling was the splendor of that Ray,
 that I must certainly have lost my senses
 had I, but for an instant, turned away. 78

And so it was, as I recall, I could
 the better bear to look, until at last
 my vision made one with the Eternal Good. 81

Oh grace abounding that had made me fit
 to fix my eyes on the eternal light
 until my vision was consumed in it! 84

I saw within Its depth how It conceives
 all things in a single volume bound by Love,
 of which the universe is the scattered leaves; 87

substance, accident, and their relation
 so fused that all I say could do no more
 than yield a glimpse of that bright revelation. 90

I think I saw the universal form
 that binds these things, for as I speak these words
 I feel my joy swell and my spirits warm. 93

Twenty-five centuries since Neptune saw
 the Argo's keel have not moved all mankind,
 recalling that adventure, to such awe 96

as I felt in an instant. My tranced being
 stared fixed and motionless upon that vision,
 ever more fervent to see in the act of seeing. 99

Experiencing that Radiance, the spirit
 is so indrawn it is impossible
 even to think of ever turning from It. 102

For the good which is the will's ultimate object
 is all subsumed in It; and, being removed,
 all is defective which in It is perfect. 105

Now in my recollection of the rest
 I have less power to speak than any infant
 wetting its tongue yet at its mother's breast; 108

and not because that Living Radiance bore
 more than one semblance, for It is unchanging
 and is forever as it was before; 111

rather, as I grew worthier to see,
 the more I looked, the more unchanging
 semblance
 appeared to change with every change in me. 114

Within the depthless deep and clear existence
 of that abyss of light three circles shown—
 three in color, one in circumference: 117

54. *which in Itself is true:* The light of God is the one light whose source is Itself. All others are a reflection of this. 65–66. *tumbling leaves . . . oracles:* The Cumean Sybil (Virgil describes her in *Aeneid,* III, 441 ff.) wrote her oracles on leaves, one letter to a leaf, then sent her message scattering on the wind. Presumably, the truth was all contained in that strew, could one only gather all the leaves and put the letters in the right order. 76–81. How can a light be so dazzling that the beholder would swoon if he looked away for an instant? Would it not be, rather, in looking at, not away from, the overpowering vision that the viewer's senses would be overcome? So it would be on earth. But now Dante, with the help of all heaven's prayers, is in the presence of God and strengthened by all he sees. It is by being so strengthened that he can see yet more. So the passage becomes a parable of grace. Stylistically it once more illustrates Dante's genius: even at this height of concept, the poet can still summon and invent new perceptions, subtlety exfoliating from subtlety.

 The simultaneous metaphoric statement, of course, is that no man can lose his good in the vision of God, but only in looking away from it.

85–87. The idea here is Platonic: the essence of all things (form) exists in the mind of God. All other things exist as *exempla.*
88. *substance:* Matter, all that exists in itself. *accident:* All that exists as a phase of matter. 92. *these things:* Substance and accident.
109–114. In the presence of God the soul grows ever more capable of perceiving God. Thus, the worthy soul's experience of God is a constant expansion of awareness. God appears to change as He is better seen. Being perfect, He is changeless within himself, for any change would be away from perfection.

the second from the first, rainbow from rainbow;
 the third, an exhalation of pure fire
 equally breathed forth by the other two. 120

But oh how much my words miss my conception,
 which is itself so far from what I saw
 that to call it feeble would be rank deception! 123

O Light Eternal fixed in Itself alone,
 by Itself alone understood, which from Itself
 loves and glows, self-knowing and self-known; 126

that second aureole which shone forth in Thee,
 conceived as a reflection of the first—
 or which appeared so to my scrutiny— 129

seemed in Itself of Its own coloration
 to be painted with man's image. I fixed my eyes
 on that alone in rapturous contemplation. 132

Like a geometer wholly dedicated
 to squaring the circle, but who cannot find,
 think as he may, the principle indicated— 135

so did I study the supernal face.
 I yearned to know just how our image merges
 into that circle, and how it there finds place; 138

but mine were not the wings for such a flight.
 Yet, as I wished, the truth I wished for came
 cleaving my mind in a great flash of light. 141

Here my powers rest from their high fantasy,
 but already I could feel my being turned—
 instinct and intellect balanced equally 144

as in a wheel whose motion nothing jars—
 by the Love that moves the Sun and the other stars. 146

· ·

COMMENTS AND QUESTIONS

1. Describe the ordering of sins in Dante's vision of hell. How does this fit with your own religious or moral beliefs?
2. How does the law of *contrapasso* (retribution) work in the punishment of each sin?
3. Describe the portrayals of Virgil and of Beatrice, and Dante's relationship with them. Do they seem real as well as allegorical?
4. Compare the story of Paolo and Francesca (Canto V of the *Inferno*) with Marie de France's "Equitan" and with *Tristan and Iseult*. What seems to be Dante's attitude toward courtly love? How can Dante fall into a swoon out of sympathy for Francesca and still judge the lovers to be deserving of hell? Does he show this double attitude elsewhere?
5. Describe Dante's portrayal of the depths of hell. Why is it made of ice rather than fire?
6. Describe the reunion of Dante and Beatrice. What understanding of love is communicated by each of them?
7. Give examples of the imagery used in the *Inferno* and in the *Paradiso*. Is Dante successful in the latter in portraying a mystical experience?
8. What points in common are there between Dante's visit to the "other world" and the visits of Gilgamesh, Odysseus, and Aeneas? What differences?

· ·

GEOFFREY CHAUCER

· ·

The Miller's Tale

Translation by Neville Coghill

Some time ago there was a rich old codger
Who lived in Oxford and who took a lodger.
The fellow was a carpenter by trade,
His lodger a poor student who had made 105
Some studies in the arts, but all his fancy
Turned to astrology and geomancy,°
And he could deal with certain propositions
And make a forecast under some conditions
About the likelihood of drought or showers 110

130–144. The central metaphor of the entire *Comedy* is the image of God and the final triumphant . . . of the elected soul returning to its Maker. On the mystery of that image, the metaphoric symphony of the *Comedy* comes to rest.

 In the second aspect of Trinal-unity, in the circle reflected from the first, Dante thinks he sees the image of mankind woven into the very substance and coloration of God. He turns the entire attention of his soul to that mystery, as a geometer might seek to shut out every other thought and dedicate himself to squaring the circle. In *Il Convivio*, II, 14, Dante asserted that the circle could not be squared, but that impossibility had not yet been firmly demonstrated in Dante's time and mathematicians still worked at the problem. Note, however, that Dante assumes the impossibility of squaring the circle as a weak mortal example of mortal impossibility. How much more impossible, he implies, to resolve the mystery of God, study as man will.

 The mystery remains beyond Dante's mortal power. Yet, there in Heaven, in a moment of grace, God revealed the truth to him in a flash of light—revealed it, that is, to the God-enlarged power of Dante's emparadised soul. On Dante's return to the mortal life, the details of that revelation vanished from his mind but the force of the revelation survives in its power on Dante's feelings.

 So ends the vision of the *Comedy*, and yet the vision endures, for ever since that revelation, Dante tells us, he feels his soul turning ever as one with the perfect motion of God's love.

107. Divination.

For those who asked at favourable hours,
Or put a question how their luck would fall
In this or that, I can't describe them all.
 This lad was known as Nicholas the Gallant,
And making love in secret was his talent, 115
For he was very close and sly, and took
Advantage of his meek and girlish look.
He rented a small chamber in the kip°
All by himself without companionship.
He decked it charmingly with herbs and fruit 120
And he himself was sweeter than the root
Of liquorice, or any fragrant herb.
His astronomic text-books were superb,
He had an astrolabe to match his art
And calculating counters laid apart 125
On handy shelves that stood above his bed.
His press was curtained coarsely and in red;
Above there lay a gallant harp in sight
On which he played melodiously at night
With such a touch that all the chamber rang; 130
It was *The Virgin's Angelus*° he sang,
And after that he sang *King William's Note,*°
And people often blessed his merry throat.
And that was how this charming scholar spent
His time and money, which his friends had sent. 135
 This carpenter had married a young wife
Not long before, and loved her more than life.
She was a girl of eighteen years of age.
Jealous he was and kept her in the cage,
For he was old and she was wild and young; 140
He thought himself quite likely to be stung.
 He might have known, were Cato on his shelf,
A man should marry someone like himself;
A man should pick an equal for his mate.
Youth and old age are often in debate. 145
His wits were dull, he'd fallen in the snare
And had to bear his cross as others bear.
 She was a pretty creature, fair and tender,
And had a weasel's body, softly slender.
She used to wear a girdle of striped silk, 150
Her apron was as white as morning milk
To deck her loins, all gusseted and pleated.
Her smock was white; embroidery repeated
Its pattern on the collar front and back,
Inside and out; it was of silk, and black. 155
And all the ribbons on her milky mutch
Were made to match her collar, even such.
She wore a broad silk fillet rather high,
And certainly she had a lecherous eye.
And she had plucked her eyebrows into bows, 160
Slenderly arched they were, and black as sloes.

And a more truly blissful sight to see
She was than blossom on a cherry-tree,
And softer than the wool upon a wether.
And by her girdle hung a purse of leather, 165
Tasselled in silk, with metal droplets, pearled.
If you went seeking up and down the world
The wisest man you met would have to wrench
His fancy to imagine such a wench.
She had a shining colour, gaily tinted, 170
And brighter than a florin newly minted,
And when she sang it was as loud and quick
As any swallow perched above a rick.
And she would skip or play some game or other
Like any kid or calf behind its mother. 175
Her mouth was sweet as mead or honey—say
A hoard of apples lying in the hay.
Skittish she was, and jolly as a colt,
Tall as a mast and upright as a bolt
Out of a bow. Her collaret revealed 180
A brooch as big as boss upon a shield.
High shoes she wore, and laced them to the top.
She was a daisy, O a lollypop
For any nobleman to take to bed
Or some good man of yeoman stock to wed. 185
 Now, gentlemen, this Gallant Nicholas
Began to romp about and make a pass
At this young woman, happening on her one day,
Her husband being out, down Osney way.
Students are sly, and giving way to whim, 190
He made a grab and caught her by the quim
And said, "O God, I love you! Can't you see
If I don't have you it's the end of me?"
Then held her haunches hard and gave a cry
"O love-me-all-at-once or I shall die!" 195
She gave a spring, just like a skittish colt
Boxed in a frame for shoeing, and with a jolt
Managed in time to wrench her head away,
And said, "Give over, Nicholas, I say!
No, I won't kiss you! Stop it! Let me go 200
Or I shall scream! I'll let the neighbours know!
Where are your manners? Take away your paws!"
 Then Nicholas began to plead his cause
And spoke so fair in proffering what he could
That in the end she promised him she would, 205
Swearing she'd love him, with a solemn promise
To be at his disposal, by St Thomas,
When she could spy an opportunity.
"My husband is so full of jealousy,
Unless you watch your step and hold your breath 210
I know for certain it will be my death,"
She said, "So keep it well under your hat."
"Oh, never mind about a thing like that,"
Said he; "A scholar doesn't have to stir
His wits so much to trick a carpenter." 215
 And so they both agreed to it, and swore
To watch their chance, as I have said before,
When things were settled thus as they thought fit,

And Nicholas had stroked her loins a bit
And kissed her sweetly, he took down his harp 220
And played away, a merry tune and sharp.
 It happened later she went off to church,
This worthy wife, one holiday, to search
Her conscience and to do the works of Christ.
She put her work aside and she enticed 225
The colour to her face to make her mark;
Her forehead shone. There was a parish clerk
Serving the church, whose name was Absalon.
His hair was all in golden curls and shone;
Just like a fan it strutted outwards, starting 230
To left and right from an accomplished parting.
Ruddy his face, his eyes as grey as goose,
His shoes cut out in tracery, as in use
In old St Paul's. The hose upon his feet
Showed scarlet through, and all his clothes were
 neat 235
And proper. In a jacket of light blue,
Flounced at the waist and tagged with laces too,
He went, and wore a surplice just as gay
And white as any blossom on the spray.
God bless my soul, he was a merry knave! 240
He knew how to let blood, cut hair and shave,
And draw up legal deeds; at other whiles
He used to dance in twenty different styles
(After the current school at Oxford though,
Casting his legs about him to and fro). 245
He played a two-stringed fiddle, did it proud,
And sang a high falsetto rather loud:
And he was just as good on the guitar.
There was no public-house in town or bar
He didn't visit with his merry face 250
If there were saucy barmaids round the place.
He was a little squeamish in the matter
Of farting, and satirical in chatter.
This Absalon, so jolly in his ways,
Would bear the censer round on holy days 255
And cense the parish women. He would cast
Many a love-lorn look before he passed,
Especially at this carpenter's young wife;
Looking at her would make a happy life
He thought, so neat, so sweet, so lecherous. 260
And I dare say if she had been a mouse
And he a cat, she'd have been pounced upon.
 In taking the collection Absalon
Would find his heart was set in such a whirl
Of love, he would take nothing from a girl, 265
For courtesy, he said, it wasn't right.
 That evening, when the moon was shining
 bright
He ups with his guitar and off he tours
On the look-out for any paramours.
Larky and amorous, away he strode 270
Until he reached the carpenter's abode
A little after cock-crow, took his stand
Beside the casement window close at hand

(It was set low upon the cottage-face)
And started singing softly and with grace, 275
 "*Now dearest lady, if there pleasure be
 In thoughts of love, think tenderly of me!*"
On his guitar he plucked a tuneful string.
 This carpenter awoke and heard him sing
And turning to his wife said, "Alison! 280
Wife! Do you hear him? There goes Absalon
Chanting away under our chamber wall."
And she replied, "Yes, John, I hear it all."
If she thought more of it she didn't tell.
 So things went on. What's better than "All's
 well"? 285
From day to day this jolly Absalon,
Wooing away, became quite woe-begone;
He lay awake all night, and all the day
Combed his thick locks and tried to pass for gay,
Wooed her by go-between and wooed by proxy, 290
Swore to be page and servant to his doxy,
Trilled and rouladed° like a nightingale,
Sent her sweet wine and mead and spicy ale,
And wafers piping hot and jars of honey,
And, as she lived in town, he offered money.° 295
For there are some a money-bag provokes
And some are won by kindness, some by strokes.
 Once, in the hope his talent might engage,
He played the part of Herod on the stage.
What was the good? Were he as bold as brass, 300
She was in love with gallant Nicholas;
However Absalon might blow his horn
His labour won him nothing but her scorn.
She looked upon him as her private ape
And held his earnest wooing all a jape. 305
There is a proverb—and it is no lie—
You'll often hear repeated: "*Nigh and Sly
Wins against Fair-and-Square who isn't there.*"
For much as Absalon might tear his hair
And rage at being seldom in her sight, 310
Nicholas, nigh and sly, stood in his light.
Now, show your paces, Nicholas you spark!
And leave lamenting to the parish clerk.
 And so it happened that one Saturday,
When the old carpenter was safe away 315
At Osney, Nicholas and Alison
Agreed at last in what was to be done.
Nicholas was to exercise his wits
On her suspicious husband's foolish fits,
And, if so be the trick worked out all right, 320
She then would sleep with Nicholas all night,
For such was his desire and hers as well;
And even quicker than it takes to tell,
Young Nicholas, who simply couldn't wait,
Went to his room on tip-toe with a plate 325
Of food and drink, enough to last a day

292. Sang. 295. As one would to a whore.

Or two, and Alison was told to say,
In case her husband asked for Nicholas,
That she had no idea where he was,
And that she hadn't set eyes on him all day 330
And thought he must be ill, she couldn't say;
And more than once the maid had given a call
And shouted but no answer came at all.

 So things went on the whole of Saturday
Without a sound from Nicholas, who lay 335
Upstairs, and ate or slept as pleased him best
Till Sunday when the sun went down to rest.

 This foolish carpenter was lost in wonder
At Nicholas; what could have got him under?
He said, "I can't help thinking, by the Mass, 340
Things can't be going right with Nicholas.
What if he took and died? God guard his ways!
A ticklish place the world is, nowadays.
I saw a corpse this morning borne to kirk
That only Monday last I saw at work. 345
Run up," he told the serving-lad, "be quick,
Shout at his door, or knock it with a brick.
Take a good look and tell me how he fares."
 The serving-boy went sturdily upstairs.
Stopped at the door and, standing there, the lad 350
Shouted away and, hammering like mad,
Cried, "Ho! What's up? Hi! Master Nicholay!
How can you lie up there asleep all day?"
 But all for nought, he didn't hear a soul.
He found a broken panel with a hole 355
Right at the bottom, useful to the cat
For creeping in; he took a look through that,
And so at last by peering through the crack
He saw this scholar gaping on his back
As if he'd caught a glimpse of the new moon. 360
Down went the boy and told his master soon
About the state in which he found the man.
 On hearing this the carpenter began
To cross himself and said, "St Frideswide bless
 us!
We little know what's coming to distress us. 365
The man has fallen, with this here astromy,
Into a fit, or lunacy maybe.
I always thought that was how it would go.
God has some secrets that we shouldn't know.
How blessed are the simple, aye, indeed, 370
That only know enough to say their creed!
Happened just so with such another student
Of astromy and he was so imprudent
As to stare upwards while he crossed a field,
Busy foreseeing what the stars revealed; 375
And what should happen but he fell down flat
Into a marl-pit. He didn't foresee that!
But by the Saints we've reached a sorry pass;
I can't help worrying for Nicholas.
He shall be scolded for his studying 380
If I know how to scold, by Christ the King!
Get me a staff to prise against the floor.

Robin, you put your shoulder to the door.
We'll shake the study out of him, I guess!"
 The pair of them began to heave and press 385
Against the door. Happened the lad was strong
And so it didn't take them very long
To heave it off its hinges; down it came.
Still as a stone lay Nicholas, with the same
Expression, gaping upwards into air. 390
The carpenter supposed it was despair
And shook him by the shoulders with a stout
And purposeful attack, and gave a shout:
"What, Nicholas! Hey! Look down! Is that a
 fashion
To act? Wake up and think upon Christ's passion. 395
I sign you with the cross from elves and sprites!"
And he began the spell for use at nights
In all four corners of the room and out
Across the threshold too and round about:
 Jesu Christ and Benedict Sainted 400
 Bless this house from creature tainted,
 Drive away night-hags, white Pater-noster,
 Where did you go St Peter's soster?°
And in the end the dandy Nicholas
Began to sigh, "And must it come to pass?" 405
He said, "Must all the world be cast away?"
The carpenter replied, "What's that you say?
Put trust in God as we do, working men."
Nicholas answered, "Fetch some liquor then,
And afterwards, in strictest secrecy, 410
I'll speak of something touching you and me,
But not another soul must know, that's plain."
 This carpenter went down and came again
Bringing some powerful ale—a largeish quart.
When each had had his share of this support 415
Young Nicholas got up and shut the door
And, sitting down beside him on the floor,
Said to the carpenter, "Now, John, my dear,
My excellent host, swear on your honour here
Not to repeat a syllable I say, 420
For here are Christ's intentions, to betray
Which to a soul puts you among the lost,
And vengeance for it at a bitter cost
Shall fall upon you. You'll be driven mad!"
"Christ and His holy blood forbid it, lad!" 425
The silly fellow answered. "I'm no blab,
Though I should say it, I'm not given to gab.
Say what you like, for I shall never tell
Man, woman or child by Him° that harrowed
 Hell!"
 "Now, John," said Nicholas, "believe you me, 430
I have found out by my astrology,
And looking at the moon when it was bright,
That Monday next, a quarter way through night,

403. *soster:* A medieval chant used to drive away evil spirits.
429. Christ.

Rain is to fall in torrents, such a scud
It will be twice as bad as Noah's Flood. 435
This world," he said, "in just about an hour,
Shall all be drowned, it's such a hideous shower,
And all mankind, with total loss of life."
 The carpenter exclaimed, "Alas, my wife!
My little Alison! Is she to drown?" 440
And in his grief he very near fell down.
"Is there no remedy," he said, "for this?"
"Thanks be to God," said Nicholas, "there is,
If you will do exactly what I say
And don't start thinking up some other way. 445
In wise old Solomon you'll find the verse
'Who takes advice shall never fare the worse,'
And so if good advice is to prevail
I undertake with neither mast nor sail
To save her yet, and save myself and you. 450
Haven't you heard how Noah was saved too
When God forewarned him and his sons and
 daughters
That all the world should sink beneath the
 waters?"
"Yes," said the carpenter, "a long time back."
"Haven't you heard," said Nicholas, "what a
 black 455
Business it was, when Noah tried to whip
His wife (who wouldn't come) on board the ship?
He'd have been better pleased, I'll undertake,
With all that weather just about to break,
If she had had a vessel of her own. 460
Now, what are we to do? We can't postpone
The thing; it's coming soon, as I was saying,
It calls for haste, not preaching or delaying.
 "I want you, now, at once, to hurry off
And fetch a shallow tub or kneading-trough 465
For each of us, but see that they are large
And such as we can float in, like a barge.
And have them loaded with sufficient victual
To last a day—we only need a little.
The waters will abate and flow away 470
Round nine o'clock upon the following day.
Robin the lad mayn't know of this, poor knave,
Nor Jill the maid, those two I cannot save.
Don't ask me why; and even if you do
I can't disclose God's secret thoughts to you. 475
You should be satisfied, unless you're mad,
To find as great a grace as Noah had.
And I shall save your wife, you needn't doubt it,
Now off you go, and hurry up about it.
 "And when the tubs have been collected, three, 480
That's one for her and for yourself and me,
Then hang them in the roof below the thatching
That no one may discover what we're hatching.
When you have finished doing what I said
And stowed the victuals in them overhead, 485
Also an axe to hack the ropes apart,
So, when the water rises, we can start,

And, lastly, when you've broken out the gable,
The garden one that's just above the stable,
So that we may cast free without delay 490
After the mighty shower has gone away,
You'll float as merrily, I undertake,
As any lily-white duck behind her drake.
And I'll call out, 'Hey, Alison! Hey, John!
Cheer yourselves up! The flood will soon be
 gone.' 495
And you'll shout back, 'Hail, Master Nicholay!
Good morning! I can see you well. It's day!'
We shall be lords for all the rest of life
Of all the world, like Noah and his wife.
 "One thing I warn you of; it's only right. 500
We must be very careful on the night,
Once we have safely managed to embark,
To hold our tongues, to utter no remark,
No cry or call, for we must fall to prayer.
This is the Lord's dear will, so have a care. 505
 "Your wife and you must hang some way apart,
For there must be no sin before we start,
No more in longing looks than in the deed.
Those are your orders. Off with you! God speed!
To-morrow night when everyone's asleep 510
We'll all go quietly upstairs and creep
Into our tubs, awaiting Heaven's grace.
And now be off. No time to put the case
At greater length, no time to sermonize;
The proverb says, 'Say nothing, send the wise.' 515
You're wise enough, I do not have to teach you.
Go, save our lives for us, as I beseech you."
 This silly carpenter then went his way
Muttering to himself, "Alas the day!"
And told his wife in strictest secrecy. 520
She was aware, far more indeed than he,
What this quaint stratagem might have in sight,
But she pretended to be dead with fright.
"Alas!" she said. "Whatever it may cost,
Hurry and help, or we shall all be lost. 525
I am your honest, true and wedded wife,
Go, dearest husband, help to save my life!"
 How fancy throws us into perturbation!
People can die of mere imagination,
So deep is the impression one can take. 530
This silly carpenter began to quake,
Before his eyes there verily seemed to be
The floods of Noah, wallowing like the sea
And drowning Alison his honey-pet.
He wept and wailed, his features were all set 535
In grief, he sighed with many a doleful grunt.
He went and got a tub, began to hunt
For kneading-troughs, found two, and had them
 sent
Home to his house in secret; then he went
And, unbeknowns, he hung them from a rafter. 540
With his own hands he made three ladders after,
Uprights and rungs, to help them in their scheme

Of climbing where they hung upon the beam.
He victualled tub and trough, and made all snug
With bread and cheese, and ale in a large jug, 545
Enough for three of them to last the day,
And, just before completing this array,
Packed off the maid and his apprentice too
To London on a job they had to do.
And on the Monday when it drew to night 550
He shut his door and dowsed the candle-light
And made quite sure all was as it should be
And shortly, up they clambered, all the three,
Silent and separate. They began to pray
And "*Pater Noster*° mum," said Nicholay, 555
And "mum" said John, and "mum" said Alison
The carpenter's devotions being done,
He sat quite still, then fell to prayer again
And waited anxiously to hear the rain.

 The carpenter, with all the work he'd seen, 560
Fell dead asleep—round curfew, must have been,
Maybe a little later on the whole.
He groaned in sleep for travail of his soul
And snored because his head was turned awry.

 Down by their ladders, stalking from on high 565
Came Nicholas and Alison, and sped
Softly downstairs, without a word, to bed,
And where this carpenter was wont to be
The revels started and the melody.
And thus lay Nicholas and Alison 570
At busy play in eager quest of fun,
Until the bell for lauds had started ringing
And in the chancel Friars began their singing.

 This parish clerk, this amorous Absalon,
Love-stricken still and very woe-begone, 575
Upon the Monday was in company
At Osney with his friends for jollity,
And chanced to ask a resident cloisterer
What had become of John the carpenter.
The fellow drew him out of church to say, 580
"Don't know; not been at work since Saturday.
I can't say where he is; I think he went
To fetch the Abbot timber. He is sent
Often enough for timber, has to go
Out to the Grange° and ston° a day or so; 585
If not he's certainly at home to-day,
But where he is I can't exactly say."

 Absalon was a jolly lad and light
Of heart; he thought, "I'll stay awake to-night;
I'm certain that I haven't seen him stirring 590
About his door since dawn; it's safe inferring
That he's away. As I'm alive I'll go
And tap his window softly at the crow
Of cock—the sill is low-set on the wall.
I shall see Alison and tell her all 595
My love-longing, and I can hardly miss

Some favour from her, at the least a kiss.
I'll get some satisfaction anyway;
There's been an itching in my mouth all day
And that's a sign of kissing at the least. 600
And all last night I dreamt about a feast.
I think I'll go and sleep an hour or two,
Then wake and have some fun, that's what I'll do."

 The first cock crew at last, and thereupon
Up rose this jolly lover Absalon 605
In gayest clothes, garnished with that and this;
But first he chewed a grain of liquorice
To charm his breath before he combed his hair.
Under his tongue the comfit nestling there
Would make him gracious. He began to roam 610
To where old John and Alison kept home
And by the casement window took his stand.
Breast-high it stood, no higher than his hand.
He gave a cough, no more than half a sound:
"Alison, honey-comb, are you around? 615
Sweet cinnamon, my little pretty bird,
Sweetheart, wake up and say a little word!
You seldom think of me in all my woe,
I sweat for love of you wherever I go!
No wonder if I do, I pine and bleat 620
As any lambkin hungering for the teat,
Believe me, darling, I'm so deep in love
I croon with longing like a turtle-dove,
I eat as little as a girl at school."
"You go away," she answered, "you Tom-fool! 625
There's no come-up-and-kiss-me here for you.
I love another and why shouldn't I too?
Better than you, by Jesu, Absalon!
Take yourself off or I shall throw a stone.
I want to get some sleep. You go to Hell!" 630
"Alas!" said Absalon. "I knew it well;
True love is always mocked and girded at;
So kiss me, if you can't do more than that,
For Jesu's love and for the love of me!"
"And if I do, will you be off?" said she. 635
"Promise you, darling," answered Absalon.
"Get ready then; wait, I'll put something on,"
She said and then she added under breath
To Nicholas, "Hush . . . we shall laugh to death!"

 This Absalon went down upon his knees; 640
"I am a lord!" he thought, "And by degrees
There may be more to come; the plot may
 thicken."
"Mercy, my love!" he said, "Your mouth, my
 chicken!"
She flung the window open then in haste
And said, "Have done, come on, no time to
 waste, 645
The neighbours here are always on the spy."

 Absalon starting wiping his mouth dry.
Dark was the night as pitch, as black as coal,
And at the window out she put her hole,
And Absalon, so fortune framed the farce. 650

555. Our Father. 585. Farm. 585. Stay.

Put up his mouth and kissed her naked arse
Most savorously before he knew of this.

 And back he started. Something was amiss;
He knew quite well a woman has no beard,
Yet something rough and hairy had appeared. 655
"What have I done?" he said. "Can that be you?"
"Teehee!" she cried and clapped the window to.
Off went poor Absalon sadly through the dark.
"A beard! a beard!" cried Nicholas the Spark.
"God's body, that was something like a joke!" 660
And Absalon, overhearing what he spoke,
Bit on his lips and nearly threw a fit
In rage and thought, "I'll pay you back for it!"

 Who's busy rubbing, scraping at his lips
With dust, with sand, with straw, with cloth,
 with chips, 665
But Absalon? He thought, "I'll bring him down!
I wouldn't let this go for all the town.
I'd take my soul and sell it to the Devil
To be revenged upon him! I'll get level.
O God, why did I let myself be fooled?" 670
 The fiery heat of love by now had cooled,
For from the time he kissed her hinder parts
He didn't give a tinker's° curse for tarts;°
His malady was cured by this endeavour
And he defied all paramours whatever. 675

 So, weeping like a child that has been whipped,
He turned away; across the road he slipped
And called on Gervase. Gervase was a smith;
His forge was full of things for ploughing with
And he was busy sharpening a share. 680
 Absalon knocked, and with an easy air
Called, "Gervase! Open up the door, come on!"
"What's that? Who's there?" "It's me, it's
 Absalon."
"What, Absalon? By Jesu's blessed tree
You're early up! Hey, *benedicite,*° 685
What's wrong? Some jolly girl as like as not
Has coaxed you out and set you on the trot.
Blessed St Neot! You know the thing I mean."
 But Absalon, who didn't give a bean
For all his joking, offered no debate. 690
He had a good deal more upon his plate
Than Gervase knew and said, "Would it be fair
To borrow that coulter° in the chimney there,
The hot one, see it? I've a job to do;
It won't take long, I'll bring it back to you." 695
Gervase replied, "Why, if you asked for gold,
A bag of sovereigns or for wealth untold,
It should be yours, as I'm an honest smith.
But, Christ, why borrow that to do it with?"
"Let that," said Absalon, "be as it may; 700
You'll hear about it all some other day."
 He caught the coulter up—the haft was cool—

And left the smithy softly with the tool,
Crept to the little window in the wall
And coughed. He knocked and gave a little call 705
Under the window as he had before.
 Alison said, "There's someone at the door.
Who's knocking there? I'll warrant it's a thief."
"Why, no," said he, "my little flower-leaf,
It's your own Absalon, my sweety-thing! 710
Look what I've brought you—it's a golden ring
My mother gave me, as I may be saved.
It's very fine, and prettily engraved;
I'll give it to you, darling, for a kiss."
 Now Nicholas had risen for a piss, 715
And thought he could improve upon the jape
And make him kiss his arse ere he escape,
And opening the window with a jerk,
Stuck out his arse, a handsome piece of work,
Buttocks and all, as far as to the haunch. 720
 Said Absalon, all set to make a launch,
"Speak, pretty bird, I know not where thou art!"
This Nicholas at once let fly a fart
As loud as if it were a thunder-clap.
He was near blinded by the blast, poor chap, 725
But his hot iron was ready; with a thump
He smote him in the middle of the rump.
 Off went the skin a hand's-breadth round about
Where the hot coulter struck and burnt it out.
Such was the pain, he thought he must be dying 730
And, mad with agony, he started crying,
"Help! Water! Water! Help! For Heaven's love!"
 The carpenter, startled from sleep above,
And hearing shouts for water and a thud,
Thought, "Heaven help us! Here comes Nowel's°
 Flood!" 735
And up he sat and with no more ado
He took his axe and smote the ropes in two
And down went everything. He didn't stop
To sell his bread and ale, but came down flop
Upon the floor and fainted right away. 740
 Up started Alison and Nicholay
And shouted, "Help!" and "Murder!" in the
 street.
The neighbours all came running up in heat
And stood there staring at the wretched man.
He lay there fainting, pale beneath his tan; 745
His arm in falling had been broken double.
But still he was obliged to face his trouble,
For when he spoke he was at once borne down
By Nicholas and his wife. They told the town
That he was mad, there'd got into his blood 750
Some sort of nonsense about "Nowel's Flood,"
That vain imaginings and fantasy
Had made him buy the kneading-tubs, that he
Had hung them in the rafters up above
And that he'd begged them both for heaven's love 755

673. Gypsy's. 673. Whores. 685. A blessing.

693. Plow blade. 735. Noah's

To sit up in the roof for company.
 All started laughing at this lunacy
And streamed upstairs to gape and pry and poke,
And treated all his sufferings as a joke.
No matter what the carpenter asserted 760
It went for nothing, no one was converted;
With powerful oaths they swore the fellow down
And he was held for mad by all the town;
Even the learned said to one another,
"The fellow must be crazy, my dear brother." 765
So to a general laughter he succumbed
 That's how the carpenter's young wife was
 plumbed
For all the tricks his jealousy could try,
And Absalon has kissed her nether eye
And Nicholas is branded on the bum. 770
And God bring all of us to Kingdom Come.

QUESTIONS

1. How do you react to "The Miller's Tale"? Does it have appeal for modern readers?
2. How deeply do you become involved with each of the characters? Is it necessary to remain detached from them? Why or why not?
3. Are these characters more or less realistic than those in earlier medieval literature, such as *The Play of Daniel*?
4. What impact does Chaucer's Christianity have on his comedy?
5. Compare the expressions of love in this tale with those in "Equitan" and *Tristan*. What justification can you find for the interpretation that this tale represents a parody of courtly love?

Summary Questions

1. Describe the tendencies in the medieval adoration of the Virgin Mary and how these are manifested in literature and art.
2. Define *courtly love*. What influenced its development?
3. Who were the troubadours and the trobairitz?
4. In what ways does Bernart de Ventadorn's music reinforce his lyrics?
5. Define *romance* and give an example.
6. Summarize Dante Alighieri's views of the proper roles of church and state.
7. Give examples of how *contrapasso* functions in the relationship between sin and punishment in the *Inferno*.
8. How did Dante's love for Beatrice influence the conception of the *Divine Comedy*?
9. In what respect does "The Miller's Tale" offer a comic view of idealized love?

Key Terms

musical phrase

barform

troubadour poetry

romance

sonnet

Holy Roman Empire

canticle

canto

hell, purgatory, paradise

Medieval Cultures

Intellectual Life and Religion

All three religions, Judaism, Christianity, and Islam, shared many of the same theological problems. If God is all-powerful, for example, how is the believer to understand the existence of evil in this world? Do people possess free will or is their destiny determined by God? In exploring such questions posed regarding their faith, all three medieval cultures, that of Islam, Byzantium, and western Europe, sought answers in Greek and Roman philosophical writings. Although many Muslim religious scholars rejected a rational approach to such questions, their explorations did serve to preserve the manuscripts for the benefit of western Europe. Generally more receptive to Greco-Roman philosophy, the Byzantines likewise played a crucial role in transmitting ancient philosophy to the Europeans.

Spiritual and Temporal Power

The Middle Ages witnessed the growth of two spheres of allegiance for every western European, the spiritual and the temporal. In his great synthesis of medieval thought, Dante outlined the proper sphere of each.

In the twelfth and thirteenth centuries, our focus of attention here, the Church claimed the right to act as the conscience of Christian rulers and their subjects, to determine proper Christian belief, and to judge offenses against the faith. While allowing discussion within broad limits, the Church permitted no questioning of basic doctrines. As it was, few had any desire to do so. Temporal rulers were advised not to interfere in matters of belief and morals and to support the judgment of the spiritual authority in such cases.

By the end of the thirteenth century, Church efforts to intervene in secular matters became so frequent that some thinkers reacted by insisting that the Church's domain was limited to religion proper and that civil morality, the dealings of people with one an-

other, was in the control of secular rulers. Underlying this distinction was a new, more positive view of human existence on earth. Dante even dared speak of a "terrestrial beatitude."

This kind of distinction between spiritual and temporal was never clearly established in either Byzantine or medieval Islamic culture. The general subjection of the patriarch of Constantinople to the emperor prevented the former from clearly carving out a sphere of jurisdiction for himself into which the emperor could not intrude. In Islam, as in Judaism, religious law was so specific that it pervaded, at least in theory, most aspects of human life. Secular concerns certainly existed, but the dominance of the religious was rarely questioned in public.

In western Europe, moreover, recognition of a certain area of consciousness as off limits to temporal powers survived in later centuries, even after the Reformation, when religious authorities were no longer able to exercise close control over it. In the eighteenth and nineteenth centuries, thinkers came to define this spiritual sphere as within the province of the individual conscience and independent of the constraints of government action. Although the Reformation itself had, as we will see, a great deal of influence on this evolution, the origins of this demand for freedom of individual conscience really lie in the Church's medieval struggle to demarcate its sphere of authority.

Monarchy and the Modern State

By the twelfth and thirteenth centuries a new form of temporal power, the medieval monarchy, had developed; it was to serve as the basis for our modern state. There were essentially two kinds of states in the ancient period—the small, tightly knit city-state and the sprawling empire that controlled a variety of separate peoples by means of a relatively small elite. To expand as the city-states Athens and Rome had done was to

become an empire, because the city-state had no means of integrating the new populations into its intensive political life. Thus it had to govern subject peoples with a corps of officials sent out from the mother city.

To the end of its existence the Byzantine state remained closely tied to the ancient Roman imperial ideal and the model of the autocratic Christian emperor represented by Constantine. While also an empire, medieval Islam was never able to establish a lasting form of government for its vast territories. The authority of the caliph as the ruler of the Muslim world was undermined by the vast extent of the realm and by the power of the military. The caliph became no more than a symbol of Muslim unity, whereas military commanders assumed the title of sultan, a term resonating with connotations of armed force.

The medieval European monarchy, on the other hand, was both larger than the city-state and more cohesive than the empire. Closely tied to the rise of the monarch's power was the development of representative institutions both at the local level and at the center, ultimately making subjects feel part of a greater whole. When a new area was incorporated into the country, *its* population too became involved in the political processes, and a sense of common identity arose. Using this sense of identity, the monarch could mobilize a far greater population than could the rulers of the city-state, demanding a greater degree of loyalty from them than could the emperor. In the centuries since the Middle Ages the supreme executive has become at least nominally an elected official; the European medieval monarchy with its representative element has served as the ancestor for the modern state adopted throughout the world.

Germanic Contributions

We have not emphasized the Germanic or "barbarian" contributions to our cultural roots, but we have at least mentioned their importance in the formation of medieval western European civilization. The personal sense of loyalty to the lord and the lord's responsibility to his people were essential ingredients in the rise of the medieval monarchy. The ruler could expect obedience, but the follower would normally be consulted in the decision-making process. Together with principles of Roman law, Germanic custom limited the ruler's freedom of action and encouraged cooperation with larger and larger groups of subjects in order to extend the operations and influence of the state.

Spiritual Centers

The great Byzantine churches, the Islamic mosques, and the medieval European cathedrals all represent centers not only of faith and religious ritual but also of the arts. Artisans, painters, craftspeople, builders, and architects worked under the patronage of their respective institutions to create a vocabulary of form and expression that met the needs of their culture and their faith. The contributions most characteristic of Byzantine Christianity are the Greek cross plan in architecture, the gold mosaic, and the icon. A highly formal and symbolic, rather than a naturalistic, style emphasized the predominance of the spiritual over the temporal. In spite of this, veneration of icons, or pictures of Christ or the saints, caused the iconoclasts to feel that believers were too attached to material objects and incited a century-long controversy. Saint Mark's Cathedral in Venice and the astounding mosaics in the churches of Ravenna attest to the influence of Byzantine art in Europe. Like Byzantine art, the literature of Byzantium shows a preference for the symbolic over the realistic. It also evokes another characteristic of this culture: a reverence for the classical Greek past that both reinforced and stood in conflict with the Christian present. Byzantium, it is important to remember, served as the transmitter of classical Greek culture to western Europe.

Like the vast Byzantine churches such as Hagia Sophia, great mosques such as the one in Cordoba, Spain, suggest by the magnificence of their architecture and decoration, along with the use of light, the presence of the world beyond in this one. Two developments characteristic of Islamic architecture—the pointed dome and the pointed arch—contribute to the sense of expansion and infinity. Since Muslim belief has tended to frown on the use of human figures in art, abstract symmetrical patterns drawn from floral, animal, and geometric forms tended to dominate decoration in mosques and palaces. In Europe, these became known as *arabesques*. These forms, along with the intricate Muslim calligraphy, finely woven textiles, ceramics, and other arts, were widely diffused in Europe and influenced European styles. Tales such as those in *The Thousand and One Nights* and other stories and poems of chivalry came to be widely read in Europe. Again, the presence of monuments such as the Great Mosque of Cordoba and the Alhambra palace testify to the impact of Islam on the West.

As the power of the Byzantine Empire waned and the Islamic empire withdrew from Europe, medieval Christianity established a cultural hegemony. Because it was such an important center for medieval life in

western Europe, we have focused much attention on the cathedral. We looked at four cultural forms related to it: the schools and the philosophy taught there; the Gothic architecture, sculpture, stained-glass painting, and theory behind them; the music performed at worship services; and the adoration of the Virgin Mary, to whom the cathedrals were dedicated. We have also seen that drama, undeveloped since classical antiquity and banned by the Church, was reborn within the mass.

The art and thought in and around the cathedral show an extraordinary diversity and creativity and a love of elaboration quite different from the simplicity and restraint of classical art and thought. Three of the great systems of the European Middle Ages—the philosophy of Thomas Aquinas, Chartres Cathedral, and Dante Alighieri's *Divine Comedy*—seem to encompass everything in this world and the next in their province, while organizing each edifice so that the whole is directed toward God. The belief that the sensual and intellectual realms of being can serve as steps into the spiritual realm is at the heart of all three of these systems. This belief also explains the medieval love of *symbolism, allegory,* and suggestion. Modern art forms owe much to their medieval predecessors, both in their use of symbols (that is, the suggestion of "another world" through physical reality) and in their use of form to express feeling. The neoclassicists of the eighteenth century thought the distorted sculptures on medieval cathedrals much inferior to the naturalistic, proportioned Greek and Roman ones. In the twentieth century we are well aware that apparent distortion is one means of expression.

"Gothic" was a disparaging term given by the neoclassicists to medieval architecture. But the nineteenth century rediscovered its beauty to such an extent that the United States, like other Western countries, became dotted with neo-Gothic churches, cathedrals, and university buildings. Today, when most people think of a religious edifice, they think of some form of Gothic style. Our universities, not only those with neo-Gothic architecture, stand as testimonies that the roots in the cathedral schools have flourished.

Medieval and Modern Music

The vocal and instrumental music composed in the monasteries and cathedral schools was the first truly Western music. Much of it is still used in religious services today; the great musical invention of medieval Europe, *polyphony,* is not only the basis of all modern music but also the feature distinguishing Western music from all other forms. Outside the Church, polyphonic music—music sung or played in more than one part—accompanied dance and provided intellectual recreation. In addition, secular poems in Latin and the vernacular languages as well were set to this new kind of music. The *motet*—music with words—could even be used to set satirical French poetry that made fun of both the Church and the political powers of the day. Although legend labels Gregorian chant as the gift of God to man, history records polyphony as a human creation. *The Play of Daniel* and the *Machaut Mass of Our Lady* illustrate the marriage of music and words within a sacred context; *Garrit Gallus* by Philippe de Vitry and *Fumeux fume* by Solage are secular entertainment for wealthy intellectuals.

Views of Women

The adoration of the Virgin Mary, a major element in medieval art and life and in Catholicism, has profoundly influenced our society's conception of women. We have seen how the Virgin was represented in twelfth- and thirteenth-century literature and art as a divine mother, an object of the highest form of spiritual love, an intercessor between humanity and God. Dante's Beatrice, transfigured from earthly object of adoration to spiritual symbol, serves a similar function. The literature of courtly love, in the centuries preceding the *Divine Comedy,* exalts the beloved and explores both the ennobling and the destructive effects of illicit love.

Some of the gestures that stem from the courtly or chivalric tradition—men opening doors for women, holding out chairs for them, paying for their entertainment on dates—are still with us. So are some of our notions about romantic love. The idea that passion could be an ennobling and spiritual, as well as a merely physical, experience also helped to raise the position of women in European society.

Transition to the Renaissance

Although in the hierarchical vision of his great epic Dante faithfully reflected the integrated vision of the medieval universe and in his elaborate allegories captured the age's sense of its profound mysteries, he drew his realistic description of many of the figures in his drama not from the culture of the cathedral or the court but from that of the city's marketplace. Whereas in Beatrice he elevated the ideal of spiritual love far beyond what it was in the work of the troubadour, the

personalities he encountered on his journey to the depths of hell and his ascent through purgatory are men and women of flesh and blood.

Chaucer's tales remind us even more that medieval men and women were full, real people who enjoyed a good laugh and that courtly love viewed in a more earthly way could be an object of comedy. By Chaucer's time, the period we call medieval was also drawing to a close in the north. The fleshed-out characters in his stories mark the transition there as well to a more realistic, less symbolic vision of humanity and the universe.

Part IV

- The Western African
 Cultural Root

12 African Backgrounds

CENTRAL ISSUES

- Principal stages of African history from earliest times to the present
- Key features of social and political organization in early and medieval Africa
- The impact of the four-hundred-year-long period of the transatlantic trade on Africa
- Comparison of the descriptions of Benin from indigenous accounts, both literary and sculptural, with those of European visitors
- Benin's contribution to world art as seen in its metal sculptures

As you saw in Chapters 1 and 2, the ancient civilizations of Mesopotamia and Egypt in the Nile valley gave rise to the world's earliest centralized states and cities. Texts from the dawn of history recount their trade and wars with one another. Ideas, religions, and technology flowed in multiple directions forming the ancient core of human achievement that preceded classical Greece and Rome. As we begin to examine the cultures of Africa when the histories of Africa, Europe, and the Americas become irrevocably entwined, it is useful to recall that one of the most ancient roots of Western civilization, as well as of our modern American one, was African.

The cultures of western Europe and those of Africa began to mingle and to affect each other during the fifteenth century. Since that time, and particularly with the beginning of the transatlantic slave trade, European, American, and

African civilizations have been inextricably intertwined. Our introduction of Africa into the humanities at this point anticipates the European age of exploration and expansion in the Renaissance, to be discussed in Volume Two, and the subsequent interaction of these cultures over a five-hundred-year period.

Africa has influenced the West economically, as well as in the social and cultural realms. Profits from trade with Africa contributed to the development of northern Europe leading to the Industrial Revolution. Subsequently, the pursuit of markets for the goods produced by this revolution was an important economic motivation for the partition of Africa and the onset of colonial rule in the late nineteenth century. Patterns of economic relationships stimulated by colonialism, wherein Africa continued to provide raw materials or primary agricultural products to the industrialized West, remained little changed by the fact of independence for most of the African states. Among the greatest challenges African leaders faced in the waning decades of the twentieth century was the intractable nature of their countries' unfavorable economic relationships with the industrialized world.

Images of Africa in the West

As Europe and America passed through the Enlightenment and into the age of democracy and nationalism, Africa remained a persistent symbol of "the other," of a civilization founded on principles of thought and religious behavior that were perceived to be fundamentally different from those of the West. The "noble savage" of the eighteenth century became the "primitive savage" at the bottom of the evolutionary ladder in the annals of social Darwinist thought. Social and religious movements springing from the latter spurred intense efforts to Christianize and to "civilize" Africans in the twentieth century. In America, it underlay missionary appeals and the Tarzan image, which, no longer as powerful as it once was, continued to influence American images of Africa well beyond the mid-twentieth century. Europeans and Americans involved in the effort to "tame" Africans, to make them more like themselves, often succumbed to the "heart of darkness" as it appears in the novel of that title by Joseph Conrad and in the works of others such as Graham Greene. This image, a creation of the European mind, was rarely informed by substantive knowledge or the capacity to accept the legitimacy of different civilizations. Nevertheless, the idea of Africa and the African exercised a significant cultural influence on Western art and thought and will appear as a theme in Volume Two of this book.

Africa and America

Perhaps more relevant to our purposes here is the direct role that Africa has played in the formation of American culture. Between the sixteenth and nineteenth centuries, more Africans came to the Americas than did people of other lands. Although the African slaves were put under great pressure to forget all aspects of their own, very diverse cultures, an amazing number of their customs were able to survive. The term "African survivals" refers to elements of African culture that African Americans retained and transformed in the New World. We will look closely at them (and their impact on the whole of American culture) at the end of this section and again in the chapter on African American culture in Volume Two. Let us turn now to the study of Africa itself, both before and after the crucial contact with the West.

The continent of Africa is so large—and so diverse in its geographical, racial, linguistic, and cultural aspects—that it is almost impossible to speak of it generally, as a whole. Although we will need to make some remarks about the entire continent, we will concentrate primarily on the area that was the homeland of most Africans sent to the New World: the western coast ranging from twenty degrees north to twenty degrees south of the equator and extending up to one thousand miles inland—roughly the areas comprising the coastline and the drainage basins of the two great rivers, the Niger and Congo (see map). We will look briefly at some important points in the history of this area, particularly the great empires that flourished around the time of the Renaissance in Europe. Our focus will be on indigenous arts, values, and systems of thought in the cultures of a few West African peoples. Formerly called "traditional" in opposition to "modern" African, indigenous values and aesthetic preferences have transformed themselves in response to historical experience without relinquishing their core. It is important to bear in mind that the concept of time in traditional African cultures is different from that in the West. Western art and thought, beginning with the Greeks, has been characterized by rapid change and a sense of evolution through time. African religions tend to emphasize the circularity, rather than the linearity, of time, and African artists put more value on community and tradition than on individuality and change. Thus, when we talk about a Yoruba style, we will not be particularly concerned with whether the work dates from the eighteenth or the twentieth century. In the case of oral poetry and tales, the dates of origin are usually not known. In the case of early African history, however, we will be interested in attempting to establish the times when the great civilizations flourished.

Stages in African History

The systematic exploration of Africa by Europeans began in the fifteenth century. Europe has been in contact for hundreds of years with the north coast of Africa and in the fourteenth century had undertaken colonization of the Canary Islands off the mainland. But in the middle decades of the fifteenth century, under the sponsorship of Prince Henry the Navigator (1394–1460), son

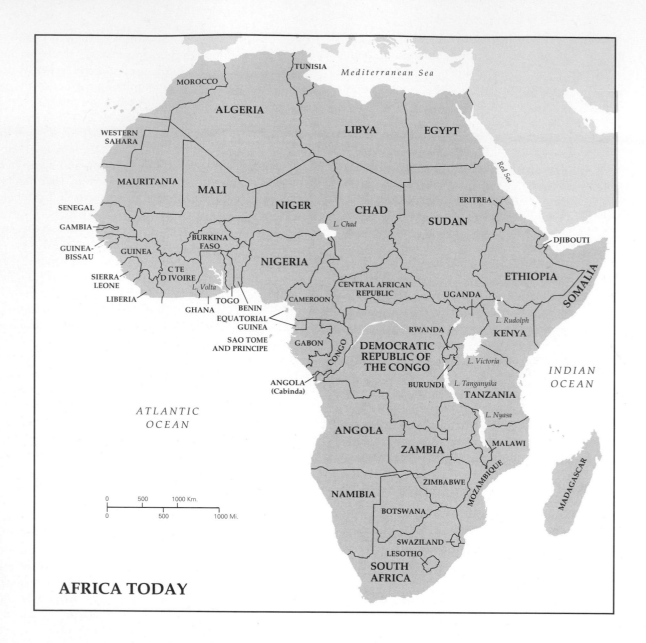

AFRICA TODAY

of John I of Portugal, a succession of ambitious expeditions was undertaken. By the time of the prince's death, Europe's knowledge of Africa extended far down the Guinea coast. By 1497 Vasco da Gama had successfully rounded the Cape of Good Hope, traveled up the east African coast, and made his way to Calicut on the west coast of India. His safe return to Lisbon in September 1499 marked the establishment of a sea route to the East, ushering in a major era in the history of Europe's relationship with Africa and Asia. Because of the significance of the European contact, the history of Africa for our purposes is divided into two periods, with the fifteenth century as the point of demarcation.

Early Africa

The sources of knowledge of African history before the late fifteenth century are various. Most written evidence

comes from travelers' accounts—primarily by Arabs who regularly traded with sub-Saharan peoples in West Africa and along the eastern coast of the continent. Few African peoples used writing, but a good deal is known from oral traditions transferred from generation to generation by specialists entrusted with preserving the history of their people. Studies of these traditions have shown that they may contain biases and time distortions because of the social and political function they have in a society at a given time. But they are also likely to contain factual details, from the recent and sometimes from the remote past, that have been retained because of their importance. Scholars have now developed techniques for analyzing oral traditions more sophisticated than those available in the past. Coupled with the conclusions of modern research in archaeology, anthropology, botany, and linguistics, these written and oral accounts have enabled historians in recent years to es-

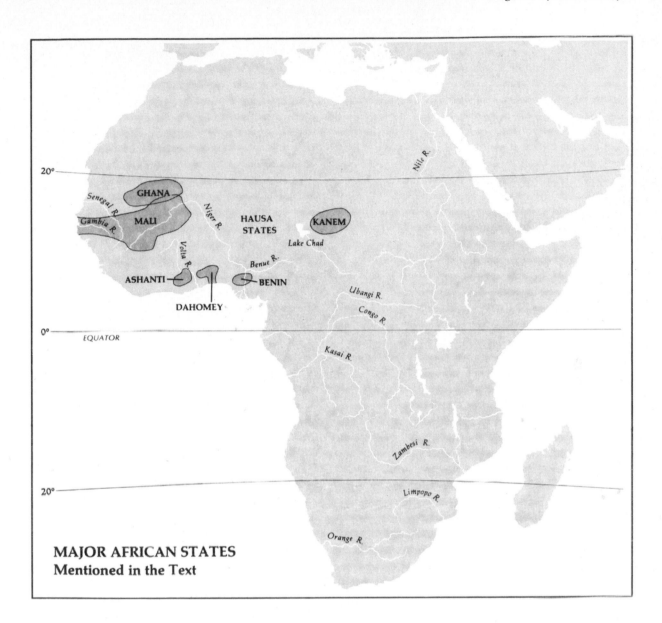

MAJOR AFRICAN STATES
Mentioned in the Text

tablish the outlines of Africa's history before the fifteenth century.

For most archaeologists Africa is the cradle of humankind, although the relationship between the early forms of humanity discovered in the Olduvai Gorge in Kenya and the peopling of the continents remains an unsolved question. On the African continent itself human society in the course of its development evolved an incredible array of cultures characterized by divergent languages and beliefs, a wide range of technological levels, and many political and social organizations.

The varying development of Africa's people is closely related to the vast diversity of ecological settings found on the continent. The major areas include North Africa, dominated by the Sahara in the west; the Nile valley; the savannah grasslands of eastern, central, and southern Africa; and the tropical rain forest of the West African coast and Congo River valley regions. The challenges of these different environments—their climates,

soils, flora, and fauna—have influenced the population growth and the choices of economic, social, and political organization of Africa's peoples.

Stone Age groupings, characterized by hunting and gathering economies and small-scale bands as the principle of social organization, were the earliest form of society in evolutionary terms. The next major stage in human development, known as the Neolithic Revolution, led to the systematic cultivation of grains and root crops and the domestication of animals. The significance of the Neolithic period lay in the creation of stable and sometimes surplus food supplies, which enabled the population to expand.

The lower Nile valley, where seasonal flooding inundated the nearby plains, was among the first Neolithic sites in Africa. Developing between the third and fourth millennia B.C., as we saw in Chapter 2, it nurtured the flowering of ancient Egypt. Spontaneous domestication of grains occurred in West Africa around

the same time. The cultivation of crops such as the yam and the banana, introduced through ancient contacts between Malaysian peoples and those of the southeastern coast of Africa, spread to the rain forest areas of central and western Africa by the beginning of the Christian era.

In northern and western Africa pastoralism, often accompanied by nomadic forms of social organization, emerged in ancient times in the grasslands and the steppe areas, where agriculture was marginally successful because of precarious rainfall. Agricultural and pastoral groups tended to be distinct, and relationships between sedentary farming and fishing communities and the pastoralists were a major factor in historical developments over the centuries for this area of Africa. Down the eastern half of the continent, however, techniques of agriculture and herding spread side by side within the same groups, and patterns of mixed farming evolved.

These stages in the development of African society can be dated only in the most general terms for most of the continent. With the introduction of metals, however, a more precise chronology of events is possible. The manufacture of metals meant more effective instruments for cultivating fields and better weapons. Greater production of food entailed population growth, and the military superiority of an army equipped with metal arms led to conquest and the creation of larger political organizations. Cities arose as political, religious, and economic centers; they were embellished with important buildings and a wealth of art objects.

Archaeology tells us that ironworking spread to sub-Saharan Africa through two principal routes: from Egypt up the Nile valley to Meroe and from Mediterranean trade to the Maghreb across the Sahara to West Africa. By the seventh or sixth century B.C., iron was being manufactured at Meroe. By the second century B.C., trade routes served as the medium for spreading the techniques of metal making as far as western Nigeria. Recent discoveries in the area north of the juncture of the Niger and the Benue rivers indicate that between 200 B.C. and A.D. 200 a rich civilization, referred to as Nok, dominated an area three hundred miles long in this river valley. Clay heads of animals and human beings, some of them going back as far as the ninth century B.C., testify to the artistic originality of the Nok peoples (Fig. 12-1).

Together with the Neolithic advances in the forested area, the production of iron triggered what is now referred to as the Bantu expansion. In the area of the Cameroon and western Nigeria agricultural, fishing, and ironworking peoples expanding in population and equipped with superior weapons spread out from their homeland toward the south and east, conquering or expelling the resident hunting and gathering peoples. Although the process endured for more than a thousand

12-1 *A Nok culture head with a fragment of an arm holding an object on the head. Originated from Nigeria, c. 500 B.C.–A.D. 200. Jemaa, Northern Nigeria. National Museum, Jos, Nigeria. (Werner Forman/Art Resource, NY)*

years, modern linguistic studies of peoples speaking Bantu languages show that gradually the Bantu speakers gained domination of the whole of central and southern Africa. Although each of the African peoples has its own language, they are all descended from Africans whose languages (like those of the Bantu speakers) ultimately derived from a common ancestral stock.

The secret of iron manufacture was only one of the items involved in African trade before the first century B.C. Trade between non-African peoples—Indians, Persians, and Arabs—and Africans along the eastern coast of the continent flourished in this period. At the same time Phoenician trading colonies in North Africa, centuries before the Roman conquest of this region, were active in exploring the Saharan oases and initiating commercial links with them. After the rapid spread of Islam across North Africa in the seventh century A.D., Arabs and Berber-speaking North Africans were the principal merchants engaging in trade with sub-Saharan

Africa. Along the West African coast, Niger Delta peoples also traded in seagoing vessels with others as far west as modern-day Ghana. In the interior, cycles of regional markets extended the frontiers of contact, permitting the exchange of agricultural, craft, and some exotic products. Barter techniques—the exchange of one item for another—were widespread, but so were currencies. Some of the latter included cowrie shells, iron bars, salt, cloth, and gold. Such patterns of long-distance trade suggest the existence of other kinds of highly developed crafts in leather goods, iron implements, and cloth products.

Increasing complexity of social and political organization accompanied economic specialization. Complementarity of roles evolved between men and women as well as between whole subgroups within a given society. In contrast to the patterns of most Western societies, African women dominated agricultural production of subsistence economies. Men sometimes assisted in the preparation of fields for cultivation, but their main responsibilities lay in hunting and in the defense of their communities. Both men and women engaged in trade, although men tended to specialize in long-distance trade, including that with the Europeans when it began. These separate and complementary economic activities were buttressed by patterns of social organization sharply delineating men's and women's roles. In some societies descent was matrilineal; that is, inheritance of goods, access to land, and group leadership passed to children through women. In these societies women themselves, while still under the daily dominance of men, had greater control over their own lives than did those in patrilineal societies.

Other kinds of social distinctions existed in addition to that between men and women. A few societies already had slavery, but the onset of the transatlantic slave trade would expand its institutionalization in African societies of the west coast. Some groups, often those with specialist knowledge of ironworking or traditional medicines, operated as distinct castes: their members married only within the group and were set apart by special rules of dress, residence, and religious taboos that regulated their relationships with others. Such groups often occupied critical political and religious roles within the larger society.

Diversity in forms of political organization also characterized African societies. Two poles of political organization have traditionally been identified: "stateless societies" and state systems. Any one society, however, might lie at a point somewhere along the continuum between these two poles. "Stateless societies" were characterized by the predominance of kinship—family, lineage, and clan—as the basis of political organization. The units within which peoples interacted tended to be relatively small. There was little concentration of authority in the hands of any one person or group, spontaneous leadership emerging as the need arose. Residence patterns in "stateless societies" ranged from dispersed family homesteads to compact villages, but an important feature of such units was the equivalence of power between them; no one group could enforce its rules on another. There were some social institutions in "stateless societies" that extended across village boundaries. Age-group, religious, and initiation societies frequently were shared by others speaking the same language and sometimes by outsiders as well. The art and ideologies of ritual surrounding such organizations provided the potential for cultural unity of widely divergent groups despite the restricted range of political authority.

At the other extreme from the stateless societies lay the states characterized by a high degree of centralization of large territories; elaborate palace and government offices functioning in a wide range of economic and political tasks; court systems with constitutional and religious authorization to enforce their decisions; complex military organization; and close association between ritual and political authority, most often focused on the king.

We saw in Chapter 1 the complex of factors that archaeology has shown to be associated with the rise of states. For West Africa, the control of iron metallurgy and the sources of other minerals, a highly developed regional trade at the borderlands between savannah and rain forest, or savannah and desert, plus increased population were critical factors in the rise of states.

The Great Medieval Kingdoms

Ghana The ancient empire of Ghana (700–1230) owed its rise to its control of the gold supply so vital to Muslim merchants engaged in the trans-Saharan trade between Morocco and the far western Sudan. Although its kings and citizenry in the early days of the empire were not Muslim themselves, the kings worked closely with the Arab merchant community. They came to adopt techniques of trade and administration, facilitated by literacy in Arabic learned through contacts with the Muslim strangers. Trans-Saharan trade and Islam spurred the emergence of other West African states like Kanem, the Hausa states, and the greatest of the successor states to Ghana, Mali. We will discuss the Mali empire in connection with the epic *Sundiata* in the next chapter.

Benin One of the first African states to engage in trade with the Europeans was Benin, centered in the forested area just north of the Niger Delta, beyond the influence of the trans-Saharan trade and Islam. Historians believe that sometime in the tenth century, people from the kingdom of Ife to the northwest merged with those of the forested area. Ife itself reached the height of

its power in the following centuries. Benin traditions claim that the founder of the major dynasty of Benin kings was Oranmiyan, the son of Oduduwa, ruler of the Ife.

After a time of troubles, the peoples of Benin had sent messages to Oduduwa requesting that he send a wise prince to rule them. After some time Oranmiyan, accompanied by courtiers and a medical specialist, settled in a palace at a place called Usama. He married a beautiful woman named Erinwinde, who gave birth to a son. Oranmiyan, as the traditions state, did not remain in Benin long; having established proper government, he resigned, saying that only a son of the land could rule such a troublesome people, and returned to Ife. His son by Erinwinde, named Eweka, was chosen by Oranmiyan to succeed him; and, at the time of Eweka's coronation, royal regalia and other symbols of office were sent by his father from Ife. Ruling many years, Eweka I strengthened the kingdom and probably began to extend Benin's influence over other peoples by settling colonies of his relatives and officers among them. Although Benin was probably never subject to Ife's political authority, the ancient city's spiritual authority is clear: the kings of Benin adopted the title *oba* from Ife. They also adopted Ife's technique of brass and bronze casting (Fig. 12-2).

Art in Benin The Benin bronzes, illustrated in Figures 12-3 through 12-7, are among the masterpieces of African art. The masks, heads, and plaques, reflecting prominent royal figures and scenes of the court, were closely associated with kingship and its rituals. For example, in Figure 12-7 can be seen the elaborate details of royal costume and paraphernalia, as well as the supreme power of the king in comparison to his subjects and servants (reflected in their relative degrees of prominence and position in the composition). Scenes of court life, including foreign visitors, were also portrayed, as illustrated by the figures of the merchant and the European soldier. These plaques were deliberate pictorial records of important events in Benin history. The naturalism of Benin art, derived from its Ife heritage, and its representation of historical scenes set it apart from other examples of traditional art.

Creation of the bronzes was the sole preserve of craftsmen appointed by the king. They were made by a technique called the *cire perdu* or "lost wax" method. Over a solid clay core a fine layer of wax was pressed and then carved in intricate detail. The wax layer was then encased in another clay mold provided with core holes for the wax to drain out when the entire piece was heated. Molten metal was poured into the open space between the inner core and outer layer of the mold. Finally, after cooling, the clay molds would be broken away, revealing the bronze object ready for fine sanding and polishing. The delicate details and regal simplicity of earlier Benin bronzes gave way in the late seventeenth and eighteenth centuries to heavier, more elaborate, but still naturalistic objects. Some scholars believe that this apparent coarsening of the Benin style can be attributed to the surplus of casting metals acquired in greater abundance through the European trade.

At the apogee of its power and influence in the sixteenth and seventeenth centuries, Benin held authority over land and peoples in a triangle whose borders went deep into the delta in the east and as far as modern-day Benin (Dahomey) in the west.

12-2 *Left: Head of an Ife king (Oni), made using the lost-wax method of bronze casting. British Museum, London. (Werner Forman/Art Resource, NY). Right: Ancient Ife mask from Wunmonijie, "Obalufon," bronze. (Reproduced by Courtesy of the Trustees of the British Museum)*

12-3 *Commemorative head, Nigeria (Court of Benin), sixteenth century, bronze, height 9¼". (The Michael C. Rockefeller Memorial Collection, The Metropolitan Museum of Art, bequest of Nelson A. Rockefeller, 1979.206.86)*

12-4 *Queen mother of Benin, sixteenth century, bronze. (Reproduced by Courtesy of the Trustees of the British Museum)*

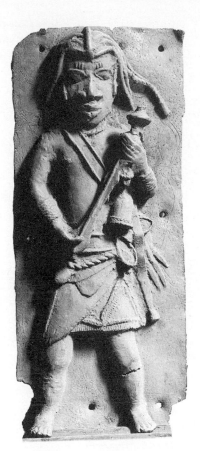

12-5 *European soldier with crossbow and ammunition, Benin bronze plaque. (Reproduced by Courtesy of the Trustees of the British Museum)*

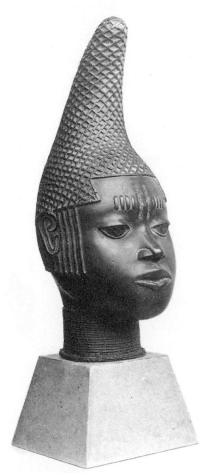

Benin and Europe From the 1480s, Portuguese explorers and merchants developed cultural, political, and commercial ties with Benin. Christian missionaries visited the kingdom, and obas sent representatives to Portugal and Rome. The obas of Benin also used the Portuguese as allies in their military campaigns during the early sixteenth century. Trade in pepper, a spice Europeans used to preserve food, preceded the transatlantic commerce. In succeeding centuries, other Europeans besides the Portuguese visited Benin, notably the Dutch and English. William Hawkins first came to Benin in 1530. Thomas Windham in 1553 found that the king, "a Blacke moore," could easily converse in Portuguese. However, since the trading nations found more profitable sources of slaves elsewhere in Africa, Benin's direct contact with the Europeans diminished. The principal causes for the kingdom's decline remain unclear. It seems certain, however, that the transatlantic slave trade engendered economic, political, and military rivals in Dahomey and Oyo in the seventeenth and eighteenth centuries. The monarchy at Benin nevertheless remained intact until the beginning of the

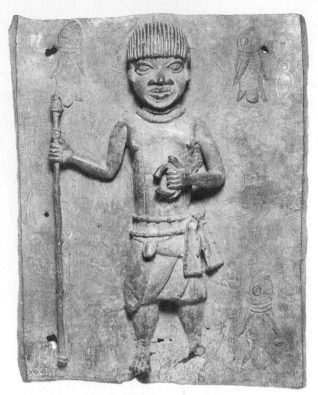

12-6 *Master merchant, Benin bronze plaque, early seventeenth century. (Reproduced by Courtesy of the Trustees of the British Museum)*

colonial era. It continues today as an important spiritual and cultural force in Nigeria.

Africa Since Contact with Europe

African history since the initial era of European contact in the fifteenth century has been one of uneven change and growth. The capture of slaves, exchange of trade goods, and arrival of Christian missionaries constituted significant elements of Africa's experience with Europe from the earliest contacts with the Portuguese from the mid-fifteenth century onward. They remained enduring themes through five hundred years of interaction dominated by the transatlantic slave trade, colonialism, and the legacies of these two eras.

The Slave Trade After the establishment of plantation agriculture in the Americas and the decimation of Native American peoples through disease and warfare, West Africans became highly sought as laborers for New World ventures. They knew Atlantic waters and tropical agriculture. They were also less vulnerable than Native Americans to the diseases of contact. Captured in raids or wars, sold as criminals or debtors, some ten to fifteen million Africans migrated to the New World

in bondage between the 1440s and the 1880s. The Atlantic system, as it came to be known, was a complex long-distance trade system between Africa, the Americas, and Europe. It did not affect all parts of the continent, nor, with some exceptions, did it dominate political and economic life of even those African societies involved throughout the entire four hundred-year period (see maps). Rather, the slave trade expanded and contracted depending on market forces in the New World, as well as on political conditions in Africa and the degree of European meddling in African affairs. Benin did not export slaves much after the 1520s. Dahomeyan kings tried to abolish the slave trade in the early eighteenth century, but by the end of the century the trade drove Dahomeyan economic and political decision making to an unprecedented degree. The parts of Central Africa that are now The Democratic Republic of the Congo and Angola suffered more upheaval than any other African region. The enduring pressures of successive European powers were intensified by direct interventions of European missionaries and military forces in the political life of those areas. The consequences of the transatlantic slave trade were enormous for the Americas and are familiar to Western readers. The consequences of the trade were at least equally momentous for Africa. Recent studies of African demographic history suggest that the loss of life in Africa and

12-7 *The oba and his assistants, bronze plaque, seventeenth century. (Reproduced by Courtesy of the Trustees of the British Museum)* **(W)**

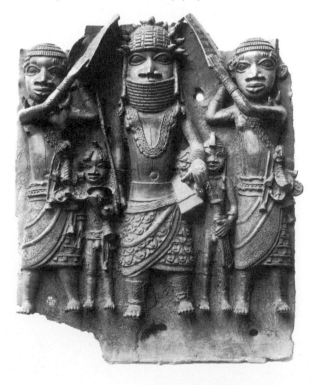

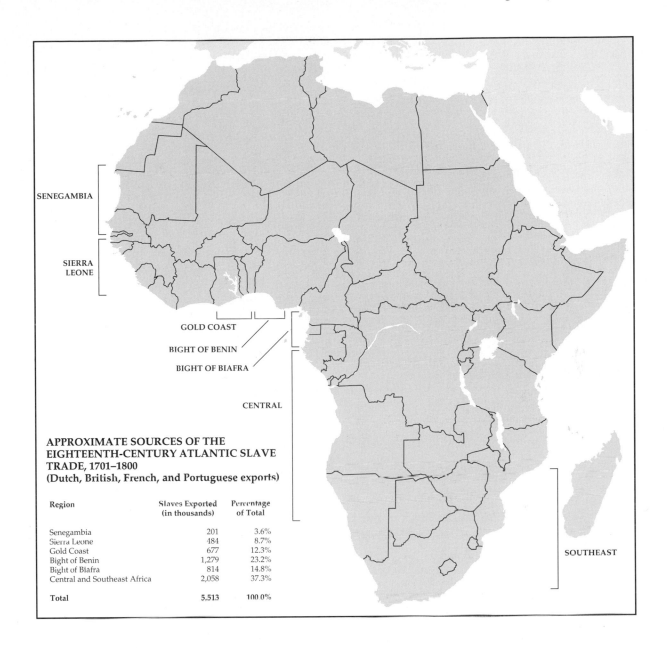

APPROXIMATE SOURCES OF THE EIGHTEENTH-CENTURY ATLANTIC SLAVE TRADE, 1701–1800
(Dutch, British, French, and Portuguese exports)

Region	Slaves Exported (in thousands)	Percentage of Total
Senegambia	201	3.6%
Sierra Leone	484	8.7%
Gold Coast	677	12.3%
Bight of Benin	1,279	23.2%
Bight of Biafra	814	14.8%
Central and Southeast Africa	2,058	37.3%
Total	5,513	100.0%

abroad in the transatlantic slave trade decreased by half what the continent's population in the mid-nineteenth century would have been without the trade. Kingdoms rose and fell, imported consumer goods replaced those of traditional manufacture, and the moral and social fabric was transformed by the loss of millions of individuals during their most productive years.

Colonialism The industrial growth and the religious and social ideologies that led to abolition of the slave trade in England and the United States by 1807 fashioned patterns of Western interaction with Africa during the nineteenth century that still emphasized commerce and religion. Africans quickly developed cash crop agriculture to meet the industrial world's demands for raw materials. Christian missionaries established stations and trained catechists. Medical, scientific, and technological discoveries enabled Europeans to explore and expand commerce to the interior of the continent. These developments became powerful economic and political forces that moved European countries to partition Africa in the late nineteenth century and to impose colonial rule. Even African peoples previously unaffected by Europe were now brought face to face with the West. Subjugated to the goals and needs of the colonial powers, African societies experienced much more intensive alteration of their political, economic, and social systems than in previous centuries. The science and technology of an industrialized Europe and a Christianity laden with Western interpretation and institutions were symbols of the Europeans' power over Africa. Some individuals and whole cultures adopted

SLAVE IMPORTS DURING THE ATLANTIC SLAVE TRADE

The circles' diameters represent relative numbers of slaves imported; Brazil was the largest single importer.

British North America

Louisiana

Mexico

Greater Antilles

Bermuda

Lesser Antilles

Madeira, Canaries, and Cape Verde Islands

Central America and Belize

Panama, Colombia, and Ecuador

Venezuela

French Guiana

São Thomé

Peru

Surinam and Guyana

Brazil

Bolivia, Paraguay, Argentina, and Uruguay

Chile

Europe

ATLANTIC OCEAN

PACIFIC OCEAN

0 500 1000 Km.
0 500 1000 Mi.

many Western forms in the hope of participating in that power; others resisted the new way. Both responses led to change in the ways that Africans perceived their world and acted in it. Now independent, African countries that emerged in the twentieth century are attempting to overcome the colonial legacy of dependence and to combine material and technological progress with a nurturing of Africa's rich cultural heritage. It is to aspects of this traditional culture that we now turn.

● THE CULTURE OF BENIN ●

The traditions of the people of Benin and accounts by early European visitors illuminate the culture of a major African state as the worlds of Africa and Europe came together. The first three selections come from *A Short History of Benin*, containing the most famous collection of Benin oral traditions. The book was compiled in 1934 by Chief Jacob V. Egharevba, a member of a distinguished family in Benin and founder of the Benin Museum. Chief Egharevba's work itself is a synthesis of traditions from many groups within Benin: among others, the *obas* themselves; the *ihogbe*, historians of deceased kings; the *ogbelaka*, royal bards; and the *iguneronmwo*, the royal brass smiths. Although most dates for the ancient period of Benin must remain relative, Chief Egharevba's work has been shown to be remarkably accurate when it can be compared with eyewitness accounts by travelers; it remains an indispensable source for the history of this African state. The fourth selection is a traditional poem extolling the oba and his office. It is taken from *African Poetry*, compiled and edited by Ulli Beier.

from *A Short History of Benin*

The Introduction of Brass-Casting from Ife

Oba Oguola wished to introduce brass-casting into Benin similar to various works of art sent him from Uhe Ife. He therefore sent to the Oghene of Uhe for a brass-smith and Igue-igha was sent to him. Igue-igha was very clever and left many designs to his successors and was in consequence deified and is worshiped to this day by brass-smiths. The practice of making brass-castings for the preservation of the records of events was originated during the reign of Oguola. He lived to a very old age.

Ewuare the Great

After the murder of Uwaifiokun, Ogus was crowned the Oba of Benin with the title Ewuare (Oworuare) meaning "It is cool" or "The trouble has ceased." (His reign traditionally began in about A.D. 1440.) Prior to his accession he caused a great conflagration in the city which lasted two days and nights as a revenge for his banishment.

Ewuare was a great magician, physician, traveler and warrior. He was also powerful, courageous and sagacious. He fought against and captured 201 towns and villages in Ekiti, Ikare, Kukuruku, Eka and the Ibo country on this side of the river Niger. He took their petty rulers captive and caused the people to pay tribute to him.

He made good roads in Benin City and especially the streets known as Akpakpaya and Utantan. In fact the town rose to importance and gained the name "City" during his reign. It was he who had the innermost and greatest of the walls and ditches made around the City and he made powerful charms and had them buried at each of the nine gateways to the city, to nullify any evil charms which might be brought by people of other countries to injure his subjects.

Ewuare was the first Oba of Benin to come into contact with Europeans, for Ruy de Sigueira visited the Benin area in 1472 although it is not known whether he actually reached the city.

The Coming of the Portuguese to Benin

Guns and Coconuts

A Portuguese explorer named John Affonso d'Aveiro visited Benin City for the first time in 1485–1486. He introduced guns and coconuts into this country.

Missionaries

It is said that John Affonso d'Aveiro came to Benin City for the second time during this reign (of Oba Esigie, which began in 1504). He advised the Oba to become a Christian, and said that Christianity would make his country better. Esigie therefore sent Ohenokun, the Olokun priest at Ughoton, with him, as an Ambassador to the King of Portugal, asking him to send priests who would teach him and his people the faith. In reply the King of Portugal sent Roman

Catholic missionaries and many rich presents, such as a copper stool (*erhe*), coral beads and a big umbrella, with an entreaty that Esigie should embrace the faith. At the same time he also gave presents to the Ambassador and his wife. The King of Portugal also sent some Portuguese traders who established trading factories at Ughoton, the old port of Benin. They traded in ivory, Benin cloths, pepper and other commodities in the King of Portugal's interest. Owing to the unhealthy state of the country their commerce soon ceased.

But John Affonso d'Aveiro with the other missionaries remained in Benin to carry on the mission work, and churches were built at Ogbelaka, Idumwerie and Akpakpava (Ikpoba Road), the last named being the "Holy Cross Cathedral.". . . The work of the Mission made progress and thousands of people were baptized before the death of the great explorer John Affonso d'Aveiro, who was buried with great lamentations by the Oba and the Christians of Benin City.

The missionaries went with Esigie to the Idah war which took place in 1515–1516.

QUESTIONS

1. Discuss the significance of metalworking and the origins of political power.
2. Note the characteristics of King Ewuare described in these selections: what values do they reflect?
3. What was the impression made by the early Portuguese visitors on their hosts?
4. How did Benin react to Christianity?

from *Benin Oral Literature*

The Oba of Benin

He who knows not the Oba
let me show him.
He has piled a throne upon a throne.
Plentiful as grains of sand on the earth
are those in front of him.
Plentiful as grains of sand on the earth
are those behind him.
There are two thousand people
to fan him.
He who owns you
is among you here.
He who owns you
has piled a throne upon a throne.

He has lived to do it this year;
even so he will live to do it again.

QUESTIONS

1. What is the effect of hyperboles (figures of exaggeration) in this poem?
2. Compare the portrait of the oba in this poem with that of Ewuare the Great in the second excerpt.
3. Compare the portrayal of the oba's power in this poem with the suggestions of his power in Figure 12-7.

EUROPEAN ACCOUNTS OF BENIN

RUY DE PINA

from the *Chronicle of John II*
Translation by J. W. Blake

Although the first European visitor was probably Ruy de Sigueira (who came, as noted in "Ewuare the Great," in 1472), John Affonso d'Aveiro was the first to engage Benin in sustained relationships with the Portuguese ruler and his subjects. Trading contact was initiated at Benin's port city of Gwato. The Portuguese description of the early period of contact is told in an excerpt from Ruy de Pina's *Chronicle of John II* (1792). Compare this version with Egharevba's: what are the differences and similarities between them?

The Discovery of the Kingdom of Benin

In this year [1486], the land of Beny beyond Myna to the Rios dos Escravos was first discovered by Joham Affom da Aveiro, who died there; whence there came to these kingdoms the first pepper from Guinee, whereof a great quantity was produced in that land; and presently samples of it were sent to Framdes [Flanders] and to other parts, and soon it fetched a great price and was held in high esteem. The king of Beny sent as ambassador to the king a negro, one of his captains, from a harbouring place by the sea, which is called Ugato [Gwato], because he desired to learn more about these lands, the arrival of people from them in his country being regarded as an unusual novelty. This ambassador was a man of good speech and natural wisdom. Great feasts were held in his honour, and he was shown many of the good things of these kingdoms. He returned to

his land in a ship of the king's, who at his departure made him a gift of rich clothes for himself and his wife: and through him he also sent a rich present to the king of such things as he understood he would greatly prize. Moreover, he sent holy and most catholic advisers with praiseworthy admonitions for the faith to administer a stern rebuke about the heresies and great idolatries and fetishes, which the negroes practise in that land. Then also there went with him new factors of the king, who were to remain in that country and to traffic for the said pepper and for other things, which pertained to the trades of the king. But owing to the fact that the land was afterwards found to be very dangerous from sickness and not so profitable as had been hoped, the trade was abandoned.

WILLEM BOSMAN

from *New and Accurate Description of the Coast of Guinea*

The next selection describes some facets of Benin culture in the seventeenth century near the apogee of the kingdom's power, but at a time when rivals elsewhere, notably Oyo, were posing a challenge. The account is a letter written to Willem Bosman by David Van Nyendael and published in Bosman's *New and Accurate Description of the Coast of Guinea* (1705). Bosman was an employee of the Dutch West India Company; during his fourteen years in West Africa he served for a time as the chief factor at Axim in the Gold Coast.

Benin in 1700

The Inhabitants of this Country, if possessed of any Riches, eat and drink very well; that is to say, of the best. The common Diet of the Rich is Beef, Mutton or Chickens, and Jammes [yams] for their Bread; which, after they have boiled, they beat very fine, in order to make Cakes of it: they frequently treat one another, and impart a Portion of their Superfluity to the Necessitous.

The meaner Sort content themselves with smoak'd or dry'd Fish, which, if salted, is very like what we in *Europe* call Raf or Reekel; their Bread is also Jammes, Bananas, and Beans; their Drink Water and *Pardon-Wine*, which is none of the best. The richer Sort Drink Water and Brandy when they can get it. The King, the Great Lords, and every Governor, who is but indifferently rich, subsist several Poor at their Place of Residence on their Charity, employing those who are fit for any Work, in order to help them to a Maintenance, and the rest they keep for God's sake, and to obtain the Character of being charitable; so that here are no Beggars: And this necessary Care succeeds so well, that we do not see many remarkably poor amongst them. . . .

The King hath a very rich Income; for his Territories are very large, and full of Governors, and each knows how many Bags of Boesies (the Money of this Country [cowries]) he must annually raise to the King, which amounts to a vast Sum, which 'tis impossible to make any Calculation of. Others, of a meaner Rank than the former, instead of Money, deliver to the King Bulls, Cows, Sheep, Chickens, Jammes, and Cloaths; in short, whatever he wants for his Housekeeping; so that he is not oblig'd to one Farthing Expense on that account, and consequently he lays up his whole pecuniary Revenue untouch'd.

Duties or Tolls on imported and exported Wares are not paid here; but everyone pays a certain Sum annually to the Governor of the Place where he lives, for the Liberty of Trading; the Viceroy sends part of it to the King; so that his Revenue being determin'd and settled, he can easily compute what he hath to expect annually.

QUESTIONS

1. Compare Ruy de Pina's *Chronicle of John II* with Egharevba's account. What are the differences and similarities between them?
2. What is the evidence of social and political stratification in the letter to Bosman? Was the Benin monarchy an oppressive one in the seventeenth century? What qualities in Benin society appealed to its Dutch observer?

Summary Questions

1. Describe the economic and technological features of early stages of African history. What were the major developments?
2. How have men's and women's roles differed historically in Africa?
3. What factors influenced the rise of African states?
4. African slaves brought to the Americas came from which parts of the continent? Which African region contributed the greatest number of slaves in the eighteenth century?
5. Look at Figure 12-5 for an African image of a European soldier. Compare this with the figure of the master merchant or with that of the oba (Figs. 12-6 and 12-7).
6. What is the evidence of social and political stratification in the letter to Bosman? What qualities in Benin society appealed to its Dutch observer?

Key Terms

Neolithic

Nok

Stone Age

Benin

Ife

cire perdu, *or lost wax*

transatlantic slave trade

colonialism

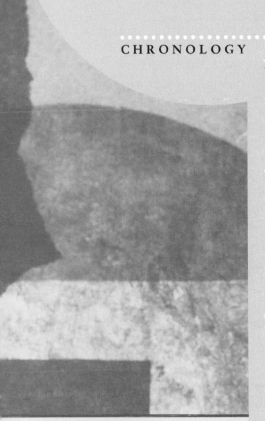

13 West African Languages and Literature: The Oral Tradition and Its Legacy

CENTRAL ISSUES

- Major written literary traditions in Africa
- The principal functions and stylistic features of African oral literary genres
- The social, moral, and religious values underlying African literatures, especially as seen in the Mande, Hausa, and Yoruba traditions
- The connections between the oral literary tradition and modern writers

The literary traditions of Africa are even more diverse than the literatures of Europe. For one thing, the languages in which they are composed are more varied. Whereas nearly all European languages can be traced back to a common "proto" language (Indo-European) and thus belong to the same language family, Africa's languages not only are more than one thousand in number but also represent four major language families. These are (1) Afro-Asiatic, including among others Arabic, Berber, Hausa, and Cushitic; (2) Nilo-Saharan; (3) Khoisan, the languages of the hunting and gathering peoples of southern Africa; and (4) Congo-Kordofanian. Most of the languages in our area of concentration spring from the last family.

Written Literature in Africa

Apart from Arabic, which has a rich tradition of written literature including some works by black Africans, only a few African languages were written before the nineteenth or twentieth century. The hieroglyphic script of ancient Egyptian appears to have no written descendant, except possibly Meroitic, which, as we saw in Chapter 2, remains undeciphered. Finding the key to Meroitic would open up a store of historical texts of great wealth and value that to date remain unusable. Ge'ez, the liturgical tongue of the Ethiopian Christian Church, and Amharic, for which the oldest documents date from the fourteenth century, are other examples with a long history. Works in Swahili and Hausa dating from the eighteenth and nineteenth centuries, respectively, can be found written in Arabic script. Modern African writers write either in their own languages in Arabic script or Roman script, or, to reach a wider audience, in French, English, or Portuguese. Recent scholarship emphasizing the continuities between oral and written modes of expression and recent decisions by some African writers to write only in African languages only reinforce the importance of oral literature. In this chapter we look at the genres of oral literature through a few select examples. At the end we include some poems that reflect the influence of oral literary patterns on three prominent writers of twentieth-century Africa: Birago Diop, Chinua Achebe, and Wole Soyinka.

Oral Literature

A century ago the expression "oral literature" seemed a contradiction in terms. "Literature," to those educated in the Western humanistic tradition, meant something written down, a book in a library. From the scholarly studies of the past fifty years, however, we are more and more aware of the oral composition of many of the great works of the Greco-Roman and Judeo-Christian tradition, most notably the epics of Homer and many parts of the Bible. This has enabled westerners to appreciate that poetry and prose of great beauty and complexity can be composed and passed down through the generations without being in written form.

The existence of an oral tradition implies a mentality very different from that of a society relying on documents. For one thing, the faculties of memory must be much more highly developed in an oral society. If the kingdom of Benin was able to rule a wide area without written documents, this was partly because it was able to rely on the extensive memories of its administrators. Many African states have preserved their histories through the *griot,* an official poet-historian whose job is to tell and transmit the history of the people. These histories may take the form of an epic poem, as in the *Sundiata.* Oral literature in Africa also includes myths, tales, riddles, proverbs, and various types of poetry.

It must be kept in mind that when we read traditional African literature in English, we are reading not only a translation from a very different language but also a written transcription of an oral event. Whether by a professional griot or by an amateur, the recitation of a tale or poem in Africa involves the performer and the act of performance as much as it involves literary skill. Appreciation of such works thus requires some creative imagination on the reader's part, but even on the written page these works can convey a great deal about African perceptions of the cosmos, creation, human relations, cultural priorities, aesthetics, and styles. Here we will focus on examples of various oral literary genres from the Mandinka peoples (in the Mande group), the Hausa, and the Yoruba (see map).

Mande and the Epic of Sundiata

Mande is the name of a cultural complex and group of languages in western Sudan. Mande peoples were among the earliest to develop agriculture in sub-Saharan Africa. Mandinka (also called Mandingo or Malinke) is one of about twelve subgroups that make up the Mande group and that formed the core population of the Mali empire. Around the year 1200 several of them were joined together in revolt against the declining empire of Ghana. The remarkable leader of this revolt was a Mandinka man named Sundiata. As a result of his military victories, Mali flourished. With its economy based on the rich agricultural lands of the upper Niger and on secure control of the gold mines of Bambuk and Bure, Mali expanded to become the largest of the medieval African empires. Included within its boundaries were peoples and lands in parts of modern Guinea, Guinea-Bissau, Mali, Sierra Leone, Liberia, Ivory Coast, Senegal, northern Ghana, and Burkina Faso. The oral epic recounting the life and exploits of Sundiata creates a hero of legendary dimensions who, like other epic heroes, has informed the cultural identity of the Mande peoples down to the present time.

The fabulous wealth and high culture of Mali became known to the outside world through the pilgrimage of Mansa Musa in 1324, portrayed in a Catalan map later that century (Fig. 13-1). He and succeeding mansas, or kings, attracted scholars from North Africa and the Middle East to Timbuktu, Mali's principal port city of the trans-Saharan trade. These scholars, together with the local people, created a great center of Islamic learning around the famous mosque of Sankore. Muslim traders of various Mande groups spread Islam far beyond the core areas around Niani, the capital, and Timbuktu, some reaching as far east as Hausaland. Succession disputes and aggressive neighbors nurtured in-

20°

Senegal R. ①
Gambia R. ②
Niger R. ①
③
Volta R. ⑫
Lake Chad
Benue R.
④
⑤ ⑦ ⑧ ⑨ ⑩ ⑪
⑥
Ubangi R.
Congo R. ⑮
EQUATOR
0°
⑯
⑬
Kasai R.
⑰
1. Fulani
2. Mandinka (Malinke)
3. Bambara
4. Dan
5. Ashanti
6. Ga
7. Ewe
8. Dahomey (Fon)
9. Yoruba
10. Benin (Edo)
11. Ibo
12. Hausa
13. Bakota
14. Bakongo
15. Mangbetu
16. Efe
17. Darasa
18. Ngombe
19. Mambunda
20. Yao
⑭
⑱
Zambesi R.
⑳
⑲
20°
Limpopo R.
Orange R.

MAJOR AFRICAN CULTURES
Mentioned in the Text

ternal tensions in the empire, which, nevertheless, survived until the seventeenth century.

Hausa

Hausa is a linguistic term describing the several million peoples in West Africa who speak Hausa as their first language. Although their homeland is northern Nigeria and southern Niger, the Hausa have been engaged in long-distance trade for centuries; there are substantial Hausa-speaking communities in northern Ghana and in every major city in West Africa. Politically, the Hausa were long ago grouped into separate walled city-states to which the surrounding rural folk owed allegiance. From about the fourteenth century (perhaps stimulated by contact with Mande traders), Islam was the religion of the courts. In the early nineteenth century a holy war, or *jihad*, sparked a revolution that re-

placed the Hausa rulers with those from another group, the Fulani, and united them into a centralized state known as the Fulani empire. The Fulani empire included within its borders many non-Muslim groups from the lands north of the Benue and Niger rivers. By creating an area of unprecedented size within which trade, agriculture, travel, and communication could develop in relative peace, the empire imposed use of the Hausa language and Islamic values on many more peoples than before.

Yoruba

Numbering several million, the Yoruba, an agricultural and trading people, reside in southwestern Nigeria and the republic of Benin. Throughout most of the period of contact between Africa and Europe, the Yoruba were subjects of the Benin and Oyo empires. The latter was a

13-1 *Catalan map, 1375. (By permission of the British Library. BL Maps Ref. A.6.[3])*

kingdom of far-flung boundaries, which disintegrated in the early nineteenth century. Oyo and the successor kingdoms were constitutional monarchies in which the power of the king was balanced by a council of state and an institutionalized priesthood. The richness of the Yoruba aesthetic is better known to outsiders than, perhaps, that of any other African people. The traditions of poetry, sculpture, and dance are founded on an elaborate system of religious beliefs and practices. The hierarchy and ritual among the Yoruba gods mirror those of traditional Yoruba political structure. Yoruba religious beliefs have been remarkably successful in retaining their dynamism through accommodation with both Christian and Islamic practices. Perhaps one of the key

reasons for this dynamism is the vitality of the poetry, myths, and proverbs and their continued integration into social, political, and religious festivals of contemporary society.

African Myths and Religions: Some Generalizations

In the chapters on Mesopotamia, Egypt, Greece, and Rome, we saw that myths are intimately allied with the religious beliefs and the values of a particular culture. Unlike legends or epics, they are not based on historical events but attempt to explain or clarify the primal mys-

terics of nature, creation, and humanity's relationship with the gods. African myths are primarily oral; they are told and sung. They are often used in religious rituals; but, because there are a great many African religions, there is also a tremendous variety in African mythology. It is possible, nevertheless, to identify certain common features in the religions of the West African peoples under consideration here and to trace fundamental themes in their mythology.

All West African religions postulate the existence of a supreme God (whose name varies with the culture), associated with the creation of the universe. One of the great questions that the African myths ask is, Why is this God now so distant from the human world? The answer (as in the Judeo-Christian doctrine of the Fall) seems to lie in the fact of human imperfection. African myths show in a variety of ways how the supreme deity, exasperated with human perversity or troublesomeness, simply withdrew from his creation, leaving the administration of it to lesser gods, natural spirits, or ancestors of living humans. Unlike the Judeo-Christian God, the African supreme being did not return to intervene in human affairs. People in Africa rarely worship the high God by direct means; rather, they seek understanding and redress through lesser deities and spirits, each of whom represents an aspect of God. Communication between people and these highly charged spiritual forces is achieved through rituals in honor of them and through sacrifice.

Another important feature of African religion is the belief in the spiritual vitality of the natural world—as it is called in the West, animism. According to this belief, supernatural spirits or "souls" (Latin, *anima*) may inhabit the bodies of animals or even inanimate parts of nature such as trees, rocks, forests, mountains, and rivers. These spirits are often guardian spirits who must be acknowledged and appeased, for some of them are capable of causing or controlling events in the natural world. The blessings of resident spirits must be sought, for example, when a new settlement is built.

The spirits inhabiting the natural world are nonhuman in origin and therefore close to the realm of the gods. Nearer to the human world are the spirits of ancestors, the dead, whose souls are very much present in the everyday world and who may, for example, come to inhabit the body of a new baby. Although the ancestral souls do not have "power" like the spirits, they do have "awareness" and can be communicated with. They may act as mediators between the living and the spirits.

All of the spirits are believed to be inherently neither good nor evil—they can affect human lives in either positive or negative ways. The beautiful and beneficent natural world can also be malevolent and destructive. To live in it, one must acknowledge those powerful forces that are outside of, but intrinsically part of, the cycles of one's life. Because of this complex relationship of people to the phenomena of the world, there is a profound duality that pervades every aspect of African life. For example, one may believe in sky spirits and earth spirits, and they may contradict each other. Some spirits, such as the "tricksters," may embody contradictory traits. It is up to human wit and ingenuity to learn to appease the spirits and to determine what course to take.

Tales (Hausa)

Myths have to do with gods, spirits, and religious questions; but tales, the second type of oral prose literature, are more concerned with the social world of human beings. All African oral literatures contain a large body of tales, divided into distinct types according to their purpose, the context in which they are told, and the status of the teller.

The oral literature of the Hausa offers two main types of tales. *Tatsuniyoyi* are entertaining stories about animals and people, generally told by the older women to young children around the fire at night. They cloak lessons in social etiquette, morality, and personal values in amusing, memorable stories. The other type, *labarai,* are told by old men to each other and to young male adults. Their subject matter is most often cultural, family, and group history. While not to be taken literally, the labarai contain factual occurrences and represent for any given period of time the Hausa's view of their own past.

Riddles

Riddles, like folk tales, are most often told at night around the fire. They, too, form the early associations in the mind of the young person with the wisdom and style of elders. Frequently uttered as a statement rather than as a question, the essence of the idea and metaphors drawn instruct the young in the indirect but pithy aphorisms about life. In addition to allusions to the natural world that approach the poetic, riddles, like some poetry, allow explicit sexual references. The cleverness and wit of the stock phrases create the entertainment and memorability of the occasion.

Proverbs

Proverbs have a special place in oral literature. Rather than being told for entertainment like riddles and tales, they are most often used within conversation and, more formally, in the litigation of disputes within a

• D A I L Y L I V E S •

• • • • *Language, Learning, and Performance*

Very early in life, an African child hears the richness of the spoken word in its many varieties. The naming ceremony, held a few days after birth, blesses the young child with the community's welcome and assigns a meaningful name. In some African communities, the name designates the special significance of the child's birth at the time—a prayer that this child may survive after many have been lost—or the name suggests that the child is the spirit of a grandparent reincarnated. A toddler spends evenings around the fire listening to the mothers and grandmothers of the village recount fairy tales about tortoise and hare, Anansi the spider—trickster stories that praise cleverness and intelligence. Or the child is challenged to figure out puzzles that impart the values or attitudes of his people.

On certain occasions throughout the year, perhaps at harvest, the village gathers around a large bonfire to hear about how things came to be the way they are or about the founding of their community. Everyone present joins in a kind of antiphonal chorus with the elder telling the story—his voice ringing out across the night and the crowd shouting a robust reply. When someone is married, or there is a funeral of a great person, praise singers recount the virtues of the couple or person celebrated. Their music simultaneously enlivens the festivities and reinforces the links between the individual and the community. Finally, on great occasions of state, praise singers such as Balla Fasseke in the epic of Sundiata remind kings and their subjects of the monarch's great exploits and of his responsibility for the preservation of the community over time. More formal than

tales or proverbs, such performances of a culture's history may go on for days. It is during these times that the performer conveys his or her skill in projecting the richness and depth of the language, learned over many years of study and practice. Repetition of important themes is balanced with tales, symbols, and even vocabulary from other languages to heighten the literary experience of the audience. The emotional intensity of such events is illustrated by the following description of a performance of *The Mwindo Epic* of the Nyanga people of the Eastern Congo.[1] The praise singer, She-Karisi Rureke, began working early in the morning and continued late into the night in a performance that lasted for twelve days.

> Large crowds of people from surrounding villages and hamlets would come to listen to the narration, to participate in the refrains of the songs, to dance. There was an atmosphere of joy and relaxation in this village. . . .

> Rureke himself was inexhaustible in words, in movements, in rhythm, even though he became tired physically. . . . Very excited by the stimulus he received from his audience, very self-confident about his knowledge, and very proud about his achievement, Rureke was able to maintain from beginning to end the coherence of his story and the unusual richness and precision of language, as well as to capture the essence of Nyanga values.

[1] Daniel Biebuyck and Kahombo C. Mateene, editors and translators, *The Mwindo Epic* (Berkeley and Los Angeles: University of California Press, 1971), p. vi.

community. The fluency with which a speaker can use proverbs is widely accepted as a measure of the person's literary skill. Social relationships, philosophical observations, and ultimate moral values are illuminated in proverbs.

Poetry

Poetry is the most prolific and complex of the oral literature genres. In addition to being concerned with hu-

manity's relationship to God and the spirits, all African poetry marks important experiences or transitions in the lives of people; birth, naming ceremony, death, love, work, and initiation frequently provide the context for the creation of poetry. The most widespread type of poetry is the praise poem. Found nearly everywhere in Africa, praise poems extol kings, courtiers, and prominent personalities in the society, as well as the gods. Sometimes called praise/abuse poetry, these poems also challenge leaders or the persons praised to live up to the

role their authority gives them. Popular poetry is composed and recited, often spontaneously, for the entertainment of the public.

Poetry, as with the ancient Greeks, is sung; and some types of poems are distinguished entirely by the style, pitch, and quality of voice associated with particular groups of singers. The merit of a poem is often judged not only by the skill of the artist-performer but

also by the successful integration of words, music, and dance. The griot may be a composer, musician, and poet, as well as a historian, and griots continue to be a living presence in Africa today. Mr. Akuguru, a griot of the Kusasi tribe from the northeast corner of Ghana, sings a praise song while accompanying himself on the gonje, a bowed, one-string instrument.

CD-1,11

● THE EPIC ●

··

from *Sundiata*

The oral epic *Sundiata* was told by the griot Mamadou Kouyaté to Djibril Tamsir Niane, who transcribed it and translated it into French in 1960. It has been translated into English by G. D. Pickett.

The Words of the Griot Mamadou Kouyaté

I am a griot. It is I, Djeli Mamadou Kouyaté, son of Bintou Kouyaté and Djeli Kedian Kouyaté, master in the art of eloquence. Since time immemorial the Kouyatés have been in the service of the Keita princes of Mali; we are vessels of speech, we are the repositories which harbour secrets many centuries old. The art of eloquence has no secrets for us; without us the names of kings would vanish into oblivion, we are the memory of mankind; by the spoken word we bring to life the deeds and exploits of kings for younger generations.

I derive my knowledge from my father Djeli Kedian, who also got it from his father; history holds no mystery for us; we teach to the vulgar just as much as we want to teach them, for it is we who keep the keys to the twelve doors of Mali.

I know the list of all the sovereigns who succeeded to the throne of Mali. I know how the black people divided into tribes, for my father bequeathed to me all his learning; I know why such and such is called Kamara, another Keita, and yet another Sibibé or Traoré; every name has a meaning, a secret import.

I teach kings the history of their ancestors so that the lives of the ancients might serve them as an example, for the world is old, but the future springs from the past.

My word is pure and free of all untruth; it is the word of my father; it is the word of my father's father. I will give you my father's words just as I received them; royal griots do not know what lying is. When a quarrel breaks out between tribes it is we who settle the difference, for we are the depositaries of oaths which the ancestors swore.

Listen to my word, you who want to know; by my mouth you will learn the history of Mali.

By my mouth you will get to know the story of the ancestor of great Mali, the story of him who, by his exploits, surpassed even Alexander the Great; he who, from the East, shed his rays upon all the countries of the West.

Listen to the story of the son of the Buffalo, the son of the Lion. I am going to tell you of Maghan Sundiata, of Mari-Djata, of Sogolon Djata, of Naré Maghan Djata; the man of many names against whom sorcery could avail nothing.

The First Kings of Mali

Listen then, sons of Mali, children of the black people, listen to my word, for I am going to tell you of Sundiata, the father of the Bright Country, of the savanna land, the ancestor of those who draw the bow, the master of a hundred vanquished kings.

I am going to talk of Sundiata, Manding Diara, Lion of Mali, Sogolon Djata, son of Sogolon, Naré Maghan Djata, son of Naré Maghan, Sogo Sogo Simbon Salaba, hero of many names.

I am going to tell you of Sundiata, he whose exploits will astonish men for a long time yet. He was great among kings, he was peerless among men; he was beloved of God because he was the last of the great conquerors.

Right at the beginning then, Mali was a province of the Bambara kings; those who are today called Mandingo, inhabitants of Mali, are not indigenous; they come from the East. Bilali Bounama, ancestor of the Keitas, was the faithful servant of the Prophet Muhammad (may the peace of God be upon him). Bilali Bounama had seven sons of whom the eldest, Lawalo, left the Holy City and came to settle in Mali; Lawalo had Latal Kalabi for a son, Latal Kalabi had Damul Kalabi who then had Lahilatoul Kalabi.

Lahilatoul Kalabi was the first black prince to make the Pilgrimage to Mecca. On his return he was robbed by brigands in the desert; his men were scattered and some died of thirst, but God saved Lahilatoul Kalabi, for he was a righteous man. He called upon the Almighty and jinn[1] appeared and recognized him as

[1] A Muslim term for invisible spirits, supernatural agencies.

king. After seven years' absence Lahilatoul was able to return, by the grace of Allah the Almighty, to Mali where none expected to see him any more.

Lahilatoul Kalabi had two sons, the elder being called Kalabi Bomba and the younger Kalabi Dauman; the elder chose royal power and reigned, while the younger preferred fortune and wealth and became the ancestor of those who go from country to country seeking their fortune.

Kalabi Bomba had Mamadi Kani for a son. Mamadi Kani was a hunter king like the first kings of Mali. It was he who invented the hunter's whistle; he communicated with the jinn of the forest and bush. These spirits had no secrets from him and he was loved by Kondolon Ni Sané. His followers were so numerous that he formed them into an army which became formidable; he often gathered them together in the bush and taught them the art of hunting. It was he who revealed to hunters the medicinal leaves which heal wounds and cure diseases. Thanks to the strength of his followers, he became king of a vast country; with them Mamadi Kani conquered all the lands which stretch from the Sankarani to the Bouré. Mamadi Kani had four sons— Kani Simbon, Kamignogo Simbon, Kabala Simbon and Simbon Tagnogokelin. They were all initiated into the art of hunting and deserved the title of Simbon. It was the lineage of Bamari Tagnogokelin which held on to the power; his son was M'Bali Nènè whose son was Bello. Bello's son was called Bello Bakon and he had a son called Maghan Kon Fatta, also called Frako Maghan Keigu, Maghan the handsome.

Maghan Kon Fatta was the father of the great Sundiata and had three wives and six children—three boys and three girls. His first wife was called Sassouma Bérété, daughter of a great divine; she was the mother of King Dankaran Touman and Princess Nana Triban. The second wife, Sogolon Kedjou, was the mother of Sundiata and the two princesses Sogolon Kolonkan and Sogolon Djamarou. The third wife was one of the Kamaras and was called Namandjé; she was the mother of Manding Bory (or Manding Bakary), who was the best friend of his half-brother Sundiata.

The Buffalo Woman

Maghan Kon Fatta, the father of Sundiata, was renowned for his beauty in every land; but he was also a good king loved by all the people. In his capital of Ni aniba he loved to sit often at the foot of the great silk-cotton tree which dominated his palace of Canco. Maghan Kon Fatta had been reigning a long time and his eldest son Dankaran Touman was already eight years old and often came to sit on the ox-hide beside his father.

Well now, one day when the king had taken up his usual position under the silk-cotton tree surrounded by his kinsmen he saw a man dressed like a hunter coming towards him; he wore the tight-fitting trousers of the favourites of Kondolon Ni Sané, and his blouse oversewn with cowries showed that he was a master of the hunting art. All present turned towards the unknown man whose bow, polished with frequent usage, shone in the sun. The man walked up in front of the king, whom he recognized in the midst of his courtiers. He bowed and said, "I salute you, king of Mali, greetings all you of Mali. I am a hunter chasing game and come from Sangaran; a fearless doe has guided me to the walls of Nianiba. By the grace of my master the great Simbon[2] my arrows have hit her and now she lies not far from your walls. As is fitting, oh king, I have come to bring you your portion." He took a leg from his leather sack whereupon the king's griot, Gnankouman Doua, seized upon the leg and said, "Stranger, whoever you may be you will be the king's guest because you respect custom; come and take your place on the mat beside us. The king is pleased because he loves righteous men." The king nodded his approval and all the courtiers agreed. The griot continued in a more familiar tone, "Oh you who come from the Sangaran, land of the favourites of Kondolon Ni Sané, you who have doubtless had an expert master, will you open your pouch of knowledge for us and instruct us with your conversation, for you have no doubt visited several lands."

The king, still silent, gave a nod of approval and a courtier added, "The hunters of Sangaran are the best soothsayers; if the stranger wishes we could learn a lot from him."

The hunter came and sat down near Gnankouman Doua who vacated one end of the mat for him. Then he said, "Griot of the king, I am not one of these hunters whose tongues are more dexterous than their arms; I am no spinner of adventure yarns, nor do I like playing upon the credulity of worthy folk; but, thanks to the lore which my master has imparted to me, I can boast of being a seer among seers."

He took out of his hunter's bag twelve cowries which he threw on the mat. The king and all his entourage now turned towards the stranger who was jumbling up the twelve shiny shells with his bare hand. Gnankouman Doua discreetly brought to the king's notice that the soothsayer was left-handed. The left hand is the hand of evil, but in the divining art it is said that left-handed people are the best. The hunter muttered some incomprehensible words in a low voice while he shuffled and jumbled the twelve cowries into different positions which he mused on at length. All of a sudden he looked up at the king and said, "Oh king, the world is full of mystery, all is hidden and we know nothing but what we can see. The silk-cotton tree springs from a tiny seed—that which defies the tempest weighs in its

[2] Honorific term for a great hunter; later applied to Sundiata.

germ no more than a grain of rice. Kingdoms are like trees; some will be silk-cotton trees, others will remain dwarf palms and the powerful silk-cotton tree will cover them with its shade. Oh, who can recognize in the little child the great king to come? The great comes from the small; truth and falsehood have both suckled at the same breast. Nothing is certain, but, sire, I can see two strangers over there coming towards your city."

He fell silent and looked in the direction of the city gates for a short while. All present silently turned towards the gates. The soothsayer returned to his cowries. He shook them in his palm with a skilled hand and then threw them out.

"King of Mali, destiny marches with great strides, Mali is about to emerge from the night. Nianiba is lighting up, but what is this light that comes from the east?"

"Hunter," said Gnankouman Doua, "your words are obscure. Make your speech comprehensible to us, speak in the clear language of your savanna."[3]

"I am coming to that now, griot. Listen to my message. Listen, sire. You have ruled over the kingdom which your ancestors bequeathed to you and you have no other ambition but to pass on this realm, intact if not increased, to your descendants; but, fine king, your successor is not yet born. I see two hunters coming to your city; they have come from afar and a woman accompanies them. Oh, that woman! She is ugly, she is hideous, she bears on her back a disfiguring hump. Her monstrous eyes seem to have been merely laid on her face, but, mystery of mysteries, this is the woman you must marry, sire, for she will be the mother of him who will make the name of Mali immortal for ever. The child will be the seventh star, the seventh conqueror of the earth. He will be more mighty than Alexander. But, oh king, for destiny to lead this woman to you a sacrifice is necessary; you must offer up a red bull, for the bull is powerful. When its blood soaks into the ground nothing more will hinder the arrival of your wife. There, I have said what I had to say, but everything is in the hands of the Almighty."

The hunter picked up his cowries and put them away in his bag.

"I am only passing through, king of Mali, and now I return to Sangaran. Farewell."

The hunter disappeared but neither the king, Naré Maghan, nor his griot, Gnankouman Doua, forgot his prophetic words; soothsayers see far ahead, their words are not always for the immediate present; man is in a hurry but time is tardy and everything has its season. . . .

After some time the old man's prophecy came to pass. One day two hunters came from the land of Do

to present to the king a young girl who, though she was shrouded in traveling clothes, was apparently a hunchback. They related to the king and his court how the king of Do Mansa-Gnemo Dearra had promised to reward anyone who killed an astounding buffalo that had been destroying the fields in the area. Having set out themselves to find the buffalo, the two hunters had befriended an old woman who confessed that she was the Buffalo of Do. She told them how to capture and kill it on the promise that when offered the reward of a beautiful young maiden, they choose an ugly girl who would be seated in the crowd.

Events transpired as the old woman had predicted, and the hunters were laughed out of town when they chose the ugly girl, Sogolon Kedjou. Unable to possess her, the hunters only later thought to present her to the king of Mali. Recognizing the fulfillment of what the old man had foretold, Naré Maghan married Sogolon.

The Lion Child

A wife quickly grows accustomed to her state. Sogolon now walked freely in the king's great enclosure and people also got used to her ugliness. But the first wife of the king, Sassouma Bérété, turned out to be unbearable. She was restless, and smarted to see the ugly Sogolon proudly flaunting her pregnancy about the palace. What would become of her, Sassouma Bérété, if her son, already eight years old, was disinherited in favour of the child that Sogolon was going to bring into the world? All the king's attentions went to the mother-to-be. On returning from the wars he would bring her the best portion of the booty—fine loin-cloths and rare jewels. Soon, dark schemes took form in the mind of Sassouma Bérété; she determined to kill Sogolon. In great secrecy she had the foremost sorcerers of Mali come to her, but they all declared themselves incapable of tackling Sogolon. In fact, from twilight onwards, three owls came and perched on the roof of her house and watched over her. For the sake of peace and quiet Sassouma said to herself, "Very well then, let him be born, this child, and then we'll see."

Sogolon's time came. The king commanded the nine greatest midwives of Mali to come to Niani, and they were now constantly in attendance on the damsel of Do. The king was in the midst of his courtiers one day when someone came to announce to him that Sogolon's labours were beginning. He sent all his courtiers away and only Gnankouman Doua stayed by his side. One would have thought that this was the first time that he had become a father, he was so worried and agitated. The whole palace kept complete silence. Doua tried to distract the sovereign with his one-stringed guitar but in vain. He even had to stop this music as it jarred on the king. Suddenly the sky darkened and great clouds coming from the east hid the sun, although it

[3] The language of those who live in the savannah grasslands is, like their environment, clear and bright.

was still the dry season. Thunder began to rumble and swift lightning rent the clouds; a few large drops of rain began to fall while a strong wind blew up. A flash of lightning accompanied by a dull rattle of thunder burst out of the east and lit up the whole sky as far as the west. Then the rain stopped and the sun appeared and it was at this very moment that a midwife came out of Sogolon's house, ran to the antechamber and announced to Naré Maghan that he was the father of a boy.

The king showed no reaction at all. He was as though in a daze. Then Doua, realizing the king's emotion, got up and signalled to two slaves who were already standing near the royal "tabala."[4] The hasty beats of the royal drum announced to Mali the birth of a son; the village tam-tams took it up and thus all Mali got the good news the same day. Shouts of joy, tam-tams and "balafons"[5] took the place of the recent silence and all the musicians of Niani made their way to the palace. His initial emotion being over, the king had got up and on leaving the antechamber he was greeted by the warm voice of Gnankouman Doua singing:

"I salute you, father; I salute you, king Naré Maghan; I salute you, Maghan Kon Fatta, Frako Maghan Keigu. The child is born whom the world awaited. Maghan, oh happy father, I salute you. The lion child, the buffalo child is born, and to announce him the Almighty has made the thunder peal, the whole sky has lit up and the earth has trembled. All hail, father, hail king Naré Maghan!"

All the griots were there and had already composed a song in praise of the royal infant. The generosity of kings makes griots eloquent, and Maghan Kon Fatta distributed on this day alone six granaries of rice among the populace. Sassouma Bérété distinguished herself by her largesses, but that deceived nobody. She was suffering in her heart but did not want to betray anything.

The name was given the eighth day after his birth. It was a great feast day and people came from all the villages of Mali while each neighbouring people brought gifts to the king. First thing in the morning a great circle had formed in front of the palace. In the middle, serving women were pounding rice which was to serve as bread, and sacrified oxen lay at the foot of the great silk-cotton tree.

In Sogolon's house the king's aunt cut off the baby's first crop of hair while the poetesses, equipped with large fans, cooled the mother who was nonchalantly stretched out on soft cushions.

[4] Ceremonial drum.

[5] A type of xylophone in which the wooden keys are often mounted upon gourds.

The king was in his antechamber but he came out followed by Doua. The crowd fell silent and Doua cried, "The child of Sogolon will be called Maghan after his father, and Mari Djata, a name which no Mandingo prince has ever borne. Sogolon's son will be the first of this name."

Straight away the griots shouted the name of the infant and the tam-tams sounded anew. The king's aunt, who had come out to hear the name of the child, went back into the house, and whispered the double name of Maghan and Mari Djata in the ear of the newly-born so that he would remember it.

The festivity ended with the distribution of meat to the heads of families and everyone dispersed joyfully. The near relatives one by one went to admire the newly-born.

Childhood

God has his mysteries which none can fathom. You, perhaps, will be a king. You can do nothing about it. You, on the other hand, will be unlucky, but you can do nothing about that either. Each man finds his way already marked out for him and he can change nothing of it.

Sogolon's son had a slow and difficult childhood. At the age of three he still crawled along on all fours while children of the same age were already walking. He had nothing of the great beauty of his father Naré Maghan. He had a head so big that he seemed unable to support it; he also had large eyes which would open wide whenever anyone entered his mother's house. He was taciturn and used to spend the whole day just sitting in the middle of the house. Whenever his mother went out he would crawl on all fours to rummage about in the calabashes in search of food, for he was very greedy.

Malicious tongues began to blab. What three-year-old has not yet taken his first steps? What three-year-old is not the despair of his parents through his whims and shifts of mood? What three-year-old is not the joy of his circle through his backwardness in talking? Sogolon Djata (for it was thus that they called him, prefixing his mother's name to his), Sogolon Djata, then, was very different from others of his own age. He spoke little and his severe face never relaxed into a smile. You would have thought that he was already thinking, and what amused children of his age bored him. Often Sogolon would make some of them come to him to keep him company. These children were already walking and she hoped that Djata, seeing his companions walking, would be tempted to do likewise. But nothing came of it. Besides, Sogolon Djata would brain the poor little things with his already strong arms and none of them would come near him any more.

The king's first wife was the first to rejoice at Sogolon Djata's infirmity. Her own son, Dankaran

Touman, was already eleven. He was a fine and lively boy, who spent the day running about the village with those of his own age. He had even begun his initiation in the bush. The king had had a bow made for him and he used to go behind the town to practise archery with his companions. Sassouma was quite happy and snapped her fingers at Sogolon, whose child was still crawling on the ground. Whenever the latter happened to pass by her house, she would say, "Come, my son, walk, jump, leap about. The jinn didn't promise you anything out of the ordinary, but I prefer a son who walks on his two legs to a lion that crawls on the ground." She spoke thus whenever Sogolon went by her door. The innuendo would go straight home and then she would burst into laughter, that diabolical laughter which a jealous woman knows how to use so well.

Her son's infirmity weighed heavily upon Sogolon Kedjou; she had resorted to all her talent as a sorceress to give strength to her son's legs, but the rarest herbs had been useless. The king himself lost hope.

How impatient man is! Naré Maghan became imperceptibly estranged but Gnankouman Doua never ceased reminding him of the hunter's words. Sogolon became pregnant again. The king hoped for a son, but it was a daughter called Kolonkan. She resembled her mother and had nothing of her father's beauty. The disheartened king debarred Sogolon from his house and she lived in semi-disgrace for a while. Naré Maghan married the daughter of one of his allies, the king of the Kamaras. She was called Namandjé and her beauty was legendary. A year later she brought a boy into the world. When the king consulted soothsayers on the destiny of this son he received the reply that Namandjé's child would be the right hand of some mighty king. The king gave the newly-born the name of Boukari. He was to be called Manding Boukari or Manding Bory later on.

Naré Maghan was very perplexed. Could it be that the stiff-jointed son of Sogolon was the one the hunter soothsayer had foretold?

"The Almighty has his mysteries," Gnankouman Doua would say and, taking up the hunter's words, added, "The silk-cotton tree emerges from a tiny seed."

One day Naré Maghan came along to the house of Nounfaïri, the blacksmith seer of Niani. He was an old, blind man. He received the king in the anteroom which served as his workshop. To the king's question he replied, "When the seed germinates growth is not always easy; great trees grow slowly but they plunge their roots deep into the ground."

"But has the seed really germinated?" said the king.

"Of course," replied the blind seer. "Only the growth is not as quick as you would like it; how impatient man is."

This interview and Doua's confidence gave the king some assurance. To the great displeasure of Sassouma Bérété the king restored Sogolon to favour and soon another daughter was born to her. She was given the name of Djamarou.

However, all of Niani talked of nothing else but the stiff-legged son of Sogolon. He was now seven and he still crawled to get about. In spite of all the king's affection, Sogolon was in despair. Naré Maghan aged and he felt his time coming to an end. Dankaran Touman, the son of Sassouma Bérété, was now a fine youth.

One day Naré Maghan made Mari Djata come to him and he spoke to the child as one speaks to an adult. "Mari Djata, I am growing old and soon I shall be no more among you, but before death takes me off I am going to give you the present each king gives his successor. In Mali every prince has his own griot. Doua's father was my father's griot, Doua is mine and the son of Doua, Balla Fasséké here, will be your griot. Be inseparable friends from this day forward. From his mouth you will hear the history of your ancestors, you will learn the art of governing Mali according to the principles which our ancestors have bequeathed to us. I have served my term and done my duty too. I have done everything which a king of Mali ought to do. I am handing an enlarged kingdom over to you and I leave you sure allies. May your destiny be accomplished, but never forget that Niani is your capital and Mali the cradle of your ancestors."

The child, as if he had understood the whole meaning of the king's words, beckoned Balla Fasséké to approach. He made room for him on the hide he was sitting on and then said, "Balla, you will be my griot."

"Yes, son of Sogolon, if it pleases God," replied Balla Fasséké.

The king and Doua exchanged glances that radiated confidence.

The Lion's Awakening

A short while after this interview between Naré Maghan and his son the king died. Sogolon's son was no more than seven years old. The council of elders met in the king's palace. It was no use Doua's defending the king's will which reserved the throne for Mari Djata, for the council took no account of Naré Maghan's wish. With the help of Sassouma Bérété's intrigues, Dankaran Touman was proclaimed king and a regency council was formed in which the queen mother was all-powerful. A short time after, Doua died.

As men have short memories, Sogolon's son was spoken of with nothing but irony and scorn. People had seen one-eyed kings, one-armed kings, and lame kings, but a stiff-legged king had never been heard tell of. No matter how great the destiny promised for Mari Djata might be, the throne could not be given to someone who had no power in his legs; if the jinn loved him, let them begin by giving him the use of his legs. Such were the remarks that Sogolon heard every day. The queen mother, Sassouma Bérété, was the source of all this gossip.

Having become all-powerful, Sassouma Bérété persecuted Sogolon because the late Naré Maghan had preferred her. She banished Sogolon and her son to a back yard of the palace. Mari Djata's mother now occupied an old hut which had served as a lumber-room of Sassouma's.

The wicked queen mother allowed free passage to all those inquisitive people who wanted to see the child that still crawled at the age of seven. Nearly all the inhabitants of Niani filed into the palace and the poor Sogolon wept to see herself thus given over to public ridicule. Mari Djata took on a ferocious look in front of the crowd of sightseers. Sogolon found a little consolation only in the love of her eldest daughter, Kolonkan. She was four and she could walk. She seemed to understand all her mother's miseries and already she helped her with the housework. Sometimes, when Sogolon was attending to the chores, it was she who stayed beside her sister Djamarou, quite small as yet.

Sogolon Kedjou and her children lived on the queen mother's left-overs, but she kept a little garden in the open ground behind the village. It was there that she passed her brightest moments looking after her onions and gnougous. One day she happened to be short of condiments and went to the queen mother to beg a little baobab leaf.

"Look you," said the malicious Sassouma, "I have a calabash full. Help yourself, you poor woman. As for me, my son knew how to walk at seven and it was he who went and picked these baobab leaves. Take them then, since your son is unequal to mine." Then she laughed derisively with that fierce laughter which cuts through your flesh and penetrates right to the bone.

Sogolon Kedjou was dumbfounded. She had never imagined that hate could be so strong in a human being. With a lump in her throat she left Sassouma's. Outside her hut Mari Djata, sitting on his useless legs, was blandly eating out of a calabash. Unable to contain herself any longer, Sogolon burst into sobs and seizing a piece of wood, hit her son.

"Oh son of misfortune, will you never walk? Through your fault I have just suffered the greatest affront of my life! What have I done, God, for you to punish me in this way?"

Mari Djata seized the piece of wood and, looking at his mother, said, "Mother, what's the matter?"

"Shut up, nothing can ever wash me clean of this insult."

"But what then?"

"Sassouma has just humiliated me over a matter of a baobab leaf. At your age her own son could walk and used to bring his mother baobab leaves."

"Cheer up, Mother, cheer up."

"No. It's too much. I can't."

"Very well then, I am going to walk today," said Mari Djata. "Go and tell my father's smiths to make me the heaviest possible iron rod. Mother, do you want just the leaves of the baobab or would you rather I brought you the whole tree?"

"Ah, my son, to wipe out this insult I want the tree and its roots at my feet outside my hut."

Balla Fasséké, who was present, ran to the master smith, Farakourou, to order an iron rod.

Sogolon had sat down in front of her hut. She was weeping softly and holding her head between her two hands. Mari Djata went calmly back to his calabash of rice and began eating again as if nothing had happened. From time to time he looked up discreetly at his mother who was murmuring in a low voice, "I want the whole tree, in front of my hut, the whole tree."

All of a sudden a voice burst into laughter behind the hut. It was the wicked Sassouma telling one of her serving women about the scene of humiliation and she was laughing loudly so that Sogolon could hear. Sogolon fled into the hut and hid her face under the blankets so as not to have before her eyes this heedless boy, who was more preoccupied with eating than with anything else. With her head buried in the bed-clothes Sogolon wept and her body shook violently. Her daughter, Sogolon Djamarou, had come and sat down beside her and she said, "Mother, Mother, don't cry. Why are you crying?"

Mari Djata had finished eating and, dragging himself along on his legs, he came and sat under the wall of the hut for the sun was scorching. What was he thinking about? He alone knew.

The royal forges were situated outside the walls and over a hundred smiths worked there. The bows, spears, arrows and shields of Niani's warriors came from there. When Balla Fasséké came to order the iron rod, Farakourou said to him, "The great day has arrived then?"

"Yes. Today is a day like any other, but it will see what no other day has seen."

The master of the forges, Farakourou, was the son of the old Nounfaïri, and he was a soothsayer like his father. In his workshops there was an enormous iron bar wrought by his father Nounfaïri. Everybody wondered what this bar was destined to be used for. Farakourou called six of his apprentices and told them to carry the iron bar to Sogolon's house.

When the smiths put the gigantic iron bar down in front of the hut the noise was so frightening that Sogolon, who was lying down, jumped up with a start. Then Balla Fasséké, son of Gnankouman Doua, spoke.

"Here is the great day, Mari Djata. I am speaking to you, Maghan, son of Sogolon. The waters of the Niger can efface the stain from the body, but they cannot wipe out an insult. Arise, young lion, roar, and may the bush know that from henceforth it has a master."

The apprentice smiths were still there, Sogolon had come out and everyone was watching Mari Djata. He

crept on all fours and came to the iron bar. Supporting himself on his knees and one hand, with the other hand he picked up the iron bar without any effort and stood it up vertically. Now he was resting on nothing but his knees and held the bar with both his hands. A deathly silence had gripped all those present. Sogolon Djata closed his eyes, held tight, the muscles in his arms tensed. With a violent jerk he threw his weight on to it and his knees left the ground. Sogolon Kedjou was all eyes and watched her son's legs which were trembling as though from an electric shock. Djata was sweating and the sweat ran from his brow. In a great effort he straightened up and was on his feet at one go—but the great bar of iron was twisted and had taken the form of a bow!

Then Balla Fasséké sang out the "Hymn to the Bow," striking up with his powerful voice:

"Take your bow, Simbon,
Take your bow and let us go.
Take your bow, Sogolon Djata."

When Sogolon saw her son standing she stood dumb for a moment, then suddenly she sang these words of thanks to God who had given her son the use of his legs:

"Oh day, what a beautiful day,
Oh day, day of joy;
Allah Almighty, you never created a finer day.
So my son is going to walk!"

Standing in the position of a soldier at ease, Sogolon Djata, supported by his enormous rod, was sweating great beads of sweat. Balla Fasséké's song had alerted the whole palace and people came running from all over to see what had happened, and each stood bewildered before Sogolon's son. The queen mother had rushed there and when she saw Mari Djata standing up she trembled from head to foot. After recovering his breath Sogolon's son dropped the bar and the crowd stood to one side. His first steps were those of a giant. Balla Fasséké fell into step and pointing his finger at Djata, he cried:

"Room, room, make room!
The lion has walked;
Hide antelopes,
Get out of his way."

Behind Niani there was a young baobab tree and it was there that the children of the town came to pick leaves for their mothers. With all his might the son of Sogolon tore up the tree and put it on his shoulders and went back to his mother. He threw the tree in front of the hut and said, "Mother, here are some baobab leaves for you. From henceforth it will be outside your hut that the women of Niani will come to stock up."

Sogolon Djata walked. From that day forward the queen mother had no more peace of mind. But what can one do against destiny? Nothing. Man, under the influence of certain illusions, thinks he can alter the course which God has mapped out, but everything he does falls into a higher order which he barely understands. That is why Sassouma's efforts were vain against Sogolon's son, everything she did lay in the child's destiny. Scorned the day before and the object of public ridicule, now Sogolon's son was as popular as he had been despised. The multitude loves and fears strength. All Niani talked of nothing but Djata; the mothers urged their sons to become hunting companions of Djata and to share his games, as if they wanted their offspring to profit from the nascent glory of the buffalo-woman's son. The words of Doua on the name-giving day came back to men's minds and Sogolon was now surrounded with much respect; in conversation people were fond of contrasting Sogolon's modesty with the pride and malice of Sassouma Bérété. It was because the former had been an exemplary wife and mother that God had granted strength to her son's legs for, it was said, the more a wife loves and respects her husband and the more she suffers for her child, the more valorous will the child be one day. Each is the child of his mother; the child is worth no more than the mother is worth. It was not astonishing that the king Dankaran Touman was so colourless, for his mother had never shown the slightest respect to her husband and never, in the presence of the late king, did she show that humility which every wife should show before her husband. People recalled her scenes of jealousy and the spiteful remarks she circulated about her co-wife and her child. And people would conclude gravely, "Nobody knows God's mystery. The snake has no legs yet it is as swift as any other animal that has four."

Sogolon Djata's popularity grew from day to day and he was surrounded by a gang of children of the same age as himself. These were Fran Kamara, son of the king of Tabon; Kamandjan, son of the king of Sibi; and other princes whose fathers had sent them to the court of Niani. The son of Namandjé, Manding Bory, was already joining in their games. Balla Fasséké followed Sogolon Djata all the time. He was past twenty and it was he who gave the child education and instruction according to Mandingo rules of conduct. Whether in town or at the hunt, he missed no opportunity of instructing his pupil. Many young boys of Niani came to join in the games of the royal child.

He liked hunting best of all. Farakourou, master of the forges, had made Djata a fine bow, and he proved himself to be a good shot with the bow. He made frequent hunting trips with his troops, and in the evening all Niani would be in the square to be present at the entry of the young hunters. The crowd would sing the "Hymn to the Bow" which Balla Fasséké had composed, and Sogolon Djata was quite young when he received the title of Simbon, or master

hunter, which is only conferred on great hunters who have proved themselves.

Every evening Sogolon Kedjou would gather Djata and his companions outside her hut. She would tell them stories about the beasts of the bush, the dumb brothers of man. Sogolon Djata learnt to distinguish between the animals; he knew why the buffalo was his mother's wraith[6] and also why the lion was the protector of his father's family. He also listened to the history of the kings which Balla Fasséké told him; enraptured by the story of Alexander the Great, the mighty king of gold and silver, whose sun shone over quite half the world. Sogolon initiated her son into certain secrets and revealed to him the names of the medicinal plants which every hunter should know. Thus, between his mother and his griot, the child got to know all that needed to be known.

Sogolon's son was now ten. The name Sogolon Djata in the rapid Mandingo language became Sundiata or Sondjata. He was a lad full of strength; his arms had the strength of ten and his biceps inspired fear in his companions. He had already that authoritative way of speaking which belongs to those who are destined to command. His brother, Manding Bory, became his best friend, and whenever Djata was seen, Manding Bory appeared too. They were like a man and his shadow. Fran Kamara and Kamandjan were the closest friends of the young princes, while Balla Fasséké followed them all like a guardian angel.

But Sundiata's popularity was so great that the queen mother became apprehensive for her son's throne. Dankaran Touman was the most retiring of men. At the age of eighteen he was still under the influence of his mother and a handful of old schemers. It was Sassouma Bérété who really reigned in his name. The queen mother wanted to put an end to this popularity by killing Sundiata and it was thus that one night she received the nine great witches of Mali. They were all old women. The eldest, and the most dangerous too, was called Soumosso Konkomba. When the nine old hags had seated themselves in a semi-circle around her bed the queen mother said:

"You who rule supreme at night, nocturnal powers, oh you who hold the secret of life, you who can put an end to one life, can you help me?"

"The night is potent," said Soumosso Konkomba. "Oh queen, tell us what is to be done, on whom must we turn the fatal blade?"

"I want to kill Sundiata," said Sassouma. "His destiny runs counter to my son's and he must be killed while there is still time. If you succeed, I promise you the finest rewards. First of all I bestow on each of you a

cow and her calf and from tomorrow go to the royal granaries and each of you will receive a hundred measures of rice and a hundred measures of hay on my authority."

"Mother of the king," rejoined Soumosso Konkomba, "life hangs by nothing but a very fine thread, but all is interwoven here below. Life has a cause, and death as well. The one comes from the other. Your hate has a cause and your action must have a cause. Mother of the king, everything holds together, our action will have no effect unless we are ourselves implicated, but Mari Djata has done us no wrong. It is, then, difficult for us to compass his death."

"But you are also concerned," replied the queen mother, "for the son of Sogolon will be a scourge to us all."

"The snake seldom bites the foot that does not walk," said one of the witches.

"Yes, but there are snakes that attack everybody. Allow Sundiata to grow up and we will all repent of it. Tomorrow go to Sogolon's vegetable patch and make a show of picking a few gnougou leaves. Mari Djata stands guard there and you will see how vicious the boy is. He won't have any respect for your age, he'll give you a good thrashing."

"That's a clever idea," said one of the old hags.

"But the cause of our discomfiture will be ourselves, for having touched something which did not belong to us."

"We could repeat the offence," said another, "and then if he beats us again we would be able to reproach him with being unkind, heartless. In that case we would be concerned, I think."

"The idea is ingenious," said Soumosso Konkomba. "Tomorrow we shall go to Sogolon's vegetable patch."

"Now there's a happy thought," concluded the queen mother, laughing for joy. "Go to the vegetable patch tomorrow and you will see that Sogolon's son is mean. Beforehand, present yourselves at the royal granaries where you will receive the grain I promised you; the cows and calves are already yours."

The old hags bowed and disappeared into the black night. The queen mother was now alone and gloated over her anticipated victory. But her daughter, Nana Triban, woke up.

"Mother, who were you talking to? I thought I heard voices."

"Sleep, my daughter, it is nothing. You didn't hear anything."

In the morning, as usual, Sundiata got his companions together in front of his mother's hut and said, "What animal are we going to hunt today?"

Kamandjan said, "I wouldn't mind if we attacked some elephants right now."

"Yes, I am of this opinion too," said Fran Kamara. "That will allow us to go far into the bush."

6 In Mandingo religion, the double of a spirit. The spirit may leave the body and incarnate itself in other persons or animals. In this case the mother's spirit became incarnate in the buffalo.

And the young band left after Sogolon had filled the hunting bags with eatables. Sundiata and his companions came back late to the village, but first Djata wanted to take a look at his mother's vegetable patch as was his custom. It was dusk. There he found the nine witches stealing gnougou leaves. They made a show of running away like thieves caught red-handed.

"Stop, stop, poor old women," said Sundiata, "what is the matter with you to run away like this? This garden belongs to all."

Straight away his companions and he filled the gourds of the old hags with leaves, aubergines and onions.

"Each time that you run short of condiments come to stock up here without fear."

"You disarm us," said one of the old crones, and another added, "And you confound us with your bounty."

"Listen, Djata," said Soumosso Konkomba, "we had come here to test you. We have no need of condiments but your generosity disarms us. We were sent here by the queen mother to provoke you and draw the anger of the nocturnal powers upon you. But nothing can be done against a heart full of kindness. And to think that we have already drawn a hundred measures of rice and a hundred measures of millet—and the queen promises us each a cow and her calf in addition. Forgive us, son of Sogolon."

"I bear you no ill-will," said Djata. "Here, I am returning from the hunt with my companions and we have killed ten elephants, so I will give you an elephant each and there you have some meat!"

"Thank you, son of Sogolon."

"Thank you, child of Justice."

"Henceforth," concluded Soumosso Konkomba, "we will watch over you." And the nine witches disappeared into the night. Sundiata and his companions continued on their way to Niani and got back after dark.

"You were really frightened; those nine witches really scared you, eh?" said Sogolon Kolonkan, Djata's young sister.

"How do you know," retorted Sundiata, astonished.

"I saw them at night hatching their scheme, but I knew there was no danger for you." Kolonkan was well versed in the art of witchcraft and watched over her brother without his suspecting it.

Sogolon, knowing the danger that awaited her children in the court ruled by the jealous Sassouma, decided to leave until such time that Djata could return in safety to reign over Mali. In a parting act of malice Dankaran Touman sent Djata's griot, Balla Fasséké, on an embassy to the king of Sosso, Soumaoro Kanté, thereby depriving Djata of his friend and teacher. There Balla Fasséké remained along with Nana Triban until the eve of Soumaoro's major battle with Sundiata.

Vowing to return, Sogolon's son and his family began their seven years of exile during which Sundiata would grow to manhood. After brief stops in Djedeba and Tabon, they remained for a time at the court of the Cissés at Wagadou. There Sundiata learned much from the merchants and officials engaged in the trans-Saharan trade. After a time the Cissé king sent them on to the king of Mema, his cousin. The king of Mema's hospitality was generous, and Sundiata quickly became a favorite at the court. His first military campaigns were fought on behalf of the king of Mema, and so valorous were his exploits that he soon was named viceroy.

Soumaoro Kanté, the Sorcerer King

While Sogolon's son was fighting his first campaign far from his native land, Mali had fallen under the domination of a new master, Soumaoro Kanté, king of Sosso.

When the embassy sent by Dankaran Touman arrived at Sosso, Soumaoro demanded that Mali should acknowledge itself tributary to Sosso. Balla Fasséké found delegates from several other kingdoms at Soumaoro's court. With his powerful army of smiths the king of Sosso had quickly imposed his power on everybody. After the defeat of Ghana and Diaghan no one dared oppose him any more. Soumaoro was descended from the line of smiths called Diarisso who first harnessed fire and taught men how to work iron, but for a long time Sosso had remained a little village of no significance. The powerful king of Ghana was the master of the country. Little by little the kingdom of Sosso had grown at the expense of Ghana and now the Kantés dominated their old masters. Like all masters of fire, Soumaoro Kanté was a great sorcerer. His fetishes had a terrible power and it was because of them that all kings trembled before him, for he could deal a swift death to whoever he pleased. He had fortified Sosso with a triple curtain wall and in the middle of the town loomed his palace, towering over the thatched huts of the villages. He had had an immense seven-storey tower built for himself and he lived on the seventh floor in the midst of his fetishes. This is why he was called "The Untouchable King."

Soumaoro let the rest of the Mandingo embassy return but he kept Balla Fasséké back and threatened to destroy Niani if Dankaran Touman did not make his submission. Frightened, the son of Sassouma immediately made his submission, and he even sent his sister, Nana Triban, to the king of Sosso.

One day when the king was away, Balla Fasséké managed to get right into the most secret chamber of the palace where Soumaoro safeguarded his fetishes. When he had pushed the door open he was transfixed with amazement at what he saw. The walls of the chamber were tapestried with human skins and there was one in the middle of the room on which the king sat;

around an earthenware jar nine heads formed a circle; when Balla had opened the door the water had become disturbed and a monstrous snake had raised its head. Balla Fasséké, who was also well versed in sorcery, recited some formulas and everything in the room fell quiet, so he continued his inspection. He saw on a perch above the bed three owls which seemed to be asleep; on the far wall hung strangely-shaped weapons, curved swords and knives with three cutting edges. He looked at the skulls attentively and recognized the nine kings killed by Soumaoro. To the right of the door he discovered a great balafon, bigger than he had ever seen in Mali. Instinctively he pounced upon it and sat down to play. The griot always has a weakness for music, for music is the griot's soul.

He began to play. He had never heard such a melodious balafon. Though scarcely touched by the hammer, the resonant wood gave out sounds of an infinite sweetness, notes clear and as pure as gold dust; under the skilful hand of Balla the instrument had found its master. He played with all his soul and the whole room was filled with wonderment. The drowsy owls, eyes half closed, began to move their heads as though with satisfaction. Everything seemed to come to life upon the strains of this magic music. The nine skulls resumed their earthly forms and blinked at hearing the solemn "Vulture Tune"; with its head resting on the rim, the snake seemed to listen from the jar. Balla Fasséké was pleased at the effect his music had had on the strange inhabitants of this ghoulish chamber, but he quite understood that this balafon was not at all like any other. It was that of a great sorcerer. Soumaoro was the only one to play this instrument. After each victory he would come and sing his own praises. No griot had ever touched it. Not all ears were made to hear that music. Soumaoro was constantly in touch with this xylophone and no matter how far away he was, one only had to touch it for him to know that someone had got into his secret chamber.

The king was not far from the town and he rushed back to his palace and climbed up to the seventh storey. Balla Fasséké heard hurried steps in the corridor and Soumaoro bounded into the room, sword in hand.

"Who is there?" he roared. "It is you, Balla Fasséké!"

The king was foaming with anger and his eyes burnt fiercely like hot embers. Yet without losing his composure the son of Doua changed key and improvised a song in honour of the king:

There he is, Soumaoro Kanté.
All hail, you who sit on the skins of kings.
All hail, Simbon of the deadly arrow.
I salute you, you who wear clothes of human skin.

This improvised tune greatly pleased Soumaoro and he had never heard such fine words. Kings are only men, and whatever iron cannot achieve against them, words can. Kings, too, are susceptible to flattery, so Soumaoro's anger abated, his heart filled with joy as he listened attentively to this sweet music:

All hail, you who wear clothes of human skin.
I salute you, you who sit on the skins of kings.

Balla sang and his voice, which was beautiful, delighted the king of Sosso.

"How sweet it is to hear one's praises sung by someone else; Balla Fasséké, you will nevermore return to Mali for from today you are my griot."

Thus Balla Fasséké, whom king Naré Maghan had given to his son Sundiata, was stolen from the latter by Dankaran Touman; now it was the king of Sosso, Soumaoro Kanté, who, in turn, stole the precious griot from the son of Sassouma Bérété. In this way war between Sundiata and Soumaoro became inevitable.

The second half of the epic relates Sundiata's leave-taking of Mema in response to the pleas for rescue of a search party sent to find him, and tells of his triumphal series of battles against the terrible Soumaoro.

Allied with the armies of his childhood friends and with those who had offered him sanctuary during his exile, Sundiata led a massive force that included the cavalry of Mema and Wagadou; blacksmiths and the mountain Djallonkes; and groups under Fran Kamara of Tabon Wana. A victory at the valley of Tabon was followed by the first clash with Soumaoro's magic at Negueboria. The fame of Sundiata spread until all the sons of Mali were under his banner. But even a warrior like Sundiata was challenged to the limits by Soumaoro's sorcery. He was saved by the clever escape from Sosso of Balla Fasséké and Nana Triban; on the eve of the battle of Krina it was they who revealed Soumaoro's secret taboo. Reunited with his master, the griot Balla Fasséké sang the praises and history of Mali and challenged the assembled armies to prove themselves worthy of their heritage. At Krina, Soumaoro's power and magic were dissolved by Sundiata's mighty army and his destruction of Soumaoro's protective fetish. Despite hard-driven pursuit by Sundiata and Soumaoro's nephew Fakoli, Soumaoro avoided capture and ultimately disappeared into a mountain cave, never to be seen again. The city of Sosso was destroyed, and the rest of Soumaoro's allies, now in disarray, were vanquished.

The final sections relate the triumphal festival, the Kouroukan Fougan or the Division of the World, and the rebuilding of Sundiata's capital at Niani.

Kouroukan Fougan or the Division of the World

Leaving Do, the land of ten thousand guns, Sundiata wended his way to Ka-ba, keeping to the river valley.

All his armies converged on Ka-ba and Fakoli and Tabon Wana entered it laden with booty. Sibi Kamandjan had gone ahead of Sundiata to prepare the great assembly which was to gather at Ka-ba, a town situated on the territory belonging to the country of Sibi. . . .

To the north of the town stretches a spacious clearing and it is there that the great assembly was to foregather. King Kamandjan had the whole clearing cleaned up and a great dais was got ready. Even before Djata's arrival the delegations from all the conquered peoples had made their way to Ka-ba. Huts were hastily built to house all these people. When all the armies had reunited, camps had to be set up in the big plain lying between the river and the town. On the appointed day the troops were drawn up on the vast square that had been prepared. As at Sibi, each people was gathered round its king's pennant. Sundiata had put on robes such as are worn by a great Muslim king. Balla Fasséké, the high master of ceremonies, set the allies around Djata's great throne. Everything was in position. The sofas,[7] forming a vast semicircle bristling with spears, stood motionless. The delegations of the various peoples had been planted at the foot of the dais. A complete silence reigned. On Sundiata's right, Balla Fasséké, holding his mighty spear, addressed the throng in this manner:

"Peace reigns today in the whole country; may it always be thus. . . ."

"Amen," replied the crowd, then the herald continued:

"I speak to you, assembled peoples. To those of Mali I convey Maghan Sundiata's greeting; greetings to those of Do, greetings to those of Ghana, to those from Mema greetings, and to those of Fakoli's tribe. Greetings to the Bobo warriors and, finally, greetings to those of Sibi and Ka-ba. To all the peoples assembled, Djata gives greetings.

"May I be humbly forgiven if I have made any omission. I am nervous before so many people gathered together.

"Peoples, here we are, after years of hard trials, gathered around our saviour, the restorer of peace and order. From the east to the west, from the north to the south, everywhere his victorious arms have established peace. I convey to you the greetings of Soumaoro's vanquisher, Maghan Sundiata, king of Mali.

"But in order to respect tradition, I must first of all address myself to the host of us all, Kamandjan, king of Sibi; Djata greets you and gives you the floor."

Kamandjan, who was sitting close by Sundiata, stood up and stepped down from the dais. He mounted his horse and brandished his sword, crying, "I salute you all, warriors of Mali, of Do, of Tabon, of Mema, of Wagadou, of Bobo, of Fakoli . . . ; warriors, peace has returned to our homes, may God long preserve it."

"Amen," replied the warriors and the crowd. The king of Sibi continued.

"In the world man suffers for a season, but never eternally. Here we are at the end of our trials. We are at peace. May God be praised. But we owe this peace to one man who, by his courage and his valiance, was able to lead our troops to victory.

"Which one of us, alone, would have dared face Soumaoro? Ay, we were all cowards. How many times did we pay him tribute? The insolent rogue thought that everything was permitted him. What family was not dishonoured by Soumaoro? He took our daughters and wives from us and we were more craven than women. He carried his insolence to the point of stealing the wife of his nephew Fakoli! We were prostrated and humiliated in front of our children. But it was in the midst of so many calamities that our destiny suddenly changed. A new sun arose in the east. After the battle of Tabon we felt ourselves to be men, we realized that Soumaoro was a human being and not an incarnation of the devil, for he was no longer invincible. A man came to us. He had heard our groans and came to our aid, like a father when he sees his son in tears. Here is that man. Maghan Sundiata, the man with two names foretold by the soothsayers.

"It is to you that I now address myself, son of Sogolon, you, the nephew of the valorous warriors of Do. Henceforth it is from you that I derive my kingdom for I acknowledge you my sovereign. My tribe and I place ourselves in your hands. I salute you, supreme chief, I salute you, Fama of Famas.[8] I salute you, Mansa!"[9]

The huzza that greeted these words was so loud that you could hear the echo repeat the tremendous clamour twelve times over. With a strong hand Kamandjan struck his spear in the ground in front of the dais and said, "Sundiata, here is my spear, it is yours."

Then he climbed up to sit in his place. Thereafter, one by one, the twelve kings of the bright savanna country got up and proclaimed Sundiata "Mansa" in their turn. Twelve royal spears were stuck in the ground in front of the dais. Sundiata had become emperor. The old tabala of Niani announced to the world that the lands of the savanna had provided themselves with one single king. When the imperial tabala had stopped reverberating, Balla Fasséké, the grand master of ceremonies, took the floor again following the crowd's ovation.

"Sundiata, Maghan Sundiata, king of Mali, in the name of the twelve kings of the "Bright Country," I salute you as 'Mansa.'"

[7] Army troops, often of slave origin.

[8] King of kings.

[9] Emperor.

The crowd shouted "Wassa, Wassa. . . . Ayé."

It was amid such joy that Balla Fasséké composed the great hymn "Niama" which the griots still sing:

Niama, Niama, Niama,
You, you serve as a shelter for all,
All come to seek refuge under you.
And as for you, Niama,
Nothing serves you for shelter,
God alone protects you.

The festival began. The musicians of all the countries were there. Each people in turn came forward to the dais under Sundiata's impassive gaze. Then the war dances began. The sofas of all the countries had lined themselves up in six ranks amid a great clatter of bows and spears knocking together. The war chiefs were on horseback. The warriors faced the enormous dais and at a signal from Balla Fasséké, the musicians, massed on the right of the dais, struck up. The heavy war drums thundered, the bolons gave off muted notes while the griot's voice gave the throng the pitch for the "Hymn to the Bow." The spearmen, advancing like hyenas in the night, held their spears above their heads; the archers of Wagadou and Tabon, walking with a noiseless tread, seemed to be lying in ambush behind bushes. They rose suddenly to their feet and let fly their arrows at imaginary enemies. In front of the great dais the Kéké-Tigui, or war chiefs, made their horses perform dance steps under the eyes of the Mansa. The horses whinnied and reared, then, overmastered by the spurs, knelt, got up and cut little capers, or else scraped the ground with their hooves.

The rapturous people shouted the "Hymn to the Bow" and clapped their hands. The sweating bodies of the warriors glistened in the sun while the exhausting rhythm of the tam-tams wrenched from them shrill cries. But presently they made way for the cavalry, beloved by Djata. The horsemen of Mema threw their swords in the air and caught them in flight, uttering mighty shouts. A smile of contentment took shape on Sundiata's lips, for he was happy to see his cavalry manoeuvre with so much skill.

In the afternoon the festivity took on a new aspect. It began with the procession of prisoners and booty. . . .

When Sosso Balla was in front of the dais, Djata made a gesture. He had just remembered the mysterious disappearance of Soumaoro inside the mountain. He became morose, but his griot Balla Fasséké noticed it and so he spoke thus:

"The son will pay for the father, Soumaoro can thank God that he is already dead."

When the procession had finished Balla Fasséké silenced everyone. The sofas got into line and the tam-tams stopped.

Sundiata got up and a graveyard silence settled on the whole place. The Mansa moved forward to the edge of the dais. Then Sundiata spoke as Mansa. Only Balla Fasséké could hear him, for a Mansa does not speak like a town-crier.

"I greet all the peoples gathered here." And Djata mentioned them all. Pulling the spear of Kamandjan, king of Sibi, out of the ground, he said:

"I give you back your kingdom, king of Sibi, for you have deserved it by your bravery; I have known you since childhood and your speech is as frank as your heart is straightforward.

"Today I ratify for ever the alliance between the Kamaras of Sibi and the Keitas of Mali. May these two people be brothers henceforth. In future, the land of the Keitas shall be the land of the Kamaras, and the property of the Kamaras shall be henceforth the property of the Keitas.

"May there nevermore be falsehood between a Kamara and a Keita, and may the Kamaras feel at home in the whole extent of my empire."

He returned the spear to Kamandjan and the king of Sibi prostrated himself before Djata, as is done when honoured by a Fama.

Sundiata took Tabon Wana's spear and said, "Fran Kamara, my friend, I return your kingdom to you. May the Djallonkés and Mandingoes be forever allies. You received me in your own domain, so may the Djallonkés be received as friends throughout Mali. I leave you the lands you have conquered, and henceforth your children and your children's children will grow up at the court of Niani where they will be treated like the princes of Mali."

One by one all the kings received their kingdoms from the very hands of Sundiata, and each one bowed before him as one bows before a Mansa.

Sundiata pronounced all the prohibitions which still obtain in relations between the tribes. To each he assigned its land, he established the rights of each people and ratified their friendships. The Kondés of the land of Do became henceforth the uncles of the imperial family of Keita, for the latter, in memory of the fruitful marriage between Naré Maghan and Sogolon, had to take a wife in Do. The Tounkaras and the Cissés became "banter-brothers" of the Keitas, while the Cissés, Bérétés and Tourés were proclaimed great divines of the empire. No kin group was forgotten at Kouroukan Fougan; each had its share in the division. To Fakoli Koroma, Sundiata gave the kingdom of Sosso, the majority of whose inhabitants were enslaved. Fakoli's tribe, the Koromas, which others call Doumbouya or Sissoko, had the monopoly of the forge, that is, of iron working. Fakoli also received from Sundiata part of the lands situated between the Bafing and Bagbé rivers. Wagadou and Mema kept their kings who continued to bear the title of Mansa, but these two kingdoms acknowledged the suzerainty of the supreme Mansa. The Konaté of Toron became the cadets of the Keitas so that on reaching maturity a Konaté could call himself Keita.

When Sogolon's son had finished distributing lands and power he turned to Balla Fasséké, his griot, and said: "As for you, Balla Fasséké, my griot, I make you grand master of ceremonies. Henceforth the Keitas will choose their griot from your tribe, from among the Kouyatés. I give the Kouyatés the right to make jokes about all the tribes, and in particular about the royal tribe of Keita."

Thus spoke the son of Sogolon at Kouroukan Fougan. Since that time his respected word has become law, the rule of conduct for all the peoples who were represented at Ka-ba.

So, Sundiata had divided the world at Kouroukan Fougan. He kept for his tribe the blessed country of Kita, but the Kamaras inhabiting the region remained masters of the soil.

If you go to Ka-ba, go and see the glade of Kouroukan Fougan and you will see a linké tree planted there, perpetuating the memory of the great gathering which witnessed the division of the world. . . .

With Sundiata peace and happiness entered Niani. Lovingly Sogolon's son had his native city rebuilt. He restored in the ancient style his father's old enclosure where he had grown up. People came from all the villages of Mali to settle in Niani. The walls had to be destroyed to enlarge the town, and new quarters were built for each kin group in the enormous army.

Sundiata had left his brother Manding Bory at Bagadou-Djeliba on the river. He was Sundiata's Kankoro Sigui, that is to say, viceroy. Manding Bory had looked after all the conquered countries. When reconstruction of the capital was finished he went to wage war in the south in order to frighten the forest peoples. He received an embassy from the country of Sangaran where a few Kondé clans had settled, and although these latter had not been represented at Kouroukan Fougan, Sundiata granted his alliance and they were placed on the same footing as the Kondés of the land of Do.

After a year Sundiata held a new assembly at Niani, but this one was the assembly of dignitaries and kings of the empire. The kings and notables of all the tribes came to Niani. The kings spoke of their administration and the dignitaries talked of their kings. Fakoli, the nephew of Soumaoro, having proved himself too independent, had to flee to evade the Mansa's anger. His lands were confiscated and the taxes of Sosso were payed directly into the granaries of Niani. In this way, every year, Sundiata gathered about him all the kings and notables; so justice prevailed everywhere, for the kings were afraid of being denounced at Niani.

Djata's justice spared nobody. He followed the very word of God. He protected the weak against the strong and people would make journeys lasting several days to come and demand justice of him. Under his sun the upright man was rewarded and the wicked one punished.

In their new-found peace the villages knew prosperity again, for with Sundiata happiness had come into everyone's home. Vast fields of millet, rice, cotton, indigo and fonio surrounded the villages. Whoever worked always had something to live on. Each year long caravans carried the taxes in kind to Niani. You could go from village to village without fearing brigands. A thief would have his right hand chopped off and if he stole again he would be put to the sword.

New villages and new towns sprang up in Mali and elsewhere. "Dyulas," or traders, became numerous and during the reign of Sundiata the world knew happiness.

There are some kings who are powerful through their military strength. Everybody trembles before them, but when they die nothing but ill is spoken of them. Others do neither good nor ill and when they die they are forgotten. Others are feared because they have power, but they know how to use it and they are loved because they love justice. Sundiata belonged to this group. He was feared, but loved as well. He was the father of Mali and gave the world peace. After him the world has not seen a greater conqueror, for he was the seventh and last conqueror. He had made the capital of an empire out of his father's village, and Niani became the navel of the earth.

QUESTIONS

1. What is the griot Djeli Mamadou Kouyaté's conception of his role of historian? How would he define history? Does his definition differ from ours?
2. What is the Malinke view of fate or destiny as expressed here?
3. What are the attributes of the hero as expressed in this Malian epic? How do they correspond with those in the *Epic of Gilgamesh*, the Homeric epics, and the *Aeneid*?
4. What are the ideals of government and of good leadership presented in this epic?
5. Seek out some *proverbs* from the text. How do they inform us in a capsulized way of Malinke values?

● MYTHS ●

Two Yoruba Myths of Creation

The myths that follow address themselves, in the context of African religion, to three basic questions: (1) How did the world begin? (creation); (2) What caused God to withdraw from the human world? and (3) Why do people have to die? These myths require a word of explanation on Yoruba religion, which will

be discussed more fully in the poetry section. The highest God, named Oludumare or Olorun, has many aspects, which are represented by lesser deities called *orisha*. One of these is Obatala, god of creation.

The Creation of Land

At the beginning everything was water. Then Olu-du-mare the supreme god sent Obatala (or Orishanla) down from heaven to create the dry land. Obatala descended on a chain and he carried with him: a snail shell filled with earth, some pieces of corn and a cock. When he arrived he placed the corn on the water, spread the earth over it and placed the cock on top. The cock immediately started to scratch and thus the land spread far and wide.

When the land had been created, the other Orisha descended from heaven in order to live on the land with Obatala.

The Creation of Man

Obatala made man out of earth. After shaping men and women he gave them to Oludumare to blow in the breath of life.

One day Obatala drank palm wine. Then he started to make hunchbacks and cripples, albinos and blind men.

From that day onwards hunchbacks and albinos and all deformed persons are sacred to Obatala. But his worshipers are forbidden to drink palm wine.

Obatala is still the one who gives shape to the new babe in the mother's womb.

QUESTIONS

1. How is the role of the supreme God, Oludumare, distinguished from that of the orisha Obatala?
2. What similarities and differences do you find in these creation myths and the story of creation in Genesis?

Myths on the Separation of Man from God

This myth comes from the Yao, one of a cluster of peoples speaking Bantu languages who live in northern Mozambique and adjacent lands in Tanzania.

Mulungu and the Beasts

In the beginning man was not, only Mulungu and his people, the beasts. They lived happily on earth.

One day a chameleon found a human pair in his fish trap. He had never seen such creatures before and he was surprised. The chameleon reported his discovery to Mulungu. Mulungu said, "Let us wait and see what the creatures will do."

The men started making fires. They set fire to the bush so that the beasts fled into the forest. Then the men set traps and killed Mulungu's people. At last Mulungu was compelled to leave the earth. Since he could not climb a tree he called for the spider.

The spider spun a thread up to the sky and down again. When he returned he said, "I have gone on high nicely, now you Mulungu go on high." And Mulungu ascended to the sky on the spider's thread to escape from the wickedness of men.

The next two myths are from the Ashanti peoples of modern Ghana. They are one of the populous Akan cultural complex, one of whose characteristics is matrilineal descent. The Ashanti state, founded around 1680, became a principal political power on the Gold Coast during the eighteenth and nineteenth centuries. Its greatness resulted in part from European trade and in part from the fact that it integrated under its king (the *asantehene*) and ruling council many more of the Akan peoples into one state than had been achieved before. The Ashanti were also splendid craftspeople whose court art, textiles, and gold weights are among the highest achievements of West African art.

The Tower to Heaven

Long, long ago Onyankopon lived on earth, or at least was very near to us. Now there was a certain old woman who used to pound her mashed yams and the pestle kept knocking up against Onyankopon, who was not then high in the sky. So Onyankopon said to the old woman: "Why do you keep doing this to me? Because of what you are doing I am going to take myself away up in the sky." And of a truth he did so.

Now the people could no longer approach Onyankopon. But the old woman thought of a way to reach him and bring him back. She instructed her children to go and search for all the mortars they could find and bring them to her. Then she told them to pile one mortar on top of another til they reached to where Onyankopon was. And her children did so, they piled up many mortars, one on top of another, til they needed only one more mortar to reach Onyankopon.

Now, since they could not find another mortar anywhere, their grandmother the old woman said to them: "Take one out from the bottom and put it on top to make them reach." So her children removed a mortar from the bottom and all the mortars rolled and fell to the ground, causing the death of many people.

QUESTIONS

1. What generalization can you make from these myths about the basic cause of humanity's fall from its idyllic relationship with God?

2. What is the difference between the relationship between God and humanity and that between God and the animals in "Mulungu and the Beasts"?
3. What does "The Tower to Heaven" say about human ingenuity in relation to God? Compare the biblical story of the tower of Babel.

Myths on the Origin of Death

The Perverted Message

In primeval times, God had familiar intercourse with men and gave them all they needed. This state, however, came to an end when some women who were grinding their food became embarrassed by God's presence and told him to go away, and beat him with their pestles. God then withdrew from the world, and left its government to the spirits.

Afterward God sent a goat from heaven to the seven human beings on earth with the following message: "There is something called death. One day it will kill some of you. Even if you die, however, you will not be altogether lost. You will come to live with me in the sky."

On the way, the goat lingered at a bush in order to eat, and when God discovered this he sent a sheep with the same message. But the sheep changed the message to the effect that men should die, and that as far as they were concerned this would be the end of all things. When the goat then arrived with her true message, men would not believe it. They had already accepted the message delivered by the sheep. Shortly afterward the first case of death took place, and God taught men to bury their dead. He also told them that as a foil to death they should be given the capacity to multiply.

According to another version, God sent the sheep with eternal life as a gift to men. But the he-goat ran on ahead and gave them death as a gift from God. They eagerly accepted this gift, as they did not know what death was. The sheep arrived after a while, but it was too late.

The Efe are a small branch of the Mbuti hunting and gathering peoples who live in the Ituri forest of Zaire. They are seminomadic and often live in symbiotic relationships with nearby black African groups. This myth is from the Efe.

The Forbidden Fruit

God created the first human being Ba-atsi with the help of the moon. He kneaded the body into shape, covered it with a skin, and poured in blood. When the man had thus been given life, God whispered in his ear that he, Ba-atsi, should beget children, and upon them he should impress the following prohibition: "Of all the trees of the forest you may eat, but of the Tahu tree you may not eat." Ba-atsi had many children, impressed upon them the prohibition, and then retired to heaven. At first men respected the commandment they had been given, and lived happily. But one day a pregnant woman was seized with an irresistible desire to eat of the forbidden fruit. She tried to persuade her husband to give her some of it. At first he refused, but after a time he gave way. He stole into the wood, picked a Tahu fruit, peeled it, and hid the peel among the leaves. But the moon had seen his action and reported it to God. God was so enraged over man's disobedience that as punishment he sent death among them.

The following myth comes from the Darasa, one of a cluster of ancient Cushitic peoples who practice intensive agriculture by irrigation and terracing of mountain slopes in southern Ethiopia.

Man Chooses Death in Exchange for Fire

Formerly men had no fire but ate all their food raw. At that time they did not need to die for when they became old, God made them young again. One day they decided to beg God for fire. They sent a messenger to God to convey their request. God replied to the messenger that he would give him fire if he was prepared to die. The man took the fire from God, but ever since then all men must die.

Madagascar, the source of this next myth, lies in the Indian Ocean off the southeastern coast of Africa. Its peoples include descendants of both mainland Africans and Malayo-Polynesians who probably followed the seasonal trade winds from southeast Asia to settle on the island around the beginning of the Christian era.

Man Chooses Death in Exchange for Children

One day God asked the first human couple who then lived in heaven what kind of death they wanted, that of the moon or that of the banana. Because the couple wondered in dismay about the implications of the two modes of death, God explained to them: the banana puts forth shoots which take its place and the moon itself comes back to life. The couple considered for a long time before they made their choice. If they elected to be childless they would avoid death, but they would also be very lonely, would themselves be forced to carry out all the work, and would not have anybody to work and strive for. Therefore they prayed to God for children, well aware of the consequences of their choice. And their prayer was granted. Since that time man's sojourn is short on this earth.

COMMENTS AND QUESTIONS

1. Notice the closeness of animals to God in comparison to people. How do you interpret the significance of the "perverted message"?
2. Compare "The Forbidden Fruit" with the similar story in Genesis. Is the religious message of the two stories the same?
3. What is the cultural significance of fire? Why would people choose it over immortality? Look up the Greek myth of Prometheus to compare it with this.
4. How are the importance of children and continuity of the community over time expressed? Notice the expression of this value in other aspects of African culture.

● TALES AND PROVERBS ●

A Labarai Tale

The labarai example below, "The Origin of All Kings"—sometimes called the Daura legend—relates the origin of the Hausa city-state political system. The legend probably developed in the eighteenth century at a time when Bornu, a kingdom to the east, exercised subtle political influence over the Hausa states. The attribution of Eastern origin (in this case Baghdad) is common among Islamic states in West Africa. The translator of this selection, and of the following tatsuniyoyi tales (with the exception of "The Kano Man," originally compiled by Frank Edgar), is Roberta Ann Dunbar.

The Origin of All Kings

This is the story of the first Kings of Daura, Kano, Katsina Gobir, Zazzau (Zaria) and Nuru (Rano), who descended from a man named Bayajibda, son of Abdullahi, King of Baghdad. Now the reason Bayajibda left Baghdad was that a heathen named Zidawa made war against them—a devastating war—and their land was divided into 40 parts.

Bayajibda went with twenty towards Bornu. Together with his soldiers they were a greater and more powerful force than the men of the King of Bornu. The Bornu king came from Syria. When Bayajibda's men realized they were more powerful than those of the King of Bornu they said to him, "Let's kill the King of Bornu so that you may succeed him."

But the King of Bornu hearing this was wary and could not be killed. The King of Bornu asked, "What is our plan for these intruders, my countrymen? The only plan I can see is to marry him off." So Bayajibda was given a daughter of the King named Magira to marry.

Peace and trust developed between them. When he went out on campaigns, Bayajibda would say to the King of Bornu, "Give me some of your men. I will take them to some villages and together we will conquer them." Sometimes he was given two thousand men; at others three thousand. But when he returned from war, he would not return with them. Rather, he set them up in towns in Bornu's territory.

After a time there were only two of Bayajibda's fellow countrymen left. He said to them, "Brothers, I want to look for a place for each of you to live." He set out with one of them and went to Kanem. He is King of Kanem. He set out with the other and went to Bagirmi. He is King of Bagirmi. Then Bayajibda, now alone, left, accompanied by his wife, the daughter of the King of Bornu, and his horse.

When the Bornu people saw that Bayajibda was alone, they kept trying to seek him out to kill him. Because of this he fled at great pace with his wife Magira who was pregnant. In this way they arrived at a certain town called Gabas. Bayajibda left his wife there as she was unable to travel further, and continued on his way. After his departure, she bore a son who was named Biram. He became King of Gabas, or as it was called Gabas of Biram.

When Bayajibda reached Daura, a queen was ruling there. Among the women who had ruled in Daura before, the first was Kufunu. After her the next was Gufunu, then Yakunu, Yakunya, Waizam, Waiwaina, Gidirgidir, Anagari, and Daura. It was she whom Bayajibda found ruling when he came.

When he arrived he alighted at the house of an old woman named Awaina and asked her to give him water. But she said to him, "Alas, my son, one can get water in this town only on Friday when people are gathered together." He replied, "I will draw water. Give me a bucket." She brought a bucket and gave him. It was nighttime when they spoke together about this.

When he had taken the bucket, he went to the well and dropped the bucket down inside. Now in the well lived a female snake. When the snake heard someone drop the bucket, she raised her head from the well and tried to kill Bayajibda. The name of the snake was Sarki. But he took out his sword, cut off her head and took the head and hid it. He drew water, drank and gave some to his horse. He took the rest to the old woman Awaina. He went into the house and lay down to rest.

At daybreak, people saw what this Arab from Syria had done. They were surprised at the size of what remained of the snake at the well. In a while the news reached Daura and she came with her warriors to the well site.

When the queen saw that the snake's head had been cut off and what remained behind, she was filled with wonder because this thing had so harassed the people. She said, "If I discover whoever has killed this snake, I will divide the kingdom in two and give him half." One man said, "I killed it." She asked, "Where is its head? If he doesn't show the head he is lying." So that man left. Another man came and exclaimed, "It was I who killed it." This one too was lying. Many men came forward, but each one was proclaiming himself falsely.

Then the old woman appeared and said, "Last night a stranger stopped at my house. He came with an animal, though whether it was an ox or a horse, I don't know. He took the bucket, drew water from the well, drank and gave some to his animal, bringing me the rest of it. Perhaps he is the one who killed the snake. We should find him and ask." So Bayajibda was summoned and Daura asked him, "Are you the one who killed the snake?" "It was I," he replied. She said, "Where is its head?" "Here it is," he said. Then the queen said, "I promised that for whoever did this thing, I would divide my town in two and give him half." He said, "Do not divide your town. As for me, I request your hand in marriage." So she married him and he lived in her house. She gave him a slave girl whom he took as a concubine. When people came to Daura's house they didn't say her name. Rather they said, "We are going to the house of Makas-Sarki, 'the killer of Sarki.'" Thus it happened that she assumed the name Sarki [the Hausa word for chief].

After some time, the concubine became pregnant although Daura did not. The concubine gave birth to a son. Bayajibda sought Daura's permission and she gave it to name him Makarabgari (Receiver of the town). After this Daura became pregnant and when she gave birth to a son, she sought her husband's permission to name him. They agreed and the child was called Bawugari. He was the first of the kings.

When Makas-Sarki, his father, died, Bawugari inherited his father's dwelling place and bore six children. The first named Gazaura, was King of Daura. Another of the same mother named Bagauda became King of Kano. Another son named Gunguma became King of Zazzau and another by the same mother named Dami became King of Gobir. The last two, also of the same mother, were Kumayau who became King of Katsina and Zamgugu who was King of Rano.

Thus ends the story of the kings.

COMMENTS AND QUESTIONS

1. The marriage between an indigenous queen and a newcomer is not an uncommon motif in legends of origin and may reflect the transition from an earlier matrilineal or matriarchal stage to a patrilineal and patriarchal stage in society. This kind of marriage is also a frequent way of explaining accommodation between foreign invaders and local people over whom they had established hegemony. Compare the story of Oedipus.

2. Political power was recognized not only because of military conquest but also because of technological expertise. Bayajibda killed the snake that had restricted Daura's water supply; he also came with an animal, the horse, unfamiliar to the old woman who gave him shelter. Does this suggest anything to you about levels of technology or modes of warfare in pre-Bayajibda Hausa society?

3. Compare this tale with the epic *Sundiata*. Is Bayajibda a hero in the same sense that Sundiata is? What is the difference in the way in which an epic and a tale present a hero?

Tatsuniyoyi Tales

Squirrel and Hedgehog

One day it was raining. Hedgehog was wandering around when she came to the door of Squirrel's hole. She greeted him and said,

"I'm really cold. Is there any room there for me to take shelter?"

Squirrel said,

"There's a little space here, come on in."

They sat down together. After a while Squirrel said,

"Hey Hedgehog, our being together like this isn't very pleasant. Your body is all prickly. Why don't you go find another spot?"

Hedgehog said,

"Gee, this place is fine for me. Whoever doesn't find this place suitable, *he* should be the one to move!"

The Blind Man with the Lamp

A young man was strolling along one night when he caught sight of a man with a lamp. When he drew near he realized that the man was blind. The boy said,

"Hey blind man, have you lost your senses? What brings you to wandering around with a lamp? Aren't day and night all the same to you?"

The blind man said,

"Of course they are, stupid. Even at night I see better than you do. I don't carry this lamp for myself, but so that you silly people without eyes don't bump into me."

Life Is Better Than Wealth

Once there was a man who was so poor he didn't know what to do. So he went to the king and said,

"I don't have anything to eat for today, or for tomorrow either. I don't have anything at all in the world save this loincloth. I'm tired of living. I want you to kill me."

The king said,

"All right."

He called some soldiers and told them to kill the man so that he could find rest. The soldiers were about to dispatch him when another came by and said,

"If you kill him, please give me his loincloth." When the poor man heard that he said,

"Stop! Take me back to the king. I have something to say."

So they took him back and the king asked them what happened. The poor man fell on his knees and said,

"Your highness, let me go. Today I have seen someone poorer than I am. Truly, life is great."

The king said,

"Be off with you and thank God that he has given you life and health."

Hasara and Riba

Hasara and Riba were sisters—same mother same father. Hasara was an extremely beautiful girl but poor Riba was ugly. Tinau and Sule sought their hands in marriage. Tinau was richer and better looking than Sule and he courted Hasara. So Sule proceeded to court Riba. The couples were married at the same time and each girl went to the home of her husband.

Now Hasara was proud and haughty. She liked elegant food, jewelry, and very expensive clothes. Riba, however, worked together with her husband. She helped him take goods to market and when they earned a profit, they put aside half of it, using the rest for their trading. Before a year was out Sule was a rich man. Tinau by that time was flat broke. To make a long story short, Tinau left Hasara with all her beauty. She married another and the same thing happened. Before the second year was past, Hasara had been married four times. But Riba is still there with her husband Sule. They are very prosperous and even have many cattle with shepherds to look after them. Whoever follows his heart's desire surely he will be wed to loss.

The Rivals

There were two boys who were courting the same girl. She couldn't decide which to accept, so she told them she would marry whichever one was the braver.

One day, the boys went to her place for a chat. When they got ready to go home, she accompanied them to the edge of the "bush." Suddenly, a leopard came upon them. The first boy hurled his spear at the leopard but missed it. The other did the same. They continued until all their spears were gone. Meanwhile the girl hid behind a tree. Then, one boy said to the other,

"Hurry home to my mother's house. There are some spears there near the bed. Gather them up and bring them back."

When the other boy departed, the one left behind fell on the leopard and wrestled with it. He got the leopard down and killed it. Then, he propped the leopard up, called to the girl, and told her to lie down in front of it. He then hid himself.

The other boy returned without any spears since they had already been borrowed by someone else. He came upon the leopard where he had left it and saw the girl lying on the ground in front of it. The boy said,

"Oh no, is that the way he is? He gets rid of me so that he can run off and lets the leopard kill the poor girl?"

Then he attacked the leopard with full force and grabbed it around the neck. The leopard's body fell over in a heap. The boy who had been hiding came out laughing.

So now, which one of them will the girl marry?

The Kano Man

This is the sharp fellow, the city slicker.

His character: A Kano man puts on a dark-blue gown, and a white Nupe one, and a black-and-white one; then he wears Kano-style trousers, either white or black-and-white; puts on a length of muslin for a turban; hangs a book over his shoulder and off he goes to school to recite the Koran; he takes a staff, a little gourd water-bottle, and away he goes. When he has finished at school, he returns home. When it is time for market he goes to market. Returning from there, when it is night, he puts on a leather loincloth, picks up a rope-ladder, and off he goes to steal. Sometimes he gets shot or wounded with a sword, and sometimes dies, and sometimes gets better.

The Kano character is also, if a rich visitor arrives, to receive him joyfully, and give him a gown, or a turban or a length of cloth. Then they get together with one of the household where he is staying and start bringing shoddy stuff to sell him. When the householder sees it, he praises its quality. They abuse his trust in them and trick him. But if the visitor is shrewd, he rejects all the stuff they bring him, saying, "I'm not buying it," and waits till he gets to the market and buys what he wants.

Trickery and fraud are Kano characteristics. Whoever you are, a Kano man will trick you—unless he thinks it can't be done. For there is no one so cowardly.

..

COMMENTS AND QUESTIONS

1. A major characteristic of African tales evident in the Hausa tatsuniyoyi is their realism and recognition of the flaws in human nature and in society. Some tales

exhort people to good behavior; others express stereotypes about people from different places or walks of life as seen here in "The Kano Man." Kano was and is a major commercial center. Its markets attracted merchants from all over West and North Africa. How does this tale's image of the Kano man—the quintessential merchant—compare with our own image of the "city slicker"?

2. Hasara and Riba are not usual Hausa names as suggested in that story. Rather they are respectively the Hausa words for "loss" and "profit." What does this tale tell you about values of work and discipline?

3. What other Hausa values are expressed in these tales?

4. What shows you that these tales are well grounded in the socioeconomic realities of the Hausa people?

5. What model is suggested in the tales "Hasara and Riba" and "The Rivals" for a proper relationship between husband and wife?

6. Do the morals to these tales appear to be "tacked on," or are they woven into the fabric of the story? Give examples.

Yoruba Riddles

These riddles are reprinted from *Black Orpheus* and the *Journal of American Folklore*.

A round calabash in the spear grass.
Ans.: Moon and stars.

We tie a horse in the house, but its mane flies above the roof.
Ans.: Fire and smoke.

We invited him to warm himself in the sun—he came. We asked him to take his bath. He said: death has come.
Ans.: Salt.

They cut off his head; they cut off his waist; his stump says he will inherit the title of his father's house.
Ans.: Yam.

Fat wife inside many thorns.
Ans.: Tongue and teeth.

We seize hold of it; the child in its womb walks away.
Ans.: Gun.

Who is it that goes down the street past the king's house without greeting the king?
Ans.: Rainwater.

People run away from her when she is pregnant. But they rejoice when she has delivered.
Ans.: A gun.

Yoruba Proverbs

Translation by Bakare Gbadamosi and Ulli Beier

The Yoruba proverbs included below are keys to the values of the Yoruba people. They sometimes express a surprising candor about political relationships, hospitality, and attitudes toward the elderly— areas where candor outside of proverbial speech would be impolitic and rude.

The dignified crawl of the earthworm arouses the envy of the cock.

A man has been beaten six times and is advised to be patient. What else is there for him to do?

When death is not ready to receive a man, it sends an expert physician at the right time.

A bachelor who asks for food too often will soon hear the price of vegetables.

Only the man whom his child buries has really got a child.

It is the honour of the father that allows the son to walk about proudly.

We are talking about pumpkins. A woman asks what are we talking about. We say: this is a man's talk. But when we gather the fruit, who will break them and cook them?

Anger does not help. Patience is the father of character.

What only stops a hawk from laughing will make the hen faint on her eggs.

The wisdom of others prevents a chief from being called a fool.

The god who favors a lazy man does not exist. It is one's hands that bring prosperity.

Everybody who comes to this world must become something. Only we don't know what.

The effort of forcing another man to be like oneself makes one an unpleasant person.

Having become king you prepare charms. Do you want to become a god?

One who takes another to court does not think that the other man has his own statement to make.

After the man has been cured, he beats the doctor.

The proud pond stands alone from the river, forgetting that water is common to both.

Mean people are common like trees in the forest.

An elderly man who cannot keep his mouth shut when he sees something strange, must use his mouth in court.

Do not be seen counting the toes of the man who has only nine.

. .

QUESTIONS

1. What Yoruba social values and philosophical beliefs can you discern in the riddles? In the proverbs?
2. Attempt to define "riddle" as a literary genre. Which riddles here show evidence of a sophisticated wit?
3. Can you compare any of the proverbs here with those in the Bible?

. .

● POETRY ●

Most of the poems that follow have been taken from the rich oral tradition of the Yoruba language. They represent not only a wide variety of forms and subjects but also the intimate relationship that exists between poetry and everyday life in Africa. Two non-Yoruba poems illustrating this relationship are a Fulani love poem and the naming poem from the Ga people in Ghana. In addition, we have included modern poems that are written in European languages but make use of traditional themes.

The ritual character of the first four Yoruba poems calls for a further explanation of Yoruba religion and traditional forms of Yoruba poetry. As noted in the introduction to Yoruba myths, in Yoruba belief the first, high God, Oludumare, is represented on earth by lesser deities called orisha. Orisha may also symbolize ancestor figures, ancient kings, and founders of cities. Each orisha is associated with some form of nature, or with a particular color or metal. Each of the four poems is a praise poem dedicated to one of the orisha. The first is about Obatala, god of creation (recall the Yoruba myths of creation); the second is about Eshu, the unpredictable god of fate and the agent for change, good and bad. The subject of the third is Oshun, the mother goddess, protector of the town of Oshogbo and source of healing and fertility; and that of the fourth, Ogun, whose association with iron and war is linked to survival, innovation, and technology. These poems are classified as *oriki* by the Yoruba—meaning poems based on names given to gods, places, rulers, and important persons. Oriki poetry is performed by professional singers or, in the case of poems about deities such as these, by the priests of the particular deity whose oriki is being sung.

Yoruba poetry is classified by the style of specific groups of performers more than by subject matter or poetic form. Whereas the oriki are sung by priests, *ijala* are sung by hunters, and the *iwi*, represented by "Children" and two Yoruba funeral songs, are poems sung by the *egungun,* the masqueraders. These have a specific religious function: they mediate between the community of the living and that of the recently dead. Masqueraders embody the spirit and imitate the voice of the person involved; during the ceremonial, dances are sacred. Reflecting the high degree of integration of religious beliefs with other aspects of social life, masqueraders may also entertain, sometimes offering social satires and commentaries.

In the Ga naming poem, as in the Yoruba iwi on children, the fragility of life, the desirability of children, and their symbolic importance as links between the living and dead appear as critical elements of belief. The poem "The Beloved" was collected by Amadou Hampaté Ba from the traditional literature of the Fulani, a nomadic group in West Africa. The Yoruba poetry is translated by Bakare Gbadamosi and Ulli Beier, the Ga poem by Neils Augustine Hesse.

. .

Oriki—Yoruba Praise Poems

Oriki Obatala

He is patient, he is not angry.
He sits in silence to pass judgement.
He sees you even when he is not looking.
He stays in a far place—but his eyes are on the town.

The granary of heaven can never be full.
The old man full of life force.

He kills the novice.
And wakens him to let him hear his words.
We leave the world to the owner of the world.

Death acts playfully till he carries away the child.
He rides on the hunchback.
He stretches out his right hand.
He stretches out his left hand.
He stands by his children and lets them succeed.
He causes them to laugh—and they laugh.
Ohoho—the father of laughter.
His eye is full of joy,
He rests in the sky like a swarm of bees.

We dance to your sixteen drums that sound jingin, jingin,
To eight of the drums we dance bending down,
To eight of the drums we dance erect.
We shake our shoulders, we shake our hips,
Munusi, munusi, munusi,
We dance to your sixteen drums.

Those who are rich owe their property to him.
Those who are poor, owe their property to him.
He takes from the rich and gives to the poor.

Whenever you take from the rich—come and give it
 to me!

Obatala—who turns blood into children.
I have only one cloth to dye with blue indigo.
I have only one headtie to dye with red camwood.
But I know that you keep twenty or thirty children
 for me
Whom I shall bear.

Oriki Eshu

When he is angry he hits a stone until it bleeds.
When he is angry he sits on the skin of an ant.
When he is angry he weeps tears of blood.

Eshu, confuser of men.
The owner of twenty slaves is sacrificing,
So that Eshu may not confuse him.
The owner of thirty "iwofa" is sacrificing,
So that Eshu may not confuse him.
Eshu confused the newly married wife.
When she stole the cowries from the sacred shrine of
 Oya
She said she had not realized
That taking two hundred cowries was stealing.
Eshu confused the head of the queen—
And she started to go naked.
Then Eshu beat her to make her cry.
Eshu, do not confuse me!
Eshu, do not confuse the load on my head.

Eshu, lover of dogs.
If a goat gets lost in Ogbe,—don't ask me.
Do you think I am a thief of goats?
If a huge sheep is missing from Ogbe—don't ask me.
Do you think I am a thief of sheep?
If any fowl get lost in Ogbe—don't ask me.
Do you think I am a thief of birds?
But if a black dog is missing from Ogbe—ask me!
You will find me eating Eshu's sacrifice in a wooden
 bowl.

Eshu slept in the house.—
But the house was too small for him.
Eshu slept on the verandah—
But the verandah was too small for him.
Eshu slept in a nut—
At last he could stretch himself.

Eshu walked through the groundnut farm.
The tuft of his hair was just visible.
If it had not been for his huge size,
He would not have been visible at all.

Having thrown a stone yesterday—he kills a bird today.

Lying down, his head hits the roof.
Standing up he cannot look into the cooking pot.
Eshu turns right into wrong, wrong into right.

Oriki Oshun

We call her and she replies with wisdom.
She can cure those whom the doctor has failed.
She cures the sick with cold water.
When she cures the child, she does not charge the
 father.
We can remain in the world without fear.
Iyalode who cures children—help me to have my
 own child.
Her medicines are free—she feeds honey to the
 children.
She is rich and her words are sweet.
Large forest with plenty of food.
Let a child embrace my body.
The touch of a child's hand is sweet.

Owner of brass. Owner of parrots' feathers.
Owner of money.

My mother, you are beautiful, very beautiful.
Your eyes sparkle like brass.
Your skin is soft and smooth.
You are black like velvet.
Everybody greets you when you descend on the world.
Everybody sings your praises.

Oriki Ogun

Ogun kills on the right and destroys on the right.
Ogun kills on the left and destroys on the left.
Ogun kills suddenly in the house and suddenly in the
 field.
Ogun kills the child with the iron with which it plays.
Ogun kills in silence.
Ogun kills the thief and the owner of the stolen goods.
Ogun kills the owner of the slave—and the slave runs
 away.
Ogun kills the owner of thirty "iwofa"—and his
 money, wealth and children disappear.
Ogun kills the owner of the house and paints the
 hearth with his blood.
Ogun is the death who pursues a child until it runs into
 the bush.
Ogun is the needle that pricks at both ends.
Ogun has water but he washes in blood.

Ogun, do not fight me. I belong only to you.
The wife of Ogun is like a tim tim.
She does not like two people to rest on her.

Ogun has many gowns. He gives them all to the
 beggars.

He gives one to the woodcock—the woodcock dyes it
　indigo.
He gives one to the coucal—the coucal dyes it in
　camwood.
He gives one to the cattle egret—the cattle egret leaves
　it white.

Ogun is not like pounded yam:
Do you think you can knead him in your hand
And eat of him until you are satisfied?
Ogun is not like maize gruel:
Do you think you can knead him in your hand
And eat of him until you are satisfied?
Ogun is not like some thing you can throw into your
　cap:
Do you think you can put on your cap and walk away
　with him?

Ogun scatters his enemies.
When the butterflies arrive at the place where the
　cheetah excretes,
They scatter in all directions.
The light shining on Ogun's face is not easy to behold.
Ogun, let me not see the red of your eye.
Ogun sacrifices an elephant to his head.
Master of iron, head of warriors,
Ogun, great chief of robbers.
Ogun wears a bloody cap.
Ogun has four hundred wives and one thousand four
　hundred children.
Ogun, the fire that sweeps the forest.
Ogun's laughter is no joke.
Ogun eats two hundred earthworms and does not vomit.

Ogun is a crazy orisha who still asks questions after
　780 years!
Whether I can reply, or whether I cannot reply.
Ogun please don't ask me anything.

The lion never allows anybody to play with his cub.
Ogun will never allow his child to be punished.
Ogun, do not reject me!
Does the woman who spins ever reject a spindle?
Does the woman who dyes ever reject a cloth?
Does the eye that sees ever reject a sight?
Ogun, do not reject me!

COMMENTS AND QUESTIONS

1. In "Oriki Obatala," note the dualistic nature of
Obatala. He is the creator, a kindly deity, who can
also kill (as in line 7). Refer to the myths of Obatala
earlier in this chapter ("The Creation of Land" and
"The Creation of Man"). What characteristics are
portrayed in both the myths and this poem?

2. Eshu, as the poem "Oriki Eshu" states, is the "con-
fuser of men." In Yoruba cosmology he symbolizes
disorder, the unexpected—and yet this quality per-
mits him to turn "wrong into right." How does the
poem express the contradictions of his character?
3. Is the *tone* of the poem on the feminine deity, Os-
hun, different from those on the masculine deities?
How so?
4. How does the poetic principle of *anaphora,* the suc-
cessive repetition of words or phrases, operate in all
of the oriki and especially in "Oriki Ogun"? What
would be the effect and usefulness of this device in
oral poetry?

Ijala—The Poetry of Yoruba Hunters

Adiye (Fowl)

One who sees corn and is glad.
The chicken wears its shin at the back.
We eat it with pounded yam.
Every fool will be buried in the cheek.
The foolish chicken has many relations:
Oil is its relative on the father's side.
Pepper and onion are its relatives on the mother's side.
If it does not see its friend salt even for a day
It will not sleep peacefully.

Etu-Duiker (Antelope)

Beautiful antelope with the slender neck.
Your thighs are worth twenty slaves.
Your arms are more precious than thirty servants.
Your neck is exquisite like a sacred carving.
You step out like a nobleman
Shaking the grass like bells.
Your facial marks are beautiful and bold
Even like those of the king of Ogbomosho.
You wash your body with white.
God has honoured you with white.
The hunter is happy when the owner of white appears.
I cannot be happy when I kill you,
Until I have found your body in the bush.
The pregnant woman demands your skin.
Lying on your skin she will bear a beautiful child.

New Yam

New yam causes the wife of yesterday to lose her
　manners,
New yam causes the head of the household to reject
　food.
It makes a rich person speak out.
Yam will pay its own debt.
"Lay me on a fine bed
And I will lay you on a fine lady."

1. What is the difference in tone between the poem on the chicken and the poem on the antelope? How do the poems render what the poets see as the essence of these two animals?
2. How is the antelope in "Etu-Duiker" personified? What dimension do *similes* give to the poem?
3. The yam, a root vegetable, is the staple food of many African peoples along the Guinea coast. Although yams are relatively easy to grow, they may be ravaged by drought or, to the contrary, rotted by untimely rains. The annual harvest of the new yams, often following a time of hardship and meager food supply, is the occasion for celebration. It is often signaled by religious rituals of thanks and communal solidarity.
4. Explain the relation of the last two lines of "New Yam" to the first part of the poem.

Iwi—The Poetry of Yoruba Masqueraders

Children

A child is like a rare bird.
A child is precious like coral.
A child is precious like brass.
You cannot buy a child on the market.
Not for all the money in the world.
The child you can buy for money is a slave.
We may have twenty slaves,
We may have thirty labourers,
Only a child brings us joy,
One's child is one's child.
The buttocks of our child are not so flat
That we should tie the beads on another child's hips.
One's child is one's child.
It may have a watery head or a square head,
One's child is one's child.
It is better to leave behind a child,
Than let the slaves inherit one's house.
A child is the beginning and end of happiness.
One must not rejoice too soon over a child.
Only the one who is buried by his child,
Is the one who has truly borne a child.
On the day of our death, our hand cannot hold a single cowrie.
We need a child to inherit our belongings.

1. Describe the style of this poem. What is the effect of the very short sentences?

2. What does this poem tell you about the importance of children in African society?

Funeral Poem I

Come nearer home,
Mother of Aina.
You knew how to produce children,
but never learned to chide them.
Come and receive the sacrifice
from your children.
You people of the road,
where did you meet her?
The mother of Kujusola
the mother of Alawede.
They met her on the road to Ede.
I thank the trees that did not fall on her.
I thank the river
that did not carry her away.
No one can bar her way
for she travels an underground path.
Like a new bride
She covers her head with a cloth.

Funeral Poem II

The hunter dies
and leaves his poverty to his gun.
The blacksmith dies
and leaves his poverty to his anvil.
The farmer dies
and leaves his poverty to his hoe.
The bird dies
and leaves its poverty to its nest.
You have died
and left me abandoned in the dark.
Where are you now?
Are you the goat
eating grass around the house?
Are you the motionless lizard
on the hot mud wall?
If I tell you not to eat earthworms
it's like asking you to go hungry.
But whatever they may eat in heaven
Partake with them.
A dead body cannot receive double punishment:
If there is not cloth to cover it—
There will always be earth to cover it.

1. What different emotions on the mourner's part are conveyed in these two poems, and how does the imagery express them?
2. How do the Yoruba beliefs that the dead live on as spirits or else are reincarnated appear in these poems?

● FULANI POETRY ●

AMADOU HAMPATÉ BA

The Beloved

Diko,
of light skin, of smooth hair and long;
her smells sweet and gentle
she never stinks of fish
she never breathes sweat
like gatherers of dry wood.
She has no bald patch on her head
like those who carry heavy loads.
Her teeth are white
her eyes are like
those of a new born fawn
that delights in the milk
that flows for the first time
from the antelope's udder.
Neither her heel nor her palm
are rough; but sweet to touch
like liver; or better still
the fluffy down of kapok.

COMMENTS AND QUESTIONS

1. The Fulani, cattle-herding nomads, stem from the grasslands of the upper Senegal River, but have migrated over the centuries as far east as the Cameroons. How does the poet reflect here an intimate familiarity with nature and especially with the bush?
2. The romantic idea of love does not play an important social role in African society. Husbands and wives may, of course, love each other; but the existence of love is not a prerequisite for marriage. Love is not a major theme in African poetry, although beautiful love lyrics, like the above, do exist. Fulani women have a reputation for being especially beautiful and exciting. What image of Diko, the beloved, do you have from this poem?
3. Compare the way in which the poet here uses imagery to describe his beloved and his feelings about her with similar techniques in the poems of Sappho (Chapter 3) and in the Song of Solomon (Chapter 8).

● GA POETRY ●

Naming Poem

May good fortune come
May our stools be clean
May our brooms be clean
In a circle of unity
 have we met

When we dig a well
May we find water
When of this water we drink
May our shoulders find peace
The stranger who has come
On his mother's head be life
On his father's head be life
Behind his back may
 darkness be
Before his face may
 all be bright
May his head the world respect
And his brethren may he know
May we have forgiveness
 to forgive him
May he work and eat
When he sees he has
 not seen
When he hears he has
 not heard
In black he has come
In white may he return
May good fortune come

COMMENTS AND QUESTIONS

1. In many African societies the naming of a child is surrounded with ceremony; it is the public recognition of the personhood of the newborn and the acknowledgment of his or her full membership in the community. The naming, or "outdooring," does not occur usually until one to two weeks following birth, when it seems certain that the child will survive its entry into the world. On the chosen day, significant members of the youngster's family may whisper the name into the child's ear before announcing it publicly. Special blessings and prayers follow, and the day is filled with gift-giving and celebration by the many relatives and guests invited to share in the occasion.
2. The Ga are a southern Ghanaian people of the Ewe linguistic subgroup of Twi speakers (just as the Ashanti, discussed earlier, are members of the Akan subgroup of Twi speakers). For many Ghanaian peoples there is a close link between the individual and the stool the individual customarily sits on (line 2); for some, a person's soul is said to reside in the stool. (See the discussion of art objects in Chapter 14.) Many rites of passage in the individual's life are carried out in connection with his or her stool, so it is appropriate that "stools" appear in connection with the naming.
3. How does the invocation of this poem illustrate by a shift in focus the link between the child and the community?
4. What are the values that the community wishes for the child?

5. What do *darkness*, *bright*, *black*, and *white* seem to signify?

● MODERN POEMS ●

The final group of poems—written by Birago Diop, a Senegalese who writes in French, and Chinua Achebe and Wole Soyinka, two Nigerians who write in English—illustrates the fact that modern African writers continue to draw inspiration from traditional beliefs and from the themes and styles of oral literature. Birago Diop was one of the Negritude writers, a group of French-speaking Africans and West Indians who found themselves alienated from a Europe they perceived as bent on stifling humanity through the ravages of industrialization and the horrors of World War I. In contrast, they acclaimed Africa's vitality in the face of colonial oppression by celebrating the tropical splendor of Africa's environment and the organic quality of its social and spiritual life. In the circular pattern of existence common to African thought, ancestors play important roles in the lives of the living. Chinua Achebe, primarily known for his fiction embedded in the philosophical concepts of the Ibo people of southern Nigeria, reiterates the theme of the circularity of existence in his poetry. Wole Soyinka, Nobel laureate in literature, has been profoundly engaged in the evolution of Nigerian political culture since the late 1950s. All of his writings, but perhaps especially his plays and his poetry, draw on Yoruba philosophical and religious ideas. The style of the poems presented here—whose subject matter is modern and contemporary—reflects the attention to imagery and metaphor from the oral literature of his people. Soyinka's poems, along with the poems of Achebe and Diop, powerfully assert African writers' embrace of their literary heritage.

BIRAGO DIOP (B. 1906)

Forefathers

Listen more often to things rather than beings.
Hear the fire's voice,
Hear the voice of water.
In the wind hear the sobbing of the trees.
It is our forefathers breathing.

The dead are not gone forever.
They are in the paling shadows
And in the darkening shadows.
The dead are not beneath the ground,
They are in the rustling tree,
In the murmuring wood,

In the still water,
In the flowing water,
In the lonely place, in the crowd;
The dead are not dead.

Listen more often to things rather than beings.
Hear the fire's voice,
Hear the voice of water.
In the wind hear the sobbing of the trees.
It is the breathing of our forefathers
Who are not gone, not beneath the ground,
Not dead.

The dead are not gone forever.
They are in a woman's breast,
A child's crying, a glowing ember,
The dead are not beneath the earth,
They are in the flickering fire,
In the weeping plant, the groaning rock,
The wooded place, the home.
The dead are not dead.

Listen more often to things rather than beings.
Hear the fire's voice,
Hear the voice of water.
In the wind hear the sobbing of the trees.
It is the breath of our forefathers.

CHINUA ACHEBE (B. 1930)

Generation Gap

A son's arrival
is the crescent moon
too new too soon to lodge
the man's returning.
His feast of re-incarnation
must await the moon's
reopening at the naming
ceremony of his
grandson.

COMMENTS AND QUESTIONS

1. Many African religions view human existence as a cyclical phenomenon wherein spirits may proceed through various phases of what we know as birth, life, and death in human, but sometimes animal, form. This view, articulated in both traditional and modern poetry, reinforces humanity's sensitivity to, and awareness of, the natural world. Compare the metaphor of nature in "Forefathers" with that in the Yoruba funeral poems.

2. How is the cyclical nature of human existence conveyed in "Forefathers," Achebe's "Generation Gap," and the iwi on children?

WOLE SOYINKA (B. 1934)

Death in the Dawn

Traveller, you must set out
At dawn. And wipe your feet upon
The dog-nose wetness of the earth.
Let sunrise quench your lamps. And watch
Faint brush pricklings in the sky light
Cottoned feet to break the early earthworm
On the hoe. Now shadows stretch with sap
Not twilight's death and sad prostration.
This soft kindling, soft receding breeds
Racing joys and apprehensions for
A naked day. Burdened hulks retract,
Stoop to the mist in faceless throng
To wake the silent markets—swift, mute
Processions on grey byways. . . . On this
Counterpane, it was—
Sudden winter at the death
Of dawn's lone trumpeter. Cascades
Of white feather-flakes. . . but it proved
A futile rite. Propitiation sped
Grimly on, before.
The right foot for joy, the left, dread
And the mother prayed, Child
May you never walk
When the road waits, famished.
Traveller, you must set forth
At dawn.
I promise marvels of the holy hour
Presages as the white cock's flapped
Perverse impalement—as who would dare
The wrathful wings of man's Progression. . . .

But such another wraith! Brother,
Silenced in the startled hug of
Your invention—is this mocked grimace
This closed contortion—I?

I Think It Rains

I think it rains
That tongues may loosen from the parch
Uncleave roof-tops of the mouth, hang
Heavy with knowledge

I saw it raise
The sudden cloud, from ashes. Settling
They joined in a ring of grey; within,
The circling spirit

Oh it must rain
These closures on the mind, binding us
In strange despairs, teaching
Purity of sadness

And how it beats
Skeined transparencies on wings
Of our desires, searing dark longings
In cruel baptisms

Rain-reeds, practised in
The grace of yielding, yet unbending
From afar, this your conjugation with my earth
Bares crouching rocks.

COMMENTS AND QUESTIONS

1. Wole Soyinka has consistently addressed human issues through the voice of Yoruba belief and expression. Although his works are masterpieces in English, and can be understood within the English reading of them, their power and subtlety are magnified for the reader who understands something of Yoruba culture. Ogun, the god of war and destruction, of the rains, of harvest, of disintegration and death, is a favorite although not always explicit subject of Soyinka's. In modern Nigeria, Ogun is god of the road, a claimant of countless lives on overcrowded highways; taxi and truck drivers are among those who worship him. He is the real subject of "Death In the Dawn." When the poet writes "May you never walk / When the road waits, famished," it is Ogun that one fears may be famished. "Death in the Dawn" is not an oriki, but go back and reread "Oriki Ogun" after you have read Soyinka's poem. What traditional images of Ogun do you find in Soyinka's poem?
2. In "I Think It Rains," Soyinka applies the concept of drought to personal "dark longings" that are assuaged by the rains. Chinua Achebe and Wa Thiong'o Ngugi are two other modern African writers who use drought to symbolize moral and or political corruption in the broader society. Note how Soyinka emphasizes the paradox of the cruelty yet the blessing of the rain.

Summary Questions

1. Based on the material in this chapter, how do the written and oral literary traditions in Africa differ from one another? Are there similarities as well?
2. What social and moral values are expressed in the Mande, Hausa, and Yoruba examples?
3. Can you see parallels with other cultures' religious beliefs about the relationship between God and human beings?
4. What ideals of government are expressed in the Mande epic and the Yoruba proverbs?
5. Can you identify similarities of metaphor and theme between the poems of the modern writers and those of the oral literary tradition?

Key Terms

Ge'ez

Meroitic

praise/abuse poetry

Animism

Sundiata

Griot

Mande

Hausa

Yoruba

orisha

oriki

ijala

iwi

14 Visual and Musical Arts of West Africa

Just as each African language has its own literary tradition, each African society has its own artistic and musical styles. We cannot hope to give even a bird's-eye view of the range and variety of African art and music in the present space. Rather, we will concentrate on the close observation of a few works in order to understand something of the African aesthetic. Because both African art and music have had a profound impact on their modern Western counterparts (see Volume 2, Chapter 35), we are already used to certain conventions, such as abstraction in art and the pentatonic (five-tone) scale in music, which shocked and puzzled earlier Western observers. We are not likely to view these arts, as did the first European colonists, as awkward, tribal, or primitive. Nevertheless, there are characteristics of African art and music that make them significantly different from Western forms and that require our attention if we are to appreciate them. In spite of the great diversity of traditions and styles, even within West Africa alone, African art shares some common premises that we will examine first in the visual realm.

Visual Arts

Art and Communal Life

One of the basic differences between Western art and African art lies in the simple fact of classification. The art of the West is usually divided into "fine" and "applied" arts. In the first category are painting, sculpture, and architecture—the arts usually studied in the humanities. The second category includes more utilitarian objects such as furniture, ceramics, textiles, and clothing. This dichotomy does not exist in African art. For the African artist, the objects of everyday life may express beauty, harmony, and philosophical concepts as much as or more than something to hang on a wall. The museum or the gallery does not exist in traditional Africa. Although some Western and African arts are "useful" in the same way—palaces for kings, temples, objects for religious ceremonies—it must be kept in mind that *all* African art has historically been integrated into life in the community in some way. At the same time, even the

CENTRAL ISSUES

- Varieties of West African visual arts and their functions
- The concepts of style area and "basic style" in understanding African art
- The main characteristics of West African music and their similarities with jazz
- The nature and significance of the Efe/Gelede festival of the Yoruba

most humble object may manifest a complex relationship between people and society and their experiences and understanding of the world.

Problems of Dating African Art

Another historical difference between African and Western art is that Africans are not preoccupied with the identity of the artist or the age of an individual piece. This is partly because the social functions of material art are so preeminent; the identity of the artist is not deemed important, and the works, once they have served their social purpose, may be discarded. However, the difference also derives from the particular ways in which the West first came to study African art—as a part of *ethnography,* or the study of different cultures. Westerners saw this art as "tribal" and even when they liked it, did not place it in the same category with Western art. Therefore, they did not ask the same questions about the origin of individual works. Recently, both African and non-African scholars have begun to develop a greater interest in the *history* of African art and in artists and schools of art. Regarding artists born in the late nineteenth century and in the twentieth, historical research may be relatively accessible. But concerning those of earlier times, even the best use of written, archaeological, and ethnographic data may not be able to uncover the kind of detail that is commonplace in studies of Western art. Most of the individual pieces studied in this chapter were made in the twentieth century. That they have found their way into collections outside of Africa is the result of factors ranging from the commercialization of African art to the judgment by those who commissioned them that they no longer fulfilled the purpose for which they were commissioned.

Meaning in African Art

Understanding the world and interpreting one's experiences in it are the basis for art everywhere. Over the centuries, Africans adhered closely to nature in all its manifestations: the cycles of birth and earth, planting and harvest, night and day, and the seasons. Yet the seasonal migration of the herds that provide food and other staples of life, the beginning of the rainy seasons, the success of the planting and subsequent harvest, the normal birth of a child are all subject to the vicissitudes of nature. This awareness of inevitability and change in the face of natural phenomena is closely related to the *animism,* or belief in natural spirits, that characterizes African religions (see Chapter 13). The necessity to appease various spirits has been a motivating force in some art. An object, usually a small statue, is created to invite a particular spirit to inhabit it. Great care is taken to make the object beautiful enough to entice the spirit to rest in it.

One might define the constant in African art and life as a tension between order and disorder, permanence and change. Ritual objects such as masks, costumes, and figurines pass on the values, laws, and beliefs of a people from one generation to another, as do the myths, tales, and poetry of the oral tradition, ensuring continuity. On the other hand, *initiation* societies and the arts and rites associated with them both teach the principles young men and women will need as adults and mark the transition of leadership from one generation to another.

African material art contains multiple layers of meaning. Any one piece may contain elements suggesting religious belief; commemoration of a ruler (as do the Benin bronzes seen in Chapter 12); regalia of office, such as pendants or staffs; or allusions to favorite mythical or tale characters that hint at ribaldry or even laughter, both powerful tools of social criticism. While often referring to the past, African sculptural forms incorporate innovative materials and modern symbols reflecting the historical experience of the people. African art, music, and oral tradition come together in ritual and festival, one of which we will study later in this chapter.

We began this section on the visual arts by discussing the differences in classification between Western and African art and by pointing out that in Africa the West's distinction between "fine" and "applied" art does not exist. But how, then, has African art been classified? Africans designate their sculptures, masks, textile patterns, and dances with names appropriate to their function or style within a given culture. On the other hand, westerners have been interested in a much broader scope—African art as a whole—and have therefore analyzed the relationship of artworks across the continent, using ethnic group or formal stylistic criteria as the basis of their categorization. One of the most interesting systems of classification is that developed some years ago by Arnold Rubin;[1] it employs a combination of geographical, artistic, and cultural criteria to identify three major zones of African sculpture: the Sudanic, the Guinea Coast, and the Equatorial. Each zone is divided into style regions and, in some instances, subregions. The sculptural art of each of these style areas has particular characteristics that distinguish it from the art forms of other regions. These characteristics may include, for example, a preference for certain types of masks, figures, or utilitarian objects over others; for emphasis on two-dimensional lines rather than on volume; for shared choice of color or medium in relation to sculpture; for the presence or absence of surface decoration; or for the degree of naturalism, as opposed to *abstractionism* or *expressionism,* in the sculpture. Art from the frontier areas of

[1] Arnold Rubin, *The Sculptor's Eye* (Washington, D.C.: Museum of African Art, 1976).

these regions is likely to show the influences of the adjacent region. The advantage of this system enables the observer to escape from rigid ethnic or formal classification to an understanding of African art that encompasses the aesthetic and the cultural; it also permits visualization of relationships on a broader scale, not only between art forms but also between art and other cultural features.

On an even broader scale, Roy Sieber developed the notion of "basic style":[2] certain characteristics of human sculptural form that are found across widely different cultural regions. These include frontal position and balanced composition; body proportions with a head to body ratio of 1:3 or 1:4, longer torso, and shortened legs; an absence of gesture or facial emotion; and cultural and temporal accuracy in body decoration and clothing. Neither style area nor basic style should be considered rigid categories. However, their relative visibility is one of the useful ways one may begin an analysis of an individual object. Although our organization of the works in this chapter is simpler than either style area or basic style, we will indicate examples of them from time to time.

Masks and Headpieces

Masks and headpieces are usually worn by men in the context of the social and religious rituals of associations, sometimes referred to as secret societies. These societies function as the community's agents for social control, education (through initiation), and communication with the spirits of the ancestors. They are particularly important and powerful in ethnic groups that do not have centralized chieftaincies or kingships. Usually the associations consist of several grades or ranks through which individuals of skill and prestige may rise to positions of great influence. They are "secret" because their specialized knowledge is reserved to initiates of the societies and because the members are anonymous to the public when performing the masked rituals or acting on behalf of the association. When an individual dons the mask, he becomes the receptacle for the spiritual force of whatever essence is portrayed and is identified as that essence by those who behold him.

The Chi Wara headpieces are found among the Bamana, who live near the upper Niger in Mali, Senegal, and Guinea (Fig. 14-1). Chi Wara (sometimes also spelled Tyiwara) is a legendary figure who taught the Bamana to cultivate with digging sticks. It is also the name of one of a series of graded associations for Ba-

mana men. In preparation for clearing the fields, two members of the association wear these headpieces in imitation of the male and female antelope—the antelope having become identified with the Chi Wara figure. They engage in ritual play to please the spirits of the earth and to ensure the earth's fertility.

These beautiful wooden forms display one of the major characteristics of much African sculpture. The artist has exaggerated those features of the animals that are most important for recognition by those who use or observe the ritual and that call attention to each animal's particular aspect. The female antelope's body is reduced to a simple flattened oval form, while the enlarged neck, head, and ears, which fit into tight curves, convey an impression of energy and strength. On her back rides a tiny young antelope whose form echoes that of the mother. The male antelope has a similar body; but his neck is formed of two curves with spiky extensions, his ears tilt backward, and his horns, stylized into a powerful upward thrust, tilt forward. The combination of curves with the antelope's spiky mane and the sharply contrasting direction of the ears and horns create a powerful sense of forward motion, whereas the female's representation seems to

14-1 *Left: Mali, Bamana Chi Wara, Chi Wara headpiece, male antelope. Right: Chi Wara headpiece, female antelope. Even though these sculptures represent animal spirits, note the head to body proportions of "basic style." (Erle and Clyta Loran Collection)*

[2] Roy Sieber, "Traditional Arts of Black Africa," in *Africa*, 2nd ed., ed. Phyllis M. Martin and Patrick O'Meara (Bloomington, Ind.: Indiana University Press, 1987), pp. 221–242.

14-2 *Above: Mali, Senufo, kponiugo, fire-spitting mask. (Phoebe Apperson Hearst Museum of Anthropology, the University of California at Berkeley)*

14-3 *Right: Zambia, Western Province, Mambunda, Samahongo initiation mask. (Copyright Livingstone Museum)*

recoil slightly from his onslaught. The distinguishing features of heads, body color, and texture are reduced or ignored. It is the power of procreation that is emphasized.

Another characteristic frequently evident in African sculpture that is also present in the Chi Wara headpieces is the sense of reduction of a single piece of wood—the trunk of a tree perhaps—from which the objects were carved. This is part of the explanation for the vertical, columnar aspects of these figures.

A mask whose rounded volume contrasts the forceful flowing motion of the Chi Wara is the *kponiugo*, or fire-spitting mask (Fig. 14-2) of the Senufo. It is used by the Lo association, a group responsible for initiation schools among the Senufo of the Côte d'Ivoire, Burkina Faso, and Mali regions. Its fearsome, expressionistic visage comprises the important features of equally important animals. The teeth are those of the crocodile; the tusks represent the warthog; the horns are those of the water buffalo or the antelope; and the chameleon, which perches on the head between the horns, is a symbol for the continuation of life. Sometimes these masks are also painted with leopard spots. Each of these animals represents a powerful spirit; and, combined in a powerful symmetry, they are said to represent the chaos of primordial times. As the wearer stalks through the night, tinder is struck under the chin to create the fire-spitting image. This wooden mask, probably cut from

green wood for lightness, was blackened. Its wearer could both invoke and provoke powerful spirits.

Another initiation mask (Fig. 14-3) is that used by the Mambunda of Zambia, a people who share many common institutions, like the *Mukanda* schools. During the instructional period of two to nine months, young boys between the ages of seven and fifteen are secluded. Among the dances performed and/or taught is one danced by the older men wearing these kinds of masks, which are used to evoke ancestral spirits and to drive away women and younger boys. It is a powerful mask that emphasizes the potential of facial curves for exaggeration. The pure symmetry of the form and the protruding mouth form sharp contrasts. The great expanse of forehead and the attached feathers across the scalp are another juxtaposition of opposites—smoothness with the ruffled feathers.

The white-faced masks, which may symbolize ancestor spirits or a young maiden, are worn by men of the Mmwo society of the northern Ibo peoples near Onitsha and Awka (Fig. 14-4). Those representing male ancestral spirits are used at funerals, festivals, and initiation rites to cause fear and awe among nonmembers of the society. These kinds of masks remind us again of the importance of the benign presence of the ancestors. One of the important stylistic features of these, as of other, masks is the reduction of features and their orderly composition into a symmetrical whole. Since a spirit,

14-4 *Nigeria, Ibo, Mmwo mask. (The University Museum, University of Pennsylvania, neg. # S8-4994)*

14-5 *Liberia, Dan mask. (Copyright Frank Willett)*

not a person, is being evoked, naturalism of form, texture, and color are not prerequisites. We have here the principle of *abstraction* used for the representation of a being not of the natural world.

The Dan mask (Fig. 14-5) seems almost realistic when compared with the white-faced mask that we have just considered. The scale of the features and their realization seem much more human. But the reduction of eyebrows to a single plane, the nose to perfect symmetry, the cheeks and chin to smooth planes, and the whole to this elegant oval shape contradicts the apparent naturalism. Like the masks of the Mmwo society and those of the Mambunda, masks of this type represent ancestral powers. They were often carried in miniature form by men as guardians and were also used to hide young boys in seclusion from the view of women.

Figurines

The possible artistic range of the transformation of the human visage is only hinted at by the masks that we have considered, but they do suggest how terribly exciting such forms must have been to Western artists when they first saw them. Pablo Picasso, one of the first European artists to be inspired by African art, used a Bakota reliquary figure (Fig. 14-6) for a series of studies. How little he understood of its real importance is

emphasized by the use to which it was actually put, that is, to drive away evil from the remains of the dead. The "head" of the figure is exaggerated to enormous size in proportion to what Picasso, concentrating on the object as a figure in space, interprets as a body. Actually, the "body" is the base, intended to hold a basket containing a skull or bones and thus to protect the remains of an ancestor.

Equestrian figures display power and authority in many African cultures but are especially prominent in the Western Sudan, where mounted cavalry played significant roles in the rise of Ghana, Mali, and Songhai.[3] The earliest images of mounted figures appear among the terra-cotta figures of the Niger River's Inland Delta found near the city of Jenne. Usually dated between the twelfth and the fourteenth century, Inland Delta terra cottas are fashioned into many different figures in addition to the equestrian ones: animals, individual men and

[3] H. M. Cole, "Riders of Power. The Mounted Leader," Chap. 7, in *Icons. Ideals and Power in the Art of Africa* (Washington, D.C., and London: The Smithsonian Institution Press for the National Museum of African Art, 1989), pp. 116–135. See also Werner Gillon, *A Short History of African Art* (London: Penguin, 1984), pp. 90–102; and Judith Perani and Fred T. Smith, *The Visual Arts of Africa* (Upper Saddle River, NJ: Prentice Hall, 1998), pp. 26–27.

14-6 *Zaire, Bakota, reliquary figure,* mbulu-nugulu, *brass-covered wood. (Phoebe Apperson Hearst Museum of Anthropology, the University of California at Berkeley)*

women, and embracing couples. Scholars speculate that the function of the terra cottas may have been sacrificial (because of their burial adjacent to walls or doorways) or commemorative of important ancestors. Or they may have been ritual objects associated with prayer. The most prominent stylistic features of these images are rounded surfaces often adorned with snakes; sitting, kneeling, as well as mounted postures; and the projection of more movement and asymmetry than is usually associated with human figurative forms in African art. The snake motif appears throughout western Sudan in many naturalistic forms as well as stylized spirals and zigzags. It is associated both with creation myths (among the Dogon) and with the founding of the Soninke empire of Ghana. Figure 14-7 projects authority and power by the alert stance and elaborate decoration of both horse and rider. The rider bears a quiver on his back, a necklace and arm bracelets or shields, a decorative motif on his helmet, a spiral insignia on his hip, and zigzag patterns on the quiver and the waistband of his uniform. His horse stands straight-legged but with its head at attention. It is adorned with an elaborate bridle and two decorative bands around its neck just below the

- Compare this rendition of the head with that of the Mambunda mask (Fig. 14-3). Notice particularly the use of incising, the way in which facial features are stylized, and how one seems volumetric and the other two-dimensional.

head and resting against its shoulders. Despite the static pose of horse and rider, the reach of the man and the position of the horse's head imply the explosive force of cavalry. Different in many features from the style of wooden figures, these terra cottas represent one of the distinctive treasures of African art.

Another way in which powerful forces could be evoked or released is shown in power figures like the Bakongo *nkisi nkondi* (Fig. 14-8). Cavities in the head or stomach were the receptacles for magical substances. These *nkisi—fetishes* or objects embodying supernatural power—could be used for benevolent or malevolent effects. The pose sometimes reflected the purpose. A stiffened pose, upraised arm, and grimacing face were used to make the forms more menacing, while nails or sharp iron studs were driven into the body to release malevolent forces as in this nkonde. The fetishes used in voodoo have their origins in this kind of object.

14-7 *Figure. Inland Niger Delta region, Mali. Possibly 13th–15th century. H: 70.5 cm (27³/₄ in.) Museum purchase 86–12–2. (Photograph by Franko Khoury. National Museum of African Art Smithsonian Institution)*

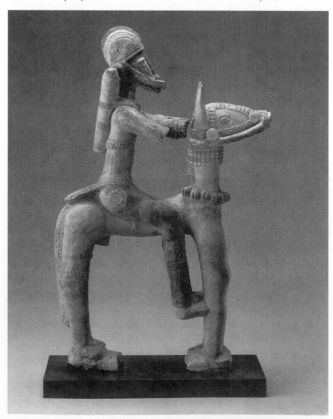

14-9 *Nigeria, Yoruba, Ifa tray. (Copyright Frank Willett)* **(W)**

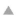

• Whose face forms the central figure of the border? What is its role?

those odu poems to be interpreted. The interpretations reflect the ordered intentions of the deities and the ancestors. But there is always the element of chance and disorder. The face of Eshu, the god of unpredictable fate and change, is inevitably present on the border of the tray. Placed opposite the priest during the divination process, the face reminds both priest and petitioner of the potential in human destiny for good or evil.

Stools

The manifestation of African spiritual and political principles in utilitarian objects is perhaps best exemplified by the Ashanti stools (Fig. 14-10). The Ashanti, like other Akan peoples of Ghana and the Côte d'Ivoire, believe that a person's spirit resides in his or her stool. When not in use, a stool is turned on its side so that no spirit other than the owner's will "sit" on the stool. Special stools are carved for an individual at important stages in his or her life, such as at puberty or marriage.

This personal metaphor was extended to that of the state at the time of the founding of the Ashanti Confederacy by the king (*asantehene*) Osei Tutu in 1701. On a particular day when the king, subchiefs, and the Ashanti people were gathered together, Osei Tutu's chief priest summoned from the heavens a Golden Stool to enshrine and protect the soul of the new nation. The Golden Stool remains the single most important item of Ashanti court regalia: it stands for leadership and union. In this way stools also became symbols of political office for those with political authority delegated by the asantehene. The high status of members of the court, such as

14-8 *Congo/Angola, Bakongo nail fetish figure,* nkisi nkondi. *(The University Museum, University of Pennsylvania, neg. #S8–70279)*

Divination Trays

Objects not representing the human figure and designed for specific, utilitarian purposes may also reflect religious principles. The Yoruba tray (Fig. 14-9) is used in the process of *divination,* foretelling the future or discovering secret knowledge. One of the features of Yoruba religion is the oracle of *Ifa,* a secret body of wisdom that may be made available to a believer through the intervention of a *babalawo,* or priest. The priest then interprets the secret body of poems, called *odu,* in various combinations, using the Ifa divination tray.

Following initial discussion and ritual cleansing, the petitioner who has come to the priest is seated opposite him. Between them lies the divination tray, which has a light layer of sand on the surface. The priest takes a number of palm nut kernels, tosses them into the air, and marks on the tray the number of those that he catches. At the end of a series of tosses he uses the number and arrangement of marks on the tray to select

the queen mother, is reflected in the ceremonial stool, which is adorned with fine sculpture and a silver sheath overlay. The intricate surface designs frequently recall proverbs that the officeholder uses to convey a message or motto of his or her rule. Ceremonial stools like that pictured are reserved for state occasions; others are specially carved for domestic and personal use. At the death of an Ashanti ruler his ceremonial stool is blackened with soot and becomes the object of propitiation in the state ancestor cult.

Kente Cloth

A further example of artistic accomplishment and political authority manifest in utilitarian objects is the *kente* cloth of the Ashanti and Ewe peoples of Ghana. Kente is a large cloth, draped for ceremonial dress, made out of narrow strips sewn together that have been woven from cotton, silk, or wool threads. While strip weaving is common in Africa, what distinguishes kente is the elaboration of silk weft inlay designs that are geometric in character. There is a hierarchy of kente weavers and designs. At the pinnacle are the royal *asasia* cloths woven exclusively for the asante-hene and his family, and for individuals granted a cloth as a symbol of loyalty or in return for services to the king. Pattern and color of the royal cloths carry special meanings appropriate to their owners. As do all kente, each asasia cloth has its name. The example shown here (Color Plate VIII) is called Everyone-Depends-on-Somebody. Its colors are gold, red, and blue. The gold and red are references to kingship and governmental power; blue refers to playfulness and humor. The equal intensity of the overall colors is coupled with the striking alternation of rectangles dominated by blue with those dominated by gold and red. The arrangement suggests the worth of both qualities in balance in the

ideal society; power and authority must be matched by humor and simplicity.

New Media Revered Sources

By the mid-twentieth century, young artists trained in Western schools began creating work that utilized materials less familiar in older traditions of African visual art, but that made clear the enduring significance of indigenous icons to their lives. Although the two works discussed here come from different schools of Yoruba art, they share the inspiration of the Yoruba religious world (see praise poems to Oshun and Ogun in Chapter 13). Asiru Olatunde's *Oshun River Legend* utilizes hammered aluminum to evoke the brightness and metals associated with Oshun, the patron deity of the Yoruba city of Oshogbo. Like the Benin plaques, size denotes relative importance—here the giant fish is a symbol for God. The woman with four breasts is the river Oshun on whose banks stands the shrine for the deity.[4] The central panel suggests a sacrificial altar/tree of life where calabash shapes sit at the end of each branch and a giant calabash rests atop. Calabashes of brass rings are brought to the shrine during the annual festival for Oshun.

In *Ogunic Exploits* (Color Plate IX), Moyo Okedeji, utilizes intense color and rhythm reminiscent of African textiles to convey the dual metaphors of the Yoruba god of iron—destruction and creativity—as they transformed the artist in a psychic encounter. Ogun's power lashes out through the hooves of the horse "mounting," or possessing, the artist, prone against the bottom left border. Other hooves strike the woman in the midst of childbirth and her child. Yet the infant derives nourishment from the dog, which, as the animal sacrificed to Ogun, establishes communication between the mortal and immortal world. In the painting, Okedeji projects this encounter as a journey of return to the spiritual sources of his culture.[5]

14-10 *Ghana, Ashanti, wooden stool for a queen mother, decorated with silver sheeting. (Reproduced by Courtesy of the Trustees of the British Museum)*

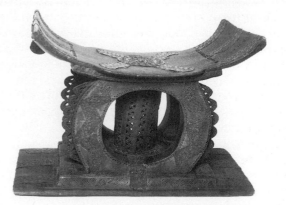

[4] Jean Kennedy, *New Currents, Ancient Rivers. Contemporary African Artists in a Generation of Change* (Washington, D.C., and London: Smithsonian Institution Press, 1992), pp. 63–66.

[5] Moyo Okedeji, "Of Gaboon Vipers and Guinea Corn: Iconographic Kinship Across the Atlantic," in *Contemporary Textures. Multidimensionality in Nigerian Art*, ed. Nkiru Nzegwe (Binghamton, N.Y.: International Society for the Study of Africa, 1999), pp. 43–68, and "Returnee Recollections. Transatlantic Transformations," in *Transatlantic Dialogue. Contemporary Art In and Out of Africa*, ed. Michael D. Harris (Chapel Hill, N.C.: Ackland Art Museum, University of North Carolina at Chapel Hill, 1999), pp. 32–51, painting on p. 72.

•••

COMMENTS AND QUESTIONS

1. How is exaggeration of natural features of human and animal forms used to stress spiritual or social principles? Give examples.

2. As has been stated above, masks may have varied purposes: some are intended to invoke powers of natural or supernatural forces. They represent mystery and the potential for good or evil. These often rely on images of the forest or bush to convey their meaning. Others symbolize civilization: human imposition of pattern and order on the natural world or idealized human values. Review the objects presented in this section and identify ones that seem to you to bear out each of these two purposes.

3. The nature-civilization contrast may be seen in statues and other sculpted objects as well. Compare the reliance on natural substance and the reliance on human reference in the images of the Bakongo figure and the Ashanti stool. Identify the different images.

4. How do the form and placement during use of the Ifa divination tray suggest general principles of Yoruba cosmology?

5. There are many elements to consider in analyzing a work of sculpture: proportion, volume and dimension, compactness versus open space, surface texture (rough versus smooth, painted or unpainted). Of those objects that incorporate aspects of naturalism and stylized interpretation of the human form, which elements contribute to the effect of naturalism? Which to the effect of stylization?

••

African visual art may be utilitarian, decorative, symbolic, spiritual, or all of these at once. Masks and sculptures emphasize communication of spiritual forces and the interpretation of cosmic order to the human community; other objects symbolize or reinforce social relationships. In Benin (Chapter 12), bronze heads and plaques served to commemorate rulers and to record important historical events. There is, as we have seen, no dichotomy between "fine" and "applied" arts in Africa. Similarly, there is no division in African music between "concert" and "folk" music. Just as there are no museums in traditional Africa, there are no concert halls; music, like visual art objects, is intended to be used as part of the rituals and celebrations of everyday life.

African Music

The first note that a careful observer of African music will surely make is some conclusion about the tremendous variety and complexity of the sounds emanating from this gigantic continent. The languages and cultures of the peoples of North Africa are closely related to those of the Arab world and the Middle East, traditions that differ—for geographic, economic, and political reasons—from those of southern, central, and West Africa. The music of this region, so oriental in its *modal, melodic,* and *improvisational* characteristics, although African for perhaps centuries, must be excluded from our consideration of indigenous African music, the music of black Africans. Likewise, one finds alongside the music of sub-Saharan Africa a tradition of Western music brought by the colonists from Europe, a practice that has its own traditions and has helped generate a new black African urban music called "high life," a chic modern music of the cities. Even when we dampen all the sounds that can be identified as "nonnative" to the original peoples of Africa, we are still engulfed in an endless variety of musics and languages and peoples. The culture and the music of the Pygmy, Bushman, and Saharan peoples are not the same as those of the Yoruba, Ashanti, and Susu ethnic groups. Here, as in the literature and art sections, we will concentrate on the music of West African societies. After discussing some general characteristics shared by the music of these societies, we will move on to a more detailed study of one specific example: music from the Festival of the Tohossou, legendary princes of the royal family from the ancient kingdom of Dahomey.

Characteristics of West African Music: Similarities with Jazz

Most music performed by Africans is part of a social activity. Of course, individual music-making takes place in response to personal or ritual needs, but most musical performance accompanies the group activities of games, religious rites, feasts, festivals, and work. Music provides an opportunity for sharing in a communal creative experience. With the transferral of Africans to the New World, this West African music deeply influenced the development of jazz, with which, as we will see, it shares many characteristics. Because of a number of factors, black slaves in America were able to maintain much of their African musical heritage, all the while joining to it certain elements of the Euro-American musical tradition. The resulting hybrid had a markedly African base. The important points to keep in mind are these: the rich West African musical tradition; the comparative cultural isolation in which many black American slaves lived; the tolerance of musical activities among the slave communities accorded by white American masters; and the compatibility of the important elements of West African music with the current tradition of Euro-American music. As West African music is communal in its basic approach, jazz, too, is a shared

creative experience: those in the normal small group of musicians, the combo, respond improvisationally to one another's musical signals and the social signals of the audience or dance crowd in a way different from the performance practice of a Western string quartet or a chamber orchestra. African musicians, when composing collectively, are part of a social interaction that often communicates a group sentiment or message, an extra-musical consideration that is found only rarely in music of the West.

Depending on the event and local customs, the performing groups may be made up of young or old, male or female, or mixed. However, there is usually a hierarchical differentiation among the players—leading roles are played by professional musicians or specialists; secondary roles are performed by the others in both choruses and instrumental ensembles. As the *Sundiata* epic indicated, in Africa the griot, or praise singer, is a highly respected musician-poet, usually a professional, in many of these societies. The leading blues singers and jazz musicians of black America are often seen to be held in the same esteem by the regular members of the black community.

Elements of African Music

Little, if any, traditional African music takes any interest in *harmony* as we know it in the West, but most African sounds are compatible with European harmonies. The leading elements of African music are *melody, rhythm, timbre* (the distinctive sound of the instruments and voices), and text. Although verbal art is intertwined with African musical art, some societies are able to convey specific messages by instrumental sounds alone. That is, *pitch* and rhythm can be explicitly equated to textual messages, for speech in some languages is musical in the sense that pitch variations affect word meanings. But "talking drums" and "talking winds" are not characteristic of the music of most of the peoples who were brought to America from Africa as slaves. Even though there may be a tendency to overemphasize this particular feature of African music because it is so unique and fascinating, we might be well advised to consider that most music is communicative in a general way once we have learned the conventions. For example, we are all familiar with the sounds of military music, love songs, sad songs, happy dance music, and so on. We know that words for one variety cannot be properly set to sounds of another, or, if they are, then a joke is intended, a mistake has been made, or something is out of kilter. In other words, the sound of the music without the words conveys a somewhat specific message anyway. In like manner, it is accurate to say that most African music communicates messages and feelings, ideas that are extramusical. But to the degree that particular sounds are wedded to specific social functions, it is probably true that African music is more communicative than most Western music.

Rhythm

The complex rhythms of most African drumming depend on the use of a recurring rhythmic pattern within the totality of the ensemble. This time-line in African music is what the jazz drummer refers to as "time," that unwavering sense of beat that must prevail regardless of what else is happening in solo or in ensemble. In its simplest form, the time-line can be projected by a "beat" or metronomic pulse that sounds audibly and continuously. But it can also function as an unsounded, but understood, quantity of the time-line part, which the musicians perceive as an *ostinato* or regularly recurring rhythm pattern. Another obvious conclusion at which the impartial observer of African music will arrive is the distinct bias toward percussion that is a part of the aesthetic of African music. As in jazz, there is a tendency to include a rhythm section in every instrumental ensemble, and surely the close association of African music and jazz with dance—both as part of the dance and as accompaniment for the dance—explains, or at least accounts for, the importance of rhythm as a chief feature of both kinds of music. In fact, African drummers often perform on the move as part of the dance. Even when stationary, African drummers—and jazz drummers—have bodies in motion, with elbows flying, shoulders leaning, fingers tapping or pressing, and heads and mouths going.

Vocal Music: Call and Response

Although drumming and rhythm are probably preeminent in West African music, great stress is laid on vocal music. An exceptional variety may be found among the themes treated, such as war songs, hunting songs, play and work songs, religious and festival songs, and social commentary, a type not unlike the artifices of the American blues musician. Eileen Southern, renowned historian of the music of black Americans, cites the following as the earliest example of an African song text written down in a European language (1800):

The winds roared, and the rains fell;
The poor white man, faint and weary,
Came and sat under our tree.
He has no mother to bring him milk,
No wife to grind his corn.

Chorus:
Let us pity the white man.
No mother has he to bring him milk,
No wife to grind his corn.

The leader-and-chorus format of much African vocal music often displays a call-and-response mode of performance; this, too, is another characteristic eagerly seized by jazz historians seeking stylistic parallels between jazz and native African music. The typical jazz performance of the vocal and instrumental blues has a singer or lead instrument perform the first half of each phrase, only to be answered by another instrumentalist or the ensemble itself. The tie between the jazz blues and the African responsorial performance may be tenuous, but the leader-chorus performance among African vocal ensembles is, in fact, the norm and a characteristic to be savored. Much is lost if the words are not understood, of course; but the virtuosity of the leader, in contrast to the solidity and enthusiastic response of the remaining performers, is a distinctive sound of the black African tradition. As we read more about the cultural traditions of black Africa, we would also do well to keep in mind these observations:

> From the first African captives, through the years of slavery, and into the present century black Americans kept alive important strands of African consciousness and verbal art in their humor, songs, dance, speech, tales, games, folk beliefs, and aphorisms. . . . Cultural diffusion between whites and blacks was by no means a one-way street with blacks the invariable beneficiaries. . . . Black relationship to the larger culture was complex and multidimensional.[6]

Music from the Festival of the Tohossou

The princes of Dahomey are called the *tohossou*, descendants of a legendary king; their worship is the object of a cult whose ceremonies are performed in the twenty temples of the city of Abomey, capital of the ancient kingdom of Dahomey (Fig. 14-11). The music for portions of these ceremonies has been recorded.[7] We should prepare ourselves to hear, in addition to the sound of human voices, the music of three oblong drums, which are beaten by sticks on one side and the naked hand on the other; three iron bells struck with a short wooden stick; pairs of rattles contained in wicker baskets; and a small bell shaken by a priest. The festivities for one tohossou last four days, and the recorded excerpts sample music from morning to nightfall of one festival day. The entire community participates: the priests, the princes (descendants of the royal line), men and women of the town, and musicians. Even children

[6] Lawrence J. Levine, *Black Culture and Black Consciousness* (London: Oxford University Press, 1977). p. 444.

[7] *Anthology of the Music of Black Africa* (Everest 3254-3), Record 3, Sides A and B.

have a part to play, and this day's ceremony will have dancing, singing, and sacrifice. As the day progresses, the bull will be bound, its throat will be slit, and a lamb will later be sacrificed to appease the spirit of the bull. The mysteries of all these ceremonies and ritual acts are not all known and entirely understood; but, since the tohossou represent proud descendants of a warrior race, there are various songs, dances, and ritual acts dealing with the enemy, fallen brothers-in-arms, vengeance, and sacred deities. The first excerpt, "Song of Zomadonou," is sung by a young man portraying Zomadonou, a reincarnated prince, his words telling of the feats that made him famous. He is accompanied by one bell, struck in two places to

CD-1,12

obtain contrasting pitches, and the song of the bell creates the time-line ostinato: High (slow) High (slow) High (quick) Low (quick). Over and over again the pattern repeats as the prince sings his song to a *pentatonic* (five-note) *scale*. As Zomadonou sings, he is answered by the chorus, their response picking up the principal melodic figure of his solo song.

The second excerpt captures the voices of a male chorus grouped around the drums. It is basically a choral song meant to accompany a serpentine dance by the women as they snake their way three times around the sacred tree and sacrificial bull. The sound of the drums is not continuous, but the rattles keep a steady beat for the dance. Occasionally, a

CD-1,13

solo voice will interject a brief exclamation, but the pattern of the music is choral song, not call and response. The music of this example is similar to the first in that the melody employs an abbreviated scale, ostinato patterns prevail, and tone production by the vocalists is full-voiced, lusty, and somewhat strained.

Adomoussi, a priest devoted to the worship of the third tohossou, performs the third excerpt himself. Striking a bell in two places, he follows with a short declamatory phrase—"O thou, when thou raise the saber it is to kill. . . Thou panther which avenges itself . . . Thou shark in the water. . . An enemy. . . ." The

CD-1,14

pattern is simple—bell, statement, bell, statement—and one can see the parallel in the country blues musician who strums a chord to arrange his thoughts and follows with the simply sung phrase. The priest has something to tell his people; his bell and method of delivery catch their attention.

The choir for the next recorded example, "The Way Is Free," is entirely composed of women. Using a piercing chest tone, the leader sings short phrases to be answered by the remaining choir members. The percussion accompaniment, which is not heavy, seems to be but loosely attached to the singing of the women. Since

no dance is employed at this point in the ceremony, the drums seem to act more as background than accompaniment. Not so for the Nifossousso dance that follows. The regular beat is stately and dignified; it accompanies a procession of women who have shed their brightly colored costumes for white loincloths in a slow procession to the temple. Following this, the men call Botro, a woman, to come and perform her dance. In the seventh example the woman advances to dance and to sing a warlike and frightening ritual with a stick that she finally plunges into the earth.

Throughout the performance of each of these snippets of music and ceremony it is obvious that certain musical sounds relate to general feelings in the same way that certain musical sounds of the Western tradition do. The priest who shouted his exclamations to the accompaniment of a bell could not have been describing a quiet forest glade; the slow processional of the noble line of women moving to the temple would have been inappropriate to accompany the active dance of Botro. The sounds of African music, although different from those we are most accustomed to hear, open up to meaningful interpretation on careful listening and a little reflection. Then, as the similarities to our own music begin to surface, we see the heritage that has blended with Euro-American music to form that American music called jazz. Only recently have American jazz musicians begun to take a new look at African roots in a search for further inspiration and replenishment, and we will see in Continuities that follow this chapter and in Volume Two how another transformation in American music has taken place as our sense of history draws us to new ideas from our past.

African Arts in Festival: The Efe/Gelede of the Western Yoruba

The unity of the arts with one another and with the values and lifestyle of a particular culture is nowhere so evident as in the ways in which people celebrate together. We have seen how the festival of Dionysus in ancient Greece brought together wine drinking, lovemaking, song, dance, mask, drama, and the architecture of the theater. The Romans honored Saturn, the god of agriculture, with a general feasting and unleashing of social restraints at the end of the year. Seeing that they could not do away with the Saturnalia, the Christians declared that Christmas would be celebrated at the end of December and retained certain pagan customs such as the yule log and the Christmas tree. Christian festivals

14-11 First day of the Yam Custom in Dahomey, *from the 1819 edition of Edward Thomas Bowdich's* Mission from Cape Coast Castle to Ashantee. *(Courtesy of the Trustees of the Boston Public Library of the City of Boston)*

also combined drama, music, visual effects, and dance, as we saw with *The Play of Daniel,* part of a Christmas celebration in the cathedral.

Western peoples continued to put on festivals and celebrations in the early modern period, and in some instances (witness Mardi Gras in New Orleans) they continue today; but modern industrialism and individualism have tended to wipe out what once seemed a communal necessity. Many of us are forced to "celebrate" our holidays by turning on the TV. In traditional African societies, however, and in countries (such as Brazil) where African influence is strong, festivals continue to be both a vital part of living and an important means of aesthetic expression. Even those Africans who are Christian or Muslim continue to participate in the festivals that have their roots in traditional religion.

The Yoruba culture, many aspects of which we have already studied, provides excellent examples of the

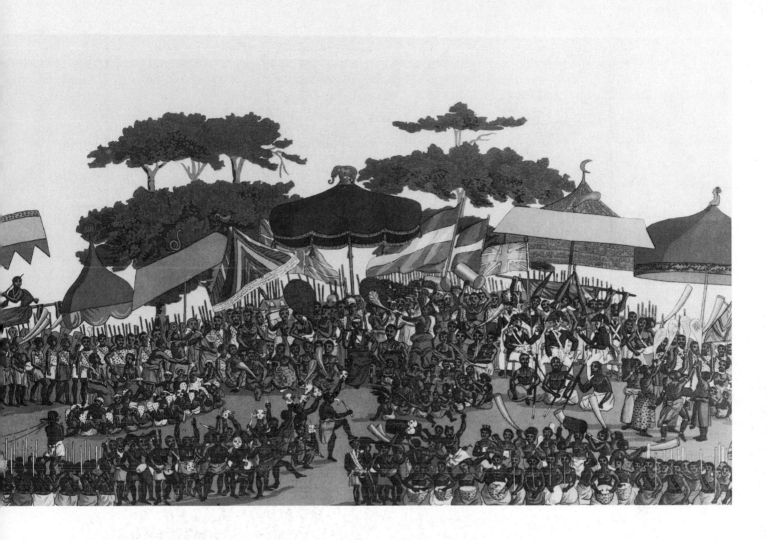

synthesis of myth, poetry, dance, music, and visual arts in traditional festivals. One of these is the Efe/Gelede, celebrated by certain Yoruba subgroups in western Nigeria and the republic of Benin. The festival occurs annually before the beginning of the spring rains (between March and May) that will initiate the agricultural activities of the coming year. One of its purposes is thus to ensure the fertility of the earth.

Significance of the Festival

In a patriarchal society where most ritual ceremonies reinforce the dominance of men over women, Efe/Gelede highlights the importance of women and serves as an occasion to recognize their spiritual powers. Women have always been symbols of fertility. The specific context of Efe/Gelede derives from the importance of Iyanla, the Earth Mother or Great Mother, feminine counterpart of the supreme god Olorun or Oludumare.

Elements of Efe/Gelede poetry, costume, and dance draw upon stories about Iyanla and her two children Efe and Gelede. At creation Oludumare assigned Iyanla the role as mother of all and gave her a calabash containing a bird. The Great Mother promised to inflict punishment on her enemies but bring wealth and children to those who appeased her. The Yoruba believe that the destructive power of Iyanla is manifested through the witches, symbolized by the bird in the calabash. Elements of the Gelede costume recall this myth. Another story recounts the birth of Efe and Gelede after the Ifa oracle advised Iyanla to make certain sacrifices and perform a special dance. This dancing is reenacted in the festival.

By honoring the Great Mother Iyanla and her children, the celebrants hope that the mystical powers granted to women by Iyanla may be channeled into constructive behavior of use to the community rather than into activity destructive to it. The festival thus

in a sense honors and celebrates all women, especially mothers. It is generally performed over a two-day period. The first, the day of Efe, is devoted primarily to poetry, the songs of Efe. The second, the day of Gelede, places more emphasis on costumes and dancing.

First Day: Efe

The Efe ceremony takes place in the market area, a setting of social, religious, and economic activity primarily involving women. Masqueraders, dancers, and a crowd of people anticipate the principal performer, Oro Efe, whose appearance manifests in costume, dance, and song the first night of the festival. The elaborate headdress and veil that emphasize Oro Efe's spiritual remove from the audience are replete with figures and colors symbolic of Yoruba orisha and beliefs (Figs. 14-12 and 14-13). The Oro Efe appears, swaying and sounding his leg rattles, swinging the whisks in his hand. His first words honor deities, ancestors, mothers, and elders. The angle of his body and slow pace express recognition and reverence to the spiritual powers. The chorus and eventually the audience join him in the second stage of the ceremony, signifying their agreement with his words. Throughout the night, performance continues with occasional interludes offered by drummers who present praise poems, proverbs, jokes, and riddles. The Oro Efe departs near dawn.

Efe Poetry

The poetry recited by the Oro Efe and in choral repetition is based on the belief that *ase*—power, authority, potential energy—can be embodied in words as well as in deities, living men and women, and the ancestors. Women are perceived to have a special ase that can be used for the good or the ill of the community. The voicing of poetry also contains ase and may be used to help direct that of the women toward potential good.

The types of poetry recited include invocation, social comment or satire, history, and funeral commemoration. Several of each type may be sung throughout the night; examples of some of these follow.

Invocation

One segment of the invocation requests blessing for the community as a whole. The songs invariably mention smallpox and cholera, scourges on the population. They plead for agricultural success, which means wealth, and for progeny. Since the mothers are associated with both procreativity and fertility of the earth, these are not surprising themes. In this example the singer prays for the end of unexpected deaths caused by farming accidents. He protests in the first line that he

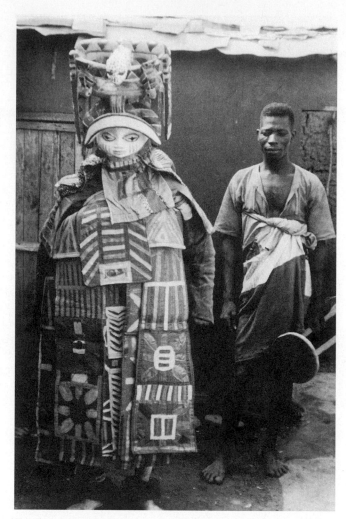

14-12 *Nigeria, Yoruba, Oro Efe in full dress. (Henry John Drewal)* **(W)**

14-13 *Benin, Yoruba, Oro Efe mask, line drawing after a photograph of Oro Efe in performance at Ketu, April 24, 1971. (Henry John Drewal)*

(the community) has offered *orijio*—medicinal leaves—to placate the mothers. Shango, god of thunder, would never strike one of his shrines; why should the progenitors, *ose* and *aje*, strike down their own offspring? Agbojo and Onidofoi, the ancestral spirits of the town, have been duly honored. Making his points, the singer displays his respect for the mothers and acknowledges their power by summoning the support of onlookers to join in his prayers.

Social Comment

In social comment songs the Oro Efe uses praises, cajolery, and condemnation to highlight events that have occurred in the community. The tone is ribald, the poetry is often sarcastic, and the images are satirical, posing the opposite to their traditional meaning. Even though the Efe ceremony is to appease the mothers, male dominance is lauded; women who have shown too great an independence from their husbands are ridiculed. The second poem bewails two outrages: not only did the man decried commit adultery against Ogunsola, but Ogunsola was in addition his elder. In the third poem the Oro Efe also stresses the theme of respect for elders by admonishing youth to remember that age, not wealth or Western education, brings wisdom.

...

Efe Poetry

Invocation

Orijio leaves charmed you to forgive my misdeeds.
Never have we suffered deaths from hoes, never from
 knives.
Have I lied?
Have I lied?
Never have we seen a thunderbolt strike a young *ose*
 tree.
Oso in the house were you not the one who gave birth
 to me?
Why do you not know us any longer?
Aje in the house, were you not the one who gave us
 birth?
Why do you not know us any longer?
Never have we seen a dog devour its child.
Never have we seen a dog devour its child.
Our mother, *opake,* forgive us our misdeed.
Our mother, do not allow me to falter
If a cult member has offended, expose him.
You joined our offering of thanksgiving to Agbojo,
Onidofoi was the one who saved us from death.
Young, old, households, and visitors, pray for my
 success.

Social Comment I

For a husband to grind pepper and grate cassava.
For a husband to grind pepper and grate cassava.
For a husband to cook *eba* and wash pots.
For a husband to cook *eba* and wash pots.
The wife you married, Sango, is wonderful.
She threatened her husband with a cutlass at the
 market.
She threatened her husband with a cutlass at the
 market.
I heard him shout to all around "help me!"
She threatened her husband with a cutlass at the market.

Social Comment II

The conceited man with all his money is teasing his
 elder.
The conceited man with all his money is teasing his
 elder.
Did Ogunsola marry his wife for you?
Did Ogunsola marry his wife for you?
Wretched person who pulls on the snake's tail.
Wretched person who pulls on the snake's tail.
If the snake bites you should I be concerned?
Wretched person who pulls on the snake's tail.

Social Comment III

Ah, truly young children are very wise.
However I say they are not as wise as their elders.
We called you to get the soup, but you went to add
 water to it.
But you are not as wise as the one who cooked it.
A goat is different from a horse, a white man is
 different from a Hausa.
You are not as wise as the one who did the cooking.

The Gelede Celebration

The Gelede is performed on the afternoon following the Efe festivities. Its purpose is to embody an approach to the mothers that appeals to their positive attributes. The priests and elders summon from the spectators attitudes necessary for the worship of the mothers: patience, indulgence, and composure. By upholding tradition and ridiculing those who offend it, the visual symbols, along with the music and dance of Gelede, attempt to please and honor the mothers.

The main performers for Gelede are masqueraders. Although they are all men, they traditionally appear in pairs portraying males or females. The pairing probably alludes to the spiritual duality assigned to the mothers, and the male and female to the two children Efe and Gelede, respectively. The costumes, which consist essentially of mask, headwrap, and leg rattles (Fig. 14-14), exaggerate the sex characteristics of the male or female. Hoops and layers of cloth accentuate the chest of the

male; a breastplate with elaborate carved breasts and wooden structures behind emphasize the female's physical attributes.

Masks consist of a head fitting over the upper portion of the masquerader's head and a superstructure above. The two components reflect different aesthetic values. The head is frontal, symmetrical, composed, and static, reflecting an ideal of patience, while the elaborate superstructure with its extended parts and asymmetrical design creates an effect of surprise. Colors in both parts are symbolic and frequently associated with the gods.

The elaborate art of the Gelede masks touches on all aspects of Yoruba life. Some of the motifs frequently occurring in them are animals, deities, social roles, historical personalities, fashion, and foreign elements. More than one motif may appear in a given mask. The principal animals of Gelede are the snake, bird, mongoose, tortoise, and lizard. Animal compositions may embody qualities of personality and behavior, as in Figure 14-15, where the snake symbolizes patience and "coolness" but is attacked by a "hot" or vengeful quadruped, the mongoose.

Goddesses, such as Oya, goddess of the Niger River (Fig. 14-16), are frequently represented in the Gelede part of the festival. Certain masks proclaim the hierarchical ordering in Yoruba social roles and religion. The mask represented in Figure 14-17 has a superstructure dominated by Yemoja, another name for Iyanla. Before the priestess is a figure prostrate in traditional greeting and at her side a small boy seeking her protection and support. This reiterates Yemoja's praises, which proclaim her the protector of children. The relative proportion suggests the religious hierarchical ordering, while the balance creates the notion of stability.

Foreigners are often portrayed in masks that include features the Yoruba associate with different cultural groups. Thus Figure 14-18 portrays a Muslim man from northern Nigeria, as indicated by the distinctive cap with its diagonal bands. Europeans are shown with products of their culture: cameras, sewing machines, cars, and trucks often appear on the masks (Fig. 14-19). These elements of Western technology are used both for sheer entertainment and for satire, but they also imply a deeper spiritual message. Technological inventions are held by Yoruba commentators to be the result of the Europeans' spiritual power. Their appearance in Gelede masks may reflect a plea to the mothers to use their own spiritual powers in a positive way.

14-14 *Nigeria, Yoruba, female Gelede dancer with breastplate carved in the form of ibeji statues, Joga-Orile/Imasai, Northern Egbado, April 1965. Regional Style Egbado. (Henry John Drewal)* (**W**)

14-15 *Nigeria, Yoruba, Gelede mask, quadruped and snake. (Reproduced by Courtesy of the Trustees of the British Museum)*

14-16 *Nigeria, Yoruba, male Gelede mask, Oya. (Courtesy of Roger Cte de la Burdé)*

14-17 *Nigeria, Yoruba, female Gelede mask, Yemoja. (Reproduced by Courtesy of the Trustees of the British Museum)*

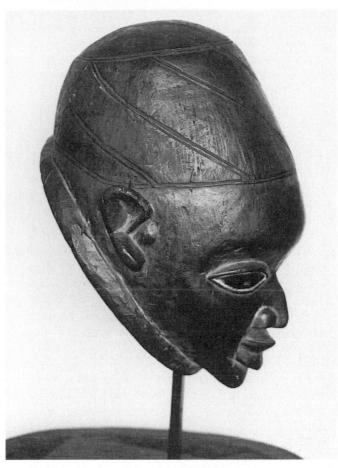

14-18 *Nigeria, Yoruba, Gelede mask. (The Strain Collection, New York)*

14-19 *Nigeria, Yoruba, Gelede mask, The Lorry. (Federal Department of Antiquities, National Museum, Lagos, Nigeria)*

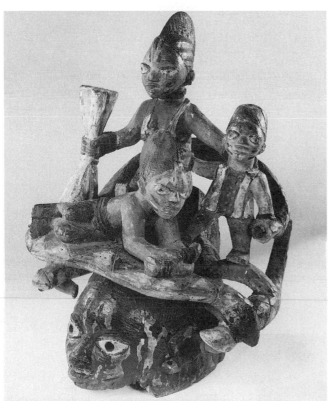

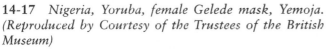

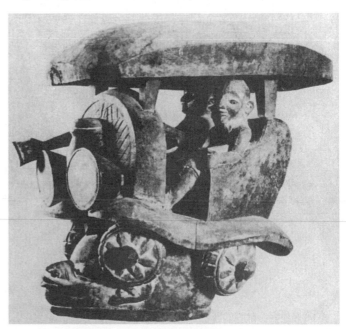

Dance

The visual imagery of the Gelede masks and costumes is enhanced by that of the dance, which is given great importance. Dance patterns in Africa, as elsewhere, evolve from habitual movements, posture, and gestures of work and play. Here the movements imitate qualities appropriate to the male or female sex, depending on the costume of the dancer. Like the words and performance of Efe and the dual composition of the masks, the dance heightens the tension inherent in this festival between male and female and within the perceived duality of the mothers. An example is the dance of the female masks performed by the young male dancer dressed as Tetede, wife of Efe. Tetede's costume with its pointed breasts emphasizes the male aggressive aspect of the feminine personality. The dance combines sequential deep knee bends, suggestive of a graceful curtsey, with a beating of shoulders and swaying of hips emphasizing female aggressivity. The dancer disguised as Efe also represents a male-female tension with both costume and mask. The heavy, layered costume suggests the ample figures of pregnant or mature women. Yet Efe's dance, accompanied by the explosion of ceremonial guns, vigorously approaches abandon as the tempo increases and the dance reaches its culmination. This abandon, although masculine in tone, implies caricature and exaggeration of movement and gesture associated with older women.

Through the festival, as seen in both the tohossou cult ceremony of the Dahomeyan kings and the Efe/Gelede of the western Yoruba, we have witnessed the interplay of many facets of African aesthetic expression. Poetry, music, song, sculptured mask, costume, and dance create together an experience of high drama for participants and observers, enhancing the social, spiritual, and moral concerns of the community. Enter-

taining and at times ribald, the performers nevertheless establish the priority of the spiritual powers that energize life on earth. They reinforce old values and symbols and acknowledge new realities. Audience and performers in communion celebrate the continuity of the community over time and affirm its vitality. While specific to certain groups of western Nigeria and Benin, these festivals evoke an essentially African mode of perception—the integration and wholeness of life.

..

COMMENTS AND QUESTIONS

1. African festivals—combining as they do music, costume, plastic art, and dance—confront all the senses with images and symbols of beliefs about human society and about spiritual forces. In reviewing this section, identify some of these in the case of Yoruba society by answering the following:
 a. What elements of the masks are symbols of the Yoruba deities?
 b. How is color used symbolically in mask and costume?
 c. How does the organization of both Efe and Gelede segments of this festival illustrate the tension in Yoruba society between the roles of men and those of women? Who are the dancers? How do their costumes and dance styles convey the tension?
2. Think of other festivals that you have studied or know about from Western traditions. Can you identify similar components and purposes in them?
3. How does the Gelede festival incorporate new experiences of cross-cultural contact of the Yoruba and integrate them into traditional Yoruba belief systems?

..

Summary Questions

1. Define the concepts of style area and basic style. Choosing one of the objects, select those features that may reflect a basic style or suggest style area features for the region from which it comes.
2. How do music and art share certain functions in African society? In what ways do those functions re-

semble or differ from those of the oral literature discussed in the preceding chapter?
3. What are the primary values that the Yoruba assert in the Efe/Gelede festival?
4. Can you identify elements representing historical experience and contact that appear in Gelede art?

Key Terms

ethnography

style area

basic style

secret societies

initiation schools

abstractionism

expressionism

naturalism

reliquary figure

divination

power figure

kente

melody

rhythm

timbre

call and response

tohossou

Efe/Gelede

The West African Cultural Root
and Its Survival in the New World

While a great diversity characterizes the many cultures on the continent of Africa and even within the area of West Africa studied here, there are certain modes of perception and cultural forms that may be characterized as African. These include, in the social realm, the veneration of elders, ancestors, and kinship ties generally, as well as the importance given to secret societies and initiation rites. We have seen that traditional religion, sometimes even among Muslim or Christian Africans, acts as a binding communal force. The close relationship with nature and the belief in a spirit world influencing it are primary motivating forces in the African arts and in the multifaceted art of the festival. African oral literature is devoted not only to religious ritual but also to moral instruction of the young and to the perpetuation of the history and traditions of a people. The griot, or oral historian–poet, plays a vital role in the latter aspect.

The traditional character of African art and culture makes the stylistic periodization that we have used in the study of Western culture somewhat irrelevant in regard to Africa. Aside from the tomb paintings and figures of ancient Egypt and Kush, the Nok sculptures, and the arts of Ife and Benin, which can be dated, our examples of literature, art, and music have been drawn from several centuries of African experience, including the present one. Festivals performed today include modern elements although they derive from ancient forms and ideas. Similarly, the poems of Diop, Achebe, and Soyinka express this continuity between ancient and modern.

General Characteristics of the African Humanities

Certain fundamental ideas and beliefs are shared across traditional African cultures. These include the commitment to a holistic view of life; the definition of community as the living, the dead, and the unborn; and a sensibility to the delicate balance between human society and natural forces in the universe—sometimes visible, sometimes invisible. If human beings must recognize the importance of natural and supernatural forces, their intelligence nevertheless is responsible for affecting their destiny. African ideas share with Western humanism a respect for the dignity of human beings and an acceptance of the foibles of human nature.

The African humanities exhibit perhaps even more than those of classical Greece a profound aesthetic and philosophical unity. Robert Farris Thompson, in his study *African Art in Motion,* has attempted to describe some of the basic principles that unite African arts and thought, particularly around the central art of dance.[1] His conclusions, presented in brief form below, are well worth our consideration.

1. Age and wisdom are venerated in African society. African art nonetheless shows a particular dynamic of age that would not in the West be associated with advanced years, for the elder is supposed to retain a certain youthful vitality. Even the terra-cotta mask from the ancient Nok culture (see Fig. 12-1), although representing a high official who would necessarily be someone of advanced years, does not show the face of an aged man. The elder dancer who executes his performance with disciplined vitality is highly regarded.

2. In dance, plastic art, and music, great attention is given to proportion and balance. Silence, or the "suspended beat" in music, and open space in art are not passive qualities but active components of the rhythmic flow. Balance is vitalized in perceiving the individual qualities and motions of body parts integrated into a whole. The ability to imagine and perform multiple rhythms in dance is an extension of this principle.

[1] Robert Farris Thompson, *African Art in Motion* (Los Angeles: University of California Press, 1974).

3. Sharpness of line and a crisp beginning and ending characterize both dance and sculpture. The Mmwo mask (Fig. 14-4) demonstrates the clear boundaries of pattern that the carver's knife establishes.

4. African arts portray an ideal of *resemblance* rather than *identity*. Sculptors, in particular, seek to represent a moral or spiritual force rather than to make an individual portrait. Although African art runs a gamut from the rather naturalistic Benin bronzes to abstract masks, it is never totally realistic or totally nonfigurative, but rather seeks a balance somewhere between the two poles.

5. *Ancestorism,* which Thompson defines as "the belief that the closest harmony with the ancient way is the highest of experiences, the force that enables a man to rise to his destiny," is a powerful motivation in the African arts. The sculpture of the mask, mythology, music, and dance are used in rites to establish links between living sons and daughters and the community of ancestors.

6. A final principle of "coolness," a word that has equivalents in many African languages, unites all the preceding ones. Aspects of "coolness" are visibility and openness, luminosity, and smoothness coupled with clarity. A dance, for example, may be characterized by extreme vitality but also by extreme control and by facial composure, the "mask of the cool." The belief in rebirth and reincarnation, which unites living vitality with orientation toward the ancestral, is an important component of "coolness." This unison of energy and balance, of "hot" movement and "cool" composure, in African art, music, and dance is perhaps the most distinctive feature of African aesthetics.

African Survivals in African American Culture

The fact that almost one million Africans, originating primarily in the western regions that we have studied, were imported to North America as a result of the slave trade has had profound effects on American culture. These effects have been transmitted to American culture as a whole by means of the continuities, or "survivals," of African culture in African American culture.

The term *African survival* is used by scholars to denote a specific form or function of an institution, ritual, belief, language, or art that is clearly identifiable with an African origin, although adapted to the New World situation. Such survivals have always been noticeable among black populations in South America and the Caribbean. North Americans of European origin, however, as well as many of African origin, tended until recently to deny that there was anything African about black American culture. Thus it was said that the American Negro had no past; his or her culture was purely a product of the slaves' adaptation to white America. In the early twentieth century, the black scholars W. E. B. DuBois and Carter Woodson were among the first to point out African survivals in the religious, social, and aesthetic life of African Americans. An anthropologist, Melville H. Herskovits, continued the investigation of this question in his work *The Myth of the Negro Past,* published in 1941. Herskovits challenged the popularly held assumption that African Americans had no cultural past. Outlining principal features of a "cultural complex" based on common patterns of behavior of the African cultures in the regions of slave origin, he identified certain features of African American culture in the Americas and the Caribbean that evolved from African cultural institutions.

Recent studies have built on Herskovits's findings. The formation of African American culture was a complex process indeed; but certain features of its social institutions, religious organizations, and beliefs, as well as its arts and letters, can now be identified as having distinctly African origins.

The Extended Family

Identification with the extended (as opposed to the nuclear) family, the great importance of children to the sense of a community's continuity over time, and the special roles played by men and women in family life are African features that have persisted in African American social life. Coupled with the latter is the acceptability of the economic independence of women. African women, unlike their European counterparts, could have rights in land and property. In certain circumstances, children born outside marriage were welcome additions to the woman's family. In many African societies children are often raised by people other than their own parents: sometimes grandparents, sometimes friends of their parents' generation. Although preferences of these types may have been reinforced by the conditions of slavery and the plight of freed slaves, they provided adaptable models for a "normal" African American family life, if different from those of the majority culture.

Groups and Associations

Types of bonding and grouping characteristic of traditional African societies reappear in various ways in African American society. At the time of initiation, African boys and girls form close bonds with their agemates that continue, in the form of a society, throughout

their lives. Age or initiation mates treat each other as brothers and sisters, granting reciprocal rights and obligations. Such groups are often the focus of festival, entertainment, and mutual support activities. Related to these groups are "titled" societies in which individuals can display their wealth and enhance their status by the purchase of a succession of "titles" bringing them recognition and respect. Titled societies also encourage cooperation in economic activities through the use of fees for insurance, burial, or investment purposes. Aspects of both the age-grade and titled societies may be seen in the structure and vitality of men's and women's groups, brotherhoods, and so on, among African Americans. Even the organization of black American churches and their auxiliary societies reflects these African patterns of association.

Importance of Oral Eloquence

The African American church, where permitted to develop independently, incorporated other social norms and roles of African society. Among these were leadership by elders and/or by individuals who were gifted speakers. In those African societies where leadership was informal or officially vested in a group of elders, individual influence and leadership were exercised through one's knowledge of custom and traditions as well as through sound judgment and rhetorical skill. Since the New World experience rarely permitted free and open public expression to black people, especially to men, these highly valued skills were developed in the single largest institution that the blacks had to themselves, the churches. Preachers in African American churches have traditionally been political leaders in a society within a society. It is significant that many of the civil rights movement's leaders were first of all ministers in black churches. Martin Luther King, Jr., for example, was a gifted politician noted as well for his eloquence and his sense of history. As such, his leadership role in African American society is reminiscent of that of the griot. In highly centralized states, the griots were important officials of the court. They exhorted troops to battle and counseled the ruler by recalling past heroes and events of their people's history. Their fate, as we have seen in the epic *Sundiata*, was closely bound to that of the king, who symbolized his people.

Oral Literature

The importance of the oral tradition in African life appears, as we have seen, not only in political and historical rhetoric but also in the tales used to transmit the wisdom of elders to the young. Some of the animal and human characters in African tales—notably Hare, Tortoise, and Spider—found their way to the New World in the tales told by African slaves to their children and to those of their masters. The transfer of animal characters was not the only African pattern to appear in this setting. The performance of the "uncle" and "auntie" figures who recited the tales was important. These stories used the theme of the trickster hare, common in African folklore, who outwitted those of superior physical strength (or social position) by his swiftness and cunning. The language of the tales was often replete with proverbs, riddles, and double meaning. They also sustained the pedagogical purpose of African tales: to impart a moral lesson or model of behavior.

Other kinds of African American tales, such as those about the origins of things, also have their roots in Africa. Religious tales containing plots about conjuring, voodoo, and natural phenomena reflect African religious practices that have been adapted to the New World setting. "Preacher" tales—ones by and about ministers—may combine elements of the trickster character with the primacy of the performance element. In the folk genre of the "black sermon" it is the preacher's skill in heightening the spiritual experience of the congregation through poetic use of the popular language that, more than the substance of the words, creates the popularity of the teller. Spirituals, Christian religious songs created in the context of slavery, often included actual hidden messages or codes. The importance of rhythm and verse is characteristic of African American field hollers, riddles, and proverbs, as well as of some of the tales. Even the recent flourishing of rap music among African American youth suggests an African legacy in both theme and style. The important element of social comment evoked in many of the lyrics, together with the emphasis on complicated rhythm, repetition, narrative eloquence, and important performance style, situates rap music well within the descendants of an African oral literary tradition.

Written Literature

Many of the themes and stylistic devices of African American folk literature mentioned above—trickster, animal, and preacher subjects; moralistic purpose; and exaggeration, double meaning, hidden messages, rhythm, and verse—have been used by black American writers in their short stories, poetry, and novels. One of the earliest examples is Charles Waddell Chesnutt's *The Conjure Woman*, published in 1899, and widely read by white as well as black Americans. In this work a series of short stories develops around an elderly former slave named Uncle Julius. Uncle Julius, the epitome of deference and helpfulness toward his employer, frequently "explains things" to him through stories strongly reminiscent of the folk tale. The strange ways of nature, conjuring, and animals are common subjects. Irony and

satire provide the tales with various levels of meaning that belie Uncle Julius's innocence and simplicity. James Weldon Johnson's *God's Trombones: Seven Negro Sermons in Verse* is an excellent early example of the use of the black folk sermon in literature. The themes and literary techniques explored by Jean Toomer in *Cane,* Ralph Ellison in *Invisible Man,* and Richard Wright in *Native Son* are more recent examples of literature reflecting black American writers' great sensitivity to their African and African American folk heritage. We will explore this connection more fully in Chapter 33.

Language

African languages themselves have left their mark on the speech of African American communities. Lorenzo Turner was the first to point out specific words from a variety of African languages in the speech of the Gullah communities off the South Carolina coast. More subtle—and, because of that, more persistent—linguistic influences were patterns of sentence construction. The speech of black Americans, long thought to be merely bad English, has been shown in recent years to be the result of an English vocabulary superimposed on grammatical and syntactical patterns common to related African languages. It is strikingly similar to contemporary African dialects derived from contact with European languages. Other African linguistic influences are even more widespread.

Beliefs

African beliefs about the nature of the universe, about humankind's relationship to the world of nature, and about human relations have also survived in African American cultures of the New World. People of African descent in Latin America and the West Indies worship and venerate numerous African deities, particularly those of the Yoruba. Often their names have been joined with those of the Christian saints whose personalities are perceived to be similar.

We have seen how the spiritual vitality of the natural world and the belief in resident spirits influence all aspects of traditional African life. Acknowledgment of the spiritual power of water remains a recognizably African feature of African American religion. It is not without reason that the Baptist Church, which baptizes by immersion in water, is the most populous black American church. The spiritual potential of plants or of objects controlled by powerful spirits appears in the New World practices of "working roots" and of voodoo. Here a human agent, using herbs or objects as an intermediary, may direct powerful spirits to hinder or assist another person, often at the request of a third party. Inveighed against as superstitions or regarded more positively as folk medicine, such skills involve closely guarded secret knowledge and have rarely been studied in a systematic way. Credible witnesses testifying to the psychic power of such skills or forces at work have in recent years led modern scientists in the fields of pharmacology and psychiatry to study these phenomena in both Africa and the New World.

Music

African music and dance are the most well known African influences on African American and American culture in general. In Africa, the two arts are not easily distinguished from poetry and song, and none of these from the pervasive quality of ritual. Above all is the predominant role of rhythm in African and African American music. It is varied and multiple in composition, often emphasizing the unexpected by the coincidence of otherwise differing rhythms on a normally unaccented beat, called *syncopation.* Jazz music was founded on this predominance of rhythm. In addition to rhythm, jazz musicians preferred harmonic scales, intervals of thirds, and the call-and-response pattern of solo instrument or voice with a chorus, all features widely used in Africa. Generally speaking, the African and African American singing style uses the voice like an instrument, placing greater emphasis on its percussive role and on particular *timbres* of voice than European music does. The call-and-response pattern of leader and chorus was a distinctive feature of African American spirituals, of course, before it was extended to the secular realm by jazz musicians.

A further transformation of the interaction of African and African American music beyond that of rap music mentioned above is the recent flowering of collaborative performances and recordings by African artists from the continent and the diaspora. These collaborations, often based on jazz principles, feature African instruments and narrative patterns to a greater extent than earlier jazz music. They also acknowledge the interconnectedness and the conscious appreciation of one another's traditions by the artists.

Dance

Although less studied than music, African American dance can be seen to bear African characteristics of form, composition, and body stance. Preferences for group dancing in lines or in circles, with movement running counterclockwise in the latter, are typical in African dance throughout the continent. A frontal pose of the face and the vigorous use of separate parts of the body to accent different rhythms of the dance were readily noticed by early European visitors to Africa. The survival of these features is generally, if not always precisely,

noted by observers of African American dance. We will see in Volume Two how African American choreographers have made use of African dance forms.

Interrelation of Arts

It seems likely that African American artistic values and expression drew on African content, form, occasion, and style; moreover, they also served to develop and sustain the slaves' self-conscious sense of community. Their extension and elaboration since slavery have created a distinctive African American aesthetic and have greatly enriched American culture as well as Western culture as a whole.

The Influence of Africa on the Western Humanities

The most direct impact of the African humanities on those of the West beyond black America has been in the fields of music and art. Artists such as Picasso who "discovered" African sculpture in the early part of this century brought a vibrant, shocking, and refreshing set of aesthetic norms to Western art. Similarly, the African rhythms that African Americans developed in jazz revitalized a tradition of Western music. Other aspects of African American culture—dance, language and poetry, religion—that have their roots in Africa have been adopted or imitated by others in the West. More indirectly, Africa has influenced the humanities in Europe and America as theme or symbol. Black people appear in Western literature and art as evil, mysterious, savage, passionate, or inherently noble. Europe's contact with Africa was a source of the important idea of cultural relativity that began in the sixteenth century. The enormous burden of guilt that slavery left to the Western mind has had its impact on the humanities, as has the phenomenon of European colonialism, in Africa and elsewhere. In Volume Two, we will see how the great flourishing of European culture that was to dominate the world in the modern era was made possible in part by the exploitation of Africa and Asia.

Part V

- The Asian
 Cultural Root

15 An Introduction to the Civilization of India

CHRONOLOGY	CULTURAL	HISTORICAL
3000 B.C.	*High Priest* and *Dancing Girl* (3000–2400)	Indus Valley (Harappan) civilization (3000–2400)
	Rigveda and the *Upanishads* (c. 1400 B.C.–A.D. 1200)	Aryan migrations (2000–1500)
1000 B.C.		Cyrus captures what is now northwestern Pakistan (530)
		Death of Gautama Buddha (486)
		Alexander the Great's invasion (327–325)
	Lion Capital and *Yakski Didarganj* (321–180)	Mauryan dynasty (321–180)
A.D. 1	Poems of Kalidasa (400s)	Gupta dynasty (320–late 400s)
A.D. 500	*Bhagavad Gita* composed (c. 500)	First entry of Muslims (711)
	Ajanta Cave (c. 600)	
	The Descent of the Ganges at Pandava Raths (625–674)	
A.D. 1000	Sufism (1100s)	Mughal Empire (1500s–1700s)
	Kevasa Temple (mid-1200s)	British rule begins (1770s)
		Great Rebellion (1857–1858)
		Independence and partition (1947)

CENTRAL ISSUES

- The birth of Indian civilization on the Indus Valley
- The Indo-European and Sanskrit languages
- The development and beliefs of Hinduism and Buddhism
- Islam in India
- Caste, class, and family in India
- Hindu painting, sculpture, architecture, music, and dance

We have traced the two major roots of the Western humanities—the Greco-Roman and Judeo-Christian traditions—down to the eve of the Renaissance, and we have studied some aspects of West African culture as another important cultural root of present-day Americans. Now we take a brief, introductory look at two other ancient and complex cultures: those of India and China. In Volume Two, we will continue to study some of the Asian influences on Western humanities and arts. We will also consider the developing relationships in all domains as a world society gradually takes shape.

With the increase in the population of people of Asian ethnic heritages, Asian cultural roots will gain more and more importance on the American continent. A full treatment of the cultures and civilizations of eastern Asia, including Japan, Korea, and others, would of course require another book. Here we

hope to explore at least a few aspects of the civilization, art, and thought of India and China, two of the societies that dominate over one-third of the modern world's population of 7 billion: China (1.2 billion), India (984 million), Pakistan (135 million), Bangladesh (128 million), Sri Lanka (19 million), and Nepal (24 million).

India and China as River Civilizations

At the other end of the immense Eurasian continental mass from Mesopotamia, two other great civilizations in what is now China and India flourished as river cultures in the millennia before the Christian era. The first of these, India, began about 2500 B.C. within the valley carved by the Indus River in the northwestern part of the Indian subcontinent. The second arose about 2000 B.C. in the lands bordering first the Huang He (Yellow) and then the Yangtze and Xi rivers. Not surprisingly, like their counterparts in Egypt and Mesopotamia, these cultures thrived on a sedentary agriculture made possible by the rich soils of their river basins; they had highly developed class structures, writing, and elaborate governing bureaucracies.

To understand the development of early Indian and Chinese civilizations, however, we must reckon with their two major differences from the other two early riverine societies. The first difference is mountains. India's northern boundary is defined by the world's most spectacular range, the Himalayas, but mountains are even more important for China. Although China contains more than four times as many people as the United States, the two countries are roughly the same size. The numerous mountain ranges, however, mean that only 10 percent of Chinese territory can be cultivated. Despite this severe restriction on food production, compared with other parts of the world, China attained a large population very early. Densely concentrated in the river valleys in the eastern part of the country, the population survived by intensive and efficient use of the land it could cultivate. In contrast to Egypt and Mesopotamia, whose basic staple was wheat, China's staple, initially millet, gradually became rice, which has the advantages of producing more calories per acre and of permitting two or three harvests a year to wheat's one. Whereas ancient Western civilizations had sufficient space to graze animals, which would serve as work animals or as food, the earliest surviving sources make clear that remarkably little land was reserved for pasture in the densely populated areas of China. Consequently, human beings were forced to provide most of the labor in the production of food.

The second major difference between descendants of the two Eastern and two Western societies concerns continuity. The zenith of the Roman Empire in the West (roughly 150 B.C. to A.D. 200) coincided with the powerful Han dynasty in China (206 B.C. to A.D. 220).

When the Han dynasty and the Roman Empire collapsed, no central state emerged again in either region for over three hundred years. In the West, however, at least in Europe, those three hundred years were a period of relative confusion and a relatively low standard of cultural activity. China, by contrast, retained the Confucian ideals of a state run by a benevolent monarch with the help of a literate elite; hence its culture continued to develop. Despite the rise and fall of various ruling families, India too did not experience anything comparable to the so-called Dark Ages in the West (the fifth to the eighth centuries).

Western civilization had not been completely erased with the fall of Rome. The Latin language, Roman law, the Italian estate or villa, and the Christian religion itself had survived the political death of the society, but they functioned in a corrupted form. Europe periodically felt the need of revivals—efforts to return to the high standards of culture and government found in antiquity. We have already examined one of these revivals, beginning in the eleventh century, and in Volume Two we will study in detail the second one, known as the Renaissance, which started in fourteenth-century Italy.

In contrast to these survivals and revivals, the Asian civilizations possessed true continuity. Although Hinduism has evolved and grown so complex as almost to defy precise description, the ancient gods (Siva, Vishnu, and Khrishna) still play significant religious roles today; the pagan gods of ancient Egypt, Greece, and Rome do not, although they remain important to our cultural patrimony.

India's Geography and Early History

The Indus River originates in the Himalayas, whose melting snows swell it into raging torrents in the spring and summer. Some eighteen hundred miles long, it flows through the states of Punjab and Sind in contemporary Pakistan, emptying into the Arabian Sea north of Karachi. It is actually a river system comprising five rivers—Chenab, Ravi, Beas, Jhelum, and Sutley—and the Punjab ("five waters") takes its name from them. As in Egypt, irrigation has been crucial to the economy of the region, not only during the period of the ancient Indus Valley civilization but also in modern times. During their rule before 1947, the British built extensive dams and moved large numbers of "colonists" into what had been desert areas sparsely populated by seminomadic pastoralists.

The ancient Indus Valley civilization came to light only in the 1920s, when British archaeologists excavated the sites of two cities: Harappa and Mohenjo-Daro (see map). These two digs confirmed the existence of a complex sophisticated society, beginning perhaps as early as 3000 B.C. and possessing regularly laid-out streets, piped water, temples, markets, coins, and writing.

On the basis of such evidence scholars have deduced the existence of a stratified class structure, government machinery, and early forms of such Hindu gods as Siva and Vishnu. However, with no equivalent to the Egyptian Rosetta stone, Harappan writing has still not been deciphered. The city thrived on long-distance trade with barbarians of Central Asia and Mesopotamia. Harappan artifacts found in Mesopo-tamia date from as early as 2400 B.C. None, however, has been found after 1600 B.C. More recent digs have extended the range of the Indus civilization over an area approximately a thousand miles long—somewhat larger than modern Pakistan.

The Aryan Migrations

The decline of the Harappan civilization probably overlapped and is partially explained by the next great notable event in ancient Indian history, which occurred between 2000 and 1500 B.C. The Aryans, who migrated into India and extended their power in these centuries, were peoples of central Asia. They came in successive waves, but how extensive these waves were, how many of them, and how long the intervals between them are almost entirely unknown. Although the Nazis in the twentieth century adopted the word *Aryan* as a racial classification, it is really a linguistic term. The Aryans appear to have been part of a dispersal of the tribes from the steppes of central Asia who since about 4000 B.C. spoke a roughly unified parent language, called Indo-European, or Aryan. By 2000 B.C. these tribes were moving into India and westward into Mesopotamia and Europe. In the 1780s British philologist Sir William Jones discovered close family connections among Greek, Latin, and Sanskrit, the language that the Aryans seem to have brought south with them into India. All modern western European languages, except Finnish and Hungarian, are derived originally from Indo-European roots—the Basque language in the Pyrenees mountain range, on the west coast of Spain and France, is thought to be the last survivor of whatever language preceded the arrival of Indo-European. Modern Aryan-derived languages—that is, Hindi, Urdu, Gujarati, Marathi, Bengali, and Punjabi—dominate northern India. By contrast, the languages of the south, such as Tamil, Melugu, and Malayalam, belong to an entirely different family, the Dravidian. For both of the language families, however, the system of writing is phonetic; that is, it represents the sounds of the words, as do the written languages of Europe and central Asia.

The initial center of the Aryan settlements along the Indus gradually extended to the Ganges River basin and further south. Overwhelmingly rural and agricultural, the society was not united under a single ruler. Rather, independent centers of power were scattered over the area of northern India. By the sixth century B.C., however, the tempo of economic life quickened, larger political agglomerations appeared, and new towns rose,

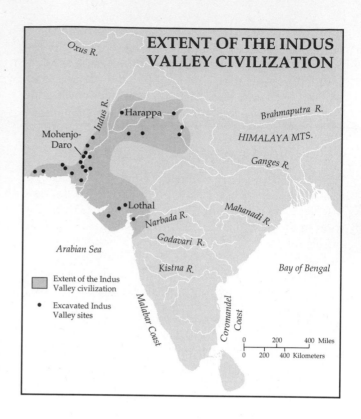

EXTENT OF THE INDUS VALLEY CIVILIZATION

Oxus R.

Indus R.

Harappa

Mohenjo-Daro

Brahmaputra R.

HIMALAYA MTS.

Ganges R.

Lothal

Narbada R.

Mahanadi R.

Godavari R.

Arabian Sea

Kistna R.

Bay of Bengal

Malabar Coast

Coromandel Coast

- Extent of the Indus Valley civilization
- • Excavated Indus Valley sites

0 200 400 Miles
0 200 400 Kilometers

especially in the Ganges Valley. The increased economic vitality stemmed in part from the intensification of international trade, especially with the lands to the West.

Western Invasions

The prosperity of the region attracted the attention of the expanding Persian empire, and in 530 B.C. the Persian emperor Cyrus, who a few years before had captured Babylon and restored the Jews to their homeland, seized what is now northwestern Pakistan. Subsequent campaigns ended in the Persian occupation of much of the western Indus Valley (modern Pakistan) and with this the center of Indian culture shifted to the Ganges Valley. Persian power remained in the Indus Valley until 327 B.C., when Alexander the Great of Macedon (356–323 B.C.), having conquered the Persian empire, invaded India. Although disease and supply problems forced him to abandon the territory after only two years, the Greek presence remained through Greek merchants and artists. Trading links greatly increased during the dynamic Hellenistic period: Greek coins and artifacts from these several centuries have been found in large numbers along the Indus. Indian art testifies to the influence exerted by Hellenistic models on native artists.

Mauryan Empire

The Mauryan period (roughly 321 B.C. to c. 180 B.C.) deserves to be regarded as formative in the history of India. The Mauryans were the first to bring virtually all

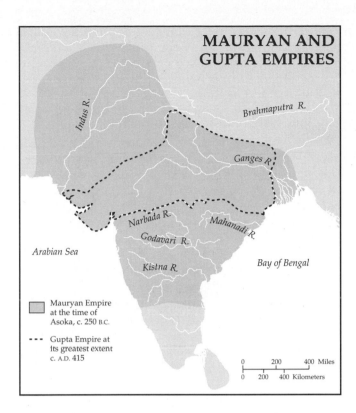

MAURYAN AND GUPTA EMPIRES

Indus R.

Brahmaputra R.

Ganges R.

Narbada R.

Mahanadi R.

Godavari R.

Arabian Sea

Kistna R.

Bay of Bengal

Mauryan Empire at the time of Asoka, c. 250 B.C.

- - - Gupta Empire at its greatest extent c. A.D. 415

0 200 400 Miles
0 200 400 Kilometers

measurably advanced by the economic prosperity and commercial ties linking regions of the country together.

The Gupta Dynasty

Although the Gupta empire (A.D. 320–late 400s), actually a confederation of small states paying tribute to the Gupta family, encompassed only the northern half of India, its influence, both political and cultural, far exceeded its borders. Using its wealth to construct elaborate monuments and maintain a rich court life, the Guptas initiated during their relatively short period of rule what is generally considered the classical age of Indian culture.

In the Gupta period Indian art and architecture, under the Mauryan empire heavily indebted to Greece and Persia, finally achieved their own expressions. The poems and plays of the greatest Indian poet, Kalidasa (fifth century), belong to this period, as does the legendary love manual, the *Kamasutra*. Although reworked over the centuries, the ancient collections of stories dealing with secular events, the *Mahabharata* and the *Ramayana,* appear to have assumed their present religious orientation at the hands of the Brahmans by this epoch. Moreover, somewhat after the breakup of the central government, around 500, the didactic *Bhagavad Gita* was composed and added to the *Mahabharata*. Despite the great variety of dialects found throughout the continent, these works, written in Sanskrit, the literary language of the elite, fostered a cultural unity, at least among the upper class throughout the subcontinent.

The fifth century also witnessed a flowering of interest in mathematics and astronomy. The invention of the zero, a discovery of incalculable importance in the development of mathematics, is attributed to this period. The late-fifth-century Indian mathematician Aryabhata suggested an explanation for quadratic equations, calculated the value of pi, and discovered the rotation of the earth on its axis. These achievements suggest that the level of mathematics in India was the highest in the ancient world.

The influx of foreigners connected with trade and the increasing mobility during a period of economic prosperity explain in part Gupta society's use of legislation to make the traditional Hindu caste system more rigid. As suggested by the concern with religious literature and the building of temples, Hindu religious fervor intensified during these centuries.

The Post-Gupta Period

From the middle of the fifth century the Gupta empire experienced a series of invasions by the Huns, a fierce people from southern Russia; one branch of them moved west to terrorize the Roman Empire and the other southeast to attack the rich lands of northern

of the landmass of the subcontinent under their control, an achievement not matched before the Mughals almost two thousand years later (see map). Emperor Asoka (c. 269–232 B.C.), under whom the Mauryan power reached its greatest extent, inscribed his decrees and commands on columns and rocks all over India. Both the official use of these means and the style of the inscriptions reflect Persian and Greek influences on the Mauryan government.

This was also the period in which India might have become Buddhist. Having set a limit to further territorial expansion, Emperor Asoka gave Buddhism the impetus that eventually changed it from a local sect to a world religion. Remorseful for the destruction of so many human lives in his war of conquest in 261 B.C., Asoka henceforth embraced peace as a permanent policy and strove to disseminate Buddhism not only throughout his territory but also, by means of missionaries, throughout all of Southeast Asia. Over the next centuries Buddhist missionaries carried their religion as far away as China, Indonesia, Japan, and Korea.

The collapse of the Mauryan dynasty ushered in a period of almost five hundred years in which the subcontinent was again fragmented into little principalities. Despite the political confusion, by the second half of this period urbanization, until then confined largely to the Ganges Valley, reached central and southern India. In the new urban centers guilds of merchants and artisans were formed and gold coinage became common. Doubtless the new effort to create a central government under the Gupta dynasty in the middle Ganges Valley was im-

India. These invasions and the dissensions within the Gupta royal family led to the fall of the Guptas and to the fragmentation of northern India for the next five hundred years. The southern half of the peninsula continued its traditional division among a number of competing states.

Islam

Islam made its first appearance in India during the eighth century in the trading communities of the northwestern coast. Gradually assimilated to Islam by the tenth century, Muslim princes from Afghanistan made periodic raids into northern India in the eleventh century to seek booty, especially in the Hindu temples. Islam itself, however, started to spread widely only in the late twelfth century, when a Turkish prince ruling in Afghanistan, Mohammed of Ghur (d. 1206), began the conquest of the northern quarter of the subcontinent and, intending to remain there permanently, established his capital at Delhi. Muslim power continued to expand after his death. By the early fourteenth century it had penetrated into southern India, forming a unified political entity somewhat larger than that ruled by the Mauryans. By 1400, however, this Turkish state was dissolving and new powers were rising, some local but others controlled by Muslim immigrants from Persia and Afghanistan. The last of these Muslim invaders, the Mughals, a people from central Asia who traced their descent back to the Mongol conquerors of Asia, entered India early in the sixteenth century. Over the next two hundred years they built an empire across northern and central India.

Hinduism

An obstacle in studying Hinduism is that, compared with other world religions such as Christianity, Islam, and Buddhism—all of which possess founders, dates of establishment, and well-defined bodies of doctrine—Hinduism is much less coherent. Indeed, the concept that India (or Hindustan) possessed a unified "religion" was actually first "imagined" by Sir William "Oriental" Jones and other British observers as late as the eighteenth century. It was they who coined the name *Hinduism,* after that of the territory, Hindustan. According to later censuses, the word *Hindu* was used to designate any native of India who was neither a Christian nor a Muslim. Even now, it would be impossible to give a clear and defensible answer as to what beliefs and practices are and are *not* Hindu. The range of beliefs, gods, rituals, and practices that are incorporated under the umbrella of "Hinduism" is almost infinite.

At about the same time that the label *Hinduism* came into being, British "Orientalists," in alliance with members of the Brahman (priestly) class, developed the concept of caste as a key to understanding India. Some

sort of caste organization, including rules governing marriage and other sorts of contact as well as food, has apparently existed in India since before records were kept, though probably not in its modern form. But the notion that caste represents the "essence" of India was also part of the comparatively recent British attempt to "imagine" India. Both caste and Hinduism were portrayed as working to keep India divided and atomized, and therefore badly in need of unifying political control: that is, the British Empire.

In short, the study of Asia (Orientalism) was closely connected to the aim of controlling and ruling Asians (imperialism). Moreover, many of the influential and authoritative books on Asia have been written by westerners. Since even twentieth-century Asian leaders such as Gandhi, Nehru, and Mao Zedong have derived so much of their understanding of their own societies from the interpretations of outsiders, it becomes sometimes difficult to disentangle fact from fiction with respect to many aspects of Asia, including religion.

A second obstacle to understanding Hinduism is that there is no clear historical break between time before Hinduism and time after its establishment. The Indus civilization had temples, gods, a priestly class, fertility rites, and religious festivals. Although these were very different from those of contemporary India, it is impossible to locate a period when the religion of India was not Hindu or to determine when Hinduism began. Moreover, although all religions have important social and economic aspects, Hinduism is so bound up with society that the question arises whether it is a religion at all. Perhaps it should be called a culture.

Instead of shutting them out, Hinduism has tolerated and absorbed competitors. Whereas Muslims pray five times a day and fast during Ramadan, and Christians recite the Apostles' Creed, Hinduism has virtually no essential doctrines or practices. Only a few Hindu sects seek converts. Some Hindus are monotheistic, worshiping God in a universalist, impersonal sense; others are polytheistic, worshiping godly personalities such as Siva, Vishnu, or Kali; still others are pantheistic, locating divinity throughout nature, for instance, in cows.

Classes and Castes

Reflecting a long-standing traditional arrangement of Indian society, the *Bhagavad Gita* (Song of Songs), dated around A.D. 500, assumes the existence of four ranks in the Hindu social system, for which the Hindi word is *varna* (category or color). Presumably, this reflects a division of Indian society following the invasion of the light-skinned Aryans but has little meaning after centuries of intermarriage. The four ranks are Brahman (priest), Ksatriya (warrior), Vaisya (merchant), and Sudra (peasant, servant). There are also people who belong to no class, and during the Gupta period this group was increasingly denied access to religious rituals

and secluded in separate communities. Really a fifth class, the group became known as the untouchables. One's class or rank had and still has little to do with economic circumstances, so that it is possible for a Sudra to be a rich peasant and a Brahman a poor priest.

While there are four classes (five if you count the untouchables), there are thousands of castes—so many that one could hope to be expert only on those of a single region. The Hindi word for caste is *jati,* a kinship term referring to lineage, clan, or tribe. Castes are primarily kinship and/or occupational groups, which are preserved by intermarriage. They occupy prescribed places, not necessarily permanent but jealously guarded, in the class pecking order. Thus Rajputs (*jati*) are Ksatriya (*varna*) while Jats (*jati*) are Vaisya (*varna*), and so on. A Hindu's last name is a caste designation.

Castes are governed by complex rules concerning marriage, occupation, and pollution. For instance, jobs requiring contact with excrement or other bodily emissions or with dead animals are inherently polluting. Nevertheless, although a group's work might be hereditarily connected with a polluting occupation such as making shoes, in which the worker is in constant contact with the skin of dead animals, the low social status of the work has to be weighed against the economic benefits. Castes (*jatis*) are governed by caste associations, which guard their group's status or seek to advance it against the status of other castes, while keeping their members in line (primarily by ostracizing offenders). Castes sometimes die out or merge into others, and they are still being created—for example, with the development of new kinds of occupations.

Under the present Indian constitution, discrimination against members of "depressed classes" (the untouchables) is illegal, and there are "compensatory discrimination" programs—Americans would recognize them as affirmative action programs—encouraging their admission into universities and government employment. In modern Indian cities, moreover, caste distinctions are sometimes unevenly observed and enforced. A link between caste and profession does continue to exist. One would not expect a man named Arora (gold merchant) to work as a sweeper removing polluting night soil, but this is not always the case. For example, there are in modern India many Brahman farmers, some of them quite poor.

Hindu Religion: The Bhagavad Gita

The Indian class and caste system is intimately connected with the ethics, rituals, and practice of Hinduism. Although Hinduism lacks the doctrinal clarity of Islam or Christianity, it does have some fundamental concepts: dharma, reincarnation, nirvana, yoga, and karma. The best way to understand them is to study primary sources such as the *Bhagavad Gita.* In some ways the *Gita* fits the model of epic poetry that we have

seen in the *Iliad,* the *Odyssey, Gilgamesh,* the *Aeneid,* and *Sundiata.* Actually part of the long epic poem known as the *Mahabharata,* the longest poem in surviving world literature (about a hundred thousand verses), the *Gita* was in the Vedic oral literature long before it was written down about 500. Like other epics, the *Gita* is in elevated style; it involves heroic or divine figures; and its material is central to the identity of a people. There is also a battlefield with opposing armies lined up. Although epic action—battles, heroic feats, and so on—abounds in the rest of the *Mahabharata,* in the *Gita* nobody fights. Instead, this philosophical text presents a long, rambling conversation between the god Krishna, appearing in human form, and the professional soldier, Arjuna. As a warrior, Arjuna's *varna* is Ksatriya.

Arjuna asks a very difficult question. An apocalyptic battle between two sets of cousins is about to take place, and one side will surely be annihilated. Arjuna is tormented by the knowledge that, if he fights, the enemy soldiers he kills will be his own kinsmen. Moreover, in war women are raped, which leads to the mixing of blood and castes, that is, to pollution—and the mixing leads to grievous wrongs. Surely he, Arjuna, should not be the instrument of so much evil. Surely he should sheath his sword, put away his legendary bow and arrows (Arjuna was a great marksman), and go home. In the course of his long answer (if he ever really does answer) Krishna, who serves as Arjuna's charioteer and bodyguard, discusses, among others, the following Hindu concepts.

1. *Dharma.* Every male person is born into a class (*varna*) and caste (*jati*), which determine what he is to do and be in life. Arjuna was born into a warrior caste; his father and, presumably, all his ancestors, were professional soldiers. His prescribed, preordained role is to fight, and therefore to kill; he is in no way responsible for the consequences.

2. *Reincarnation.* Life and death are not real; they are only illusions. Bodies are only transient; it is the soul that counts. Arjuna can neither kill nor be killed. He is the instrument of God's will, the means by which other souls are released from their particular rungs, before being raised or lowered on the ladder of reincarnation. By killing enemies physically, Arjuna is actually doing them a service. The goal is ultimate release (*mokhsha*), a kind of bliss, when at last the cycle of births and rebirths is ended.

3. *Karma.* The progress of a soul up and down the ladder depends on karma, the accumulated record of many lives. One builds up good karma by performing the dharma belonging to one's station in life (caste/class). Arjuna is from a warrior caste; his job is to fight. Krishna tells him to get on with it—but Arjuna never really does.

Buddhism

Siddhartha Gautama (c. 563–486 B.C.), known as Buddha ("one who has awakened"), was a member of a Ksatriya (warrior) caste, probably from what is now Nepal. Buddha came from within the Hindu tradition, and in some ways can be regarded as a Hindu guru (holy man). For though he revolted against certain aspects of Hinduism, especially caste and the Brahman pretensions of divinity, he retained others, notably karma, reincarnation, yoga, and nirvana. Buddha himself made no claim that he was a god or that he had founded "a religion." As a young aristocrat, in the second stage of life, that of a householder (see "Daily Lives"), he left his wife and son and went into the wilderness, where he engaged in the deep, extended meditation known as *yoga*, a word that refers to the link or yoke between body and soul. He concluded that existence was a great wheel. Life consists of suffering (or sorrow). Suffering is based on desire. Since desire cannot be fulfilled, the only way to stop suffering is to stop desiring. And the only way to do that is through yoga. By means of such concentration, a person can even ignore pain to the point that it no longer exists and can even rise above the endless cycle of rebirths (perpetual suffering) and achieve *nirvana* (the absence of suffering).

Through his teachings Buddha sought to provide the guidance or law necessary for governing the wheel of existence, which would now become the wheel of the law that would help his followers to attain the contemplative state. However, while for Buddha contemplation was an end in itself, the stopping of suffering, it is not hard to see how in time the stopping of suffering (nirvana) could be interpreted as salvation, or heaven. By the first century A.D. if not earlier, one strain of Buddhism arrived at just this interpretation.

This version of Buddhism acknowledged Buddha as having been the incarnation of the eternal heavenly Buddha. It also developed a whole series of deities, the bodhisattvas or various manifestations of Buddha, to whom worshipers could pray for their salvation. Known as Mahayana or the Greater Vehicle, Mahayana Buddhism was rivaled by Hinayana Buddhism or the Lesser Vehicle. This older version of the faith claimed to remain loyal to Buddha's own conception of himself as a teacher and of nirvana as a state of mind limited to this life.

Gautama Buddha and his successors, whether Hinayana or Mahayana Buddhists, institutionalized their religion in monasteries, in which monks (and sometimes nuns) practiced the contemplative life. These monasteries were much like those of medieval Europe, where routines such as the Rule of Saint Benedict regimented lives to the degree that everyday details ceased to matter. Scattered along the trade routes, these monastic houses became the vehicle for extending Buddhism into central Asia, Tibet, China, and eventually Southeast Asia, Korea, and Japan. But in India itself, Buddha's attack on the vested interests of the entrenched Brahmans naturally raised their anger. Consequently, although Buddhism thrived for centuries, especially in the third and second centuries B.C. under the Mauryan dynasty, by the seventh century A.D. it could no longer be counted as a major religion of the Indian subcontinent. However, it continued to flourish in several regions of the south until the fourteenth century.

With the coming of Muslim rulers to northwestern India in A.D. 711 and conversions of local peoples to Islam, the religious landscape of the subcontinent became even more complex in the following centuries. The great schisms between the various branches of Islam, the orthodoxies and debates of Sunni and Shite, affected Muslims in India. Simultaneously, with the efflorescence of Sufiism in the twelfth century and major centers of Islam developing in India, the ideas and practices of Buddhism and Upanishadic Hinduism, along with Christianity and Neoplatonism, were integrated within an Islamic framework in Sufiism. Through Islam, Indian culture became linked to the Arabic, Persian, and central Asian worlds.

The Village

India is a nation of villages. In 1981 only 23.2 percent of the population lived in towns and cities of over a hundred thousand, compared with 78.9 percent for the United Kingdom, 68.9 percent for the United States, and 68.1 percent for Japan. In the Gupta period the degree of Indian urbanization would have been much less. The typical social unit today as then is the village of perhaps two to five thousand people. Villages are rather close together, and there are a great many of them. They are compact, with houses clustered around courtyards, and old ones have walls for protection. A typical village has two or three lineages (*jatis*) of different ranks. In a Rajput village, for instance, the dominant *jati* would be Rajput (Ksatriya), but the village would also have a *jati* or two from the Sudra or from the depressed classes (untouchables); obviously, somebody has to do the work viewed as demeaning. A village may belong to a landlord, to whom its residents pay rent. Some 70 percent of the Indian people are still engaged in agriculture. In rural areas villagers work in the surrounding fields. They grow some food for their own consumption, but most of it goes to the market, which will be in a nearby town, serving a cluster of a dozen or so villages. If the village is near a city, many of its residents may work there. Considering its huge total populations, India has comparatively few really big cities. Mahatma Gandhi, the leader of the Indian freedom struggle, said India was "a hundred thousand villages."

● D A I L Y L I V E S ●

···· *The Indian Family Past and Present*

Modern Indian society, particularly in its basis in the family, contains characteristics that reflect a strong continuity with its ancient past. Although only barely relevant to actual behavior today, the "stages of life" concept still provides a sort of abstract model of a Hindu male's passage from youth to old age. There are four stages:

1. *Student stage.* Attentive, obedient, and celibate, the youth studies the classics under a tutor.

2. *Householder stage.* The young man marries and sires many children—especially sons, who will perform the rituals at his funeral and carry on the family line.

3. *Retirement stage.* His sons grown but still living with their wives under his roof, he begins to make way for them.

4. *Last stage.* The old man prepares for death and the next round in the cycle; in the classic form, he renounces wife and family and goes out into the world, begging bowl in hand and naked except for a loincloth, to live entirely on charity.

The stages of life are closely connected to the family system, which was and remains a joint-family system. Kinship in most of India is patrilineal. After a marriage ceremony, often involving ruinously expensive dowries, a daughter joins her husband's family, moving into his parents' household, where she serves as a kind of apprentice to her mother-in-law. The extended-family system, with all the brothers living together with their wives and children with the parents, was a social ideal. Although it is less likely today that all the brothers will live together, an extended-family network is still common. There are various festivals that celebrate family ties, especially those of brother and sister. In a household, often all the children of various brothers will be given first names starting with the same letter of the alphabet to indicate both their generational and familial ties.

The system is highly patriarchal. Although females have caste, it is that of their fathers and then of their husbands. Typically, marriages were and are arranged. As in many other societies, including medieval Europe, the woman was thought to be sexually aggressive and insatiable; when she reached puberty, she would have lovers; therefore, it followed that she should be married before puberty. Sometimes very young girls were married off to old men, and the widow's lot was particularly hard. Her reason for existence (her husband) was gone, her family often treated her with contempt, and, although the custom of widow-burning (*saiti*) has long been illegal, it still occasionally happens. The role of the wife was to serve her lord and master. There is a classic story of a mother who watched her child burn to death but did not attempt rescue for fear of waking her husband, who was sleeping with his head on her lap. (A god rewarded her correct behavior by restoring the child.)

In practice, no marriage could work well that way and did not in the past. There is give and take and bargaining, with the wife always possessing at least one very effective means of coercion. Moreover, Indian love manuals typically reveal what, compared with most Western approaches to the subject, may be regarded as an unusual degree of sensitivity to women's feelings. According to the *Kamasutra*, a husband should take a week to ten days after the wedding before consummating the marriage.

Indian Literature

As we have seen, the classical language of Indian sacred and literary writings is Sanskrit. Writing in Sanskrit extended from approximately 1400 B.C. to A.D. 1200. The earliest known writings in Sanskrit are the *Rigveda,* a collection of hymns in worship of deities embodied in forces of nature, such as the sun and the wind. Prose commentaries on the Vedic hymns, known as the *Brah-* mans and the *Upanishads,* followed them. One of the important ideas developed in these commentaries is the notion that sacrifice is essential to maintaining cosmic order and divine favor. They also deal with mystical knowledge, such as the identity between the self (*atman*) and the godhead (*Brahman*).

The two great Indian epics in Sanskrit are the *Ramayana* and the *Mahabharata,* which took shape over centuries and reached their final form only in the third

or fourth century A.D. We have discussed the latter in connection with the *Bhagavad Gita*. The *Ramayana* portrays a hero, Rama, who for the sake of truth and righteousness, can sacrifice his great love, Sitâ. Like *Gilgamesh* and the Homeric epics, these extremely long poems were first oral compositions, gradually written down. Later written literature includes shorter epics, stories, romances, and a wealth of dramatic writing. The aim of Sanskrit poetry and drama was not so much to develop character and plot as to evoke emotion, or *rasa,* through a variety of meters and sound effects.

As in the other arts, the Gupta period saw a flowering in literature. Besides the well-known *Kamasutra*, the plays and poetry of India's greatest classical dramatist, Kalidasa, are from this period. Kalidasa is admired not only for his literary skill but also for his portrayals of love and his adaptations of Hindu mythological and religious traditions. For example, in a poem entitled the *Kumarasambhava,* on the birth of the leader Jumara, Kalidasa depicts the father and mother of the universe, Siva and Devi, as they express their desire and sublime love for each other. His masterpiece is considered to be the drama *Sakuntala,* a depiction of the binding of earth with idealized, spiritual love. In sharp contrast to Western tradition, tragedy is unknown in classical Indian literature, for tradition dictates the necessity of a happy ending.

It is generally agreed that after Kalidasa Sanskrit literature became more stylized and artificial. Even more than was the case with Latin in the West, writers continued for centuries to use what was for all practical purposes a dead language. Gradually, however, literature in the many different vernacular languages established itself, creating a variety of literary traditions too numerous to be discussed here. In the twentieth century, writing in Hindi, Bengali, and English has been most notable. The poet Rabindranath Tagore, who wrote in both Bengali and English, won the Nobel prize for literature in 1913. The best known Indo-English writer today is Salman Rushdie, whose novel *The Satanic Verses,* set in modern Islamic India, won him not only international fame but also a death threat from the Islamic government of Iran, because his work was interpreted by some as slandering Islam.

Art and Architecture

Beginnings in the Indus Valley

Every early society produces remarkable artifacts. Those at Harappa and Mohenjo-Daro are no exceptions. Two examples, the *High Priest* (Fig. 15-1), carved from limestone, and the *Dancing Girl* (Fig. 15-2), in copper, present two techniques that seem to be consistent with the art of other early cultures: a hierarchical, formal design presenting an idealized, abstracted image

15-1 High Priest. *Limestone, height 7". Indus culture from Mohenjo-Daro. Karachi Museum, Pakistan. (Borromeo/ Art Resource, NY)*

▲

- Compare the face of *High Priest* with the central figure in the Abu Temple group (Fig. 1-3) and with the figure of Hammurabi (Fig. 1-11).
- What characteristics are common to the three figures? For example, are details of anatomy stylized or are the faces lifelike? Do the men look powerful? If so, what contributes to that impression? What does not?

of power and grandeur, and a naturalistic, fluid, organic technique that can capture a sense of movement and the moment. Comparison with similar examples from Mesopotamia and Egypt reinforces our sense that these makers were observers of people and their many activities, whether those of ritual or play.

The arrival of the Aryans ended the Indus Valley settlements and introduced new ways that were absorbed by the country. Rooted in the everyday life of its many villages, the local cults were overlaid by what appear to have been the more rational and abstract religious conceptions of the Aryans. The rise of Buddhism profoundly shaped India's builders and artists generally. Although it was a rival religion, it provided the basis for a Hindu artistic language that fed Hindu art and architecture from the end of the Gupta period onward.

15-2　Dancing Girl. *Copper, height 4¼". Indus culture from Mohenjo-Daro. (National Museum, New Delhi)*

• Which figures, whether in three-dimensional sculpture or low relief, can be best compared with *Dancing Girl*? Could you determine what class or group she represents in a hierarchical society? How do the words *naturalistic* and *lifelike* apply to this figure?

The Impact of Buddhism

The three basic architectural forms established by the Buddhists—the *vihara,* or monastic cell group, the *chaitya,* or hall of worship, and the *stupa,* or a burial-like mound for holy relics—were used for creating retreats where pilgrims might come for contemplation. Many such retreats were carved in the living rock of mountains or located in improved caves; on the plains, platforms, elevated to recall the mountains, were topped with carved stone towers. The route into the hall and around the stupa was ritually prescribed. The walls and columns were carved and decorated with stories from the life of Buddha. The procession into the hall and the stupa was planned to stimulate contemplation and the desire to seek enlightenment.

During the Mauryan period, when Buddhism received maximum official support, artists borrowed from Persia to create a particularly distinct capital for many columns that were erected around the countryside to commemorate Buddha. The Lion Capital excavated at Sarnath has a plinth decorated with four wheels and four animals in high relief (Fig. 15-3). This form supports four lions, symbols of royalty, back to back. The lions resemble those found at Persepolis, but the animals are more naturalistic and the wheel refers to Buddha's law designed to guide human existence. Phallic in form, these memorial columns represent the

male impulse, which, with its female counterpart, is a constant idea throughout Indian art.

The female force is represented by life-bearing, life-giving, and loving female figures such as the Mauryan yakski, a nature deity found at Didarganj (Fig. 15-4). This sandstone figure has the very large breasts, small waist, and large hips that are fundamental attributes of the Indian female form in art, not only Buddhist but Hindu as well.

15-3　*Lion Capital, from Ashoka column in Sarnath. Polished chunar sandstone, height 84". Maurya period. Museum of Archaeology, Sarnath. (Bildarchiv Preussischer Kulturbesitz, Berlin)*

15-5 *The Great Stupa. Sanchi, India. Shunga and early Andhra periods, third century* B.C.*–early first century* A.D. *(Superstock)*

15-4 *Yakski Didarganj, Bihar. Sandstone. Patna Museum, Patna, India. (Bildarchiv Preussischer Kulturbesitz, Berlin)*

The Great Stupa at Sanchi (Fig. 15-5), created between the third and the early first centuries B.C., and the chaitya (hall) at Karle, constructed in the early second century A.D. (Fig. 15-6), represent two of the many important architectural sites associated with Buddha from this period. Late-second-century sculptures such as the serpent king Nayaraja found at Mathura indicate the presence of Western influences during this time (Fig. 15-7). Naturalism, abstraction, and the creation of a style appropriate to present Buddha join in works such as those showing Buddha in meditation (Fig. 15-8). This example shows a youthful Buddha seated frontally in one of the yoga *asanos,* or positions. Buddha presents an image of humility, containment, and control.

The Caves at Ajanta give the best idea of the very complex building programs the faith inspired. The façade of the chaitya (hall of worship) found in Cave 19 is hardly architecture—just a very large sculpted porch with many images of Buddha (Fig. 15-9). The chaitya of Cave 26 has elaborate carved columns, capitals adorned with stories, and a high, arched roof (Fig. 15-10). At the far end of the hall a seated Buddha, who turns the Wheel of Law, faces frontally from the base of the stupa.

The interior would have been richly painted and in the dim light and flaring torches it creates an experience of timelessness and wonder. Most walls were also adorned with paintings, which many scholars consider the most important decoration at Ajanta. The noble figure of the "beautiful bodhisattva," which represents one of the manifestations of the eternal Buddha, Padmapani, holding a blue lotus, has an elegant face with downcast eyes and projects an ideal of compassion and humility frequently found in Buddhist images (Fig. 15-11).

Many scholars consider the art and building of the Gupta dynasty (320s–late 400s) to be the classic period for Buddhism. In these centuries, the diffusion of Buddhist art carried the new forms across Asia to China and Japan. At the same time these years mark the beginnings of a truly Hindu art.

Hindu Art and Architecture

The Hindu cosmology is essential for some grasp of Hindu art. Soon after the Aryan invasion, the fertility cults of the first people, the Dravidians, joined with religious organizational conceptions of the newcomers such as class and the pantheon of gods they brought with them. The great trinity was Brahma, the creator; Vishnu, the preserver; and Siva, the destroyer. Vishnu has many avatars or incarnations, of which Krishna, the embodied divine lover, is the most famous and the most

15-6 *Nave of the chaitya (hall), Karle Caves, India. Early second century* A.D. *(Borromeo/Art Resource, NY)*

◀

• What characteristics do this chaitya and the chaitya shown in Figure 15-10 have in common with the naves of Western churches? Consider length, height and distance between columns. What is the effect of combining the arch with the column? How does this compare with the arch and column system used at the Coliseum in Rome?

15-7 *Serpent king Nayaraja. Mathura period, India, second–third century. Musée Guimet, Paris. (Giraudon/Art Resource, NY)*

15-8 *Buddha in meditation. Gandhara period. Karachi Museum, Karachi, Pakistan. (Giraudon/Art Resource, NY)*

15-9 *Chaitya façade of cave temple no. 19. Post-Gupta period. Ajanta Caves, Maharashtra, India. First half of sixth century* A.D. *(SEF/Art Resource, NY)* **(W)**

15-10 *Interior of chaitya, Cave 26, Ajanta, India. Post-Gupta period, c.* A.D. *600–642. (Bildarchiv Preussischer Kulturbesitz, Berlin)*

15-11 *Fresco, Cave 1, Ajanta Cave, Maharashtra, India,* A.D. *600 (Information Service of India)*

represented artistically. Siva, as Nataraja, the lord of the cosmic dance, is also a favored source of representation (Fig. 15-12). The first artistic principle to understand is that the image is not a holy fetish but stands for the supreme being and is used to stimulate contemplation. The image must be accurate so that if the god requires numerous arms or heads those elements must be presented.

The holy places of the Hindus are organized along an axis, with one or more square halls, the mandapa, placed on a sikhara, which means mountain platform. Like the Buddhists, the Hindus erected freestanding buildings or carved temples into the mountains. The seventh-century Durga temple at Aihole has a chaitya and tower much like those at a Buddhist site (Fig. 15-13). The Pandava Raths (five monumental shrines) at Mamallapuram, constructed in the early seventh century, present five different models for shrines (Fig. 15-14). The complex roof shapes as well as elaborate decoration of surfaces with architectural elements and figures reinforce the feeling shared by most scholars that sculpture is the Hindu medium. The intricate sculptural arrangement, the *Descent of the Ganges,* carved into two giant granite boulders, also at the site, enhances this idea (Fig. 15-15).

The *Descent,* carved between 625 and 674, combines with water captured above it to produce memorable images in which water and forms seem animated by movement. Current opinion identifies the subject as the Penance of Arjuna, the hero of the *Bhagavad Gita,*

15-12 Nataraja: Siva as King of Dance. *South India, Chola period, eleventh century. Bronze, height 111.5 cm. (Copyright The Cleveland Museum of Art, 1996. Purchase from the J. H. Wade Fund, 1930.331)*

◀

• Compare Siva with Augustus of Prima Porta (Fig. 7-2). What do the figures have in common? Can gods be compared with kings? How do the artists let you know the differences?

15-13 *Durga Temple, exterior view, late seventh century. Aihole, Karnataka (Mysore), India. (Borromeo/Art Resource, NY)*

15-14 *The Pandava Raths, rock-cut temples, seventh century. Mamallapuram, Tamil Nadu, India. (Art Resource, NY)* **(W)**

who receives a favor from Siva for his practice of austerity. Arjuna appears twice: in an ascetic pose with one foot elevated and looking at the sun; and seated in contemplation before a shrine. Siva, grantor of the favor, is the Ganges, the Holy River. The tightly filled and animated composition is a microcosm: deities of the river,

lions, bears, elephants, gods, angels, and people are rendered with a naturalism that is heightened by the roughness of the granite (Fig. 15-16).

The growth of power and wealth among the ruling elite, along with people's desire to celebrate the local and regional manifestations of Hinduism, produced fabulous

15-15 *Descent of the Ganges. Bas relief, mid-seventh century. Mamalla-puram, Tamil Nadu, India. (Vanni/ Art Resource, NY)*

Hindu sites all over the Indian subcontinent. The Lin-garaja Temple in Bhubaneswar (c. 1000), the Surya Deul (the Black Pagoda, c. 1240), and the Kevasa Temple (1268, Fig. 15-17) present different but no less memorable examples of architecture and sculpture, which capture the Western imagination because of similarities with the richness of the Gothic ideal in building and decoration. The decoration here ranges from highly serious and idealized images from the Hindu cosmology to the reality of daily life and the experience of birth and death.

A thirteenth-century copper sculpture, *Jnanasambandar, a Shaiva Saint,* which recounts a childhood prank, shows a young, round child who balances on one foot and thus appears to dance as he runs (Fig. 15-18). His outflung arm, elegantly raised foot, and beautifully symmetrical face capture the transient energy of life. While it is impossible to summarize in these few paragraphs the incredible creativity of the Indian makers and the diversity of their monuments, this dancing figure takes us up to the time of the arrival of Muslim culture, which reshaped Indian art in the following centuries.

Music and Dance

Each of the many ethnic groups of the Indian subcontinent has its own variety of music, dance, and related art forms. In recent years one kind of Indian music, generally known as Indian classical music, has been spread abroad through concerts, broadcasts, and recordings and has gained a worldwide audience of appreciative listeners. Despite the incursions of radio, television, and recordings of pop, rock, jazz, and Western classical music into the Indian subcontinent, Indian music appears to have been little influenced by the

West. Still, because of the popularity and fame of composer and teacher Ravi Shankar, who plays the *sitar* (a long-necked lute), most westerners consider Indian classical music to be the sounds of an Indian chamber ensemble of sitar and *tabla* (a pair of drums), often

15-16 *Elephants (detail), Descent to the Ganges. Bas relief, mid-seventh century. Mamallapuram, Tamil Nadu, India. (Bildarchiv Preussischer Kulturbesitz, Berlin)*

with the addition of voice or violin. In fact, this kind of music represents just one of hundreds of kinds of local Indian musical traditions.

In central India we can even listen to the music of Indian tribes believed to have inhabited the area long before the Aryan immigrations between 2000 and 1500 B.C. occurred. These people were known in the Sanskrit writings as the *Adivasi*, "those who have lived here since the beginnings." Comprising groups of hunters, gatherers, and slash-and-burn peasants, these societies of aboriginal tribes and outcast Hindus number today approximately forty million people. Their tribal music and dances have been handed down from father to son, mother to daughter, and master to apprentice in an unwritten tradition over the centuries.

As with aboriginal peoples all over the world, their musical art is functional, ritualistic, and intimately tied to the activities of daily life and to their deities. The marriage dance of the tribe of Dandami Maria of Belar, for example, is both a sacred ritual and a social activity. This dance requires bison-horn headdresses for the men and other handmade ornaments for both men and women. When they begin, the young men first dance in a circle while the young women dance separately outside the circle in a row. The large, two-headed drum, which accompanies the dance in the first excerpt, is beaten on one side with the hand and on the other with a stick. One young man carries a bell-shaped wooden slit-drum and beats it with two sticks, and the young women

dance and beat the ground with dancing sticks fitted with small iron bells. Soon the young women begin singing (second excerpt), and after a while, to the background of dancing and drumming, a male dancer adds the playing of a bison horn. Then the young men join in the singing, using an alternating call-and-response pattern with the women. The women throw bracelets and rings into the circle, and the young men pick them up with the prongs of the horns of their headdresses. Some ancient fertility rite probably served as the origin of this dance, ritual, and music, and even the ornaments and instruments are gender-designated as male and female.

In sharp contrast to the communal tribal music of the Dandami Maria of central India, the music of the Kathakali Dance Theater of south India is performed by professional musicians, who study music theory and

▼

• Compare this figure with *Nataraja: Siva as King of Dance* (Fig. 15-12). What characteristics do the sculptures have in common—materials, three-dimensionality? What others? What devices do the artists use to suggest motion and movement? Compare the two figures with the *Dancing Girl* (Fig. 15-2). Whose gestures are stylized?

15-18 Jnanasambandar, a Shaiva Saint. *Thirteenth-century bronze sculpture. 26" high (66.0 cm). (The Nelson-Atkins Museum of Art, Kansas City, Missouri. Purchase: Nelson Trust, 1930.331)* **(W)**

15-17 *View of the Kevasa Temple, Hindu, mid-thirteenth century. Hoysala dynasty. Somnathpur, India. (SEF/Art Resource, NY)*

Cheriyil Amrita Shastrigal

···

from the *Lavanâsuravadham*

CD-1, 19

Hanumân, the monkey hero, is tethered by two
children of Princess Sitâ, Prince Rama's wife.

[Sitâ sings to the monkey]

1) Sundara mama thanaya	[×3]	1) Fairest of children,	[×3]
vandeniyam srî Hanumân	[×2]	O Holy Hanumân, all should worship you.	[×2]
2) Bandhichathu mahâ pâpam	[×2]	2) A sin to see you bound;	[×2]
bandha môchanam cheithâlum	[×2]	(speaking to her children) you must set him free	
		immediately.	[×2]

[Short dance interlude]
[Sitâ continues]

3) Janakan me thâthanennu	[×3]	3) Janaka is my father,	[×3]
janagal uracheiyunnu	[×2]	The people know this.	[×2]
4) Kanivôten jivaneyum	[×2]	4) Life and a gentleness	[×2]
jenippicha Janakânne	[×2]	were given me by Janaka	[×2]
Janakanne		Janaka did this.	

[Dance interlude]
[Entrance of other actors]
[Hanumân sings to Sitâ]

5) Sukhamo Dêvi	[×2]	5) Greetings, fair one!	[×2]
sâmpratham iha the		Your presence here is a good omen.	
6) Sukhamo Dêvi	[×2]	6) Greetings, fair one!	[×2]
sâmpratham iha the		Your presence here is a good omen.	
7) Sukhamo Dêvi		7) Greetings, fair one!	
sûkretha nidhê jâtham sudinam	[×3]	Glory on the day you were born.	[×3]

[Dance interlude]
[The scene continues]

performance and who memorize a vast repertoire of classical Vedic material. In an excerpt from a play, *Lavanâsuravadham*, written in the nineteenth century by Cheriyil Amrita Shastrigal in a regional Indian dialect, two male singers relate an episode of the *Ramayana*. The text deals with the emotions felt by the monkey hero, Hanumân, a follower of Prince Rama, and Rama's wife Sitâ, when Sitâ and Hanumân are reunited after a long separation.

CD-1, 19

The singers are accompanied by a drone string instrument played with a bow, two drums, one small gong, and a pair of cymbals. On the stage, actor-dancers in appropriate makeup and costume employ a codified gestural repertoire of hand, wrist, forearm, head, leg, and body movements to interpret the text in a nonverbal language. The music itself is based on a complex Indian music theory of *ragas* and *talas*. The ragas are pairs of musical scales with particular melodic features fitting for the time of day, the season of the year, the nature of the performance, and other nonmusical factors. The ragas come in pairs, one serving for ascent and one proper for descent. Talas are equally complex systems of rhythmic cycles; they not only keep time and set the pace for the piece but also help generate the form. The sense of suspension, timelessness, and ethereal being conveyed by this music is very much in keeping with southern Indian Hindu aesthetic theory,

15-19 *Concert held at the U.N. General Assembly Hall: Yehudi Menuhin on violin joins Ravi Shankar and his classic ensemble of sitar, tabla, and tempura. (Omikron Collection/ Photo Researchers, Inc., #9B0979)*

philosophy, and spiritual thought, which is related to yoga (concentration) and *yajña* (sacrifice).

One of the key features of Indian musical theory is almost diametrically opposed to the systems and methods of Western musical thinking, and hence Europeans and Americans often find it difficult to understand the processes of Indian classical music. Whereas the westerner learns to perform by progressing from simple to ever more complex music and practices, the Indian musician comes to mature performance by knowing intuitively the truth of the artistic experience, through yoga and *yajña,* and then gives it proper expression. Also, subtlety and propriety are far more important than complexity and artifice. Still, the music is indeed complex. Moreover, the language of finger and body movement adds high artifice, as well as another layer of complexity, to the performance, for one must interpret the dance to fully appreciate the theatrical experience.

The basic instruments of the classical Indian chamber music ensemble are the Indian lute and a drum or drums. The most common Indian lute is the sitar, but a *sarod,* a similar instrument but with a shorter neck, may be substituted for the sitar or added to the ensemble, just as a violin or voice is also often added to the group (Fig. 15-19). The performance of a single piece of music may last twenty, thirty, or forty minutes or even longer. A single performance consists of the exposition of a raga and is an improvisation that must follow strict rules but also spontaneously reveal the intuitively known truths possessed in the raga and in the performer's psyche. Each pair of scales that constitutes a single raga holds an infinite number of truths—musical, philosophical, poetic, and religious—and it is the duty of a great artist to expound or develop the raga for his listener.

In an excerpt from a performance by Brij Narayan on the sarod, accompanied by Zakir Hussain on the tabla, Narayan exposes and elaborates a form of raga named *lalit.* He first presents the raga in a more or less straightforward manner. Then he begins to elaborate the ideas as they emerge, being careful never to leave the bounds of *lalit.* Making the music **CD-1, 20** more informative and profound, he interprets relationships and meanings—musical, sensual, and philosophical. In this slow and continuous development, he expounds the raga. The complete recorded performance lasts fifty minutes. *Lalit* should be performed in the early morning.

A *lalit* expresses complex feelings of longing. Indian poets and artists sometimes try to visualize and make concrete the sense, or inner being, of this mystical pair of scales, and when Indian artists paint their vision of *lalit,* they often depict a young maiden anxiously awaiting her lover. Certain important tones, which are normally present in other ragas and are expected by the ears of experienced listeners, are absent in this raga. Their absence is as essential to the correct performance of this music of longing as is the presence of the tones and rhythms and time cycles that are actually sounded in the performance of *lalit.* You might note that the same can be said of regular rhythm and accompaniment. Not until thirteen minutes and forty-five seconds into the performance does a beat, or regular pulse, get established. One yearns for it, and when it arrives and the accompanying drums still do not sound, one longs for them, too. Will they join in? Will the beat disappear? The longing becomes almost physical. Will there ever be a sense of completion and fulfillment?

from the *Bhagavad Gita*

Translation by R. Zaehner

The *Bhagavad Gita* is actually an episode in the long epic, written in Sanskrit, called the *Mahabharata*, from the name of King Bharata, a legendary ancient ruler of the Indo-Aryans. Bharata's eldest son, Dhritarashtra, was born blind, and the youngest, Pandu, would have inherited his kingdom but died at an early age. Pandu's five children, including Arjuna, came under the care of Dhritarashtra, who wanted his own sons to inherit the kingdom. His eldest son plotted to kill the sons of Pandu, but they were saved by their cousin Lord Krishna, who was a god in human form. He was in fact the *avatar,* or incarnation, of the supreme God, Vishnu.

The sons of Pandu were eventually forced into exile, but on their return as young men, they demanded their kingdom. War then seemed inevitable. The righteous clan of Pandu worshiped Krishna, but the evil clan of Dhritarashtra did not. Krishna became the charioteer of Arjuna, who was to fight as a bowman. The *Gita* consists of their dialogue as the two armies prepare for battle. It is thus not an epic in the usual sense of the word, but one of the most profoundly spiritual works in all of world literature.

Dhritarashtra said: "On the field of justice, the Kurufield, my men and the sons of Pandu too [stand] massed together ready for the fight. . . ."

Then Pandu's son [Arjuna], whose banner is an ape . . . took up his bow: the clash of arms was on. Then between the two armies, Sire, he addressed Krishna in these words: "Halt the chariot, unfallen [Lord], that I may scan these men drawn up, spoiling for the fight, [that I may see] with whom I must do battle in this enterprise of war. . . .

"Krishna, when I see these mine own folk standing [before me], spoiling for the fight, my limbs give way, my mouth dries up, trembling seizes upon my body, and my [body's] hairs stand up in dread. My bow . . . slips from my hand, my very skin is all ablaze; I cannot stand and my mind seems to wander. Krishna, adverse omens too I see, nor can I discern aught good in striking down in battle mine own folk. Krishna, I do not long for victory nor yet for things of pleasure. What should I do with a kingdom? . . . Those for whose sake we covet . . . stand [here arrayed] for battle . . . teachers, fathers, sons, and grandsires too; uncles, fathers-in-law, grandsons, brothers-in-law—kinsmen all. Krishna, though they should slay [me], yet would I not slay them. . . . Should we slaughter Dhritarashtra's sons, Krishna, what sweetness then is ours? Evil, and only evil, would come to dwell with us, hate us as they may. . . . To ruin a family is wickedness. Once the family is ruined, the primeval family laws collapse. Once law is destroyed, then lawlessness overwhelms all . . . family. With lawlessness triumphant . . . the family's women are debauched; once the women are debauched, there will be a mixing of caste. The mixing of caste leads to hell. . . . O let the sons of Dhritarashtra . . . slay me in battle though I, unarmed myself, will offer no defence; therein were greater happiness for me."

So saying Arjuna sat down upon the chariot seat [though] battle [had begun], let slip his bow and arrows, his mind distraught with grief. . . .

[Part of Krishna's extended answer]: "Never was there a time when I was not, nor you, nor yet these princes, nor will there be a time when we shall cease to be—all of us hereafter. Just as in this body the embodied [self] must pass through childhood, youth, and old age, so too [at death] will it assume another body: in this a thoughtful man is not perplexed. But contacts with the objects of sense give rise to heat and cold, pleasure and pain: they come and go, impermanent. Put up with them, Arjuna. . . .

"Of what is not there is no becoming; of what is there is no ceasing to be: for the boundary-line between these two is seen by men who see things as they really are. Yes, indestructible [alone] is that—know this—by which this whole universe was spun: no one can bring destruction on that which does not pass away. . . . Fight then, scion of Bharata. . . . It [the embodied self] does not slay, nor is it slain. Never is it born nor dies; never did it come to be nor will it ever come to be again; unborn, eternal, everlasting. . . . It is not slain when the body is slain. . . . As a man casts off his worn-out clothes and takes on new ones, so does the embodied [self] cast off its worn-out bodies and enters other new

ones. Weapons do not cut it nor does fire burn it, the waters do not wet it nor does the wind dry it. Uncuttable, unburnable, unwettable, undryable it is—eternal, roving, everywhere, firm-set, unmoved, primeval. Unmanifest, unthinkable, immutable is it called; then realize it thus and do not grieve [about it]. . . .

"Likewise consider your own [caste-]duty, then too you have no cause to quail. . . . Happy the warriors indeed who become involved in such a war as this, presented by pure chance and opening the doors of paradise. But if you will not wage this war prescribed by [your caste-]duty, then by casting off both duty and honour, you will bring evil on yourself. . . . If you are slain, paradise is yours, and if you gain the victory, yours is the earth to enjoy. Stand up, then . . . resolute for the fight. . . .

"Work alone is your proper business, never the fruits [it may produce]. . . . Stand fast in Yoga, surrendering attachment; in success and failure be the same and then get busy with your works. . . . For lower far is [the path of] active work [for its own sake] than the spiritual exercise of the soul. . . . For those wise men who are integrated by the soul . . . , who have renounced the fruit that is born of works, these will be freed from the bondage of [re]birth and fare to that region that knows no ill. When your soul passes beyond delusion's turbid quicksands, then will you learn disgust for what has been heard . . . and for what may yet be heard. When your soul, by scripture once bewildered, stands motionless and still, immovable in ecstasy, then will you attain to sameness-and-indifference (*yoga*). . . ."

Arjuna said: "What is the mark of the man of steady wisdom immersed in ecstasy? How does he speak, this man of steadied thought? How sit? How talk?"

The Blessed Lord said: "When a man puts from him all desires that prey upon the mind, himself contented in self alone, then is he called a man of steady wisdom. . . . Let him sit, curbing [all desires], integrated, intent on Me: for firmly established is that man's wisdom whose senses are subdued. . . . The man who puts away all desires and roams around from longing freed, who does not think, 'This I am,' or 'This is mine,' draws near to peace. This is the fixed, still state of Brahman; he who wins through to this is nevermore perplexed. Standing therein at the time of death, to Nirvana, that is Brahman, too it goes. . . ."

Arjuna said: "Then by what impelled does [mortal] man do evil unwilling though he be? He is driven to it by force, or so it seems to me."

The Blessed Lord said: "Desire it is: Anger it is—arising from the constituent of Passion—all devouring, mightily wicked, know that this is [your] enemy on earth. . . . Exalted are the senses, or so they say; higher than the senses is the mind; yet higher than the mind the soul: what is beyond the soul is he. So know him who is yet higher than the soul, and make firm [this] self yourself. Vanquish the enemy, Arjuna! [Swift is he] to change his form, and hard is he to conquer. . . .

"When thought, held well in check, is stilled in self alone, then is a man from longing freed though all desires assail him. . . . As a lamp might stand in a windless place, unflickering—this likeness has been heard of such athletes of the spirit (*yogis*) who control their thought and practice integration of the self. . . .

"Whoso at the hour of death, abandoning his mortal frame, bears Me in mind and passes on, accedes to my own mode of being: there is no doubt of this. Whatever state a man may bear in mind when in the end he casts his mortal frame aside, even to that state does he accede, for ever does that state make him grow into itself. Then muse upon Me always and fight; for if you fix your mind and soul on Me, you will, nothing doubting, come to Me. . . . The worlds right up to Brahma's realm [dissolve and] evolve again; but he who comes right nigh to Me shall never be born again.

"Some to return, some never to return, athletes of the spirit set forth when they pass on. . . . All this the athlete of the spirit leaves behind who knows this [secret teaching; and knowing it] he draws right nigh to the exalted primal state. . . . Men who put no faith in this law of righteousness fail to reach Me and must return to the road of recurring death.

"By Me, Unmanifest in all forms, all this universe was spun; in Me subsist all beings, I do not subsist in them. . . . These works [of mine] neither bind nor limit Me: as one indifferent I sit among these works, detached. [A world of] moving and unmoving things material Nature brings to birth while I look on and supervise; this is the cause . . . by which the world revolves.

"For that a human form I have assumed fools scorn Me, knowing nothing of my higher state—great Lord of contingent beings. Vain their hopes and vain their deeds, . . . vain their wit; a monstrous devilish nature they embrace which leads [them far] astray. . . . I am the rite, the sacrifice, the offering for the dead, the healing herb; I am the sacred formula, the sacred butter am I; I am the fire. . . . I am the father of this world, mother, ordainer, grandsire. . . . [I am] the Way, sustainer, Lord, and witness, [true] home and refuge, friend—origin and dissolution and the stable state [between]—a treasure-house, the seed that passes not away. It is I who pour out heat, hold back the rain and send it forth; deathlessness am I and death, what is and what is not. . . ."

The Blessed Lord said: "With roots above and boughs beneath, they say, the undying fig-tree [stands]; its leaves are the Vedic hymns; who knows it know the Veda [Scripture]. Below, above, its branches straggle out, well nourished by the constituents; sense-objects are the twigs. Below its roots proliferate inseparably

linked with works in the world of men. No form of it can here be comprehended, no end and no beginning, no sure abiding-place: this fig-tree with its roots too fatly nourished—[take] the stout ax of detachment and cut it down! . . ."

The Blessed Lord said: "Fearless and pure in heart, steadfast in the exercise of wisdom, open-handed and restrained, performing sacrifice, intent on studying Holy Writ, ascetic and upright, none hurting, truthful, from anger free, renouncing [all], at peace, averse to calumny, compassionate to [all] beings, free from nagging greed, gentle, modest, never fickle, ardent, patient, enduring, pure, not treacherous nor arrogant—such is the man who is born to [inherit] a godly destiny. A hypocrite, proud of himself and arrogant, angry, harsh and ignorant is the man who is born to [inherit] a devilish destiny. . . . But do not worry, Arjuna, [for] you are born to a godly destiny. . . . Puffed up with self-conceit, unbending, maddened by their pride in wealth, [hypocrites] offer sacrifices that are but sacrifice in name and not in the way prescribed. . . . Desire—Anger—Greed: this is the triple gate of hell, destruction of the self: therefore avoid these three. . . .

"To Brahmans, princes, peasants-and-artisans, and serfs works have been variously assigned . . . , and they arise from the nature of things as they are. Calm, self-restraint, ascetic practice, purity, long-suffering and uprightness, wisdom in theory as in practice, religious faith—[these] are the works of Brahmans, inhering in their nature. High courage, ardor, endurance, skill in battle, unwillingness to flee, an open hand, a lordly mien—[these] are the works of princes, inhering in their nature [too]. To till the fields, protect the [cattle], and engage in trade, [these] are the works of peasants-and-artisans, inhering in their nature; but works whose very soul is service inhere in the nature of the serf.

"By [doing] the work that is proper to him [and] rejoicing [in the doing], a man succeeds, perfects himself. [Now] hear just how a man perfects himself by [doing and] rejoicing in his proper work. By dedicating the work that is proper [to his caste] to Him who is the source of the activity of all beings, by whom this whole universe is spun, a man attains perfection and success. Better [to do] one's own [caste-]duty, though devoid of merit, than [to do] another's, however well performed. By doing the work prescribed by his own nature a man meets with no defilement. Never should a man give up the work to which he is born, defective though it be: for every enterprise is choked by defects, as fire by smoke.

"With soul detached from everything, with self subdued, [all] longing gone, renounce: and so you will find complete success. . . . Perfection found, now learn from Me how you may reach Brahman too. . . . Let a man be integrated by his soul [now] cleansed, let him restrain [him]self with constancy, abandon objects of sense—sound and all the rest—passion and hate let him cast out; let him live apart, eat lightly, restrain speech, body, and mind; let him practice meditation constantly, let him cultivate dispassion; let him give up all thought of 'I,' force, pride, desire and anger and possessiveness, let him not think of anything as 'mine,' at peace—[if he does this] to becoming Brahman is he conformed.

"Brahman become, with self serene, he grieves not nor desires; the same to all contingent beings he gains the highest love-and-loyalty to Me. By love-and-loyalty he comes to know Me as I really am, how great I am and who; and once he knows Me as I am, he enters [Me] forthwith. Let him then do all manner of works continually, putting his trust in Me; for by my grace he will attain to an eternal, changeless state. . . ."

Sanjaya[1] said: "So did I hear this wondrous dialogue of [Krishna] and the high-souled Arjuna, [and as I listened] I shuddered with delight. By Vyasa's favor have I heard this highest mystery, this spiritual exercise from Krishna, the Lord of spiritual exercise (*yoga*) himself, as He in person told it. O King, as often as I recall this marvelous, holy dialogue of Arjuna and Krishna, I thrill with joy, and thrill with joy again. . . . Wherever Krishna is, the Lord of spiritual exercise, wherever Arjuna, holder of the bow, there is good fortune, victory, success, sound policy assured. . . ."

QUESTIONS

1. In the *Bhagavad Gita,* "Brahman" is used to describe both a class of people and a state of being. What is the relationship?
2. How does Krishna answer Arjuna's question? Should Arjuna have been satisfied with it?
3. What comparisons can you make between the religious and ethical beliefs expounded here and those of Western tradition?

from the *Kamasutra of Vatsyayana*
Translation by Richard Burton

These passages are from the famous Hindu love manual, which consists of a collation of earlier manuscripts by a scholar of the fifth century A.D., named Vatsyayana. Although this is not the primary reason the work is ordinarily consulted, it does portray the

[1] Sanjaya, an unidentified recorder of the dialogue.

flavor of life among the educated urban classes of the Gupta period, and especially attitudes toward women. The translator is the nineteenth-century English explorer Sir Richard Burton.

Part I, Chapter 1: On Marriage

When a girl of the same caste, and a virgin, is married in accordance with the precepts of Holy Writ, the results of such a union are: the acquisition of *Dharma* and *Artha* [material prosperity], offspring, affinity, increase of friends, and untarnished love. For this reason a man should fix his affections upon a girl who is of good family, whose parents are alive, and who is three years or more younger than himself. She should be born of a highly respectable family, possessed of wealth, well connected, and with good hair, nails, teeth, ears, eyes, and breasts, neither more nor less than they ought to be, and no one of them entirely wanting, and not troubled with a sickly body. The man should, of course, also possess these qualities himself. But at all events . . . , a girl who has been already joined with others (i.e., no longer a maiden) should never be loved, for it would be reproachable to do such a thing.

Now in order to bring about a marriage with such a girl . . . , the parents and relations of the man should exert themselves, as also such friends of the man as may be desired to assist in the matter. These friends should bring to the notice of the girl's parents, the faults, both present and future, of all the other men who may wish to marry her, and should at the same time extol even to exaggeration all the excellences, ancestral and paternal, of their friend, so as to endear him to them, and particularly to those that may be liked by the girl's mother. One of the friends should also disguise himself as an astrologer, and declare the future good fortune and wealth of his friend by showing the existence of all the lucky omens and signs, the good influence of planets, the auspicious entrance of the sun into a sign of the Zodiac, propitious stars and fortunate marks on his body. Others again should rouse the jealousy of the girl's mother by telling her that their friend has a chance of getting from some other quarter even a better girl than hers. . . .

When a girl becomes marriageable her parents should dress her smartly, and should place her where she can be easily seen by all. Every afternoon, having dressed her and decorated her in a becoming manner, they should send her with her female companions to sports, sacrifices, and marriage ceremonies, and thus show her to advantage in society, because she is a kind of merchandise. They should also receive with kind words and signs of friendliness those of an auspicious appearance who may come accompanied by their friends and relations for the purpose of marrying their daughter, and under some pretext or other having first dressed her becomingly, should present her to them. After this they should await the pleasure of fortune. . . .

Chapter 2: Of Creating Confidence in the Girl

For the first three days after marriage, the girl and her husband should sleep on the floor, abstain from sexual pleasures, and eat their food without seasoning it either with alkali or salt. For the next seven days they should bathe amidst the sounds of auspicious musical instruments, should decorate themselves, dine together, and pay attention to their relations as well as to those who may have come to witness their marriage. This is applicable to persons of all castes. On the night of the tenth day the man should begin in a lonely place with soft words, and thus create confidence in the girl. . . . Women being of a tender nature, want tender beginnings, and when they are forcibly approached by men with whom they are but slightly acquainted, they sometimes suddenly become haters of sexual connection, and sometimes even haters of the male sex. The man should therefore approach the girl according to her liking, and should make use of those devices by which he may be able to establish himself more and more into her confidence. . . .

Part II, Chapter 1: On the Manner of Living of a Virtuous Woman, and of Her Behavior During the Absence of Her Husband

A virtuous woman, who has affection for her husband, should act in conformity with his wishes as if he were a divine being, and with his consent should take upon herself the whole care of his family. She should keep the whole house well cleaned, and arrange flowers of various kinds in different parts of it, and make the floor smooth and polished so as to give the whole a neat and becoming appearance. She should surround the house with a garden, and place ready in it all the materials required for the morning, noon, and evening sacrifices. . . . Towards the parents, relations, friends, sisters, and servants of her husband she should behave as they deserve.

The wife should always avoid the company of female beggars, female Buddhist mendicants, unchaste and roguish women, female fortune tellers and witches. As regards meals she should always consider what her husband likes and dislikes, and what things are good for him, and what are injurious to him. When she hears the sounds of his footsteps coming home she should at once get up, and be ready to do whatever he may command her, and either order her female servant to wash his feet, or wash them herself. . . . In the event of any misconduct on the part of her husband, she should not blame him excessively, though she be a little displeased. . . .

Chapter 2: On the Conduct of the Elder Wife Towards the Other Wives . . .

From the very beginning a wife should endeavor to attract the heart of her husband by showing to him continually her devotion, her good temper, and her wisdom. If however, she bears him no children, she should herself tell her husband to marry another woman. And when the second wife is married, and brought to the house, the first wife should give her a position superior to her own, and look upon her as a sister. . . . If the younger wife does anything to displease her husband the elder one should not neglect her, but should always be ready to give her the most careful advice. . . . Her children she should treat as her own. . . .

A man marrying many wives should act fairly towards them all. He should neither disregard nor pass over their faults, and should not reveal to one wife the love, passion, bodily blemishes, and confidential reproaches of the other. . . . One of them he should please by secret confidence, another by secret respect, and another by secret flattery, and he should please them all. . . .

QUESTIONS

1. How would you characterize the attitude toward women in these selections from the *Kamasutra*?
2. Compare the attitude toward love and courtship here with the courtly love tradition of the West.

The Buddha's Sermon in the Deer Park[1]

Thus I have heard. Once the Lord was at Varanasi [a sacred city on the Ganges], at the deer park called Isipatana. There he addressed the five monks:

There are two ends not to be served by a wanderer. What are these two? The pursuit of desires and of the pleasure which springs from desire, which is base, common, leading to rebirth, ignoble, and unprofitable; and the pursuit of pain and hardship, which is grievous, ignoble, and unprofitable. The Middle Way of the Tathagata [He who has attained] avoids both these ends. It is enlightened, it brings clear vision, it makes for wisdom, and leads to peace, insight, enlightenment, and Nirvana. What is the Middle Way? . . . It is the Noble Eightfold Path—Right Views, Right Resolve, Right Speech, Right Conduct, Right

Livelihood, Right Effort, Right Mindfulness, and Right Concentration. This is the Middle Way. . . .

And this is the Noble Truth of Sorrow. Birth is sorrow, age is sorrow, disease is sorrow, death is sorrow; contact with the unpleasant is sorrow, separation from the pleasant is sorrow, every wish unfulfilled is sorrow—in short all the five components of individuality [forms, sensations, perceptions, psychic dispositions, and consciousness] are sorrow.

And this is the Noble Truth of the Arising of Sorrow. It arises from craving, which leads to rebirth, which brings delight and passion, and seeks pleasure now here, now there—the craving for sensual pleasure, the craving for continued life, the craving for power.

And this is the Noble Truth of the Stopping of Sorrow. It is the complete stopping of that craving, so that no passion remains, leaving it, being emancipated from it, being released from it, giving no place to it.

And this is the Noble Truth of the Way which Leads to the Stopping of Sorrow. It is the Noble Eightfold Path—Right Views, Right Resolve, Right Speech, Right Conduct, Right Livelihood, Right Effort, Right Mindfulness, and Right Concentration.

QUESTIONS

1. Does Buddha's sermon strike you as religious?
2. In what important ways, if any, does Buddha's sermon differ from the precepts of the *Bhagavad Gita*?

As we have seen, Mahayana Buddhism, a later form of Buddhism originating in the first and second centuries A.D., carried much further the tendencies to view Buddha as a god and to equate nirvana with salvation and an afterlife. The following texts are from this later, Mahayana, period.

from *The Bodhisattva*

The bodhisattva [divine savior] is endowed with wisdom of a kind whereby he looks on all beings as though victims going to the slaughter. And immense compassion grips him. His divine eye sees . . . innumerable beings, and he is filled with great distress at what he sees, for many bear the burden of past deeds which will be punished in purgatory, others will have unfortunate rebirths which will divide them from the Buddha and his teachings, others must soon be slain, others are caught in the net of false doctrine, others cannot find the path (of salvation), while others have gained a favorable rebirth only to lose it again.

[1] Also often called "The Buddha's First Sermon."

So he pours out his love and compassion upon all those beings, and attends to them, thinking, "I shall become the savior of all beings, and set them free from their sufferings."

[In the following selection, the Christ-like bodhisattva suffers for the sake of humanity.]

All creatures are in pain . . . , all suffer from bad and hindering karma . . . so that they cannot see the Buddhas[1] or hear the Law of Righteousness or know the Order. . . . All that mass of pain and evil karma I take in my own body. . . . I take upon myself the burden of sorrow. . . . I must set them all free, I must save the whole world from the forest of birth, old age, disease, and rebirth, from misfortune and sin, from the round of birth and death, from the toils of heresy. . . . For all beings are caught in the net of craving, encompassed by ignorance, held by the desire for existence; they are doomed to destruction, shut in a cage of pain. . . . It is better that I alone suffer than that all beings sink to the worlds of misfortune. There I shall give myself into bondage, to redeem all the world from the forest of purgatory, from rebirth as beasts, from the realm of death.

[Although the following story is strikingly like the New Testament parable of the Prodigal Son (Luke 15:11–22), it was almost surely developed independently.]

A man parted from his father and went to another city; and he dwelt there for many years. . . . The father grew rich and the son poor. While the son wandered in all directions [begging] in order to get food and clothes, the father moved to another land, where he lived in great luxury. . . . In course of time the son . . . came to the city where his father dwelled. Now the poor man's father . . . forever thought of the son whom he had lost . . . , and thought: "I am old, and well advanced in years, and though I have great possessions I have no son. . . ."

Then the poor man . . . came to the rich man's home. And the rich man was sitting in great pomp. . . . When he saw him the poor man was terrified. . . . But the rich man . . . recognized his son as soon as he saw him; and he was full of joy. . . . Thenceforward the householder called the poor man "son," and the latter felt towards the householder as a son feels towards his father. So the householder . . . employed him in clearing away refuse for twenty years. [The son lived sparingly in a straw hut.]

Then the householder fell ill, and felt that the hour of his death was near. . . . And the poor man accepted the rich man's wealth . . . , but personally he cared nothing for it, and asked for no share of it. . . . He still lived in the straw hut, and thought of himself as just as poor as before. Thus the householder proved that his son was frugal, mature . . . humble and meek. . . . [So the rich man announced]: "Listen, gentlemen! This is my son, whom I begot. . . . To him I leave all my family revenues, and my private wealth he shall have as his own."

QUESTIONS

1. How do these texts differ from Gautama Buddha's sermon in the Deer Park?
2. If, as seems clear, there was no direct Christian influence on the development of Buddhism, how would you account for the similarities?

[1] In Mahayana Buddhism the great Buddha, Gautama, was regarded as the latest in a series of Buddhas, and it was assumed there would be others.

Summary Questions

1. What was the earliest civilization in India?
2. What was the effect of the Aryan migrations?
3. How can *Hinduism* be defined?
4. Describe the subject matter of the *Bhagavad Gita* and name three primary Hindu concepts found in it.
5. Who was the Buddha and what was his principal message?
6. What is the caste system and how does it affect Indian life?
7. How is Hinduism expressed in sculpture and architecture?
8. How does Indian musical theory differ from its Western counterpart?

Key Terms

Indo-European

Sanskrit

Aryan

dharma

reincarnation

yoga

karma

Hindu stages of life

Brahma

Vishnu

Siva

Krishna

Hinayana and Mahayana Buddhism

vihara

chaitya

stupa

sitar

raga

tala

16

An Introduction to the Civilization of China

CENTRAL ISSUES

- The sharp division in social structure of ancient and medieval China and its basis in religion
- Chinese religion from the earliest dynasties to Confucianism, Daoism, and Buddhism
- The cultural integration of China by the third century A.D.
- The development of a centralized, bureaucratic state by A.D. 900
- The advanced character of Chinese scientific and technological development in the Middle Ages
- Reasons for European world supremacy after 1500
- Chinese poetry, architecture, painting, ceramics, and music

In prehistoric times the opening into China provided by the Huang He River (often called the Yellow River) furnished the most likely means of entry to the first settlers from Inner Mongolia. Although signs of early cultivation mark the banks of the two other major rivers of China, the Xi and the Yangtze, the first historically ascertainable political organization, the Xia dynasty, emerged about 2000 B.C. in the valley formed by the Huang He. However, little is known about this northern Chinese political and social organization.

Early Dynasties: Shang and Zhou (Chou)

The Shang dynasty, which followed the Xia dynasty about 1500 B.C., probably attained its power through its superior military abilities; its armies had horse-drawn chariots already in use in Egypt and Mesopotamia. At its greatest height

this dynasty governed a large area of land spreading out from both banks of the river (about forty thousand square miles) by means of a tribute arrangement with the rulers of subjected tribes (see map).

Around 1000 B.C. this dynasty in turn was replaced by the Zhou (Chou)[1], a dynasty originating in the same river valley. Like the Shang, the Zhou wielded power over a large number of princes, who acknowledged Zhou supremacy while directly governing their own people. The Chinese term for China (*Zhongguo*, or *Middle Kingdom*) derives from this period, when the fiefdoms of Zhou vassals surrounded the Zhou kingdom, which was in the middle. After 700 B.C., however, under attack from aggressive central Asian tribes, the Zhou dynasty gradually lost direction, and its power was ultimately divided among some of the princes over whom it had ruled. But the disintegration of the Zhou empire did not bring chaos; rather, a number of states rose out of the wreckage. By 221 B.C. one of them, Qin (Ch'in) (from which the name *China* derives), emerged as a new imperial power—after a century-long process of absorbing its neighboring states.

Social Structure

The society of these early kingdoms of the Shang and Zhou was marked by a sharp divide between nobles and peasants. Nobles alone possessed land, bore arms, and consequently possessed wealth. Tied to the soil belonging to a landlord, the peasants usually lived out on the fields in the summer, and in the winter months in mud huts in the village. This condition of total subjection to the landlord became traditional for Chinese peasants down to modern times.

Essentially, the status of nobility enjoyed by the landlord derived from kinship ties. Whereas the nonnoble population was left to worship local deities of the soil and fertility, the nobility's religious life focused on ritual practices linked to the worship of their ancestors. In a sense, only the nobles were recognized as having families. By the Zhou period there were about a hundred noble clans, each claiming descent from a hero or a god. Each clan in turn was divided into a number of families. These families shared the responsibility of

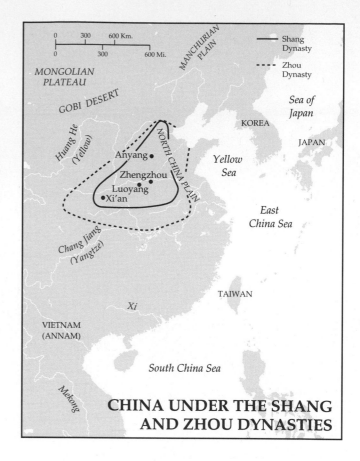

CHINA UNDER THE SHANG AND ZHOU DYNASTIES

honoring the common ancestor with appropriate rites, and within each family all members were obligated to shoulder the family's contribution to the rituals.

The ruler's lordship over this nobility stemmed from his central religious role in the society. His task was to act according to *te*, or virtue, so as to please not only the ancestor gods but the high god who reigned over all these lesser gods. While under the Shang this high god was known as Lord on High, or *Shabg Di*; under the Zhou the supreme deity was known as *Tian*, or Heaven. In time Heaven came to be seen as the guardian of the moral order of the universe; the emperor's duty was to uphold that order. Through model performance and unceasing protection of the rituals connected with ancestor worship, that is, demonstrations of *te*, the king hoped to ensure the birth of an heir for the kingdom, ample harvests for his people, and victories in war. Given the belief that knowledge of the divine was revealed through the stars and oracles, the king, who had almost no bureaucracy to help him govern, surrounded himself with learned men skilled in reading the signs concealing the future.

Economics

A number of developments in the Zhou period stimulated the economy and encouraged urbanization. Already

[1] There are two principal methods of romanizing the Chinese language: Wade-Giles and pinyin. The older Wade-Giles system was developed by Europeans and was the common method for romanization until the late twentieth century. The pinyin system, which was introduced by the Chinese themselves in the 1950s and which is now the official romanization system of the People's Republic of China, has become the most accepted method for use in scholarship and journalism. Pinyin is much closer than Wade-Giles to actual pronunciation. For the most part, pinyin is pronounced just as it looks. This text uses pinyin romanization, followed at first mention in many cases by the Wade-Giles equivalent in parentheses.

in the early years of the dynasty, advances in fertilizers and irrigation appear to have increased the food supply. The cultivation of the mulberry tree suggests that China's most famous textile, silk, was already being produced. The introduction of iron to replace bronze roughly around the seventh century B.C. further affected agriculture. More resistant than bronze, iron, used for plowshares, permitted the cultivation of lands too hard to till up to then. Closely linked to agricultural improvements, the increase in population led to the rise of towns, some of them of considerable size, and the creation of merchants, a group that had no status within the traditional hierarchy.

Writing

The Chinese writing system is totally original in its conceptual principle. It is not an alphabetical system, in which each letter is a sign with a phonetic value and words are spelled out with several such letters of a given alphabet. Instead, in Chinese every written sign is a semantic unit, a complete word. By the time of the Shang dynasty already more than two thousand such symbols, or characters, had developed. Our knowledge of the earliest Chinese writings comes from the oracle bones. Questions asked by the diviners and the answers given by the spirits and gods were carved out on the special bones used for divinations; prayers were written out rather than recited. Some symbols were stylized pictographs and ranged from the simple to the complicated. For example, the characters for sun, moon, and tree are quite recognizable as these objects. The character for sacrifice, on the other hand, is extremely complicated and shows two hands holding a bird upside down over a symbol that indicates the "spirits." Ideographs, or signs depicting abstract ideas, such as the symbol for "spirit," form the majority of Chinese characters in the writing system. Many characters introduced later into the writing system are part phonetic and part pictographic and ideographic. For example, the ideograph for "peace," which is a combination of the pictograph of a woman and a roof, is pronounced the same way as the word for "table." The word for "table" is written by combining the ideograph for "peace" with the pictograph for "tree" or "wood."

Despite its complexity, the Chinese writing system was not an impediment to learning. With the Confucian emphasis on education and the early establishment of public schools in villages all over China, it seems that until the nineteenth century the proportion of educated people in China was higher than in the West. The Chinese writing system was standardized during the Qin dynasty by imperial order. Now there are more than fifty thousand characters in standard reference dictionaries. The great advantage of the Chinese writing system is that it can be read and understood by people

speaking many different dialects and languages because the written word is not related to its pronunciation. Hence the Chinese writing system helped to unite the vast region of China; it also spread to distant areas, including Japan, Korea, and Vietnam.

Religion and Philosophical Thought

The nobles' ancestor worship and popular veneration of local gods were only two manifestations of Chinese religious tendencies in this earliest historic period. As already suggested, by the time of the Zhou dynasty, the sense that a moral order pervaded the universe appears to have become a fundamental element in religious and philosophical thinking. At the most basic level, this moral order involved a balance and harmony between the forces (or processes) that run through nature and life, commonly known as *yin* and *yang*. These correspond to female/male, cold/hot, and the like (Fig. 16-1).

In some ways Chinese thought is comparable to that of the West. Like the pre-Socratic Greeks, for instance, the Chinese concluded that the world was composed of four elements: earth, air, fire, and water. Ancient Chinese and Western medicine shared a belief in the harmony of what European physicians called humors: blood, phlegm, choler (yellow bile), and melancholy. In China the specific elements were different, but the basic concepts were much the same.

However, although medical theories were similar, a major difference divided Chinese from Western thinking. Whereas the Chinese *yin* and *yang* were blended, intertwined, and integrated from the outset, the Western mind traditionally thought in terms of clashes of opposites, of sharply conflicting forces of good and evil, right and wrong, thesis and antithesis. If struggle is a key word in Western civilization—the nineteenth-century English naturalist Charles Darwin and his contemporary, German founder of communism Karl Marx, come to mind—then the key word in Chinese civilization would be harmony. This does not of course imply

16-1 *Yin-yang circle.*

the absence of harmony in the West or the lack of violent conflict in China.

Religion under the Shang and Zhou was marked by the absence of a priestly class. While specially learned men would provide advice on matters of ritual and interpret divine signs, the king and heads of families performed the rituals themselves. Religion, moreover, was formalistic and focused on conduct; beyond the universalistic conceptions sketched above, the Chinese showed little love of abstract theological thought. The secular, this-worldly orientation of early Chinese religion encouraged the spread and massive acceptance of Confucianism.

Confucianism

The sage-philosopher Confucius (551–479 B.C.) lived about a century before the Greek philosopher Socrates. However, the word *Confucianism,* used to signify his thought, was apparently invented only in the sixteenth century by Portuguese missionaries, who (like the British in the eighteenth century) were trying to understand the society they wanted to convert. Other "Confucians," notably Mencius (390–305 B.C.), who has often been compared with Plato, were at least as important as the founder in the evolution of Confucian ideas. Although Confucianism is sometimes regarded as a religion, it had no doctrine, no priests, no missionaries, and no belief in salvation or an afterlife. Confucianism took centuries to permeate Chinese society, but there is no doubt of the profound long-term impact of the Confucian mentality on the development and character of imperial China.

Like Socrates, Confucius was not a systematic philosopher. He asked perceptive, disturbing questions and made wise though sometimes paradoxical statements, leaving it to others to weave the fragments into a coherent whole. Also like Socrates, he was troubled by the morals and condition of his society. He looked back to a mythical Golden Age, when rulers had been uncorrupted and their people prosperous and contented. He preached the simple virtues: veneration of the old, service by the strong, protection of the weak, paternalism by the government. Above all, he stressed the temperament, character, and behavior of the gentleman (*zhunzi*).

Confucius intentionally redefined the contemporary term for nobleman, *zhunzi,* by giving the word an ethical rather than a social signification. The inner-balanced disposition of the gentleman was reflected in both word and deed. Chief among his virtues were humanity and courtesy. Trustworthy and moderate, gentle and determined, he avoided violence and indecent acts of any kind. Honesty, integrity, loyalty, and the pursuit of the knowledge of ethics were other virtues of the *zhunzi.* In a later development, filial piety would also come to be counted among the Confucian virtues. There seems to have been no parallel idea for women in the strongly patriarchal thought.

Daoism (Taoism)

The origins and definition of Daoism are even less precise. The word *dao* (*tao*) is usually translated as "the way" or "the way of the universe." In contrast to the practical, humanistic focus of Confucianism, Daoism teaches abandonment of the self to the natural rhythms of day and night, winter and summer, youth and age, and of the universe. One seeks "the way" not through rational thought but through meditation. The origins of Daoism are attributed to a certain Lao Zi (Lao-tzu), who is said to have lived in the sixth century B.C. The name, however, means "old master," and the person could be legendary. Lao Zi is reputed to be the author of the classic poetic text of Daoism, the *Dao De Jing* (*Tao-te Ching*), although it does not seem to have been written down until the third century B.C.

Like Confucianism, Daoism has sometimes been regarded as a religion—and with more justification, since at various times there were priests and missionaries, called Daoists (followers of the way). Entirely lacking, however, was anything resembling sin, salvation, or an afterlife. On the contrary, Daoistic teachings focus on health, balance, beauty, and enjoyment in this world. Western scholars have tended to regard Confucianism and Daoism as bitter rivals, but that probably reflects their own predisposition to look for clashes of opposites; in reality there seems to have been a good deal of blending. Again, the yin/yang model seems more valid. Confucianism, as we will see, evolved into an ideology for the gentry at work, validating authoritative position. Daoism was an ideology more appropriate for play, that is, for cultured amusement, appreciation, and enjoyment.

Daoism also contains a good deal of mysticism. It has often been regarded as a bridge between the ideas of the elite and folk religion. Its influence has been traced in Buddhism, Shinto, and other religions throughout Asia. Its emphasis on tolerance, harmony, equilibrium—everything in balance, everything in tune—made it especially important in the arts: visual, performing, and literary. Nevertheless, neither Daoism nor, certainly, Confucianism was a religion in the usual sense of the word. Indeed, although it had plenty of folk beliefs, local fertility figures, and veneration for ancestors, traditional China may have been the most rational and humanistic and the least dogmatically religious society in the world. The eighteenth-century philosophe Voltaire, as we shall see in Volume Two, considered China the model of the tolerant society he sought to create in Europe in his own day.

Qin and Han Dynasties (221–206 B.C. and 206 B.C.–A.D. 221)

The unification of China north of the Yangtze River in 221 B.C. is frequently seen as initiating a new era in Chinese history. The new emperor himself seems to have had some sense of turning a page in Chinese history when he proclaimed himself "the first emperor." The country was divided into thirty-six districts without regard to former boundaries; laws and taxation were made uniform in all of them. The peasants no longer had to owe primary obedience to their landlords but rather to the central government. This provided the government with an enormous potential supply of men for military and public work projects. Creating a huge army, the emperor extended his control to the southern border of modern China. At the same time he initiated ambitious building projects: the construction of a series of great roads leading from the capital, the creation of great canals for transport and irrigation, and the amalgamation and extension of the segments of walls already erected along China's northern frontier to keep out invaders.

The Qin dynasty lasted less than two decades, but the Han dynasty, which succeeded it, had no reason to abandon the political structure created by the Qin. Over the next four hundred years, despite occasional threats to their authority, the Han emperors managed to solidify the institutions of central government and to create a conception of China that included almost all the territories now considered parts of China (see map). The Han emperors, moreover, expanded Chinese au-

thority into central Asia, that is, into Turkestan and Mongolia, establishing close economic and political relationships with nomadic tribes there. The variety of interchanges resulting from these contacts served to bring these outlying areas into the Chinese cultural sphere.

The first mention of contact between China and Europe occurred under the Han in A.D. 97, when a representative of the Chinese government traveled in the Roman Empire. However, already in the previous century the Chinese were known in the West as the producers of silk. Indeed, in Latin the word for Chinese, *sericus,* derives from *sericum,* or silk. Generally, though, direct contact between the two empires was infrequent. the Romans usually purchased Chinese luxuries through middlemen whose interest it was to discourage direct trade.

The reign of one of the early Han emperors, Wudi (141–87 B.C.), marks the transition between the traditional practice of choosing public officials from among the noble classes and the selection of officials on the basis of competitive examinations. Wudi (Wu Ti), who wanted to supervise all aspects of central government himself, aggressively sought throughout the kingdom capable men to fill offices in his government and instituted an examination system for determining the qualifications of the applicants. The systematic creation of a professional bureaucracy selected by competitive examination would, however, reach its full development only under the Tang dynasty (A.D. 618–907).

During the Han dynasty (206 B.C.–A.D. 221), China achieved cultural, as well as political, unity under rulers from the north. The political unification

brought tremendous economic benefits to the Yangtze region. By the last years of the dynasty, the north became increasingly dependent on rice from the south for food. Not only did the cultivation of rice expand but new, more productive varieties were introduced. Within the south itself the increase in food production sparked demographic growth and led to greater urbanization. Over the next few centuries the south became the richest, most populous region of China and the center for a booming Chinese trade with the rest of Southeast Asia.

Science and Technology

The art and literature of the Han dynasty lacked distinction, but science and technology advanced rapidly during this four-hundred-year period. Despite the proliferation of official documents beginning in Wudi's reign, the imperial Palace Writers had only silk and strips of wood for writing material. Both had disadvantages: the first was expensive and the second bulky. By the second century A.D., however, the administrative elite of the empire was using paper made from fabrics such as cotton or linen and from bark pulp. Passing from East to West, paper made its first appearance in Muslim Spain about 950 and in southern Italy only in 1154. Furthermore, even in ancient Rome China was noted for the excellence of its iron production, and substantial quantities of steel were forged starting in the second century B.C. By the time Christ was born, the Chinese had invented the water mill and wheelbarrow, and by the second century A.D. they produced the first seismograph.

Buddhism

The collapse of the Han dynasty in A.D. 222 was followed by the longest period of anarchy in China's history (220–586). Called the Age of Dispersal, it was marked by a constant succession of dynasties in both north and south competing for dominance, as well as by invasions of northern peoples only slightly touched by Chinese influence. Not surprisingly, Buddhism spread through China in those centuries. This religion from a foreign culture promised an answer to the suffering multitudes of the war-torn country.

Why China itself did not develop one of the great world religions is unclear. What *is* apparent is the gap or niche that could be filled by imported faiths. Of these the most significant was Buddhism. At first glance Buddhism would seem to have contrasted strongly with Chinese cultural values. It advocated celibacy, which threatened the institution of the family, and preached otherworldly values, which contradicted the practical and humanistic orientation of Chinese society. Moreover, the Buddhist monastery, with its internal government, ran counter to political centralism.

The promise of an afterlife, which Confucianism and Daoism lacked, helps explain why Buddhism in its Mahayana form spread in the time of troubles between the third and sixth centuries and why it was to become the most powerful religion in East Asia. Although the Buddhist concept of karma might appear to limit the individual's ability to attain salvation, it does allow one's deeds in this life to have some effect on one's future existence. Consequently, it offered hope that salvation could be worked for. Buddhism, moreover, proved adaptable to the practical Chinese tradition in some ways, especially in its recognition of the honors due to ancestors.

Sui and Tang Dynasties (581–618 and 618–907)

During the brief period in which it reestablished a unified China, the concentration of the Sui dynasty on southern China reflected the increasing importance of that area of the country. The frequent wars in the north and the numerous invasions of central Asians had caused a population shift to the south of the Yangtze, where the longer growing season also made possible higher population densities. Great canal builders, the Sui emperors drafted a million workers to construct the Grand Canal between the Yangtze and their capital at Changan, in order to expedite the shipment of rice north. The Mongols in the thirteenth century would extend the canal farther north, to their capital at Beijing (Peking). Defeated in its attempt to annex Korea and preoccupied with a series of peasant revolts, the Sui family lost power to a military aristocracy on the northwest border of the country, which in 618 invaded the Chinese heartland, captured Changan, and created a new dynastic line, the Tang.

Product of a border region with close ties to the nomadic tribes of central Asia, the Tang created a powerful army in which the cavalry played a major role. At the height of their power the Tang emperors maintained 700,000 warhorses. Within the first fifty years of their reign, in the west they expanded their authority as far as Afghanistan, made Tibet a dependency, and entered northeastern India. To the north they conquered Korea and to the south absorbed the northern half of modern Vietnam.

To a degree unknown in later centuries, the Tang welcomed foreigners, and foreign cultural influences are clearly reflected in the cultural and artistic spheres of Tang society. The Tang in turn spread Chinese culture not only to the areas that they conquered but also beyond, to the islands of Japan and Indonesia. Perhaps owing to the close connections of the imperial family with the nomadic culture of central Asia, where women from important families had political power and some freedom of mobility, the status of Chinese women im-

THE MONGOL EMPIRE, EARLY THIRTEENTH CENTURY

POLAND

HUNGARY

• Moscow

• Riazan

• Kiev
UKRAINE

Constantinople

CRIMEA

SIBERIA

• Sarai

• (Old) Sarai

ARMENIA

AZERBAIJAN

MESOPOTAMIA

EGYPT

• Tabriz

Baghdad •

IRAN

ARABIA

Samarkand •
Balkh •

TRANSOXIANA

• Herat

Karakorum •

JAPAN

Beijing (Khan-balikh) •

Hangzhou

Delhi •

INDIA

BURMA

ANNAM

CHAMPA

Angkor •

Mongol Empire at its greatest extent

Route of Marco Polo

Mongol raids

0 500 1000 Miles

0 500 1000 Kilometers

proved enormously in this period. Women enjoyed greater control over property and were able to divorce and remarry with greater ease. Tang imperial women rode horses, many were educated in the classics, and several participated in court politics.

Most remarkable, perhaps, was the action of the imperial concubine Wu. Holding the reigns of power after the death of the emperor in 683, she had herself proclaimed emperor in 690—the only woman in Chinese history to assume the title. However, the traditional Confucian emphasis on male dominance returned with the waning of Tang power in the early tenth century.

The empire of the Tang is generally viewed as the age of bureaucracy. Competitive examinations for appointments in the imperial government, already selec-

tively used under the Han, were now extended throughout the government. Indeed, the government created schools to prepare candidates. The training provided by these schools was literary in its orientation and required many years. Although there were exceptions, it was available mainly to children of the landowning class. Nonetheless, once brought into the system, the bureaucrat, indoctrinated with Confucian values and owing his livelihood and authority to the imperial government, became the emperor's man.

Thus, beginning with the Tang dynasty, the imperial government—aside from the imperial family and closest associates at court—was a meritocracy whose membership shared a common education and set of moral standards. This situation contrasted sharply with that in

• D A I L Y L I V E S •

•••• *Traveling in Mongol China*

Born in 1304 in Muslim Morocco, Ibn Battuta was the greatest traveler of the fourteenth century. Starting on a pilgrimage to Mecca in 1325, the pious Muslim did not return home again until 1354, after covering 75,000 miles in thirty years. His travels took him to every Muslim country, to southern Europe, India, China, and the islands of the Indonesian archipelago. He went to China in 1332, about fifty years after Marco Polo, and wrote a perceptive account of Chinese society and culture. The most striking aspect of the following selection from his book *Travels in Asia and Africa 1325–1354,*[a] concerns Ibn Battuta's observations on the Chinese use of paper money rather than gold and silver for currency. The use of paper money would not become widespread in western Europe until the late

eighteenth century, and gold and silver would continue to circulate as money down into the twenty-first.

The land of China is of vast extent, and abounding in produce, fruits, grain, gold and silver. In this respect there is no country in the world that can rival it. It is traversed by the river called the "Water of Life," which rises in some mountains, called the "Mountain of Apes," near the city of Khán-Báliq [Peking] and flows through the centre of China for the space of six months' journey, until finally it reaches Sin as-Sin [Canton]. It is bordered by villages, fields, fruit gardens, and bazaars, just like the Egyptian Nile, only that [the country through which runs] this river is even more richly cultivated and populous, and there are many waterwheels on it.

The Chinese use neither [gold] dinars nor [silver] dirhams in their commerce. All the gold and silver that comes into their country is cast by them into ingots, as we have described. Their buying and

a. Ibn Battuta, *Travels in Asia and Africa 1325–1354,* trans. and ed. H.A.R. Gibb (London: Routledge, 1929), pp. 282, 284, 287.

western Europe, where, until the nineteenth century, political power generally stayed in the hands of a hereditary aristocracy. Moreover, the rewards of political office in China tended to draw into government service men of the highest talent and ensured a degree of social mobility. Essentially conservative, like the Confucian ideology, which formed its standards, this bureaucracy provided continuity and stability for the country over the centuries despite the succession of regimes. The competitive examination was to remain a fundamental institution of Chinese government until 1911—the time of the revolution that toppled the Qing dynasty and led to the creation of the Republic of China.

Another element of stability institutionalized in the Tang period was the clear demarcation established by the emperors between local responsibilities, such as poverty relief and public works, assigned to the local landholders of the area, and matters of peace and justice, left mostly within the domain of imperial officials. Although the latter had some supervisory authority over its actions, the local power structure remained largely free of imperial interference. Consequently, the arrangement insulated localities from the effects of violent shifts at the center of imperial power. It also fostered social stability and conservative tendencies, the dominant traits of Chinese society for the next thousand years.

By the late Tang period, then, the basic patterns that Chinese society retained into the twentieth century were already in place: a centralized, bureaucratic state dominated by an independently recruited elite; a landed gentry with a large measure of local control; and a mass of illiterate, poverty-stricken peasants, whose only means of protest were sporadic, bloody revolts. In the West society gained a dynamic element with the rise of a merchant class, which was ready for innovation and eager for self-government. But the merchant class in the great cities of China, though often very rich, had no interest in challenging the traditional order of things. Because the imperial examination system allowed their sons to gain political power and social status through the bureaucracy, the members of the merchant class endorsed the status quo.

At least from 221 B.C. on, the normal course throughout Chinese history has been the loss of central control, followed by its restoration. Despite the breakup of Tang power and a half-century of political fragmentation, the institutions established by the Tang endured

selling is carried on exclusively by means of pieces of paper, each of the size of the palm of the hand, and stamped with the sultan's seal. Twenty-five of these pieces of paper are called a *bálisht,* which takes the place of the dinar with us [as the unit of currency]. When these notes become torn by handling, one takes them to an office corresponding to our mint, and receives their equivalent in new notes on delivering up the old ones. This transaction is made without charge and involves no expense, for those who have the duty of making the notes receive regular salaries from the sultan. Indeed the direction of that office is given to one of their principal amirs. If anyone goes to the bazaar with a silver dirham or a dinar, intending to buy something, no one will accept it from him or pay any attention to him until he changes it for *bálisht,* and with that he may buy what he will.

China is the safest and best regulated of countries for a traveller. A man may go by himself a nine months' journey, carrying with him large sums of money, without any fear on that account. The system by which they ensure his safety is as follows. At every post-station in their country they have a hostelry controlled by an officer, who is stationed there with a company of horsemen and footsoldiers. After sunset or later in the evening the officer visits the hostelry with his clerk, registers the names of all travellers staying there for the night, seals up the list, and locks them into the hostelry. After sunrise he returns with his clerk, calls each person by name, and writes a detailed description of them on the list. He then sends a man with them to conduct them to the next post-station and bring back a clearance certificate from the controller there to the effect that all these persons have arrived at that station. If the guide does not produce this document, he is held responsible for them. This is the practice at every station in their country from Sin as-Sin to Khán-Báliq. In these hostelries there is everything that the traveller requires in the way of provisions, especially fowls and geese. Sheep on the other hand, are scarce with them.

and could be used by the Song dynasty (960–1279) after it had unified the country. After 1126, however, Chinese unity was again destroyed by internal rebellion, and Song authority became limited to the southern half of the country. In 1215 under Genghis Kahn the Mongols invaded northern China, but the area under Song control was only conquered under Genghis' grandson, Kublai Khan in 1279. By this time Mongol power, with its capital at Beijing, extended from Korea and Northern India to western Russia (see map, p. 473). After briefly experimenting with ruling the country through foreigners such as Marco Polo, the Mongols likewise returned to the traditional administrative elite and reestablished landlord control of local affairs. The Ming dynasty (1368–1644), a native Chinese dynasty, merely carried the ancient traditions forward.

Later Science and Technology

The increasing conservatism of Chinese society from the time of the Tang dynasty on seems to have had little effect on the originality of Chinese thinking in science and technology. The earliest use of inked seals occurred in China between A.D. 600 and 700. By 1030 the Chinese were using movable type for printing books—four hundred years before Johann Gutenberg of Mainz cast the first movable type in Europe. Seagoing junks, carrying a thousand men and able to sail both before and close to the wind, were products of the eleventh century. The compass and the stern post rudder for navigation appeared in China at about the same time. Gunpowder bombs were introduced in Chinese warfare by the mid-twelfth century, and mortars made first of wood and then of metal are found in the thirteenth century.

Gunpowder appears to have reached Europe by 1300 by means of the Mongols and the Arabs, and there gunpowder and the printing press were to have dynamic, revolutionary implications. Gunpowder leveled the playing field, making it easy for an ordinary soldier to kill a knight. It also made warfare too expensive for anybody except kings to afford, which increased the power of central governments compared with aristocrats. The printing press made it possible to publish all kinds of materials (books, newspapers, sermons) cheaply and in large quantity, greatly accelerating the flow of ideas and propaganda. Oddly enough, in China, the place of their discovery, these inventions had nothing like the same revolutionary impact they had in

Europe; whereas these innovations transformed Europe, China simply absorbed them.

Foreign Trade

By A.D. 1000 China's cities were the largest in the world; several of them numbered perhaps a million inhabitants. Trade was vital to the maintenance of these large populations, but most of the exchange of goods and services was internal. Remarkably self-sufficient, producing the vast majority of what it needed, China exported for the most part silk and pottery ("china") and imported largely luxuries and narcotics (for example, opium from India). As a much later Chinese emperor told the envoy from George III of England in the 1790s, his country possessed all things necessary and had no use for "toys" made by barbarians in a despicable little island, cut off from China.

Why Not China? Why Europe?

In terms of scientific and technological achievement, until the late 1400s the civilizations of China and Europe seem to have been about equal. During the sixteenth century Europe forged ahead technologically, but by then it was already expanding its influence. The first of the great voyages to the east and west of Europe took place in the 1490s. Vasco da Gama successfully rounded the Cape of Good Hope to reach the East. Columbus sought a new route to the same destination by sailing west, and though he failed in this effort, he did bump into an unknown continent, later to be called America. These voyages had enormous consequences for both Europe and the world. The world gained access to the American miracle crops, especially the potato, which supported a population explosion in European countries such as Germany and Ireland; Indian corn (maize), which became a staple in parts of Europe and Africa; and manioc (cassava) and sweet potatoes, which had the same impact on Asia as well as sections of Africa. By gaining first access to American raw materials, especially silver, furs, and timber, Europeans profited directly. They also profited from being the main carriers of the growing trade with Asia. Yet, until the Industrial Revolution of the early nineteenth century, Europeans were producing virtually nothing that Asians needed or wanted. Their ships went out loaded with silver, returning with Asian products and manufactured goods—spices, silk, tea, and cotton goods. Europeans were not more "advanced" than Asia.

China also possessed the technology for such voyages. In the early fifteenth century Chinese ships were sailing all over the Pacific and Indian oceans. The Muslim admiral Zheng He had led an expedition of about a hundred ships as far as the southeastern coast of Africa. (Columbus, by contrast, had only three ships.) But when Vasco da Gama reached the Indian Ocean in the 1490s, he found a power vacuum. There had been a court fight in China, the proexpansion faction had lost, and the voyages were abruptly halted—a political decision.

Why did China not produce a Columbus or a Vasco da Gama? There were many differences between Europe and China: religious, social, and cultural. Probably the most important one was China's being a land-based empire. Intent on defending its borders rather than expanding, China was obsessed with maintaining internal stability, not with seeking riches overseas. Furthermore, Europe as a whole did not expand—just Portugal, then Spain, then Holland, then France and England. Without question the expansion of Europe was forced by the fierce rivalry among its intensely competitive nation-states. At the Chinese capital, the factional fight resulted in a recall of the ships. Europe had no central authority that could have made such a decision. While the Chinese held back, state competition drove the Europeans on—and outward. Competition made the Europeans more resourceful than the Chinese, as well as a lot more aggressive.

Chinese Poetry

Although the Chinese literary tradition, like others, has taken many forms and modern Chinese novels are now beginning to be widely read in the West, the highest form of literary expression in China has traditionally been poetry. Chinese poetry, even in translation, has also awakened the most interest among Europeans and Americans. As we will see in Volume Two, translators such as Arthur Waley and Ezra Pound introduced English-speaking readers to Chinese poetry in the early twentieth century. They were fascinated by the brilliance of its images and its remarkable accessibility.

Like other aspects of Chinese culture, Chinese poetry has both a long history and exceptional continuity. Oral poems and songs were composed and performed from ancient times on, but the first written collection, the *Shi Jing,* or "classic of songs," dates from around 600 B.C. Chinese inventions of paper and later the printing press helped to disseminate poetry to the literate public throughout the country. Both the study of classical poetry and the writing of one's own poetry were, in the Confucian tradition, essential to the education of a gentleman.

Unlike India, Mesopotamia, or Greece, China produced no epic poem to celebrate important battles and heroic feats. This may reflect the influence of Confucianism, which was more attuned to social life and human virtues than to military glory. Many Chinese poems also show the influence of Daoism or Buddhism with their mystical but clear portrayal of human beings in nature, in particular the serenity of retreat to the mountains. Chinese poetry tends to be *occasional,* that is, written

for particular events such as a meeting or parting of friends, a banquet, or a trip. In addition, it has played a political role, as in celebrating the virtues of an emperor or giving voice to social complaints of common people. There is also a tradition of love poetry—much of it written from the woman's point of view—although this is less important than in European poetry. Using a Western category, we would classify most Chinese poetry as *lyric,* since it is brief, treats a concentrated impression, and speaks through the "I" of the poet.

Early Chinese poetry was in the form of the *fu,* a form of rhymed poetry in prose that was long, descriptive, and highly stylized. The best-known form, however, is the *shi,* a short poem containing an even number of lines, with end rhymes in each line. The *shi* line usually consists of four or five monosyllabic characters. Daoists and Buddhists favored the *shi* as a way of rebelling against what they considered to be the stifling style of the *fu.* Here is an example from the work of the poet Liu Zongyuan, who lived from A.D. 773 to 819, during the Tang dynasty. Entitled "River Snow," it has often been illustrated by Chinese painters. As can be seen from the original reprinted here, it is a poem in five-character lines. The phonetic transcription gives some idea of the use of sound and rhyme.

The figure of the lone fisherman often suggests a state of ultimate freedom for Chinese painters as well as poets. This poem illustrates the conciseness and economy of Chinese poetry, and the difficulty of translating it effectively. Nevertheless, Chinese poetry has proved accessible to readers of English through the sensuous

16-2 *Red earthenware tripod jug, Kui. Third or early second millennium* B.C., *excavated in 1960 at Weifang, Shantung, China. (Erich Lessing/Art Resource, NY)*

clarity of its images, often very visual, and its portrayal of universal human emotional states.

Art and Architecture

The Neolithic culture of China that parallels the Indus Valley civilization is named for the ceramic ware found there: the painted pottery culture and the black pottery culture. These ceramic finds (Fig. 16-2) seem to presage

LIU ZONGYUAN

River Snow
Translation by Burton Watson

千山鳥飛絕，	Qian shan niao fei jue	From a thousand hills, bird flights have vanished;
萬徑人蹤滅。	wan jing ren zong mie	on ten thousand paths, human traces wiped out:
孤舟簑笠翁，	gu zhou sou li weng	lone boat, an old man in straw cape and hat,
獨釣寒江雪。	du diao han jiang xue	fishing alone in the cold river snow.[2]

2 From Burton Watson, ed., *The Columbia Book of Chinese Poetry* (New York: Columbia University Press, 1984), p. 11.

16-3 *Good sancai and blue glazed globular tripod censer, Tang dynasty. (Christie's Images, Ltd. 1999)*

what, for many westerners, has been one of the most significant and continuous manifestations of a Chinese aesthetic: a formal and technical mastery of materials that spans millennia and has produced a seemingly endless number of ceramic works of art, such as the globular tripod censer (Fig. 16-3).

Creations in jade, metals, especially bronze, and silk textiles parallel these wonderful pieces. Chinese bronzes from the Shang period are some of the best examples of metallurgical craftsmanship in the world (Fig. 16-4). Thousands of vessels and weapons used in religious rituals have been discovered in the ruins of Shang cities. The most common ceremonial vessels found had been made by the *cire perdu* bronze-casting method. They are hollow-legged tripods, wine goblets, and covered tureens in square and rectangular shapes that are very particular to East Asia. The vessels are decorated with elaborate designs in high relief and incised lines. The chief design elements on many of them are ornate masks called *taotie*, or animal masks, which give a frontal view of an animal head. These masks are totally unlike designs known in the ancient West but bear a striking similarity to animal designs found on totem poles among Native Americans of the Pacific Northwest and among the peoples of the South Seas.

16-4 *Covered wine vessel (yu), eleventh–tenth century* B.C. *Chinese, Western Zhou dynasty, early period. Bronze. Height: 25 cm (9.8"). (Courtesy, Museum of Fine Arts, Boston. Anna Mitchell Richards Fund)*

The importance of writing and the styles of calligraphy in Chinese culture, however, seem to have shaped the art of China as much as materials or purpose. Painting on handscroll, hanging scroll, and single leaf seems to reinforce and parallel the development of calligraphy (Fig. 16-5).

Chinese architecture, which many scholars have described as human-centered rather than religiously motivated, appears to grow from the private house around its interior courtyard (Fig. 16-6) to complexes that include the offices, audience halls, and palaces of the person who is the son of heaven, god on earth, and ruler of the kingdom (Fig. 16-7).

16-5 Returning Home, *by Qian Xuan. Yuan dynasty, c. 1285. Ink and color on paper, 42" × 10¼" (106.6 × 26 cm). (The Metropolitan Museum of Art, Gift of John C. Ferguson, 1913, #13.220.124)*

16-6 *Typical one-courtyard housing in Beijing, China.*
(Superstock)

◀

• What other societies we have studied developed courtyard housing? What circumstances in each society encouraged the creation of courtyard housing? What materials are used in China?

Tang ceramics and some paintings of the Song dynasty, with a brief look at the Forbidden City, the imperial capital of the Ming.

Tang Painting and Ceramics

Tang China may have been the best-governed, strongest, richest, and most cosmopolitan land in the world of its time. This openness lessened the weight of custom and tradition so that the arts were freer to change. In painting, the subject matter expanded: representations of figures and landscapes joined the religious paintings typical of previous periods. Because of their military, social, and political importance, horses became one of the prime subjects of Tang art (Fig. 16-8). Tang artists initiated ideas that would be sources for Song painting. The challenging times also produced artists like Yan Liben, who was a highly placed court administrator, as well as an important court artist who provided designs for architecture, sculpture, and wall paintings. One of the four reliefs he designed for Emperor Tai Zong combines realism and abstraction to create a powerful image of his horse and groom (Fig. 16-9).

Ceramics—earthenware, stoneware, and porcelain—all provided materials for wonderful three-dimensional figures, which survive from tomb burials. Figures of harpists and horses, as well as of other animals, servants, soldiers, and singers, were produced by ceramic artists to provide company in the tomb and in the after-

The profound impact of Buddha and his religion on the art of China cannot be ignored. But even during the Buddhist ascendancy, native Chinese forms and ideas persisted. With the collapse of the Han dynasty, the educated ruling classes fled south, away from the barbarians. There, Confucianism and Daoism had persisted and thus became the primary influences on the art of subsequent centuries.

Rather than attempting to survey the evolution of art during these centuries, we will focus here on a few

16-7 *Tai-he Men (Gate of Supreme Harmony). Forbidden City, Beijing, China.*
(Superstock)

16-8 Two Horses and Groom, *by Han Kan (active* A.D. *742–756). Album leaf, slight color and ink on silk, height 10⅞". Tang dynasty. (National Palace Museum, Taibei, Taiwan)* **(W)**

16-9 *Horse of Emperor Tang Tai Zong with general from Shensi. Limestone relief designed by Yan Liben, seventh century. Height 68". (University of Pennsylvania Museum, neg. #XS8-62844)*

life for the deceased. Like the relief of the horse and groom, the earthenware harpist in Figure 16-10 demonstrates a combination of careful observation, color, and stylization that successfully infuses these sculptures with life.

The same extraordinary skill was extended to the development of materials. Earthenware and stoneware had long been known, but during the Tang period these relatively low-fired wares were joined by the true porcelains, such as Xing ware, which are the highest-fired ceramics. Xing ware has a pure white porcelain body; the pitcher in Figure 16-11 is an unusually complex and impressive example of it. With its bird's-head lip and a robust ovoid body decorated with floral incising, this vase stands for the vigor, worldliness, and energy of the Tang society.

16-10 *Harpist. China, Tang dynasty, eighth century. Lead-glazed earthenware, height 32.1 cm. (Copyright The Cleveland Museum of Art, 1966. Edward L. Whittemore Fund, 1931.450)*

Song Landscape Painting

During the rule of the Song dynasty, the civilian population responded with pacifism to the constant pressure of the people along China's northern borders. This pressure resulted in a contraction of the kingdom and led to an inward focus, which gave rise to a Neo-Confucianism that allied aspects of Buddhism, Daoism, and the older Confucian doctrines.

The society also had the patronage and leisure required to produce great art. In this atmosphere, an important academy of painting in East Asia developed. The literature from the period details a complex picture of masters, theories, students, and instructions for painting. Although few early paintings survive, they are

known by many later copies. In this context a true school of landscape painting evolved whose artists were concerned with rendering the appearance of nature. Sherman Lee, a noted authority on Chinese art, writes: "The changing, variegated, visible landscape has become a map of the one, unchangeable moral and metaphysical heart of things and therefore a fit subject for understanding. Painting a landscape, as well as observing one either real or painted, has become an act of spiritual knowing and regeneration."[3]

The diversity of the work produced is so great that scholars usually organize the styles of painting into five categories: courtly, monumental, literal, lyrical, and spontaneous. The courtly style, originating in Tang art, influenced the other developments as well.

The monumental style is the mode of the landscape. *Buddhist Retreat by Stream and Mountains,* by Juran, active between A.D. 960 and 980, is a hanging scroll seventy-three inches long (Fig. 16-12). The painting has

16-12 Buddhist Retreat by Stream and Mountains, *attributed to Juran, Chinese, active c. 960–980, Northern Song dynasty. Hanging scroll, ink on silk, height 185.4 cm. (Copyright The Cleveland Museum of Art, 1996. Gift of Katherine Holden Thayer, 1959.348)*

16-11 *Ewer. Xing ware, height 15⅜". China, Tang dynasty. (British Museum, London)*

[3] Sherman Lee, *A History of Far Eastern Art* (New York: Abrams, 1982), pp. 344–45.

a vertical format, which is demanded by the scroll. Foreground and background are clearly separated with a modest transitional middle ground. The monochromatic brushwork appears soft, open, and wet, creating a sense of atmosphere and light. The scroll is similarly organized in *Travelers Amid Mountains and Streams* (Fig. 16-13) by Fan Kuan (active c. A.D. 990–1030). The ink-on-silk painting almost perfectly represents the position of human beings in a natural setting, which takes precedence over people who move through it and either choose to contemplate its greatness or, in the face of nature's indifference, ignore the comfort and enlightenment that contemplation can bring.

The literal style is identified with artists who created simple masterworks such as *Ladies Preparing Newly Woven Silk* (Fig. 16-14). Famous practitioners like Ma Yuan and Xia Gui brought vigor and simplicity to the handscroll paintings, which unroll horizontally and therefore are organized horizontally. The lyrical paintings entitled *Flying Geese over Distant Mountains, Returning to the Village in Mist from the Ferry, The Clear and Sonorous Air of the Fisherman's Flute,* and *Boats Moored at Night in a Misty Bay* from the scroll *Twelve Views of Landscape* by Xia Gui (active c. 1220–1250) contrast sharply with the power of the monumental landscape; they appear romantic and distant, views of nature isolated in time and space, like Li Shan's *Wind and Snow in the Firpines* (Fig. 16-15).

The fifth style, the spontaneous, has its origins in ink drawing. *Six Persimmons,* an ink-on-paper single sheet, was painted in the early thirteenth century by the artist Mu-Qi (also thought to be called Fa-Chang) (Fig. 16-16). The persimmons are reduced to a few elegant, eloquent strokes that suggest volume and mass in a shallow but clear space. This work bears a close resemblance to paintings from eighteenth-century Europe in the reduction of means to achieve a simple, elegant end.

16-13 Travelers Amid Mountains and Streams, *Fan Kuan (active c. 990–1030). Hanging scroll, ink on silk, height 81¼". Northern Song dynasty. (National Museum of Art, Taibei, Taiwan)*

16-14 Ladies Preparing Newly Woven Silk, *attributed to Emperor Huizong. China, Northern Song dynasty, early twelfth century. Handscroll, ink, color, and gold on silk. 37 × 145.3 cm. (Courtesy, Museum of Fine Arts, Boston)*

16-15 *Li Shan (active early thirteenth century),* Wind and Snow in the Firpines, *Jin dynasty. Handscroll, ink and color on silk, 29.7 × 79.2 cm. (Freer Gallery of Art, Washington, D.C.)*

16-16 Six Persimmons, *by Mu-Qi (Fa-Chang). Ink on paper, width 14¼″. Southern Song Dynasty. (Daitoku-ji, Kyoto)*

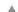

• This painting seems, to some westerners, very contemporary in concept and execution and could be compared not only with nineteenth- and twentieth-century European painting, but also with American advertising art. What characteristics of the work support these ideas? Is the painting abstract or stylized, naturalistic or realistic?

The vitality of landscape painting also testifies to the important role of the artist in Chinese society. Artists were not specialists isolated from society as we have come to think of them in the West. They were of-

ten poets, scholars, and even bureaucrats as well as artists. These multiple roles were not mutually exclusive but rather mutually reinforcing.

The Imperial City and the Garden

The human-centered nature of Chinese art and poetry is also present in the evolution of architecture. In a nation of great numbers of people confined to a tight landscape, the duality of community and privacy is vividly created in the architecture of the house, the royal court, and the garden.

The courtyard house is an expression of the desire for privacy and interiority. "Inside his walls, he [a Chinese] regulates human relationships to achieve internal harmony, to him the highest goal on earth."[4]

Cities in China have traditionally been made up of *fang,* that is, squares of courtyard houses within a network of streets. A prominent location within the fang was considered to be prestigious. The capital city held the central and most complex house and courtyard—the emperor's home. In the last six hundred years of the empire, this was known as the Forbidden City in Beijing.

The imperial city sits within three sets of walls: those of the city itself, those of Beijing, and finally, at a great distance, the Great Wall, erected millennia before. The organization of the space within the city is difficult to grasp without experiencing it. The combination of courtyards, gates, elevated platforms, distances, and the

[4] Nelson I. Wu, *Chinese and Indian Architecture (The Great Ages of World Architecture)* (New York: George Braziller, 1963), p. 35.

scale of the buildings is designed to create a sense of going in and going up (Fig. 16-17). The complex is arranged along a south-facing axis that culminates in the emperor's audience hall. The series of courtyards and rectangular pavilions is complemented by the circular and semicircular forms of intermediate spaces such as the Temple of Heaven, a circular domed space where the emperor offers annual prayers. This orderly process of spaces is balanced by the garden.

The Chinese were not the only people to enjoy the landscaped garden where one could go for repose. The Persians, the Romans, and the Italians of the Renaissance all had such gardens. The Chinese garden of the Ming dynasty is a place that is composed like a painting. This idea came to Europe in the eighteenth century, and the garden *à la chinoise* became the rage. The English took it most seriously—so much so that the pagoda became a stock figure in the magnificent landscape gardens at many great country houses. But the essential idea—to seek nature in its infinite variety and its stark objectivity as a place for contemplation and for recognition of life's transitoriness—matched with many of the impulses that informed Song landscape painting. It also resonated in subsequent Chinese painting and the poetry of a people who found themselves at the center of the earth, in the Middle Kingdom.

Music

There is no single type of Chinese music. The vast area of Asia that includes the People's Republic of China and Taiwan holds not only the musical traditions of the ethnic majority, the Chinese, but also those of the many minority populations of Inner Mongolia, Tibet, and elsewhere. In each of these civilizations, many classical, popular, folk, and sacred kinds of music have developed, evolved, changed, disappeared, or crystallized.

Throughout the centuries China has been both giver and taker in its cultural exchange with the outside world—especially with the areas now called Japan and Korea, but also with the Near East, North Africa, and even Europe by way of the silk and spice trade routes. Over the past hundred years, a few of the many important types of Chinese classical and popular music have been exported and performed in Europe and America and have received great attention and critical acclaim. Their beauty and exotic qualities have appealed not only to a popular audience in the West but also to Western composers, such as Debussy, Ravel, and Puccini, and have provided material for new areas of expression. But it is the intrinsic beauty of the music and drama that commends itself for listening and enjoyment today.

Among the great classical traditions of China, perhaps the most famous is that which we call Chinese opera, an outgrowth of music for the imperial court beginning over two thousand years ago in the Qin dynasty and extending to the last dynasty, the Qing (1644–1911). At first hearing, this music sounds very different from Western music, so let us first consider the similarities. Like Western music, Chinese music is melodic, and both Chinese and Western melodies use scales. The major difference between Chinese and Western scales lies in the division of the octave—that is, the number and placement of tones within a specified melodic range. Whereas westerners have become accustomed to a single arrangement of pitches, Asians have incorporated different groupings into their music. Western listeners can learn to recognize individual Asian melodies but often find it difficult to reproduce them because the pitch organization is unfamiliar. Chinese melodies have form and rhythm and involve improvisation and accompaniment, as well as other features familiar to Western listeners, but often the characteristics of these elements vary from those in European music.

Peking Opera

Chinese opera is a classical type of music, just as is grand opera in the West. Both are performed and reperformed in a basically unchanging style for an audience familiar with the plots, characters, costumes, famous performers, and well-loved numbers. However, Eastern and Western plots differ, and the methods of vocal production, the nature of the respective languages (such as Chinese and Italian), the stylization, costume, dance,

16-17 *Summer Palace, Beijing, China. (Superstock)* **(W)**

and the instruments of accompaniment are dissimilar enough to create interesting points for comparison. These differences, as well as the similarities, help to build drama and to create excitement, beauty, and art. Furthermore, Chinese music is just as emotional as is that of the West. Even Confucius, writing in the sixth century B.C. argued, as did Plato in classical Greece, that music affects the emotions. He urged that it be used for education as both moderation in life and lack of excess in music lead to fulfillment, satisfaction, and maturity—ideas that are universal rather than Eastern or Western.

Chinese opera is more properly called Peking opera because acting companies were brought from southern China to Peking (now called Beijing) in 1790 to celebrate the eightieth birthday of the emperor, and the Peking opera style was established at this time. The Peking opera's repertoire comprises about four hundred plays, whose heroes derive from ancient and mythological times. Even though written during the past two centuries, these dramas are all anonymous. The musicians of the orchestra—four to eight instrumentalists—play without a score or conductor. They are divided into two sections: civil instruments (strings and most woodwinds) and military instruments (drums, cymbals, gongs, and occasional loud wind instruments). The roles are stylized, and the singers of parts representing women and youths must sing in a high-pitched falsetto—even the women singing women's roles. Originally, only men and boys were allowed on stage, but this is no longer the case. Many conventions and gestures have become stylized and are learned by both the actors and the audience. For example, a male character laughs with his face uncovered, but a woman laughs behind her sleeve. The *er hu,* a two-stringed bowed instrument, accompanies tender events, such as peaceful sleep or the contemplation of beautiful nature, but the *sou na,* a Chinese reed instrument similar to the oboe, accompanies group action, such as the entrance of courtiers. Acrobatic dances of sword- and spear-wielding men to the sound of percussion instruments portray military attacks. The characters sometimes wear masks and always use makeup. Red indicates courage; black, vigor; blue, cruelty. These conventions, combined with stylized actions, athletic dance, well-known plots, and a minimum of scenery, accompany the melodies and songs that tell the stories, express the emotions, and unify an evening's entertainment.

Many of the characters are traditional, and one can expect each to perform his or her share of the drama—the old man, the old woman, the young heroine, the scholar-lover, the king, the warrior, the priest. Among the male roles, the lovers, scholars, and youthful warriors never wear beards, and their makeup is very like that of the female characters, white and pink. The acrobats play bandits, supernatural spirits, or opposing warriors, and they perform high leaps above each other, incredible handsprings, and somersaults. They often wrestle, box, or fight with bows, swords, and spears.

One opera, *The Emperor's Farewell to His Favorite,* has remained very popular with theatergoers in Beijing and has been introduced to the West through the film *Farewell, My Concubine.* The plot centers on the king of a Chinese state in the third century B.C. Although he is courageous, he is also impulsive and violent, and these characteristics lead to ultimate disaster, for his opponents are thoughtful strategists. Wherever he travels, even to battle, the king brings his favorite courtesan with him. When he goes to battle, in armor, she accompanies him in her own chariot. The opera focuses on the day when, after seventy successful previous battles, the king fights in the mountains, is defeated, and is surrounded by an approaching enemy.

Fearing for his mistress, he tells her to give herself up to the enemy and thus save her life. Instead, she comforts him and performs a ritual dance. As she dances she tells him that the ancients do not lie, that "greatness and decadence are only one step apart." At the end of her dance, she takes a sword and kills herself. The king takes up his sword, too, and charges his enemies. Finally, when he is about to be subdued, he kills himself. His faithful horse, distraught at seeing his dead master, leaps into the river and is drowned. The drama ends as the instruments of the orchestra play music to represent the neighing of the drowning animal. All the elements of tragedy, in the Western sense, are here. The protagonist is more than an ordinary man, but he is also a hero with a flaw that leads to his destruction. Before the end, a recognition scene takes place, and he sees life and himself in a new light. Though he grows, he still must pay the penalty.

Another traditional Peking opera, *Beating the Dragon Robe,* bears some resemblance to the Oedipus story of classical Greece, but is also markedly different. When a son is born to Emperor Chao Chen I of the Song dynasty (A.D. 960–1279), two servants steal the child immediately after his birth and put a tailless cat in his place. The emperor banishes the empress for having given birth to a devil, and the child is raised by a courtesan who claims he is her son by the emperor. In manhood, he ascends the throne after his father's death and becomes Emperor Chao Chen II. During a festival, an official of the court accuses the emperor of lack of filial respect, for he has not recognized his own mother, an old, blind beggar woman. The emperor is displeased and orders the official's arrest. However, when he learns the truth, he performs acts of humility to show his regret and restores his mother to the throne. When the empress miraculously regains her sight and sees her son for the first time, she commands that her son be beaten—an

impossible act and an insoluble dilemma. Emperors cannot be punished. The official saves the day by suggesting that the emperor's robe, the Dragon Robe, be beaten instead. By this symbolic fulfillment of the empress's command, the law is satisfied; the official is promoted, and mother and son are reconciled.

CD-1,21

When *Beating the Dragon Robe* opens, the instruments of the orchestra announce the presence of Emperor Chao Chen I and his attendants. He sings, in falsetto, and recites:

> Phoenix Pavilion, Dragon Tower, may the Kingdom reign forever!

A court official declares:

> Felicitations to the Emperor! May he live 10,000 years!

The emperor sings:

> As my Imperial hat is mounted with nine dragons,
> So shines the sun on my nine continents.
> As the Big Dipper bows to the stars of the southern heavens,
> So do all peoples of the 10,000 nations bow before me.
> I am the Emperor Chao Chen of the Sung Dynasty.
> Since I ascended the throne, the winds have been calm and the rains abundant.
> The country is prosperous and the people are at peace.

And the opera continues.

from the *Analecta (Commentaries and Sayings) of Confucius*
Translation by Arthur Waley

Personality and Character

1. [In his leisure hours, Confucius was easy in his manner and cheerful in his expression. Confucius was gentle yet firm, dignified but not harsh, respectful yet well at ease. . . .]

6. [Confucius said that he was] "a person who forgets to eat when he is enthusiastic about something, forgets all his worries in his enjoyment of it, and is not aware that old age is coming on."

16. [Confucius also said]: "At fifteen, I set my heart on learning. At thirty, I was firmly established. At forty, I had no more doubts. At fifty, I knew the Will of Heaven. At sixty, I was ready to listen to it. At seventy, I could follow my heart's desire without transgressing what was right."

Education

22. Confucius said: "By nature men are pretty much alike; it is learning and practice that set them apart."

23. Confucius said: "In education there are no class distinctions."

32. Confucius said: "A young man's duty is to be filial to his parents at home and respectful to his elders abroad, to be circumspect and truthful, and while overflowing with love for all men, to associate himself with humanity (*jen* [*ren*]). If, when all that is done, he has any energy to spare, then let him study the polite arts."

Humanity

45. Fan Ch'ih [Fan Chi] asked about humanity. Confucius said: "Love men."

46. Tzu Chang [Zi Zhang] asked Confucius about humanity. Confucius said: "To be able to practice five virtues everywhere in the world constitutes humanity." Tzu Chang begged to know what these were. Confucius said: "Courtesy, magnanimity, good faith, diligence, and kindness. He who is courteous is not humiliated, he who is magnanimous wins the multitude, he who is of good faith is trusted by the people, he who is diligent attains his objective, and he who is kind can get service from the people."

53. Confucius said: "Riches and honor are what every man desires, but if they can be obtained only by transgressing the right way, they must not be held."

Relations with Parents

56. Tzu Yu [Zi You] asked about filial piety. Confucius said: "Nowadays a filial son is just a man who keeps his parents in food. But even dogs or horses are given food. If there is no feeling of reverence, wherein lies the difference?"

Religious Sentiment

67. Tzu Lu [Zi Lu] asked about the worship of ghosts and spirits. Confucius said: "We don't know yet how to serve men, how can we know about serving the spirits?" "What about death," was the next question. Confucius said: "We don't know yet about life, how can we know about death?"

68. Confucius said: "Devote yourself to the proper demands of the people, respect the ghosts and spirits but keep them at a distance—this may be called wisdom."

72. Confucius said: "He who sins against Heaven has none to whom he can pray."

74. Tzu Kung [Zi Gong] said: "The Master's views on culture and refinement we can comprehend. But his discourses about man's nature and the ways of Heaven none of us can comprehend."

77. The Master did not talk about weird things, physical exploits, disorders, and spirits.

The Gentleman

78. Confucius said: "When nature exceeds art you have the rustic. When art exceeds nature you have the clerk. It is only when art and nature are harmoniously blended that you have the gentleman.

79. If a gentleman departs from humanity, how can he bear the name?

81. The gentleman has neither anxiety nor fear.

82. The way of the gentleman is threefold. I myself have not been able to attain any of them. Being humane, he has no anxieties; being wise, he has no perplexities; being brave, he has no fear." Tzu Kung said: "But, Master, that is your own way."

Government

95. Confucius said: "If a ruler himself is upright, all will go well without orders. But if he himself is not upright, even though he gives orders they will not be obeyed.

96. He cultivates himself so as to be able to bring comfort to the whole populace.

98. Just so you genuinely desire the good, the people will be good. The virtue of the gentleman may be compared to the wind and that of the commoner to the weeds. The weeds under the force of the wind cannot but bend."

100. Tzu Kung asked about government. Confucius said: "The essentials are sufficient food, sufficient troops, and the confidence of the people." Tzu Kung said: "Suppose you were forced to give up one of these three, which would you let go first?" Confucius said: "The troops." Tzu Kung asked again: "If you are forced to give up one of the two remaining, which would you let go?" Confucius said: "Food. For from of old, death has been the lot of all men, but a people without faith cannot survive."

QUESTIONS

1. From the admittedly fragmentary evidence you have been given, describe your conception of Confucius as a human being.
2. What do you understand by the term *Confucian*?
3. Do you think that the frequently made comparison of Confucius with Socrates is justified?

LAO ZI

Dao De Jing (Tao-te Ching)

It is unclear whether there was an actual poet named Lao Zi (Lao-tzu), and when or where he lived. Chinese scholars refer to the texts by the name of the author (or alleged author), as might be done for Homer. The poems from which these sections are taken are thought to come from about the fifth century B.C., though that too is uncertain.

The Tao [Dao] that can be told of
Is not the eternal Tao;
The name that can be named
Is not the eternal name.
Nameless, it is the origin of Heaven and earth;
Namable, it is the mother of all things.

Always nonexistent,
That we may apprehend its inner secret;
Always existent,
That we may discern its outer manifestations.
These two are the same;
Only as they manifest themselves they receive different
 names.

That they are the same is the mystery.
Mystery of all mysteries!
The door of all subtleties! . . .

The Tao is empty [like a bowl],
It is used, though perhaps never full.
It is fathomless, possibly the progenitor of all things.
It blunts all sharpness,
It unties all tangles;
It is in harmony with all light,
It is one with all dust.
Deep and clear it seems forever to remain.
I do not know whose son it is,
A phenomenon that apparently preceded the Lord. . . .

He who knows the eternal is all-embracing;
He who is all-embracing is impartial,
To be impartial is to be kingly,
To be kingly is to be heavenly,
To be heavenly is to be one with the Tao,
To be one with the Tao is to endure forever.
Such a one, though his body perish, is never exposed to
 danger. . . .

It was when the Great Tao declined,
That there appeared humanity and righteousness,
It was when knowledge and intelligence arose,
That there appeared much hypocrisy.
It was when the six relations lost their harmony,
That there was talk of filial piety and paternal
 affection.
It was when the country fell into chaos and
 confusion,
That there was talk of loyalty and trustworthiness. . . .

There was something nebulous but complete,
Born before Heaven and earth.
Silent, empty,
Self-sufficient and unchanging,
Resolving without cease and without fail,
It acts as the mother of the world.

I do not know its name,
And address it as "Tao."
Attempting to give it a name, I shall call it "Great."
To be great is to pass on.
To pass on is to go further and further away.
To go further and further away is to return.

Therefore Tao is great, Heaven is great, earth is great,
And the king is also great.
These are the Great Four in the universe,
And the king is one of them.
Man follows the ways of earth,
Earth follows the ways of Heaven;
Heaven follows the ways of Tao;
Tao follows the ways of itself. . . .

Tao gave birth to One; One gave birth to Two; Two gave birth to Three; Three gave birth to all to myriad things. The myriad things carry the yin on their backs and hold the yang in their embrace, and derive their harmony from the permeation of these forces. . . .

Of all things yielding and weak in the world,
None is more so than water,
But for attacking what is unyielding and strong,
Nothing is superior to it,
Nothing can take its place.

That the weak overcomes the strong,
And the yielding overcomes the unyielding,
Everyone knows this,
But no one can translate it into action.

Therefore the sage says:
"He who takes the dirt of the country,
Is the lord of the state;
He who bears the calamities of the country,
Is the king of the world."
Truth sounds paradoxical! . . .

GOU XIANG

Commentary on the Chuang Tzu

Chuang Tzu (Zhuang Zi in pinyin) was a Daoist philosopher of the fourth century B.C. Gou Xiang (Kuo Hsiang) was an admirer of the so-called neo-Daoist period. He died in A.D. 312.

Contentment

If a person is perfectly at ease with his spirit and physical power, whether he lifts something heavy or carries something light, it is due to the fact that he is us-ing his strength to a desired degree. If a person loves fame and is fond of supremacy and is not satisfied even when he has broken his back in the attempt, it is due to the fact that human knowledge knows no limit. Therefore what is called knowledge is born of our losing our balance and will be eliminated when ultimate capacity is realized intuitively. Intuitively realizing ultimate capacity means allowing one's lot to reach its highest degree, and [in the case of lifting weights] not adding so much as an ounce beyond that. Therefore though a person carries ten thousand pounds, if it is equal to his capacity he will suddenly forget the weight upon his body. Though a person attends to ten thousand matters [if his capacity is equal to them] he will be utterly unaware that the affairs are upon him. These are the fundamentals for the cultivation of life. . . . If one attains the Mean and intuitively realizes the proper limit, everything can be done. The cultivation of life does not seek to exceed one's lot but to preserve the principle of things and to live out one's allotted span of life.

Joy and sorrow are the results of gains and losses. A gentleman who profoundly penetrates all things and is in harmony with their transformations will be contented with whatever time may bring. He follows the course of nature in whatever situation he may be. He will be intuitively united with creation. He will be himself wherever he may be. Where does gain or loss, life or death, come in? Therefore, if one lets what he has received from nature take its own course, there will be no place for joy or sorrow.

QUESTIONS

1. Why do you suppose you don't understand Daoism?
2. Is Gou Xiang's definition of contentment persuasive?
3. Do the metaphors in the *Dao De Jing* guide the reader toward an intuitive perception of the "Dao"? Can you apply this same intuition to your viewing of Daoist painting?

ZONG BING

Introduction to Landscape Painting

Zong Bing (Tsung Ping, A.D. 375–443) was a Daoist painter, although none of his artistic creations has survived. The Daoist philosophy of wholeness, maintaining that art must represent not only the outward appearance but the indwelling spirit of inanimate objects such as mountains or seas, is an important influence on Chinese art.

Having embraced Tao [Dao] the sage responds harmoniously to things. Having purified his mind, the

worthy man enjoys forms. As to landscapes, they exist in material substance and soar into the realm of the spirit. . . . Mountains and rivers in their form pay homage to Tao, and the man of humanity delights in them. Do not the sage [Confucius] and mountains and rivers have much in common?

I was strongly attached to the Lu and Heng Mountains and had missed for a long time Mounts Ching and Wu, and [like Confucius] did not realize that old age was coming on. I am ashamed that I can no longer concentrate my vital power or nourish my body. . . . Therefore I draw forms and spread colors, and create these mountain peaks capped with clouds.

Now, the Principle that was lost in ancient times may, through imagination, be found in the thousand years yet to come. Meanings that are subtle and beyond the expression of words and symbols may be grasped by the mind through books and writings. How much more so in my case, when I have personally lingered among [the mountains] and, with my own eyes, observed them all around me, so that I render forms as I find the forms to be and apply colors as I see them! . . .

If truth is understood as what is responsive to the eye and appreciable to the mind, then when the representation is skillful, the eye also responds and the mind also appreciates. Such response and appreciation arouse the spirit. As the spirit soars high, truth is attained. What is there to gain by merely searching for the dark crags? . . .

And so I live in leisure and nourish my vital power. I drain clean the wine-cup, play the lute, lay down the picture of scenery, face it in silence, and, while seated, travel beyond the four borders of the land, never leaving the realm where nature exerts her influence, and alone responding to the call of wilderness. Here the cliffs and peaks seem to rise to soaring heights, and groves in the midst of clouds are dense and extend to the vanishing point. Sages and virtuous men of far antiquity come back to live in my imagination and all interesting things come together in my spirit and in my thoughts. What else need I do? I gratify my spirit, that is all. What is there that is more important than gratifying the spirit?

QUESTIONS

1. In what way is this statement Daoist?
2. How might a painter who was not a Daoist explain the craft of painting differently?

● OTHER BUDDHIST ● COMMENTARY

In order for Buddhism to take root in China, its proponents had to synthesize it with Chinese ethics and philosophy. Their foremost spokesman was Mou Zi (Mou Tzu), but very little is known about him.

Mou Tzu [Mou Zi] said: All written works need not necessarily be the words of Confucius, and all medicine does not necessarily consist of the formulae of [the famous physician] P'ien-ch'ueh. What accords with principle is to be followed, what heals the sick is good. . . . The records and teachings of the Five Classics do not contain everything. Even if the Buddha is not mentioned in them, what occasion is there for suspicion? . . .

Why Do Monks Not Marry?

The questioner said: Now of felicities there is none greater than the continuation of one's line, of unfilial conduct there is none worse than childlessness. The monks forsake wife and children, reject property and wealth. Some do not marry all their lives. How opposed this conduct is to felicity and filial piety! . . .

Mou Tzu said: Wives, children, and property are the luxuries of the world, but simple living and inaction are the wonders of the Way. . . . The monk practices the Way and substitutes them for the pleasure of disporting himself in the world. He accumulates goodness and wisdom in exchange for the joys of wife and children.

[Another Buddhist, Hui-Yuan (A.D. 334–417), commented on the question of immortality.]

Question: The receipt of spirit is limited to one life. When the life is exhausted, the breath evaporates, and it is the same as nothing. The spirit, though it is more subtle than matter, is still a transformed manifestation of the yin and the yang. When they have been transformed there is life; when they are transformed again there is death. When they come together there is a beginning; when they disperse there is an end. If one reasons from this, one must know that the spirit and the body are transformed together, and that originally they are of the same line. . . . Also, the spirit resides in the body as fire is in the wood. While [the body] lives [the spirit] exists, but when [the body] crumbles [the spirit] must perish. When the body departs the soul disperses and has no dwelling. When the tree rots the fire dies out and has nothing to attach to. That is the principle. . . .

Answer: What is the spirit? It is subtlety that has reached the extreme and become immaterial. . . . The spirit is in perfect accord and has no creator; it is subtle to the extreme and has no name. In response to beings it moves; borrowing an individual lot [the life of a person] it acts. It responds to things but it is not a thing; therefore though the things may change it does not perish. It borrows a lot [in life] but it is not itself that lot; therefore though the lot be run out, it does not end. Having feelings, it can respond to things; having intelligence, it can be found [embodied] in allotted destinies.

There are subtle and gross destinies and therefore the nature of each is different. There are bright and dull intellects and therefore their understanding is not always the same. . . . The feelings have a way of uniting with physical things, and the spirit has the power of moving imperceptibly. But a person of penetrating perception returns to the Source, while one who is lost in the principle merely runs after physical things. . . .

The passage of fire to firewood is like the passage of the soul to a new body. The passage of fire to different firewood is like the passage of the soul to a new body. . . . The person in error, seeing the body wither in one life, thinks that the spirit and the feelings perish with it. It is as if one were to see the fire die out in one piece of wood, and say that all fire had been exhausted for all time.

QUESTIONS

1. What criticisms of Buddhism by Confucians is Mou Zi trying to answer?
2. How does Hui-Yuan respond to the questioner, who clearly believes that the spirit dies with the body? Does the movement of the spirit ever cease?

BAN JIEYU (PAN CHIEH-YÜ)

Poem in Rhyme-Prose Form

Translation by Burton Watson

Lady Pan, a favorite concubine of Emperor Ch'eng [Cheng] (32–7 B.C.), is known by her court title *Chieh-yü* or Beautiful Companion, her personal name being unknown. She bore the emperor two sons but both died in infancy. Later, when she lost favor and was slandered by rivals, she asked permission to take up residence in the eastern palace, the Palace of Lasting Trust, where she waited on the empress dowager. In the following untitled poem in *fu* form, she gives vent to her sadness.[1]

Virtue of ancestors handed down
bestowed on me precious life as a human being,
allowed me, humble creature, to ascend to the palace,
to fill a lower rank in the women's quarters.
I enjoyed the holy sovereign's most generous grace,
basked in the radiance of sun and moon.
Burning rays of redness shone on me,
I was granted highest favor in the Tseng-ch'eng Lodge.
Already receiving blessings beyond what I deserved,
I yet ventured to hope for more happy times,
sighing repeatedly, waking or asleep,

undoing my girdle strings with thoughts of the past.[2]
I spread out paintings of women, made them my mirror,
looked to my instructress, queried her on the *Odes*;
I was moved by the warning of the woman who crows,
pained at the sins of the lovely Pao-ssu;
I praised Huang and Ying, wives of the lord of Yü,
admired Jen and Ssu, mothers of Chou.[3]
Though I'm foolish and uncouth, no match for these,
would I dare turn my thoughts away, let them be
 forgotten?
The years pass in sorrow and apprehension;
I grieve for lush flowers that no longer flourish,[4]
weep for the Yang-lu Hall, Hall of the Wild Mulberry,[5]
babes in swaddling clothes who met with woe.
Surely it was due to no error of mine!
Heaven's decrees—can they never be changed?
Before I knew it, the bright sun had veiled its light,
leaving me in the dusk of evening,
but still the ruler's kindness sustains and shelters me;
in spite of faults, I have not been cast off.
I serve the empress dowager in her eastern palace,
take my place among lesser maids in the Palace of
 Lasting Trust;
I help to sprinkle and sweep among the curtains,
and shall do so till death brings my term to a close.
Then may my bones find rest at the foot of the hill,
a little shade of pine and cypress left over for my grave.

Recapitulation:
Hidden in the black palace, gloomy and chill,
main gates bolted, gates to inner quarters barred,
dust in the painted hall, moss on marble stairs,
courtyards rank with green grass growing,
spacious rooms shadowy, curtains dark,
chamber windows gaping, wind sharp and cold,
blowing my skirts, stirring their crimson gauze,
flapping, rustling them, making the silk sound.
My spirit roams far off to places secret and still;
since my lord departed, who finds joy in me?
I look down at red flagstones, remembering how he
 trod them,
look up at cloudy rafters, two streams of tears flowing;

1 [Translator's introduction and notes.]

2 When a girl was about to be married, her father fastened the strings of her girdle and gave her words of instruction and warning; Lady Pan is recalling that time.

3 A hen that crows at dawn in place of the rooster is an ancient symbol for a domineering woman; the specific reference here is to Ta-chi, concubine of the evil last ruler of the Shang dynasty. The beautiful but treacherous Pao-ssu brought about the downfall of King Yu of the Chou. O-huang and Nü-ying were daughters of the sage ruler Yao; he gave them in marriage to his successor to the throne Shun, the lord of Yü. T'ai-jen and T'ai-ssu were the mothers of kings Wen and Wu respectively, the founders of the Chou dynasty. Most of these women are mentioned in the *Book of Odes* and were no doubt depicted in the paintings that Lady Pan was perusing for her instruction.

4 The flowers are her own fading youth and beauty.

5 The halls are the places where she bore her two sons.

then I turn to left and right, my expression softening,
dip the winged wine cup to drive away care.
I reflect that man, born into this world,
passes as swiftly as though floating on a stream.
Already I've known fame and eminence,
the finest gifts the living can enjoy.
I will strive to please my spirit, taste every delight,
since true happiness cannot be counted on.
"Green Robe"—"White Flower"—in ancient times as
 now.[6]

Song of Regret
Translation by Burton Watson

The poem is of uncertain date, though it has tradi-
tionally been attributed to Lady Pan.

To begin I cut fine silk of Ch'i,
white and pure as frost or snow,
shape it to make a paired-joy fan,
round, round as the luminous moon,
to go in and out of my lord's breast;
when lifted, to stir him a gentle breeze.
But always I dread the coming of autumn,
cold winds that scatter the burning heat,
when it will be laid away in the hamper,
love and favor cut off midway.

QUESTIONS

1. What information does the first poem give about the
 position of women in the Chinese royal court?
2. What is the tone in each poem and what emotions
 are expressed?
3. What images does the poet use? Do they seem
 specifically Chinese?

● POETS OF THE TANG DYNASTY: ●
WANG WEI AND LI BO

Wang Wei (c. 699–761) was a devout Buddhist, and a
painter and musician as well as a poet. Like many
other writers and intellectuals, he was a civil servant,
having passed the examination at an early age. Some
of his poetry is about court functions, but he is best

known for the poems on nature written during his pe-
riods of voluntary or imposed exile in the country. His
observations of the phenomena of nature, to which
human beings do not appear to be superior, may be
considered characteristic of Mahayana Buddhism.

The best-known Chinese poet in the West is un-
doubtedly Li Bo (Li Po, 701–762), perhaps because
of his spontaneity and the originality of his imagina-
tion. Like Wang Wei, he served Emperor Xuan Zong
in the imperial court, but because of his eccentricity,
he was eventually dismissed. He then began to travel
extensively throughout China, producing about a
thousand poems on the spiritual refreshment pro-
vided by nature, as well as on the carefree life,
friendship, and love of wine.

WANG WEI

from *Joys of the Country*
Translation by Burton Watson

Lush lush, fragrant grasses in autumn green;
tall tall, towering pines in summer cold;
cows and sheep come home by themselves to village
 lanes;
little boys know nothing of capped and robed officials.

Seeing Someone Off

We dismount; I give you wine
and ask, where are you off to?
You answer, nothing goes right!—
back home to lie down by Southern Mountain.
Go then—I'll ask no more—
there's no end to white clouds there.

At My Country Home in Chung-nan

Middle Age—I grow somewhat fond of the Way,
my evening home at the foot of the southern hills.
When moods come I follow them alone,
to no purpose learning fine things for myself,
going till I come to where the river ends,
sitting and watching when clouds rise up.
By chance I meet an old man of the woods;
we talk and laugh—we have no "going-home" time.

Visiting the Temple of Accumulated Fragrance

I didn't know where the temple was,
pushing mile on mile among cloudy peaks;
old trees, peopleless paths,

[6] The song in the *Odes* entitled "Green Robe," no. 27, is said to de-
scribe a wife whose place has been usurped by concubines; "White
Flower," no. 229, is traditionally interpreted as censuring King Yu
of the Chou for putting aside his consort Queen Shen in favor of the
evil Pao-ssu. Lady Pan compares herself to these unfortunate
women of antiquity.

deep mountains, somewhere a bell.
Brook voices choke over craggy boulders,
sun rays turn cold in the green pines.
At dusk by the bend of a deserted pond,
a monk in meditation, taming poison dragons.[1]

Weather Newly Cleared, the View at Evening

Weather newly cleared, plains and meadows seem
 broader,
far as the eye can see, not a smudge of dust.
The hamlet gate overlooks the ferry landing,
village trees stretching down to the valley mouth.
White river shining beyond the paddies,
emerald peaks jutting up behind the hills—
these are the farming months, when no one's idle,
whole families out working in the southern fields.

QUESTIONS

1. How would you characterize Wang Wei's style?
2. To which landscape paintings can you compare his
 poetry? How?

LI BO

In Yüeh Viewing the Past

Translation by Burton Watson

Kou-chien [Goujian] was the ruler of Yüeh who
overthrew King Fu-ch'a [Fucha] of Wu.[1]

Kou-chien, king of Yüeh, came back from the broken
 land of Wu;
his brave men returned to their homes, all in robes of
 brocade.
Ladies in waiting like flowers filled his spring palace
where now only the partridges fly.

Autumn Cove

At Autumn Cove, so many white monkeys,
bounding, leaping up like snowflakes in flight!
They coax and pull their young ones down from the
 branches
to drink and frolic with the water-borne moon.

Viewing the Waterfall at Mount Lu

Sunlight streaming on Incense Stone kindles violet
 smoke;
far off I watch the waterfall plunge to the long river,
flying waters descending straight three thousand feet,
till I think the Milky Way has tumbled from the ninth
 height of Heaven.

Spring Night in Lo-yang— Hearing a Flute

The willow-breaking song is sung at parting, when
 people break off willow wands to use as gifts.

In what house, the jade flute that sends these dark
 notes drifting,
scattering on the spring wind that fills Lo-yang?
Tonight if we should hear the willow breaking song,
who could help but long for the gardens of home?

Still Night Thoughts

Moonlight in front of my bed—
I took it for frost on the ground!
I lift my eyes to watch the mountain moon,
lower them and dream of home.

Summer Day in the Mountains

Too lazy to wave the white plume fan,
stripped to the waist in the green wood's midst,
I loose my headcloth, hang it on a stony wall,
bare my topknot for the pine winds to riffle.

At Yellow Crane Tower Taking Leave of Meng-Hao-jan as He Sets off for Kuang-ling

The poet Meng Hao-jan [Meng Haoran] (689–740)
parted from Li Bo at Yellow Crane Tower, overlook-
ing the Yangtze at Wu-ch'ang in Hupei, to sail east
down the river to Yang-chou in Kiangsu.

My old friend takes leave of the west at Yellow Crane
 Tower,
in misty third-month blossoms goes downstream to
 Yang-chou.
The far-off shape of his lone sail disappears in the blue-
 green void,
and all I see is the long river flowing to the edge of the
 sky.

[1] The poison dragons are passions and illusions that impede enlight-
enment. They also recall the tale of a poison dragon that lived in a
lake and killed passing merchants until it was subdued by a certain
Prince P'an-t'o through the use of spells. The dragon changed into a
man and apologized for its evil ways. [Translator's note.]

[1] [Translator's introductions.]

Thinking of East Mountain

East Mountain is in Shao-hsing [Shaoxing] in Chekiang [Zhejiang].

It's been so long since I headed for East Mountain—
how many times have the roses bloomed?
White clouds have scattered themselves away—
and this bright moon—whose house is it setting on?

Seeing a Friend Off

Green hills sloping from the northern wall,
white water rounding the eastern city:
once parted from this place
the lone weed tumbles ten thousand miles.
Drifting clouds—a traveler's thoughts;
setting sun—an old friend's heart.
Wave hands and let us take leave now,
hsiao-hsiao our hesitant horses neighing.

A Night with a Friend

Dousing clean a thousand old cares,
sticking it out through a hundred pots of wine,
a good night needing the best of conversation,
a brilliant moon that will not let us sleep—
drunk we lie down in empty hills,
heaven and earth our quilt and pillow.

QUESTIONS

1. What seems to be Li Bo's philosophy of life?
2. Do you see any resemblance to Daoism in Li Bo's poetry?
3. Compare Li Bo's view of nature with that of Wang Wei.
4. What effect does the visual imagery of Chinese poetry have on you? Can you imagine it painted? Can you compare it with any poetry with which you are familiar?

Summary Questions

1. How did the religion of the nobles differ from that of the peasants? How did Chinese kingship reflect yet a third level of religious belief?
2. To what extent are Confucianism and Daoism religions in the Western sense?
3. What were the great accomplishments of the Han dynasty (206 B.C.–A.D. 221)?

4. In what sense was Chinese society a meritocracy by 900?
5. Why did western Europe and not China become the leading area of world power after 1500?
6. Compare and contrast the Chinese conceptions of poetry, painting, and music with their western counterparts.

Key Terms

ideograph

calligraphy

yin and yang

Confucianism

Daoism and dao

dynasty

fu

shi

porcelain

scroll

the Forbidden City

the Peking opera

The Civilizations of India and China

We have attempted to provide here a brief introduction to two vast and complex civilizations, focusing on some of the ways in which cultural values and the humanities in Asia both contrast and interact with those in the West. Perhaps one of the most salient features of the Asian societies to the westerner is the continuity of tradition in civilizations almost as old as those of Egypt and Mesopotamia, whereas Western history is marked by a pattern of rupture and change. Another contrast is the stress on harmony or reconciliation in Asian culture and the often violent clash of opposites in the West. Clearly such generalizations do not always hold true, and vast differences between India and China as well as within each civilization must also be considered.

Political Structures

For India and China, as for the other two great riverine cultures, Mesopotamia and Egypt, the model of a mature political organization was the imperial state: a successful ruling family expanded its control over large areas of land and over peoples who usually spoke various languages and shared different traditions. In both India and China the initial sources of imperial power were organized in northern areas and moved to conquer the southern regions of the country. By 200 B.C. the northern and southern parts of China were already unified under one government and, despite temporary divisions, remained united down to modern times. Fifty years earlier the Mauryan dynasty in India had accomplished the same feat, conquering most of the landmass of the subcontinent. Less than a century later, however, power again became fragmented. Although empires rose and fell during the following centuries, no imperial power in India until the seventeenth century matched the extent of domination achieved by the Mauryans. Consequently, because India never had the experience of China in being unified over a long period of time, the country exhibited greater cultural and linguistic diversity, especially between north and south.

China owed much of its political stability to its bureaucracy. Already in an incipient form around 100 B.C., the bureaucracy reached its final development as a meritocracy in the seventh and eighth centuries A.D. Thoroughly indoctrinated in the ways of imperial administration and deeply educated in the Confucian culture, the civil servants of the empire provided a continuity of government at the provincial level. Thus, despite sometimes violent political upheavals and invasions, they prevented wholesale rupture with political traditions. No other country had anything like this corps of civil servants before the nineteenth century.

The imperial structure of not only Asian but also Middle Eastern empires contrasted starkly with the political organizations of western Europe taking shape in the twelfth and thirteenth centuries. The barbarian invasions fragmented Europe politically over a long period of time—an experience unknown in other areas. Hence central power could be rebuilt only on a small scale and only after painful compromises with a fiercely independent warrior nobility. Helped by the economic revival, a new kind of political model, the medieval monarchy, arose after 1100. Encompassing a smaller territory than the traditional empire and restrained by law and custom, the medieval monarchy enjoyed an extraordinary degree of unity, based on a common language and common historical traditions. Centuries later, as the medieval monarchy changed into the nation-state, it threatened the existence of all imperial organizations.

Economic and Social Life

Until the late eighteenth century, every economy in the world was based on agriculture, and the Indian and Chinese economies were no exception. Both countries, however, witnessed a significant urban development. It

was most marked in China, where already under the Han (206 B.C.–A.D. 221) several cities may have had a million inhabitants. These large urban populations were maintained by intensive trade in food staples and luxury products, such as spices and costly fabrics, with other regions of the country and with areas outside. Chinese manufacturers of silk catered to aristocratic tastes throughout Southeast Asia and India and, by means of the Arabs, as far away as Spain. In the period from the fall of Rome in the fifth century to roughly 1200, Pacific and Indian Ocean trade dwarfed by its proportions commercial traffic along the Atlantic coast and the Mediterranean.

The immense resources of Indian and Chinese emperors, moreover, permitted them to embark on public projects inconceivable in western Europe until the seventeenth and eighteenth centuries. The emperors of China, in particular, used their resources in men and materials to construct vast systems of canals and irrigation projects, as well as erect what became the greatest human construction of all time, the Great Wall, stretching for over fifteen hundred miles.

By the start of the sixteenth century, western Europe owed to China inventions such as paper and movable type, key elements in the European Renaissance; the compass and sternpost rudder, vital for long-distance ocean travel and exploration; and gunpowder, a basic contribution to what would become the West's military superiority over the rest of the world. As for India, the Indian invention of the zero made modern mathematics possible. However, most Indian mathematical and astronomical discoveries did not reach the West.

The social structure of both Asian countries tended to be rigid, but for different reasons. In India, at least from the Gupta period on (fourth to fifth century A.D.), the caste system, anchored in the Hindu religion, became legally defined. Although never completely effective, it remained in place until modern times. These barriers often made it difficult for members from the lower castes to attain wealth. If they managed to do so, the lack of a high social position impeded them in exercising the political influence usually associated with money.

Even though class differentiation in China had little basis in religion, the social hierarchy was only somewhat less rigid than in India. The harsh economics of a society with limited but highly productive land and a population always pushing on the limits of sustenance gave immense power to landlords over those who tilled the soil. Throughout the centuries the urban economy fostered a rich, thriving merchant class. As in India it had little impact on politics, but not because of religion. In China the existence of a bureaucracy based on merit offered the capable sons of successful merchants an entry into the political elite. By drawing off the most ambitious members of the merchant class into the political establishment, the government prevented the merchant class from gaining political vigor and demanding a share of power.

Such co-opting of the merchant class did not occur in western Europe to any significant extent. By and large the warrior nobility of this society lived in the countryside. As the economic revival starting in the eleventh century encouraged urbanization, the merchant class grew in numbers and came to dominate city governments. Mostly unable to meld with the nobility, the merchants increasingly demanded that the monarchy recognize them as a political force since it had already given such recognition to the nobility. Because European monarchs were forced to respect the interests of both merchants and nobles, industrial and commercial concerns played a role in state policy unknown in the imperial societies of the East.

Religion and Philosophy

India gave birth to two of the world's great religions, Hinduism and Buddhism. It has also been greatly influenced by a third, Islam, and to some extent by a fourth, Christianity. Because the pantheon of Hindu gods is so extensive and the body of doctrines so vast, it is difficult to speak of a Hindu theology. Nonetheless, we have discussed some fundamental principles of Hinduism as they are explained by the god Krishna in the *Bhagavad Gita*: dharma, one's role in life; reincarnation, the progress of the soul through a cycle of deaths and rebirths until it ultimately attains peace in nirvana; and karma, the accumulated record of many lives. In addition, Hinduism recommends the practice of yoga, a word that means the bond or yoke between body and spirit. Although it has many different forms, yoga basically involves asceticism, or the disciplining of the body in order to enhance concentration and meditation and lead one to spiritual awakening. The form that emphasizes physical conditioning, hatha yoga, is now commonly practiced everywhere in the West.

The founder of Buddhism, Gautama Buddha, began his life as a devout Hindu and carried these beliefs and practices into the new religion. However, he sought to simplify the caste system, which was a crucial part of the Hindu culture. Buddha also developed a body of ethical teachings based on the notion of compassion that resembles in many ways the teachings of Jesus. In Mahayana Buddhism, his emphasis on the cessation of suffering through the attainment of nirvana was interpreted as a form of salvation not unlike the Christian belief in heaven.

Mahayana Buddhism played a less important role in India than in China, which did not develop a great world religion of its own. The two important Chinese systems of thought, Confucianism and Daoism, emphasize life in this world rather than in the next, although the mystical element of Daoism may also be considered religious. Often compared with Socrates, Confucius taught by asking provocative questions and making paradoxical statements, leaving their systematic interpretation to others. The "Confucian" system, whereby bureaucrats were chosen through competitive examinations rather than through class privilege, had a profound impact on Chinese society. Like the followers of Socrates, Confucians sought the best way to live in this world and espoused the practice of virtues such as honesty, loyalty, and integrity. Daoism appears to contrast with Confucianism in that its followers seek "the way" through the abandonment of the self to the natural rhythms of the universe rather than through rational thought. Yet in practice, the two are often blended. Buddhism, Confucianism, and Daoism, sometimes together, all had a profound impact on Chinese artistic expression.

Languages and Literature

Modern India has such a vast array of widely different languages that the former colonial language, English, must be used as the official bureaucratic tongue. The classical language of northern India, Sanskrit, gave birth to the language family known as Indo-European, which includes Greek, Latin, and all the major languages of modern Europe. Sanskrit was for centuries the literary language of India. The world's longest epic poem, the *Mahabharata,* as well as the other great Indian epic, the *Ramayana,* the famous love manual, the *Kamasutra,* and the dramas of Kalidasa were all written in Sanskrit. Modern Indian writers, however, use the many spoken languages, including English.

The Chinese language differs from other languages of the world in that it is primarily ideographic, or consisting of signs that represent ideas. Unlike India, China has a unified written language, although its spoken languages vary. Written Chinese is difficult to master, and calligraphy, often in combination with painting, is important as an art form. The Chinese invention of the printing press helped to disseminate Chinese literature throughout the empire. Unlike India, Mesopotamia, Greece, or Rome, China produced no epic poem to celebrate war and heroic feats. Influenced by Confucianism, Chinese literature tends rather to celebrate social virtues and investigate ethical issues. China has a rich tradition in drama and the novel, but it is its poetry—primarily lyric poetry—that has captured the imagina-

tion of the West and influenced a number of European and American poets. Often permeated by Daoism and sometimes by Buddhism, Chinese poetry tends to render emotional and mystical states through the concise visual portrayal of human beings in nature.

Art and Architecture

As in medieval Europe, art and architecture in India from its beginnings until the modern era have served primarily religious functions. The original Hindu temples and sculptures were eventually influenced both by Buddhism and by Western ideas from Greece. Both Buddhists and Hindus created temples and decorated caves for purposes of contemplation by pilgrims. One theme that runs throughout all Indian art is the emphasis on male and female forces, such as phallic columns and loving, fertile female figures. Since in this chapter we have focused on Hindu and Buddhist India, rather than on Muslim India, we have not discussed the most famous of all Indian monuments, the Taj Mahal—an architectural phenomenon unique in the world.

Whereas not much is known about the architects, sculptors, and painters of Hindu and Buddhist India, in China the position of artists as scholars, teachers, and thinkers was clearly established. Traditional Chinese art also displays an integration of ceramics, textiles, and furniture with painting, sculpture, and architecture—the type of integration that also existed in the West but changed with the Renaissance. Many believe that a view of the maker as artist is responsible for the creation of masterworks of true porcelain (china), stoneware and earthenware, carved jade, cast bronzes, and silk textiles. Although Chinese art is not nearly so linked to religion as Indian art, it also produced great Buddhist temples and sculptures. But perhaps the most distinct creations of Chinese architecture are the private house and the emperor's palace with their gardens; they had a profound impact on the West from the eighteenth century on. Chinese painting, usually on scrolls and depicting landscapes, displays an extraordinary variety of styles and subjects. While not religious, it often shows the influence of Daoism by encouraging the contemplation of the place of human beings in the vastness of nature.

Music

The musical traditions of India and China differ so much from those of the West that Indian and Chinese music is perhaps more difficult for westerners to approach than the other art forms. Based on the raga, a pair of scales, Indian music is intimately bound with

philosophy and spiritual thought, and the musician must practice yoga and contemplation to achieve mastery. Classical Indian music is often performed with dance, which has its own complex symbolic language. Chinese music is best known through the classical Peking opera, a highly stylized form of musical drama. As in Western music, but with very different results, certain instruments and certain melodies are used to produce emotional effects. In spite of its difference from the European tradition, Chinese music has influenced composers such as Debussy, Ravel, and Puccini.

The social structures, thought, religion, and the arts of these two ancient civilizations, as well as of other Asian cultures, have had a profound effect on the Western humanities, both in terms of influence and in terms of Europeans' perceptions of Asians as the exotic "other." We will explore various aspects of this interaction in Volume Two.

Glossary

Italics are used within the definitions to indicate terms that are themselves defined elsewhere in the glossary and, in a few cases, to distinguish titles of works or foreign words.

ABA Form MUSIC: A particular organization of parts used in a musical *composition* in which there are three units, the first and third of which are the same. See *Da capo aria*.

Abbey Religious body governed by an abbot or abbess, or the collection of buildings themselves, also called a monastery.

Absolutism The theory that all political power in a society is derived from one authority, normally a monarch.

Abstract VISUAL ARTS: Not representational or *illusionistic*. Describes painting or sculpture that simplifies or distills figures from the material world into *forms*, lines, *colors*.

Affect MUSIC: The production of emotional reactions in the listener by certain musical sounds, according to a theory from the baroque period. For example, sorrow should be characterized by slow-moving music, hatred by very repulsive harmonies.

African Survival A specific form or function of an institution, ritual, belief, language, or art that is clearly identifiable with an African origin, although adapted to the situation of African descendants in the New World.

Allegory LITERATURE, VISUAL ARTS: The technique of making concrete things, animals, or persons represent abstract ideas or morals. A literary allegory usually takes the form of a *narrative* which may be read on at least two levels; for example, Dante's *Divine Comedy*. Medieval sculptures often have allegorical significance.

Altarpiece VISUAL ARTS: A painted or sculptured decoration on canvas or panels placed behind or above an altar.

Ambulatory ARCHITECTURE: A covered passageway for walking. In a church, the semicircular passage around the main altar.

Anaphora (ah-na'fo-rah) LITERATURE: A rhetorical figure which uses the repetition of the same word or phrase to introduce two or more clauses or lines of verse.

Animism The belief that parts of nature, such as water, trees, etc., have souls and can influence human events. The term is used by Westerners to describe African religions.

Antiphon MUSIC: In Gregorian chant, a short text from the Scriptures or elsewhere set to music in a simple *style*, and sung before and after a Psalm or a canticle.

Antiphonal MUSIC: See *Antiphony*.

Antiphony (an-ti'fo-ny) MUSIC: The sound produced by *choirs* or instruments "answering" one another. For instance, one choir will sing, and then it is "answered" by another choir.

Antithesis LITERATURE: The balance of parallel word groups conveying opposing ideas.

Apse (aap'ss) ARCHITECTURE: A large semicircular or polygonal *niche*, *domed* or *vaulted*. In a Roman *basilica* the apse was placed at one or both ends or sides of the building. In a Christian church it is usually placed at the east end of the *nave* beyond the *choir*.

Arcade ARCHITECTURE: A covered walk made of *arches* on *piers* or *columns*, rather than *lintels*.

Arch ARCHITECTURE: 1. Commonly, any curved structural member that is used to span an opening. 2. Specifically, restricted to the spanning members of a curved opening that are constructed of wedge-shaped stones called *voussoirs*. Arches may be of many shapes, basically round or pointed. See Roman Architecture (Ch. 7) and Gothic Architecture (Ch. 10).

Archaic 1. Obsolete. 2. In its formative or early stages.

Architrave (ahr'kuh-trave) ARCHITECTURE: A *beam* that rests directly on the *columns*; the lowest part of the *entablature*.

Aria (ah'ree-ah) MUSIC: An elaborate *composition* for solo voice with instrumental accompaniment.

Aristocracy Form of government from Greek word meaning "rule by the few for the common good."

Arpeggiated MUSIC: Describes a rippling effect produced by playing the notes of a chord one after another instead of simultaneously. See *Chord*.

Asantehene (a-sahn'tee-hee-nee) The Akan term for the King of the Ashanti state.

Asc (ah-say') Yoruba word meaning power, authority, potential energy.

Atman Hindu word for self.

Atmospheric Perspective See *Perspective*.

Atonal MUSIC: Describes music written with an intentional disregard for a central keynote (or tonal center). This style of composition was developed after World War I by Arnold Schoenberg and his followers.

Aulos (ow'los) MUSIC: The most important wind instrument of the ancient Greeks. It is not a flute (as is often stated), but a shrill-sounding oboe. It originated in the Orient and was associated with the orgiastic rites of the god Dionysus.

Axis VISUAL ARTS: The imaginary line that can be passed through a building or a figure, around which the principal parts revolve. See *Balance*.

Balance VISUAL ARTS: The creation of an apparent equilibrium or *harmony* between all the parts of a *composition*, be it a building, painting, or sculpture.

Ballad A narrative poem or song in short stanzas, usually with a refrain, often handed down orally.

Balustrade ARCHITECTURE: A rail or handrail along the top edge of a roof or balcony, made up of a top horizontal rail, a bottom rail, and short *columns* between.

Baptistry ARCHITECTURE: The building or room for performing the rite of baptism. Contains a basin or pool.

Baroque Term first applied to the visual arts and later to the music and literature of the 17th and 18th centuries to designate a style characterized by energy, movement, realism, and violent contrasts. The baroque style is often set in opposition to the orderly and formal "classical" style of the High Renaissance.

Barrel Vault See *Vault*.

Base ARCHITECTURE: 1. The lowest visible part of a building. 2. The slab on which some *column* shafts rest. See *Orders.*

Basilica (bah-sil′i-cah) ARCHITECTURE: A large, rectangular hall with a central space surrounded by aisles on the sides and an *apse* at one or each end or side. The basilica was used as a court of justice by the Romans and adopted by the early Christians as a church.

Bay ARCHITECTURE: One of a series of regularly repeated spaces of a building marked off by vertical elements.

Beam ARCHITECTURE: A large piece of squared timber, long in proportion to its breadth and thickness, used for spanning spaces. A *lintel* is a specific kind of beam.

Blank Verse LITERATURE: Unrhymed lines in *iambic pentameter.* A common form for dramatic verse in English. See Shakespeare (Ch. 20).

Boss ARCHITECTURE: The circular *keystone* at the crossing of diagonal *ribs.* May be richly carved and decorated.

Brahman Hindu word for godhead. Also refers to the priestly class.

Buttress ARCHITECTURE: The vertical exterior mass of masonry built at right angles into the *wall* to strengthen it and to counteract the lateral *thrust* of a *vault* or arch. Architecture of the Gothic period developed this *form* into the flying buttress, which is a combination of the regular or *pier*-like buttress and the arched buttress. See *Chartres* (Ch. 10).

Cadence MUSIC: A formula or cliché that indicates a point of repose. The cadence is one of several possible melodic, rhythmic, or harmonic combinations that signal a slowing down or stopping of the forward motion.

Calligraphy The art of beautiful handwriting—important in Chinese poetry and painting.

Candace Title of the Queen Mother in Nubia.

Cantilever ARCHITECTURE: 1. A horizontally projecting member, sometimes called a bracket, used to carry the cornice or eaves of a building. 2. A beam or slab, projecting beyond the wall or supporting column, whose outward thrust or span is held down at one end only. See Robie House (Ch. 32).

Capital ARCHITECTURE: The uppermost or crowning member of a *column*, *pilaster*, or *pier* that forms the visual transition from the post to the *lintel* above. See *Orders.*

Caryatid (kahr′ee-ah-tid) ARCHITECTURE: The name given a *column* when it is disguised as a female figure.

Caste The term used to translate Hindu *jati*, a kinship and/or occupational group in Indian society.

Casting SCULPTURE: A method of reproducing sculpture through the use of a mold that is the receptacle for a liquid which hardens when cooled. The method may be used to produce solid or hollow cast *forms.*

Cathedral Principal church of a diocese, literally the location of the bishop's throne, or cathedra.

Cella ARCHITECTURE: The principal chamber of a Greek or Roman temple, housing the cult image.

Centering ARCHITECTURE: The temporary wooden *structure* that supports an *arch* or dome while it is being erected.

Chaitya ARCHITECTURE: Buddhist term for the hall of worship.

Chapel ARCHITECTURE: 1. A small church. 2. A separate compartment in a large church that has its own altar.

Choir ARCHITECTURE: The part of the church reserved for clergy and singers, usually the space between the crossing and the *apse.* MUSIC: A group of singers in a church.

Chord MUSIC: The simultaneous sounding of three or more usually harmonious *tones.*

Chordal MUSIC: Characterized by the employment of *chords* in a logical progression of harmonies.

Choreographer DANCE: Person responsible for the *choreography* of a dance.

Choreography DANCE: The design and arrangement of the movements of a ballet or modern dance.

Chromatic MUSIC: Describes a scale progressing by half-tones instead of the normal degrees of the scale; e.g., in C major: c-c#-d-d#-e instead of c-d-e. VISUAL ARTS: Refers to the visual spectrum of hues. See *Color.*

Cire Perdu (seer pehr-doo′) SCULPTURE: French expression meaning "lost wax." Technique for making bronze sculpture that involves molding wax over a clay mold, encasing it with another clay mold, heating the mold, then allowing the wax to drain out and replacing it with molten bronze.

Classic, Classical ALL ARTS: Recognized generally to be excellent, time-tested. LITERATURE AND VISUAL ARTS: 1. From ancient Greece or Rome. 2. From "classical" (fifth century B.C.) Greece or having properties such as *harmony*, *balance*, moderation and magnitude characteristic of art of that period. MUSIC The musical *style* of the late 18th century. Leading composers in the classical style are Haydn, Mozart, and the early Beethoven.

Clerestory (clear′story) ARCHITECTURE: An upper story in a building that carries windows or openings for the transmission of light to the space beneath.

Coda MUSIC: A passage of music added to the end of a piece to confirm an impression of finality.

Coffer, Coffering ARCHITECTURE: Originally a casket or box, later, a recessed ceiling panel. Coffering is a technique for making a ceiling of recessed panels.

Collage (kohl-lahzh′) VISUAL ARTS: From the French, *coller*, "to glue." A technique for creating *compositions* by pasting or in some way attaching a variety of materials or objects to a flat surface or canvas.

Colonnade ARCHITECTURE: A series of regularly spaced *columns* supporting a *lintel* or *entablature.*

Color VISUAL ARTS: A quality perceived in objects by the human eye that derives from the length of the light waves reflected by individual surfaces. The visible spectrum is divided into six basic hues: red, orange, yellow, green, blue, and violet. Red, yellow and blue are called the *primary colors*; the others, which result from mixing adjacent primary colors, are called *secondary colors.* White, black, and grays result from mixing these six hues and are not *chromatic*: they cannot be distinguished by hue, only by value. Value is the property of a color that distinguishes it as light or dark. Colors that are "high" in value are light colors; those that are "low" in value are dark colors. Adding white to a color will raise its value to make a *tint*; adding black to a color will lower its value to make a *shade.* Saturation is the property of a color by which its vividness or purity is distinguished. See also *Complementary Colors, Cool Colors, Warm Colors.*

Column ARCHITECTURE: A cylindrical, upright post or pillar. It may contain three parts: *base*, shaft, and *capital.*

Comedy LITERATURE: A drama that ends happily, intended to provoke laughter from its audience. Comedy often includes *satire* on types of characters or societies.

Complementary Colors VISUAL ARTS: Hues that form a neutral gray when mixed but, when juxtaposed, form a sharp contrast. The complementary of any *primary color* (red, yel-

low, or blue) is made by mixing the other two primaries. Example: The complementary of red is green, obtained by mixing yellow with blue.

Composition VISUAL ARTS: The arrangements of elements within the work in order to create a certain effect based on a variety of principles and conventions: e.g., *balance, color, contour, focal point,* proportion, scale, *symmetry, volume.* MUSIC: The putting together of elements such as *melody, harmony, rhythm,* and orchestration into a musical *form.* The term may be used similarly to denote a putting together of elements in a dance or film. LITERATURE The act of composing an oral or written work.

Compound Pier ARCHITECTURE: A *pier* or post made up of attached *columns.* See *Chartres* (Ch. 10).

Concerto (con-chair'toe) MUSIC: A composition for one or more solo instruments and an orchestra, each competing with the other on an equal basis.

Content ALL ARTS: What the *form* contains and means. Content may include subject matter and theme. The quality of a work of art is often judged by the appropriateness, or apparent inseparability, of form and content.

Continuo MUSIC: In the scores of baroque composers (Bach, Handel) the bass part, performed by the harpsichord or organ, together with a viola da gamba or cello. The continuo, during the baroque era, provided the harmonic structure of the pieces being performed.

Contour PAINTING, DRAWING: The visible edge or outline of an object, *form* or shape, used especially to suggest volume or mass by means of the distinctness, thickness, or color of the edge or line.

Contrapuntal (con-tra-pun'tal) MUSIC: In a *style* that employs *counterpoint.*

Cool Colors VISUAL ARTS: Blues, greens, and associated hues. Cool colors will appear to recede from the viewer in a picture, while *warm colors* will tend to project.

Cornice ARCHITECTURE: 1. The horizontal projection that finishes the top of a *wall.* 2. In classical architecture, the third or uppermost horizontal section of an *entablature.* See *Orders.*

Counterpoint MUSIC: Music consisting of two or more *melodies* played simultaneously. The term is practically synonymous with *polyphony.*

Couplet LITERATURE: Two lines of poetry together, of the same meter and rhyme.

Crossing In a church, the intersection of the *nave* and *transept* in front of the *apse.*

Cuneiform Writing system used in Mesopotamia, based on wedge shapes.

Da Capo Aria (dah cah'poh ahr'ee-ah) MUSIC: A particular type of *aria* that developed in the baroque period (17th and 18th centuries). It consists of two sections, the first of which is repeated after the second. The result is the *ABA form.* See *Aria, ABA Form.*

Deduction PHILOSOPHY: Reasoning from a general principle to a specific fact or case, or from a premise to a logical conclusion.

Democracy From the Greek word meaning "rule by the people." A form of government in which the electorate is coincident with the adult population (sometimes only the adult males) of a community.

Demotic The most simplified, "popular" Egyptian writing system.

Despotism Government by a ruler with unlimited powers.

Dharma Hindu term for one's role in life, determined by class and *caste.*

Dialectic PHILOSOPHY: 1. Platonic—A method of logical examination of beliefs, proceeding by question and answer. 2. Hegelian and Marxian—A logical method that proceeds by the contradiction of opposites (thesis, antithesis) to their resolution in a synthesis.

Dome ARCHITECTURE: A curved or hemispherical roof structure spanning a space and resting on a curved, circular, or polygonal *base.* Theoretically, a dome is an *arch* rotated 360 degrees around a central *axis.* See *Pantheon* (Ch. 7).

Drapery SCULPTURE: The clothing of a figure or *form* in a usually nonspecific but *tactile* and responsive material.

Drum ARCHITECTURE: The cylindrical or polygonal *structure* that rises above the body of a building to support a *dome.*

Duration MUSIC: The time-value assigned to a musical note; that is, how long it is to be played or sung.

Dynamics MUSIC: Words or signs that indicate the varying degrees of loudness in the music. For instance, *forte* (loud), *piano* (soft, quiet), *diminuendo* (decrease volume gradually).

Ego In Freudian theory, one of the three parts of the mind. The ego is the conscious, controlling, self-directed part.

Egungun (eh-goon-goon) Yoruba masqueraders concerned with mediating between the community of the living and that of the recently dead.

Elevation ARCHITECTURE: 1. Generally, a term that refers to one of the sides of a building. 2. Specifically, a drawing or graphic representation showing one face or side of a building. It can be of the interior or exterior.

Empiricism PHILOSOPHY: The theory that knowledge is derived from observation of nature and by experiment.

Entablature ARCHITECTURE: The upper section of a classical *order* resting on the capitals of the columns and including architrave, frieze, *cornice,* and pediment.

Epic LITERATURE: A long *narrative* poem that recounts an event of importance in a culture's history and presents a hero of that culture. See section on Homer (Ch. 3).

Episode LITERATURE: In Greek tragedy, a section of action between two choruses. In drama and fiction generally, a group of events having unity in itself. A story is created from a series of related episodes. A fiction is said to be episodic if the episodes fall into no logical relationship.

Epithet LITERATURE: A short phrase used to modify a noun by pointing out a salient characteristic. Epithets (e.g., Homer's "swift-footed Achilles") are often used in epic poetry.

Eros In Greek mythology, son of Aphrodite and god of sexual love, called "Cupid" by the Romans.

Ethics PHILOSOPHY: The branch of philosophy dealing with problems of good and bad, right and wrong, in human conduct.

Façade (fa-sahd') ARCHITECTURE: A face of a building.

Fetish Statue or other object believed to embody supernatural power.

Figurative VISUAL ARTS: Describes painting or sculpture in which the human body and the objects of habitual visual experience are clearly recognizable in the work.

Fluting ARCHITECTURE: The grooves or channels, usually parallel, that decorate the shafts of *columns.* Fluting may run up and down a shaft or around the shaft in various directions.

Focal Point VISUAL ARTS: The place of major or dominant interest on which the eyes repeatedly focus in a painting, drawing, or architectural arrangement.

Foreshortening PAINTING: The method of representing objects or parts of objects as if seen from an angle so that the object seems to recede into space instead of being seen in a frontal or profile view. The technique is based on the principle of continuous diminution in size along the length of the object or figure. See *Perspective* and *Vanishing Point*.

Form ALL ARTS: The arrangement or organization of the elements of a work of art in space (visual arts) or time (literary, musical, performing arts). A form may be conventional or imposed by tradition (the Greek temple, the sonnet, the sonata, the five-act play) or original with the artist. In the latter case, form is said to follow from, or adapt itself to, *content*.

Free Verse LITERATURE: Poetic lines with no conventional meter or rhyme.

Fresco PAINTING: The technique of making a painting on new, wet plaster. Fresco painting was particularly favored in Italy from Roman times until the eighteenth century. See Ch. 18.

Frieze ARCHITECTURE: 1. Middle horizontal element of the classical *entablature*. See *Orders*. 2. A decorative band near the top of an interior wall that is below the *cornice* molding.

Frontality (adj. frontally) Artistic device used by the Egyptians whereby part of the body appears frontally and part in profile.

Fugal MUSIC: Characteristic of the *fugue*.

Fugue (fewg) MUSIC: A *composition* based on a *theme* (known as the *subject*) that is stated at the beginning in one voice part alone and is then restated by the other voice parts in succession. The theme reappears at various places throughout the composition in one voice part or another in combination with forms of itself.

Gable ARCHITECTURE: The triangular space at the end of a building formed by the slopes of a pitched roof, extending from the *cornice* or eaves to the *ridge*. In classical architecture the gable is called a *pediment*.

Gallery ARCHITECTURE: A long, covered area, usually elevated, that acts as a passageway on the inside or exterior of a building.

Genre (john'ruh) LITERATURE: A literary type or form. Genres include *tragedy*, *comedy*, *epic*, *lyric*, *novel*, short story, essay.

Greco-Roman Belonging to the cultures of ancient Greece and Rome.

Grid VISUAL ARTS: A pattern of vertical and horizontal lines forming squares of uniform size on a chart, map, drawing, etc.

Griot (gree-oh') African oral poet, musician, and historian.

Groin Vault See *Vault*.

Ground Plan ARCHITECTURE: A drawing of a horizontal *section* of a building that shows the arrangement of the *walls*, windows, supports and other elements. A ground plan is used to produce blueprints.

Ground Plane PAINTING: In a picture, the surface, apparently receding into the distance, on which the figures seem to stand. It is sometimes thought of as comparable to a kind of stage space.

Harmonic Modulation MUSIC: The change of key within a composition. Modulations are accomplished by means of a *chord* (or chords) common to the old key as well as the new one.

Harmony MUSIC: The chordal structure of music familiar to most Western listeners in the pleasing or appropriate sounds of the accompaniment of popular songs by guitars, keyboards, or bands.

Hebraic Belonging to the Hebrews, Jews, or Israelites. Refers primarily to the culture of the ancient Hebrews of biblical times.

Hebraism Hebrew culture, thought, institutions.

Hellenic Greek. Usually refers to the "classical" period of Greek culture; i.e., the fifth and fourth centuries B.C.

Hellenism The culture of ancient Greece.

Hellenistic Literally, "Greek-like." Refers to Greek history and artistic style from the third century B.C.

Hieratic Egyptian writing system; a simplified cursive form of hieroglyphics. See *Hieroglyphic*.

Hieroglyphic Egyptian writing system, originally based on pictures.

Homophonic (hawm-o-fon'ic) Characteristic of *homophony*.

Homophony (hoh-maw'foh-nee) MUSIC: A single *melody* line supported by its accompanying *chords* and/or voice parts. See *Monophony*, *Polyphony*, *Chord*, and *Texture*.

Hubris (hyoo'bris) A Greek word meaning arrogance or excessive pride.

Hue See *Color*.

Hyperbole (high-purr'boh-lee) LITERATURE: A figure of speech that uses obvious exaggeration.

Iamb (eye'amb) LITERATURE: A metrical "foot" consisting of one short (or unaccented) syllable and one long (or accented) syllable. Example: hĕllō.

Iambic Pentameter (eye-am'bic pen-tam'eh-ter) LITERATURE: The most common metrical line in English verse, consisting of five *iambs*. Example, from Shakespeare: "Shăll Ī cŏmparē theĕ tō ă sūmmĕr's dāy?"

Id In Freudian theory, one of the three parts of the mind. The id is the instinctive, non-controlled part.

Ideograph Sign depicting an abstract idea in Chinese writing.

Ifa (ee'fah) A Yoruba system of divination in which a priest advises his clients of proper courses of behavior based upon the casting of palm kernels and the interpretation of poems chosen for their numerical links to the patterns of thrown kernels.

Illusionism VISUAL ARTS: The attempt by artists to create the illusion of reality in their work. Illusionism may also be called realism. It is important to remember that illusionism is not the motivating intention of all works of art.

Image ALL ARTS: The representation of sense impressions to the imagination. Images are a fundamental part of the language of art. They differ from the abstract terminology of science and philosophy in that they are a means whereby complex emotional experience is communicated. Images may be tactile, auditory, olfactory, etc., but the word is ordinarily used for visual impressions.

Imagery LITERATURE: Patterns of images in a specific work or in the entire works of an author. May refer to a specific type (animal imagery, garden imagery). VISUAL ARTS: The objects, *forms* or shapes depicted by the artist in a particular work.

Impasto (em-pah'stoh) PAINTING: Paint that has the consistency of thick paste, used for bright highlights or to suggest *texture*. Examples: Rembrandt and Van Gogh.

Improvisation MUSIC: The art of performing spontaneously rather than recreating written music.

Induction PHILOSOPHY: Reasoning from particular facts or cases to a general conclusion.

Inflection MUSIC: The shaping or changing of a musical passage in a way that is unique to the individual performer of the music.

Initiation Ceremonies or rites by which a young person is brought into manhood or womanhood, or an older person is made a member of a secret society, brotherhood, etc.

Inquisition A former tribunal in the Roman Catholic Church directed at the suppression of heresy.

Irony LITERATURE: A manner of speaking by which the author says the opposite of what he means, characteristically using words of praise to imply scorn. Dramatic or tragic irony means that the audience is aware of truths which the character speaking does not understand.

Iwi (ee'wee) Yoruba poems sung by *Egungun* masqueraders.

Jamb ARCHITECTURE: A vertical member at either side of a door frame or window frame. When sculpture is attached to this member it is called a jamb sculpture or jamb figure. See *Chartres* (Ch. 10).

Karma Hindu term for the accumulated record of the many lives an individual has led through *reincarnation*.

Kente (ken'teh) Large ceremonial cloth from Ghana made of narrow strips sewn together and distinguished by elaborate, multicolored geometric designs of silk.

Keystone ARCHITECTURE: The central wedge-shaped stone of an *arch* that locks together the others.

Komos Greek word for a revel. Root of the word *comedy*.

Kouros (koo'rohs), **Kore** (koh'ray) SCULPTURE: Greek for a male nude votive figure, female votive figure.

Labarai (lah-bah-rye') Hausa tales told by old men, involving cultural, family, and group history.

Lantern ARCHITECTURE: The windowed turret or tower-like form that crowns a *dome* or roof.

Libretto (lih-bret'toe) MUSIC: The text of an opera, *oratorio*, or other dramatic musical work.

Linear Perspective See *Perspective*.

Lintel ARCHITECTURE: The horizontal member or *beam* that spans an opening between two upright members, or posts, over a window, door, or similar opening.

Lyric LITERATURE: A short poem or song characterized by personal feeling and intense emotional expression. Originally, in Greece, lyrics were accompanied by the music of a lyre.

Matrilineal System of descent in which inheritance of goods, access to land, and group leadership pass to the children through the family of the mother.

Medium (pl. media) ALL ARTS: 1. The material or materials with which the artist works. Examples from VISUAL ARTS: paint, stone, wood, bronze, plaster, concrete. MUSIC: sound. LITERATURE: language. CINEMA: film. DANCE: human body. DRAMA: language, costume, lighting, actors, sound, etc. 2. Modern means of communication (television, radio, newspapers). 3. PAINTING: A substance such as oil, egg, or water with which *pigment* is mixed.

Melodic Elaboration MUSIC: The ornamentation of *melody* by one or more of a number of possible musical devices, such as added notes, interval changes, etc.

Melody MUSIC: A succession of musical *tones*. Often the melody is known as the "tune," and is not to be confused with the other accompanying parts of a song. See *Homophony*.

Metaphor LITERATURE: A figure of speech that states or implies an analogy between two objects or between an object and a mental or emotional state. Example: "My days are in the yellow leaf;/The flowers and fruits of love are gone" (Byron) makes an analogy between the poet's life and the seasonal changes of a tree.

Metaphorical Describing statements or representations to be taken as analogy, not to be taken literally.

Meter POETRY: A regularly recurring rhythmic pattern. Meter in English is most commonly measured by accents, or stresses, and syllables. The most common metric "foot" in English is the *iamb*. The most common verse line is the *iambic pentameter* (five iambs). MUSIC: A pattern of fixed temporal units. For example, ¾ meter means one beat to a quarter note and three beats to a measure. In a musical *composition* meter is the basic grouping of notes in time.

Metope (meh'toh-pay) ARCHITECTURE: The blank space of block between the *triglyphs* in the Doric *frieze*, sometimes sculpted in low *relief*. See *Orders*.

Modal MUSIC: Describes a type of music conforming to the scale patterns of the medieval Church *modes*. See *Modes*.

Modeling VISUAL ARTS: 1. The creation of a three-dimensional *form* in clay or other responsive material, such as wax, soap, soft bone, ivory, etc. 2. By analogy, in painting and drawing, the process of suggesting a three-dimensional *form* by the creation of *shade* and shadow.

Modernism Generic name given to a variety of movements in all the arts, beginning in the early 20th century. Promotes a subjective or inner view of reality and uses diverse experimental techniques.

Modes MUSIC: Melodic scales used for church music of the Middle Ages. The modes are organized according to *pitches* similar to our modern major and minor scales, yet different enough to set them apart from the modern scales.

Molding ARCHITECTURE: A member used in construction or decoration that produces a variety in edges or contours by virtue of its curved surface.

Monastery The dwelling place of a community of monks. See *Abbey*.

Monasticism A way of life assumed by those who voluntarily separate themselves from the world to contemplate divine nature. See *Monastery*.

Monophonic (mo-no-fohn'ic) Characteristic of *monophony*.

Monophony (mo-nof'o-nee) MUSIC: A simple *melody* without additional parts of accompaniment, such as the music of a flute playing alone or of a woman singing by herself. See *Homophony*, *Polyphony*, *Texture*.

Mosaic VISUAL ARTS: A *form* of surface decoration made by inlaying small pieces of glass, tile, enamel, or varicolored stones in a cement or plaster matrix or ground.

Motet (moh-tette') MUSIC: Usually an unaccompanied choral composition based on a Latin sacred text. The motet was one of the most important forms of *polyphonic* composition from the thirteenth through the seventeenth centuries.

Motif (moh-teef'), **Motive** (moh-teev') LITERATURE: A basic element that recurs, and may serve as a kind of foundation, in a long poem, fiction, or drama. A young woman awakened by love is the motif of many tales, such as *Sleeping Beauty*. VISUAL ARTS: An element of design repeated and developed in a painting, sculpture, or building. MUSIC: A

recurring melodic phrase, sometimes used as a basis for variation.

Mural PAINTING: Large painting in oil, fresco, or other *medium* made for a particular *wall*, ceiling, or similar large surface.

Myth Stories developed anonymously within a culture that attempt to explain natural events from a supernatural or religious point of view.

Mythology The body of myths from a particular cultural group.

Naos (nah'ohs) ARCHITECTURE: Greek word for the *cella* or main body of a Greek temple.

Narrative LITERATURE: 1. (noun) Any *form* that tells a story or recounts a sequence of events (*novel, tale,* essay, article, film). 2. (adj.) In story form, recounting.

Narthex ARCHITECTURE: The entrance hall or porch that stands before the *nave* of a church.

Naturalism LITERATURE, VISUAL ARTS: Faithful adherence to the appearance of nature or outer reality.

Nave ARCHITECTURE: In Roman architecture, the central space of a *basilica*; in Christian architecture, the central longitudinal or circular space in the church, bounded by aisles.

Nave Arcade ARCHITECTURE: The open passageway or screen between the central space and the *side aisles* in a church.

Nemesis (neh'ma-sis) Greek goddess of Fate. Word means retribution, punishment.

Neoclassicism ALL ARTS: A movement that flourished in Europe and America in the late seventeenth and eighteenth centuries, heavily influenced by the classical style of Greece and Rome. Neoclassical art and literature is characterized by sobriety, balance, logic, and restraint. The corresponding musical style (18th century) is usually called *classical*.

Neolithic The stage in the evolution of human societies when peoples began systematic cultivation and the domestication of animals.

Niche (nish) ARCHITECTURE: A semicircular or similarly shaped recess in a wall designed to contain sculpture, an urn, or other object. It is usually covered by a half*dome*.

Nirvana Hindu and Buddhist term for ultimate blissful peace.

Nonobjective VISUAL ARTS: Not representing objects in the material world.

Novel LITERATURE: A lengthy prose narrative, traditionally spanning a broad period of time, containing a plot and developing characters. The modern European novel took form in the eighteenth century.

Oba Name for the chief ruler of Benin.

Oculus (ock'you-luhs) ARCHITECTURE: Circular opening at the crown of a *dome*. See *Pantheon* (Ch. 7).

Odu (oh'doo) A secret body of poetry used in the Yoruba *Ifa* divination process.

Oil Painting The practice of painting by using *pigments* suspended in oil (walnut, linseed, etc.).

Oligarchy (oh'lih-gar-key) Greek work meaning "rule by the few." Rule by the few where the state is primarily utilized to serve the interest of the governors. Traditionally contrasted with *aristocracy*, rule by the few for the common good.

Olorun (oh-low'roon), **Oludumare** (oh-loo-doo-mah'ray) The Yoruba term for the supreme high deity.

Open Fifths MUSIC: *Chords*, normally made of three sounds, with the middle *pitch* absent.

Oratorio MUSIC: An extended musical setting for solo voices, chorus, and orchestra, of a religious or contemplative nature. An oratorio is performed in a concert hall or church, without scenery, costumes, or physical action. One of the greatest examples is Handel's *Messiah*.

Orchestration MUSIC: Orchestration is the art of writing music for the instruments of the orchestra that will bring out desired effects of the various instruments. Indeed, it is the art of "blending" the voices of the orchestra so that a pleasing sound is the end result.

Orders ARCHITECTURE: Types of *columns* with *entablatures* developed in classical Greece. The orders are basically three: Doric, Ionic, and Corinthian. They determine not only the scale and therefore dimensions of a temple but also the experience generated by the building, or its *style*. See section on Greek Architecture and diagram of the orders (Ch. 4).

Oriki (ohr-ee'key) Yoruba term meaning praise poems based on names given to gods, places, rulers, and important persons.

Orisha (ohr-ee'sha) In Yoruba religion, lesser gods (below the chief god) and sometimes ancestor figures, ancient kings, and founders of cities who have been deified.

Ostinato (aw-stee-nah'toe) MUSIC: Italian for obstinate or stubborn; the persistent repetition of a clearly defined *melody*, usually in the same voice. This device is often used in a bass part to organize a *composition* for successive variations.

Oxymoron (ock-see-mohr'on) LITERATURE: A figure of speech that brings together two contradictory terms, such as "sweet sorrow."

Palazzo (pa-laht'so) ARCHITECTURE: Italian for palace, or large, impressive building.

Palladian ARCHITECTURE: Designating the Renaissance architectural style of Andrea Palladio.

Panel Painting A painting made on a ground or panel of wood, as distinguished from a *fresco* or a painting on canvas.

Parapet ARCHITECTURE: In an exterior *wall*, the part entirely above the roof. The term may also describe a low wall that acts as a guard at a sudden edge or drop, as on the edge of a roof, battlement, or wall.

Parody LITERATURE: A work that exaggerates or burlesques another, serious one. Often a parody pokes fun at an author and his style. The parody may be compared to a visual caricature or cartoon.

Pathos (pay'thaws) ALL ARTS: A quality that sets off deep feeling or compassion in the spectator or reader.

Patrilineal System of descent in which inheritance of goods, access to land, and group leadership passes to the children through the family of the father.

Pediment ARCHITECTURE: In classical architecture the triangular space at the end of a roof formed by the sloping ridges of the roof. The pediment was often filled with decoration which could be painted or sculpted or both.

Pentatonic Scale MUSIC: Five-note scale that occurs in the music of nearly all ancient cultures. It is common in West African music and is found in jazz.

Perspective VISUAL ARTS: Generally, the representation of three-dimensional objects in space on a two-dimensional surface. There are a variety of means to achieve this. The most familiar is that of "linear perspective" developed

in the fifteenth century and codified by Brunelleschi, in which all parallel lines and edges of surfaces recede at the same angle and are drawn, on the picture plane, to converge at a single *vanishing point*. The process of diminution in size of objects with respect to location is very regular and precise. Other techniques, often used in combination with linear perspective, include: (a) vertical perspective—objects further from the observer are shown higher up on the picture, (b) diagonal perspective—objects are not only higher but aligned along an oblique *axis* producing the sensation of continuous recession, (c) overlapping, (d) *foreshortening*, (e) *modeling*, (f) *shadows*, and (g) atmospheric perspective, the use of conventions such as blurring of outlines, alternation of hue toward blue, and decrease of *color* saturation.

Philosophe (fee-low-soph') Eighteenth-century French intellectual and writer; not usually a systematic philosopher.

Phrase MUSIC: A natural division of the *melody*; in a manner of speaking, a musical "sentence."

Picture Plane PAINTING: The surface on which the picture is painted.

Picture Space PAINTING: The space that extends behind or beyond the picture plane; created by devices such as *linear perspective*. Picture space is usually described by foreground, middleground, and background.

Pier ARCHITECTURE: A *column*, post, or similar member designed to carry a great load; may also refer to a thickened vertical mass within the *wall* designed to provide additional support.

Pigment PAINTING: The grains or powder that give a *medium* its *color*. Can be derived from a variety of sources: clays, stones, metals, shells, animal and vegetable matter.

Pilaster (pih'lass-ter) ARCHITECTURE: A flattened engaged *column* or *pier* that may have a *capital* and *base*. It may be purely decorative or it may reinforce a *wall*.

Pitch MUSIC: A technical term identifying a single musical sound, taking into consideration the frequency of its fundamental vibrations. Some songs, or instruments, are pitched high and others are pitched low.

Plan See *Ground Plan*.

Plane A flat surface.

Plasticity VISUAL ARTS: The quality of roundness, palpability, solidity, or three-dimensionality of a *form*.

Plinth A block or slab on which a statue, pedestal, or column is placed, and, by extension, the base on which a building rests or appears to rest.

Podium ARCHITECTURE: The high platform or *base* of a Roman temple, or any elevated platform.

Polis (poh'liss) The ancient Greek city-state.

Polyphonic (paul-ee-fon'ick) Characteristic of *polyphony*.

Polyphony (paul-if'o-nee) MUSIC: Describes *composition* or *improvisations* in which more than one *melody* sounds simultaneously—that is, two or more tunes at the same time. Polyphony is characterized by the combining of a number of individual melodies into a harmonizing and agreeable whole. See *Homophony, Monophony,* and *Texture*.

Portico ARCHITECTURE: Porch or covered walk consisting of a roof supported by *columns*.

Post-and-Lintel ARCHITECTURE: An essential system of building characterized by the use of uprights—posts—which support horizontal *beams—lintels*—in order to span spaces. Used as supports for a window or door, the posts are the *jambs* and the *lintel* is the window head.

Primary Colors Red, Yellow, Blue—the three primary hues of the spectrum. See *Color*.

Pronaos (pro'nah-ohs) ARCHITECTURE: In classical architecture, the inner *portico* or room in front of the *naos* or *cella*.

Prose LITERATURE: Generally, may mean any kind of discourse, written or spoken, which cannot be classified as poetry. More specifically, prose refers to written expression characterized by logical, grammatical order, *style*, and even *rhythm* (but not *meter*).

Proverb A saying that succinctly and effectively expresses a truth recognized by a community or a wise observation about life. Proverbs are most often transmitted orally.

Rasa LITERATURE: Sanskrit term for emotion evoked through poetic meter and sound effects.

Rationalism PHILOSOPHY: The theory that general principles are essentially deductive; i.e., deducible from an examination of human reason. Reason, not the senses, is the ultimate source of basic truths.

Realism LITERATURE, VISUAL ARTS: A movement which began in the mid-nineteenth century and which holds that art should be a faithful reproduction of reality and that artists should deal with contemporary people and their everyday experience.

Recitative (reh-see-tah-teev') MUSIC: A vocal style used to introduce ideas and persons in the musical *composition*, or to relate a given amount of information within a short period of time. The recitative has practically no melodic value. This device is employed extensively in Handel's *Messiah*.

Reincarnation Hindu belief that the soul progresses through a cycle of deaths and rebirths until it ultimately attains peace.

Relief Sculpture Sculpture that is not freestanding but projects from a surface of which it is a part. A slight projection is called low relief (bas-relief); a more pronounced projection, high relief.

Republic A form of government in which ultimate power resides in the hands of a fairly large number of people but not necessarily the entire community. This power is exercised through representatives. The word derives from Latin meaning "public thing."

Response MUSIC: A solo-chorus relationship in which the soloist alternates performance with the chorus. The response is a particularly noteworthy device in traditional African music as well as in Gregorian chant.

Responsorial MUSIC: Describing the performance of a chant in alternation between a soloist and a chorus. (It is unlike antiphonal music, where alternating choruses sing.)

Rhythm ALL ARTS: An overall sense of systematic movement. In music, poetry, and dance this movement may be literally felt; in the visual arts it refers to the regular repetition of a *form*, conveying a sense of movement by the contrast between a form and its interval.

Rib ARCHITECTURE: Generally a curved structural member that supports any curved shape or panel.

Ribbed Vault ARCHITECTURE: A *vault* whose sections seem to be supported or are supported by slender, curved structural members that also define the sections of the vault. The ribs may run either transversely, that is from side to side, or diagonally, from corner to corner of the vault.

Riddle A form of popular, usually oral, literature that asks an answer to a veiled question. Riddles often make use of striking *images* and *metaphors*.

Ridge ARCHITECTURE: The line defined by the meeting of the two sides of a sloping roof.

Romance LITERATURE: A long narrative in a *Romance language*, presenting chivalrous ideals, heroes involved in adventures, and love affairs from medieval legends.

Romance Language One of the languages that developed from popular Latin speech during the Middle Ages, and that exist now as French, Italian, Spanish, Portuguese, Catalan, Provençal, Romanic, and Rumanian.

Romanesque An artistic movement of the eleventh and twelfth centuries, primarily in architecture. The name comes from similarities with Roman architecture.

Romanticism A movement in all of the arts as well as in philosophy, religion, and politics that spread throughout Europe and America in the early nineteenth century. The romantics revolted against the Neoclassical emphasis on order and reason and substituted an inclination for nature and imagination. See Ch. 27.

Rose Window ARCHITECTURE: The round ornamental window frequently found over the entrances of Gothic cathedrals.

Sarcophagus (sahr-cough′a-gus) A large stone coffin. It may be elaborately carved and decorated.

Satire A mode of expression that criticizes social institutions or human foibles humorously. The Romans invented the verse satire, but satire may appear in any literary *genre*, in visual art, in film, mime, and dance.

Satyr (say′ter) **Play** LITERATURE: A light, burlesque play given along with *tragedies* and *comedies* at the festival of Dionysus in ancient Athens.

Scholasticism PHILOSOPHY: A way of thought that attempted to reconcile Christian truth with truth established by natural reason. Originating in the early Middle Ages, it reached its height in the thirteenth century in response to the recovery of Aristotle's scientific and philosophical writings.

Secondary Colors See *Color*.

Section ARCHITECTURE: The drawing that represents a vertical slide through the interior or exterior of a building, showing the relation of floor to floor.

Shade PAINTING: A *color* mixed with black. Mixing a color with white produces a *tint*.

Shading VISUAL ARTS: The process of indicating by graphics or paint the change in *color* of an object when light falls on its surface revealing its three-dimensional qualities. Shading can be produced not only by a change of color, but also by the addition of black, brown, or gray, or by drawing techniques.

Shadow VISUAL ARTS: The *form* cast by an object in response to the direction of light.

Shed Roof ARCHITECTURE: A roof shape with only one sloping *plane*, such as the roof of a lean-to, or that over the *side aisle* in a Gothic or Romanesque church.

Side Aisle ARCHITECTURE: The aisles on either side of, and therefore parallel to, the *nave* in a Christian church or Roman *basilica*.

Simile (sim′eh-lee) LITERATURE: A type of *metaphor* which makes an explicit comparison. Example: "My love is like a red, red rose."

Sonata MUSIC: An important form of instrumental music in use from the baroque era to the present. It is a *composition* usually with three or four movements, each movement adhering to a pattern of contrasting tempos. Example: Allegro, Adagio, Scherzo, Allegro.

Sonnet LITERATURE: A *lyric* poem of fourteen lines, following one of several conventions. The two main types of sonnet are the Italian (Petrarchan) which divides the poem into octave (eight lines) and sestet (six lines) and the English (Shakespearean) which divides the poem into three quatrains of four lines each and a final rhyming couplet.

Span ARCHITECTURE: The interval between two posts, *arches*, *walls*, or other supports.

Stained Glass ARCHITECTURE: Glass to which a *color* is added during its molten state, or glass which is given a hue by firing or otherwise causing color to adhere to the glass.

Stela (stee′la) ARCHITECTURE: In classical Greece a stone upright or slab used commemoratively; it may mark a grave or record an offering or important event.

Stretto MUSIC: The repetition of a *theme (subject)* that has been collapsed by diminishing the time values of the notes. As a result, the listener is literally propelled to the dramatic end or climactic conclusion of the music. Handel used this *fugal* device effectively in the last chorus of his *Messiah*.

Structure ALL ARTS: The relationship of the parts to the whole in a work of art. A structure may be mechanical (division of a play into acts, a symphony into movements) or may be more concealed and based on such things as the inter-relationships of *images*, *themes*, *motifs*, *colors*, shapes. In a *narrative* the structure usually refers to the arrangement of the sequence of events. In architecture structure may refer either to the actual system of building or to the relationships between the elements of the system of building.

Stupa ARCHITECTURE: Buddhist term for a burial-like mound for holy relics.

Style ALL ARTS: Characteristics of *form* and technique that enable us to identify a particular work with a certain historical period, place, group, or individual. Painters in Florence in the 15th and 16th centuries used *perspective*, *color*, etc., in ways that allow us to identify a Renaissance style, but within that group we may distinguish the individual style of Leonardo from that of Raphael. The impressionist painters in France at the end of the nineteenth century used light and *color* in a particular way: a painting in which this technique is followed has an impressionistic style. But the use of certain *forms*, *colors*, design and *composition* enables us to distinguish within this group the style of Renoir from that of Monet. Afro-European *rhythms* and *improvisation* distinguish a jazz style, but within that general category are many schools of jazz or even different styles of one individual, such as Duke Ellington. Literary style is determined by choices of words, sentence *structure* and syntax *rhythm*, figurative language, rhetorical devices, etc. One may speak of an ornate, simple, formal, or colloquial style; of a period style such as *Neoclassical*, *romantic*, *realist*; or of an individual's style. Style is sometimes contrasted with *content*.

Stylization The reduction of visual characteristics of objects or persons to conventional, repeated ways of presentation, for instance, hair reduced to circles inscribed on the head, eyes represented as round openings, and leaves as flat circles. Compare *abstract*.

Subject ALL ARTS: What the work is about. The subject of the painting "Mont Ste Victoire" is that particular mountain; the subject of Richard Wright's *Native Son* is a young black man in Chicago. MUSIC: The *melody* used as the basis of a *contrapuntal composition* (e.g., the subject of a *fugue*).

Suite MUSIC: An important instrumental form of baroque music, consisting of a grouping of several dancelike movements, all in the same key.

Superego In Freudian theory, one of the three parts of the mind. The superego is the censuring faculty, replacing parents or other authorities.

Symbol VISUAL ARTS, LITERATURE: An *image* that suggests an idea, a spiritual or religious concept, or an emotion beyond itself. It differs from *metaphor* in that the term of comparison is not explicitly stated. Symbols may be conventional; i.e., have a culturally defined meaning such as the Christian cross or the Jewish star of David. Since the nineteenth century, symbols have tended to denote a variety or an ambiguity of meanings.

Symbolism 1. The use of symbol in any art. 2. A literary school which began in France in the late nineteenth century, characterized by the use of obscure or ambiguous *symbols*.

Symmetry VISUAL ARTS: The balance of proportions achieved by the repetition of parts on either side of a central *axis*. The two sides may be identical, in which case we can speak of bilateral symmetry.

Syncopation MUSIC: A rhythmic device characterized as a deliberate disturbance of a regularly recurring pulse. Accented offbeats or irregular *meter* changes are two means of achieving syncopation.

Tactile VISUAL ARTS, LITERATURE: Refers to the sense of touch. In the visual arts, tactile *values* are created by techniques and conventions that specifically stimulate the sense of touch in order to enhance suggestions of weight, *volume* (roundness), visual approximation, and therefore three-dimensionality. Writers may also create tactile effects, as in the description of cloth or skin.

Tale LITERATURE: A simple *narrative*, whose subject matter may be real or imaginary, and whose purpose is primarily to entertain. Tales may also make use of "morals" to instruct.

Tatsuniyoyi (taht-soon-yoh'yee) Hausa tales about animals and people told by old women to entertain and instruct young children.

Tempera (tehm'per-ah) PAINTING: Technique in which the *pigment* is suspended in egg, glue, or a similar soluble *medium*, like water. Tempera paint dries very quickly and does not blend easily, producing a matte (flat, nonreflective) surface, because, unlike *oil paint*, it is essentially an opaque medium.

Texture VISUAL ARTS: Surface quality (rough, smooth, grainy, etc.) LITERATURE: Elements such as *imagery*, sound patterns, etc. apart from the *subject* and *structure* of the work. MUSIC: The working relationship between the *melody* line and the other accompanying parts, or the characteristic "weaving" of a musical *composition*. There are three basic musical textures: *Monophonic* (a single line), *Homophonic* (a melody supported by *chords*), and *Polyphonic* (multiple melodic lines).

Thanatos Greek word for death. For Freud, the death-wish or death-force, opposed to Eros, the life force.

Theme VISUAL ARTS: A *color* or pattern taken as a subject for repetition and modification. Example: a piece of sculpture may have a cubical theme. MUSIC: A *melody* which constitutes the basis of variation and development. Example: "The Ode to Joy" song in the last movement of Beethoven's *Ninth Symphony*. LITERATURE AND PERFORMING ARTS: An emotion or idea that receives major attention in the work. A novel or film may contain several themes, such as love, war, death. A dance may be composed on the theme of struggle, joy, etc. Theme is sometimes used in this sense for visual arts and music as well.

Threnody (threh'no-dee) MUSIC: A song of lamentation, a very mournful song.

Through-Composed MUSIC: Describes a type of song in which new music is provided for each stanza. A through-composed song is thus unlike most modern hymns, folk, and popular songs, which use the same tune for each stanza.

Thrust ARCHITECTURE: The downward and outward pressure exerted by a *vault* or *dome* on the *walls* supporting it.

Timbre (taam'bruh) MUSIC: The quality of "color" of a particular musical *tone* produced by the various instruments. For instance, the very "nasal" sound of the oboe is markedly different from the very "pure" sound of the flute.

Tint VISUAL ARTS: The *color* achieved by adding white to a hue to raise its *value*, in contrast to a *shade*, which is a hue mixed with black to lower its value.

Tonal MUSIC: Organized around a pitch center. A tonal *composition* is one in which the *pitches* of all the various *chords* and *melodies* relate well to one another. Tonal music has a recognizable beginning, middle, and end. See *Chord, Melody, Pitch*.

Tonality MUSIC: The specific *tonal* organization of a composition.

Tone ALL ARTS: The creation of a mood or an emotional state. In painting, tone may refer specifically to the prevailing effect of a *color*. Thus, a painting may be said to have a silvery, bluish, light, or dark tone as well as a wistful, melancholy, or joyful tone. The term may also refer to *value* or *shade* (see *Color*). In literature, tone usually describes the prevailing attitude of an author toward his material, audience, or both. Thus a tone may be cynical, sentimental, satirical, etc. In music, "tone color" may be used as a synonym for *timbre*. Tone in music also means a sound of definite *pitch* and duration (as distinct from noise), the true building material of music. The notes on a written page of music are merely symbols that represent the tones that actually make the music.

Tornada (tore-nah'dah) MUSIC: In troubadour songs, a short stanza added at the end as a "send-off."

Tracery ARCHITECTURE: The curvilinear or rectilinear pattern of open stonework or wood that supports the glass or other transparent or translucent material in a window or similar opening. May also be used generally to refer to decorative patterns carved similarly on wood or stone.

Tragedy LITERATURE: A serious drama that recounts the events in the life of a great person which bring him or her from fortune to misfortune. Tragedies usually meditate on the relation between human beings and their destiny. Tragedies first developed in ancient Greece; other great periods of tragedy include Elizabethan England and France under Louis XIV. The word is sometimes used to describe a novel or story.

Transept ARCHITECTURE: The transverse portion of a church that crosses the central *axis* of the *nave* at right angles between the nave and *apse* to form a cross-shaped (cruciform) planned building.

Triglyph (try'glif) ARCHITECTURE: The block carved with three channels or grooves that alternates with the *metopes* is a classical Doric *frieze*. See *Orders*.

Triumphal Arch ARCHITECTURE: The monumental urban gateway, invented by the Romans, set up along a major street to commemorate important military successes. It may have one or three arched openings and is usually decorated with inscriptions, *reliefs*, and freestanding sculpture on the top.

Trope MUSIC: Lengthened musical passage or elaboration on the Mass used during the Middle Ages. LITERATURE: 1. Verbal amplification of the text of the Mass. 2. A figure of speech.

Troubadour A lyric poet and singer, including wandering minstrels, originating in Provence in the eleventh century and flourishing throughout southern France, northern Italy, and Eastern Spain during the twelfth and thirteenth centuries.

Truss ARCHITECTURE: Originally a wooden structural member composed of smaller, lighter pieces of wood joined to form rigid triangles and capable of spanning spaces by acting as a *beam*.

Tympanum (tihm′pah-nuhm) ARCHITECTURE: The triangular or similarly shaped space enclosed by an *arch* or *pediment*.

Tyranny In ancient Greece, meant "rule of the strong man." Historically, came to mean arbitrary rule of one, but generally taken to mean arbitrary political rule of any kind.

Value See *Color*.

Vanishing Point PAINTING: The point or points of convergence for all lines forming an angle to the *picture plane* in pictures constructed according to the principles of linear *perspective*.

Vault ARCHITECTURE: The covering or spanning of a space employing the principle of the *arch* and using masonry, brick, plaster, or similar malleable materials. The extension of an arch infinitely in one plane creates a barrel or tunnel vault. The intersection of two barrel vaults at right angles to each other produces a cross or groin vault. *Ribs* are sometimes placed along the intersections of a groin vault to produce a *ribbed vault*.

Veneer VISUAL ARTS: A thin layer of precious or valuable material glued or otherwise attached to the surface of another, less expensive, or less beautiful material. The Romans, for example, applied thin layers of marble to the concrete and rubble fill surfaces of their buildings to produce a more splendid effect. In this century, valuable woods like walnut or mahogany are applied as veneers to the surfaces of plywood.

Verisimilitude Literally, "true-seeming." LITERATURE: A doctrine prevalent in the *Neoclassical* period, which holds that elements in a story must be so arranged that they seem to be true or that they could actually occur. VISUAL ARTS: The effect of near-perfect emulation or reproduction of objects in the visual world. Not to be confused with *realism*.

Vernacular The common daily speech of the people; non-literary language. During the Middle Ages, any language that was not Latin.

Viewpoint The position or place from which the viewer looks at an object or the visual field.

Vihara ARCHITECTURE: Buddhist term for the monastic cell group.

Vizier A chief administrator.

Volume ARCHITECTURE: Refers to the void or solid three-dimensional quality of a space or *form* whether completely enclosed or created by the presence of forms which act as boundaries. Compare the "volume" of the *Parthenon* with the "volume" of the *Pantheon*.

Volute A spiral or scroll-like ornamental form, which may be used either as a purely decorative or as a supporting member in an architectural ensemble. The curvilinear portion of an Ionic capital is a volute, and by extension a portion of such a shape is a volute.

Voussoir (voo-swahr′) ARCHITECTURE: The wedge-shaped stone or masonry unit of an *arch*, wider at the top and tapering toward the bottom.

Wall ARCHITECTURE: A broad, substantial upright slab that acts as an enclosing *form* capable of supporting its own weight and the weight of *beams* or *arches* to span and enclose space.

Warm Colors VISUAL ARTS: The hues commonly associated with warmth—yellow, red, and orange. In *compositions* the warm colors tend to advance, in contrast to the *cool colors*, which tend to recede from the viewer.

Watercolor PAINTING: Technique using water as the *medium* for very fine *pigment*. Watercolor dries very fast and can be extremely transparent.

Yoga Hindu word meaning the yoke between body and soul. It refers to deep breathing exercises, meditation, and physical conditioning.

Ziggurat ARCHITECTURE: The Mesopotamian temple-tower.

Credits

Index